Larousse
Dictionary of
PAINTERS

Larousse Dictionary of PAINTERS

HAMLYN

Originally published as *le Larousse des grands peintres* under the direction of
Michel Laclotte, chief curator of painting at the Louvre Museum, Paris
© Copyright Librairie Larousse, 1976
© Copyright English text The Hamlyn Publishing Group 1981

Revised edition 1989

Published by The Hamlyn Publishing Group Limited
Michelin House, 81 Fulham Road, London SW3 6RB

ISBN 0 600 34035 X

Set in 9 on 9pt Monophoto Lasercomp Bembo (2 units of set reduced) by
Filmtype Services, Scarborough, North Yorkshire

Produced by Mandarin Offset
Printed and bound in Hong Kong

CONTENTS

INTRODUCTION

'Occasionally, in a way that transcends nature, a single person is marvellously endowed by heaven with beauty, grace and talent in such abundance that he leaves other men far behind; all his actions seem inspired, and indeed everything he does clearly comes from God rather than from human art. Everyone acknowledged that this was true of Leonardo da Vinci.'

These words were written more than 400 years ago by Giorgio Vasari, the first man to relate the story of the visual arts in post-medieval times. Vasari's *Lives of the Most Excellent Painters, Sculptors and Architects* is, like this book, composed of a number of short biographies and shares with it the premise that a knowledge of an artist's life is indispensable to the appreciation of his works. Of course, in Vasari's time man held a more mystical view of the artist and of humanity in general than in our own. It was scarcely doubted, then, that a man received his genius (or dullness) through the agency of God.

Our own century conceives of both God and the artist rather differently. God is no longer universally accepted as the creator of man, the first figurative artist, as he was by Vasari. Artists, similarly, have ceased to be heroes, superior to other men in a moral as well as in a technical sense. Nowadays we want to know not about 'inspiration' but hard facts about their training, the journeys they made, their friends, their enemies – every detail that can help us assess their character. This means that artists are now subjected to indignities as never before. Leonardo himself has, for example, been put on the analyst's couch. The dreams recorded in his notebooks have been carefully examined and the facts of his childhood scrutinized. In short, Leonardo has been psychoanalysed, as far as any man of his era can be. The results are recorded in Sigmund Freud's *Leonardo da Vinci: A psycho-sexual study of an infantile reminiscence* (first English translation, 1916).

Freud's psychoanalytic method is not the only technique that the scholars of the 20th century have employed to make the study of art more scientific. Infrared photography and X-radiography (also quite useful to medicine) are now complemented by infrared reflectography, so that the layers of a painting which are invisible to the naked eye can be studied. Dendrochronology enables us to examine the wood panel on which an old painting was made, and tells us when the tree from which the panel originated was felled. Gas chromatography helps us to discover whether a picture was painted in egg tempera or oil. The pigments used on any particular painting can be readily identified from microscopic samples.

All this tells us, however, considerably less about a painting than a few relevant facts about the man who painted it. The essential key to a work of art is still a knowledge of its creator's life and how his mind worked. Anyone who doubts this has never stood in front of the rhapsodic view of *Weymouth Bay* in the National Gallery, London, and rehearsed the circumstances of its creation. It was painted by John Constable on his honeymoon after what must have been one of the longest, most dismal and frustrating courtships in history. On the death of his father, whose disapproval had occasioned their distress, Maria Bicknall and Constable became free to marry, and *Weymouth Bay* chronicles their relief and joy.

Since the time of Constable, from Romanticism, say, to Abstract Expressionism and after, it has become normal to judge the painting according to the aims of the painter. To enjoy to the full the fantastic visions of the Douanier Rousseau, we need to know that he described himself as a 'realist'; and to truly sense the spirit of the jungles he created, we should be conscious that he got no deeper into the undergrowth than the tropical houses of the Jardin des Plantes in Paris would allow. We should also be aware that he referred frequently to 'his Mexican journey' made, supposedly, in his youth – a voyage which was as compulsively fictional as his greatest paintings.

And surely nothing can illuminate for us more fiercely the genesis of Kandinsky's early abstract paintings than his own account of his return home one evening. Entering a twilight room, he was confronted by something totally unexpected – leaning against the wall was a picture which was both abstract and beautiful. It was one of Kandinsky's own figurative works the wrong way up.

Each painting contains something of its painter. It is, literally, how he leaves his mark. This was true even in the days when artists were as much tradesmen as geniuses. It is hard to believe nowadays but, in the Renaissance period, when a painting was commissioned its patron could decree its size, subject matter, the number of figures to be included, their identities and the types of pigment to be employed. Yet the artist seems to have been supremely capable of dealing with such strictures, for the art of painting achieved then perhaps a greater variety than at any time before or since. Thus the facts of a Renaissance painter's life are equally useful to us. We need only know, for example, that Piero della Francesca wrote treatises on geometry to see more clearly the basis of his uniquely harmonic paintings. To learn that he had to give up painting when struck blind makes the grandeur of even his achievement suddenly precariously human. And how could we hope to gain insight into Piero di Cosimo's bizarre interpretations of Classical antiquity, were we not aware that his life-style was equally eccentric? It appears that he would shut himself in a loft and subsist on eggs, cooking 50 at a time. With this knowledge we can surely see certain of his paintings almost as records of the hallucinations of a recluse.

Some measure of the importance of biographical detail is gained from occasions where we have none. In the case of artists whose names are not known, we have to invent them. So are born the *Master of the St Veronica* and the *Master of Moulins*. Perhaps ignorance makes our curiosity all the greater. Was the *Master of the St Bartholomew Altarpiece* as mischievous as his art suggests or the *Master of René d'Anjou* as love-struck? Of course, the paintings are still great, their quality unchanged for the lack of a fleshly author, but the spectator's view of them is necessarily incomplete. We are condemned to see the art without the life, and as a result the paintings made by these anonymous abstractions become puzzles rather than pleasures. The study of art is already too full of enigmas for us to relish yet another problem.

Ultimately the aim of this book is to present the means, if not to understand the artist – no book can aspire to do that – at least to sympathize with him. We can enjoy life with Rubens, taking pleasure in his last golden years spent at the Château de Steen with his young wife and their growing family. Equally, we can suffer with Van Gogh.

Each of the paintings which decorate the following pages constitutes a part of the life of the man who made it. Unlike the works of nature, clouds or trees for example, which although visually exciting, have no meaning, paintings communicate the thought of the artist to the mind of the spectator. To be alive today and to be able to look into the life of a Vermeer or a Van Eyck is both a privilege and a pleasure. It is something which is made easier by this book.

ALISTAIR SMITH

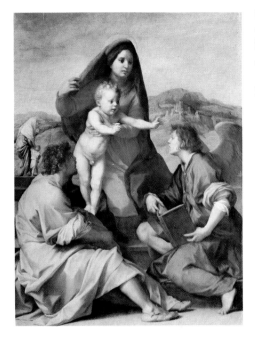

Madonna della Scala, Prado; *The Virgin and Child*, 1519-20, Rome, Gal. Borghese). The simplicity and monumental balance of the large fresco *The Tribute to Caesar* at Poggio a Caiano (1520-1) were in their turn to influence those Florentine artists of the late 16th century who were trying to break free of the conventions of a retrograde Mannerism. However, in his last works Andrea abandoned the clear composition and lucid colours of such paintings as the *Madonna del Sacco* (1525, Florence, cloister of the Church of the Annunziata) and of the *Pietà* (Florence, Pitti) in favour of an increased use of drapery, which favoured virtuosity in modelling (*Assumption*, Florence, Pitti).

Andrea del Sarto epitomizes Florentine classicism, combining the subtlety of Leonardo with the formality of Raphael and Fra Bartolommeo. At the same time he displays a restless sensitivity, especially in his portraits (Florence, Uffizi and Pitti; Prado), that reflects the Florentine unease that was to lead to Mannerism. His influence was felt by artists as diverse as Bugiardini, Franciabigio, Bacchiacca and Puligo. F.V.

Angelico
Fra (Giovanni Angelico da Fiesole)

Italian painter
b.Vicchio di Mugello(?), c.1400 – d.Rome, 1455

Fra Angelico is now known to have been born considerably later than 1387, his former commonly accepted birth date. On 31st October 1417, under his secular name of 'Guido di Pietro', he joined the company of friars of S. Niccolò at the Church of the Carmine in Florence while he was still a layman. This seems to be borne out in the accounts for a panel, now lost, that he executed for the Ghierardini Chapel at the Church of S. Stefano al Ponte (although another set of accounts from the Hospital of S. Maria Nuova, in 1423, refers to the 'painting of a cross'

by 'Fra Giovanni of the brothers of S. Domenico da Fiesole'.) The label 'Angelico' is commonly attributed to Vasari, although it is known to have been previously applied by Fra Domenico da Corella when writing in 1469.

Fra Angelico was far from being a humble, secluded friar, for his reputation as an artist soon became widespread. In a letter written in 1438, Domenico Veneziano names him and Fra Filippo Lippi as the only important Florentine painters, and, of the two, it was Fra Angelico who was commissioned to decorate the Cappella del Sacramento of St Peter's, in Rome. Nor did his calling stand in the way of his welcoming the new ideas of the Renaissance. In fact, he was well ahead of Lippi and of Uccello in this respect, and was the first to grasp the significance of the new architectural ideas of Brunelleschi and the pictorial revolution of Masaccio – although he interpreted them as a return to the purity and simplicity of the classical and Early Christian eras. The 19th century followed Vasari in seeing Fra Angelico as a creator of edifying, devotional works, such as the reliquaries painted for Fra Giovanni Masi (Florence, S. Marco Museum; Boston, Gardner Museum). However, today it is his links with the Early Renaissance, his innovations, and the influence of Masaccio, evident throughout his early works, that are stressed.

First period. Early paintings such as the *St Jerome* of 1424 (Princeton, University Museum) are the first to reveal the influence of Masaccio. Some scholars, however, have seen Fra Angelico in the years immediately following being attracted by the style of Gentile da Fabriano in such works as the *Altarpiece of St Domenico* at Fiesole (predella in London, N.G.), before Masaccio's in-

fluence returned in full force about 1430. At about this time Fra Angelico began painting small panels like *The Naming of St John the Baptist* (Florence, S. Marco Museum), a *Nativity* and *Agony in the Garden* (Forli, Pin.) and *The Conversion of St Augustine* (Cherbourg Museum). Here, the forms and the use of space recall Masaccio's frescoes *The Tribute Money, The Expulsion of Adam and Eve* and *The Raising of Theophilus's Son* (in the Brancacci Chapel, Florence, Church of the Carmine).

1430-45. The outcome of these studies was the masterly *Coronation of the Virgin* (Louvre), painted about 1435, and set up over one of the three altars in the Church of S. Domenico at Fiesole. It displays a striking mastery of perspective, and the spatial rhythms of the figures, already perceived as volumes, is such that it is easy to see how much such a work must have fascinated Domenico Veneziano and Piero della Francesca. By comparison, the *Linaiuoli Altarpiece* (*The Madonna of the Linen Guild*) (1433, Florence, S. Marco Museum) shows a weakening of this extraordinary spatial awareness. The angelic musicians seem almost like a floral decoration against the gold background and the space of the small scenes in the predella is less homogeneous. Coming after the death of Masaccio, this was a critical moment in the Renaissance when a resurgent Gothic culture still held sway over the art of Florence.

Ranking with the *Linaiuoli Altarpiece* are a beautiful *Annunciation* (Cortona, Diocesan Museum); the *Altarpiece* of the Convent of Annalena (Florence, S. Marco Museum); the *Coronation of the Virgin* (Uffizi); the famous *Deposition* (Florence, S. Marco Museum); and a *Virgin and Child Enthroned*, also in S. Marco, in which the

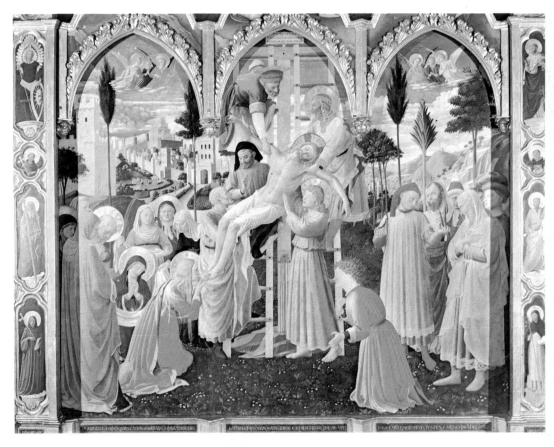

▲ Andrea del Sarto
The Madonna della Scala
Wood. 177cm × 135cm
Madrid, Museo del Prado

▲ Fra Angelico
The Deposition
Wood. 176cm × 185cm
Florence, Museo di San Marco

influence of Lorenzo Monaco is so plain that the work is frequently ascribed to Fra Angelico's early period, around 1420. Documentary evidence, however, provides a firm dating of 1436 for the *Lamentation* (Florence, S. Marco Museum), a work in which the sense of devotion is in contrast with the more everyday frescoes of the Convent of S. Marco that followed between the years 1438 and 1445.

Before this Fra Angelico had painted a *Polyptych* in 1437 (Perugia, G.N.), the admirable predella of which is in the Vatican. But the masterpiece of this period is the *Altarpiece* commissioned by Cosimo and Lorenzo de' Medici for the high altar of the church of the Convent of S. Marco. Painted about 1440 or a little later, the work displays a remarkable transparency in its forms, even when they are in shadow, that suggests the influence of Domenico Veneziano (known to have been in Florence from 1439). The predella depicts the *Story of Sts Cosmas and Damian*. One panel of this, together with the main body of the altarpiece, is today in the S. Marco Museum; the remaining two panels are shared between the Louvre and the Alte Pinakothek at Munich.

Rome. The next phase of Fra Angelico's artistic development took place in Rome. There he was accompanied by his young pupil, Benozzo Gozzoli. He is known to have been in Florence in July 1445, and had arrived in Rome by May 1446. To this period belong the frescoes on two sections of the vault of the Chapel of the Madonna of S. Brizio in Orvieto Cathedral, painted with Gozzoli during the summer vacation. Records show that in 1449 Fra Angelico was paid for decorating a chapel dedicated to S. Niccolò (or Chapel of the Blessed Sacrament) in the Vatican, but it has not survived. Only the Chapel of Nicholas V – usually identified with 'the Pope's secret chapel' – has been preserved, with its *Scenes from the Lives of St Stephen and St Lawrence*, executed in 1448. Here, the monumental but sober effects, together with the grouping of large forms, show Fra Angelico at his closest yet to the spirit of the Renaissance.

Last years. June 1450 found Fra Angelico back in Florence, this time as Prior of the Convent of S. Domenico in Fiesole. With the help of pupils, he executed during this period the doors for the *ex-voto* cupboard in the Church of the Annunziata and the *Altarpiece of Bosco ai Frati* (both in Florence, S. Marco Museum). The second seems almost like a youthful work of Benozzo Gozzoli. In 1452 he turned down a commission to decorate the apse of Prato Cathedral. In December 1454 he was in Perugia, and on 18th February 1455 he died in Rome and was buried in the Church of S. Maria sopra Minerva.

Fra Angelico's influence. Fra Angelico was the leader, or at least the model, of whole groups of Florentine miniaturists and painters, among them Battista di Biagio Sanguigni, Zanobi Strozzi, the Master of the Buckingham Palace Madonna, Domenico di Michelino, Andrea di Giusto, and above all Benozzo Gozzoli. But he is equally important for the influence that he exercised on painters such as Pesellino and Fra Filippo Lippi who had no direct contact with him. Through works such as the *Coronation*, too, he influenced Domenico Veneziano and Piero della Francesca, and hence the course of Italian painting. L.B.

Antonello da Messina
Italian painter
b.Messina, c.1430 – d.Messina, 1479

Trained in Sicily and Naples, where, according to Summonte (1524), he was a pupil of the court painter Colantonio, Antonello is considered the greatest southern Italian artist of the mid-15th century. In the first half of the century Naples and Sicily had close links with Spanish and Netherlandish painters. Sicily, in fact, was a cultural province of Spain, which in its turn was strongly influenced by The Netherlands – so much so that Vasari believed that Antonello must have visited the Low Countries, although this idea is no longer tenable. When Naples came under the dominion of Aragon, it became a brilliant centre, and a magnet for artists from near and far who came to view the works of Jan van Eyck, Petrus Christus, Jacomart Baço and Juan Rexach, as well as Netherlandish and northern French tapestries, miniatures, and French and Provençal paintings. Antonello himself spent several periods in Naples between 1450 and 1463. The possibility that he may have met Petrus Christus in Milan during these years, once suggested to account for Antonello's northern-influenced work, no longer seems likely.

Early period. The importance of the links between Naples and Valencia at this time are borne out by the stylistic influence of the Valencian painter Jacomart Baço on Antonello's early works, such as *St Zosimus* (Syracuse Cathedral), *The Virgin of the Annunciation* (Venice, Forti Coll.), *St Lucy* for the church of the same name in Messina (now in Messina Museum) and the *Portrait of a Monk* (Meersburg, West Germany, Kister Coll.). However, Antonello's provincial background gave rise to other characteristics, in particular a rather solemn composition and simplified forms. His master Colantonio, too, was influential.

At this time, Neapolitan art was limited in output and reflects the influence of Jean Fouquet and the Master of the Aix Annunciation, mingled with more direct imitations of Netherlandish

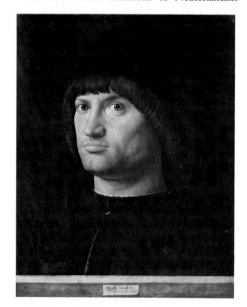

▲ Antonello da Messina
The 'Condottiere'
Wood. 35cm × 28cm
Paris, Musée du Louvre

painting. Colantonio absorbed these influences and passed them on to his brilliant pupil. Antonello's work, in fact, gained from this eclecticism and works such as the two panels *Abraham Served by the Angels* and *St Jerome at Prayer* (Reggio di Calabria Museum) and the slightly later *Crucifixion* (Bucharest Museum) demonstrate his continuing assimilation of Netherlandish influences. The lost polyptych of S. Niccolò was a further reminder of his Neapolitan period, being clearly inspired by the *Altarpiece of St Vincent Ferrer* in the Church of St Peter the Martyr in Naples, attributed to Colantonio.

Antonello and the Tuscan Renaissance. By 1465 Antonello's vision had changed radically, in both its formal and spiritual aspects – a change closely connected with the developments taking place in Tuscany at this time. The change can be seen in a remarkably concrete way in *The Saviour of the World* (1465, London, N.G.) Here, repainting has altered the fingers of Christ's hand so that instead of touching the chest (as in the original version) they are foreshortened and point outwards, thus drawing the spectator into the new pictorial space and increasing his sense of involvement. Such a treatment of space indicates a complete conversion to the most revolutionary new ideas of the Tuscan Renaissance, which may be seen embodied in the masterpieces of Piero della Francesca at Arezzo, in which the use of perspective gives their full value to buildings and volumes.

When and how the change in Antonello's art occurred is hard to determine. Sicilian sources make no mention of him between 1465 and 1472, and it is possible that during these years he may

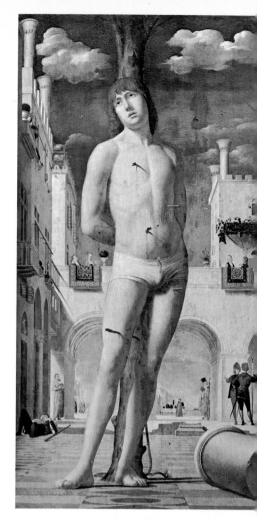

▲ Antonello da Messina
St Sebastian (1475)
Canvas. 171cm × 85cm
Dresden, Gemäldegalerie

have visited Rome, Milan or Venice and there have become acquainted with the new ideas of the Renaissance. The *Polyptych of St Gregory* of 1473 (Messina Museum) shows how his vision had crystallized in a totally different way: the analytical Flemish archaism of his early works was absorbed once again in an original texture, the outcome of his study of contemporary Tuscan theories of volume and perspective. However, it is with the *Ecce Homo* of 1470 (Metropolitan Museum) – other versions of which are now in Genoa (Palazzo Spinola), Piacenza (1473, Alberoni College) and Vienna (1474, private coll.) – and with the *Annunciation* of the Palazzolo Acreide (1474, Syracuse Museum) that the Renaissance reached its peak in southern Italy.

These works, with their mastery of forms and spatial values and their awareness of light, which, in a diffuse and luminous way, determines the volumes, show the extent to which Antonello had absorbed the lessons of Piero della Francesca. The Benson *Madonna* (Washington, N.G.), very pure and unreal in its ivory-coloured clarity, is a characteristic example of the way Antonello matches a rigorous style with a lyrical expressiveness to create a tender, intimate scene.

Compared with *The Virgin of the Annunciation* (or *St Rosalie*) (Baltimore, W.A.G.), generally held to be an early work, the Benson *Madonna* is a striking advance.

Antonello in Venice. The period 1475-6, which Antonello spent in Venice, produced some fine portraits – the *Portrait of an Unknown Man* (Rome, Gal. Borghese), *The 'Condottiere'* (Louvre) and the *Trivulzio Portrait* (Turin Museum) – as well as altarpieces such as the *St Sebastian* for the Church of S. Giuliano (Dresden, Gg) and the *Madonna with Saints* of the Church of S. Cassiano (fragments in Vienna, K.M.) that are among the most solemn and moving of any produced during the 15th century. The perfection of these works decisively influenced Venetian painting at the end of the 15th century – either directly or through the effect they had on Giovanni Bellini. In his large-scale works Antonello achieved a purity of rhythm and colour which became elements of a broad monumental synthesis. Smaller paintings, however, such as the versions of the *Crucifixion* (1475, Antwerp Museum; 1475 or 1477, London, N.G.), are marked by a concern for objective description that is typically Flemish. A painting of *St Jerome in his Study* (London, N.G.) also probably dates from this period, although some authorities believe it to be an early work.

Final period. Antonello returned to Sicily at the end of 1476 and it was here that he produced his final masterpiece, a new version of *The Virgin of the Annunciation* (Palermo Museum). An earlier painting on the same theme (Munich, Alte Pin.) had been executed at the same time as *The Polyptych of St Gregory*, three years previously. The later work shows Antonello as an artist who, from being a stranger to the ideas of the Renaissance, became one of its principal exponents, although he always remained an independent figure. His genius, however, had little effect on Sicily and southern Italy, where there were few really creative artists. It was in Venice that his influence was felt most profoundly and where the richness of his work determined the way to be taken by the great painters of a new generation, in particular such notable ones as Mantegna and Carpaccio. R.C.

John James Audubon ▶
Chick-wills-widow birds
Engraving
Birds of America (1827–38)

Audubon
John James
American painter
b.Cayes, Haiti, 1785 – d.New York, 1851

More than any of his contemporaries John James Audubon embodied that fusion of art and science sought by so many American painters of the late 18th and early 19th centuries. The great French naturalist Cuvier praised Audubon's work as 'the most magnificent monument raised by art to science'. Audubon's masterpiece, *The Birds of America*, grew directly from his observation and from the practice of his craft; yet it is probable that he would never have attained fame as either painter or naturalist had he not failed as a businessman.

Audubon was the natural son of a French sea-captain who took him to France as a boy, and he grew up near Nantes. For a very short time in 1802 he appears to have studied with Jacques Louis David, but in 1803 he left for the United States where his father owned a plantation, Mill Grove, not far from Philadelphia. He was from earliest youth interested in wildlife, in hunting, and in drawing. When he married his neighbour, Lucy Bakewell, in 1808, the young couple set off for the Kentucky frontier where Audubon opened a store in Louisville. He was not a successful businessman, perhaps because he thought of himself as an amateur naturalist in an epoch when most naturalists were wealthy amateurs; and he was always drawing birds instead of attending to the shop. When a mill he partly owned in Henderson, Kentucky, went bankrupt in 1819, he was finally obliged to turn to art for a livelihood. He did chalk portraits for 20 dollars apiece, then moved to Cincinnati where he gave dancing and drawing lessons. Travelling to New Orleans with his family, he began to collaborate with a young draughtsman, Joseph Mason, whom he trained to do habitats for his birds.

Audubon worked best in watercolour or pastel; he never really mastered oil, even for portraits. But he developed a way of rendering his birds in as lifelike a manner as possible by fixing a freshly killed bird in order to draw it accurately. In his work he retained a marked preference for profiles and silhouettes, not only in the portraits, but even in his studies of birds. This linearity betrays his Parisian training, but in addition to a feeling for line, he was gifted with a sense of colour. By 1820 he had conceived the idea of publishing his bird studies, that is, of turning what had been a passionate hobby into an artistic-scientific business enterprise.

In 1822 his wife became a governess and supported the family so that Audubon could work full-time on the project – finding more birds and, above all, finding a publisher. Unable to secure one in Philadelphia, he went to England in 1826 and there succeeded. He remained in England for three years and thereafter, until 1839, divided his time between Europe and America, soliciting subscriptions and copying his watercolours; but the projected work was enormous: four volumes, containing 435 engravings. The first engraver he worked with, William Lizan, abandoned the project after less than a year; early in 1827 the work was taken up by Robert Havell Jr, who finished only in June of 1838.

With the appearance of the first plates, Audubon's reputation grew quickly. He returned to the United States in 1829, and in 1831-2 made a trip to Florida, collaborating with George Lehman who produced the backgrounds. By 1832 the *Birds* had become a family affair, and his two sons

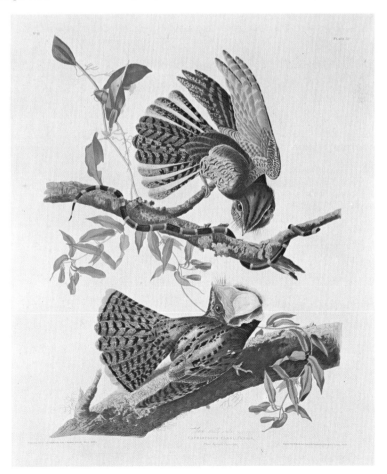

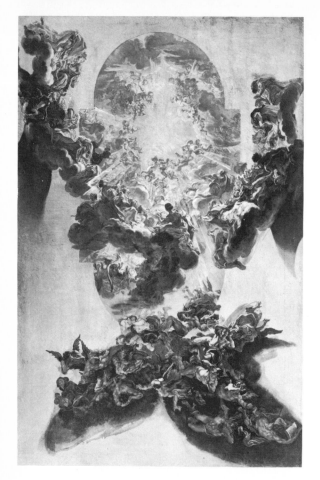

began to help him, while his wife handled the voluminous business correspondence.

In 1843 he travelled up the Missouri, now determined also to depict the mammals of North America. In this work, *The Viviparous Quadrupeds of North America*, he collaborated with the Revd John Bachman, who wrote the text. Audubon's style changed little during his active life as an artist; he displayed the same mastery in rendering the texture of fur as he did of feathers, but he also in his late work showed a marked predilection for small animals – chipmunk, rabbit, squirrel – perhaps because the method he had developed for birds (hunting, fixing, drawing and measuring) was more easily transferred on this scale; also, perhaps, because he was especially fond of small creatures. He died in 1851, three years before the mammal project was completed. D.R.

Baciccio or Baciccia
(Giovanni Battista Gaulli)
Italian painter
b.Genoa, 1639 – d.Rome, 1709

Baciccio received his early training in Genoa where he studied the works of Perino del Vaga (in the Palazzo Doria), and those of Barocci, Rubens and Van Dyck, before leaving for Rome in 1657. He was to spend the rest of his life in the city, completing his training there, and coming under the influence of Raphael, Pietro da Cortona and Correggio. Bernini became his teacher and patron, introducing him to the papal court as a portrait- and fresco-painter, and putting his way commissions, such as that for the decoration of the pendentives of the Church of S. Agnese (1666-72) and, later, the decoration of the Church of the Gesù (1672-85). Under Bernini's influence Baciccio's taste for the Baroque developed, one result of this being his many celebrated portraits of popes and cardinals, such as that of *Pope Clement IX* (Rome, G.N.). The Spanish critic Munoz, in fact, was led to describe Baciccio as 'Bernini as a painter'.

The period until 1672 is notable for Baciccio's frescoes of *St Martha* in the Collegio Romano and is characterized by a stylistic eclecticism that appears to hesitate between classicism and the Baroque. His first official commission, *The Virgin and Child between St Rock and St Anthony* (1660-6, Rome, Church of S. Rocco), is full of warm tones and reflects the mingled influences of Rubens, Van Dyck and Strozzi. The colder colours and linear style of other works, however, such as the *Pietà* in the Incisa della Rochetta Collection in Rome (*c*.1667), proclaim a kind of academic eclecticism, inspired in turn by Annibale Carracci, Domenichino and Poussin. Bernini's growing influence, too, is evident, especially in the angular treatment of folds. By the end of this period, in the *Four Christian Virtues* in the Church of S. Agnese, Baciccio succeeded in fusing these different elements into a homogeneous and personal art.

The period from 1672 to 1685 saw Baciccio reach maturity as an artist, mainly under the influence of Bernini. During this time he painted his first works, emerging as a great Baroque decorator in the service of the Church Triumphant, following in the line of Pietro da Cortona.

The altar-paintings of the period, such as *The Adoration of the Shepherds* (Fermo, Church of S. Maria del Carmine) and *The Virgin and Child with St Anne* (Rome, Church of S. Francesco a Ripa, Altieri Chapel), are rhythmically constructed compositions, with dense colours fading into the light, and sculptural draperies.

It was the period, too, when Baciccio transformed Vignola's Gesù, the 'white church' of the Counter-Reformation, into a Baroque edifice, decorating the vault of the nave with his painting of *The Glorification of the Name of Jesus* (sketch, Rome, Gal. Spada). This work is the mature expression of the revolutionary pictorial concepts that Baciccio had learned from Bernini and which had already been suggested in the Cornaro Chapel. Here, the sense of illusion stems from the plasticity of the painted figures, mingled with the stucco-work, and from their movement, beyond the architectural frame, over the bays of the vault into the actual space of the church. For the first time the characteristic composition of late Baroque frescoes is on view, with the juxtapositions of the dark areas influencing the arrangement of the figures.

The works of 1685 to 1709 may be seen as evidence of Baciccio's adjustment to the general movement of taste towards the classicism of painters such as Maratta; Baciccio's earlier leanings towards classicism are revived in the paler colours, slower rhythms, calmer expressions and pallid faces of paintings such as *Christ and the Virgin with St Nicholas of Bari* (Rome, Church of S. Maddalena) and *The Sermon of St John the Baptist* (Louvre). Other works, such as *The Combat between Hector and Achilles* (Beauvais Museum), are close to the classical tradition of Poussin. Baciccio's final fresco, *The Triumph of the Franciscan Order* (Rome, Church of S. Apostoli), betrays a lack of daring, but some of the last paintings, such as *The Presentation of the Child Jesus at the Temple* (Rieti, Church of S. Pietro Martire), show that he preserved a certain vitality in this medium.

More than Andrea Pozzo, his contemporary, Baciccio was the true heir of Bernini and of Pietro da Cortona. One of the last great Baroque painters in Rome, he was a forerunner of the art of the 18th century. His drawings, more than 200 of which are in the Kunsthistorischesmuseum at Düsseldorf, are an essential basis for an understanding of his work. S.De.

Bacon
Francis
English painter
b.Dublin, 1909

Bacon is a self-taught painter who began his career as a designer of furniture and carpets and as a decorator (he exhibited in his studio in 1930). He came to London in 1925 and, after spending the two following years in Berlin and Paris, where he saw an exhibition of Picasso's works, he began painting at the end of 1929. He often broke off his work and destroyed most of the paintings of these early years: only about ten canvases survive from the period 1929-44. The first exhibition of his work was held at the Hanover Gallery in London in 1949, followed by exhibitions in New

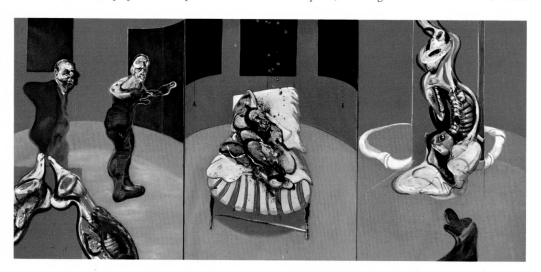

▲ Baciccio
The Glorification of the Name of Jesus
Canvas. 179 cm × 120 cm
Sketch for the dome of the Gesù, Rome
Rome, Galleria Spada

▲ Francis Bacon
Three Studies for a Crucifixion (1962)
Canvas. Each panel: 198 cm × 144 cm
New York, The Solomon R. Guggenheim Museum

York in 1953 and Paris, at the Rive Droite Gallery, in 1957.

Bacon has always been an independent figure in contemporary painting, although his early works were influenced by Surrealism (*Painting*, 1946, New York, M.O.M.A.). Most of his works feature two, or sometimes three, isolated figures, either stationary or in movement. He has painted religious subjects since 1933, in particular the *Crucifixion*, but without any concession to traditional treatments (*Three Studies of Figures at the Foot of a Crucifixion*, 1944, London, Tate Gal.). An already existing image often serves as a point of departure as in the paintings based on Van Gogh's *Self-Portrait* (1957), Velázquez's *Pope Innocent X* (1953, 1960), the shrieking nurse from Eisenstein's film *The Battleship Potemkin* (1957), or a newspaper photograph of a gesticulating politician.

Bacon's work aims to strike the spectator to the depths of his being. It is a quality that might be labelled 'existential' in that the individual is frequently portrayed in the depths of his isolation (for example, in his bedroom, or in bed) or depicted against an almost totally abstract background. The sense of isolation is accentuated by a frequent use of triptychs in which the figures are juxtaposed without communicating, producing a feeling, at once sequential and syncopated, of a film image (*Studies of the Human Body*, 1970, private coll.). Apart from photographs and the cinema, Bacon often uses for his own ends the formal and emotional content of contemporary art movements, from Expressionism to Minimal Art. But the essence of his work lies in an original view of the human body and face, presented with haggard expressions that are, however, full of a rending truth. Bacon's figures are on the edge of disintegration. Paradoxically they are painted in banal, offhand poses: sitting, recumbent, sprawled out, asleep, making love or defecating (*Two Figures on the Grass*, 1954, New York, private coll.). Similarities in posture and situation are used to compare man with animals – e.g. with dogs (1953, New York, M.O.M.A.), or, more often, monkeys (*Chimpanzee*, 1955, Stuttgart, Staatsgal.). Using certain faces, notably his own, Bacon has produced some striking variations by matching his use of colour to expressions (*Self-Portraits*, 1967, 1972, 1973; *George Dyer and Isabel Rawsthorne*, 1968; *Henrietta Moraes*, 1969).

Bacon, particularly influential in Italy between 1950 and 1960, can also be seen as the forerunner of the French Nouvelle Figuration movement. He lives in London, and his work is found in many English, American and German galleries. An important retrospective exhibition of his work was held in 1971-2 in Paris, at the Grand Palais, and at the Kunsthalle in Düsseldorf. A.Bo. and M.A.S.

Baldung
Hans (known as Grien)
German painter
b.Gmünd, Swabia, 1484/5–d.Strasbourg, 1545

Baldung was born into a prominent and cultivated family in Strasbourg, where his father was legal adviser to the Bishop from 1492. After serving an apprenticeship with a follower of Schongauer, Baldung, whose personal talent was already well developed, entered Dürer's studio in

Hans Baldung ▶
Eve, the Serpent and Death
Wood. 64cm × 33cm
Ottawa, National Gallery of Canada

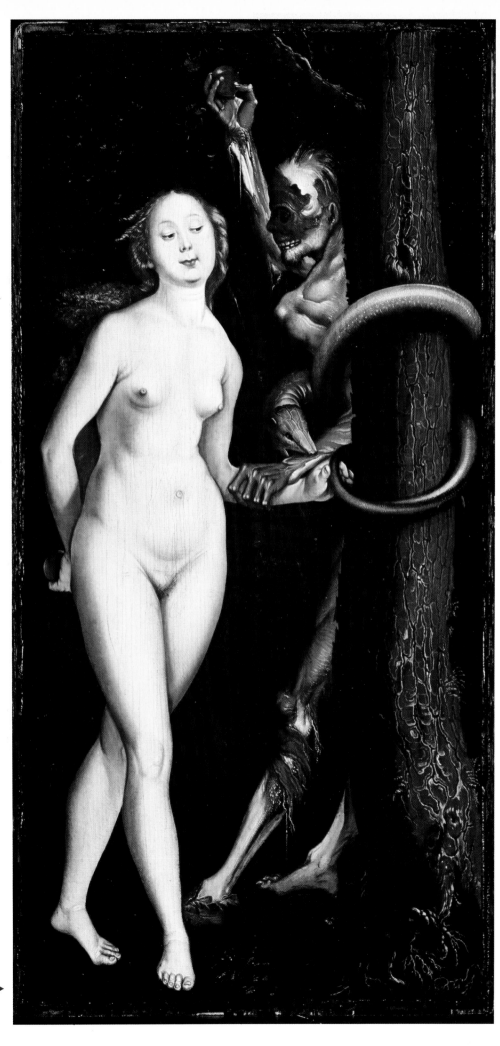

Nuremberg in 1503. Here, his close companions were Hans von Kulmbach, Hans Schäuffelein and Hans Leu, and it may have been to differentiate himself from them – and also because of a fondness for the colour green – that he began to sign his work, first with a vine-leaf and afterwards with a monogram formed from the linked letters 'HBG' (Grien).

Baldung enjoyed a privileged position in the studio: he was given important commissions to design church windows (for Grossgründlach Church in 1505, and for St Lawrence's Church in Nuremberg and the Church of the Holy Cross in Gmünd the following year). These favours continued even while Dürer was away in Italy in 1505. His graphic work was equally important at this time; it included the 35 wood-engravings to Ulrich Pinder's *Beschlossen Gart des Rosenkranz Mariä* (*The Enclosed Garden of the Virgin's Rosary*), published in 1505, and a collection of engravings notable for their energy and imagination. In 1507 Baldung painted two altarpieces ordered by Cardinal Albrecht of Brandenburg for the church at Halle – *The Adoration of the Magi* (Berlin-Dahlem) and *St Sebastian* (Nuremberg Museum). The works display the influence of Dürer and of Lucas Cranach, but also manifest a new and very personal use of colour and effects of contrast.

Following this Baldung may have renewed his contacts with Dürer at Nuremberg, but it is certain that he returned to Strasbourg where he acquired the rights of a burgher at Easter 1509 and his mastership the following year. Following Dürer and Cranach, he developed a bold style, both colourful and decorative, which bore fruit in commissions from, among others, the Margrave Christopher of Baden (*Votive Image*, Karlsruhe Museum) and Erhart Kienig, Commander of the Convent of St John in the Green Island, Strasbourg (*Mass of St Gregory*, Cleveland Museum). The sensual force of the wood-engravings of this period, too, helped to establish his reputation.

In May 1512, after painting a *Crucifixion* for the Convent of Schütteren in Strasbourg (Berlin-Dahlem), Baldung settled for five years at Freiburg-im-Breisgau, where he was commissioned to paint for the cathedral an important altarpiece for the choir and the altarpiece of the Schnewlin family. The first of these shows the *Coronation of the Virgin* on the central panel and the *Crucifixion* on the back, framed by shutters with figures of *St Peter and St Paul* and scenes from the *Life of the Virgin*. The second, of which

the sculptured part, painted by Baldung, was executed by Hans Weiditz, shows the *Rest on the Flight into Egypt*, surrounded, on the shutters, by the *Annunciation*, the *Baptism of Christ* and *St John on Patmos*. Baldung also made a series of wood-engravings and illustrations, as well as drawings and cartoons for the windows of the cathedral – carried out in the Ropstein studio under the direction of the Alsatian Hans Gitschmann.

Following this very fertile period, Baldung returned in the spring of 1517 to Strasbourg, where he was to spend the rest of his life. He became a member of the town's Grand Council and a supporter of the Reformation – which, however, did not greatly affect his output, as his inspiration was secular in character. His last altar-painting, a *Martyrdom of St Sebastian* of 1522, was, like the earlier version of 1507, carried out for Archbishop Albrecht of Brandenburg. He made the acquaintance of the first generation of Strasbourg humanists, men of liberal spirit such as the two Sturms and Martin Bucer, and sought to bring to his painting the character and sadness to be found in the human face.

From 1529 he turned to the new humanist theatre for inspiration – an influence that is clearly visible, to varying degrees, in such compositions as *Pyramus and Thisbe* (Berlin-Dahlem), *Hercules and Antaeus* (Kassel Museum), *Mucius Scaevola* (Dresden, Gg) and in several versions of *The Virgin and Child* in the museums of Berlin, Nuremberg and Vercelli.

In his final years, Baldung's work is notable for its emphasis on design at the expense of painterly quality, sometimes bearing a curious resemblance to bas-relief, as in *The Virgin and Child* in the Strasbourg Museum. Even when he borrowed various details – movements, ornaments, architecture – from other artists, Baldung eschewed overt Italianism. Of his later works *The Seven Ages of Man* (Leipzig Museum) and *The Road to Death* (Rennes Museum; possibly a copy of an original that has disappeared) sum up his concept of life.

The product of a violent temperament, Baldung's paintings are marked by disquiet and sensuality: witches' sabbaths, scenes of *Death and the Maiden* (Vienna, Ottawa, Basel and Berlin Museums), and female allegories (Munich, Alte Pin.). The same characteristics are found in his portraits, which are often brutally accurate, and in his humanist interpretations of traditional religious themes. V.B.

Balla
Giacomo
Italian painter
b. Turin, 1871 – d. Rome, 1958

One of the pioneers of Futurism, Balla was a self-taught painter. He began his career with landscapes that owed much to the sketching tradition of 19th-century Turin and more generally, to a naturalist tradition, impregnated with Symbolism and influenced by the Divisionists (Pelizza da Volpedo, Segantini and Previati). A stay in Paris in 1900 put him more directly in touch with Divisionism. From 1895, inspired by his socialist and humanitarian ideals, Balla worked in Rome on paintings which suggested social aspects of the contemporary world (technological progress, the industrial suburbs) – themes that Futurism was to develop. Around 1900 Boccioni and Severini began visiting him in his studio and together they exchanged ideas on form and subject-matter that were to prove the basis of Futurism. The world of work inspired Balla to a series of paintings marked by a lucid, careful naturalism: *Bankruptcy* (1902, Rome, Cosmelli Coll.); *The Worker's Day* (1904, Rome, Balla Coll.).

In 1909 *The Arc-Light* (New York, M.O.M.A.) marked a decisive moment for Futurism, with its decomposition of light that opened up the way to a non-figurative synthesis of formal elements. Around 1910, like the other Futurists, Balla began to study movement and speed in works such as *Speed of a Car* (1912, New York, M.O.M.A.), *Studies of the Flight of Swifts* (1913, New York, M.O.M.A.), the famous *Dynamism of a Dog on a Leash* (1912, G. Goodyear and the Buffalo Fine Arts Academy), and *Rhythms of the Bow* (1912, London, private coll., on loan to the Tate Gal.)

Although he was one of the pioneers of Futurism and signed its two manifestos, Balla was not a theoretician and based his ideas intuitively on his own works. He took the decomposition of movement as far as it would go, achieving a pure, Constructivist form of abstraction that marks him as a forerunner of non-figuration (the series *Line-Speed, Whirlwinds*, 1914; *Speed Landscape* and the series *Compenetrazioni iridescenti* (*Iridescent Interpretations*), begun in 1912; *Mercury Passing before the Sun as seen through a Telescope*, 1914, Milan, Mattioli Coll. and Vienna, Museum of the 20th Century; study in Paris, M.N.A.M.). In 1915 he

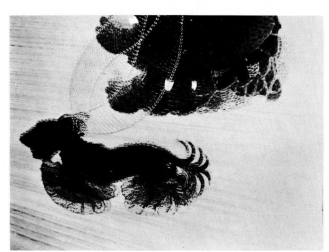

▲ Giacomo Balla
Dynamism of a Dog on a Leash (1912)
Canvas. 90 cm × 118 cm
New York, G. Goodyear and the Buffalo Fine Arts
Academy

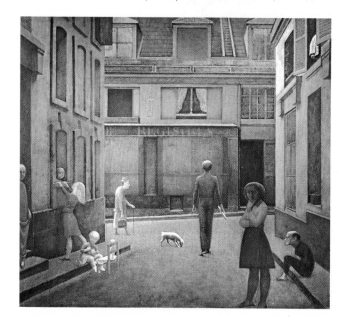

produced a number of dynamically abstract compositions supporting Italy's intervention in the war (*Patriotic Song, Piazza di Siena*, Turin, private coll.) and from the end of the war until about 1930 he continued to paint pictures in which the rhythm has a metaphysical role to play (*Landscape plus Sensation of Water-Melon, c.*1918, Rome, Swiss Institute; *Landscape Drama, c.*1930, Milan, private coll.). In 1925 he contributed two large tapestries, *Sea, Sail and Wind* and *Futurist Spirit*, to the International Exhibition of Decorative Arts in Paris.

Besides painting and designing tapestries, Balla also practised a number of other techniques: sculpture, decoration (furniture, fabrics, theatre designs), architecture and drawing. The year 1930 marked a return to figurative painting, the most interesting expressions of this being his portraits and his last urban landscapes. He exhibited at the Venice Biennale for the first time in 1909, then in 1926 and 1930 with the Futurists, taking part in all their shows. His paintings are to be found in the museums of modern art in New York, Rome, Milan, Zürich, as well as in many private collections, notably the Balla Collection in Rome. L.M.

Balthus
(Balthazar Klossowski de Rola)
French painter
b.Paris,1908

Balthus's father was an art critic and his mother a painter, and through them he met Bonnard, Derain and Roussel. He began painting at the age of 16 and had his early drawings published by the poet Rilke, whom he had met in Switzerland, and who also contributed a preface to them (*Mitsou: Quarante Images*, Zürich and Leipzig, 1921). The works painted before 1930, especially the Parisian scenes, display various influences, among them that of Bonnard (*Jardin du Luxembourg* [*The Luxembourg Gardens*], *c.*1927, New York, private coll.).

His first exhibition was held in Paris in 1934 and at about the same time his style and subject-matter took on a new precision: scenes of daily life (*La Rue* [*The Street*], 1933, United States, private coll.); interiors (*Jeune fille au chat* [*Girl with a cat*], 1937, Chicago, private coll.); and portraits (*Derain*, 1936; *Miró et sa fille* [*Miró and his daughter*], 1937-8 – both New York, M.O.M.A.; *Marie Laure de Noailles*, private coll.). In spite of Balthus's interest in Surrealism (he was linked with Artaud and Giacometti), these paintings probably owe more to the fantastic realism of such German artists as Grosz, Dix and Beckmann, or to the French group Forces Nouvelles (1935) than to Surrealism proper. The year 1940 saw the beginning of what might be termed Balthus's 'intimate erotic' phase: paintings of little girls indoors, asleep, at their toilet, innocent or perverted, calm or upset (*Le Salon* [*The Drawing Room*], 1942, New York, private coll.; *La Chambre* [*The Room*], 1949-52, Switzerland, private coll.).

The classical rigour of Balthus's composition has often been remarked upon – he is a great admirer of Piero della Francesca and faithful to the tradition of Cézanne and Seurat – as has the suggestion of stage-settings in his compositions (*Passage du Commerce-St-André*, 1952-4, Paris, private coll.). Measured and economical, his

work owes its flat, attractively grainy patches of colour to his study of medieval frescoes. Design seems to take precedence over colour, which, around 1960, becomes more subtle, particularly in the landscapes painted at Morvan, which combine the rhythmic feeling of Cézanne with the strict geometry and sense of marvel of 15th-century landscapes (*Grand Paysage*, 1960, Paris, private coll.).

He is a brilliant draughtsman who moves easily from one medium to another – pencil, pen, charcoal, watercolour. He has illustrated Emily Brontë's *Wuthering Heights* (1933), has done stage designs for *The Cenci* (adapted by his friend Ataud) as well as for a production of *Cosi fan Tutte* at the Aix Festival and for Camus's *La Peste* and *L'Etat de Siège* (Camus wrote the introduction for his exhibition at the Matisse Gallery in New York in 1949).

He likes to return to the same theme, sometimes making interesting variations on the same composition, with a taste for series that once again recalls Cézanne: *Les Joueurs de cartes* (*The Card Players*) (1944-5, Paris, private coll.; 1948-50, England, private coll.; 1973, Rotterdam, B.V.B.); *Le Rêve* (*The Dream*) (1955-6, 1956-7, Paris, private coll.); *Trois Soeurs* (*Three Sisters*) (1959-64; 1964-5; 1965, Paris, private coll.). Balthus's wide cultural background, ranging from Piero della Francesca and Uccello to Poussin and Ingres, can sometimes result in paintings, such as *La Montagne* (*The Mountain*) (1936, New York, private coll.), which appear very close to Courbet, and at others to Eastern art in a wide variety of forms (*La Chambre turque* [*The Turkish Room*], Paris, M.N.A.M.)

From 1961 to 1977 Balthus was Director of the French Academy in Rome. He has exhibited little, but from 1966 has had important retrospective shows of his work: in Paris (1966), at the Tate Gallery, London (1968), and at Marseilles Museum (1973). Drawings exhibited in Paris in 1971, at the Galerie Claude Bernard, particularly his studies of youthful nudes, mark him as the heir to the 19th-century tradition of Degas, Cézanne and Bonnard. L.E.

Barbari
Jacopo de'
Italian painter
b.Venice,c.1450–d.Malines,1512/16

Barbari is known to have been in Germany in the service of the Emperor Maximilian after 1490, returning to Venice before 1500. While in Germany he practised metal-engraving in the manner of Mantegna, using certain graphic refinements derived from Schongauer, and also during this period began painting in the manner of Alvise Vivarini (*Holy Family with Donor*, Berlin-Dahlem). For three years, he worked on his masterpiece, the *Plan of Venice*, a woodcut printed in 1500 by Anton Kolb of Nuremberg.

A wandering artist, Barbari left Venice once more to find employment as a portrait-painter and miniaturist, first with the Emperor (1500), and then with the Archduke of Saxony (Wittenberg, 1503), the Elector of Brandenburg (1508), Philip of Burgundy (Suytberg, 1509), and finally Margaret of Austria, Regent of the Netherlands (Malines, from 1510). Portraits from this period

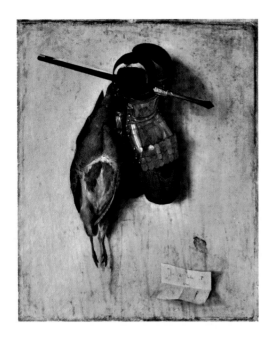

include *Henry of Mecklenburg* (1507, The Hague, Mauritshuis) and the *Portrait of a Young Man* (1505, Vienna, K.M.).

In the course of his travels, Barbari met Dürer, Cranach, Wolgemuth, Gossaert and Lucas van Leyden, and came to be highly regarded in the courts of Germany and the Low Countries, where there was a great interest in the Italian Renaissance. The protegé of Kolb, he was admired by Dürer, who recognized the debt he owed to Barbari for his knowledge of human anatomy. In return, Dürer's influence resulted in the delicacy of such works as *Still Life with Partridge* (1504, Munich, Alte Pin.) and *A Sparrowhawk* (London, N.G.). It was through Barbari that artists like Gossaert and Van Orley gained their knowledge of Italian culture. A.B.

Barocci
Federico
Italian painter
b.Urbino,c.1535–d.Urbino,1612

Although there are no records, Federico Baroccio, called Barocci, is known to have undergone his training in Rome, around 1555, in the circle of the Zuccaro family. A *St Sebastian*, painted in 1557-8 for Urbino Cathedral, reveals, among echoes of Raphael and Michelangelo, affinities with the expressive deformities of Mannerism. During a second stay in Rome Barocci supervised the decoration of Pius IV's Casino at the Vatican (1561-3), which, in its somewhat forced complexity, recalls the similar style adopted by the Zuccari at the same time in the Sala Regia of the Vatican. But with his first masterpiece, *The Deposition* (1567-9), in Urbino Cathedral, Barocci broke completely with the rather stereotyped formulae of Mannerism to reveal a completely personal style which, by means of simple dramatic effects, was capable of arousing basic emotions. He now settled permanently at the court of Urbino. The many devotional works and several portraits, such as that of *Francisco Maria della*

◀ Balthus
Passage du Commerce-St-André (1952-4)
Canvas. 295 cm × 330 cm
Paris, Private Collection

▲ Jacopo de' Barbari
Still Life with Partridge (1504)
Wood. 52 cm × 42 cm
Munich, Alte Pinakothek

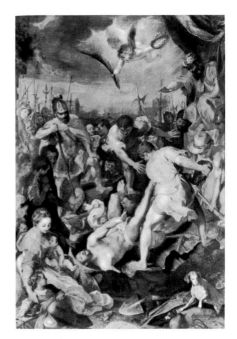

Rovere (1583, Uffizi) that he painted for the ducal family show a delicate Mannerist grace and a striving for unusual harmonies. In paintings such as the *Rest on the Flight into Egypt* (1570, Vatican) and the *Virgin with Cat* (*c.*1573-4, London, N.G.) the influence of Correggio is plain in the flowing outlines of the figures and the lightness of the draperies.

The works of the years that followed are in a different vein, displaying a new breadth and boldness. These are extraordinary paintings, with inarticulated forms and circular rhythms, marked by a fervour that seems to reflect the spirit of the Counter-Reformation (*The Madonna of the People*, 1575-9, Uffizi; *The Martyrdom of S. Vitale*, 1583, Brera). Barocci continued to explore the possibilities of space and colour in large altarpieces, several of which are still *in situ*. Works such as *The Circumcision* (1590, Louvre), *The Presentation in the Temple* (1593-4, Rome, Chiesa Nuova) and *The Madonna of the Rosary* (*c.*1590, Senigallia, Bishop's Palace) already foreshadow the 18th century. *The Flight of Aeneas* (Vatican), painted between 1586 and 1589 for the Emperor Rudolph II, is distinguished by tender colour, a subtle use of voids, and free light effects—characteristics shared by the intimate 'nocturnes' of Barocci's last years (*Nativity*, *c.*1597, Prado). Some of his many drawings, executed with great freedom, employ pastel.

Barocci was a painter of provincial background, who trained in Rome in the wake of Raphael, developed, at the very centre of Mannerism, original methods which were to be taken up by Baroque art. F.V.

Bartolommeo
Fra (Baccio della Porta)
Italian painter
b.Florence, 1475 – d.Florence, 1517

A key figure of the Renaissance in Florence in the early years of the 16th century, Fra Bartolommeo

appears as the embodiment of the conflicting elements in the artistic culture of his time, hesitating between the example of Raphael (who was in Florence in 1506) and the nervous anti-realism of early Mannerism, which began to be felt around 1510-15. Known by the monastic name that he bore in the Convent of S. Marco, Florence, where some of his best work is still to be found, he received his training in Umbria, being particularly influenced by the work of Perugino. A pupil of Cosimo Rosselli at the same time as Albertinelli and Piero di Cosimo, he spent some time in Venice in 1508 and in Rome in 1514, a stay which influenced him profoundly. Albertinelli remained a friend and collaborator, completing what was probably Fra Bartolommeo's first work, an *Annunciation* (Volterra Cathedral).

During the same period, Fra Bartolommeo completed, in grisaille, the two sides of the shutters of a tabernacle which was to hold a *Virgin* by Donatello (*Nativity, Circumcision* and *Annunciation*, Uffizi) and a large fresco, *The Last Judgement* (Florence, S. Marco Museum). He assumed the monk's habit in 1500 at Prato, and on his return to Florence painted *The Vision of St Bernard* for the Church of the Badia (Florence, Accademia). This was a calm, simplified version of the painting by Fra Filippino Lippi for the same church, and was completed only in 1507.

On his return from a short visit to Venice, Fra Bartolommeo set up, in 1509, the studio of San Marco with Albertinelli, where, after 1512, Fra Paolino and Sogliani also worked. This was the period when Fra Bartolommeo painted his largest works: *The Mystical Marriage of St Catherine* (1511, Louvre); the *Carondelet Altarpiece*, in collaboration with Albertinelli (1511-12, Besançon Cathedral); *God the Father with Two Saints* (1509, Lucca Museum); and *The Madonna with St Anne and Ten Saints*, carried out in 1512 for the Signoria of Florence but left incomplete (Florence, S. Marco Museum). These are rather cold syntheses of the new ideas of the High Renaissance, painted under the influence of Raphael and Leonardo.

In 1514 Fra Bartolommeo visited Rome where he was commissioned to execute two monumental figures of *St Peter* and *St Paul* for the Church of S. Silvestro al Quirinale, which were later carried out by Raphael (Vatican). The works of his last years, such as the *Madonna della Misericordia* (1515,

Lucca Museum), *Salvator Mundi* (1516, Florence, Pitti) and an *Annunciation* (1515, Louvre), are marked by a rather studied emphasis. The extremely formal construction of the *Deposition* in the Pitti Palace, completed after Fra Bartolommeo's death by Bugiardini, was to influence some of the work of the young Andrea del Sarto.

Fra Bartolommeo's early pen-and-ink drawings, in their free and supple workmanship, are in the highly cursive tradition found in late 15th century Florence in the drawings of Filippino Lippi and Piero di Cosimo. Some are rare and subtle studies in pure landscape, carried out with a freedom of expression remarkable for their time (Louvre; and series of *Landscapes*, formerly in the Gabuzzi Collection). F.V.

Bassano
(Jacopo da Ponte)
Italian painter
b.Bassano, c.1515 – d.Bassano, 1592

After studying with his father, Francesco, Bassano went to Venice to work in the studio of Bonifacio de Pitati. In 1535 he painted for the town hall of Bassano three works on biblical themes (Bassano Museum), which are a synthesis of Bonifacio's influence and his own ideas. Coming from the 'mainland', Bassano was responsive to northern Italian realism but equally to Mannerist currents. Between 1535 and 1540 he showed interest in the painting of Pordenone and took from him a plastic structure on to which – now free from the influence of Bonifacio – he could graft portraits of an astonishing realism (*Samson and the Philistines*, Dresden, Gg.; *Adoration of the Magi*, Exeter Coll., Burghley House, Lincolnshire).

Mannerism, in full flood in Venice around 1540, opened up new possibilities to him, and he responded to it with enthusiasm. Each of his paintings was, to him, an experiment.

1540-50. During this period Bassano produced, in succession, a series of works of widely different character: *The Martyrdom of St Catherine* (Bassano Museum), which recalls Pontormo; *The Beheading of St John the Baptist* (Copenhagen, S.M.f.K.), where the slender figures, set in a more constricted space, are wholly Emilian in their elegance; *The Road to Calvary* (Bradford Coll., Weston Park, England), inspired by German engravings; the *Rest on the Flight into Egypt* (Milan, Ambrosiana), where the Mannerist rhythms set off violently truthful insights. Prints reaching Venice from Emilia and the north suggested exciting, whirling sequences to him. His colour became lighter and his tones lost their warmth.

1550-60. This decade saw Bassano's style mature. *The Last Supper* (*c.*1550, Rome, Gal. Borghese), which marks the end of a period for Bassano, is proof that he had studied Tintoretto's chiaroscuro and shows that he was familiar with the work of Schiavone (*Road to Calvary*, Budapest Museum). The formal tension is still very strong, while the space contains details which, in their realism, resemble the work of 17th-century Spanish painters. The realism of the previous decade takes on a new appearance. Before, the details had been confined within severe outlines; now they appear, as

 Federico Barocci
The Martyrdom of St Vitale (1583)
Canvas. 392 cm × 269 cm
Milan, Pinacoteca di Brera

▲ Fra Bartolommeo
The Mystic Marriage of St Catherine (1511)
Wood. 257 cm × 228 cm
Paris, Musée du Louvre

in *Lazarus and Dives* (Cleveland Museum), in a space full of shadows, with the result that they are far more evocative. Shadows now acquire their true atmospheric value; dawns and sunsets give to the compositions in which they appear the character of real landscapes. In this period, a remarkable luminosity, the cool colouring of which derives from a very broad application of pigment, infuses Bassano's work and gives it a lyrical, imaginative feeling that owes much to Mannerism. At this time, too, Bassano began to interpret the Bible afresh in paintings set in pastoral landscapes.

1560–70. The *Crucifixion* of the Church of S. Teonisto (1562, Treviso Museum) is an essential landmark in the chronology of Bassano's output as a painter, which otherwise is difficult to reconstruct. Christ on the cross stands out in isolation against a wide sky darkened by heavy clouds crossed by gleams of light, while lower down, where Mary and John are standing, the light is cold and limpid. El Greco found this remarkable new vision overwhelming, as did Veronese. With *St Jerome* (Venice, Accademia) Bassano pursues the same course, but more profoundly, to arrive at a truth that foreshadows Borgianni and the realism of the 17th century.

In *The Adoration of the Shepherds* (1568, Bassano Museum), one of a series of large altar-paintings, Bassano began a new phase of his development. Freed from the hallucinatory fantasies of earlier years, he abandoned himself to the lyricism of light and the magic of touch in narrative paintings that blend the natural and the artificial. Bucolic and pastoral in inspiration, paintings of this period draw upon widely differing biblical episodes for their subject-matter; they include

cycles on the Flood and on the life and Passion of Christ. They are set in the countryside, or in palaces and kitchens, often at night, where the play of light, of torches, candles and glowing coals takes on an important role (*Departure for Canaan*, Venice, Doge's Palace; *Annunciation to the Shepherds*, Prague Museum). The rural inspiration of this period also appears in a series of allegories of the months and seasons, illustrating agricultural and domestic life at different times of the year.

These bucolic paintings were very popular with collectors in Venice and abroad, and Bassano was called upon to produce many replicas of the original paintings. Work was spread throughout his studio, with, from about 1570, his son Francesco – later joined by his other sons – playing a particularly active role. As a result, attribution of individual works is difficult.

Last period. Around 1580 Bassano's style underwent a further change. His interpretation of scenes from the Passion becomes more tragic, overwhelmed by a feeling of suffering. Born from the extreme experiences of his youth and from his confrontation with the late works of Titian and Tintoretto (*Susannah and the Elders*, 1585, Nîmes Museum), the drama of the last works is entirely new.

Bassano spent his whole life peacefully in his native city, producing works for the churches there and in the vicinity, at a distance from Venice, the scene of the triumphs of Veronese and Tintoretto. In spite of this, he is, with them, one of the major figures of Venetian Mannerism, and he is so in a completely personal way. His art oscillates between two tendencies: the one,

imaginative and hallucinatory, was to recur in El Greco; the other, naturalistic and luminous, has led him to be compared with Velázquez and the Impressionists.

Bassano's sons. Bassano had four sons who were also painters: Francesco (b.Bassano, 1549 – d. Venice, 1592); Leandro (b.Bassano, 1557 – d. Venice, 1622); Gerolamo (b.Bassano, 1566 – d. Venice, 1621); and Giambattista (b.Bassano, 1553 – d.Bassano, 1613). Two of them, Francesco and Leandro, became famous. Francesco, who settled in Venice in 1579, continued to paint domestic and country scenes and later produced a number of works in the style of the school of Tintoretto (Venice, Doge's Palace). Leandro, who arrived in Venice some years later, was distinguished as a portraitist and adapted his father's style to suit the taste of Venice at the end of the 16th century (series of *Months*, Vienna, K.M.) A.B.

Batoni
Pompeo Girolamo
Italian painter
b.Lucca, 1708 – d.Rome, 1787

After studying at various schools of drawing in Lucca Batoni settled in Rome where he came under the influence of painters such as Conca, Masucci and Imperiali, working in the classical style of Maratta. Imperiali, the most classical of them all and the least affected by the rococo,

▲ Jacopo Bassano
Lazarus and Dives
Canvas. 146 cm × 221 cm
Ohio, Cleveland Museum of Art

became his real master and it was through him that Batoni was introduced to English circles.

Between 1730 and 1740 Batoni explored the sources of classicism. He drew from the antique and copied Raphael and the Carracci, studies that bore fruit in the most classical works of his career: the altar-paintings for the Church of S. Gregorio al Cielo (c.1732-4), among them *The Virgin and Four of the Blessed*, his first important work; and for the Church of SS. Celso and Giuliano (1738), *S. Filippo Neri Adoring the Virgin* (c.1733-8, Rome, Incisa della Rocchetta Coll.) and a *Presentation in the Temple* (Brescia, Church of S. Maria della Pace). Batoni's classicism sometimes extends to the type of purism associated with Domenichino or Sassoferrato (*The Visitation*, Rome, Pallavicini Gal.). Batoni also expressed himself in landscape, enlivening views in the style of Jan Frans van Bloemen (known as Orizzonte) with figures.

But after 1740, possibly as the result of studying Correggio and Parmigianino, Batoni abandoned this severe style and his fidelity to Bolognese fashions, and turned towards the Baroque. His change of direction is marked by a masterpiece, *The Fall of Simon Magus*, an altar-painting ordered by Pope Benedict XIV for St Peter's, and later destined for the Church of S. Maria Maggiore – a dramatic, almost romantic work. The new mood can be seen, also, in such allegorical paintings as *Time destroying Beauty* (1746, London, N.G.) and in mythological works like *Hercules at the Crossroads* (1742), *The Infant Hercules Strangling the Serpents* (1763, Uffizi) and *The Flight from Troy* (Turin, Gal. Sabauda). He became increasingly involved in portraiture, the most anti-classical genre of all, and thanks to the success of his portraits of the *Duke* and *Duchess of Württemberg* (1753-4, Stuttgart, Württembergische Landesbibliothek), emerged as the most fashionable European portrait painter of the mid-18th century.

His paintings on historical themes became

equally renowned: he not only painted *Joseph II with his Brother Peter-Leopold* (1769, Vienna, K.M.), but also sold many historical and mythological paintings abroad: to France (*The Death of Mark Antony*, 1763, Brest Museum); to Frederick the Great (*Alexander and the Family of Darius*, 1775, Potsdam, Sans-Souci); to Catherine the Great and to Portugal (seven paintings for the altar of the Basilica of Estrella in Lisbon, 1731-4). Above all, he was the portrait painter of English people on the Grand Tour.

Inspired by the French fashion for allegorical portraits (*The Marquise Merenda as Flora*, 1740, Forlì, Merenda Coll.; *A Lady of the Milltown Family as a Shepherdess*, 1751, London, Mahon Coll.; *Isabella Potocka as Melpomene*, Kracòw, Czartoryski Museum; *Alexandra Potocki as Polymnia*, Warsaw Museum), and, having probably become acquainted with the beginnings of English portraiture through the work of Angelica Kaufmann, he created a style of portraiture that appealed to his English customers. This was one in which the sitters are painted against a background of ruins, or of a classical statue, or the Roman Campagna. No fewer than 70 portraits of English people on the Grand Tour are known, painted after 1744. As time went by, Batoni's portraits became more natural, particularly after 1730. The backgrounds are dispensed with and the subjects, for the most part, are painted half-length in spontaneous attitudes (*Mgr Onorato Caetani*, 1782, Rome, Caetani Coll.; *Prince Giustiniani*, 1785, Rome, Busiri-Vici Coll.).

Whether Batoni can be described as a Neoclassicist is open to dispute. Insofar as he foreshadowed Neoclassicism, it was through the form, not the content, of his painting – through his smooth, porcelain-like finish, not through any concern for archaeological accuracy or moral dignity. He is the painter of an aristocratic world which felt the fascination of antiquity without making it a moral yardstick. His art, poised between the tradition of Roman classicism and nascent Neoclassicism, remains independent and personal and represents a significant stage in the history of 18th-century painting. S.Dc.

Bazaine
Jean
French painter
b.Paris,1904

After taking a university degree, Bazaine enrolled at the École des Beaux Arts in Paris to study sculpture – an art he had practised since childhood – under Landowski. He also began painting and after 1924 concentrated entirely upon it, taking part in the Autumn Salon from 1931 onwards and holding his first one-man exhibition in the following year. Bonnard was among those who visited him and gave him encouragement. Bazaine soon abandoned naturalism, although he continued to look to external reality to help him express his feelings (*Nature morte devant une fenêtre* [*Still life in front of a window*], 1942, Paris, private coll.). During the war, he helped organize the first avant-garde exhibition to take place under the German occupation. It was held at the Galerie Braun in May 1941 and its deliberately provocative title, 'Twenty young painters in the French tradition', reflected its aim

to serve as a manifesto for the painters of Bazaine's generation.

He continued to exhibit during the war and in the years immediately following, often in company with Lapicque, Estève and Jacques Villon. He developed a non-figurative pictorial language employing large basic symbols drawn from nature in huge rhythmic compositions (*Vent de mer* [*Wind on the Sea*], 1949, Paris, M.N.A.M.; *Orage au Jardin* [*Storm in the Garden*], 1952, Eindhoven, Van Abbemuseum; *La Terre et le Ciel* [*Earth and Heaven*], 1950, St-Paul-de-Vence, Fondation Maeght). This non-figurative tendency differs fundamentally from abstract art, which Bazaine criticized in his *Notes sur la peinture d'aujourd'hui* (*Notes on the Painting of Today*), published in Paris in 1948.

Bazaine is a seeker after perfection; he elaborates each painting slowly, frequently employing a large number of preliminary drawings and notes on colour values. He has carried out important monumental works. Apart from the large mosaic for the UNESCO building in Paris (1960), and those on the liner *France* (1961) and in the Maison de la Radio, these have all been ecclesiastical: windows for the church at Assy (1943-7), mosaics for the façade (1951) and windows (1954) for the church at Audincourt, windows for a reception centre at Noisy-le-Grand (1958). In his most recent work, at St Guénolé, Brittany, he has developed a freer organization of light and form (*Vent sur les pierres* [*Wind on Stones*], 1971). R.V.G.

Beardsley
Aubrey Vincent
English illustrator
b.Brighton,1872–d.Menton,1898

After leaving school in Brighton Beardsley worked briefly in an architect's office and then became a clerk in an insurance company. About 1890 his drawings, on which he had been working during his spare time, became known in a

▲ Pompeo Batoni
Time destroying Beauty (1746)
Canvas. 135cm × 96cm
London, National Gallery

▲ Jean Bazaine
Entre la pierre et l'eau (1964)
Canvas. 195cm × 130cm
Paris, Musée National d'Art Moderne

limited way, and in 1892 he received his first commission from John Dent, the publisher, to illustrate a two-volume edition of *Le Morte d'Arthur*. For this endeavour Beardsley produced in excess of 500 preparatory drawings which reveal the influence of Botticelli, Crivelli and Dürer, among others, and in which he interpreted his ideas in a manner that was clearly derived from the Pre-Raphaelites. During the same period he also drew very witty vignettes for Dent's *Bon Mots* series.

In 1894 Beardsley's illustrations to Oscar Wilde's *Salome* were published, with considerable impact, and in the same year he was asked to become art editor of the *Yellow Book*, a new journal founded by John Lane, a senior partner in the Bodley Head firm of publishers. The *Salome* drawings show that Beardsley was very much an admirer of Whistler and that he had further distorted the Pre-Raphaelite decorativeness of his earlier work, dramatising their designs in a manner derived from Japanese prints. Like the illustrations in each of the four numbers of the *Yellow Book*, they either astonished or appalled the public.

Beardsley became something of a celebrity, and he enjoyed a brief period of fame and notoriety in London society. However, his success was short-lived, for in 1895 Wilde was arrested after the collapse of his libel case against Lord Queensberry and, as he and Beardsley were seen as kindred spirits, considerable pressure was put on Lane to remove Beardsley from his position of art editor of the *Yellow Book* and to withdraw his drawings from the next number of the magazine. Beardsley was thus left without a job.

Shortly afterwards he was approached by Leonard Smithers, a publisher and bookseller, who asked him to contribute to the *Savoy*, another new magazine, with a more limited circulation, which he and Arthur Symons, the writer, had just founded. To the *Savoy*, which lasted until December 1896, Beardsley submitted three poems, 'Under the Hill' (a fragment of an erotic parody of the legend of Tannhäuser and Venus), and some of his finest designs. Smithers also published Beardsley's illustrations to the *Lysistrata*, *The Rape of the Lock* – a series suggested by Edmund Gosse – and to Ernest Dowson's play *The Pierrot of the Minute*. The two latter series show the clear influence of Watteau and of the precious elegance of 18th-century France.

In 1896 and 1897 Beardsley suffered greatly from the consumption that had been diagnosed as early as 1879, and during brief periods in Brussels, Bournemouth, Dieppe, Paris and Menton his work was punctuated by spells of illness. As well as being supported by Smithers in a desultory fashion, Beardsley also received money from Mark André Raffalovich, the wealthy son of a Russian-Jewish banker, whose desire it was to convert the young artist to the Roman Catholic faith. In 1897 Beardsley produced six illustrations to Gautier's *Mademoiselle de Maupin*, consisting of a frontispiece in watercolour and five drawings in Indian ink and wash, using a full scale of tones, which was a new development in his style.

Something of the inner conflict of Beardsley's last months is expressed in his final works, the illustrations to Ben Jonson's *Volpone*, and is further revealed in his correspondence – for Beardsley had been received into the Roman Catholic church on 31st March, 1897, and his pious letters to his spiritual mentor Raffalovich differ profoundly from those to Smithers, which were rather more worldly. Nine days before his death on 16th March, 1898, Beardsley sent a note to Smithers begging him to destroy all his indecent drawings.

Beardsley's graphic work was superbly suited to the contemporary line-block method of reproduction, which allowed no half-tones, and, as such, was technically very accomplished. His style is the epitome of the *fin-de-siècle* ideal of strange and grotesque beauty, but it was also capable of expressing deft and ironic comments on the decay of the Victorian age. J.H.

Beccafumi
(Domenico Mecarino)
Italian painter
b.Valdibiana, c.1486 – d.Siena, 1551

Little is known about the origins of Beccafumi. Side by side with the strange and sharply graphic Florentine Mannerism of Pontormo and Rosso, he challenged the ordered compositions of such painters as Perugino and Fra Bartolommeo, with his own imaginative and delicate version of Mannerism. First mentioned in 1502, in Siena, he appears to have been in Rome between 1510 and 1512, where he studied Michelangelo and Raphael, notably the bas-reliefs in grisaille in the School of Athens. According to Vasari he decorated the façade of a house in the Borgo. Returning to Siena, he worked in 1513 on frescoes in the Hospital of S. Maria della Scala. The mysterious transformation of the figures by a subtle lighting technique which makes the outlines virtually disappear was to characterize all Beccafumi's work (*Triptych of the Trinity* for this same chapel, Siena, P.N.). From now on his style was to remain fixed and similar features – contorted figures with tapering outlines – appear in the works that he painted before a second trip to Rome, around 1519. These include an altarpiece of the *Stigmata of St Catherine* (1513-15, Siena, P.N.) and *Scenes from the Life of the Virgin* in the Oratory of S. Bernadino – works which are more Umbrian in style than hitherto.

An interesting sidelight on Beccafumi's style is

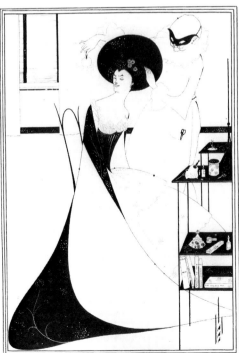

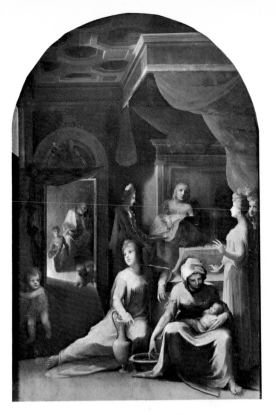

provided by the series of cartoons of *Scenes from the Old Testament* that he made for the decoration of the floor of Siena Cathedral in marble; these span the period from 1519 to 1544, when the work was finally completed. His taste for unusual light effects and non-naturalistic colour was given full play in the deliberately anti-classical works that he painted between 1520 and 1530, such as the *Nativity* for the Church of S. Martino and especially the two paintings showing the *Fall of the Rebel Angels* (Church of the Carmine and Siena, P.N.). Further evidence of the development of his Mannerism is provided by the bold foreshortening in the paintings in the Sala del Concistoro of the Palazzo Communale in Siena – works midway in style between the Palazzo del Tè in Mantua and Primaticcio's work at Fontainebleau.

On his return from a visit to Genoa Beccafumi carried out a series of paintings for Siena Cathedral, among them *Moses Breaking the Tablets of the Law* and *Apostles* (1538-9). Their rather nervous animation (also found in his engravings in chiaroscuro) contrasts with the intimacy of his *Birth of the Virgin* (c.1540, Siena, P.N.). The recent discovery of drawings showing that Beccafumi knew Michelangelo's *Last Judgement* seems to support the theory that he made a final trip to Rome. In his last years, he worked on the apse of Siena Cathedral and executed some angels in bronze (1550-1) for the pilasters there. F.V.

Beckmann
Max
German painter
b.Leipzig, 1884 – d.New York, 1950

After training at the Weimar Academy from 1899 to 1903, Beckmann went to live in Paris in 1903. His first sight of the *Pietà of Avignon* at the exhibition of French Primitives there the following year proved a revelation – evidence of his early fascination with Gothic painting. At the end of

1904 he settled in Berlin where he exhibited with the Sezession in 1906. The same year, he was awarded a scholarship to study in Florence.

To begin with, Beckmann's work was in the style of the German Impressionists; like others of the group, he looked to the 19th century for inspiration. His *Young Men beside the Lake* (1905, Weimar Museum) reveals the influence of the monumental compositions of Von Marées, and *The Wreck of the Titanic* (1912, St Louis, City Art Museum) of Delacroix – although he also felt affinities with Piero della Francesca and Signorelli. At the same time, a work such as the *Scene of Agony* (1906, Munich, private coll.) displays a taste for the pathetic that distantly recalls Munch. However, at the same time that Expressionism was emerging, he moved towards an objective awareness of reality that became evident in *The Street* (1914, New York, private coll.) and continued to form an important element in his work – self-portraits, paintings, drawings and engravings (*Small Self-Portrait*, 1912). This last work was executed in drypoint, probably the medium in which Beckmann was most successful, although he also produced a collection of lithographs (*The Return of Eurydice*) in 1909.

After establishing himself with some success in pre-war Berlin, where he exhibited at Paul Cassirer's in 1913, Beckmann volunteered for the medical corps at the outbreak of war and was posted to East Prussia and then to Flanders. After a nervous breakdown in 1915, he was invalided out and settled in Frankfurt-am-Main. The engravings of the early years of the war – exhibited in Berlin in 1917 – display a sharp and sensitive response to the conflict (*The Grenade*, 1915, drypoint). In slightly later works he looks back to the tradition of the Gothic altarpiece, crowding a narrow space with slender figures (*Descent from the Cross*, 1917, New York, M.O.M.A.; *Self-Portrait with a Red Scarf*, 1917, Stuttgart, Staatsgal).

This phase of Beckmann's work culminated in the cataclysmic *Night* (1918-19, Düsseldorf, K.N.W.), a vivid symbol of the condition of Germany in the immediate post-war years. Later, his work was to become calmer in tone, without losing the stylistic advances he had made during the war years. By participating in the Neue Sachlichkeit (New Objectivity) movement in 1925 he showed that he considered himself to be a witness of his age, but at the same time one who drew

▲ Max Beckmann
Night (1918-9)
Canvas. 133 cm × 154 cm
Düsseldorf, Kunstsammlung Nordrhein-Westphalen

from events general truths which he illuminated from within (*Voyage to Berlin*, ten lithographs, 1922; *Dance at Baden-Baden*, 1923, Munich, private coll.).

Beckmann experimented with a variety of genres and subjects: landscapes of an ambiguous serenity (*Spring Landscape*, 1924, Cologne, W.R.M.), still lifes, circus scenes, nudes, self-portraits and portraits. The portraits stand out with unmistakeable authority, aided by their contrasting tones (*Quappi in a White Shawl*, 1925, private coll.). In the circus paintings, acrobats (with whom Beckmann secretly identified) are shown in dangerous situations, trying to achieve impossible feats of balance (*Tightrope-Walker*, 1921, drypoint).

Between 1925 and 1933, when he moved to Berlin, Beckmann taught in Frankfurt, paying frequent visits to Italy and to Paris, where he held an exhibition in 1931. In 1937 he left Berlin for Amsterdam. Here he spent the years of the Second World War before leaving in 1947 for the United States, where he was already known, settling in St Louis. His style in the years from 1932 onwards relies on an increasing use of symbols, deployed in monumental triptychs, and abandons plasticity in favour of two-dimensional forms (*Departure* 1932-3, New York, M.O.M.A.; *The Temptation of St Anthony*, 1936-7, Santa Barbara, California, private coll.; *Acrobats* 1939, St Louis, private coll.). Together with the self-portraits, which continued to be central to his work (*Self-Portrait in Black*, 1944, Munich, Neue Pin.), these triptychs and other complex compositions filled with stiff, mythological figures, with nudes, objects and animals, reveal a universe of cold, almost abstract cruelty. *Beginning* (1949, Metropolitan Museum) is a foreshortened vision of human destiny and amounts to Beckmann's spiritual testament. It champions the rights of the individual in the face of the growing collectivism of the 20th century.

Beckmann's last set of lithographs, *Day and Dream*, appeared in New York in 1946. Examples of his work are to be found mainly in German and American public collections. M.A.S.

Bellange (or de Bellange)
Jacques
French draughtsman and engraver
b.Nancy, late 16th century – d.Nancy(?), before 1624

Little is known of Bellange's life, which seems to have been spent almost entirely in Lorraine. He became court painter at Nancy in 1603 where, three years later, he restored the Galerie des Cerfs in the Ducal Palace. In the same year he played a leading part in organizing the festivities to mark the marriage of Henri of Lorraine to Margareta of Gonzaga. A visit to France in 1608 to study the decoration of the royal châteaux (among them possibly Fontainebleau) was the prelude to a series of frescoes, which have now disappeared, for the Ducal Palace in Nancy. He is last mentioned in 1617.

Bellange's decorations have all been lost, together with the greater part of his easel-paintings (apart from a signed *Angel of the Annun-*

ciation, now in the Karlsruhe Museum, and a *Lamentation over the Dead Christ*, recently discovered in the Hermitage). His engravings and drawings, however, give a fair indication of his style, although there is a possibility of confusion due to the fact that the name 'Bellange' may cover the work of other Lorraine artists of the day, particularly that of Bellange's namesake, Thierry Bellange. The drawings (Louvre; Paris, E.N.B.A.; Musée Lorrain de Nancy; drawings collections of Munich, Berlin and the Hermitage), mainly in red chalk or pen, push Mannerism to its extreme limits; while Bellange's superb engravings of the *Annunciation*, the *Carrying of the Cross*, the *Holy Woman at the Tomb* and the *Hurdy-Gurdy Player* mingle elegance with perversity in a way that has found particular favour with our own age. P.R.

Bellini
Jacopo
first mentioned 1423 – d. Venice, 1470/1
Gentile
b. Venice, 1429 – d. Venice, 1507
Giovanni
b. Venice, c. 1430 – d. Venice, 1516

Family of Italian painters

Jacopo Bellini. Jacopo may have received his training in Florence under Gentile da Fabriano between 1423 and 1425 and if so may have come to know the masterpieces of Florentine art of the period. In 1424 Bellini appears to have been in Venice, a city in which he was to spend his working life and where his sons Giovanni and Gentile joined him in his studio after 1450. A *Crucifixion* (now lost) of 1436, painted for Verona Cathedral, a centre of Gothic, revealed Gentile's influence. Around 1451, Jacopo appears, with Pisanello, at Ferrara, where he painted the portrait (now lost) of *Lionello d'Este* and also the *Madonna of Lionello d'Este*, one of the finest examples of the final phase of courtly Italian Gothic.

The first signs that Bellini was beginning to be influenced by the ideas of the Early Renaissance are to be found in a number of paintings of the *Madonna* (Lovere, Gal. Tadini). Another *Madonna*, of 1448 (Brera), utilizes perspective (in the parapet in the foreground and the open book), although somewhat tentatively. Given Bellini's background, it seems likely that the source of these ideas was Antonio Vivarini (who in turn had come under the influence of Masolino during the latter's visit to Venice some time between 1435 and 1440) rather than the Tuscan artists working in Venice between 1440 and 1450. *Christ on the Cross* (Verona, Museo Civico) marks a real change in style, however; a severe work, it uses perspective rigorously and logically. So, too, do many of the drawings in the two famous albums (*c*.1445) in the British Museum and the Louvre.

In spite of this, Bellini never handled space with the assurance of the Tuscan artists and his imagination remained fundamentally Gothic. Evidence of this may be found in the way in which he produced the drawings in the two albums, allowing them to cross from one page to the next, combining more than one scene in a single space. This process is, of course, charac-

teristically Gothic and foreign to Renaissance concepts which demanded an exact use of space. It can be seen, then, that Jacopo Bellini's work, like that of Vivarini, comes at a rather uncertain point in the Venetian Renaissance, between the end of International Gothic in the first three decades of the century, and the beginning of Mantegna's work in Padua and Giovanni Bellini's in Venice around 1450.

Gentile Bellini. Gentile was the elder son of Jacopo Bellini. Together with his father and half-brother Giovanni he is known to have signed the lost altarpiece (1460) of the Chapel of Gattamelata

in the Basilica del Santo in Padua. Mantegna's influence is visible in the figures of *St Mark, St Theodore, St Jerome* and *St Francis* with which Gentile decorated the organ shutters of St Mark's in 1464 (Venice, Museum of St Mark's). He evidently had difficulty in containing all his subject-matter within the foreshortened composition: the landscape behind the figures of St Francis and St Jerome, with its wooded hills and steep rocks, rises vertically, heaped up by the foreshortening, and has been said to resemble an old Chinese painting. *The Blessed Lorenzo Giustiniani* (1465, Venice, Accademia) displays Gentile's characteristic style of portraiture, painted in profile and surrounded by a sharp, incisive line. The subject, isolated in the middle of the canvas and as though enfolded in his surplice, does not form a volume in space but dissolves in an interplay of lines that accentuate the bony planes of the face.

Mantegna's influence (he was the brother-in-law of Gentile and Giovanni) also appears in the *Pietà* of 1472 (?) in the Doge's Palace, probably painted by the two brothers in collaboration when they shared a studio in 1471. Gentile's talent for portraiture bore fruit when he painted the Emperor Frederick III who visited Venice in 1469; he was rewarded by being created a knight and Count Palatine. Similar commissions followed in 1474, when he was appointed offical portrait painter to the Doges. In 1479-80 he painted the *Sultan Mahomet II* (London, N.G.) during a visit to Constantinople – a period when he also came under the influence of the Persian miniaturists (*Turkish Artist*, Boston, Gardner Museum).

At the same time he was undertaking many commissions for narrative works, nearly all of them now lost. In 1446 he continued the decoration, begun by his father, of the Scuola Grande of St Mark's. In 1474 he was commissioned to paint on canvas the subject which Gentile da Fabriano and Pisanello had treated in fresco (destroyed) in the Hall of the Grand Council, a work which he

◀ Jacques Bellange
The Angel of the Annunciation
Engraving

▲ Jacopo Bellini
A Warrior presents Hannibal's head to Prusia
Drawing. 42 cm × 29 cm
Paris, Cabinet des Dessins, Musée du Louvre

Gentile Bellini ▲
The Miracle of the Cross on the Bridge of San Lorenzo (1500)
Canvas. 323 cm × 450 cm
Venice, Gallerie dell'Accademia

carried out in collaboration with Giovanni and a number of other painters. Three large canvases, completed later for the Scuola of S. Giovanni Evangelista (Venice, Accademia), have survived and show the influence of Carpaccio, particularly in the deepening of the spatial field and in a new use of colour. But, in the end, the complexity of Carpaccio's compositions drove Gentile back to the models provided by his father's drawings, where he found solutions to the problems of perspective that were more mechanical and easier to grasp. The best of his work is to be found in *The Procession in the Piazza San Marco* (1496), where the figures stand out against the jade green of the water, in *The Miracle of the Cross on the Bridge of San Lorenzo* (1500) and in the polychrome marble paving in *The Healing of Pietro de' Ludovici* (1501).

▲ Giovanni Bellini
St Francis in Ecstasy
Wood. 120 cm × 137 cm
New York, Frick Collection

Giovanni Bellini. The natural son of Jacopo Bellini and thus Gentile's half-brother, Giovanni grew up at a time when Uccello, Fra Filippo Lippi, Andrea del Castagno and Donatello were all working in Padua and Venice. The resulting revolution in the art of Venice and the surrounding region first became manifest in the works of Mantegna, but Giovanni Bellini, in his turn, was to have an even more decisive effect upon Venetian painting.

He began painting about 1449 and by 1459 was already at the head of his own studio in Venice. His father's study of the new ideas of Renaissance art, although not very thorough, must have affected him very early on, and from 1450 he would have been aware of what might be learned from his brother-in-law Mantegna. The *Crucifixion* in

the Correr Museum in Venice demonstrates how well he had absorbed Mantegna's lessons, notably in the foreshortening of Christ's body and the treatment of the rocks on which the Cross is planted. At the same time Giovanni's own artistic personality emerges strongly in the way that the drama of the Crucifixion is humanized by its setting, with Christ's body shown against a river landscape in the light of dawn. These lovingly explored landscape backgrounds of Giovanni, dominated by deep greens and by skies which, clear at dawn, become lightly tinged at sunset, are less systematic in their classicism than those of Mantegna. The spectator will discover in them feelings that have nothing to do with Mantegna's restricted world. Thus, in *The Agony in The Garden* (c.1460, London, N.G.), which is derived

from Mantegna's painting on the same subject (1457, Tours Museum), Bellini brings the landscape to life by his lively feeling for colour and light, while retaining the geological structure inspired by Mantegna. In the famous *Pietà* (Brera) Mantegna's smooth marble is converted by Bellini into suffering flesh.

The *Pietà* foreshadows the masterpiece of the decade 1460-70: the *Polyptych of St Vincent Ferrer* (1464, Venice, Church of SS. Giovanni and Paolo). The painting is notable for its use of light, which glows from top to bottom of the figures of the saints, outlining them with an incisiveness and energy that recall some aspects of the work of Andrea del Castagno. The figure of St Christopher is set in a landscape with the sun low on the horizon; against the setting sun, the river banks are reflected, in perspective, like the sky, in the transparent water of the river. It is this passion for man and nature that separates Bellini from Mantegna, from whom he took his use of space but not his brother-in-law's schematization and concern for architectural detail. Bellini found himself drawn instead towards the work of Piero della Francesca, in which the laws of perspective were put at the service of exalted ends. Piero's influence can be plainly seen in the *Coronation of the Virgin* (Pesaro Museum), which some authorities date around 1473 and others between 1470 and 1471. Space is no longer divided up, as it is in the polyptychs of the period; instead, unified by perspective, it draws together in a new way the buildings, the figures, the throne and the landscape.

A knowledge of the works of Piero della Francesca was obviously essential to this maturing of Giovanni's art and, like the arrival of Antonello da Messina in Venice in 1475, decisive for the future course of Venetian painting. It was the conjunction of these two circumstances that, around 1475, brought the Renaissance to Venice and led to the original work of the last quarter of the century (Carpaccio, Cima, Montagna).

The Resurrection of Christ (Berlin–Dahlem) can be dated around 1480, as can *St Jerome* (Florence, Pitti, Contini-Bonacossi Donation) and *St Francis in Ecstasy* (New York, Frick Coll.). In these works Bellini continued to give formal expression to the relationship between man and nature, filling the rational space of the Tuscans with the infinite variety of the Italian landscape and the entire range of human feeling (for instance, that of maternity in his many studies of the *Madonna and Child*). Giovanni's love of precision is never merely episodic, but each detail has its part to play in the overall arrangement of space.

In *Christ on the Cross* (*c*.1485, Florence, Corsini Coll.) Giovanni first deploys ideas that he was to elaborate in a group of works painted a little later. The picture has been described as, on the one hand, 'a strictly measured perspective painting', with bold planes inspired by Antonello, and, on the other, as 'an enlarged space, no longer empty but enriched with an atmosphere that sweetens the relationships between the volumes'. The perfectly calculated distribution of space in the triptych of the Frari (1488, Venice, Church of the Frari) reveals the influence of its abstraction and the geometric rigour of its volumes; at the same time, in *The Transfiguration* (*c*.1485, Naples, Capodimonte), a new luminosity fills the composition and softens the outlines of the planes. In the closed universe of the *Altarpiece* of the Church of S. Giobbe (*c*.1485, Venice, Accademia) the light, full of shadows and golden reflections from

the mosaics, envelops the volumes and humanizes everything that Giovanni took from Antonello.

Giovanni's search for a more regular, more solemn and monumental space was accompanied by an attempt to achieve greater pictorial effects, and his works of this period (*Paliotto of the Doge Barbarigo*, 1488, Murano, Church of St Peter Martyr) prefigure the tendencies of the 16th century. The series of paintings of the *Madonna and Child*, dating from around 1490, shows a striking mastery of Renaissance space and an apparently inexhaustible inventiveness comparable to that of the early portraits of Titian.

From his various stays in the Veneto, Romagna and the Marches, Giovanni brought back a vision of medieval walled towns, encircled by fertile hills, and of rivers spanned by ancient bridges – a vision that offers the most profound insight into the Italian landscape. In it one can follow the course of the past, with campaniles from Ravenna found side by side with Roman campaniles and Gothic towers. It is a historical landscape based entirely upon the natural landscape, in which nature itself, like those hills arranged by the hand of man, takes on a meaning that is also historical. The bright colours and the detail, stemming from Piero della Francesca, are less the outcome of a quest for realism than of a very lively awareness of the world. The spatial volumes appear to be produced naturally from the play of light, while the rigorous perspective plan is concealed by the free orchestration of tones.

The Sacred Allegory (Uffizi) heralds the new century. Works such as this and the *Giovanelli Sacra Conversazione* and a *Pietà* (both Venice, Accademia), *The Madonna of the Meadow* (London, N.G.), *The Baptism of Christ* (Vicenza, Church of S. Corona) and the *S. Zaccaria Altarpiece* (1505, Venice, Church of S. Zaccaria) may have inspired Dürer to label Bellini as the most important Venetian painter of his day. Bellini's landscapes from this period take on an autumnal lyricism and the figures in them acquire a new freedom. In the altarpiece of S. Zaccaria they seem to come alive in the glowing luminosity of the apse, while the colour, steeped in shadow and light, here equals that of Giorgione at his most inspired.

The works of Giovanni's last years (a *Madonna*, 1510, Brera; an *Assumption*, Murano, the S. Giovanni Crisostomo *Altarpiece*, 1513, Venice,

Church of S. Giovanni Crisostomo) are stamped with the monumentality and the pictorial qualities of the works of his young contemporaries, Giorgione and Titian. Bellini, who was one of the originators of the new style, adapted himself perfectly to it (the *Woman at her Toilet* 1515, Vienna, K.M.). His classicism made no distinction between the sacred and the profane and was not affected by the new taste for classical or secular subjects. Rather, these themes allowed him to counter the too systematic classicism of the new generation. From his *Intoxication of Noah* (1516, Besançon Museum) there emerges a profoundly youthful attachment to life, an abandonment to existence: the strawberry-red of the drapery, the living, gilded flesh of Noah as he lies sprawled out on his back, the tender green of the grass, the cup touched by the dusty light, are set against a background of vines and autumnal foliage. His classicism remains the same in this provocative, naturalistic affirmation, which only in his old age developed its uncompromising character. There are few other examples of such an evolution as Giovanni's – of an artist who took Venetian painting from the lifelessness of the end of the Gothic era to the threshold of modern painting. A.B.

Bellotto
Bernardo (also known as Canaletto the Younger)
Italian painter
b.Venice, 1720 – d.Warsaw, 1780

The son of Lorenzo Bellotto and Fiorenza Canal, sister of Canaletto, Bellotto worked in Canaletto's studio from 1735 onwards. He was inscribed as a member of the corporation of Venetian painters from 1738 to 1743. On 8th December 1740 he signed and dated a drawing of the *Square of St John and St Paul* in Venice (Darmstadt Museum) which he copied from Canaletto, and yet which already shows an individual approach to the view paintings of his uncle. In 1742 Bellotto travelled to Rome, and probably also to Florence and Lucca; his view of the *Ponte S. Angelo* (Detroit, Inst. of Arts), which is generally held to date from this period, displays great originality in the

▲ Bernardo Bellotto
View of Dresden
Canvas. 95cm × 165cm
Dresden, Gemäldegalerie

intensity of the shadows and its panoramic breadth. A tendency towards naturalism, which by now clearly distinguished his work from that of Canaletto, may have resulted from a study of 17th-century landscape painting, such as that of Viviano Codazzi (?). In Rome, too, he may have come to appreciate a certain 'Dutch' perfection in the landscapes of Claude Lorrain.

In the years that followed Bellotto did not live regularly in Venice. He worked in Lombardy in 1744 for Count Antonio Simonetta, during which time he painted a *View of Vaprio* (Metropolitan Museum) and *The Villa Melzi* (Brera). In 1745, in Turin, he completed the *Views of Turin* (Turin, Gal. Sabauda) for Charles Emmanuel III of Savoy, and also, as several of his works testify, spent some time in Verona where he seems to have met the painter Pietro Rotari. A study of the portraits of Vittore Ghislandi and of Giacomo Ceruti's paintings on popular subjects seems to have strengthened Bellotto's profoundly naturalistic bent.

In July 1747 he settled with his wife and son Lorenzo in Dresden at the court of Frederick Augustus II of Saxony, who appointed him court painter the following year. He remained in Dresden until 1758, a period which saw his series of *Fourteen Views of Dresden* (Dresden, Gg.) as well as his masterpiece, the *Eleven Views of Pirna*

(Dresden, Gg). He repeated this latter series on a smaller scale for the prime minister, Count Brühl, and for a number of private patrons. Probably, too, he was influenced at this time by the great Dutch landscape painters of the previous century, in particular the urban views of Gerrit Berckheyde and of Jan van der Heyden (he left an engraving of a painting attributed to the latter, which was in Count Brühl's collection), as well as by the landscapes of de Koninck.

In 1758 Bellotto left Dresden and spent three years in the service of the Empress Maria Theresa in Vienna where he painted, notably, the *Seven Great Views of Vienna and its Surroundings* (Vienna, K.M.). He was in Munich in 1761 (*View of Munich*, Bayerisches Nationalmuseum) and then returned to Dresden in 1762. Frederick Augustus II and Count Brühl both died in 1763 and Bellotto lost his position as court painter, but when the Academy of Fine Arts was founded in 1764 he was given the post of teacher of perspective. He then produced his *Imaginary Views* (Dresden, Gg; Warsaw Museum) and *Allegories* (Dresden, Gg). The paintings of this 'second Saxon period' gradually lose the broad, 'pre-Impressionist' characteristics of Bellotto's work in Pirna and take on an analytical precision of a Neoclassical or neo-Dutch kind, similar to that of Zoffany or Philip Hackaert.

This new style distinguishes the work of Bellotto's final years, which were spent in Poland. In 1767 he visited St Petersburg, but was persuaded by Stanislas II of Poland to go to Warsaw, where he stayed until his death, being appointed court painter in 1768. From this final period date his famous series of *Twenty-four Views of Warsaw* (Warsaw Museum) and two historical paintings, *The Election of Stanislas Augustus* (1778, Warsaw Museum) and *The Entry of George Ossolinksi into Rome in 1663* (1779, Wroclaw Museum).

G.P.

Bellows
George Wesley

American painter
b.Columbus, Ohio, 1882 – d.New York, 1925

George Wesley Bellows was the only son of an elderly couple who exemplified the Mid-Western virtues of honest business practice and evangelical religion. From earliest youth he seemed determined to be an artist, an ambition tempered only by an almost equally fervent desire to excel in sports. He attended Ohio State University from

1901 (where he enrolled in an art class), and contributed cartoons to student publications, basing his linear style on the fashionable illustrators John Singer Sargent, Anders Zorn and, especially, Charles Dana Gibson. Before graduating, however, and in the face of stiff paternal opposition Bellows left for New York to enrol in 1904 in the New York School of Art headed by William Merritt Chase. There, under the influence of a young instructor, Robert Henri, he began painting scenes of low-life Manhattan, an entirely new subject matter in American painting at the turn of the century. Fellow-students also influenced by Henri included Edward Hopper, Rockwell Kent and Glenn O. Coleman. Another of Bellow's instructors was John Sloan, and through these men Bellows met the entire circle, half of them from Philadelphia, who constituted 'The Eight', or the American Ashcan School: Luks, Shinn, Glackens, Prendergast, Lawson – those realists who were determined to create a purely American art on the basis of the unique qualities of American life.

By 1905 Bellows had already painted one street scene in the Henri manner. In 1907 he painted a large canvas, *Forty-Two Kids* (Washington; Corcoran Gal.), depicting two groups of immigrant children, that united Ashcan subject matter with the mid-18th-century line that Bellows had learnt from Hogarth. This odd combination of realist subject matter and traditional composition characterized Bellows's work for the remainder of his career.

About the same time as he found the possibility of employing an underlying compositional structure he became fascinated with the colour system of Hardesty Maratta, an American painter turned paint manufacturer. Maratta had developed a system of colour relationships that attempted to quantify colour values. If employed correctly, the choice of a few basic hues led inevitably to the determination of all the rest of the colour scheme in each particular work. Robert Henri used the same formula in his pictures. Subsequently, Bellows became the most famous advocate of Jay Hambidge's theory of 'dynamic symmetry', an American variation of the 'Golden Section' proportional schemes. Its use is evident in his lithograph, *Dempsey-Firpo* (1924, New York, M.O.M.A.).

By 1907 Bellows had begun to attract attention. *Forty-Two Kids, River Rats* and two prize-fighting paintings, *A Knockout* and *Club Night*, are teeming with the vitality of low life, yet all very carefully composed. The two latter paintings foreshadow *Stag at Sharkey's* (1909, Cleveland Museum of Art), in which Bellows achieved a new liquidity of movement while applying paint with an energy that was exceptional even among painters of the Ashcan Group. Despite his identification with popular themes, he was elected an Associate of the National Academy at the age of 27, one of the youngest artists to receive the honour.

One of the reasons the Academy so quickly responded to Bellows, while withholding approval from many of the older members of 'The Eight', was the fact that there were clear references to the old masters in Bellows's paintings. In *Stag at Sharkey's*, for instance, the ringside spectators are immediately reminiscent of Goya. At the same time, there were other sides to Bellows: he was an accomplished landscape artist, and he could paint society polo players with the same verve as ordinary people on the *Beach at Coney Island* (1910).

His almost universal appeal was uncanny. By 1910 a critic had compared him favourably to Matisse, writing that when it came to the portrayal of movement Matisse was 'ladylike in comparison with the red blood of Bellows'.

Bellows was active in promoting the Armory Show of 1913, and his view of contemporary European painting was largely shaped by what he saw there, for he never went to Europe. He defended French experimentalism, from which he adopted certain compositional elements, but this did not affect his increasing popularity with a large public. His portraits of children were as popular as his sport scenes.

Bellows represents the last innocent and isolated period in American art. After him no young painter could hold together the increasingly divergent tendencies of avant-garde painting on the one hand, and the academicism of the established art institutions on the other. D.R.

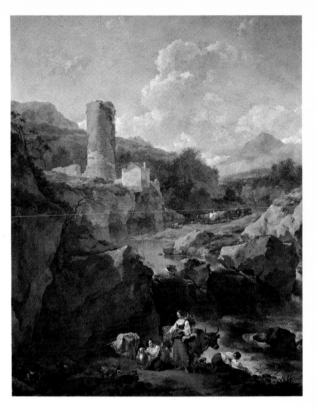

Berchem
Nicolaes Pietersz
Dutch painter
b.Haarlem, 1620 – d.Amsterdam, 1683

The son of the still-life painter Pieter Claesz, Berchem trained with Jan van Goyen, Nicolaes Moyaert, Pieter Grebber and Jan Wils, who, however, left no lasting influence on his work. In 1642 he was admitted to the Haarlem Guild of Painters and fell under the spell of Pieter van Laer, who had returned to Haarlem in 1639 after a period in Italy. Van Laer's Italianate landscapes, with their shepherds and flocks, which he had begun painting about 1630, became the main motif in Berchem's own work (*Landscape with Laban and Rachel*, 1643, Munich, Alte Pin.). Their atmosphere and light suggest that he, too, visited Italy, perhaps between 1643 and 1645, although there is no documentary evidence for this. The style of these early paintings, although still a little clumsy, recalls that of Van Laer. The composition is notable for the way in which the shepherds and their animals are grouped around a clump of trees to one side of the canvas.

Around 1650 Berchem painted several remarkable biblical and mythological scenes, reminiscent of the historical works of Salomon de Bray and of Caesar van Everdingen. It was only after 1650 that Berchem's talent as a landscape painter really began to assert itself, possibly as the result of a second stay in Italy which might have taken place in the years 1653-5 (*Landscape with Large Trees*, 1658, Louvre). He was certainly influenced by the work of his contemporaries, Jan Both and Jan Asselijn. Berchem's art was inventive and universal in its sympathies, without being in any way eclectic. Through the use of a particular series of motifs – hills, water, trees, shepherds and their flocks – he achieved great diversity of composition, style and atmosphere (*Landscape with Animals*, 1656, Rijksmuseum). In the course of a single year Berchem sometimes painted works that differed profoundly from one another in conception and execution. His last display a kind of nervous dynamism, but succeed in striking a balance between spontaneity and order.

More than 800 paintings by Berchem are known, as well as a series of engravings of shepherds and animals and a large number of

drawings. His work, which seems to foreshadow the rococo style, was especially influential for French pastoral painters of the 18th century (*Landscape with Tower*, 1656, Rijksmuseum). Until the end of the 19th century he was one of the most highly regarded of the 17th-century Dutch painters, but during the Impressionist period he fell out of fashion (Constable had already advised collectors to burn their Berchems) and has only recently come back into favour. His work is found in most of the major galleries, notably the Rijksmuseum, the Louvre, the Hermitage, Dresden (Gg), London (N.G.) and Munich (Alte Pin.). A.Bl.

Berghe
Frits van den
Belgian painter
b.Ghent, 1883 – d.Ghent, 1939

The son of the librarian at Ghent University, Van den Berghe lived from 1904 to 1914 at Laethem-St-Martin, except for a six-month stay in the United States in 1913. The works of this period – landscapes, interiors, nudes – are still Impressionist in feeling. Before the German invasion of Belgium in 1914 Van den Berghe reached Amsterdam where he renewed an acquaintance with Gustave de Smet. From then until 1926 the careers of the two painters were to be interlinked. In Holland Van den Berghe became involved with Cubism and was exposed to German Expressionism and Negro art. In 1919-20 he executed a number of woodcuts and lino-cuts in a heavy, simplified style, the erotic or poetic features of which were to remain in his work to the end (*L'Attente* [*Waiting*], 1919, wood; *Peintre du Soleil* [*Painter of the Sun*], 1920, wood). The paintings of this period display similar characteristics and resemble to some degree the art of Die Brücke (*Le Semeur* [*The Sower*], 1919, Brussels, private coll.; *Portrait of Mme Brulez*, 1920, private coll.). Cubist influences make

◄ George Wesley Bellows
Stag at Sharkey's (1909)
Canvas. 92 cm × 123 cm
Ohio, Cleveland Museum of Art, Hinman H. Hurlbut Collection

Nicolaes Berchem ▲
Landscape with Tower (1656)
Canvas. 88 cm × 70 cm
Amsterdam, Rijksmuseum

themselves apparent, rather more discreetly, in paintings executed in a lighter technique, in which spatial problems are balanced against those of expression (*Malpertuis*, 1922, private coll.).

On his return to Belgium in 1922 Van den Berghe settled with de Smet in Afsnee and then, in 1926, in Ghent where he spent the rest of his life. These years saw Van den Berghe's major contributions to Flemish Expressionism. To begin with, the provincial, rural atmosphere of the countryside around Ghent inspired him to produce paintings distinguished by a robustly plastic imagery and warm and supple colours (*Dimanche* [*Sunday*], 1923, Brussels, M.A.M.; *Le Lys* [*The Lily*], 1923, Basel Museum). But their freshness and humour soon gave way to a dream-like anxiety and an eroticism which were not far removed from Surrealism (*L'Éternel Vagabond* [*The Eternal Vagabond*], 1925, Ostend Museum; *Le Flûtiste* [*The Flautist*], 1925, Basel Museum). At the same time, in urban scenes, he dealt in a personal and satirical way with the themes preoccupying European realists in the mid-1920s (*Cinéma*, gouache on paper, *c.*1925-6, Brussels, M.A.M.; *Scènes de Maison close, I, II, III* [*Brothel Scenes*], 1927, gouaches).

The clearest change in Van den Berghe's style and vision took place in 1927, when the figures in his paintings lost their heaviness and took on a curiously troubled relationship with the world (*L'Homme des nuages* [*The Man of the Clouds*], 1927, Grenoble Museum; *Naissance* [*Birth*], 1927, Basel Museum). From 1928 this new-found delicacy of approach towards subject matter and colour, with its predominantly orange-red and gold tones, appears in fantasy paintings such as *Mercure* (private coll.), as well as in others that are either deliberately shocking or sometimes more poetic and relaxed. During this period Van den Berghe was also producing drawings for the satirical periodical *Koekoek* and the Ghent left-wing newspaper *Vooruit*. A number of these drawings, in Chinese ink (which he first started using in his youth), powerfully depict the cadaverous inmates of the concentration camps. His paintings during the 1930s sometimes show affinities with Ensor and Ernst, but also a characteristically Flemish approach to Surrealism which counterpoints his political engagement. In this latter respect Van

den Berghe is among the most representative of the painters of his generation. M.A.S.

Bermejo
Bartolomé
Spanish painter
active late 15th century

There are few hard facts available about Bermejo's life. According to the inscription on the *Pietà* (1490) in Barcelona Cathedral he was born in Córdoba, although his style is unlike that of other Andalusian painters. Indeed, his work does not readily suggest the influence of any particular school. He has been considered as part of the Aragon School because he was working here around the years 1474, 1486 and 1495, in collaboration with Martin Bernat, Miguel Ximénez and Jaime Huguet – although whether he was the creator of an Aragonese style or merely working within an existing tradition is a matter of dispute. Other theories suggest that he may have been in touch with Nuño Gonçalves or Van Eyck, and Bermejo's *Death of the Virgin* (Berlin-Dahlem) does, in fact, have certain similarities with the work of contemporary artists in Bruges and Ghent. On the other hand, *The Triptych of the Virgin and Child with Donors* (Acqui Cathedral) is clear evidence of contact with Italy. Because of the Hebrew inscriptions on certain panels, it has also been suggested that Bermejo may have been a converted Jew.

Bermejo's work does not achieve the beauty of execution of his Flemish contemporaries, but it has a profound strength and a monumental construction, to which are allied a sense of the concrete and an individual view of character. In landscape Bermejo was essentially a naturalist, with a sure touch for capturing the effects of light and shade. The figures in his later paintings are more subtly modelled and with greater pathos than those in earlier works painted in the Aragon style.

Certain works, executed by Bermejo between 1474 and 1495, can be identified and dated with certainty from documentary evidence. They include four panels, three of them signed, as well as stained glass in Barcelona Cathedral, which he was commissioned to design in 1493-5. Between 1474 and 1477 he painted, for the parish of Daroca in Aragon, an altarpiece, the central panel of which, *The Blessing of St Dominic of Silos*, is now in the Prado. Bermejo used a pyramidal construction and a frontal arrangement. The general concept remains subordinate to the plan, but jewellery, embroidery and decorative allegorical subjects are emphasized, with the realism of the faces in marked contrast to the stiffness and ornamental richness of the throne and garments. The impressive gilded figure of the saint has seldom been surpassed in its peaceful majesty.

The *Pietà* in Barcelona Cathedral bears the inscription: *Opus Bartholomei Vermeio Cordubensis implusa Lodovici de Spla barcinonensis archidiaconi absolutum XXIII aprilis anno salutis christianae MCCCCLXXXX.* This painting, dated 1490, with its dramatic content and its chromatic quality, and the expressive vigour of its praying figure, is a fine example of Bermejo's mature style. The luminosity and depth of the great landscape are one of his most successful efforts as a painter in this genre, which has been practised

very little by Spanish artists. The glass in the cathedral was made by Fontanet, after a design by Bermejo on the theme of *Noli me tangere*. The nine other windows that he designed at the same time for the cupola have now disappeared.

The two other known and signed panels are undated: the *St Michael* from Tous near Alcira (Luton Hoo, Bedfordshire, Wernher Coll.), signed 'Bartolemeus Rubeus', and the *Virgin of Monferato* in Acqui Cathedral, Italy, in which the twilight landscape is treated in a naturalistic manner and with the same luminosity as that of the *Pietà* in Barcelona Cathedral.

Other works generally attributed to Bermejo include: *The Death of the Virgin* in Berlin-Dahlem and the *Pietà* in the Mateu Collection in Barcelona, which probably dates from his time in Valencia. The altarpiece of *S. Engracia de Daroca* in Aragon has been split up: the centre showing St Engracia is in the Gardner Museum in Boston; the side-panels are divided between the museums of Daroca, Bilbao and San Diego, California; and four panels dating from the Catalan period and showing episodes in the life of Christ are divided between the Museo de Bellas Artes and the Amatller Foundation in Barcelona. M.D.P.

Berruguete
Pedro
Spanish painter
b.Paredes de Nava, c.1450 – d.Paredes de Nava, 1504

A native of Old Castile where, in the second half of the 15th century artistic activity was dominated by the Flemish painters brought in by the Catho-

lic kings, Berruguete followed the Gothic tradition and at the same time enriched it with new ideas from the Italian Renaissance.

Berruguete spent the years from 1472 to 1482 in Italy where he collaborated on the decoration of the *Studiolo* of Federico da Montefeltro in the Ducal Palace in Urbino. The work included the *Portrait of Duke Federico with his Son Guidobaldo* (Urbino), and 28 figures of classical and humanist philosophers and scholars, portrayed half-length in two rows above a decoration of marquetry (14 in the Louvre; 14 in the palace at Urbino).

The plan of the whole is perhaps the work of an Italian (possibly Melozzo da Forlì) and part of it may have been carried out by a Fleming, Justus of Ghent (often identified with Joos van Wassenhove), but the energy and plasticity with which the hands and faces of most of the figures in the top row are modelled are clear evidence of Berruguete's intervention. It has also been seen in the panel showing the *Duke, his Son and Members of his Court Receiving Lessons from a Humanist* (Hampton Court) and in four *Allegories of the Liberal Arts* painted for the Palace library (two in London, N.G.; two formerly in Berlin).

During his stay in Urbino Berruguete must have met many of the artists attracted there by the Duke's patronage, and certainly Piero della Francesca, who commissioned him to paint Federico's hands and helmet in his *Virgin among the Saints* (Brera). It is likely that Berruguete also visited Tuscany and Venice, where he painted *Christ Upheld by Two Angels* (Brera) for the Church of S. Maria della Carità.

His departure from Italy probably coincided with the death of Duke Federico in 1482. On his return to Spain he decorated the Sagrario of Toledo Cathedral in 1483 with a fresco (destroyed in the 16th century). Of his other frescoes nothing is left apart from two episodes from the *Life of St Peter* (Chapel of St Peter, Toledo Cathedral). Berruguete's principal activity, however, lay in the large number of altarpieces that he painted in the provinces of Palencia, Burgos, Segovia and Ávila. Two panels from the *Life of St John the Baptist* (Church of S. Maria del Campo) and *The Mass of St Gregory* (Toledo Cathedral) must have been painted shortly after his return from Urbino. Memories of the fluted pilasters and shell-shaped spandrels of Renaissance architecture remain fresh, as does the arrangement of space and light learned from Piero della Francesca.

Berruguete also painted important panels for three churches in Paredes de Nava, his birthplace: *St Peter Martyr* (parish museum of S. Eulalia); scenes from the *Story of St Helena* and *The Miracle of the Cross* (Church of St John the Baptist) and the *Altarpiece of the Virgin* (Church of S. Eulalia). This last work has been reset in Baroque panelling, but retains Berruguete's usual arrangement; one of the scenes, a visit of the High Priest to Mary in the Temple, is very rare in subject matter.

At Becerril de Campos the *Altarpiece of the Virgin* (Church of S. Maria) marks a new stage in Berruguete's development. As memories of Italy began to fade he turned back to Gothic forms which seem to epitomize the Castile of the Catholic kings. Spatial settings are more restrained, facial expression more realistic, and more emphasis is laid on the gilded backgrounds, the panelled ceilings and the accessories. The three scenes in the *Life of the Virgin* (Palencia, Episcopal Palace) and the *Miracle of Sts Cosmas and Damian* (Covarrubias, Collegiate Church) also

belong to this period. Berruguete next worked for the Convent of St Tomás of Ávila, whose Prior was the notorious Torquemada, Grand Inquisitor and confessor to the Queen. The four large quadrangular scenes which Berruguete painted as an altarpiece for the convent are of striking originality. Large-scale figures, visible from a distance and drawn with an incisive line against a flat background, give the whole a monumental character.

These same qualities are found in the scenes from the *Altarpiece of the Passion* (Ávila Cathedral), for which Berruguete is recorded as having been paid in 1499. His part in the work was limited to the *Agony*, the *Scourging* and the eight figures at the foot of the predella, the remainder being completed after his death by Santa Cruz and Juan de Borgoña. Berruguete was primarily a painter of large altarpieces and very seldom worked on a smaller scale. There is, however, a small devotional painting of the *Virgin and Child* (private coll. and Palencia Cathedral). The Palencia region was one of the most active artistic centres in Spain during the 16th century, and many artists, such as the Masters of Becerril and of Portillo, followed in Berruguete's footsteps. C.Re.

Bertram
(known as Master Bertram)
German painter
b. Minden, c. 1340/5 – d. before 1415

The earliest German painter whose name has come down to us, Master Bertram seems to have been born into a middle-class family from Minden. While he was still young the family appears to have moved to Hamburg where Bertram's name is found in the city's accounts from 1367 to 1387. In 1390 he planned a pilgrimage to Rome and made his first will, followed by a second one in 1410, where he calls himself 'Bertram, city painter of Hamburg'. He died before 1415, the year in which some Minden relatives claimed their rights as his heirs.

Bertram was a remarkable personality who emerges as the outstanding figure in the art of north Germany during the 14th century. His masterpiece is the *Altarpiece of Grabow* (1379, Hamburg Museum), so called after the town in Mecklenburg where it was housed from the 18th century until 1903. Painted for the Church of St Peter in Hamburg where it was placed in position in 1383, the altarpiece is huge, more than 21ft wide, and decorated with a host of sculptured figures and a series of 24 paintings. One of the most important examples of early painted panels in Germany, the altarpiece has two pairs of shutters which were opened only on feast days.

When the outer shutters are open they reveal two rows of 12 paintings depicting 18 scenes from *Genesis* (from the Creation to the story of Isaac) and six scenes from the *Infancy of Christ* (from the Annunciation to the Flight into Egypt). When both pairs of shutters are open the sculpted altarpiece is made visible. In the middle of the central coffer is the *Crucifixion*, between the two rows, one above the other, of *Prophets, Apostles* and *Saints* in niches, which also fill the coffering of the shutters. It seems probable that Bertram was responsible for these sculptures, although

contemporary documents refer to him only as a painter.

The everyday appearance of the closed altarpiece need not concern us, as the outer paintings have disappeared, but the surviving paintings are striking in their monumental simplification. The modernity of Bertram's art lies in his attempt to suggest volume by modelling large figures with light against a gilded background and outlining them by very clear drawing. The decor is reduced to essentials but includes a number of everyday objects and nature studies, such as plants or animals, which are rendered with great fidelity. The solemnity of the representation suits the breadth of the iconographic plan, which illustrates the story of the Redemption from the time of the Creation.

Also recognized as a characteristic work of Bertram's is the *Altarpiece of the Passion* (Hanover Museum), a wholly painted triptych which has close links with the *Altarpiece of St Peter* and explores similar ways of expressing space and volume. In this case, however, the dignified simplicity of the former is succeeded by a more flowing narrative style that denotes the influence of late 14th-century Franco-Flemish art, and indicates the new direction that German art was taking. The shutters open to reveal, in two rows, 16 paintings illustrating the *Passion of Christ* from the Entry into Jerusalem until Pentecost. It has been suggested that the work is identifiable as the *Altarpiece of the Virgin* offered in 1394 to the Church of St John in Hamburg by the Brotherhood of Corpus Christi of the *Flanderfahrer*

Pedro Berruguete ▲
Auto-da-fé presided over by St Dominic
Canvas. 154 cm × 92 cm
Madrid, Museo del Prado

(seafarers trading with Flanders). Other altar-pieces have been grouped around these two authenticated works: the large *Altarpiece of the Life of the Virgin* from Buxtehude (Hamburg Museum) is generally considered as a work of Bertram's studio, executed around 1410 by a pupil; but six scenes from the *Life of Christ*, with two shutters (Paris, Musée des Arts Décoratifs), the remains of an important altarpiece in a mark-edly Hanoverian style, can be regarded as by Bertram's own hand.

The sources of Bertram's art are obscure. His Westphalian origins no doubt account for the similarity of his iconographic schemes to those of contemporary altarpieces from that area. But it is quite unlike them in style – indeed there is more resemblance to Bohemian art of the third quarter of the 14th century, such as the work of Theodoric of Prague, with whom he shares similar concerns.

Bertram is one of the best examples of the nascent realism of the schools of the north, but his powerful, ingenious art does not seem to have exercised a great deal of influence. From 1420 it was superseded by the more elegant, vital International Gothic brought in from western courts, which Master Francke, Bertram's successor in Hamburg and who had himself come from the Low Countries, was to spread through the whole of northern Germany. N.R.

Bierstadt
Albert

American painter
b.Solingen, Germany, 1830 – d.New York, 1902

Albert Bierstadt, a meteoric figure in mid-19th century American landscape painting, gained and lost an international reputation between 1860 and 1880. His fortunes and declining fame during the last 20 years of his life reflect the dominant late-19th century attitude towards the Hudson River School.

Bierstadt was born in Solingen, Germany, in 1830, but was brought at the age of two to New Bedford, Massachusetts, where his father pursued the trade of cooper. Bierstadt worked as a cake decorator for a local baker and subsequently for a frame maker in the bustling, cosmopolitan whaling port. By 1850 he was advertising himself as an artist, had exhibited locally, sold work to sea cap-tains and was known as a coming artist as far away as Boston. A visit to an exhibition of contemporary German painting in New York decided him to return to Germany to study at Düsseldorf, a city close to his birthplace.

The Düsseldorf Academy in 1854 had over 300 students. Of the Americans drawn there to study under Lessing and Achenbach, Worthington Whittridge and Leutze had preceded Bierstadt, and Gifford was there as well. Gifford and Bierstadt travelled together to Italy, passing through Switzerland where the Alpine subjects of Alexandre Calame made a profound and lasting impression on Bierstadt.

Returning to New Bedford in 1857, Bierstadt went on a sketching tour of the White Mountains in New Hampshire the following year, a fitting pilgrimage since the area of that time was often proclaimed as the 'American Alps'. The taste for picturesque scenery fostered by the development of the railroads and hotel building was in its infancy, and Bierstadt participated fully, joining a Baltimore and Ohio railway promotion, an 'Artists Excursion' train to Wheeling, West Virginia, in 1858. It was the first of many such associations, the best known being his collaboration with British hotel builders in Estes Park, Colorado.

In 1859 Bierstadt made his first Western tour, joining a wagon train that crossed the continent. On a second tour, in 1863, he traversed the Great Plains, encountered buffalo, Indians, storms – all adventures typical of the westward migration – and these he captured on vast panoramic canvases – such as *Lander's Peak* (1863), *Domes of the Yosemite* (1864), *Storm in the Rocky Mountains* (1864), and *The Oregon Trail* (1867). This genre proved so popular that he was immediately rated with Frederick Church and, by 1860, had been elected to the National Academy. The mythic rhetoric of these canvases, with their appeal to the contemporary feeling of empire building or 'Manifest Destiny', proved as popular with European as with American collectors, and the paintings commanded enormous prices. In the 1860s and 1870s Bierstadt was America's most successful painter, so successful that in London he was received not only by Gladstone, Browning and Landseer, but by Queen Victoria. He exhibited his *Storm in the Rocky Mountains* at the Paris Exposition of 1867 to such acclaim that Napoleon III awarded him the Légion d'Honneur.

While in Europe he continued to paint American scenes from memory, and on his return to America reversed the process, producing Alpine scenes for the market. His identification with the landscape and incident he painted was so great that he became a kind of tour leader for European dignitaries who wanted to see with their own eyes the rapidly disappearing American Wild West; and all these activities and personalities were deliberately exploited by the artist to promote the sale of his paintings.

Already by 1872, however, the inevitable warning note was being sounded by the geologist-author-critic Clarence King, who accused the artist of exaggeration and lack of fidelity to nature. As a younger, Munich-trained group of artists began to move into New York in the 1870s, Bierstadt's reputation began to decline. John Weir of the Yale School of Fine Arts went so far as to accuse him of seeking sensational and meretricious effects in his entries at the Philadelphia Centennial Exhibition art show, and by the 1880s the critical tide had begun to run strongly against him in articles that stated bluntly that his

▲ Master Bertram
The Creation of Eve; Tree of Knowledge;
Original Sin; The Annunciation; The Nativity; The
Adoration of the Kings (1379)
Wood. 172 cm × 172 cm (Panel from the Altarpiece of
Grabow) Hamburg, Kunsthalle

work was not worth the high prices paid for it. In 1889 the panel charged with selecting American entries for the Paris World Fair actually refused to accord Bierstadt a place. He retaliated by exercising his privilege as a member of the Légion d'Honneur to show a work in the Salon, and exhibited his *Last of the Buffalo*. An even more humiliating experience awaited him, however, when his entry for the World Columbian Exposition at Chicago in 1893 , the giant *Landing of Columbus* was refused. By 1895 he was bankrupt, and when he died in 1902 he passed almost without notice.

Bierstadt made few concessions to the changing tastes of the last years of the 19th century as far as his painting style, formed in Düsseldorf, was concerned, but in the effort to switch from landscape to mythic history painting, exemplified by the *Landing of Columbus*, he manifested an awareness that, at least commercially, the West was temporarily finished as a subject for artistic exploitation. The techniques he had learned as a youth in Germany, notably his thin and liquid handling of oil paint, were described in one of his obituaries as 'dry and colourless'. The turn-of-the-century taste for the Munich style, together with the rise of the Barbizon School and even French Impressionism on the American market, were principally responsible, even more than his own personality, for the long eclipse of Bier-

stadt's reputation, a reputation that reached its nadir between 1940 and 1950, when his paintings could be bought for as little as two dollars apiece.

D.R.

Blake
Peter

English painter
b.Dartford, Kent, 1932

Blake studied at Gravesend School of Art, and from 1953 to 1956 at the Royal College of Art where he was a contemporary of Robyn Denny, Richard Smith and Joe Tilson. The paintings of children reading comics and wearing badges which Blake made as a student clearly foreshadow the direction in which his art was to develop, and a research award in 1956-7 to study popular culture in Europe confirmed this.

Circus and fairground subjects quickly gave way to British and American pop singers and film stars, and in his *Self-Portrait with Badges* of 1961 Blake presents himself as a be-jeaned fan of the American singer, Elvis Presley. In the 1960s he continued to produce paintings and collages,

often incorporating objects, in which strippers, wrestlers, boxers and singers were portrayed; this was a major contribution to what was to become known as 'Pop Art'.

Not only did Blake portray the *1962 Beatles* (1964, Robert Fraser Gal., London), he also designed the sleeve for their most successful album, *Sergeant Peppers's Lonely Hearts Club Band* (1967), and this public association did much to establish his international reputation. His exhibitions have been relatively few, however – the only important retrospectives were held at Bristol in 1969 and at Amsterdam in 1973 – because Blake has always worked slowly and produced little, taking many years over a picture. Almost all his paintings are of people, and in many cases an existing photograph or postcard forms the basis of the composition.

Blake has taught part-time at the Royal College of Art since 1964 and from 1972 has lived in Somerset, where with artist friends he has established a 'Brotherhood of Ruralists'. Already in 1963 Blake proclaimed 'For me, pop art is often rooted in nostalgia: the nostalgia of old, popular things', and his work of the 1970s carries more references to the fairies of *A Midsummer Night's Dream* and to the Victorian world of Lewis Carroll's *Alice in Wonderland* (including a series of prints) than it does to urban pop culture.

Paintings of his friends and of his family –

▲ Albert Bierstadt
Landscape
Canvas. 33 cm × 41 cm
Cambridge, Massachusetts, Fogg Art Museum,
Gift – Mr. and Mrs. Frederick H. Curtis

In 1779 he entered the Royal Academy schools, exhibiting at the Academy in 1780 and on several subsequent occasions, but a quarrel with the President, Sir Joshua Reynolds, led Blake to develop a general hostility towards institutions of all kinds. His engraver's training resulted in a style founded on precision of execution and sharpness of outline, in contrast to the painterly mode then prevailing at the Academy. His early experiences also introduced him to Neoclassicism, with which his emphasis on outline may be connected. Unlike most of his contemporaries, he never drew from the life and rarely painted portraits, landscapes or genre scenes.

Although he began by working in the then relatively popular field of historical painting, depicting scenes from England's past, his favourite subjects throughout his life were figurative allegories drawn from the Bible and literary sources like Shakespeare's plays, Milton's poems, Dante's *Divine Comedy*, and his own writings. The artists he admired were those, such as Barry, Mortimer, Fuseli and Flaxman, who shared his own extremist tendencies. He was attracted to political radicalism and supported both the American and French Revolutions, although he withdrew from politics after the Terror. In religion he came close to the doctrines of Swedenborg and hated the Church of England for its narrowness and hypocrisy. All this stamped Blake as an 'outsider' and one of the first Romantics.

His first masterpieces of visual art were his illustrations, executed in the unusual medium of hand-coloured relief etching, to his own *Songs of Innocence* (1789) and *Songs of Experience* (1794). These poems – anti-Augustan, with Elizabethan echoes and very simple in diction – are among the finest lyrics in English. The novelty of the illustrations lay in the integration of text and decoration, almost as in a medieval illuminated manuscript, and in the tender, simple linear style. Simultaneously, Blake began writing his first 'prophetic books' – long complex unrhymed poems influenced by the Bible and Milton: *The*

Book of Thel (1789), *The Marriage of Heaven and Hell* (c.1790-3) and uncharacteristically, in prose, *The French Revolution* (1791). Among their themes are the need for self-sacrifice and rebirth through death, the denial of the reality of matter, of eternal punishment and of authority.

In 1793 Blake moved from Soho, where he had lived up till then, to Lambeth, and went through a period of extreme pessimism. He wrote further prophetic books, developing the same themes as before but in still more abstruse and desperate terms: *Visions of the Daughters of Albion* and *America* (1793), *Europe* and *The First Book of Urizen* (1794), *The Book of Los* and *The Song of Los* (1795) and *Vala*, rewritten as *The Four Zoas* (1795-1804). At this period Blake regarded God's creation of the world as evil and identified Jehovah with his invented character, Urizen, the tyrannical author of the moral law. To Urizen he opposed Orc, the spirit of rebellion, but later saw a greater life-giving force in Christ, the forgiver of sins. His fundamental sympathies lay with things pertaining to the infinite – imagination, inspiration, poetic genius, faith – while rejecting those that pertained to the finite – materialism, reason, codes of conventional conduct. This mode of thinking in opposites, or 'contraries', shows his debt to Neoplatonism.

Although Blake illustrated almost all his books, his most important designs during the Lambeth period were his miscellaneous 'large colour-prints' (c.1795). Their subjects – *God creating Adam, Nebuchadnezzar, Pity* (from *Macbeth*, I, vii), *The House of Death* (from *Paradise Lost*, XI, 477-93) – depended on his usual sources, but he often re-interpreted the texts to suit his own ideas. In style these prints are broadly composed, highly coloured and extremely powerful, and display the influence of Michelangelo, Fuseli and other artists – for although Blake claimed to have invented all his forms himself, he borrowed freely, if often unconsciously. They well reveal the visual characteristsics of his work: naked or loosely draped figures, heavily muscled but curiously boneless; swirling flame-like lines; and

especially his two daughters – have always been an important element in Blake's work and, with his withdrawal from London to the English countryside, the character of his art has changed. His readiness to exhibit at the Royal Academy and his acceptance of associate membership in 1975, together with his constant preoccupation with craftsmanship and fine drawing, suggest that his early association with the avant-garde was an accidental one. A.Bo.

Blake
William

English painter and poet
b.London, 1757 – d.London, 1827

The son of a hosier, Blake received lessons from the age of ten at a London drawing school, then between 1772 and 1779 trained under the engraver, James Basire, who had him make drawings for an engraved record of medieval sculpture. This aroused Blake's interest in Gothic art.

▲ Peter Blake
Masked Zebra Kid (1965)
Wood. 55 cm × 27 cm
London, Tate Gallery

▲ William Blake
The Circle of Lust: Paolo and Francesca
Watercolour. 37 cm × 52 cm
Birmingham Museum and Art Gallery

an almost total absence of shadows, conventional space and perspective.

From 1799 to about 1805 Blake produced some 37 paintings in tempera and nearly 100 water-colours on biblical subjects for a civil servant, Thomas Butts, who was almost his only patron at this period. Their mood is more stately and more lyrical than that of the colour-prints, and, in fact, on moving in 1800 to Felpham, Sussex, at the suggestion of another of his few friends, the poet William Hayley, Blake began to recover his spirits. Soon after returning to London in 1803 he began a new poem, *Milton*, and from now on produced many watercolours on Miltonic sub-jects. Between about 1804 and 1820 he wrote and illustrated his longest poem, *Jerusalem*. In 1809 he held a one-man exhibition of his works in Lon-don, which was a disaster financially, but the *Descriptive Catalogue* accompanying it, together with his annotations to Reynolds's *Discourses*, is the main source of Blake's views on the visual arts. Around 1818-20 he executed a series of water-colours to *The Book of Job* (engraved 1823-5), again using the text to illustrate his own philosophy, which centred more and more on the doctrine of forgiveness. This doctrine was also the theme of his interpretation of Dante's *Divine Comedy*, which he began illustrating about 1824 but left unfinished at his death.

Blake regarded his designs, like his poems, as 'visions of eternity' and stated: 'One power alone makes a poet: imagination, the divine vision.' But, although 'vision' and 'visionary' are the key-words when discussing Blake, he always, and rightly, maintained that his visionary perceptions were not, as might be expected, vague and in-definite but sharp and minutely clear. He was thought extremely eccentric by most of his con-temporaries and his genius began to be widely appreciated only in the 1860s. But he was not so isolated or so unrepresentative a figure as has sometimes been supposed, and his last years were lightened by the friendship of a small group of young artists, notably Palmer and Linnell, who were deeply inspired by him.

The Tate Gallery, London, houses a notable collection of Blake's works, which are also well represented in the British Museum. In the United States Blake's drawings and illustrated books are to be found in Boston (M.F.A.); New York (Pier-point Morgan Library); Cambridge (Fogg Art Museum); San Marino (Huntington Library and Art Gal.); and Philadelphia (Lessing J. Rosenwald Coll.). M.K.

Blechen
Karl

German painter
b.Cottbus, 1798 – d.Berlin, 1840

In 1822 Blechen gave up a commercial career in order to study landscape painting at the Berlin Academy. During a visit to Switzerland in 1828 he met Dahl and probably Friedrich, and was in-fluenced by their ideas on landscape. The arch-itect K.F. Schinkel recommended him to a job in Berlin as a theatre designer and thereafter a noticeably dramatic element appears in his land-scapes: the balance between nature and the work of man which gives the idealized landscape a feel-ing of harmony was in Blechen often transformed

into a sort of antagonism. A period in Italy in 1828-9 proved influential: new motifs appeared in his work, while his colours were intensified and became one of the essential elements of his style. He made many studies after nature, in oil, water-colour, pencil and pen, and these became the basis of larger paintings. In 1831 he was appointed teacher of landscape at the Berlin Academy but in 1839 succumbed to a mental illness. Little under-stood during his lifetime and exerting little in-fluence on his contemporaries, Blechen now ap-ears as the leading German exponent of a certain tradition of landscape painting, at once subjective and realistic, which was to be continued, notably by Menzel.

Blechen's work is found in many German gal-leries, among them those of Berlin, Dresden (Gg), Hamburg, Munich (Neue Pin.), Cologne (W.R.M.), Stuttgart (Staatsgal.), as well as at Winterthur in Switzerland. H.B.S.

Bles
Herri Met de

Flemish painter
b.Bouvignes, near Dinant, c.1510 – d.1555(?)

A painter of lively landscape scenes, Bles developed the ideas of Joachim Patinir, as can be seen in such works as *The Holy Family* (Basel Museum), the *Landscape with Copper Mine* (Uffizi) and *Moses and the Burning Bush* (Naples, Capodimonte). But Bles's compositions are more fragmented, with jagged shapes seeming to float in a misty atmosphere. Evidence about Bles's life is scanty; he may even have been Patinir's nephew, Henri. 'Met de Bles' is a nickname meaning 'with a topknot'. Moreover, there are no signed or attested works by him. It is known that he lived in Italy under the name of 'Henri de Dinant' or the surname 'Civetta', because of the owl which he introduced into his paintings (there is an owl in his self-portrait engraved in 1600 by Philipp Galle). He ended his days at the court of Ferrara.

This owl emblem, which other painters also used, appears in a group of similar paintings, such as the *Landscape with the Good Samaritan* (1557?, Namur, Musée Archéologique), *Landscape with Mine Workings* (Budapest Museum), *Landscape with the Flight into Egypt* (Copenhagen, S.M.f.K) and *The Sermon of St John the Baptist* (Dresden, Gg. and Vienna, K.M.). These works display stylistic elements that have resulted in many other paintings being attributed to Bles: rather discon-nected brushstrokes, a fairly narrow range of colour, and highly detailed composition in which the imaginative competes with a degree of real-ism that foreshadows the Flemish landscapes of the second half of the 16th century. J.L.

Karl Blechen ▲
Gothic Church in Ruins (1826)
Canvas. 130 cm × 96 cm
Dresden, Gemäldegalerie

▲ Herri met de Bles
Landscape with Copper Mine
Wood. 83 cm × 114 cm
Florence, Galleria degli Uffizi

Bloemaert
Abraham

Dutch painter
b.Gorinchem, 1564 – d.Utrecht, 1651

Bloemaert was the son of a sculptor and architect, Cornelis Bloemaert. In 1580, at the age of 16, he went to Paris where for the next four years he studied under Jean Bassot and Hieronymus Francken and came into contact with the art of Toussaint Dubreuil. On his return to Utrecht in 1583, he worked in the studio of Gerrit Splinter and of Joos de Beer. Apart from a period in Amsterdam with his father between 1591 and 1593, he remained in Utrecht for the rest of his life.

Bloemaert held high office in the Utrecht Guild of Painters and also had a considerable reputation as an etcher, but is chiefly remembered as a painter of unusually wide range. In parallel with the Haarlem Mannerist circle, which included such painters as Cornelis van Haarlem and Goltzius, he developed a form of late Mannerism, touched with Italianism. A portrait painter (*Portrait of a Woman*, Philadelphia, Museum of Art; *Portrait of a Man*, 1647, Utrecht Centraal Museum), he was particularly noted for his religious paintings: *Moses Striking the Rock* (Metropolitan Museum), with its sharp colours and twisted forms so typical of his tormented expressionism; *Judith Showing the People the Head of Holofernes* (Vienna, K.M.); *The Preaching of St John the Baptist* (Rijksmuseum; museums of Nancy and Brunswick; Schleissheim Castle); *The Raising of Lazarus* (1607, Munich, Alte Pin.); *The Adoration of the Magi* (1612, Louvre); and others extending to 1632.

He is also known for his mythological scenes: *The Marriage of Thetis and Peleus* (Mauritshuis), painted in 1591-3 during his stay in Amsterdam, which influenced Cornelis van Haarlem when he came to tackle the same subject (Haarlem, Frans Hals Museum); *The Death of Niobe's Children (1591)* and *Venus and Adonis* (1632; both Copenhagen, S.M.f.K.); *Latona and the Peasants* (1646, Utrecht, Centraal Museum), all with rich, pleasant compositions, flowing draperies and rather too charming figures – but full of fascinating excess. Landscape also played an important part in many of his paintings.

Part of the broad current of European Mannerism, Bloemaert also exercised a great influence

through his studio where he trained artists including Cornelis van Poelenburgh, Gerrit and Willem van Honthorst, and Jan Baptist Weenix. He was also a prolific and gifted draughtsman, and the figures, animals and landscapes in his paintings all show his facility in this direction. Naturalistic details appear early on in his landscapes, which were widely admired by later generations of artists, thanks to his son Frederick, who published various editions of his father's *Tekenboek* (*Drawing Book*). J.V.

Boccioni
Umberto

Italian painter and sculptor
b.Reggio di Calabria, 1882 – d.Verona, 1916

Together with Severini, Boccioni spent some time in Balla's studio in Rome in 1901, and the experience proved formative. After a stay in Paris in 1906, he settled in Milan the following year. His series of *Suburbs* (1908-10) reflects the aesthetic of Balla and Italian Divisionism with its social concern, rigorous naturalism and deliberately asymmetric composition. The realism of Boccioni's early works gradually gave way to an art of psychological suggestion marked by social symbolism (*The City Rises*, 1911, New York, M.O.M.A.) and angry emotional analysis (*Mourning*, 1910, New York, Margarete Schultz Coll.); and the celebrated series of *States of Mind*: *The Farewells* (1911, New York, private coll.). In the course of working out his Divisionist ideas, Boccioni achieved dynamic effects that prefigure Futurism (*Riot in the Gallery*, 1910, Milan, Jesi Coll.).

In 1910 Boccioni became friendly with the poet Marinetti and the painters Carrà and Russolo. From their meetings Futurism was born. That same year Boccioni wrote the *Manifesto of Futurist Painting*. From then onwards he was associated with the struggles of the group, organizing exhibitions in the European capitals and collaborating in the review *Larcerba*. In 1912 he signed the *Technical Manifesto of Futurist Sculpture* in which he outlined his aesthetic. He was the most active,

as well as the most important of the Futurists. His first Futurist works, painting and sculptures, date from 1911 (*Laugh,* New York, M.O.M.A.).

After another period in Paris (1911-12) with Severini and Marinetti, Boccioni pursued to its furthest limit Futurism's fundamental concern: the construction of dynamic forms based on the concepts of 'simultaneity' and 'force-lines'. At the same time he developed his ideas in a series of theoretical writings and embodied them in works like *Matter* (1912, Milan, private coll.), and in the series of 'dynamisms' (*Dynamism of a Human Body*, 1913, Milan, G.A.M.). Perhaps his greatest studies of dynamic sensations are in bronze sculpture (*Development of a Bottle in Space*, 1913, New York, M.O.M.A., and *Unique Forms of Continuity in Space*, 1913, New York, M.O.M.A.). Here, with great sensitivity, he attempted to define the relationships between Futurism and Cubism through a dynamic conception of volumes. His last works (series of gouaches and drawings, 1912-13; *Portrait of Ferruccio Busoni*, 1916, Rome, G.A.M.) show him looking back to Cézanne.

Boccioni was represented in all the exhibitions of the Futurist group, and soon after his death was the subject of a large retrospective exhibition. In 1966 the Venice Biennale showed his work as painter and sculptor and at the same time Reggio di Calabria organized an exhibition of his graphic work. He is very well represented in New York (M.O.M.A.) and in Italy. L.M.

Böcklin
Arnold

Swiss painter
b.Basel, 1827 – d.Fiesole, 1901

Böcklin trained in Düsseldorf between 1845 and 1847 under Johann Wilhelm Schirmer, whose influence can be seen in the idealized landscapes he painted in his youth. During 1847 he spent short periods in Brussels, Antwerp, Zürich and Geneva (with Calame), visited Paris the following year, and then returned to Basel for two years before leaving for Rome in 1850. There, under the influence of Dreber, he developed a more

▲ Abraham Bloemaert
Judith Showing the People the Head of Holofernes
(1593)
Wood. 37 cm × 44 cm
Vienna, Kunsthistorisches Museum

▲ Umberto Boccioni
States of Mind: The Farewells (1911)
Canvas. 71 cm × 94 cm
New York, Private Collection

rigorous style of composition and a range of lighter colours. In 1857 he decorated the house of the playwright Wedekind in Hanover with landscapes and in 1859 painted *Pan in the Bullrushes* (Munich, Neue Pin.), the first work to reveal his highly personal vision of nature.

After teaching for two years at Weimar, he worked again in Rome from 1862 to 1866, visited Naples and Pompeii, and in 1864 and 1865 painted two versions of the *Villa by the Sea* (both of them in the Schackgalerie in Munich). He returned to Basel for five years between 1866 and 1871 and during this period executed the frescoes on the staircase of the former Basel Museum (1868-70). From 1871 to 1874 he lived in Munich and there painted such well-known pictures as *Triton and Nereid* (1873-4, Munich, Schackgal; 1875, Berlin, N.G.), and *Ulysses and Calypso* (1883, Basel Museum). He became the centre of a circle of artists that included, during the period of ten years (1875-85) that he spent in Florence, Von Marées. In 1880 Böcklin painted the first of five versions of *The Isle of the Dead* (Leipzig and Basel museums). From 1885 to 1892 he lived at Hottingen, near Zürich, and then, until his death, at Fiesole.

Much criticized in his early years, by the end of the century he was considered the most eminent painter in the German tradition, and in later years was often commissioned to execute copies of his early paintings. But the taste for Impressionism very soon affected his reputation and he had no real successors. Like Runge – although he was unaware of his work – he restored a neglected dimension to landscape through his introduction of human figures. His best works are striking for their careful, suggestive treatment of nature, for their fantastic, usually monumental figures, and for their simple composition and powerful colours.

Although in his last years Böcklin was often inspired by philosophical and literary concepts, these were always subordinated to formal composition in his work. For a long time he was forgotten or misjudged, but today, rather like Gustave Moreau, he has again found many admirers, who are attracted by the oddities of his imagination and the poetic quality of his symbolism. He is particularly well represented in the Basel Museum. H.B.S.

Boilly
Louis Léopold
French painter
b.La Basée, 1761 – d.Paris, 1845

The son of a wood sculptor, Boilly spent part of his youth in Douai (1774-8) before moving to Arras where he may have learned the art of *trompe l'oeil* from the painter Doncre. In 1785 he settled in Paris and early in his career received the support and patronage of a M. Calvet de la Palun who commissioned from him a group of eight works (four in St Omer Museum) on themes that he himself had chosen. Painted between 1789 and 1791, these small scenes with moralizing or gallant subjects (*Les Malheurs de l'amour* [*The Sorrows of Love*], London, Wallace Coll.) recall the work of Fragonard in their careful use of colour and tactile effects. Boilly exhibited at the Salon for over 30 years, from 1791 to 1824, and his continuing popularity during the years of the Revolution, the Directory and the Empire is an interesting reflection on the catholic taste of the age, when art lovers, impelled by the kind of curiosity fostered by the *Encyclopédistes*, were capable of appreciating at one and the same time both the grandeur of large historical paintings and the intimacy of small genre scenes in the northern tradition. Boilly celebrated contemporary events in such works as *Le Triomphe de Marat* (*The Triumph of Marat*) (1794, Lille Museum), painted as a public affirmation of his support for the Republic. He was less interested in recording the historical event as such than in capturing its atmosphere in rapid brushwork.

Boilly's virtuosity, and the fantasy and humour of his inspiration found free expression in his scenes from Parisian life, executed in a style close to that of vignettes. At other times his minute attention to detail could give an illusionist quality to his work – particularly when he used grisaille in imitation of engraving (*Les Galeries de Port-Royal*, 1809, Louvre). Such a concern for detail is a reminder of Boilly's familiarity with the works of such 17th-century Dutch painters as Ter Borch, Dou and Van Mieris, in which he was the first to foster an interest among collectors. He was a

chronicler of artistic life, too, and his series of *Studios* – a popular subject throughout the 19th century (*Houden dans son Atelier* [*Houdon in his Studio*], 1803, Paris, Musée des Arts Décoratifs) – is an example of the diversity of his portraits (of which he painted over 1,000).

Throughout this busy career Boilly stood apart from the main current of Neoclassicism (*Christ: trompe l'oeil*, 1812, Oxford, the Dulvertoon Trustees, on loan to Magdalen College), preferring a more spontaneous depiction of reality to the strict application of Neoclassicist principles. His work is found mainly in France (Paris, Louvre, and musées Carnavalet and Marmottan; Lille and St Omer museums), in London (Wallace Coll.) and in Leningrad (Hermitage). C.M.

Bonington
Richard Parkes
English painter
b.Arnold, Notts, 1802 – d.London, 1828

Born in England, Bonington moved with his family to Calais in 1817, where he became a pupil of Louis Francia, an artist trained in the English watercolour tradition. He then went to Paris where he studied under Gros for a short time. However, he remained primarily interested in landscape, and his first exhibited works (at the Salon of 1822) were two watercolours of Normandy. His *Cathedral and Port of Rouen* (*c*.1821, British Museum) shows him still working in the post-Girtin topographical tradition, but the watercolours he executed on his subsequent annual tours have a higher colour and more daring brushwork, revealing the effects of his study in Paris and growing interest in oil-painting. In the 1824 Salon he exhibited four landscapes in oils and was awarded a gold medal together with his fellow-countrymen Constable and Copley Fielding. From 1825 he paid yearly visits to London and became well known there; but the most significant event of his first visit was a meeting with Delacroix. Returning to Paris, they shared a studio, and while Delacroix benefited from the technical brilliance of his watercolours, Bonington was inspired to attempt historical and oriental costume pieces.

The year 1826 was the peak of Bonington's short career. He produced works like *Coastal*

Arnold Böcklin ▲
Ulysses and Calypso (1883)
Wood. 104 cm × 150 cm
Basel, Kunstmuseum

Louis Boilly ▲
Christophe Philippe Oberkampf, ses deux fils et sa fille aînée devant la manufacture de Jouy (1803)
Canvas. 97 cm × 127 cm
Paris, Private Collection

Scene in Picardy (Kingston-upon-Hull, Ferens Art Gal.) in which his exceptional feeling for atmosphere was combined with a formal pictorial basis. In the summer of the same year he visited Italy. The flickering light and brightly coloured buildings of Venice were ideally suited to his technique, and the sketches he made there, such as that of the *Colleoni Monument* (Louvre), are among his finest work. He later produced several views of Venice and his history pieces, such as *Henry IV and the Spanish Ambassador* (London, Wallace Coll.), while being close to Delacroix, show even greater links with Venetian painting.

From 1824 he published several lithographs and produced work for Baron Taylor's *Voyages pittoresques dans l'ancienne France*, demonstrating the spontaneous quality of this new medium. He was a prominent figure in French art circles in the 1820s as a representative of the fashionable English style of painting. In England he contributed to the development of the 19th-century picturesque landscape, but his own work, while always of a very high quality, sometimes justifies Delacroix's remark that he was 'carried away by his own brilliance'.

The contents of Bonington's studio were auctioned after his death in 1829. He is well represented in most of the major English galleries (especially at Nottingham and in the Wallace Collection, London), as well as in the Louvre. w.v.

Bonnard
Pierre

French Painter
b.Fontenay-aux-Roses, 1867 – d.Le Cannet, 1947

Bonnard was born into a comfortably placed middle-class family and started painting very young, in a style close to that of Corot. He painted landscapes in the Dauphiné, where his father had a house in the village of Grand-Lemps. After doing well at secondary school and university, he took up a civil service career, but at the same time enrolled at the Académie Julian in 1887, where he met Maurice Denis and Paul Ranson. Influenced by the synthetist doctrines that Paul Serusier had brought back from Pont Aven, in 1889 Bonnard formed with these three and with Vallotton, Vuillard and Maillol the Nabis group, who called themselves 'pupils of Gauguin'.

Although Bonnard is often considered as the most brilliant follower of the Impressionists, his early canvases show that he knew very little of Monet and Renoir and was, in fact, influenced by the attitude of young painters in Paris in the 1890s, which was resolutely hostile to Impressionism. He seems, too, always to have had reservations about Gauguin and the Symbolists, and he was of far too ironic and modest a character to share in the sentimental and vaguely mystical preoccupations of the Nabis. In spite of this, the influences to which he was subjected at this period proved decisive and persisted throughout his life. Like all the 'pupils of Gauguin', he 'simplified line and exalted colour' (so much so that a critic referred to his 'violent tachism' at his first exhibition). He used colour in an often arbitrary way without worrying about its relationship with light, preferring the arabesque to the modelled, deliberately neglecting perspective and distance, tightening the composition and tending to erect planes on the surface of the picture.

He developed an expressive form of distortion, akin to caricature, and discarded representation in favour of a decorative, often capricious and humorous interpretation of reality. Bonnard, in fact, was above all a decorator. For a long time he enjoyed making decorative panels (*Femmes au jardin* [*Women in the Garden*], 1891, Mrs Frank Jay Gould's Coll.; two panels of the *Place Clichy*, 1912 and 1928, Besançon Museum). His first wholly individual works were in the realm of graphics: coloured lithographs (*Quelques Aspects de la vie de Paris* [*Aspects of Parisian Life*], published by Vollard in 1899); book illustrations (*Daphnis et Chloé*, 1902, Jules Renard's *Histoires naturelles*, 1904) and posters (*France-Champagne*, 1891; *Revue blanche*, 1894).

This side of Bonnard's output shows, too, the influence of Japanese prints (his friends nicknamed him '*Le Nabi très japonard*') in its employment of certain decorative motifs (flowers on material, checks on a cloth) (*Partie de Croquet* [*Croquet Party*], 1892, United States, private coll.) and of plunging perspectives and unexpected cut-offs (*La Loge* [*The Box*], 1908, Bernheim-Jeune Coll.).

Around 1900 Bonnard began depicting the everyday life of Paris in scenes and townscapes that have been compared to the poetry of Verlaine. In general, these paintings are smaller and less highly coloured than similar scenes by the Impressionists and they are notable for their mixture of the droll and the melancholy, as well as for an attempt to reduce the scene to intimate and familiar terms (*Le Cheval de fiacre* [*The Cab Horse*], 1895, United States, private coll). This intimacy is found again in Bonnard's interiors, which suggest the pleasures and dreams of domestic life with the most poetic subtlety (*Jeune Femme à la lampe* [*Young Woman by Lamplight*], 1900, Bern Museum), and in his nudes, a genre which he took up around 1900, possibly under the influence of Degas, and continued to explore for almost 40 years, until 1938.

The early nudes are sombre, with a rather *fin de siècle* atmosphere about them, but these give way around 1910 to paintings of nudes at their toilet which are lighter and more broadly treated, without any neurotic or sensual overtones, and which suggest with the most casual gaiety the background of intimate femininity (*Nu à contre jour* (*Nude against the Light*). 1908, Brussels, M.A.M.). And when, between the wars, the washbasins and water jugs that had suggested a rather rudimentary sort of hygiene gave place to bathtubs, there followed the remarkable series of 'nudes in the bath', which are perhaps Bonnard's

◄ Richard Bonington
The Piazza San Marco, Venice (c.1827)
Canvas. 100 cm × 87 cm
London, Wallace Collection

masterpieces. In them he displays an acute awareness of the endless variety of effects which light introduces to colour (*Nu dans le baignoire* [*Nude in the Bath Tub*], 1937, Paris, Petit Palais). Bonnard's study of the nude, in fact, was the starting-point for a gradual change in his style which enlarged the scene, lightened his colours, abandoned a strictly colourist point of view and reintroduced the Impressionist light.

Like most of his contemporaries, Bonnard went through a period of crisis and uncertainty between 1914 and the post-war years. This crisis was all the more acute since he was a victim of the intellectual climate created by Cubism in European painting. His readherence to Impressionism came at the exact moment that it was being denounced by the supporters of logic and constructive geometry in painting as the very symbol of sensual decadence and fleeting sentiment. Bonnard then sought to disperse the light of his painting around a solid armature of oblique, contrary planes – the motif of the French window in *La Salle à manger de campagne* (*Dining Room in the Country*) (1913, Minneapolis, Inst. of Arts) is an early example. After the war, he surmounted this crisis and went on to create a series of paintings around 1925 (*La Table* [*The Table*] and *Le Bain* [*The Bath*], both London, Tate Gal.) which sum up what is essential in his art. Bonnard now limited himself to a small number of subjects: garden scenes, meals, sea paintings and still lifes, a genre in which he excelled and was very prolific.

After 1925, Bonnard lived in the Midi, where he had bought a house at Cannet. The paintings of 1930-40 are as a rule remarkable for their

monumental intention, for the much freer character of the composition, and for the richness, complexity and sometimes strangeness of their colouring (*Nu devant la glace* [*Nude at the Mirror*], 1933, Venice, G.A.M., Ca' Pesaro; *Intérieur blanc* [*White Interior*], 1933, Grenoble Museum). His vision of nature took on an almost disordered lyricism (*Le Jardin* (*The Garden*), Paris, Petit Palais) which at times verged on the ecstatic. Whether Bonnard in his last years was moving towards a 'final manner' is hard to tell, since most of the paintings of 1940-7 which were found in his studio after his death were so far from being finished that it is impossible to judge his intentions.

A.F.

Borch
Gerard ter

Dutch painter
b.Zwolle, 1617–d.Deventer, 1681

Although he was very precocious Ter Borch was slow to find his own style and came under many different influences. In 1632 he stayed in Amsterdam, and in 1633 went to work in Haarlem with Pieter de Molijn; before July 1635 he was in London. The three delightful small genre paintings of military life must date from this period. Executed with a meticulous technique already typical of the artist, they are similar to the works of Blekker or Pieter Post, who each painted a *Rear View of a*

Horseman (one example at Boston, M.F.A.). Ter Borch had a great fondness for painting his models from behind, a technique he used in his psychological masterpiece *Company in an Interior*, ('*The Fatherly Reprimand*') (Rijksmuseum). The influence of Hendrik Avercamp is more evident in *Fisherman on the River Bank* (Copenhagen, S.M.f.K.), and that of such intimist painters as Codde and Duyster in *Soldiers Gambling at the Inn* (1636, Rouen Museum), which carries the seed of that discreet and ironic realism that is the essence of Ter Borch's art.

From 1636 to 1643 almost nothing is known of Ter Borch's activities, except that he travelled abroad on numerous occasions, particularly to Italy, as his astonishing nocturnal painting, *Procession of Flagellants* (Rotterdam, B.V.B.), bears out. There is no doubt about this picture's Romanist style when it is compared to similar subjects by Pieter van Laer and Aniello Falcone; compare also Ter Borch's *Battle Scene* (Wilton, Pembroke Coll.). According to a reliable source – a poem by Roldanus, written in Zwolle in 1654 – Ter Borch also went to Spain and painted Philip IV (known today from a copy, Amsterdam, private coll.).

When he was next known to be in Holland, about 1639-40, Ter Borch painted guardroom scenes (London, V. & A.), as well as a great many portraits in a very small format, some almost miniatures, in which he employs the background and harsh style of his larger portraits – although this harshness was later to disappear (Richmond, Virginia Museum of Fine Arts; San Francisco, M.H. de Young Memorial Museum). It is very

Pierre Bonnard ▲
Nu dans la baignoire (1937)
Canvas. 94 cm × 147 cm
Paris, Musée du Petit Palais

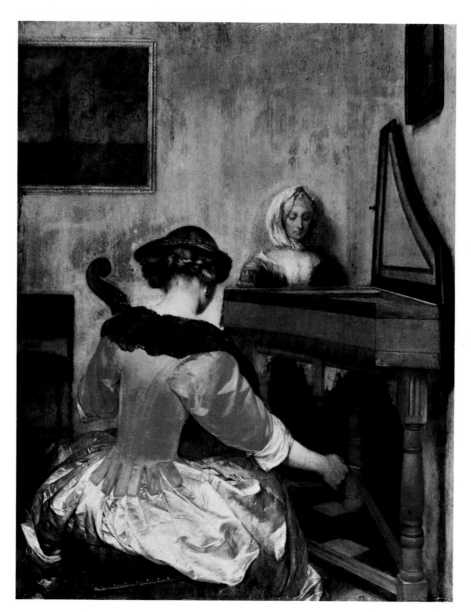

Young Boy Ridding his Dog of Fleas (Munich, Alte Pin.), painted against a unified grey background, the moving *Reading Lesson* (Louvre) and *Company in an Interior* (the so-called '*Fatherly Reprimand*') (*c*.1654, Rijksmuseum), which is, in fact, a wonderful little *comédie galante* between a young singer and his sweetheart in the presence of an unwanted third party.

Ter Borch married in 1654 at Deventer where he henceforth made his home. His activity as a society portrait painter, especially his pictures of such noble Amsterdam families as the Pancras's, the Vicqs (1670; Rijksmuseum and Hamburg Museum), the Graeffs (*c*.1674; fine portraits of Jacob de Graeff in the Rijksmuseum and of Cornelius in the Mauritshuis), as well as his genre paintings, show a close understanding of the increasingly aristocratic world of Dutch society. His methods scarcely changed, except in the detail of costumes, a new intricacy in the accessories, and a greater refinement of light and shade, to the extent even of sometimes affecting his technical virtuosity.

Examples of works from this late period are innumerable: *The Gallant Officer* (*c*.1662-3, Louvre); *The Game of Cards* (Los Angeles, County Museum of Art); *The Duet* (*c*.1670, London, N.G., and Louvre), and finest of all, *The Concert* (*c*.1675, Berlin-Dahlem), in which the composition is comparable to that of Vermeer. However, between 1660 and 1670, Ter Borch concentrated increasingly on portraiture, playing inexhaustibly with fine variations of grey, like a premature Whistler. Apart from the portraits of the Graeffs, there is *The Young Nobleman* (Louvre), a *Self-Portrait* (Mauritshuis) and *The Couples* (pendants; Prague Museum; Cologne, W.R.M.; Metropolitan Museum, Lehman Coll.).

J.F.

Borgianni
Orazio

Italian painter
b.Rome, 1578 – d.Rome, 1616

Borgianni received his training in Italy and Spain during the critical phase of transition from late Mannerism to Baroque at the end of the 16th and the beginning of the 17th centuries. He spent two periods in Spain, the first probably from 1598 to 1602, the second, which is documented, from 1604 to 1605. Borgianni's individuality as an artist is already apparent in the works of his first Spanish period, among them *St Christopher* (Barcelona, Milicua Coll.) and *Christ on the Cross* (Cadiz Museum), with a fantastic landscape in the background. But it is in the cycle of paintings illustrating the *Life of the Virgin* in the Convent of Portacoeli in Valladolid (1604-5) that he demonstrated his powerfully dramatic style, which was founded on that of Tintoretto, in such compositions as *The Presentation of the Virgin*, together with a reminder of the diffused light of Correggio in the *Assumption*. There is also a resemblance to the work of Rubens. Although he was open to various influences – the Carracci, the Venetians and possibly El Greco – Borgianni nevertheless went his own way and never became part of any particular school. Yet he was one of those who introduced Caravaggio's ideas into Spain.

During his last period in Rome, from 1605 to

likely that he also worked in Antwerp and perhaps in France.

In 1644 Ter Borch was once again in Holland, as revealed by his portraits of the Van der Schalke family (Rijksmuseum), which are among his most attractive works. Towards the end of 1645 he went to Münster to find employment for his talents as a portraitist among the diplomats and dignitaries gathered there to conclude the Treaty of Münster. From these years date a number of very fine small portraits, often in the form of lockets, such as those of *Godard van Reede* of Utrecht (Zuylen Castle, near Utrecht), *The Duc de Longueville*, the chief French negotiator, (equestrian portrait, New York, Historical Society), and *The Spanish Count de Peñeranda* (Rotterdam, B.V.B.). In addition there is the famous group portrait painted on copper (London, N.G.), which shows in the greatest detail the 60 dignitaries at the final session when the Treaty of Münster was concluded. The painting measures 17 × 23 in., large for Ter Borch. Of equal interest historically is his *Arrival of the Negotiator Adriaen Pauw at Münster in 1646* (Münster Museum).

On his return to Holland in 1648 Ter Borch

took up genre scenes once more, and during the following decade established a truly personal style in this type of painting. His evolution is visible in his choice of subjects, which increasingly treat a peaceable and bourgeois society. When his theme is courtly his manner becomes increasingly expressive and elegant. He also reduced the number of figures in each painting so that the viewer's interest would not be dissipated. He gave up open-air scenes and used a subtle chiaroscuro for his interiors, which prevented details from being over-defined and helped to increase the spatial depth without sacrificing the intimacy of domestic life. In this way Ter Borch attained a unique balance between psychological observation and the poetry of objects and space, avoiding the illusionistic exaggerations of Dou and opening the way for mid-century intimists. His greatest triumph lay in the tenderness and delicate humanity he showed towards his subjects, the softness of his light and his exquisite colour.

The artist never surpassed his first masterpieces of about 1650, such as *Maternal Care* Mauritshuis), the *Little Girl* (Rotterdam, Van der Vorm Museum), *Young Girl at her Mirror* (Rijksmuseum),

▲ Gerard ter Borch
The Concert
Wood. 56 cm × 44 cm
Berlin-Dahlem, Gemäldegalerie

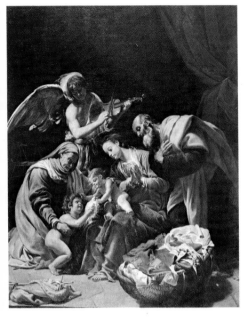

1616, Borgianni produced his best work. His *Death of St John the Evangelist* (Dresden, Gg), with its huge figures and strange poetry, is in the tradition of Mannerism, and he also rediscovered the Emilian classicism of the Carracci and Lanfranco, to whom his *Apparition of the Virgin to St Francis* (1608, Sezze, Cemetery Chapel) was formerly attributed. *St Charles Borromeo Adoring the Holy Trinity* (c.1611-12, Rome, Church of S. Carlo alle Quattro Fontane), with its prominent central figure set against an unreal background of classical ruins, and absorbed in a celestial vision, makes Borgianni seem profoundly religious, almost visionary.

In the last years of his life he abandoned this lyric art for more sculptural, and frankly luminist, compositions in the style of Caravaggio: *The Birth of the Virgin* (Savona, Santuario della Misericordia); *The Holy Family* (Rome, G.N.), which is remarkable for its still life in the foreground; and a *Pietà* (Rome, Gal. Spada). Although the 17th-century writer Baglione, in his *Lives of the Painters* (1642), calls Borgianni Caravaggio's worst enemy, he was, in fact, one of the first painters who really understood the lessons of Caravaggio's art.　　　　S.De.

Borrassa
Luis
Spanish painter
b.Gerona, c.1360 – d.Barcelona, c.1425

Born into a family of minor artists in Gerona, Borrassa became the first representative of the International Gothic style in Catalonia. He is known to have painted eleven altarpieces between 1402 (*Altarpiece of Copons*, Valencia, private coll.) and 1424 but only a few have survived in their entirety, although many paintings are plausibly attributed to him. He settled in Barcelona about 1383 and organized an important studio. The large altarpiece which he painted for the church of the Convent of St Damian at this period no longer exists, but the panel of the altarpiece

(c.1385-90, Paris, Musée des Arts Décoratifs), representing the *Nativity, Adoration of the Magi and Resurrection*, and continuing the Italianate tradition of Destorrents and the brothers Pedro and Jaime Serra, survives as an example of his early style.

With the *Altarpiece of the Holy Spirit* of Pedro Serra (Collegiate Church of Manresa) Borrassa reached maturity as an artist. The theme was one that was then being taken up by painters as well as sculptors, and Borrassa's version emerges as a work of tragic realism in which each character's suffering is expressed in a different way. Blocks of intense colour are separated by the figure of the Virgin, shown wrapped in a dark garment. Thereafter, Borrassa adopted the international style, with its intermingled Flemish, Parisian and Burgundian elements. Gerona at this period attracted many foreign artists seeking patronage from the future king of Aragon, John I, and his wife, Violanta de Bar, niece of Charles V, and Borrassa must have met many of them, as well as being influenced by the German and Tuscan artists who helped to make Valencia one of the leading centres of International Gothic.

Borrassa's masterpiece is the *Altarpiece of St Clare* (1414), made for the convent of the Order of St Clare at Vich. In its original form the altarpiece was nearly 20ft high and consisted of four rows of panels, one above the other; it is now exhibited in sections in Vich Museum at Barcelona.

The works that followed were more modest: the *Altarpiece of St John the Baptist* (c.1415-20, Paris, Musée des Arts Décoratifs), which is preserved whole, shows the skeletal image of the saint against the customary gilt background. The side scenes are set in a rocky landscape (*Preaching of the Saint*), sometimes with a few scattered trees (*Baptism of Christ*). *Herod's Banquet*, linked with *The Beheading of St John*, is notable for the elegance of the costumes.

Borrassa dominated the artistic scene of Barcelona from 1390 to about 1420. His type of altarpiece, with its rows of paintings one above the other, his brilliant colouring and his technical processes, were an example to his many pupils and imitators – although they were not always successful in capturing his ease, which enabled him successfully to mix violence with worldly grace, or his refinement of manner. He exercised a beneficent influence on such Catalan artists as

Juan Mates and the Master of Roussillon, while his successor as leader of the Barcelona school, Bernardo Martorell, was greatly in his debt.

L.E.

Bosch
Hieronymus
Netherlandish painter
b. 's Hertogenbosch, 1453(?) – d. 's Hertogenbosch, 1516

Bosch's family probably originated from Aachen, but had been settled in 's Hertogenbosch for at least two generations before his birth. It is known that both his grandfather Jan and his father Anton van Aeken were painters, and also that in 1481 Bosch was married to Aleyt, daughter of a comfortably placed merchant, Goyarts van der Mervenne, but that they remained childless. After 1486 Bosch is mentioned as a member of the religious Brotherhood of Our Lady, and this may well explain the sources of his inspiration. The few commissions that he is known to have undertaken, such as the shutters of a sculptured altarpiece for the Brotherhood (1488-9) and a *Last Judgement* for Philip the Fair (1504), cannot be associated with any surviving works, and the evolution of his style has been reconstituted from internal evidence.

Early work. Bosch's earliest paintings, *Christ on the Cross* (Brussels, M.A.A.) and two versions of *Ecce Homo* (Frankfurt, Städel. Inst., and Boston, M.F.A.), are not particularly original, apart from the near-caricatured features of some of the figures. *The Seven Deadly Sins* (Prado), on the other hand, treats a less familiar theme with a humour which shows its popular inspiration. Each episode is developed in the manner of a genre scene, with the emphasis on human attitudes rather than on the backgrounds. The same vein of humour reappears in the more allegorical *Marriage of Cana* (Rotterdam, B.V.B.), and more particularly in *The Death of the Miser* (Washington, N.G.) and *The Ship of Fools* (Louvre). This latter painting is perhaps the first-known treatment of a subject dear to Bosch, that of human folly unmindful of Christian teaching, and reflects an essentially critical and moral vision. It is also the first of Bosch's paintings to employ a technique in which the figures are painted in with a few brushstrokes or with light, suggestive touches over an incisive drawing that often shows through the thin paint.

Other works possibly belonging to this early period include: four panels depicting *Heaven and Hell* (Venice, Doges' Palace – mentioned after 1521 as forming part of the collection of Cardinal Grimani), which are mystical interpretations of medieval legends on the theme of the after-life; two paintings, *The Flood* and *Hell* (Rotterdam, B.V.B.), on the back of which are four scenes, the meaning of which is obscure; and a *Carrying of the Cross* (Vienna, K.M.).

Maturity. Among the major works of Bosch's maturity are the large triptychs acquired by Philip II of Spain. *The Haywain* (Prado) develops the theme of human folly. The *Original Sin* and *Hell*, painted on the shutters, flank a mysterious scene dominated by realistic figures mingling with

▲ Orazio Borgianni
The Holy Family
Canvas. 257 cm × 202 cm
Rome, Galleria Nazionale d'Arte Antica

◀ Luis Borrassa
The Healing of Agbar, King of Edessa
Wood. 154 cm × 130 cm
(panel of the Altarpiece of St Clare) (1414)
Vich, Museo Arqueológico Artístico Episcopal

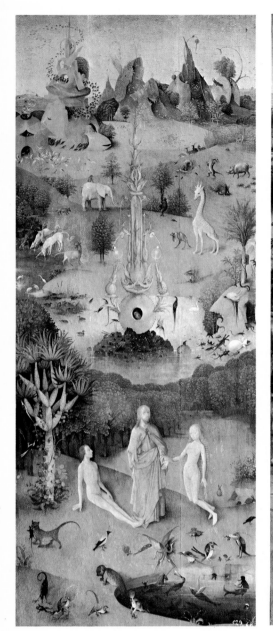

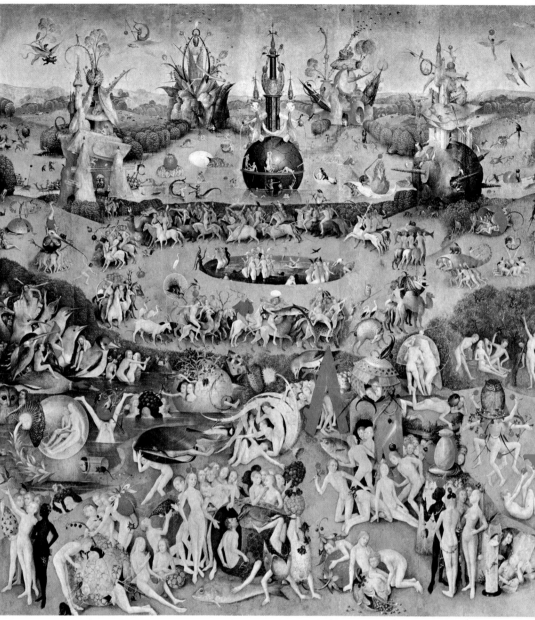

imaginary, diabolical creatures – an association which from then on was to characterize Bosch's art. The monsters are presented with an inexhaustible inventiveness and a remarkable feeling for anatomical plausibility. *The Temptation of St Anthony* (Lisbon, M.A.A.), which appealed so forcibly to Flaubert, is justifiably ranked among Bosch's most famous and enigmatic works. From *The Golden Legend* the episodes are developed with extraordinarily imaginative verve, with each detail apparently implying subtle allegories, although the essential theme remains the struggle between good and evil. The subjects on the back of the shutters are *The Carrying of the Cross* and *The Arrest of Christ*, together with *The Death of Judas*. *The Last Judgement*, in the Akademie, Vienna, is probably a work that is partly overpainted or perhaps an old copy of Bosch's original.

The Garden of Earthly Delights (Prado), Bosch's major work, has aroused the most varied comments. On the back of the shutters, the creation of the world is shown in a powerful and poetic

image, with the elements being formed in a globe emerging from black emptiness. When open, the triptych shows, between Heaven and Hell, the Garden of Delights: a fantastic landscape, thickly peopled with nude figures, some in couples, some in groups, together with gigantic vegetal forms and strange animals. Some commentators have seen the painting as evidence that Bosch belonged to the Adamites, a heretical sect, although the existence of such sects at the end of the 15th century is far from certain. More probably, the central panel deals with human temptation and decay, which here engender the pleasures of the senses and lust. The giant fruits are sexual symbols and recall a description of the work by Siguenza in 1576 as 'the painting of vainglory and the taste for strawberry or pomegranate, the taste of which is over almost before it has been experienced'.

A work close in style to *The Garden of Delights* is a fragment representing *Hell* (Munich, Alte Pin.), which may once have formed part of the

Last Judgement painted for Philip the Fair in 1504. *St John at Patmos* (Berlin-Dahlem) is remarkable for the quality of its landscape: the relative distances of the planes are still marked by the colour transitions beloved of the primitives. The painting is, however, a realistic depiction of the Dutch landscape, flat and dominated by water. Similar qualities are evident in *St Jerome at Prayer* (Ghent Museum), an even more passionate rendering of abandonment to mystical communion. Two triptychs in the Doges' Palace, *Altar of the Hermits* and *Triptych of St Julia*, are unfortunately in poor condition. Other paintings in the same series include a *St Christopher* (Rotterdam, B.V.B.), a *St John the Baptist in the Wilderness* (Madrid, Lazaro Galdiano Museum), and a *St Anthony* (Prado), in which the landscape is notable for the luxuriance of the trees.

The last years of Bosch's productive life are distinguished by several large masterpieces. *The Carrying of the Cross* (Ghent Museum) is composed of a magical mosaic of faces, among which

Hieronymus Bosch ▲
The Garden of Earthly Delights
Wood. 220 cm × 195 cm (central panel)
220 cm × 97 cm (side panel)
Madrid, Museo del Prado

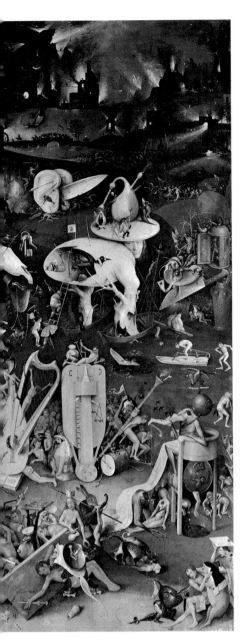

those of Christ and St Veronica stand out by virtue of their purity. *The Adoration of the Magi* (Prado) juxtaposes, in a landscape closely resembling that of the Berlin-Dahlem *St John*, the divine world of the evangelist with a fantastic world in order to emphasize the presence of evil pressing in on Christ. *The Prodigal Son* (Rotterdam, B.V.B.), a memorable and disturbing portrayal of a vagabond, is perhaps Bosch's finest work technically, with its poetic harmonies of brown and grey relieved by differing tones of pale red.

Bosch's work is exceptionally important in the art of his time because of the sense of mystery it conveys, as well as for its visual inventiveness. Bosch is essentially a moralist and his work must be seen as the product of a mature religious sensibility, animated by the *Devotio moderna* movement. His obvious pleasure in depicting monsters and the frequent presence of sexual imagery can doubtless be interpreted by psychoanalysis, but such an analysis can only supplement the essential themes of his work. A.Ch.

Botticelli
Sandro (Alessandro di Mariano dei Filipepi)

Italian painter
b.Florence, 1445 – d.Florence, 1510

A pupil of Fra Filippo Lippi, Botticelli spent his working life in Florence, apart from a period in Rome during 1481 and 1482, when he contributed the *Story of Moses* to the decoration of the Sistine Chapel.

Botticelli and the Medici. Botticelli was closely connected with the Medici family. His first work for them was a standard which he painted for a tournament organized by Giuliano de' Medici, of whom Botticelli later painted several portraits (Washington, N.G.). After the Pazzi conspiracy (1478), Botticelli made effigies of the plotters who had been hanged. In the *Adoration of the Magi* (Uffizi) it is the Medici and their followers who serve as models for the figures in the procession, while it was for Lorenzo di Pierfranco de' Medici that Botticelli painted his most famous secular pictures, *Primavera* and *The Birth of Venus* (both Uffizi), and made his drawings for the *Divine Comedy*. The events that overwhelmed Florence at the end of the 15th century shook him profoundly: the death of Lorenzo the Magnificent (1492) and the expulsion of his son Piero (1494) meant for Botticelli the end of the world that had welcomed and the honoured him as its favourite painter.

Early years. Botticelli began his career as a pupil of Fra Filippo Lippi at about the same time as Verrocchio and the Pollaiuolo brothers began their activity. His first works, the many paintings of the *Virgin and Child* (Uffizi; Louvre; London, N.G.), were all modelled on those of Lippi, to whom they were sometimes attributed. Botticelli's line, however, differs markedly from that of his master and his contemporaries: the drawing, heavy in Lippi, in Botticelli became light and subtle, and the tension animating the figures in Verrocchio and Pollaiuolo is suddenly softened. This can be seen in *Fortitude* (Uffizi), painted in 1470 to complete the series of *Virtues* by Piero del Pollaiuolo, or in the *St Sebastian* (Berlin-Dahlem), where the taut line of his contemporaries becomes loosened in an almost elegaic way. The same softening can be seen in the two *Scenes from the Life of Judith* (Uffizi), where the cruel, masculine heroine has become a melancholy woman draped in flowing garments that emphasize the rhythm of the walking figure. Botticelli avoided the culmination of the drama and preferred to show the scene that followed it, the discovery of the headless corpse of Holofernes.

His *Primavera*, painted for the Villa Medici at Castello, is dated 1478. Inspired by some lines of Poliziano's *Stanze per la goistra* (*Poems for the Joust*), it is one of the most extraordinary of all interpretations of classical myth. Botticelli's approach to the ancient world differs profoundly from that of the 'fathers' of the Renaissance 50 years earlier. Where they affirmed the presence of a new humanity in a world as seen through a new perspective, the laws of which they eagerly sought through the study and measurement of classical architecture, Botticelli created a classical

universe that was above all a nostalgic evocation of the past, an escape from reality. The classical buildings which he painted in the background of *The Adoration of the Magi* (Uffizi) appear not in their original condition but as fragile, romantic ruins.

In the very complex frescoes of the Sistine Chapel (1481-2), Botticelli seems to have been irked by the need to develop an enclosed, articulated narrative. The figures in the *Primavera* had been linked not by any dialogue but by imperceptible linear rhythms, and here his temperament led him to create a single scene. The most successful parts of these frescoes are probably certain details, such as the children with firewood, and the intense portraits of people, notably Zephora, one of the daughters of Jethro (*The Trials of Moses*).

1482-98. On his return to Florence, Botticelli painted his most famous Madonnas and the large circular pictures (*tondi*), including the *Madonna of the Magnificat* and the *Madonna of the Pomegranate* (Uffizi). His linear sense was accentuated in the circular rhythm of the composition, as well as in the harmonious arrangement of the figures, which are perfectly adapted to the format of the painting. The *Altarpiece of St Barnabas* can be dated about 1490, as can *The Coronation of St Mark* and the *Annunciation* of the monks of Cestello. In these works, all now in the Florentine galleries (Uffizi, Pitti), a sharper line is evident; there is a greater animation in the gestures, and an almost convulsive piling up of the linear rhythms (for instance, in the draperies of the two figures in the *Annunciation*).

Botticelli's line had already reached the furthest limit of its possibilities in *The Birth of Venus* (*c.*1484, Uffizi), especially in the confused mass of blonde hair. Works like the *Pietà* (Munich, Alte Pin., and Milan, Poldi-Pezzoli Museum), the *Mystic Nativity* (1501, London, N.G.) and the various versions of *The Story of St Zenobius* (London, N.G.; Metropolitan Museum; Dresden, Gg) are clearly distinguished from their predecessors by the break in the line and the intensity and violence of the colours.

Last period. The preaching of Savonarola, and then his death (1498), brought about a serious spiritual crisis in Botticelli. He was then living with his brother Simone, one of the most fervent disciples of Savonarola, whose preaching against the licence and corruption of the times, and the 'bonfires of vanities' in the piazzas of Florence, must have filled Botticelli's hypersensitive soul with doubts and scruples about his past. From the end of the 15th century until his death, he continued to paint historical and mythological subjects but only as vehicles for moral messages, such as the one in the *Calumny* (Uffizi). He found equal inspiration in the 'virtuous' stories of *Lucretia* (Boston, Gardner Museum) and *Virginia* (Bergamo, Acad. Carrara). The sacred paintings of his last years, such as the dramatic *Mystic Nativity* (London, N.G.), include moralizing allusions and sybilline inscriptions about the wickedness of Italy and its imminent punishment. In the *Crucifixion* (Cambridge, Massachusetts, Fogg Art Museum) he used an almost Dantesque allegorical sequence (the angel striking a fox, the wolf escaping from the Magdalene's garments) against a background showing Florence plunged in a sombre storm.

The very high quality of Botticelli's painting

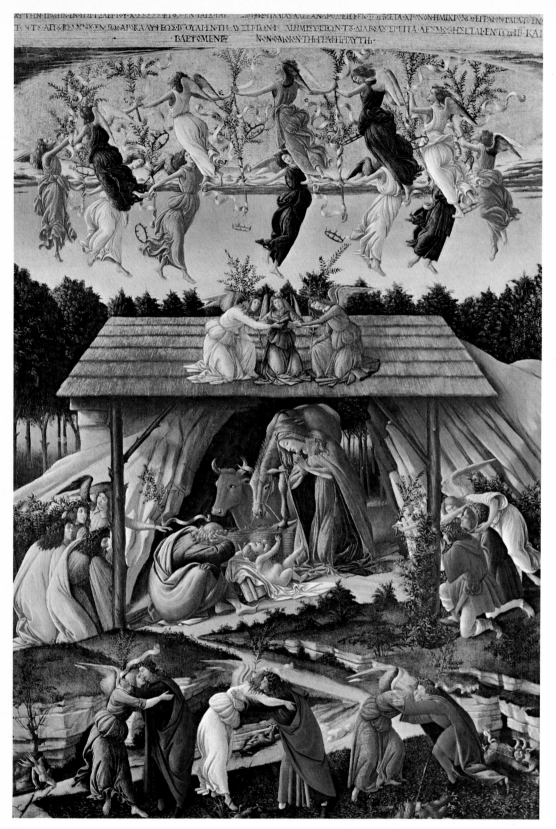

was not matched by his influence on his contemporaries. Only his young pupil Filippino Lippi understood his difficult, aristocratic style. His other Florentine imitators (for instance, Jacopo del Sellaio and Bartolommeo di Giovanni) misunderstood his art and transmuted the fluid cadences of his line into clumsy mechanical devices. Botticelli held no attraction for the artists of the early 16th century, who were drawn to the 'new manner' created in Florence by Leonardo da Vinci, Michelangelo and Raphael.

The aristocratic humanism of Medici society found in Botticelli its remarkable visual interpreter. His poetic idealism contrasted strongly with the bourgeois art of Ghirlandaio and the fantastic realism of Piero di Cosimo. For a long time Botticelli was forgotten, and was not rediscovered until the 19th century when he aroused, particularly among English artists, from the Pre-Raphaelites to the exponents of Art Nouveau, a passionate admiration which had been denied him at the end of his life. M.B.

Boucher
François

French painter
b.Paris, 1703 – d.Paris, 1770

For the greater part of his career Boucher was brilliantly successful, enjoying continued royal patronage and the friendship of the great, including that of Mme de Pompadour. After 1760, however, the public turned agained this elegant art, finding its apparent facility not to its taste. Both Chardin and David admired this highly gifted painter, the latter saying of him, 'Only Boucher counts'. However, critics remained cool towards Boucher for a century until his rediscovery by the Goncourts. Further reappraisal at the turn of the century did much to restore his reputation. Even today, however, his work remains little known and poorly understood.

Youth (1720-35). The son of an obscure embroidery draughtsman, Nicolas Boucher, Boucher entered Francois Lemoyne's studio around 1720 and quickly assimilated his decorative style, derived from Venetian painting. But it was his work as an illustrator that was to prove formative. To earn his living, the young artist joined the studio of J.F. Cars (father of Laurent Cars, who was to work for a long time with Boucher) and for several years designed vignettes to illustrate essays. In 1723 he won the *Prix de Rome* at the Académie (*Evilmérodach délivre Joachim prisonnier de Nabuchodonosor* [*Evilmirodack Delivers Joachim from Imprisonment*], 1724, London, private coll.), and in 1727 left for Rome where he remained until 1731. There he studied the works of Albano, Domenichino, Correggio and Pietro da Cortona, together with those of Castiglione at Genoa and Parma, and the decorations of Venice. He drew some heads from Trajan's Column and was apparently moved by the grandeur of the classical ruins (*La Foire au Village* [*The Village Fair*], 1736).

In 1733 he married Marie-Jeanne Buseau, who was to serve him as his model, and returned to his work as an illustrator: the very fine *Moliére* of 1734-6, in collaboration with Oppenord (drawings, E. de Rothschild Coll.), a series of *Cris de Paris*, etc. Throughout his career Boucher continued to provide publishers with drawings, notably for a *Boccaccio* of 1757. His friendship with Meissonnier dates from this period, and Boucher helped to spread the rococo taste that Meissonnier had initiated. At the same time he was received at the Académie (*Renaud et Armide* [*Rinaldo and Armida*], 1734, Louvre) and began a long official career: professor (1737), director of the Académie and chief painter to the King (1765).

Maturity (1736-c.1760). This was a period of intense activity for Boucher, who divided his time between the royal tapestry workshops of Beauvais and the Gobelins, of which he was inspector from 1755 to 1765, designing for the theatre and the opera commissions from the King and Mme de Pompadour and, to a lesser extent, from his art-loving friends. From 1736 he designed a series of tapestry *Pastorales*, such as the *Histoire de Psyché* (*Story of Psyche*), 1739 and *Psyché recevant les honneurs divins* (*Psyche receiving Divine Honours*) (Blois Museum); hence the presence of pastoral paintings in the Salon of that date

(decorations, now lost, for the *Petits Appartements* at Fontainebleau).

The fancy and unreality of the subject assured him of an immediate success (the *Histoire de Psyché* was remade eight times between 1741 and 1770 for, among others, the King of Sweden, the King of Naples, and the Spanish ambassador). Here Boucher showed real originality, transforming the grandiose art of Le Brun into an asymmetrical decoration, where curves and counter-curves play upon very carefully studied perspectives. Boucher's main works for the Gobelins were two series of the *Amours des dieux* (*Loves of the Gods*), some of the compositions of which were later used again in the *Metamorphoses* in 1767.

The *Divertissements chinois* (Chinese tapestries) (offered by Louis XV to the Emperor Ch'ien Lung; sketches in Besancon Museum, 1742), the designs for ornamental porcelain for the Sèvres factory, particularly between 1757 and 1767, together with the large number of sets created for the theatre and opera, gained Boucher recognition as an imaginative designer.

Mme de Pompadour, who gave Boucher apartments in the Louvre in 1752, played a particularly important part in his career. Her commissions included the decoration of the dining room at Fontainebleau (1748), *Arion* (1749, Metropolitan Museum) and the ceiling of the Cabinet du Conseil (1753, *in situ*), as well as the design of tapestries for La Muette. Above all, she employed him at Bellevue (*Adoration des bergers* [*Adoration of the Shepherds*], 1750, Lyons Museum) and at Crécy, where he designed statues for the park, small allegories of love and a series of *Seasons*, which contain many reminders of Watteau's paintings (*Les Amusements de l'hiver* [*Winter Diversions*], 1755, New York, Frick Coll.).

Last years. In 1752, Sir Joshua Reynolds, passing through Paris, noted that Boucher did a great deal of 'hack work'. Certainly he took on too many commissions, and he himself admitted to having done more than 10,000 drawings. Diderot

reproached him for his facility and for his use of colour ('copper inflamed with nitre'). After the death of Mme de Pompadour, in 1764, Boucher continued to exhibit at the Salon, although public taste had now turned to Greuze and Fragonard. In spite of weakened eyesight, he continued to lead an extremely active life: a trip to Flanders with Boisset (1766), religious paintings (*Adoration des bergers*, 1764, Versailles Cathedral), decoration of the Hôtel de Marcilly (1769) and many sets for operas.

Boucher's art. His celebration of women created a new genre that was perfectly in tune with the Parisian society of his day and had an equal appeal at the time of the Second Empire. He was not concerned with tenderness nor did he seek to move people, but aimed rather at capturing full-blown beauty or piquant charm. He is the painter of happiness, not so much erotic as sensual, in the highly refined, perfectly finished manner of his drawings. Similar qualities mark his mythological scenes, which are the essence and the best part of his work, and his very beautiful portraits (*Mme de Pompadour*, Munich, Alte Pin.; Edinburgh, N.G.). He was also a landscape artist of imagination and charm (*L'Ermite* [*The Hermit*], 1742, Hermitage), a great decorative painter and the most remarkable designer of the 18th century.

C.C.

Boudin
Eugène
French painter
b.Honfleur, 1824 – d.Deauville, 1898

The son of a sailor, Boudin began painting as a child and at the age of 20 opened a stationer's shop in Le Havre, where he exhibited paintings by visiting artists. It was thus that he met Isabey, Troyon, Couture and Millet, who gave him ad-

vice and encouragement. He then gave up commerce for art, going to Paris in 1847 where he copied his chosen masters, the Flemish and Dutch landscape painters, at the Louvre. On the strength of two paintings which he exhibited at Le Havre in 1850, he was awarded a grant for three years by the town and spent them working alone, sometimes in Paris, but more often at Le Havre or Honfleur, at the St Simeon farm. It was here that he found his true vocation, painting in the open air.

In 1858 a decisive event in Boudin's life occurred when he met Monet, then aged 17. Monet was never to forget his debt to the older man who infused him with a feeling for the ever-changing aspects of nature. A meeting with Courbet led to a lifelong friendship and together the two men met Baudelaire, who was enthusiastic about Boudin's work, particularly his pastel studies of clouds (Honfleur Museum). In 1859 Boudin made his first appearance at the Salon with *Le Pardon de Sainte Anne* (*The Forgiveness of St Anne*) (Havre Museum), and from 1863, continued to exhibit there every year. From 1861 he spent the winters in Paris where he became friendly with Corot and Daubigny and collaborated with Troyon, for whom he painted skies; but in the fine weather he fled the capital in search of space and sea air. At Trouville, in 1862, Monet presented him to Jongkind whose sensibility was so much like his own, although Jongkind's tougher character helped to free Boudin from his timidity.

After a public sale of his works in 1868, Boudin's years of poverty were over. He continued to travel, visiting Normandy, Brittany, northern France and the Midi, Holland and Venice – wanderings which helped to maintain the flow of his inspiration. His many views of harbours such as Le Havre, Trouville, Bordeaux and Antwerp, his beach scenes, his washerwomen, and his flocks were not so much variations on a theme as re-statements. It is not surprising, therefore, that the Impressionists should have invited this precursor of theirs to take part in their

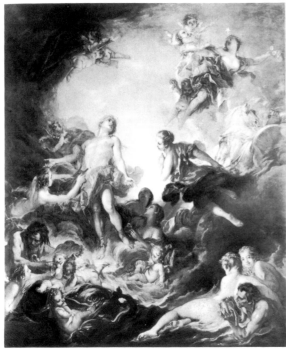

▲ François Boucher
Le Lever du Soleil
Canvas. 316 cm × 265 cm
London, Wallace Collection

Eugène Boudin
Le Havre, Coucher du soleil sur le rivage, marée basse
(1884)
Canvas. 117 cm × 160 cm
Saint-Lô, Musée d'Art

first show in 1874. In 1881 the dealer Durand-Ruel bought his output and organized several exhibitions for him in Paris and Boston.

At his death in 1898, Boudin left a considerable amount of work in his studio: favourite paintings, together with thousands of studies and rough sketches, the bulk of the latter, more than 6,000 in all, going to the Louvre. It is among these spontaneous outpourings that much of Boudin's best work is to be found, rather than in the overdone, often too careful, paintings; for, although he had absorbed the lessons of the old masters, the advice of Isabey and Troyon, the examples of Jongkind, Corot and Daubigny, and been influenced by, as well as influencing Monet, he relied above all on his instinct, on his sharp, rapid vision. He was an interpreter of movement: of water, clouds, the subtleties of the atmosphere, the eddies of a crowd. It was through this gift for seizing what was elusive that he prepared the way for Impressionism. H.T.

Bouts
Dirk (Dieric, Dirc)
Flemish painter
b.Haarlem, c.1420(?) – d.Louvain, 1475

The scant information that we have about Bouts's life tells us little more than that he came from Haarlem and that from 1457 onwards he was comfortably established in Louvain. His marriage to Catherine van der Bruggen (nicknamed Metten Gelde, i.e. 'the moneyed'), by whom he had four children, appears to have taken place about 1448. From the internal evidence of his paintings, however, it is almost certain that in his youth he was strongly influenced by the followers of Jan van Eyck.

The only works documented as being by Bouts

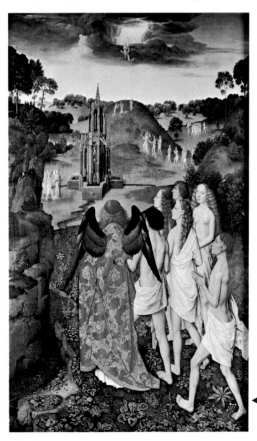

◀ Dirk Bouts
The Earthly Paradise
Wood. 115cm × 70cm
Lille, Musée des Beaux Arts

are a triptych of the *Last Supper*, painted in 1468 for the Collegiate Church of St Peter, Louvain, and two paintings illustrating the *Legend of the Emperor Otto* (Brussels, M.B.A.), originally intended for Louvain Town Hall. On the evidence of these two works many other paintings can be reliably attributed, of which the two closest in style are *The Martyrdom of St Erasmus* (Louvain, St Peter's), which was carried out for the same brotherhood as the *Last Supper*, and a *Portrait of a Man* (dated 1462, London, N.G.), which displays an austerity similar to that of the Brussels paintings. More animated and more dramatic in theme are a triptych of the *Deposition* (Granada, Capilla Real), a *Pietà* (Louvre) and *Christ Placed in the Tomb* (London, N.G.), painted on linen. Each of these paintings reveals a knowledge of the works of Rogier van der Weyden, from whom Bouts borrowed elements of composition, a tendency to elongate the shapes, and a certain pathos.

Elsewhere in Bouts's works the dominant influence is that of Van Eyck, notably in *The Virgin and Child* (London, N.G.), *The Coronation of the Virgin* (Vienna, Akademie), *The Martyrdom of St Hippolytus* (Bruges, Church of St Sauveur), *Moses and the Burning Bush* (Philadelphia, Museum of Art) and particularly *Ecce Agnus Dei* (on loan to Munich, Alte Pin., from the Wittelsbacher Ausgleichsfonds). In the London *Virgin and Child* Bouts uses a formula with which he was to have considerable success: the figures are portrayed half-length against a silk drapery, while a nearby window offers a glimpse of a landscape painted with minute attention to detail.

Also worthy of mention are two side-panels from an altarpiece which shows *Heaven* and *Hell* (Lille Museum) and an altarpiece of the *Life of the Virgin* (Prado) that is generally agreed to be Bouts's earliest surviving work. *The Arrest of Christ*, *The Pearl of Brabant* and a *Resurrection* (all Munich, Alte Pin.) are among the numerous other paintings attributed to Bouts to be found today in public and private collections in Britain, Germany, Holland, Belgium and the United States. Bouts's paintings were widely copied during his lifetime, some of the copies being based on the London *Virgin and Child*, others taking the form of a diptych showing half-length figures of Christ crowned with thorns and the Virgin at prayer. They are evidence of the success that Bouts enjoyed in his own day. J.L.

Braque
Georges
French painter
b.Argenteuil, 1882 – d.Paris, 1963

Early years. Braque was born into an artisan family and spent his childhood in Le Havre before beginning work as a painter and decorator, a trade that both his father and grandfather had followed. He received no formal artistic training, being, as he always afterwards claimed, self-taught. His apprenticeship is evident in his knowledge of materials and in the workmanlike and deliberately matter-of-fact approach of the paintings of his Cubist period and later. In 1900 he went to Paris where, in the winter of 1905-6, he became an adherent of the Fauves; it was Matisse and Derain, he later acknowledged, who had opened up new

paths in painting for him. In 1906 he stayed in Antwerp with Othon Friesz and in the summer of 1907 at La Ciotat and L'Estaque where he was inspired to paint a series of small seascapes in an elegant Fauvist style (*La Ciotat*, 1907, Paris, M.N.A.M.).

Cubism. In the autumn of 1907 two events occurred that were to cause Braque to change direction radically: the retrospective exhibition of Cézanne's work at the Autumn Salon and his meeting with Picasso, whose *Demoiselles d'Avignon* affected him profoundly. The large *Nu debout* (*Standing Nude*) (Paris, private coll.) that he painted that winter shows this double influence and also, perhaps, that of African art. During the following summer he painted, at L'Estaque, a series of landscapes in which the colour was simplified and in which perspective and design were reduced to a few compact geometric forms – the cubes that the critic Louis Vauxcelles remarked upon when the paintings were exhibited at Kahnweiler's in November 1908 (*Maisons à L'Estaque* [*Houses at L'Estaque*], 1908, Bern Museum).

In the landscapes painted in Normandy in 1908, and at La Roche-Guyon (*Château de la Roche-Guyon*, 1909, Stockholm, private coll.), the masses are less starkly opposed and appear more as a mosaic of planes. This was because Braque at the time was trying to paint the space between objects, instead of interpreting them by modelling them in space, as traditional perspective does; this, for him, was the main purpose of Cubism. This Cubist 'search for space' led him to abandon landscape for still life which seemed to offer him space that was almost tactile and reflected, as he himself said, his urge to touch rather than to see things. The still lifes that he painted in 1910 are characterized by their austere colours and by the placing of the constituent parts of the objects on a single plane (*Verre sur la table* [*Glass on the Table*], London, private coll.).

From the end of 1909 Braque worked closely with Picasso and together the two men elaborated the theories of analytical Cubism. So close, in fact, was the association that it is difficult to distinguish the contribution of each. Braque's still lifes, often of musical instruments, became increasingly monumental, with objects broken down into hard, shining facets to suggest a simultaneous view of their various aspects. In the paintings of 1911 volumes are more or less flattened out and reduced to a geometry of sharp angles and barely perceptible curves, while broken brushstrokes are used to unite the surface of the painting and give it a vibrant appearance. The introduction of *trompe l'oeil* elements, such as lettering, besides serving a decorative purpose, brought out the physical aspect of the canvas seen as a painting surface (*Le Portugais* [*The Portuguese*], 1911, Basel Museum).

Another of Braque's innovations, dating from 1913, was the use of coloured adhesive paper, which allowed him to reintroduce colour as such to his paintings but in a way that, as he claimed, dissociated the colour from form so that its independence could be seen through its relationship with form. The technique heralded synthetic Cubism (*Guitar et programme du cinéma* [*Guitar and Cinema Programme*], 1913, Picasso Coll.), although this is a term that more properly applies to the works of Gris and should be used with caution in relation to Braque. The paintings of this period are remarkable for their lightness. Abstract structures of simple, superimposed planes, they sug-

gest space without depth, on which objects are evoked by a few cursive and fragmented marks (*L'Aria de Bach* [*Bach Aria*], Paris, private coll.).

Post-war: the still lifes. Braque was called up in 1914 and, after being seriously wounded the following year, did not resume work until 1917. Immediately after the war he began to produce what were in essence still lifes in which qualities of good taste and dignity superseded the boldness and creative vigour of the years 1907-14. The paintings were still Cubist in style, with objects analysed into elements and planes, then reassembled into vigorous plastic and decorative rhythms. Braque also experimented with massive seascapes and beach scenes with grounded boats (*Falaises* [*Cliffs*], 1938, Chicago, private coll.), recalling memories of walks near the house that he had bought at Varengeville, near Dieppe, in 1930. The human figure rarely appeared in his work of this period, except in the fine series of *Canéphores* (1922-7, inspired by the Greek convention of figures with baskets on their heads), Braque's tribute to the Neoclassicism of the 1920s and probably an echo of Picasso's giants.

Between the wars Braque, in fact, established himself as France's leading painter, the inheritor of the national virtues and depository of the classical tradition, which he defined in his *Cahier de Georges Braque: 1917-1947* (1948, 1956). Hand in hand with this Neoclassicism went the group of works inspired by the art and poetry of ancient Greece: the etchings for Hesiod's *Theogons* (1931), the four remarkable engraved plaster casts (*plâtres gravés*) on mythological themes, also made in 1931 (*Herakles*, Paris, Aimé Maeght Coll.), and most of the sculptures.

Braque's work after 1920 is notable for its stylistic coherence, most of his output consisting either of relatively small works of the *cabinet d'amateur* kind or of large, more ambitious, works, often elaborated over a long period. There is no evolution in the true sense but rather − in spite of Braque's extremely limited range − a succession of new themes linked each time with a new mode of expressing relationships between line and volume, form and colour.

The series of *Guéridons* (table-top still lifes) and the sombre, richly textured still lifes of 1918-20, which often feature a bunch of grapes juxtaposed with a musical instrument (*Nature morte à la guitare* [*Still Life with Guitar*], 1919, St Louis, private coll.), were followed by paintings of fireplaces and marble tables (*Nature morte à la table dè marbre* [*Still life with Marble Table*], 1925, Paris, M.N.A.M.) in greens, browns and blacks, which are concerned principally with expressing volumes. Fruit and fabric in the still lifes combine into rounded forms that are almost Baroque in their curving line.

After 1928 Braque's colours tend to become lighter and, in general, the paintings have a more fluid and less sensual feel (*Mandoline bleue* [*Blue Mandolin*], 1930, St Louis, City Art Gal.). Their free and floating line has close resemblances to Picasso's curvilinear Cubism of 1923-4 (*Nature morte à la pipe* [*Still Life with Pipe*]. Basel Museum). The two tendencies joined together on the eve of war in great, brightly coloured ornamental canvases, full of imagination and animation (*Nature morte à la mandoline* [*Still life with Mandolin*], 1938, Chicago, private coll.). At the same time human figures reappear in some compositions. Shown from two aspects, full face and in profile, corresponding to a shadowy and a lit

side, they recall the earlier works of Picasso (*Le Peintre et son modèle* [*The Painter and his Model*], 1939, New York, private coll.).

Last works: the 'Ateliers'. The war inspired more serious works, which reflect the austerity of the times (*La Table de Cuisine* [*The Kitchen Table*], 1942, Paris, M.N.A.M.). After 1947 Braque's activity was often interrupted by illness, but between 1949 and 1956 he completed his series of *Ateliers* (*Studios*), eight paintings that attempt to

sum up the themes and experiments of his past work (*Atelier VI*, 1950-1, St Paul-de-Vence, Maeght Foundation).

The motif of the bird that appears in some of these paintings, its wings outspread in abstract space, reappears as the theme of the decoration that Braque carried out in 1952-3 for the ceiling of the Etruscan Hall in the Louvre. It appears to symbolize Braque's need, at the end of his life, to escape from the enclosed inanimate world of all his other painting. He also executed cartoons for

Georges Braque ▲
Le Portugais (1911)
Canvas. 117 cm × 81 cm
Basel, Kunstmuseum

the windows of the Chapel of St Dominique at Varengeville and for the Chapel of St Bernard at the Maeght Foundation in St Paul-de-Vence.

He is well represented in New York (M.O.M.A.) and in Paris (M.N.A.M.), as well as in most major galleries throughout the world.

A.F.

Breitner
Georg Hendrik

Dutch painter
b.Rotterdam, 1857 – d.Amsterdam, 1923

Breitner's early drawings and watercolours (*c*.1872, Rijksmuseum, Print Room) display a liking for horses and military scenes, themes that he pursued during his training (1876-9) at The Hague Academy (*The Trumpeter of the Yellow Hussars, c*.1886, Utrecht, Museum Van Baaren). During this period he made contact with the painters of The Hague School, worked with W. Maris in 1880 and collaborated on a *Panorama of Scheveningen* with Hendrik Mesdag. However, his reading of Flaubert, Zola and the Goncourts helped to strengthen his growing inclination towards contemporary themes, while meetings with Van Gogh in 1882-3 may have pushed him in the direction of realistic social portrayals like the scenes of peasants that he painted (after Millet)

in 1883 and 1885. A stay in Paris between May and November 1884, on the other hand, does not appear to have affected him deeply, although he was aware of the work of the Impressionists, as well as that of Courbet, Millet and Corot. Like Van Gogh at the same period, Breitner remained attached to Dutch painting of the 17th century, and copied Jan Steen and Rembrandt (*The Anatomy Lesson*, 1885, Amsterdam, Stedelijk Museum).

Breitner's best work was done between 1885 and about 1900. After settling in Amsterdam in 1886 he became the most notable interpreter of its everyday life through his paintings of familiar street scenes and ordinary people (*Two Women, c*.1890, Otterlo, Kröller-Müller Museum). He established a reputation as leader of the 'Dutch Impressionists' (who also included such artists as Verster, Israels and Bishop-Robertson) because of his modernity and interest in Japanese art. In fact, his bold technique, with its broad quick brushstrokes or use of the palette knife, was closer to that of Hals (*Evening in Amsterdam*, Antwerp Museum; *Bridge with Three Women, c*.1897, Amsterdam, Stedelijk Museum). He also used photographs a great deal, both for documentation and also to experiment with effects of arrangement and contrast. Their influence can be seen in the incisive self-portraits (1882; 1885-6, The Hague, Gemeentemuseum), painted in the realistic Dutch tradition.

Breitner's palette always included blacks and browns and it is only in his fine, vigorous studies of nudes (Rotterdam, B.V.B.; The Hague, Gemeentemuseum; Amsterdam, Stedelijk Museum; Antwerp Museum) and in his interiors (*The Red Kimono*, 1893, The Hague, Gemeentemuseum) that a slightly lighter range of colours appears. His first retrospective exhibition was held in Amsterdam in 1901. During the early years of the century he travelled abroad on a number of occasions – to Norway in 1900, to Belgium in 1907, and to the United States in 1909. These experiences, together with his continuing interest in photography, may have contributed towards the calmer style of this period, with its sense of lyricism and objectivity.

M.A.S.

Bril
Paul

Flemish painter
b.Antwerp, 1554 – d.Rome, 1626

Through his frescoes and easel paintings Bril played an important part in the evolution of the European landscape tradition. Around 1575 he settled in Rome, where he was accepted by the Academy of St Luke in 1582. He worked with his brother Matthew on the decoration of rooms in the Vatican. He followed this with decorations for the Pauline chapel of the Church of S. Maria Maggiore that are characteristically Flemish in their careful pictorialism. A change of style is evident in the frescoes of about 1599-1600 in the Church of S. Cecilia and such Roman townhouses as the Palazzo Rospigliosi, which, in their scale and simplicity, reveal the influence of the school of Girolamo Muziano. Other influences, notably the miniature painting of Elsheimer, led to a further change of style and method. Bril now devoted his efforts almost entirely to easel paint-

ings of Roman sites. In his *Views of Rome*, painted on panel (1600, Augsburg Museum; Brunswick, Herzog Anton Ulrich Museum; Dresden, Gg; Speyer Museum), he emerges as the creator of the Roman landscape, a genre that brought him a lasting success.

Bril's fresco of the *Martyrdom of St Clement* (1602 [?], Vatican, Sala Clementina) shows a broadening of style that becomes more marked in his *Harbour Views* (1611 [?], Milan, Biblioteca Ambrosiana; Brussels Museum). But he never completely forgot the Flemish tradition, which reveals itself in such features as the abundant foliage or the presence of water in the foreground of his paintings (*Mountainous Landscape*, 1608, Dresden, Gg; *Fishermen*, 1624, Louvre; *Landscape with Waterfall*, 1926, Hanover Museum).

Bril's landscapes, although decorative, are always pictorial. Their harmony derives from balance, something that established him as the forerunner of classical landscape painters like Poussin and Claude, whose model was, in fact, a pupil of Bril's, Agostino Tassi. The new style ran counter to that of Gillis van Coninxloo and other northern forerunners of the Baroque, but its success speedily attracted imitators such as Martin Ryckaert, Willem van Nieulandt, Balthasar Lauwers and, to a lesser degree, Jacques Fouquières.

J.L.

Bronzino
(Angelo di Cosimo)

Italian painter
b.Monticelli, 1503 – d.Florence, 1572

In Bronzino, the mainstream of Tuscan Mannerism, with its delicate stylization and boundless decorative inventiveness, found one of its most notable exponents. After an initial apprenticeship with Raffaellino del Garbo, Bronzino became a pupil of Pontormo and acted as his assistant in decorating the Charterhouse at Galluzzo (1522-5) and the Capponi chapel of the Church of S. Felicità (1525-8). Here, Bronzino's equable *tondi* of the *Evangelists* in the vault are in sharp contrast to Pontormo's highly strung anti-realism. Following the siege of Florence in 1530, Bronzino entered the service of the Dukes of Urbino at Pesaro where he painted a *Portrait of Guidobaldo da Montefeltro* (Florence, Pitti) and also collaborated on the fresco decoration of the Villa Imperiale.

On his return to Florence in 1532 he again collaborated with Pontormo, this time in decorations for the villas at Careggi and Castello, and in 1539 assisted with preparations for the entry to Florence of Eleanor of Toledo, wife of Cosimo I. He was commissioned to decorate the chapel of Eleanor in the Palazzo Vecchio with frescoes of the *Flood* and of the *Brazen Serpent*, as well as decorating the vault – work that took him until 1564 to complete. Meanwhile he had become official portrait painter to the Florentine court and his artificial style quickly came to dominate the art of court portraiture throughout Europe. Set against a neutral background, with imposing architectural perspectives, his portraits of *Cosimo I*, of *Eleanor of Toledo and her Son* and of *Bartolommeo and Lucrezia Panciatichi* exhibit a cold, smooth quality in the painting of the flesh that makes it appear to have been carved from some precious material.

▲ Paul Bril
Landscape with Diana and her Nymphs
Wood. 103 cm × 146 cm
Paris, Musée du Louvre

▲ Georg Breitner
Bridge with Three Women (*c*.1897)
Canvas. 57 cm × 59 cm
Amsterdam, Stedelijk Museum

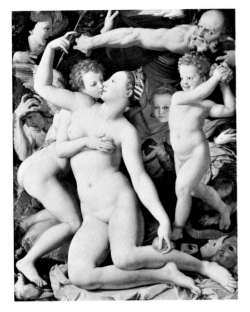

A *Deposition* painted around 1545 for Eleanor's chapel displays a similar, rather frozen perfection (Besançon Museum; replaced in the chapel with a replica). Round about the same time Bronzino also executed for Francis I a complex allegory of *Venus and Cupid* (London, N.G.). During a visit to Rome in 1546-7 he painted a further series of portraits (*Giannettino Doria*, Rome, Gal. Doria-Pamphili) and, like his master Pontormo, made a close study of the works of Michelangelo. In Bronzino, however, Michelangelesque motifs become rather dry and academic (*Christ in Limbo*, 1552, Florence, Church of S. Croce; *The Story of Joseph*, tapestries, 1546-53, Florence, Palazzo Vecchio).

In 1564, together with Cellini, Vasari and Ammannati, he organized the ceremonies for Michelangelo's funeral at the Church of S. Lorenzo and took over from Pontormo the task of completing the frescoes (now disappeared) in the choir of that church. The startling forms and rather conventional virtuosity of Bronzino's last works (*Martyrdom of St Lawrence*, 1569, Florence, Church of S. Lorenzo) were endlessly copied by Florentine artists at the end of the century, particularly by his pupil Allori. F.V.

Brouwer
Adriaen
Flemish painter
b.Oudenaarde, 1605/6 – d.Antwerp, 1638

As far as can be established Brouwer was living in Antwerp in 1622 and in Amsterdam in 1625. In 1628 he entered Frans Hals's studio in Haarlem, and in 1631 returned to Antwerp and settled there. His works are not easy to identify, none of them being signed, and only a few bear his monogram. However, about 80 paintings are generally attributed to him, together with a number of drawings.

The works of Brouwer's Dutch period are distinct from those painted in Flanders, the former still revealing the faint influence of the elder Bruegel. An *Inn Interior* (Rotterdam, B.V.B.), a

Peasant Scene (Mauritshuis) and *The Smokers* (Kassel Museum) are peopled by near-caricatured yet lifelike figures whose vitality is still completely Flemish. Brouwer's return to Antwerp was marked by an increased output of portraits such as the *Head of a Peasant* (Oosterbeek, private coll.), the *Man with a Pointed Hat* (Rotterdam, B.V.B.) and the *Self-Portrait* (Mauritshuis), while the use of chiaroscuro learned in Holland gives his paintings a new depth (*The Smoke-filled Room*, Louvre; *The Dice-Players*, Dresden, Gg).

In the landscapes that followed he associated nature with human activity, displaying a taste for twilight and nocturnal scenes, together with a feeling for tragedy. There is a sinister, romantic air about paintings such as *Landscape by Moonlight* (Berlin-Dahlem), *The Open-Air Drinkers* (Lugano, Thyssen Coll.) and *Twilight Landscape* (Louvre), in which destitute figures, greatly foreshortened, merge into a landscape background.

Brouwer was held in high esteem during his lifetime (Rubens owned 17 of his paintings and Rembrandt eight) and had many imitators. His advanced ideas on landscape were further developed by Teniers, while Dutch painters such as Van Ostade, Sorgh and Bloot, and Flemish painters such as Van Craesbeck, David Ryckaert III and Teniers the Younger were inspired by his genre paintings. J.L.

Brown
Ford Madox
English painter
b.Calais, 1821 – d.London, 1893

Ford Madox Brown was brought up on the Continent and worked in Bruges, Ghent and then Antwerp in the studio of Wappers. In 1840 he was in Paris where he became conversant with the works of Delacroix and Delaroche, both of whom were significant for him. When he came to England he failed to achieve results in the competition for Westminster Hall. In 1846 he departed for Rome, where he came under the influence of the Nazarene school of German artists, as is evidenced by his canvas of *Chaucer at the Court of Edward III* (1851, Sydney, Municipal Gal.).

After his return to England in 1846, his work

attracted the attention of Rossetti who became in 1848 his pupil and associate. Despite this relationship, Ford Madox Brown did not align himself with the Pre-Raphaelite Brotherhood on its foundation in 1848, but his work has, nonetheless, numerous affinities with the Brotherhood's aims. His uncompromising belief in realism led him to work in the open air (*Autumn Afternoon in England*, 1854, Birmingham, City Museum) and was even used in subjects with a strong moral tone (*Work*, 1852-63, Manchester, City A.G., an allegory on physical labour). It was sometimes applied to contemporary events (*The Last of England*, 1852-3, Birmingham, City Museum).

Some years later he became part of the Arts and Crafts movement and one of the founders of Morris & Co. (1861). Like Rossetti, he found refuge in a sensual romanticism which motivated the frescoes in Manchester Town Hall (1875-92) illustrating the history of the city.

While he had considerable influence on the main movements of the 19th century, his aims were never completely assimilated and his great talents have never been completely recognized. He is best represented at Manchester (City A.G.) and Birmingham (City Museum). W.V.

Bruegel
Pieter, the Elder (also spelt Brueghel)
Netherlandish painter
b.Brueghel or Breda, 1525/30(?) – d.Brussels, 1569

Different sources give different birthplaces for the founder of the famous family of painters. In recent years Breda (mentioned by Guicciardini) has been accorded greater credibility than Van Mander's suggestion of Brueghel (two obscure villages bearing this name exist, neither near Breda). He was accepted as a Master in the Antwerp Guild in 1551, which presupposes his birth between 1525 and 1530.

Bruegel was almost certainly the apprentice of Pieter Coecke van Aelst (*d.Brussels, 1550); he married Coecke's daughter, Mayken, in 1563. In 1552 and 1553, Bruegel made his first visit to Italy, travelling via France. In Italy he was accompanied by the painter and designer Marten de Vos, who possibly painted the figures in

▲ Bronzino
An Allegory
Wood. 146cm × 116cm
London, National Gallery

▲ Ford Madox Brown
The Last of England (1852–3)
Wood. 83cm × 75cm
Birmingham Museum and Art Gallery

Adrian Brouwer ▲
Twilight Landscape
Wood. 17cm × 26cm
Paris, Musée du Louvre

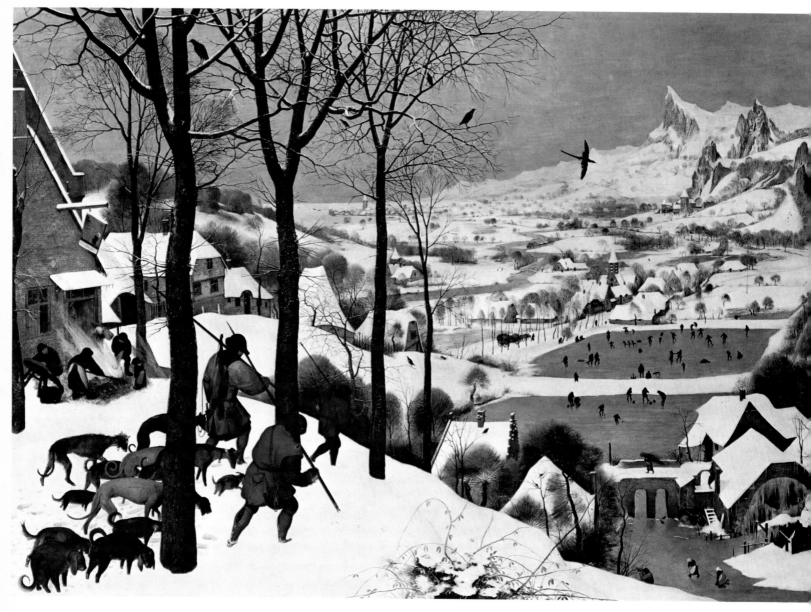

Bruegel's first signed and dated painting (*Christ on the Sea of Tiberias*, 1553, Brussels, Pauw Coll.) Bruegel visited Sicily and in 1553 he was in Rome, where he seems to have sold a number of landscapes to the miniaturist Giulio Clovio.

The route of his return to the Netherlands is uncertain but the drawings of Alpine subjects which resulted are extremely important. One (Chatsworth, Duke of Devonshire's Coll.) is dated 1555, which suggests that these mountain drawings were in fact worked up after his return to Antwerp. From them he developed 12 prints (*Large Mountain Series*) and an elaborate composition (*Great Alpine Landscape*), published in Antwerp by the important firm of Hieronymus Cock. Cock also published Breugel's series of satirical, moralizing designs which earned him the epithet of 'the second Bosch' (*The Temptation of St Anthony*, 1556; *Big Fish Eat Little Fish*, 1557, after a drawing of 1556; *The Seven Deadly Sins*, 1558). These works made Bruegel's reputation and he continued to work in this vein until well into the 1560s.

Most of Bruegel's dated paintings were made between 1559 and 1568, during which time he operated simultaneously as painter and designer of engravings. In 1563 he took up residence in Brussels, perhaps fleeing Antwerp for fear of religious persecution but more likely to be near his patron, Cardinal Granvelle, President of the Netherlands Council of State. In Antwerp Niclaes Jonghelinck had been Bruegel's greatest patron, owning 16 paintings. His brother Jacob, a sculptor, was, in fact, close to Granvelle.

While in Brussels, Bruegel was commissioned by the town council to make some visual document of the excavation of the Brussels-Antwerp canal, then under construction, but his death on 9th September 1569 intervened. The inscription on his tomb has been recognized as being based on the thought of the famous humanist and geographer Ortelius of Antwerp and it is certain that Bruegel was in contact with Ortelius's intellectual friends, including Plantin the publisher.

The paintings. Establishing the development of Bruegel's style is complicated by the fact that many copies exist, some of them made by his sons Pieter and Jan, but the autograph drawings are useful in disentangling problems of attribution. Bruegel's landscape drawings show the influence of the Netherlandish tradition exemplified by Patenier, but also demonstrate some contact with woodcuts by Titian. However, his treatment improves on their work in terms of realism and detail. The high viewpoint employed by him in his *Large Landscape Series* is particularly novel and imparts to the panorama a feeling of universality. For his satirical prints he made a considerable study of the figure and evolved a method of showing people from behind, thereby endowing his studies with a generalizing, universalizing force equal to that of his landscape technique.

The panoramas of the landscapes and crowds of protagonists of some of the satirical prints unite in the justly famous *Children's Games* (1560, Vienna, K.M.), a picture which reduces the great affairs of the adult world to the scale of foolish and sinful pastimes. Other crowded compositions, evidently derived from the principles of Bosch, are *Dulle*

 Pieter Bruegel the Elder
Hunters in the Snow (1565)
Wood. 117cm × 162cm
Vienna, Kunsthistorisches Museum

Griet (1562, Antwerp, Mayer van den Bergh Museum) and *The Fall of the Rebel Angels* (1562, Brussels, M.A.A.). Most notable of this period is his *Two Monkeys* (1562, Berlin-Dahlem), a masterpiece of originality. The two disturbingly human creatures are chained together – an enigmatic reference to the human condition.

After his move to Brussels, Bruegel's style was influenced through greater contact with Italian works, including Raphael's tapestries showing the *Acts of the Apostles*, and his figures became more amplified (*The Adoration of the Magi*, 1564, London, N.G.). His most famous paintings, the series of the *Months* (three in Vienna, K.M.; one in New York, Metropolitan Museum; one in Prague, N.M.), were painted in 1565; five are extant. Although basing these on the early calendar illustrations to *Books of Hours*, Bruegel increases the importance of nature so that man's actions do not dominate the landscape but become part of it. Man is controlled by the seasons. The paintings are unique in their perception of the almost oppressive atmosphere of the outdoors. Other compositions balance figures and settings (*The Massacre of the Innocents*, 1566, Hampton Court, and Vienna, K.M.; *The Numbering at Bethlehem*, 1566, Brussels, M.A.A.), while some concentrate more on satire through the clumsy figures (*Wedding Dance*, 1566, Detroit, Institute of Arts; *Peasant Wedding*, c.1566, Vienna, K.M.).

Bruegel's last painting is the *Magpie on the Gallows* (1568, Darmstadt, Hessisches Landesmuseum). Its landscape has a new luminosity and almost miniature touch. It combines a panoramic landscape with a small but greatly expressive figure group and a meaning which is clearly moralizing although not yet explained in detail – an amalgam of the various facets of his art.

Bruegel's style and subject matter were most closely followed by his son, Pieter Bruegel the Younger, who copied and adapted many of his compositions, beginning some years after his father's death. The second son, Jan, developed his own art, founded on his father's perception of landscape, but endowed nature with his own miniature, drawing-room lustre, earning the name 'Velvet Bruegel'.

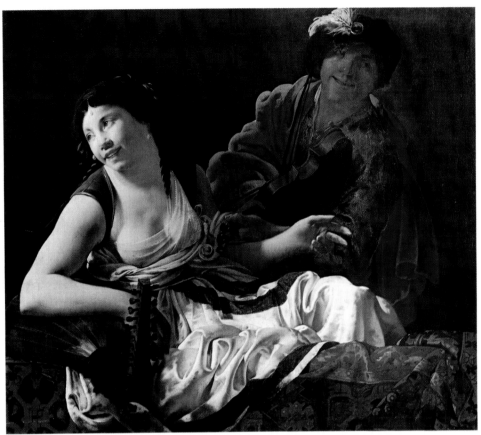

Although he was greatly admired by Rubens and emulated by a good number of lesser artists – Savery, Brouwer, the Grimmers, Lucas and Maerten van Valckenborch, and Joos de Momper – Bruegel's reputation suffered an eclipse from the middle of the 17th century until his real rediscovery in the later part of the 19th. He is now recognized as the major Netherlandish master of the 16th century, and one of the most innovatory painters in the history of art, exerting an appeal both for the scholar and for the lay public.

A.Sm.

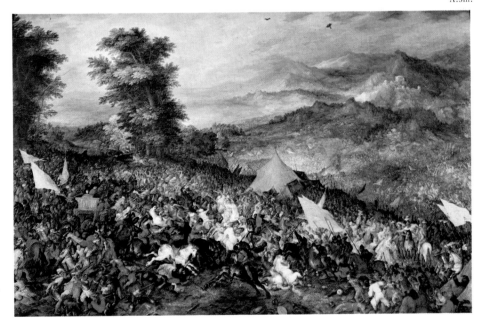

▲ Jan 'Velvet' Bruegel
The Battle of Arbelles
Wood. 86 cm × 135 cm
Paris, Musée du Louvre

Brugghen
Hendrick Jansz ter

Dutch painter
b.Deventer (?), 1588(?) – d.Utrecht, 1629

With Baburen and Honthorst, Ter Brugghen is one of the great masters of northern Caravaggism. Arriving in Utrecht when he was very young, he became a pupil of Abraham Bloemaert, but soon left for Italy (c.1604), where he stayed for ten years. Most of his time was spent in Rome where he became part of the circle of Caravaggio and his followers, including Orazio Gentileschi. Not only did he borrow such characteristic tenebrist effects as the play of artificial light and the contrast of light and shadow, but also Caravaggio's technique of painting straight on to the canvas without any preparatory drawing. In 1615 he went back to Utrecht where he was enrolled in the Guild of St Luke in 1616-17.

No fully authenticated painting from Ter Brugghen's time in Rome has survived, and the period of his dated work covers only the last nine years of his life, from 1620 to 1629. When he was 32 he painted *Christ Mocked* (Copenhagen, S.M. f.K.; another version in Paris, Musée de l'Assistance Publique), his first signed and dated work, and important for its mixture of Caravaggism (opposing masses of light and shade, plebeian characters) and deliberate archaism (figures influenced by Lucas van Leyden; the sharp brushstrokes taken from the 16th-century Netherlandish painter Marinus van Reymerswaele and close in feeling to Woutersz).

From 1621 his production was divided between

▲ Hendrick ter Brugghen
The Duet (1629)
Canvas. 90 cm × 127 cm
Rome, Galleria Nazionale d'Arte Antica, Palazzo Barberini

religious and musical subjects. This same year he painted the *Calling of St Matthew* (Utrecht, Centraal Museum; another version in Le Havre Museum). This shows a more than thematic analogy with Caravaggio's picture (in the Church of S. Luigi dei Francesi in Rome) and *The Four Evangelists* (1621, Deventer, Town Hall), in which the composition recalls Marinus van Reymerswaele, but in which the concentration on hands and faces is typical of his own Caravaggist style. *The Beheading of St John the Baptist* (Edinburgh, N.G.), based on an engraving by Dürer, is treated in a grandiloquent style that is entirely his own.

Other works display an individualized Caravaggism: *David Hailed by the Women* (1623, Raleigh, North Carolina Museum); *Lazarus the Pauper* (1625, Utrecht, Centraal Museum; *St Sebastian Succoured by the Holy Women*, probably one of the most touching of all the painter's works (1625, Oberlin, Allen Memorial Art Museum); *Jacob and Laban* (1627, London, N.G.; another version 1628[?], Cologne, W.R.M.); and *David Playing his Harp* (1628, Warsaw Museum). The *Crucifixion* in the Metropolitan Museum, inspired by Grünewald, is deliberately traditional.

Ter Brugghen painted a number of scenes from everyday life that are almost picaresque in feeling: *The Sleeping Soldier* (Utrecht, Centraal Museum); *The Dice Throwers* (1623, Minneapolis, Inst. of Arts). But his favourite themes were musical: male and female musicians singing solo or in duets, playing the flute, the lute or the bagpipes (1621, Kassel Museum, Vienna, K.M. and Bordeaux Museum; 1624, Oxford, Ashmolean Museum; 1627, Augsburg Museum; 1628, Louvre and Basel Museum; 1629, Rome, G.N.). These paintings, influenced by or derived from Gentileschi and, especially, Manfredi, reveal a personal treatment of the theme, often painted against a light background. Curves occupy an important place, notably in the bouffant sleeves of the figures. Usually striped blue and white, in an extremely subtle tonal range, they seem to approach the viewer, giving an illusion of spatial depth.

Ter Brugghen is both one of Caravaggio's closest followers and a Caravaggist with a very personal style. He did not found a studio but his work, parallel to that of Baburen and Honthorst, influenced such artists as Bylert, Lievens, Bor, Bramer, and perhaps even Georges de La Tour. The most resounding echo of his style comes, however, in Vermeer, who owes the foundation of his clear and peaceful luminism, the extraordinary pearly qualities of his paint and his bright but subtle palette to the influence of Ter Brugghen.
J.V.

BUR

46

Burgkmair
Hans

German painter
b.Augsburg, 1473 – d.Augsburg, 1531

Burgkmair was the most important of the 'Italianizing' painters of the school of Augsburg. Playing a role equivalent to that of Dürer in Nuremberg, he was one of the first to introduce the artistic ideas of the Renaissance to northern Europe. He first studied with his father, continued his apprenticeship under Schongauer at

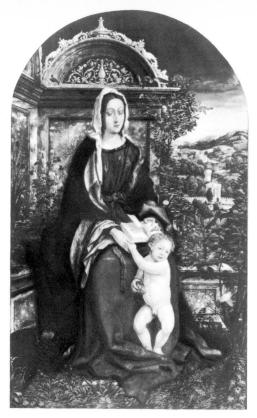

Colmar about 1488, and then some years later went to Italy. He was admitted to the Augsberg Guild of Painters in 1498. Together with Hans Holbein the Elder, he was commissioned to paint a cycle of Roman basilicas for the Convent of St Catherine (*Basilica of St Peter*, 1501; *Basilica of St John Lateran*, 1502; *Basilica of the Holy Cross*, 1504; all Augsburg Museum).

He visited Italy again between 1506 and 1508, staying in Venice and Milan. Now the influence of Italian painting became progressively stronger in his work, whether in the almost Leonardo-like modelling and the warm, golden light of the two pictures of the *Virgin and Child* (1509-10, Nuremberg Museum), or in the Renaissance architectural background of his *Coronation of the Virgin* (1507, Augsburg Museum).

On his return to Augsburg Burgkmair devoted

himself for a time almost exclusively to woodcuts before, about 1518-19, creating two important altarpieces, *St John on Patmos* and a *Crucifixion* (Munich, Alte Pin.), notable both for the size and monumentality of some of the figures and for the beauty of the landscapes. His last works show a return to a more close-knit style of composition (*Esther before Ahasuerus*, 1528, Munich, Alte Pin.).

Burgkmair produced few portraits (the strange, macabre *Portrait of the Artist and his Wife* [1529, Vienna, K.M.] is now ascribed to Furtnagel) but, in contrast, was active as a printmaker. In the service of Maximilian I he carried out many drawings for engravings, among them the great series of *Triumphs* (135 plates, engraved by various artists, 1515-19, but published only in 1796), a monument to imperial glory. His designs for the woodcuts for Maximilian's books – *Genealogy*, the *White King* and the *History of Sir Theuerdank*, evoke the spirit of the German Renaissance.
A.C.S.

Burne-Jones
Sir Edward Coley

English painter
b.Birmingham, 1833 – d.London, 1898

Educated at King Edward's School, Birmingham, Burne-Jones was originally intended for holy orders, but at Oxford became connected with William Morris, with whom he shared an admiration for Rossetti's illustrations for Allingham's *The Maids of Elfin Mere*. In 1855 the two friends went to France, notably to Beauvais, where Burne-Jones admired the cathedral, to him a symbol of medieval art. Rossetti, whom he met in 1856, encouraged him to paint, and, with Morris, they then founded the second Pre-Raphaelite group, which carried out the frescoes of the Oxford Union (1858), in line with their neomedieval aesthetic. Burne-Jones was still inspired by Rossetti, as can be seen in *Clerk Saunders* (1861, London, Tate Gal.), but after two visits to Italy in 1859 and 1862 (the latter in company with

▲ Hans Burgkmair
Virgin and Child (1509–10)
Wood. 164 cm × 103 cm
Nuremberg, Germanisches Nationalmuseum

▲ Edward Burne-Jones
Laus Veneris (1873–5)
Canvas. 122 cm × 183 cm
Newcastle-upon-Tyne, Laing Art Gallery and Museum

Ruskin), he began to be interested in the painters of the Italian quattrocento, in particular Botticelli and Mantegna, although also in Michelangelo.

He showed seven of his oil paintings at the Grosvenor Gallery in 1877, and continued to exhibit for the next ten years. The gallery thus became the centre of the new Pre-Raphaelite movement. Later Burne-Jones was to exhibit at the New Gallery. His reputation increased and reached its highest point when, with Leighton, he appeared as Britain's representative at the Paris Exhibition of 1882. He had already exhibited at the 1874 Exhibition (*The Enchantment of Merlin*, 1874, Port Sunlight, Lady Lever Art Gallery). In 1894 he was made a baronet. During this period he designed for Morris, his most remarkable work being his illustrations for the Kelmscott Press (*Chaucer*, 1894).

Rejecting the contemporary world (except for a few portraits), he illustrated medieval or antique subjects, charging these with a symbolism that owed much to the poetry of William Morris. He was especially fond of creating cycles of paintings dealing, in a number of episodes, with a myth or a legend: *The Story of Pygmalion* (1869-79, Birmingham City Museum); *The Briar Rose* (*The Sleeping Beauty*, after Tennyson), a group of six paintings carried out between 1871 and 1890 (Buscot Park, Farington Coll.; a second series in three paintings at the Ponce Museum, São Paulo); *The Story of Perseus*, in eleven compositions, inspired by Morris's *Earthly Paradise*, painted after 1875 for Lord Balfour and today in the Staatsgalerie, Stuttgart (a second series, in watercolour, at Southampton Museum). Other important works include: *The Mirror of Venus* (1872-7, Lisbon, Gulbenkian Foundation); *Laus Veneris* (1873-5, Newcastle Museum); *The Golden Staircase* (1880, London, Tate Gal.); *King Cophetua and the Beggar Maid* (1884, London, Tate Gal.) – his most popular work; *The Wheel of Fortune* (Paris, private coll.); *The Garden of Pan* (1887, Melbourne, N.G.); and *Love among the Ruins* (Wightwick Manor, National Trust).

Like most of the Pre-Raphaelites, Burne-Jones was an inventive, sensitive draughtsman, particularly in watercolour (*The Flower-Book*, 1882-98, British Museum), and made many designs for stained-glass windows (churches in Dundee, Easthampstead, Allerton and Edinburgh) and tapestries. He was internationally honoured, and his contemporaries found the grace of his pensive figures irresistible, their ideal beauty nostalgically evoking the past. After a period in which he was forgotten, even despised, he has once again found fervent admirers in our own day. This is partly because of the renewed interest in symbolism, of which he was one of the prophets (an artist like Khnopff owed him a great deal) and partly because today people see more clearly the remarkable qualities of his poetic vision and the modernity of his style, which is linked with the boldest activities of Art Nouveau. L.E.

Callot
Jacques

French engraver and draughtsman
b.Nancy, 1592 – d.Nancy, 1635

After several trips to Italy Callot was apprenticed at the age of 15 to a goldsmith in Nancy,

Demange Crocq, with whom he learned the rudiments of drawing. Before 1612, the date when he is known to have settled in Florence, he was in Rome with an engraver from Troyes, Philippe Thomasin, who taught him his craft. Callot stayed in Florence for nine years under the protection of Christine of Lorraine, and while he was there gained the friendship of the famous engraver Giulio Parigi. In Florence Callot engraved two of his masterpieces, *The Temptation of St Anthony* (c.1616) and *The Fair at Impruneta* (c.1620).

In 1621, back in Nancy, Callot engraved many of the drawings he had made in Italy (*The Hunchbacks, The Balli di Sfessania* [or *The Italian Comedians*] and the *Great Passion*). In 1624 he married Catherine Kuttinger. For the time being he did not obtain the leading position at the court of Lorraine he had hoped for – it was then occupied by Claude Deruet, the official painter since 1620, whose portrait he was to engrave in 1632, (preparatory drawing in the Louvre).

After visiting Breda in 1627 to make an engraving of the siege of the town, Callot commemorated two other sieges in the same medium, on orders from Louis XIII: those of St Martin-de-Ré and La Rochelle. Between 1628 and 1631 he made several visits to Paris where he entrusted Israël Henriet with the publication of his plates. On his final return to Nancy in 1632, Callot witnessed the end of Lorraine as an independent duchy after it had been three times invaded by French troops and devastated by the plague. In this atmosphere he published his last works: *The Disasters of War* (1633) and the second version of *The Temptation of St Anthony*.

As far as is known, Callot was not a painter; certainly no painting has come down to us. His drawings and engravings, however, assure him a place as one of the greatest masters of the 17th century in Lorraine, alongside Claude, Georges de La Tour and Jacques Bellange. His engravings, particularly his etchings (a technique he perfected), became popular throughout Europe. They show an exceptional mastery of the genre: highly concentrated, crowded with figures, they nevertheless sacrifice the subject itself to the detail. But it is above all the drawings (most of them in the Hermitage, the British Museum, the Uffizi and Chatsworth, the Duke of Devonshire's Coll.) that give Callot his exceptional place in French art of the 17th century. Wide-ranging in technique and subject matter – theatre, landscape, religious subjects and scenes taken from nature – they mix irony with the most accurate and lively eye for cruel reality. P.R.

Campin
Robert

Netherlandish painter
b.Valenciennes, c.1378 – d.Tournai, 1444

Mentioned at Tournai after 1406, Robert Campin held an important position in the city's life. He was a very busy painter, with a wide-ranging output – from frescoes to cartoons for tapestries, as well as many more modest undertakings. He trained a large number of apprentices in his studio, among the more eminent being Jacques Daret and Rogier van der Weyden. He was also a politician who took a very active part in

municipal affairs between 1423 and 1428, when they were run, in effect, by the artists' guilds. In 1428 he was forbidden to hold any public office because he had refused to bear witness against a citizen accused of sedition, and some years later he was condemned a second time on account of his relations with a woman named Laurence Polette, but this ban was lifted after the Duchess of Hainault had intervened.

No work of his has been identified with certainty in documents. His identification with the Master of Flémalle (see p.259) aroused heated controversy. Today this identification, although not finally established, appears at least highly probable. A.Ch.

Canaletto
(Antonio Canal)

Italian painter
b.Venice, 1697 – d.Venice, 1768

Like his father, Bernardo Canal, a painter for the stage, Canaletto began in the world of theatre design. During a stay in Rome in 1719-20, he designed sets for Scarlatti's operas. In Rome, he probably met Vanvitelli and some Dutch viewpainters and *bambocciati* (painters of low life), from whom he acquired an exact awareness of perspective and a feeling for the life of ordinary people. They urged him to give up the theatre and devote himself to real scenery, with the result that he gradually abandoned this purely decorative genre to which he was unsuited by temperament.

In 1720, on his return to Venice, he became a member of the painters' guild and learned something of the work of Marco Ricci and Luca Carlevaris. In the earliest of his *vedute* ('townscapes'), the *Piazza San Marco* (1723, Lugano, Thyssen

Jacques Callot ▲
L'Homme qui ferme un oeil
Drawing. 24 cm × 16 cm
Florence, Galleria degli Uffizi

Coll.), the small, exquisite figures suggest a certain link with those of Carlevaris, but the alternation of light and shade is more reminiscent of Ricci. The four *Views of Venice* (Montreal, Pillow Coll.), painted between 1725 and 1726, are presented so that the light creates rich pictorial effects on the cracked plasterwork and brick.

In 1726, Canaletto painted several allegorical compositions for the theatrical impresario Owen MacSwinny, the first of the English clients who were to be so important for him. The light is brighter and warmer, and enriched by deep tones in the six large *Views of the Piazza San Marco* (1726-7, Windsor Castle), while a more effective use of perspective suggests greater scale. This panoramic breadth, together with a warm light, characterizes *The Stonemason's Yard* (London, N.G.), the finest example of Canaletto's early style.

From the end of the 1720s, the 'ideal views' and the concern with chiaroscuro give way to 'real views' of Venice or the lagoon, and a brighter light. This marks the beginning of Canaletto's most original achievement, that of 'phenomenological' light, calculated to depict reality with objectivity and precision. As an enlightened man and a true representative of the European thought and culture of his day, Canaletto avoided every form of representation that could not be reduced to scientific rules. He made use of the optical chamber from a perfectionist desire to seize truth in space and to paint it in the most rational and objective way possible.

Canaletto's poetic quality derives not from a romantic view of his subject, but from his strict objectivity; he painted the history of Venice, a gay, sunny city, rich and aristocratic, never suspecting its imminent decline. The change in his style is clearly visible in the two large scenes in the Crespi Collection in Milan: *The Reception of the Ambassador Bolagno at the Doge's Palace* and *The*

Departure of the Bucintoro for the Ceremony of Marriage with the Sea. In these works the thick paint of the period of chiaroscuro is replaced by a more fluid, more thinly spread method that gives the scene a rainwashed air.

Shortly after 1730, Canaletto painted a series of Venetian views for the Duke of Bedford (Woburn Abbey). The city is seen calmly, never transfigured, and always faithfully depicted within the framework of its buildings and in the colour of its atmosphere. *The Quay of the Piazzetta* and *San Marco and the Doges' Palace* in Washington (N.G.) date from the same period. In *The Doge visiting the Church and Scuola di San Rocco* (London, N.G.) the joyful confusion of the holiday crowd is conveyed by snaky rhythms, violent curvilinear touches and vibrant specks of colour, from which a jewel-like light leaps and shimmers.

Towards the end of the 1740s Canaletto began to decrease the size of his buildings and outlines, matching this with an increase in the size of his space. *The Bacino of San Marco* (Boston, M.F.A.) is an example of this.

For a number of years Canaletto had been in touch with an Englishman, Joseph Smith, who combined the dual role of patron and agent, serving as an intermediary with English customers. Canaletto's album of engravings is appropriately dedicated to 'His Britannic Majesty's Consul to the Republic of St Mark', a post to which Smith was appointed in 1744. The 31 etchings in the collection were made over a period of several years. Partly idealized and partly copied from reality, they show the lagoon and the landscapes of the hinterland and succeed in capturing the feeling of the atmosphere even without colour.

Canaletto probably made a second journey to Rome in 1742-3. This appears to be borne out by several overdoors made for Smith (Windsor Castle) which displays a fanciful taste and inventive oddity that recall Pannini's *Capriccii*. England was

Canaletto's second area of activity. His views were highly appreciated by the English, not only by those making the Grand Tour, but by those who, in their own country, found his rational simplicity appealing. Today over 200 paintings, more than one half his signed output, are in British galleries and collections. During two stays in London between 1746 and 1753, organized by Smith, the cold, limpid luminosity of the English sky, together with the contemplative detachment that he had made his own, inspired him to produce works in which lyricism and immutability predominate.

He painted many views of the Thames. *The Thames and City seen from Richmond House* (1746, Goodwood, Duke of Richmond and Gordon's Coll.) shows an imposing prospect composed around the broad bend of the river and the diagonal of the terrace; the southern light shows up the rococo curves of the pink and blue outlines. In the *The Old Horse Guards, seen from St James's Park* (1749, Earl of Malmesbury's Coll.), the perspective spreads in an unlikely way along the broad main walk, while the charm of the gentle, quiet English countryside dominates the views of *Warwick Castle* (Birmingham Museum and Art Gallery).

Back in Venice in 1755, Canaletto found a changed climate, both artistically and commercially (it is significant that the Academy waited until 1763 before admitting him). In these last years he painted the *Portico of the Palace* (Venice, Accademia) and the *Interior of San Marco* (Windsor Castle) in a way that was new for this painter of sunlight. There is a suggestion of whirling mysterious ghosts in the shadows of the basilica.

When Canaletto died, he had opened up the way that led, through the English landscape painters of the 18th century, to the lucid romanticism of Corot. He exercised a considerable influence not merely on major artists such as his nephew Bernardo Bellotto, Francesco Guardi and Michele Marieschi, but upon a number of Italian imitators (G.B. Cimaroli, Giovanni Richter, Francesco Tironi, Giuseppe Moretti, Giovanni Migliara) and others, mainly English (Samuel Scott, William James). M.C.V.

Cano
Alonso

Spanish painter
b.Granada, 1601 – d.Granada, 1667

One of the most interesting figures in 17th-century Spain, Cano led a restless and unsettled life. The son of Miguel Cano, a carver of altarpieces, he left home at an early age for Seville where, in 1616, he entered Francisco Pacheco's studio. He seems also to have worked at the same time in the studio of the sculptor Montañes. He obtained his mastership in 1626 and began to work on important pieces of sculpture.

In 1638 he entered the service of the Duke of Olivares in Madrid. During this Madrid period Cano concentrated on painting. Surviving compositions show him to have abandoned the dark colours and sombre modelling (inspired by the young Velázquez) of the Seville period (*S. Francesco Borgia*, 1624, Seville Museum) for a lighter manner, marked by bright colours and freer

 Canaletto
The Quay of the Piazetta
Canvas. 115 cm × 153 cm
Washington, D.C., National Gallery of Art

brushwork (*Christ on the Cross*, 1643, Madrid, private coll.).

In 1644 his wife was murdered and, although Cano was involved in the trial, he seems to have been absolved from any part in the crime, for, after a short stay in Valencia, he took up his work at court again (*The Kings of the Goths*, Prado, altarpiece of the Church of Getafe, near Madrid, 1645). During the following years his style continued to lighten and he pursued the quest for ideal beauty and a clear, refined colour in the Venetian style, while remaining sensitive to that of Velázquez (*The Miracle of the Well*, Prado; *The Immaculate Conception*, Vitoria Museum).

In 1652 he returned to his native city of Granada as canon-bursar of the cathedral and began work on a large cycle of seven paintings of the *Life of the Virgin* for the choir, conceived in a style of Baroque grandiloquence. Constant struggles with the cathedral authorities, who protested that he had not, as he claimed, been commissioned to undertake the work, led finally to his expulsion. Forced to return to Madrid in 1657, he once again worked for the churches (*Christ at the Pillar*, Carmelites of Ávila), but the following year, after a successful lawsuit, he returned to Granada as an ordained priest and settled down to work again. Among the paintings of this final period is *The Madonna of the Rosary* (Málaga Cathedral, 1665-6).

Among his other works, now outside Spain, are the *Via Dolorosa* in Worcester (Massachusetts) Museum, *The Vision of St John the Evangelist* in London (Wallace Coll.) and *Christ in Limbo* in Los Angeles (County Museum of Art). Cano's primary reputation is as a sculptor, but he is also one of Spain's greatest painters and perhaps the only one who, being inspired directly by the Renaissance, conceived an art very far removed from naturalism and steeped in a lyrical longing for ideal beauty. He was also a very fertile decorator, and his influence in the School of Granada was widespread. A.E.P.S.

Cappelle
Jan van de

Dutch painter
b.Amsterdam, 1626 – d. Amsterdam, 1679

Cappelle was a dyer by trade, who learned to paint and then worked as an amateur. After 1663 no dated works of his are known, which makes it seem likely that, like so many other Dutch artists (Hobbema, Van der Neer), he worked full-time at his art.

Cappelle was rich, and in contact with Rembrandt, who painted his portrait, as, too, did Hals and Eeckhout. At his death Cappelle left an enormous art collection that included 500 engravings by Rembrandt, 900 drawings by Avercamp, 16 pictures by Porcellis, 10 paintings and more than 400 drawings by Van Goyen, other paintings and drawings by Van de Velde, Molyn, and Seghers, as well as numerous works by de Vlieger (90 paintings and 1,300 drawings either by de Vlieger himself or in copies by Cappelle).

His own work was mainly in the genre of seascapes, at first inspired by those of de Vlieger and characterized by harmonies of silvery grey, then becoming more personal in style. He excelled at conveying the mingling of air and water,

the transparency of the water under restless, moving skies full of very light clouds, in a rich, warm mixture of grey-brown and light-coloured tones. His study of the reflection of sails and hulls on the calm water is particularly notable. Of all the Dutch marine painters. Cappelle is one of the most poetic: his calm seas have a mystery that, although achieved with different, more natural methods, suggests the poetry of Claude. He was also an innovator who foreshadowed the younger Van der Velde.

Besides seascapes, Cappelle also painted some winter landscapes (some good examples, dated 1653, are in the Mauritshuis), which are comparable with those of Jacob van Ruisdael. It is in London (N.G.) that Cappelle can best be studied, for he has at least eight seascapes here. Other works of his – and they are relatively rare – are in the museums of Amsterdam, Rotterdam, The Hague, Cologne, Chicago and Toledo. J.F.

Caravaggio
(Michelangelo Merisi or Mersighi or Amerighi)

Italian painter
b.Caravaggio, Lombardy, c.1570-3 – d.Porto Ercole, 1610

Before leaving Lombardy, where he was born, to seek his fortune in Rome, Caravaggio spent several years in Milan (from April 1584) as an apprentice in the studio of Simone Peterzano. This is the least-known part of this revolutionary painter's career. The problem of his training goes hand in hand with that of his critical reputation. While he was still alive Zuccaro contemptuously referred to him as a poor imitator of Giorgione, while his supporters lauded him as a painter who had no master but nature (encouraged, it must be admitted by Caravaggio himself, who used to say that he could find quite enough teachers in nature). Only Giustiniani saw, behind the naturalistic spontaneity of his paintings, the conscious participation in the 'return to nature' movement that was the central preoccupation of Italian painting between the 16th and 17th cen-

turies. Academic critics, on the other hand, reproached Caravaggio for painting scenes without history and without action, and for representing religious scenes without proper regard for the iconography laid down by the Church.

Although Caravaggio's poetic realism fascinated painters like Courbet, Manet and Cézanne, it was not until the 20th century that his achievement was really examined by the critics, and in particular by Longhi who defined his style and role in European painting. Caravaggio's support of the realistic, antihumanist ideas that characterize the best of Lombard work in the 15th and 16th centuries, as well as his relationship with painters like Savoldo, Moretto, Lotto and the Campi brothers, remains an established fact that is essential for any understanding of his work as a whole.

But recent critics have tended to grant him a wider scope, stressing, in particular, the Venetian characteristics he probably acquired in the neo-Giorgionesque atmosphere of Milan.

Early Years in Rome. There is no need to linger over the adventures and quarrels with which Caravaggio's life was strewn. They are of interest only insofar as they help to explain his character and to determine the chronology of his career. When he was about 20 he managed to find patrons and aristocratic collectors in Rome, in spite of the differences between his style and that officially approved in artistic circles at the time. He never lost touch with everyday life, and continued to find the characters in his paintings among ordinary people. In spite of imprisonment, flight, and every kind of trouble, he continued to produce masterpieces marked by a capacity for profound meditation and a poetic understanding such as is found only in the greatest masters.

It seems reasonable to set the date of his arrival in Rome between 1591 and 1592; and on his journey there he almost certainly saw the work of artists like Giotto and Masaccio, whom he was to equal in the power of his innovatory vision. In Rome, he found life difficult to begin with, earning his living by producing crude works to be sold cheaply, while at the same time he began working on paintings of his own. During a stay in hospital at S. Maria della Consolazione he

▲ Alonso Cano
The Miracle of the Well
Canvas 216 cm × 149 cm
Madrid, Museo del Prado

Jan van de Cappelle ▲
Boats near the Coast
Canvas. 61 cm × 84 cm
Toledo Museum of Art, Ohio

painted a number of pictures that were sent to Seville by the Spanish prior of the hospital.

Caravaggio next attended the school of the Cavaliere d'Arpino, a charming, but superficial painter who had no influence upon him and whom he soon left to settle in the household of Cardinal del Monte. In his first period in Rome he produced a group of small easel paintings for collectors, the chronological order of which has been much discussed. The style of these works already appears as markedly personal and their position in relation to 16th-century tradition quite clearly defined. Essentially anti-Mannerist in the relationship of space and image, they take from Mannerism the intense, nervous line, while the light colours and the backgrounds bring out the vitality of the subjects.

Their most original characteristic is the choice of subject and also the freedom of interpretation with which traditional subjects are invested. For the first time in the history of European painting the theme of *Bacchus* (Uffizi) becomes little more than a pretext for the depiction of all kinds of

natural products and everyday objects which, in fact, are the true protagonists of the scene; the adolescent figure of the god, crowned with vine-leaves, is treated almost mockingly, and is scarcely distinguishable from the *Boy with a Basket of Fruit* (Rome, Gal. Borghese). For the first time, an ordinary incident like that of the *Boy Bitten by a Lizard* (Florence, Longhi Foundation) and a biblical event like the *Sacrifice of Isaac* (Uffizi) are given the same degree of pictorial significance and treated with the same seriousness and dramatic force.

There was no hierarchy of values in the many aspects of reality that fed Caravaggio's inspiration. Thus, in another painting Bacchus is represented as a sickly, undernourished lad from the taverns (*The Sick Bacchus*, Rome, Gal. Borghese), while *The Penitent Magdalene* (Rome, Gal. Doria-Pamphili) is seen not as a courtesan, but as a woman of the people, alone with her sufferings in a poor, bare room. Thus, too, *The Rest on the Flight into Egypt* (Rome, Gal. Doria-Pamphili) is shown as a slice of life comparable to such secular

paintings as *The Fortune-Teller* (Louvre), *The Lute-Player* (Hermitage), and *The Cardsharpers* (original now lost). Finally, the single motif of the *Basket of Fruit* (Ambrosiana, Milan) strikes the onlooker with its tangible reality. Considered as the first and one of the finest of modern still lifes because of its rejection of decoration or merely descriptive charm, the painting marks a break with the genre paintings that preceded it, with their air of intellectual enjoyment.

Rome: the later years. The paintings for the Contarelli chapel in the Church of S. Luigi dei Francesi, the dates of which have recently been established as 1599-1600 for the side-panels (*The Calling of St Matthew* and *The Martyrdom of St Matthew*) and as 1600-02 for the altar painting (*St Matthew and the Angel*), mark an important stage in Caravaggio's career. These paintings were closely preceded by a number of works that display the first signs of a change of style that probably owed something to the arrival in Rome of Annibale Carracci in 1595, and in any case

 Caravaggio
The Rest on the Flight into Egypt
Canvas. 130cm × 180cm
Rome, Galleria Doria Pamphili

showed a change of attitude towards official classical culture. *The Supper at Emmaus* (London, N.G.), with its more exaggerated perspective and its more austere and solemn tone in fact seems an answer to the grand manner of the Bolognese School, while *St John the Baptist* (in the two versions in the Gal. Capitolina and the Gal. Doria-Pamphili in Rome) and *Amor Victorious* (Berlin-Dahlem) – a kind of parody – are an open, even ironic display of Caravaggio's acquaintance with the 16th-century classical tradition.

After his youthful, lighthearted rejection of tradition, Caravaggio now seems to have gone through a period of reflection, and an anxious examination of the realistic interpretation of religious events. His artistic beliefs were consolidated, and their revolutionary nature commanded acceptance all the more readily because of the calm certainty with which they were expressed. Boldly translated into contemporary settings (a card table in *The Calling of St Matthew*, the interior of a Roman church in *The Martyrdom of St Matthew*), the happenings in Caravaggio's religious paintings are caught in their physical and spiritual reality through the revealing role of light. Directed from the side, from a source outside the painting, this is used to pick out the essential elements of the composition, obeying not objective optical laws but the expressive demands of the artist, halting movements suddenly, as in a snapshot, and plunging the scene into silent, dramatic chiaroscuro. This was the affirmation of Caravaggio's luminism, the cultural roots of which are to be found in Mannerism.

The first version of the altar painting (destroyed in Berlin in 1945) was thought too realistic and insufficiently reverent and was therefore refused. The second was conceived in a more classical way. It is particularly striking for the solidity of the draperies that enfold the angel, as if to hold him up in his flight (Caravaggio was wholly incapable of making an angel fly) as well as for its colours, with their restrained and rather meagre range, which seem to break up at the violent shock of the light against the sombre background of the canvas.

Although the colour effects of this painting suggest a Venetian influence in its use of light, it is related to two paintings of the previous year (*The Crucifixion of St Peter* and *The Conversion of St Paul*) for the Cerasi chapel in the Church of S. Maria del Popolo, finished, according to documents, in November 1601. Even more intense than the paintings in the Contarelli chapel, these two works are the result of a deeper interpretation of religious subjects, which were from then on almost the only ones dealt with by Caravaggio. Biblical history is translated into popular terms. This, according to some authorities, can be related to the preaching of St Ignatius Loyola and St Philip Neri. In the Cerasi chapel paintings realism is taken to its extreme limits (for instance, the horse's rump in the foreground in *The Conversion of St Paul*, which shocked Caravaggio's contemporaries). Through a transformation of chiaroscuro into deep darkness, pierced by occasional shafts of light, the scenes themselves appear with a shattering truth.

Caravaggio's other paintings in Rome, before he fled following a murder, can be grouped together with these. Around 1602-4 his classical ideas (*The Entombment*, Vatican) seem to have found a balance with *The Madonna of Loreto* (1603-5), painted for the Church of S. Agostino, in which the sculptural beauty of the Virgin is animated by a human tenderness in the silent dialogue with her humble adorers. Caravaggio chose the daughter of one of his poor neighbours as a model for the Virgin in *The Madonna of the Serpent* (Rome, Gal. Borghese). Painted in 1605 for the brotherhood of the Palafrenieri, the composition is notable for its unusual iconography.

At the same time darkness became more pronounced in his paintings, not as a complementary element of light but as one in opposition to it. This may be seen in the *St Jerome* and the *David* in Rome (Gal. Borghese), in the *St Jerome* in the monastery of Montserrat, and particularly in *The Death of the Virgin* (Louvre), a silent tragedy lit by a reddish glow. The realism of this latter work outraged Caravaggio's contemporaries.

Flight from Rome. Works made in Naples, Malta and Sicily. Accused of murder, Caravaggio fled Rome and went into hiding on the estates of Prince Colonna. It was probably while he was here that he painted a *Supper at Emmaus* (Brera), treating it as a low-life tavern scene, in which individual figures emerge from a background of darkness. In Naples in 1607 he worked feverishly, but most of the paintings from this period are now lost. Those that survive, *The Virgin with the Rosary*, (Vienna, K.M.), *The Seven Works of Mercy* (Naples, Church of Pio Monte della Misericordia), a *Salome with the Head of St John the Baptist* (London, N.G.), and a *Flagellation* (Naples, Church of S. Domenico Maggiore) show a change of style towards plastic and monumental effects reminiscent of the classical and Mannerist traditions. However, they are confined in this case to relationships between darkness and light and are used to exalt the most basic aspects of human reality.

At the beginning of 1607 Caravaggio was in Malta where, for the Order of St John, he painted two portraits of *Alof de Wignacourt* (one of which has been identified by some authorities with the portrait in the Louvre), a *Beheading of St John the Baptist* and a *St Jerome* for the Cathedral of St John in Valletta. For these works Caravaggio was created a Knight of the Order. After a stay in Naples, Caravaggio returned to the themes that had occupied him before his flight from Rome, enriching them with a new interest in the pictorial material.

He continued in the same way in Sicily, where he landed in October 1608. During his wanderings – which ended tragically, after a sea crossing, with his death on a beach in Lazio on 18th July 1610 – he created such masterpieces as *The Burial of St Lucy* (Syracuse, Church of S. Lucia), *The Resurrection of Lazarus* and *The Adoration of the Shepherds* (both Messina Museum), a *Nativity* (Palermo, Church of S. Lorenzo), a *Salome* (Escorial) and probably the *St John the Baptist* in the Borghese Gallery in Rome. To the end he remained faithful to everyday life in its humblest aspects which, in his last works, take on an unequalled spirituality and a sober nobility.

Influence The revolution carried out by Caravaggio in matters of form and iconography was the result of a radical change in the relationship between the painter and the world. His influence was all the greater because it came in response to a generally felt need for renewal and change and because he was able to achieve this in a highly original, individual and sensitive way without recourse to a codified language. In spite of this, his example led to the establishment of a number of formulas – naturalistic depiction of objects, life-sized figures, lighting from outside the picture, and the expressive use of chiaroscuro – that were taken up and spread by his followers. Italian painters such as Gentileschi, Saraceni, Borgianni, Manfredi, Serodine and, outside Italy,

▲ Caravaggio
The Calling of St Matthew
Canvas. 322 cm × 340 cm
Rome, Church of San Luigi dei Francesi

Honthorst, Ter Brugghen, Ribera, Valentin, Vouet, La Tour, Leclerc, Tournier, and many others, became known as Caravaggesque painters, although Caravaggio himself never had any wish to found a school.

His influence on European painting ranged from an adoption of his attitude of mind to a close adherence to his pictorial style. In general, his 17th-century followers represented the opposition to the classical rhetoric of the academies, and to the brilliant, illusionist and decorative spirit of the Baroque. Caravaggism can be seen as one of the principal sources of 17th-century painting, drawn upon by artists as dissimilar as Elsheimer, Velázquez and Rembrandt. G.R.C.

Carpaccio
Vittore

Italian painter
b. Venice, c.1465 – d. Venice, 1525

The son of a leather merchant, Carpaccio occupies a leading and unusual position in the history of Venetian painting during the 15th century. His training is still a matter of dispute. Once wrongly believed to have been apprenticed to Bastiani, he was then thought to have been influenced by the Bellini family, especially Gentile, and, even more importantly, by Antonello da Messina, an influence transmitted through Vivarini and Montagna. Carpaccio's style and taste – both very untypical of Venice – also suggest links with Flemish art and with Italian painting outside Venice (Ferrara, The Marches, Umbria and Tuscany), a fact that would seem to indicate that he had travelled a good deal. The theory that Carpaccio made a journey to the East is even harder to substantiate: his liking for subjects that evoked the eastern world may be explained by a knowledge of the woodcuts of Reeuwich (*Travels in the Holy Land*, 1486), or even observation of the special character of Venetian life at the time.

Christ among the Apostles (Florence, Contini-Bonacossi Coll.) is thought to be an early work. Its volumes recall Antonello da Messina and its colours Montagna. With the cycle of the *Story of St Ursula* (1490-6, Venice Accademia), for the Scuola di S. Orsola, Carpaccio emerges as a mature and original artist. Inspired by the *Golden Legend*, the eight episodes depicting the life of the saint were painted out of narrative order. They comprise *The Arrival of the English Ambassadors, The Dismissal of the Ambassadors, The Meeting of the Betrothed and the Departure on Pilgrimage* (1495), *The Pilgrims' Meeting with the Pope, The Saint's Dream, The Arrival in Cologne (1490), The Martyrdom of the Pilgrims and the Saint's Burial* (1493).

The altarpiece of the *Glory of the Saint*, although dated 1491, was probably painted a little earlier. In this cycle, Carpaccio's narrative talents appear in all their vividness. He was interested in everything around him, in all the seemingly irrelevant details of living, and in these paintings the religious events become amazingly alive and human, set in an imaginative, gay, exuberant world.

Carpaccio, however, was much more than a great pictorial artist. His painting is based on a lucid analysis of form, a sure awareness of the function of perspective in defining space, and a rich, luminous colour that sometimes suggests

the tonalism of the 16th century. His studies of figures are based on a profound understanding of the humanist culture that was so powerful in Venice at that time. This can be seen by comparing his paintings with the colder, more superficial work of Gentile Bellini, with whom he competed in making the cycle of the *Story of the Cross* for the Scuola di S.Giovanni Evangelista. The outstanding *Miracle of the Relic of the Cross* (1494, Venice, Accademia), in which the scene is set beside the Rialto Bridge, is also a valuable document about Venice and its life at the end of the 15th century.

At the same time as he was working on *The Blood of Christ* (1496, Udine Museum), a *Holy Family* (Avignon, Petit Palais) and projects for the Doge's Palace (1501 and 1507, lost in the fire of 1577), Carpaccio was also engaged on decorating the Scuole in Venice. In the Scuola di S. Giorgio degli Schiavoni (1501-7), in a series of paintings that are still *in situ*, he told the story of St Jerome (*St Jerome and the Lion in the Convent, Burial of St Jerome, St Augustine in his Study*), of St Triphonius and of St George (*St George and the Dragon, Triumph of St George, Baptism of the Selenites*).

His narrative style, always enlivened by the conjunction of the real with the fabulous, was now enriched with more dynamic rhythms and a deeper humanity. The more complex arrangement of the painting shows the episodes in a very broad perspective, and the buildings have an oriental appearance, together with touches that suggest the Lombard School. Carpaccio's microscopic vision brings an equal curiosity to bear both on realistic atmosphere and gloomy fantasies.

This taste for the macabre appears again in the two masterpieces, in the Metropolitan Museum (*Meditation on the Passion of Christ*) and in Berlin-Dahlem (*Lamentation over the Dead Christ*). He

limits himself to observations of detail, without allowing the tragic themes to affect the smiling serenity of landscape and skies or of the agile and colourful animals. The same animals enliven the Venetian langour of the *Two Courtesans* in the Museo Correr (so much admired by Ruskin) and animate the fairy-tale garden that forms a delicate background to the figure *The Knight* (1510, Lugano, Thyssen Coll.). At the same time as he produced these masterpieces of fantasy and invention, Carpaccio painted the monumental *Presentation of Christ in the Temple* for the Church of S. Giobbe (1510, Accademia), which reflects his study of the ideas of Giovanni Bellini.

Founded upon a vision that was essentially 15th-century, both in its strengths and its limitations, Carpaccio's creative powers seemed to wane during the second decade of the 16th century, as though he had been overcome by the modernity of the new spirit in Venetian art. On the other hand the burden of his work was often lightened by help from his studio, evident in the series of six *Scenes from the Life of the Virgin* painted for the Scuola degli Albanesi (today divided between the Accademia Carrara at Bergamo, the Brera, the Museo Correr and the Ca' d'Oro in Venice).

His *Scenes from the Life of St Stephen* in the Scuola di S. Stefano (1511-20, now divided between the Brera, the Louvre, and the Stuttgart and Berlin museums) nevertheless still retain, particularly in certain episodes (*The Dispute*, 1514, Brera; *St Stephen Preaching*, Louvre), the luminous colour, concrete feeling for space, formal exactness and the airy, limpid quality characteristic of the best of his work. However, his late paintings, executed in collaboration with his sons Benedetto and Piero, show that a decline into dryness and academicism (works in the Capodistria Cathedral and Museum) had set in. F.Z.B.

▲ Vittore Carpaccio
Lamentation over the Dead Christ
Canvas. 145 cm × 185 cm
Berlin-Dahlem, Gemäldegalerie

Carracci
Annibale

Italian painter
b.Bologna, 1560 – d.Rome, 1609

Annibale's gifts as a painter may be explained by the fact that there were already two painters in his family, his cousin Lodovico and his brother Agostino. He trained as a painter with the Mannerist, Prospero Fontana, but, like his brother, began his career as an engraver, his first original effort appearing in 1581. His first altarpiece, a *Crucifix* (1583) for the Church of S. Nicolò in Bologna, set him ahead of Lodovico and Agostino. He then sought other teachers outside Bologna and was particularly influenced by Barocci, whose style can be detected in *The Baptism of Christ*, painted in 1585 for the Church of S. Gregorio in Bologna. At the same time, he studied the works of the Campi family and Jacopo Bassano, and displayed an interest in the most commonplace aspects of everyday life.

He practised several forms of painting, portraiture, landscape and mural decoration, and in the Palazzo Fava in Bologna worked with Lodovico and Agostino on a frieze illustrating the *Story of Jason*. A little later, in another room in the palace, he painted, this time on his own, a *History of Europe*, which revealed the influences he had undergone during a journey to Padua and Venice. In accordance with the principles laid down by the Academy of the Incamminati which, in 1585-6, he and his brother and cousin had accepted as ideals, he carried out imposing altarpieces for Bologna, Parma and Reggio. The frieze of the Palazzo Magnani in Bologna (*The History of Rome*), painted between 1588 and 1592, shows the same characteristics. It is hard to say exactly what part each of the three Carracci had in this work. It does, however, reveal a common desire to respond in the manner of the great 16th-century masters, Correggio, Titian and Veronese, who idealized reality while respecting the forms of nature, and was in a way the Carracci's artistic manifesto.

During the few years that Annibale spent in Bologna he painted strongly naturalistic portraits, a style that he had already adopted in such genre scenes as *The Butcher's Shop* at Christ Church, Oxford, or the famous *Bean Eater* in the Galleria Colonna in Rome. However, he excelled above all in painting landscapes, a genre to which he brought fresh life by his romantic, although never unreal, interpretations. He painted life on the hills around Bologna, the rivers with their fishermen and boatmen, and the travellers and huntsmen, against a background of trees in warm autumn colours. It was only later, in Rome, that his vision became more severe and solemn, implying a concept of nature that conformed to the theory of the *beau idéal*.

In 1595 he was called to Rome by Cardinal Odoardo Farnese, and began work on the *St Roch giving Alms* (Dresden Gg). Conceived on classical principles, the painting marks a change in style. It is a complex, balanced composition, employing rhythmic, solemn cadences and slow majestic movements, with a statuesque quality to its figures. Naturalism, however, continued to enrich Carracci's new vision, feeding his sensibility, even though in Rome he gave up the direct representation of reality. His first work in Rome,

the fresco decoration of the Camerino in the Palazzo Farnese, illustrated the *Stories of Hercules and of Ulysses* and was surrounded by grisailles that reveal a profound study of classical antiquity.

About two years later, he began a new decoration in fresco for the gallery of the Palazzo Farnese, in which his brother Agostino also took part, and then several of his pupils, among them Domenichino, Albani and Lanfranco. This imposing work, which took five years to complete, allowed full scope for Annibale's genius. The theme was the exaltation of classical antiquity, represented by the *Loves of the Gods*. He treated this within the framework of mock architecture of great complexity including figures, some of which were painted in such a way as to suggest real people, others bronze or marble statues lit by a shifting golden light. A powerful atmospheric effect seems to come from the corners of the vault through windows opening on to the sky. The work introduced a concept of decoration that was to be developed throughout the age of Baroque painting.

During this same period he also executed altar-paintings and secular works, including landscapes. In 1602 he was commissioned to decorate the Herrera chapel in the Church of St Giacomo degli Spagnoli (*The Life of St Diego*); the frescoes (today divided among a number of Spanish museums) were carried out by his pupils in 1607. At around this time he was entrusted by Cardinal Aldobrandi with the decoration of a chapel in his palazzo, and produced a series of canvases in the form of lunettes representing episodes in the life of the Virgin, against a background of landscape. Annibale himself painted *The Flight into Egypt* and *The Deposition*. Now housed in the Galleria Doria-Pamphili in Rome, the series began the heroic genre of landscape painting and served as a model for Domenichino and Claude.

In 1605, after contracting an incurable disease, Annibale was forced to give up painting, although he continued to draw and to direct works carried out by his pupils. He died in the summer of 1609, universally mourned. The general admiration for his work lasted for 150 years, until Winckelmann and certain Neoclassical critics questioned his greatness, seeing in him a rather eclectic imitator.

Carracci's work includes a great many powerful, authoritative drawings (studies from nature, landscapes, caricatures, projects for large decorations), often in black chalk, touched up with white. The Louvre and the Royal Collection in Great Britain (Windsor Castle) house a number of series. E.B.

Carracci
Lodovico

Italian painter
b.Bologna, 1555 – d.Bologna, 1619

After training with Prospero Fontana, Lodovico widened his experience by visits to Florence, Parma, Mantua and Venice. The influence of Bartolomeo Cesi is noticeable in the simple, strict construction of such youthful works as *The Annunciation* (Bologna, P.N.) and *The Vision of St Francis* (Rijksmuseum), both painted in Bologna. The works painted here and elsewhere reveal a tendency towards naturalism and make use of strongly contrasted chiaroscuro. Typical of his way of painting at this time are *The Conversion of St Paul* (1587), *The Madonna of the Bargellini* (1588), *The Madonna of the Scalzi* (all three in Bologna, P.N.), *The Flagellation* (Douai Museum),

▲ Annibale Carracci
The Galleria Farnese
Fresco
Rome, Palazzo Farnese

and his masterpiece, *The Madonna with St Francis and St Joseph* (1591, Cento Museum, Emilia). The fervour of their pictorial imagination and their subtlety of feeling are equally impressive. Carracci's warm and passionate temperament found its outlet only in religious painting, but his works in this genre are remote from any experimental spirit or intellectualism.

Carracci was very much attached to his birthplace, Bologna, and seldom left it, and then only for short periods. In 1607-8 he visited Piacenza to carry out frescoes for the choir of the cathedral, but all the other commissions he received from Piacenza and from elsewhere in Emilia or Lombardy were always carried out in his home town. He refused to conform to current taste, and thus quickly appeared old-fashioned in comparison with the new trends in Bolognese art exemplified

by the work of Guido Reni and Albani in Bologna and Domenichino and Lanfranco in Rome.

He spent his final years teaching and directing the Academy which he had founded with his famous cousins. His last important work was a series of frescoes which he carried out (1604-5) with his pupils in the cloister of the Church of S. Michele in Bosco. Today they are so badly damaged that it is hard to appreciate them except through reproductions. Although his example played a determining role in the education of artists like Guercino and, later, Crespi, he never achieved the fame of his cousin Annibale and his influence remained limited. E.B.

Carreño de Miranda
Juan
Spanish painter
b. Ávila, 1614 – d. Madrid, 1685

Born into a noble family in Asturias, at the age of 11 Carreño went to Madrid and entered the studio of Pedro de las Cuevas. Later he worked with Bartolomeo Román, an imitator of Rubens and pupil of Velázquez. In style and technique Carreño's first works are closely modelled on those of the Flemish painters, while already displaying a feeling for classical composition rare among Spanish painters. *St Francis Preaching to the Fishes* (1646, Villanueva y Geltrú, Balaguer Museum) and especially *The Annunciation* (1653, Madrid, Hospital of the Orden Tercera) show obvious borrowings from Rubens. The breadth of his forms, the fluency of his draughtsmanship, his glowing colours and golden light owe nothing to his compatriots.

It seems that his output increased considerably between 1650 and 1660, a period during which he produced many religious paintings, all of them signed and dated. Carreño held an official position at the court of Philip IV and often assisted Velázquez, who, some time between 1655 and 1659, probably suggested that he should help him in decorating the Hall of Mirrors in the Alcázar in Madrid. Carreño, who knew the technique of fresco painting, undertook two works (destroyed in the Alcázar fire in 1734). The cupola of the Church of S. Antonio de los Portugueses, carried out to a plan by the Italian decorator, Michele Colonna, and heavily touched up by Giordano, does not allow any exact judgement of Carreño's skill in this field, nor does a cupola in Toledo Cathedral wholly repainted in the 18th century by Maella.

In 1657 Carreño painted the *Dream of Pope Honorius* (now disappeared) in the church of the College of St Thomas in Madrid, a composition that aroused the admiration of Colonna, who declared Carreño to be the best painter at the Spanish court.

Carreño's close and lasting collaboration with Velázquez may be considered the turning point in his development. It was then that, without giving up his Flemish aesthetic, he acquired those qualities of gravity and passion that gave his work an authentically Spanish flavour. The only true follower of Velázquez, Carreño resolved, thanks to him, problems of light, atmosphere and space in an altogether new way. The change already noticeable in *St Dominic* (1661, Budapest Museum) becomes obvious in Carreño's master-

piece, *The Foundation of the Order of Trinitarians* (1666, Louvre), painted for the Trinitarians of Pamplona.

The figures in this painting are harmoniously grouped in a clear, luminous space, defined according to the concepts of Velázquez. Their intensity, the rich, bright colours – blue, red, brownish gold – vigorously applied, seem to anticipate those of Delacroix. In other paintings of the same period Carreño achieved a happy compromise between the example of Velázquez, the memory of Titian, and the north European style to which he was still attached (*St Anne*, 1669, Prado; *The Immaculate Conception*, 1670, New York, Hispanic Society; *The Assumption*, Poznań Museum).

In 1669, he was appointed painter to the king and in 1671 *pintor de cámara*. There ensued a successful period as a portrait painter. Apart from the many portraits of *Charles II as a Child* (Berlin, K.M.); Vienna, Harrach Coll.; Prado), in which he produced striking images of the sickly young prince, Carreño also painted several versions of *Mariana of Austria in Mourning* (Prado; Vienna, K.M.). He also left important portraits of eminent people at the court, such as the *Marqués de Santa Cruz* (Madrid, private coll.) and the *Russian Ambassador, Peter Ivanovich Potemkin* (Prado). J.B.

Cassatt
Mary Stevenson
American painter
b. Allegheny City, 1844 – d. Paris, 1926

Mary Cassatt, an unlikely candidate to be the first American painter to have participated actively in an avant-garde movement of international importance, was the fifth child of Robert Simpson Cassatt, a well-to-do broker. The family moved to Philadelphia in 1849 and made an extended trip to Europe from 1851 to 1855. Mary enrolled in the Pennsylvania Academy of the Fine Arts in 1861 and was exposed to a conventional academic curriculum for more than four years. In 1866 she secured permission from her family to return to Europe (where she spent most of her long life) and entered the Paris atelier of Charles Chaplin.

But her real teachers were the old masters, especially Correggio, whose work at Parma she copied extensively during 1871–2, and the new artists she had come to admire, specifically Courbet and Manet. She laboured hard to perfect her painting techniques, and by 1872, when her entries were first accepted by the Paris Salon, she was ready to cast away much of what she had so painstakingly learned. At the Salon of 1874 her work was admired by Degas who asked her to join the Impressionists, with whom she first exhibited in 1879.

Degas's style of the 1870s was the formative influence on Mary Cassatt. It makes its initial appearance in the odd perspectives and asymmetrical arrangements of her compositions, as well as in the new incisiveness of her drawing. From Degas Mary Cassatt received both lessons and sharp criticism. But her favourite subject matter, the intimate relationship between women and their children, was wholly her own. Her development also proceeded differently from that of Degas. By the late 1880s she had begun to ab-

▲ Juan Carreño de Miranda
The Foundation of the Order of Trinitarians (1666)
Canvas. 500 cm × 327 cm
Paris, Musée du Louvre

▲ Lodovico Carracci
The Flagellation
Canvas. 189 cm × 265 cm
Douai, Musée de la Chartreuse

sorb the influence of Japanese prints in a distinctly original manner. Her painting became drier, the colours brighter and flatter, and the compositions developed a rich sense of two-dimensional pattern.

The Bath (1891–2) (Art Institute of Chicago) is a characteristic work from the period when Mary Cassatt finally gained the self-confidence to allow an exhibition of her works to be mounted at Durand-Ruel's. In this painting the view down towards a floor covered by a rich oriental rug is combined with a glimpse of a floral-patterned rear wall. The striped house-dress of the mother contrasts boldly with these smaller and more intricate decorative schemes, and locks the whole into so striking a design that the absorption of the woman and child in a homely act of foot-washing is reduced in anecdotal importance.

However, the level of Mary Cassatt's psychological penetration was very high, chiefly because she never allowed her vision to be clouded by sentimentality. She was asked to contribute a mural for the women's pavilion at the World's Columbian Exposition in Chicago in 1893. The only genuinely distinguished artist asked to participate in that venture, she was also the least known to the average American public.

At about the same time as Cassatt began to establish her reputation in France she became a serious and innovative printmaker, a master of coloured drypoint and aquatint whose proofs were eagerly sought by connoisseurs on both sides of the Atlantic. Although during the decades following she was often awarded prizes and asked to serve on juries, she always refused, remaining loyal to the spirit of the original Impressionist group, which had declared its independence from juries, medals and awards. She was thus a lively critic of the American art establishment, which she viewed as modelling itself on the mistakes of the French academic art world, and she was forthright in her criticism of American museums, even when these increasingly sought her work.

At the same time, because of her social standing and the wealth of her brother, Alexander Cassatt,

the President of the Pennsylvania Railroad, she exerted a profound influence on the formation of many major American art collections, notably those of Mrs H. O. Havemeyer and James Stillman. She did not merely direct her friends towards the purchase of the work of her fellow-Impressionists, but was equally responsible for the acquisition of works by El Greco and Goya. An energetic defender of modern art, she was the friend of Whistler but regarded Sargent as shallow. She had little sympathy, however, with the later innovations of Matisse or the Cubists, regarding both as seekers after sensationalism.

Towards the end of her life she developed cataracts, which led to a complete loss of sight, and from about 1912 she was no longer able even to execute the pastels which, increasingly after the turn of the century, had become her favourite medium. She died at her home, the Château de Beau Fresne, near Paris, having exerted a greater influence on the development of American collecting than on the evolution of the course of painting in the United States. D.R.

Castiglione
Giovanni Benedetto (known as 'Il Grechetto')

Italian painter
b.Genoa, c.1611 – d.Mantua, 1663 or 1665

Castiglione lived in Genoa until 1632. His masters included Paggi, de Ferrari and Van Dyck (during his second stay in Genoa between 1621 and 1627). He then turned to genre painters of Flemish origin, particularly to a pupil of Snyders, Johann Roos (in Genoa from 1614 to 1638). From him he took a type of painting showing heavily laden animals and which suggested both Aertsen and Beuckelaer. Bassano, whose work was certainly not unknown in Genoa, must also have had an influence on him.

By now he was a naturalistic painter in the north European tradition, producing what were in effect animal scenes, although on the pretext of a biblical subject, such as *Abraham's Journey*

(Dusseldorf, K.M.) – subjects that he was to continue to use throughout his career. He also produced etchings (including some of turbaned heads), showing that he had studied those of Rembrandt; he was in fact the first Italian to discover Rembrandt. Caravaggism, therefore, came to him via northern European painting, and throughout his life Rembrandt continued to be a source of inspiration, especially in his graphic work.

Castiglione left Genoa for Rome in 1632. He spent two periods there, the first in 1632-5 and the second in 1647-51. Between these two visits he is thought to have passed some time in Naples, where he is mentioned in 1635, as well as in various other Italian towns, principally Genoa (c.1645). During his first stay in Rome he came to know the circle of Poussin and Cassiano dal Pozzo. Stylistically, he was close to Testa and Mola, who were also in Rome.

His style grew less Flemish and, in the years 1630-5, he developed a facility for Poussin's neo-Venetianism. His repertoire broadened, his style became better ordered and his colour warmer; at the same time his composition grew lighter and his drawing more fluent. He elaborated a technique of sketching in oils on paper, probably inherited from Flemish and Venetian art, that allowed him to employ colours such as vermilion, which he was the only artist to use at the time. He also invented the technique of monotype, which consisted of making a single copy from a metal plate bearing a drawing in ink. These two processes allowed a greater freedom, particularly in developing chiaroscuro effects.

On his return to Genoa, Castiglione painted large religious compositions in a markedly Baroque style: *The Adoration of the Shepherds* (1645, Church of S. Luca); *St Bernard Adoring Christ on the Cross* (Church of S. Martino at S. Pier d'Arena); *St James Expelling the Moors from Spain* (Oratory of S. Giacomo della Marina). The first-named of these is notable for its sense of space, while in *St Bernard* the feeling of ecstasy which Castiglione was to develop later in his sketches appears for the first time. Rubens was at this period the most important influence on Castiglione, as appears in the painting of *St James expelling the Moors*, which is drawn directly from Ruben's hunting scenes.

During his second stay in Rome (1647-51) Castiglione drew away from Poussin, who had by then become too classical and intellectual for him. Through the Raggi and Fiorenzi families, he became acquainted with Bernini and Cortona. Under the latter's influence he employed the 'grand manner' for a time (the *Immaculate Conception* for the Church of the Cappuccini in Osimo, Minneapolis, Inst. of Arts). But the dominant note in his painting is the fantastic and the picturesque, as appears in *Diogenes* (Prado) or the *Offering to Pan* (Genoa, Durazzo Coll.). These works are akin to the strange studies of Testa and exercised a considerable influence upon Salvator Rosa.

The last period of his life, from 1651 to 1665, was spent mostly in Mantua, where he was painter at the court of the Gonzaga family. His brushwork became freer after a journey to Venice in 1648, under the influence of the great Venetians and of a contemporary, Johann Liss, but mainly through contact with the art of Fetti, his predecessor at the court in Mantua. Although he continued to paint philosophical and picturesque subjects, the human figure now became the main

▲ Mary Cassatt
The Bath (1891–2)
Art Institute of Chicago

▲ Giovanni Castiglione
The Adoration of the Shepherds
Copperplate. 68 cm × 52 cm
Paris, Musée du Louvre

centre of interest in his paintings (*The Discovery of Cyrus*, Dublin, N.G.). The latent influence of Bernini and Rubens appeared in drawings such as *Moses Receiving the Tablets of the Law* (Windsor Castle), strengthening the Baroque tendency that had already been noticeable in Genoa in 1645.

Between 1659 and 1665 he worked in Mantua, Genoa, Parma and Venice, but remained permanently in the service of the Gonzagas. He then reverted to his early style, producing compositions that are often distinguished by a heap of game in the foreground and tiny figures in the distance. But Mannerism gave place to the Baroque, as is evident in the *Money-Changers Expelled from the Temple* (Louvre) or the *Journey of the Children of Israel* (Brera).

Rather like Bernini and Strozzi, Castiglione ended his career on a mystical note with a series of drawings and sketches of Franciscan saints in ecstasy or Christ on the Cross. Thus, at the end of his life, he seems to have been the leader of a movement of mystical Genoese painting that began with Strozzi and also included Piola and de Ferrari.

Historically, Castiglione was a significant figure in that phase of Italian art when it was being regenerated by Flemish and Dutch painting. As a Baroque painter he exploited the style at all levels. He possessed a virtuoso technique that could be turned to rustic genre painting or the 'grand manner' and he was also an extraordinarily good draughtsman and engraver. In the 18th century he had a great influence upon Sebastiano Ricci, the Tiepoli and particularly Fragonard (*Adoration of the Shepherds*, Louvre). S.Dc.

Cavallini
Pietro
Italian painter
b.Rome, c.1250–d. c.1330

It is known that during a long career Cavallini worked in the most important churches of Rome and Naples, carrying out commissions for such prominent figures as Bertoldo Stefaneschi, and Charles and Robert of Anjou. Among his surviving works the oldest in Rome is the mosaic that once bore the fragmentary inscription 'Petrus', in

the apse of S. Maria in Trastevere (1291), depicting six scenes from the *Life of the Virgin* and *The Donor, Bertoldo Stefaneschi, being presented to the Virgin by St Peter*. A little later, Cavallini carried out frescoes in the Church of S. Cecilia in Trastevere. The great scene of the *Last Judgement*, discovered in 1901 behind the choir stalls and the only part of the whole decorative programme to have survived, is undoubtedly his most important and successful work.

In Naples (1308) he worked for the Anjou family. The participation of others in his workshop and major alterations subsequently carried out make it impossible to tell exactly what part he himself took in the painting of a fresco in the Duomo (chapel of S. Lorenzo, *Tree of Jesse*) or in the extensive series of frescoes in the Church of S. Maria Donnaregina (*The Last Judgement, Apostles and Prophets*). Most of his works in Rome, mentioned by Ghiberti and Vasari, have been lost, while almost nothing of the mosaic of about 1321, made for the basilica of S. Paolo fuori le Mura in Rome, is left.

Cavallini occupies a leading position in Italian painting at the end of the 13th and the beginning of the 14th centuries, comparable to that of Cimabue and Duccio. Like most painters of his generation he was educated in a culture that was still Byzantine but he did not passively assimilate its conventional forms. On the contrary, he strove to re-create freely forms based on antique models. In so choosing, he allied himself with the great tradition of medieval Roman painting, enjoying the same artistic experience as the painters of the crypt of Anagni Cathedral.

Cavallini grew out of the same tradition as Giotto and it may be that their relationship was that of two great contemporaries rather than of master and pupil. The breadth of form and solidity of the figures in the frescoes in S. Cecilia are comparable to what Giotto was later to achieve in the frescoes of the Arena Chapel in Padua. In Cavallini, colour gives autonomy to the forms. Intense, penetrating shadows throw the figures into relief and endow them with a solemn placidity. The creation of real faces may express both religious fervour and human warmth. These characteristics of Cavallini's art imbue his work with the highest poetry and an entirely personal power of expression. Roman and Neapolitan painters of the 14th century as well as Umbrian painters owed him a great deal. B.T.

Cavallino
Bernardo
Italian painter
b.Naples, 1616–d.Naples, 1656

Cavallino was the most lyrical and sensitive of 17th-century Neapolitan painters and his style strongly influenced many of his contemporaries. His own early works reflect the influence of Massimo Stanzione (*The Meeting at the Golden Gate*, Budapest Museum, wrongly attributed to Stanzione; *The Martyrdom of St Bartholomew*, Naples, Capodimonte). Soon, however, he took up the Caravaggist style, at that time popular in Naples as a result of a visit by Velázquez and the spread of the Roman culture of the *bamboccianti*.

Cavallino followed the fashion for the small-format paintings popular with the last of Caravaggio's followers while remaining faithful, to begin with at least, to the subject-matter of Stanzione and his imitators: scenes from the Old and New Testaments (*Abigail and David*, Milan, Castello Sforzesco; *Esther and Assuerus*, Uffizi); other religious scenes (*The Death of the Virgin*, Warsaw Museum) and mythological subjects (*The Rape of Europa*, Liverpool, Walker Art Gal.). His works, particularly his early paintings, are like a small-scale anthology of quotations from Caravaggio, displaying a softening of the contrasts of light and a theatrical presentation, free from naturalism.

Around 1635–40 Neapolitan painting came under the influence of Van Dyck, whose work was then becoming better known in Genoa and Sicily (as well as in Spain). Some of his paintings had found their way to Naples, together with one of his followers, Pietro Novelli. Cavallino quickly took up this new style. For the violent contrasts of light and shade of his early work, he substituted increasingly refined pictorial effects, elegant colours and delicate shadows. His painting of *St Cecilia* (1645, Florence, Palazzo Vecchio) marks the beginning of this process, which came increasingly to dominate his work.

Cavallino lightened his colours and laid tone after tone upon the light shades; his figures acquired a softness and charm that seem to anticipate the grace of the 18th century. Isolated figures and individual portraits become more

▲ Pietro Cavallini
The Presentation in the Temple
Mosaic
Rome, Church of S. Maria in Trastevere

Bernardo Cavallino ▲
The Finding of Moses
Canvas. 102 cm × 129 cm
Brunswick, Herzog Anton Ulrich Museum

numerous. They combined a new feeling for the everyday with a lyrical expression (*The Singer*, Naples, Capodimonte; *St Cecilia*, Boston, M.F.A.; *Judith* – the masterpiece of his maturity – Stockholm, Nm).

Compositions containing a number of figures, nearly always of genre scenes (two scenes from *Jerusalem Delivered*, Munich, Alte Pin.; *The Finding of Moses* and *Abigail*, Brunswick, Herzog Anton Ulrich Museum), can be seen as part of the same development, prefiguring the aristocratic refinements of Arcadian painting. In Cavallino Neapolitan painting found, during the period of its evolution from luminism to naturalism, a high point of the lyrical style. In his own day, however, Cavallino was an isolated figure. In comparison with the successes of the neo-Venetian and Roman Baroque styles, his highly personal manner, with its overtones of mystery and touches of graceful fragility, appeared out of date. R.C.

Cézanne
Paul
French painter
b. Aix-en-Provence, 1839 – d. Aix-en-Provence, 1906

Having started life as a labourer and a hatter, Cézanne's father became a banker in 1847, and was thus able to give his son a secure financial future. From 1852 to 1858 Cézanne received a solid education in the humanities at the Collège Bourbon in Aix. Here he became a friend of Zola. After leaving school he studied law at university but, encouraged by Zola to follow a more independent life-style, he turned to painting. *Les Quatre Saisons* (*The Four Seasons*) (1860, Paris, Petit Palais), with which he decorated the 'Jas de Bouffan', a country house which his father had just brought, is mainly notable for a youthful clumsiness. He moved to Paris where, in 1861, he attended the Académie Suisse and received advice from Villevieille, but his lack of experience discouraged him. He went back to his father's bank for a short time, but his vocation for painting now seemed definite.

From 1862 to 1869, moving between Paris and Aix, Cézanne, who knew only the Caravagesque paintings in the churches of Aix and the important modern collections of the Musée Granet, witnessed the conflict between the dull, cultured eclecticism of official circles and the revolutionary realism of Courbet, Manet and the Refusés of 1863. Delacroix's work, which combined traditional subject-matter with a modern, painterly style, appeared to Cézanne, in the retrospective exhibition of 1864, to offer a direction that suited him. Receptive to all these different influences, Cézanne went to meetings at the Café Guerbois and was fascinated by the bold and emotional effects of the work of Géricault and Daumier.

Cézanne translated his excessive feelings and his suffering into what he called his *couillard* (i.e. 'butch') manner. Using startling, muddy paint, heavy with thick black pigment, he painted scenes of an erotic, macabre kind inspired by the Baroque Italians and Spaniards and some of their imitators, such as Ribot (*L'Orgie* [*The Orgy*], 1864-8 Lecomte Coll.; *La Madeleine* [*The Mag-*

dalene], 1869, Louvre, Jeu de Paume; and *L'Autopsie* [*The Autopsy*], 1876-9, Lecomte Coll.).

His portraits and still-life paintings were more carefully considered, and show a surprising strength and intensity (*Le Nègre Scipion* [*The Negro Scipio*], 1865, São Paulo Museum; *Portrait d'Emperaire* [*Portrait of Achille Emperaire*], 1866, Louvre, Jeu de Paume; *La Pendule au marbre noire*, [*The Black Marble Clock*], 1869-71, Paris, private coll.). He remained unaffected by the outbreak of the Franco-Prussian War, and stayed at L'Estaque, painting boldly coloured landscapes of the beaches (*La Neige fondante à l'Estaque* [*Melting Snow at L'Estaque*], 1870, Zürich, Bührle Coll.).

Contacts with Impressionism. Ready by now to learn from the Impressionists, Cézanne settled at Auvers-sur-Oise in 1872-3, near Pissarro, who was to prove a considerable influence. Secure in his personal life with his mistress, Hortense Fiquet, who had just given him a son, and with his friends Guillaumin and Dr Gachet around him, he painted landscapes like the *Maison du pendu* (*House of the Hanged Man*) (1873, Louvre, Jeu de Paume) and still lifes like the *Buffet* (*Sideboard*) in the Budapest Museum (1873-7) that reveal a strongly personal vision.

Preserving psychological analysis for his challenging, passionate self-portraits (Lecomte Coll., *c.* 1873-6; Washington, Phillips Coll., *c.*1877), Cézanne concentrated in his other works on capturing the subtleties of volume and tone. The geometrical arrangement of *Mme Cézanne au fauteuil rouge* (*Mme Cézanne in a Red Armchair*) (1877, Boston, M.F.A.), the calm dialogue of *Nature morte au vase et aux fruits* (*Still Life with Vase of Fruit*) (*c.*1877, Metropolitan Museum), the arrangement of trees in the *Clos des Mathurins* (*c.* 1877, Moscow, Pushkin Museum) – all show a preoccupation with form and composition. The rhythmic variations and deliberately stylized bodies in the *Lutte d'amour* (*Battle of the Sexes*) (1875-6, Washington, private coll.) and the *Bathers*, male and female, which from that time on he began to paint, recall Rubens and Titian.

In 1874 Cézanne exhibited at the first Impressionist show at Nadar's and in 1877 showed 16 oils and watercolours at the Impressionist exhibition in the Rue Pelletier. After this, hurt by the sneers of press and public, he no longer exhibited with his friends.

At intervals, Cézanne visited Paris where he would sometimes be seen at the Nouvelle-Athènes café. More often, however, he was in the provinces (his father, who disapproved of his domestic life, had cut off his allowance): with Zola at Médan in 1880; with Pissarro at Pontoise in 1881; with Renoir at La Roche-Guyon, then at Marseilles, where he met Monticelli, in 1883; with Monet and Renoir at L'Estaque in 1884; and with Chocquet at Hattenville in 1886. This was a time of fertile maturity, when Cézanne moved away from the Impressionists, improved his brushwork, and worked ceaselessly at the same motifs.

He wanted to 'do Poussin from life' by treating nature 'with cylinder and sphere'. Accordingly the subjects which he chose from nature, among them *Gardanne* (1886, Merion, Barnes Foundation), the rocks at Aix (1887, London, Tate Gal.), and the sea at L'Estaque (1882-5, Metropolitan Museum, Louvre; 1886-90, Chicago, Art Inst.), were submitted to a process of analysis partly based on geometrical principles, and partly on the desire to release the medium of painting from its

primary descriptive function. The light harmony of *Vase bleu* (*Blue Vase*) (1883-7, Louvre, Jeu de Paume) seems to preserve the delicacy of his watercolours, with their controlled rhythm and fine lines.

Cézanne produced over 400 of these watercolours but, outside a small circle of collectors that included Renoir and Degas, they remained unknown until Vollard exhibited them in 1905. They include such remarkable works as *La Route* (*The Road*) (1883-7, Chicago, Art Inst.); *Le Lac d'Annecy* (1896, St Louis, Missouri, City Art Gal.); *Trois Crânes* (*Three Skulls*) (1900-6, Chicago, Art Inst.); and the *Pont des Trois-Sautets* (1906, Cincinnati Museum).

Irritable, defiant and, from 1886, increasingly isolated (in that year his father had died and he had broken off relations with Zola, whose *L'Oeuvre*, which had used him partly as a model, had wounded him), Cézanne was known to only a few intimates. But although a mysterious figure, he had a certain fame. The Nabis, led by Bernard, Sérusier, and Maurice Denis, were from then on profoundly influenced by him. He showed a painting at the Paris Exhibition in 1889, and in 1890 was invited to exhibit with Les Vingt in Brussels. The 100 paintings shown at Vollard's in 1895 aroused a great deal of attention and resulted in a rise in the value of his work. In 1900 he showed three works at the World Fair, and the Berlin Museum bought one.

Final period. Between about 1890 and 1900 Cézanne produced a group of major works that, in contrast to the brilliant and ephemeral world of the Impressionists, aimed to be 'something solid, like the art of the museums'. In the breadth of *Femme à la cafétière* (*Woman with a Coffee Pot*) in the Louvre (*c.*1890), in the dynamic and masterly *Mardi gras* (1888, Moscow, Pushkin Museum), or in the important series of *Joueurs de cartes* (*Card Players*), probably inspired by the work of Le Nain in Aix Museum (1890-5, Merion, Barnes Foundation; Metropolitan Museum; London, Courtauld Inst. Galleries; Louvre), Cézanne showed the full range of his genius. Analysis often charged with emotion characterizes *Le Garçon au gilet rouge* (*The Boy with the Red Waistcoat*)

Paul Cézanne ▲
Portrait de Gustave Geffroy (1895)
Canvas. 116 cm × 89 cm
Paris, Musée du Louvre

(1890-5, Zürich, Bührle Coll.), *Le Fumeur accoudé*
(*Man Smoking and Leaning on his Elbow*) (1890,
Mannheim Museum), *Vollard* (1899, Paris, Petit
Palais) and *Le Lac d'Annecy* (1896, London, Cour-
tauld Inst. Galleries).

Admired by young painters (he was visited by
Bernard Camoin while, at the Salon des Indé-
pendents of 1901, Maurice Denis exhibited his
Homage à Cézanne), and finally recognized at the
Autumn Salon of 1903, Cézanne continued to
work at the themes that obsessed him. He
produced endless *Baigneurs* paintings (1900-5,
Merion, Barnes Foundation; London, N.G.). These
themes were epitomized in his masterpiece, the
Grandes Baigneuses of the Museum of Art in
Philadelphia (1898-1905).

With allusive, nervous brushwork, in the
short time that remained to him he created the
dreamlike vibration of *Le Château noir* (1904-06,
Moscow, Pushkin Museum; Philadelphia, Mu-
seum of Art; Zürich, Bührle Coll). He died on
22nd October 1906.

Cézanne's vision, once again revealed in the
Autumn Salon of 1907 (57 paintings), was taken
over and transformed by the Cubists and adopted
by the Fauves. It was spread abroad in England by
the Post-Impressionist exhibitions organized in
1912 and 1913 by Roger Fry, in Germany by the
Sonderbund exhibition at Cologne in 1912, in
Italy by the Secessione exhibition in Rome in
1913 and in the United States by the Armory
Show in 1913). This vision appeared from then on
and for a considerable time to come as the essential
basis for all pictorial analysis.

Cézanne's work includes about 900 paintings
and 400 watercolours, and is represented in most
major galleries throughout the world, notably the
Barnes Foundation (Merion, Pennsylvania), the
Metropolitan Museum and the Museum of
Modern Art in New York, and the Courtauld In-
stitute Galleries, London, and the National Gal-
lery, London. His paintings in the Louvre com-
prise mainly the Donation Walter Guillaume and
works in the Jeu de Paume. The most important
private collection is the Pellerin-Lecomte Collec-
tion. G.V.

Chagall
Marc

French painter of Russian origin
b.Vitebsk, 1887 – d.St.-Paul-de-Vence, 1985

Chagall came from a modest background but at
an early age he showed talent for drawing and
began to work with a local painter, Jehudo Pen.
In 1907 he went to St Petersburg and, while
studying at the Imperial School of Fine Arts, also
attended the courses on modern art given by
Bakst. These revealed to him certain aspects of
French painting and awakened in him a desire to
go to Paris.

His first paintings already show a markedly
personal talent. Inspired by the everyday life of
Vitebsk and infused with the spirit of the Jewish
Hassid doctrine (which stressed the value of a
mystical and physical outpouring), their discreet
colour and arrangement sometimes suggest the
Nabis , but they already possess the spontaneous
fantasy that distinguishes all Chagall's work: (*Mort*
[*Death*] and *Petit Salon* [*Little Drawing Room*];
1908, coll. of the artist).

In August 1910 Chagall arrived in Paris and
quickly became part of the artistic life of the
capital, meeting Delaunay, Gleizes and Metzin-
ger, as well as Cendrars and Apollinaire who
were enthusiastic about his painting. From Van
Gogh and the Fauves Chagall first learnt about
colour, an element essential to him (*L'Atelier* [*The
Studio*], 1910, *Le Père* [*The Father*], 1910-11,
private coll), while in Cubism and the Luminist
ideas of Delaunay he found a new approach to
formal relationships.

His composition now gained in clarity and
dynamism, and his drawing in firmness: *Moi et le
village* (*I and my Village*) (1911, New York,
M.O.M.A.) was the first synthesis, on a theme he
often treated, of the poetic folklore that formed
his subject-matter and the principles then ruling
in Paris. *À ma fiancée* (*To my Fiancée*) (1911, Bern
Museum) is rich in an erotic symbolism very rare
at that time in Parisian circles.

In the works that followed Chagall exploited
Cubism rather more deliberately, but always in
an original manner, with highly saturated colours
fading quickly away and solidly constructed
motifs (*À la Russie, aux ânes et aux autres*, [*To
Russia*, to *Donkeys and Others*], 1911-12, Paris,
M.N.A.M.: *Le soldat boit* [*The Soldier Drinks*],

Paul Cézanne ▲
La Montagne Sainte Victoire
Canvas. 71 cm × 92 cm
Philadelphia, Philadelphia Museum of Art

1912-13, New York, Guggenheim Museum). Through Apollinaire Chagall met Walden in Paris in 1912, then exhibited in Berlin at the first German Autumn Salon in 1913 and at Der Sturm Gallery in June-July 1914.

The outbreak of the First World War found Chagall back in Vitebsk. During 1914-15 he executed a number of highly expressive paintings on Jewish themes in bright colours (*Le Juif en rose* [*The Jew in Pink*], 1914, Leningrad, Russian Museum). In 1917 he at first found favour with the Revolutionary government, thanks to Lunarcharsky, the commissar for education, whom he had known in Paris, and was appointed commissar for fine arts in his province. In 1918 the first monograph on his work appeared.

But he was disappointed by the shifts in policy on the arts. He opposed Malevich, gave up his functions in 1920 and left Vitebsk for Moscow where he worked in the Jewish Theatre, designing scenery and costumes for three plays by Sholom Aleichem (1921). The paintings of this second Russian period were not dissimilar from his earlier work. They included a series of views of Vitebsk and some compositions inspired by his marriage (*Autoportrait au verre de vin* [*Self-Portrait with a Glass of Wine*], 1917, Paris, M.N.A.M.). Others, however, show a brief and remarkable resurgence of Cubism, with an unexpected fidelity to its spirit (*Paysage Cubiste* [*Cubist Landscape*], 1919, Bern, private coll.) while he also experimented with the use of thick paint (*Le Père*, 1921, coll. of the artist).

In 1922 Chagall left Russia for Berlin, where he met Grosz, Hofer, Meidner and Archipenko and learnt a number of engraving processes. He engraved for Paul Cassirer illustrations for his autobiography *Mein Leben* (26 etchings and drypoints, published without a text in Berlin, 1923; the French translation, *Ma Vie*, was published in Paris in 1933). Following these first efforts at engraving, on his return to Paris in September 1923 Chagall received large commissions from Vollard: illustrations for Gogol's *Dead Souls* (118 etchings, 1924-5), for the *Fables* of La Fontaine (100 etchings, 1926-31) and for the Bible (105 etchings, 1931-9, of which 39 plates were re-engraved and completed between 1952 and 1956). During this last work, Chagall made a journey to Palestine in 1931 and to Amsterdam in 1932 to study Rembrandt's engravings.

Chagall now came to know France better from visits to Brittany, the Auvergne, Provence and Savoy. The familiar bestiary of Vitebsk was enriched by the more and more frequent presence of fish and cocks, figures in a subject matter that had complex symbolic implications (*Le Temps n'a pas de rives* [*Time is a River without Banks*], 1939-1941, New York, M.O.M.A.). The increasingly troubled political climate inspired him to paint *La Révolution* (which he later destroyed) in 1937, the year in which he obtained French nationality. The following year, the *Crucifixion blanche* (*White Crucifixion*) (Chicago, Art Inst.) inaugurated a more symbolic series concerning the sufferings of the Jewish people.

From 1941 to 1948 Chagall lived in the United States. During this long and painful exile (his wife died in 1944) he designed decor and costumes for *Aleko* (1942) and *The Firebird* (1945), and produced 13 colour lithographs for the album *Four Tales from the Arabian Nights*. On his return to France, Chagall settled in Vence from 1949. New techniques attracted him (ceramics and sculpture) and Paris inspired a series of paintings

(1953-6), poetic reveries in diffused, ashy colours (the *Ponts de la Seine* [*Bridges of the Seine*], 1953, New York, private coll.)

He had a great many commissions, producing ceramics and stained glass for the baptistery at Assy (1957); settings and costumes for *Daphnis and Chloe* (1958; the lithographic suite appeared in 1961); stained glass for Metz Cathedral (1960-8) and for the synagogue of the hospital in Jerusalem (1960-2); decor for the ceiling of the Opéra in Paris (1963-5); mosaics for Nice University (*Histoire d'Ulysse* [*Story of Ulysses*], 1968), and for a square in Chicago (*The Four Seasons*, 1974); stained glass for the Fraumünster church in Zürich and for Rheims Cathedral (1974); and also several series of graphic works. In July 1973, a Chagall Museum was set up in Nice, devoted to the 'Biblical Message'.

Chagall's art effortlessly combined the emotional mobility of his Slav and Jewish background with the rational spirit of the West. In the last analysis, what he offers, with his bunches of flowers or his twilight lovers under the sign of the cock or goat, is reality reconciled with fable. He is represented in most of the world's great galleries, particularly in Paris (M.N.A.M.), New York, (M.O.M.A. and Guggenheim Museum), Philadelphia (Museum of Art), London (Tate Gal.) and Amsterdam (Stedelijk Museum). M.A.S.

Champaigne or Champagne
Philippe de

French painter of Flemish origin
b.Brussels, 1602 – d.Paris, 1674

A pupil of Jean Bouillon in Brussels from 1614 to 1618, Champaigne then entered the studio of the miniaturist Michel de Bourdeaux. In 1619 he worked in Mons with an unknown painter, returning to Brussels the following year to be taught by the landscape painter Fouquières. In 1621, turning down the chance of entering Rubens's studio, he set off for Italy, travelling, not through Germany, like most Flemish painters, but through Paris.

Here he remained, and went into the studio of Lallemand, from whose drawings, in 1625, he painted *Sainte Geneviève implorée par le Corps de Ville* (*The Town Councillors imploring St Geneviève*) for the Church of St Geneviève-du-Mont in Paris (today in the church of Montigny-Lemcoup, Seine-et-Marne). Living in the Collège de Laon, where Poussin, to whom he gave one of his landscapes, was also residing, he contributed, likewise with landscapes, to the decoration of the Palais du Luxembourg, under the direction of Nicolas Duchesne (1622-6).

In 1627 he went back to Brussels, and might perhaps have stayed there if Claude Maugis, Marie de Medici's intendant, had not offered him Duchesne's post of *valet de chambre* to the King, as well as an annual income of 1,200 livres and lodging in the Luxembourg. Attracted by the work and the advantages it would bring him, Champaigne returned to Paris on 10th January 1628 where, on 30th November of the same year, he married Duchesne's daughter.

The evolution of Champaigne's style following his return to Paris reveals a number of influences. Although he was not, properly speaking,

Flemish, his early training had been close to the Flemish painters. Some of his first paintings, the *Trois Âges* (*Three Ages*) of 1627 (Paris, Landry Coll.) and the *Petite Fille au Faucon* (*Girl with Falcon*) of 1628 (Louvre) are similar in style to Cornelis de Vos. And what the Dijon Museum has of his work recalls Jordaens's studies of heads.

This Flemish background was to become progressively less apparent with time, but it was not altogether rejected. As a landscape painter, Champaigne was never to forget the lesson of Fouquières. As a portrait painter, he was to excel in the painting of skin and fabrics like those of Van Dyck. As a painter of religious works and as a decorator he was not without a certain opulence and in all his works he employed the sophisticated painterly methods of the artists of the southern Netherlands. But this time in Lallemand's studio had put him into touch with Mannerism and he acquired a very French taste for order and style, as well as a feeling for reflection and discipline that may have come to him through contact with Poussin.

From this came an art that, if not deliberately eclectic, was certainly composite, for, without having been to Italy, Champaigne was also affected by Caravaggism, by the academic classicism of the Carracci, by neo-Venetianism, and by the Baroque. All of these left their mark on the paintings which Marie de' Medici ordered from him, as well as those from his studio, in 1628-9, for the Carmelite convent in the Faubourg St Jacques in Paris: *Nativité* (Lyons Museum), *Présentation au Temple* (Dijon Museum), *Résurrection de Lazare* (Grenoble Museum), *L'Assomption* (Gréoux-les-Bains, Rousset Chapel), and *Pentecôte* (church of Libourne).

In 1629 he was granted naturalization. His work found great favour both with Marie de' Medici and Louis XIII who, in 1634, commissioned his *Réception du duc le Longueville dans l'ordre du Saint-Esprit* (Toulouse Museum). He also appears to have been Richelieu's favourite

Marc Chagall ▲
Moi et le village (1911)
Canvas. 191 cm × 150 cm
New York, Museum of Modern Art

painter, and was commissioned by him about 1630 to decorate the Galerie des Objets d'Art and the Galerie des Hommes Illustres in the Palais-Cardinal, a task which he shared with Vouet.

Three works have survived from this latter series: *Gaston de Foix* at Versailles, *Monluc* in the Duc de Montesquiou-Fezensac's collection and *Louis XIII*, known as *La Victoire*, in the Louvre.

He was now official painter to the court. In 1637, the King commissioned his *Voeu de Louis XIII* (*Vow of Louis XIII*) (Caen Museum). He was equally esteemed by the Church, and in 1631-2 decorated the Convent of the Filles du Calvaire near the Luxembourg and the Carmelite convent in the Rue Chapon with mural paintings. In the latter he also painted an *Ascension* and a *Pentecôte*.

Richelieu's death in 1642, followed by that of Louis XIII in 1643, made no difference to Champaigne's position and in 1648 he took part in the founding of the Royal Academy of Painting and Sculpture. He made several portraits of *Louis XIV* (drawing in the Louvre) and worked for Anne of Austria. In 1645, at the Convent of Val-de-Grâce, he painted four landscapes of scenes taken from *Les Pères du désert* (*The Desert Fathers*) (Louvre, Tours Museum, and Mainz, Mittelrheinisches Landesmuseum). In 1646, at the Palais Royal, he decorated the Queen's Oratory with a *Mariage de la Vierge* and an *Annonciation* (both London, Wallace Coll.).

In 1643 or soon after, his relationship with the Jansenist Seminary of Port Royal began, starting with his portrait of *Martin de Barcos* (1643, Great Britain, private coll.) and the posthumous one of *Saint Cyran* (many copies, the best in Grenoble Museum). After this date relations were close between Champaigne and Port Royal circles. In 1648 he sent his two daughters as boarders to Port

Royal. He painted many different types of works for the Jansenists (*Last Supper*, 1648, Louvre), a *Good Shepherd* and *Ecce Homo* (both Granges Museum), executed frontispieces for several books by Jansenists, and painted 14 portraits of people at Port Royal. These were often from their death-masks, sometimes from life, but in the latter case generally without their knowledge, since they were too humble to allow themselves to be made the subject of a portrait (portraits of the directors of Port Royal, *Singlin* and *Sacy*; of individuals, such as *Antoine le Maître*, *Arnauld d'Andilly* and *Pontis*; of nuns, such as *Mère Angelique*, *Mère Agnès*, and *Soeur Catherine de Sainte Suzanne Champaigne*, the latter two being studies for the *Ex Voto* of 1662, in which he thanked God for the miraculous recovery of his daughter Catherine on 7th January 1662). These Port Royal paintings mark the peak of Champaigne's achievement.

His style in the years 1643-62 followed the general movement in Paris at the time – that of La Hyre and Le Sueur – towards a purer taste, a barer arrangement and a more severe classicism, but also (in works like *La Légende de Saint Gervais et Saint Protais*) pursued the moderate form of Baroque that had appeared in his work around 1629-30. It was now clear that his preferred path was one in which he could give free rein to this feeling for austerity and spirituality, even for the contemplative life. As he could only do this in the paintings for Port Royal or the Jansenists, it is not surprising that it was there that he gave the best of himself. He probably reached the highest point in his religious painting with the *Christ mort étendu sur son linceul* (*Dead Christ Laid Out on His Shroud*) (Louvre), in which it is worth comparing the nobility, reserve and inner feeling with the ex-

pressionism of Holbein's famous painting. In portraiture the height of his achievement was certainly the paintings of nuns and of the directors of Port Royal.

After 1662 Champaigne's fertility appeared to be exhausted. Louis XIV admittedly ordered a *Réception du duc d'Anjou dans l'ordre du Saint-Esprit* (known by the copy made by Carle van Loo in Grenoble Museum), and in 1666 commissioned him and his nephew to decorate the Grand Dauphin's rooms in the Tuileries.

But the taste of the young court turned away from him. Champaigne belonged to an age that had gone and he had little sympathy with the values of the new. B.D.

Chardin
Jean-Baptiste Siméon
French painter
b.Paris, 1699 – d.Paris, 1779

Chardin's whole life was spent in Paris, between the Rue de Seine, where he was born, the Rue Princesse and the Rue du Four, where he lived in a number of places, and the Louvre, where he lived from 1757 until his death.

A pupil of Pierre Jacques Cazes and of Noël Coypel, he was received as a master-painter in the Académie de St Luc in 1724. Four years later, he exhibited four still-life paintings, among them *La Raie* (*The Rayfish*) (Louvre), and was admitted that same year to the Royal Academy of Painting and Sculpture thanks, it would seem, to the good offices of Largillière. Received and made a member on the same day, he offered *La Raie* and *Le Buffet* (Louvre) and from then onwards faithfully attended its meetings. In 1731 he married Marguerite Saintard, to whom he had been engaged since 1720. A son was born the same year, whom his father was to try, in vain, to make into a painter of historical scenes.

In spite of his early success, Chardin was forced to accept 'unsatisfactory' tasks, such as assisting Jean Baptiste van Loo with the restoration of the Galerie François I at Fontainebleau. It was during this same period that Chardin turned to painting genre scenes in the Dutch manner (*Dame cachetant une lettre* [*Woman Sealing a Letter*], 1733, Berlin, Charlottenburg). In 1735 he lost his wife. The inventory made after her death shows that they were in fairly easy circumstances. In 1737 the Salon, which had been held only once since 1704, showed eight of Chardin's paintings and he continued to exhibit there faithfully right up to the year of his death.

Some of his most charming paintings of children date from about 1738; *Jeune homme au violon* (*Young Man with A Violin*), *L'Enfant au toton* (*Child with a Top*) (both in the Louvre). He was presented to Louis XV in 1740 and offered the King his *Mère Laborieuse* (*The Industrious Mother*) and *Bénédicité* (*Saying Grace*) (both in the Louvre). In 1744 he married again; his wife was Marguerite Pouget, whom he was to immortalize through a pastel 30 years later (now in the Louvre). His reputation was then at its height, Louis XV paid 1,500 livres for the *Serinette* (*The Bird Organ*) (1752, New York, Frick Coll.), the only painting by Chardin which the King bought. As a mark of confidence, his colleagues at the Salon entrusted him with the hanging of paintings, a task that he

▲ Philippe de Champaigne
La mère Catherine-Agnès Arnaud et la soeur Catherine de Sainte-Suzanne (1662)
Canvas. 165cm × 229cm
Paris, Musée du Louvre

The precision of detail, the limpidity of the light and the wholly classical beauty of the people, are all found again in the *Virgin with the Orange Tree* (*c.*1495, Venice, Accademia), which contains one of his most beautiful landscapes, that of the castle of Salvatore di Collalto.

Cima's open-air settings were the result of Giovanni Bellini's influence, while that of Carpaccio can be seen in the many-coloured buildings in certain small paintings like *The Ambassador before a Sultan* (Zürich Museum) or *The Miracle of St Mark* (Berlin-Dahlem). Cima's thoughtful temperament, which made him inclined to reflect upon old subjects rather than invent new ones, resulted in many paintings of the *Virgin and Child*. The most successful of these is undoubtedly the one in the Church of S. Maria della Consolazione d'Este (Padua), dated 1504, in which Mary is depicted as a healthy country girl wearing brilliant shades of red, blue and yellow, and is a monumental figure. His feeling for nature, and the silent dialogue between dreaming figures, appears to foreshadow the idylls of Giorgione.

The change of proportion and the large shady garden in the *Adoration of the Shepherds with Saints* (S. Maria del Carmelo, Venice) confirm the links between Cima's inspiration and Giorgione's world, as does the choice of new humanistic and mythological subjects. *Endymion Asleep* and *The Judgement of Midas* (Parma, G.N.), *The Duel on the Seashore* (Berlin-Dahlem) and *Bacchus and Ariadne* (Milan, Poldi-Pezzoli Museum) are conceived with a delicacy of colour that comes near to a feeling for tone.

However, although Cima was often inspired by the best ideas of his contemporaries, his style remained entirely individual and continued to find within itself the possibility of renewal, as is shown by the *St Peter Enthroned* (1516, Brera) where, putting aside the tonal painting and other new ideas of the 16th century, he returned to the formal arrangement of the previous century and to quiet and classical images. M.C.V.

fluence, also found in the works of Coppo di Marcovaldo, while the pathos of the foreshortened body of Christ recalls the art of Giunta Pisano, the most influential Pisan painter during the first half of the 13th century.

The *Crucifix* (partly destroyed by the floods in 1967) in the Church of S. Croce in Florence seems to date from a little later; it is certainly earlier than the *Crucifix* of Deodato Orlandi (1288, Lucca, Pinacoteca) or even than that already mentioned, by Coppo di Marcovaldo (1274). In this work, as well as in the great *Maestà* (Louvre) from the Church of S. Francesco in Pisa fresh impulses appear, possibly the fruit of Cimabue's studies in Rome and, more especially, of the works of the sculptor Nicola Pisano in Pisa. There is a marked swing away from a Byzantine style and an at-

tempt, under the sway of stronger Gothic influences, to return to the heritage of the late classical era.

Cimabue abandons the rigid Byzantinism for a gentler, subtler style, highly sensitive, especially in its treatment of flesh. Draperies with heavy sculptural folds replace fabrics of gold thread. Through the subtle animation of his folds, Cimabue manages to suggest an effect of moving imprecision, in sharp contrast with the static plasticity of the Byzantines. Moreover, his use – particularly at the beginning – of delicate colouring (blues, pinks, mauves, pale yellows) is particularly pleasing. It is possible that Cimabue may have been encouraged in this by the example of a contemporary Pisan painter, the so-called Master of San Martino.

Cimabue
(Cenni di Pepi)
Italian painter
b. c.1240–d. after 1302

Cimabue's reputation owes much to Dante who, in company with the poet Guido Guinizelli and the miniaturist Oderisi da Gubbio, hailed him as the greatest of Giotto's predecessors. According to Florentine critical tradition (Ghiberti, *Il Libro di Antonio Billi*), Cimabue was Giotto's master. Doubts expressed at the beginning of the 20th century as to whether, in fact, Cimabue ever existed have receded in the face of evidence that he was in Rome in 1272 and in Pisa in 1301, where he worked on the mosaic of the apse of the cathedral. The figure of *St John the Baptist* has survived and serves as a basis for modern critics to reconstruct his work.

Cimabue's earliest work is generally believed to be the *Crucifix* in the Church of S. Domenico in Arezzo, which appears to have been painted earlier than a similar work by Coppo di Marcovaldo and his son Salerno at Pistoia (1274). It may even date from before Cimabue's stay in Rome in 1272. The enamel-like surface and the treatment of the draperies suggest Byzantine in-

Cima da Conegliano ▲
Holy Family with Saints
Wood. 54 cm × 71 cm
Lisbon, Calouste Gulbenkian Foundation

▲ Cimabue
Crucifixion
Fresco
Assisi, Basilica of S. Francesco (Upper Church)

The frescoes in the transept of the Upper Church of S. Francesco in Assisi today seem less bright, mainly because of the poor state of preservation and the alteration of the colours. The paintings on the vault represent the *Four Evangelists* and on the walls *Scenes from the Life of the Virgin*, the *Mission of the Apostles*, the *Apocalypse*, *Angels* and *Crucifixion*. Although their dating is controversial, recent research suggest that they were executed about 1278-9. This hypothesis seems to be confirmed by Cimabue's inclusion in the fresco of *St Mark the Evangelist* of a view of Rome, including the Palace of the Senators decorated with the arms of the Orsini family, an apparent reference to the fact that Pope Nicholas III, who was an Orsini, became a senator in Rome from September 1278 to August 1280.

The frescoes at Assisi and a panel representing *St Francis* (Museum of S. Maria degli Angeli, near Assisi) established Cimabue as the greatest Florentine painter of his day. His influence became a determining force in the development of Tuscan painting. It was particularly felt by the leading painter in Siena, Duccio (*Rucellai Madonna*, 1285, Uffizi), by Manfredino da Pistoia (frescoes of 1282, Genoa, Accad. Ligustica) and by Corso di Buono, head of the Painters' Guild in Florence in 1295 (frescoes of Montelupo).

The famous *Maestà* from the Church of S. Trinità (Uffizi), which closely resembles the work of Corso di Buono, shows a broader arrangement and a calmer pictorial rhythm than the Pisa *Maestà* (Louvre). Other works by Cimabue or his studio may have been influenced in their turn by the young Duccio, then by Giotto. Among these are the fresco of the Lower Church of S. Francesco at Assisi (*Maestà with St Francis*) and the *Madonna Enthroned with Sts Francis and Dominic* (Florence, Pitti, Contini-Bonacossi Donation).

Cimabue, who was the master of his generation, also collaborated in the famous cycle of mosaics in the Baptistery in Florence. Analysis is made difficult by the difference in medium and also because of the damaged state of the mosaics. Nevertheless, it would appear that Cimabue spent some considerable time on this work, taking it up at the point where Coppo di Marcovaldo, or another artist of his generation, relinquished it and continuing, either alone or with close collaborators, up to the final stories, where two different artists appear with a more modern style.

G.P.

Claesz
Pieter

Dutch painter
b.Burgsteinfurt, Westphalia, 1597/8 – d.Haarlem, 1661

Pieter Claesz was the father of the painter Nicolaes Pietersz, who took the surname Berchem, and a master of the Haarlem school of still life whose work is distinguished by its 'monochromist' tendency. He settled in Haarlem some time before 1617, and worked there until his death, painting a number of Vanitas still lifes but above all 'breakfast pieces' and 'banquet pieces'.

His youthful works, painted between 1621 and about 1630 (*Studio with a Vanitas Still Life*, 1628[?], Rijksmuseum; *Vanitas*, 1624, Dresden Gg; *Still*

Life with Musical Instruments, 1625, Louvre), are close to those of Floris van Dijck and Nicolaes Gillis. His genuinely 'monochrome' period extended from 1630 to about 1640. One of the best examples of it is the *Still Life* of 1636 (Rotterdam, B.V.B.), which is more concentrated and coherent than the others. The objects are more closely linked and the tonality is centred on a range of grey-browns.

From about 1640 until his death Claesz's style developed in a more decorative and monumental way under the influence of Jan Davidsz de Heem, as is shown by the still-life paintings in Brussels (1643, M.A.A.), the Strasbourg and Nantes Museums (1644), The Hague (1644, Mauritshuis) and London (1649, N.G.). Through the refinement and intimacy of his compositions, Claesz, like Heda, opened up the way to a new concept of the still life.

J.V.

Claude
(Claude Gellée; also known as Claude Lorrain)

French painter
b.Chamagne, 1600 – d.Rome, 1682

Orphaned at an early age, Claude went to live in Rome between 1613 and 1620 where he became the servant and then the pupil of Agostino Tassi, whose style he adopted in its entirety. Two other sources of inspiration were less decisive: a two-year stay in Naples where he lived with Gottfried Wals of Cologne, from whom no works survive; and a year in Nancy in 1625 as assistant to Claude Deruet. His beginnings are lost in the anonymity of the Tassi school which was itself a continuation of the art of Bril and of Elsheimer. The German artist Sandrart encouraged Claude to draw out of doors, the Dutchman Breenbergh probably influenced his graphic development, and he was in contact with Swanevelt, the Dutch engraver.

From 1620 to about 1630 Claude imitated his Roman master in his fresco work, of which only one decoration, for the Palazzo Crecenzi, remains. From then on he only left Rome for relatively short excursions into the countryside. Neither his life nor his artistic development were marked by any startling event.

Commissions from Cardinal Bentivoglio and Pope Urban VIII ensured his success after 1630 and his fame continued to grow. Claude worked mainly for Rome's most illustrious dignitaries: popes, princes, and cardinals, as well as ambassadors, and members of the French and other foreign nobility. His two principal buyers were, around 1638, the King of Spain and, after this date, Prince Lorenzo Onofrio Colonna.

His output before 1629 is little known. From his first phase come small, very fine copperplate engravings in the Elsheimer tradition (United Kingdom, colls. of the Dukes of Westminster and Rutland), some landscapes on canvas, at first a little rough in treatment, with genre or pastoral figures in the style of Van Laer (1629, Philadelphia, Museum of Art; 1630, Cleveland Museum), and some harbour scenes. These works are characterized by the use of picturesque motifs (broken trees, waterfalls, architectural follies) and often by a diagonal composition and sunset effects. The most important paintings from this

period are *Céphale et Procris* (destroyed, formerly in Berlin) and two series of landscapes on religious themes in the Prado.

Around 1640 the influence of the classical landscapes of Annibale Carracci and of Domenichino becomes evident in a more solid composition and calmer atmosphere. The paintings were now larger and the subjects often religious, sometimes classical: Le *Moulin* (*The Mill*) and La *Reine de Saba* (*The Embarkation of The Queen of Sheba*) (1648, London, N.G.); Le *Temple de Delphes* (*The Temple of Delphi*) (*c.*1650, Rome, Gal. Doria-Pamphili).

During the 1650s, when Claude was at the height of his powers, he turned to a monumental style distinguished by large canvases, severe composition and subject matter frequently drawn from the Old Testament: *Parnasse* (*Parnassus*) (Edinburgh, N.G.); L'*Adoration du veau d'or* (*The Adoration of the Golden Calf*) (Karlsruhe Museum); *Laban* (Petworth House, Sussex, Duke of Richmond's Coll.); Le *Sermon sur la Montagne* (*The Sermon on the Mount*) (1656, New York, Frick Coll.); *Esther* (destroyed).

If this phase may be described as heroic, the artist's last two decades, which mark the supreme achievement of his career, are more classical, not to say backward-looking. Though still imposing in concept, the paintings became more lyrical in expression, more delicate in detail: Le *Château enchanté* (*The Enchanted Castle*) (United Kingdom, Loyd Coll.). The compositions are new and audacious. He now drew subjects from the *Aeneid*, sometimes alluding to the family or the life of the buyer, and increased his repertoire of figures: the four *Heures du jour* (*Times of the Day*) (Hermitage); *Oracle d'Apolle* (*The Oracle of Apollo*) and Le *Débarquement d'Enée* (*The Landing of Aeneas*) (United Kingdom, Fairhaven Coll.): *Egérie* (*Egeria*) (Naples, Capodimonte): the *Parnasse* (Jacksonville, United States); *Chasse d'Ascagne* (*The Hunt of Ascanius*) (Oxford, Ashmolean Museum).

The representative par excellence of classical landscape, Claude in his art presents an idealized concept of his theme: with few exceptions the sites of his paintings tend to be imaginary. The composition, depending on the dimensions of the canvas, contains a varying number of planes and features (groups of trees, buildings). The layout tends to be based upon simple mathematical proportions (thirds and quarters of the height or width). Almost all his works were executed in pairs, illustrating the same theme and with the same interior proportions, but contrasted in composition, atmosphere and time of day, as well as in such features as the species and disposition of the trees, and even the style of building. Cold light streaming in from the left indicates morning; coming from the right, with its warm sunsets, it indicates evening.

The secret of Claude's art lies in his profound evocation of space, which owes as much to his observation of the Roman landscape as to a study

▲ Pieter Claesz
Still Life (1627)
Wood. 26 cm × 37 cm
The Hague, Mauritshuis

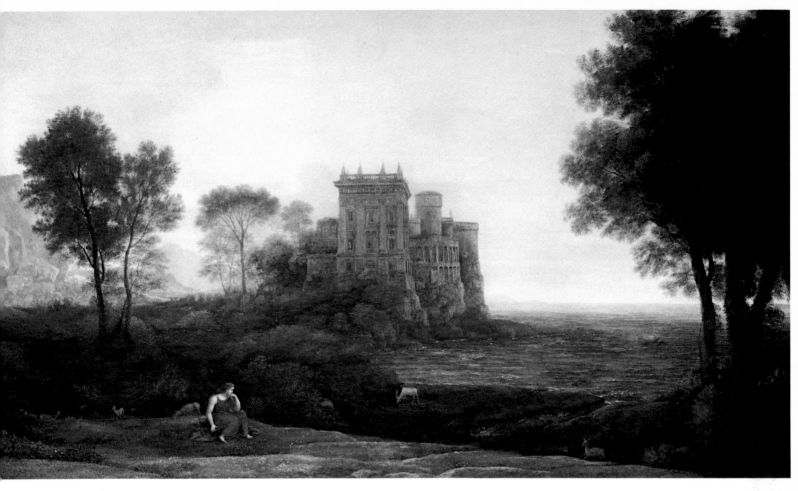

of light and atmosphere. He followed the mainstream of painting during his century by his lighting effects, the depth of his spaces and the realistic study of nature, as much as by his idealized presentation.

With over 1,200 known drawings, all very skilled, Claude emerges as one of the greatest of all draughtsmen. The inventory made after his death mentions a dozen or so albums. It probably includes the Wildenstein album which contains 60 drawings spanning his entire career, revealing the influence of Tassi and Deruet during the 1620s, that of Breenburgh about 1630 and the development of his mature style after 1633.

There are in fact two principal groups of drawings: the studies from life made on a particular theme (numerous during the earlier years), and those made in the studio, which are typical of the artist's later development. But whether executed outdoors or in the studio, all his drawings reveal the same careful structure and pictorial effects and may thus be numbered among his finished works. Rapid sketches by Claude are rare indeed.

After 1636 Claude systematically copied his paintings in chronological order into a 200-page book, the *Liber veritatis* (British Museum, which also possesses over 500 drawings by Claude). The book was twice engraved by Earlom during the 1770s, then by Caracciolo (1815). Claude executed 40-odd pastoral engravings, mostly before 1642. These engraved plates are not from his original works, but are closely linked with known pictures. They reflect the influence of Elsheimer, of Van Laer and possibly of Gottfried Wals, and seem to indicate the rapport between the artist and the Dutch landscape painters living in Rome during the 1630s.

Claude had only one pupil, Angeluccio, who died young, but the influence of his painting, esp-

ecially that of his first period, was immense, even during his lifetime, particularly on Dughet and his school, and on certain Dutch artists who painted in the Italian style. In Italy his example was followed right up until the beginning of the 19th century by such classical landscape painters as Orizzonte, Vanvitelli, Locatelli and Anesì. His influence extended to France (Patel, Rousseau) and to Germany, where Claude came to represent the very idea of Italy in literature (Goethe) as well as in painting. In England where, around 1850, almost the whole of Claude's output was to be found, his painting was equally influential (from Wilson to Turner). His concept of the picturesque, so dear to 18th-century sensibilities, influenced the layout of many country estates. M.Ro.

Clouet
François

French painter
b. Tours, c. 1520 – d. Paris, 1572

François was the son of Jean Clouet, whom he succeeded as Painter to the King in 1541, becoming a naturalized French citizen in 1551. Famous under four kings, he spent his career mainly in portraiture, although he also undertook the other duties that fell to a court painter. In 1547 he made a death mask of Francis I and in 1559 of Henry II, and was also associated with Marc Béchot, a sculptor, and five other painters in the arrangements for funerals and coronations – with 'mummeries, ceremonies, tourneys and other things connected with them'. His activity is occasionally mentioned. In 1552 he decorated with 'lakes,

flourishes and crescents' a small chest made by Scibec de Carpi. In 1568, he was in the service of Claude Gouffier and his wife, Claude de Beaune. In 1570-2 he was paid for two banners for the king's trumpets and some armour, and in 1572 he painted a miniature of the queen (presumably Elizabeth of Austria) for the Queen of Spain.

The last time he is mentioned shows that he was consulted about the coinage. Catherine de' Medici, who thought highly of him, collected his drawings, 551 of which she gave to her granddaughter Chrétienne de Lorraine (some at Chantilly, Musée Condé). He was praised by the poets, notably Ronsard, who described a lost work of his, which showed his mistress, naked. For a long time he was confused with his father, the nickname 'Janet' which they both bore having no doubt contributed to the confusion.

Only two signed paintings by Clouet are known: the portrait of his friend and neighbour the apothecary *Pierre Quthe* (1562, Louvre); and the *Dame au bain* (*Lady in her Bath*) (Washington, N.G.). A drawing of *Charles IX* which bears the date 1566 (Hermitage) has served as a basis for the attribution to him of a painting of *Charles IX* (Vienna, K.M.) and a series of drawings (most of them at Chantilly, Musée Condé, and in Paris, B.N.). A very few paintings can be matched with some of these works, such as *Henri II en pied* (*Henry II, Full-Length*) (Uffizi) and excellent studio copies. According to old writers, François Clouet was also a remarkable miniaturist: the *François I à cheval* (*Franis I on Horseback*) in the Louvre and the *Henri II à cheval* (*Henry II on Horseback*) in the Uffizi have been attributed to him (but sometimes, also, to his father Jean).

As a number of references and the *Dame au bain* prove, François Clouet, unlike his father, was not merely a portrait painter. He probably

Claude ▲
Le Château enchanté (1664)
Canvas. 88 cm × 152 cm
Loyd Collection (on loan to the National Gallery, London)

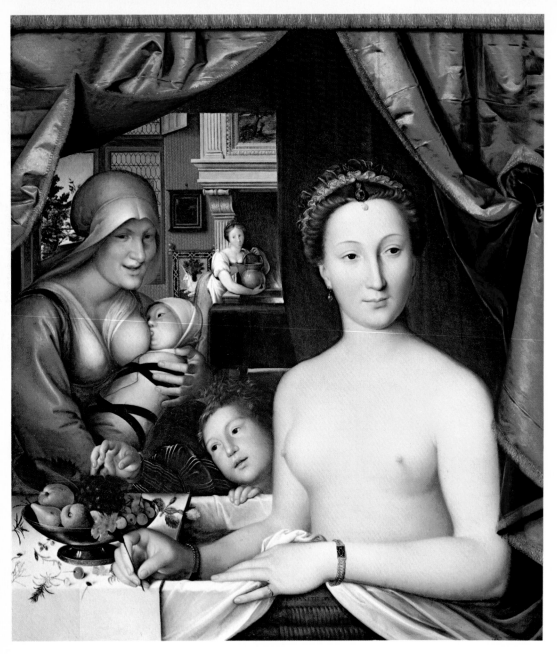

at the French court during the reign of Louis XII, but the first mention of him occurs in 1516 as a painter to Francis I. Like the other court painters, Perréal, Bourdichon, Nicolas Belin and Barthélemy Guéty, he was paid a salary of 180 livres. Between 1521 and 1525 he lived in Tours where he married a jeweller's daughter and, at the request of her uncle, agreed on 10th May 1522 to paint a *St Jerome*, for the Church of St Pierre-du-Boile in Tours. In 1523 he provided a Paris embroiderer with a design for *Les Quatre Évangélistes d'or*. Around 1525-7 he settled in the capital where, in 1529, he succeeded Bourdichon and became the equal of Perréal. In 1533 he was Painter to the King and his *valet de chambre*. He appears to have died some time before November 1541.

During his lifetime Clouet was rich and famous, and was even referred to, in 1539, as the equal of Michelangelo. His assistants included Petit-Jean Champion and his own son, François. No signed works by Clouet have come down to us, but about 130 pencil drawings of people at the court, (the majority in Chantilly, Musée Condé), made as preliminary sketches for paintings between 1536 and 1540, the time during which Clouet's career is documented, are generally agreed to be by him.

Among these is a drawing of Guillaume Budé (who said that Clouet had painted his portrait about 1536), which corresponds to the panel now in the Metropolitan Museum. Thus, by analogy, all the group of drawings at Chantilly and a few paintings can also be attributed to him. These latter include: *Le Dauphin François* (Antwerp Museum); *Charlotte de France* (Chicago, Epstein Coll.); *François I* (Louvre); *Claude de Lorraine* (Florence, Pitti); *Louis de Clèves* (Bergamo, Accad. Carrara); and *L'Homme au Petrarque* (*The Man with a Volume of Petrarch*) (Hampton Court).

Some authorities are doubtful about the inclusion of the *François I* at the Louvre (seeing in it the hand of François Clouet), but would add to the list the painting *Marie d'Assigny, Madame de Canaples* (Edinburgh, N.G.) and *L'Homme aux pièces d'or* (*Portrait of a Banker*) (St Louis, Missouri, City Art Museum). The (lost) portrait of *Madeleine de France* (previously in the Édouard de Rothschild Coll., Paris) and another portrait of *Charlotte de France* (Minneapolis, Inst. of Arts)

painted the *Bain de Diane* (*Diana's Bath*) (Rouen Museum), the success and importance of which is confirmed by a number of copies. He may also have been the creator of certain genre scenes, such as the *Scène de comédie* (*Comedy Scene*) or the *Enfants se plaignant à l'Amour* (*Children complaining to Love*), engraved under the name (Janet or Genet) and published by Le Blon. This group of secular works also includes compositions such as *La Belle et le Billet*, known in a number of examples (France, private coll.; Lugano, Thyssen Coll.). His influence can be seen in a number of works that have remained anonymous, the best known of which are *Poppaea Sabina* (Geneva, Musée Rath) and the *Femmes au bain* (*Women Bathing*) in the Louvre.

Trained by his father, François Clouet probably began his career as Jean's assistant. According to one authority signs of this collaboration may be seen in the *François I* in the Louvre. This is traditionally attributed to Jean but the hands may have been painted by François. The son, however, soon moved on to an art that was more complex and skilful than his father's, and one marked by a number of influences – Italian, Dutch and German. His painted portraits, which

are extremely delicate and distinguished, indeed a little cold, are admirable examples of court painting in France in the 16th century (*Elizabeth of Austria*, Louvre).

François Clouet's drawings lack the simplicity of his father's, and their economy of means: he uses a richer and more complex technique to describe his sitters, yet never distracts attention from the character of their faces (*Marguerite de France enfant* (*Margaret of France as a Child*) (Chantilly, Musée Condé). His influence was enormous in France and even abroad in portraiture and in genre painting. S.B.

Clouet
Jean
French painter, probably of Flemish origin
b.1485/90–d.c.1541

Jean Clouet (like his brother Pollet, a painter at the court of Navarre) almost certainly came from the Low Countries. He probably became a painter

 François Clouet
Dame au bain
Wood. 92 cm × 81 cm
Washington, D.C., National Gallery of Art

▲ Jean Clouet
L'Homme au Petrarque
Wood. 40 cm × 35 cm
Hampton Court, Royal Collection

have also been attributed to Clouet. An engraving by Thévet (*Hommes illustres* [*Famous Men*]) shows us the lost portrait of Oronce Finé.

In addition Clouet is believed to have painted a number of miniatures, for which some of the drawings at Chantilly are preparatory sketches (*Charles de Cossé*, Metropolitan Museum), as well as portraits in the form of round medallions of the heroes of the Battle of Marignano (*Commentaires de la guerre gallique* [*Commentaries on the Gallic War*], Paris, B.N.), although those have also been attributed to Perréal. The equestrian portrait of *François I* (Louvre) may have been painted by either Jean or François Clouet.

Clouet's paintings, although so few have survived, would have ranked very highly in their day. They are all portraits, a genre in which Clouet seems to have specialized after his arrival in Paris, and one that assured him success. Generally painted on small panels, these works were already rather old fashioned in style, with the sitters shown half-length, their faces lit by a bland light, the hands rather clumsily placed in the foreground.

Without ever renouncing his Flemish training, which was most in evidence at the beginning of his career, Clouet evolved a broader, more solid, and simpler style, under the influence of such French artists as Fouquet, the Master of Moulins and Perréal, and Italian painters such as Solario and Leonardo. His drawings, in red chalk and black pencil, are sober and methodical, ignoring accessories in order to concentrate on the face. They are closely linked with the paintings, being often studies for the portraits, but were very soon appreciated for themselves. Jean Clouet helped to create the taste for the 'pencil' genre, which remained popular in France until the first half of the 17th century. S.B.

Coello
Claudio

Spanish painter of Portuguese descent
b.Madrid, 1642 – d.Madrid, 1693

After training with Francisco Rizi, Coello made a journey to Rome, as his signature on a drawing shows. On his return he became one of the most important painters of the School of Madrid. He was a friend of Carreño, who helped him to gain access to the royal collections, where he studied the Venetian and Flemish masters, whose influence is prominent in his first works, large altar-paintings such as the *Annunciation* (1668, Madrid, Convent of S. Plácido). He worked in distemper and fresco, often in collaboration with Jiménez Donoso (Sacristy of Toledo Cathedral, 1671).

In 1680 he decorated the arches in honour of the entry of Queen Marie-Louise of Orléans and in 1683 was named Painter to the King. In 1684 he carried out the mural decorations of the Church of la Mantería in Saragossa, and, on his return to Madrid, the mythological scenes of the Queen's Gallery at the Alcázar (now lost). On the death of Francisco Rizi in 1685, he took over the large painting that Rizi had been preparing for the Escorial. Signed in 1690 with the title of *pintor de cámara*, this work, *La Sagrada Forma*, is Coello's masterpiece and depicts the relic of the sacred host of Gorrum being presented to Charles II of Spain.

In the year of his death he painted the large *Martyrdom of St Stephen* for the Church of S. Esteban in Salamanca.

The last leading figure of the Spanish Baroque, Coello was an artist of considerable complexity. Colour played a major role in his work, and he loved the warm, delicate tones of the Venetians. He is wholly Baroque in his feeling for the dynamism of composition, yet, at the same time, he had a balanced view of reality which lent seriousness and weight to his figures and made him an excellent portrait painter. As a decorator (mural paintings in Saragossa, Church of the Mantería), he was heir to the Italian tradition, while in the *Sagrada Forma* of the Escorial, his feeling for space, perspective and atmosphere is close to that of Velázquez. His best paintings, executed with fluid, light, measured brushstrokes, followed the example of Velázquez (*Virgin and Child Adored by St Louis*, Prado).

Among his other works are *The Triumph of St Augustine* (1664, Prado), the *Altarpiece of St Gertrude* and that of *St Benedict and St Scholastica* (Madrid, Convent of S. Plácido). *The Martyrdom of St John the Evangelist* (church of Torrejon de Ardoz, near Madrid), *The Apparition of the Virgin to St Dominic* (Madrid, San Fernando Academy), *The Miracle of St Peter of Alcantara* (Munich, Alte Pin.) and *The Holy Family* (Budapest Museum).
 A.E.P.S.

Cole
Thomas

b.Bolton-le-Moor, Lancashire, 1801 – d.Catskill, New York, 1848

Cole's family emigrated to America from England in 1819, settling first in Philadelphia, then in Steubenville, Ohio. After working for a wood-engraver in Philadelphia, Cole rejoined his family in Ohio where he learnt the rudiments of painting from a German portrait painter called Stein. About 1822 he painted some portraits, without great success, and worked on several religious paintings. The following year he was back in Philadelphia where he attended the Pennsylvania Academy of Fine Arts and probably saw the landscapes of Doughty and Thomas Birch. A little later he settled in New York. A journey up the Hudson resulted in a number of paintings that quickly established his reputation. To this period belongs a *Scene from 'The Last of the Mohicans'* (1827, two versions : Hartford, Connecticut, Wadsworth Atheneum; and Cooperstown, New York State Historical Association), inspired by the novel of J. Fenimore Cooper, which had just been published.

In 1829 Cole set sail for Europe where he stayed for two years. He exhibited in London, without success (Royal Academy and British Institution) and visited Paris and Italy, spending a long time in Florence. This journey had a great influence on his career. First-hand study of the old masters led to an improvement in his style, and the iconography of his paintings was transformed.

Apart from the large panoramic landscapes in which he tried to emulate Claude or Turner (*The Oxbow*, 1836, Metropolitan Museum; *The Dream of Arcadia*, 1838, St Louis, City Art Museum), he produced works of fantasy (*The Titan's Goblet*,

1833, Metropolitan Museum) and paintings on philosophical-historical themes (*The Course of Empire*, five paintings, 1836, New York Historical Society; *The Voyage of Life*, four paintings, Washington, N.G.; *The Architect's Dream*, 1840, Toledo, Ohio, Museum of Art).

Disappointed by the lack of interest in his work, Cole went back to Europe in 1841-2 and travelled in France, Greece, Switzerland and Italy. He returned to America, by now convinced of his vocation as a religious painter, and spent the rest of his life in isolation in the Catskill Mountains, where he developed a theory of nature as the visible expression of God. There he painted pictures such as *View of an American Lake* (1844, Detroit, Inst. of Arts), *The Cross in the Desert* (1845, Louvre) and *The Vision* (1848, New York, Brooklyn Museum).

His last works, milestones in the history of American landscape, exemplify the theories he had put forward in 1841 in his poetic *Lecture on American Scenery*. Cole is the chief representative of American Romanticism and founder of the Hudson River School. His work is found mainly in American Museums – in New York (Metropolitan Museum and New York Historical Society), as well as in Washington, Baltimore, Chicago, Detroit, Hartford, Cleveland and Providence. S.C. and J.P.M.

Claudio Coello ▲
Virgin and Child Adored by St Louis
Canvas. 229 cm × 249 cm
Madrid, Museo del Prado

Thomas Cole ▲
The Oxbow (1836)
Canvas. 130 cm × 193 cm
New York, Metropolitan Museum of Art

Colville
Alex

Canadian painter
b. Toronto, 1920

As a child, Alex Colville moved to Amherst, Nova Scotia, where the desolate landscape and the luminous grey light peculiar to the eastern provinces of Canada had a profound effect on him. Apart from a period in the Canadian army from 1942 to 1946 (the last two years as an official war artist), a stint as a visiting artist at the University of California, Santa Cruz, in 1967-8 and six months spent in West Berlin in 1971, Colville has lived his entire life in the Maritime Provinces.

From 1938 to 1942 Colville studied and worked very closely with Stanley Royle at Mount Allison University in Sackville, New Brunswick. It was Royle who interested him in Post-Impressionism and it could be said that Colville's technique owes a debt to Seurat's researches. With this technique small, cross-hatched touches of colour are built up on the picture surface with fine sable brushes. It is a painstaking method and requires three or four months to finish a canvas. The touches are only visible upon close examination; from a distance they give the effect of luminosity. Colville began by applying the technique to tempera, but around 1958 he extended it to oil.

On his return from the war Colville joined the teaching staff of Mount Allison University and remained a member until 1963. He has continued to live in Sackville with his wife and four children, preferring the stillness and solitude of a small town and the austerity of the surrounding landscape.

In *The Swimming Race* the relationship between time and space is suggested in a way characteristic of Colville. Four swimmers are seen at four different stages of diving into a pool. They are portrayed at the moment that the referee has blown his whistle and yet they seem motionless. Only one figure has disturbed the still surface of the water and the splash she creates seems to be equally frozen in time. This theme of four figures

portrayed in four different states of motion was used by Colville in an earlier work, *Four Figures on Wharf* (1952), which shows his wife in four stages of undress standing on a wharf surrounded by a motionless sea.

The waiting figure at the edge of the sea is, in fact, a reference to Colville's return from the war, but it is much more hermetic than *The Swimming Race*, which depicts a specific event at a local swimming pool. However, by deliberately excluding the spectators, by positioning the referee in the distance and by lining the swimmers up on the vanishing point of the perspective of the pool Colville has given a feeling of disquieting permanence to what is essentially an ephemeral moment.

Colville usually uses members of his family for his models but they are not meant to be specific and personal images; rather they epitomize ordinary middle-class people involved in common and shared experiences. *Family and Rainstorm* (1955) shows a mother and her two children hurrying into a car to escape an approaching rainstorm. The details of the car and the clothing of the figures are meticulously painted, but this concession to the particular is then denied by portraying the figures as they turn away from the spectator, thus making the image timeless.

Colville's paintings often convey a sense of the extremes of temperature to be found in the Canadian climate. This is especially noticeable in *To Prince Edward Island* (1965), which shows a woman staring at the spectator through huge binoculars, watched by a man behind her partially hidden from view. There is an overwhelming feeling of the intense heat of a summer day, while the touches of yellowish-green and dull red convey a sensation of the light which accompanies this extreme heat. This particular light seems to be unique to North America and may be seen in 19th-century luminist landscape painting.

Colville often uses calm and arrested motion to suggest alienation and loneliness. In *Woman at Clothes-Line* a housewife stands with one foot poised for its next step, obviously not enjoying the task of hanging out wet clothes to dry on a cold autumn day, but nevertheless doing it because she is trapped by her predicament.

In another category of paintings Colville has

portrayed his wife nude in intimate and often revealing poses. One of the earliest of these, *Nude and Dummy* (1950), is one of the first works in which he clearly articulated his mature style. A later work, *June Day* (1962), shows his wife with her back turned, undressing in a tent on the beach. The images are depersonalized, symbolizing the eternal and timeless presence of woman.

The details in Colville's paintings are always meticulous and correct, but he does not use photographs. He has influenced a whole younger generation of painters including Ken Danby, Tom Forrestall and Christopher Pratt who are known as 'magic' realists because of the photographic quality of their work. Colville himself is often given this label, but it is misleading because in a sense the disturbing images he creates from ordinary scenes and events bring him much closer to Surrealism. Ultimately, however, he cannot be categorized in either way.

Although his work has not always received the attention it deserves in Canada, his stature as an artist had been officially recognized. In 1966 he represented Canada at the Venice Biennale, in 1967 he designed the coinage to commemorate Canada's Centennial and he has received honorary degrees from a number of Canadian universities. Since 1952, when he showed for the first time in New York, he has had many exhibitions abroad, including ones in Germany and England.

A.G.

Constable
John

English painter
b. East Bergholt, Suffolk, 1776 – d. London, 1837

Constable's position in English landscape painting is rivalled only by that of Turner, from whom he differed radically, drawing inspiration from his native scenery rather than seeking grandeur in a wide range of subjects. He also differed from Turner in the laboriousness of his development and in that his genius was recognized only late in his life.

His first works were so unpromising that he began to follow his father's occupation as a miller; but, encouraged by the connoisseur Sir George Beaumont and the painter Farington, he eventually decided to become an artist. He joined the Royal Academy Schools in 1799, but developed more as a result of his independent study of English 18th-century and classical landscapes, as can be seen in his *Dedham Vale* (1802, London, V. & A.), which has affinities with Claude's *Hagar and the Angel* (London, N.G.), of which he made a copy).

In 1802, the year he first exhibited at the Royal Academy, he came to realize the limitations of working within an accepted tradition of landscape painting. In a letter to a friend he stated: 'For the last two years I have been running after pictures, and seeking the truth at second hand...I shall shortly return to East Bergholt where I shall make laborious studies from nature... and I shall endeavour to get a pure and unaffected representation of the scenes that may employ me...there is room enough for a natural painter.'

In the succeeding years he pursued this direct study of nature undeviatingly, apart from some half-hearted attempts to make a living as a painter

◄ Alex Colville
Swimming Race (1958)
Board, 61 cm × 96 cm
Ottawa, National Gallery of Canada

of portraits and religious works. During this period he made some watercolours in the manner of Thomas Girtin on his only visit to the Lake District, in 1806. He adopted the practice of making oil sketches on the spot, and by 1811 had evolved a great breadth and intimacy in these by means of a direct application of paint on a red ground, thereby retaining the individuality of each object without losing the total unity (*Lock and Cottages on the Stour*, *c.*1811, London, V. & A.).

His finished pictures, meanwhile, had remained more within the tradition of composed landscapes, as can be seen in his *Dedham Vale* (1811, private coll.), and during the next few years he was concerned with achieving the atmospheric spontaneity and intimate composition of his sketches in his larger works. Living under emotional stress caused by objections raised to his courtship of Maria Bicknell (whom he married in 1816 after her father's death), he spent a considerable amount of time in East Bergholt.

Two surviving sketchbooks, from 1813 and 1814, reveal his intense observation of natural phenomena, which can also be seen in his 'portraits' of trees, and in his studies of foliage and rural implements. His *Boat-building near Flatford Mill* (1814, London, V. & A.), which was painted largely in the open air, was his first success in achieving the directness he sought on a large scale. It led to his famous series of exhibition landscapes, all of which were shown at the Royal Academy: *Flatford Mill* (1817, London, N.G.); *The White Horse* (1819, New York, Frick Coll.); *Dedham Mill* (1820, London, V. & A.); *The Hay-*

wain (1821, London, N.G.); *View on the Stour* (1822, private coll.); *The Leaping Horse* (1825, London, Royal Academy).

All these paintings were based on the countryside close to the banks of the Stour near his home and are often dependent on sketches and compositional studies made in the preceding years, as in the case of *The Haywain*, which originated from a study of *Willy Lot's House* (*c.* 1810-15, London, V. & A.). In all cases they were produced after a careful process of preparation, including a full-scale sketch, to ensure the retention of atmospheric veracity and compositional immediacy, in which the figures pursue natural activities, rather than merely form compositional groups.

With works of this type Constable achieved a certain degree of recognition, and he was made an A.R.A. in 1819. However, it was in France that he was most enthusiastically received. As a consequence of Géricault's seeing *The Haywain* at the Royal Academy in 1821, the English art dealer Arrowsmith arranged for it to be brought to France, where it was exhibited in the Salon of 1824 and awarded a gold medal. It was admired by the French Romantics, especially Delacroix, for its freshness and brightness.

This was also the period of Constable's first large commissioned work. Since 1797 he had been befriended by the Fisher family, and had stayed with them several times at Salisbury. He was now asked by the elder Fisher, the Bishop of Salisbury, to paint a view of *Salisbury Cathedral*, which, like many of his large paintings, exists in

several versions (1823, London, V. & A.). The picturesque nature of this work is rather out of line with his development at this point, as he was tending towards a more scientific study of natural phenomena.

In 1821-2 he made a series of cloud studies in Hampstead (which he had begun to frequent in 1819), recording the exact time and date of execution and often the prevailing weather. These were possibly made under the influence of Luke Howard's recent classification entitled *On the Modification of Clouds*, and Constable obviously considered them a vital step in the understanding of the light source that controls the appearance of nature. 'I have often been advised', he wrote to John Fisher in 1821, 'to consider my sky as a white sheet thrown behind the objects. Certainly, if the sky is obtrusive, as mine are, it is bad; but if the sky is evaded, as mine are not, it is worse. The sky is the source of light in nature and governs everything.'

A visit to Brighton in 1824, necessitated by his wife's poor health, intensified his study of atmospheric effects, and what he called the 'chiaruscuro of nature', the tonal gradations of natural light. To obtain this effect he adopted several techniques that brought him severe criticism, such as covering his canvases with white flecks to simulate the sparkle of wet leaves and dew, and the use of rougher brushwork and the palette knife to secure a greater variety of textures, as in *Hadleigh Castle* (1829, New York, Mellon Coll.).

In 1829 he was elected R.A., but in the same

▲ John Constable
Full-scale study for **'The Leaping Horse'** (1824–5)
Canvas. 129 cm × 188 cm
London, Victoria and Albert Museum

year his wife died and the severe depression that overcame him after the end of this exceptionally happy marriage darkened his last years. His work became more elemental, as in his *Salisbury Cathedral from the Meadows* (1831, private coll.), and his technique was sometimes over-elaborate. From 1829 to 1833 he supervised David Lucas's masterful mezzotints of his works (done partly in emulation of Turner's *Liber Studiorum*), which helped to increase his popularity.

In 1833 he started giving lectures at the Royal Academy on the history of landscape painting, which reveal his profound knowledge of the work of his predecessors and are invaluable for unerstanding his attitude to art. The intention of his mature work was an unaffected representation of the countryside, 'embodying a pure apprehension of natural effect'. However, this naturalism was by no means dispassionate, and his emotive attitude to his subject matter can be seen in the way that he constantly portrayed scenery that had a personal bond for him, such as the countryside he had known from his childhood and the places where his friends lived. Like Wordsworth, whom he met in 1806, he believed in the study of the natural world and humble life, but always from the point of view of involvement.

His work had no sequel in England: it was condemned by Ruskin and had little in common with Turner's or the Pre-Raphaelites' attitude to nature. His real influence was in France, where he

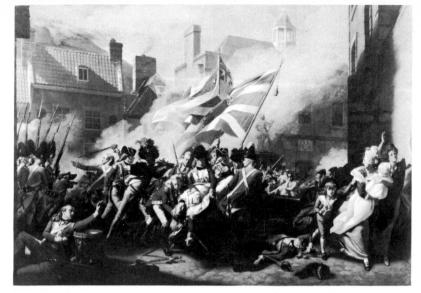

stimulated the Romantics' interest in greater freedom of treatment and, later on, was an important factor in the creative development of the Barbizon painters. W.V.

Copley
John Singleton

American painter
b.Boston, 1738 – d.London, 1815

Copley was self-taught, and became the first artist on American soil to gain an international reputation. From the early 1750s he worked as a portrait painter among the middle classes of his native city of Boston. His fame led to his being called to New York and Philadelphia in 1771-2. With remarkable intuition, he adapted the style of English painting – which he knew only through engravings – to the depiction of the Puritan society of the east coast. Although the figures in them are rather clumsily arranged, his portraits show a rare sharpness of observation, which is translated by careful realism and great probity of technique (*Mrs Sylvanus Bourne*, Metropolitan Museum). These American portraits remain the most highly regarded and popular part of his output.

The provincial character of Copley's style vanished when he arrived in London in 1774. He very soon absorbed the mellow technique of his contemporaries, notably Reynolds and, following the example of Benjamin West, also painted historical scenes. Three of these deserve mention: *Brook Watson and the Shark* (1778, several versions, notably in Boston, M.F.A. and Detroit, Inst. of Arts), in which he transformed a curious episode into a heroic event; *The Death of Chatham* (1780, London, Tate Gal.); and *The Death of Major Peirson* (1783, London, Tate Gal.)

These are all convincing examples of the application of Neoclassical theories to the illustration of contemporary history. With West, he thus helped to create the genre of historical painting in England. His success was so great that he succeeded Reynolds in 1792 as President of the Royal Academy. Later, however, his popularity waned. This, combined with ill health, meant that he painted little and sold less after 1800.

Copley is represented in many American galleries, notably in Boston (M.F.A.), as well as in London (Tate Gal.). S.C.

Coppo di Marcovaldo

Italian painter
b.Florence; active 1250-75

Certain facts about Coppo's life can be established from contemporary references. In 1260 he took part in the Battle of Montaperti and was led off in captivity to Siena. The following year he signed the *Madonna* in the Church of the Servi in Siena. In 1274, with his son Salerno, he painted the *Cross* in the cathedral at Pistoia. Two important paintings dating from about the same time as the Siena *Madonna* have also been attributed to him: the *Crucifix* in the Museum of San Gimignano; and the *Madonna* in the Church of S. Martino dei Servi at Orvieto. More recently, because of a remarkable similarity of expression, the mosaic of *Hell* in the Baptistery in Florence has been compared with this group of works.

Coppo took up with even more vigour the powerful plastic expressiveness of such Florentine artists as the Master of Vico l'Abate or the Master of the S. Francesco Bardi. While his contemporary Cimabue took his models from the classical period and from the most poetic of Byzantine art, Coppo based his language on late Byzantine formulas, exaggerating their dramatic expressiveness and accentuating their linearity. An exception is the *Crucifix* of Pistoia, a late work in which the plasticity is less vehement and which betrays the influence of Cimabue. Coppo's long stay in Siena was one of the most important factors in the formation of the Sienese School. B.T.

Corinth
Lovis

German painter
b.Tapiau, East Prussia, 1858 – d.Zandvoort, Holland, 1925

Corinth began his training at the Königsberg Academy in 1876, and continued at the Academy at Munich between 1880 and 1884. After visiting Holland and Antwerp, he became a pupil of Bouguereau at the Académie Julian in Paris (1884-7) and made many studies from the nude. He experimented with various styles, moving from 17th-century Flemish-Dutch realism to

◀ Coppo di Marcovaldo
Madonna and Child enthroned with two Angels
Wood. 238 cm × 135 cm
Orvieto, Church of S. Maria dei Servi

▲ John Singleton Copley
The Death of Major Peirson (1783)
Canvas. 251 cm × 365 cm
London, Tate Gallery

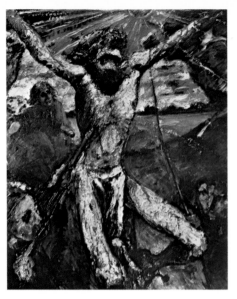

Courbet, Manet and Bastien-Lepage. After a long stay in Munich (1891-1900), he settled in Berlin, where he played an important part in the Sezession, of which he became President in 1911.

Until that time, Corinth remained faithful to a powerful, rather sad realism, which punctuates an *oeuvre* sometimes given over to the classical nostalgia typical of the late 19th century. His work was always very varied and included: religious compositions (*Descent from the Cross*, 1906, Leipzig Museum); biblical paintings (*Salome*, 1899, Leipzig Museum); genre scenes that are already Expressionist in feeling, with brushstrokes and a use of colour that resulted from a highly original synthesis of Hals and of Impressionism (the theme of *The Slaughterhouse*, 1892 and 1893, Stuttgart, Staatsgal.); nudes of robust sensuality, close to those of Courbet (1899, Bremen Museum; 1906, Hamburg Museum); and portraits and self-portraits (1901, Winterthur Museum).

A serious illness in 1911-12 brought a change of vision. A new fervour and power of execution – a more spontaneous act of creation – frequently became apparent, but tended to destroy the subject. This was particularly so in the series of landscapes, many of them built on a dominance of blues and greens, which the region of Walchensee in Bavaria inspired in him between 1918 and 1925 (1921, Saarbbücken Museum; *Easter at Walchensee*, 1922, New York, private coll.).

Although hostile to Expressionism, and so rarely tempted to simplify the surface with flat colours (*Woman in a Yellow Chair*, 1913, New York, private coll.), he was nonetheless affected by the movement. This is less apparent in his fine, decisive self-portraits (1918, Cologne, W.R.M.; 1921, Ulm Museum) than in several late works such as *The Red Christ* (1922, Munich, Neue Pin.) and the portrait of *Bernt Grönvold* (1923, Bremen Museum). Paradoxically, his last paintings combine a monumental effect with a certain weakness in formal structure, the outcome of greatly fragmented brushwork consciously reminiscent of late Rembrandt (*Susannah and the Elders*, 1923, Hanover Museum; *Ecce Homo*, 1925, Basel Museum).

With Liebermann and Slevogt, Corinth is the leading representative of German Impressionism. His works are found mainly in Swiss and German museums. He painted nearly 1,000 pictures and made over 900 prints, mostly drypoint and lithographs, after 1891. He used a quick, sharp, complex line, and the subject emerges from a rich orchestration of grey (*Susannah at the Bath*, 1920, drypoint; *Dante's Barque*, 1921-2, drypoint, after

Delacroix; *Lovers in a Landscape*, 1923, drypoint). His lithographs, produced by a technique of dynamic rubbings, include *The Death of Jesus* (1923) and a number of cycles inspired by subjects more proper to the old masters (*Luther, Anne Boleyn, Götz von Berlichingen*).　　　　M.A.S.

Corneille de Lyon

French painter of Dutch origin
b. The Hague, c.1500/10 – d.Lyons, c.1574

Originally from The Hague, Corneille de Lyon acquired his surname from the many years he lived in Lyons, where he had already been settled for some time when the poet Jean Second visited him in 1534. Corneille is mentioned as painter of the Dauphin, the future Henry II. Naturalized in 1547, in 1551 he bore the title of Painter to the King and *valet de chambre*. He is last mentioned in Lyons in 1574 and must have died soon afterwards. The portrait of *Pierre Aymerie* (France, private coll.), which says on the back that it was painted in 1533 by 'Cornelius of The Hague', may serve as a basis for the attribution of many paintings.

Virtually nothing is known about his origins, although in style and technique his work suggests that he was trained in Flanders. His output has been reconstructed, starting with paintings documented as by him in the collection of Roger de Gaignières (1642-1715). Some of these have been found at Versailles (*Madame de Pompadour de la maison des Cars; Beatrice Pacheco*), others at Chantilly (*Mme de Lansac*) and at the Louvre (*Charles de La Rochefoucauld, comte de Randan; Jacques Bertaut*). With these may be included paintings that bear on the back the seal of Colbert de Torcy, who in 1715 sold the Gaignières collection (*Charles de Cossé-Brissac*, Metropolitan Museum) for the King. Without such means, few paintings can be attributed to Corneille (among them the *Portrait presumé de Clément Marot*, Louvre).

His works, bust portraits of the French aristocracy, painted between 1530 and 1570, enjoyed a great vogue, which is shown in the

numerous references to them and the copies made. The portraits are all small and carefully executed, painted against blue or green backgrounds, with great refinement of style. Corneille had a flourishing studio in which he was helped by his son, Corneille, and his daughter, who herself had an excellent reputation as a painter. His influence is visible in such artists as the Master of Rieux-Châteauneuf, and seems to have spread internationally. No drawings can be attributed to him with certainty.　　　　S.B.

Cornelis van Haarlem
(Cornelis Cornelisz)

Dutch painter
b.Haarlem, 1562 – d.Haarlem, 1638

With Van Mander and Hendrick Goltzius, Cornelis is one of the leading representatives of Haarlem Mannerism. The son of Cornelis Thomasz, he was a pupil of Pieter Pietersz Aertsen at Haarlem in 1573. In 1579 he went to France, where, like Wtewael, he came under the influence of the School of Fontainebleau. At Antwerp he spent some time in the studio of Gillis Coignet. In 1583 he settled in Haarlem, at the time of the great Mannerist advance initiated by Spranger.

His first works date from the period following 1585 and include the *Charity* (Valenciennes Museum), described and praised at length by Van Mander. It displays a supple style still influenced by the School of Fontainebleau. A year or two later his Mannerist period – properly so-called – began with *Susannah and the Elders* (Nuremberg Museum), in which the elongation, the tension and the careful pose of the model go beyond Spranger, who was to inspire Cornelis.

In 1589 he painted *Noah's Family* (Quimper Museum), an extraordinary study of bloated nudes that is a parody of monumental classical sculpture and, in particular, of the *Apollo Belvedere*. *The Massacre of the Innocents* (1590, Haarlem, Franz Hals Museum) is the epitome of Mannerist painting, violent to the point of outrageousness, seeking to produce a real visual shock. *The Wedding of Thetis and Peleus* (1593,

▲ Lovis Corinth
The Red Christ (1922)
Wood. 129 cm × 108 cm
Munich, Neue Pinakothek

▲ Corneille de Lyon
Charles de La Rochefoucauld, comte de Randan
Wood. 15 cm × 13 cm
Paris, Musée du Louvre

▲ Cornelis van Haarlem
Bathsheba (1594)
Wood. 77 cm × 64 cm
Amsterdam, Rijksmuseum

Haarlem, Franz Hals Museum) bows to Spranger, but also reveals the influence of the nudes of Abraham Bloemaert.

About this time, Cornelis's style improved and developed a more harmonious, academic manner, as revealed in *The Baptism of Christ* (1593, Utrecht, Centraal Museum), where the formal calm and Venetian range of colours suggest, for instance, the work of Dirck Barendsz. This peaceable Mannerism can also be seen in *Adam and Eve in the Garden of Eden* and above all in *Bathsheba* (1594, Rijksmuseum), one of Cornelis's masterpieces. The curious *Still Life in the Kitchen* (1596, Linz, private coll.) stands apart from the rest of Cornelis's work and recalls that of Aertsen. In the same year he painted *The Garden of Love* (Berlin, Grünewald Castle), a sensual yet idealized composition, and the point of departure for artists like Esaias van de Velde and painters of the fashionable society of Haarlem and Amsterdam (Dirck Hals, Buytewech).

After 1600 Cornelis painted many *genre* scenes on mythological or biblical themes. Male and female figures are depicted half-length, with round, flat faces and undulating bodies, against a sombre background or set in a landscape (*Venus and Adonis*, 1614, Caen Museum; *The World before the Flood*, 1615, Toulouse Museum). He also continued to paint religious scenes, such as *Christ Blessing the Children* (1633, Haarlem, Frans Hals Museum), and *The Assembly of Gods and Goddesses* (*Ceres, Bacchus, Venus and Cupid*, 1624, Lille Museum). J.V.

Cornelius
Peter von

German painter
b. Düsseldorf, 1783 – d.Berlin, 1867

After studying in Düsseldorf Academy from 1795 to 1809, where he was first influenced by the school of David, then by the German primitives, Cornelius settled in Frankfurt. There he began a cycle of drawings to Goethe's *Faust* (completed in 1816). In 1811 he left for Rome and became a member of the Nazarenes, in which he was soon, with Overbeck, to play a dominant role. In his style, now imbued with the art of Raphael and Michelangelo, the Nazarene ideal was fused with a classicism inspired by Asmus Carstens (*The Wise and Foolish Virgins*, Düsseldorf, K.M.). From 1816 to 1818 he collaborated with the Nazarenes on the frescoes of the Casa Bartholdy (*Joseph Recognized by his Brothers*, East Berlin, N.G.), and, in 1817, on those of the villa of the Marchese Massimo, where he made a sketch for a ceiling inspired by Dante's *Paradise*.

In 1819 he was called by Prince Ludwig of Bavaria to Munich to decorate the Glyptothek, where he dealt with subjects inspired by Hesiod and Homer. During 1830-40 he painted frescoes in the Church of St Louis in Munich, notably the *The Last Judgement* (*in situ*). Director of the Düsseldorf Academy (1821-5), then of the Munich Academy (1825-41), he exercised a profound influence and is considered as the leading painter of idealized historical scenes, characterized by feelings at once Christian and humanist.

In 1840 Cornelius was called by Frederick William IV of Prussia to Berlin. Here, he made sketches (Berlin, N.G.) for frescoes destined for

the decoration of a burial place for the Hohenzollerns, the Campo Santo, which were never carried out (*The Four Horsemen of the Apocalypse*, influenced by Dürer and the works of Phidias, which he had seen in London). Even though his influence upon his contemporaries was strongly opposed after about 1840 by the progress of Realism, he remains responsible for the attempt to resurrect monumental art through the fresco, which was to become the source of the 'colossal' style in German art at the end of the 19th century. He had great admirers in France, among them Ingres, Gérard and Delacroix. H.B.S. and L.A.W.

Corot
Jean-Baptiste Camille

French painter
b.Paris, 1796 – d.Paris, 1875

Corot was born into a family of well-to-do tradespeople in Paris. His father, who had started as a hairdresser, was a draper. His mother, a dressmaker, had a busy shop in the Rue du Bac. Both planned that their son would become a shopkeeper, but he showed such dislike of the idea that in 1822 they gave way to his pleas and allowed him a small income so that he could follow his vocation as a painter.

Corot sought the advice of a contemporary, Michallon, the first painter of historical landscapes to win the Prix de Rome, which had been set up in 1817. Michallon told Corot to paint what he saw. However, he died prematurely and Corot then took lessons from Michallon's teacher, J.V. Bertin, who had been trained in the Neoclassical school, and who taught Corot from some of his own historical landscapes in the style of Poussin – although, as a disciple of de Valenciennes, he also encouraged Corot to work from nature.

In 1825 Corot left for Italy where he lived for three years. In Rome a new spirit was to be found among landscape painters, who had come there from all over Europe. Scandinavian, German, British and Russian painters were all breaking with academic tradition and working out of doors, creating, in the startling Mediterranean light and the harmoniously ordered natural landscape, an art that was at once classical and realistic, without reference to earlier masters. Corot became part of the group of French artists around Aligny, Bodinier, Edouard Bertin and Léopold Robert.

During this first stay in Rome he made no at-

tempt to study Michelangelo or Raphael, an apparent lack of curiosity that resulted from a profound indifference to the example of the past and a confidence in his own instinct. Such confidence was not misplaced, for his first Italian studies possessed an unexpected maturity. And though Corot might draw more 'noble' paintings from them, paintings that would please the traditionalist jury of the Salon, these later works were no better. If one compares the version of the *Pont de Narni* (*Bridge at Narni*) (1827, Louvre) with the painting made for the Salon of the same year (Ottawa, N.G.), it is obvious that the latter work lacks the freshness of vision and the feeling for brushwork of the study.

By nature restless, Corot was always on the move. He travelled through Normandy, Brittany, Burgundy, Morvan, the Auvergne, Saintonge, Picardy, Provence, and his wanderings carried him as far as Switzerland, the Low Countries and London. Everywhere he painted with the idea (which was to be central to the Impressionists) that light created life (*La Cathédrale de Chartres*, 1830, Louvre; *Saint-Paterne d'Orléans*, 1843, Strasbourg Museum; *Le Moulin de Saint-Nicolas-lès-Arras*, 1874, Louvre).

He also worked at Barbizon and was aware, like the other artists who gathered there, of the influence of the Dutch 17th-century painters, although with him it was tempered by the revelations he had known in Italy and by his own independence of spirit. *La Forêt de Fontainebleau* (1831, Washington, N.G.), *Vue de Soissons* (1833, Otterlo, Kröller-Müller), and *Le Pont de Rouen* (1834, Rouen Museum) show this.

On the other hand, his paintings differed in feeling from those of the landscape painters of Barbizon. Italy had taught him the creative power of light, the skies of the Île-de-France taught him its modulations, expressed in a pearly colour that silvers the paintings he brought back from a second journey to Italy in 1833 (views of Volterra, Florence and Venice) to no less a degree than the studies made at Avignon in 1836 (Louvre; London, N.G.; The Hague, Mesdag Museum).

He raised to perfection an art that created atmosphere by subtle variations of tone. Each stage of his career was marked by masterpieces: *Le Port de La Rochelle* (1852, New Haven, Connecticut, Yale University Art Gal.); *La Cathédrale de Mantes* (*c.*1868, Rheims Museum); *Le Beffroi de Douai* (*The Belfry at Douai*) (1871, Louvre); *Intérieur de la cathédrale de Sens* (1874, Louvre), the last one painted when Corot was nearly 80.

After 1835 Corot's fame rested not on his sketches, which in many ways are the most attractive part of his work, but on the pictures he sent to the Salons. These were elaborate compositions of huge landscapes animated by biblical or mythological figures: *Silène* (*Silenus*) (1838, United States, private coll.); *La Fuite en Egyte* (*The Flight into Egypt*) (1840, Rosny Church); *Homer et les bergers* (*Homer and the Shepherds*) (1845, St Lô Museum); *Destruction de Sodome* (1857, Metropolitan Museum); *Macbeth et les sorcières* (*Macbeth and the Witches*) (1859, London, Wallace Coll.). He also painted more evocative landscapes peopled with nymphs, and *Souvenirs* of Ville d'Avray or Italy, the latter even more numerous after his third trip to Italy in 1843.

This aspect of Corot's work, which brought him a considerable degree of success, has been too severely criticized. Corot always accepted too

▲ Peter von Cornelius
The Wise and Foolish Virgins
Canvas. 114 cm × 153 cm
Düsseldorf, Kunstmuseum

of 1844: *L'Homme au chien* (*Man with a Dog*) (1842, Paris, Petit Palais). It was soon followed by *L'Homme Blessé* (*The Wounded Man*) (1844, Louvre), *Les Amants heureux* (*The Happy Lovers*) (Salon of 1845; Paris, Petit Palais, and Lyons Museum) and *L'Homme à la pipe* (*Man with a Pipe*) (1846, Montpellier Museum).

This disposition to paint himself was motivated less by an ingenuous narcissism than by a lyrical feeling that reveals the romanticism he despised but which found a perfect expression in this search for himself. The female figures in his youthful work are also romantic. Sometimes they are inspired by the writings of Victor Hugo or Georges Sand, such as *Le Nu allongé* (*Reclining Nude*) (c.1841, Boston, M.F.A.); or poetically transposed from reality (*Le Hamac* [*The Hammock*], Salon of 1845, Winterthur, Oskar Reinhart Coll.).

The year 1847 marked a turning point in Courbet's career. This was the time of his visit to Holland that was to open up to him the world of Rembrandt and to determine his future. *The Night Watch* and *The Anatomy Lesson* revealed to him the means of reaching his ideal of realism. On his return he produced for the 1849 Salon, *L'Après-dîner à Ornans*, a very large painting, which was bought by the state and today hangs in Lille Museum. In this painting one can feel, in spite of its debt to Dutch painting, the living real-

ity that animates the two masterpieces undertaken during that same year: the *Casseurs des pierres* (*The Stone-Breakers*) (destroyed in Dresden during the Second World War) and the *Enterrement à Ornans* (*The Funeral at Ornans*) (Louvre), which scandalized the Salon in 1850 and began the series of disputes in which Courbet was to be involved. Even his admirers, such as Delacroix, regretted that he put his powerful talent at the service of vulgarity.

Nevertheless, in this composition, Courbet lifts everyday ugliness to a level of universality, investing the figures (each one of whom he knew personally) and a familiar village scene with a monumental grandeur and nobility. The same feeling marks the *Retour de la foire des paysans de Flagey* (*The Peasants of Flagey Returning from the Fair*) (1850, Besançon Museum) and *Les Cribleuses* (*The Grain-Sifters*) (1854, Nantes Museum). His family furnished the models for these work, which, capturing as they do the essence of an actual event, go beyond genre painting. *L'Incendie* (*The Fire*) (1851, Paris, Petit Palais), an immense unfinished painting, Courbet's only urban scene, is also a masterly work and a sort of modern counterpart to Rembrandt's *Night Watch*.

The prosaic nature of Courbet's subjects, however, alienated the public, which was even more affronted by what it took to be the indecency of his realistic nudes. At the Salon of 1853, the Em-

peror Napoleon III flogged the all-too-credible buttocks of his *Baigneuses* (*Bathers*) (Montpellier Museum) with his riding-whip. Courbet's landscapes, with their concern for truth, are among the greatest in a century which produced so many of them. He was a faithful portrayer of nature, and as such a notable interpreter of the special clarity of the light in Franche-Comté (*Les Demoiselles de village* [*The Village Maidens*], 1852, Metropolitan Museum), and of the dry light of the south, which he had first come to know at Montpellier in 1854 during his first stay with his patron, the collector Bruyas.

He immortalized this visit with *La Rencontre* (*The Meeting*), also known as '*Bonjour, monsieur Courbet*' (Montpellier Museum). At the same he discovered the sea (*La Mer à Palavas*, Sète Museum), which he was to find again after 1865 on the Channel coast (Trouville, Étretat), capturing its waves and currents with rough-looking brushstrokes (*La Vague* [*The Wave*], 1870, Louvre; *La Mer*, 1870, Berlin, N.G.).

For the Paris Exposition of 1855 Courbet conceived the idea of painting his studio: *L'Atelier* (Louvre). With this masterly composition, which was given the paradoxical subtitle of *Allégorie réelle*, he became an historical painter not just of an event but of a philosophy. With the help of real-looking people, he sought to symbolize his friendships and ideals, his dislikes and hatreds,

▲ Gustave Courbet
Les Demoiselles des bords de la Seine (1856)
Canvas. 174 cm × 200 cm
Paris, Musée du Petit Palais

combining his feelings as a man with his tastes as a painter. Portraits, still-life paintings, and landscapes, lit by the presence of one of the most beautiful female nudes in French painting, make up the whole. But the jury turned down the work, as well as *Enterrement à Ornans*, put in with it.

Courbet took up the challenge and erected a booth called 'The Pavilion of Realism' on the edge of the exhibition. There he presented an 'Exhibition of Forty Paintings', publishing his 'Manifesto of Realism' in the catalogue. Amidst jeers, sarcasm and some encouragement, he became the acknowledged leader of the movement.

Each Salon that followed became an occasion for conflict. The most notable stages were in 1856, with *Les Demoiselles des bords de la Seine* (*Girls on the Banks of the Seine*) (Paris, Petit Palais); in 1861, with *Le Cerf à l'eau* (*The Stag Drinking*) (Marseilles Museum), which displayed a genius for depicting the tragic aspect of hunting scenes; in 1866, with *La Remise des chevreuils* (*Covert of Roedeer*) (Louvre); and in 1870, with *La Falaise d'Étretat* (*The Cliff at Étretat*) (Louvre), in which the great mass of rocks contrasts with the limpid and luminous atmosphere.

Courbet's life in Paris was punctuated by many trips. Apart from frequent visits to Ornans, he travelled elsewhere in France and abroad. He stayed again with Bruyas at Montpellier, went on a triumphant five-month tour of Germany in 1858 and, in 1862, brought back from a walking tour in Saintonge beautiful still-life paintings of flowers and fruit. From 1865 he was attracted to the coast of Normandy. There he painted, that year, *La Jeune Fille aux mouettes* (*Girl with Seagulls*) (New York, private coll.), the striking *Jeunes Anglaises devant la fenêtre* (*English Girls at the Window*) (Copenhagen, N.C.G.), as well as the very modern-looking bathers (*La Dame au podoscaphe* [*The Podoscaphe*], 1865, Paris, private coll.) or some that were still classical in feeling (*La Baigneuse* [*The Bather*], 1868, Metropolitan Museum).

It was at this same time, between 1864 and 1870, that he painted his finest nudes, in which the degree of direct sensuality excludes neither poetry nor feeling, in spite of the boldness of some of them (*La Femme au perroquet* [*Woman with a Parrot*], Metropolitan Museum; *Les Dormeuses* [*Sleep*], 1866, Paris, Petit Palais), which were more or less contemporary with Ingres's *Le Bain turc*.

In 1867 he held an exhibition of about 100 of his works in a tent set up on the Pont de l'Alma. By the time of the outbreak of the Franco-Prussian War in 1870 his fame was assured. Following the Commune, however, he was accused of being involved in the pulling down of the column in the Place Vendôme and was condemned, after a vindictive trial, to ruin and exile. His bragging and the jealousy he had aroused made people forget the debt which France owed him. Using his influence with his friends in the Commune, Courbet did in fact help to save the Louvre from the fire at the Tuileries.

Imprisoned in Sainte-Pélagie, he made a last *Self-Portrait* (Ornans Museum) and some still-life paintings. Then, forced to leave the country in 1873, he found a welcome in Switzerland. He had been deprived of his property and brought low by mental and physical suffering, and his genius quickly deteriorated. Courbet was a victim of his own liking for bravado. By his boldness and his contempt for convention he exaggerated the

opinions more diplomatically expressed by his friends Baudelaire, Castagnary, Duranty, Vallès, and above all Proudhon, who exercised so great an influence over him and whose memory he honoured in 1865 with the striking portrait at the Petit Palais, *Proudhon et ses enfants*.

His provocativeness made jealous people spiteful. The 'Realist Manifesto' was put about as a profession of faith, whereas his first aim was to fight Romanticism and academic ideas. Although he wanted a 'true' art for the proletarian masses, his proselytizing efforts should not be exaggerated. He was a painter before he was a propagandist, translating what his own private universe offered into a feeling for the people. He was carried away by the generous and revolutionary aspects of socialism, but showed more ingenuousness than fanaticism in his commitment.

The revolution he brought to the art of painting was not confined to a choice of subjects taken from everyday life. He also introduced a new way of working. He was heir to Géricault's realism, but did not practise his fervent, passionate manner. His brushwork, which was massive and solid, suggested the worker's toil and gave his painting a concrete presence. His genius, the correctness of his drawing and of his compositions, the sureness of his eye and hand, his knowledge of grey and of half-tones – all meant that he nearly always avoided vulgarity.

Courbet exchanged with his contemporaries, whom he often met (Corot, the Barbizon painters, Boudin, and later Manet, Jongkind and Whistler), the enlightened ideas that prepared the way for Impressionism, but in France his influence was confined to a renewal of vision and of sources of inspiration. His energetic activity had no direct successors. Abroad, though, it was otherwise. Repin in Russia, De Groux and Meunier in Belgium, and above all Leibl in Germany were deeply influenced by him. H.T.

Coypel
Antoine

French painter
b.Paris, 1661 – d.Paris, 1722

Coypel was a very precocious pupil of his father, Noël Coypel, whom he accompanied to Rome

during the latter's time there as Director of the Académie de France from 1673 to 1675. The young Antoine was a child prodigy, and studied Raphael, the Carraccis and classical art, as well as, on the way home, Correggio (whose work he was to remember all his life), Titian and Veronese.

His first works have unfortunately been lost, notably those with which he decorated the Church of the Assumption. However, *La Conception de la Vierge*, known through an engraving by Tardieu, shows an astonishing illusionist virtuosity for an artist not yet 20 years old. On the other hand, his first work for the Académie has been preserved, an *Allégorie des Victoires* (*Allegory of the Victories of Louis XIV*) (1681, Montpellier Museum; another *Allégorie* with a very similar style and date is at Versailles). The style of this work is perfectly formed and is characterized by an abundance of more or less unarticulated and strongly expressive figures, a warm use of colour, and virtuoso draughtsmanship. The influence of his father (notably in a certain arbitrariness in the forms and a metallic look about the draperies) and, more particularly, that of Le Brun in the systematic search for the expression of intense emotion was to last throughout his life.

Antoine Coypel received many commissions from Louis XIV for Marly, the Trianon, Meudon, and Versailles, but his principal patron was the Duke of Orléans, whose first painter he became. Around 1690-2, at a time when he was designing medals on the life of the king, his pictorial style was strongly influenced by Rubens (*Démocrite* [*Democritus*], Louvre; *Baptême du Christ* [*Baptism of Christ*], Church of St Riquier). He followed these with his most famous works, which were engraved and often copied, but are now lost: *Bacchus et Ariane* (*Bacchus and Ariadne*) and *Le Triomphe de Galatée* (*The Triumph of Galatea*). With their slightly laboured grace, these prepared the way for the agreeable art of the 18th century. *Diane au bain* (*Diana Bathing*) (Épinal Museum) and *Silène barbouillé de mûres* (*Silenus Smeared with Berries*) (Rheims Museum), painted in 1701 for Meudon, are in the same style.

In the years 1695-7 Coypel painted an important series of works on subjects taken from the Old Testament: *Esther et Assuérus* (*Esther and Ahasuerus*), *Athalie chassé du temple* (*Athaliah driven from the Temple*) (Louvre); *Sacrifice de Jephté* (*Sacrifice of Jephta*) (Dijon Museum), and *Suzanne justifiée* (*Susanna Justified*) (Prado). The composition of these works (which he was to take up

▲ Antoine Coypel
L'Olympe
Canvas. 95 cm × 195 cm
Sketch for the ceiling of the Galerie d'Énée in the Palais Royal.
Angers, Musée des Beaux-Arts

again in a large format around 1710 in order to make cartoons for tapestries from them) is better arranged and more comprehensible.

In the same vein, *Eliézer et Rébecca*, painted for the king in 1701 (Louvre), rejuvenated the classical tradition by its charm and gay colours. At the end of his life, apart from large paintings for Notre Dame (now lost), Coypel painted two tapestry cartoons on subjects drawn from the Iliad: *Colère d'Achille* (*The Anger of Achilles*) and *Adieux d'Hector et Andromaque* (*The Parting of Hector and Andromache*) (Tours Museum).

But above all, Coypel was a great decorator. Although he played no part in the decoration of the Invalides (the architect was an enemy of his father), his Galerie d'Énée in the Palais Royal was on an equally imposing scale. He began in 1703-5 with the vault, in which he revived the mid-17th-century tradition of Le Brun and Perrier, by using simulated openings, well-matched paintings and groups of ornaments. Nothing survives of this work; but there is a beautiful sketch of the central part in Angers Museum.

From 1714 to 1717, Coypel decorated the walls with large paintings inspired by the *Aeneid*, which unite a Rubens-like use of colour and a Correggiesque grace in a single elegant synthesis (several in a bad state in the Louvre; *Énée et Anchise* [*Aeneas and Anchises*] and *Mort de Didon* [*The Death of Dido*] in Montpellier Museum; *Énée et Achate apparaissent à Didon* [*Aeneas and Achates before Dido*], Arras Museum).

In 1709, he decorated the vault of the chapel at Versailles with a large composition, again distinguished by false openings and ornaments in *trompe l'oeil*, that ranks with the Roman decorations of Gaulli, which Coypel had no doubt admired.

Coypel became Director of the Royal Academy of Painting and Sculpture in 1714 and, First Painter to the King in 1715 (thanks to which the Louvre has several hundred of his admirable drawings, often in three colours) and was ennobled in 1717. A painter with literary learnings, he published the interesting *Discours* on his art in 1721. His interest in the theatre was to become a real passion in his son, Charles-Antoine Coypel, whose art in many respects was a continuation of his own. A.S.

Cozens
John Robert
English painter
b.London, 1752 – d.London, 1797

Cozens was taught to paint by his father Alexander Cozens and exhibited his first work in 1767. However, he made only one contribution to the Royal Academy, an oil painting of *Hannibal Crossing the Alps* (1776), which influenced the young Turner. In 1776 Cozens set out for Italy with the writer Richard Payne Knight and started painting the mountain scenery of the Alps. He was in Rome in 1778, returning to London in 1779. A typical example of his work on this first Italian tour is *Etna from the Grotta del Capro* (1777, British Museum).

Soon after this Cozens struck up a friendship with the art collector, William Beckford, who was a close friend of his father, and, with Beckford as his patron, made a second journey to Italy

in 1782, arriving in Rome in June. He painted many imposing pictures of the Italian lakes and the countryside around Rome, and made a number of notable drawings of Lake Nemi. It was on the strength of these works that Constable was to call him 'the greatest genius that ever touched landscape'. Cozens returned to England in 1783.

In 1794 he became mentally deranged and was attended and supported by Dr Monro and Sir George Beaumont, later famous as the patron of Constable. Thomas Girtin and Turner both spent some time in Dr Monro's house, and it was here that they saw Cozens's work, which greatly influenced them.

Many of Alexander Cozens's ideas were put into practice by his son. Both belonged to what has been called the 'Southern School' of English landscape painting, so named because of its preference for subject matter from southern Europe. Cozens's own works avoid both the merely topographical and the picturesque and, although they are in the European tradition of landscape, they are not derivative from Claude or Gaspard Dughet. In his pictures Cozens captured a mood of solitude and peace, bringing to his Swiss and Italian landscapes a feeling of evening quietude. J.N.S.

Cranach
Lucas, the Elder
German painter
b.Kronach, 1472 – d.Weimar, 1553

The painter Lucas, as he is called in old documents, owes his name to the town of Kronach in Upper Franconia where he was born. Nothing is known of his early years.

The first of Cranach's surviving works were painted in Vienna immediately after 1500. They include, from around 1501, a *Crucifixion* (Vienna, K.M.) and two altar-panels representing *St Valentine* and the *Stigmatization of St Francis* (Vienna, Akademie), followed in 1502 by a panel of *St Jerome Penitent* and three wood-engravings; two *Crucifixions* and a *St Stephen*, dated. Full of reminders of Dürer's *Apocalypse* (1498), all these works are characterized by bony figures with grimacing expressions, together with a marked feeling for nature, evident in the predominance of landscape, or, in the case of *St Stephen*, in the two trees full of dragons and angels, which serve as a frame.

The dynamism of these paintings is strikingly echoed in a contemporary wood-engraving of *The Agony in the Garden* made about 1503 (unique proof, Metropolitan Museum), and in the *Crucifixion* of 1503 (Munich, Alte Pin.). In this latter picture the crosses, by their positioning, are integrated into the landscape much more than they would have been had they been shown from the front, an arrangement that stresses the human rather than the redemptive meaning of the event.

Cranach's double portraits of the Viennese humanist *Johann Cuspinian and his wife* (Winterthur, Oskar Reinhart Coll.), painted about 1502-3, and of the Rector of Vienna University *Johann Stephen Reuss* (1503, Nuremberg Museum) and his wife (Berlin-Dahlem) reveal his close contacts with Viennese humanist circles, as do a series of drawings representing the *Months*, commissioned by Dr Fuchswagen and executed after the classical

model of *Filokalus* in Vienna (Vienna, Staatsbibliothek). The representation of these models in natural surroundings is an interest common to painters of the Danube School. *The Rest on the Flight into Egypt* (c.1504, Berlin-Dahlem) – probably one of the last paintings Cranach made in Austria – is well known for the charm of its idyllic landscape.

In 1504 Cranach entered the service of the Elector of Saxony, Frederick the Wise, and spent the rest of his life in Wittenberg as court painter to three successive electors.

At Wittenberg he became famous, was Burgomaster in 1537 and 1540, and was a friend of Luther and Melanchton. This did not prevent him, however, from undertaking commissions from Cardinal Albrecht von Brandenburg, one of the great patrons of his day. By comparing the earliest works he produced at Wittenberg, *The Martyrdom of St Catherine* of 1506 (Dresden, Gg), with a recently discovered panel on the same subject (Budapest, private coll.), probably dating from the end of his time in Austria, it is possible to gauge his development. The dynamic and aggressive figures in the Budapest panel have, in the Wittenberg painting, become careful and unemphatic; the spirit that characterized the early works has gone. In the field of engraving – for instance, in the *St Anthony* of 1506 – the dynamic style of his early days was maintained rather longer, but the features that are first evident in *The Martyrdom of St Catherine* gradually become more apparent.

A journey to the Low Countries (about 1508-9) considerably increased his painter's vocabulary, but had little influence on his style – a style to which he adhered for the rest of his life and which, not without reason, has been considered a diminution of his art. Abandoning his early concern with integrating the figures in a whole, he sought something entirely different. In the *Altarpiece of the Holy Family* of 1511 (Vienna, Akademie) the figures that stand out against a sober background of buildings are shown in isolation. This tendency to isolation emerges even more strongly in an altarpiece, dated 1526, *Cardinal Albrecht von Brandenburg as St Jerome in his Study* (Sarasota, Ringling Museum), which can be seen as a paraphrase of Dürer's engraving.

Dürer's engraving owes its power to its all-enveloping atmosphere, but this is totally absent from Cranach's painting. Every figure and object is clearly defined, and a wider perspective is introduced, which makes it possible to create more space around objects. The landscape itself – which had previously been treated as a living space for the human figure – is now used as

John Cozens ▲
Lake Nemi looking towards Genzano
Watercolour. 36 cm × 53 cm
University of Manchester, Whitworth Art Gallery

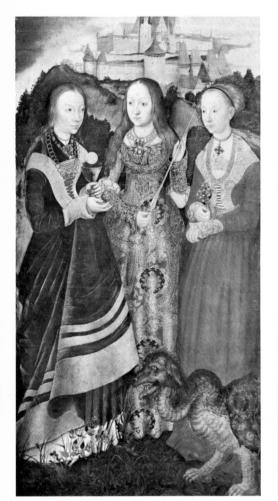

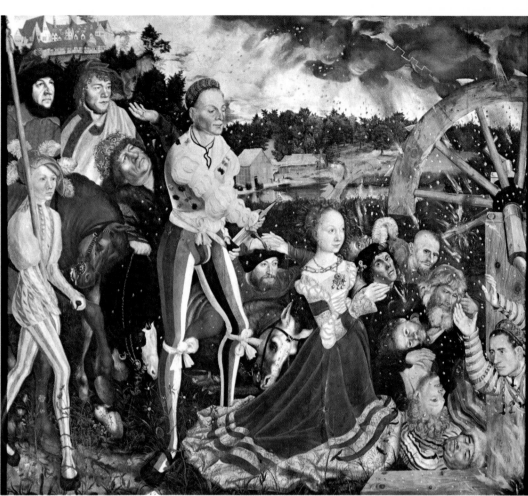

decor – a feature that was to become even more marked, in such later paintings as *The Deer Hunt* of 1529 (Vienna, K.M.) where the horizon is raised. The tendency to isolate the figures appears, too, in the many paintings of *Venus* and *Lucretia*. Set against a sombre background, they are reminiscent of Botticelli's *Venus* in the way they are presented.

Cranach's paintings of nudes and mythological scenes (to be found in most major collections, notably Munich, Alte Pin.) were mainly carried out during the reign of the Elector Johann (1526-32). Much of his earlier production had been of religious works – altarpieces (one of the most important from Torgau, in Frankfurt, Städel. Inst.) and Madonnas. An important exception was portraiture, which had played a major role in his career from the beginning. Cranach has bequeathed images not only of the Electors of Saxony (*Frederick the Wise*, *c*.1519-20, Zürich, Kunsthaus) and others of similar rank (several in the Rheims Museum), but also of Martin Luther, whom he painted several times, as well as making numerous wood and copper engravings of the portraits. Vigorously drawn, the faces stand out decoratively against a generally uniform, evenly lit background.

Thanks to his relationship with Luther, Cranach was called upon to translate the most important subjects of the new doctrine into images. These works are not always very remarkable as works of art, but they are important as didactic illustrations of newly coined theological subjects.

Original Sin and *Redemption* can be considered as the first codifications of Protestant iconography, which spread very widely.

The catalogue of Cranach's work includes 400 items, which implies that a studio was involved. It was the custom always slightly to vary the figures in the versions demanded by the many customers, one version never being exactly like another. The change that has been noticed after 1537 in Cranach's signature (the dragon with raised wings turned into a dragon with wings outspread) has been variously interpreted. The hypothesis that after that date Cranach retired from his studio to give way to his son, Lucas the Younger (1515-86), does not seem justified by works carried out after 1537. There is no change of style between the paintings before and after that date. The *Self-Portrait* (Uffizi) of 1550, that is, three years before his death, bears witness to Cranach's unimpaired creative powers. A.R.

Crespi
Giuseppe Maria
Italian painter
b.Bologna, 1665 – d.Bologna, 1747

Crespi was first taught by D.M. Canuti, then in the studio of Cignani (1684-6). For a further two years he was in close touch with G.A. Burrini,

who helped to influence him in the direction of Venetian painting. He stayed in Venice twice and also visited Parma, Urbino and Pesaro. The Bolognese tradition also played an important part in his education, notably the work of Lodovico Carracci and of Guercino, whom he even tried to copy. His first datable work is the altarpiece of the church of Bergantino (Rovigo) of 1688, to be followed in 1690 by the *St Anthony Tempted by Demons* (Bologna, Church of S. Nicola degli Albari), which is Baroque in its dramatic arrangement.

The masterpiece of these years, however, is the fresco decoration of two rooms in the Palazzo Pepoli Campogrande in Bologna (1691). The mythological subject matter (*Hercules in the Chariot Drawn by the Hours* and *Banquet of the Gods*) is treated with gentleness and a degree of pathos, while the realism of some of the details is at odds with the classical tendencies of the school of Bologna, at that time represented by Gignani, Franceschini and Creti.

During the last decade of the 17th century Crespi painted some of his most important works, such as *The Girl with a Dove* (Birmingham, City Museum) and *The Musician* (Boston, M.F.A.), in a straightforwardly naturalistic style. At the beginning of the 18th century he painted *The Education of Achilles* for Prince Eugene of Savoy (Vienna, K.M), a work that can be compared with other important paintings such as his *Aeneas, Charon and the Sibyl* (Vienna, K.M.), *Tarquin and Lucretia* (Washington, N.G.), *The*

▲ Lucas Cranach the Elder
Martyrdom of St Catherine (wings showing **Saints**)
Wood. 126 cm × 138 cm (central panel)
124 cm × 66 cm (side panel)
Dresden, Gemäldegalerie

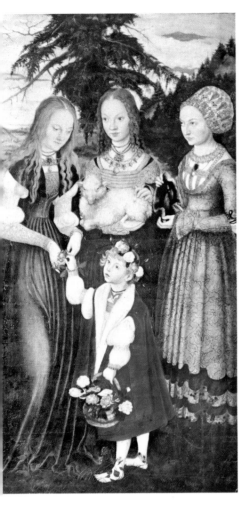

Trojans Blinding Polymnestor (Brussels, M.A.A.) and the altarpiece of *The Ecstasy of the Blessed Margaret* (Cortona, Diocesan Museum), commissioned by Prince Ferdinand of Tuscany. Crespi also offered him, in 1708, *The Massacre of the Innocents* (Uffizi), painted two years earlier, and in exchange was given hospitality at the court of Florence.

In 1709 he was again the guest, with his family, of the prince, who had him stay for six months in his villa at Pratolino where he painted the famous *Fair of Poggio a Caiano* (Uffizi), a work that recalls not only Bassano but Crespi's interest in Dutch genre painting, which he must have been able to study in the Medici collections. The *Fair* is a 'slice of life' that shows Crespi's talent for vivid scene-painting, but the series of *Sacraments* (Dresden, Gg), painted about 1712 for Cardinal Ottoboni, reveals a close study of the art of Rembrandt. This group of seven paintings is Crespi's masterpiece, and one of the major achievements of Italian painting in the 18th century.

In the same truthfully realistic spirit he also conceived the *trompe l'oeil* of the *Music Books* (Bologna, Conservatory of Music). The scenes in *The Life of a Singer* and those of *Bertoldo*, illustrated respectively by the painting of *The Flea* (several examples: one in the Uffizi, one in the Louvre) and by small paintings on copper in the Galleria Doria-Pamphili in Rome, again show his taste for genre paintings, at which he was a master (the *Girl Washing Up*, Florence, Pitti, Contini-Bonacossi Donation; the *Hovels*, Bologna, P.N.).

He transmitted this taste to artists like Piazzetta and Pietro Longhi, who spent some time in his studio in Bologna.

Crespi's later activity consisted mainly of religious paintings (*The Virgin and Child with Three Saints*, 1722, Sarzana Cathedral; 1728-9, Bergamo, Church of S. Paolo d'Argon), with darker colours and a heavier technique. But he also painted a number of important secular works, such as those for Cardinal Ruffo (*David and Abigail, Moses Saved from the Waters*, Rome, Palazzo Venezia), as well as the admirable *Confession of the Queen of Bohemia* (Turin, Gal. Sabauda) and the *Portrait of Cardinal Lamertini* (Vatican), the last example of a series of singularly penetrating portraits: the *Postman* (Karlsruhe Museum), *General Palffy* (Dresden, Gg), *A Family*, and *The Hunter* (both Bologna, P.N.).

R.R.

Crivelli
Carlo

Italian painter
b.Venice, c.1430/5 – d.Ascoli, 1493/1500

The son of a certain Jacopo Crivelli, a Venetian who was himself a painter, Crivelli is first mentioned in 1457 during a condemnation in Venice for adultery. Nothing is known about his training, but something of its initial stages may be deduced from his first signed work, *The Virgin and Child with Instruments of the Passion* (Verona, Castel Vecchio), the inventiveness of which reveals the formal and decorative elements of mid-15th century Paduan art, which at that time was just beginning to turn to the new ideas of the Tuscan Renaissance.

After several years in Zara (in present-day Yugoslavia), Crivelli returned to The Marches in 1468, where he signed and dated the *Polyptych* of the Church of S. Silvestro in Massa Fermana and where, working in various centres of the region, he was to stay until his death. In spite of some evidence that he was influenced by the Ferrara School and by Flemish work brought to the Este court by Rogier van der Weyden, he lived in cul-

tural isolation. The result was that he turned for inspiration to the Paduan style, developing it in a remarkable way under the influence both of the late Gothic spirit and that of the Renaissance.

Crivelli left many polyptychs in The Marches. Some of them were later dismembered, such as that of Porto S. Giorgio, which is now divided between the National Gallery in London (*Sts Peter and Paul*), the National Gallery in Washington (*Madonna*, central panel), the Gardner Museum in Boston (*St George and the Dragon*), the Institute of Arts in Detroit (*Pietà*), the Tulsa Museum (*Two Saints*), and the Kraków Museum (*Two Saints*).

The structure of these compositions, the taste of which is Gothic, and the constant, slightly archaic use of a gold background is accompanied by a use of form that is altogether modern and in accordance with the vision of the Renaissance. This appears in the clearly plastic outline given to the figures and in a very obvious wish to situate them in space through a rigorous study of perspective. The various *Scenes from the Passion* that make up the delightful predella of the polyptych of Massa Fermana are good examples of this.

It is hard to establish an exact chronology for the series of *Virgins* by Crivelli, from the masterpiece in the Corridonia Museum to the *Virgins* at Bergamo (Accad. Carrara), Ancona (Museo Civico, an undoubtedly youthful work), or in the Metropolitan Museum. The *Virgin*, a fragment of a polyptych in the Macerata Museum, is dated (1470).

Crivelli's style attains full maturity in the large altarpiece in Ascoli Cathedral (1473); its three rows have remained complete. The refinement of the plastic modelling, the angular rhythm of the composition, the very careful depiction, elaborated with a sharp graphic sense and an imaginative feeling for contrasting situations, the luxurious elegance of the clothes and even the delicate play of the hands (there is another example of this in the *St Mary Magdalene* in the Rijksmuseum), make this work a masterpiece.

The triptych of Montefiore dell'Aso (Church of S. Lucia) is now known to be entirely by Crivelli's hand and marks another important stage in his evolution. It once formed part of a polyptych which is hard to reconstruct, although other parts of it are probably the central panel of the *Virgin* and the *St Francis* in the Musée d'Art Ancien, Brussels, the *Pietà* in the National Gallery London, and series of *Saints* forming the predella and dispersed among museums, especially in Detroit, Williamstown and Honolulu.

These major works are evidence, too, of Crivelli's expressive range. They were followed by a less impressive style – that is, a more mannered and decorative form of painting, sustained, however, by extreme refinement. The Brera *Virgin with a Candle* (after 1490), the centre of a triptych once in the cathedral of Camerino, of which the panel with the *Saints* is today in the Accademia in Venice, is the perfect example of this.

Crivelli's last known work is the *Coronation of the Virgin* (1493, formerly in the Church of S. Francesco in Fabriano, now in the Brera), an extremely dense composition with an elaborate decoration, and a lunette showing a *Pietà*. The flamboyant expressionism that marked the previous versions of the same subject (those in Detroit and London, already mentioned, and in the Metropolitan Museum, the Museum of Art in Philadelphia and the Museum of Fine Arts in Boston) is succeeded by a gentler, more feeling note.

Cuyp
Aelbert

Dutch painter
b.Dordrecht, 1620 – d.Dordrecht, 1691

A prominent citizen of Dordrecht, Cuyp held the office of 'Regent' there on a number of occasions. He produced mainly landscapes, but also biblical scenes, still-life paintings with birds, and portraits (Rijksmuseum, Louvre). This diversity of genres is explained by the fact that he lived in a small provincial town where his prospective clients could not find painters specializing in each genre, as they could in large Dutch towns.

Although written sources do not reveal that Cuyp ever left his home town of Dordrecht, his views of Delft, Nijmegen (Woburn Abbey, Duke of Bedford's Coll.; Indianapolis, Herron Art Museum) and Utrecht suggest that he did in fact move away. His father, Jacob Gerritsz, had been trained at Utrecht under Abraham Bloemaert and the clear influence of the Utrecht style on Cuyp's work means that he, too, must have spent some time in Utrecht, probably between 1645 and 1650 (as the *Landscape around Utrecht* in Strasbourg Museum may show).

He began by painting large expanses of relatively straightforward landscape, in a range of subtle yellow-brown tones, used in a way that bears close resemblances to the art of Jan van Goyen, who, around 1640, had a great vogue in Holland. A little later Cuyp began to model the animals and plants in his paintings more subtly, and the natural effect of sunlight started to engage his attention.

His work shows many similarities with the pictures of birds by the Utrecht painter Gysbert de Hondecoeter. The importance given to natural light had, in any case, been accepted since the time of Cornelis van Poelenburgh, who had travelled in Italy and had there elaborated a new technique to show the bright, warm clarity of the south. His indirect influence on Cuyp is obvious throughout this period. Cuyp was above all a great admirer of Jan Both, who had returned to Utrecht in 1641 after a stay in Italy. From him he took the warm, golden tone of his paintings and the luminous touches that lighten the trunks of his trees and the stems of his plants.

Until now Cuyp had composed his landscapes with the help of small motifs; but henceforth, following Both's example, he gave a broader

Among important works in the second part of Crivelli's career are: two altarpieces in the National Gallery, London, which came from the Church of S. Domenico in Ascoli Piceno, and a number of panels displayed as a single polyptych under the name of the *Demidoff Altarpiece* (one of them is dated 1476); the *St James of the Marches* (1477, Louvre); the *Madonna* in Budapest Museum; the triptych from Camerino Cathedral (1482, Brera; pinnacles divided between the Städelsches Kunstinstitut in Frankfurt and the Abegg-Stockar Collection in Zürich); the famous *Annunciation* from the Church of Santissima Annunziata in Ascoli Piceno (1486, London, N.G.); *The Blessed Gabriele Ferretti in Ecstasy*, formerly in the Church of S. Francesco in Matelica (London, N.G.); and *The Handing of the Keys to St Peter* (1488, Berlin-Dahlem). F.Z.B.

Crome
John

English painter
b.Norwich, 1768 – d.Norwich, 1821

Crome was a vital figure in the growth of the Norwich School, of which he remains the most prominent member. Apprenticed to a sign painter, he apparently taught himself to paint, mainly by copying English and Dutch landscapes in local collections. Around 1797 he became a drawing master, several times accompanying a local family to the Lake District and Derbyshire in this capacity. In 1803 he was a founder-member of the Norwich Society of Artists, becoming President in 1808. He remained a contributor throughout his life, exhibiting only occasionally in London. He visited Paris in 1814 to see the works that had been appropriated by Napoleon.

Although it is difficult to trace in detail, his development as an artist was slow and strongly dependent on his predecessors. In his early work (*Slate Quarries, c.*1802-5, London, Tate Gal.) the influence of English masters like Wilson and Gainsborough seems to predominate, but works like *The Lime Kiln* (*c.*1805-6, private coll.) show a turning towards Dutch models.

He often attempted to give his native Norfolk scenery a sense of light similar to Hobbema and Ruisdael (*Marlingford Grove*, 1815, Port Sunlight, Lady Lever Art Gal.; *Yarmouth Harbour, c.*1817, London, Tate Gal.), but in the last years of his life he developed breadth and an atmosphere that are very much his own, as in *The Poringland Oak* (*c.*1818-20, London, Tate Gal.). Although he was an uneven artist, his best works are of a very high quality. He is well represented in London (Tate

▲ Carlo Crivelli
Altarpiece (Virgin and Child; Saints; Pietà) (1473)
Wood. 270 cm × 270 cm
Ascoli Picena, Cathedral of Sant'Emidio

▲ John Crome
Mousehold Heath, Norwich (1818-20)
Canvas. 109 cm × 180 cm
London, Tate Gallery

from his theories, but the portraits painted at this time, in their sobriety and frankness, set him in the great line of French portrait painters from Fouquet to Cézanne (*M. et Mme Mongez*, 1812, Louvre; *Sieyès*, 1817, Cambridge, Massachusetts, Fogg Art Museum; the *Comte de Turenne*, Copenhagen, N.C.G.; the *Comtesse Daru*, 1820, New York, Frick Coll.), as does his reworking of the *Sacre* (1821, Versailles), with the help of his pupil and collaborator Georges Rouget. He died in Brussels on 2nd December 1825, a respected and venerated figure.

In turn admired and decried, proclaimed by his supporters as the renewer of French painting and by Delacroix as 'the father of modern painting', David was also accused of fostering, through his theories, the worst kind of academicism, yet the influence of his direct and deliberate art, no less than his powerful vision, was profound. To the classicists, such as Ingres and his pupils, he transmitted ideas, a language, a sense of formal beauty, and to the Romantics, through Gros, the epic inspiration that led him to conceive enormous paintings or huge decorative pieces. His work, in consequence, still poses unresolved problems, for it exemplifies that 'remarkable mixture of realism and the ideal' that Delacroix was to speak of later. While believing that classical art was 'the great school of modern painters', David at the same time observed nature with an intensity rarely found. 	A.C.S.

Davis
Stuart
American painter
b.Philadelphia, 1894 – d.New York, 1964

Davis left school at the age of 16 in order to work under Robert Henri in New York (1910-13), exhibiting five watercolours at the Armory Show when he was only 19. The show played an important role in his future development by introducing him to the French avant-garde and particularly to Duchamp and Picabia, whose work and activity in New York taught him that any subject could

be the source of a work of art. He held his first one-man show in 1917 in New York at the Sheridan Square Gallery. In 1921 his painting *Lucky Strike* (New York, M.O.M.A.), based on the brand of cigarettes of the same name, was the first example of commercial design to be introduced into American art. From 1920 to about 1930 Davis worked at abstract compositions in which he attempted to integrate bright colours and subjects taken from everyday life (series of *Egg-Beaters*, 1927-8, New York, Whitney Museum).

In 1928 he travelled to Paris, returning to New York in 1930 with a fully established personal style in which subjects, events, landscapes, abstract signs and symbols were intimately linked (*Place Pasdeloup*, 1928, New York, Whitney Museum; *Barber's Shop*, 1930, United States, private coll.). He conceived extraordinary amalgams of objects representing still lifes in *trompe l'oeil* of the American 19th century and these prefigured the Pop Art of the 1960s (*Still Life*, '*Little Giant*', 1950, Richmond, Virginia, Museum of Fine Art). At the same time he played an active role in the evolution of contemporary painting and continued to extend the range and intensity of his colour.

Davis is represented in New York (M.O.M.A.; Guggenheim Museum; Whitney Museum), Washington (Phillips Coll.), in Cambridge, Massachusetts (Fogg Art Museum), at Harvard University, at the museums of San Francisco and Baltimore, at the University of Iowa (School of Art Gal.), at Minneapolis (Walker Art Centre), at Philadelphia (Museum of Art; Pennsylvania Academy of Fine Arts) and at Richmond, Virginia (Museum of Fine Art). 	D.R.

De Chirico
Giorgio
Italian painter
b.Volos, Thessaly, 1888 – d.Rome, 1978

Born in Greece of Italian parents, de Chirico began by studying at the Academy in Athens; but

it was in Munich, between 1906 and 1909, that he received his real artistic education. His work is founded on the cult of classical antiquity, on a scholarly understanding of mythology, and on German philosophy and painting, especially that of Böcklin. During a period in Paris between 1911 and 1914 he came to know Apollinaire (*Premonitory Portrait of Guillaume Apollinaire*, 1914, Paris, M.N.A.M.) and Picasso, who introduced him to the artistic and literary avant-garde.

Metaphysical painting, of which de Chirico was one of the pioneers, was born officially in 1915. Before that date, his paintings, translating a traditional 'solid and exact reality', in opposition to all the avant-garde movements, already expressed an introspective and imaginative dimension. Then he produced his first '*Places d'Italie*', emblematic compositions whose architectural décors took their empty spaces from the arcaded piazzas of Ferrara and Turin (*Mystery and Melancholy of a Street*, 1914, New Canaan, Connecticut, Stanley Resor Coll.). The minutely analysed reality, the bright, concealed space inserted in a classical Renaissance perspective, became, through imaginative transposition, the expression of a dreamlike surreality. It is in this empty space that the 'Play-figure' appears, a key character in metaphysical painting. During this period, apart from the '*Places d'Italie*', de Chirico painted the series of *Disquieting Muses* (1916, Milan, Mattioli Coll.), *Hector and Andromache* (1917, Milan, Mattioli Coll.) and *The Great Metaphysician* (1917, New York, M.O.M.A.).

After 1919 he adopted an openly hostile attitude towards the 'modern spirit' and reverted to a deliberately classical style of painting; the literary references and the evocation of Greek and Roman remains were an excuse for intellectual irony and for displaying a technique that combined the emphatic sumptuousness of Romantic painting with an obsessional precision of form.

In his last works de Chirico took up again the themes of his metaphysical period: the lay-figure and the mythology, but also a more obvious Surrealist symbolism. The irony and detachment are still there, but also an increasingly sensitive fullness of form. After 1968 de Chirico was also involved with sculpture, transposing the same iconographic forms into polished precious metal.

Jacques David ▲
Les Licteurs rapportent à Brutus les corps de ses fils
(1789)
Canvas. 323 cm × 422 cm
Paris, Musée du Louvre

Stuart Davis ▲
Egg-Beater no.2 (1927)
Canvas. 48 cm × 55 cm
New York, Whitney Museum of American Art

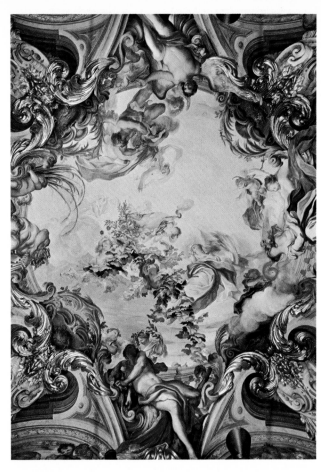

De Chirico's first one-man exhibition was held in 1936 in New York and was followed by many others in Paris and Rome. He had retrospectives at the Venice Biennales of 1948 and 1956, at the Palazzo Reale in Milan in 1970 and at the Musée Marmottan in Paris in 1975. He also worked in the theatre and wrote books (*Hebdomeros*, Paris, 1929; *Memoirs*, Rome, 1945). His works are found in many galleries, notably in Chicago (Art Inst.), Rome (G.A.M.), Stockholm (Nm), Hamburg, New York (M.O.M.A.) and Paris (M.N.A.M.), and in many private collections, Italian (Milan, Jesi, Toninelli and Mattioli colls.), French and English (London, Penrose Coll.). 　　　　　　　　　　　　　L.M.

De Ferrari
Gregorio

Italian painter
b.Porto Maurizio, 1647 – d.Genoa, 1726

De Ferrari arrived in Genoa in 1665, where he entered the studio of Domenico Fiasella. He gained little from his master, however, being more influenced by the work of Valerio Castello and of Puget, who was in Genoa in 1666-7. When Fiasella died in 1669 de Ferrari moved to Parma, where he stayed until 1673, studying and copying Correggio (*Copy of the Cupola of Parma Cathedral*, Genoa, Accad. Ligustica); already he was showing a taste for light colours and whirling draperies, which clearly foreshadowed the developments which were to take place in the 18th century. It seems certain that he must have learned from Baciccio, who was probably in Parma at the time, of the new Roman discoveries and the use of luminous brushstrokes.

On his return to Genoa in 1673 de Ferrari worked with his friend Domenico Piola, whose daughter he was to marry the following year and whose art he was to influence profoundly. In 1674 he painted the fresco of the *Glory of St Andrea Avellino* for the Church of S. Siro, a work that is more luminous and closer to Correggio than the neighbouring composition by Piola, which shows the influence of Carlone.

In this same period de Ferrari produced a number of altarpieces that reveal his debt to Parma, and in which his pre-rococo style was established, a style characterized by pastel tones and a feeling of tenderness: *The Rest on the Flight into Egypt* (1676, Genoa, Church of S. Siro); *Tobias Burying the Bodies* (Genoa, Oratorio della Morte ed Orazione); and *Ecstasy of St Francis* (Genoa, Church of S. Siro).

He went on to apply this style to large fresco decorations in the Genoese palazzi. In the Palazzzo Cambiaso Centurione, at Fossatello (1684), he painted allegories of the *Liberal Arts* and *Military Glory*, linking stucco and fresco closely, using garlands of flowers in imitation of Guidobono; in the Palazzo Balbi, at Zerbino (which later became the Palazzo Groppalo), he painted the *Times*, the *Seasons* and the *Hall of Ruins*, in which he showed that he had freed himself from the stylistic influence of Carlone and Piola. The frescoes in the Palazzo Balbi Senarega (ceiling with *Scenes from the Life of Hercules*, *Cephalus and Aurora*, and *Triumphs*) also belong to the same period.

Castello, Fiasella and Piola also carried out work in the Palazzo Balbi Senarega, and the transformation of taste that had taken place since 1650 is interesting to note, especially the way in which de Ferrari's delicate version of Emilian Mannerism, with its luminous colour, rich in blues and yellows, foreshadowed the 18th century.

He made no effort to achieve scenographic effects, and the decorations which best announce the agreeable style of the French 18th century are those he made in the Palazzo Rosso after 1690 (*Spring* and *Summer*), and particularly those in the Palazzo Granello (*Cupid and Psyche* and *Neptune and Amphitrite*). He is known, too, to have worked in Turin (*Triumph of a Warrior*, Royal Palace) and in Marseilles.

In these last years he gave a rococo twist to Bernini's late sculptures in paintings like the *Death of St Scolastica* (Genoa, Church of S. Stefano) and carried out a number of experiments (*Musical Allegory*, Madrid, Lazaro Galdiano Museum).

In his last decorative work, executed with the aid of his son Lorenzo and of Francesco Costa in the Church of S. Camillo (S. Croce) in Portoria, he introduced the novel concept of a unified scheme of decoration for the cupola and the vault of the choir.

The painter's lifetime coincided with a time of cultural renewal in Genoa, in which painting and sculpture enriched each other, and de Ferrari was one of the most notable figures of this period in the city's history. The most original master of decoration in Genoa, he established a style in which the lessons of Puget mingled with the example of Castiglione, to achieve a pre-rococo interpretation of Correggio. Some French 18th-century painters understood and assimilated de Ferrari's art, notably Fragonard, who was able to see two of de Ferrari's works (*St Nicholas of Tolentino* and an *Assumption* at his birthplace, Grasse, and who, during his visit to Italy in 1773, was enthusiastic about the Palazzo Balbi decorations).

The galleries of the Palazzo Bianco and Palazzo Rosso in Genoa have a number of important canvases by Gregorio de Ferrari, as well as a fine collection of drawings. 　　　　　S.De.

▲ Giorgio de Chirico
Premonitory Portrait of Guillaume Apollinaire (1914)
Canvas. 81 cm × 65 cm
Paris, Musée National d'Art Moderne

▲ Gregorio de Ferrari
Allegory of Summer
Fresco
Genoa, Palazzo Rosso

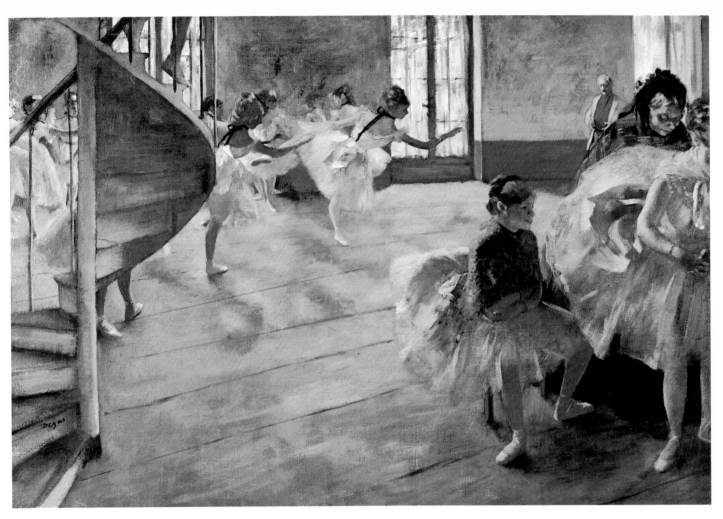

Degas
Hilaire Germain Edgar

French painter
b.Paris, 1834 – d.Paris, 1917

Degas came from an important banking family, and, after receiving a classical education, entered the studio of Lamothe in 1855, where the teaching of Ingres and Flandrin was perpetuated. His first works (1853-9) were self-portraits and family portraits which already reveal great qualities of simplicity (*René Degas à l'encrier* [*René Degas with an Inkwell*], 1855, Northampton, Massachusetts, Smith College, Museum of Art).

Degas travelled in Italy between 1856 and 1860, where he discovered and avidly copied the Florentine masters, and on his return to Paris painted a number of historical works in a quasi-orthodox style: *Petites Filles spartiates provoquant des garçons* (*Young Spartans Exercising*) (1860, London, N.G.); *Sémiramis construisant Babylon* (*Semirams Building Babylon*) (1861, Louvre, Jeu de Paume); and *Scène de guerre du Moyen Âge* (*War Scene from the Middle Ages*) (1865, Louvre, Jeu de Paume). The preparatory drawings that he made for these paintings, however, studies of draperies and nudes, already display a confident, vigorous graphic line (*Femme nue debout* [*Standing Nude*], 1865, Louvre, Jeu de Paume). They show a thorough mastery of the lesson of Ingres, whom Degas, throughout his life, held to be the greatest painter of his age.

The remarkable series of portraits of Degas's family and friends, painted between 1858 and 1870, are also close in spirit to Ingres in their association of a sense of reality with the concept of ideal beauty. The *Portrait de la famille Bellelli*, *Portrait de Thérèse Degas, duchesse Morbilli* (*Portrait of Thérèse Degas, Duchess Morbilli*) composition, with Ingres-like drawing and delicate colouring, and Degas's studies, in pastel or oils, of the various figures in the portrait are among the most harmonious he ever made. His *Portrait de Thérèse Degas, duchesse Morbilli* (*Portrait of Thérèse Degas, Duchess Morbilli*) (*c*.1863, Louvre, Jeu de Paume), and that of a slender, serious *Jeune Femme*, who may have been Giulia Bellelli (1867, Louvre, Jeu de Paume), have a delicate psychological depth and certain charm.

Degas's development found critical outlet in the theories of Louis-Émile Duranty, whose article on *La Nouvelle Peinture* echoed his interest in Baudelaire's modernism and in unconventional subjects – for example the world of the turf and the theatre – highly coloured and artificial settings with which his social life had already made him familiar. He took to observing unusual aspects of them; about 1860-2, he began to paint his first racecourse scenes (*Aux courses en province* [*At the Racecourse in the Country*], 1870-3, Boston, M.F.A.).

Very soon he became interested in the dance and in opera. He painted the *Portrait de Mlle Fiocre dans le ballet de 'La Source'* (*Portrait of Mlle Fiocre in the Ballet, 'La Source'*) (1866-8, Brooklyn Museum), an odd, almost Symbolist painting, with an acid turquoise in the dancer's dress, and followed this, in 1872, with *Le Foyer de la danse à l'Opéra* (*The Dance Foyer at the Opéra*) (Louvre, Jeu de Paume), with its pale blue-greys and yellows. It was during this period that he used

new and original effects in his arrangement of the composition, which was now often asymmetrical: *L'Orchestre de l'Opéra* (*The Orchestra of the Opéra*) (1868-9, Louvre, Jeu de Paume). He also introduced traces of the Japanese style then in fashion (*Femme aux chrysanthèmes* [*Woman with Chrysanthemums*], 1865, Metropolitan Museum).

Following a visit with his brother René to his mother's family in New Orleans, Degas painted his *Bureau de Coton* (*The Cotton Office*) (1873, Pau Museum), in which his studies in realism are apparent. He met Édouard Manet, whose bourgeois tastes and artistic admirations he shared, at the Louvre. Both were interested in certain naturalist subjects, but Degas stubbornly resisted the cult of the countryside, together with the Impressionist dogma of painting out of doors and working directly from the subject. Although he visited the Café Guerbois until 1870, then the Café de la Nouvelle-Athènes, where he enjoyed meeting Manet, Zola and Cézanne, Degas never really shared the fascination for *plein-air* painting, and concern with changes in light; instead, he studied movement and sought to translate the bizarre new realism of photography into the medium of painting. However, he was psychologically on their side, and when the group held its first exhibition in 1874 at the photographer Nadar's he displayed ten paintings in it. And although he was not excluded from the official Salon, he continued to exhibit regularly with the Impressionists until 1886, after which time he allowed his entire output to be handled by his faithful dealers, in particular Durand-Ruel.

Degas's art, in fact, does give an extraordinary sense of fleeting impressions, but it is also reflective, built-up, seeking perfection and, through it,

 Edgar Degas
La Répétition
Canvas. 68 cm × 103 cm
Glasgow Art Gallery and Museum, Burrell Collection

profundity. Above all, Degas cared for line: his swift, precise drawings show his remarkable skill and his feeling for movement, analysed and projected in a single sweep of the pencil (the Louvre has some exciting series of studies, and the Bibliothèque Nationale in Paris several sketchbooks). In order to break up the lack of movement in his canvases, he used off-centre composition, raised the line of the horizon, over-turned perspective and indulged in compositions which are often cut off abruptly by the frame. He also turned his mind quite often to photography, and practised it himself. But he loved exploiting in his compositions the dazzle of artificial light, which emphasized forms. In his oil paintings and pastels, which became more frequent after 1880, the tones were brilliant blues, rich reds and oranges; and the monochrome planes shimmered from the few brushstrokes of pure colour that enlivened them.

Degas probed restlessly, tirelessly trying out each pose and each subject again and again. He rejected Symbolism, which meant escape, and the aestheticism of Art Nouveau, which he found decadent. Ignoring outside advice, criticism or even compliments, he relied on his own judgement alone, and refused all official honours in order to avoid the risk of compromise. His awkward, intransigent character was made gloomier after 1878 by a financial failure that ruined his family; although he paid off the debts he was now worried about money and became more ill-tempered and pessimistic than ever. In spite of this misanthropy he was fond of Manet and Gustave Moreau and proved a helpful friend to the sculptor Albert Bartholomé on the death of his wife, Périe de Fleury.

Lucid and ironic, Degas was a sharp observer of everyday life. His famous dancers are above all ethereal, childish creatures, transfigured by the phosphorescent gleam of the footlights (*Répétition de ballet sur la scène* [*Ballet Rehearsal on the Stage*], 1874, Louvre, Jeu de Paume); they are suspended, coloured arabesques; but they are also, paradoxically, stupid little urchins exhausted by the monotony of rehearsals, resting, stretching, adjusting their hair or their clothes with clumsy movements, whey-faced and splay-footed (*Danseuses dans les coulisses* [*Dancers in the Wings*], 1890-5, St Louis, Missouri, City Art Gal.).

In fact, Degas was not seeking any seductive grace in the ballet. He liked absurd positions best, and unlikely-looking feats of balance. His eye was even more pitiless when he looked at women at their toilet. He watched them at length, in the bath, getting out of the bath, soaping themselves, rubbing themselves, washing neck, leg or torso (*Le Bain* [*The Bath*], c.1890, Chicago Art Inst.). He showed them in detail, caught them at moments when they might think themselves alone, crouching animal-like, grotesquely busy with intimate care of themselves, scratching themselves. Many of these works are exhibited in pastel (*La Sortie de bain* [*After the Bath*], 1885, New York, M.O.M.A.; *Femme se coiffant* [*Woman Combing her Hair*], 1887-90, Louvre, Jeu de Paume).

Degas's vision was no more indulgent when he looked at working-class women or the café world. He painted subjects of which Zola approved, but not in the Realist manner of Courbet. His *Repasseuses au travail* (*Women Ironing*) (1884, Louvre, Jeu de Paume), his laundresses and seamstresses, his young milliner crouched over the table making a hat, make no moral or political

statement: they merely evoke, in a masterly way, a moment in the lives of ordinary people. These works are notable for their bold composition and violent use of colour, as exemplified by the three hats in *Chez la modiste* (*At the Milliner's*) (1882, Metropolitan Museum), standing out against an orange wall.

In 1876, Degas painted *Au Café* (also known as *L'Absinthe*, Louvre, Jeu de Paume), a portrait of Marcellin Desboutin and the actress Ellen Andrée sitting at a table in the Café de la Nouvelle-Athènes, motionless and haggard in their distress. It was the only 'wretched' picture of his career, and was strongly criticized when it was exhibited in Paris and London in 1893. In his *Femmes à la terrasse d'un café, le soir* (*Evening: Women on the Terrace of a Café*) (1887, Louvre, Jeu de Paume) the monkey-like faces of the women are set against the winkling background of the boulevard. The same use of light paint is found in the *Café-concert des Ambassadeurs* (*Café-Concert at the Ambassadeurs*) (1876-7, Lyons Museum), in which the singer stands out among the lamps. Degas also depicted the circus, the excitements of the Stock Exchange, cocottes and even brothels in a set of masterly monotypes, some of which examine light and shade more completely than any of his other works.

Like his delicate *Au Luxembourg* (*In the Luxembourg Gardens*) (1876-80, Montpellier Museum), several attractive studies (Louvre) show that this middle-class Parisian also loved landscapes; in these pictures he omitted detail in order to express only a poetic, meditative calm. In 1869 he produced a series of bare seascapes in pastel, then, about 1890, a number of monotypes drawn from memory of valleys and broad meadows.

From as early as the 1870s Degas's sight was deteriorating, which may account for his extensive use of pastel. His infirmity thus made him use, ahead of his time, the unbridled methods and high-coloured shadows of the Fauves (*Danseuses* [*Dancers*], 1899, Toledo, Ohio, Museum of Art). When he was almost totally blind, Degas retreated into himself, bitter and isolated, but continued with sculpture, which he had taken up from 1881.

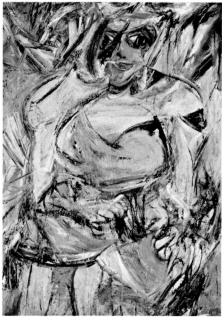

▲ Willem de Kooning
Woman, II (1952)
Canvas. 149 cm × 109 cm
New York, Museum of Modern Art, gift of Mrs J. Rockefeller the 3rd.

His art, ceaselessly renewed, and with an innovatory realism, influenced his contemporaries strongly. Toulouse-Lautrec, whom Degas defended from the beginning of his career, inherited his taste for drawing and his sharp observation of Parisian life. The French and Belgian academic realists took from him his subject matter, and sometimes – as in the case of Besnard or Boldini – his flamboyant colour. But it was the Nabis above all, including Bonnard, who were most in tune with the intimate spirit of Degas's work, with its harsh tones, and were to transpose it into a happier world. Most of his large output (over 2,000 paintings and pastels) is now in the Louvre and in the major American galleries, notably the Metropolitan Museum. T.B.

De Kooning
Willem
American painter of Dutch origins
b.Rotterdam, 1904

De Kooning left school at the age of 12 and was apprenticed to a firm of commercial artists and decorators, studying art in the evenings at the Rotterdam Academie voor Beeldende Kunsten en Technische from 1915 to 1924. In 1924 he studied in Belgium, and in 1926 he emigrated to the United States where he worked as a house painter and commercial artist. He brought with him a wide yet intimate knowledge of European abstraction, and during the 1930s he painted in several styles. In the Federal Arts Project his work showed the most sophisticated awareness of Picasso of any American artist other than Arshile Gorky, an influence that extended beyond mere imitation of Picasso's style in the 1930s to comprise an understanding of the role of Cubist structure. In the late 1930s Gorky and de Kooning, who shared a similar regard for the works of the old masters, worked together in the same studio. Both were interested in the human figure as well as in abstraction, and de Kooning has consistently alternated his interest between the two, although in recent years he seems to have settled on figure painting, particularly of women.

It was not until 1948 that de Kooning had his first one-man show at the Charles Egan Gallery in New York but for several years before he had been identified as a leader of the new school of painting, enjoying a towering reputation among artists. His work is less influenced by Surrealism than that of any other major painter of his generation and is founded on an astonishing pictorial tension, where figure-ground relationships are allowed to flow into one another, and fragmented anatomical shapes are loosely located in space.

His painting of the late 1940s and early 1950s was characterized by a ferocious toughness; the brush was encouraged to sweep across the canvas, leaving drips and splashes; the canvas appeared attacked and the forms themselves ripped apart (*Gotham News*, 1955-6, Buffalo, Albright-Knox Gal.; *Easter Monday*, 1956, Metropolitan Museum). Thus, the work seems always in the process of being painted, for the powerful traces of creation and destruction always remain evident even after it has been completed. The resultant sense of constant struggle became part of the myth of American Action Painting, and the style and scale of de Kooning's paintings, both

abstract, as in *Door to the River* (1960, New York, Whitney Museum), and figurative, as in *Woman 1* (1950-2, New York, M.O.M.A.), were the principal influence on the host of younger painters (Norman Bluhm, Joan Mitchell, Alfred Leslie, Michael Goldberg) who made up the 'second generation' of Abstract Expressionist artists. From about 1963 de Kooning's art became somewhat more gentle, even lyrical and poetic, and figure painting predominated over abstract work. D.R.

Delacroix
Eugène

French painter
b.Charenton, St Maurice, 1798 – d.Paris, 1863

Although inscribed in the register of the district of Charenton as the fourth child of Victoire Oeben and Charles Delacroix, Eugène Delacroix may

have been the natural son of Talleyrand. This relationship would explain the patronage that advanced his career at the outset. Orphaned at the age of 16, Delacroix received a good classical education at the Lycée Impérial (today the Lycée Louis-le-Grand) before entering the studio of Guérin in 1816, on the advice of his uncle, the painter Henri Riesener; the following year he was at the École des Beaux Arts.

Out of sympathy with Guérin's academic ideas, Delacroix was keenly aware of the new impulse given to painting by Gros and Géricault. His first works (*Vierge des moissons* [*Virgin of the Harvests*], 1819, Orcement Church; *Vierge du Sacré-Coeur* [*Virgin of the Sacred Heart*], 1821, Ajaccio Cathedral) are still in imitation of the Italian masters of the Renaissance and the 17th century, but the *Barque de Dante* (*Barque of Dante*) (Louvre), exhibited at the Salon of 1822 and bought by the state, shows other influences, notably that of Géricault's *Radeau de la Méduse* (*Raft of the Medusa*). Variously greeted by the critics, the work was warmly praised by Adolphe Thiers. That same year, on 3rd September, Delacroix

began his famous *Journal* at Louroux (Indre-et-Loire) where he was spending his holidays with his brother, Charles Henry.

At the 1824 Salon, Delacroix, who from now on became a regular exhibitor there, showed his *Massacre de Scio* (*Massacre at Chios*) (Louvre). This large composition, inspired by the struggle of the Greeks against the Turks, proclaimed his affinity with the Romantic, as opposed to the classical, painters, who were then grouped around Ingres; at the same Salon Ingres exhibited *Le Voeu de Louis XIII* (*The Vow of Louis XIII*) (Montauban Cathedral). Delacroix, despite his misgivings, found himself hailed as the leader of the Romantic school.

The summer of the following year was spent in England. Here Delacroix, who was already familiar with the art of Constable and Bonington through his friends the Fieldings, extended his knowledge of English art in London, worked at his technique in order to make it more flexible, and attended a number of Shakespearean productions, which filled him with enthusiasm. Motifs from Shakespeare's plays proved a fruitful source

DEL

93

▲ Eugène Delacroix
La Mort de Sardanapale (1827)
Canvas. 392 cm × 496 cm
Paris, Musée du Louvre

of inspiration until the end of his life: in paintings (*Cléopâtre et le paysan* [*Cleopatra and the Peasant*], 1839, United States, William Acland Memorial Art Centre; *Hamlet*, 1839, Louvre; *Mort d'Ophélie* [*Death of Ophelia*], 1844, Louvre; *Desdémone maudite par son père* [*Desdemona Cursed by her Father*], 1852, Rheims Museum), engravings (Series of *Hamlet*, 1843) and drawings. It was in London, too, that he was to discover another source of dramatic subjects when he went to an opera inspired by Goethe's *Faust*; the series of 17 lithographs that he made the following year brought warm praise from Goethe himself.

On his return to France Delacroix exhibited the *Mort de Sardanapale* (Louvre), inspired by Byron's tragedy *Sardanapalus*, at the Salon of 1827. The boldness of this work aroused violent opposition from the critics. While working assiduously – portraits, historical subjects (*Bataille de Poitiers*, 1830, Louvre; *Bataille de Nancy*, 1831, Musée de Nancy), literary subjects (*Assassinat de l'evêque de Liège* [*Assassination of the Bishop of Liège*], 1831, Louvre) – Delacroix was at this time leading an active social life, meeting in the Parisian salons such people as Stendhal, Merimée and Dumas. It was in these circles that he was soon to make the acquaintance of George Sand, to whom he took such a liking and who he was to portray standing behind Chopin as he improvised at the piano (1838, Louvre, and Ordrupgaard Collection, near Copenhagen). He would spend the summer with his cousins at Valmont where, in 1834, he was to make his one and only attempt at decoration in fresco.

His *Liberté guidant le peuple* (*Liberty leading the People*) (Louvre, 1830), an echo of the Revolution of 1830, which was both a superlative summing up of and a conclusion to his romantic youth, confirmed him as the successor to Gros and Géricault, but with a deeper register. Gifted with a powerful sense of the heroic, in this masterpiece Delacroix transformed historical fact into an epic.

The year 1832 was a decisive one for Delacroix. A meeting with Comte Charles de Mornay, who was in charge of a mission to the Sultan of Morocco, led to Delacroix being attached to the embassy, which left Toulon on 11th January 1832 and arrived in Tangier on the 25th of the same month. Thanks to the sketchbooks that Delacroix kept (two in the Louvre, one in Chantilly) and to his *Correspondence*, we can follow almost day by day the journey to Morocco, Algiers and Spain, which to Delacroix was a revelation not only of classical antiquity, but also of the magic of colour and light.

Delacroix's return to France coincided with a period of intense activity. Together with a continuous programme of mural decoration (an activity that continued throughout his career), he produced an increasing number of easel paintings. While he worked, helped by some of his pupils (Andrieu, Lassalle-Bordes), on the decorations commissioned by Thiers for the Salon du Roi and the library of the Palais Bourbon (1833-8; 1838-47), then on the library of the Palais du Luxembourg (1840-6), Delacroix never ceased to exhibit at the Salon. His memories of Morocco led to the creation of his most important works, in which the romantic fervour of his early days was abandoned in favour of a calm, balanced composition: *Les Femmes d'Alger* (*Women of Algiers*) (1834, Louvre); *Noce juive dans le Maroc* (*Jewish Wedding in Moroccco*) (1841, Louvre); *Le Sultan du Maroc* (*The Sultan of Morocco*) (1845, Toulouse, Musée des Augustins); *Comédiens ou*

bouffons arabes (*The Comedians or Arab Clowns*) (1848, Tours Museum); and *Les Convulsionnaires de Tanger* (*The Fanatics of Tangiers*) (*c*.1836-8, United States, private coll.)

The same synthesis of lyricism and a classical treatment occurs in the historical works painted at this time, of which the most moving is *L'Entrée des croisés à Constantinople* (*The Entry of the Crusaders into Constantinople*) (1841, Louvre). After 1842 he also found fresh themes in the study of nature: bouquets of flowers – painted mostly at George Sand's house at Nohant – landscapes with mountains and forests, seascapes, all revealing a sharp observation joined to a sensitivity that prefigures that of the Impressionists (*La Mer vue des hauteurs de Dieppe* [*The Sea from above Dieppe*], 1852, Paris, private coll.). Finally his study of animals, particularly wild ones, led him, between 1848 and 1861, to paint many lion and tiger hunts, pretexts for multiple variations of forms and colours (*Chasse aux lions* [*Lion Hunt*], sketch, France, private coll.).

The last ten years of Delacroix's life were marked by three important decorative groups: the central ceiling of the Galerie d'Apollon at the Louvre (1850), the Salon de la Paix at the Hôtel de Ville in Paris – destroyed by fire in 1871 (sketch of the ceiling, Musée Carnavalet) – and the Chapelle des Saints Anges at the Church of St Sulpice. Suffering from tuberculosis of the throat, Delacroix, who in 1855 had a triumph at the Exposition Universelle with 42 paintings, including several new ones (*Chasse aux lions* [*Lion Hunt*], Bordeaux Museum), now lived without official recognition. In 1857 he was elected to the Institut, after six unsuccessful attempts, and exhibited for the last time at the Salon in 1859 (*Ovide en exil chez les Scythes* [*Ovid among the Scythians*], London, N.G.; *Herminie chez les bergers* [*Erminia with the Shepherds*], Stockholm, Nm). He then devoted himself entirely to the decoration of St Sulpice, which he finished in 1861, after superhuman efforts. Of the two large compositions that decorate the side-walls of the chapel – *Héliodore chassé du Temple* (*Heliodorus Chased from the Temple*) and

La Lutte de Jacob avec l'ange (*Jacob Wrestling with the Angel*) – the second can be considered as Delacroix's spiritual testament; after it he was to paint only a few canvases. On 13th August 1863 he died in his apartment at 6, Place de Furstenberg. Close to St Sulpice, it had been his home since 1857. The year after his death, in accordance with his wishes, the contents of his studio were dispersed.

The last of the great masters in the tradition of the Renaissance by virtue of his taste for large historical, mythological, religious or literary compositions and his profoundly decorative sense, Delacroix was also, as Baudelaire noted, the first of the moderns. His studies of colours and their complementary qualities and his 'ragged' brushwork foreshadow the Impressionists, just as his 'tachisme' and the violence of his tones prefigure Fauve, Expressionist or even abstract painting. As an art critic and the author of an important *Journal* that is a literary masterpiece in its own right, Delacroix, in addition, made a lasting contribution to 19th-century culture. M.S.

Delaunay
Robert

French painter
b.Paris, 1885 – d.Montpellier, 1941

Robert Delaunay's artistic journey from Gauguin and Cézanne to abstraction, of which he was one of the pioneers, is one of the most representative in the history of contemporary art. Influenced to begin with by Impressionism, then by Gauguin's Breton paintings, Delaunay, in 1906, came strongly under the sway of the Post-Impressionists. But it was Cézanne who proved to be decisive in his artistic development, causing him to examine the problem of the non-coincidence of volume and colour (one of the key concerns of Cubism), which he solved in a very personal way, notably

▲ Eugène Delacroix
La Liberté guidant le peuple (1830)
Canvas. 260 cm × 325 cm
Paris, Musée du Louvre

in his famous *Self-Portrait* of 1909 (Paris, M.N.A.M.). His Cubism was highly original. Since 1906, he had surrounded the lightest of his motifs with a sort of luminous halo; in the series of *Saint-Séverin* (1909-10, New York, Guggenheim Museum; Philadelphia, Museum of Art; Minneapolis, Walker Art Centre; Stockholm, Nm), which opened his Cubist period, the light curves the lines of the pillars and cuts into those of the vault and floor.

This way of disintegrating the form was accentuated even more in the many paintings of the *Eiffel Tower* that Delaunay produced between 1909 and 1911 (New York, Guggenheim Museum; Basel Museum). Here he abandoned totally the traditional constructive apparatus of the painting; under the dissolving action of the light, which spreads from everywhere, the descriptive image is scattered into distinct fragments, obeying different – sometimes opposing – perspectives. The composition no longer consists in harmonizing the various figurative elements, but in achieving a synthesis of the juxtaposed formal elements, to which the relative independence of the details imparts a new feeling of mobility.

Delaunay soon became convinced that linear drawing stemmed from classical aesthetics and that any return to it must involve a fatal reversion to the descriptive spirit – something he denounced in the other Cubists whose analytical painting seemed to him 'painted with spiders' webs'. This was why, having once broken his line, he made himself abandon it completely. In the *Villes* (*Towns*) of 1910-11 (Paris, M.N.A.M.) he went back to the divided brushstroke of his Post-Impressionist period, which allowed him to delimit forms without using drawing. In his landscapes of Laon, painted at the beginning of 1912, he adopted an uncompromisingly chromatic technique (to which he adhered thereafter) in which form was indicated merely by the juxtaposition of coloured areas, and space by differences of tone, without any lines at all. The enormous painting *La Ville de Paris* (1909-12, Paris, M.N.A.M.) sums up and closes what Delaunay called his 'destructive period'.

Orphism.
It was in 1912, with the series of *Fenêtres* (*Windows*) (Grenoble Museum; Philadelphia, Museum of Art), that Delaunay put into effect his concept of painting which 'would technically have nothing but colour in it, contrasts of colours, but developing in time and seen all at once at a single movement'. No artist in France, even among the Fauves, had yet dared to make colour the sole object of painting. According to Delaunay, colour, before his time, had always been considered as colouring, whereas, for him, it sufficed in itself. From then on, it replaced all other pictorial means – drawing, volume, perspective, chiaroscuro – in his work. This did not imply that the end these means would allow him to reach had been totally abolished, but that Delaunay meant to reach it only through colour. It was colour that gave his work its revolutionary character, because, as he liked to say, in order to create a new expression, entirely new methods are needed. In the *Fenêtres* space was no longer shown by linear or aerial perspective, but by the contrast of colours which created a depth that was free from all use – even covert – of chiaroscuro.

With *Le Disque* (*Disc, First Non-Objective Painting*) (1912, Meriden, Connecticut, Burton G. Tremaine Coll.) and the series of *Formes circulaires* (*Circular Forms*) (1912-13, New York, M.O.M.A.;

Amsterdam, Stedelijk Museum), Delaunay discovered another quality in colour: its dynamic power. In other words he realized that by juxtaposing colours he obtained vibrations which were rapid or less rapid in proportion to the closeness, intensity and surface of the colours, and that he could thus create movements, control them as he liked, make them enter into the composition. What distinguished his dynamism from that of the Futurists was that it was not a description of movement, but a purely physical mobility of colours.

Equally personal was his idea of abstraction. His *Disque* and his *Formes circulaires* are entirely non-figurative works that place him among the pioneers of abstract painting; but their concept was never at all systematic. What was important in Delaunay's eyes, in fact, was not that the painting should be free of all visual reference to external reality, but that its technique should be 'anti-descriptive'. This was so in *L'Équipe de Cardiff* (*The Cardiff Team*) of 1912-13 (Paris, M.A.M. de la Ville) and the *Hommage à Blériot* of 1914 (Paris, M.N.A.M.; Grenoble Museum), in which the subjects are of subordinate importance, but the technique shows a clear progress in the mastery of colour. The contrasts are more expressive, and rhythms flow from them without need of continuity. In *Hommage à Blériot* the spiral rhythms of the *Formes circulaires* are transformed into discs, a formal arrangement that allows a better use of contrasts and a greater continuity in the expression of unity.

Sonia Delaunay.
The role played by Sonia Delaunay in the development of this new art should not be underestimated. First married to Wilhelm Uhde, she adopted, after her marriage to Robert Delaunay in 1910, under the double influence of Gauguin and Van Gogh, a Fauvism marked by extremely violent, dense colour that was typically Slavonic. While her husband was going through a period of relative austerity with regard to colour, she never ceased to remain faithful to pure colour, and her unwavering commitment to it was certainly not unconnected with her husband's decisive evolution in 1912, an evolution with which she was immediately and naturally associated. She applied the style to the design of fabrics, embroideries, book-binding and particularly clothes, but also painted several masterpieces, among them *Le Bal Bullier* (1913, Paris, M.N.A.M.) and *Prismes électriques* (*Electric Prisms*) (1914, Paris, M.N.A.M.), and sought passionately to synthesize poetry and painting with her illustrations for Blaise Cendrar's *Prose du Transsibérien* (1913, Paris, M.N.A.M.).

The Iberian and post-war period.
In Spain and Portugal, where the Delaunays spent the war years, Robert sought in particular to apply his new technique to the representation of the human body (*Femmes nues lisant* [*Naked Women Reading*]) and everyday objects (*Natures mortes portugaises* [*Portuguese Still Lifes*], Baltimore, Museum of Art; Paris, M.N.A.M.; Montpellier Museum), as well as deepening what he called 'dissonances', that is, the relationships between colours in rapid vibrations; while Sonia, in the same spirit, painted landscapes and still lifes.

Although it is marked by admirable works like the *Manège de cochons* (*Merry-go-round of Pigs*) (1922, Paris, M.N.A.M.), *L'Équipe de Cardiff* (1922-3, private coll.) and the series of *Coureurs* (*Runners*) (1924-30, private coll.), Delaunay's

production during the 1920s showed that he was passing through a phase of assimilation, sometimes of hesitation, during which he was perfecting his style rather than making further advances. It was, on the other hand, Sonia's great decorative period: between 1921 and 1933 she launched avant-garde fashion in Paris, notably after the Exposition Internationale des Arts Décoratifs in 1925, where the *Boutique Simultanée* she presented with the couturier Jacques Heim was internationally successful.

The second abstract period. It was in 1930 that Delaunay's second great creative period began. That year he attacked the problem of *Formes circulaires* once again (1930-1, New York, Guggenheim Museum; Zürich, Kunsthaus and Meyer Coll.; Paris, Gal. Louis Carré), bringing to it a perfected technique and increased dynamism. However, it was with the magnificent paintings of *Joie de vivre* (1930-1, Ottawa, N.G.; Paris, Sonia Delaunay Coll.) that he really found the solution he was seeking. Having stated that in the *Formes circulaires* 'the coloured elements contrast well, but are not closed', he found a formal arrangement that really allowed for a plastic limitation and concentration in the composition: discs. From then onwards, he was in total mastery of his craft and free to express himself as he understood it. Using colours in their 'giratory form', he painted *Rythmes* (*Rhythms*) (1930-7, Paris, M.N.A.M.; Grenoble Museum; Liège, Fernand Graindorge Coll.; Paris, Sonia Delaunay

Coll.), which have close analogies with the rhythms of music; *Rythmes sans fin* (*Endless Rhythms*) (1933-4, Paris, Sonia Delaunay Coll., M.N.A.M., Gal. Louis Carré), in which the rhythms give rise to other rhythms by interpenetrating one another on both sides of a central line; and *Rythmes-Hélices* (*Spiral Rhythms*) (1934-6, Paris, Sonia Delaunay Coll.), in which they develop in a deliberately spiral movement.

Towards a monumental art. Delaunay was the first to be aware of the monumental character of his works. In the winter of 1938-9 he expressed his belief that it was possible for one painting to lead to another and then to a third, thus creating a whole. 'This leads us to architecture. This type of painting, in fact, does not destroy architecture, because you can very well make it work upon a wall'. From 1930 he had begun to carry out his *Rythmes en relief* (*Rhythms in Relief*) (1930-6, Paris, Sonia Delaunay Coll.), which had led him to use and even create new materials, one of the properties of which was total resistance to the atmosphere. This property, and the fact that these reliefs always kept to a plan, seemed to imply that Delaunay would inevitably move over to monumental art.

When the organizers of the Exposition Universelle of 1937 asked him to decorate two buildings, they gave him the chance of realizing his dream of integrating his art into architecture. The huge panels and reliefs that he made in response to the commission were an entirely new departure for Delaunay, in which he broke through the narrow confines of easel painting to create a general synthesis of the plastic arts. This same monumental spirit is evident, too, in his last works, the large *Rythme circulaire* (*Circular Rhythm*) (1937, New York, Guggenheim Museum) and the three *Rythmes* of 1938 in the Musée National d'Art Moderne in Paris, which form a kind of spiritual testament. The illness of which he died three years later put an end to any further advance.

Together with his wife, Delaunay established the basis for a pictorial concept of art that was radically different from that which had reigned since the Renaissance. Their bold departure from traditional ways of thinking enabled them to give colour an absolute, polyvalent role. Through colour alone they managed to suggest a positive and original interpretation of space, one strictly linked to time, and with a physical dynamism in the material, that was wholly in accordance with its specific place in contemporary scientific thought. The Musée National d'Art Moderne in Paris has a room given over to Robert and Sonia Delaunay. Robert Delaunay is also represented in the Musée d'Art Moderne de la Ville de Paris, in the Museum of Modern Art in New York and in the Museum of Art in Philadelphia, as well as in most of the other great museums of modern art. G.H.

Delvaux
Paul
Belgian painter
b.Huy, 1897

Paul Delvaux attended the Academy in Brussels and visited France and Italy. From around 1925 he was exhibiting regularly, but it was not until 1936

that he began to develop a characteristic style of dreamlike townscapes and interiors peopled with women, sages and skeletons, and to pursue themes like the *Phases of the Moon*. His early works were unremarkable but pleasant impressionist paintings. After 1928 he introduced into his landscapes simplified male and female nudes after the style of Modigliani, and between 1930 and 1934 he went through an expressionist period, with paintings of fairs and village festivals, and mask-like portraits of women that testify to his interest in the work of James Ensor. It is remarkable that these works totally ignore the mainstream of European modernist paintings from Cubism onwards.

During the years 1934-5 Claude Spaak and E.L.T. Mesens introduced Delvaux to Surrealism, through work in galleries and in private collections. After an initial reaction of horror he was finally 'won over' by Magritte, who with de Chirico and Dali became his predominant influences. However, whereas de Chirico and Magritte subtly incorporated devices derived from collage, enabling them to manipulate and juxtapose objects remote from one another in scale and association, and yet at the same time paint in a very literal style, Delvaux still looked back to and considered himself within what he called 'the great tradition' of Renaissance painting. Unlike de Chirico, he did not use contradictory perspective to create an 'impossible' and disorientating space in his paintings.

Delvaux stayed on the periphery of the Surrealist movement, and did not participate directly in the activities of either the Belgian group (dominated by Magritte) or the French, remaining indifferent to their political and philosophical interests. He was included in the Paris International Exhibition of Surrealism in 1938, and in

1941 André Breton, the Surrealist leader, wrote of him in *Genèse et perspective artistique du surréalisme* (*Artistic Genesis and Perspective of Surrealism*): 'The sap of Surrealism rises too from the great roots of dream-life to nourish the paintings of Paul Delvaux.... Delvaux has turned the whole universe into a single realm in which one woman, always the same woman, reigns over the great suburbs of the heart ...'

Sleeping Venus was painted in 1944 while flying bombs were threatening Brussels – where Delvaux had stayed working in his studio throughout the German occupation. He remembers the last days of the war as being filled with a peculiar anxiety: 'It is my belief that, perhaps unconsciously, I have put into the subject of this picture a certain mysterious and tangible disquiet – the classical town with its temples lit by the moon, with, on the right, a strange building with horses' heads which I took from the old Royal Circus at Brussels, some figures in agitation with, as contrast, this calm sleeping Venus, watched over by a black dressmaker's dummy and a skeleton'. (Letter to the Tate Gallery, 31st May 1957.)

The nude attended by a skeleton appeared earlier in a strange canvas of 1932, also called *Sleeping Venus*. The skeleton, he later said, had terrified him as a child in the natural-history room at his school. The nude may go back through Ingres to Titian, but Delvaux owes the theme of eroticism and death to such northern artists as Hans Baldung, whose *Death and the Maiden* (1517) haunted him.

Delvaux clearly shares many of the Surrealists' preoccupations: the reintroduction of the poetic into painting, the exploration of the marvellous, techniques of disorientations. In *Les Vases Communicants* (*The Communicating Vessels*) (1932) Breton describes the 'inherent need of the dream

▲ Paul Delvaux
Sleeping Venus (1944)
Canvas. 173 cm × 200 cm
London, Tate Gallery

to *magnify* and to *dramatize* – to present in one of the most interesting theatrical forms what is in reality conceived and developed quite slowly ...', and discusses not only interpretation of dreams in a narrow Freudian sense but also – and this is crucial to an understanding of Delvaux's 'dream' pictures – the full and rich unconscious relationship between dreams, waking and sleeping, and man's imaginative powers. D.A.

Demuth
Charles
American painter
b.Lancaster, Pennsylvania, 1883 – d.Lancaster, 1935

Demuth came of a long-established family of German descent, prominent in the tobacco business. The family had been settled in America since well before the Revolution and by the late 19th century could be thought of as provincial gentry, sufficiently wealthy, not only to encourage the arts, but to participate in them. Charles's father, Ferdinand, was a serious amateur photographer and encouraged and supported his son in his artistic predilections. However, it was not until 1905 that Demuth enrolled in the Pennsylvania Academy of the Fine Arts.

He was well-to-do, a snob, and wholly absorbed with an image of *fin-de-siècle* art that embraced with enthusiasm flower painting, china painting and even needle-point. He wrote stories and plays that reveal his admiration for Oscar Wilde and he tried to model himself on a naïve idea of European decadence before he had any direct knowledge, for example, of French Symbolism in poetry or painting. The fact that he was sickly – a hip injury had made him permanently lame at the age of four – caused him to identify with Toulouse-Lautrec and to play all his life the role of a gifted amateur who had no need to support himself through his art. Thus, in effect, he remained a student at the Academy until he was 30, but with the difference that he was able to go to Paris for long periods of study, as he did in 1907-8 and in 1912-15.

It was only gradually that Demuth absorbed the influences that were to determine his mature style, for although he had ample opportunity to study the innovations of Fauvism and Cubism there is no evidence that these affected him until the arrival of Duchamp, Picabia and Gleizes in New York during the First World War. Then, overlapping and transparent planes began to appear in his watercolours, which were usually still lifes or studies of old houses. A trip to Bermuda in 1917, when Gleizes was working on the island, appears to have been decisive in formulating Demuth's delicate and intricate style. His figure pieces remained more anecdotal, often verging on caricature, but by 1918-19 these, too, took on the thin, flat, trembling look of obsessive pattern-making.

Just as Demuth had begun to achieve a personal style and a genuine knowledge of contemporary art and literature, stimulated by the circle of foreign artists in New York, by the American group around Stieglitz, and by his long-established friendship with the American poet William Carlos Williams, he fell seriously ill with diabetes. In 1922-3 he was obliged to seek treatment in a sanatorium. By now, urgency was added to an already mature style and, while some of the wit and fascination with low life disappeared from his watercolours, he began to paint the architectural-industrial landscapes such as *Aucassin and Nicolette* of 1922 that secured his fame.

In 1923-4 he started to produce the first of his homages to the artists and writers he admired, including works dedicated to Arthur Dove, Georgia O'Keeffe, Gertrude Stein and William Carlos Williams. They are apparently often arbitrary arrangements of letters, forms and occasionally realistic details, such as a pear, or leaves, or a mask. The greatest of these is the 1928 'poster portrait' (this is what Demuth called these: actually oil on composition board) *I Saw the Figure Five in Gold* (Homage to William Carlos Williams) (Metropolitan Museum). This work, whose title is a quotation from Williams, is based on the gold number '5' painted on the side of a brilliant red fire engine. In its organization of cornered diagonals and incorporation of fragments from street lights, letters and buildings titled into different perspective views, the work's debt to the Broadway Cubism (1915-17) of Albert Gleizes is clear, yet it succeeds in being a deeply personal, as well as public, statement about the impact of a modern poem.

Finally, *My Egypt* (1927, New York, Whitney Museum of American Art), like the earlier *Aucassin works,* plays on what for the public was an arcane comparison between Demuth's own Lancaster, Pennsylvania, and ancient Egyptian architecture, but for Demuth's coterie of informed friends was a moving and valid, even frightening, analogy. His popularity, as judged from participation in exhibitions and from favourable reviews, increased as his health continued to deteriorate. In October 1935 he died in his home town of the effects of diabetes.

Demuth is permanently identified as one of the major figures associated with Stieglitz's galleries of the 1920s, An American Place and The Intimate Gallery, which made a conscious effort to establish the independence of the first wave of American 20th-century modern art from its European sources. But more than that of Marin, O'Keeffe and Hartley, his work remains informed by the neurotic, even neurasthenic flavour he cultivated as a youth, because it conformed to his notions of what decadent, Symbolist European art represented at the turn of the century. D.R.

▲ Charles Demuth
Buildings, Lancaster (1930)
Composition board. 61 cm × 51 cm
New York, Whitney Museum of American Art.
Anonymous loan

Denis
Maurice

French painter
b.Granville, 1870 – d.St Germain-en-Laye, 1943

At the age of 17 Denis entered the Académie Julian to prepare for the École des Beaux Arts, and from October of the following year (1888) took part in the formation of the Nabis group. Paul Sérusier had just spent the summer in Brittany where, under Gauguin's direction, he had painted the famous landscape known as the *Talisman* (formerly in the Denis Coll.), and was now spreading Gauguin's aesthetic ideas among the group. However, it was left to Denis, who although the youngest was also the most thoughtful and literary-minded of the group, to publish the first Nabi manifesto, derived from the ideas of Pont-Aven: *Définition du Néo-Traditionnisme*. Published in the journal *Art et Critique* in August 1890, the statement contained one of the most famous definitions in modern painting: 'A painting, before it is a war-horse, a naked woman or an anecdote of some kind, is essentially a plane surface covered with colours assembled in a certain order.'

At this time Denis fully justified the nickname given to him by his friends, *le Nabi aux belles icônes*, because of the simplified and slightly archaic character of his painting. On the one hand, he was influenced less by Japanese art (as, for example, was Bonnard) than by the Italian Primitives, particularly Fra Angelico; on the other, he was drawn towards religious subjects and to exaltation of the Christian family: *Le Mystère catholique* (*The Catholic Mystery*) (1889, Switzerland, Poncet Coll.); *La Procession* (*Procession*) (1892, New York, Altschul Coll.); *Le Matin de Pâques* (*Easter Morning*) (1893, Rouen, private coll.), *Visite à l'accouchée* (*Visit to the Woman in Confinement*) (1895, Paris, private coll.); and *Les Pèlerins d'Emmaüs* (*The Pilgrims of Emmaus*) (1895, St Germain-en-Laye, Prieuré). He often used his wife as a model (*Marthe au piano*, 1891, St Germain-en-Laye, Prieuré) and his family (*Sinite Parvulos*, 1900, Neuss, Clemens Sels Museum). These intimate images, often tinged with tender humour, are some of the happiest in his whole work.

After flirting with Divisionism, Denis turned to a clear, unmodelled style, with sinuous rhythms that are reminiscent of Art Nouveau. At the same time he was producing illustrations in a Symbolist style for Verlaine's *Sagesse* (1889), Gide's *Le Voyage d'Urien* (30 lithographs, 1893) and the *Imitation of Christ* (115 woodcuts, published by Vollard in 1903), as well as his first large decorative panels, *Les Muses* (*The Muses*) (1893, Paris, M.N.A.M.). Visits to Italy (1895-8 and 1907) strengthened his admiration for the Renaissance, and led him to abandon the Nabi and Art Nouveau styles in favour of the classical tradition, evident after 1898, in such large decorative compositions as those of the Théâtre des Champs-Élysées (1910-13). In 1919, together with Rouault and Desvallières, he founded the Ateliers d'Art Sacré.

He was an excellent critic, whose interests may be gauged from the titles of his collected criticism: *From Symbolism and Gauguin towards a New Classical Order* (1912), *New Theories on Modern and*

Religious Art (1922), *Charms and Lessons from Italy* (1933), and *History of Religious Art* (1939). The three volumes of his journal were published in Paris between 1957 and 1959. The Musée National d'Art Moderne in Paris has several of his paintings, notably *Hommage à Cézanne* (1900).

Denis also executed numerous mural decorations in churches (the Chapelle de la Ste Croix at Vésinet; the Chapelle du Prieuré; the Church of St Louis at Vincennes; the Franciscan chapel in Rouen; the Chapelle de la Clarté at Perros-Guirec; the Church of the Sacré-Coeur at St Ouen; the Church of St Martin at Vienne; the Church of the St Esprit in Paris; the Monastery of Lapoutroie in Alsace; the Basilica of Thonon); in private houses; and in public buildings (Paris: Petit Palais, Sénat, Palais de Chaillot).

His last illustrations, to Claudel's *L'Annonce faite à Marie*, begun in 1926, were published in 1943.

A museum containing an important collection of his works, donated by his children, is to be organized at the Prieuré, in St Germain-en-Laye, where he lived and worked for a long time. F.C.

Derain
André

French painter
b.Chatou, 1880 – d.Chambourcy, 1954

Derain's parents, who were in trade, planned that he should become an engineer, but his vocation was discovered when he was very young. At the age of 19 he entered the Académie Carrière, where he concentrated on painting, encouraged by his friend Vlaminck, whom he met in 1900. Together, in the same year, they rented a studio in the Île de Chatou, which became one of the cradles of Fauvism. Dissimilar in temperament, the two young men soon went their separate ways, Vlaminck claiming that he was 'all instinct', while Derain's restless questioning nature drew him towards a more reflective approach and towards the art of the museums. It was at the Louvre, in fact, where he had gone to make copies, that he attracted the attention of Matisse by the freedom and forcefulness of his interpreta-

tions. A long period of military service from 1900 to 1904 curtailed his production, although he managed to keep up an interesting correspondence with Vlaminck.

In 1904 Matisse managed to persuade Derain's parents to allow their son to follow the profession of a painter and among the works that Derain produced that year the vigorous *Péniches au Pecq* (*Barges at Le Pecq*) (Paris, M.N.A.M.), with its pure, violent colours, is notable. Derain spent the summer of 1905 at Collioure with Matisse. His technique at this time, with its broad, square brushstrokes, is similar to that of Matisse, who had never wholly abandoned Divisionism, although he had not yet achieved Matisse's feeling for colour and authority.

Derain's landscapes were exhibited in the famous *cage aux fauves* in the next Autumn Salon (Collioure, Troyes, Pierre Lévy Coll.). Ambroise Vollard, to whom Matisse had introduced him, bought everything Derain produced and suggested that he should go to London where, in 1905 and 1906, he painted the famous pictures of Hyde Park and the flamboyant series of Thames-side paintings (St Tropez, Musée de l'Annonciade).

After 1907 the network of his friendships and influences changed: he left Chatou and Vlaminck, and settled in Montmartre, in the Rue de Tourlaque, near the Bateau-Lavoir and his new friends, Braque, Max Jacob, Apollinaire, Van Dongen and Picasso. Without sacrificing colour – from which he had drawn intense effects at Chatou, Collioure and London – he detached himself from it, as did Braque during the same period. Although he did not go so far as to adhere to Cubism, until about 1910 he structured his work more and more strongly, notably in his landscapes of Cassis (Troyes, Pierre Lévy Coll.) and in his *Baigneuses* (*Bathers*) (1908, Troyes, Pierre Lévy Coll.), probably influenced by Picasso's *Demoiselles d'Avignon*. *Le Pont de Cagnes* (*The Bridge at Cagnes*) (Washington, N.G.) and *Vue de Cadaqués* (*View of Cadaqués*) (1910, Basel Museum), on the other hand, suggest Cézanne. Other influences, too, appear in Derain's work at this time: 15th-century Italian and Flemish painting (*À travers la fenêtre* [*Window at Vers*], *c*.1912, New York, M.O.M.A.); popular imagery (*Le Chevalier X* [*The Knight X*], 1914, Hermitage); or medieval painting (*Les Buveurs* [*The Topers*], 1913, Tokyo, Kabutoya Museum).

▲ Maurice Denis
Les Pèlerins d'Emmaüs (1895)
Canvas. 177 cm × 278 cm
Prieuré, Saint Germain-en-Laye

During the 15 years following the war, which had not merely scattered the whole group of young painters but had reawakened nationalist, traditional feelings among critics and public, Derain was hailed as 'the greatest living French painter'. He was praised for his eclecticism, a characteristic dominant in his work, which today is counted against him. The culture he had acquired in the museums became more and more apparent in his technique and in his pictorial solutions: his nudes sometimes recall Courbet, sometimes Renoir; his landscapes sometimes echo Corot (*La Basilique de Saint-Maximin*, Paris, M.N.A.M.), sometimes the Barbizon School, or even Magnasco (*Les Bacchantes [The Bacchantes]*, 1954, Troyes, Pierre Lévy Coll.). His portraits, many of them brilliant, evoke – depending on the type of model – Byzantinism, Venice, Spanish painting or Ingres.

It was the art of the theatre that now inspired, either indirectly or directly, Derain's most personal work: his impressive *Pierrot et Arlequin* (*Pierrot and Harlequin*) (1924, Paris, Donation Walter Guillaume); or the sets and costumes for Diaghilev's *La Boutique fantasque* (1919), Satie's *Jack in the box* (1926), and *The Barber of Seville* (1953) for Aix-en-Provence.

Derain was also an excellent illustrator, generally using wood-engraving, a technique he had practised since 1906: *L'Enchanteur pourrissant* of Apollinaire (1909); *Les Oeuvres burlesques et mystiques du frère Matorel mort au couvent de Barcelone* of Max Jacob (1912); the *Mont-de-Piété* of André Breton (1916); and *Héliogabale* by Antonin Artaud (1934). Derain's return to traditional values after a brilliant Fauve period coincided with the creation of Cubism by his friends Braque and Picasso, and his rejection of it may have turned his ambitions in other directions.

Afterwards, his work showed, often brilliantly and convincingly, an infinitely gifted and intelligent artist, but one whose personal doubts,

need for points of reference and urge to create a new French classicism deliberately kept him swimming against the tide.

Derain is represented in most of the principle collections in Europe and the United States, as well as in many private collections, the most important of which is that of Pierre Lévy at Troyes.

F.C.

Dix
Otto

German painter
b.Untermhaus, 1891 – d.Hemmenhofen, 1969

After a period of apprenticeship with a decorator in Gera (1905-9), Dix studied at the School of Decorative Arts in Dresden from 1910 to 1914. His first works are in the German tradition of the 15th and 16th centuries, then, from 1914 to 1919, he was influenced by Die Brücke; and even more by Futurism. Like the other artists of his generation, he was profoundly marked by the war – he served on both the Russian and the Western fronts from 1914 to 1918, and recorded his experiences in some 600 drawings, watercolours and gouaches – then by the confused, violent political climate of Germany following the Armistice. The paintings of 1920 reflect this situation and are an amazing amalgam of Dadaist technique (collages: he took part in the great exhibition which was mounted at the Dada Club in Berlin in 1920) and of two-dimensional Expressionism (*The Barricade* and *The Wounded*, both disappeared; and *Mutilated Skat Players*, private coll.; the *Prague Street, Dresden*, Stuttgart, Staatsgal.; *Matchseller, I*, Stuttgart, Staatsgal.).

In the same year Dix's characteristic style emerged: essentially graphic, employing a cold, strident colour, in the line of the expressive, ambiguous tradition of the 16th century (Baldung,

Dürer, Cranach, Grünewald). He applied it to his treatment of contemporary themes: the evocation of a fantastic horror in *The Trench* (1920-3, disappeared after 1938); portraits full of presence (*Urologist-dermatologist Koch*, 1921, Cologne, W.R.M.; *Sylvia von Harden*, 1926, Paris, M.N.A.M.; *The Artist's Parents*, 1924, Hanover Museum); satire on the modern city (*The Great City*, 1927, Stuttgart, Gal. der Stadt); direct observation of ugly human situations (*Pregnant Woman*, 1930-1); and babies (*Holding a New-Born Infant*, 1927, private coll.).

His engraved work (first woodcut in 1913; fine series in wood in 1919: *The Cry*) culminated in the etchings carried out during the 1920s: the series of *Women* and *Circus Artistes* (1922) and, above all, 50 etchings of exceptional truth and intensity on the theme of *War* (1923-4; published in 1924 in Berlin, fully revealed in 1961). Dix used old techniques: distemper and glazing in painting, silverpoint in drawing; he produced a number of very beautiful drawings, including studies of his son Ursus as a baby, in 1927, and some very Dürer-like plants, nudes and landscapes. He was rightly considered the leader of the Neue Sachlichkeit movement (New Objectivity), which held its first exhibition in Mannheim in 1925.

After 1930 he somewhat abandoned this approach in favour of less astringent attitudes, even in dealing with the subject of *War* (four panels in Dresden, Gg, 1929-32). Increasingly, too, he borrowed from the old masters (including themes such as the Temptation of St Anthony, St Christopher and Vanity), producing paintings and silverpoints of nudes of a Cranach-like poetry, as well as landscapes, mainly in the form of drawings (*Ideal Landscape of Hegau*, 1934, Aachen, private coll.). From 1927 to 1933 he taught at the Academy in Dresden, and retired in 1936 to Hemmenhofen beside Lake Constance. After 1946 he practised a kind of late Expressionism that was more supple and pictorial.

Dix left the most remarkable representation of pre-Nazi German society. This vision, at once impartial, uncommitted and sometimes almost unbearably truthful, has been better understood in his figurative paintings than in the subjective abstractions of the years 1945-60. It is significant that Dix, like Bacon later, often referred to the philosophy of Nietzsche. He is represented mainly in the German galleries, as well as in New York (M.O.M.A.).

M.A.S.

▲ André Derain
Pont sur la Tamise (1906)
Canvas. 81 cm × 100 cm
St Tropez, Musée de l'Annonciade

Otto Dix ▲
Matchseller I (1920)
Canvas. 141 cm × 166 cm
Stuttgart, Staatsgalerie

Dolci
Carlo

Italian painter
b.Florence, 1616 – d.Florence, 1686

Dolci's first works, painted when he was very young, in about 1632, were portraits in a naturalistic vein, followed, under the influence of his master, Jacopo Vignali (*Fra Ainolfo dei Bardi*, Florence, Pitti), by a religious painting that contains a strong element of pathos. In these early works Dolci seems to have been torn between vaguely naturalistic ideas and the memory of the 'ideal beauty' of the Tuscan 16th century. The copies and reworkings of his paintings are mainly of the works from this period, evidence of their popularity. He also produced paintings that display a facile, conventional piety (*St Andrew Adoring his Cross*, 1646, Florence, Pitti).

About 1650 Dolci turned to a new manner, compact and brilliant, full of a subtlety and precision that reflect the Dutch and Flemish taste introduced to the Tuscan court by artists like Van Mieris. Although Dolci continued to paint mainly religious subjects, often featuring figures of saints in a condition of ecstasy, he began to emphasize the details of decor, furniture, and fabrics, often achieving very fine effects of figurative animation, reinforced by a delicate use of colour (*St Cecilia*, Hermitage; *Salome*, Glasgow, Art Gal.; Dresden, Gg; *The Vision of St Louis of Toulouse*, Florence, Pitti). Although he was forced to make concessions to the piety of his customers – among them the Grand Duke Cosimo III – who provided him with substantial earnings, his vitality and originality were nevertheless remarkable. After about 1675, however, his melancholy nature led him to turn in on himself and he painted very little more. E.B.

Domenichino
(Domenico Zampieri)

Italian painter
b.Bologna, 1581 – d.Naples, 1641

After a short apprenticeship with the Mannerist painter Denis Calvaert, who influenced him strongly, Domenichino entered the school run by the Carracci, where he soon distinguished himself as an extraordinarily gifted decorator. He worked with the Carracci on the decoration of the Oratory of S. Colombano (*The Entombment*). In 1602 he went to Rome to study in the classicizing circles dominated by Annibale Carracci, and collaborated with him on many works (Palazzo Farnese: *Girl with Unicorn*, *Narcissus*).

Although he quickly settled into a monumental style of painting, on lofty themes, Domenichino also, throughout his life, made landscape paintings, mostly small canvases that reveal a freshness of observation and a profound feeling for the beauty of nature. These works, which are hard to date, are also echoed, throughout his career, by the landscape backgrounds of many altarpieces. The finest examples of landscapes are *The Ford* (Rome, Gal. Doria-Pamphili), *St Jerome* (Glasgow, Art Gal.), *The Baptism* (Cambridge, Fitz-william Museum), the two *Histories of Hercules*, *The Flight into Egypt* and *Hermione with the Shepherds* (all four in the Louvre).

Domenichino's first major success, a fresco depicting the *Flagellation of St Andrew*, in the oratory of S. Andrea in the Church of S. Gregorio al Cielo, was painted in 1608 (in competition with Guido Reni, who was decorating the opposite wall). His two masterpieces followed: the fresco decoration of the St Nilus chapel in the Abbey of Grottaferrata (Lazio), and that of the Polet chapel, dedicated to St Cecilia, in the Church of S. Luigi dei Francesi, Rome.

Before painting the *Life of St Cecilia* (1614), he had started an altarpiece showing the *Last Communion of St Jerome* (Vatican). This work is full of brilliant colour, which was unusual for Domenichino, who, except in his landscapes, generally adhered to the classical norms derived from antiquity and the art of Raphael. This same pictorial strength, which is characteristic of this particular phase in his development, reappears in the two large frescoes of S. Luigi dei Francesi. Within the framework of an arrangement based upon the famous models of Raphael, the paintings contain fine naturalistic observation that bears witness to the fact that Domenichino was closer to life and to reality than to ideal images based on the theories of beauty that he himself had developed.

In the years that followed Domenichino gave himself over to a rigid classicism that involved him in an over-intellectual view of the past and the stifling of his own more original inspiration. The mythological frescoes of the Villa Aldobrandini in Frascati (1615-16, London, N.G.), *The Hunt of Diana* (1616, Rome, Gal. Borghese) and the frescoes in the vault of the choir of S. Andrea della Valle (*Scenes from the Life of St Andrew*, 1622-7) show him at his best, creatively, inspired by the poetic ideas of ideal beauty. But during this same period he produced many other works that cannot be set on the same level and that also reflect an incurable crisis.

He stayed in Fano for a while, then for a longer period in Bologna, and eventually went to Rome where Pope Gregory XV named him pontifical architect in 1621 and obtained for him the commission for the decoration of S. Andrea della Valle. Gregory XV's early death and the rise of more modern painters, such as Lanfranco and Pietro da Cortona, left Domenichino, who had nevertheless produced some of the most important works of his time, very much isolated in Rome, and little appreciated. He left and went to Naples where he settled in 1630 after accepting a commission to decorate the chapel of S. Gennaro in the Cathedral. After an unhappy time, both personally and artistically, he died, having failed to complete the work or establish himself in the artistic life of the city. E.B.

Domenico Veneziano
(Domenico di Bartolomeo)

Italian painter
b.Venice (?), 1405(?) – d.Florence, 1461

Domenico Veneziano is first mentioned in 1438, when he was painting a room in the Palazzo Baglioni in Perugia (no longer extant) and wrote to Piero de' Medici to ask if he might work in

▲ Carlo Dolci
Salome
Canvas. 95 cm × 80 cm
Dresden, Gemäldegalerie

▲ Domenichino
The Flight into Egypt
Canvas. 165 cm × 212 cm
Paris, Musée du Louvre

Florence. We know nothing about him before that date, and the problem of his training and early years has been much discussed. Domenico addressed Piero de' Medici in a tone that was at once deferential and familiar, as if he had already met him, and he also revealed a very good knowledge of Florentine painting at the time. He knew, for instance, that Filippo Lippi was then busy painting the *Barbadori Altarpiece* (Louvre) and that Fra Angelico had had many commissions, and he hoped that Cosimo de' Medici would commission him to paint an altarpiece.

It has been suggested that Domenico may have known the Medici in Venice (where Cosimo had stayed during his exile in 1433-4), and that news of the activity of Florence may have reached Umbria where Fra Angelico's altarpiece was set up in the Church of S. Domenico in Perugia in 1437. But it has also been said that the artist may have made the acquaintance of the Medici in Florence itself, an idea that appears to be borne out by the fact that Domenico's earliest-known work, the tondo of the *Adoration of the Magi* (*c*.1435, Berlin-Dahlem), certainly came from Florence, and reveals, perfectly integrated with each other, the fairy-tale world of International Gothic and the new construction in perspective of the Renaissance.

Domenico could have acquired the Gothic elements of this style in Venice, where the tradition was still alive, and where Pisanello had painted his frescoes in the Doge's Palace in 1419; but the sureness with which meadows and mountains, roads and castles, are arranged in depth in this tondo, according to the rules of perspective, and the way the figures are situated in space, cannot be explained unless Domenico had had direct knowledge of Florentine experiments, through the work of Fra Angelico.

Another hypothesis about Domenico Veneziano's early years suggests that he was in Rome before 1438, and was close to Masolino, who was then painting frescoes in the Church of S. Clemente and from whom he learned his tender, luminous use of colour. In contrast, another theory sees the Berlin tondo as a fairly late work, a partial return to Gothic forms after the bare and strict perspective of the *Tabernacle of the Carnesecchi* (London, N.G.) and the sculptural qualities of the *Virgin* in Bucharest Museum.

Only a few surviving works can be attributed with certainty to Domenico, the two documented and dated cycles of frescoes, in Perugia and in the Church of S. Egidio in Florence (where they were started a year after his letter to Piero de' Medici), having been destroyed. There remain the *Tabernacle of the Carnesecchi* (already mentioned, which is signed, as is the *Virgin and Child*), the versions of the *Virgin and Child* in Settignano (Berenson Coll.) and Washington (N.G.), and the signed altarpiece painted for the Church of S. Lucia dei Magnoli (Uffizi; *The Virgin and Child with Sts Francis, John the Baptist, Zenobius and Lucy*) which are the most important products of his time in Florence. The predella of this altarpiece is today divided between the National Gallery in Washington (*Stigmatization of St Francis, St John in the Desert*) the Fitzwilliam Museum in Cambridge (*Annunciation, Miracle of St Zenobius*) and Berlin-Dahlem (*Martyrdom of St Lucy*). One of his last works is the fresco representing *Sts Francis and John the Baptist*, taken from the walls of Santa Croce in Florence (now in the museum of the same church).

Domenico Veneziano was not very well known in Florence because he appeared there at the time in which painting, with Filippo Lippi and Andrea del Castagno, was concentrating increasingly on graphic tension and a bold line at the expense of the effects of colour that were Domenico's primary concern. In the altarpiece of S. Lucia de Magnoli, for instance, and the panels of its predella, the architecture is a marquetry of green, pink and white, and the figures are zones of red, grey and sky-blue: the line which defines them is merely the edge of the patches of colour. There is no doubt, however, that Domenico was influenced in his later years by the Florentine atmosphere after 1450, as is revealed, for example, in his fresco in Santa Croce of *Sts Francis and John the Baptist*, in which the drawing seems sharper and more clearly defined.

Thus, although he was one of the outstanding personalities of his time, his influence upon the mainstream of Florentine art, exemplified by Filippo Lippi and Andrea del Castagno, was less marked than upon the work of more modest painters, such as Giovanni di Francesco and Baldovinetti (although, in his first frescoes for the Church of S. Apollonia, Andrea seems touched by the luminous world of Domenico). His presence in Perugia, on the other hand, was a major influence in the work of artists like Boccati, Bonfigli and the young Perugino. However, his greatest follower was undoubtedly Piero della Francesca, whose radiant purity of colour is derived from Domenico.

Domenico Veneziano died a poor man, in 1461. Vasari's claim that he was murdered by Andrea del Castagno, who was jealous of his gifts, has no basis in fact, since Andrea died of the plague four years before Domenico. By its very excess, however, the legend reveals the lack of understanding of Domenico as a man and an artist in the Florence of his day.　　　　M.B.

▲ Domenico Veneziano
Annunciation (panel from the predella of the Altarpiece of
S. Lucia de' Mognoli)
Wood. 27 cm × 54 cm
Cambridge, Fitzwilliam Museum

Cosmas and Damian, Rome, Gal. Borghese). But he continued to paint allegorical and mythological compositions that gave a great deal of scope for imaginary landscapes (*Apollo and Daphne*, Rome, Gal. Borghese; *Circe*, Washington, N.G.; *Diana and Callisto*, Rome, Gal. Borghese). He visited Pesaro in 1537-8, where he painted exquisite decorations in the Camera delle Cariatide of the Villa Imperiale. In his final years he painted little, and is last mentioned in Venice in 1542.

With Parmigianino, Dosso dominated Emilian Mannerist painting. Girolamo da Carpi and Niccolò dell' Abbate were the two greatest beneficiaries of this double influence. At Cremona younger landscape painters such as the Campi brothers, Camillo Boccaccino and Sofonisba Anguissola were influenced by him, and even Giulio Romano was affected by his imaginary landscapes. C.M.G.

Dosso Dossi
(Giovanni di Luteo)
Italian painter
b.Ferrara, c.1489 – d.Ferrara, 1542

Mentioned by Ariosto in his *Orlando Furioso*, Dosso between 1522 and 1540 held a high position at the court of Ferrara under Alfonso I and Ercole II d'Este. According to Vasari, he received his first teaching from Costa, the most eminent artist in Emilia around 1500; but quite soon, after several visits to Venice, he became a disciple of Giorgione, together with Palma Vecchio and Titian, with whom he visited Mantua in 1519 and admired Mantegna's paintings for the Studiolo of Isabella d'Este. During this period Dosso was attempting to sever his connections with Emilia and to assimilate Venetian art; in their chiaroscuro and dynamic composition his *Sacred Conversations* (Philadelphia, Museum of Art, Johnson Coll.; Rome, Gal. Capitolina) are comparable with equivalent works by Titian and Cariani. Dosso's more eclectic *Bacchanal* at Castel Sant'Angelo in Rome contains references to classical antiquity, and to his Roman models, Michelangelo and Raphael.

Dosso used greens and golds in a particularly individual way. His imaginative fantasy appears in his many paintings of mythological themes such as his *Melissa* (Rome, Gal. Borghese), *The Departure of the Argonauts*, (Washington, N.G.), the *Scenes from the Aeneid* (Ottawa, N.G.; Birmingham, Barber Inst. of Arts) and *Jupiter and Mercury* (Vienna, K.M.), which reveal a poetry akin to that of Giorgione.

After 1522 and the *Madonna with St George and St Michael* – his first fully documented work, painted for the high altar of Modena Cathedral (Pin. Estense) – Dosso moved away from Titian and allowed a lyrical feeling for nature and a very personal sense of fantasy to enter his work; at the same time he adopted a broader style that reflects the influence of Roman taste. A *St Jerome* (Vienna, K.M.) is the only signed work. New ways of arranging forms in space and a study of the effects of texture are evident in his portraits, painted with a direct realism (*Portrait of a Man*, Louvre). He was equally distinguished as a painter of frescoes, notably those in the Palace of Trento (1532, Camera del Camin Nero) – where he was inspired by the sibyls in the Sistine Chapel – and those commissioned by Ercole II in the villas around Ferrara, such as the Belvedere and the Belriguardo. In 1530-1 he finished the large polyptych of *St Andrew* in Ferrara, left by Garofalo (P.N.)

The last phase of Dosso's activity opened with a large *Immaculate Conception*, painted for Modena in 1532 (destroyed in Dresden during the Second World War). Evidence of the Mannerism that was spreading throughout central Italy began to appear in his work: his colours became darker and the metaphysical content of his pictures, which were filled with strange figures, was intensified (*Sts*

Dou
Gerrit
Dutch painter
b.Leiden, 1613 – d.Leiden, 1675

The son of a glass-painter who lived close to Rembrandt in Leiden, Dou entered Rembrandt's studio at the age of 15, remaining there until 1631-2, when the master left for Amsterdam. Like Joris van Vliet, Rembrandt's other pupil during his time in Leiden, Dou was entirely dominated in his early work by the teaching of his master, of whose works he made, quite literally, pastiches. He used the same models and adopted the same poses. He also painted Rembrandt's father, often in the guise of a warrior, an oriental or an astronomer (Kassel Museum; Hermitage), Rembrandt's mother, frequently shown reading the Bible (Kassel Museum; Rijksmuseum; Berlin-Dahlem; Dresden, Gg; Louvre), and Rembrandt himself at work (*Portrait of Rembrandt at his Easel*, Boston, M.F.A.), as well as pictures of hermits at prayer (Munich, Alte Pin.; Dresden, Gg; London, Wallace Coll.; Rijksmuseum). The paintings are notable for their sombre colours, their sober and realistic, precise technique, and the fluency with which details and accessories are handled.

Once Rembrandt had left, Dou soon acquired a style of his own, gradually abandoning portraiture for genre painting, to which he brought an increasing meticulousness that established his reputation. As early as 1641 the Swedish diplomat Spiering provided him with a large annual income on condition Dou gave him first choice of his works. In 1648 Dou entered the Guild of St Luke in Leiden; in 1660 the States of Holland bought three of his paintings (one of which, *The Young Mother*, is in the Mauritshuis) as a gift for Charles II when he was staying at The Hague.

Apart from the complimentary things written by his contemporaries, who compared him with Zeuxis and Parrhasius, one of the most interesting signs of Dou's success was the permanent exhibition of 29 of his paintings, belonging to the famous collector Johan de Bye, which was opened in 1665 in the house of the painter Hannot. This constitutes one of the very first exhibitions, in the modern sense of the word. The pictures on view included some of Dou's most famous, such as *Woman with Dropsy* and *The Trumpet Player*

▲ Dosso Dossi
The Departure of the Argonauts
Canvas. 60 cm × 88 cm
Washington, D.C., National Gallery of Art

▲ Gerrit Dou
The Trumpet Player
Wood. 37 cm × 29 cm
Paris, Musée du Louvre

(Louvre), *Boy and Girl in a Wine Cellar* (Dresden, Gg), and *The Night School* (Rijksmuseum). Dou's works commanded extraordinarily high prices, both in his lifetime and above all in the 18th and 19th centuries.

During his second period Dou moved a long way from Rembrandt: his colours became brighter and his technique progressively smoother and more exact – which led, undeniably, to a coldness that detracted from a number of his paintings. He used, with remarkable success, a motif originally taken from Rembrandt, but which he now enjoyed solely as a pretext for *trompe l'oeil*: this was the niche.

In Dou's work the niche usually contains a woman busy with some household task, or sometimes a doctor. These were excuses for variations on detailed still-life studies, in which the true genius of Dou is perhaps best revealed (the shutters in *Woman with Dropsy* or *The Trumpet Player*; and in *Boy and Girl in a Wine Cellar*); he had an exceptional gift for still life, but one that he rarely cultivated for its own sake. Among innumerable examples of these peasant-women, seen in half-figures, with their very sophisticatedly rustic air – characteristic of the preciosity of the time – are those in Vienna (K.M.), London, (Buckingham Palace and N.G.), Cambridge, Turin, the Louvre, and Schwerin. Dou's other speciality – although one that seems rather odd in the context of a purely artificial virtuosity – was the chiaroscuro effects of candlelight. The most famous of such works remains *The Night School*, but other good examples of his use of chiaroscuro are to be found in the museums of Dresden (*Girl Gathering Grapes*), Munich, Leiden (*The Astronomer*), Brussels (*Portrait of the Artist Drawing*) and Cologne.

With its smooth, cold execution, its overworked illusionism and somewhat dull rustic genre, the whole of Dou's work bears within it the seeds of the decadence from which Dutch painting was to suffer at the end of the 17th century and throughout the 18th. In spite of this, he was an important figure during his day, as the large number of his pupils and imitators bears witness: they include Metsu and Frans van Mieris I, the most gifted, then, after 1660, P. van Slingeland, G. Schalcken, Dominicus van Tol, who was Dou's nephew, B. Maton, M. Naiveu and Karel de Moor. Besides these, others like A. van Gaesbeeck, Q. van Brekelenkam, J. van Staveren, J. van Spreeuwen, Pieter Leermans and Abraham de Pape all profited from the advice and help, if not the actual teaching, of Dou. The glory of founding the Leiden school of 'fine' painters is all his.

At one time he was overpraised; today he seems likely to be unjustly neglected. We can still respect the amazing qualities of execution in the *Woman with Dropsy*, and take pleasure in a perfect technique that finds its own poetry while remaining intelligent and measured, as in the *Young Mother* at the Mauritshuis. J.F.

Doughty
Thomas
American painter
b.Philadelphia, 1793 – d.New York, 1856

Thomas Doughty was one of the earliest, if not the first of American landscape artists to achieve an international reputation. Although Philadelphia, of all American cities at the beginning of the 19th century, offered the most organized programme for the study of the fine arts, Doughty began his adult life in the leather business. As a painter he was almost wholly self-taught and he did not begin to work seriously until he was almost 30 years old, in about 1823. He quickly developed a reputation for his paintings of quiet river and mountain scenery, and was as rapidly rewarded with membership of the Pennsylvania Academy (1824) and honorary membership of the new National Academy in New York (1827). Identified with a reverential, humble attitude before nature, what Doughty learned of high art before his first trip to England in 1837-8 came from the copies he made of old-master paintings in Robert Gilmor's private collection.

In 1828 Doughty was drawn to Boston where he received many commissions to do verist portraits of lands and estates, and occasional imaginary Italianate scenes. His view of the *Mill Pond and Mills, Lowell, Massachusetts* (c.1833, Cambridge, Massachusetts, Harvard Business School) is such a work, showing the desired harmonious interaction between the newly created industrial town and its natural setting, the first clearly not violating the second. By the mid-1830s William Dunlap, the first American historian of native art, regarded Doughty as without peer in the new field of landscape painting. His best-known works, almost all rural scenes, had already been reproduced (1830-4) in the *Cabinet of Natural History* and *American Rural Sports*. As these lithographed subjects indicate, Doughty did not altogether eliminate anecdotal interest, but he reduced the prominence of figures, and let action take a back seat to setting. He blurred the traditional genres of painting, that is the subject categories, at first perhaps from ignorance, but after 1830, deliberately. He worked from nature, but nature was carefully arranged, increasingly so after his European trips, the second of which took place in 1845-6.

Doughty may be said to have paved the way for the English-born Thomas Cole (who arrived in the United States only in 1818) and may be regarded therefore as the native-born founder of the Hudson River School. Indeed, he lived at Newburgh, New York, in the Hudson Valley in 1839-40, but did not hesitate to visit the most remote places in the eastern United States if they promised picturesque views. Thus, he painted the *Mount Desert Lighthouse* (1847, Newark Museum), off the coast of Maine, again anticipating Cole.

In his later works Doughty increasingly moved toward the highly constructed and imaginative landscape, even at the expense of the realistic depictions of a particular scene. Thus, he was actually criticized by the same collector, Robert Gilmor, whose European pictures he had studied so carefully around 1820, for failing to represent nature truthfully. But, by contrast with that of his followers, Doughty's work remained unmannered and retained to the end a homespun quality. At the time of his death he saw triumph the taste he had helped to inaugurate. D.R.

Drysdale
Russell
Australian painter
b.Bognor Regis, Sussex, 1912 – d.Sydney, 1981

Drysdale's depiction of the outback of Australia, where the white man appears to exist precariously and transiently in the vast expanses and the black man becomes part of the topography, has, with the passage of time, attained almost mythic status. The speed with which the urban life-style

▲ Thomas Doughty
Field and Stream
Wadsworth Atheneum, Hartford Connecticut, The Ella
Gallup Sumner and Mary Catlin Sumner Collection

sion to his interpretation by turning to the aborigines as subjects. For him, their relationship with the land was one of deeper interdependence and understanding. Although his style changed gradually over these years his preoccupation was never with style as such, but always with finding the most appropriate means of realizing his subject. This concern with expressing his vision of the outback continued to be the focus of his work. L.C.

Dubuffet
Jean
French painter
b.Le Havre, 1901 – d.Paris, 1985

Dubuffet was born into a family of wine-merchants and attended the lycée in Le Havre, where he became enthusiastic about drawing, then, in 1916, enrolled at the school of fine arts. In 1918 he went to the Académie Julian in Paris for six months, but then decided to work alone. Equally interested in literature, music, and foreign languages, he was at this time feeling his way. He became convinced that Western art was dying from too high a degree of self-consciousness: post-war painting was, in fact, a reaction against the revolution that had taken place in the early years of the century. From 1925 he therefore decided to devote himself to commerce, settling at Bercy in 1930 and returning to painting only in 1933. Two years later, looking for a new means of expression, he sculpted marionettes and made life-masks. In 1937 he gave up painting for a second time, and it was only five years later that he finally took it up as a career. His early works, from 1926 to 1936 (drawings, portraits, various studies), are notable for their incisive graphic technique and a sharp feeling for character.

From the time of his first exhibition at the Galerie Drouin, this self-taught artist in his forties was to renew the figurative vocabulary of painting simply by looking at the spectacle of life with a new eye, bringing to it an unexpected, barbaric candour (*Mirobolus, Macadam et Cie, Hautes Pâtes*). His views of the Paris Metro (the *Dessous de la capitale* [*The Capital's Underground*] pictures), his portraits (1947) and his nudes (*Corps de dames* [*Women's Bodies*], 1950) in turn outraged and antagonized nearly all the critics, because of the fierce destructive spirit vented in them, although, paradoxically, the image itself kept wholeness and exactness, in a very high state of tension (*Fautrier araignée au front*, 1947, New York, private coll.; *L'Oursonne* 1950, private coll.).

All these works were executed in brown, earthy colours, except for those painted in the Sahara (which Dubuffet visited three times between 1947 and 1949, notably El Golea), which were violently coloured. This kind of painting also called for new techniques and Dubuffet turned to unexpected materials, including even grit and grease, as well as mixing different media, such as oil paint and lacquer, in his search for effective combinations. His liking for natural textures (old walls, ruts in the road, rust) led him to compose strange mental landscapes, or pure 'texturologies', dense, monochrome works with an intense closeness to the materials used (*Sols et terrains* [*Soil and Ground*], 1952; *Pâtes battues* [*Beaten Paste*], 1953), on which rudimentary signs were impressed, the marks of a human presence. The moving *Petites*

in Australia has developed over the past 40 years meant that Drysdale's world was no longer part of the national cultural heritage through direct experience but was imbibed through the work of writers, poets and artists. Drysdale himself, however, stood apart from this romanticizing current, for his vision was based on personal knowledge of this world, acquired during childhood. Unlike many of his generation, who spent part of their youth moving between Australia and England, Drysdale was not torn between a dual allegiance to two cultures but found his most profound experiences in the rural life of the Riverina and Queensland. Subjects from this background form the basis of his mature work.

After studying under George Bell in Melbourne between 1935 and 1937, during which time he received a sound technical training as well as developing a method of drawing that relied more on memory than on working directly from the model, Drysdale left for Paris where he immersed himself in current styles, especially those of the School of Paris. Upon his return to Australia following the outbreak of war, he quickly discarded these borrowed idioms when

he discovered the type of subject matter most meaningful to him. His first mature works, such as *Moody's Pub* (1941), date from this time. Characteristically, he isolates his figures beyond the confines of the canvas. Sometimes a few trees or buildings clustering protectively together interrupt these horizontal expanses. The figures stand stoically, passive in the face of the timeless, even ominous presence of the earth.

Drysdale's tendency to avoid anecdotal narrative, together with his method of working in the studio away from the subject, allowed him to simplify his composition to its essential ingredients. Figures are held in tension with the landscape, they never become merely a means of enlivening the panoramic scene; on the other hand, the setting is never reduced to a mere backdrop. Through this careful balancing of the two distinct components Drysdale expresses his sense of the way in which man and nature come together in this milieu. Drysdale's themes are therefore not concerned simply with the isolation or alienation of man, but with a more complex interaction between man and his environment.

In the 1950s Drysdale added a further dimen-

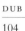 Russell Drysdale
Snake Bay at Night
Hobart, Tasmanian Museum and Art Gallery

Statues de la vie précaire (Little Images of a Precarious Life) (1954) – in which clinkers, pieces of sponge and old newspapers are used – reveal a similar search, as do the collections of imprints (starting with Petits Tableaux d'ailes de papillons [Little Pictures of Butterflies' Wings], in 1953). In these Dubuffet, in his own words, is making a celebration of the wild, ancient fossilized remains of the past.

A stay in the Auvergne in the summer of 1954 set off a series of studies of cows, in which the reassuring placidity inherent in the subject gave way to a grotesque, disquieting turbulence (La Belle Fessue [Beautiful Buttocks], United States, private coll.). After going in for lithography (Phénomènes [Phenomena], 1958), Dubuffet took up the theme of beards, depicting them in their various forms wth touching nostalgia (Fleur de barbe [Bearded Flower], drawings in Chinese ink, 1960; gouaches and paintings entitled As-tu cueilli la fleur de barbe? [Have you picked the bearded Flower?])

Side by side with these cheerful, somewhat disconcerting works, Dubuffet's exhibitions of art brut (the first of which was held in Paris in 1949) showed, if not the sources, at least the means of expression which he kept to: the drawing of a child who failed to realize he was drawing for the edification of the grown-ups, anonymous graffiti on leprous walls, the burlesque or obscene scribbles on the partitions of public urinals, or in the changing rooms of public baths – revealing all kinds of searing, corroded longings – the authentic, ingenuous work of the involuntary artist; the work, too, of lunatics of all kinds. It is significant that Dubuffet should have been pledged to these works, whose authors reveal a spirited wild state in their way of looking at things, a state splendidly defined by André Breton in 1928.

After 1962 Dubuffet exhibited his cycle of L'Hourloupe several times (1967, Paris, Gal. Claude Bernard and Gal. Jeanne Bûcher; 1971, Gal. Jeanne Bûcher). In this he arranged his forms in a seemingly more rational way than he had done so far, with the expressiveness replaced by a complex imagery, a dappled puzzle made up of largely everyday motifs (staircases, coffee-pots, people with dogs, bicycles: Bicyclette 2, 1972, private coll.). Dubuffet then turned the same aesthetic methods to architectural plans, deliberately breaking with rationalism (always more or less demanded in this discipline), and to sculptures made in polyester (Bidon l'Esbroufe, 1967, New York, Guggenheim Museum), in epoxy resin, and in sheet iron painted in polyurethane (Don Coucoubazar, 1972-3, Paris, Gal. Jeanne Bucher).

Dubuffet was a lively, poetic writer whose Mémoire pour le développement de mes travaux à partir de 1952 (in Rétrospective Jean Dubuffet, Paris, 1960–1) is the best commentary on his own method. His entire work was a coherent development of the aesthetic of the creative find, which, from Picasso to some of the Surrealists (Ernst, Masson), has been the most fruitful in the art of the 20th century; a lucid questioning approach that suddenly, to the artist's own amazement, comes upon virgin soil. Dubuffet himself said that he was always suspended between the most wretched, dirty daub and the small miracle.

The Musée des Arts Décoratifs in Paris in 1967 received an important donation from the artist. His book, Asphyxiante Culture, was published the following year. Between 1960 and 1962, with

Asger Jorn, Dubuffet made musical recordings, compositions using classical, exotic and primitive instruments. M.A.S.

Duccio di Buoninsegna

Italian painter
b.Siena,c.1260–d.Siena,1318/19

Duccio is first mentioned in documents dating from 1278 that concern the decoration of twelve strong-boxes for the town council; the following year he was paid for painting a cover for the Biccherna. But these documents tell us nothing about the early training of a man who, only a few years later, was to prove his very high level of culture and the prestige he enjoyed when he was given the Rucellai Madonna to paint for the confraternity of the Laudesi at the Church of S. Maria Novella in Florence. This masterly work (now in the Uffizi), which has only the most slender connection with the old Byzantine-oriented art of Siena, inaugurated a new tradition in Sienese painting, if not in that of Florence, which at this time was dominated by the art of Cimabue. It was, in fact, Duccio's contact with the work of the Florentine master that seems to have inspired him to break away from the archaic 13th-century Sienese traditions.

In order to construct a plausible hypothesis about Duccio's mysterious beginnings, some historians have suggested that he came at a time of flux in Italian dugento painting when one finds both the Byzantine-influenced expressive art of Coppo di Marcovaldo (who was in Siena in 1261) and the first reflections of the art of Cimabue prior to the frescoes in the Upper Church of S. Francesco, Assisi. Certain works (a Crucifix, Florence, Palazzo Vecchio and Carmine) have

been attributed speculatively to Duccio in the period around 1280.

As evidence of Duccio's relationship with Cimabue, other authorities have also recognized his presence among the painters who, probably under Cimabue's direction, executed the Scenes from the Old Testament in the Upper Church of S. Francesco, Assisi. The remains of the Crucifixion and one of the figures of Angels in the transept are the parts that seem to support this identification most convincingly, which, on the chronological level, seems most plausible if these works are taken to have been painted by Duccio before 1285, the date of the Rucellai Madonna.

A possibly earlier work is the Madonna and Child, previously at Crevole (Siena, Opera del Duomo), also attributed to Duccio. It is a sad image of great nobility, in which the influence of Cimabue is still mingled with Byzantine features. These same ideas survive, although less obviously, in the Rucellai Madonna, where the old schemes, interpreted with concentration, mingle with the elegant new Gothic sensitivity. Here Cimabue's plastic strength is fined down to the lightness of an ivory carving, and softened by a glowing, truer colour.

This early maturity of style in Duccio in its turn was to influence Cimabue, to the extent that there is still critical disagreement as to which of the two painters was responsible for such works as the Madonna and Child in Castelfiorentino, the Flagellation in the Frick Collection, New York, or the Maestà, in the Church of S. Maria dei Servi, Bologna.

Of the works of the years 1285-1308 that are indisputably Duccio's, several are particularly significant, such as the small Maestà (Bern Museum), the tiny Madonna of the Franciscans (Siena, P.N.), and the drawing for the stained-glass window in the choir of Siena Cathedral, which according to documents dates from 1288. The attribution of a number of other works from

▲ Jean Dubuffet
Pierre de vie
Hardboard. 77cm × 105cm
Zürich, Kunsthaus

this period, however, has not yet been generally agreed. These include: the *Madonna and Child Enthroned* (Turin, Gal. Sabauda); the small triptych with the *Madonna and Child Enthroned* and the *Scenes from the Life of Christ and St Francis*, unfortunately damaged (Cambridge, Massachusetts, Fogg Art Museum); the *Crucifix* in the Castello di Bracciano; and the *Madonna and Child* (Siena, P.N.).

Critics, on the other hand, are agreed with regard to the works that lead up to the masterly conclusion of Duccio's career, the large *Maestà* painted for the high altar of Siena Cathedral. These include the *Madonna and Child* of the Stoclet Collection, Brussels, the triptych with the *Madonna and Two Saints* of the National Gallery in London, and the *Madonna and Child* of the Galleria Nazionale in Perugia. It is generally agreed that Duccio's workshop had a certain part in the execution of the polyptych (no. 28 of the Pinacoteca Nazionale in Siena), and in the very fine triptychs (with a *Crucifixion* in the central panel) of the Museum of Fine Arts in Boston and of the Royal Collection, Hampton Court.

It is known that in 1302 Duccio painted a *Maestà* for the chapel inside the Palazzo Pubblico. The influence of this work, which today is lost, must be sought in the many other *Maestà* paintings in Duccio's circle, where his thinking was certainly reflected. On the other hand, the *Maestà* of Siena Cathedral (Siena, Museo dell'Opera), for which a contract was drawn up on 9th October 1308, is preserved almost intact. The painting was solemnly moved from Duccio's workshop to the cathedral on 9th June 1311. It was painted on both sides and completed by a predella. In 1506 the painting was removed from the high altar, and later its two faces were separated, which involved the scattering of several panels of the

▲ Duccio di Buoninsegna
Maestà (Rucellai Madonna) (1285)
Wood. 450 cm × 290 cm
Florence, Galleria degli Uffizi

predella, today mostly divided among a number of collections and museums (London, N.G.; New York, Frick Coll.; Washington, N.G.; Fort Worth, Texas, Art Center Museum; Lugano, Thyssen Coll.).

The heavenly throng surrounding the *Madonna and Child* on the front of the altarpiece derives from Duccio's earlier sources of inspiration; on the rear he executed, in close-knit succession,

scenes from the *Passion of Christ*. Here, better than anywhere, it is possible to evaluate Duccio's considered and personal assimilation of contemporary Florentine experiments in the definition of space, an assimilation that proves the detached consideration that Duccio gave to Giotto's art. The spirit of his art did not change a great deal: it still hesitated between a longing for religious symbolism and the taste for a lively, dramatic narrative

▲ Duccio di Buoninsegna
Christ before Ananias. The Denial of St Peter.
(Fragment from the *Maestà*) (1308–11)
Wood. 99 cm × 53 cm
Siena, Museo dell'Opera della Metropolitana

that was suited to the everyday Gothic language.

The only work belonging to the last – obscure – period of Duccio's activity (he died between 1318 and 1319) is a polyptych with the *Madonna and Saints* (Siena, P.N., no. 47). Here, the figure of the Virgin, of a monumental simplicity and breadth, reveals Duccio's lively sympathy with the new culture, which, although it was to leave him behind, was also to honour him. C.V.

From 1290 Duccio, who was the real founder of the Sienese school, exercised a profound influence upon the large number of artists trained in his workshop, and sometimes collaborating in his work. Among those nearest to him, and the most gifted, were the Master of Badia a Isola, who was active before 1300, the Master of Città di Castello, Ugolino di Norio, and Segna di Buonaventura (whose sons Niccolò and Francesco later in the century continued Duccio's style), as well as the painter of the remarkable *Maestà* of Massa Marittima. The early works, too, of such artists as Simone Martini (*Maestà* in the Palazzo Pubblico in Siena) and Pietro Lorenzetti (*Maestà* in Cortona) owed much to Duccio's example.
 L.E.

Duchamp
Marcel
American painter of French origin
b.Blainville, 1887 – d.Neuilly, 1968

Duchamp, whose genius was exercised in destroying the art of his surroundings, was born into a middle-class family (his father was a notary) which had two other great artists in it: his brothers Jacques Villon and Raymond Duchamp-Villon. He began painting in 1902 (*Chapel at Blainville*, Philadelphia, Museum of Art, Arensberg Coll.), studied at the Académie Julian (1904-5), and painted landscapes and portraits influenced by the Neo-Impressionists and the Nabis (*Portrait of Yvonne Duchamp*, 1907; *Maison rouge dans les pommiers* [*Red House and Orchards*] 1908; both New York, private colls.). He also made sketches in the style of Lautrec and the *fin-de-siècle* humorists for the *Courrier français* and *Le Rire* (1905-10), and until 1910, under the influence of Cézanne and the Fauves, continued to paint in a fairly modern manner, without any notable aggression or daring (*Nu aux bas noirs* [*Nude with Black Stockings*], 1910, New York, private coll.).

However, while staying at Puteaux with his brothers, who knew Gleizes, La Fresnaye and Kupka, he began to absorb some of the lessons of Cubism and, in 1911, produced works in which he added to the multiple schematizations and perspectives of Cubism a personal idea of movement (*Dulcinea, Sonata, Yvonne et Magdeleine déchiquetées* [*Yvonne and Magdeleine Torn in Tatters*], Philadelphia, Museum of Art, Arensberg Coll.; *Joueurs d'échecs* [*Chess Players*], Paris, M.N.A.M.).

Was he inspired by the Futurists? It has been shown that when he painted the Puteaux canvases he was perfectly conscious of their aesthetic background and also that he must have been aware of the series of figures in movement that Kupka had been painting since 1910, or even 1909 (Paris, M.N.A.M.). Duchamp's first *Nu descendant un escalier* (*Nude Descending a Staircase*), in fact, dates from 1911 (Philadelphia, Museum of Art, Arens-

berg Coll.), and it was followed, in 1912, by a series of important works devoted to the expression of movement, in which he assimilated the influence of Futurism, of chronophotography, and of Kupka. In these dark-coloured paintings figures face one another or are intertwined, figures that are either still or quick, like machines, and not without humour (*Le Roi et la reine entourés de nus vites* [*King and Queen Surrounded by Quick Nudes*], 1912, Philadelphia, Museum of Art, Arensberg Coll.). These paintings cannot be separated from those of Picabia who, at about the same time, was producing dynamic works that carried abstraction to its limits (*Danses à la source* [*Dances at the Spring*], Philadelphia, Museum of Art, Arensberg Coll.; *Udnie, jeune fille américaine* [*Udnie, American Girl*], 1913, Paris, M.N.A.M.).

In 1913 Duchamp abruptly turned his back on his work to that date in order to elaborate, in a leisurely way, in the form of work notes, an entirely personal system, dominated by the study, at once serious and lighthearted, of the exact sciences. From this philosophical activity came the *Stoppages-Étalon* (New York, M.O.M.A.). These half-scientific objects foreshadowed his 'ready-mades', the first of which, a *Bicycle Wheel* perched on a stool (Milan, Gal. Schwarz), dates from the same year. There followed, among others, the *Porte-bouteilles* (*Bottle-Carrier*) (Milan, Gal. Schwarz), *Apolinere Enamelled* (1916-17, Philadelphia, Museum of Art, Arensberg Coll.), *L.H.O.O.Q.* (New York, private coll.), and the moustached version of the *Mona Lisa* (1919), as well as variants on the 'ready-made': simple, 'helped', 'rectified', 'imitated', 'imitated-rectified' or 'served', according to the degree to which Duchamp had intervened in ready-made elements.

After 1913 Duchamp began to plan his famous painting on glass, the *Mariée mise à nu par ses célibataires, même* (*The Bride Stripped Bare by her Bachelors*) (1915-23, Philadelphia, Museum of Art, Arensberg Coll.). In this, his masterpiece, Duchamp reveals his gift for pure absurdity, together with his philosophy of love and desire. The work has been seen as a plan of a machine for loving, which through its actual arrangement (the feminine symbol in the upper part, the masculine ones below) expresses the fundamental difficulty of physical unity, in which the woman, through her imaginative power, is always above, and the man, held down by his instinct, is below. The nine ridiculous 'moulds', representing bachelors, fiercely show their impotence (priest, department-store delivery man, gendarme, soldier, policeman, undertakers' man, flunkey, waiter, stationmaster), while the chocolate grinder at the bottom on the right is the image of the lonely pleasure of the bachelor who grinds his own chocolate, all alone. A second version of the *Mariée* was made in 1961 by Duchamp and Ulf Linde (Stockholm, Moderna Museet).

The *Nude Descending a Staircase* was a *succès de scandale* when it was exhibited at the Armory Show in 1913. From 1915 to 1918, with Picabia, Duchamp was settled in New York, to which he brought what was to be the spirit of the Dada movement. In 1917 his *Fountain* (Milan, Gal. Schwarz), a particularly aggressive 'ready-made' (a urinal), provoked a resounding scandal. In 1918 Duchamp painted his last picture, the title of which, *Tu m'* (New Haven, Yale University Art Gal.), is a significant farewell to art. Invited to the Dada Salon in Paris in June 1920, he replied with a telegram: 'Pode bal'.

Between Paris and New York he was now to concentrate on the great glass, the *Mariée*, on a few 'ready-mades' (*Optique de précision* [*Precision Optics*], 1920, New Haven, Yale University Art Gal.), and above all on the game of chess, which he adored, and taught for a living. In spite of this his fame continued to grow; the Surrealists considered him one of themselves; they celebrated his break with art and his choice of life-style, noisily spreading his views, although Duchamp himself, in fact, made little of them. It was not so much his work as his life that was put forward as an example of perfect moral strictness. In his absurd objects the authentic poetry of black humour was seen, and behind his themes a consistent metaphysical attitude. All this fervour and wit, however, did not deflect him from the life he had chosen. In spite of his constant support of Surrealism, he never went back to its views.

In 1967-8, however, he produced some drawings and engravings, that were both humorous and erotic, made up of details from famous works: *The Kiss, The Turkish Bath*, Courbet's *Woman in White Stockings*; others took up the themes of the *Mariée* or of love. The first edition of the *Boîte en valise*, which contained, in a miniature form, his main works (one example in the M.N.A.M.), appeared in 1938. A philosopher who strayed briefly into the plastic arts, Duchamp adopted a way of life that embodied the prime philosophical virtue: freedom. Almost all his work is in the Museum of Art in Philadelphia, thanks to the Arensberg Bequest, made in 1950
 P.Ge.

Marcel Duchamp ▲
La Mariée mise à nu par ses célibataires, même
(1915–23)
Oil and lead wire on glass. 280 cm × 173 cm
Philadelphia Museum of Art, Arensberg Collection

Dufy
Raoul

French painter
b.Le Havre, 1877 – d.Forcalquier, 1953

Dufy grew up in Le Havre in a very musical family, which accounts for the presence of certain themes in his work, such as concerts. At the age of 14 he went to work in an importer's office, but from 1892 onwards was able to go to evening classes given by the painter Lhuillier at the school of fine arts in Le Havre, where he met Othon Friesz. His first enthusiasm was for Boudin, whom he discovered in the local museum, and for Delacroix whose *Justice de Trajan (Trajan's Justice)* (Rouen Museum) he later said was one of the most violent impressions of his life.

In 1900, three years after Friesz, Dufy obtained a municipal scholarship to go and work in Paris. He enrolled at the École des Beaux Arts in Bonnat's studio where he came under the influence of the Impressionists, Manet, Monet and Pissarro, and also displayed an interest in the Post-Impressionists, especially in Lautrec, whose incisive line filled him with enthusiasm. He began to have some success, but the new style he took up from 1904 to about 1906 temporarily diminished this.

During this period Dufy and his friend Marquet worked together using similar styles, at Fécamp, Trouville and Le Havre. *Rue pavoisée (Street with Flags)* and *Affiches à Trouville (Posters at Trouville)* (1906, Paris, M.N.A.M.) and *Trois Ombrelles (Three Sunshades)* (1906, Houston, private coll.) are, as far as touch, colour and subject matter go, Fauve paintings, but with a sensitivity that is still Impressionist. Dufy himself said that his own evolution towards a new sort of painting began in 1905, when he discovered

Matisse's *Luxe, calme et volupté* at the Autumn Salon: 'Impressionist realism lost its charm for me, in the contemplation of the miracle of the imagination translated into design and colour.' *Jeanne dans les fleurs (Jeanne with Flowers)* (1907, Le Havre Museum) clearly shows the influence of Matisse.

The great Cézanne retrospective in 1907 and a visit to L'Estaque the following year with Braque reinforced in Dufy the need for structure although this did not take him as far as Cubism (*Arbres à l'Estaque [Trees at L'Estaque]*, 1908, Paris, M.N.A.M.). The vividness of colour, allied with a clear graphic line, in *La Dame en rose (The Woman in Pink)* (1908, Paris, M.N.A.M.) is reminiscent of Van Gogh, and even German Expressionism, which Dufy came to know properly the following year when he visited Munich with Friesz.

Around 1909 Dufy's art took on a new lightness, became filled with grace and humour, and displayed considerable decorative charm in the treatment of paint and outlines (*Le Bois de Boulogne*, 1909, Nice Museum; *Le Jardin abandonné [The Deserted Garden]*, 1913, Paris, M.N.A.M.).

After illustrating with wood-engravings several books by friends who were poets (*Bestiaire d'Orphée* by Apollinaire, 1910), Dufy became interested in decorative art; with the help of the couturier Paul Poiret he started designing textiles (1911) and from 1912 to 1930 designed fabrics for the firm of Bianchini-Ferrier. In 1920, with Fauconnet, he carried out the decor for *Le Boeuf sur le toit* (text by Jean Cocteau, music by Darius Milhaud). In the end, he proclaimed himself a decorator rather than a painter by exhibiting regularly, after 1921, at the Salon des Artistes Décorateurs, by making fountains and plans for swimming pools with the ceramic artist Artigas, and by decorating (1925) Poiret's three famous boats, *Amours*, *Délices* and *Orgues*.

After the war, starting with the large compositions of *Vence* in 1919 (Chicago and Nice

museums), Dufy's painting matured into his definitive style. Following a formula to which he was to remain attached, he superimposed a lively, 'Baroque', 'curly' drawing on to patches of pure colour. The result was frequently witty and almost always joyful in atmosphere. This influenced his choice of subjects: he would contrast a moving crowd, translated by the graphic line, with the surrounding unity achieved by his use of flat, bright colours. Moving elements were set against a calm space: a lawn, a stretch of water (*Cowes Regatta*, 1930, Paris, Louis Carré Coll.; *Nogent, pont rose et chemin de fer [Pink Bridge and Railway at Nogent]*, c.1933, Le Havre Museum) or a racecourse (*Courses [Races]*, 1935, Aga Khan's Coll.).

After the war he gave up wood-engraving for lithography and practised watercolour painting more and more. In 1935 he took on a new medium: paints prepared by the chemist Maroger, which allowed him to obtain the lightness and freshness of watercolour. The result of these years of experimenting with decoration was, in 1937, *La Fée Électricité (The Electrified Fairy)*, a gigantic decoration for a pavilion at the Paris Exposition, where the fantasy of the detail, unexpected in so severe a subject, is tempered by the demands of the composition (Paris, M.A.M. de la Ville).

At the end of his life, Dufy developed a greater austerity, in which his playfulness was matched with a new intensity: a series of *Ateliers (Studios)* (1942), almost monochrome canvases (*Console Jaune [Yellow Console]*, 1947, Paris, Louis Carré Coll.; *Violin rouge [Red Violin]*, 1948, Paris, private coll.). In 1952, a year before his death, he received the International Grand Prix at the 26th Biennale in Venice. In the course of his long career he also executed many drawings in pen and pencil; often considered his best work, these display his characteristic conciseness, liveliness and humour (a large collection in the M.N.A.M. in Paris). Between the wars Dufy was the amused visual reporter of the sights offered by a peaceful, playful world, sometimes natural (cornfields, white-crested waves) and sometimes artificial (beaches, regattas, ports, concert-halls).　　F.C.

Dughet
Gaspard

French painter
b.Rome, 1615–d.Rome, 1675

In Rome, in 1630, Poussin married Anne Dughet, the daughter of a French pastrycook settled in Italy and the sister of Gaspard Dughet. From 1631 to 1635 Gaspard shared his brother-in-law's house, and it was probably Poussin who started him painting. Noticing the young man's love of nature and hunting, Poussin turned his attention towards the study of landscape. Between 1647 and 1651 Dughet painted the frescoes for the Church of S. Martino ai Monti in Rome, and, from that time on, his reputation was established. He worked for the King of Spain, the Duke of Tuscany and the Doria and Colonna families (the Doria and Colonna galleries still have important series of landscapes by him).

Dughet's success derived from a style that the great painters from Bologna, as well as Poussin

▲ Raoul Dufy
Les Trois Ombrelles (1906)
Canvas. 60 cm × 73 cm
Houston, Private Collection

and Claude, had shown at its best. Although he seems to have confined himself to landscape, Dughet exploited its resources to the full in media that ranged from oil, tempera, gouache and fresco, to an admirable set of drawings, some in black stone (Düsseldorf), others in lead (these are often confused with those of his brother-in-law).

Romantic by temperament, Dughet painted a more savage, less tidy, less sunny nature than that of Claude or of Poussin, but also one more sensitive to changes of weather and season (*Tempest*, London, Denis Mahon Coll.). Forgotten for over a century, Dughet has now once more established his claim to attention. His works, which are often compared with those of his most illustrious rival, Salvator Rosa, were often imitated and sought out, particularly by the English connoisseurs of the 18th century; this explains their abundance in English collections and galleries (Oxford, Liverpool, London). P.R.

Dürer
Albrecht

German painter
b.Nuremberg, 1471 – d.Nuremberg, 1528

Dürer's work is universal in its significance and in the extent of its influence. Dürer created a synthesis almost unequalled in the history of art between the principles of the Renaissance and those of the north. He is, thus, the last representative of the Gothic generation from which he had emerged, and the first modern artist north of the Alps.

Formative years. The Dürer family originated in Hungary where Albrecht's grandfather, and then his father, had been goldsmiths; after a stay in the Low Countries, his father settled in Nuremberg in 1455. It seems likely that the young Dürer received his first training in the artisan tradition of his father's workshop. If so, it was an excellent apprenticeship for his later development as a draughtsman and engraver. It was, in fact, his graphic work, rather than his paintings, that brought him international fame in his own lifetime. Throughout the 16th century the whole of Europe copied his many drawings and prints. His earliest surviving work is a *Self-Portrait* in silverpoint (1484, Albertina), which strikingly demonstrates his technical precocity.

In 1486 he began his apprenticeship as a painter in the studio of Michael Wolgemut, a disciple of Hans Pleydenwurff, who had been instrumental in bringing the style of the Netherlands to Germany. The works which the young Dürer made at this time, although rather more decorative, show the influence of the monumental style of his master (The *Cemetery of St John*, watercolour and gouache, *c.*1489, Bremen Museum).

In the spring of 1490, when his apprenticeship was over, Dürer left Nuremberg to extend his experience. He was away four years, but lacking information, we can only guess what the stages of his journey were. It has been suggested that he probably hesitated between Colmar, famous as the home of Schongauer, and the region of Frankfurt and Mainz where, it seems, the mysterious but no less celebrated Master of the Housebook was working. However, an interpretation of documents and an analysis of the style of the

works of this period, in which the influence of Geertgen tot Sint Jans and of Dirk Bouts is visible, makes it seem likely that Dürer must have carried on to the Low Countries, there to study works in the tradition of which he had been educated, that of Van Eyck and Van der Weyden.

In the spring of 1492 he retraced his footsteps and stayed at Colmar. Martin Schongauer had died the previous year, but his three brothers received Dürer and introduced him to their fourth brother Georg, who lived in Basel. There, thanks also to introductions from his godfather, the famous publisher Anton Koberger, Dürer entered humanist circles where he was immediately made welcome and became friendly with Johannes Amerbach.

During these years on the move Dürer concentrated above all on graphic work: drawings and plans for woodcuts in which were mingled the influences of Schongauer and the inventive freedom of the Master of the Housebook. *St Jerome Caring for the Lion* (1492), the frontispiece of an edition of St Jerome's letters, is the only attested print of this period, but Dürer is accepted as being the illustrator of other works, such as Bergmann von Olpe's *Ship of Fools*, and is known to have prepared designs for Amerbach's edition of the works of Terence, although few were used. Also from this period comes Dürer's first painted *Self-Portrait* (1492, Louvre), a masterpiece of introspection; he chose to inscribe the portrait with the words 'My life will proceed as ordained on high'.

First visit to Italy. The year 1493 found Dürer in Strasbourg. The following year he returned to Nuremberg again, where he married Agnes, the daughter of the upper-class Hans Frey, shortly before leaving once more, this time for Venice. This journey had an altogether exceptional effect on him. To most of Dürer's contemporaries the living sources of art were still Bruges and Ghent, the Renaissance having been considered an exclusively Italian movement, offering German artists merely a stock of decorative motifs borrowed from antiquity. But Dürer saw in Italy a true renewal of thought and of the artistic vision, and he flung himself enthusiastically into the study of Venetian life and art, sketching from life, visiting

the studios, copying Mantegna, Credi, Pollaiuolo, Carpaccio and Bellini, and gradually assimilating the new aesthetic ideas, particularly in the fields of perspective and the treatment of the nude.

At the same time as his interest was being aroused in artistic theories, he displayed a strong curiosity about nature, a feature that was to underlie the whole of his work. And so, mostly after his return home, he made a series of views of the landscape he had passed through (northern Italy, the Tyrol): the *Wehlschpirg* (1495, Oxford, Ashmolean Museum), *Pond in the Woods* (1495, British Museum) and *View of Arco* (1495, Louvre). These free, fresh watercolours, which are touching in their modernity, consistency, and expressive use of colours, may be contrasted, because of their concrete vision and direct experience of nature, with more traditional approaches to nature which resulted in studies such as *The Crab* (*c.*1495, Rotterdam, B.V.B.), *The Large Clump of Grass* (1503, Albertina).

Maturity. In 1495 Dürer was back in Nuremberg, and, thanks to the patronage of Frederick the Wise, a period of intense activity now opened up before him. On the stylistic level, he achieved a fusion between the lessons he had learned in Italy and those of his apprenticeship in the Germano-Flemish tradition, while, from the iconographical point of view, he showed an eclectic taste: the humanist portrait, biblical themes, philosophical allegories, genre scenes and satires.

As well as an impressive series of engravings, among which the cycle of the *Apocalypse* stands out as one of the wonders of German art, he produced a dozen paintings in 1500. A polyptych, ordered by Frederick, was conceived by Dürer but carried out by his assistants (*The Seven Sorrows*, 1496, Dresden, Gg, and the *Mater Dolorosa*, 1496, Munich, Alte Pin.); a second, known as the *Altarpiece of Wittenberg* (1496-7, Dresden, Gg), is entirely by his own hand. For the *Virgin Adoring the Child*, Dürer borrowed the arrangement of the Flemish nativities, while the precision of the modelling, the elements of still life in the foreground and the bare architectural perspective of the background suggest Mantegna or Squarcione. The composition as a whole, with its hard

▲ Gaspard Dughet
Paysage avec saint Augustin
Rome, Galeria Doria Pamphili

Munich, Alte Pin.) is much more disturbing. Here, Dürer portrays himself as a sort of Christ risen from the darkness in a monumental bareness, with the long golden locks that provoked sarcasm in Venice falling symmetrically over his shoulders. Was he identifying his genius as an artist with the divine creative genius, was it a profession of faith in the classicism of the Renaissance, or was it an idealized monument to his own glory?

The problem remains unsolved. The last work of his triumphant youthful period is a *Lamentation* (*c*.1500, Munich, Alte Pin.). Still marked with the austere gravity of Wolgemut, this work transcends whatever may be archaic or narrow in the plan by opening up, above the body of Christ and the pyramid-shaped arrangement of the figures, the ideal landscape of a cosmic Jerusalem.

Second visit to Italy. During these years, and above all after 1500, Dürer's interest in the rational foundations of art was growing. His first visit to Italy had shown him that it was impossible to have true artistic creation without theoretical knowledge: the meeting with Jacopo de' Barbari and his discovery, in 1503, of Leonardo's drawings confirmed this for him. It was in this state of mind that, between 1502 and 1504, he painted the famous *Paumgärtner Altarpiece* (Munich, Alte Pin.). The central panel bears a *Nativity* conceived according to traditional Gothic norms, but, for the first time, Dürer rationalized the construction of the decor by applying the laws of perspective to it very rigorously. The severe side-panels, portraits of Lucas and Stephan Paumgärtner as *St George* and *St Eustace*, are thus the result of careful studies of proportion.

Still more remarkable is *The Adoration of the Magi*, painted in 1504 for Frederick the Wise (Uffizi), in which the study of perspective and proportions is undertaken with matchless precision, the direction of the point of flight being oriented diagonally, according to a movement that was to be characteristic of Baroque art. Through the ingenious arrangement of contrasts and the natural dialogue of the figures with their surroundings, Dürer surpassed the kind of mystical warmth that impregnated the *Lamentation* or, even more, the *Paumgärtner·Altarpiece* and here arrived at a limpid synthesis that irresistibly recalls Leonardo.

In the autumn of 1505 Dürer returned to Venice, partly to escape the plague which was raging in Nuremberg, but also because he felt an urgent need to work on his use of colour in what was the painters' city *par excellence*. His fame as a draughtsman and engraver had preceded him, and he was received with honour in cultural and political circles in Venice. But the painters, with the exception of Giovanni Bellini, showed themselves jealous or even openly hostile.

Irritated to find those who copied his prints criticizing his colouring, Dürer flung down a sort of challenge with the first commission he received after his arrival: the *Rosenkranzfest* (*The Feast of the Rose Garlands*) for the church of the German colony (1506, Prague Museum), a work which, since it constitutes the conclusion and the synthesis of his previous evolution, is without doubt the major work of his career. The composition, once again, is very broadly derived from the type of *Sacra Conversazione* favoured by Bellini, but for the solemn and meditative aspects of the traditional representation of this theme Dürer substituted an atmosphere of effervescence,

but flexible drawing and muted tones, has an atmosphere of solemn piety that is not unrelated, as has been suggested, to the *Pietà* paintings of Giovanni Bellini. The side-panels (*St Anthony* and *St Sebastian*), which were painted later (*c*.1504), are stylistically more supple, but their realism, and the abundant flesh of the *putti*, contrast with the spiritual elevation of the central panel.

Together with these altarpieces, Dürer painted his *Frederick the Wise* (1496, Berlin-Dahlem). In this, every decorative or descriptive element is abandoned in favour of psychological penetration, formal bareness being the only means of expressing the inner tension of the sitter. In comparison with this masterly work, the portrait of *Oswalt Krell* (1499, Munich, Alte Pin.) shows a certain regression: a multiplication of elements in the composition, an opening out on to a perspec-

tive of landscape, a rather too emphatic placing of the figure and a traditional construction based on the complementary contrast between red and green. In the meantime Dürer had painted several other portraits (including those of his *Father* and *Katharina Fürlegerin*), which we know only through copies, as well as the *Haller Madonna* (*c*.1497, Washington, N.G.) in the style of Giovanni Bellini's *Madonnas*.

Five years after the *Self-Portrait* in the Louvre he returned to the genre with the *Self-Portrait* (1498) now in the Prado, and it is possible to see in the haughty bearing and formal elegance of the clothes, and in the careful arrangement of pose and decor, the distance covered by the young man, who, at 27, was beginning to be known as the greatest creative artist of his generation. The *Self-Portrait* painted two years later (1500,

▲ Albrecht Dürer
Self-Portrait (1498)
Wood. 52 cm × 41 cm
Madrid, Museo del Prado

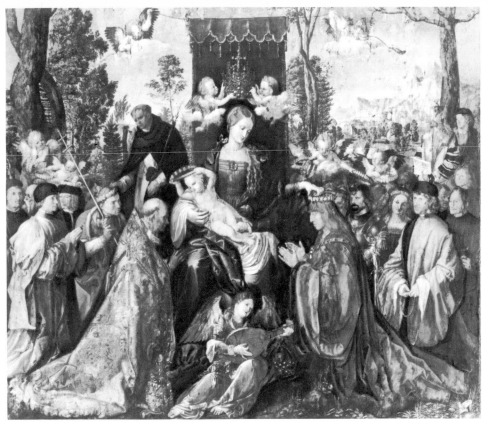

ordered around the central pyramid – Virgin, Pope and Emperor – and poetically balanced by the ethereal landscape that opens out in the background. It is not so much the structure, however, as the colour that gives the composition its supreme feeling of order. Treated subtly, with luminous touches, it achieves the profound contrast and unity of the Venetian spirit, while a majestic lyricism, inherited from the Rhenish painters of the 15th century, orders the ceremonial of the scene.

Besides this masterpiece, other works, smaller but no lower in quality, deserve attention: *The Virgin of the Siskin* (1506, Berlin-Dahlem), which reveals the attention Dürer devoted to the problem of colour as well as the influence of Giovanni Bellini; *Christ among the Doctors* (1506, Lugano, Thyssen Coll.), an expressive contrast between the youthful beauty of Christ and the sometimes caricatured elderliness of the doctors; the *Young Venetian Woman* (1505, Vienna, K.M.), unfinished, but with a delicacy and a warmth of tone that evoke Carpaccio; and finally, a *Portrait of a Woman* (*c.*1507, Berlin-Dahlem), softly modelled against a bright blue background.

On the theoretical level, this second stay in Venice was of prime importance. Having discovered the autonomous power of colour and his own power of expression, Dürer tried to elaborate an absolute colour, transcending what to him seemed too detailed in the chiaroscuro of Venice, while at the same time, with the help of Euclid, Vitruvius and many studies of the human body, he sought the mathematical secret of the formal classical ideal. The culminating point of his studies is the *Adam and Eve* in the Prado (1507), which, in its incomparable abstract harmony, can be considered Dürer's synthesis of the ideal beauty.

Later works. On his return to Nuremberg, Dürer painted an altarpiece on a subject that was very popular in Germany at the time, the *Martyrdom of the Ten Thousand* (1508, Vienna, K.M.),

which he followed with an *Adoration of the Holy Trinity* (1511, Vienna, K.M.). These works have in common a composition based on the multiplication of figures and, notably in the *Holy Trinity*, on the spherical – Copernican – construction of space, which gives them a visionary character that prefigures Altdorfer, Bruegel, Tintoretto and the masters of the Baroque. They do not, however, mark a notable stage in Dürer's evolution. In fact, once away from the climate of Venice, he showed a tendency to revert to the graphic style of his earlier works, and his colours lost some of their brightness and suppleness. In any case, after 1510, he concentrated on engraving, producing large and small versions of the *Passion*, the *Life of the Virgin*, and then, in 1513-14, his masterpieces, *The Knight, Death and the Devil*, and *Melencolia I*.

Having found a new patron in the Emperor Maximilian I in 1512, Dürer was given frequent diplomatic missions by the Council of Nuremberg. Thus, in 1518, he was at the Diet of Augsburg and on that occasion made a number of portraits in the great tradition of Augsburg (*Maximilian I*, 1519, Vienna, K.M.). *St Anne, the Virgin and Child* (1519, Metropolitan Museum) is the most remarkable work of this period, in which few paintings were produced; its delicate composition in soft white tones marks a further move towards the Mannerism already evident in the decorative style of *St Philip* and *St James* (1516, Uffizi).

Maximilian's death, together with financial difficulties, led Dürer in 1520 to the court of Charles V in order to restore his funds. He stayed in the Low Countries for nearly a year, meeting Charles V, Margaret of Austria, Christian II and, more importantly, Erasmus, Quentin Metsys, Patinir, Lucas van Leyden and Van Orley, and studying the Flemish masters – Van Eyck in Ghent, Van der Goes in Brussels – as well as Michelangelo's *Madonna* in Bruges.

However, his creative activity was slowing down. The death of Maximilian marked the end of Dürer's great period, defined by the start of

the Reformation (*c.*1519), and then the outbreak of the Peasants' War in 1525. 'Dürer is in bad form' his friend Pirkheimer remarked. He had supported Luther and when he heard the (false) news that he had been assassinated, he put all his hopes in Erasmus, though trembling for the future.

In his *Vision of a Dream* (watercolour, 1525, Vienna, K.M.) the human race is depicted as being swept away by a second Flood. From then on, his work was a profound reflection of mind, and he was one of the first artists to believe in the simple, austere theology of the reformers. 'When I was young', he told Melanchthon, 'I engraved new, varied works; now ... I am beginning to consider nature in its original purity and to understand that the supreme expression of art is simplicity.' Seen in this perspective, his last monumental work, the *Four Apostles* (1526, Munich, Alte Pin.), has the value of a spiritual testament. Together, these four figures personify man, his ages and humours: on the left-hand shutter, John, young and sanguine, accompanied by a phlegmatic Peter, stooping with age; on the right, the fiery Mark, with Paul, who is grave and imperturbable.

Dürer began a number of theoretical treatises around 1512-13 and finished them in the last years of his life: *Treatise on Measurement*, which appeared in 1525, *Treatise on Fortifications* (1527), and the four books on the *Proportions of the Human Body*, published six months after his death. These works, which have been compared in importance with Luther's Bible, were intended to form part of a theoretical encyclopedia of art, to be entitled *Food for Apprentice Painters*, the object of which was to establish an order, based on the universal order of nature, for the practice, knowledge and meaning of art. B.Z.

Dyce
William

Scottish painter
b.Aberdeen, 1806 – d.London, 1864

After leaving school, Dyce persuaded his father to allow him to attend the Royal Academy Schools. However, he soon left London, and visited Rome in 1825, where he spent about nine months. On his second visit, two years later, he painted a *Madonna and Child* that was very much admired by Overbeck, one of the German Nazarenes, by whom Dyce was clearly influenced. The Nazarenes' cool precision, distinct colouring and hard line pervaded Dyce's work throughout the following years, as can be seen in a later *Madonna and Child* (*c.*1838, Nottingham, Castle Museum) and in *Joash Shooting the Arrow of Deliverance* (1844, Hamburg, Kunsthalle). Official recognition was soon forthcoming; Dyce was elected an Associate of the Royal Academy in 1844 and a full Academician in 1848.

Dyce had become interested in fresco painting on his early visits to Rome, at a time when the Nazarenes were researching that technique, and in 1846 he painted his fresco of the *Baptism of Ethelbert*, part of the new decoration of the Houses of Parliament, as well as touring Italy to study the medium. While there he was particularly impressed by Raphael's frescoes in the Vatican Stanze, and by Pinturicchio. He became a

▲ Albrecht Dürer
The Feast of the Rose Garlands (1506)
Wood. 162 cm × 194 cm
Prague, Národni Galeri

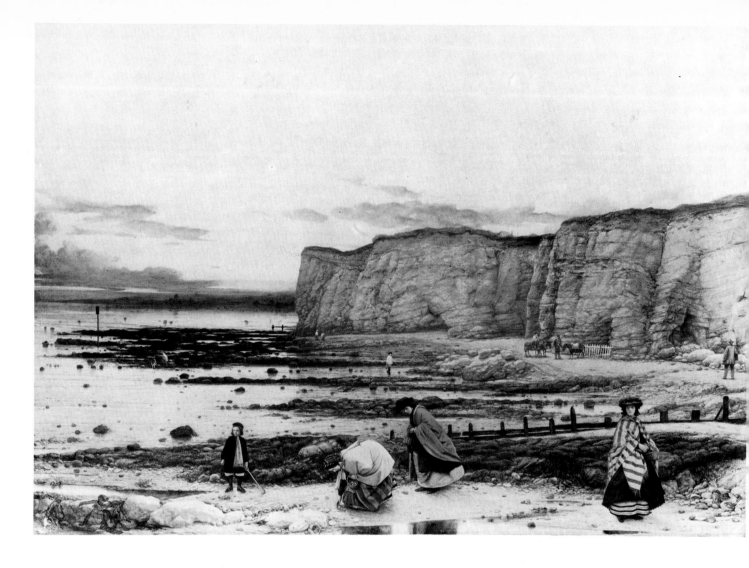

favourite artist of Prince Albert, who was chairman of the commission responsible for the decoration of the Houses of Parliament, and received further commissions from him. They included a fresco for the garden pavilion in Buckingham Palace, a fresco of *Neptune and Britannia* for Osborne House on the Isle of Wight, and a painting of *St Joseph*, as a pair to the *Madonna and Child* which he had already painted for the Royal Collection at Osborne.

In 1847 Dyce began the decoration of the Queen's Robing Room in the Palace of Westminster, which comprised frescoes of *Courtesy, Faith* or *Religion,* and *Generosity.* The task occupied him until his death, although he also worked on other paintings concurrently.

Both Dyce's interest in the Nazarenes and his own example were important influences on the style of the Pre-Raphaelites, and he was one of the older generation of artists who was most sympathetic to them. Nevertheless, in 1855, Ruskin criticized him as representing a false development of Pre-Raphaelitism, 'consisting in imitation of the old religious masters'.

In his last years, however, Dyce began to pay greater attention to natural detail, partly under the influence of early Netherlandish painters; and this is evident in works such as *Titian's First Essay in Colour* (1857, Aberdeen, Art Gal.) and in *George Herbert at Bemerton* (1861, London, Guildhall). Rather ironically, as Dyce was personally devoted to Christian art and to the revival of fresco painting, his best-known work is an extremely precise landscape that he painted during a holiday in

Kent. In *Pegwell Bay* (1859, London, Tate Gal.) the artist recalled a particular experience that took place on 5th October 1858: the faces are portraits of his wife, his son and his sister-in-law, and while the painting is meticulously executed, it is also full of personal feeling. In several paintings that stem from a journey to the Isle of Arran in 1859 Dyce combined his interest in Christian art and his detailed painting of nature. In these pictures, which include *The Man of Sorrows* (United Kingdom, private coll.), and in *The Agony in the Garden* (Liverpool, Walker Art Gal.), Dyce may have used the Pre-Raphaelite practice of later setting the figure into a landscape that was painted on the spot.

William Dyce was outstanding among the artists of his time for the breadth of his education and interests. He was a devout leader of the High Church movement, a composer of church music, and something of a musical scholar; he also wrote about ecclesiastical architecture and made illustrations for the Book of Common Prayer. He was an expert on industrial art, and particularly on stained glass, which he both designed and executed. He was involved in the establishment of the Schools of Design at Somerset House from 1838 to 1843, and was a leading member of the Royal Academy, the presidency of which he declined in 1850. With a considerable knowledge of the art of the past, Dyce became the first Professor of the Theory of the Fine Arts at King's College, London, and was asked to advise on the administration of the National Gallery and on the development of its collection. J.H.

 William Dyce
Pegwell Bay, Kent (1859–60)
Canvas. 64 cm × 89 cm
London, Tate Gallery

Dyck
Sir Anthony Van

Flemish painter
b.Antwerp, 1599 – d.London, 1641

Formative years in Antwerp. Van Dyck was born into a middle-class family in Antwerp and lost his mother when he was eight years old. In October 1609 he was apprenticed to the painter Hendrick van Balen, whom he probably left at the age of 16 or 17. The artistic atmosphere of Antwerp, dominated by the art of Rubens, favoured an early flowering of Van Dyck's gifts. On 11th February 1618 Van Dyck was received as master of the Guild of St Luke in Antwerp, and from then on could accept commissions in his own name. It was about this time that he became the assistant, although not the pupil, of Rubens, and this collaboration enriched his work.

Van Dyck's first paintings (1616–c.1618), a series of *Busts of Apostles* (Dresden, Gg.; Besançon Museum), a *Man's Head* (Aix-en-Provence Museum) and a *Study of a Head* (Louvre), are notable for their realistic, Caravaggesque style, their vigorous structure and sweeping brushstrokes. His youthful work shows affinities, too, with Jordaens, with whom Van Dyck worked in Rubens's studio. Rubens at that time painted sketches, from which Van Dyck carried out *Bacchanal* (Berlin-Dahlem) and *St Ambrose and the Emperor*

Theodosius (London, N.G.). *The Portrait of Jac-queline van Caestre* (Brussels, M.A.A.), long attributed to Rubens, is evidence of the considerable influence that the master exercised over his young collaborator. At the same time that he was working as Rubens's assistant, Van Dyck was following his own career: the small-scale, idealized forms of his *St Martin Dividing his Cloak* (Saventhem church) and *The Martyrdom of St Sebastian* (Louvre) bear little resemblance to Rubens's powerful, violent masses.

Van Dyck then began his career as a portrait painter. His *Family Portrait* (Hermitage) shows, as one would expect, analogies with the Flemish tradition in composition and brushwork. From 1618 to 1620 a new ceremony and stateliness entered his portraits, sometimes at odds with his desire to characterize the sitter as an individual; his *Cornelis van der Geest* (London, N.G.), his *Self-Portraits* (Hermitage; Munich, Alte Pin.) and his portrait of *Snyders* (New York, Frick Coll.) all display these mixed intentions. In 1620 and 1621 Van Dyck spent several months at the English court where the Earl of Arundel had prepared the way for him. Despite being paid £100 by the King, he does not seem to have been very successful because the portrait painter Daniel Mytens was already enjoying favour at the court. He went back to Antwerp at the end of February 1621, and on 3rd October of the same year set off on a long visit to Italy.

Italian period. On 20th November 1621 Van Dyck arrived in Genoa. The following year he moved to Rome where he was received by Cardinal Bentivoglio. In the month of August 1622 he stayed in Venice. In the spring of 1624 he visited Rome, Florence and Palermo, and even went as far as Marseilles in 1625. But from 1623 to 1627 Genoa was his centre; here he became portrait painter to the aristocracy and also received many commissions to decorate churches.

Italy deepened his instinctive taste for linear harmony and his gifts as a colourist. The great Venetian painters influenced him above all else. *Susannah and the Elders* (Munich, Alte Pin.) and *The Tribute Money* (Genoa, Gal. di Palazzo Bianco) were inspired by Titian's paintings; *The Three Ages of Man* (Vicenza Museum) was probably influenced by a work of Giorgione, now lost. At the same time Van Dyck was indebted to the school of Bologna: *The Virgin with the Rosary* (Palermo, Oratory of the Rosary) continues the aesthetic ideas of the school of the Carracci. *The Holy Family* (Turin, Gal. Sabauda) shows the classical harmony of a Correggio.

Van Dyck's originality is greater in his *Christ on the Cross with Sts Francis and Bernard and a Donor* in the Church of S. Michele, near Rapallo. Although the religious feeling in it is weaker, somewhat pious, and sometimes sensual as well, his brilliant and consistently able use of colour produces an elegance that heralds the rococo. In his portrait of a *Genoese Lady and her Daughter* (Brussels, M.A.A.) and in the equestrian portrait of *Antonio Giulio Brignole Sale* (Genoa, Gal. di Palazzo Rosso) he achieves a refined ideal much suited to the Genoese aristocracy. Rejecting realism, he considerably reduced the size of his models' hands, thus lengthening their outline, as in the *Marchesa Balbi* (Washington, N.G.) and the portrait supposedly of the *Marchesa Doria* (Louvre).

Van Dyck's influence was prolonged in Genoa by Strozzi and Valerio Castello, and in Palermo

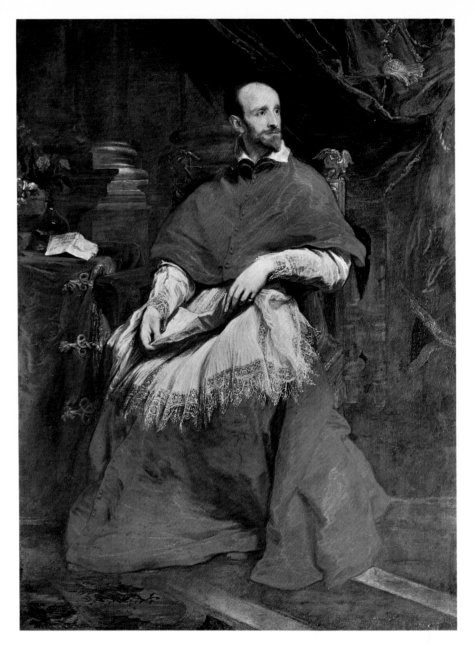

by Pietro Novelli. By the time he left Italy, he had given the 17th century its greatest examples of portraiture.

It was during this stay in Italy, as well as in his first period in Antwerp, that Van Dyck produced the bulk of his drawings. Many were preparatory studies for large compositions. Hamburg Museum owns the drawings for the *Arrest of Christ* (Prado); other drawings such as the *Sufferings of Job* (Louvre) are studies after Rubens; yet others are studies after Titian (an entire notebook of sketches, Chatsworth, Devonshire Coll.). Rapid sketches are characterized by their Baroque fervour and their vigorous, overlapping lines (*The Martyrdom of St Catherine*, Paris, E.N.B.A.). Van Dyck drew less later on and came to prefer studies in pen or brush to those in pencil.

Second period in Antwerp. By the end of 1627 Van Dyck was back in Antwerp where during the course of the next five years he received many commissions. In his portraits he adapted himself to the demands of the middle classes; those of *Peter Stevens* (1627, Mauritshuis) and of *Snyders and his Wife* (Kassel Museum), for example, differ from those of the Italian aristocracy in their reversion to the Flemish tradition. The sitters, only the

upper halves of whom are shown, are portrayed with greater reserve and psychological simplicity. In the portraits of *Anne Wake* (Mauritshuis) and of *Martin Pepjin* (1632, Antwerp Museum) Van Dyck concentrates upon bringing out the warm colouring of the faces. His technique then gained greatly in lightness, finesse and unity in his portraits of *J. de Waele* (Munich, Alte Pin.) and of *Jean de Montfort* (Vienna, K.M.).

He was assured of European success by the publication of a collection of engravings, known as *The Iconography*, for which he prepared drawings and grisailles and which aimed to diffuse the likeness of illustrious men of the age. Eighty plates engraved by Vorsterman, Bolswert, and Pontius appeared in 1636, followed by a second more complete posthumous edition of 1645. In this second series, Van Dyck himself engraved only about twenty etchings and some portraits of artists, among them those of Lucas Vorsterman, Joos de Momper, and Jan Snellinck, as well as his own portrait.

After 1628 religious painting occupied an important place in Van Dyck's output and examples can be found in the churches of Antwerp, Malines, Ghent, Courtai and Termonde. Although there can be no doubt of the deep feeling

▲ Anthony Van Dyck
Portrait of Cardinal Bentivoglio (1623)
Canvas. 195 cm × 147 cm
Florence, Palazzo Pitti

underlying these works, their Baroque aesthetic ideas touch us rather less today, as can be judged by the feeble grace of *The Adoration of the Shepherds* (Termonde, Church of Notre Dame), the rather dull *Ecstasy of St Augustine* (Antwerp, Church of St Augustine), and the over-obvious suffering of the *Lamentation over Christ* (Antwerp, M.A.A.). Nevertheless, Van Dyck's religious art is important for its truth as for its elegance (*The Virgin and Child with Two Donors*, Louvre; *St Sebastian*, Munich, Alte Pin. *The Flight into Egypt*, Munich, Alte Pin.).

Two mythological paintings, *Rinaldo and Armida*, commissioned in 1629 by Endymion Porter, Charles I of England's agent (two versions, Louvre and Baltimore, Museum of Art), and *Cupid and Psyche* (Royal Collection, Hampton Court), assured Van Dyck's success at the court of Charles I. Their poetic atmosphere, the grace and elegance of the figures and the light, rich colouring was to influence French 18th-century painters like Lemoyne, Coypel and Boucher.

English period. On 1st April 1632 Van Dyck arrived in London at the invitation of Sir Kenelm Digby. On 5th July of the same year he was appointed by the King 'principalle paynter in Ordinary to their Majesties' and knighted. His career in London was interrupted by two visits to Flanders: in Brussels, in 1634, he painted a portrait of the *Cardinal-Infante Ferdinand* (Prado), the new Governor of Flanders, as well as people at the court, such as the *Marqués de Moncada* (Louvre) and *Prince Thomas of Savoy* (Turin, Gal. Sabauda). Also in 1634 he painted a *Pietà*, now in Munich (Alte Pin.), and probably the group of *Magistrates of Brussels* that had been commissioned in 1628 (destroyed in 1695, sketch in Paris, E.N.B.A.).

On his return to London in 1635 he planned to decorate the walls of the Banqueting Hall in Whitehall – the ceiling of which Rubens had earlier painted – with a set of tapestries. Van Dyck's cartoons dealt with ceremonies of the Order of the Garter, but the difficulties of the royal treasury meant that the plan was abandoned in 1638.

Van Dyck left London a second time in 1640, the year of his marriage to an Englishwoman, Mary Ruthven. He went to Antwerp, where Rubens had just died, and possibly to Paris. On his return to London in the spring of 1641 he fell seriously ill and he died on 9th December. He was buried in the choir of St Paul's Cathedral, where the King had an epitaph placed.

While a resident of Blackfriars, London, Van Dyck concentrated exclusively on portraits. The

400 or so that he painted between 1632 and 1641 reveal inequalities and sometimes negligence in their execution. His studio made a large number of copies and painted costumes and draperies in his works. Nonetheless, it was during this period that he achieved such masterpieces as his *Equestrian Portrait of Charles I* (London, N.G.) and that of *Charles I Hunting* (Louvre), where the sovereign is placed in a large Flemish-style landscape the lightness of which recalls the watercolours of wooded valleys and views painted at the same time (British Museum; Chatsworth, Devonshire Coll.). In the portraits of *Robert Rich, Earl of Warwick* (1635, Metropolitan Museum), of the *Earl of Strafford* (1636, Petworth, Egremont Coll.) and of *George Digby and William Russell* (Althorp, Spencer Coll.), the mannered gestures and flowing draperies foreshadow Romanticism (e.g. Lawrence), as do the portraits of *James Stuart, Duke of Lennox* (Metropolitan Museum), the *Countess of Bedford* (c.1640, Petworth, Egremont Coll.) and *John and Bernard Stuart* (London, Mountbatten Coll.).

Van Dyck's free, bold technique, the orderly arrangement of his figures, as in his portrait of the *Children of Charles I* (Turin, Gal. Sabauda) or of *Prince William II and his Young Wife* (Rijksmuseum) – his last work, painted in 1641 – and the virtuosity in the treatment of satins and fabrics were to have an enormous influence upon portrait painters, both English (Lely, Dobson, Greenhill and Kneller) and Flemish (Hanneman and Coques). His art, too, was to inspire the French painters of the 18th century, but above all it was to make an indelible impression upon Reynolds and Gainsborough, the leaders of the English school in the 18th century. P.H.P.

Eakins
Thomas

American painter
b.Philadelphia, 1844 – d.Philadelphia, 1916

In 1861 Eakins entered the Pennsylvania Academy of Fine Arts and while he was enrolled there also followed the anatomy courses at the Jefferson Medical College. In 1886 he went to France to complete his training, entering the course of Gérôme at the École Nationale des Beaux Arts, where he worked hard at drawing. A stay in Spain (1869-70) revealed Velázquez and Ribera to him and reinforced his own concept of realism. After his return home in 1870 he did not leave Philadelphia again, staying to become, through his portraits, his interiors and his outdoor scenes (*Max Schmitt in a Single Scull*, 1871, Metropolitan Museum), the main interpreter of the urban middle class.

He looked upon painting as a scientific document, close to mathematics, which he also enjoyed, and to photography, which he practised a great deal (studies of male nudes in the open air, posing and in movement). *The Gross Clinic* (1875, Philadelphia, Jefferson Medical College) shows the drama of science fighting illness and death. The open-air scenes, which are precise and luminous, often show rowing races on the Schuylkill River (*The Biglen Brothers Racing*, Washington, N.G.) as well as nude swimmers bathing (*The Swimming Hole*, 1883, Fort Worth, Texas, Art Center Museum).

Eakins also showed an interest in boxing and the atmosphere of the ring (*Between Rounds*, 1899, Philadelphia, Museum of Art) and in the social condition of blacks (*Negro Boy Dancing*, Metropolitan Museum). His portraits were an important part of his work and their quality makes them sometimes comparable with Courbet's. One of the most famous is that of his illustrious contemporary and friend *Walt Whitman* (1887, Philadelphia, Pennsylvania Academy of Fine Arts), whom he also photographed. He taught at the Academy and became its director in 1882. With Homer, Eakins is the main representative of American realism and aroused the interest of the Pop artists of the 1960s. Most of his work is to be found in the Museum of Art in Philadelphia, the Metropolitan Museum in New York, the Corcoran Gallery in Washington, the Brooklyn Museum in New York and the Art Center Museum at Fort Worth (Texas). L.E.

Eckersberg
Khristoffer Vilhelm

Danish painter
b.Blaakro, 1783 – d.Copenhagen, 1853

Educated at the Academy in Copenhagen, Eckersberg was influenced by French Neoclassicism during his stay in Paris (1810-13). He studied under David from September 1811 to June 1813 and described his personality and teaching percipiently in his correspondence and diary. He then painted historical compositions, such as *Hagar and Ishmael in the Desert* (1812-13, Nivagaards Malerisamling), as well as studies from the living model (*Nude Study*, 1813, Copenhagen, S.M.f.K.). Paris and its surroundings also inspired him to produce some delicate views: *The Edge of the Bois de Boulogne* (1812, Copenhagen, C. L. Davids Samling); *The Environs of Meudon* and *The Pont Royal* (1813, Copenhagen, S.M.f.K.).

In Rome, where he stayed after 1813, he made contact with his fellow-countryman Thorvaldsen and painted a monumental portrait of him (1814, Copenhagen, Ny Carlsberg Glyptotek). Other works from this period include a *Portrait of a Young Woman* (1814, Copenhagen, Hirschprungske Samling), historical paintings (*Alcyone*, 1813, *The Passage through the Red Sea*, 1813-16; both Copenhagen, S.M.f.K.), and above all a fine series of views of Rome and its surroundings, characterized by careful drawing, a delicate light and very clear tones (*View from the Via Sacra*, Copenhagen, N.C.G.; *View from the Colosseum*, *The Villa Borghese*, *The Villa Albani*, *Fontana Acetosa*, Copenhagen, S.M.f.K.; *St Peter's Square*, *The Colosseum*, Copenhagen, Thorvaldsen Museum; *The Colonnade of St Peter's*, Copenhagen, C. L. Davids Samling).

Eckersberg is one of the most delicate interpreters of the Roman landscape. He was also sometimes inspired by scenes of everyday life (*At the Porta Santa of St Peter's*, 1814-15, Nivagaards Malerisamling; *Roman Carnival*, 1814, Copenhagen, S.M.f.K.), which he described with a very sure touch. The firm composition he had learnt in David's studio, joined to an innate sense of the value of light and a clear and objective vision, led him to establish a style, in both landscape and portraiture, which was to be central to that of the Danish golden age.

▲ Thomas Eakins
Max Schmitt in a Single Scull (1871)
Canvas. 82 cm × 116 cm
New York, Metropolitan Museum of Art

On his return to Copenhagen in 1816 Eckersberg became a member of the Academy, then a teacher, and around 1828 was commissioned to paint pictures illustrating Danish history for the Palace of Christiansborg, a task for which he was not particularly well suited. On the other hand, with his nudes (*Woman at the Mirror*, Copenhagen, Hirschprungske Samling) and his portraits (*Baron and Baroness Billebrahe*, 1817, Copenhagen, N.C.G.; *Fru Lovenskjold and her Daughter*, 1817; *The Nathanson Family*, 1818; *Emilie Henriette Massmann*, 1820; *The Nathanson Sisters*, 1820; all Copenhagen, S.M.f.K.), he affirmed a strictly classical elegance.

Eckersberg left admirable views of the Danish countryside and coasts, luminous and cleanly constructed, but with a degree, too, of lyricism. He made a speciality of views of ports and boats, which he painted with a detail that displayed a perfect knowledge of the construction of sailing ships and of navigation (Copenhagen, S.M.f.K. and Hirschprungske Samling; Louvre). Eckersberg was also a theorist, who published works on perspective (1833–41). The influence of his teaching was decisive in the formation of Wilhem Bendz, Constantin Hansen and Christen Købke.

H.B. and L.E.

Elsheimer
Adam
*German painter
b.Frankfurt, 1578 – d.Rome, 1610*

After working in the studio of Philip Uffenbach in Frankfurt from 1593 to 1598, Elsheimer left his native city and, travelling via Munich, went to Venice, where he worked for a time with Hans Rottenhammer. He seems to have been particularly impressed by the works of Titian, Veronese and Tintoretto, whose influence can be seen in the luminous range of blues, yellows and reds in the small painting on copper of 1599, *The Holy Family with Angels* (Berlin-Dahlem), and in the *Sacrifice of St Paul at Lystra* (1599, Frankfurt, Städel. Inst.). But Elsheimer was also inspired, both technically and stylistically, by the lesser painter, Rottenhammer, who also liked to paint on copper.

In 1600 Elsheimer settled in Rome, remaining there until his death. *The Education of Bacchus* (Frankfurt, Städel. Inst.), a landscape with small mythological figures, from this first Roman period, is, in spite of the motifs from around the city depicted in the background, still wholly Mannerist in style, following the landscape tradition established by Dutch painters (e.g. Schoubroeck) in Frankenthal, a town near Frankfurt. Unlike them, however, Elsheimer does not overwhelm his paintings with the thick foliage of trees. The compositional plan of the Frankenthal painters had been introduced to Rome by Paul Bril, whom Elsheimer had met and with whom he became closely linked. In the middle of the painting the foliage of a clump of trees lightened by the sun stands out delicately against the grey of the clouds and allows the eye to travel freely over the low, luminous horizon.

Elsheimer was then attracted by Caravaggio's innovations, with their strong contrasts of light and shade. The monumentality of Annibale Carracci's landscapes and Domenichino's landscapes peopled with anecdotal figures also influenced him away from the Dutch concept of landscape towards the new Italian view.

Although Elsheimer continued to paint pictures in very small format, the composition was to give them a monumental breadth that makes them comparable with large Italian Baroque paintings. His famous landscape *Dawn* (Brunswick, Herzog Anton Ulrich Museum) is a mixture of romantic ideal, idyllic reality and a delicate technique that recalls that of the miniature, only more broadly conceived. The contrasts of light and shade, the softening of planes that lose themselves in an imprecise atmosphere of hazy grey-blue, are elements that derive from Baroque art. A formal structure reduced to extremely simple elements of composition, the brightness of the morning atmosphere, the clarity of the air, and a light which pierces through the clouds, all unite to give this tiny work an entirely new monumentality. This simplicity, this way of rendering a strong feeling for nature, differs from the grandiose decorative arrangement of heroic landscape as

Annibale Carracci or Poussin used it, and prefigures the landscapes of Rembrandt or Claude.

In the same way, the nocturnal effect of *Philemon and Baucis* (Dresden, Gg) – the first painting of an interior in the modern sense of the word – foreshadows the intimate painters of the Dutch school. Elsheimer took his subject from the *Metamorphoses* of Ovid, but rather than an evening meal in a poor village interior, he was depicting a world of fable in which men and gods, linked by an intimate feeling of understanding, could become friends. It was 50 years before this subject was to be treated again – by Rembrandt, who had seen this painting, in one of his late works – and in the same sort of way, as a poetic and visionary rendering of the divine.

Among Elsheimer's other important works are landscapes enlivened by figures (*The Good Samaritan*, Louvre; *Apollo and Coronis*, Corsham, Wilts., Methuen Coll.; *Tobias and the Angel*, Frankfurt, Historisches Museum), some of them with startling effects of moonlight (*The Flight into Egypt*, 1609, Munich, Alte Pin.); scenes of artificially lit interiors (*Judith*, London, Apsley House, Wellington Coll.); and mythological or religious compositions that include very large numbers of figures (*The Martyrdom of St Lawrence*, London, N.G.; *The Martyrdom of St Stephen*, Edinburgh, N.G.), and occasionally have a touch of the fantastic (*The Burning of Troy*, Munich, Alte Pin.; *St Paul Shipwrecked*, London, N.G.). The Städelsches Kunstinstitut in Frankfurt has a fine collection of Elsheimer's work.

Elsheimer was also a remarkable draughtsman. His intensely realistic studies of figures served as models for Rembrandt, who probably owned a large number of them. As it is with his painting, so it is with his drawings: it is hard to identify the sites of his landscapes, made mostly in pencil with an extremely pictorial technique; their outlines, lightly indicated, and with broad strokes, show an extremely sure touch. The landscapes are not studies in realism but ideal images, created by the grouping of different motifs and harmoniously

▲ Christoffer Eckersberg
Woman at the Mirror
Canvas. 32 cm × 25 cm
Copenhagen, Hirschprung Collection

▲ Adam Elsheimer
Dawn
Copperplate. 17 cm × 22 cm
Brunswick, Herzog Anton Ulrich Museum

formulated in a Baroque spirit. Those in gouache, dark grey with highlights of white and a few touches of colour, show a complete mastery in the treatment of space, which is to be found again only in the late work of Rembrandt.

Elsheimer's art was followed in Germany only by such secondary artists as Johann König and Thomas von Hagelstein. Rather, it was among the leading representatives of Baroque painting that he found his admirers: Rubens was part of his entourage in Rome; Rembrandt was introduced to his work through Count Hendrik Goudt and by his master Pieter Lastman. It was Elsheimer, too, who prepared the way for the spatial vision of Claude and the 'Roman' landscapes of the Low Countries (Poelenburgh, Pynas, Breenbergh, Uyttenbroeck). He also exercised a decisive influence on Saraceni. Rubens, in a letter sent to Rome on the occasion of Elsheimer's death, wrote: 'I have never seen his equal in the realm of small figures, of landscapes, and of so many other subjects.' G.A.

Engelbrechtsz
Cornelis

Netherlandish painter
b.Leiden, 1468–d.Leiden, 1533

Engelbrechtsz was trained in the Antwerp studio of Colijn de Coter, who followed the tradition of the great 15th-century masters. An early work, a tondo of the *Man of Sorrows* (1500-5, Aix-en-Provence Museum), with its calm, restrained feeling, is derived, through de Coter, from the art of Van der Weyden. After 1508 the refined calligraphic style of the Late Gothic is felt in the triptych of the *Crucifixion* (Leiden Museum), the shutters of which represent the *Bronze Serpent* (on the right) and the *Sacrifice of Abraham* (on the left). Works like *The Lamentation* (Ghent Museum; Munich, Alte Pin.) or the triptych of the *Descent from the Cross* (*c*.1512, Leiden Museum; Rijksmuseum) also reveal the influence of the Late Gothic in the exaggeration of folds and contours, and in their refined colours. The climax of this 'Mannerist' style is *Constantine and St Helena* (Munich, Alte Pin.), in which the attenuated, elegant forms and the details of clothes and armour match the studied colours (blues, oranges, purples) and thus endow the work with its feeling of tension.

Among other works by Engelbrechtsz are: *The Descent from the Cross* (Munich, Alte Pin.); *The Holy Family* (Sigmaringen Museum); *Christ at the House of Lazarus* (Rotterdam, B.V.B.); *Christ Taking Leave of his Mother* (Rotterdam, B.V.B.); *Calvary* (Antwerp Museum); and two works in which landscape plays an important part, *The Story of the Syrian Captain Naaman* (Vienna, K.M.) and *The Sermon on the Mount* (Berlin-Dahlem).

Cornelis Engelbrechtsz was one of the last representatives of Late Gothic Mannerism; the importance of his studio, in which, apart from his three sons, Lucas van Leyden and Aertgen van Leyden also worked, made Leiden a Mannerist centre to rival Antwerp. This remarkable painter, whose tense graphic style sought to achieve effects and contrasts through colours, ended an age; it was his pupil, Lucas van Leyden, who opened up the way to the new style. J.V.

Ensor
James

Belgian painter
b.Ostend, 1860–d.Ostend, 1949

Ensor's father was English, his mother Flemish, and he showed a great talent for drawing while very young. Two painters in Ostend gave him lessons, and from the age of 15 he painted small views of the town, remarkable for the exactness of their observation and their sensitivity to atmosphere (*Plaine flamande* [*Flemish Plain*], 1876, Brussels, private coll.). From 1877 to 1880 he attended the Academy in Brussels where he profited especially from the advice of its director Jean Portaels, who introduced orientalism to Belgium.

Although he was not responsive to academic teaching, Ensor studied the old masters and made innumerable sketches after Hals, Rembrandt, Goya, Callot and – closer to his own time – Turner, Daumier and Manet. In 1879 he began his 'sombre period' (which lasted until about 1882), notably with three very small *Self-Portraits* in which the acuteness of observation is served, paradoxically, by a heavy technique, the paint being worked with a palette-knife (Brussels and Ghent, private colls.). A sort of 'Belgian Impressionism', with dim colours given more importance than light ones, appears in the 'bourgeois interiors' inspired by daily life in Ostend (*Dame en bleu* [*Woman in Blue*], 1881, Brussels, M.A.M.; *Après-midi à Ostende* [*Afternoon in Ostend*], 1881 Antwerp Museum).

The lightening of Ensor's palette, which took place in 1882, was accompanied by a rapid evolution in the spirit of his work. He suffered from the provincialism of his surroundings in Ostend and found refuge and understanding in Brussels with Ernest and Mariette Rousseau, who were to become his first collectors. He exhibited with a number of art groups in Brussels (La Chrysalide, L'Essor), then, in 1884, became a

▲ Cornelis Engelbrechtsz
Constantine and St Helena
Wood. 87 cm × 56 cm
Munich, Alte Pinakothek

founder-member of the Groupe des Vingt although they were not always prepared to welcome everything he sent in to them.

Masks – those of the carnival at Ostend in which he loved to take part, and which he had known from childhood in the shop his parents kept – now occupied a leading place in his work. The mask first appeared in 1879 in a carnival scene (*Masque regardant un nègre bateleur* [*Mask Watching a Negro Acrobat*], private coll.), but the most significant paintings came between 1887 and 1891. The mask's alter ego was the skeleton, itself often used as a disguise (*Masques se disputant un pendu* [*Masks Quarrelling over a Hanged Man*], 1891, Antwerp Museum) or as a death symbol: *Squelette regardant des chinoiseries* (*Skeleton Looking at Chinoiserie*) (1885, Brussels, private coll.), a masterpiece of macabre, unexpected humour, notable for its speed of handling and delicate colouring.

Between 1887 and about 1890 Ensor produced religious paintings that count among his boldest, both for the richness and depth of their colour (*Temptation of St Anthony*, 1887, New York, M.O.M.A.), and for the lack of realism of the graphic work (*La Chute des anges rebelles* [*Fall of the Rebel Angels*], 1889, Antwerp Museum; *Christ calmant les eaux*, [*Christ Calming the Waters*], 1891, Ostend, Musée Ensor). The virulently satirical *L'Entrée du Christ à Bruxelles* (*Entry of Christ into Brussels*) (1888, Antwerp Museum), Ensor's most characteristic work and one refused by Les Vingt, associates the mask with its religious theme; painted in Ostend, it was preceded by six large charcoal studies (1885-6), entitled *Les Auréoles du Christ ou les sensibilités de la lumière* (*The Haloes of Christ or Feelings of Light*). The painting is a development of the third *auréole*, *La vive et rayonnante Entrée à Jérusalem*)) (*The Joyous Entry into Jerusalem*) (1885, Ghent Museum), and the original purpose, which was not very mystical or symbolic, has been transformed.

Ensor to some extent came to terms with the society in which he had to live lending his art the cover of a Flemish-style 'morality', prefigured in the 16th century by Bosch, Bruegel and the Mannerists, in which biblical subjects were used for social satire. The frail, tiny figure of Christ is a solitary gleam of serenity dragged along by the enormous billowing crowd, the faces of which, in the foreground, have the aspect of masks, symbols of hypocrisy. The rough texture and discordant colouring of the carnival masks allowed Ensor to bring dissonance and an exaggerated expression to his art. 'The mask', Ensor wrote, 'gives me freshness of tones, heightened expression, sumptuous decor, large unexpected gestures, disorderly movements, exquisite turbulence.' A number of Ensor's paintings after 1888 are in a direct line of descent from the *Entrée du Christ* (*L'Intrigue* [*The Intrigue*], 1890, Antwerp Museum; *L'Homme de douleur* [*The Man of Sorrows*], 1899, Ghent, private coll.), a work which was to influence Van den Berghe.

During this fertile period Ensor did not entirely abandon landscape (views of the beach and port of Ostend) or still life; he treated both in very light colours, with a rich use of white (*Barques échouées* [*Beached Boats*], 1892, Brussels, private coll.). In this period, too, he never allowed his work as a painter to take over from what he was doing as a draughtsman and etcher (he produced his first etchings in 1886), in which he exploited line, as well as often very Rembrandtesque effects of light and shade.

In the engravings he reinterprets subjects from

his paintings, as well as creating original compositions (*La Cathédrale*, [*The Cathedral*], etching, 1886 and 1896) and intimate studies (*Le Réverbère*, etching, 1888). Crowd effects, rendered with humour in a swift, cursive line, triumph in *La Bataille des éperons d'or* (*The Battle of the Golden Spurs*) (etching, 1895) and *Les Bains à Ostende* (*Bathing at Ostend*) (etching, 1899). Ensor's self-portraits – paintings, drawings and engravings – show a self-obsession which he was ready to admit smacked of parody (*Ensor au chapeau fleuri* [*The Artist in a Floral Hat*], 1883, Ostend, Musée Ensor), of the absurd, and of the macabre (*Mon portrait en 1960*, [*Self-Portrait, 1960*], an etching in which he shows himself reduced to a skeleton).

This fertility of invention and sureness of hand was not prolonged much after 1900. Ensor still had half a century to live, but the essential part of his work had been done in less than 20 years. The effervescence of his creation seems to have lost the very power of regeneration that characterized it; from then on he 'systematically gave himself up to plagiarizing himself' (P. Haesaerts, in *James Ensor*, Brussels, 1957). The views of Ostend followed one another, always in very pale tones (*Port d'Ostende au crépuscle par temps d'orage* [*Stormy Evening at the Port of Ostend*], 1933, Paris, private coll.), and he sometimes took up the themes of his sombre period, but without the same success. Created a baron in 1929, he lived at Ostend, the object of a rather belated recognition which he did not overvalue; several years before his death he stopped painting altogether.

Ensor's genius owed little to his contemporaries and he had no successors. Although he was the forerunner of Surrealism (he shared its taste for the strange, fascinating object), as well as of Expressionism, the evolution of these two important styles of Belgian and European painting followed ways that were clearly different from those he had opened up. From 1886 to 1922 he made 138 engravings, as well as two sets of lithographs: *Scènes de la vie du Christ* (*Scenes from the Life of Christ*) (31 lithographs, 1921) and *La Gamme d'amour* (*The Gamut of Love*) (22 lithographs, 1929). Ensor is well represented in Belgian galleries (Antwerp, Brussels and Ostend), as well as in New York (M.O.M.A.), Paris (*Dame en détresse* [*Woman in Distress*], 1882, Louvre) and in important private collections.

M.A.S.

Ernst
Max

French painter of German origin
b.Brühl, Rhineland, 1891 – d.Paris, 1976

Ernst's work is among the most personal in modern art, at the same time most clearly a part of its history. Throughout his place in the vanguard of Dadaism and Surrealism Ernst was one of the pioneers of the *Nouvelle Réalité*, and this by virtue of his unique imagination. From adolescence his reading of the Romantics had revealed to him the treasures of the Germanic imagination, while the friendship of Macke, whom he met in Bonn, initiated him into Expressionism. He discovered Van Gogh, Kandinsky and other masters of modern art, and his first paintings showed the influence of them all; the

prints of this period (1911-12), on lino, were like those of Die Brücke. In 1913 he exhibited in the first German Autumn Salon, organized by Walden in Berlin, and the same year in Bonn and Cologne with the Rhineland Expressionists. Called up in the war, he was able to continue painting (*Fish Battle*, 1917, watercolour, private coll.).

The war precipitated a crisis of nihilism, and it was then that Ernst made the discovery, which was of paramount importance for his style, of the Dada movement. In 1919, in Cologne, he re-encountered Hans Arp, whom he had first met in 1914, and together with Baargeld they founded the famous 'Central W/3'; his activity, which at first had been political, became purely artistic. While Dadaism in Cologne went its way, Ernst, apart from producing the eight lithographs of *Fiat modes, pereat ars* (1919), in which lay-figures evolve in Chirico-like surroundings elaborated a personal technique of collage based on the fortuitous meeting of two distinct realities on an unsuitable plane, of which the first products were the 'fatagagas' (*Fabrication de Tableaux Garantis Gazométriques*), whose parenthood he shared with Arp (*Laocoön*, 1920, private coll.).

When Dada came to an end in Cologne in 1920 Ernst went to Paris at Breton's invitation and exhibited at the Galerie Au Sans Pareil in May 1921. The paintings of the early 1920s drew away from de Chirico and suggested the beginnings of Surrealism (*Éléphant Célèbes* [*Celebes*], 1921, London, Tate Gal.; *Seestück* [*Seascape*], 1921, Paris, private coll.; *Oedipus Rex*, 1922, Paris, private coll.). The collages of the same years were made by cutting up postal sales catalogues, technical encyclopaedias, illustrations from the works of Jules Verne, photographs and graphics (*Les Pléiades*, 1921, private coll.).

▲ Max Ernst
La Grande Forêt (1927)
Canvas. 114 cm × 146 cm
Basel, Öffentliche Kunstsammlung

James Ensor ▲
L'Entrée du Christ à Bruxelles (1888)
Canvas. 258 cm × 431 cm
Antwerp, Musée Royal des Beaux-Arts

While Dada was disintegrating under the impulse of Surrealism, Ernst himself was going through a crisis of conscience. Very closely linked with Breton, Eluard, Desnos and Péret (*Le Rendez-vous des amis* [*The Friends' Rendezvous*], 1922, Cologne, W.R.M.), he evolved, at the same time as the other members of the group, towards a more methodical exploration of the unconscious than that of Dada. His subjects became more defined: a fixed cosmos – stars, a motionless sea, towns, mineral forests (*Grande Forêt* [*The Great Forest*], 1927, Basel Museum), fossilized flowers – in which the bird motif symbolized the love of freedom and of the lack of constraint of the artist (*Aux 100,000 colombes* [*To the Hundred Thousand Doves*], 1925, Paris, private coll.). The wind, too, appears as a theme (*La Mariée du vent* [*The Tempest*], 1926, private coll.), as do fire and love (*Une nuit d'amour* [*A Night of Love*], 1927, private coll.).

His technique, enriched by the 'frottage' process which he devised in 1925 (sheets of paper laid on strips of floor and rubbed with lead; the process was then extended to other objects), excelled in representing the sense of a massive universe, in which he never failed to find similar associations (*Le Fleuve Amour* [*Love River*], 1925, Houston, Texas, Menil Family Coll.; *Le Start du*

châtaignier [*Chestnut Tree*], 1925, Zürich, private coll.). This technique, and this universe, were from then on to be more deeply examined rather than diversified. Collages (*La Femme 100 têtes* [*The Woman with 100 heads*], 1929; *Une Semaine de bonté* [*A Week of Goodness*], 1934), rubbings (*Histoire naturelle* [*Natural History*], 1926), prints, photomontages, all explore and link incompatible elements, the incongruous coupling of which, at the mercy of Ernst's imagination, gives rise to a disquieting poetry (*La Femme 100 têtes ouvre sa manche auguste* [*The Woman with 100 Heads Opens her Majestic Sleeve*], collage, 1929, Houston, Menil Family Coll.).

At the same time the paintings continued to explore Max Ernst's imaginary universe more widely and seriously; their visionary poetry links them with the great introspective tradition of German romanticism (*Vieillard, femme et fleur* [*Old Man, Woman and Flower*], 1923, New York, M.O.M.A.; *Vision provoquée par l'aspect nocturne de la porte Saint-Denis* [*Vision brought on by the Porte Saint-Denis at Night*], 1927, Brussels, private coll.; *Monument aux oiseaux* [*Monument to the Birds*], 1927, private coll.; *Le Nageur aveugle* [*The Blind Swimmer*], 1934, United States, private coll.; *La Ville entière* [*The Entire City*], 1935-6, Zürich, Kunsthaus; *Barbares marchant vers l'ouest*

[*Barbarians Marching Westwards*], 1935, private coll.). As war drew closer, Ernst's work became more and more steeped in disquiet.

Ernst sculpted and painted large compositions in which life appears as though paralysed (*Un peu de calme* [*A Little Calm*], 1939, private coll.; *Europe après la pluie II* [*Europe after the Rain*], 1940-2, Hartford, Connecticut, Wadsworth Atheneum). After breaking with the Surrealists in 1938, he emigrated to the United States in 1941, where, having settled in New York, he exercised a lively influence on young American painters. Together with Masson he appears to have employed the technique of dripping, adopted and developed philosophically by Pollock and his followers (*L'Oeil du silence* [*The Eye of Silence*], 1943-4, St Louis, Missouri, Washington University Gal. of Art; *La Planète affolée* [*The Crazy Planet*], 1942, Tel Aviv Museum; *Tête d'homme intriguée par le vol d'une mouche non euclidienne* [*Head of a Man Intrigued by the Flight of a Non-Euclidian Fly*], 1947, private coll.).

Ernst's meeting with Dorothea Tanning in 1943 proved to be the beginning of a peaceful, very fertile period. In 1946 they settled in Sedona, in the mountains of Arizona, and did not return to France until 1955. Active and thoughtful, Ernst then created obscure poetic compositions, either

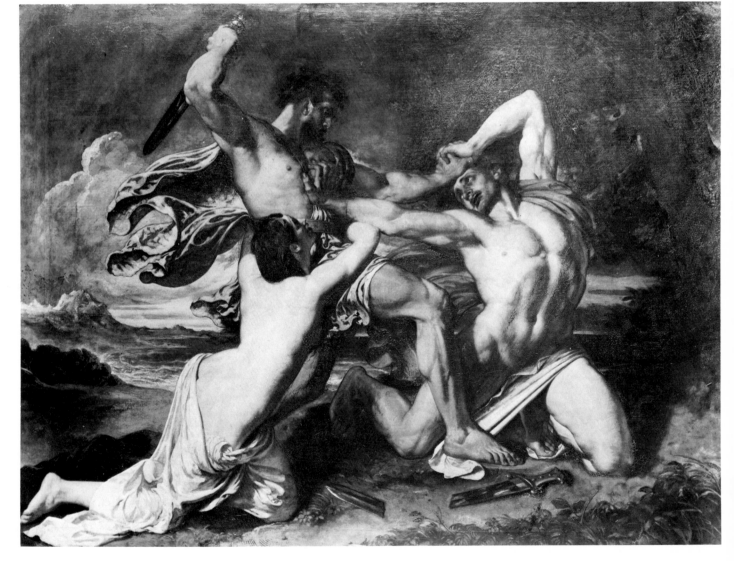

▲ William Etty
The Combat: Woman Pleading for the Vanquished
(1825)
Canvas. 254 cm × 341 cm
Edinburgh, National Gallery of Scotland

sculpted or painted, in which the theme of the sovereign pair (*Le Roi jouant avec la Reine* [*The King Playing with the Queen*], 1944, private coll.) mingled with his familiar dark places and with memories of childhood on the Rhine (*Nuit rhénane* [*Rhineland Night*], 1944, Paris, private coll.). He divided his time between Paris and Huismes, in Touraine, still producing a great deal of work marked by the same poetic fervour (*Pour une école de harengs* [*For a School of Herrings*], 1965, Paris, private coll.; *Configurations*, collages and rubbings, 1974). His work, which is among the most distinguished of the 20th century, is to be found in most of the great European and American galleries, but especially in important private collections (Venice, Peggy Guggenheim Foundation; Houston, Menil Family Coll.). P.G.

Etty
William

English painter
b. York, 1787 – d. York, 1849

The seventh son of a miller, Etty was apprenticed to a printer in Hull for seven years, although he always wanted to be a painter. He then went to London, where, supported by his family, he learned to draw from the antique. Soon afterwards he painted a *Cupid and Psyche* which, with the help of Opie and Fuseli, qualified him for entry to the Royal Academy Schools. While studying at the Academy Etty stayed in the home of Sir Thomas Lawrence, but apparently received little instruction. In 1811 he succeeded in having two of his paintings accepted for exhibition.

Etty visited Italy in 1816, and again in 1822, when he spent 18 months in Rome, Florence and Venice. He particularly admired the Venetians, Titian, Tintoretto and Veronese, and discovered 'the power of colour and chiaroscuro', which he subsequently attempted to incorporate in his own paintings.

Although he had some success with exhibits at the British Institution and the Royal Academy in 1820 and 1821, Etty was still regarded by some of his contemporaries as rather a dull artist, who had little chance of ever really distinguishing himself. This opinion as probably partly due to the fact that he continued to attend courses at the Academy, studying there almost every night. He worked incessantly, and like a student, remained poor for many years.

In 1824 he was elected to the Academy as an Associate Member and exhibited *Pandora Crowned by the Seasons* (Leeds, City Art Gal.), which was bought by Lawrence. In the following year he painted *The Combat: Woman Pleading for the Vanquished* (Edinburgh, N.G.), which was also bought by an artist, this time John Martin. In 1827 he exhibited the first of the three ambitious *Judith* paintings (all three, Edinburgh, N.G.), and in 1828 he became a full Academician. Two years later he visited Paris, for the fifth time, and was there during the Revolution of 1830; on his return he gave vivid accounts of what he had seen, and announced that he had had enough of the Continent, and that he did not intend to leave England again.

Etty painted a large number of pictures, and nearly all of them included female nudes. He wrote: 'Finding God's most glorious work to be

Woman, that all human beauty had been concentrated in her, I resolved to dedicate myself to painting – not the Draper's or Milliner's work – but God's more glorious work, more finely than ever had been done.' His nudes shocked many people, and there was much criticism of his paintings on the grounds of indecency. *The Times*, for instance, thought that his pictures were 'entirely too luscious for the public eye'. The *Spectator* described *The Sirens and Ulysses* (or *The Wages of Sin are Death* 1837, Manchester City Art Gal.) as 'a disgusting combination of voluptuousness and loathsome putridity – glowing in colour and wonderful in execution, but conceived in the worst possible taste'. However, Etty painted with earnest moral purpose, and he resented such comments; his sincerity is borne out by his shy and reserved personality.

In 1846, when his health was declining, Etty ceased to paint small pictures, and devoted his time to the completion of his last series of paintings, the three *Joan of Arc* canvases (present whereabouts unknown), which were exhibited separately in 1847. In 1848 he returned to York, by this time a famous man, and died there in the following year, on November 13th. A week before his death he went to London to see an exhibition of his collected works at the Society of Arts. In his last years Etty's paintings began to sell for high prices, and with the patronage of men like Joseph Gillcott, who first mass-produced pen-nibs, he made a considerable amount of money.

Etty had some influence on a number of artists, including Watts and Millais, although his work – especially the exhibited paintings – was never completely successful. His figures are frequently marred by faulty anatomy and bad drawing, but his rich and vital colouring, with its strong echoes of the Venetians and Rubens, is unusual for the time, and important in the development of English painting in the 19th century. J.H.

Evenepoel
Henri

Belgian painter
b. Nice, 1872 – d. Paris, 1899

After following evening courses at the Academy of St Josse, Evenepoel attended a class in decorative art at Brussels Academy. He attached himself briefly to Galland's studio when he arrived in Paris in 1892, before going on to Gustave Moreau's (1893) where he met Rouault. He later was to meet and form a relationship with Matisse. In 1894 he designed a number of posters for Belgian firms, but the everyday life of Paris fascinated him, as is shown by the studies of character that appear in his many sketches.

The work of Manet, which he saw at Durand-Ruel's, came as a revelation to him and influenced his *Homme en rouge* (*Man in Red*) (1894, Brussels, M.A.M.) and particularly his *Espagnol à Paris* (*A Spaniard in Paris*) (1899, Ghent Museum). Paintings like *Le Caveau du Soleil d'or* (*The Cellar of the Soleil d'Or*) (1896, Brussels, private coll.) and *Le Café d'Harcourt* (1897, Frankfurt, Städel. Inst.) recall the Impressionists in their evocation of atmosphere, and Toulouse-Lautrec in their expressive sharpness, although their vigour is

entirely northern. This spontaneous reaction to the life immediately around him explains Evenepoel's liking for portraits, and those he left of his cousin Louise (whom he loved, and who returned his love) and of her two children are among his best (*La Dame au chapeau blanc* [*Woman with the White Hat*], 1897, London, private coll.).

As a rule Evenepoel expressed himself in dark colours, with very similar tones (*Le Noyé du pont des Arts* [*The Drowned Man at the Pont des Arts*], 1895, Ixelles Museum), but a stay in Algiers at the end of 1897 and the beginning of 1898, taken to restore his already failing health as well as to separate him from his cousin, resulted in a change of style. These Algerian landscapes and scenes of local customs, painted in Blida and Tipaza, are distinguished by their warmer colours and the sharper drawing of their figures; the simplification of the arrangement as well as the economy of the colour relationships sometimes suggests the boldness of the Fauves (*Femmes au narguilé* [*Women Smoking*], 1898, Ghent, private coll.).

This short experience led to a new relaxation in Evenepoel's style, evident in *La Promenade du dimanche* (*The Sunday Walk*) (1899, Liège Museum) and in the last portraits, which, although still soberly constructed, are more movingly painted, using, as delicate counterpoint to the ochres and blacks, a patch of tender blue, or a touch of pale pink or gold (*Henriette au grand chapeau* [*Henriette with the Large Hat*], 1899, Brussels, M.A.M.

Evenepoel died at the age of 27 and left work of already equally high quality from 1897 onwards. His taste for direct observation, realistic in the northern manner, is varied by a lively interest in unexpected means of composition (notably some inspired by photography) that links him closely with his age. Above all, his tenderness towards people and his concern for the most fleeting aspects of life make him a brother in spirit of Bonnard and Vuillard. M.A.S.

Eworth
Hans

Anglo-Flemish painter
active 1540-73

Eworth was born in Antwerp, where he was listed as a freeman, and entered the Antwerp Guild of St Luke in 1540. His name appears in a number of different forms, Eywoodes, Evertz, Evance,

I for French ambassadors, which shows that he was once more working at the court: although he was almost certainly the official portraitist of Mary, he had fallen from favour during Elizabeth's reign, possibly because of Catholic connections. J.H.

Eyck
Jan van
Flemish painter
b. c.1395 – d. Bruges, 1441

Jan van Eyck is first mentioned in connection with payment for services in The Hague to Count John of Holland between 1422 and 1424. His place of birth is thought to be – though without complete certainty – Maeseyck, a village in the Meuse valley, in the diocese of Liège.

His earliest known works seem to be illuminations of several pages of the *Hours of Milan-Turin*, made either for Duke William IV of Bavaria some time before 1417 or, more likely, for Count John between 1422 and 1424 (*The Kiss of Judas, St Julian and St Martha in a Boat, The Prayer of a Sovereign Prince*, previously in Turin, B.N., all destroyed; *Birth of St John the Baptist, Mass of the Dead*, Turin, Museo Civico). The general spirit of these compositions is realistic, but the line of the figures and the delicacy of the colouring shows the persistence of the International Gothic style. Some other pages (those grouped together under the label *Hand G* by Hulin de Loo in his analysis of the manuscript) may also be by Van Eyck, and in these the precision and delicacy of the light effects are especially remarkable.

From May 1425 we find Van Eyck in the service of Philip the Good, Duke of Burgundy, with whom he was to remain until his death. From 1426 to 1429 he was settled in Lille. In 1426 he made two secret journeys, possibly to make portraits of princesses whom the Duke, who was a widower, thought he might marry. From 19th October 1428 to Christmas 1429 he formed part of the embassy that went to Lisbon to arrange the marriage of Philip the Good with Isabella of Portugal. On this occasion he made two portraits of Isabella, whom the Duke married in 1430 (both portraits lost).

We know little of his service with the Duke, except that in 1433 he was working at the Coudenberg Palace in Brussels. The first of his works seems to have been the *Virgin in the Church* (Berlin-Dahlem), which suggests an interior lit by a light as delicate and ethereal as that in the pages of Turin.

The first landmark in his career is the altarpiece of the *Mystic Lamb* (Ghent, Church of S. Bavon). It is inscribed with a verse saying that it was begun by Hubert van Eyck (Jan's brother, who died in 1426), and that it was finished by Jan in 1432. The surprising size of the plan led Van Eyck to use rather different formulas in the various parts. The lower panels, on the inside of the altarpiece, show fairly small figures in a large landscape: in style they are still like the illuminations and may have been carried out in collaboration with his brother Hubert. On the other hand, in the upper panels there are figures that are nearly half life-size, differing considerably in scale from the rest of the figures in the panels. The most remarkable are Adam and Eve, who are the

Huet and Suete being amongst the variants, although he commonly signed his works with the monogram 'HE'. Eworth's importance in the history of 16th-century English painting is largely due to the fact that he is one of the few artists of the period whose development can be fairly clearly observed through the evidence of signed and dated works. He is known to have been in London in 1549, and he can be traced there until 1573. There are about 30 known paintings that are signed and dated, and many show both an awareness of the character of the sitter, and a sensitive nervous style, which enliven the 'iconic' portraiture of the time.

Eworth's earliest known work is a small panel of a *Turk on Horseback* (United Kingdom, Yarborough Coll.), which is dated 1549, and which probably depicts the Grand Turk. It is an elegant and decorative painting and bears little resemblance to the portraits of the 1550s. Two early portraits of *Thomas Wyndham* (private coll.) and *Sir John Luttrell* (private coll., and London, Courtauld Inst. Galleries) are of an uncle and nephew. Wyndham is portrayed in front of a battlefield, which probably refers to his part in the Scottish campaign of 1547. Sir John is seen naked to the waist, wading in rough seas, where there is a foundering ship; he gazes at a figure of Peace in the sky, whose attendants hold his spear, armour, horse and money-bags. The allegory may be a reference to the treaty with France that was made in 1550. In these paintings Eworth draws heavily on his early training, as they closely follow contemporary Antwerp styles.

In 1554 Eworth painted a portrait of Mary I (London, Society of Antiquaries) which shows the influence of Holbein, the most important portraitist in England during the first half of the century. Other works, such as *Lady Dacre* (Ottawa, N.G.), also reveal Eworth's debt to Holbein. By 1559, when he completed the fine double portrait of the *Duchess of Suffolk and Adrian Stoke* (United Kingdom, Wynne-Finch Coll.), Eworth had also absorbed some of the stylistic characteristics of Anthonis Mor.

Two companion portraits of 1562 and 1563, *Thomas, Duke of Norfolk* (United Kingdom, private coll.) and *The Duchess of Norfolk* (United Kingdom, Neville Coll.), were conceived as a single unit, both sitters being before a continuous armorial tapestry, but they are otherwise typical products of the Elizabethan era.

After 1569 Eworth's paintings are rare, and those that are attributed to him are not certainly by his hand. In 1572 he designed the decor and costumes for a series of fêtes staged by Elizabeth

first monumental nudes to be found in northern European painting.

The coherent treatment of the exterior of the polyptych reveals a certain unity of conception: the proportion between the panels of one level and those of the other is well balanced and shows a monumental feeling. The figures of the donors, Jodocus Vydt and his wife Elisabeth Borluut, are depicted in powerful outline beneath the arches where they are praying, while the *Annunciation* in the second row takes place in an interior which opens out, through a window, on to a medieval square. The panels as a whole are harmonized in a much darker range of colours than that of the interior, which suggests grisaille and has a more sculptural, decorative character.

After 1432 come dated works: *Portrait of Tymotheos* (1432, London, N.G.), identified with the musician Gilles Binchois; and *The Man in the Red Turban* (1433, London, N.G.), sometimes considered to be a self-portrait. The same date (1433) appears on a small panel of a *Virgin and Child* (Melbourne, N.G.), which has been shown to be merely an old copy of a lost original. One of Van Eyck's masterpieces, the portrait of *Giovanni Arnolfini and his Wife* (London, N.G.), is dated 1434. The two figures appear in the foreground of a domestic interior which displays a deep interest in light effects. Above a looking glass behind the couple, whose backs are reflected in it, is written: '*Johannes de Eyck fuit hic*' ('Jan van Eyck was here'), and it is indeed possible to see in the mirror two other figures, who would theoretically be in the position of the spectator, in the entrance to the room (one of them might be the painter): characteristic details of a completely realistic kind, which also shows a taste for *trompe l'oeil*.

In 1436 Van Eyck painted the portrait of a goldsmith of Bruges, *Jean de Leeuw* (Vienna, K.M.), and the *Virgin of Canon van der Paele* (Bruges Museum), his largest work after the *Ghent Altarpiece*. In spite of the solemnity of the scene, which is set in a church, the dignitary is shown with a realism that has a touch of humour about it. In 1437 two small works suggest a microscopic world: *St Barbara* (Antwerp Museum), unfinished, shows, behind the saint, a lively workyard in which stands a tower, an attribute of the saint; a small triptych (*The Virgin and Child between St Michael and St Catherine*, Dresden, Gg) transposes the spirit of the *Virgin of Canon van der Paele* into a miniature world.

The year 1439 saw the creation of two very different works. One is the portrait of *Margarethe van Eyck* (Bruges Museum), a half-figure severely set behind a marble frame, and with a remarkable human presence. The other, *The Virgin at the Fountain* (Antwerp Museum), is in the same style as the small works: a precious, crystalline world surrounds the delicate outline of the Virgin. Finally, it is probable that in 1440-1 Jan van Eyck worked on the *Madonna of Nicolas van Maelbeck* (Great Britain, private coll.), which remained unfinished and was intended for the Church of St Martin in Ypres.

In addition to these works, which are dated by an inscription on the original frame, often with the motto 'ALC IXH XAN' (als ich kan', 'as I can'), there are several important paintings which are harder to place chronologically. The *Annunciation* in the National Gallery, Washington (formerly in the Hermitage), is probably one of Van Eyck's earliest works; it has certain affinities with the *Ghent Altarpiece* but is in a more archaic style. The surprising *Portrait of a Cardinal* (Vienna, K.M.), of which an exact preparatory drawing also survives (Dresden, Print Room), is no longer thought to be of Cardinal Albergati. The portrait of *Baudoin de Lannoy* (Berlin-Dahlem) is later than 1431. The *Virgin and Child*, from the collection of the Duke of Lucca (Frankfurt, Städel. Inst.), is close in style to the *Ghent Altarpiece*.

Finally, the *Madonna of Chancellor Rolin* (Louvre), painted for the Duke of Burgundy's adviser and destined for his chapel in Autun Cathedral, may date from around 1430. Between the Virgin and the donor, through a triple arcade, appears a remarkably exact urban landscape; in essence the view is that of Liège, although Van Eyck has altered certain details. The *Virgin and Child with Saints* (New York, Frick Coll.) poses several problems; it is possible that the work was commissioned by the prior Jan Vos, but less likely that it can be dated only from the nomination of the monk as prior in Bruges in 1441; it seems probable that it was finished by Petrus Christus.

Several other paintings are of less certain provenance. This is the case with two panels showing the *Crucifixion* and the *Last Judgement* (Metropolitan Museum), which are in a more illustrative and archaic style than most of the works that can be attributed with certainty. It is possibly also the case with the two versions of *St Francis with the Stigmata* (Philadelphia, Museum of Art, Johnson Coll.; Turin, Gal. Sabauda). It is above all the case with a *St Jerome in his Cell* (Detroit, Inst. of Arts), which is dated 1442, the year after Van Eyck's death. This last painting has also been thought to be of much later origin.

A *Carrying of the Cross* (Budapest Museum) and a drawing of an *Adoration of the Magi* (Berlin-Dahlem), both of them probably youthful works, are often taken for copies of lost works by Jan van Eyck. It is also thought that he may have painted two works that are fundamental to the birth and development of secular painting in Europe, today known only from descriptions or later interpretations: a *Woman at her Toilet* and a *Merchant at his Account Books*.

In the 17th century Van Eyck was generally credited with the invention of oil painting, although, in fact, the medium was known earlier; however, he seems to have made its use more general. His method remains very personal, and seems based on the superimposition of layers of different kinds, one on top of the other, making use of their transparent quality.

There is some difficulty in distinguishing the work of Jan van Eyck from that of his brother Hubert. Several references in the archives of Ghent in 1425 and 1426 refer to Hubert, the text of whose epitaph was published by Mark van Vaernewyck in 1568. It is very hard to make out what was Hubert van Eyck's part in the painting of the *Ghent Altarpiece*. The most varied hypotheses have been put forward, none of them conclusive. All are agreed, however, in seeing the lower panel of the centre (the *Adoration of the Lamb*) as the essential part of Hubert's work, even though it must be admitted that it was later partially repainted by his brother Jan.

Although it is now generally thought that he was not the illuminator of certain pages in the *Milan-Turin Hours*, it is often thought that he was responsible for two paintings: *The Three Marys at the Tomb* (Rotterdam, B.V.B.) and an *Annunciation* (Metropolitan Museum, Freidsam Coll.). His art here seems linked to the International Gothic style, evident in the fluidity of his elegant figures, in which one can at the same time discern a precise realism that analyses the world in its complexity and above all in its richness. However, these gifts do not distinguish his work from that of Jan van Eyck except in very subtle ways, and one can understand the temptation, succumbed to by some critics, to see in Hubert merely an imaginary figure. A.Ch.

Fabritius
Carel

Dutch painter
b.Midden-Beemster, 1622 – d.Delft, 1654

Around 1641 Carel Pietersz adopted the name Fabritius, which refers to his early training as a joiner (*faber* = carpenter). His brother Barent also used the same surname. Their father, Pieter Carelsz, was a schoolmaster but he also practised painting, and was probably their first teacher. After his marriage in September 1641 Carel settled in Amsterdam and became a pupil of Rem-

▲ Carel Fabritius
The Sentinel (1654)
Canvas. 68 cm × 58 cm
Schwerin, Staatliches Museum

▲ Jan van Eyck
The Madonna of Chancellor Rolin
Wood. 66 cm × 62 cm
Paris, Musée du Louvre

brandt at the same time as Hoogstraeten, around 1642. His time with Rembrandt must have been fairly short, for in 1643 he was widowed and returned to Midden-Beemster, where he lived until he married again in 1650 (paying occasional visits to Amsterdam in 1647-8).

Fabritius's second wife came from Delft and Fabritius's presence there is documented from 1651 and confirmed by the fact that he joined the Guild of St Luke in the town. He died on 12th October 1654, as a result of injuries received in the tragic explosion of a gunpowder mill that blew up the entire town – an accident often shown in the paintings of the time, notably those of Vermeer and above all of Egbert van der Poel, who made a speciality of the subject (examples at the National Gallery in London, the Rijksmuseum, and the Prinsenhof Museum in Delft).

Although he died young, Fabritius was already famous in his own day, and has the distinction of having been, if not the master (there are no proofs of this), at least a decisive influence on the formation of Vermeer. There is, in fact, nothing more Vermeer-like than Fabritius's last work, his *Goldfinch* of 1654 (Mauritshuis), in which the bird shows up against a creamy, intensely luminous background. Fabritius's use of *trompe l'oeil* is also like Vermeer's, as is his employment of illusionist perspectives, that favourite device of painters of interiors. Without optical boxes like those of Hoogstraeten (London, N.G.) – attributed to Fabritius by a number of 17th-century inventors – the curious *View of Delft* of 1652 (London, N.G.), with its double vanishing point and its foreground jutting out on the left, would be enough to prove his interest in this kind of problem.

It has always been hard to make a proper assessment of Fabritius, because his paintings are extremely rare. In fact, we know mainly late ones, like *The Sentinel* in Schwerin Museum (1654), *The Goldfinch* and a powerful *Portrait of a Man*, depicted in head and shoulders against a light sky (1654, London, N.G.). This last is especially interesting for its free adaptation of a theme of Rembrandt, although there is no proof that it is a self-portrait.

A few works from the 1640s, such as *The Raising of Lazarus* (Warsaw Museum) and *The Martyrdom of St John the Baptist* (Rijksmuseum), reveal the influence of Rembrandt in their liking for thick paint, a rich colour that emphasizes accents with vigorous touches, and a freedom of technique that allows the exploitation of the granular effects that Vermeer liked. There are also the processes cultivated in the key painting in Rotterdam Museum (*c.*1650?), the *Self-Portrait*, which is at once so much like Rembrandt in its casualness and so characteristic in its sweeping pre-Vermeer technique. The rest of Fabritius's work consists of heads of old men, a very fashionable exercise in Rembrandt's studio (various examples in the Louvre, at the Mauritshuis, and in Groningen Museum). J.F.

Fantin-Latour
Henri
French painter
b.Grenoble, 1836 – d.Buré, Orne, 1904

Fantin-Latour received his first teaching from his father, who had been well known as a portrait painter in Grenoble. Having arrived in Paris as a child with his family, he entered the studio of Lecoq de Boisbaudran in 1851; but it was at the Louvre that he discovered his masters in Titian, Veronese, Van Dyck and Watteau. His friendship with Whistler took him to England where he soon became known, and where he stayed four times between 1859 and 1881, coming into contact with the Pre-Raphaelites and particularly Rossetti.

The first paintings he sent to the Salon in 1859 were refused (*Self-Portrait*, Grenoble Museum). He had better luck in 1861, but after being refused again in 1863 took part in the Salon des Refusés and continued to exhibit regularly at the Salon after 1864. His first works were portraits: individual ones (*Édouard Manet*, 1867, Chicago, Art Inst.; *Mme Fantin-Latour*, 1877, Grenoble Museum); double portraits (*Deux Soeurs* [*Two Sisters*], 1859, Antwerp Museum; *Mr and Mrs Edwards*, 1875, London, Tate Gal; *La Lecture* [*The Reading*], 1877, Lyons Museum); and collective portraits, which are the best known and through their grouping suggest those of 17th-century Holland. Today they are in the Louvre (Jeu de Paume): *Hommage à Delacroix* (1864), *L'Atelier des Batignolles* (*A Studio in the Batignolles Quarter*) (1870), *Un coin de table* (*A Corner of the Table*) (1872), and *Autour du piano* (*Around the Piano*) (1885). They give a credible image of artists and writers.

But Fantin's art found two other forms of expression: still life and poetic composition. The still life paintings, like the portraits, are realistic in feeling. Painted with a very careful brush, they are crowded with flowers, fruit and objects, brightly but subtly lit. The *Nature morte des fiançailles* (*Betrothal: Still Life*) (1869, Grenoble Museum) is the most moving of all his paintings. In contrast to the realism of the still lifes, his poetic compositions disclose an unreal, fairy world peopled by scantily clad nymphs, which prolongs the memory of Prud'hon and adds a Pre-Raphaelite influence to it. Most of these works were inspired by Fantin's passion for music. He took his subjects from Schumann, Wagner and Berlioz and paid homage to Berlioz in his allegory in Grenoble Museum, *L'Anniversaire* (*Anniversary*) (1876). In the same way his enthusiasm for opera inspired an important series of lithographs, especially those devoted to Berlioz and Wagner.

Fantin was closely connected with the Impressionists whom he met at the Café Guerbois and admired, but he was dissociated from the movement by a traditional way of working, by the reserve and psychological interest in his portraits, by the precise drawing in his still lifes and by his liking for black and grey, for dark harmonies. As one of the last *intimistes* he was close to Carrière. H.T.

Fattori
Giovanni
Italian painter
b.Leghorn, 1825 – d.Florence, 1908

Fattori studied first in Leghorn, then in Florence (1846-8) with Giuseppe Bezzuoli, a painter of portraits and of historical works with a romantic bent. This training was to influence him for a long time (*Mary Stuart*, 1859, Florence, G.A.M.), even after he had had joined in 1859 the Macchiaioli group of realist painters who worked from nature (*macchia* is a 'patch' or 'blob' and alludes to the type of brushwork which these painters employed to create effects of chiaroscuro). His painting of the *Italian Camp after the Battle of Magenta* (1861-2, Florence, G.A.M.) incorporated the results of his experiments with a new style, based on the contrast between dark and light zones of colour and forming a pattern of masses. The style, however, was better suited to his smaller paintings. Originating as sketches, these then soon developed into independently conceived works (*French Soldiers*, 1859, Crema, private coll.).

At the same time as he was creating his large battle scenes (*The Battle of Montebello*, 1862, *Assault on the Madonna delle Scoperte*, 1864; both Leghorn Museum). Fattori also painted an important series of smaller works, many of them in a horizontal format that was emphasized by the play of bands of contrasting colours. It was in these works that he was at his most successful, full of a careful lyricism (*Bathing-Hut*, Florence, private coll; *The Rotonda di Palmieri*, 1866, Florence, G.A.M.; *Pine Forest at Castiglioncello*, Milan, private coll.; *The Millstone*, Leghorn Museum; *Signora Martinelli at Castiglioncello*, Leghorn Museum; *Rest*, 1887, Brera).

Fattori was appointed a professor at the Academy in Florence in 1869. In the course of the

Giovanni Fattori ▲
The Rotonda di Palmieri (1886)
Wood. 12 cm × 35 cm
Florence, Galleria d'Arte Moderna

Henri Fantin-Latour ▲
Un coin de table (1872)
Canvas. 160 cm × 225 cm
Paris, Musée du Louvre

following decades he continued to paint military pictures (*The Battle of Custoza*, 1876-80, Florence, G.A.M.), and rustic scenes (*Branding the Bulls*, Genoa, private coll.). His style was now distinguished by an accentuation of the graphic construction and, a little later, by a sentimental tendency that belonged to social realism (*The Cavalryman*, 1882; *The Dead Horse*, 1903). He also left portraits (*Portrait of the Artist's First Wife*, 1864, Rome, G.A.M.; *Diego Martinelli at Castiglioncello*, Milan, Jucker Coll.; *Portrait of his Step-Daughter*, 1889, Florence, G.A.M.) that sometimes recall the models of Bezzuoli, as well as a large output of engravings which helped to establish him as the leading member of the Macchiaioli movement. The Galleria d'Arte Moderna in Florence has a fine collection of his works, and examples can also be seen in Leghorn Museum. A.M.M.

Feininger
Lyonel

American painter
b.New York, 1871 – d.New York, 1956

After being taught the violin by his parents, Feininger went to Germany in 1887 to continue his musical studies. Here, however, he discovered his vocation as a painter and gave up music, studying in Hamburg, Berlin and at the Colarossi Academy in Paris before starting work in Berlin in 1893 as a caricaturist on satirical publications. Back in Paris in 1906, he published strip cartoons in the *Chicago Tribune*, and came into contact with Robert Delaunay, who was to have a decisive influence on his development. From then onwards he abandoned drawing for painting. In 1911 he discovered Cubism.

To begin with, Feininger's art was inspired by a sort of International Modern Style in which hints of Beardsley mingled with the influence of Lautrec or Steinlen: elongated figures, Japanese motifs and a musical, if not literary, use of line and dissonances (*L'Impatiente*, 1907, New York, Feininger Coll.; *The Riot*, 1910, New York, M.O.M.A.). In 1912 he met the painters of Die Brücke and was associated with Schmidt-Rottluff. With Marc, Klee and Kandinsky, he

◀ Lyonel Feininger
Gelmeroda IX (1926)
Canvas. 108 cm × 80 cm
Essen, Folkwang Museum

took part in the manifestations of the Blaue Reiter in Munich and Berlin in 1913. Freed from the anecdotal and from literary motifs, his art became steeped in futurist romanticism. Cubist analysis was spiritualized in an atmosphere in which forms and spaces interpenetrated one another and melted in the dynamism of colours (*The Sidewheeler II*, 1913, Detroit, Inst. of Arts; *Self-Portrait*, 1915, University of Houston). His first one-man show took place in the Der Sturm Gallery, Berlin, in 1917.

From 1919 to 1933 Feininger taught painting and engraving at the Bauhaus. During the winter of 1918-19 he made over 100 woodcuts, a discipline that was to influence his arrangement of space, which soon became simplified (*Wood-Engraving* 1918, York, T.H. Coll.; *Promenade*, 1918, New York, M.O.M.A.). The broad black masses and few, short, irregular lines gave way to networks of lines, either parallel or convergent, that sufficed to create volumes (*Cathedral of Socialism*, for the first Manifesto of the Bauhaus, 1919). From 1919 to 1924 he was director of the studio of engraving at the Bauhaus and published several series of plates (among them *Zwölf Holzschnitte* [*12 Woodcuts*], 1923) and many postcards.

In 1924, with Kandinsky, Klee and Jawlensky, he founded the short-lived group Die Blauen Vier, heir of the Blaue Reiter. Architectural subjects gave place to series of seascapes, and country or urban landscapes, and the subtle, well-managed structure of the planes underwent a stylization which reduced it to horizontals and verticals: *The Steamship 'Odin'* (1924, Halle Museum), series of *Gelmeroda* (1926, Essen, Folkwang Museum), and *Kolberg* (1930, Essen, Folkwang Museum). After the Bauhaus was closed in 1933 and Feininger listed among the degenerate painters, he returned in 1937 to the United States, where he was already well known.

In the American works architecture took on some importance, notably in the series *Manhattan* (New York, M.O.M.A.), but it was always treated poetically. The form was disembodied so that a spiritual quality could penetrate the world of appearances, a quality which, in general, could be summed up as an awareness of human insignificance in the face of nature. Feininger was drawn to the technique of lithography and made many landscapes in this form (*Dorfkirche* [*Village Church*], 1954; *Manhattan II*, 1951, Lugano, Ketterer Coll.), in which patches of colour with imprecise edges cover a very dense construction of fine, always straight lines.

After his return to the United States he enjoyed a good deal of fame. He is represented in German galleries (Essen; Hamburg; Cologne; Munich, Neue Pin.); in American galleries (New York, Guggenheim Museum and M.O.M.A.; Philadelphia; Detroit; Minneapolis; St Louis, Washington University Gal. of Art); and in the Musée National d'Art Moderne in Paris. B.Z. and E.M.

Fernández
Alejo

Spanish painter
b.Córdoba, c.1475 – d.Seville, 1545

Fernández, who, strangely enough, was of German origin (a document mentions '*Maestro Alexo, pintor alemán*'), dominated the Andalusian school of the first third of the 16th century. The son-in-law of the Córdoban painter Pedro Fernández, he lived in Córdoba until 1508. From this period date *Christ at the Pillar* (Córdoba Museum) and the triptych of the *Last Supper* (Saragossa, Basilica del Pilar), in which the figures are set in vast architectural perspectives. This phase, however, seems to have been over by the time that Fernández was installed in Seville, where he had been summoned by the cathedral authorities, and where he settled permanently.

In his first large-scale work, an altarpiece for the Cathedral (*The Meeting at the Beautiful Gate*, *The Birth of the Virgin*, *The Adoration of the Magi*, *The Presentation in the Temple*), the richness of the decor and the minuteness of the detail suggest Gothic sources of inspiration (Schongauer's engraving of the *Adoration of the Magi*). Like other Castilian painters at this time, Fernández took his inspiration from a mixture of Flemish and Italian sources; the treatment of draperies, and in some cases of faces, shows affinities with the style of Quentin Metsys and with the Antwerp Mannerists, and also with the painters of the last generation of the 15th century. The Bramantesque character of some of his buildings (*The Flagellation*, Prado) has been noted.

Commissions poured into Fernández's studio. He began to paint his altarpieces in a new way, grouping the various figures, which had previously been set side by side, around a central figure (1520, Seville, altarpiece of the Chapel of Maese Rodrigo; Marchena, altarpiece of the Church of S. Juan). His favourite subject was the Virgin and Child, always steeped in gentle melancholy (*The Virgin of the Rose*, Seville, Church of S. Ana; *The Virgin Suckling the Child*, Convent of Villasana de Mena). The careful technique of the early paintings was not maintained in the paintings executed towards the end of his life, in which the drawing, which was less sure, and the proportions and poses, which were often incorrect, reveal the intervention of assistants (*Pietà*, 1527, Seville Cathedral). *The Virgin of the Navigators* (c.1535, Alcázar of Seville), sheltering sailors, merchants and captains under her ample cloak, takes up again the medieval theme of the Virgin of Compassion, renewed by the epic qualities of the conquistadors. A.C.

Fetti
Domenico

Italian painter
b.Rome, c.1589 – d.Venice, 1623

For the first part of his short career Fetti was in Rome where he was the protégé of Cardinal Ferdinando Gonzaga. When the latter became Duke of Mantua, he called Fetti to his court at the beginning of 1614, gave him several commissions and made him inspector of his gallery. Sent by the Duke to Venice in 1621 to buy paintings, Fetti took refuge there after a short return to Mantua in 1622, following an incident involving a Mantuan nobleman. He died while still very young, in Venice, on 4th April the following year, a victim of 'malignant fevers' or, according to Baglione, following a number of 'disorderly incidents'.

Fetti was trained in Rome in the school of Cigoli (his *Ecce Homo* in the Uffizi shows this),

but, attracted by Caravaggio, he became particularly interested in Borgianni's neo-Venetian interpretation of Caravaggism. He saw in Rubens (who was in Rome at the beginning of the century) not only a great Baroque painter but an admirer of the Venetians. These attitudes were of critical importance in setting Fetti upon the path he took; although he was not Venetian, he was able to make himself part of Venetian culture during his short stay in Venice, assimilating the heritage of the Venetian 16th century and contributing to the renewal of its painting in the 17th century.

It is hard to follow the evolution of Fetti's style during his short career, because his work – the large or small religious paintings (*Parables*, which brought him fame, and others on mythological subjects) – were seldom dated.

In his large painting of the *Multiplication of the Loaves and Fishes* (Mantua, Ducal Palace), probably painted in Mantua after his return from Venice in 1621, Fetti showed his knowledge of the great 16th-century Venetians, in particular Tintoretto. At the same time the naturalistic interpretation of this Gospel narrative, with its touches of popular realism characteristic of the 17th century, bore the mark of Caravaggio. Nevertheless, Fetti's expressive system was undoubtedly new and independent of all cultural constraints. His light, vibrant brush and luminous colour sought to evoke a universe that was inspired at once by poetic realism and by visions born of an unquiet, almost romantic imagination. It was the world of the pensive *Melancholy* (Louvre; Venice, Accademia), of the arrogant *David* (Louvre; Venice, Accademia) and of the many famous *Parables*, among them *The Last Piece of Silver* (Florence, Pitti: Dresden, Gg), *The Labourers in the Vineyard* and *The Prodigal Son* (Dresden, Gg; Caen Museum; London, Seilern Coll.), *The Good Samaritan* (San Diego, California, Museum, and Boston, M.F.A.) and *The Pearl of Great Price* (Dresden, Gg; Kansas City Museum; Caen Museum). Together these form a masterly group.

Fetti's taste for anecdotes, in the manner of the northern genre painters, recalls the sensibility of Bassano, but also prefigures that of the Bamboccianti. These works seem, however, to show a feeling of disquiet, in spite of the liveliness of the colour, which suggests the example of Veronese. Some dramatically realistic episodes suggest Bruegel (*The Blind Men* in Dresden, Gg, and Birmingham, Barber Inst. of Arts). Conceived according to the 16th-century Venetian tradition, *The Flight into Egypt* (Vienna, K.M.) shows analogies with the art of Tintoretto, with Veronese's use of light, and, in a completely new

way, with Elsheimer's concept of landscape. The exquisite mythological paintings of *Perseus and Andromeda*, *Hero and Leander* and the *Triumph of Galatea* (Vienna, K.M.) exemplify Fetti's role not only in Venetian painting, but also in Italian Baroque as a whole, revealing a more elegaic attitude and a more delicate colour that foreshadows the 18th century. F.Z.B.

Feuerbach
Anselm

German painter
b.Speyer, 1829 – d.Venice, 1880

From 1845 to 1848 Feuerbach studied at the Akademie in Düsseldorf, where he was a pupil of Lessing, Sohn, Schadow and Schirmer, then went on to Munich, to Von Kaulbach's studio. In 1850 he was living in Antwerp and from 1851 to 1854 in Paris, where he was influenced by Courbet and particularly by Couture, as the colouring and technique of his first work, *Hafis Before an Inn* (1852, Mannheim Museum), demonstrate. After a stay in Karlsruhe, he went to Venice in 1855, where he steeped himself in the work of Palma, Titian and Veronese; from there he went to Florence, then on to Rome. Here, his solemn melancholy style matured under the influence of the Italian Renaissance. He painted scenes in-

spired by the life and work of Dante, Ariosto, Petrarch and Shakespeare, compositions using biblical subjects and subjects taken from Greek mythology, as well as groups of figures without literary connections. From 1861 to 1865 he painted many portraits of his Roman model Nanna Risi, who corresponded to his ideal of severe, melancholy beauty (*Woman Playing a Mandolin*, 1865, Hamburg Museum).

The principal works from his time in Rome, which continued until 1873, are: *Iphigenia* (1862, 1871, Darmstadt Museum and Stuttgart, Staatsgal.); a *Pietà* (1863, Munich, Schackgal.); *Hafis at the Fountain* (1866, Munich, Schackgal.); *Medea* (1870, Munich, Neue Pin.); *The Banquet of Plato* (1869, 1873, Karlsruhe Museum and Berlin, N.G.); and *The Battle of the Amazons* (1873, Nuremberg, Städtische Kunstsammlungen).

From 1873 to 1876 he taught at the Akademie in Vienna and decorated the ceilings of its building. Then he stayed in Nuremberg and in Venice. Under the influence of the Venetian Renaissance, he painted the *Concert* in 1878 (formerly in Berlin, N.G., now destroyed). Apart from his historical paintings, he painted landscapes, portraits and self-portraits (1852 and 1878, Karlsruhe Museum).

Feuerbach's aim was to counter the often banal historical paintings of his day with works with a greater depth of meaning. Although these paintings reflected his austere concept of things, they

Domenico Fetti ▲
Hero and Leander
Wood. 41 cm × 97 cm
Vienna, Kunsthistorisches Museum

Anselm Feuerbach ▲
Iphigenia (1862)
Canvas. 294 cm × 174 cm
Darmstadt, Hessisches Landesmuseum

Alejo Fernández ▲
The Adoration of the Magi
Wood. Panel of the altarpiece in the Sacristy of Seville Cathedral

were often lacking in life. He used colour skilfully, but deliberately confined his palette to a few, generally cold, tones, in order to give prominence to the drawing, and prepared for the painting of his largest and most striking works with studies in which the drawing was extraordinarily emphatic. His work was marked by his humanist culture, which gave a profound significance to its literary content, although a strong sense of form balanced this. Feuerbach was little understood by his contemporaries and had few followers. H.B.S.

Flegel
Georg

German painter
b.Olmütz, 1566 – d.Frankfurt am Main, 1636

After working as an apprentice in the studio of the wandering Flemish painter Lucas van Valckenborch, Flegel was active in Frankfurt where, at the turn of the 17th century, he became the first German artist to become involved in the development of the still life. Fruit, bottles, cups, food – seen since the 15th century as no more than unconnected elements in a painting – were given a life of their own, and their representation was raised to a genre.

Most of Flegel's work, which is undated, was done between 1610 and 1635. His large *Meal Prepared on a Table* (Speyer Museum) is an excellent example of the type of painting known as a '*déjeuner*', in which the elements, formerly distributed in isolation, are now synthesized. Ob-

jects, represented with austere exactness, were, through artistic transposition, now called upon to suggest a universal harmony.

In his late works (1635-8) Flegel used the brownish tones of candlelight (*Kitchen by Candlelight*, Karlsruhe Museum) to suggest the ephemeral character of earthly things, as in a painting of *Vanitas*. With his watercolours and miniatures (Berlin-Dahlem), in which fruits, plants and insects are painted with the most careful precision, Flegel originated the botanical collections so much enjoyed in the 17th and 18th centuries.

His paintings (of which there are about 30 certain attributions) are found in the following galleries: Basel, Brussels (M.A.A.), Cologne (W.R.M.), Darmstadt, Frankfurt (Historisches Museum), Gotha, Karlsruhe, Munich (Alte Pin.), New York (Metropolitan Museum), Hamburg, Paris (Musée des Arts Décoratifs), Prague and Stuttgart (Staatsgal.), as well as in various private collections. G.A.

Floris
Frans

Flemish painter
b.Antwerp, c.1518 – d.Antwerp, 1570

Floris was the son of the sculptor Cornelis Floris and in 1538 became a pupil of Lambert Lombard in Liège; in 1540 he was inscribed as master in the Guild of Antwerp. About 1541 he went to Rome

where he was deeply impressed by Michelangelo's *Last Judgement*, of which he made many drawings, and where he also studied the work of Tintoretto, Vasari, Daniele da Volterra, Salviati and Zuccaro, as well as the antiquities. On his return to Antwerp he had enormous success and soon acquired a fortune which enabled him to build a very grand house in the Italian style.

Having become the main exponent of Roman ideas in Antwerp, Floris painted religious subjects, mythological compositions and portraits, all with virtuosity, and at the same time ran a studio where he had over 100 pupils. His contemporaries considered him an important innovator, and he had great influence on those around him, but in fact, although gifted and able, Floris generally produced rather superficial works. He became a truly inspired creator only when, forgetting all his study of style, he allowed himself to be carried away by the reality of his subject, which gave his work verve and spontaneity (paintings of the *Holy Family* in Douai Museum and Brussels, M.A.A.).

From the beginning of his career Floris aimed to succeed by exploiting the knowledge he had brought back from Italy. His first signed and dated paintings go back to 1547: a triptych of *Five Saints* (Rome, private coll.) in which Venetian influences appear; and *Venus and Mars Caught in Vulcan's Net* (Berlin-Dahlem). In this latter painting Floris was inspired by the style of Lucas van Leyden. *The Fall of the Rebel Angels* (Antwerp Museum) bears a monogram and the date 1554. Here, Floris tried to equal the heroic, monumental style of Michelangelo, without really making

▲ Frans Floris
Old Woman (1558)
Wood. 108 cm × 85 cm
Caen, Musée des Beaux-Arts

▲ Georg Flegel
Meal Prepared on a Table
Copperplate. 78 cm × 67 cm
Speyer, Staatsgemäldesammlung

the forms and movements, which he wanted to be impressive, really come alive. In 1554 he also painted a triptych of the *Crucifixation* for the church of Arnstadt. The *Woman Playing a Harp* (1555, Bucharest, private coll.) and *St Luke* (1556, Antwerp Museum) are not unlike the other careful paintings of the time. In none of these works, in which he somewhat departed from the Flemish tradition in his need for intense colours and a close link with reality, did Floris ever manage to achieve success.

His true talent appeared in a pair of portraits dating from 1558: the *Old Woman* (Caen Museum) and the *Man with a Falcon* (Brunswick, Herzog Anton Ulrich Museum). Contrary to the usual practice in portraits of the time, in which the sitters were shown in stiff, conventional poses, Floris managed to catch in a direct, magisterial way the mobility of his subjects' facial expression, the feeling of the moment and the charm of a living presence.

The moving sincerity of these masterpieces, however, is not found in *Adam and Eve* (1560, Uffizi) nor in the *Banquet of the Marine Gods* (Stockholm, Nm), which bears a monogram and the date 1561. This latter painting does not noticeably differ from the *Parnassus*, painted in 1550 and now in Antwerp Museum. Floris's wish to equal the Italians in compositions of this kind does not always have a satisfactory result: he never manages to create an impression of space nor to establish a synthetic rhythm linking the various groups of his composition. Equally laborious is the *Last Judgement* of 1565 (Vienna, K.M.). A larger version of this subject appears in a triptych in Brussels (Musée Royal des Beaux Arts), signed with a monogram and dated 1566. *The Adoration of the Magi* (Brussels, M.A.A.), left unfinished when he died, was taken over by his pupil Hieronymus Francken and bears the monograms of the two painters as well as the date 1571. Looking at his undisputed works, Floris's style does not seem to have evolved in any special way, and the enthusiasm of Van Mander and his contemporaries for this virtuoso painter, who as a rule betrayed his facility, is not shared unreservedly today. W.L.

Foppa
Vincenzo
Italian painter
b.Brescia, c.1430 – d.Brescia, c.1515

The first representative of the Renaissance in Lombardy, Foppa imprinted it with a character of its own that survived into the next century. The early *Madonna and Angels* (c.1450-5, Settignano, Berenson Coll.) still shows the influence of the International Gothic and particularly of Michelino da Besozzo, but there is already a relative unity of colour created by natural light. The *Crucifixion of Christ and the Two Thieves* (1456, Bergamo, Accad. Carrara) is set under a classical arch rendered in perspective, in the manner of Mantegna, but the landscape in the background still shows an altogether Gothic imagination; reminders of Filippo Lippi and Jacopo Bellini are joined to the more modern Paduan taste. The two *Madonnas* of the Castello Sforzesco in Milan, the composition of which is also clearly influenced by Mantegna, date from the same period.

On the other hand, the fine *St Jerome* (Bergamo, Accad. Carrara), sometimes dated immediately after the Bergamo *Crucifixion*, must have been painted later, in the period of Foppa's maturity, for the natural light so typical of his mature style here replaces the abstract, diffused light of Florentine painting. The work should therefore be dated from the period 1462-4.

During this same period Foppa also began work on the frescoes in the Portinari Chapel of the Church of S. Eustorgio in Milan, which he completed in 1468. These frescoes show a solemnly composed structure of Paduan origin, true to the strict Tuscan rules of perspective and with an extraordinarily advanced treatment of space, a concept that was to become typical of the art of Lombardy. The result of this evolution appears particularly in the *Scenes from the Life of St Peter Martyr* painted in the lunettes. It is possible to see, in the representation of the wood where the martyrdom of the saint is taking place, signs of contact with northern art, perhaps a result of Foppa's visit to Genoa in 1461, where Netherlandish influence was strong.

The frescoes on the vault of the Averoldi Chapel in the Church of S. Maria del Carmine in Brescia (the *Evangelists* and the *Fathers of the Church*), painted in 1475, the large polyptych (*Virgin with Angels*, with eight *Saints* in two tiers and the *Stigmatization of St Francis*) painted for the Church of S. Maria delle Grazie in Bergamo (today in the Brera) and the *Nativity* in the church of Chiesanuova near Brescia (shutters with *St John the Baptist* and *St. Apollonia*, Geneva, private coll.) are all works of Foppa's maturity. At this period his naturalism takes on a very special note of austerity. By closely linking dull local colours and natural light, he creates the grey tones which are peculiar to his work and which show up the gilding of the complex frames of these altarpieces. Such architecturally structured polyptychs were to be used by all Lombard artists up to Gaudenzio Ferrari. This type of monumental altarpiece reached its peak in the *Fornari Polyptych* in Savona Museum (1489) and in the *Polyptych* (1490) of the high altar in Savona Cathedral (Oratory of S. Maria di Castello), both of which were extremely influential, especially on the painters of Nice.

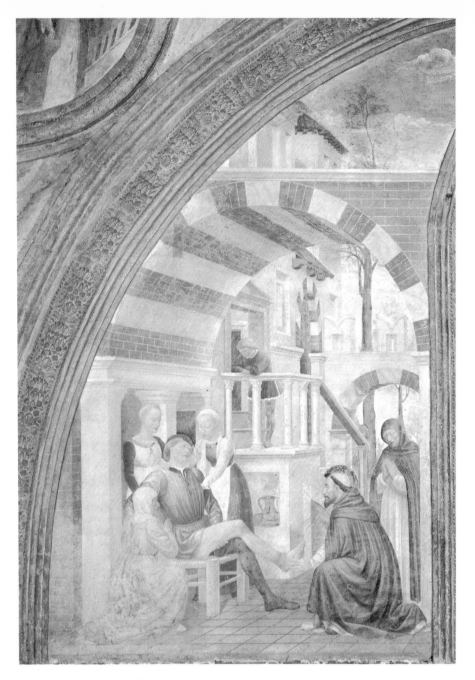

▲ Vincenzo Foppa
The Miracle at Narni
Frescoed lunette in the Portinari Chapel
Milan, Church of S. Eustorgio

The altarpieces of Savona show a certain taste for the archaic. They were made before Foppa was in touch with Bramante, whose presence in Lombardy is documented in 1477. This influence produced a monumental quality which appeared in the frescoes that were once in the Church of S. Maria di Brera and are today in the Brera (*Pietà, Martyrdom of St Sebastian; The Madonna between the two Sts John*, dated 1485); their gilded magnificence reappears in an *Annunciation* in a private collection in Milan. A stained-glass window in Milan Cathedral, which has been attributed to Foppa, can also be set with certainty in this period.

Foppa's late works (*The Adoration of the Magi*, London, N.G.; the Orzinuovi standard with the *Virgin and Two Saints* on one side and *St Sebastian between St Roch and St George* on the other, 1514, Brescia, Pin. Tosio Martinengo; the startling frescoes of *Scenes from the Life of the Virgin* in an oratory in Vigevano) take no account of the work of Leonardo. Foppa remained faithful to the rustic, archaicizing tradition of Lombardy, which was to be taken up happily by Moretto and, to some extent, by Savoldo. At the same time he introduced the experiments of the Renaissance in the depiction of the human form and of space and created an awareness of the problem of light that henceforward was to characterize the art of the region. M.R.

Fouquet
Jean
French painter
b. Tours, c.1420 – d. Tours, c.1480

The greatest French painter of the 15th century, famous for 100 years, then forgotten until last century, Fouquet's life can be pieced together only from scrappy, allusive snippets of information that are sometimes hard to interpret. Only one work bears a contemporary inscription

ascribing it to him: the illuminated manuscript of the *Antiquités judaïques*. After that, his work has to be reconstructed from internal evidence, and the chronology is hard to establish with any certainty.

Fouquet is said to have been the son of a priest and himself to have taken holy orders; but even this is uncertain. He is known to have made a journey to Italy while still young: between 1444 and 1446 he painted a portrait of Pope Eugenius IV in Rome, which excited the admiration of the Italians. It is not certain whether, as has been thought, he was back in Tours by 1448. In 1461 he was commissioned to paint the mortuary effigy of Charles VII and to prepare the solemn entry of Louis XI into Tours. The will of Bishop Jean Bernard (1463) stipulates that Fouquet should be given the commission for an altarpiece of the *Assumption* for the church of Candes (Indre-et-Loire). In 1470 Fouquet received payment for paintings for the newly created Order of St Michael, and in 1472 and 1474 for two prayerbooks for Marie de Clèves and Philippe de Commines. In 1474 he presented Louis XI with a model for his future tomb and in 1475 bore the title of King's Painter. In 1476 he contributed to the decorations for the entry of the King of Portugal, Alfonso V, into Tours. He is mentioned as being still alive in 1477 and as dead in 1481. We know that he had two sons, Louis and François, who, like him, were painters.

It is not known where or how Fouquet was trained; perhaps in the studio of the Master of Bedford in Paris, or else at Bourges in the tradition of the Limbourg brothers; at all events it was in an atmosphere that was still Gothic in spirit. He was the first painter to bring the ideas of the Renaissance into French art. All efforts to identify his early works have failed. He appears suddenly as a painter of repute with the portrait of Pope Eugenius IV and of two of his kinsmen, painted in Rome (known from an engraving showing the Pope alone). The importance of this commission, given to a foreign painter, suggests that Fouquet already held an official appointment as painter. It therefore seems reasonable to set the portrait of Charles VII, King of France (Louvre), in the period before his journey to Italy; its archaic arrangement in a small space and its style, which shows no signs of Italian influence, all seem to suggest the early period.

These first two works show that Fouquet knew contemporary Netherlandish portraits; he used their three-quarter presentation and imitated their analytical realism. But as well as the living and sensitive interpretation of the portrait, there was already a concern for rounded volumes and a monumental authority, which throughout his career was to be characteristic of him and which, it has been suggested, he must have acquired through contact with the great French tradition of Gothic statuary.

On his return from Italy Fouquet settled in Tours where he was in future to work for the town, the court and the royal officials. *Les Heures d'Étienne Chevalier*, Treasurer of France, were printed before 1461, probably shortly after his return, for they show in a striking way the effect of his experience in Italy. The book has now been taken to pieces, and 47 separate pages remain (40 of them in the Musée Condé at Chantilly and two in the Louvre); half of these are arranged in an original way on two levels, the lower one serving as an anecdotal or decorative complement to the main story.

From Italy Fouquet brought not only the new ornamental motifs of the Renaissance, but above all a passion, unusual in France, for three-dimensional space and for the play of volumes in this space. He shows a profound understanding of the Florentine art of the time – that is, that of Masaccio, Domenico Veneziano and Fra Angelico, examples of whose work could have been seen in Rome, but whom he must have studied in Florence itself. These studies suited Fouquet's own taste: in Italy he learned linear perspective – which he was not, however, to apply scientifically. These intellectual discoveries did not run counter to his liking for reality: he chose as the backgrounds to his paintings places in Tours or buildings in Paris, and was at pains to depict exactly everyday life, the intimate atmosphere of interiors, and aerial views of landscapes. These qualities were to become more emphatic as the exact memory of his Italian visit faded.

Les Heures d'Étienne Chevalier must have been very well known, because many books of hours from Fouquet's studio (New York, Pierpoint Morgan Library), or of artists who were influenced by him, such as Jean Colombe (*Heures de Laval*, Paris, B.N.), copy some of its compositions.

From the same period comes the *Diptych of Melun*, a votive diptych ordered by the same Étienne Chevalier for the church in his birthplace and, according to tradition, in memory of Agnès Sorel (d.1450), whose features are reproduced in the Virgin (*Étienne Chevalier avec Saint Étienne*, Berlin-Dahlem; *La Vierge entourée d'anges* [*The Virgin with Angels*], Antwerp Museum). The frame of the diptych was decorated with medallions of gilt enamel: the *Portrait de l'artiste* (*Portrait of the Artist*) (Louvre), the first known self-portrait of a French painter and the first example in France of a new Italian technique, was probably one of them.

The *Pietà de Nouans* (church of Nouans, Indre-et-Loire), a large altarpiece, possibly painted with the help of his studio, probably comes from the same period; the date has been argued, but the insistence on the smooth, sculptural aspect of the volumes sets the *Pietà* in the same period as the *Diptych*. The portrait of *Guillaume Jouvenel des Ursins*, Chancellor of France (Louvre), at once a sensitively modelled portrait and, against the gilt armorial background, a symbolic effigy of social success, should be set in about 1460 on account of its less deliberately sculptural style, and the age and style of dress of the model (preparatory drawing in Berlin, Print Room).

The rest of Fouquet's work consists mainly of illuminated manuscripts, in which his studio sometimes helped him. *Des cas des nobles hommes et femmes malheureuses* by Boccaccio (Munich Library), copied in 1458 and painted for Laurent Girard, Controller-General of Finance, was made with the collaboration of his studio, except for the large frontispiece showing the judicial bench at Vendôme in 1458, which is one of Fouquet's masterpieces of layout. The *Grandes Chroniques de France* (Paris, B.N.) bears no indication of date and no dedication; it was perhaps made for Charles VII in 1458. The style of the illustrations places the work close to the Boccaccio, that is, around 1460. The small historical pictures, often treated in two juxtaposed episodes, show a less subtle atmosphere than those of the *Heures d'Étienne Chevalier*, but affirm a sense of history that foreshadows the great works of the end of

▲ Jean Fouquet
Étienne Chevalier avec Saint Étienne
Wood. 93 cm × 85 cm
Berlin-Dahlem, Gemäldegalerie

Fouquet's career. About 1470 Fouquet painted for Louis XI the frontispiece of the *Statuts de l'ordre de Saint-Michel* (Paris, B.N.), a masterpiece of delicacy in the way colour is used in the service of a profound feeling for official grandeur.

In his final years, between 1470 and 1475, Fouquet illustrated four pages of an *Histoire ancienne*, for an unknown customer (Louvre), and the *Antiquités judaïques* (Paris, B.N.), a manuscript of the Duc de Berry which had been left incomplete and which Fouquet finished for Jacques d'Armagnac before 1475.

Many other miniatures – particularly from books of hours – are attributed to Fouquet. Some, of lower quality or showing a different spirit, are more likely to be the work of his studio or of unknown artists who were trained through contact with him, or perhaps of his sons (Paris, B.N. and Bibliothèque Mazarine; New York, Pierpont Morgan Library; Sheffield, Art Gal.; Hague Library). However, apart from this immediate influence, which can be seen in the roundness of volume, the gold hatchings, the choice of decor, the type of arrangement on the page in two rows

or the borrowing from his compositions, Fouquet had no real disciples or followers: it was still too early for the lesson of the Renaissance, which he was the first to bring to France, to be learned. His successors, Bourdichon and Colombe, far from understanding the broad rhythm of compositions in which man and nature were balanced, took from his art nothing but an image without substance, and Fouquet remains the only classical painter of the 15th century north of the Alps. N.R.

Fragonard
Jean Honoré
French painter
b.Grasse, 1732 – d.Paris, 1806

At first idolized by his contemporaries as one of the great European masters of the 18th century, and the representative of a certain 'French spirit' whose work fetched enormous prices on the

▲ Jean Fouquet
La Conversion de Saint Paul
16 cm × 12 cm
Illumination from *Le Livre d'heures d'Étienne Chevalier*
Chantilly, Musée Condé

international market, Fragonard soon suffered a reversal of reputation that left him almost forgotten for nearly 100 years. The study by the Goncourt brothers in 1865, and the spread of his works through cheap forms of engraving helped to restore him to his former glory. The oblivion into which he had fallen, however, gave rise to stories of his private life in which he was the lover of La Guimard, a fashionable dancer, the Colombe sisters, actresses at the Théâtre Italien, and Marguerite Gérard, his sister-in-law, all of which seem to have been pure invention. At the same time the catalogue of his works, which varies a great deal between one author and another, was swollen by many copies and by the paintings of a number of his contemporaries, such as Taraval, who are now more or less forgotten. Once fact is disentangled from legend it is clear that Fragonard was not merely the seductive and slightly insipid incarnation of the rococo spirit, but that he expressed with unusual sensitivity the aims and the uncertainties of the half-century of painting from the Versailles of Louis XV to the Paris of Napoleon.

Formative years (*c.*1746-61). Fragonard was born into a modest but comfortably placed family in Grasse but lived in Paris from the age of six or seven; it was thus unfair to call him, as some did, a 'provincial painter'. Destined for a career as a notary's clerk, he turned instead to painting, and, on the suggestion of Boucher, entered Chardin's studio. This appears to have been unsuited to him for he cut short his apprenticeship and returned to Boucher, who this time recognized his genius. He became Boucher's favourite pupil, and won first prize in the competition for the Prix de Rome in 1752. Fragonard then went to the École des Élèves Protégés directed by Carle van Loo, where, before leaving for Rome, he was able to catch up on his perhaps neglected artistic education (1753-6).

To this period (that is, until he was 24) a very large number of paintings have been ascribed: works of artificial inspiration, very close to Boucher in style and already very confident (about 90 out of the 545 in Wildenstein's catalogue). In fact, however, the works that can be attributed to him with certainty – *Jéroboam sacrifiant aux idoles* (*Jeroboam Sacrificing to the Idols*), presented for the Prix de Rome competition (1752, Paris, E.N.B.A.), *Psyche Showing her Sisters her Gifts from Cupid* and *Le Lavement des pieds* (*The Washing of the Feet*), ordered by the brotherhood of the Blessed Sacrament at Grasse (1754-5; it remains in the Cathedral) – show a schoolboy attempt to achieve the 'grand manner', a brilliant but judicious style, hesitating between the manner of his contemporaries and the models of the 17th century. From the Parisian collections he must have become acquainted with the northern schools (particularly Rembrandt: copy of the Crozat *Sainte Famille* (*Holy Family*), but he seems to have been very little affected by them.

The maturing of Fragonard's style came with the years in Italy. He was welcomed at the Académie de France in Rome at the end of 1756 by Natoire, who at first treated him with a degree of reserve, but was then so carried away that he allowed him to stay on until 1761. At first Fragonard was bewildered by what he saw, but soon learned to choose his models, helped in this by two friends who were to be of decisive importance to him: Hubert Robert, who had already been in Rome for two years, and the Abbé de St

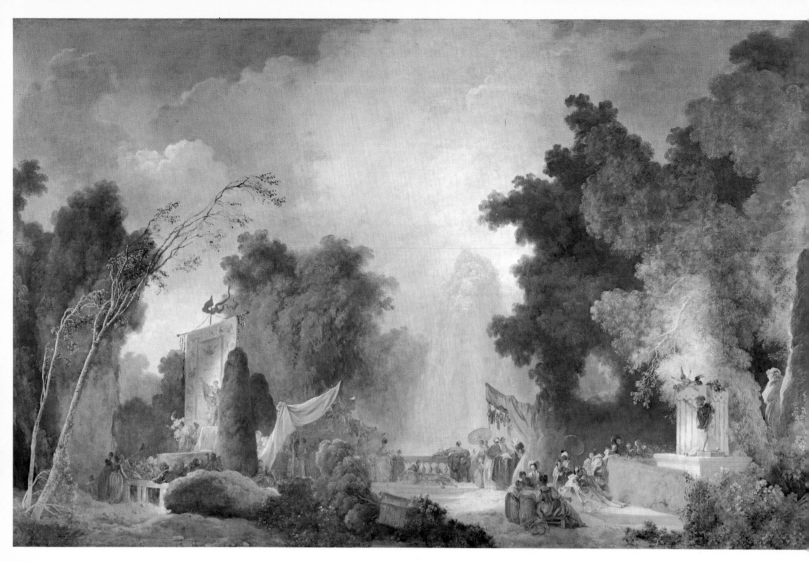

Non, a rich young art lover, who arrived in 1759. The latter developed a passionate admiration for Fragonard's paintings, took him to work at Tivoli (1760), then at Naples (winter of 1760-1), and accompanied him on his return to Paris via Bologna, Venice and Genoa.

Inspiration from the most varied sources – the Carracci, Veronese, Solimena, Tiepolo – characterizes the fine series of etchings that Fragonard published in 1764 following his return to Paris. These years in Italy were among the most fertile of his career: sensitive landscapes built up on well-conceived contrasts of values (*Le Petit Parc* [*The Little Park*], *c*.1760, London, Wallace Coll.), sometimes enlivened by dramatic movement (*L'Orage* [*The Storm*], 1759, Louvre); and complex genre scenes, set down with a casual air, but in which the low life is composed in the manner of 'great painting' (*La Lessive* [*The Washing*], St Louis, Missouri, City Art Gal.; *La Famille italienne* [*The Italian Family*], Metropolitan Museum). The main themes are now apparent, and Fragonard's brush has achieved all its speed and sureness.

Second period in Paris (1761-73). Back in Paris in September 1761, with St Non as his patron, Fragonard was welcomed as a painter with an established reputation. The work which was to admit him to the Académie (*Corésus et Callirhoé*, Louvre) was long pondered (sketch in Angers Museum); praised by Diderot, it was bought by the King. He was given a commission for the Gobelins (not carried out) and a studio in the Louvre. In 1768 he married a girl of 22, Marie-

Anne Gérard, who also came from Grasse and was also a painter; it appears to have been a happy, solid marriage.

Meanwhile, his career took an unexpected turn: he refused the honours of the Académie, did not paint the picture asked of him for his reception, and soon gave up historical painting and large-scale decoration (*Projet de plafond* [*Ceiling Project*]), Besançon Museum) in favour of smaller works, which were equally profitable: piquant subjects such as *L'Escarpolette* (*The Swing*) (1767, London, Wallace Coll.), agreeable or *galant* genre scenes, which were a direct continuation of Boucher's work, and landscapes that show the influence of northern painters (*Paysage aux laveuses* [*Landscape with Washerwomen*], Grasse Museum).

The quickness and freedom of his style are best exemplified in his 15 'imaginary portraits', painted about 1769 (eight today are in the Louvre, among them *L'Étude* [*Study*], *La Musique* [*Music*] and *Diderot*), and the two matching ones inspired by the story of *Renaud et Armide* (*Rinaldo and Armida*) (Paris, Veil-Picard Coll.). All these elements are summed up in the large panels commissioned by Mme du Barry for the Pavilion at Louveciennes, which marked the height of Fragonard's career (1770-3, New York, Frick Coll.).

Fragonard's success was now enormous: but his art already seemed to have been superseded. In those same years Neoclassicism was coming into its own in Paris, and the young painters who remained faithful to the rococo were strongly attacked. Soon after its installation the decoration

at Louveciennes was denounced in a violent pamphlet (*Dialogues sur la peinture*, attributed to Renou), which pilloried it as the very example of the kind of thing fashionable among ignorant people. The panels were withdrawn (and taken back by the artist) and replaced by four compositions by Vien. Fragonard seems to have been greatly upset by his critics. His friend the banker Bergeret took him and his wife on a long trip (1773-4) to the Midi, then to Italy, where they stayed in Rome and Naples, returning through Austria. The journey resulted in a series of drawings in red chalk and lead pencil (studies of landscape or of popular types) that are among the finest Fragonard ever made.

Third period in Paris (1774-1806). Fragonard's return to Paris in 1774 began a period of more than thirty years (half his career) of which little is known. His fame dwindled with the rise of the new generation, and the Revolution provided the final blow. Although at first receptive to new ideas (*Au génie de Franklin* [*To the Genius of Franklin*], engraved by Marguerite Gérard, 1778), Fragonard later became more cautious. The death of his daughter Rosalie in 1788 was a heavy blow, and he even left Paris for Grasse (1790-1). He had lost the greater part of his considerable fortune, and his customers were either in exile or ruined.

Fragonard escaped poverty, thanks to his one-time pupil David, and to his technical expertise: he found work as restorer at the Museum (the future Louvre; 1793-1800); and although he him-

 Jean Fragonard
La Fête à Saint-Cloud
Canvas. 216 cm × 335 cm
Paris, Banque de France

self lacked admirers, the work of his sister-in-law and pupil, Marguerite Gérard, was increasingly appreciated, while the reputation of his son Evariste, who had been taught by David, was growing. Surrounded by his family and a few faithful friends, 'bon papa Frago' seems to have survived the Revolution without too much bitterness. He died after a short illness on 22nd August 1806.

His output during these latter years is comparatively little known. Much of it has disappeared; and there is a tendency to attribute to Fragonard his wife's portraits of children or Marguerite Gérard's genre paintings. The criticisms he had suffered, the second visit to Italy and the evolution of taste in Paris, all seem to have affected Fragonard's sensitive temperament deeply, and to have made him renew entirely his style. His colour became lighter, and he strove to achieve golden or silvery harmonies that verged on the monochrome. His technique, although it never lacked confidence, developed a greater degree of finish; sometimes he looked to the northern painters and foreshadowed Boilly (*Le Baiser dérobé* [*The Stolen Kiss*], before 1788, Hermitage); at others he appears to recall Le Sueur (*La Fontaine d'amour* [*The Fountain of Love*], before 1785, London, Wallace Coll.) and to lead on to David.

His inspiration involved him less in Romanstyle heroics than in allegory (*Hommage rendu par les Éléments à la Nature* (*Homage Rendered to Nature by the Elements*], 1780, destroyed), and particularly in the creation of evocative, elegaic works where he could continue to indulge his taste for landscape and love scenes. The feeling of the time, and its philosophical ideas, were reflected in these works in a very personal way, a way that included sentimentality in the style of Greuze or Rousseau (*Dites donc s'il vous plaît* [*Say so if you please*], London, Wallace Coll.). With this Fragonard mixed touches of melancholy (*Le Chiffre* [*The Number*], London, Wallace Coll.), passion (*Le Verrou* [*The Bolt*], Louvre; *L'Invocation à l'Amour* [*Invocation to Love*], sketch, Louvre), or eroticism (*Le Sacrifice de la rose* [*The Sacrifice of the Rose*], private coll.), which have no equivalent except in the poetry of Parny or Chénier and which led directly, across and beyond the art of David, to Romanticism. The dominant influence of Neoclassicism, supported by the personality of David and by the political climate of the age, does not lessen the importance of these developments, which although they had only a small audience at the time, appear increasingly necessary to an understanding of this complex period.

Viewed in this light, Fragonard's long career appears as one of the most fruitful of the 18th century. Too often reduced to what the Goncourts called 'the cherub of erotic painting', Fragonard found a variety of inspiration, from large genre scenes to religious paintings which are still little known (*La Visitation* [*The Visitation*], sketch, private coll.), and could use all the subtleties of landscape as well as those of feminine grace.

By nature Fragonard was inclined (like Rubens before him, and like Renoir or Bonnard after him) to ignore the sombre side of life – old age, tragedy, remorse – but his art was not for that reason incapable of reaching the height of the great visionaries (*Vivat adhuc Amor*, pencil, Albertina). He was called frivolous but under his gaiety he hid unusual depths of feeling and of thought. From piquant improvisations (*La Gimblette* [*The Biscuit*], Paris,

Veil-Picard Coll.), or somewhat insipid trifles (*La Leçon de musique* [*The Music Lesson*], Louvre), he passed without difficulty to an exalted lyricism when he dealt with the richness of nature, as in the theme of the half-wild garden, treated with increasing profundity from the time of his views of Tivoli until the *Fête à Rambouillet* in the Gulbenkian Foundation in Lisbon, and the astonishing *Fête à Saint-Cloud* in the Banque de France, in Paris.

Fragonard's mastery, however, is nowhere more evident than when he considered the varied faces of love: spiritual eroticism (*Le Feu aux poudres* [*The Powder Fired*], Louvre), *galant* incidents (*L'Escarpolette* [*The Swing*]), wild pleasure (*L'Instant désiré* [*The Desired Moment*], Paris, Veil-Picard Coll.), but also the surprises of adolescence (*L'Enjeu perdu* [*The Lost Stake*], before 1761, Metropolitan Museum; sketch in the Hermitage), the fullness of requited love (*La Famille heureuse* [*The Happy Family*], Paris Veil-Picard Coll.), elegaic dreaming (*Le Chiffre* [*The Number*]), and romantic fervour (*Le Serment à l'Amour* [*The Oath to Love*], engraved by Mathieu in 1786, which sometimes rises to a kind of symbolism that recalls Lucretius (*La Fontaine d'amour* [*The Fountain of Love*]). This insistent search, which is richer and more varied than that of any other artist or writer of the time would be enough to set Fragonard among the great poets of the Western tradition.

J.T.

Francis
Sam

American painter
b.San Mateo, California, 1923

After studying medicine and psychology at Berkeley, California, Francis served in the Air Force from 1943 to 1945. When he was in hospital recovering from wounds, he became interested in painting, encouraged by a friend, David Parks, a teacher at the School of Fine Arts in San Francisco, and exhibited there for the first time in

▲ Sam Francis
Shining Dark (1958)
Canvas. 201 cm × 134 cm
New York, The Solomon R. Guggenheim Museum

1948. In 1950 he went to Paris, where he lived for a long time, with frequent stays in New York and California and journeys round the world from 1957 to 1959. These took him to Mexico, India, Siam, Hong Kong and Japan, where he stayed several times to work. He returned to the United States in 1961 and settled at Santa Monica, California, in 1962.

Francis has had many succcessful exhibitions: in New York (1956, Martha Jackson Gal.); in London (1957, Gimpel Fils Gal.); in Tokyo and Osaka; in Düsseldorf (1959, Kunsthalle); and in Switzerland, where in 1956 he created an important mural triptych for the Kunsthalle in Basel, before the Kunsthalle in Berne gave him a large one-man show in 1960. It was in Paris, however, that he made his reputation; in 1952 the Galerie Nina Dausset put on his first exhibition, and others soon followed at the Galerie Rive Droite, in 1955 and 1956, the latter under the aegis of Michel Tapié, who, in *Un art autre*, had already set Sam Francis among the *signifiants de l'informel*, to which he brought, after Pollock, a new spatial dimension on the American scale.

It is in fact the sense of space, as a place into which light is poured, that conditions the tachiste expression of Francis, who himself has said that 'space is colour' and thus recognizes the importance of the example of Monet and Matisse. Working on a very large scale in broad, vigorous patches of colour, light or dark, he modulates the surface to create moving spaces impregnated with an intense life. In his 'blues' (1967-8) he progressively extended the space separating the patches of colour, pushing the colour out towards the edges of the canvas in order to emphasize the 'open form' of the white field.

His works are found in many American galleries (notably in New York, M.O.M.A. and Guggenheim Museum), as well as in London (Tate Gal.), Paris (M.N.A.M.) and Zürich (Kunsthaus). R.V.G.

Francke
(also known as Master Francke)

German painter
active in Hamburg during the first half of the 15th century

Master Francke was one of the most original representatives in Germany of the International Gothic, interpreting its courtly forms in a style of religious expressionism into which he translated directly his meditations on the Passion or on the lives of the saints. There are few documents referring to his life. He was a Dominican monk (which explains why his name appears on no municipal registers) from Zutphen in Gelderland, where he must have been born between 1380 and 1390. He painted two panels of the Virgin and St John the Baptist for Münster Cathedral, probably before 1420 (destroyed). In 1424 he signed a contract with the brotherhood of the Englandfahrer for an altarpiece for the Church of St John in Hamburg, which has survived and has allowed all the rest of his work to be judged stylistically. Then, in 1429, as his fame spread round the Baltic to the towns affiliated to the Hansa, he painted an altarpiece for another religious brotherhood in Reval, Estonia (destroyed).

Francke's surviving work consists of two paintings representing the *Man of Sorrows* (Leipzig and

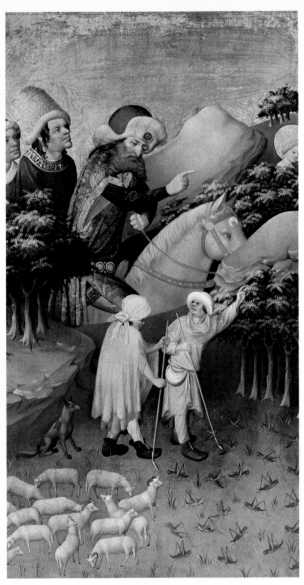

influence of the Franco-Flemish International Gothic style, mostly imported by the Duchess Marie of Gelderland, a French princess. He borrowed from manuscripts of about 1410, known directly or else through collections of models, detailed motifs or formulas of composition. His taste for simple forms and flat space reduced to the interplay of characters resembles that of the Limbourg brothers in the *Très Riches Heures.*

In Westphalia he learned the German version of the International Gothic, particularly from the *Niederwildungen Altarpiece* of Konrad von Soest, from which he borrowed the composition of his *Crucifixion* and the style of faces, hands and folds in the drapery. From this period date *The Man of Sorrows* in Leipzig (*c.*1420) and *The Altarpiece of St Thomas* (1424). The absence of anatomy and modelling, the flowing folds, the calligraphic lines, the composition without depth, all suggest these came early in his career. Further study of Western painting then led to the *Altarpiece of St Barbara* (*c.*1430-5) and *The Man of Sorrows* in Hamburg (*c.*1435-40), which reveal a new taste for volume, modelling, heavy, puffed-out folds and landscapes painted in depth.

Master Francke's career thus comes half-way between late International Gothic and realism. A regional, monkish painter, with a wholly personal inspiration, he did not establish a school. Several of the altarpieces in North Germany or in the Hanseatic towns, however, recall his forms, motifs and method of narrative expression, and prolong them (e.g. in the work of Johann Koerbecke).

N.R.

Friedrich
Caspar David

German painter
b.Greifswald,1774 – d.Dresden,1840

After studying at the Academy of Fine Arts in Copenhagen, where he came to know the work of Abildgaard, Friedrich settled in Dresden. Here he became friendly with the poet Ludwig Tieck and the painters Carus, Runge, Kersting and Dahl. His first successes were with large, precise drawings in sepia, particularly of scenes on the island of Rügen (Hamburg Museum; Albertina; Weimar Museum). Outside influences had little effect upon him; his profound feeling for nature, and a scrupulous observation of reality were the sources of his originality.

At various times (1801, 1802, 1806) he returned to the area in which he had been born and from this contact created a style of landscape that was wholly personal. About the same time he also began to paint in oils (*Mist*, Vienna, K.M.; *Dolmen in the Snow*, Dresden, Gg). In his altarpiece for the Chapel of the Castle of Count Thun at Tetschen (*The Cross on the Mountain*, 1808, Dresden, Gg) he used landscape to express his religious feeling. *The Monk on the Seashore* (1809, Berlin, N.G.) is the most perfect expression of his transcendental idea of landscape. His *Abbey in a Forest* (1809) and the *Landscape in the Riesengebirge* (1811; both Berlin, Charlottenburg) are among the most striking works of this period.

Visits to the Baltic coast in 1809, to the Riesengebirge in 1810 and to the Harz Mountains in 1811 enriched his subject matter. Into his mountain landscapes he transposed the forms which the seashore had inspired in him. Among his landscapes of this period are *The Rainbow* (Essen, Folkwang Museum), the *Landscape in the Riesengebirge* (Moscow, Pushkin Museum), and *Morning in the Harz Mountains* (Berlin, N.G.).

In the next period Friedrich's search for universality limited the expression of his imagination and his formal language. But a new evolution can be seen after two trips to the shores of the Baltic in 1815 and 1818 (the *Cross on the Shore of the Baltic*, Berlin, Charlottenburg; *Ships in the Port*, Potsdam, Sans Souci): now he was inspired more directly by nature and chose idyllic subjects.

After 1820 he painted not only seaside views and landscapes set in the foothills but also mountain views, after studies made by friends who were artists (C.G. Carus, A. Heinrich), such as *The Watzmann* (1824, Berlin, N.G.) and *High Mountains* (destroyed; previously in Berlin, N.G.). Friedrich also painted views of the Arctic Ocean, only one of which has survived (*Frozen Sea*, 1823, Hamburg Museum). About 1825 melancholy landscapes began to dominate his production. During his final period the painting became more supple and his colour more intense. After 1835, following a stroke, he produced nothing but drawings.

In Friedrich the concept of nature was subordinate neither to literal description nor to idealization. Natural subjects were considered as symbols of divine revelation. Thus mountains were the symbols of God, rocks represented faith, pine trees a gathering of believers. This language of symbols was generally developed from an observation of the unchanging face of nature and owed little to orthodox symbolism. The landscape background was the reflection of the afterlife, and the foreground, mostly plunged in darkness, symbolized the earthly world. Figures seen from behind, common in Friedrich's work, personified the religious man who considered his earthly existence as a preparation for eternal life (*The Voyager above the Sea of Clouds*, Hamburg Museum; *Two Men Contemplating the Moon*, Dresden, Gg; *Girl before the Setting Sun*, Essen, Folkwang Museum). The many allusions to death have a positive value; they are a necessary condition for signifying transcendence.

Friedrich's oil paintings are mainly landscapes – syntheses of subjects taken from life – but his watercolours, like his drawings, with the exception of those in sepia, are direct studies from nature.

Friedrich's landscapes were appreciated by the public from the beginning of the 19th century, but his *Tetschen Altarpiece* and his *Monk on the Seashore* met with a hostile reception. His fame reached its height in 1810, when the ruling house of Prussia bought several of his works. In 1816 he was made a member of the Dresden Akademie and in 1824 Professor Extraordinary. However, with the exception of Carus, Blechen and Dahl, he had little influence upon his contemporaries. His symbolic concept of art could not match the prosaic spirit of the Biedermeier period.

Rediscovered at the beginning of the present century, Friedrich appears today to be the greatest German landscape painter of the 19th century. His work is represented in most German galleries, especially in Berlin (N.G.), Dresden and Hamburg, which have important collections, as well as in Bremen, Essen, Karlsruhe, Hanover, Leipzig (*The Ages of Man*, 1835), Kiel, Cologne and Munich. It can also be seen in Vienna, Leningrad,

Hamburg museums), and two large altarpieces with shutters. *The Altarpiece of St Barbara* (Helsinki Museum), probably painted for the cathedral of the Hanseatic port of Åbo in Finland, has an interior that appears to have been carved in his studio, or according to his designs, and double shutters painted with eight scenes from the life of St Barbara. Of the *Altarpiece of the Englandfahrer*, known as the *Altarpiece of St Thomas à Becket* (Hamburg Museum), there remains a fragment of the central panel (a *Crucifixion*), and from the double shutters, four *Scenes from the Infancy of Christ* and two *Scenes from the History of St Thomas à Becket* on a red starry background.

It has been suggested that the *Altarpiece of St Barbara* may have been painted by Francke at the beginning of his career, when he was in close touch with French miniatures, in a spirit that was open to the outside world, and that the *Altarpiece of St Thomas* is a later work in which he limited himself to essentials in order to express a subjective vision. A different and more likely chronology, however, would suggest that here was a medieval painter evolving towards realism under the various artistic influences of his period.

It appears that Francke's background was a decisive factor in his evolution; in Gelderland he would have found a special imagery and above all an atmosphere of mystical expressionism translated artistically in a simplified, effective narrative. There, too, he would have come under the

Master Francke
The Pursuit of St Barbara
Wood. 95 cm × 54 cm
(Panel of *The Altarpiece of St Barbara*)
Helsinki, Nationalmuseum

Moscow, Winterthur (*Chalk Cliffs on Rügen*), Oslo, Prague (*Northern Sea in the Moonlight* and *Moonlight*) and the Louvre (*Tree with Crows*).

H.B.S.

Frith
William Powell
English painter
b.Harrogate, 1819 – d.London, 1909

Frith was the son of a Harrogate innkeeper; he studied at Sass's evening school (1835-7) in Bloomsbury, and after two years he was admitted to the Royal Academy Schools. In 1840 he first exhibited subject pictures, and he became an Associate Member of the Royal Academy five years later. Frith visited Belgium, Holland and Germany in 1850, and in 1853 he became a full Academician, after the death of Turner. Many of his early pictures depicted scenes from Shakespeare, Goldsmith and Scott, which corresponded with contemporary taste.

▲ Caspar Friedrich
Moon Rising over the Sea
Canvas. 55 cm × 71 cm
Berlin, Nationalgalerie

▲ William Powell Frith
Derby Day (detail) (1856–8)
Canvas. 102 cm × 223 cm (whole painting)
London, Tate Gallery

In 1837 Frith declared his intention to paint scenes from everyday life, and although he continued to produce historical scenes, his greatest works fall into the former category. His diploma picture, *The Sleepy Model* (1853, London, Royal Academy), a portrait of himself and a model in a studio, is a good example of his less ambitious works in that vein.

On 30th September 1851 Frith began to make one of many sketches of the seaside at Ramsgate, and with foresight he wrote: 'If successful [it] will considerably alter my practice.' The finished picture, *Life at the Seaside* or *Ramsgate Sands* (1854, United Kingdom, Royal Coll.), became immensely popular when it was exhibited at the Royal Academy, and it is amongst the best pictorial representations of the Victorian age. Queen Victoria, who purchased the painting, subsequently asked Frith to paint a picture of the marriage of the Princess Royal, as well as another of the marriage of Edward VII, then Prince of Wales. The first offer was declined, and the second was accepted.

Derby Day (1858, London, Tate Gal.) was a later picture in the mode of *Ramsgate Sands* and was equally successful. Ruskin described it as 'a kind of cross between John Leech and Wilkie, and a dash of daguerreotype here and there and some pretty seasoning with Dickens's sentiment'. Frith painted another major work, *The Railway Station*, in 1862 (Egham, Surrey, Royal Holloway College), and after visits to Italy in 1875, and to Belgium and Holland in 1880, he completed *The Private View of the Royal Academy* (1883, United Kingdom, private coll.), which contained many portraits of well-known figures of the day, including Oscar Wilde.

Frith charged high prices for these pictures, and, with the sale of their copyright for engravings, he became quite wealthy. The profusion of detailed anecdotal incidents in his paintings probably accounts for their extraordinary contemporary appeal, which, on at least one occasion, caused the Academy to put up barriers to protect the pictures from admiring crowds. His deliberate awareness of popular taste is reflected by the fact that when there was a revival of interest in historical painting during the 1860s Frith painted a large picture in that manner, at the suggestion of a dealer. He later referred to the incident as 'a matter of everlasting regret to me, from my conviction that my reputation will rest upon the pictures I have painted from life about me'.

Apart from being a member of 'The Clique', a group of artists that included Richard Dadd, John Phillip and H. N. O'Neill, Frith counted amongst his friends many of the best-known painters of

the day, as well as several writers, including Dickens. His ability to respond to general taste, and his immediate success, besides the overtly bourgeois nature of his style, did nothing to endear Frith to the more avant-garde aesthetes. Nevertheless, Frith's finest paintings are splendid depictions of life in Victoria's reign, and his memoirs, written when he was over 70, contain amusing and interesting insights into the artistic circles of the time. J.H.

Furini
Francesco
Italian painter
b.Florence, 1603 – d.Florence, 1646

Trained in the academic circle of Biliverti and Matteo Rosselli, Furini completed his artistic education with a visit to Rome (where he met his fellow-countryman Giovanni da San Giovanni), and another to Venice. He became a priest in 1644 without abandoning painting, which he practised in his parish of S. Ansano in Mugello. But he was soon persuaded back to Florence by the rich customers who demanded of him canvases on mythological subjects (*Death of Adonis*, Budapest Museum; *Hylas and the Nymphs*, Florence, Pitti) or on religious themes (*Adam and Eve*, Florence, Pitti; *Lot and his Daughters*, Prado; *The Magdalene*, Vienna, K.M.; *St Lucy*, Rome, Gal. Spada), in which the female nude, in languorous poses, predominated.

Furini's painting, soft and enveloped in a bluish haze, does not follow the Tuscan realism of his day, but remains the expression of a sophisticated idealism, steeped in eroticism. Apart from several church paintings and those already mentioned, Furini's work includes two frescoes painted in 1636 for the Museo degli Argenti of the Pitti, in honour of Lorenzo the Magnificent, and a series of drawings of great sensitivity (Uffizi, Print Room). His accomplishment in painting nudes and his vocation for the priesthood was a subject which inspired a philosophical poem by Robert Browning. E.B.

Fuseli or Füssli
Johann Heinrich
Swiss painter
b.Zürich, 1741 – d.London, 1825

Through his father, Johann Kaspar Füssli, a painter, the author of a *History of the Leading Painters in Switzerland*, and owner of a collection of Swiss and German drawings, the young Fuseli became part of the literary and artistic life of Zürich. He was closely linked with Bodmer, who introduced him to Shakespeare, Milton and Wieland's *Nibelungen*, and met Winckelmann and Lavater, the physiognomist. His artistic career began with drawings taken from works in his father's collection; he illustrated an edition of *Till Eulenspiegel* which showed his liking for caricature and excess.

In 1764 he went to London and became a friend of Reynolds. Here he adopted the anglicized spelling of his name. Two influences from that visit remained with him: one was the classical in-

fluence of Winckelmann, whose *Thoughts on Imitation* he translated, the other the romantic influence of a number of poetic works, particularly those of Milton.

On Reynolds's advice, Fuseli went to Rome in 1770, where he found greater inspiration in Michelangelo's frescoes than in the study of antiquities, and copied two prophets from the Sistine Chapel (*Roman Album*, British Museum). It was when he saw the ceiling of the Sistine Chapel that he conceived the idea of painting a Shakespearean cycle, which he later put into execution. He painted 16 works, which have now disappeared, on Shakespearean themes during this period in Rome. He met the Danish painter Abildgaard and the Swedish sculptor Sergel, and his influence over them was to have a considerable effect on the development of Neoclassical art in Scandinavia. On his return to Zürich, he painted *Fuseli in Conversation with Bodmer* (1779, Zürich, Kunsthaus), in which his talent as a portrait painter came close to that of Reynolds.

In 1779 he went to London for a second time, and remained there until his death. With *The Nightmare* (1781, Detroit, Inst. of Arts; other versions: Stafford, Harrowby Coll.; Frankfurt, Goethe Museum), Fuseli opened up the way for dreams and the fantastic in art, and, before the publication of Goya's etchings, was the forerunner of Surrealism. From 1786 to 1800 he made two cycles of paintings after Shakespeare and Milton, which are important in the development of the genre of history painting in England. For Boydell's Shakespeare Gallery he illustrated high points from *Macbeth*, *The Tempest* and *King Lear*, in a series of nine paintings which heralded Romanticism. The Milton Gallery in London opened in 1799 by presenting 40 of his works – tragic and pessimistic in their inspiration. In spite of their limited success, Fuseli painted another seven in 1800.

In 1799 he was appointed Professor of Painting at the Royal Academy, to which he had been admitted in 1790 with his *Thor Battering the Midgard Serpent* (London, Royal Academy). He taught at the Academy for over 20 years and published his lectures. In 1814, 1817 and 1820 he painted canvases on the theme of the *Nibelungenlied* and exhibited at the Academy. His last works were mostly mythological paintings, inspired by Romanticism.

His influence on William Blake, with whom he became friendly in 1787, was a determining factor in Blake's formation. In their drawing both respected the classical principles of composition, but in Fuseli the effects of chiaroscuro play a greater role; both shared a taste for the fantastic and the unreal. Their heroes seem to emerge from a chaotic dreamlike world and are distinguished by violent movements and spiritual intensity. Fuseli was inspired by the poets of the ancient world, by Dante and the great English and German dramatists. Women had an important place in this inspiration, appearing as magicians, as fantastic beings, or in the seductive guise of rather sophisticated actresses. Fuseli's genius lay not so much in the rather cold composition or the colour of his paintings as in his unconstrained pictorial imagination which the Romantics and, later on, the Surrealists invoked.

Fuseli is particularly well represented in the Tate Gallery in London, in the museums of Basel, Lucerne and Winterthur, and above all in the Kunsthaus in Zürich, which has a considerable collection of paintings and drawings. E.R.

▲ Francesco Furini
Hylas and the Nymphs
Canvas. 230 cm × 261 cm
Florence, Palazzo Pitti

Fyt
Johannes or Jan

Flemish painter
b.Antwerp, 1611 – d.Antwerp, 1661

After Snyders, Daniel Seghers and Jan Bruegel, Fyt was the leading Flemish painter of flowers and still-life subjects in the 17th century. His work is less decorative and more varied than that of Snyders, and in a smaller format. More devoted to a truly pictorial lyricism, a virtuoso in the supple, firm and exact way in which he used light brushwork, producing effective contrasts of light and shade and warm brown tones, Fyt was a fascinating illusionist who loved playing with the effects of objects and their sculptural, plastic quality. He was, too, a master of moving, dramatic compositions who liked to deploy his motifs against a background of vibrant, cloudy skies. To traditional subjects such as hunting trophies, heaps of game watched by dogs, garlands of flowers and fruit, and backyards, Fyt brought Baroque stability and breadth, a sort of vigorous, unintellectual pathos (in this, he was far removed from Rubens whose influence could be seen in Snyders).

Fyt began his training with Hans van den Berch in Antwerp about 1621-2, and then entered Snyders's studio. To Snyders, Fyt owed the basis of his style, even though he developed in another way in reaction to the skilful, opulent Snyders, who always used clearly graphic arrangements and harmonies in bright, but light-coloured, tones. In 1629-30, with financial assistance from Snyders, Fyt became a master, then travelled. From 1633 to 1639 he was in Paris, then in Italy, notably in Venice and Rome. In 1641 his presence at Antwerp is documented, and he seems to have remained in the city, marrying there, rather late, in 1654. His name often appears in the archives of Antwerp because of the many lawsuits in which he was involved.

Famous and highly considered in his lifetime, Fyt had few pupils although many followers and imitators, including Jeroom Pickaert and above all Pieter Boel, who, together with David de Koninck, was the most gifted; and the German painter of hunting pictures, Ruthart, owed more to Fyt than to Snyders. On the other hand, like many other Flemish artists, Fyt often collaborated with painters of figures, such as Erasmus Quellinus (work of 1644 in London, Wallace Coll.; other examples in Antwerp Museum and Berlin-Dahlem), Schut, Jordaens and Willeboirts Boschaerts (paintings of 1644 in Dessau Museum and of 1650 in Vienna, K.M.).

Fyt's output was reasonably varied: his favourite subjects were eagles and hunting dogs, always painted with a literal, insistent realism that was typical of him; his paintings of fruit and vases of flowers are rather rarer (three examples from 1660 in Wörlitz and Mosigkau museums and the Buys Coll. in Rotterdam). He was prolific; there are more than 160 signed paintings with dates ranging from 1641 to 1661 and at least as many again attributed to him with some certainty. Despite this, it is hard to discern a clear evolution of style, which is not at all the case with many artists specializing in still-life painting and flowers.

Fyt is represented in most of the major international galleries (Vienna, Prado, Munich, London, Dresden, Milan, Leningrad, Paris, San Francisco, Budapest). Among his masterpieces, and most characteristic of him is the large *Eagles Feeding* (Antwerp Museum), with a broad, effective background of landscape, the opulent *Still Life with a Dog Cart* (Brussels, M.A.A.), the luxurious *Still Life with a Dead Peacock* (Rotterdam, B.V.B.), the *Still Life with Dead Birds and a Cat* (Brera), with the intimate, glowing effect of a Chardin, and the tumultuous *Fight Between a Cockerel and a Turkey* (Brussels, M.A.A.), painted with almost too calligraphic a technique.

A fine rarity among Fyt's paintings is his study of a *Landscape with Two Horses* (Brunswick, Herzog Anton Ulrich Museum). A skilful engraver, Fyt deserves to be remembered even more as a draughtsman, particularly for the very beautiful and vigorous series of drawings in black and crayon on coloured paper in the Hermitage (as well as for his *Study of a Dog* in Antwerp Museum, formerly also in Russia). J.F.

Gainsborough
Thomas

English painter
b.Sudbury, Suffolk, 1717 – d.London, 1788

The son of a cloth-merchant, from an early age Gainsborough showed a talent for drawing and a fondness for Dutch landscapes, which he could have seen in Suffolk and in London sale rooms. He arrived in London in 1740, where he seems to have studied chiefly by frequenting artists' studios rather than by a regular apprenticeship. One of his teachers was probably Hubert Gravelot, the drawing master of St Martin's Lane Academy. He was also influenced by Gravelot's associate, Francis Hayman, who taught painting there.

His early works fall into two categories: the first consists of landscapes based on Dutch sources, especially Ruisdael and Wynants, reinforced by the study of nature; the second of groups of small figures, usually in pairs, in landscape settings, influenced by English conversation pieces and by the French rococo idiom of Gravelot and Hayman. These paintings have great charm but a certain amateurish stiffness (*Self-Portrait, with his wife Margaret*, c.1746, Louvre; *Mr and Mrs Andrews*, c.1750, London, N.G.). The landscape background of this latter work is, however, more naturalistic than in any other English painting before Constable.

In 1746 Gainsborough married Margaret Burr, by whom he had two daughters whom he painted as children in the late 1750s in three appealing sketch-like pictures (London, N.G. and V. & A.). About 1748 he returned to Sudbury, soon afterwards settling in the nearby town of Ipswich, where he lived until he moved to Bath. In 1755 he received his first important landscape commission, for two overmantels for the Duke of Bedford: *Peasant with Two Horses* and *Woodcutter courting a Milkmaid* (London, Duke of Bedford Coll.). These are rustic idylls partly in the manner of Boucher but with passages of tender natural observation. At the same time he was painting portraits of Suffolk patrons with increasing skill.

On moving to Bath in 1759 he entered fashionable society and turned to life-sized, full-length portraits, which were henceforth to be his main source of income. His landscapes were produced for pleasure. Although partly dependent on drawings from nature, their compositions were invented by himself, using rocks, moss, fragments of glass and branches of trees brought into the studio as models. The themes of these landscapes echo contemporary country life, not classical poetry, and breathe a pastoral, picturesque air. In style and handling they show rococo influence (*Peasants going to Market*, 1773, Egham Green, Surrey, Royal Holloway College).

In Bath, his portrait style acquired a new elegance and assurance, derived from the study of Van Dyck, whose works he saw in nearby country houses. Even more than most English painters, Gainsborough liked to place his sitters in a landscape setting. Unlike his rival and contemporary, Reynolds, he preferred modern to classical dress, hated allegory and apparently never used assistants to paint the drapery. He considered the dress a part of the sitter's likeness, for which he had an exceptional gift.

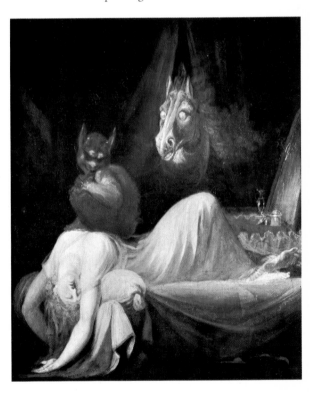

Johannes Fyt ▲
Still Life with Mushrooms
Wood. 49 cm × 63 cm
Brussels, Musées Royaux des Beaux-Arts

Johann Fuseli ▲
The Nightmare (1781)
Canvas. 75 cm × 64 cm
Frankfurt, Goethemuseum

The portraits of his Bath period are vibrantly alive, though too exquisite to be quite real, and are beautifully and fluently painted with shimmering dress textures, sophisticated in manner yet informal in pose. They mirror a society that cultivated elegance and fashion as a way of life, although that society was slightly shocked by the insouciance of Gainsborough's interpretation of it (*Lady Alston*, c.1765, Louvre; *Countess Howe*, c.1763-4, London, Kenwood, Iveagh Bequest); *The Duke* and *Duchess of Montagu*, c.1768, Duke of Buccleuch's Coll.; and the famous 'Blue Boy' [*Master Jonathan Buttall*], 1770, San Marino, California, Huntington Art Gallery).

From 1761 Gainsborough exhibited at the newly founded Society of Artists, London. In 1768 he became a founder member of the Royal Academy (the only artist then living in the provinces to be invited) and sent two portraits and a landscape to the first exhibition of the Academy in 1769. In 1774 he moved to London, taking a part of Schomberg House, Pall Mall, where he lived until his death. His London style continued that of his Bath period, becoming looser, grander and sometimes darker (*Mrs Graham*, 1777, Edinburgh, N.G.; the oboist, *Johann Fischer*, husband of the artist's daughter, 1780, London, Buckingham Palace). The influence of Rubens also became apparent, especially in his landscapes (*The Watering Place*, 1777, London, N.G).

Soon after settling in London Gainsborough took up the experiments with artificial light of the scene painter, P.J. de Loutherbourg, and painted a series of small landscapes on glass (c.1783), which were intended to be mounted in a box and lit from behind by a candle. In 1781 he was first patronized by George III and Queen Charlotte (portraits of them and other members of the Royal Family are at Windsor Castle), succeeding Ramsay as their favourite portrait painter.

From 1777 he was championed in the press by the Rev. Henry Bate (later Sir Henry Bate-Dudley). Otherwise both press and public were generally baffled by his portraits on account of their 'unfinished' look and were indifferent to his landscapes until his last years. In 1784 he finally quarrelled with the Royal Academy, which had refused to hang his pictures in a position from which the brilliance of their brushwork could be seen. From then on he held an annual exhibition of his work at Schomberg House.

In his last years Gainsborough painted a num-

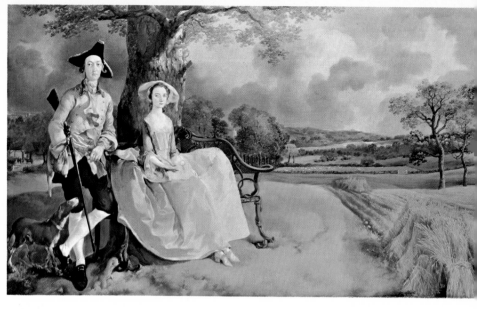

ber of notable portraits, including those of *Mrs 'Perdita' Robinson* (London, Wallace Coll.), *Mrs Sheridan* (1785-6, Washington, N.G.), *Mrs Siddons* and *Mr and Mrs Hallett*, known as *The Morning Walk* (1785; both London, N.G.). In addition, he experimented with new types of picture, especially the 'fancy piece' – a kind of genre portrait or portrait-group in a rustic setting with titles like *Peasant Girl with Pigs* (1782, Castle Howard, Howard Coll.) and *The Woodgatherers* (1787, Metropolitan Museum). These picturesque idealizations of pastoral life were more popular than any other category of his work at the end of his life and for a generation after his death.

Another new genre that Gainsborough developed at this time was the seascape. He exhibited two at the Royal Academy in 1781, one calm, the other a storm (London, Grosvenor Estate). New influences on him included Murillo, Watteau, Gaspard Dughet (in his mountain landscapes) and Snyders. From 1772 his nephew, Gainsborough Dupont, became his only recorded pupil. He carried on Gainsborough's portrait style, which otherwise had little influence, after his death. His landscapes, reversing the position in his lifetime, were now widely admired.

Gainsborough the man was gay, impulsive and a delightful letter writer. He loved music and preferred the company of actors and musicians to that of literary men. As an artist he relied more on innate natural talent than on thought or study. The sources of his style were French, Flemish and Dutch rather than classical or Italian, and, in an age when an Italian journey was almost obligatory for a north European painter, it is characteristic of him that he never went abroad. The best account of him remains Reynolds's 14th *Discourse* delivered after his death: a perceptive and sympathetic account from an artist who was in almost every respect his opposite. M.K.

Gallego
Fernando
Spanish painter
active 1468 – 1507

Together with Bermejo, Gallego was the most original of the creators of the Hispano-Flemish style, but we do not know the date of his birth or of his death, nor where he was trained. Recent

studies, however, have provided a full knowledge of his work. In 1468 Gallego worked in Plasencia Cathedral; then in 1473 he painted six altarpieces (lost) for Coria Cathedral. Between 1478 and 1490, he worked in the Church of S. Lorenzo, Toro, in the library of Salamanca University and on the altarpiece of Ciudad Rodrigo Cathedral. He began work on a large altarpiece for Zamora Cathedral in 1495 (today, in sections in the church of Arcenillas). In 1507 he collaborated in the decoration of the rostrum of the University of Salamanca, and must have died shortly afterwards.

His fame in the Tierra de Campos was so great that copies and old Flemish paintings were attributed to him. This must have been the case with the *Virgin of the Fly* in the collegiate church of Toro and the triptych in Cadiz Museum. On the basis of his style it has been suggested that Gallego either made a journey to Flanders or absorbed the Flemish influence through Jorge Inglés. Although the figures recall those of Bouts, Gallego's dryness and expressive force are remote from the dreamy atmosphere of Flemish painting. The dramatic feeling, and the special way in which fabrics are draped, also suggest the influence of Witz.

However, Gallego always retained his taste for regional figures and the landscape of his province. In his early works he tended to elongate the figures and to fold his fabrics stiffly, but he used gold in moderation. These characteristics, as well as the richness of his colours, became less pronounced as the years went by. In his later work, his technique was less careful and more realistic.

Gallego's first work seems to have been the *Altarpiece of St Ildefonso* in Zamora Cathedral. It has been thought to have been painted about 1466, but the relationship between it and the engravings of Schongauer suggest a date around 1480. The triptych of Salamanca Cathedral (*The Virgin with St Christopher and St Andrew*) probably dates from the same period. The decoration of the vault of the University of Salamanca is especially interesting for its themes, which are taken from classical mythology (*Signs of the Zodiac, Hercules*), and painted in oils and tempera. Gallego paid more attention to the decorative aspect in the large altarpiece of the cathedral in Ciudad Rodrigo (today, dispersed; major part in the University of Arizona, Tucson, Kress Coll.).

The *Altarpiece of St Lorenzo de Toro* can be dated 1492, judging by the arms of Beatrice de Fonseca.

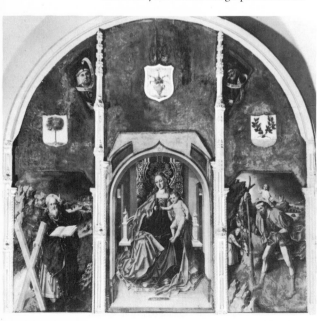

◄ Fernando Gallego
The Virgin with St Christopher and St Andrew
Wood. 190 cm × 197 cm
Salamanca, Museo Diocesano

▲ Thomas Gainsborough
Mr and Mrs Andrews (c.1750)
Canvas. 70 cm × 118 cm
London, National Gallery

The central panel is today in the Prado. The *Altarpiece of Arcenillas* is already a late work, certain weaknesses of which suggest that Gallego's pupils had a hand in it. The Altarpiece of St Catherine in Salamanca Cathedral is Gallego's own work, as well as the additions to the large altarpiece of Dello Delli in the same cathedral. Some authorities, however, believe that both these are the work of Gallego's brother Francisco, mentioned in 1500 as a gilder and as the painter of an altarpiece depicting St Catherine. Possibly it is a case of the same man expressing himself in various ways.

Other notable works by Gallego include *The Virgin of Pity*, the *Crucifixion* in the Prado, the *St Peter* in Dijon Museum, and the altarpieces of Peñaranda, Villaflores and Cantelpino, which have been divided among private collections.

<div align="right">M.D.P.</div>

Gauguin
Paul

French painter
b.Paris, 1848 – d.Atuana, Marquesas Islands, 1903

Gauguin was born during the revolution of 1848. His father, an obscure liberal journalist, went into exile after the coup d'état of 1851 and died in Panama, while the family went on to Lima, Peru. Gauguin's mother's ancestors were Peruvian nobles, and he was marked from childhood by the imaginative, messianic atmosphere of his family circle, retaining strange memories of a visit to his uncle, Don Pio de Tristan y Moscoso, in Lima. Back in Orléans as a schoolboy in 1855, he dreamed of escape and from 1865 to 1871 worked as an apprentice pilot in the merchant navy, sailing between South America and Scandinavia. Then, encouraged by his godfather, Arosa, in 1871 he began a very successful career with the stockbroker Bertin, and two years later married a Danish girl, Mette Gad.

Early years. Arosa collected paintings and had taste. His example, and friendship with Pissarro, encouraged Gauguin to buy Impressionist paintings, particularly between 1879 and 1882 (Jongkind, Manet, Pissarro, Guillaumin, Cézanne, Renoir, Degas and Mary Cassatt). Then he started painting and sculpting himself, as an amateur. He worked from life with Bouillot, and painted in the style of Bonvin and Lépine (*La Seine au pont d'Iéna*, 1875, Louvre). In 1876 he exhibited a painting at the Salon. He was soon influenced by Pissarro, and exhibited with the Impressionists during 1880-2, being praised enthusiastically by Huysmans for a solid, realistic *Nude* (1881, Copenhagen, N.C.G.).

These encouraging successes and a financial crisis led him to abandon his business career in 1883 in order to concentrate entirely on painting. For two years, between Rouen and Copenhagen, Gauguin tried to find a balance in his life, but it proved impossible and when he returned to Paris in June 1885 his family life was over and he found himself in penury. However, in 1886 he showed 19 canvases at the eighth Impressionist Exhibition: his originality was already evident in the disquieting rhythms of his landscapes.

Pont Aven. After a summer stay at Pont Aven, where he met Émile Bernard and Charles Laval,

Gauguin returned to Paris. There he created interestingly simplified ceramics with Chaplet and met Van Gogh. A journey to Martinique in 1887 with Laval showed him the synthetic value of colours and revived the influence of Cézanne and Degas. On his return, and during his second stay at Pont Aven in 1888, Gauguin joined with Anquetin and Bernard in their experiments made under the influence of Puvis de Chavannes and of Japanese prints. It was a decisive moment for Gauguin, who, at the age of 40, was elaborating an original style by integrating the *cloisonnisme* and Symbolism of his friends with his own experience of colour. The 'rustic and superstitious simplicity' of the *Vision après le sermon* (*The Vision after the Sermon*) (1888, Edinburgh, N.G.), or the scarlet harmonies of *La Fête Gloanec* (Orléans Museum) proclaimed Gauguin's mastery of his medium.

Gauguin shared in the Symbolist ideas of Aurier and the utopian ideas of Van Gogh, but during their dramatic meeting at Arles from October to December 1888 he quickly became disappointed. Apart from the clash of their temperaments, Gauguin declared himself to be – as his 'composed' view of *Alyscamps* (Louvre, Jeu de Paume) bears witness – above all a classicist, a man who cared for balance and harmony. Back in Paris, he made a large number of ceramic objects with curious anthropomorphic decoration and, under Bernard's influence, a series of eleven lithographs.

A one-man show organized by Théo van Gogh in November 1888, then his participation in the group exhibitions of the Cercle Volponi during the Paris Exposition and those of Les Vingt in Brussels, revealed, in spite of sarcasm and indifference, Gauguin's leading position in the so-called 'School of Pont Aven'. Undiminished vitality, Bernard's absence, and the support of less-important followers strengthened the freedom and confidence shown by Gauguin in the works painted at Pont Aven, then at Le Pouldu, in 1889 and 1890. He absorbed the lessons of Cézanne (*Portrait de Marie Derrien*, Chicago, Art Inst.) and of primitive art, which he had known from childhood and whose qualities he found again in Breton art (*Christ jaune* [*The Yellow Christ*], Buffalo, Albright-Knox Art Gal.), uniting an increasingly egocentric mysticism (*Christ au jardin des oliviers* [*The Agony in the Garden*], Palm Beach, Florida, Museum) with a taste for the strange and barbarous (*Nirvana*, Hartford, Connecticut, Wadsworth Atheneum).

Gauguin was interested in a variety of media, and tapped the power of primitive bas-reliefs in some wood-sculptures (*Soyez amoureuses et vous serez heureuses* [*Love and Be Happy*], Boston, M.F.A.). Back in Paris, he became the leading artist at the literary gatherings at the Café Voltaire. He then painted a large symbolic work with disquieting sensual echoes, *La Perte du pucelage* (*The Loss of Maidenhood*) (New York, W.P. Chrysler Coll.), and, supported by his friends, prepared to set off for Tahiti.

Tahiti. A fairly successful auction of his works on 23rd February 1891 allowed him to sail on 4th April after a banquet had been given in his honour by the Symbolists. His only etching, engraved before he left, is a portrait of Mallarmé. Dazzled by the beauty of the Polynesian natives and landscape, Gauguin immediately saw in Tahiti the broad classical rhythms of Egyptian bas-reliefs (*Ta Matete*, Basel Museum), the tender spirituality

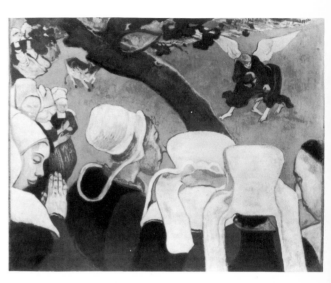

of the Italian primitives (*Ia orana Maria*, Metropolitan Museum), and the flat colourful plants of Japanese prints (*Pastorales tahitiennes* [*Tahitian Pastorals*], Moscow, Pushkin Museum), which he used with exceptional freedom of modelling and colour (*Siesta*, New York, Haupt Coll.).

He heightened the luxuriance of tropical colour, and often brought to its dusky incandescence the mysterious symbolism of pagan myths (*La Lune et la Terre* [*The Moon and The Earth*], New York, M.O.M.A.) and a sense of terror that was both superstitious and sensual (*L'Esprit des morts veille* [*The Spirit of the Dead Keeps Vigil*], New York, Goodyear Coll.).

Again without means of support, Gauguin returned to France from 1893 to 1895. Depressed by his isolation, scornfully and ostentatiously cultivating an air of exoticism that was henceforth to be quite artificial, he exhibited at Durand-Ruel's, but was successful only in arousing curiosity. The paintings of that time were an aggressive, nostalgic attempt to recall what he had experienced in Tahiti and to show up the evils of civilization (*Annah la Javanaise*, Zürich, Kunsthaus; *Mahana no Atua*, Chicago, Art Inst.). He went back to Pouldu and Pont Aven, where he was injured in a brawl and unable to move. It was then that he made an astonishing group of wood-engravings in which he expressed the silent terror of religious practices in Tahiti, making use of a precise technique full of contrasts, which was a revival of the form of early woodcuts.

After being forced to sell up the contents of his studio, Gauguin returned to Tahiti in March 1895. Alone and in debt, depressed and ill, he went through a terrible crisis, made worse by the death of his daughter Aline. A sense of the wretchedness of human destiny, and a growing need for plastic solidity and classical rhythms, increasingly marked his work (*Nevermore*, 1897, London, Courtauld Inst.; *Maternité*, c. 1896, New York, Rockefeller Coll.). Before his attempt at suicide in February 1898, he painted a large composition, *D'où venons-nous? où sommes-nous? où allons-nous?* (*Where do we come from? Where are we? Where are we going?*) (1897, Boston, M.F.A.); a pictorial testament in which 'what is premature vanishes and life surges up' sumptuously through the austere subject.

After 1898, regularly supported by Vollard, and then by several faithful admirers including Fayet, Gauguin found himself free of material

worries, although constantly at odds with the civil and religious authorities on the island. He expressed his messianic sense that he was being persecuted in two publications, *Les Guêpes* and *Le Sourire*, illustrated with wood-engravings, and in the wood-engravings that decorated his house, 'La Maison du Jouir' (Louvre, Jeu de Paume; Boston, M.F.A.). In 1899, he painted *Les Seins aux Fleurs Rouges* (*Tahitian Women with Mango Blossoms*) (Metropolitan Museum) and *Trois Tahitiens* (*Three Tahitians*) (Edinburgh, N.G.), which again reveal the strange secret charm of the broad volumes he used.

After he had settled in Atuana on the Marquesas island of Hiva Oa in 1901, Gauguin became progressively weaker, and accentuated with vibrant brushstrokes the profoundly delicate relationship between his greens, violets and pinks (*Et l'or de leur corps* [*The Gold of their Bodies*], 1901, Louvre, Jeu de Paume; *L'Appel* (*The Call*), 1902, Cleveland Museum; *Chevaux sur la plage*

(*Horses on the Beach*), 1902, Paris, Niarchos Coll.).

In his last years he wrote a great deal: letters to his friends, a study of *The Modern Spirit and Catholicism* and *Before and After*, an important meditation, although anecdotal and romanticized, upon his life and work. He died at Atuana on 8th May 1903.

Gauguin's influence. Through exhibitions arranged after his death, Gauguin's influence soon spread beyond the Pont Aven circle and the Nabis, who learned about him through Sérusier. The work of Willumsen in Denmark, Munch in Norway, Modersohn Becker in Germany, Hodler in Switzerland, Nonell in Spain and also Picasso in his pink and blue periods – all foreshadow the even more significant borrowings of the Fauves, such Cubists as Le Fresnaye, and Expressionists like Jawlensky, Müller, Pechstein and Kirschner.

Gauguin's work is in all the great galleries, in-

cluding the Louvre (Jeu de Paume), which has a fine collection. A Gauguin Museum was set up in Tahiti in 1965, and contains many documents connected with his life and work. G.V.

Geertgen tot Sint Jans

Dutch painter
active second half of the 15th century

Van Mander's testimony (1604) is our only source of information about Geertgen, who was born in Leiden and disappeared at the age of 28. Trained in Haarlem under Aelbert van Ouwater, he lived in the monastery of the Knights of St John in that town as a guest. The exact dates of his activity are not known for sure, but they are certainly after 1460 and before 1495.

 Paul Gauguin
Siesta (1893)
Canvas. 87 cm × 116 cm
New York, Haupt Collection

Geertgen's major work was a large triptych painted for the monastery in which he lived. A single shutter escaped destruction in the religious upheavals of the 16th century and has allowed his work to be assessed (Vienna, K.M.). On the inner side is painted the *Lamentation over the Dead Christ*. A strictly ordered composition, the static nature of which is accentuated by an angular modelling that makes the figures look like wooden sculptures, gives the paintings an austere solemnity. The central scene is surrounded by a landscape, the rhythm of which derives from trees with carefully painted leaves set in the almost concentric arcs of a circle. On the reverse of the panel a curious scene illustrates the *Story of the Relics of St John the Baptist*. Behind the saint's tomb a group of men are shown in the act of making off with the relics, and these are none other than the Knights of St John. Each of them is certainly a portrait, and their joint presence makes this the first known group portrait in Holland, the starting point of a long and rich tradition.

The painting closest to this wing in style is a *Raising of Lazarus* (Louvre), which takes up a number of details of Ouwater's *Raising of Lazarus* (Berlin-Dahlem), but is set in the open air in a broad landscape dotted with trees and stretches of water. A triptych of the *Adoration of the Magi* (Prague Museum), unfortunately damaged, closely resembles these two works, but is less mature, a youthful work. The background is enlivened by a restless group of the Magi's followers. On the shutters, the donors are presented by warrior saints, among them the figure of St Bavon, a version of which is to be found in a small panel in the Hermitage.

Four other small panels form, with these, the best of Geertgen's work. *The Adoration of the Magi* in Cleveland Museum takes up the theme of the Prague triptych again, while accentuating its dramatic tone: all attention is focused on the faces of the characters, which are rough in their plastic expression, but which translate feelings very expressively. *St John the Baptist in the Desert* (Berlin-Dahlem) is a surprising masterpiece: the peasant figure of the saint lost in thought prefigures, by its attitude, Dürer's *Melencolia I*, but in a simpler style. The luxuriant landscape is the most beautiful painted by Geertgen, and follows the tradition of Van Eyck in its precise depiction of detail, such as grass and leaves. The large areas of green are interrupted by the surfaces of water, treated as carefully reflecting mirrors.

In *The Man of Sorrows* (Utrecht, Diocesan Museum) the body of the Saviour, covered in bleeding wounds, has a sculptural quality that admirably serves the seriousness of the subject. A panel forming a portable altarpiece (Milan, Ambrosiana) depicts the *Virgin and Child* in a composition close to that of Bouts.

Finally, the *Nativity* in the National Gallery, London, is one of the first nocturnal treatments of the subject. The child lying in the manger provides a luminous focal point for the whole scene. The relationship of these different works with the art of Hugo van der Goes has often been noted. Although the two artists have certain features in common, Geertgen never reveals so dramatic and disturbed a feeling as Hugo. An almost serene sense of meditation, even when it is passionately felt, animates each work.

Other paintings can equally well be attributed to him. Two of the *Adoration of the Magi* (Rijksmuseum and Winterthur, Oskar Reinhart Coll.) are sadder and more hesitant than the one in

Prague. A curious *Holy Kindred* (Rijksmuseum) assembles the company in the nave of a Gothic church. The *Virgin and Child* in Berlin-Dahlem develops the small panel of the Ambrosiana on a larger scale, at the expense of its ingenuous freshness. Much further in style from the main works are a *Tree of Jesse* (Rijksmuseum), previously attributed to Mostaert, and a small painting of the *Virgin of the Apocalypse* (Rotterdam, B.V.B.), surrounded by a throng of angel musicians, who seem to be emerging from the darkness through a violent use of light. A.Ch.

Gentile da Fabriano

Italian painter
b.Fabriano, c.1370 – d.Rome, 1427

It is not known where or with whom Gentile received his training, but the most likely hypothesis is that he was taught in the cultivated circle of painters and miniaturists of Umbria and The Marches. His first known works came from Fabriano, in The Marches, the town in which he

was born. Nevertheless, they contain certain northern Italian elements, particularly Lombard ones, which suggests that he may have spent some time in Lombardy at the end of the 14th century. Gentile's earliest work, the *Madonna with St Nicholas and St Catherine* (Berlin-Dahlem), conceived as a *sacra conversazione* in which angel musicians are seen among the trees of a garden, recalls certain inventions of the Lombard miniaturists, notably in the aristocratic grace of the figure of St Catherine.

A document of 1408 mentions Gentile's presence in Venice where he painted an altarpiece, now lost. In 1409 he painted an important fresco, no longer extant, in the Hall of the Grand Council in the Doge's Palace in Venice. This decoration must have had a decisive influence upon Venetian painters, especially Pisanello and Jacopo Bellini. Around 1401 in all probability Gentile painted a polyptych for the Church of Valle Romita, near Fabriano (now in the Brera). The central panel represents the *Coronation of the Virgin*: against a background of gold, the group of figures with their elegant draperies takes on a heraldic meaning. In the side-panels (*Sts Jerome, Francis, Mary Magdalene* and *Dominic*), the luxury of the gold background seems to transfer itself to the four

▲ Geertgen tot Sint Jans
The Holy Kindred
Wood. 137cm × 105cm
Amsterdam, Rijksmuseum

figures of saints who seem to grow out of the flower-strewn field, richly dressed in a range of dense, harshly contrasting colours.

In the same way the four scenes in the upper tier (*St John the Baptist in the Desert; Death of St Peter Martyr; St Anthony of Padua; Stigmatization of St Francis*), which take place in gardens surrounded by low walls, are painted with a refined realism in which the play of heavy shadows mingles with an oblique light. The fine panel of the *Stigmatization of St Francis* (Crenna di Gallarate, Carminati Coll.) is interpreted in a similar way. The light bathes the mountainside, clings to the trees and boldly outlines the saint's companion.

Between 1414 and 1419 Gentile was in Brescia to decorate a chapel, now destroyed, in the medieval palace of Broletto. The *Madonna* in Pisa (M.N.) and the one in Washington (N.G.) belong to the same period. Both feature very luxurious materials, brocades, and gold embroideries; both are painted with extraordinary delicacy.

After a stay in Fabriano in 1420, Gentile went on to Florence in 1422. The following year he painted for Palla Strozzi the famous *Adoration of the Magi* (Uffizi). In commissioning it Strozzi, the richest man in Florence, seemed to aim at offering the Florentines the most luxurious altarpiece they had ever seen. Gentile brought a passionate realism to his richly depicted scene. The composition runs in a diagonal from foreground to background. These are connected by the long column of horsemen that starts on the hill where the star appears and stops at the feet of the Virgin, as if in feudal, chivalrous homage. This is not a religious procession, but a luxurious secular one with courtesans, pages and huntsmen accompanied by animals (falcons, cheetahs, hares and monkeys).

Light dominates in the marvellous scenes of the predella (that on the right, showing *The Presentation in the Temple*, is in the Louvre), in *The Flight into Egypt* (landscape) and in the *Nativity* (effects of night light). A wonderfully inventive touch is seen in the small pilasters of the polyptych, which have been transformed into espaliers covered in a profusion of flowers, depicted with an exactness that makes them one of the first true still lifes. The inspiration for this probably came from Lombard manuscripts.

In Florence, in 1425, Gentile signed and dated another important work, the *Quaratesi Polyptych*, painted for the Church of S. Niccolò d'Oltrarno, today divided between the British royal collection (*The Madonna with Angels*), the Uffizi (*Sts Mary Magdalene, Nicholas, John the Baptist, George*), the Vatican (the predella, with four *Scenes from the Life of St Nicholas*) and the National Gallery in Washington (a *Scene from the Life of St Nicholas*, the fifth panel of the predella). The *Madonna En-*

throned, in the centre, has a very different monumentality, already almost that of the new Florentine style, so that it appears like the extraordinary panel of the *Madonna with St Lawrence and St Julian* (New York, Frick Coll.).

But these formal signs were only marginally important. What matters in the *Quaratesi Polyptych* is the exquisite tapestry of the background, the splendid embroidered tunic of *St Nicholas*, the sophisticated elegance of the chivalrous *St George* (Uffizi), and above all the surprising descriptive details of the predella, which Vasari considered one of Gentile's finest works: the romantic impression given by the sea in the *Miracle of St Nicholas* (Vatican) and the faint shadow of the church in the *Pilgrims on the Tomb of St Nicholas* (Washington, N.G.).

The works Gentile painted between 1425 and 1426 in Siena (*Madonna de' Notai*) are lost, as well as the frescoes carried out in 1427 for the Church of S. Giovanni in Laterano, Rome. Nothing is left of his last works except the very damaged *Madonna* (Velletri Cathedral), executed in Rome in 1427. Gentile's work is one of the highest expressions of the International Gothic style, in some ways comparable with the art of the Limbourg brothers and the studies of light made by Van Eyck.

A tireless traveller, a passionate experimenter with the various pictorial traditions he found in the most important Italian centres and which he assimilated into his own genius, Gentile da Fabriano remains the spokesman of the aristocratic, courtly society, the exquisite civilization of the 'waning of the Middle Ages'. This private universe could not leave any significant mark upon Florence, which was already feeling the effects of Masaccio's innovations. However, Gentile was greatly admired in Florentine circles. A century later, according to Vasari, Michelangelo said that 'in painting his hand was like his name (Gentile)'. Gentile's influence was felt most strongly in the north, where the achievement of Pisanello, Jacopo Bellini and Giambono cannot be understood without reference to his work. L.C.V.

Gentileschi
Orazio
Italian painter
b.Pisa, 1563 – d.London, 1639

From his early training in Tuscany with his half-brother Aurelio Lomi, a late Mannerist, Gentileschi retained a taste for delicate draperies, clear

forms and cold colour, and a certain reserve towards too great a degree of realism. In Rome from 1585 to 1620, he was one of the few artists who, with Carlo Saraceni, was directly in touch with Caravaggio, and was one of the first to assimilate his style – at the same time as Borgianni and Manfredi. But he never displayed more than a moderate naturalism, and was inspired by Caravaggio's early works, such as *The Rest on the Flight into Egypt* or *The Magdalene* (Rome, Doria-Pamphili Gal.), which were still anecdotal and highly coloured, steeped in a cold light and remaining within the Lombard tradition.

Gentileschi kept a basis of Florentine culture, which can be seen quite clearly in his first works: a *Circumcision* (fresco, 1593, Rome, Church of S. Maria Maggiore) and *St Thaddeus* (c.1600, Rome, Church of S. Giovanni in Laterano). This is also apparent in the *Baptism of Christ* of S. Maria della Pace, the *Circumcision* in the Church of the Gesù at Ancona and the *Assumption* in the Church of the Capuchins in Turin, which show to a moderate degree the influence of Caravaggio.

About 1600 he also worked on very large decorations, in collaboration with Agostino Tassi, at the Quirinal and later in the *loggetta* of the Palazzo Rospigliosi at Montecavallo (1611-12). Works like *St Francis and the Angel* (Rome, G.N.), *David* (Rome, Gal. Spada), the *Virgin and Child* (formerly in the Contini-Bonacossi Coll., now in the Fogg Art Museum, Harvard University, Cambridge, Massachusetts), and *Judith* (Hartford, Connecticut, Wadsworth Atheneum), generally dated within the same period, show a clear relationship with Caravaggio's organization of his paintings, his naturalism and his use of light.

Gentileschi found a completely personal style after staying in The Marches (c.1613 – c.1619), where he decorated the chapel in Fabriano Cathedral with frescoes of *Scenes from the Passion of Christ* and executed altarpieces for the same church (a *Crucifixion*), and for the Church of S. Benedetto (*St Charles Borromeo*) and for the Church of S. Domenico (*Madonna of the Rosary*). During this period he produced some of his subtlest works: *The Mystic Marriage of St Catherine* (Urbino, G.N.), *The Virgin and Child with St Clare and an Angel* (c.1616, Urbino, G.N.), and possibly, too, the admirable *St Cecilia with St Valerian and St Tiburtius* (Brera).

Then, in 1621, he went to Genoa where he carried out a whole series of works, most of which have disappeared (such as the frescoes for the loggia of Sampierdarena and paintings for the Genoese palazzi). However, the *Danaë* in Cleveland Museum and the *Annunciation*, still in the Church of S. Siro, have survived.

▲ Gentile da Fabriano
The Flight into Egypt
Wood. 25 cm × 88 cm (panel from the predella of the altarpiece of *The Adoration of the Magi*) (1422)
Florence, Galleria degli Uffizi

The *Annunciation* (Turin, Gal. Sabauda), executed in 1623 for Charles Emmanuel of Savoy, is courtly and patrician, painted with luminous whites and enveloped in a diffused light. It is a kind of conclusion of Gentileschi's activity in Italy, contemporary with the flowering of Caravaggism in Rome. The poetic *Lute Player* (Washington, N.G.) must also be set in the same period. This is Gentileschi's masterpiece, an aristocratic version of popular Caravaggesque musical paintings.

After his stay in Genoa, and a possible brief visit to Turin, Gentileschi went to France. He entered the service of Marie de' Medici, painting large allegories such as *La Félicité publique triomphant des dangers* (Louvre) for the Palais du Luxembourg, and a *Diana* (Nantes Museum). He had a direct influence upon French painters, among them Jean Monier, Louis Le Nain, La Hyre and Philippe de Champaigne, and equally on the Dutch artists who visited the Luxembourg, such as Van Bronckhorst, who passed on the subtle Caravaggism of Gentileschi to his pupil, Caesar van Everdingen.

Forced to compete in Paris with Rubens, who painted the *Vie de Marie de Médicis* at the Luxembourg, and faced with the success of Baglione, he decided to leave. He accepted an invitation to go to the court of Charles I in England, where he remained until his death. His time in London (1629-39) was a period of large-scale decoration for the King and the Duke of Buckingham (at Greenwich, York House, Somerset House and Marlborough House), none of which has survived, and of the reinterpretation of subjects he had already dealt with in France and Italy. These included the *Rest on the Flight into Egypt* (1626, Vienna, K.M.; Louvre; Birmingham, City Museum), *The Penitent Magdalene* (Vienna, K.M.), and *Lot and his Daughters* (Ottawa, N.G.; Berlin-Dahlem).

One of his last works was *Moses saved from the Waters* (Prado) painted for Philip IV of Spain in 1633 (the copy painted for Charles I is now at

Castle Howard, Yorkshire), an open-air scene, the extreme refinement of which poses the question of the relationship between Van Dyck, then in London, and Gentileschi.

There was, in fact, little that was purely Baroque in Gentileschi's work, but it had something post-Mannerist about it, which cared little for the movement of living forms but rendered the solidity of bodies and the quality of things by the interplay of values and subtle changes in the light. It was the painting of the new middle class, as far from the classic intellectualism of Poussin as it was from the brutal naturalism of Caravaggio's late works. In order to find anything like it one must look to Holland in the middle of the 17th century, to the school of Utrecht, to Ter Borch and Vermeer. Because of his stays in France and England and because of the very nature of his painting, Gentileschi was one of the chief propagators of Caravaggism in Europe, where he spread a gentler version of it. S.De.

Gérard
François

French painter
b.Rome, 1770 – d.Paris, 1837

Gérard's mother was Italian and his father worked for Cardinal de Bernis, French ambassador to the Holy See. Having spent the first 12 years of his life in Rome, he followed his family to Paris and as early as 1782 was exercising his gifts as a

draughtsman with the sculptor Pajou, then, in 1784, with the painter Brenet. But, carried away by the enthusiasm that greeted the *Serment des Horaces* (*Oath of the Horatii*) at the Salon of 1785, he went into the studio of David in 1786 to study painting. Together with his fellow-pupil Girodet he won the Prix de Rome in 1789. At a time when the troubles of the Revolution limited artistic activity, Gérard saw to the needs of his family by providing illustrations for the editions of Virgil and Racine published by the Didot brothers.

He had his first success at the Salon in 1795 with his *Bellisaire portant son guide piqué par un serpent* (*Belisarius carrying his Guide, Bitten by a Serpent*). The miniaturist Jean-Baptiste Isabey offered to find a buyer for the painting, and in return Gérard painted him with his daughter and dog. The simple, original setting harmonizes with the warm sincerity that emanates from this portrait (1795, Louvre). Praise was less unanimous for *Psyché et l'Amour* (*Cupid and Psyche*) (Salon of 1798, Louvre), where, on the pretext of purity, Gérard succumbed to the marmoreal coldness and archness of the 'over-polished' style.

To this same period belong the first portraits which, through their elegance and psychological delicacy, brought Gérard fame: *La Révellière-Lépeaux* (1797, Angers Museum) and *La Comtesse Regnault de Saint-Jean-d'Angély* (1798, Louvre). The graceful poses of the sitters are exactly those of portraits of the Italian Renaissance. Gérard's original interpretation of David's style often gives the measure of his personality: *Le Modèle* (c.1800, Washington, N.G.).

Gérard enjoyed real success only after 1800, when Napoleon gave him commissions. He not

▲ François Gérard
Portrait de Jean Baptiste Isabey et de sa fille (1795)
Canvas. 194 cm × 130 cm
Paris, Musée du Louvre

▲ Orazio Gentileschi
The Lute Player
Canvas. 144 cm × 130 cm
Washington, D.C., National Gallery of Art.

only painted Napoleon's portrait in *L'Empereur en costume de sacre* (*The Emperor in Coronation Robes*) (1805, one version at Versailles, another at Malmaison), but was the official portrait painter of the imperial family, the Empire's dignitaries and foreign sovereigns. When the contents of Gérard's studio were sold, Versailles Museum bought 84 small sketches, representing many of these sitters, a number of whose portraits are still in private collections.

By means of the suppleness of the lines and richness of the colouring, together with the varied settings, which seek to suggest a framework for the life of the sitter, Gérard escaped the stiffness of official portraiture: as, for instance, in *Joséphine à Malmaison* (1802, Malmaison), *Madame Mère* (1803, Versailles), *Murat* (1805, Versailles), *La Reine Julie et ses filles* (1807: copy in the collection of Prince Napoleon). Less official but no less famous is the portrait of *Mme Récamier* (1805, Paris, Musée Carnavalet).

Gérard's commissions were not confined to portraiture, however. He also carried out decorations for the imperial residences. Between 1800 and 1801 he painted, for the Salon Doré at Malmaison, the illustration for a poem by Ossian as a companion piece to a similar work by Girodet. Like that of Girodet, Gérard's interpretation is vibrant with passionate suffering and a moonlit atmosphere, and yet less strange, because more clearly arranged and without any contemporary allusions. Both works have now been restored to their original place, Gérard's painting being a copy of the lost original. Then, as a permanent commemoration of the battle, the Emperor commissioned Gérard to paint a ceiling in the Tuileries Palace with the *Victoire d'Austerlitz*. On the restoration of the Bourbons, this was transferred to the Galerie des Batailles at Versailles, while its frame of allegorical figures went to the Louvre. The balance of the composition and the radiating light give the work a solemn grandeur.

The fall of the Empire had no effect on Gérard's career. He was presented to Louis XVIII by Talleyrand, made his *Standing Portrait of the King* (1814, Versailles) and became the King's principal painter in 1817, receiving the title of baron in 1819.

All the sovereigns assembled in Paris in 1814 commissioned Gérard to paint their portraits: *Alexander I of Russia*, *Frederick William III of Prussia* (sketches at Versailles). Indeed, his contemporaries called him 'the painter of kings and the king of painters'. Prince Augustus of Prussia also commissioned him to paint the famous *Corinne au cap Misène* (1819, Lyons Museum), which although it appeared to be in homage to Mme de Staël, was secretly a tribute to Mme Récamier, to whom he offered it.

At the same time, Gérard continued as a recorder of historical events, working under the King's orders and painting for him *L'entrée de Henri IV à Paris* (1817, Versailles). This was a noble, picturesque subject which bore an obvious analogy with the return of the Bourbons. Later, he painted for Charles X the *Sacre de 1825 à Reims* (*Coronation of 1825 at Rheims*) (1829, Versailles), which is merely a monotonous assemblage of figures. The renewal of religious feeling aroused by the Restoration induced Gérard to paint a *Sainte Thérèse* (1827, Paris, Infirmerie Sainte Thérèse), which aroused the admiration of Chateaubriand.

About 1820 Gérard's portraiture showed a certain decline. The modelling sometimes lost its firmness, the style became more calculated to

please, in the English manner: *Lady Jersey* (1819) and, above all, the *Comtesse de Laborde* (1823), sketches for which are at Versailles. Handicapped by failing health and sight, Gérard produced only minor works in the reign of Louis-Philippe.

Classicism had now run its course and although he had the constant help of Mlle Godefroid in carrying out his many commissions, he had not attracted any followers. He had, however, encouraged the early work of several painters, among them Ary Scheffer, Léopold Robert and even Ingres, who all came to his house. For over 30 years Gérard's salon had been the resort of society people, intellectuals and artists, among whom musicians had pride of place. F.M.

Géricault
Théodore
French painter
b.Rouen, 1791 – d.Paris, 1824

Géricault spent his childhood in Rouen in the uneasy atmosphere of the Revolution, and lost his mother when he was only ten. His father, who had made a fortune trading in tobacco, did not oppose his wish to paint and arranged for him to be excused his military service. Géricault very early on developed a passion for horses, which were to be a major theme in his work. He rode on the family estate of Mortain and with his uncle near Versailles, where the imperial stables were situated.

After studying at the Lycée Impérial (now the Lycée Louis-le-Grand) in Paris, he spent a formative period from 1808 to about 1812, first in the studio of Carle Vernet, well known for his studies of horses, and then with Guérin who taught him the principles and technique of David and recognized his originality. Géricault made studies from the antique, from life, and from the old masters, but, above all, he visited the Louvre,

which, from 1808, housed the Borghese collection. There made more than 30 copies of works by Titian, Rubens, Caravaggio, Jouvenet, Van Dyck, Prud'hon and Salvator Rosa.

After these three years of intense, lonely work, the study of horses (at Versailles) and of military subjects – the direct reflections of outside events – were mainly to occupy Géricault until 1816. His *Officier de chasseurs à cheval chargeant* (*Cavalry Officer Charging*) (Louvre; sketches in Rouen Museum and at the Louvre), exhibited at the Salon of 1812, brought him to the notice of his contemporaries. The format for a single figure was monumental, which was unusual at the time. Certain technical effects are derived from Rubens, and the actual position of the horse from Gros, but the work also reveals a sharp sense of plastic relief and inventive brushwork in the management of the paint.

The *Cuirassier blessé* (*Wounded Cuirassier*) of 1814 (Louvre; sketch also in the Louvre; larger version in New York, Brooklyn Museum) is not only the antithesis, in its subject matter, of the painting of 1812 but also very different in execution, less attractive, and with large flat surfaces that once again recall Gros.

Between these two paintings came the small studies of soldiers thickly and vigorously painted (Vienna, K.M.), the relief and simplification of which prefigures Courbet: *Portrait d'un officier de carabiniers* (*Portrait of a Carabinier*) (Rouen Museum). The *Retraite de Russie* (*Retreat from Russia*) (New York, private coll.) was a theme that made a lasting impact on Géricault's imagination, and from then on the images of ordeal, decay and death often feature in his work (*Charrette avec des blessés* [*Wagon with Wounded*], London, private coll.). The small painting of the *Mort d'Hippolyte* (*Death of Hippolyta*) (Montpellier Museum), on the other hand, with its clear debt to Girodet, shows new classical interests.

Géricault set off for Italy in 1816. In Florence, and then in Rome, he was mainly interested in Michelangelo (foreshadowing the taste of the next generation), and also in Raphael, whom he ad-

▲ Théodore Géricault
Le Four à plâtre
Canvas. 50 cm × 61 cm
Paris, Musée du Louvre

mired for the clarity and balance of his compositions. In Rome he met Ingres and greatly appreciated his drawings. Géricault's Italian production includes drawings of a very correct classicism, the intelligent assimilation of 17th-century art, some erotic scenes of powerful frankness, and the various versions of the *Course des chevaux barbes* (*Race of Riderless Horses*), which were stages on the way to a large composition that never saw the light. The version in Baltimore (W.A.G.), possibly the first, is the most original. The version in Rouen Museum, *Cheval arrêté par des esclaves* (*Horse stopped by Slaves*), subordinates realism to a pure, plastic rhythm. That in the Louvre, possibly Géricault's final version, associates a solid architectural volume, on which men and animals stand out in strong relief, with a discreet allusion to the spectators.

Géricault returned to France in the autumn of 1817 after only a year away, a time he himself thought quite long enough; indeed, the traditional journey to Italy, significantly, had fallen out of favour and did not regain its popularity until the end of the century. Géricault went back to the studio in the Rue des Martyrs, which he had occupied since 1813, and worked in a variety of genres before shutting himself away to complete the painting of *Le Radeau de la Méduse* (*The Raft of the Medusa*).

Géricault now sought his inspiration increasingly in contemporary events. *Le Domptage de taureaux* (*The Taming of the Bulls*) (Cambridge, Massachusetts, Fogg Art Museum), inspired by the sacrifice of Mithras (drawing in the Louvre) and probably painted soon after his return to Paris, is still impregnated with the atmosphere of Rome. Géricault drew and painted, in watercolour, cats and dogs, as well as animals observed in the Jardin des Plantes (the zoo had been established in 1794), sometimes accompanied by Delacroix and Barye, and made portraits of friends' children. Above all, he practised lithography – with Gros, he was one of the first in France to do so – and the drawing, which at first was timid, had something of the regularity of copper-engravings.

Apart from the seven plates dealing with Napoleon's army, which were made in the middle of the Restoration, the most interesting are the *Chevaux se battant dans une écurie* (*Horses Fighting in a Stable*), a work rich in well-modulated greys, and the *Combat de boxe* (*Boxing Match*), which shows Géricault's lively interest in the problem of black slavery (abolished in France only in 1848). Probably inspired by English sporting prints, which he could have seen at Vernet's, Géricault matched a black pugilist against a white one.

At the same time the scandal of the shipwreck of the *Méduse* offered him another chance, which he seized eagerly. *Le Radeau de la Méduse* (1819, Louvre; sketches in Rouen and the Louvre) is, in Géricault's career, the last work to which his classical culture finally brought him, as it did in the *Courses des chevaux barbes* to the 'modern', realistic representation of the scene. Géricault finished *Le Radeau de la Méduse* in a studio in the Faubourg du Roule, near the Beaujon hospital, where he was able to carry out a number of studies of corpses and limbs of executed men in striking relief (Louvre; Stockholm, Nm; Bayonne Museum), destined to show the fearful reality of conditions of survival on the raft. In spite of its realistic detail, the canvas is striking for its classicism and the variety of influences which it evokes:

classical sculpture, Michelangelo, Caravaggio, the Bolognese painters.

The painting was greeted with some reserve because of the very ambiguity of its drawing and its effects, and also because it was too easily seen as a criticism of the government by the liberal opposition.

In the spring of 1820, Géricault left for England, with Brunet and the lithographer Charlet, to exhibit *Le Radeau de la Méduse* successfully at the Egyptian Hall in London, then in Dublin. England gave Géricault a sharp sense of the way the contemporary world was evolving, while the new objectivity shown towards nature by English painters like Constable struck him forcibly. The 18 months or so of his visit were marked by a return to lithography and to the theme of sport. An engraving by Rosenberg (1816), after a painting by Pollard, provided the inspiration for Géricault's *Derby d'Epsom* (1821, Louvre; studies in the Louvre and at Bayonne Museum), a work that directly foreshadowed Degas.

However, the studies of workhouses or horses pulling coal-carts (Mannheim Museum; Philadelphia, Museum of Art) form a more coherent series, remarkable for the density of the atmosphere, the relief of the forms, which are more pictorial than ever, and the final stage in Géricault's treatment of the horse which, at the end of a swift evolution, had now become strictly utilitarian.

Géricault's last works in Paris show a tightening of the effects derived from light, which he considered had been too much scattered in his English works. Evidence of the new trend can be seen in *Four à plâtre* (*The Lime-Kiln*) (Louvre). He also tried to remedy this fault in his lithographs; these were published purely for money, since he had spent almost all he had on extravagant living.

As well as drawings of contemporary historical subjects, plans for enormous paintings that were never carried out, he left five portraits of madmen (Ghent, Winterthur, Springfield, Lyons, Louvre). Five other paintings on this theme apparently existed, but the *Vendéen* in the Louvre, which is close to the madmen in technique, does not seem to be part of the series. The realism of these works is quite exceptional, and Géricault's successors were quite unable to match this combination of objectivity and penetration.

A fall from his horse in Montmartre was eventually to prove fatal, but the complications of his last illness were probably due to venereal disease. The sale of his studio soon after his death scattered many of his works, which were hard to find again. He exhibited only three paintings during his short career of barely twelve years, yet this career had covered one of the most crucial periods of French culture. M.A.S.

Ghirlandaio
(Domenico Bigordi)
Italian painter
b.Florence, 1449 – d.Florence, 1494

According to Vasari, Ghirlandaio owed his surname to his father, a goldsmith, who was very talented in the making of garlands to adorn the hair of the girls of Florence. Ghirlandaio was also a goldsmith but – again according to Vasari – soon moved on to painting under the direction of

Baldovinetti. However, in the very first works attributed to him – the fresco of *St Barbara, St Jerome and St Anthony Abbot* in the small parish church of Cercina, near Florence (*c*.1470) and the fresco in the church of Ognissanti, in Florence (1473) (the *Madonna of Mercy with the Vespucci Family and the Dead Christ*) he displayed a bold eclecticism, drawn from all the main currents of Florentine painting, from Verrocchio to the late works of Lippi, and even from Masaccio.

The clarity of the Cercina fresco, which recalls Baldovinetti's handling of light, and the portraits which appear in the Ognissanti fresco, are characteristic of his early studies. In spite of repaintings, it is already possible to recognize in these portraits of members of the wealthy Florentine bourgeoisie that gift for careful observation which was to make Ghirlandaio the most famous and sought-after master of the end of the 15th century.

The masterpiece of his early period, however, is the fresco decoration consisting of two *Scenes from the Life of St Fina* in the collegiate church of San Gimignano, which he finished in 1475. In the arrangement of these scenes, Ghirlandaio reveals a profound mastery of narrative: the description is clear and finely composed (the saint's death in the bare room; the funeral taking place against a background of the towers of San Gimignano). Above all, he shows his talent for capturing the essence of character in the way that the figures taking part in the funeral procession appear as absent-minded or involved, attentive or smiling.

In 1480 Ghirlandaio painted a fresco of the *Last Supper* for the refectory of Ognissanti, and the admirable *St Jerome in his Study* for the Church of Ognissanti, as well as several altarpieces. The following year he went to Rome to paint a number of frescoes in the Sistine Chapel (*Calling of Sts Peter and Andrew*; twelve *Popes*), with the aid of numerous assistants. On his return to Florence, about 1483, he painted two altarpieces: the *Madonna with Sts Denis the Areopagite, Dominic, Clement and Thomas Aquinas* for Monticelli (Uffizi), and the *Madonna with Sts Michael, Justus, Zenobius and Raphael* for the Church of S. Giusto (Uffizi; predella divided between the N.G., London, the Inst. of Arts, Detroit, and the Metropolitan Museum). At the same time he and his brothers painted more frescoes in the Palazzo Vecchio in Florence (Hall of the Lilies).

In Ghirlandaio's altarpieces the pictorial element is luminous and compact, and details are

Ghirlandaio ▲
The Adoration of the Shepherds (1485)
Wood. 167 cm × 167 cm
Florence, Church of S. Trinità, Sassetti Chapel

executed carefully and analytically. The composition is well organized, becoming increasingly complex around the main figures in comparison with the simple arrangement of his early works, and the draughtsmanship is perfect. These qualities, however, were often weakened by too great a reliance on assistants in his workshop products.

Ghirlandaio painted his two most important cycles of frescoes for the Sassetti and Tornabuoni families: *Scenes from the Life of St Francis* in the Sassetti chapel in the Church of S. Trinità (1483-1485) and *Scenes from the Life of the Virgin* for Giovanni Tornabuoni in the choir of S. Maria Novella in Florence (1486-90). These works are immensely interesting as faithful reflections of Florentine customs at the end of the 15th century. Ghirlandaio mixed the religious theme with secular scenes that showed Florentine buildings and surrounding countryside. His figures are dressed in contemporary clothes and have the features of his patrons.

The Adoration of the Shepherds (1485), painted for the altar of the Sassetti Chapel in S. Trinità, is particularly significant in Ghirlandaio's *oeuvre*. It is the first work painted in Florence to reveal the influence of the Portinari altarpiece by Hugo van der Goes, which had recently arrived in the city. This influence can be observed most notably in the acute realism with which the shepherds are depicted.

Ghirlandaio's main works are the following: the *tondo* of the *Adoration of the Magi* (1487, Uffizi); the altarpiece of the *Adoration of the Magi* for the church of the hospital of the Innocenti (the contract for which stipulated that it must be entirely the work of the master, but which nevertheless involved the intervention of many assistants, as documents confirm); and the fine *Visitation* for the Church of S. Maria Maddalena dei Pazzi (1491, Louvre), which, according to Vasari, was finished by Ghirlandaio's two brothers, David and Benedetto. Among his portraits (apart from the contemporary figures in his altarpieces and frescoes) are that of *Lucrezia Tornabuoni* (1488, Lugano, Thyssen Coll.), of an *Old Man with a Child* (Louvre), and of *Francesco Sassetti with his Son* (Metropolitan Museum). M.B.

Ghislandi
Vittore (known as Fra Galgario)
Italian painter
b.Bergamo, 1655 – d.Bergamo, 1745

Among the great 18th-century European portrait painters, Ghislandi represents an original style that links the naturalist Lombard tradition with the neo-Rembrandtesque taste of central Europe, as opposed to the French court portraits. At Bergamo he was a pupil of Giacomo Cotta and Bartolomeo Bianchini, and then went on to Venice where he stayed for thirteen years (1675-88) and, according to his pupil and biographer Tassi, spent his time 'making large studies after the works of Titian and Paolo Veronese'. From 1693 to 1705 he spent another extended period in Venice as pupil and collaborator in the studio of Sebastiano Bombelli.

It was during this time that he discovered the portrait painting of central Europe, as represented

by the Bohemian, Johann Kupeczký, who was in Venice from 1687 until 1709. Ghislandi must have turned to the Rembrandtesque style of portrait painting being practised in central Europe in those same years. This is confirmed by the fact that he spent some time with Salomon Adler, who died in Milan in January 1709. It was only after 1705 (*Portrait of Cecilia Colleoni*, Bergamo, Colleoni Coll.), following his final return to Bergamo (where he entered the convent of Galgario, taking its name as his own), that the results of this long period of study are evident in his mingling of the chromatic tradition of Venetian painting with the more 'naturalistic' effects of the local tradition of Bergamo and of Lombardy in general. It is not surprising, therefore, that Ghislandi was now ready to appreciate the profound significance of Rembrandt, in particular his 'proto-impressionist' technique. We know that he made a copy of Rembrandt's *Self-Portrait* in the Uffizi, bought by Augustus III for Dresden in 1742.

The *Portrait of Dr Bernardi Bolognese* (Bergamo, Bernardi Coll.) and the *Portrait of Count Secco Suardo* (Bergamo, Accad. Carrara) were painted in 1717. After 1732, according to Tassi, 'the artist began to paint all the flesh parts with his finger, and never again used a brush, except in a few unimportant places or to give a final touch; and in this way he made excellent heads, with thick impasto.' His *Self-Portrait* (Bergamo, Accad. Carrara) is dated 1737, the year in which he also finished the portrait of *Francesco Maria Bruntino* (Bergamo, Accad. Carrara), using this new technique. This work, with its simple construction and its psychological penetration, is outstanding among 'bourgeois' portraits in the first half of the 18th century.

His portraits include other fine works: the portrait of *Isabella Camozzi de' Gherardi* (Costa di Mezzate, Camozzi-Vertova Coll.); the *Young Man in a Three-Cornered Hat* (Milan, Museo Poldi-Pezzoli); *Bartolomeo Albani* (Milan, Beltrami Coll.); and *Father G.B. Pecorari degli Ambiveri* (1739, Bergamo, Suardo Coll.). In these the type of portrait of the 18th-century court gives way to a new relationship between painter and subject, with Ghislandi thus placing himself on the threshold of the 'plebeian' painting practised by Giacomo Ceruti.

Ghislandi's best portraits, with a few exceptions (Venice, Accademia; Raleigh, North Carolina, Museum; Lyons Museum; Washington, N.G.; Budapest Museum), are mostly found in Lombardy, particularly at the Accademia Carrara in Bergamo, in the Brera and in the Poldi-Pezzoli Museum in Milan, as well as in many private collections. G.P.

▲ Vittore Ghislandi
Young Man in a Three-Cornered Hat
Canvas. 109 cm × 87 cm
Milan, Museo Poldi-Pezzoli

Giacometti
Alberto
Swiss sculptor and painter
b.Stampa, 1901 – d.Coire, 1966

Although Giacometti owes his major recognition to his sculpture, his two-dimensional work is also important. The son of a painter, Giacometti attended the École des Arts et Métiers in Geneva, then, after a year in Italy (1920-1), where Cimabue, Giotto and Tintoretto particularly impressed him, went to Paris in 1922 and studied with Archipenko and Bourdelle. From 1925 he shared a studio with his brother Diego who, especially after 1935, served as his model. He spent the war years in Geneva and, in 1949, married Annette Arm.

After an early period, during which he was influenced by Neo-Impressionism (*Rome*, watercolour, 1921), Giacometti followed Cubism for some time (1925-8), then, in 1930, Surrealism (*Femme*, 1926, Zürich, Kunsthaus). But Surrealist orthodoxy soon became intolerable to an artist of his power and originality, and for the eight years following 1935 he concentrated on the representation of the human figure, almost exclusively in sculpture.

After 1945, however, he returned constantly to pictorial and graphic forms of expression: drawings (*Coin d'atelier* [*Corner of a Studio*], pencil, 1957), lithography and etchings (*Nu aux fleurs* [*Nude with Flowers*], 1960), illustrations (André Breton's *L'Air de l'eau*; Georges Bataille's *Histoire des rats*; René Char's *Poèmes des deux années*; Éluard and Genet); and finally a series of paintings (*Isaku Yanaihara*, 1958, Paris, Gal. Claude Bernard), together with numerous portraits of Annette and of Diego.

Monochrome – grey on grey – dominated by linear elements that articulate the space, his drawings and paintings extend and help to define his work as a sculptor. As in his three-dimensional work, Giacometti organized and constructed the bare relationship between figure and space into one that led to an absolutely truthful and unified sense of the subject.

Giacometti's work may be seen in New York (M.O.M.A.), Pittsburgh (Carnegie Inst.), Paris (M.N.A.M., *Portrait de Yanaihara*, 1956), Detroit (Inst. of Arts), St Paul-de-Vence (Maeght Foundation), Zürich (Giacometti Foundation), London (Tate Gal.) and in private collections. B.Z.

Giordano
Luca
Italian painter
b.Naples, 1634 – d.Naples, 1705

This exceptionally fertile artist, who was internationally known during his lifetime, is often thought of today as a pleasant but superficial painter who always sought the easy solution and who was too ready to borrow, if not to copy, from others, and worked too fast on his own paintings. This view, which to some extent derives from long-standing objections to Baroque art as a whole, is not entirely unfounded if it is based on

Giordano's entire output – his innumerable easel paintings and his enormous frescoes in both Italy and Spain. His work consists of several thousand paintings and there are few galleries of any importance in which he is not represented.

Nevertheless, if we take account of the practice of using studio assistants, as well as of the inevitable inequalities in performance that no artist can avoid when he has commissions pouring in upon him, and if, as a result, we concentrate upon those which Giordano painted entirely himself, then he emerges as one of the most sensitive artists in 17th-century Europe.

According to contemporary sources, Giordano's training took the form of imitating Ribera closely, and he seems to have tackled painting straight away with the feeling that there were unresolved problems in Naples. The group of works (such as the portraits of *Philosophers* in Hamburg and Vienna museums) that can be attributed to him before his first documented activity (in 1653) shows, in fact, a desire to deal with the various elements that around 1635 had provoked the crisis of naturalism originated by Caravaggio in Naples.

This need to live through the experiences of others before attempting innovations of his own was to be of prime importance throughout Giordano's career. So, having begun to follow the aging Ribera in his transition from Caravaggism to the principles of the Baroque, Giordano went to Rome, and then on to Venice, where he painted a few altarpieces and, in particular, studied Veronese. On his return to Naples, he painted two pictures for the Church of S. Pietro ad Aram in 1654. These were *Scenes from the Life of St Peter*, the backgrounds of which were, in fact, inspired by Veronese and reveal, in general, a return to the 'grand manner' of the 16th century, the point of departure for Baroque art.

The same characteristics appear in *St Nicolas of Bari* in the Church of S. Brigida, and in the two canvases of 1658 for the Church of S. Agostino degli Scalzi, in which Venetian influence is dominant, transformed, however, by a more fluid touch and by intense points of light. These paintings also show that Giordano had studied the work of Mattia Preti, as well as coming close to Rubens, an influence already visible in *St Lucy taken to Martyrdom* (1657, Milan, Canessa Coll.).

Later, having arrived at a calmer manner and a freedom of style comparable with that of Pietro da Cortona (*Holy Family*, c.1660, Aurora, New York, Wells College), Giordano returned to the classicism of the Carraccis and of Poussin, which can be seen in the balanced arrangement and in the greater importance given to drawing in his two altarpieces (*The Flight into Egypt* and *The Massacre of the Innocents*) in the Church of S. Teresa at Chiaia (1664).

Giordano's youthful works reveal the hesitations that beset him in his progress towards Baroque decoration. After another journey to Venice (where he painted and signed an *Assumption of the Virgin* at the Church of the Salute) and to Florence in 1667, he opted for the style of Pietro da Cortona, with its tender and graceful forms, and gentle light (*Virgin of the Rosary*, Crispano, parish church). About 1674, in Venice once again, he executed two altarpieces of *The Birth of the Virgin* and *The Presentation of the Virgin* for the Church of the Salute, the immediate success of which confirmed his reputation.

A little later, he began the large fresco decorations that were to prove his most successful works. A cycle destined for the Church of S. Gregorio Armeno in Naples (finished in 1679) reveals for the first time the vein of gentle poetry and humanity that was to distinguish his work from that of the other great contemporary Italian decorators, Pietro da Cortona, Lanfranco and Baciccio. He was, in fact, well aware of their work, to the extent of adopting their techniques and, on occasions, their manner, but his style, instead of falling into a learned eclecticism, had great freshness and spontaneity.

In Florence, where he was called in 1680 to paint the dome of the Orsini chapel at the Carmine, he suddenly reverted to a Venetian style (and, in particular, to that of Bassano), probably as the result of a need to rediscover reality and to express it with a dense, luminist technique (*Christ and the Magdalene*, Florence, Corsini Coll.; *Pastoral*, Bologna, P.N.). This time in Florence also gave him the opportunity to study the work of Pietro da Cortona at the Pitti Palace, and led him to grasp the concept of making the incredible credible. From these experiences was born the fresco decoration in the gallery and library of the Palazzo Medici – Riccardi (1682-3), a large, luminous fable in which the themes of the *Apotheosis of Human Life and of the Medici Dynasty* and of *Divine Knowledge* are laid out according to a strict allegorical, symbolic and mythological plan, yet with a perfect freedom of invention, in a unified composition that is at once bold and balanced.

The year 1684, the date of Giordano's return to Naples, marks a new period of stylistic experiment: the study of Bernini's light (the altarpiece of the Church of Rosariello alle Pigne, c.1687), a closer approach to Lanfranco, a return to classicism, sustained by an interest in French painters such as Le Brun and Mignard, and finally the evolution, around 1689, of a new and very synthetic personal style, expressed through rapid brushwork and clear light (paintings for Marie Louise d'Orléans at the Escorial, and in Naples, Museum of S. Martino).

Giordano went to the court of Spain in 1692. The large decorations he carried out for Charles II played a considerable part in the development of Spanish art during the next century, all the more so because he was able to absorb the most modern aspects of Velázquez's work, thus making himself to some degree the heir to the Spanish 17th-century tradition. In addition, he managed to combine the various trends in Italian painting during his working life. The result not only pleased his royal patron but at the same time answered his own need to create an original art form out of eclecticism.

Between 1692 and 1694, Giordano decorated the vaults of the Escalera and of the church of the Escorial in fresco. In the former, which related the story of St Lawrence above a frieze showing the Battle of St Quentin, he abandoned plasticity in favour of describing form freely with light and colour, creating effects of amazing lightness. In the latter, the swirling images of the small cupolas above the altars are contrasted with the static construction of the decorative system of the vault, in

▲ Luca Giordano
Allegory of Agriculture
Ceiling fresco
Florence, Palazzo Medici-Riccardi

Alberto Giacometti ▲
Diego (1951)
Canvas. 80 cm × 65 cm
Zürich, Kunsthaus

which the figures are concentrated at the base of the composition, while, vertically, the light falls in waves, sometimes producing golden reflections, sometimes transparent effects, in the colours.

The frescoes for the Buen Retiro and the palace of the Queen Mother, as well as the paintings for the palace of Aranjuez (c.1696-7), have been lost. Of the decoration of the Casón del Buen Retiro (c.1697) with the *Allegory of the Golden Fleece*, there remains only the vault, but originally the walls were covered with simulated tapestries, and the whole, probably inspired by Moorish decoration, must have achieved a height of fantasy.

The principles of decoration used in the church of the Escorial appear again in the vault of the sacristy of Toledo Cathedral (1697-8). However, Giordano then went back to plastic forms and intense colour, the obverse of which appeared in the Chapel Royal of the Alcázar, today lost, but

documented by sketches (Naples, private collection) that are essentially anti-naturalistic, rich in ornamental motifs close to the French 'grand manner'. Giordano's last work in Spain was the decoration of the Church of S. Antonio de los Portugueses (1700), of which the preparatory sketches (London, N.G.; Auckland, Art Gal.; Dijon, Musée Magnin) seem to prefigure the style of Goya in their conciseness and expressive power.

This modernity, which shows Giordano's capacity for renewal until the end of his life, reappears in the works carried out after his return to Naples in 1702. Here, all his previous styles of expression culminate in a poetry that is pure imagination. At times it appears to prefigure Romanticism (paintings for the Church of S. Maria Egiziaca and the Church of S. Maria Donna Regina in Naples; *The Beheading of St Januarius* for the Church of S. Spirito dei

Napoletani in Rome; frescoes for the sacristy of the Church of S. Brigida, Naples). At others it is luminous and fresh, in the style of the rococo period that succeeded him (frescoes depicting the *Triumph of Judith* in the treasury chapel in the Convent of S. Martino, Naples, in 1704). G.R.C.

Giorgione
(Giorgio da Castelfranco)
Italian pianter
b.Castelfranco Veneto, 1477/8 – d.Venice, 1510

Little is known about Giorgione's life, not even his real name. His contemporaries called him, in Venetian dialect, 'Zorzi', and he was not referred to as Giorgione until after 1548, in Paolo Pino's *Dialogo della Pittura*. Nor is the date of his birth known. Vasari sets it in 1477 in the first edition of his *Lives of the Painters* and in 1478 in the second. In 1507 Giorgione is recorded as having painted a picture (now lost) for the Doge's Palace in Venice and in 1508 was paid for frescoes of the Fondaco dei Tedeschi. A letter of 25th October 1510 from Isabella d'Este to Taddeo Albano proves that she had been told of Giorgione's death, and the answer from Albano, on 7th November, confirms it: 'The man called Zorzi died of exhaustion as much as plague'. According to Vasari, Giorgione was a courteous man who could join in elegant conversation and music, and in Venice frequented the refined and cultivated but rather exclusive circles of the Vendramin, Marcello, Venier and Contarini families.

To reconstruct and classify Giorgione's artistic production, when his career was so short, is no less difficult. Marcantonio Michiel, who listed the works he had seen in Venice, from 1525 to 1543, has been of great help to historians. But not until the 19th century, and above all our own day, have critics managed to free Giorgione's artistic personality from the romantic myths that surrounded it, although this does not mean that the problems have all been solved or that there are no areas of dissension.

It is generally agreed, however, that the following works belong to Giorgione's first period: the *Holy Family*, known as the *Benson Madonna* (Washington, N.G.), *The Virgin and Child with St Catherine and St John the Baptist*, (Venice, Accademia) and *The Adoration of the Shepherds* (Washington, N.G., formerly Allendale Coll.). These paintings show Giorgione still close to the style of the 15th century, especially to that of Giovanni Bellini, but also to that of Cima.

The influence of Dürer and other northern artists has also been noticed – although Giorgione was already more interested than they were in landscape. That in the Allendale *Adoration* is notable for its sweep and depth. A new light, too, envelops the scene, while the group of figures – off-centre towards the right and thus clear of the landscape – emerges and is dissolved in the deep shadow of the cave.

These characteristics of Giorgione's early manner appear in *Judith* (Hermitage). The figure, with a subtle, controlled rhythm, influenced by the art of Umbria and Emilia, and touched with reminiscences of Leonardo, is set in a small space in the foreground which opens up and spreads out towards the indeterminate line of a pinkish-orange horizon.

▲ Giorgione
The Tempest
Canvas. 82 cm × 73 cm
Venice, Galleria dell'Accademia

The *Portrait of a Young Man* (Berlin-Dahlem) recalls Antonello da Messina in its three-quarter pose and Giovanni Bellini in the motif of the parapet, but the light is no longer defined, as it is in these painters, by thick zones of colour. It becomes, itself, the infinitely refined lilac-pink of the clothes, the oval of the dreaming face, and the puffed-out brown hair. *The Child with the Arrow* (Vienna, K.M.), in contrast, emerges from the half-light in the manner of Leonardo, but with more abandon in the passage of the forms, impregnated with light.

The influence of Umbria and Emilia appears once again in the composition of the famous altar-painting at Castelfranco. One of the few works by Giorgione to be accepted by all historians, it shows the *Virgin and Child with St Liberale and St Francis* (Church of S. Liberale). Instead of the old Bellini-style plan, Giorgione here uses the new motif of the Virgin placed on a very high throne standing out against the background of an extensive landscape. Commissioned by Tuzio Costanzo in memory of his son Matteo (who died in 1504), the painting has no clear narrative intention: the figures live their meditative personal life, united nevertheless by that harmony of colour and light, in places cold or dim, in others sweet or brilliant, that is the true co-ordinating element of the composition.

The portrait of *Laura* (Vienna, K.M.), as an inscription on the back of the painting reveals, dates from 1506. Its simple power shows that Giorgione had by now freed himself from all influences and from the 'genial timidity' that characterized his early works. Full artistic maturity was reached in *The Tempest* (Venice, Accademia). This canvas, which is quite small, shows a stream, some ruins, trees, and, farther off, a village under a stormy sky lit with flashes of lightning. On the left a young soldier is standing; on the right a naked woman is holding her child. Without looking for the cultural allusions and literary overtones that Giorgione certainly embodied in this new theme, it can be said that the true protagonist of *The Tempest* is nature, with its spontaneous happenings and its perpetual, disquieting renewal, of which man is so much a part that he is only one of its transient aspects.

The *Madonna Reading* (Oxford, Ashmolean Museum), on the other hand, is monumental. It appears, in fact, as a block inscribed in a large triangle animated by red, turquoise and yellow, but with a very gentle and secret feeling to it. Of the frescoes painted in 1508 on the front of the Fondaco dei Tedeschi, which included figures and decorative motifs, only some barely distinguishable fragments of figures survive. However, one of them, a naked woman, suggests that they, too, were both monumental and brightly coloured.

The Three Philosophers (Vienna, K.M.) has often been thought to deal with the philosophical currents at the beginning of the 16th century, and in particular with the tendencies dominant at the University of Padua, which Giorgione must certainly have known. One critic has seen in the painting the three successive phases of Aristotelianism. The philosophers have also been said to symbolize the three ages of man.

The synthesis of man and nature is also to be seen in the *Sleeping Venus* (Dresden, Gg), in the undulating, very pure line of the nude that is echoed by the soft curve of the hills. Titian was employed to add to the landscape a group of houses and probably, in the foreground, the

draperies with silvery reflections. From this moment on it becomes more and more difficult to determine where Titian's collaboration begins and ends.

The *Concert champêtre* (Louvre) is one of the most striking examples of this problem. To many art historians works such as *Christ and the Adulteress* in Glasgow (Art. Gal.) must be by Titian alone. Yet the mysterious fluidity that links the two absorbed musicians and the two indifferent beauties to the gentle landscape under the setting sun of a sweltering day cannot be anything but Giorgione's; nor can the sober use of reds and yellows, and the transparency of the picture's surface obtained by glazes. At the most it can be said that Titian completed a work left unfinished by Giorgione. A final intervention by Titian would explain the density and richness of the colouring.

From the start, when his work was full of influences and cultural allusions, to the time that he grew out of them, Giorgione's creative imagination freed him from restrictive academicism and formulated a new language. M.C.V.

The artists who were influenced directly and decisively by Giorgione, include, apart from Titian and possibly even Giovanni Bellini, Catena, Sebastiano del Piombo, Palma Vecchio, Cariani, Romanino, Savoldo, Pordenone and Dosso Dossi.

The following paintings have also been attributed to Giorgione by some authorities: *The Adoration of the Magi* (London, N.G.); *The Trial of Moses* and *The Judgement of Solomon* (in part; Uffizi); the *Virgin and Child in a Landscape* (Hermitage); *The Old Woman* (Venice, Accademia); a *Landscape*, known as *Il Tramonto* (London, N.G.); and *The Flautist* (Rome, Gal. Borghese). L.E.

Giotto di Bondone

Italian painter
b.Colle di Vespignano, 1266/76(?) – d.Florence, 1337

Giotto has always been considered to be the founder of modern painting. His activity coincided almost exactly with a period of great economic expansion in Florence, and he was the favourite artist of the new middle class of bankers and merchants who dominated the city.

Giotto was born, probably a little before 1267 (a date that has become accepted through long usage), at Colle, a part of the commune of Vespignano, near Vicchio di Mugello – according to tradition into a peasant family. Cimabue was supposed to have 'discovered' him as he was drawing pictures of his sheep on a rock. What probably happened is that the family moved into Florence, as many others were doing at the time, and set their son to work in the workshop of the local master-painter. Giotto's style is not incompatible with the fact that this local master could, indeed, have been Cimabue. After this (*c*.1280), Giotto may have paid his first visit to Rome, then immediately afterwards to Assisi, towns in which he was soon to produce some of his most remarkable work.

The Assisi frescoes. Authorities are divided on the matter of Giotto's early artistic activity. Early sources (Riccobaldo Ferrarese, Ghiberti, Vasari) claimed that he was the painter of the frescoes in the Upper Church of S. Francesco at Assisi. This was for long disputed but has recently found defenders. These have had their view confirmed

▲ Giotto di Bondone
The Flight into Egypt
Fresco
Padua, Scrovegni Chapel (Arena Chapel)

by a tradition (which goes back to Ghiberti) attributing the *Virgin and Child* in the Church of S. Giorgio alla Costa (Florence) to Giotto, and it cannot be denied that there is similarity of style between this and the frescoes at Assisi. Moreover, the narrative altarpiece (Louvre) depicting *The Stigmatization of St. Francis*, with predella scenes showing *The Dream of Innocent II*, *The Confirmation of the Rule*, and *The Preaching to the Birds*, which is signed 'Opus locti Florentini', takes up, with slight yet intelligent variations, the composition of the equivalent scenes in Assisi.

The large *Crucifix* in the Church of S. Maria Novella (Florence), which a document as early as 1312 attributes to Giotto, is the Florentine masterpiece of this first, controversial, period. In this work, which was certainly painted before 1290, the artist uses an entirely new manner, majestic but at the same time modern and human in its representation of the dead Christ. Giotto here broke decisively with the tradition of Byzantine suffering, which was still very much alive in the symbolic *Crucifixes* of his master, Cimabue.

During this period Giotto became known, and the influence of his new style, although still confined to a minority, began to make itself felt in Florentine painting (Maestro di Varlungo, Maestro di San Gaggio, Ultimo Maestro del Battistero). Probably around 1287, Giotto married Ciuta (Ricevuta) di Lapo del Pela. By her he had four sons (among them Francesco, a painter without much reputation, who was inscribed in the guild in 1341) and four daughters, the eldest of whom married a painter, Rico di Lapo, and was the mother of the well-known Stefano, father in turn of Giotto the Younger, known as Giottino.

At the same time that he was painting the *Scenes from the Old and New Testaments* and *Scenes from the Life of St Francis* (Assisi, S. Francesco,

Upper Church), in which his assistants played a large part, Giotto was also active in Rome, but unfortunately no indisputably signed works remain. But his influence on local painting at the time can be shown (Maestro di Vescovio, Magister Conxolus, Cavallini) and, of the cycle of frescoes carried out under his direction at the time of the first jubilee (1300), there remains a fragment in poor condition (*Boniface VIII Instituting the Jubilee*, Rome, Church of S. Giovanni in Laterano).

Rimini and Padua. By now, Giotto was over 30, a fully established master-painter with his own studio, many assistants and a certain degree of prosperity (his properties in Florence are mentioned in documents of 1301 and 1304). Dante's judgement that 'Cimabue thought himself the first in the realm of painting, but now it is Giotto who has the fame,' appears to be borne out by the fact that Giotto was the first Tuscan painter to work in northern Italy, at Rimini and Padua.

Giotto's presence in Rimini had an enormous effect on the local school. All that has survived of his time there is a splendid but fragmentary *Crucifix* (Rimini, Church of S. Francesco) which was undoubtedly painted before 1309. But evidence of his stay in Padua can still be seen in the votive chapel of Enrico Scrovegni (the Arena Chapel), with its cycle of frescoes of *Scenes from the Life of Christ*, the *Allegories of Vices and Virtues*, and the *Last Judgement*, unanimously considered as Giotto's major work and the one in which he allowed his assistants to intervene least. Comparisons of style and the study of documents place this masterpiece between 1303 and 1305.

The sculptural monumentality of the figures, the three-dimensional quality of the fictive architecture and the finely foreshortened objects, as

well as the extraordinary sureness with which space is built up, in anticipation of the studies in perspective of the 15th century, together with the dramatic intensity of the narrative, mark a final break on Giotto's part with Byzantine tradition and earn him a unique position in the mainstream of Gothic culture. At the same time, a new use of light and colour shows that in Padua Giotto had increasingly abandoned the harsh plasticity that had appeared in the Assisi cycle. Here the colour was gradually enriched in a way that was to produce the sweet and 'unified', free and delicate painting of his later period.

After 1311 an increasing number of documents attest his presence in Florence (1314, 1318, 1320, 1325, 1326, 1327), where he was active in looking after his property. Thus in 1314 he had no fewer than six lawsuits in hand against tardy or bankrupt debtors. In 1327 he became a member of the guild of the *medici e speziali* which, from that date onwards, accepted painters as well. The following year he was in Naples in the service of King Robert of Anjou.

Chronology of Giotto's mature works. There are no certain dates for the many works that came out of Giotto's studio between 1305 (Arena Chapel) and 1328 (the time of his stay in Naples). But study of the development of his style, together with comparison with other paintings of the period, suggests the following chronology:

1303-c.1305: *Crucifix* (Rimini, Church of S. Francesco); *Madonna in Majesty among the Angels and Saints* (Uffizi; originally in the Church of Ognissanti).

1308-c.1310: *Raising of Lazarus* and *Scenes from the Life of Mary Magdalene* (frescoes, Assisi, S. Francesco, Lower Church, chapel of St Mary Magdalene).

 Giotto di Bondone
St Francis appearing to the Chapter of Arles
Fresco
Florence, Church of Santa Croce, Bardi Chapel

1309-c.1310: Polyptych with the Madonna and Child with Sts Eugenius, Miniato, Zanobius and Crescentius; on the back, the *Annunciation with Sts Reparata and Mary Magdalene and Sts John the Baptist and Nicholas* (Florence, Church of S. Maria del Fiore; originally in the old cathedral, S. Reparata).

About 1310: Dormition of the Virgin (Berlin-Dahlem; originally in the Church of Ognissanti).

1310-c.1320: Scenes from the Infancy of Christ and four *Franciscan Allegories* (The 'Vele' frescoes) (Assisi, S. Francesco, Lower Church, vaults of the right transept and of the crossing of the transept), where Giotto experimented for the first time in painting *a secco* (i.e., on to dry plaster) on the wall, a technique he used (*c.*1313) in preference to the traditional *buon fresco* technique (painting on to wet plaster) in the *Scenes from the Life of St John the Baptist and St John the Evangelist* (Florence, Church of S. Croce, Peruzzi chapel), so famous that they were later studied by the young Michelangelo.

1315-c.1320: Polyptych with Christ Blessing between the Virgin, St John the Evangelist, St John the Baptist and St Francis (Raleigh, North Carolina, Museum; originally, perhaps, from the altar of Peruzzi chapel); *polyptych with the Madonna and Child between Sts Stephen, John the Evangelist, Francis and Lawrence* (Washington, N.G.; Florence, Horne Museum; Paris, Musée Jacquemart-André; and eight panels with *Scenes from the Life of Christ* which may perhaps have originally been part of the same ensemble (Boston, Gardner Museum; Metropolitan Museum; London, N.G.; Florence, Berenson Coll.; Munich, Alte Pin.).

1320-c.1325: Double-sided altarpiece showing *Christ Enthroned, The Martyrdom of St Peter, The Beheading of St Paul*, with, on the back, *St Peter Enthroned among Sts James, Paul, Andrew and John the Evangelist* (the *Stefaneschi Altarpiece*, Vatican Pinacoteca, previously on the high altar of St Peter's). In the frescoes of the *Scenes from the Life of St Francis* (frescoes, Florence, Church of S. Croce, Bardi chapel) Giotto dealt with some of the same themes found in Assisi, and this repetition allows us to assess his progress over a period of 30 years of activity.

About 1328: Polyptych with the *Madonna and Child Enthroned between Sts Peter, Gabriel, Michael and Paul* (Bologna, P.N.; previously on the high altar of the Church of S. Maria degli Angeli, signed 'Opus magistri locti de Florentia').

Giotto's studio. It has been long observed that the works mentioned above, which to some extent reflect the evolution of Giotto's ideas, cannot be considered absolutely homogeneous and, in fact, show that he often used assistants to whom he allowed – according to the circumstances – more or less independence.

To define Giotto's own work, therefore, depends largely on the identification of his assistants and the part they took in the production of his studio. Ascertaining which works are attributable to Giotto himself could help establish the part played by his pupils. This is a particularly controversial matter, although it is now known that the post-Paduan works that differ from those painted in Padua are not necessarily by the hand of a pupil. First one has to take into consideration that Giotto's own style evolved, and that later on he brought to Florentine painting a more aristocratic, Gothic feeling and a richer colouring.

On the other hand, we can hardly fail to attribute to Giotto himself, because he applied them from the beginning (from the last decade of the 13th century), the extraordinary ideas of space and architecture in perspective that appear precisely in the most disputed of his works, from the frescoes of the transept in Assisi to the Stefaneschi altarpiece.

The best known of Giotto's assistants has been variously named: 'Maestro oblungo', 'Maestro del Politico Stefaneschi', 'Maestro del Politico de S. Reparata' or 'Parente di Giotto'. He can, in fact, be credited with other works of high quality that are sometimes attributed to Giotto himself: the large *Crucifix* in the church of Ognissanti; the diptych with the *Crucifixion* and the *Madonna and Child Enthroned among the Saints and Virtues* (Strasbourg Museum; New York, Wildenstein Coll.); the *Crucifixion* in Berlin-Dahlem; and the frescoes of the *Miracles of St Francis after his Death* (Assisi, S. Francesco, Lower Church, right transept).

Naples and Florence. From 1328 to 1333 Giotto, together with many of his pupils, worked in the service of Robert of Anjou at the Neapolitan court. Almost nothing has survived from this period, but some remnants of the activity of his studio in Naples bear witness to the development of the tendencies that appeared in the Stefaneschi altarpiece and the frescoes in the Bardi chapel, towards a more refined use of colour and a Gothicizing, aristocratic taste. A fragment of a large fresco with a *Lamentation for the Dead Christ* (Naples, Church of S. Chiara, choir of the Poor Clares) is particularly close to the frescoes of the transept of Assisi. Another fresco with the *Lord's Table* (*Multiplication of the Loaves and Fishes in the Presence of St Francis and St Clare*, Naples, Convent of S. Chiara, chapter house) clearly reflects the art of the 'Parente di Giotto'. Above all the interesting heads of *Saints* and *Famous Men* that appear in the embrasures of the windows of the chapel of S. Barbara at Castelnuovo (Naples) reveal a variety of styles that clearly indicates the presence of several assistants, among whom may be distinguished another Florentine painter, Maso di Banco. Here, as elsewhere, signs of the early work of Taddeo Gaddi, traditionally regarded as the most direct heir of Giotto's art, are less certain.

On his return to Florence, Giotto was appointed master of the works for the cathedral and superintendent of the walls and fortifications of the city (12th April 1334). Among the products of his workshop at this time the large polyptych in five panels with the *Coronation of the Virgin*, signed on the predella 'Opus magistri locti' (Florence, Church of S. Croce, Baroncelli chapel), most clearly connects with the early style of the Taddeo Gaddi.

As master of the works in the cathedral, Giotto directed the early stages of the building of the famous campanile (begun on 18th July 1334). Between then and his death on 8th January 1337, he stayed in Milan where he worked for Azzone Visconti. The paintings made at that time have all been lost, but that his presence was felt is clear in the work of Lombard painters in the years that followed.

The last work undertaken by his workshop, and which Giotto could not have seen finished, was the frescoes of *Scenes from the Life of St Mary Magdalene, Paradise* (with the famous portrait of Dante) and *Hell* (Florence, Bargello, chapel of the Podestà. In spite of its poor state of preservation, it is possible to recognize, through the excellent work of various members of this workshop, the final inspiration of the creator of Italian painting.

Giotto's influence in Italy. At his death Giotto left Italian art in a very different state from that in which he found it. Cennino Cennini's famous remark that Giotto took 'the art of painting from Greek to Latin' by leading it to the 'modern' can be taken literally, in the sense that the passage of Italian figurative art from the Byzantine world ('Greek') to the Gothic Western ('Latin') was favoured, more than by any other single factor, by Giotto's works.

This happened in Rome, in Umbria (the progress of artists from the generation of the Maestro di San Francesco to that of the Maestro di Cesi and the Maestro del Farneto), in the Romagna (Giuliano da Rimini, Giovanni da Rimini, Pietro da Rimini) and at the same time, although in a more complex way, in northern Italy (Maestro dei Fissiraga at Lodi, Maestro delle Sante Faustina e Liberata and Maestro di Sant' Abbondio at Como).

What happened in Tuscany is obvious: there, the way in which Duccio's style in Siena was transmuted by the Lorenzetti brothers can be explained only by the brothers' stay in Florence and their knowledge of the works of Giotto and his followers. In other Tuscan towns (San Gimignano, Pisa, Arezzo) Giotto's style was carried on by minor artists, but men who, from Memmo di Filipuccio to Buonamico Buffalmaco, had the good fortune to know the works of Giotto well.

This revival did not take place in painting alone. The art of sculpture also experienced a renewal in the works of Nicola Pisano and Arnolfo di Cambio from the beginning of the 14th century. Later sculptors rejected the passionate, pathetic quality of Giovanni Pisano and developed a new interest in a more classically measured, more solid interpretation of the Gothic. This was the case with the Sienese artist Tino di Camaino and, above all, with the great Andrea Pisano, who, according to tradition, made the bas-reliefs of the campanile in Florence (*c.*1335-43) after drawings by Giotto himself. G.P.

Giovanetti
Matteo

*Italian painter
documented from 1322 to 1368*

The main painter of the School of Avignon in the 14th century, Giovanetti was born in Viterbo, from where his family came. A document of 1326 mentions his presence in the town as Prior of the Church of S. Martino. He is mentioned for the first time in Avignon in 1343, where he was part of the team of Italian and French painters employed to carry out frescoes in the Tour de la Garderobe in the Papal Palace. The subjects are hunting scenes and fishing, treated in the spirit of French Gothic naturalism, as found in the scenes in the tapestries of Arras. However, the interpretation of these subjects shows a sense of space that is characteristic of Italian culture, and which had already been introduced into Provence by Tuscan and Sienese artists such as the Master of the Codex of St George, the Master of the

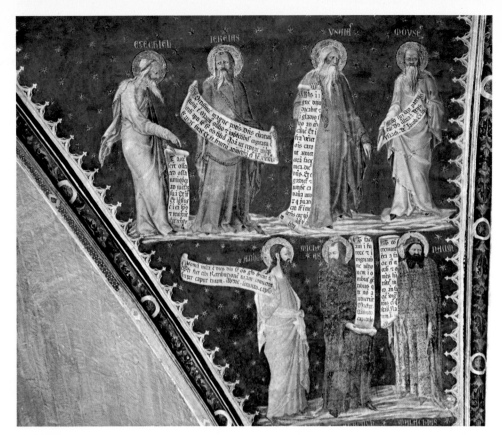

Panneaux d'Aix and, above all, Simone Martini, in whom can be seen the direct spiritual antecedents of Giovanetti.

In the natural freshness of these famous frescoes it is hard to distinguish the extent of Giovanetti's participation. His strong artistic personality appears much more clearly in the frescoes of the St Martial chapel in the Papal Palace, which he carried out alone or with only limited help from assistants. The preservation of these paintings compensates a little for the loss of those in the papal chapel of St Michel, also in the Papal Palace, which were carried out at the same time, and of other frescoes painted for Clement VI and Napoleone Orsini at Villeneuve-lès-Avignon.

The scenes with which Giovanetti illustrated the *Life of St Martial*, the evangelist of Aquitaine, are full of vitality, characterized by incisive portraits and powers of description that invite the onlooker to follow the unfolding of the story. It was also on the commission of Clement VI that Giovanetti carried out the decoration of the consistory hall in the Papal Palace, destroyed by fire shortly afterwards, and that of the chapel of St John the Baptist, which still survives.

The moderation of his ideas of space, which were derived from Tuscan precepts and the ideas of Ambrogio Lorenzetti, give a sense of limpidity and harmony to the whole; but its greatest charm comes from the pure range of its colours, impregnated by a luminosity that proclaims the ingenuous, marvellous world of the courtly painter. It is in the same spirit, and with even more enthusiasm, that Giovanetti must have conceived the mural cycle in the audience chamber, dominated by a large fresco of the *Last Judgement*. But all that remains of this important work is a section of the vault: the extraordinary world of the *Vingt Prophètes et la Sibylle d'Erythrée* (*Twenty Prophets and the Erythrean Sibyl*) (1352-3), in which the heavenly group of learned men discuss inscriptions on immense scrolls against a background of starry skies, takes on the accents of the French Gothic.

Giovanetti was the dominant personality in the large group of artists employed by the Papal court, and later carried out decorations for Innocent VI, which have now disappeared, and frescoes for a chapel dedicated to St John the Baptist at the Charterhouse of Villeneuve-lès-Avignon (*c*.1355-6), where his evolution along Gothic and descriptive lines achieves a surprising degree of freedom. After a long interval Giovanetti was in the service of Urban V (1365), but nothing remains of the work done then for the Papal Palace or for Montpellier (*Scenes from the Life of St Benedict*, painted on fifty pieces of linen, 1367).

That same year he went with Urban V and his court to Rome. In January 1368 he was paid for work done at the Vatican: this is the last known document in which he is mentioned. He also made a few paintings on panel. He has been credited with a triptych showing the *Virgin between St Hermagorus and St Fortunatus* (divided between Paris, private coll., and Venice, Correr Museum; other panels of the same small triptych, known from old photographs, have now disappeared) and a *Christ on the Cross with Saints* (Viterbo, private coll.). C.V.

Giovanni di Paolo

Italian painter
b.Siena, 1395/9 – d.Siena, 1482

Giovanni di Paolo probably received his training from the followers of Taddeo di Bartolo and Gregorio di Cecco. He is known to have delivered his first commissions in 1420 and 1423 but these are now lost, and his earliest works to survive are parts of the *Pecci Polyptych* (1426). These include the central panel (*The Virgin and Angels*, Castelnuovo Berardenga, Prepositura), two side-panels (*St Dominic* and *St John the Bap-*

tist, Siena, P.N.) and the altar-panels (*The Raising of Lazarus; The Ascent to Calvary; The Deposition; The Entombment*, Baltimore, Walters Art Gallery; and *The Crucifixion*, Altenburg, Lindenau Museum).

The quick incisive style of *Christ Suffering and Triumphant*, (Siena, P.N.) expresses with particular intensity Giovanni's moving and exalted vision. At heart he was a medievalist who turned his back on the principles of the Renaissance to pursue an ideal of lofty, suffering spirituality, mingled with frenzied unreality and an archaic religiosity. In the surviving *Branchini Panel* (*The Virgin and Child*, 1427, formerly Basel, Hirsch Coll., now Norton Simon Foundation) the influence of Gentile da Fabriano can be seen in certain decorative details, although it does not affect the coherence of the work as a whole.

The innovations in Sienese art of this period, introduced largely by Sassetta, affected di Paolo's later works only formally, as may be seen in the surviving panels of the Fondi Predella, dated 1436 (*The Crucifixion; The Presentation in the Temple; The Flight into Egypt*, Siena, P.N.; *The Adoration of the Magi*, Otterlo, Kröller-Müller).

Sassetta's ideas are here transformed into visions of Gothic unreality corresponding to Ambrogio Lorenzetti's rediscovery of landscape, as shown in the astonishing *Flight into Egypt*. The *Pizzicaiuoli Polyptych* (1447-9, now split up), *The Presentation in the Temple* (Siena, P.N.), and the *Scenes from the Life of St Catherine of Siena* (Lugano, Thyssen Coll.; Metropolitan Museum; Minneapolis, Inst. of Arts; Detroit, Inst. of Arts) provide further evidence of Giovanni's capacity for translating the new ideas of Vecchietta or Pietro di Giovanni d'Ambrogio, for example, into archaic language.

Giovanni achieved an unsurpassed level of dramatic expressiveness in the various versions of the *Crucifixion* (1440, Siena, P.N.; 1440, Siena, Church of S. Pietro Ovile; Dublin, N.G.), and in the famous and masterly *Scenes from the Life of St John the Baptist* (Chicago, Art Inst.; Metropolitan Museum; Münster Museum; Norton Simon Foundation), in which the fervour of his ascetic vision is exalted to a point where it resembles the Gothic stylization of Lorenzo Monaco in its most visionary form.

Giovanni di Paolo's documented output is very considerable, and includes many works that once formed part of polyptychs. Among the more remarkable are, in chronological order: *Agony in the Garden* and *The Deposition* (Vatican), which certainly date from before 1440; *The Madonna of Humility* (two versions: Siena, P.N. and Boston, M.F.A.); *Paradise* and *The Expulsion from Paradise* (Metropolitan Museum); the 1445 Uffizi Polyptych; the altarpiece showing the *Infancy of Christ* (the *Annunciation*, Washington, N.G.; the *Nativity*, Vatican; *The Adoration of the Magi*, Cleveland Museum; *The Presentation in the Temple*, Metropolitan Museum); the *Calvary*, (Berlin-Dahlem), of which certain elements were inspired by Gentile da Fabriano; the *St Nicholas Altarpiece* (1453, Siena, P.N.); the *Pienza Altarpiece* (1463); the predella showing the *Last Judgement* (Siena, P.N.), the *S. Galgano Altarpiece* (Siena, P.N.); and the *St Jerome* (Siena, Opera del Duomo). His very last works, including the *St Sylvester Polyptych* (1475) at Staggia (Siena, P.N.), display an unmistakable decline in style. Among the followers of this inimitable and rather solitary painter, the most notable was undoubtedly the more independent Pellegrino di Mariano. C.V.

▲ Matteo Giovanetti
Prophets (1352–3)
Fresco
Avignon, Musée du Palais des Papes

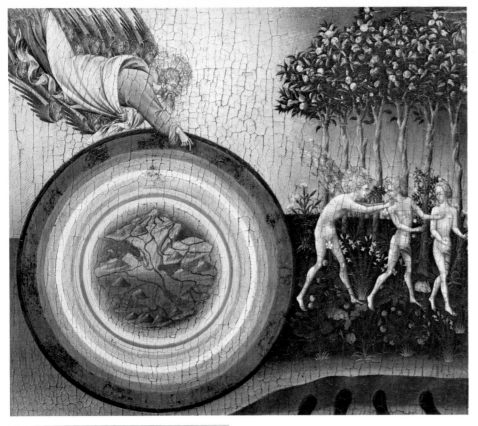

Girtin
Thomas

English painter
b.London, 1775 – d.London, 1802

Girtin first took lessons in painting from a Mr Fisher, and then, in 1789, he was apprenticed to the watercolourist, Edward Dayes. In 1792 Dayes and Girtin were working in close association with the antiquarian James Moore. Girtin received six shillings a day from Moore and may have toured Scotland with him in 1792. In the early 1790s he worked for John Raphael Smith, colouring prints. Here Girtin first met Turner. In his early years Girtin worked very much in the style of Dayes, but by 1794 he was beginning to formulate an individual style of his own. Two drawings of *Peterborough Cathedral* (1795) and *Lichfield West Front* (both Oxford, Ashmolean Museum) demonstrated his early maturity.

In about 1794 Turner and Girtin were employed by Thomas Monro in the evenings, and spent much time in copying the outlines and unfinished drawings of Cozens. In 1796 Girtin toured Scotland and the North of England where he treated architectural subjects (1799, *Durham Cathedral*, Manchester, Whitworth Art Gal.). The following year he visited the South-West and in 1798 North Wales. In the last years of the century he painted a huge panorama of London, entitled *Eidometropolis*, which was opened to the public. From 1801 until 1802, the year of his death, Girtin was resident in Paris, where he made a series of sketches that were published posthumously (in 1803) as soft-ground etchings and may originally have been intended for a project similar to his London panorama.

Girtin was undoubtedly one of the greatest of watercolour painters: Turner is said to have remarked that had Girtin lived he himself would have starved. Girtin enhanced the technique of watercolour, abandoning the old process of coloured monochromes for the richer tones of direct colour and using an absorbent off-white cartridge paper. This led to the development of the unique style of his later years, where in such works as *Kirkstall Abbey* (1800, London, V & A) he liberates the composition from classical references, building the structure from the natural forms of the scene, and maintains a masterful control over the emotive powers of tone and colour.

He was also expanding his subject-matter to include pure landscapes, especially moorland and mountain scenes, painting a bold sweep of empty foreground which led the eye to the middle distance and background. His feeling for space and the form of hills and valleys was particularly notable. Above all, he rescued watercolour from its bondage to topographical and architectural drawing and gave it a position of its own in the history of art, placing it on a level with oil painting.

The British Museum has more than 100 of Girtin's works. J.N.S. and W.V.

Giulio Romano
(Giulio Pippi)

Italian painter
b.Rome, 1499 – d.Mantua, 1546

Architect as well as painter, Giulio Romano began his career as an assistant to Raphael in the Vatican, but after 1527 broke free from the influence of his master to set the mark of his own powerful artistic personality on the new Mannerist style, which displayed a liberated attitude to classical influence.

His career as a painter falls into two phases: his contribution to the paintings in the Vatican until the death of Raphael in 1520; then, following the sack of Rome in 1527, a new period of activity at Mantua where he was introduced by Baldassare Castiglione to Federigo Gonzaga, the son of Isabella d'Este, who entrusted him with the monumental task of decorating the Palazzo del Tè.

There is some doubt about Giulio's share in Raphael's production, and some commentators would disagree with parts of the following.

In 1515 Giulio supplied some of the preliminary drawings for a series of tapestries of *The Acts of the Apostles*, based on ideas put forward by Raphael. He also translated some of Raphael's cartoons into the frescoes of the Sala del Incendio (*The Battle of Ostia*, 1515-16). At the same time he was working on the decorations for the Loggias, for which he designed a series of 52 scenes from the Old Testament. Small in size and contrasting in style, these are linked by a play of stylized motifs known as 'grotesques'; at the time these were highly original although they have now become part of the universal vocabulary of ornament.

Giulio was also responsible for a major part of the frescoes that make up the *Story of Psyche* in the Farnesina – again carried out from Raphael's

▲ Giovanni di Paolo
The Expulsion from Paradise
Wood. 45 cm × 52 cm (predella panel)
New York, Metropolitan Museum of Art, Cloisters

▲ Thomas Girtin
Kirkstall Abbey (1800)
Watercolour. 31 cm × 51 cm
London, Victoria and Albert Museum

preliminary sketches (1518). He also worked on several of Raphael's later religious paintings, such as *The Ascent to Calvary* (Prado), *The Holy Family of Francis I* (Louvre), *The Stoning of St Stephen* (Genoa, Church of S. Stefano) and various portraits (*Joanna of Aragon*, Louvre; the *Fornarina*, Moscow, Pushkin Museum).

A commission from Cardinal Giulio de' Medici in 1520 to decorate the Loggia of the Villa Madama was completed by Giulio, in collaboration with Giovanni da Udine, the following year. The same patron, now Pope Clement VII, anxious to finish the decoration of the Stanze, entrusted Giulio with the frescoes in the Sala de Constantino (1523-25). These vast, overflowing compositions, with their subtle perspective, recall Giulio's paintings of the same period, such as *The Madonna with Cat* (Naples, Capodimonte), and *The Holy Family and Saints* (Rome, Church of S. Maria dell'Anima).

In Mantua Giulio and his pupils carried out a complete decorative scheme for the Palazzo del Tè. The inner surface of the walls and ceilings were entirely covered with stuccoes and paintings to produce a colourful and overwhelming effect. Two of the more important sections display interesting differences in style: in the northern part of the building, the Sala di Psiche (1527-31) is distinguished by the subtle interplay of medallions and lunettes, with ceiling effects; the Sala dei Giganti (1532-4) in the south is a seething mass of exaggerated forms much admired by Vasari. Other rooms, such as the Sala dei Venti, develop cosmic themes. By combining in one continuous decor all the most varied resources of theatrical illusion, the Palazzo del Tè had a considerable influence on later Mannerist painters, in particular on Primaticcio who was in Mantua from 1525 or 1526 until 1532, and carried the influence to France where he was in the service of Francis I.

The latter part of Giulio Romano's career was devoted to architecture, although he also continued to work as a painter. The most notable fruits of these later years are the decorations planned for the choir and apse of Verona Cathedral (*c*.1534, *Scenes from the Life of the Virgin*, executed by F. Torbido); a *Nativity* (1531, Louvre), painted for the Boschetti chapel in the Church of S. Andrea, Mantua; a series of mythological tableaux (*Jupiter's Family*), painted for the Duke of Mantua (London, N.G. and

Queen's Gal., Buckingham Palace); and an important series of tapestry cartoons commissioned by Francis I (*History of Scipio*, Louvre and Hermitage). Giulio is also infamous for his designs for a series of *Erotic Loves of the Gods*, well-known in their time but now destroyed. F.V.

Giusto di Menabuoi
(Giusto da Padova)

Italian painter
b.Florence(?) – active 1363-91

Documentary evidence concerning Giusto di Menabuoi is scanty but he is generally recognized as an important link between Florentine art after Giotto and north European art of the second half of the 14th century. His first authenticated work is *The Virgin in Majesty* (Montignose di Massa, private coll.; panels with *Saints*, Athens, Georgia, University of Georgia Museum of Arts). Dating from 1363, it was painted for Isotta di Terciago who, it is thought, came from Lombardy. A fresco of *The Last Judgement* in the choir of the Abbey of Viboldone near Milan, which appears to date from the 1350s or soon after, has also been attributed to Giusto.

His unmistakable affinity of style with the art of Padua (especially in the later works) contrasts with a purely northern narrative clarity and a vivid use of colour which suggest an indigenous artist, although one influenced by Florentine culture. The little *Triptych* (centre, *Coronation of the Virgin*; side panels, *Scenes from the Life of the Virgin*, London, N.G.) dates from 1367. Its delicate treatment of the Virgin in the tradition of Giotto shows resemblances to the work of Agnolo Gaddi.

The frescoes in the Baptistery in Padua are Giusto's masterpiece. Commissioned by the painter's patroness, Fina Buzzacarina dei Carraresi, who is buried there, they were finished in 1376 or soon after. Although close to the north European style of such painters as Tommaso da Modena, Altichiero and Jacopo Avanzi, the frescoes also display a formal, abstract purity that is still Florentine, and an impressive architectonic blending of the whole with the details.

These characteristics are particularly evident in the rigorous theological symbolism of the cupola (*The Garden of Eden, Scenes from the Old Testament*), although in the *Scenes from the Life of Christ* that decorate the walls Giusto's normally discreet style opens out slightly. North European concern with descriptive and psychological detail emerges more plainly in the *Scenes from the Lives of St James and St Philip* in the Conti chapel (completed in 1383) of the Santo in Padua, although it leads to a clash of styles; whereas in Giusto's last-known work, *The Coronation of the Virgin*, a fresco decorating a lunette in the entrance to the Santo cloister, the style is elevated and purified. Among other works attributed to Giusto are two pictures illustrating the *Apocalypse* (Fürstenau, Erback Coll.). M.R.

Goes
Hugo van der

Netherlandish painter
b.Zealand(?)1435/45 – d.Grondael,1482

It is not known for certain where Hugo van der Goes received his training, although it is possible that he was a pupil of Dirk Bouts. That a close relationship existed between the two artists is suggested by the fact that late in life, in 1480, Hugo was summoned to Louvain to value the panels comprising *The Justice of Otto*, left unfinished by Bouts at his death. He also executed a panel depicting donors for the *St Hippolytus* triptych (Bruges, Church of S. Sauveur), another of Bout's works.

On 5th May 1467, under the patronage of Justus of Ghent (Joos van Wassenhove), Hugo was received into the Ghent Guild of Painters, and undertook a variety of commissions. In 1468, he worked on the preparations for the marriage of Charles the Bold to Margaret of York in Bruges. In 1469 and 1471-2, he was concerned with the ceremonial entry of the Duke into Ghent. The year 1473 found him decorating the Chapel of St Pharahilde for the memorial service to Duke Philip the Good; and almost every year he received payments for painting coats-of-arms. In 1474-5, he became Dean of the Guild of St Luke.

Around 1478, however, he left Ghent to become a novice at the Monastery of the Roode Kloster near Brussels. In 1481, during a journey to Cologne, he suffered a mental breakdown which produced severe depression, and it is said that the Abbot attempted to soothe him by having music played to him. He almost certainly continued to paint during his stay in the monastery, and was visited by many princely patrons who were drawn by his fame.

No chronological order has been established for Van der Goes's works. Certain small paintings, still hesitant in treatment, may represent his early work, but some art historians doubt their attribution. In *The Virgin and Child* (Philadelphia, Museum of Art, Johnson Coll.), based on models by Bouts, the articulations are sharply defined – a technique that can also be seen in the small panel of the *Crucifixion* (Venice, Museo Correr), and in a *Lamentation on the Death of Christ* (Granada, Rodríguez Acosta Foundation, Gomez Moreno Bequest). Compared with the *Monforte Altarpiece* (Berlin-Dahlem) the style of these works is very different and far more fully developed.

▲ Giulio Romano
Wedding Banquet of Cupid and Psyche
Fresco from the Sala di Psyche
Mantua, Palazzo del Tè

The Adoration of the Magi is a massive work with a poetic precision of detail that derives from Jan van Eyck – although the influence of Rogier van der Weyden is equally evident, particularly in the figure of the Virgin. Van der Goes, however, did not adopt Rogier's graphic style, preferring instead the plasticity of Van Eyck. Authorities differ as to whether the painting is a youthful work or one of his maturity, when he painted the Portinari Altarpiece – although the later dating seems unlikely, given the stylistic differences between the two works.

The fame of the altarpiece can be gauged by the fact that it was freely copied by the Master of Frankfurt (Antwerp Museum). A fragment of a side-panel depicting the bust of a donor being presented by St John the Baptist (Baltimore, W.A.G.) matches the Berlin altarpiece in its power, although the humanity of the saint's face lends it a more tangible presence.

The great triptych commissioned by the Florentine merchant Tommaso Portinari for the Church of S. Egidio in Florence is Hugo's chief work, and one of the most impressive of the entire 15th century. The central panel of The Adoration of the Shepherds, in particular, reaches unusual heights of emotional intensity. The emaciated figure of the naked Infant Jesus lies on the ground, isolated from the adoration and meditation that surround him. The Virgin sorrowfully contemplates the Child's destiny while the shepherds burst on the scene with an enthusiasm which contrasts with the solemnity of the bystanders.

Predominantly cold colours contribute to the feelings expressed. On the side-panels the donors kneel to pray before their patron saints amidst a harsh winter landscape, depicted with delicate precision and great attention to the quality of light. The reverse of these panels carries a dramatic Annunciation in grisaille.

The same feeling of drama animates most of Hugo's works and reaches its fullest expression in those dating from his later years. The Adoration of the Shepherds (Berlin-Dahlem) takes up again the theme of the Portinari Altarpiece, but more concisely and with a spontaneity highlighted by the presence of two prophets opening a curtain to display the scene around the crib. A small diptych in the Vienna Museum links the Fall of Man with the Deposition. Variously dated from the artist's earlier or later years, it moves with the same troubled passion which not only lends drama to the Lamentation but also underlines the isolation of Adam and Eve inside a teeming Garden of Eden. The little Virgin and Child at the Städelsches Kunstinstitut, Frankfurt, to which side-panels have been added by another hand, is similar in its effect.

A group of paintings in tempera (Pavia, Munich, Toledo) have also been attributed. The most remarkable of these consists of a diptych dedicated to the theme of the Deposition (Berlin-Dahlem and Wildenstein Coll.). Two organ doors (James III and Margaret of Scotland Presented by Saints; reverse, Sir Edward Bonkil Worshipping the Trinity), painted around 1478 for Sir Edward Bonkil (Holyrood Palace, on loan to Edinburgh, N.G.), were completed by another hand. The Death of the Virgin (Bruges Museum), with its remarkable group of mourning apostles standing around the bed of the Virgin, possibly dates from Hugo's years at the Roode Kloster.

His works were much copied, and from these we are able to form an impression of a number of original compositions that have now disappeared.

A.Ch.

Gogh
Vincent van

Dutch painter
b.Groot Zunder, Brabant, 1853 – d.Auvers-sur-Oise, 1890

Birth of a vocation. From the age of nine Van Gogh showed a lively talent for drawing, but it was not until relatively late, in 1880, after a series of emotional and religious crises, that he became aware of his true vocation. This occurred after his return from the coal-mining district of the

Hugo van der Goes ▲
The Adoration of the Shepherds
Wood. 97 cm × 247 cm
Berlin-Dahlem, Gemäldegalerie

Giusto de' Menabuoi ▲
The Annunciation
Fresco
Padua, Cathedral Baptistery

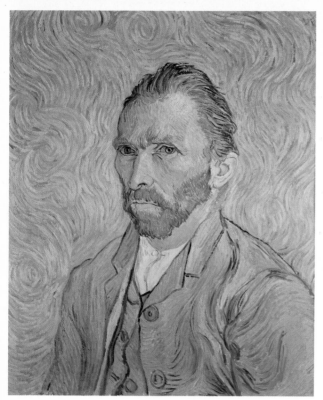

studying the wood-engravings and lithographs in the copies of the *Graphic* and the *Illustrated London News* that he had brought back from his stay in London (1873-5). He also worked with water-colour (*Rooftops*, 1882, Paris, private coll.), and arrived at oil-painting only after these years of patient effort. In The Hague, where he worked briefly with Breitner on studies for street scenes, he was given his first and only commission: twelve pen drawings of views of the town from his uncle, an Amsterdam picture dealer.

It was also in The Hague that he executed a black-lead drawing of *Sorrow* (April 1882, The Hague, private coll.), an allegorical figure for which Sien, the pregnant prostitute, was the model. The theme of despair, the purely graphic style, and the feeling of acute tension that make this a masterly example of proto-Symbolism are comparable to Klimt and Schiele.

As a draughtsman Van Gogh acquired his mastery at Nuenen where his subjects, ordinary men and women such as peasants and weavers, usually at work, were depicted with an instinctive sympathy and were never exaggerated (*Peasant gleaning, Back and Profile*, 1885, Otterlo, Kröller-Müller). His paintings were characterized by dramatic chiaroscuro, impasto and an expressive foreshortening recalling certain aspects of Hals and Rembrandt: 'I am sorry that some of today's painters deprive us of bistre and bitumen, with which so many fine pictures have been painted,' he replied to his brother, who, from Paris, where he had worked since 1880, tried to persuade Vincent to lighten his palette as the Impressionists were doing.

The Potato-Eaters (1885; two large versions, Amsterdam, Rijksmuseum Vincent van Gogh, and Otterlo, Kröller-Müller) represents the culmination of the Dutch period. Although it is not one of Van Gogh's best works, it is important apart from its historical significance for the understanding of his art. Later, in the asylum at St Rémy, Van Gogh remembered it when nostalgically recalling the north. 'I have tried to make it clear', he wrote, 'how these people eating their potatoes under the lamplight, have dug the earth with those very hands they put in the dish; and so the painting speaks of manual labour and how they have honestly earned their food.'

From the end of November 1885 until the end of February 1886 Van Gogh was in Antwerp. It was an important period in his career, for it marked the development of his interest in colour under the dual influence of Rubens, whom he discovered in the museums, and the Japanese prints that he had collected (he later owned about 200).

The cycle of self-portraits was begun in Antwerp where he painted the astonishing *Skull with Cigarette* (Amsterdam, Rijksmuseum Vincent van Gogh), a piece of black humour very rare with him, and very much reminiscent of Ensor.

Paris and Arles. But it was in Paris where he lived from February 1886 to February 1888 that his vision was transformed. After a very short time working under Corman in his studio, where he met Toulouse-Lautrec and became very friendly with him, Van Gogh joined forces with Pissarro, Gauguin and Émile Bernard and regularly frequented Julien Tanguy's shop (*Portrait*, Paris, Rodin Museum). His palette lightened, although discreetly, in 1886, and this became especially noticeable in his small flower paintings (*Geranium*, Holland, Lachem, private coll.). From

his Japanese prints (sometimes most faithfully copied on canvas) Van Gogh learned a freer arrangement of the composition and the use of planes of flat colour. He also experimented with a form of Impressionism (in 1887 he worked with Signac), a method quite at odds with his own style.

His extremely personal art was born of these two technically opposed approaches. The passionate intensity of his period at Nuenen, still visible during his first months in Paris (*Head of a Woman*, 1886, Basel, Staechelin Coll.), disappeared in a series of works that are full of vivid light and feeling, and marked by a liveliness of execution and fresh colours, with whites, pinks and blues predominating: restaurant interiors (1887, Otterlo, Kröller-Müller); views of Montmartre (*Gardens on the Butte Montmartre*, 1887, Amsterdam, Stedelijk Museum).

Long discussions with Gauguin and Bernard, however, led Van Gogh to the belief that he should abandon Impressionism and Neo-Impressionism. In February 1888 he left for Arles, hoping to find in the Midi, of which Lautrec had spoken to him, more light and more colour. Realizing that the development of his painting must henceforward follow the path of colour, he reacted very quickly, once he had left Paris, against Impressionism and its allusive character (*Pont de l'Anglois*, 1888, Otterlo, Kröller-Müller). It was this concentration on line and colour that had interested him in the Japanese (*Plaine de la Crau*, 1888, Amsterdam, Rijksmuseum Vincent van Gogh) and in Gauguin, whom he admired, and who, at his invitation, came to Arles (20th October 1888).

This first experience of communal artistic life ended with the crisis of December 23rd, when Van Gogh tried to attack Gauguin, then mutilated his own left ear (*Self-Portrait with Cut Ear*, 1889, Chicago, private coll.). Apart from its pathological implications (the first signs of the epileptic nature of Van Gogh's subsequent illness), the incident is revealing of the different temperaments of the two artists. Gauguin was fundamentally classical, even in his quest for wide oceans and lost paradises. Van Gogh, whose conflicts were always dramatically resolved, worked in a modern style. During the 18 months of life that were left to him, Van Gogh tried, by working furiously, to hold back the fits of insanity that intermittently attacked him. Gauguin's influence, which was not very beneficial in some paintings where the arrangement is too studied (*La Promenade*, [*Memory of the Garden at Etten*], November 1888, Hermitage), elsewhere was more successfully absorbed as in the *Dance Hall at Arles* (1888, Louvre, Jeu de Paume) or in the final version of *La Berceuse* (*The Rocking Chair*) (1889, Basel, Staechelin Coll.).

St Rémy and Arles. *La Berceuse* was painted soon after Van Gogh had left the hospital in Arles after an enforced stay in March 1889. While he was there he had been visited by Signac, but had suffered from the hostility of the other patients. In May he entered voluntarily the asylum of St Paul-de-Mausole at St Rémy-de-Provence where he remained for a year, from May 1889 to May 1890. During this period he was attacked by three terrible bouts of madness, which left him utterly prostrated.

These two periods at Arles and St Rémy, however, produced many fully developed works, landscapes, flower paintings and portraits. In

Borinage in Belgium where he had been a preacher from December 1878 to July 1879 (his father was a pastor). 'I told myself', he wrote in August 1880, "I will take up my pencil which I have forsaken in my great discouragement, I will get down once more to drawing", and since then nothing has been the same for me.'

Van Gogh's intense need for communication with his fellow men would have met with no response had it not been for the increasing moral and financial support that his younger brother, Theo, gave him throughout his life. The sources of Van Gogh's inspiration were his reading from the Bible, Dickens, Zola, Michelet and Hugo, and, among painters, Rembrandt, Dupré, Jules Breton, Daumier, Daubigny and, above all, Millet. 'For me,' he wrote, 'it is not Manet who is the most modern of painters, but Millet, who for so many has opened up distant horizons.'

At the beginning of his career Van Gogh consciously set out to portray the humble, recognizing their unprofitable toil, as he had, not long before, attempted to bring them consolation through religion and, in the same way, was to try to give shelter to a prostitute (The Hague, 1882-3). At the same time he was developing an intellectual curiosity about contemporary art and literature.

Before his Belgian visit, Van Gogh had begun his working life as an employee of the Goupil Art Gallery (at branches in The Hague, London and Paris, 1869-76), where his brother also worked in 1873. Afterwards he was apprenticed in a bookshop at Dordrecht (1877), and at the same time was studying for the church. His artistic career falls into two great periods – corresponding to his periods of residence in Holland and France respectively. A short but decisive time in Antwerp acted as a connecting factor between the two.

The Dutch period. The Dutch period (Etten, The Hague, Drenthe, and especially Nuenen; December 1883-November 1885) reflects Van Gogh's experiences in the Borinage when he was in daily contact with material and moral wretchedness. He set himself to perfect his drawing,

 Vincent van Gogh
Self-Portrait (1889)
Canvas. 65 cm × 54 cm
Paris, Musée du Louvre

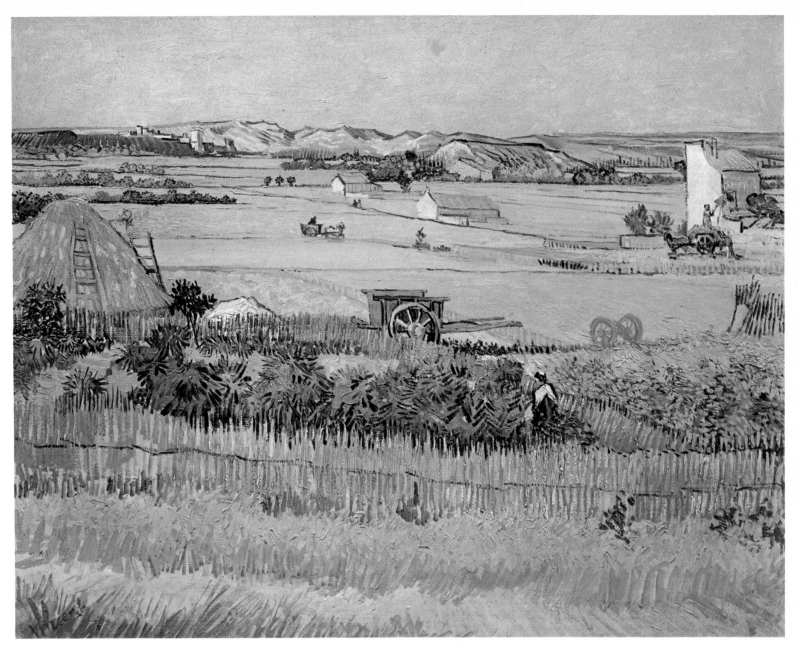

these Van Gogh used colour in a very personal manner, based on the harmony of yellows, greens, blues and purples (*Poplars*, 1889, Munich, Neue Pin.; *The Hayrick*, 1889, Otterlo, Kröller-Müller). The broad planes soaked in heightened colour that formed his backgrounds (*L'Arlésienne*, 1888, Metropolitan Museum and Louvre, Jeu de Paume), the heritage of Japanese prints and Gauguin's influence, increasingly gave way to a dynamic animation and the broken brushstrokes of Neo-Impressionism (*Olive Trees* 1889, Otterlo, Kröller-Müller), although the real origin of the technique was to be found in his drawings done in the Japanese fashion with bamboo or cut-reed (*La Crau, View from Montmajour*, Arles, 1888, pen, reed and pencil; Amsterdam, Rijksmuseum Vincent van Gogh).

Although Van Gogh had stated that he aimed to express with red and green, violent human passions', he, in fact, used warm tones very sparingly. Some of the Arles portraits are governed by strong drawing with concise accents and ostentatious but thin colour (*Young Man with a Cap*, 1888, private coll.). Those painted at St Rémy, however, are distinguished by sinuous supple handling and a more impasted surface (*Portrait de*

Trabu, 1889, Soleure, private coll.).

These characteristics are typical also of the masterpieces Van Gogh produced at Auvers-sur-Oise (*The Church at Auvers, Thatched Cottages at Cordeville*, Louvre, Jeu de Paume) where Dr Gachet took him in and cared for him during the final stage of his life (May-July 1890). But these pictures, harsh and uneven in style, were the first signs of a growing anguish before the threat of new breakdowns, from which he freed himself on July 27th with a revolver shot (he died on the morning of the 29th).

In January of that year an article by Albert Aurier in the *Mercure de France* had drawn attention to Van Gogh's art for the first time. In February Theo (who died in January 1891) had informed his brother of the sale of one of his paintings, *Red Orchard*, at the Salon des XX in Brussels to the Belgian artist Anna Boch for 400 francs (now in Moscow, Pushkin Museum).

The long series of self-portraits are an unequalled record of Van Gogh's struggle against the harshness of his social and material conditions, against hunger, illness and loneliness, all his problems being finally resolved through the genius of his art.

Influence. After Nuenen, Van Gogh's graphic work was devoted to landscape studies. These watercolours and drawings in many different techniques (Indian ink, graphite pencil, black pencil, charcoal and charcoal soaked in oil) are of outstanding quality, equal to that of his painting. Reality is caught and transformed with a poignant intensity (*Cornfield with Cypresses*, 1889, Amsterdam, Rijksmuseum Vincent van Gogh).

Van Gogh exerted a complex influence. To the Fauves he showed how composition could be achieved through colour and to the Expressionists, more occupied with moral significance, the symbolic part that colour could have. The paintings of his French period played a greater part in the evolution of modern art, while his Dutch paintings aroused less interest until the First World War, when the Belgian – Dutch Expressionist school found inspiration in the harsh virtues of an existence lived close to the soil.

Van Gogh's true descendants may well be found here, particularly in the later works of Permeke, painted when he lived at Jabbeke. In the last pictures, such as the *Cornfield with Crows* and *Trees, Roots and Branches* (both Amsterdam, Rijksmuseum Vincent van Gogh), the feverish

▲ Vincent van Gogh
La Plaine de la Crau (1888)
Canvas. 72 cm × 92 cm
Amsterdam, Rijksmuseum Vincent van Gogh

haste of the execution and the closeness of the viewpoint, entailing some loss of identity for the motif, herald some contemporary movements, notably Abstract Expressionism.

Van Gogh's catalogue, compiled by J.-B. de La Faille, was brought up to date in 1970 by the author. It comprises more than 850 paintings, together with nine lithographs made in Holland and a single etching executed at Auvers (*Portrait of Dr Gachet*), pulled from the doctor's press. There are fine collections of Van Gogh's work in Holland in Amsterdam (Stedelijk Museum and the Van Gogh Museum, opened in 1972), and at Otterlo (Kröller-Müller) where the public collections make up almost half of his entire output. The Louvre (Jeu de Paume) has, thanks especially to the Gachet donation, about 20 paintings and souvenirs from the last years of the artist's life.

Most important American art galleries have some of the greatest paintings, especially those in Boston (M.F.A.), Chicago (Art Inst.), Cambridge (Fogg Art Museum), Cleveland, Detroit (Inst. of Arts), Kansas City, Merion (Barnes Foundation), New Haven (Yale University Art Gal.), New York (Metropolitan Museum and M.O.M.A.), Philadelphia (Museum of Art), St Louis (City Art Gal.), Toledo (Museum of Art) and Washington (N.G. and Phillips Coll.).

M.A.S.

Goltzius
Hendrik

Dutch painter and engraver
b.Mulbrecht, near Venlo, 1558 – d.Haarlem, 1616

The eldest son of Jan Goltzius II and brother of Jacob II, in 1575 Hendrick Goltzius studied engraving with the master-engraver Coornhert, then with Philippe Galle. In 1576 he settled in Haarlem. His early engravings and drawings, before his departure for Germany and Italy in 1590, were influenced by the frenzied Mannerism of the Flemish painter Bartholomew Spranger, some of whose compositions he engraved.

From this period date the engravings of *Marcus Curtius* (1586), of *Mars and Minerva*, of *Minerva and Mercury* (1588) and the very fine series of *Prophets and Sibyls* (Rijksmuseum, Print Room). These engravings are typically Mannerist in their studied composition and in the proportions of the

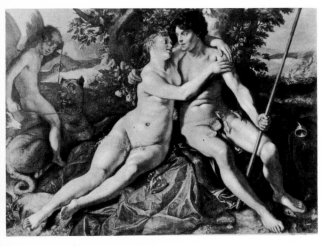

▲ Hendrick Goltzius
Venus and Adonis (1614)
Canvas. 114cm × 191 cm
Munich, Alte Pinakothek

restless figures with their elongated bodies and small heads.

Between 1587 and 1588 Goltzius executed a series of seven engravings tracing the history of the *Creation* (Haarlem, Teyler Museum, Print Room) and preparatory pen drawings for his illustrations to Ovid's *Metamorphoses*, printed in 1590 (Amiens, Besançon, Hamburg museums; Leiden, Print Room). This is one of the last works to be influenced by Spranger.

In 1590 Goltzius left for Italy, travelling by way of Munich, and visiting Bologna, Venice and Florence, where he painted the sculptor Gianbologna's portrait. On arriving in Rome, he made a number of drawings and copied some of the more famous works of the Renaissance masters, including Michelangelo's *Moses*. He also much admired Raphael's frescoes in the Farnesina. After a visit to Naples, he worked for the Jesuits in Rome, but was back in Haarlem by the end of 1591.

During 1592 he engraved several series, including *The Nine Muses* (Berlin-Dahlem, Print Room) and *The Seven Virtues* (Copenhagen, S.M.f.K.). He followed these in 1593-4 with the series known as *The Life of the Virgin*, in which each print was deliberately done in the style of a different artist (Dürer, Lucas van Leyden, Raphael, Parmigianino and Bassano). It is often regarded as his masterpiece (Haarlem, Teyler Museum, Print Room).

Goltzius's experiences in Italy in fact proved decisive. He reacted against Spranger and developed a calmer form of Mannerism, distinguished by a knowledgeable eclecticism and classical tendencies. Raphael's influence is plain, but so too, curiously enough, is that of Dürer and Lucas van Leyden, whose work is openly parodied. Several large-scale landscape drawings reveal the influence of Titian and Campagnola, as well as of Muziano (there is a fine example in the Orléans museum).

In 1596 he executed a series of drawings representing the *Gods* (Rijksmuseum, Print Room) and between 1596 and 1598 engraved several versions of the *Passion*, which he dedicated to Cardinal Federico Borromeo. His work as an engraver earned him a huge and lasting reputation and he rightly remains one of the best-known engravers of the 16th century.

In 1600 Goltzius's art took a new direction when he turned to painting. *Susannah and the Elders* (1607, Douai Museum) is a work remarkable for the realistic precision of its detail and for its happy blend of the crafts of engraver and painter. The works of the following period are dominated by the influence of Rubens, a particularly fine example being the *Venus and Adonis* of 1614 (Munich, Alte Pin.), where vividness of colour is allied to opulent forms and scenic richness without losing Goltzius's characteristic firmness of touch, almost grating in its cold insistence.

In the delicate *Jupiter and Antiope* (1616, Louvre) the position of Antiope brings to mind Michelangelo's *Night*. Parallel to the influence of Rubens, there are also numerous references to Titian and to Venetian art in general in works such as *Adam and Eve* (Hermitage), *Christ Crowned with Thorns* (Utrecht, Centraal Museum), and *St Sebastian* (1615, Münster Museum). The Douai *The Old Woman and the Young Man*, dating from 1614, shows an interesting tendency towards genre painting of the style that was to come to flower in following generations. There is a pitiless realism about the painting that is well in keeping with Goltzius's inherent Mannerism.

J.V.

Gonçalves
Nuño

Portuguese painter
active during the second half of the 15th century

Gonçalves's name is first recorded in 1450, when he was appointed court painter to King Alfonso V. The last mention of him comes in 1492, which is thus probably the year in which he died. It is known that in 1470 he painted the altarpiece in the royal chapel at Sintra but this is unfortunately no longer in existence. We know, too, from the *Dialogues* (1548) of the Portuguese artist Francisco de Holandá that he also painted the great *St Vincent Altarpiece* in Lisbon Cathedral, which was dismantled and replaced at the end of the 17th century. Shortly before the 1755 earthquake, which destroyed Lisbon and left the cathedral in ruins, these paintings were transferred to the Bishop's Palace on the outskirts of the town, a building which withstood the earthquake.

The remains of this 15th-century altarpiece thus escaped destruction, but all trace of them was lost until in 1882 six magnificent 15th-century paintings on wood were discovered in the Monastery of St Vincent, Lisbon, and after restoration in 1908, were generally accepted as being Gonçalves's *Veneration of St Vincent* (now in Lisbon, M.A.A.). To this work there can be added half-a-dozen attributions – paintings on wood, similar in style and technique, of which the most interesting are two life-size panels, one being merely a fragment, representing stages in the martyrdom of St Vincent.

Gonçalves's growing reputation derives largely from this exceptional series of paintings, remarkable less for their composition than for their lifelike draughtsmanship and the psychological acuity of the included portraits. The *St Vincent* panels, some of the most richly decorated in existence, show a distant yet lively gathering of people from all walks of life – princes, priests, monks and knights – united in their contemplation of an enigmatic central figure, clearly a saint. The faces are painted with matchless economy.

Gonçalves's sense of colour, at once brilliant and 'harmonic', suggests that he had learnt from the Flemish painters, whose ideas were at that time disseminated throughout the Iberian peninsula. However, he occasionally employs the surprisingly modern technique of a full brush, without the heavy finishes of the Flemish masters, and this, together with a remarkable use of white, and of differing shades of purple, enables him to capture directly profound and dramatic truths about human nature.

He has been called the best of all the early Hispanic painters but the strength and originality of his realism, in fact, raise him to the rank of one of the great masters of his time. His huge range and massive energy serve to convey a noble and solemn view of mankind that reflects the humanist tendencies of 15th-century Europe.

In view of how little is known about Portuguese studios of that time, it is difficult to imagine what sort of training Gonçalves received. The idea that he might have been apprenticed to Van Eyck, who was in Portugal in 1428-9, has been discounted for chronological and stylistic reasons. Equally it has been claimed that Gonçalves was in France in 1476 as part of Alfonso V's retinue when the latter visited Louis XI.

But the suggestion that the painter met Jean Fouquet during the course of this journey does not account for Gonçalves's earlier works.

The possibility has also been put forward that there is a relation between his painting and that of the Avignon school, but if so this is no more than the spontaneous and common evolution undergone by provincial schools far removed from the main creative centres. Some authorities have credited him with *The Man with the Glass of Wine* (Louvre) and the *Portrait of a Young Man* (1456, Vaduz, Liechtenstein Coll.), but these attributions have yet to be confirmed. A.da G.

Gorky
Arshile

American painter
b.Armenia, 1904 – d.Sherman, Connecticut, 1948

After emigrating to the United States in 1920, Gorky settled in New York around 1925, where he taught at the Grand Central School of Art, becoming friends with Stuart Davis and, in 1933, with Willem de Kooning. At this time his work was strongly influenced by Picasso, in particular by the studio interiors dating from 1927-8. However, he substituted for Picasso's hard, linear contours a freer and more dynamic treatment (*The Artist and his Mother*, 1926-9, New York, Whitney Museum).

Allusions to organic or anatomical shapes, deliberately ambiguous, became more and more frequent, particularly in the late 1930s (*Garden in Sochi*, 1940, New York, M.O.M.A.). In 1942, during the war, Gorky lectured on the art of camouflage and at the same time pursued his own inquiries into the connection between the real and the surreal.

His discovery of André Breton and the Surrealists two years later proved a turning point.

From the techniques of automatism, the example of Matta and, more particularly, of Miró, whose biomorphic figures he copied, he acquired a fresh view of the way that his art might develop. It was around this time that Breton used the word 'hybrids' to describe Gorky's allusive images, born of the unconscious in the form of archetypes or primitive symbols full of sexual innuendo.

Because he combined the representational with a degree of automatism, Gorky may be considered both as one of the last of the Surrealists (he was the last member to be admitted to the group) and as the first of the Abstract Expressionists (*The Liver is the Cock's Comb*, 1944, Buffalo, Albright-Knox Art Gal.; *Water of the Flowery Mill*, 1944, New York, M.O.M.A.). He abandoned oil painting for grisailles in pale shades, crossed by fluid penstrokes which suggest a secret, organic life. One of the best pictures of this period is *The Landscape Table* (1945, Paris, M.N.A.M.).

In his later works the outlines harden, becoming more menacing, sharp or broken (*Agony*, 1947, New York, M.O.M.A.). This dramatic intensity coincided with a series of disasters which befell him in real life. In 1946 a fire in his studio destroyed 17 canvases. In 1947 he became seriously ill and committed suicide the following year. J.C.

Gossaert
Jan (also known as Mabuse)

Flemish painter
b.Maubeuge, 1478/88 – d.Breda, 1532

It is not known where Gossaert was apprenticed but in 1503 he was registered as a master of the Antwerp guild. In 1508-9 he travelled to Rome in the retinue of Philip of Burgundy, and the following year he settled in Middleburg in Zeeland where he worked on Philip's palace of Sobourg.

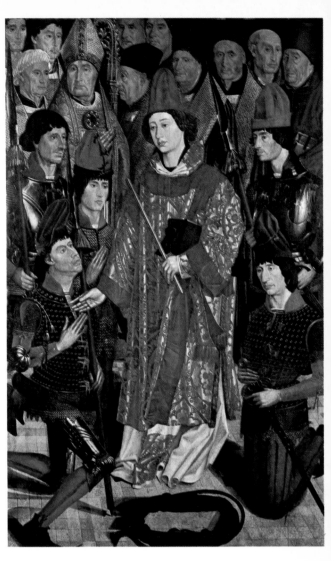

From this period dates a diptych of the *Virgin and Child, Antonio Siciliano Presented by St Anthony* (Rome, Gal. Doria Pamphili), as well as the *Malvagna Triptych* (centre, *The Virgin and Child with Angels Playing Musical Instruments*, Palermo, G.N.), and *The Adoration of the Magi* (London, N.G.). These works display a variety of influences, including borrowings from 15th-century art, from Dürer and from Italian painters. In *St Luke Painting the Virgin* (1515, Prague Museum), classical architecture serves as a base for Gothic ornamentation.

In 1516 Gossaert worked on the decorations for the funeral cortège of King Ferdinand the Catholic and, in 1517, in Malines, he painted the portrait of *Jean Carondelet Praying to the Virgin* (diptych, Louvre), as well as those of other notables. At this time he was living in Wijklez-Duurstede on the Rhine where Philip, who had been made Bishop of Utrecht, was in residence, and he remained here until the death of his patron in 1523.

Gossaert also painted secular works, and *Neptune and Amphitrite* (Berlin-Dahlem), *Hercules* (Birmingham, Barber Inst.), *The Metamorphosis of Hermaphrodite and Salmacis* (Rotterdam, B.V.B.) and *Venus and Cupid* (Brussels, M.A.A.) are clearly Renaissance in spirit. Of the religious works painted between 1517 and 1524, only two of note have survived: *The Virgin with St Luke* (Vienna, K.M.) and the altarpiece (1521) commissioned by the banker Pedro Salamanca for his chapel in the Church of the Augustines in Bruges.

On his return to Middelburg in 1525, Gossaert

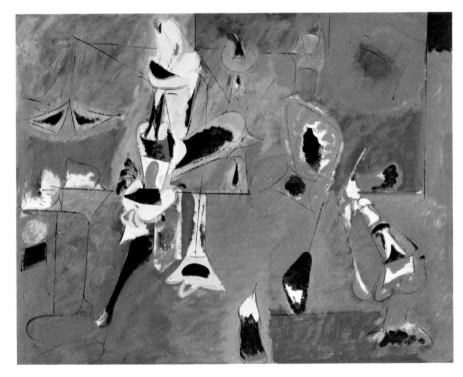

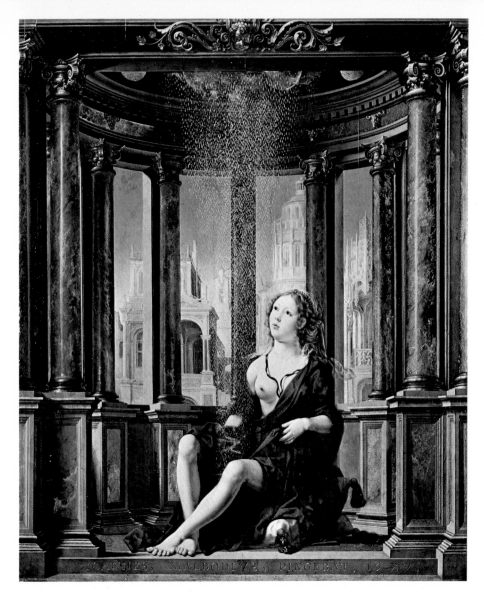

entered the service of Adolphus of Burgundy, on whose estates he lived from then on. For Christian II of Denmark he painted *The Three Children of King Christian* (Hampton Court) and between 1526 and 1528 drew sketches for the tomb of Isabella of Austria, Queen of Denmark. From these later years date several versions of the *Virgin and Child* (Metropolitan Museum; Prado; Mauritshuis; Brussels, M.A.A.), a *Danaë* (1527, Munich, Alte Pin.) and a *Man of Sorrows* (now lost). All of these were carefully executed works, as, too, were the portraits of this period (Kassel Museum; London, N.G.; Manchester, New Hampshire, Currier Art Gal.; Berlin-Dahlem; *Double Portrait*, London, N.G.).

Gossaert occupies an important place in the art of the Netherlands, to which, at the beginning of the 16th century, he introduced the spirit and forms of the Italian Renaissance. Yet he remains a painter in transition, for he never escaped the influence of the northern tradition. In his drawings, for instance, he uses Renaissance forms, but his linear style is conclusively an example of Gothic art. Not until his pupil Lambert Lombard reached maturity did a northern artist display an absolute conviction about the superiority of the Italian Renaissance.

The catalogue of Gossaert's work is large, consisting of over 80 paintings in private or public collections in Antwerp, Berlin, Birmingham, Brussels, Cambridge (Massachusetts), Detroit, Hamburg, Houston, The Hague, Lisbon, London, Madrid, New York, Nuremberg, Toledo and Washington. J.L.

Goya
(Francisco de Goya y Lucientes)
Spanish painter
b.Fuendetodos, Aragon, 1746 – d.Bordeaux, 1828

Early years. The son of a master gilder, José Goya, and of Gracia Lucientes, Goya – although very little is known about his childhood and education – is generally thought to have attended the Escuelas Pías in Saragossa and to have studied under José Luzán, a painter of no great distinction. In 1763, he left for Madrid where he made an unsuccessful attempt to win a scholarship to the Academy of San Fernando (a failure repeated in 1776). He made the conventional visit to Rome, living there between 1767 and 1771. He returned to Saragossa where, in 1772, he painted several large pictures for the Charterhouse of Aula Dei which show signs of his Baroque training. In October 1771 Goya received his first commission to paint frescoes and decorations for the vault of the Church of Nuestra Señora del Pilar in Saragossa. This work, *The Adoration of the*

Name of God, follows faithfully the Baroque sketches and other designs left by Corrado Giaquinto.

Tapestry cartoons and first portraits. In 1773 Goya tried his luck once more in Madrid where he settled down and married Josefa Bayeu. His wife's three brothers were painters, notably Francisco, Goya's senior by many years (Goya later sometimes claimed to be his pupil). From 1774 onwards he executed for the Royal Tapestry Factory of Santa Barbara several series of cartoons for tapestries (43 of which are in the Prado) to be worked for the royal palaces.

The collaboration lasted nearly 20 years and spans Goya's development as an artist, the series being executed in 1774-5, 1776-80, 1786-8 and 1791-2. For the first two series Goya drew his inspiration from paintings by Houasse dating from 1730, and his sketches show a preponderance of folk scenes, and of hunting and fishing tableaux (*The Tea*, 1776; *The Sunshade*, 1778). With the development of his style he attached growing importance to figures set against a light, blurred background.

In December 1778 Goya sent his friend Martín Zapater some aquatints that he had made of the paintings of Velázquez in the royal collections, an exercise which gave him the opportunity to familiarize himself with Velázquez's works. In 1780 Goya was admitted into the Academy of San Fernando with his *Crucifix* (Prado), but he left again for Saragossa where he had been asked to paint three half-cupolas in the Church of Nuestra Señora del Pilar. The following year he was commissioned to paint the altar of the Church of S. Francisco el Grande in Madrid, a laboriously executed work (*The Preaching of S. Bernardino*).

Round about this time he made the acquaintance of a number of influential people, whose portraits he painted, and who were to become his patrons (*Count Floridablanca*, 1783, Madrid, Banco Urquijo; the *Infante Don Luis* and members of his family, 1783 and 1784, Italy, private coll.; portraits of the *Infante*, Cleveland Museum, and of the *Infanta*, Munich, Alte Pin.; the architect *Ventura Rodríguez*, 1784, Stockholm Nm; and after 1785, portraits of the *Family of the Duke and Duchess of Osuna*, Prado).

Painter to the king. Appointed painter to the king in July 1786, Goya began the series of portraits of the directors of the Bank of San Carlos (Madrid, Bank of Spain), and completed that of the *Marquesa de Pontejos* (Washington, N.G.). He became the most fashionable painter in Madrid society and his letters to Zapater reveal his material success. This optimism is reflected in the third series of tapestry cartoons (1786-8), *Las Floreras, La Era* and *La Vendimia* (Prado). In 1787 he completed a series of seven *Rural Scenes*, similar in style to his tapestry cartoons, for the apartments of the Duchess of Osuna at Alemada, near Madrid (six in private collections; one in Budapest, former Herzog Coll.).

Meanwhile, he continued to paint religious works for churches at Valdermoro, S. Ana de Valladolid, and for Toledo Cathedral (1789). That same year saw his first use of the fantastic in his *Life of S. Francisco de Borja* in Valencia Cathedral (the sketches, even freer, are in the collection of the Marquis of Santa Cruz in Madrid).

In 1789, Goya was named court painter to the new King, Charles IV, whose portrait he painted on numerous occasions, as also that of Queen

Maria Luisa (the most important of these are in the Prado and the royal palace in Madrid). During the next few years he also painted portraits of the *Duke and Duchess of Osuna and their Children* (Prado), the *Countess del Carpio*, the *Marquesa de la Solana* (Louvre), the actress Maria Rosario Fernández, known as *La Tirana* (Madrid, San Fernando Academy), the historian *Ceán Bermúdez* (Madrid, Marquis de Perinat's Coll.) and the collector *Sebastián Martínez* (Metropolitan Museum). The undisputed master of Spanish portrait-painting, Goya created at this period works that are remarkable for their richness of colour, with greys and greens predominating.

1792: illness and aftermath. At the end of 1792, while on his way to Cadiz, Goya became seriously ill. The illness lasted several months and left him deaf, but he nonetheless managed to send the Academy 11 paintings in January 1793. Executed on tinplate, these included eight bull-fighting scenes (Madrid, private coll.), *The Travelling Comedians* (Prado) and *The Fools' Playground* (Dallas, Southern Methodist University, Meadows Museum). The famous pictures from the San Fernando Academy (*The Burial of the Sardine* and the *Procession of the Flagellants* in particular) were formerly believed to be part of this group, but are now known to have been painted much later, around 1808. Goya's illness brought about a profound change in his work. From being a painter of agreeable scenes and fine portraits he became an artist of powerful originality.

In a letter dating from around 1795 he told Zapater that he was about to paint the portrait of the *Duchess of Alba* who had visited his studio (Madrid, Duchess of Alba's Coll.). After the death of her husband, the Marquis of Villafranca, in 1796, he joined the duchess at Sanlúcar de Barrameda and during his stay in the country painted her in a number of scenes from the life, as well as in several more evocative or fanciful works, some of which reflect a considerable degree of intimacy.

His portrait of the *Duchess in Mourning* (New York, Hispanic Society) shows her standing, pointing to the inscription *Goya solo* in the sand, while two rings bearing the words *Goya Alba* may also be discerned. For a long time Goya

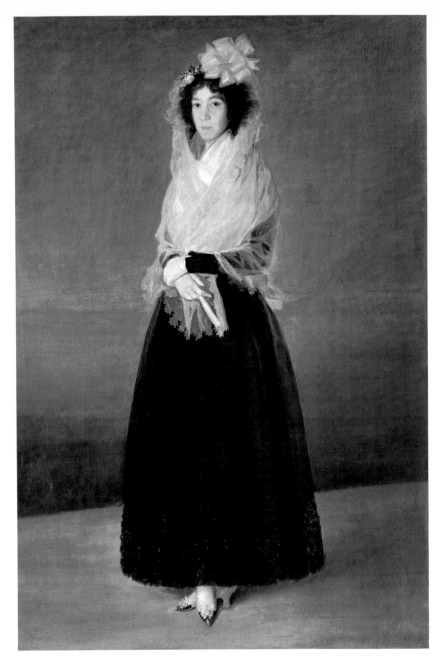

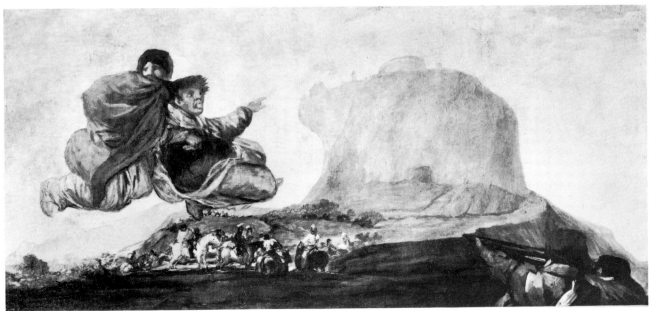

Goya ▲
To the Witches' Sabbath (1819–23)
Canvas. 123 cm × 265 cm
Madrid, Museo del Prado

Goya ▲
Portrait of the Countess del Carpio, Marquesa de la Solana
Canvas. 181 cm × 122 cm
Paris, Musée du Louvre

remained obsessed by her image, and she reappears constantly in his drawings and engravings. This passion may have given rise to two of the Prado's greatest masterpieces, the *Naked Maja* and the *Clothed Maja* (1798-1805), but this is by no means certain.

After the death of his brother-in-law, Francisco Bayeu, Goya was appointed Director of the Academy of Fine Arts in 1795, a position which his poor health obliged him to relinquish two years later. Between 1795 and 1798 Goya painted many religious scenes, notably in Cadiz, as well as portraits of government ministers: *Jovellanos* (Prado), *Saavedra* (London, Courtauld Inst. Galleries), *Yriarte* (Strasbourg Museum) and *Valdés* (Barnard Castle, Bowes Museum). In 1798 the Duke and Duchess of Osuna commissioned from him a series of small paintings, including several on the theme of the afterlife. During that same year he painted the portrait of *General Urrutia* (Prado) as well as that of the French ambassador *Guillemardet* (Louvre).

This same period, the spring of 1798, saw the creation of one of Goya's masterpieces, the magnificent frescoes for S. Antonio de la Florida in Madrid, a work that he completed after working at it continuously. The cupola depicts the miracle of a dead man being brought back to life by St Anthony before the astonished eyes of a motley crowd.

The following year Goya published his best-known set of engravings, the *Caprichos*. These consist of 80 aquatinted etchings, richly graduated in tone, many of them based on drawings which he made at Sanlúcar (Sanlúcar Sketchbooks). The series takes a broad look at humanity, at its follies and inadequacies, and constitutes an astonishing satire on the human condition. The same year Goya completed seven small paintings for the Duchess of Osuna, notably the *San Isidro Fields* (Prado), a calm and unforced masterpiece in which landscape plays a greater role than usual.

The major portraits. During this same period Goya executed the portrait of the writer *Fernández de Moratin* (Madrid, S. Fernando Acad.), the two portraits of *Queen Maria Luisa* wearing a black mantilla on horseback (Prado), as well as the *Equestrian Portrait of Charles IV* (Prado). In the following years Goya continued to work this exceptionally rich vein. In 1800 he painted the youthful and fragile-looking *Countess of Chinchón* (Madrid, Duke of Sueca Coll.), dressed in white and seated on a couch.

In June of the same year he began the great portrait of the *Family of Charles IV* (Prado). Here, the figures are depicted standing in one of the rooms of the palace, as though they were watching someone posing for the painter, who can be discerned to the left in the semi-darkness, together with the portrait he is working on – a device that brings to mind Velázquez's *Las Meninas*. The richness of the colours, the juxtaposition of silky, shimmering fabrics, the glint of jewels and crosses dispel any sense of monotony and give movement and life to the formally attired group. The composition is in the form of a frieze, with Queen Maria Luisa as the central figure.

Between 1800 and 1808, the year in which war broke out, Goya's talent as a portrait painter reached its peak. Works from this period include *The Prince of Peace* (1801, Madrid, S. Fernando Acad.); *The Duke and Duchess of Fernán Núñez* (1803, Madrid, Duke of Fernán Núñez's Coll.);

The Marquis de San Andrián (1804, Pamplona Museum); *Doña Isabel Cobos de Porcel* (1805, London, N.G.); *Don Pantaleón Pérez de Nenin* (Madrid, Banco Exterior); and *Ferdinand VII on Horseback* (1808, Madrid, S. Fernando Acad.), commissioned just before the start of the Spanish revolt against Napoleon's army.

In 1806 an event which became the talk of Spain, the capture of the bandit Maragato by the monk Zaldivia, inspired Goya to produce his own version of the drama. The resulting sequence of six small readily understood paintings (Chicago, Art Inst.) is evidence of Goya's feeling for a style of popular realism.

The Peninsular War. The rebellion against the French occupation, resulting from the dissolution of the *ancien régime* and Spain's political and economic bankruptcy, produced a divided response in Goya. Almost certainly, like many Spaniards he hoped for deep-rooted reforms in society, yet the brutality of Napoleon's soldiers and the cruelty of war prevented him from supporting the new rulers. Caught between two points of view, both equally hateful to him, though for different reasons, Goya passed the difficult war years in a somewhat ambiguous position, at times appearing to act as an *afrancesado*, at others like a patriot in revolt.

Once again he turned to engraving, and began working around 1810 on the series known as *The Disasters of War*, a violent reaction against the atrocities committed by the French troops. After 1814 he painted two great works, *The Second of May* and *The Third of May* (Prado). His use of colour was undergoing a change, with browns and blacks beginning to predominate, as can be seen from the portraits of *General Guye* (New York, private coll.), of the minister *Romero* (Chicago, private coll.), of the cleric *Juan Antonio Llorente* (São Paulo Museum) and of his friends the *Silvelas* (Prado).

Even more eloquent are the paintings Goya retained in his own studio: *The Colossus* (Prado); *Lazarillo de Tormes* (Madrid, Marañón Coll.); *The Blacksmith* (New York, Frick Coll.); *Majas on the Balcony* (Switzerland, private coll.); *Youth and Old Age* (Lille Museum). Between 1805 and 1810 he must also have executed several still lifes (the 1812 catalogue mentions 12), among which is the arresting *Sheep's Head* in the Louvre.

The Restoration (1814–24). In March 1814 King Ferdinand VII returned to Spain, and Goya was able to justify his position sufficiently to retain his post as court painter. In his royal portraits (Prado), as in others finished soon after the Restoration (*The Duke of San Carlos*, Saragossa Museum; *The Bishop of Marcopolis*, Worcester, Massachusetts, Museum), he added strokes of brilliant colour – reds, yellows and blues – to the predominating sombre tones. At the age of 69 Goya painted two *Self-Portraits* (Madrid, S. Fernando Acad. and Prado) and, during the same year (1815), the immense *Junta of the Philippines*, presided over by the king (Castres Museum). The basic idea was borrowed from Velázquez, but its execution is utterly personal and the sombre atmosphere of the great hall is faithfully reproduced.

Engravings and 'black' paintings. In 1816 Goya published the 33 etchings comprising the *Tauromaquia*. The series was undertaken in order to illustrate a history of bullfighting but before

long the artist changed his mind and, rather than rely on the accounts of others, engraved his own memories of fights witnessed in the Plaza. He was still painting portraits: his grandson *Mariano* (Madrid, Duke of Alberquerque's Coll.), *The Duke of Osuna*, son of his patrons (Bayonne Museum), *The Duchess of Abrantes*, his sister (Madrid, private coll.), and he also executed a great religious work, *Sts Justa and Rufina* (Seville Cathedral; sketch in the Prado).

At the age of 73, Goya learned the new technique of lithography (the *Old Woman Spinning* is dated 1819). By the end of August his most important religious work, *The Last Communion of St Joseph of Calasanz*, was in position on the altar of the Esculapian church in Madrid. In this moving and unconventional work, the sombre atmosphere is dominated by the dying saint's terrible expression of faith.

Seriously ill once more, Goya painted a self-portrait, and *The Artist with his Physician, Dr Arrieta* (Minneapolis, Inst. of Arts), as well as those of other friends. As usual he turned to etching during his convalescence, constantly enriching the technique by complex processes. This time he produced the extraordinary series known as the *Disparates* or *Proverbs* in which he gave his imagination free reign to produce the most mysterious and fantastic visions. Though the exceptional beauty of these etchings is immediately apparent, the meaning of several is unclear, linked as they are with the decorations to Goya's house (1820-2).

In 1819 Goya had bought a house on the banks of the Manzanares near Madrid in which he decorated the drawing-room and the dining-room. From here come the 14 so-called 'black' paintings (Prado), painted in oils directly on to the walls. They represent a closed world in which hideousness in all its forms finds expression, and in which the myth of Saturn, the symbol of death and destruction, constantly recurs. Goya's companion, his wife's cousin, Leocadia Weiss, shown at the entrance dressed in black, leans on a sort of hummock overlooked by the balustrade of a tomb, a reminder no doubt that the artist had recently been close to death.

The more surprising scenes, some of which are difficult to interpret, include the *Fight with Cudgels*, *The Buried Dog*, only the head of which emerges from a deserted landscape, and *Two Women and a Man*. All are boldly painted with a completely free technique, remarkable for the constant use of the scraper to spread the colours, redeeming this hallucinatory world where ugliness, horror and debasement reign.

Final years in Bordeaux. In 1823 a sudden change in the course of Spanish politics led Ferdinand VII, who had accepted the constitution of 1820, to re-establish the power of the throne, with help from the Duke of Angoulême's expedition. Liberals found themselves persecuted and Goya sought refuge with one of his friends, the priest Don José de Duasso, whose portrait he painted (Seville Museum) before he fled Spain. He was probably encouraged in this move by Leocadia Weiss, whose son, a prominent liberal, was killed during the coup which accompanied the invasion. Goya was followed into exile by the Weiss family.

After spending June and July of 1824 in Paris, where he painted unassuming portraits of his friends the *Ferrers* (Rome, private coll.) and a *Bullfight* in contrasting colours (Rome, private

coll.), he returned to Bordeaux. Here, except for occasional visits to Madrid, he remained until his death. A voluntary exile, he asked first that his visitor's permit of 1825 be extended, then that he be pensioned off on full salary and allowed to live in France.

Goya's later portraits of his friends date from his stay in Bordeaux: *Fernández Moratin* (Bilbao Museum); *Galos* (Merion, Pennsylvania, Barnes Foundation); *Juan de Maguiro* (Prado); *José Pio de Molina* (Winterthur, Oskar Reinhart Coll.). He also left some small, brilliantly coloured paintings (Prado; Oxford, Ashmolean Museum) executed in very thick paint and devoted to the theme of the bullfight, as well as a series of lithographs on the same subject, of which four form a famous set known as *The Bordeaux Bulls*.

His miniatures on ivory are also worthy of note and these are mentioned by Goya in one of his letters to Ferrer. Some 23 have been identified out of a total of 40 or so (*Man Looking for Fleas*, Los Angeles, private coll.; *Maja and Celestina*, London, private coll.). But *The Milkmaid from Bordeaux* (Prado) is one of the most famous of the later works. Coming as it does at the end of a long series of paintings of young women of the people, this picture represents all that is most graceful and delicate in Goya's art, as well as the ultimate achievement of his technique. From the same period comes *The Nun* (England, private coll.), which differs from other works in its abrupt and vigorous simplicity, and foreshadows the Expressionists.

Goya is represented in all the world's great art galleries, but the greater part of his work is in Madrid, in both private and public collections, mainly in the Prado. X. de S.

Goyen
Jan Josephsz van
Dutch painter
b.Leiden, 1596 – d.The Hague, 1656

Jan van Goyen began studying painting at an early age with Coenraet Adriaens Schilperoort, Isaack van Swanenburch and Jan Arentsz de Man, before working for two years in the studio of a certain Willem Gerritsz in Hoorn. Van Swanenburch's historical tableaux would seem to have little in common with the work of his pupil. The other masters were more or less renowned as landscape artists in their day but, as none of their work survives, it is impossible to know how far the traditions of the Leiden school influenced Van Goyen. On the other hand, we do know that he spent a year in France in 1615. After his return to Leiden he worked for a further year in the studio of Esaias van de Velde in Haarlem, and this apprenticeship was of paramount importance in his development, as his first paintings bear witness.

From 1620 right up until his death Van Goyen dated every one of his paintings, which makes it easy to trace the development of his style. Between 1620 and 1626 his landscapes consisted of architectural subjects and scattered groups of people, painted in bright colours with brown outlines (*Street in Bilt, with Troops*, 1623, Brunswick, Herzog Anton Ulrich Museum). Thus he became one of the creators of the 'realistic' Dutch landscape. At this period Van Goyen executed a num-

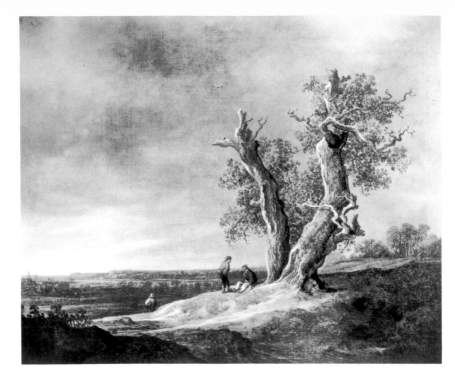

ber of small round paintings on a common theme (*Summer* and *Winter*, *The Four Seasons*), following the example of the Flemish masters of the second half of the 16th century. Another influence is that of Jan Bruegel whose landscapes painted at the beginning of the 17th century are peopled by figures similar to those in Van Goyen's pictures, and executed in a technique not unlike that of Van Goyen.

Between 1625 and 1630 or thereabouts, Van Goyen's style changed radically, the bright colours giving way to 'monochromes'. Henceforth, he employed only green, yellow, brown and intermediate hues for his landscapes and the figures and buildings in them. At the same time, the compositions become less complex: from now on, the accent is on a simple architectural group, a single clump of trees, or a solitary hill placed to one side of the picture. Figures and buildings, grouped along the diagonal in a descending line, thus take on a secondary importance. The picture no longer owes its vivacity or its variety to an accumulation of picturesque details, but to the interplay of light and shade which seems to bathe the landscape in great waves, and which at the same time gives it its dynamic character and a certain coherence (*Landscape of Hill with Farm*, 1632, Hanover Museum).

From 1630 on, water begins to play an increasingly important role in Van Goyen's landscapes. The works of Salomon van Ruysdael from the same period reveal a similar technique in their representation of the lakes and rivers of Holland, and there is little doubt that the two artists gained inspiration from each other. Van Goyen was beginning to acquire a wholly personal virtuosity, thanks to relatively simple methods. The accumulation of detail that characterizes the years 1620-6 and the still-Mannerist dynamism of his work around 1630 now gives way to a greater economy and clarity. The lower part of his paintings, often barely a quarter of the canvas, is subdivided into superimposed layers of land and water. Subtle touches give these layers a living rhythm: small boats with their crews, and clusters of cattle or buildings painted with masterly fluidity.

Van Goyen's brushstrokes are always visible (as are Frans Hals's), something which endows his

paintings with a great feeling of life. Processions of clouds – a characteristic element of the Dutch landscape – float across a sky which often occupies a good three-quarters of the canvas, and reinforce yet further the majestic effect of the whole. His compositions gradually became simpler and during the last 15 years of his life he was producing truly monumental works (*Two Oak Trees*, 1641, Rijksmuseum; *View over the Rhine*, 1646, Utrecht, Centraal Museum).

Van Goyen made numerous sketches from the life – before 1625 using a pen, but later in pencil. Several hundred sketches of this type, together with a few notebooks, remain. Many of the pages are dated and in the majority of cases it is possible to state where the drawings were made, because of the ease with which various landmarks can be identified. Van Goyen composed the paintings in his own studio, using the drawings for reference. In spite of their apparent realism, the landscapes were in fact re-invented. Van Goyen would introduce the outline of a city, such as Leiden, into areas which did not wholly accord with the topography. In his case, realism consisted of faithfully evoking the atmosphere of Holland with its waters and its grey, lowering skies.

Van Goyen's many imitators bear witness to his success in his own lifetime, as do the two commissions he received. One was from the Stadtholder William II and the other from the city of The Hague, where Van Goyen settled around 1631 after a stay in Leiden. Apart from a short spell in Haarlem he lived in The Hague until his death, and in 1651 painted an immense *View of The Hague* for the municipal authorities.

He sold a large number of his works and the details of these commercial transactions are to be found in various documents. It would seem that he also invested considerable sums of money in buying paintings, houses and tulips (bulbs were a precious commodity at this time and led to financial speculation on a ridiculous scale). However, he was not always successful in business and there must have been times when his financial situation was precarious, to say the least.

During the 18th and early 19th centuries, Van Goyen's work was largely forgotten. He was criticized for the dullness of his colours and the lack of detail. However, together with Frans

▲ Jan van Goyen
Two Oak Trees (1641)
Canvas. 88 cm × 110 cm
Amsterdam, Rijksmuseum

Hals, he was one of the painters whose exceptional qualities were eventually rediscovered thanks to the vision of the Impressionists. Today he is much admired and often considered (perhaps excessively so) as the representative par excellence of the Dutch landscape artist of the early 17th century. His paintings abound, and he is represented in all the museums of Holland as well as the majority of the great galleries of Europe and the United States. His drawings are to be found chiefly in the Rijksmuseum, in the Hamburg Museum, in Brussels (M.A.A.) and in Dresden (Print Room). A.Bl.

Graf
Urs, the Elder

Swiss painter and engraver
b.Solothurn, c.1485 – d.Basel, 1527/8

Graf received a rudimentary training from his father, who was a goldsmith, before going on to Basel to complete his studies. In 1503, in Strasbourg, he executed a series of drawings which were engraved and published by Knobloch in 1506. The following years saw him in Basel, Zürich, Strasbourg and Solothurn. He had a passionate temperament which several times landed him in prison, and he rarely spent more than a few months in the same town. He received numerous commissions for drawings which, reproduced as prints, became immensely successful (*The Life of Jesus*, published in Strasbourg in 1508, Basel Museum).

In 1511 he married a young women from Basel, acquired citizen's rights and, the following year, enlisted as a mercenary with the force sent to the aid of Pope Julius II in Milan. In 1513 he was in Dijon, then in Lucerne, where he finished a *Monstrance* and a *Reliquary* for the Abbey of St Urban. He took part in the Battle of Marignano. The records for the next few years reveal nothing but a series of convictions for assault and acts against public order. Banished from Basel in 1518, Graf was recalled the following year to become the city's official coin-engraver. In 1521 he fought as a mercenary once again, this time outside Milan. His name appears for the last time in 1526.

Graf is responsible for a few stained-glass windows (*Banneret*, 1507; *Ulrich of Hohensax*, after 1515, both in the Zürich Kunsthaus), and for two paintings, *The Savage Year* and *St George and the Dragon*, in tones of grey on a blue background (Basel Museum). But his true genius is to be found in the 300-odd engravings and drawings that he executed between 1503 and 1525, almost all of which carry his monogram. Exuberant and spontaneous, he chose his themes from characters who were familiar to him: women and soldiers for the most part, sketched with sharpness and humour, and with a sense of heightened realism, in which frenzy and death are ever-present. Open to all influences, he succeeded in integrating them into a wholly personal style, and one which developed in the course of his travels.

His earlier work is Late Gothic in manner, before moving closer to Schongauer, whom he sometimes copied line for line. He also drew inspiration from the anatomical studies of Hans Wechtlin, from the chiaroscuro of Hans Baldung and from Dürer's powerful incisiveness and sense of irony. After his service in Italy, Renaissance

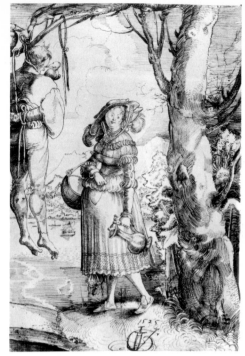

motifs such as decorative friezes, *putti* and mythological figures make their appearance (*The Young Madwoman*, 1513, Basel Museum; *Madam Venus and the Knight*, 1517, Rijksmuseum) and his drawings, while retaining their slightly contorted metallic clarity, acquire the passionate, tremulous fluidity to which he owes his fame (*The Devil Halting a Fleeing Lansquenet*, 1516; *The Death of St Sebastian*, 1517; *The Woman and the Hanged Man*, 1525; a *Flagellation*, 1526; all in the Basel Museum.) B.Z.

Greco, El
(Domenikos Theotokopoulos)

Spanish painter of Greek origin
b.Candia, Crete, 1541 – d.Toledo, 1614

Domenikos Theotokopoulos, the painter who was later to achieve renown under the name of 'El Greco', was born in Candia, then the capital of Venetian Crete, of a probably Catholic family of tax-collectors or customs officials. It is known, too, that his elder brother, Manussos, ruined after being proved an embezzler, spent the last years of his life in Toledo with Domenikos. His name is mentioned in Candia in 1566 as a master-painter. Much, however, remains to be discovered about these early years in Crete.

Italian period. Equally obscure is the period of his apprenticeship in Venice. It is not known whether he worked in Venice before 1566 or only afterwards. He certainly spent less time in Italy than has previously been supposed. In 1570 he went to Rome and, according to the register of the St Luke Academy in 1572, this 'young man from Candia, a pupil of Titian' was recommended by the Croatian miniaturist, Giulio Clovio, to Cardinal Alexander Farnese. Among the humanists who frequented the Farnese Palace he came into contact with members of the Spanish clergy, including Pedro Chacón, a canon of Toledo Cathedral. This was the period when great abbeys and the vast Escorial Palace were being built in Spain, and this is probably why El Greco decided to go there. He arrived in Toledo in the spring of

1577 and remained in that city until he died.

El Greco's Italian period, long ignored by art historians, has been the subject of much attention over the past 50 years, and a number of paintings showing both Byzantine and Venetian influences have been attributed to El Greco. None of these works, however, is indisputably his, not even the polyptych found in Modena (Pin. Estense) and signed 'Domenikos', the style of which is mainly Byzantine. Neither are the paintings depicting *St Francis Revealing the Stigmata* (Geneva, private coll.; and Naples, Capodimonte), in which landscape plays an important role, in the Venetian tradition, but which are treated in rapid, nervous fashion.

In those of his works that are purely Venetian in style, such as *The Curing of the Man Born Blind* (Parma, G.N. and Dresden, Gg) or *Christ Driving the Traders from the Temple* (Washington, N.G.), the concept of space derives above all from Tintoretto, while the iridescent richness of colour comes from Titian. El Greco had clearly made a detailed study of perspective and there is more skill in the handling of architectural backgrounds than in the movement of the crowd. Probably his most accomplished canvas from this period is an *Annunciation* (c.1575, Prado), which is completely Venetian in style.

El Greco's time in Rome influenced his work far less than the years in Venice. Reminders of classical antiquity, of the art of Michelangelo and of the Mannerists are evident in two versions of the *Pietà* (Philadelphia Museum of Art, Johnson Coll.; New York, Hispanic Society), and also in his later paintings, which recall the *Farnese Hercules* and the *Laocoön*. But here, too, El Greco owes more to Titian than to any other master. In his *Young Boy Lighting a Candle* (c.1570, Naples, Capodimonte) he uses the candle for the first time as a source of light, drawing inspiration from Titian's *Nativity* (Florence, Pitti) and opening the way to the study of light which would follow towards the end of the century.

During his years in Italy he also executed many portraits – a genre in which he excelled – in similar vein to the Venetian portraits. *Giulio Clovio* (Naples, Capodimonte), *G.B.Porta* (Copenhagen, S.M.f.K.), *The Governor of Malta, Vincentio Anastagi* (New York, Frick Coll.) are painted with a minute respect for physical appearance, which, however, does not detract from the grandeur of the composition.

Spanish period. After the years of relative obscurity in Italy, El Greco came into his own in Toledo with his triumphant *Assumption* painted for the high altar of the Abbey of S. Domingo el Antiguo (1577, Chicago, Art Inst.). Although the richness of colour still suggests Venice, and the composition also reveals borrowings from Titian's Frari *Assumption*, the lack of depth and the animated poses of the figures are Mannerist traits. *The Trinity* (Prado), which formed the upper part of the same altarpiece, is unique among El Greco's work in its sculptural quality drawn directly from Michelangelo.

In *The Resurrection* (still *in situ*) a new El Greco appears: dramatic, eloquent, mysterious. He followed this with the *Espolio* (*Disrobing of Christ*) (1577-9, Toledo Cathedral), one of his most original creations. The foreshortening reveals the influence of the Italian Renaissance, but the iconography is Byzantine in origin, and the intensity of the colours, particularly the haunting scarlet of Christ's tunic, is powerfully emotive. The

▲ Urs Graf the Elder
The Woman and the Hanged Man (1525)
Pen drawing. 32 cm × 22 cm
Basel, Kunstmuseum

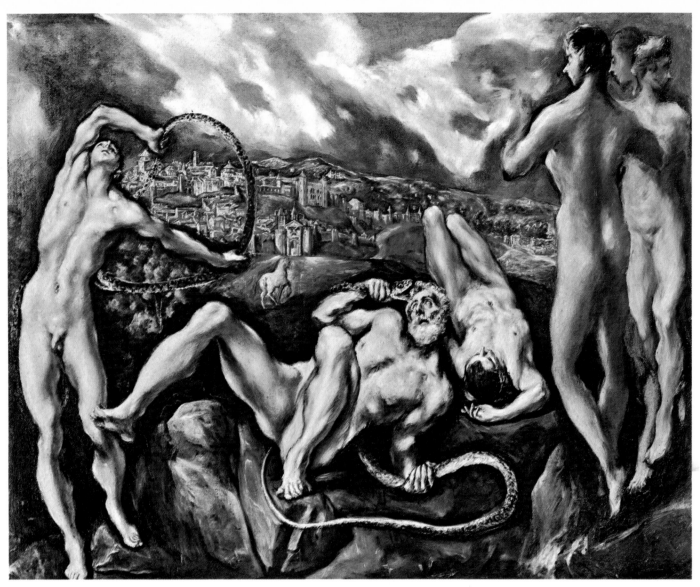

painting also marks the first appearance of the type of female model beloved of El Greco: the long, thin face with large sad eyes was probably that of Jeronima de las Cuevas of Toledo, El Greco's wife, or possibly mistress.

In the *Allegory of the Holy Alliance* (Escorial) – also known as *The Triumph of the Name of Jesus* – medieval elements become transfigured by the artist's visionary perception. This composition, formerly known as *The Dream of Philip II*, appears to have been painted in 1578 for the king on the occasion of the death of his half-brother, Don Juan of Austria. *The Martyrdom of St Maurice* (1582, Escorial), also executed for Philip II, displeased both the King and the clergy – probably because of its lack of realism and its sharp colours – with the result that El Greco ceased to work for the court.

He turned instead to devotional paintings: *St Veronica* (Madrid, Caturla Coll.), *St Francis Receiving the Stigmata* (Madrid, Marquis de Pidal Coll.) and *Christ on the Cross*. The *Crucifixion with Two Donors* (Louvre) is a forerunner of his greatest work, *The Burial of Count Orgaz* (1586, Toledo, Church of S. Tomé). This austere yet sumptuous composition, which depicts the entire heavenly hierarchy attending a burial service, is, in fact, a synthesis of the Toledo society of the day. Clergy, lawyers and soldiers, all of them El Greco's patrons, were able to recognize themselves in this and other canvases.

Better than any native-born painter, El Greco succeeded in capturing the solemn gravity of Castilian noblemen in a series of portraits. The *Gentleman with his Hand at his Breast* (Prado), the humanist *Covarrubias* (Louvre) and *Captain Julián Romero de las Hazanas* (Prado) were all painted in black and white, and are classical in their austerity and precision. *Cardinal Niño de Guevara* (Metropolitan Museum), a richly coloured work, blends psychological observation with a solemn representation of the Grand Inquisitor.

During the last 30 years of his stay in Toledo El Greco created a new iconography in conformity with the edicts of the Council of Trent: penitent saints, scenes from the Passion and the lives of the Holy Family are subjects that occur frequently in his works and those of his studio. Religious fervour, a respect for physical appearance and the use of hot colour (deep reds, golden yellows) characterize paintings on the themes of *Christ Carrying the Cross* (Prado; Metropolitan Museum), *The Magdalene* (Budapest Museum; Sitges, Cau Ferrat Museum) and *The Tears of St Peter* (Toledo, Hospital de Tavera). *The Holy Family* (Prado; Toledo, Hospital de Tavera, and Santa Cruz Museum) is one of his happiest creations, with its sad gracefulness and the striking freshness of its colours.

Later years. After 1595 or thereabouts, El Greco increasingly abandoned realism in favour of the rich fantasies suggested by his imagination. His figures grow more elongated and disembodied, and become more and more like the flames which occasionally illuminate his paintings. This development is particularly noticeable in the works painted between 1596 and 1600 for the College of S. Maria of Aragon, in Madrid: *The Annunciation* (Villanueva y Geltrú, Balaguer Museum); *The Adoration of the Shepherds* (Bucharest Museum); and *The Baptism of Christ* (Prado). This accentuation of vertical lines reaches a climax in the decorations for the Chapel of St Joseph, in Toledo (1599), of which only the paintings for the high altar (*St Joseph and the Infant Jesus*, *The Coronation of the Virgin*) remain in place, and from which comes *St Martin and the Beggar* (1599, Washington, N.G.).

Suggestions that El Greco had either become short-sighted or had lost his reason are not borne out by the fact that in this latter painting the distortion of the figure of the mendicant is allied with a more formal treatment of the horse. The famous *View of Toledo* (Metropolitan Museum), showing the city under a threatening, stormy sky, reveals his emotional style as applied to landscape. At the same time, El Greco often took up again subjects that he had treated earlier in his career – the *Adoration of the Shepherds* (Bucharest Museum); the *Resurrection* (Prado) – but the new works are marked by an atmosphere of anguish and yearning for the afterlife.

▲ El Greco
Laocoön
Canvas. 137 cm × 172 cm
Washington, D.C., National Gallery of Art

Cold colours, pale light, insubstantial bodies and emaciated faces characterize the five canvases painted for the Hospital de la Caridad at Illesca, near Toledo, between 1603 and 1605. *St Ildefonso* and *The Virgin of Charity* transpose medieval themes into a world of religious ecstasy. *St Dominic at Prayer* (Toledo Cathedral), a lone figure lost in a desolate landscape, is one of the most moving creations by an artist who also dedicated several paintings to the history of the Franciscans, including *St Francis and Brother Leon meditating upon Death* (numerous versions, notably in the Prado; in Ottawa, N.G.; in Valencia, Patriarchal College) and *The Vision of the Flaming Torch* (Cadiz, Hospital del Carmen; Madrid, Cerralbo Museum).

The canvases of El Greco's last years reveal all his visions, dreams and aspirations. His studio, meanwhile (which included his son Jorge Manuel), was turning out copies of the favourite objects of Spanish devotion: sets of *Apostles*, and portraits of the saints (Toledo, Cathedral and El Greco Museum), their tormented, deliberately distorted and abnormally elongated bodies painted with broad brushstrokes.

The autumnal splendour of El Greco's colouring is shown to its greatest advantage in the *Assumption* painted after 1607 for the Church of S. Vicente and now in Toledo Museum. A new height of exaltation is reached in *The Fifth Seal of the Apocalypse* (Metropolitan Museum), which is very similar to the *Laocoön* (Washington, N.G.), the only mythological theme ever attempted by El Greco. The composition of the *View of Toledo* (Toledo, El Greco Museum) prefigures that of Cézanne and shows how extraordinarily sure was the artist's touch shortly before his death. His last work, *The Baptism of Christ*, painted for the Hospital de Tavera in Toledo, was left unfinished.

Throughout his career El Greco's creative imagination blended and transfigured the various elements which fed it: the Cretan heritage, the lessons of the Italian Renaissance and the atmosphere of Toledo. After being largely forgotten, El Greco was rediscovered at the end of the 19th century when the extravagant and solitary nature of his genius was much admired by critics such as Maurice Barrès. The components of El Greco's pictorial alchemy are still a matter for discussion: elongation of form is something common to all the Mannerists, but only El Greco, the last and greatest of them, gave it a mystical meaning and the sense of transcendental yearning. This profound originality came to fruition in the spiritual climate of Toledo, where, by now in full command of his technique, El Greco was able to unlock the vast, almost exclusively religious treasure-house of Spanish art, from which secular themes, with the exception of the landscape and the portrait, had been banned.

More than any other painter, El Greco depended on his surroundings when it came to finding models or seeking inspiration. But he remains an isolated figure because of the way in which he interprets the outside world, and he has no real disciples (the best, Luis Tristan, soon moved on to the tenebrism of Caravaggio). Only Velázquez, who admired and sought out his works, can in some ways, by virtue of the boldness of his 'impressionist' technique, be considered El Greco's spiritual descendant. A.C. and P.G.

Greuze
Jean-Baptiste
French painter
b. Tournus, 1725 – d. Paris, 1805

Greuze is known to have studied in Lyons with Grandon (official painter to the city from 1749 until 1762) and to have gone to Paris around 1750. The *St Francis* from the Church of Mary Magdalene in Tournus probably dates from this time. In Paris Greuze became a pupil of Natoire at the Royal Academy but decided against becoming a conventional academic painter. However, in 1755 the Salon accepted his *Père de famille expliquant la Bible* (*A Father explaining the Bible to his Family*), his portrait of *Sylvestre* and other small-scale but elegant works. The critics greeted with enthusiasm his scenes of family life with their clear moral intent – although they also had a tinge of preciosity that gradually turned into more overt sensuality, a characteristic feature of Greuze's work.

From the start Greuze was a careful observer, an admirer of the Dutch school with whom he shared a concern for his subject matter, allied with a delicate understanding. In September 1755 he accompanied the Abbé Gougenot, a member of the Grand Council, to Naples and then on to Rome, where he spent about a year. Greuze's travels in Italy gave him a taste for the picturesque (evident in the paintings he exhibited at the 1757 Salon: *Un Oiseleur accordant sa guitare* [*A Bird-Catcher tuning his Guitar*], Warsaw Museum; *La Paresseuse italienne* [*The Lazy Italian Woman*], Hartford, Connecticut, Wadsworth Atheneum; *L'Oeuf cassé* [*The Broken Egg*], Metropolitan Museum; *Le Geste napolitain* [*The Neapolitan Gesture*], Worcester, Massachusetts, Museum).

However, he seems to have remained unmoved by the fashion for classical antiquities (Piranesi's *Roman Antiquities* had just been published) and by the pre-Romantic enthusiasm of Fragonard or Robert for the ruins and landscapes of Italy. His painting, instead, remains noteworthy for the type of face found in the works of 17th-century Bolognese painters, and he also introduced a new mode (*Une Jeune Fille qui pleure la mort de son oiseau* [*Young Girl Weeping over a Dead Bird*], Louvre), the ambiguity of which caught the public imagination.

With *L'Accordée du village* (*The Village Betrothal*), shown at the 1761 Salon (Louvre), Greuze broke fresh ground, creating a genre scene with a historical background – a blend which enabled him to express his subjects' feeling more fully. The painting was a huge success, and he followed it with *Le Paralytique secouru par ses enfants* (*The Paralytic nursed by his Children*) (1763, Hermitage) and *La Mère bien-aimée* (*The Beloved Mother*) (1767, Marquis de Laborde Coll.). The anecdotal quality of Greuze's work during this period is reminiscent of Jan Steen, while at the same time it aims at the *grande idée* advocated by Diderot.

In 1769 Greuze's painting of *Sévère et Caracalla* (*The Emperor Severus reproaching Caracalla*) (Louvre) provoked an uproar of hostility from both the Academy and the public. He executed a number of preparatory drawings for the figures: from antiquity (*Papinien*, 1768, Louvre; *Caracalla*, 1768, Bayonne Museum; and for the figure of *Fortune* from the *Grand Cabinet Romain* by Michel-Ange de la Chaussée, 1706), as well as from nature, and in them he displays great sensitivity (*Busts of Septimius Severus*, 1768, Paris, E.N.B.A.).

These historical works, painted between 1767 and 1769, demanded of Greuze an austerity and precision which he carried over into his pictures on moral themes. The colours became darker, the gestures more dignified, and attitudes and expressions, however humble the drama, are marked by a new tension (*Le Gâteau des rois* [*The Twelfth-Night Cake*], 1774, Montpellier Museum; *La Dame de charité* [*Our Lady of Charity*], 1775, Lyons Museum; *La Malédiction paternelle* [*A Father's Curse*] and *Le Fils puni* [*The Prodigal Son*], 1777-8, Louvre; and *Le Retour de l'ivrogne* [*The Return of the Drunkard*], Portland, Oregon, Art Museum).

Greuze enjoyed a tremendous success, thanks partly to the way that he made use of the press to publicize such works as *La Cruche cassée* (*The Broken Jug*) (Louvre). His standing with the Imperial Russian court, too, was particularly high and he had many imitators, such as Bounieu, Aubry, Bilcoq and G.M. Kraus. But his genre paintings, varying in style between Chardin and Hogarth – though without the latter's irony – began to fall out of favour around 1780 and he turned to portrait painting.

From the start of his career (*Self-Portrait*, Louvre) he displayed as much finesse as La Tour, but with a feeling for realism which is reminiscent of Chardin (*Georges Gougenot de Croissy*, c.1756, Brussels, M.A.A.) and of Rembrandt (*Portrait d'homme* [*Portrait of a Man*], 1755, Louvre). The candour that distinguishes his best portraits (*Babuti*, Paris, David-Weill Coll.; *Wille*, 1763, Paris, Musée Jacquemart-André) is found, too, in the admirable sets of drawings in the Hermitage and the Louvre. Others are in the Tournus Museum, in the Albertina and in the British Museum. C.C.

Gris
Juan
Spanish painter
b. Madrid, 1887 – d. Boulogne-sur-Seine, 1927

Gris's real name – which he used until shortly before leaving Spain – was José Victoriano González and, in accordance with his parents' wishes,

 Jean-Baptiste Greuze
Le Gâteau des Rois (1774)
Canvas. 72 cm × 91 cm
Montpellier, Musée Fabre

he entered the Escuela de Artes y Manufacturas in Madrid in 1902. After two years at the school, however, he abandoned the study of science to devote himself full-time to painting – a vocation to which he had long felt drawn. His first teacher was an elderly academic who, as Gris said later, did nothing but fill him with revulsion for 'good' painting.

Influenced by the German reviews *Simplicissimus* and *Jugend* (to which his friend Willy Geiger contributed), Gris turned for a while to the Jugendstil (or Art Nouveau), which to most painters in Madrid at that time represented art in its most advanced form. But this failed to satisfy him for long and, feeling the need for new surroundings and fresh stimuli, he decided in 1906 to leave for Paris, where several compatriots had already settled and where he was particularly drawn by Picasso's growing fame. He found a studio close to Picasso's, in the famous Bateau Lavoir.

Having had to sell all his belongings to pay for the journey, he was forced to work for a living and for nearly five years he produced humorous drawings for the illustrated newspapers, notably *L'Assiette au beurre*, *Le Charivari* and *Le Cri de Paris*. The work left him little time for painting and it was not until around 1911 that he was free to devote himself to serious art.

Just 24 years old, and without any real training, Gris did not at first aim at a personal aesthetic, but was content, instead, to follow in the footsteps of Picasso and Braque, whose experiments he had noted (all three had stayed in Céret together in 1911) and whose views he shared. His first paintings, in 1911, were concerned with the problem of light (*Le Livre* [*The Book*], Paris, Michel Leiris Coll.; *Portrait de Maurice Raynal*, Paris, private coll.; and *Natures mortes* [*Still Lifes*], New York, M.O.M.A., and Otterlo, Kröller-Müller). It was not until the following year that he began to incorporate in his work recognizably Cubist features, such as upsetting the foreground and presenting a multiple viewpoint (*Hommage à Picasso*, Chicago, Art Inst.; *Guitare et fleurs* [*Guitar and Flowers*], New York, M.O.M.A.). By the summer of 1912, however, he had fully embraced the Cubist principles.

Though he is often cited as the most orthodox of the Cubists, Gris never entirely relinquished his individuality. His painting differs from that of his imitators in its highly personal use of colour and its bolder composition. Refusing to give 'local colour' an exclusive worth, he was content merely to present an idea of the subject (except for certain objects which defy analysis, such as a mirror, print or a reproduction of a painting, which would be introduced unaltered into the composition). He used fresh, lively colours, sometimes in contrasting tones (*Le Fumeur* [*The Smoker*], 1913, New York, Armand P. Bartos Coll.; *Le Torero* [*The Bullfighter*], 1913, Key West, Mrs Ernest Hemingway Coll.; and *Les Trois Cartes* [*Playing Cards*], Bern Museum, Rupf Foundation). When he showed the same object from several different viewpoints he united these in a single image rather than presenting them separately. The rigorous plasticity of various representative elements did not, however, exclude feeling.

From late 1914 onwards, and particularly in the collages (*La Bouteille de Banyuls*, Bern Museum, Rupf Foundation; *Nature morte aux roses* [*Still Life with Roses*], Paris, location unknown; *Nature morte* [*Still Life*], Otterlo, Kröller-Müller; *Nature morte au verre de bière* [*Still Life with Beer Mug*],

Chicago, Samuel A. Marx Coll.), it is possible to sense a growing dissatisfaction with analytic methods and a move towards a more synthetic way of working in which objects are wherever possible reduced to their permanent components.

.This new vision crystallized in the fine *Nature morte au livre, à la pipe et aux verres* (*Still Life with Book, Pipe and Glasses*) (1915, New York, Ralph F. Colin Coll.). The transition from one method to the other did not, in fact, take place overnight. Many of the canvases executed between 1915 and 1917 betray Gris's hesitation about which course to follow. Sometimes he seems to lose sight of an object, concentrating instead on the composition of a picture (*Nature morte ovale* [*Oval Still Life*], 1915, Paris, private coll.; *La Place Ravignan*, 1915; *La Lampe*, 1916, Philadelphia, Museum of Art, Arensberg Coll.; *Violon*, 1916, Detroit, Isadore Levin Coll.).

At other times he comes back to the object but, in his desire to avoid the difficulties of analysis, gives only a sketchy representation, verging sometimes on the stylized (*Nature morte au poème* [*Still Life with Poem*], 1915, Radnor, Henry Clifford Coll.; *Violon*, 1916, Basel Museum; *Nature morte aux cartes à jouer* [*Still Life with Playing Cards*], 1916, St Louis, Missouri, Washington University Art Gal.; *L'Échiquier* [*The Chess Board*], 1917, New York, M.O.M.A.). It was not, in fact, until early 1918 that he felt he had mastered the new synthetic method.

It will be seen from this that the war years were decisive for Gris. They were a time of unceasing work, despite sometimes acute financial problems – for his dealer Kahnweiler, as a German subject, had not been allowed to return to France, and Gris, feeling himself still bound by his contract, for a long time refused to sell to others. Nonetheless, he produced some superb paintings during this time. His work between 1918 and 1920 is remarkable for its powerful architectural plasticity and purity of expression (*Nature morte au compotier* [*Still Life with Fruit Bowl*], 1918, Bern Museum, Rupf Foundation; *Guitare et compotier* [*Guitar and Fruit Bowl*], 1919, Paris, private coll.; *Guitare et bouteille* [*Guitar and Bottle*], 1920, Nice, private coll.).

In contrast, the period from 1921 to 1923 is marked by a new-found lyricism and a heightened use of colour (*Le Canigou*, 1921, Buffalo, Albright-Knox Art Gal.; *Devant la baie* [*In Front of the Bay*], 1921, Cambridge, Massachusetts, Gus-

tave Kahnweiler Coll.; *Le Cahier de musique* [*The Music Score*], 1922, New York, Marie Harriman Gal.; *Arlequin assis* [*Seated Harlequin*], 1923, New York, Herschel Carey Walker Coll.).

The works of the last three years of Gris's life are probably his best, and in many ways represent the high point of Cubism. In fact, Gris's methods mark the ultimate expression of the long epistemological search begun by Picasso in 1906. Although the latter was undoubtedly the creator of the new method, which he employed from 1913 onwards, he was, as always, eager to move on to new discoveries and contented himself with producing the solution without ever seeking to elaborate it.

Thus it was Gris who, having taken it over, refined and enriched it to the point where it became, in a sense, his own property. Instead of enumerating the various aspects of an object in the manner of analytical Cubism, the painter aimed to grasp intuitively the essence of an object, that which makes it what it is and renders its existence possible. Certain features of an object – the colour of a glass, the material from which a pipe is made – vary. Others are intrinsic and affect the very possibility of the object's being. These simply cannot be changed. And it was these intrinsic elements alone that Gris retained from now on.

However, the problem of method was aggravated by a problem of 'visualization'. During his analytical period Gris made a visual study of an object in order to arrive at its structure. Now, he began with the structure to arrive at the object. His description of his method has become familiar: 'Cézanne made a cylinder out of a bottle. I start from the cylinder to create a special kind of individual object. I make a bottle out of a cylinder.' Similarly, a white parallelogram becomes the page of a book or a sheet of music; a rectangle becomes a table; an oval, a pear or a lemon; two trapezia facing each other, a guitar. From a straight line, which suddenly curves, emerges a pipe; a wavy line becomes the edging of a tablecloth. This is what Gris called 'qualifying objects'.

The paintings dating from this later period are the outcome of a perfect balance between the richness of their spiritual content and the dictates of structure. They bear the stamp of a private poetry and a controlled feeling (*La Table du Peintre* [*The Painter's Table*], 1925, Heidelberg, Reuter Coll.; *Le Tapis bleu* [*The Blue Carpet*], 1925, Paris, M.N.A.M.; *Guitare et feuillet de musique* [*Guitar and Music Score*], 1926, New York, Daniel Saidenberg Coll.; *Guitare jaune* [*Yellow Guitar*], 1926, Paris, private coll.; and *Compotier et livre* [*Fruit Bowl and Book*], 1927, Lund, Sweden, Sandblom Coll.). These works are among the masterpieces of the Cubist movement.

A striking serenity emerges from these paintings; yet they were executed at a time when Gris's health was growing daily worse and making any effort painful. In 1920 he had suffered an attack of pleurisy as the result of his hard and impoverished life, and, despite frequent journeys to the south of France, he never completely recovered. He died on 11th May 1927 at Boulogne-sur-Seine where he had lived since 1922. Against the physical distress of his final years, however, could be set the knowledge of his growing fame among art-lovers and critics alike.

Besides his other work, Gris also executed 34 lithographs and etchings, mainly illustrations.

G.H.

▲ Juan Gris
Hommage à Picasso (1912)
Canvas. 93 cm × 74 cm
Art Institute of Chicago

Gros
Antoine Jean
French painter
b.Paris, 1771 – d.Meudon, 1835

The son of a miniaturist, Gros entered David's studio at the age of 15 and in 1787 also began studying painting at the Royal Academy. Neoclassicism, however, awoke little response in him and he was drawn instead towards the work of Rubens. *Antiochus et Éléazar* (St-Lô Museum), Gros's unsuccessful entry for the 1792 Prix de Rome, is unusually Baroque for the period. There is a violence in the attitudes of the figures, which was to remain typical of his work.

Fearing that he might be denounced for his moderate opinions, Gros left Revolutionary Paris early in 1793 and spent the next eight years in Italy, first in Genoa, then in Milan. A short stay in Florence was particularly rewarding. Surviving albums of sketches show the wide range of his interests: side by side with copies from classical antiquity are sketches after Masaccio, Andrea del Sarto, Pontormo, and Rubens, subjects drawn from a catalogue of ancient vases published by J. W. Tischbein, and drawings after Flaxman.

For his own compositions Gros chose subjects such as *Malvina Mourning Oscar*, taken from Ossian, or *Young Mourning his Daughter* – themes which illustrate the pre-Romantic vogue. His only finished paintings, however, are portraits, of which he painted a large number, mainly of members of Genoese society, including *Madame Pasteur* (Louvre), the wife of a French banker.

At the end of 1796 Gros accompanied Joséphine de Beauharnais, who had been staying in Genoa, to Milan where he painted his famous *Bonaparte au pont d'Arcole* (Bonaparte at Arcole) (Versailles; sketch in the Louvre). He was appointed to the commission responsible for choosing works of art to be sent back to France and travelled throughout Italy, visiting Rome in the spring of 1797.

On his return to Paris in 1801 he exhibited his *Sappho à Leucate* (*Sappho at Leucadia*) (Bayeux Museum), a painting which he had begun in Italy and which, with its theme of suicide, allied to the nocturnal gloom of the landscape, typifies the young painter's Romantic leanings. But his main works were concerned with a different kind of Romanticism.

Around this time Gros submitted a sketch of *La Bataille de Nazareth* (Nantes Museum) as part of an exhibition that the Louvre was devoting to this theme. The jury's decision in his favour provoked a scandal. His vivid use of colour was seen as a return to the *genre gracieux* of the 18th century and not as something new. However, with *Les Pestiférés de Jaffa* (*The Plague Victims of Jaffa*) (Louvre), exhibited at the 1804 Salon, Gros firmly established his reputation as the greatest colourist of the French school.

He followed this, at the 1806 Salon, with *La Bataille d'Aboukir* (Versailles). The composition is in the form of a frieze dominated by a monumental figure, but displays a bold disregard of balance and a feeling for movement unheard of at this time.

In 1807 Gros won another competition with his *Bataille d'Eylau* (Louvre), which was exhibited at the Salon of 1808. Napoleon is depicted in a human light, riding through the field of battle after the engagement. The Emperor's pale features pleased the Romantic sensibilities of the public, although at the same time they were disturbed by the dead and wounded in the foreground of the painting. Such realism cannot, in Gros, be construed as a protest against war; rather, it was the Romantic's search for powerful means of expression.

Gros's attitude towards his art differed from that of younger painters such as Géricault and Delacroix. He worked almost exclusively to commission, never from any inner motivation or search for perfection. Nor was he dependent on inspiration. To the astonishment of Delacroix, he could paint by the clock. But his drawings and paintings have an energy of colour and movement

(*Alexandre domptant Bucéphale* [(*Alexander Taming Bucephalus*], Paris, private coll.) which betray his Romantic temperament.

In the conflict between Romantics and classicists during the 1820s the term 'Romantic', the interpretation of which was always vague, was applied to anything that turned its back on the ancient world in favour of greater realism. With his *Bataille de Nazareth*, Gros took up his position outside the classical tradition. Although Napoleon's policy favoured contemporary subjects, Gros was the only official artist to make this domain his own. What is most original and Romantic in Gros is his realistic portrayal of dead soldiers, plague victims, or fighting men. When Romanticism triumphed, its supporters paid homage to Gros and he was bracketed with Géricault and Delacroix.

With the restoration of the Bourbons official taste veered towards religious and historical themes, and the paintings on contemporary themes which Gros exhibited at the Salons of 1817 and 1819, such as *Louis XVIII quittant le palais des Tuileries* (*Louis XVIII Leaving the Palace of the Tuileries*, Versailles), no longer had the same appeal as those painted in Napoleon's day.

The period saw a revival of academicism, and, influenced by the exiled David, whose pupils he had inherited, Gros returned to a more classical style. At the Salon of 1822 he exhibited *Saul* and *Bacchus et Ariane*. In 1824 he completed the painting of the cupola of the Pantheon, which he had been commissioned to do in 1811 and for which Charles X made him a baron. His social standing was never higher, but at the same time his creative spark was almost gone. He was a professor at the École des Beaux Arts, a member of the Institut and honorary member of several foreign institutions, yet official recognition did not prevent him from drowning himself in the Seine on 26th June 1835.

He had for long cherished the illusion that he alone stood for truth at a time of artistic decadence, and when this vision faded he came to understand the anachronistic quality of his art and the justification for the violent criticism directed against his *Hercule et Diomède* (Toulouse Museum), exhibited at the 1835 Salon. M.Br.

Grünewald
Mathias
(Mathis Gothart Nithart)
German painter
b.Würzburg, 1445/50 or 1475/80 – d.Halle, 1528 or 1531/2

The problem of Grünewald's identity. The name Grünewald did not become current until 1675 when Joachim von Sandrart attached the name 'Grün' to the initials 'MG' found on the famous *Isenheim Altarpiece* (Colmar, Unterlinden Museum). The Aschaffenburg archives reveal that in 1489 a 'Meister Mathis' painted the iron cross on the tower of the chapel of St Elisabeth's Hospital; his presence there is recorded between 1480 and 1490. For 11th November 1500, the archives at Seligenstadt near Frankfurt further record the name of 'Meister Mathis'. He reappears the following year and in 1502 there is mention of a 'Meister Mathis, Bildschnitzer' ('sculptor'). The accounts for this same town include

▲ Antoine Gros
Bonaparte visitant les pestiférés de Jaffa
Canvas. 523 cm × 715 cm
Paris, Musée du Louvre

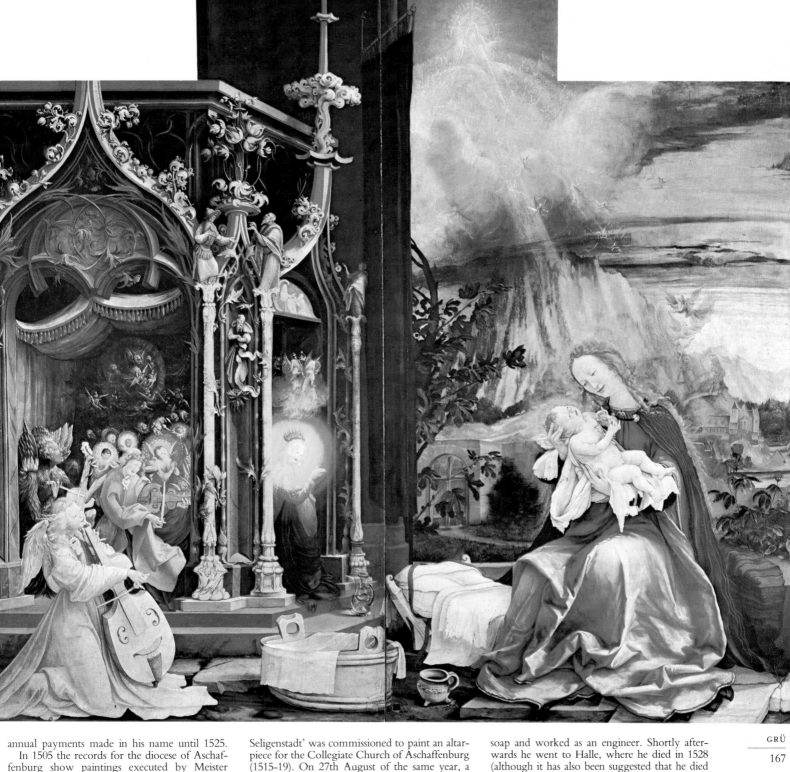

annual payments made in his name until 1525.

In 1505 the records for the diocese of Aschaffenburg show paintings executed by Meister Mathis in honour of the curate Jean Ritzmann who had died the previous year. Mathis had entered the service of the Bishop of Mainz, Uriel von Gemmingen, who lived in Aschaffenburg, not only as painter but also as general overseer.

In 1510 a certain 'Master Mathis Nithart', known as 'Gothart von Würzburg', is listed as *Wasserkunstmacher*, ('waterworks engineer'). Between 1514 and 1516, a long-drawn-out lawsuit in Frankfurt-am-Main brought him renewed publicity. Earlier he had delivered to the Dominicans in this city the *Heller Altarpiece* (1509) and a panel (1511). On 15th August 1514, 'Meister Mathis of Seligenstadt' was commissioned to paint an altarpiece for the Collegiate Church of Aschaffenburg (1515-19). On 27th August of the same year, a protocol from the chapter of Mainz Cathedral gives the terms of a petition addressed by 'Meister Mathis Gothart, the painter and stonecutter'.

It has been established that Grünewald finished the *Isenheim Altarpiece* in 1516, the year in which the preceptor of the Antonites in Colmar died. The artist returned to Aschaffenburg that same year and entered the service of Cardinal Albrecht of Brandenburg, successor to Uriel von Gemmingen and Grünewald's patron. In 1526, in the aftermath of the Peasants' War and the Reformation, Grünewald fell out of favour with the cardinal and settled in Frankfurt, where he manufactured soap and worked as an engineer. Shortly afterwards he went to Halle, where he died in 1528 (although it has also been suggested that he died in 1531 or 1532 in the Odenwald region while in the service of Archbishop von Erbach).

Together, these facts give substance to the painter's personality, even though it cannot be proved that they all refer to one and the same man. There is a possibility, too, that the face in the *Portrait of a Young Man*, signed 'MN' and dated 1475 (Chicago, Art Inst.) is that of Grünewald himself because of its resemblance to the rather older face of *St Sebastian* in the *Isenheim Altarpiece*. If this is in fact the case, Grünewald must have been born between 1445 and 1450 and have died some 80 years later.

▲ Mathias Grünewald
The Incarnation of the Son of God
Wood. 265 cm × 304 cm
(panels from the Isenheim Altarpiece)
Colmar, Musée d'Unterlinden

Grünewald's known work. The catalogue of Grünewald's generally accepted work goes as follows.

1503. Wings of the altarpiece (triptych) in Linderhardt Church, near Bayreuth, taken from the church at Bindlach (1685); central panel, carved; wings, painted on two panels with *Fourteen Helpers in Need*; *The Mocking of Christ* (Munich, Alte Pin.), probably donated by John of Kronberg to the Aschaffenburg Church in memory of his sister Apollonia who died in December 1503.

After 1503. The *Crucifixion* in Basel Museum; part of a panel for an altarpiece which has been in various collections since 1775.

1509. Two wings from the *Heller Altarpiece*, donated in 1509 to the Dominican church of Frankfurt-am-Main by Jacob Heller. The pieces, painted in grisaille by Grünewald, are divided between the Karlsruhe Museum (*St Elizabeth, St Lucy*) and the Städelsches Kunstinstitut in Frankfurt (*St Laurence, St Cyriacus*).

After 1509. The *Crucifixion* (Washington, N.G., Kress Coll.), formerly in Duke William V of Bavaria's collection, signed 'MG.' Fifteen copies have been identified.

1511-16. The *Altarpiece* of the church of the monastery of the Antonites at Isenheim, Alsace, with the central part carved by Nicholas of Hagenau in 1505 (the carver's identity has recently been contested), during the time of the Preceptor, Jean d'Orliac. The altarpiece was placed at the rear of the canons' choir, behind the rood-screen. Sick members of the congregation could see the dominating presence of the great St Anthony.

The two fixed wings, the predella and the four moving panels were commissioned from Mathis Nithart by the Preceptor of the Antonites, Guido Guersi. A *Lamentation of Christ* occupies the predella. The front of the left wing is given to *St Anthony* and the right to *St Sebastian* (the order was reversed in 1966). On the central panel the *Crucifixion* is framed by the *Virgin, St John the Baptist* and *Mary Magdalene* (the date 1515 appears

on the jar of ointment carried by the latter). On the second surface, the *Annunciation* (left) and the *Resurrection* (right) frame the *Nativity* in accordance with the symbolic concept of St Bridget of Sweden. On the third surface, the left wing tells the story of the meeting between the *Holy Hermits, St Anthony and St Paul*. St Anthony bears the features of Guido Guersi. *The Temptation of St Anthony* hangs to the right; the central panel is carved.

This altarpiece, Grünewald's most important work, was inspired by the *Revelations* of Bridget of Sweden and, it would also appear, by Ludolph of Saxony and St Bonaventura. It reveals the theological preoccupations of Guido Guersi and an experience of hospital life which the artist must certainly have acquired among the sick of Isenheim.

1519. The altarpiece (triptych) of the *Miracle of the Snow* (*Maria-Schnee-Altar*) from Aschaffenburg Church, commissioned from Meister Mathis in 1514 by Canon Heinrich Ritzmann. The frame, which is still preserved *in situ*, carries the name of the donors Heinrich Ritzmann and Kaspar Schantz, as well as the date 1519 and the monogram 'GMN' (Gothart Mathis Nithart). Of this work there remains only one of the wings (*The Miracle of the Snow*, Freiburg-in-Breisgau Museum) and a panel (*The Virgin of Stuppach*), probably by Grünewald, which was kept at Bad Mergentheim in Württemberg until 1809 before being bought by Stuppach.

1525. *St Erasmus and St Maurice* (Munich, Alte Pin.) was mentioned in 1525 in the inventory of Halle Collegiate Church and transported around 1540 to Aschaffenburg by Cardinal Albrecht of Brandenburg. St Erasmus's features are those of the Cardinal.

After 1525. The *Carrying of the Cross* and, on the reverse, the *Crucifixion* probably came from the parish church of Tauberbischofsheim (Karlsruhe Museum); front and obverse of a panel cut in 1883; *The Lamentation of Christ* (Aschaffenburg Church), probably the predella of a large altar-

piece, with the arms of Cardinal Albrecht and of Archbishop Dietrich von Erbach.

Thirty-six drawings, all of high quality, and all studies for paintings (Karlsruhe, West Berlin, East Berlin, Dresden, Weimar, Stockholm, Erlangen and Oxford museums; Albertina and Louvre) also form part of the Grünewald catalogue and often confirm attributions. The drawings discovered after the Second World War near Marburg, on the other hand, lack this degree of certainty.

Grünewald's art. The works that can be definitely attributed to Grünewald reveal him as an exceptional figure, although not a completely isolated one, for the work of Gossaert in Flanders and of Masaccio in Italy, for example, sometimes bears close resemblances. But Grünewald seems never to have borrowed from others, and to have passed on only a little to his successors. The facts concerning his apprenticeship are obscure in the extreme. He may have been born around 1480, not far from Aschaffenburg, into a family of modest means. He may have acquired the rudiments of his craft in the studio of Hans Fyell, about the time when the elder Holbein was painting the altarpiece in the Dominican church. Another view is that he was a pupil of Dürer's. But whoever he studied with, he was not much influenced by them, and equally, he formed no new school.

There are no known pupils, no imitators – although some of the woodcarvings and works in gold and silver from Halle Cathedral (now in Munich, Alte Pin.) may have been inspired by Grünewald's *St Erasmus and St Maurice*. It is possible, too, that certain painters and engravers could, through an occasional similarity of detail, be described as his followers. The author of the Marburg drawings comes into the latter category. The violent expressiveness, the sometimes rather abstract brilliance of forms, the magic of light and colour, together with the highly personal spirituality of these works suggest a most unusual character, and an artist on the outside of established tradition. V.B.

Guardi
Francesco
Italian painter
b.Venice, 1712 – d.Venice, 1792

Guardi's early work cannot be dissociated from that of his brother Gian Antonio, his elder by several years, who directed a well-known studio in Venice. To begin with, Guardi worked with his brother, gradually become more independent until, following Gian Antonio's death in 1760, he took over the workshop. Like him he specialized in painting figures or historical subjects, but a swift, incisive touch and a new sensitivity to atmosphere, linking people with their surroundings, soon became apparent in such youthful works as *Faith* and *Hope* (1747, Sarasota, Ringling Museum), with their shimmering figures set in vast, luminous landscapes.

These qualities reappear in *The Miracle of a Dominican Saint* (c.1765, Vienna, K.M.) with its swift, broken strokes, small figures painted from life, and greenish-blue atmosphere. Critical opinion remains divided as to which of the two

▲ Gian Antonio Guardi
The Departure of Tobias
Canvas. 78 cm × 87 cm (organ case)
Venice, Church of Angelo Raffaele

Guardi brothers painted the *Scenes from the Life of Tobias* in the Cantoria of the Church of the Angelo Raffaele in Venice. The free and impressionistic treatment, the silvery atmosphere closely linking people and landscape, and the violent reds certainly recall something of Francesco Guardi's historical paintings, as well as his famous *vedute* (views).

Guardi, in fact, owed his fame largely to his talent for painting views, and they ensured him a leading place, if not in Venice, then abroad, where his works were eagerly sought after. Influenced first by Marco Ricci, whose style can be discerned in such youthful works as the *Fantastic Landscape* in the Hermitage, probably painted before 1750, he then came under the influence of Canaletto; but to his *Views* of Venice and the lagoon he brought a wholly original interpretation, as can be seen in his *Piazza S. Marco* (London, N.G.). Although the composition is clearly in the style of Canaletto, the colour, as has been noted, takes on a new and more active role, shading off into the light.

The series of twelve paintings known as the *Feste Dogali*, based on prints by Brustolon (1766), date from around 1770. Dispersed among many galleries (Louvre, Brussels [M.A.A.], Nantes and Grenoble), these paintings are *vedute* in which actual events (the coronation festivities for the Doge Alvise IV Mocenigo in 1763) serve as a pretext for the depiction of a number of the sights of Venice, rendered with a great feeling for space and luminosity. Bathed in a continuously mobile play of light, the image loses its firmness and dissolves into something fantastical and fleeting. Of this series, *The Doge on the Bucentaur* (Louvre), in which the outlines are clearly visible among the vivid glow of colour, is of particular interest.

Guardi alternated these official views with his famous series of *Capricci*, in which the luminosity gradually becomes brighter and a more straightforward realism, in the manner of Ricci, makes its appearance. In the *Capriccio on the Lagoon* (Metropolitan Museum), which unfolds beneath a watery sky, the painter lingers over patched sails and cracked walls, blending realism and fantasy.

In 1782 Guardi turned once again to depicting the formal aspects of Venice in two series of paintings. Among the first, *The Gala Concert* (Munich, Alte Pin.) is painted in muted greens and browns, but enlivened by scattered lights and countless sparks of fire. In the second series, painted in honour of Pope Pius VI, the fantastic perspective of the interiors creates a moving sense of emptiness, as in *Pontifical Ceremony in the Church of SS. Giovanni e Paolo* (Cleveland Museum), where twilight figures move through the naves of the church. The more subdued colours of these late works reflect the change in Guardi, now grown introspective and solitary, a change that is particularly evident in the Uffizi *Capriccio*, in which the content seems to have dissolved into a poetic evocation of deep nostalgia. F. d'A.

There are over 1,000 paintings by Guardi in existence. Most of the major galleries of Europe and the United States have one or more of his views of Venice, or Mestre, or of his *Capricci*. Apart from the works mentioned above and those in the Venice galleries, there are particularly fine landscapes in the Poldi-Pezzoli Museum, Milan; the Gulbenkian Foundation, Lisbon; the Nissim de Camondo Museum, Paris; the National Gallery, London; the Metropolitan Museum; the Vienna Akademie; the Cagnola Foundation, Gazzada; the Thyssen Collection, Lugano; and the Accademia Carrara, Bergamo.

Guardi's graphic work includes figures, decorative projects, *macchiette* (caricatures) and views. The lightness of the wash and vivacity of the penwork animates every page, producing unexpected effects of luminosity and atmosphere. L.E.

Guardi
Gian Antonio
Italian painter
b.Vienna, 1699 – d.Venice, 1760

For long eclipsed by the fame of his younger brother Francesco, Gian Antonio Guardi has recently undergone a critical re-estimation. A member of the Venice Academy from the time of its foundation in 1756 (possibly on the recommendation of his brother-in-law, Tiepolo) he is known to have been commissioned between 1730 and 1745 or thereabouts by Count Johann von der Schulenburg to execute a number of copies from the masters (Veronese, Sebastiano Ricci, Solimena, Van Loo). They include: a *Last Supper* (after Ricci) in Saale Museum; portraits of *Philip V*, *Elizabeth Farnese* and *Ferdinand of Spain* (after Van Loo) in the Schulenburg Collection in Hanover; and *Alexander before the Army of Darius* (after Langetti) in the Pushkin Museum in Moscow.

Identifying his other works is a delicate task, but it is now generally agreed that most of the figures formerly attributed to Francesco Guardi were in fact the work of Gian Antonio, with occasional help from his younger brother. This means that Gian Antonio's catalogue now includes the signed *Death of St Joseph* (East Berlin, Bode Museum), altarpieces with the *Virgin and Saints* in the church of Vigo d'Anaunia (inspired by Solimena), the church of the Belvedere di Aquileia (inspired by Ricci) and in the church of Cerete Basso (inspired by Veronese), as well as *The Vision of St John of Matha* (Pasiano Church), decorative panels (*Aurora, Neptune, Cybele, Mars*, ceiling, Venice, Cini Coll.), easel paintings (*Turkish Scenes*, Lugano, Thyssen Coll.) and narrative cycles. These illustrate *Jerusalem Delivered* (London, private coll.), scenes from the *History of Rome* (Oslo, Bogstad Villa) and the *Story of Joseph* (Milan, private coll.).

Critical opinion remains divided concerning the attribution to Gian Antonio or to his brother Francesco of the scenes depicting the *Story of Tobias*, which decorates the organ of the Church of the Angelo Raffaele in Venice. It has been described as one of the masterpieces of 18th-century Venetian painting. Curiously, a good number of these paintings are freely transcribed or borrowed compositions from contemporary painters or from the old masters, but they bear the mark of Gian Antonio's own originality and pictorial fantasy – the product of an extreme virtuosity of touch, always light and effervescent, and of his luminous colours. L.E.

Guercino
(Gian Francesco Barbieri)
Italian painter
b.Cento di Ferrara, 1591 – d.Bologna, 1666

Guercino was born in the province of Ferrara, which at that time looked to Venice for artistic leadership, and in his youth was much impressed by the achievement of Ferrara painting, and by Dosso Dossi in particular. In spite of this he very soon found himself attracted by the developments in nearby Bologna, where the Carracci had already made a name for themselves as innovators. Guercino especially admired Lodovico Carracci,

▲ Francesco Guardi
The Doge on the Bucentaur
Canvas. 67 cm × 100 cm
Paris, Musée du Louvre

whose altarpiece painted for the Church of the Cappuccini he had been able to see in Cento itself. This painting had a marked influence on the development of his style, in particular the vibrant use of paint, supported and linked by invisible lines which govern the composition without interrupting the viewer's visual imagination. He continued, however, to live in his native city, apart from brief absences, until 1642, leading a simple life, dedicated to his art which for Guercino was the expression of sincere and strongly felt sentiments, without intellectual pretensions or regard for established rules.

By 1618 he had developed sufficient command of his technique to produce a succession of masterpieces in the years immediately following. Of these *St William of Aquitaine* (1620, Bologna, P.N.), *St Francis in Ecstasy and St Benedict* (Louvre), *The Burial of St Petronilla* (1622/3, Rome, Gal. Capitolina) and the frescoes, including *Night* and *Dawn* (1621, Rome, Casino Ludovisi), are outstanding. The splashes of light that he used, in the Venetian manner, to pick out areas of warm colour give these works a subjective naturalism comparable only with the tragic, lucid masterpieces of Caravaggio. Like Caravaggio's this was a concept of art based on imitation of nature and although Guercino's supple, undulating style set him apart from the great Lombard master, Caravaggio's influence is plain in some of the settings that Guercino employed in such paintings as *The Prodigal Son* (Vienna, K.M.) or *The Betrayal of Christ* (Cambridge, Fitzwilliam Museum).

However, a stay in Rome (between 1621 and 1623) as part of the entourage of Pope Gregory XV led Guercino to a study of classicism, at that time supported by such noted Bolognese painters as Domenichino and Guido Reni. On his return

to Cento, he sought to temper his pictorial impetuosity by strict adherence to the rules of draughtsmanship, by a study of composition in keeping with classical aesthetics, and by the gradual elimination of the *macchia*, that is, of the creation of figures and objects, clouds or landscapes by means of contrasts of light and shade which had characterized his youthful work and were the main reason for his early fame.

This suppression of his natural tendencies led to the appearance, in most of Guercino's later works, of some of Reni's most academic features. At his most successful, however, Guercino was able to use them to sustain a style which, in its formal clarity and homogeneity, as much as in its classical monumentality, resembles the best of Sassoferrato. Among the most notable examples are *Christ Appearing to the Virgin* (1630, Cento, Pin.) and *The Mystic Marriage of St Catherine* (1650, Modena, Pin. Estense). These were works of great nobility which look as though they were conceived in the France of Louis XIII but, in fact, are by the hand of an artist who spent almost the whole of his life in the small town of Cento, refusing personal invitations from the kings of England and France and whose travels (with the exception of a brief trip to Venice and his two-year stay in Rome) were confined to the region of Emilia.

Apart from his considerable output of paintings, Guercino also left a large number of drawings which have been much sought after since his own day (Windsor Castle; British Museum; Albertina; Louvre; Uffizi; Haarlem, Teyler Museum; London, Mahon Coll.; Faschenfeld, Koenig-Faschenfeld Coll.). Because of the spontaneity encouraged by the medium, even the late drawings continue to display the naturalism of Guercino's earlier period. E.B.

Hals
Frans

Dutch painter
b.Antwerp (probably), c.1581 – d.Haarlem, 1666

Life. By 1591 the Hals family had already moved to Haarlem, as is shown by the fact that Frans's brother Dirck was baptized there that year. Some time between 1600 and 1603 Frans studied under the painter Carel van Mander. Van Mander's Italian culture and Mannerist style probably failed to influence Hals very deeply, since he never went to Italy as part of his training, although this was normally expected among the Haarlem Mannerists. Hals's earliest known works date from around 1610, at which time he was a member of the Guild of St Luke in Haarlem.

Although he was then approaching 30, no work prior to this has yet been attributed to him. His first son, Harmen, who also became a painter, was baptized in 1611. He had eight more children from his second marriage. His first important commission, *The Banquet of the Officers of the Archers of St George*, dates from 1616. In 1633, he was chosen to execute the portrait of the *Company of Captain Reynier Reael* (1637, Rijksmuseum), to be delivered to Amsterdam. In 1641 came a new commission: *The Governors of the St Elizabeth Hospital in Haarlem* (Haarlem, Frans Hals Museum). By 1644 Hals was on the council of the Haarlem guild.

Hals's life took a turn for the worse in 1654 when his assets were seized. In 1662 he was obliged to ask for help from the municipality and the following year an annuity of 200 guilders was granted him for life. Around 1664, when he was over 80, Hals painted moving studies of the *Men-Governors* and the *Lady-Governors of the Old Men's Home at Haarlem* (both Haarlem, Frans Hals Museum). His old age was similar to that of Rembrandt, both men dying penniless. On 1st September 1666 he was buried in the choir of St Bavon's Church in Haarlem.

Style and early works. Hals's training with Van Mander brought him into contact with the Haarlem Mannerists and through them he came to know the engravings of Goltzius, and Cornelisz's early paintings of trade guilds in which he originated the tradition of depicting figures from the waist up, a feature which often leads to overcrowding or too systematic a composition. Hals soon left behind any Italian influences and sought instead the highest degree of objective realism. Like Van der Helst, Ravesteyn and many of his contemporaries, Hals is the painter of the 17th-century Dutch bourgeoisie, depicting them in vast patriotic compositions such as various *Banquets*, as well as in individual portraits, with an accuracy that makes no attempt to look beyond the physical presence. His true genius lies in a new freedom of handling, a highly personal use of colour, and a bold concept of textures, hues and light, all drawn together by a masterly touch.

Hals's work consists of a great number of signed and dated portraits. The first of these are from around 1610: *Portrait of Jacobus Zaffius* (1611, Haarlem, Frans Hals Museum) and a *Man Holding a Skull* (Birmingham, Barber Inst.). These still have something of the stiffness that characterizes such 16th-century painters as Cornelis Ketel, Anthonis Mor or Dirck Barendsz, but show, too, that by now Hals had broken with Mannerism and had found the essence of his own style through his confident mastery of the technique of depicting flesh colours in tones of crimson or pure, cold white.

The Banquet of the Officers of the Archers of St George (1616, Haarlem, Frans Hals Museum) is conventional in its subject matter and composition and, in fact, resembles a painting on the same subject by Cornelisz van Haarlem. Although the composition is still a little disjointed, Hals has nonetheless abandoned the set images of his predecessors, and introduced a general feeling of animation and a new spatial awareness – created by the oblique poses and the use of diagonals – as well as the occasional bold and powerful brushstrokes. Only now was he able to capture that spontaneity of pose and expression which makes him second to none in his portraits painted from life.

The charming *Child with his Nursemaid* (c.1620, Berlin-Dahlem) does not have the sickly look of Velázquez's *Infantas*. Models do not 'pose' for Hals. Instead, he catches each one in the style which best suits his temperament. At the same time Hals never repeats a pose exactly. He worked at his palette to achieve the rich blacks, with their reflected lights, and the paler tones which stand out so vividly in masterpieces such as *The Laughing Cavalier* (1624, London, Wallace Coll.), the *Portrait of Isaac Massa* (1626, Toronto Museum) or that of *Willem van Heythuyzen* (Brussels, Musée Royal des Beaux Arts).

Character portraits. In the years from around 1620-5 to 1630, Hals painted his great series of character portraits. These include the *Buffoon Playing the Lute* (Paris, Rothschild Coll.), *The Merry Drinker* (Rijksmuseum), *The Bohemian Girl* (c.1628-30, Louvre), the disturbing *Malle-Babbe*, an old witch with an owl (Berlin-Dahlem), *Peeckelhaering* (Kassel Museum), the so-called *Mulatto* (Leipzig Museum), *Two Young Musicians* (Kassel Museum) and *Two Children* (Rotterdam, B.V.B.). These themes are the only ones that Hals borrowed from the Utrecht followers of Caravaggio. Their boldness is evident in the swift brushstrokes that effortlessly convey light, colour and animation. The medium is never thick, always varying between the light and smooth and the free-flowing, built up in layers.

Hals was not always entirely successful with his compositions: his search for animation occasionally resulted in a lack of order, as in *The Banquet of the Officers of the Archers of St Hadrian* (c.1627, Haarlem, Franz Hals Museum). But from around 1630 or 1635 Hals sought to simplify his compositions and to smooth out the contours; the backgrounds become darker and the colours even stronger. *The Reunion of the Officers of the Archers of St Hadrian* (c.1635, Haarlem, Frans Hals Museum) is devoid of movement: only the inclination of the heads and torsos animates this long, horizontal and static work. Here, too, Hals attempted a background of landscape, but its dark hues make it very unlike the kind of open-air

landscape we expect nowadays. Probably this conventional setting was the work of a pupil, like that in *The Officers of the Archers of St George* of around 1639 (Haarlem, Frans Hals Museum).

Final period. *The Governors of the St Elizabeth Hospital in Haarlem* (1641) foreshadows the change of style of Hals's last compositions. The influence of Rembrandt can be seen in the slanting play of light and especially in the tenser atmosphere, in a tauter, more introspective style. The colours in Hals's final paintings, although undimmed, are reduced to a pure silvery white and deep blacks interspersed with subtle tints, as in the *Portrait of a Man* (1633) in the National Gallery, London, and a similar work in the Metropolitan Museum, the *Portrait of Joseph Coymans* (1644, Hartford, Connecticut, Wadsworth Atheneum) and of his wife *Dorothea Berck* (1644, Baltimore Museum of Art), the portrait of *Stephanus Geraerdts* (Antwerp Museum) and of his wife *Isabella Coymans* (Paris, Rothschild Coll.).

Hals, now very old, played more and more with the contrast between black and white, and the contours tend to become blurred, as in the *Portrait of a Man* in the Musée Jacquemart-André in Paris, and those of the Kassel or Mauritshuis museums (1660), or in the portrait of *W. Cross* (Munich, Alte Pin.). At the same time, the objectivity which had formerly been his chief characteristic gives way to an expressionistic tendency, to an inner tension which makes the paintings of

the *Men-Governors* and *Lady-Governors* (both 1664), especially the latter, so very striking.

In the 19th century it was Hals whom avantgarde painters, particularly Manet, quoted as their authority for their audacious technique. His pupils included Pieter Codde, Jan Miense Molenaer and possibly Judith Leyster, but only Adriaen Brouwer, who frequented his studio in 1628, managed to achieve a personal style worthy of the genius of Frans Hals. P.H.P.

Hamilton
Gavin

Scottish painter
b.Lanarkshire, 1723 – d.Rome, 1798

Born in Lanarkshire, Hamilton eventually settled in Rome where he became an important influence on the development of Neoclassicism, anticipating the doctrines of Jacques Louis David by several years. Apart from his career as a painter, he was a successful dealer in antiquities, his most notable discoveries being the *Hermes* that was found at Hadrian's Villa, Tivoli, in 1769, the *Wounded Amazon*, found in 1799 at Tor Colombaro, and the *Towneley Venus* at Ostia in 1786. In 1773 he published *Schola Italica Picturae*, which illustrated paintings by Leonardo, Raphael,

▲ Frans Hals
The Men-Governors of the Old Men's Home at Haarlem (c.1664)
Canvas. 172 cm × 256 cm
Haarlem, Frans Hals Museum

▲ Gavin Hamilton
Achilles Lamenting the Death of Patroclus
Edinburgh, National Gallery of Scotland

Michelangelo, the Carracci, Guido Reni and Caravaggio.

Hamilton began his career as a portrait painter, a field in which he showed little originality but considerable talent. In his early portrait of *Elizabeth Gunning, Duchess of Hamilton*, dating from about 1752-5 (Edinburgh, Holyrood House, on loan from Hamilton Coll.) the artist painted with superficial elegance, showing the influence of Agostino Masucci, with whom he had studied in Rome on his first visit in 1748. One picture, painted on a grand scale, *Wood and Dawkins Discovering Palmyra* (1758, Glasgow University), presages Hamilton's classical ideas, for the two main figures are dressed in togas and are supposed to echo heroic ideals of the past. The picture contrasts interestingly with his later portrait, *The 8th Duke of Hamilton with Dr John Moore and Ensign Moore* (1777, Lennoxlove, Hamilton Coll.), where he poses the sitters in contemporary dress against a background of Roman ruins, suggesting their cultivated interest in the antique.

By the end of the 1750s Hamilton had established himself in Rome and soon became known as the leading Scottish painter in Italy. He was a graduate of Glasgow University, and the intellectual training he received was doubtless of great value to him in his study of classicism. As early as 1748 Hamilton had become interested in classical antiquity after visits to Pompeii and Herculaneum, and he chose classical themes with great care, incorporating them into his own conception of history painting, which was then generally held to be the noblest form of art. The themes were intended to be 'affecting', or morally enriching, and they were expected to stimulate noble reactions in the mind of the observer. Hamilton felt that Baroque and rococo styles of painting were decadent, and that the true function of art could only be revitalized through the imita-

tion of the antique. In the 1760s he painted a series of Homeric subjects in which he attempted to embody these aims.

In the first of his Homeric paintings, *Andromache Bewailing the Death of Hector*, completed in 1760 (now lost, but known through an engraving), the emotional subject was treated with a taut restraint that is fully in keeping with the controlled composition, which shows the influence of Poussin. The details of architecture and costume are as accurate as contemporary knowledge permitted, and the figures are contained in a shallow space in the manner of classical bas-reliefs. Winckelmann, a principal theorist of Neoclassicism, praised the work for its fine composition and 'Greek forms' but condemned its colouring as unsubtle. Hamilton maintained tight compositional and emotional control throughout the first Homeric series, as well as in the second, which he painted between 1782 and 1784 for the Villa Borghese (now in the Museo di Roma). The paintings of the later series are, on the whole, less frieze-like than before, with cooler colouring and a greater sense of action.

Hamilton was one of the wealthiest artists in Rome and moved in a cultured milieu. His income from paintings was substantial (he received £300 for his *Achilles Lamenting the Death of Patroclus*), and it was richly augmented by his ever-increasing activities as a dealer in antiquities and in old master pictures. He employed Domenico Cunego to engrave his compositions, which spread his fame and influence, as well as helping the sale of his works. Probably his most important commission was the second Homeric series, which came from Prince Borghese to whom he had sold several pieces of classical statuary. Hamilton supervised the decoration of the *Stanza d'Elena* for the Prince: it was a complete exemplification of Neoclassicism, for as well as

Hamilton's own paintings, the statues and bas-reliefs in the room were representative of the new style. J.H.

Hamilton
Richard

British painter
b.London,1922

As a young man Hamilton worked in advertising and display, and then for four years during the war, from 1941 to 1945, as an engineering draughtsman, attending art classes only occasionally. His serious study began at the Slade School in 1948 (lasting until 1951), where he painted little and concentrated on drawing and engraving.

In 1951 Hamilton devised an exhibition 'Growth and Form', based on ideas in D'Arcy Thompson's book of the same name, published in 1917. The exhibition was held at the Institute of Contemporary Arts in London, and until 1955 Hamilton was a prominent member of the Independent Group at the I.C.A., which he convened with Reyner Banham, John McHale and Lawrence Alloway, and to which the sculptors Paolozzi and Turnbull and the architects Crosby, Stirling, Wilson and the Smithsons belonged.

From 1953 until 1966 Hamilton taught at Newcastle University, and presented his ideas in two further specially designed exhibitions, 'Man, Machine and Motion' in 1955 and 'An Exhibit' in 1957, both of which were shown at Newcastle and at the I.C.A. in London. He was also active as a disciple of Marcel Duchamp, publishing a typographic version of *The Green Box* in 1960, and remaking *The Large Glass* for the Tate Gal-

joyed considerable fame and often returned to Europe, but favoured as subjects scenes of New England and Long Island. From time to time he also painted townscapes of Boston or New York, and in these revealed an affinity for isolated genre subjects, thus anticipating the interest in street life that was to be the dominant interest of the next generation of American painters, those identified with 'the Eight'. D.R.

Heemskerck
Maerten Jacobz van
Netherlandish painter
b.Heemskerck, near Haarlem, 1498 – d.Haarlem, 1574

After training initially with Cornelis Willemsz in Haarlem, then with Jan Lucasz in Delft, Heemskerck spent the years 1527 to 1529 in Jan van Scorel's studios. Scorel's influence is visible in the double portrait of *Anna Codde* and *Pieter Bicker Gerritsz*, Deputy Mayor of Amsterdam (1529, Rijksmuseum), with its areas of free colour and its contrasts between light and shade. *The Portrait of the Artist's Father* (Metropolitan Museum), *Judas and Tamar* (Potsdam, Sans-Souci), and *St Luke Painting the Virgin* (Haarlem, Frans Hals Museum) date from 1532. The last-named still has something of Scorel in its use of classical accessories, in the twisted folds of the garments, allied to an impressive setting and a love of picturesque details such as the saint's spectacles or the abnormally enlarged *cartellino*.

In 1532 Heemskerck left for Italy where he stayed until 1536. Three of these years were spent in Rome where he made drawings from antiquity and copies of Michelangelo – preserved in two famous notebooks now in the Print Room of the Berlin-Dahlem Museum. In 1536 he returned to Haarlem where, under the dual influence of Scorel and Michelangelo, his Romanism began to take on an expressionist aspect. An exception are the portraits, which maintain their serenity: *Portrait of Johannes Colmanus* (1538, Rijksmuseum), *Portrait of a Man* (c.1545, Rotterdam, B.V.B.), *Portrait of a Woman at the Spinning-Wheel* (Lugano, Thyssen Coll.) and *Family Portrait* (Kassel Museum). This last is fascinating by reason of its clashing colour and its strongly accentuated outlines against a pale background.

By contrast, in his historical paintings Heemskerck indulges in a plethora of lines and projections, as, for example, in the enormous triptych depicting the *Crucifixion* painted between 1538 and 1541 for the Church of St Laurence of Alkmaar (Sweden, Linköping Church). In 1540 he was elected Dean of the Guild of St Luke, and in the same year painted *The Entombment* (Rotterdam, B.V.B.).

In 1542 Heemskerck left Haarlem for Amsterdam where he spent two years. His *Calvary* (1543, Ghent Museum; duplicate in the Hermitage), teeming with agitated figures, is yet another characteristic example of his taut style. After his return to Haarlem in 1544, Heemskerck's manner, although still highly decorative, gradually grew more subdued. A reworking of the theme of *St Luke Painting the Virgin* (Rennes Museum) is a work from his full maturity and much calmer than the Haarlem version. Although it contains a measure of stiffness and pedantry, the

early as 1888. When Hassam returned to New York in 1889, his friends were still talking about the December 1888 exhibition of Robinson's Impressionist paintings staged by the Society of American Artists. Hassam, together with John Twachtman and J. Alden Weir, was encouraged to adapt the French manner to American subjects.

In 1898, under Twachtman's leadership, a group of Impressionist-orientated artists withdrew from the Society of American Artists in order to avoid the rulings of academic juries. This group called itself 'Ten American Painters' and included Hassam, Frank Benson, Joseph de Camp, Thomas Dewing, Willard Metcalf, Robert Reed, Edward Simmons, Edmund Tarbell and Weir. If Twachtman marked one end of the Impressionist spectrum, with his predilection for gentle, misty landscapes, the other was represented by Hassam whose brilliant and sparkling compositions consistently employed the strongest effects of pure colour.

In addition, Hassam, more than his colleagues, understood the compelling pattern and impasto surface that could be developed by the rigorous application of small strokes of paint. This led to Hassam experimenting with compositional frameworks of almost orthogonal strength and, in his seascapes especially, he appears to relate as much to the Neo-Impressionists as to their predecessors.

The greater emphasis that Hassam placed on structure accounts for the quality of his etched work. Translating effects of sunlight and shadow into black and white, some of this artist's most daring compositions were achieved on plates no more than nine or ten inches high. Hassam en-

▲ Frederick Hassam
Fifth Avenue in Winter
Pittsburgh, Carnegie Institute, Museum of Art

▲ Hans Hartung
T. 1949–26 (1949)
Canvas. 97 cm × 146 cm
Stockholm, Moderna Museet

painting harks back to the dignity of Michelangelo, especially in the figure of the Virgin, and to classical antiquity (the whole painting is alive with ideas drawn from Greek and Roman statuary).

In 1552 Heemskerck painted a view of the *Ancient Arenas* (Lille Museum), a kind of archaeological reverie compounded of his memories of Rome. He took up this theme again the following year in his *Self-Portrait* (Cambridge, Fitzwilliam Museum), in which a view of the Colosseum fills the background. That same year he decorated the Church of St Bavon in Haarlem. In 1555-6 he executed a series of seven drawings tracing the *Story of David* (Louvre), preparatory to their being engraved by Philipp Galle in Antwerp. The series brings out certain characteristics of Heemskerck's technique, particularly the clear outlines of the figures and the close, short cross-hatching.

The period 1559-60 gave rise to the triptych *The Man of Sorrows*, surrounded by donors (Haarlem, Frans Hals Museum), *Ecce Homo* (Rotterdam, B.V.B.) and *The Entombment* (Brussels, M.A.A.), in which Heemskerck returned to the forms beloved of Scorel, although in a calmer vein. The works of his later years include the *Erythrean Sibyl* (1564, Rijksmuseum), the *Lamentation* (1566, Delft Museum) and, one of his very last works, *The Good Samaritan* (1568, Haarlem, Frans Hals Museum), in which landscape is relatively important.

As Scorel's most important follower, Heemskerck, together with his teacher and Frans Floris, was one of the first to bring the Italian style, and more especially the art of Michelangelo, to the Netherlands. His fertile, tormented, sometimes grandiloquent style verges on Mannerism. With Floris and Maerten de Vos he was one of the painters who most strongly influenced the engravers of the period. J.V.

Hemessen
Jan Sanders van

Netherlandish painter
b.Hemiksen, c.1500 – d.Haarlem, c.1565

A pupil of Hendrick van Cleve in Antwerp in 1519, Van Hemessen became a member of the Antwerp guild of masons in 1524. He probably moved to Haarlem around 1551 and may also

have spent some time in Italy about 1530. Some authorities have identified him with the Brunswick Monogrammist, a view now out of fashion. Van Hemessen's signed and dated works cover the period between 1531 and 1557. With Aertsen, Beuckelaer and Marius van Reymerswaele he belongs to the group of Antwerp painters who drew their inspiration from everyday life. His matter-of-fact approach and realistic style always succeed in bringing his subjects to life, but at the same time this sense of the commonplace tends to secularize religious themes. His works are monumental in character, with their exaggerated volumes, boldly foreshortened figures, striking reliefs, insistent, disorganized movements, grotesque details and vividly contrasting, if not always harmonious, colours. Because of the directness of his style and his plasticity, he is considered one of the main precursors of Pieter Bruegel.

Van Hemessen's earliest surviving painting is a *St Jerome* dating from 1531 (Lisbon, M.A.A.). For such an early work the boldness of the representation, the foreshortening and the dramatic and massive style are remarkable. These innovations, however, are less apparent in *The Adoration of the Magi* (1534), currently in the British royal collection, a painting similar in many respects to the works of Van Hemessen's contemporaries in Antwerp. The painter's personality emerges more strongly in *The Prodigal Son* (1536, Brussels, M.A.A.), in which the parable is transformed into a popular, anecdotal scene. The prodigal son, surrounded by pimps and prostitutes, is shown squandering his birthright in a brothel. The half-length figures are presented in direct and vivid fashion, those in the foreground appearing very large.

The artist here abandons a classical sense of order in favour of a naturalistic, even disorganized, composition, in which the narrative liveliness, the accuracy of the detail, and the close observation of people and objects aim at realism above all else. This minutely detailed traditional execution is in direct opposition to the massive concept of the whole. These same innovatory tendencies may be found in *The Calling of Matthew* (1536, Munich, Alte Pin.) in which Hemessen depicts a tax-collector's office.

There are no new elements in *Susannah and the Elders* (Barcelona, private coll.) nor in the *St Jerome* of 1543 (Hermitage). But a change begins to take place around 1544, especially in *Ecce Homo* (Düsseldorf, K.M.) and in *The Virgin and Child* (Stockholm, Nm), paintings in which Hemessen succeeds for the first time in conveying a sense of space as much by the composition of his figures as by the use of background. In *Isaac Blessing Jacob* (1551, Sweden, Osterby) Hemessen, in the style of the Italian Mannerists, enlarges his figures so that, together with the effects produced by lighting and foreshortening, they appear to leap out of the painting. This same emphasis on foreshortening figures in the very forefront of the picture is found again in *The Young Tobias Restoring His Father's Sight* (1555, Louvre).

The muddled composition and heavy-handedness of the vast painting known as *Christ Expelling the Merchants from the Temple* (1556, Nancy Museum) seem to foreshadow Hemessen's decline. His last painting (1557, London, private coll.) portrays *St Jerome* once more. To his signed and dated paintings may be added certain pictures which bear his signature but no date. One of the most important to be attributed to Hemessen is *The Joyful Company* (Karlsruhe Museum). It resembles the Brussels (M.A.A.) *Prodigal Son* in its moralizing view of man when faced with the temptation of pleasure at three stages of his life, and in its vivid style and careful execution. W.L.

▲ Jan van Hemessen
The Joyful Company
Wood. 83 cm × 111 cm
Karlsruhe, Staatliche Kunsthalle

▲ Maerten van Heemskerck
Family Portrait
Wood. 119 cm × 140 cm
Kassel, Staatliche Gemäldegalerie

Herrera
Francisco, the Elder

Spanish painter
b.Seville, c.1585-90 – d.Madrid, after 1657

One of the most important figures of the first generation of Sevillian Baroque painters, Herrera became something of a legend because of his violent temper, which was said to terrify his students. He himself is believed to have been a pupil of Pachecho. The first of his works to come down to us are in the Mannerist tradition and include *Pentecost* (1617, Toledo, El Greco Museum) and the great *Triumph of St Hermenegildo* (1624, Seville, Church of S. Hermenegildo), composed in superimposed layers. Between 1627 and 1629 he executed for the College of S. Buenaventura a series of four paintings as part of *The Story of St Bonaventura* (two in the Louvre, one in the Prado, one at Robert Jones University, Greenville, South Carolina), which Zurbarán completed.

Herrera's personal style was by this time fully developed. It was marked by a sometimes acid realism, lively characterization and brilliant colours which bear no trace of tenebrism. His free, flowing technique, however, can seem almost brutal and the composition is occasionally clumsy. His best works are probably those painted between 1636 (*St Jerome*, Rouen Museum) and 1648 (*St Joseph*, Madrid, Lázaro Galdiano Museum), a time when intense expressiveness was allied to a powerful technique and a delicate use of subdued colours, notably terracotta.

His representations of prophets and scholars take on epic proportions, as in the imposing *St Basil Dictating* (Louvre), painted in 1639 for the College of St Basil in Seville. Other works from this period are simpler and more intimate (*The Holy Family with St John the Baptist*, 1637, Bilbao Museum). *The Miracle of the Loaves and Fishes* (Madrid, Archbishop's Palace), the only surviving picture of the four painted in 1647 for the Archbishop of Seville, reveals a new interest in landscape. A magnificent craftsman, Herrera was

also praised by earlier writers for his genre paintings and still lifes, but no work survives from this period which can definitely be attributed to him. On the other hand, there is in the Prado a *Head of a Martyr*, signed by Herrera, and it is possible that he was the originator of this genre which Valdés Leal was to make famous.

During the last years of his life Herrera lived at court but nothing survives from this time in Madrid. A.E.P.S.

Heyden
Jan van der

Dutch painter
b.Gorinchem, 1637 – d.Amsterdam, 1712

After settling in Amsterdam in 1650, Van der Heyden became noted as a painter of urban landscapes, which he depicted in an even more painstaking fashion than his contemporary Berckheyde. Amsterdam itself was his favourite subject, and he brought to its representation a remarkable precision and delicacy of touch that succeeded in conveying at one and the same time the poetry of brick, the fluidity of the atmosphere and the play of light, as well as the clear outlines of trees and buildings reflected in the peaceful waters of a canal – *The Dam* and *The Martelaarsgracht* (Rijksmuseum), *The Westerkerk* (London, Wallace Coll.), the *Herengracht* (1668, Louvre) and the *Gracht* (Karlsruhe Museum).

Van der Heyden's use of light in these paintings is outstanding but their definition and precision also reveal his training as an engineer. From 1668

onwards, in fact, he became interested in the problems of street lighting, as well as publishing a work about fire-hoses and making engravings of his inventions (preliminary sketches in Rijksmuseum, Print Room). This does not necessarily mean, however, that all his landscapes were topographically correct, rather the reverse. He delighted in introducing architectural themes that he had noted in the course of his voyages down the Rhine into landscapes that were otherwise authentically Dutch, bathing the whole in idealized and softly poetic light in the manner of Potter or Adriaen van de Velde (who, in fact, 'filled out' many of his landscapes.)

The German tour took place some time before 1661, when he visited Cologne (*View of Cologne*, London, N.G., and Wallace Coll.; Hermitage), Emmerich [*St Aldegonda of Emmerich*], Louvre) and Düsseldorf (*Jesuit Church in Düsseldorf*, 1667, Mauritshuis). He also paid a visit to Brussels prior to 1673 (*The Palace of the Dukes of Burgundy*, Louvre; Dresden, Gg; Kassel Museum), and he may also have visited London. His rare still-life paintings (Budapest Museum; 1664, Mauritshuis; Vienna, Akademie; Leningrad, Museum of the History of Religion) are extremely spare, with a geometrical accuracy that would be rather unattractive were it not for the quality of strangeness that distinguishes the works.

Van der Heyden's pleasant style and the delicate, even virtuoso execution of his pictures were to exercise a considerable influence over 18th-century painters of urban landscapes, in particular such people as Ten Compe, Ouwater, La Fargue and Prins who, like Van der Heyden, yielded to a kind of sentimental exploitation of this pre-eminent national theme: the evocation of Dutch towns in their slumbrous calm. J.V.

▲ Francisco Herrera
Saint Basil Dictating (1639)
Canvas. 250 cm × 195 cm
Paris, Musée du Louvre

▲ Jan van der Heyden
The Gracht
Wood. 36 cm × 44 cm
Karlsruhe, Staatliche Kunsthalle

Hilliard
Nicholas

English miniaturist
b.Exeter, 1547 – d.London, 1619

Apprenticed to the Queen's goldsmith, Robert Brandon, in 1562, by 1572 Hilliard was practising as a miniaturist under the direct patronage of Queen Elizabeth I and her favourite, the Earl of Leicester. Hilliard spent the years 1576-9 in France as *valet de chambre* in the service of François, Duc d'Alençon, but was induced to return to England to work for the Queen and later for her successor, James I. Hilliard was a spendthrift by nature and his old age was clouded by debts and by his fall from fashionable esteem.

From the date of his earliest miniature of the Queen (1572, London, National Portrait Gal.) until his death his style remained fundamentally unchanged, reaching the zenith of its popularity between about 1570 and 1590. Brightly coloured and two-dimensional, the style is based on line and in its origins is a blend of Holbein's late miniatures and the tender intimacy of Clouet's chalk portrait-drawings. In his *Treatise on the Art of Limning* Hilliard describes how the views of the Queen had conditioned his art. She believed that shadow was used only by artists whose work possessed 'a grosser line' and therefore 'chose her place to sit in for that purpose in the open alley of a goodly garden, where no tree was near her nor any shadow at all.'

Hilliard's most important miniatures are: a *Self-Portrait* (1577) and a portrait of his wife, *Alice* (1578, London, V. & A.); *Sir Walter Raleigh* (*c*.1585, London, National Portrait Gal.); *Young Man among Roses* (*c*.1590, London, V. & A.); *Queen Elizabeth I* (*c*.1600, London, V. & A.); and *Charles I as Prince of Wales* (1614, Belvoir Castle, Earl of Rutland's Coll.). Hilliard also painted large-scale portraits and two of *Queen Elizabeth I* can be attributed with some certainty to him (*c*.1570-5, Liverpool, Walker Art Gal. and London, National Portrait Gal., on loan to Tate Gal.). In his old age he wrote, but never published, the fragmentary *Treatise on the Art of Limning* (mentioned above), propounding aesthetic attitudes derived from Paolo Lomazzo's *Trattato della Pittura* (1584), as translated in part by Richard Haydocke (1598). Hilliard's tiny miniatures are the visual quintessence of the Elizabethan age and were to have an influence upon a whole generation of artists. R.S.

Young Man among Roses (*c*.1590)
Miniature. 13 cm × 6 cm
London, Victoria and Albert Museum

Hobbema
Meyndert

Dutch painter
b.Amsterdam, 1638 – d.Amsterdam, 1709

Little is known for certain about Hobbema's career. He was Jacob van Ruisdael's pupil in Amsterdam from around 1657 to 1660 (and perhaps longer) and, as a result, the two men became friends. In 1668 he married a servant girl who was to bear him three children, and the following year was appointed comptroller of wine and oil in Amsterdam, an administrative post which obviously took up a lot of his time, for his activity as a painter diminished considerably after 1669. He would seem to have spent his whole life in Amsterdam, although it has also been suggested that he worked at Geldorp or Overijssel or even in the Rhineland near Düsseldorf.

Few of Hobbema's landscapes represent a real locale. Instead they abound with motifs inspired by the earlier compositions of Ruisdael, in whose footsteps Hobbema followed until around 1664. His earliest known work, a *Landscape with River* (Detroit, Inst. of Arts), dates from 1658 and was a favourite subject of the young artist. The *Landscapes* of 1659 (Grenoble Museum; Edinburgh, N.G.) are derived from Ruisdael, to whom he again turned for inspiration in 1660 in his forest landscapes: *A Woody Landscape with a Cottage* (London, N.G.) and *The Edge of the Woods, with Farm* (1662, Munich, Alte Pin.). The foliage in paintings such as the *Landscape with Forest near Haarlem* (1663, Brussels, M.A.A.), *The Forest* (Hermitage) or *The Village among Trees* (1665, New York, Frick Coll.) is defined with extreme precision. *The Haarlem Lock, Amsterdam* (London, N.G.), one of his rare urban views, was probably painted in 1662.

In the landscapes painted during his maturity, Hobbema's style began to develop in a manner quite unlike that of Ruisdael. In its minute realism and fidelity to its subject matter it ran directly counter to Ruisdael's vision of the painting as an entity. The forms in Hobbema's paintings are presented down to the last detail. His *Watermill* (Louvre) is a masterpiece of analytical precision, of which it has been said that 'everything appears to have been finely engraved before being painted, and then beautifully painted over this sharp engraving'. In fact, the backgrounds to Hobbema's landscapes are too detailed; they lack the sense of infinity and the great vistas found in Ruisdael.

Hobbema remained unaffected, too, by the lyricism of the pre-Romantic era. For all this, there is a naturalism and an intimate sense of the poetry of nature in his work which emerges with strength and simplicity in such paintings as *Landscape in Sunshine* (Rotterdam, B.V.B.), *The Cottage by the River's Edge* (Rijksmuseum), the *View of Deventer* (Mauritshuis) and *A Road Winding Past Cottages* (London, N.G.). These landscapes (together with a few rare drawings in the Rijksmuseum, the Teyler Museum in Haarlem and the Petit Palais in Paris) all appear to date from before 1669.

His obsessive search for technical perfection sometimes causes him to lapse into the stereotyped, as is seen in his taste for variations on the same theme. From time to time, also, he will disrupt the harmony of a landscape by too crude a light in an attempt to penetrate the mystery of Ruisdael's luminosity, or be tempted to heighten the greens, browns and blues by the crimson splash of a tiled roof – something which became common to his work.

And yet, when he uses subdued tones, and aims at a monochromatic effect, he is unrivalled, as in the *Windmills* (Paris, Petit Palais) or the *Oak Trees by a Pond* (Munich, Alte Pin.), where he brings a virtuoso's touch to the play of reflections. His great skies with their white clouds give life to the dark masses of his trees. A characteristic melancholy emerges from these landscapes with their cold greens and dark, dank waters.

His last works, painted after 1669, *The Ruins of Brederode Castle* (1671, London, N.G.) and *The Avenue, Middelharnis* (1689, London, N.G.) are among the greatest masterpieces of the Dutch landscape school. They are perfect in treatment

The Avenue, Middelharnis (1689)
Canvas. 103 cm × 141 cm
London, National Gallery

and their peaceful naturalism inspired the English landscape painters, who copied them even down to their subject matter. P.H.P.

Hockney
David

English painter
b.Bradford, 1937

Hockney studied at the Bradford College of Art, and from 1959 until 1962 at the Royal College of Art, where his contemporaries included Allen Jones and R.B. Kitaj. Together they initiated a new direction in painting which rejected the mainly American-inspired abstractions then prevalent in British art. This was subsequently to be labelled 'Pop Art', and associated with the work of slightly older artists such as Richard Hamilton and Peter Blake. The artists have, however, little in common, save a rejection of abstract art, and the label, like most art terms, is clumsy and not accepted by the artists themselves.

From the beginning Hockney showed that he was an artist of unmistakable style and originality. He painted pictures about himself and his experiences, about his friends and his life-style. A first visit to New York in 1961 was the beginning of a love affair with the United States that has persisted throughout Hockney's career. He has continued to draw inspiration from the American scene and has painted southern California with a memorable affection and honesty that probably no native American artist has achieved. Paintings of Hollywood swimming pools in 1964-5 led to the *Splashes* series of 1966-7 and to portraits in which swimming pools assume unusual importance. The buildings and domestic interiors of Los Angeles have also provided occasion for witty comment.

In the 1960s Hockney began to travel widely, and this restlessness has continued, to such an extent that he has frequently changed his place of residence, moving backwards and forwards across the Atlantic, and at times preferring Paris to London, or New York to Los Angeles. His international celebrity grew very quickly, culminating in Jack Hazan's film of 1974, *A Bigger Splash*, which presented a largely fictitious portrait of Hockney that the artist himself corrected in his very frank and revealing autobiography of 1976. In this Hockney showed himself to be a hardworking and serious artist, relatively unaffected by his status as a cult figure and still searching for new ways of extending himself.

The most ambitious pictures of the 1970s have usually been portraits, and especially such double portraits as *Christopher Isherwood and Don Bachardy* (1968, private coll.), *Henry Geldzahler and Christopher Scott* (1969, New York, Harry N. Abrams Family Coll.), *Mr and Mrs Clark and Percy* (1970-1, private coll.) and *My Parents and Myself* (1975-6, artist's coll.). These are highly finished, technically accomplished works that convey a strong impression of the sitters' characters and of the artist's relationship to the sitters. Still-life painting has also interested Hockney, and in *Contre-jour in the French Style* (1974, Kasmin Ltd., London) he painted a window of the Louvre with illusionistic subtlety and grave distinction. His paintings and drawing may be mannered and eccentric at times, but the imagery is always

arresting and the skill of execution indisputable.

Hockney's work has been widely exhibited, but the only important retrospective exhibitions have been at the Whitechapel Gallery in 1970 and at the Musée des Arts Décoratifs in Paris in 1974. His graphic work is considerable, and his designs for Stravinsky's *The Rake's Progress* (1975) and Mozart's *The Magic Flute* (1978) at Glyndebourne were innovative and much acclaimed. There is already a considerable distance between the naïvely expressionist early work, at times frankly homosexual and always autobiographical in content, and the detached objective view of things that the magisterial pictures of the 1970s convey. Only Hockney's wit remains constant.

A.Bo.

Hodler
Ferdinand

Swiss painter
b.Bern, 1853 – d.Geneva, 1918

Hodler's parents were wretchedly poor and both had died by the time he reached the age of 14. As a child he started painting posters, then 'Swiss views' for the tourists who visited Thun. After moving to Geneva in 1892 he studied for five years under Menn, who had himself been a pupil of Ingres and a friend of Corot. During these five years Menn turned Hodler into an artist capable of such paintings as the landscape *Torrent at Frontenex* (1874, private coll.) and the portrait *The Student* (1894, Zürich, Kunsthaus), as well as *The Gymnasts' Feast* (1876), a vast composition which was subsequently destroyed. However, a second version was painted and now hangs in the Kunsthaus.

Hodler's earlier paintings drew their inspiration from real life and are noteworthy for their strong line and clean balanced settings, together with rather dark tones and use of contrasting chiaroscuro. A visit to Madrid, however, led to a lightening of Hodler's palette (*The Banks of the Manzanarés*, 1879, Geneva Museum) and showed that he had finally broken away from Menn's influence.

Hodler's fight for recognition during the 1880s is reflected in a number of aggressively realistic paintings, such as *The Madman* (1881, Bern Museum) – although at other times he can appear almost humble and resigned (*Prayer in the Canton of Bern*, 1880-1, Bern Museum), pursuing a mood of contemplative, even mythical symbolism (*Intimate Dialogue with Nature*, 1884, Bern Museum). His tendency to accentuate the contours of figures is an attempt at monumentality and not an expressionistic or visionary distortion. A symmetrical order reigns over his com-

▲ David Hockney
Peter getting out of Nick's Pool (*c*. 1966)
Canvas. 213 cm × 213 cm
Liverpool, Walker Art Gallery

positions, which finds its expression in the land-scapes through dominating parallels and high mountains.

Night (1889-90, Bern Museum) is the key work of this 'parallelism', a style of composition which was to dominate Hodler's work from now on, and which consists in repeating similar shapes so as to give the painting its architectonic and decorative unity. Banned in Geneva, *Night* was first shown in Paris at the instigation of Puvis de Chavannes. Hodler's pessimistic vein reached its most extreme point with *Disappointed Souls* (1891-2, Bern Museum), which was the chief attraction of the first Salon de la Rose-Croix.

Two instances of the way in which Hodler applied his theory of parallelism to landscape may be seen in the strict symmetry of the avenue of trees in *Autumn Evening* (1892, Neuchâtel Museum) and – following his first painting of a lake viewed from above – in the elliptical rhythm of the clouds and banks in *Lake Geneva Seen from Chexbres* (1895, Zürich, Kunsthaus).

With its imposing and vividly coloured group of lansquenets in the style of Urs Graf or Manuel Deutsch, Hodler's fresco of the *Retreat from Marignano* (1900, Zürich, Schweizerisches Landes-museum; sketch in Stuttgart, Staatsgal.) signals the revival of wall painting at the beginning of the 20th century. The fresco made Hodler's name known throughout Europe and led to a flood of commissions, mainly from Austria and Germany but also from Venice and Paris, that marked the end of nearly 50 years of privation. *Day* (1899-1900, Bern Museum) expresses the sense of wonder experienced by a group of five female figures seated in the open in the light of the rising sun.

With Hodler's new-found fame came a new op-timism, evident in his use of bright, sometimes crude, colours. For the next ten years, in paint-ings such as *Spring* (1901, Essen, Folkwang Museum) and the *Woman in Ecstasy* (1911, Geneva Museum), the enraptured poses of his somewhat graceless women alternate with the complacent, even brutal aspect of the men. In his com-positions, all of which he returned to several times over, Hodler pushes his use of the orna-mental to the point of frenzy, making him one of the exponents of the Jugendstil or Art Nouveau. Only *Love* (1908, private coll.) and *Glimpse into Infinity* (1915, Basel Museum), with its five blue figures linked in calm communion, escape from this excess.

In *The Departure of the Students of Jena* (1908, Jena University), Hodler unfolds the event of 1813 in two superimposed registers: below, the soldiers prepare to depart; above, the column is on the march. With its percussive outlines and rhythmic composition, this is one of the key works in 20th-century monumental painting.

Hodler painted innumerable portraits, in which the men are always shown full face, while the women's heads are slightly bowed (*The Italian Woman*, 1910, Basel Museum). In addition, there are some 50 *Self-Portraits* painted at various times throughout his career which, like similar works by Van Gogh, Cézanne or Munch, serve the pur-pose of self-assessment at suitable intervals (1914, Schaffhausen Museum).

Hodler's underlying realism reappears in two cycles of paintings on the theme of death. The subject of the first cycle. *A. Dupin, Deceased* (1909, Solothurn Museum), was the mother of Hodler's son, and of the second, painted in 1914-1915, the mother of his daughter (*Death Agony of V. Godé*, Basel Museum). The sharp-ness of touch and the bitter colours with which Hodler depicts these encounters with death are unique in European painting.

It was in nature, however, that Hodler found the theme which most clearly corresponded to his powerful temperament and at the same time satis-fied his need for harmony. Trees and water, and above all mountains and lakes, were his favourite subjects, to which he returned time and time again. His lakes, seen from the horizontal and reflecting cloud-capped mountain ranges, display a classical sense of balance (*Silvaplana Lake*, 1907, Zürich, Kunsthaus), while his mountains, massively structured and painted with broad strokes, have an elemental vitality (*The Breithorn*, 1911, Lucerne Museum). In certain landscapes an expressive intensity of colour is added to the breadth of line. The great strength of these cosmic visions place Hodler as a landscape painter on a level with Van Gogh or Cézanne (*Climbing through the Mist at Caux*, 1917, Zürich, Kunsthaus).

Hodler was typically Swiss in his isolation. He developed apart from the direct influence of his contemporaries. Although his work stimulated a generation of German and Austrian Expression-ists, he founded no school, not even among his successors in Switzerland. Though mainly a 19th-century painter, Hodler must be regarded as one of the precursors of the 20th century by virtue of his contribution to the 'style of 1900', but even more so because of the new dimension which he alone reintroduced to art: monumentality. Major collections of his works are to be found in the museums of Basel, Geneva, Zürich and Bern.

J.Br.

Hogarth
William
English painter
b.London, 1697 – d.London, 1764

Hogarth served his apprenticeship with Ellis Gamble, a silver-plate engraver specializing in coats of arms, and learned how to apply rich and complex decoration to a small area. Around 1720 Hogarth set up as an engraver on his own ac-count, but during the 1720s earned his living mainly from shop signs and signboards of a popular character. In 1721, following the South Sea Bubble crisis, he produced his *Evil Effects of Lotteries*. At the same time he was caricaturing events in the world of the theatre and in 1723-4 published a print, *Masquerades and Operas*, attack-ing the frivolity of the English theatre of the day.

In 1728 he painted a scene from *The Beggar's Opera* (several versions; London, Tate Gal. and private coll.), first performed that same year in Lincoln's Inn Fields, in which he portrayed not only the actors but also part of the aristocratic audience. During the 1720s he also illustrated a number of books, including Butler's *Hudibras*, for which he produced two sets of illustrations (1725-6). He also produced (*c*.1725) two illustra-tions for *Paradise Lost*, but those were possibly rejected by Tonson for his 1725 edition.

The year 1729 was marked by Hogarth's emer-gence as a painter as well as an engraver, and also by his marriage to Sir James Thornhill's daughter. Works from this year include a large picture of *Henry VIII and Anne Boleyn* (since destroyed) for Vauxhall Gardens, probably based on a print produced the previous year; it was Hogarth's first attempt at a large-scale 'historical' painting. Be-tween 1729 and 1733 he earned a successful living as a portrait painter, working for a mainly aristocratic clientèle. At the same time, he was instrumental in introducing the 'conversation piece' into England. Notable examples of this genre, in which a group of people are depicted as if in conversation, are his *Wollaston Family* (1730, on loan to Leicester Art Gal.), *The Marriage of Stephen Beckingham and Mary Cox* (1729, Metropolitan Museum), *The Reception at Wanstead House* (1730-31, Philadelphia, Museum of Art), and *The Indian Emperor* (1732, private coll.).

In the early 1730s Hogarth produced his first two satirical cycles, *A Harlot's Progress* (1730-32, six scenes, original paintings destroyed), and *A Rake's Progress* (1735, eight scenes, original paint-

▲ Ferdinand Hodler
Night (1889-90)
Canvas. 116 cm × 299 cm
Bern, Kunstmuseum

ings, London, Soane Museum). These two series were something quite new in English art, and marked the beginning of a genre which owed little or nothing to Dutch or French models. Described by Hogarth as 'modern moral subjects', they satirized human beings who made up the society of the first half of the 18th century, rather than generalized types.

They reached a wide public through engravings and it was the financial success of the *Progresses* that led Hogarth to attempt 'history' painting on a grandiose scale. He produced *The Good Samaritan* and *The Pool of Bethseda* for St Bartholomew's Hospital, the general composition of both being taken from Raphael and Rembrandt, although the handling is more rococo. Another series, *A Day in London* (1737, four scenes, private coll.), was followed by his portrait of *Captain Coram* (1740, London, Foundling Hospital). This was a new departure in English portraiture; it was a formal painting, not of a king or an aristocrat, but of a successful middle-class adventurer with all the trappings of his prosperity.

Among the best known of the many portraits that Hogarth painted in the course of his career are: *Mary Edwards* (c.1740, New York, Frick Coll.); *The Graham Children* (1742, London, Tate Gal.); *Benjamin Hoadly* (c.1743), *Mrs Salter* (1744), *Self-Portrait with Dog* (1745) and *The Painter's Servants* (mid 1750s) – all four of which are in the Tate Gallery, London; and *Garrick and his Wife* (1757, Windsor Castle).

In 1745 Hogarth produced another series which this time portrayed high life – *Marriage à la Mode* (six scenes, original paintings, London, N.G.); and in the following year he painted *Garrick as Richard III* (Liverpool, Walker Art Gal.), depicting the actor on stage during the play. In 1748 he painted *Calais Gate* (London, Tate Gal.) and produced the series *Industry and Idleness*, the most didactic and moralizing of all his works. This was followed in 1749-50 by *The March to Finchley* (London, Foundling Hospital). In 1753 he published a treatise, *The Analysis of Beauty*, which put forward the idea that all beauty is based on a serpentine line. In 1753-4 he painted an *Election* series (four scenes, London, Soane Museum), which was also engraved, and in 1756 executed an altarpiece for St Mary Redcliffe, Bristol (triptych: *The Ascension*; *The Three Marys at the Sepulchre*; *The Closing of the Sepulchre*; on loan to Bristol, City Art Gal.). His last attempt at 'history' painting in the grand manner was the *Sigismunda* (1759, London, Tate Gal.), which at the time was generally considered to be a failure.

William Hogarth was a complex character. He ridiculed all forms of artistic snobbishness and attacked the so-called 'connoisseurs', but at the same time he painted conventional 'history' paintings on a grand scale, and wanted to shine as a 'history' painter. He was deeply conscious of being English and believed that English painters should be proud of their native land and not mimic Italian customs and practices. He signed a picture of a man he painted in 1741, 'W. Hogarth Anglus Pinxit'.

As well as being very 'English' he was attuned to contemporary attitudes of mind and the mental climate of his age. His cycles are very close in essence to the novels of Fielding, combining as they do realism and perception with satire and morality. Through the medium of engraving his moral tales reached a wide public, both aristocratic and middle-class, and were far superior to the popular engravings which had preceded his works in this

field. He managed to break the stranglehold of portraiture on English art and introduce subject matter with contemporary relevance. Hogarth was very much a literary painter. His paintings can be read, and it was this quality which led Hazlitt to place him among the English comic writers.

Formally, Hogarth belongs to the age of the rococo. His brushstrokes have a delicacy and spontaneity that rival those of any French contemporary artist. This extraordinary freedom of treatment can best be appreciated in some of his more informal, sketch-like paintings such as the charming and celebrated *Shrimp Girl* (London, N.G.), *At the Tailor's* (London, Tate Gal.) and *The Ball* (1745, Camberwell, South London Art Gal.). Even in his 'serious' paintings his style resembles that of Amigoni in its freshness and bravura. Hogarth's essential importance, however, lies in the cycles and series that were engraved. It was the contemporaneity and realism of these which formed his major contribution to English and European art. J.N.S.

Holbein
Hans, the Younger
German painter
b.Augsburg, 1497/8 – d.London, 1543

Early years. Holbein received his early training from his father, Hans Holbein the Elder, and perhaps from Hans Burgkmair, whom he probably met while still young. Around 1515 he travelled to Basel with his brother Ambrosius and painted his first known work, a table-top, which is still largely medieval in composition (Zürich, Schweizerisches Landesmuseum). It seems likely that he worked in the studio of Hans Herbst, but his precocious talent led to early independence and he was soon moving among humanist circles. In 1516 he illustrated a copy of the *Praise of Folly* (Basel, 1515 ed.) of Erasmus, whose friend he later became. Already he was showing signs of a freer, more detached view of the world.

Basel (1516-26). In 1516 Holbein began to move amongst the wealthy merchant population of the city and executed many commissions for them, including portraits of the Burgomaster *Jakob Meyer* and his wife, *Dorothea Kannengiesser* (1516, Basel Museum). In 1517 he helped his father to decorate the façade of the Hertenstein house, Lucerne (destroyed in 1824), in an Italian Renaissance style. At this time he painted a *Lamentation on the Death of Christ* (1519, known only through a copy). It is probable that, about this time, he went to Italy, for his later work proclaims a knowledge of Mantegna's paintings in Mantua.

After becoming a member of the Zum Himmel guild in 1519 he took over his dead brother's studio and married Elsbeth Schmid. This was the start of a period of intense production lasting right up to his departure for England in 1526. During this time he painted very nearly all the religious works which survive, as well as an appreciable number of murals (in houses belonging to the aristocracy of Basel and the Council Chamber of the Town Hall). All of these have unfortunately been destroyed but their sheer scope is an indication of Holbein's reputation.

Between 1519 and 1520, Holbein and his assistants produced five scenes of the Passion, of which *The Last Supper* and *The Flagellation* are entirely by his hand (Basel Museum). In these paintings Holbein's art varies between a powerful German expressionism inherited from the late Gothic period through the intermediary of Grünewald – whose influence is particularly visible in the extraordinary *Dead Christ* (1521, Basel Museum) – and the 'objectivity' of the artists of the Italian High Renaissance, with its mixture of the religious and the secular. In his *Gerster Altarpiece* (1522, Solothurn Museum) the figures are Germanic in concept but are integrated into a Renaissance composition.

From this time (1524?) date the *Scenes from the Passion* (Basel Museum) and the graceful figures of *Venus* and *Lais of Corinth* (1526, Basel Museum). These paintings presuppose the influence of Leonardo whose later works Holbein may have seen in France around 1523-4. *The Virgin with the Family of Burgomaster Meyer* (1526, Darmstadt, Prince of Hesse Coll.), painted for the altar of the chapel of the Meyer's castle near Basel, is a masterpiece from this period. After his return from England, Holbein added to this the posthumous portrait of Frau Meyer. Also from 1526 come the *Organ Doors* from Basel Cathedral (Basel, Kunstmuseum) with their massive effigies of the Virgin and three saints executed in grisaille.

The influence of Leonardo is again evident, particularly in the flesh tints. Between 1523-6 Holbein probably went to France. In these years he worked on his famous *Dance of Death*, of which three blocks were made in 1527 (Berlin-Dahlem, Print Room). The first edition, consisting of 41 engravings, was printed in Lyons in 1538 by the Trechsel brothers. He had also executed some of his best-loved portraits by this time: *Portrait of a Woman* (1517?, Mauritshuis), *Bonifacius Amerbach* (1519, Basel Museum) and

▲ Hans Holbein the Younger
Portrait of Georg Gisze (1532)
Wood. 96 cm × 85 cm
Berlin-Dahlem, Gemäldegalerie

studies of *Erasmus* (1523, Longford Castle, Radnor Coll.; Louvre; Basel Museum).

London and Basel (1526-31). In 1526, probably on the advice of Erasmus, who recommended him to Sir Thomas More, Holbein fled the Reformation and settled for two years in London where his fame as a portrait painter grew rapidly (*Sir Thomas More*, 1527, New York, Frick Coll.; *Sir Henry Guildford*, 1527, Windsor Castle; *Archbishop Warham*, 1527, Louvre; *Nicolas Kratzer*, 1528, Louvre; *Thomas Godsalve and his Son*, 1528, Dresden, Gg).

On his return to Basel Holbein continued to paint portraits and decorate facades, but in 1529 a decree of the Town Council banning religious painting led eventually to his quitting the city for England once more, in 1532. Before this, however, he completed the decoration of the house Zum Kaiserstuhl (preliminary sketches, Basel Museum) and also probably made a visit to northern Italy. By now in full command of his technique, Holbein brought a human warmth to his painting which shows the extent to which he had assimilated Flemish models. But the expressiveness was confined to a certain degree by the peaceful classicism of his compositions, with the result that even domestic subjects take on something of the power of symbolism.

Towards 1530 Holbein completed the decoration of the Basel Council Chamber, of which a few fragments survive in the Basel Museum. He also made a number of wood-engravings, notably the 94 *Icones historiarum Veteris Testamenti*, published in Lyons in 1538 by the Trechsel brothers, as well as a dozen designs for stained-glass windows, the only religious art permitted, on the theme of the *Passion* (Basel Museum).

London (1532-45). By the time Holbein returned to London in 1532 More had fallen out of favour with the King, so Holbein found patrons among the London representatives of the Hanseatic League, for whom he painted a large number of portraits. Those of *Georg Gisze* (1532, Berlin-Dahlem), of *Dirk Tybis* (1533, Vienna, K.M.), of *Derich Born* (1533, Windsor Castle) and of *The Young Merchant* (1541, Vienna, K.M.) are among the best known. His patrons also commissioned from him decorative works, including a *Triumphal Arch* for the coronation of Anne Boleyn (sketch, 1533, Berlin-Dahlem, Print Room) and *The Triumph of Wealth* and *The Triumph of Poverty* (1533, drawing and engraving in the Louvre).

After 1533 much of his time was devoted to commissions from Henry VIII, and in 1536 he entered the King's service, probably on the recommendation of Thomas Cromwell whose portrait, now vanished, he painted in 1534. His activity grew more diverse for, apart from the decorative works and a dozen or so miniatures, for which he had learned the technique from Lucas Horenbout, he also executed a number of studies of pieces of jewellery.

This period was marked by the production of a very important series of portraits, including those of *Robert Cheseman* (1533, Mauritshuis), *'The Ambassadors'* (1533, London, N.G.), *Charles de Solier* (1534-5, Dresden, Gg), *Richard Southwell* (1536, Uffizi), *Christina of Denmark* (1538, London, N.G.), *Anne of Cleves* (1539, Louvre), *Edward, Prince of Wales* (1539, Washington, N.G.), *Thomas Howard, Duke of Norfolk* (1539-40, Windsor Castle), *Henry VIII* (1540, Rome, G.N.) and

John Chambers (1542, London, N.G.). Some paintings are known only by their preliminary sketches in the royal collection in Windsor Castle.

By now Holbein was able to organize his surfaces with incomparable mastery. In their composition his portraits derive from paintings like the Mona Lisa, but other influences can also be seen: Gossaert, Massys and Italian painters in the service of Henry VIII, to whom Holbein was in debted for the decorative formality of his full-size, full-length portraits. Moreover, Holbein certainly knew about the work of the Fontainebleau School and the drawings of Clouet. In 1538, while on a mission to Burgundy, he made a detour through Lyons and Basel where the Town Council offered him better working conditions, but he decided not to remain, and by 1541 was back in London. His last-known work (1543) is a drawing for a watch for Henry VIII.

Because of the loss of the greater part of his large-scale works, Holbein tends to be regarded only as a portrait painter – although one of the greatest of all time. Open to all influences, from Grünewald to Leonardo, from Massys to the School of Fontainebleau and contemporary English painters, he created from them an international synthesis unique in the paintings of the early 16th century. His art is based on the solutions to two problems, which were also the ones attempted by his father: draughtsmanship, the vehicle of expressive accuracy; and composition, based on minute study of perspective, in which the structures of space vary constantly until, in the later portraits, they have arrived at a kind of equilibrium between realism and abstraction, between Gothic tradition and Renaissance humanism.

Holbein's contact with Erasmus and More led to the incorporation in his art of humanist ideas which permeate his religious paintings and reveal a constant, troubled search for an understanding of the mysteries of being, which goes beyond the outward appearance of the portrait, as in 'The Ambassadors' (London, N.G.), which is simultaneously a double portrait and a memento mori.

Although he dominated the first half of the 16th century in Germany, Switzerland and England, the arrival at the court of Henry VIII in 1540 of a number of Flemish painters ended Holbein's influence over succeeding generations. In 1543 the terrible plague which had London in its grip claimed him when he was at the height of his vigour and fame. B.Z.

Homer
Winslow

American painter
b.Boston, 1836 – d.Prout's Neck, Maine, 1910

After an apprenticeship as a lithographer (1854-7), Homer worked until 1875 as an illustrator for the New York magazine *Harper's Weekly*, to which he contributed illustrated reports on the Civil War. He did not take up oil-painting until he was in his thirties, when he began painting genre scenes inspired by the war and military life in general (*Prisoners from the Front*, 1866, Metropolitan Museum) and by the countryside (*The Morning Bell*, New Haven, Connecticut, Yale University Art Gal.). After a visit to Paris (1866-7) his style grew closer to that of the early Impressionists, and the open-air subjects he favoured – scenes of country life and seascapes – were now treated with broad clear touches, contained within a vigorous draughtsmanship (*Long Branch, New Jersey*, 1869, Boston, M.F.A.). He was also influenced by Japanese prints.

He settled at Prout's Neck on the Maine seaboard, making trips each summer to the Adirondacks or Canada, and each winter to Florida or the West Indies. In 1881-2 he paid a long visit to England. After 1881 his painting became more sombre in tone, with a more fleshed-out technique. He depicted the hardships of the sailor's life, concentrating on man's heroic nature in his fight against the elements (*The Alarm Bell*, 1886, Metropolitan Museum), the power of the sea (*Sunshine on the Coast*, 1890, Toledo, Ohio, Museum of Art; *The Gulf Stream*, 1899, Metropolitan Museum), or his own particular brand of poetry (*Summer Night*, 1890, Louvre).

He also painted hunting scenes (*The Stag*, 1892, Washington, N.G.) and wild animals (*Ducks*, Washington, N.G.). His watercolours, whether evocations of his travels or preparatory sketches for other compositions (Boston, M.F.A.; Chicago, Art Inst.; Metropolitan Museum; New York, Cooper Union Museum; Brooklyn Museum) are vividly coloured. Even during his lifetime Homer was looked upon as the archetypal American painter. This realism is the spontaneous expression of his genius, but it is subordinated to a lofty concept of human worth. S.C.

▲ Winslow Homer
The Morning Bell
Canvas. 60 cm × 97 cm
New Haven, Connecticut, Yale University Art Gallery,
Bequest of Stephen Carlton Clark

Honthorst
Gerrit van

Dutch painter
b. Utrecht, 1590 – d. Utrecht, 1656

With Ter Brugghen and Baburen, Honthorst was mainly responsible for introducing the new style of Caravaggio to Utrecht and to the Netherlands in general. After studying under Abraham Bloemaert in Utrecht, Honthorst arrived in Rome, between 1610 and 1612, where he became a follower of Caravaggio and, thanks to the patronage of Cardinal Scipione Borghese and the Grand Duke of Tuscany, was commissioned to provide works for a number of churches. He returned to Utrecht in 1620 and was admitted to the painters' guild in 1622. In his native city he enjoyed considerable success, producing a number of religious and genre paintings, and employing 25 pupils.

Invited by Charles I in 1628 to the English court, he painted several portraits and a *Mercury Presenting the Liberal Arts to Apollo and Diana* (Royal Collection, Hampton Court). In 1635 he carried out a number of large-scale historical compositions for King Christian IV of Denmark. In 1637 he was admitted to the guild of The Hague and became the favourite painter at the court of the Prince of Orange. He executed mythological paintings for the Rijswijk and Honselaersdijk palaces, the degree of participation of his pupils depending on how busy he was with commissions.

In Italy Honthorst was known as 'Gherardo delle Notti' because of the candlelight effects he favoured in his pictures, as in *The Flagellation* (1612), or *Christ Crowned with Thorns* (1615, Rome, Church of S. Maria in Aquiro). *The Beheading of John the Baptist* (1618, Rome, Church of S. Maria della Scala) is dramatically foreshortened and realistic, following the example of Caravaggio. In *The Christ Child and St Joseph* the lighted candle has the effect of simplifying both planes and masses (Montecompatri, Abbey of S. Silvestro, and Hermitage) and in *The Denial of St Peter* (Rennes Museum) the technique is close to that of Georges de La Tour.

But after his return to Utrecht what Honthorst finally retained of Caravaggio was his earlier, lighter style – although Italian influence may also be seen in the grand decorative manner, learned from the Carracci, which tempered his chiaroscuro and set limits to his realism (*The Adoration of the Shepherds*, 1620, Uffizi).

▲ Gerrit van Honthorst
The Christ Child and St Joseph
Canvas. 137 cm × 185 cm
Leningrad, Hermitage

In genre paintings, such as *The Banquet* (1620, Uffizi), *The Concert* (1624, Louvre) or *The Dentist* (1627, Louvre), Honthorst showed a taste for half-lengths – one in the foreground acting as a foil while others, more brightly coloured, are surrounded by chiaroscuro effects. The lifelike humour of these pieces represents an important move away from Caravaggio. By contrast, there is an air of conventionality in the *Allegory of the King and Queen of Bohemia and their Family* (1636, Hanover, Herrenhausen Museum) and in the *Allegory of the Marriage of Frederic Hendrick to Amalia van Solms* (1650, the Hague, Huis ten Bosch). These large compositions represent the less interesting part of Honthorst's output as do, for the most part, the portraits which emanated from his studio. P.H.P.

Hooch
Pieter de

Dutch painter
b. Rotterdam, 1629 – d. Amsterdam, 1684(?)

For a long time Pieter de Hooch's early works were little known, and his late works forgotten. Only the works of his maturity, which rank second only to the interiors of Vermeer and the

Delft school, were considered worthy of attention. His early works, in fact, are very different from those of his fine Delft period which evoke an atmosphere of inner contemplation and peaceful domesticity. Although he was a pupil of Berchem, he seemed almost unaffected by the Italianate pastoral style of his master, and began by painting scenes of the guardhouse or the inn, popular subjects at that time in Haarlem (*Cavalier with Peasants*, Moscow, Pushkin Museum; *The Empty Glass*, Rotterdam, B.V.B.; *The Inn*, Philadelphia, Museum of Art, Johnson Coll.).

The subjects were far from serious, but de Hooch nonetheless took great pains over his handling of light, even if he still practised the Caravaggesque trick of letting a beam of light fall from a window (*The Cardplayers*, Paris, former Pereire Coll.) or using artificial lighting as in *By the Fireside* (Rome, Gal. Corsini), in which the figures form a screen for the light. In *The Levée* (Hermitage) he was already beginning to appreciate the possibilities in the confined space of an interior.

In 1654, the year of his marriage, de Hooch settled in Delft and was admitted to the Delft Guild of Painters a year later. Carel Fabritius, Delft's most important artist, had died in 1654 and Vermeer, his junior by three years, was only at the start of his career. De Hooch remained in Delft from 1654 until about 1662, during which time he painted most of his best work. In place of

▲ Pieter de Hooch
Woman Drinking (1658)
Canvas. 68 cm × 60 cm
Paris, Musée du Louvre

his earlier subjects he now depicted either domestic life and interiors (*The Pantry*, Rijksmuseum; *Woman Spinning*, London, Royal Coll.; *A Mother's Care*, Rijksmuseum) or intimate scenes (*Woman Drinking*, 1658, Louvre). The early Delft paintings exploit only a relatively small range of colours, but soon de Hooch moved on to using a great many subtle shades in paintings such as *An Interior Scene* (London, N.G.) and *The Mother* (Berlin–Dahlem). The role accorded to lighting and atmosphere tends to reduce the anecdotal impact of the themes.

De Hooch's originality lay in creating a web of relationships and affinities between the figures and the surrounding objects in his paintings: masses, shapes and colours blend together in a rhythmic plasticity which emanates from this subtle interplay (*The Laceworker*, Paris, Netherlands Inst.; *The Cardplayers*, London, Royal Coll.). De Hooch was also an innovator in his use of space: the *Courtyard of a House in Delft* (1658, London, N.G.; Mauritshuis) and *Boy Carrying Pomegranates* (London, Wallace Coll.) contrast light and airy exteriors with the close perspectives of a room. In the *Lady and her Servant* (Hermitage), however, in which the forms are drawn in *contrapposto*, converging perspective lines lead the eye from one point to another.

In 1662, for unknown reasons, de Hooch left Delft for Amsterdam where he remained until his death; his last work is dated 1684. He continued to paint in the style of his Delft period until about 1670, evoking the stillness of objects or people within his Dutch interiors with their bourgeois luxury (*The Cardplayers*, Louvre; *By the Fireside*, New York, Frick Coll.; *Lady Reading a Letter*, Budapest Museum) or the minor ceremonial of household chores (*Woman Peeling Apples*, 1663, London, Wallace Coll.; *Woman Weighing Gold*, Berlin-Dahlem). The last work reveals affinities with Vermeer, but this was no more than a passing influence. Although by now de Hooch was less of an innovator, the realism and acuity of these later paintings still called for an extremely careful finish.

From 1670 the reserve and sensitivity which up till then had marked his intimate scenes gave way to a coarseness not far removed from that of Jan Steen (*The Love Letter*, Stockholm, Nm; *The Minuet*, 1675, Philadelphia, Museum of Art; *The Singer*, Hermitage; *A Musical Party*, 1677, London, N.G.). His output at this time was considerable and not always free from the commonplace. His figures, accentuated by touches of light, became more complicated and more mannered (*The Park*, Windsor Castle; *The Conversation*, Lisbon, M.A.A.), with the result that his later paintings were for long attributed to contemporaries such as Ochtervelt, Hoogstraeten, Brekelenkam and Janssens. At his best, however, Pieter de Hooch evokes the supreme harmonies of Jan Vermeer. P.H.P.

Hopper
Edward

American painter
b.Nyack, New York, 1882 – d.New York, 1967

Hopper trained at the New York School of Art under Kenneth Hayes Miller and Robert Henri from 1900 to 1906. Between 1906 and 1910 he

made three trips to Europe, spending most of his time in France. Unlike most Americans who visited Europe at that time, he remained comparatively unaffected by the new developments in European painting. He learned one or two lessons from the Neo-Impressionists but was quite unaware of the birth of Cubism, and his surviving canvases from this period reveal his sober and compact style in the process of formation (the *Quai des Grands Augustins*, 1909, New York, Whitney Museum).

He took part in 1908 in a mixed exhibition at the Harmony Club and again at the Armory Show (*Sailing*, 1913, James H. Beal Coll.). Although the canvases he showed here found a buyer, success was slow in coming and he was not to sell another painting until 1923. Between 1915 and 1920 he was forced to work as a commercial illustrator to make ends meet, and, in consequence, his painting was curtailed – although in 1915 he began a brilliant series of etchings (*Night Shadows*, 1921; *Train and Bathers*, 1930).

Hopper led an uneventful life, dedicated entirely to his painting. After 1910 he made no attempt to return to Europe but travelled extensively throughout the United States and Mexico. His choice of subjects – American landscapes, solitary figures in hotel rooms or bars, the world of the theatre – often led to charges that he was a mere illustrator, but he always denied this. His 'Americanness' lies less in his subject matter than in the way he painted it, which is open, direct and solid. Later it was to be much admired by the exponents of Pop Art, whose precursor Hopper is sometimes said to be.

Hopper's output was considerable but cannot be classified into periods. His style, in fact, changed little between 1913 and 1965, and this consistency, typical of the man, also explains the grandeur of his work. His best-known pictures include *Early Sunday Morning* (1930, New York, Whitney Museum); *Room in Brooklyn* (1932, Boston, M.F.A.); *New York Movie* (1939, New York, M.O.M.A.); *Gas* (1940, M.O.M.A.); *Nighthawks* (1942, Chicago, Art Inst.); *Second Storey Sunlight* (1960, New York, Whitney Museum).

In 1933 Hopper was the subject of a retrospective exhibition at the Museum of Modern Art, while the Whitney Museum devoted exhibitions to him in 1950, 1964 and again in 1971 after the gallery had come into possession of several thousand works, nearly the entire contents of his

workshop, bequeathed to it by the artist in his will. Hopper represented the United States at the Venice Biennale of 1948, together with Calder, Stuart Davis and Kuniyoshi. J.P.M.

Huber
Wolfgang (Wolf)

Austrian painter
b.Feldkirch(?), Vorarlberg, c.1485 – d.Passau, 1553

The last important representative of the Danube school of painting, Huber produced his earliest-known painting, an *Epitaph*, in 1517 (fragment, Kremsmünster Monastery, Tyrol). In 1515, by which time he had already settled in Passau, he was commissioned to paint panels for an altarpiece dedicated to *St Anne* (Feldkirch, parish church), a work he finished in 1521. On the richly carved reverse is a *Lamentation* (*in situ*), while the recently rediscovered side-wings (Bregenz, Vorarlberger Landesmuseum) are decorated with scenes from the *Life of St Joachim and St Anne* and of the *Infancy of Christ*. These paintings, and the related panel representing *Christ's Leavetaking* (1519, Vienna, K.M.), are notable for their vivid sense of space. The design of the buildings reveals the influence of Altdorfer and Bramante, without which Huber's skill would be hard to explain, and the figures that of Dürer's woodcuts.

From the decade 1520 to 1530 there survive a *Deposition from the Cross* (1521, Louvre) and fragments from three altarpieces: a *Flagellation* and a *Crowning with Thorns* from the St Florian altarpiece, dating from 1525; a *Mount of Olives* and *Arrest of Christ* (Munich, Alte Pin.) from another altarpiece depicting the Passion; and, finally, two leaves from a third altarpiece decorated with *Scenes from the Life of the Virgin* (Berlin-Dahlem; Munich, Bayerisches Nationalmuseum). All these works, as well as *The Erection of the Cross* (Vienna, K.M.), are striking for their extreme plasticity and for the prominence given to each figure within the painting. Huber also indulges in pronounced foreshortening, and a degree of caricature of his figures.

Before the discovery of his paintings Huber was known only for his drawings. An early example, the *Landscape with the Mondsee* (1510,

▲ Edward Hopper
Early Sunday Morning (1930)
Canvas. 88 cm × 152 cm
New York, Whitney Museum of American Art

Nuremberg Museum), is a simple outline drawing quite devoid of stylistic conventions and which, were it not dated and initialled, would have been hard to place in period. The many later drawings that have survived reveal Altdorfer's influence in the rhythm of the composition and the technique of employing a pale outline over a dark background.

In certain portrait drawings, probably dating from 1510 to 1520, the models appear almost aggressively ugly (Erlangen Museum; Berlin-Dahlem; Dresden Gg). Huber was also the author of some remarkable painted portraits, including those of *Anton Hundertpfundt* (1526, Dublin, N.G.) and the humanist *Jacob Ziegler* (Vienna, K.M.) – but in these, as in his altarpieces, Huber bowed to the wishes of his clients. Although he occasionally produced sketches for portraits and for religious scenes, most of his drawings are landscapes. Extremely true to nature, these works display Huber's talent at its most profound. A.R.

Huguet
Jaime

Spanish painter
b.Valls, c.1415 – d.Barcelona, 1492

A leading Gothic painter of the second half of the 15th century, Huguet represents the last phase of the golden age of Barcelona. He settled there in 1448 after working first in Saragossa, then in Tarragona, at that time a notable artistic centre thanks to the patronage of the Archbishop. After the death of Martorell Huguet's studio became the most active and the most productive in Barcelona. His work bears the marks of a contained emotion, and a sense of mysticism and grandeur that sets it apart from that of Martorell and Luis

Dalmau. He was interested, too, in problems of space and light, as well as in landscape, but, generally, the demands of his artisan merchant clientèle forced him to remain faithful to the traditional gilt backgrounds which sometimes give his paintings a sumptuously archaic look.

His many works, most of which are documented, were successful from the start. The *St George Triptych* (Berlin-Dahlem and Barcelona, M.A.C.) probably dates from his period in Aragon: it shows the pensive, melancholy figure of the saint, in armour, together with the princess, who carries his arms, against a background of green countryside and blue sky. The *Vallmoll Altarpiece* (1447-50, Barcelona, M.A.C.), an impressive representation of the Virgin seated with the Child upon her lap, and surrounded by angelic musicians of Flemish appearance, reveals the influence of Dalmau. Another panel from the same altarpiece, the *Annunciation*, is in Tarragona Museum. A small altarpiece made up of three compositions, *Annunciation*, *Epiphany* and *Calvary* (before 1450, Vich Museum), displays in the second and third scenes a rustic landscape in which stand a couple of fortified manor-houses. The courtly elegance of *The Epiphany* reflects the Gothic influence of Martorell.

Between 1450 and 1455 Huguet painted *The Entombment* (Louvre), a traditional theme but treated here in relief, with the subject standing out from the background of sky. A fine altarpiece of the *Flagellation* (Louvre), executed during the same period for the shoemakers' guild in Barcelona, shows an elegant arcade set against a luminous landscape with trees, a church and hazy blue hills, through which a road meanders.

Huguet's style had now reached maturity and his works became much broader in scope. The five surviving panels of the *St Vincent de Sarriá Altarpiece* (Barcelona, M.A.C.), probably painted between 1458 and 1460, are notable, in addition to the liturgical ostentation, for the minute detail with which each face is depicted, particularly in

the astonishing group of singers in *The Ordination of St Vincent.* Geometric severity and a monumental grandeur reveal the care devoted to plastic construction, a feature which from now on was to distinguish Huguet's work from the purely linear themes of the International Gothic style.

The *St Anthony Abbot Altarpiece* (1455-8), destroyed during the 1909 uprisings, included six narrative compositions as well as an impressive portrayal of the saint shown seated with a crozier in one hand and an open book in the other. Of the *Retailers' Altarpiece*, dedicated to St Michael the Archangel (1455-60, Barcelona, M.A.C.), only the charming *Virgin and Child with Four Saints* and the three wings remain: *Victory of St Michael over the Antichrist*; *The Apparition of the Saint over the Palace of the Holy Spirit in Rome*; and *The Miracle of Mont St Michel*, in which a mother and her newborn baby escape from the rising waves.

The great *Altarpiece of St Abdon and St Senen* survives intact (1459-60, Tarrassa, Church of S. Maria de Egara) and is dedicated to the patron saints of Catalonian farmers. The saints are shown as two elegantly dressed young men standing on a mosaic pavement in broad daylight, haughty and full of melancholy. The wings depict scenes of their martyrdom, often in picturesquely realistic fashion, particularly the *Translation of the Relics to the Abbey of Arles-sur-Tech*.

The monumental *High Constable's Altarpiece* was commissioned by Dom Pedro of Portugal, who became King Peter IV, for the royal chapel in Barcelona (1464-5, Barcelona Historical Museum). It describes the *Joys of the Virgin*, among which the most important is the *Epiphany*, with its rich procession of kings, including one said to be Peter IV. The *St Augustine Altarpiece*, commissioned in 1463 by the tanners' guild for their chapel in the Church of the Augustines, was not completed until 1480. The eight surviving panels (Barcelona, M.A.C.) reveal an accumulation of detail which nevertheless does not detract from the grave solemnity of scenes such as the consecration of the saint as bishop.

The central scene of an altarpiece destined for the basketmakers' guild also survives: this is *St Michael the Archangel and St Bernard* (1468, Barcelona, Diocesan Museum), in which St Michael's rich dalmatic contrasts with the homespun robe of St Bernard. Finally, three separate figures, *St Anne*, *St Bartholomew* and *St Mary Magdalene* (Barcelona, M.A.C.), from the Church of S. Martín de Portegas, formed part of an altarpiece commissioned in 1465.

During his later years Huguet seems to have survived on his reputation and to have made something of an industry of his painting (*St Thecle Altarpiece*, Barcelona Cathedral, 1486). His individuality was swamped by that of his studio collaborators, amongst whom the most active were the various members of the Bergos family.

Huguet occupies an important position in 15th-century Spanish painting and in European art in general. Although he was a product of the Catalan tradition with its narrative grace and taste for sumptuous decors, as well as being tied by his customers' preference for outmoded formulae such as embossed gilt backgrounds, and by his own attachment to medieval lyricism, he was, in spite of all this, a 'modern' painter who was aware of the importance of unity of space and light, as well as of monumental construction. He thus forms part of a Mediterranean school of artists who were also found in Italy and Provence.

M.Be. and L.E.

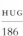 Wolf Huber ▲
The Flight into Egypt
Wood. 56 cm × 56 cm
Berlin-Dahlem, Gemäldegalerie

Hunt
William Holman
English painter
b. London, 1827 – d.London, 1910

The son of a warehouse manager, he began a career in business before studying art at the Royal Academy. His reading of the first volume of Ruskin's *Modern Painters* in 1846 convinced him of the need for greater reality and seriousness in contemporary art, and with Millais, Rossetti and four others he founded the Pre-Raphaelite Brotherhood in 1848. Unlike the others, he remained faithful to the precepts of this movement. Although he was not immediately successful, his *Light of the World* (1854, Oxford, Keble College) became immensely popular. This spiritual allegory, painted with painstaking naturalism, was exhibited with *The Awakening Conscience* (1854, private coll.), a contemporary morality which was intended as its pendant. He made three trips to Palestine, in 1854, 1869 and 1875, to enhance the verisimilitude of his biblical scenes, although this accuracy sometimes obscured the significance of his symbolism, as with *The Scapegoat* (1854, Port Sunlight, Lady Lever Art Gal.). His work often suffers from over-elaboration and harsh tonalities, but the power of his best concepts is undeniable. In 1905 he published a history of Pre-Raphaelitism which, despite its bias against Rossetti, is an invaluable source book. w.v.

Ingres
Jean Auguste Dominique
French painter
b.Montauban, 1780 – d.Paris, 1867

Ingres received his first lessons from his father, Joseph Ingres, a painter and sculptor, who taught him drawing, and also how to play the violin. Ingres's formal education in Montauban, however, was limited, a fact that he was to regret all his life. In 1791 he entered the Académie Royale

in Toulouse where his tutors included Joseph Roques, a former pupil of Vien's (David's tutor), and the sculptor Jean-Pierre Vigan. He also took lessons from the landscape painter Jean Briant and from the violinist Lejeune, and at one point even became second violin in an orchestra. Throughout his life, in fact, music remained a passion second only to painting. Armed with glowing references, he left for Paris in 1797.

Paris (1797-1806). Upon his arrival Ingres entered David's studio at a time when David was engaged on painting *Les Sabines*. Studious but rather wild, Ingres shared few of his fellow-pupils' interests. Nonetheless, Ingres was profoundly influenced by the studio, where he stayed until 1801. He painted several *Nude Studies* of men (Montauban Museum; Paris, E.N.B.A.) and in 1801 won the Grand Prix de Rome with his *Ambassadeurs d'Agamemnon*, Paris, E.N.B.A.; sketch in Stockholm, Nm).

For financial and political reasons he was unable to travel immediately to Rome but moved into a former Capuchin abbey where he was not far from other pupils of David, including Gros, Girodet, Granet and the Florentine sculptor Bartolini. It was here that he executed his first commissions and his first major works, all of them portraits: *Auto-Portrait à l'âge de vingt-quatre ans* (*Portrait of the Artist aged Twenty-Four*) (1804, later retouched, Chantilly, Musée Condé), the three portraits of the *Famille Rivière* (1805, Louvre) and *Napoléon 1er sur le trône impérial* (*Napoleon I on the Imperial Throne*), (1806, Paris, Musée de l'Armée). These works, exhibited at the 1806 Salon, were severely criticized for their 'detached and unfeeling' atmosphere and their 'gothic' style, copied from Jan van Eyck. Ingres was deeply and lastingly affected by this lack of understanding, which he often encountered in future years.

Rome (1806-20). Ingres arrived at the Villa Medici in October 1806 after stopping off in Florence to admire Masaccio's frescoes. After finishing two fine portraits of *Granet* and *Madame Devauçay* (1807, Aix-en-Provence Museum; Chantilly, Musée Condé) he painted several nudes, notably *The Valpinçon Bather* (1808, Louvre) and *Woman Bathing* (Bayonne Museum). The former, when it was seen in Paris, was highly

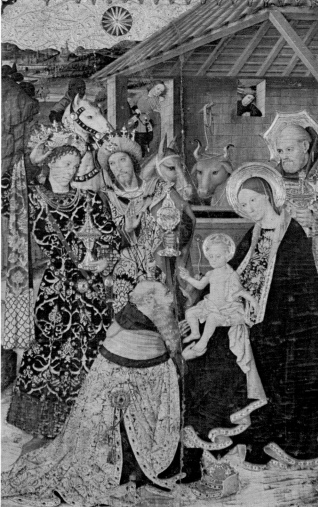

praised for its delicate reliefs and reflected light, in contrast with the expressive stylization of his last offering from Rome, *Jupiter et Thétis* (1811, Aix-en-Provence Museum), which provoked disputes in Parisian art circles.

He painted several official portraits (*Marcotte d'Argenteuil*, 1810, Washington, N.G.; *Moltedo*, 1810, Metropolitan Museum; *Cordier*, 1811, Louvre; *Bochet*, 1811, Louvre; *Devillers*, 1811, Zürich, Bührle Foundation) as well as enormous compositions such as *Romulus vainqueur d'Acron* (*Triumph of Romulus over Acron*) (1812, Paris, E.N.B.A., deposited in the Louvre), painted in an archaic style, and *Le Songe d'Ossian* (*The Dream of Ossian*) (1813, Montauban Museum), which is pre-Romantic in inspiration.

In 1813 Ingres married a milliner, Madeleine Chapelle, and in 1814, on his return from a stay in Naples (where he painted a *Dormeuse* [*Woman Sleeping*], now disappeared), date three important works in which his skill at expressive arabesques reaches its peak: the portrait of *Madame de Senonnes*, finished in 1816 (Nantes Museum), the *Grande Odalisque* (Louvre) and *Paolo et Francèsca* (Chantilly, Musée Condé).

With the overthrow of Napoleon in 1815 Ingres lost his clientèle and in order to earn a living was forced to execute pencil portraits of members of the new British colony (*Les Soeurs Montagu*, 1815, London, private coll.) or family scenes (*La Famille Stamaty*, 1818, Louvre). He despised this type of work, yet his remarkable talent emerges in the elegant unforced poses and the incisive precision with which the features are drawn. He

William Holman Hunt ▲
The Scapegoat (1854)
Canvas. 86 cm × 136 cm
Port Sunlight, Lady Lever Art Gallery

Jaime Huguet ▲
The Adoration of the Magi
Wood. Central panel of an altarpiece
1464–65
Barcelona, Museo de Historia de la Ciudad

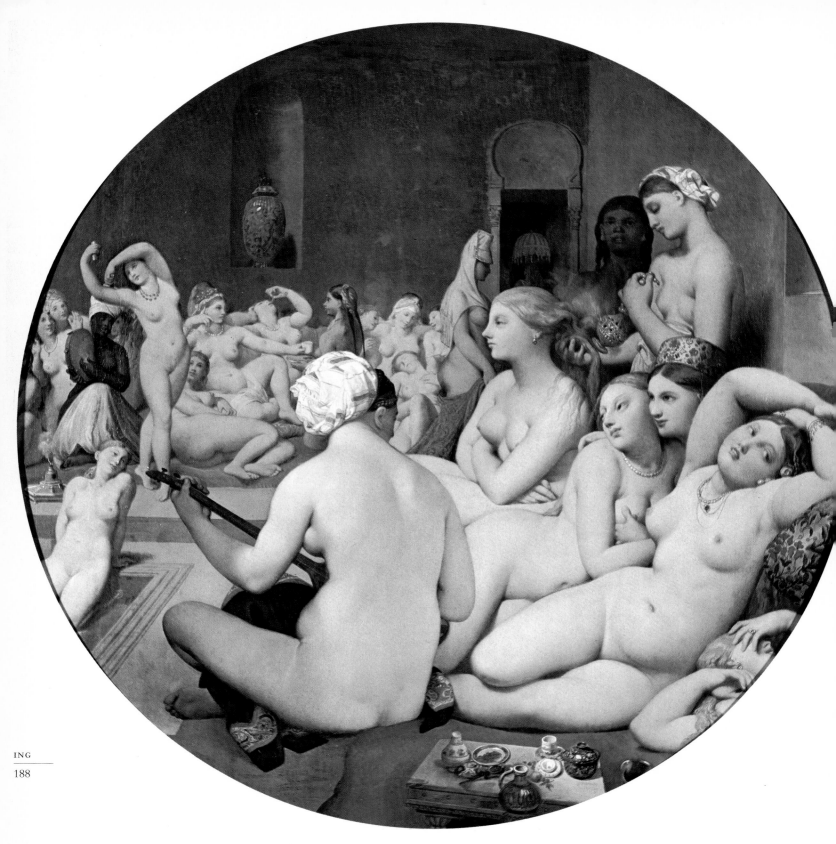

was also painting small canvases on historical themes: *Henri IV recevant l'ambassadeur d'Espagne* (*Henry IV receiving the Spanish Ambassador*) (1817, Paris, Petit Palais); *La Mort de François 1er* (*Death of Francis I*) (1818, Paris, Petit Palais).

Florence and Paris (1820–35). In 1820, at the invitation of his one-time fellow-student, the sculp-

tor Lorenzo Bartolini, Ingres went to live in Florence for four years. Here he studied Raphael, painted a number of excellent portraits (*Bartolini*, 1820, Louvre; *Gouriev*, 1821, Hermitage; *M. Leblanc and Mme Leblanc* (1823, both Metropolitan Museum) and executed an important commission for the French government *Le Voeu de Louis XIII* (*The Vow of Louis XIII*) (1820-4, placed in position

in Montauban Cathedral in 1826 on the occasion of a performance of Cherubini's *Coronation Mass*).

In October 1824 Ingres took *Le Voeu* to Paris where it was triumphantly received at the Salon. Its religious theme and its evocation of the Raphael *Madonnas* made it appear as a symbol of classicism and tradition in the face of Delacroix's *Massacre at Chios*, one of the first manifestations

▲ Ingres
Le Bain turc (1863)
Canvas on wood. Diameter 108 cm
Paris, Musée du Louvre

of Romanticism, which was exhibited at the same Salon. From then on Ingres took over the role of defender of classicism, and his official career was a brilliant one. He was awarded the Légion d'Honneur and was elected to the Academy in 1825. He also opened a studio and began training a considerable number of young painters. *L'Apothéose d'Homère* (1827, Louvre), painted for a ceiling in the Louvre, was warmly greeted by the proponents of the classical style, who saw it as a counterblast to Delacroix's *Death of Sardanapalus*.

The *Portrait de M. Bertin* (1832, Louvre) marks one of the high points of Ingres's work, both in its truthful portrayal of individual character and as a social portrait of the *grande bourgeoisie* during the age of Louis Philippe. His *Martyre de St Symphorien* (*Martyrdom of Saint Symphorian*) (1834, Autun Cathedral), however, proved a failure and he resolved never to exhibit at a Salon again. Instead he accepted the post of Director of the French Academy at the Villa Medici in Rome.

Rome (1835–41) and Paris (1841-67). At the Villa Medici Ingres was greeted in triumph by several of his former pupils, and afterwards spent most of his time supervising the redecoration of the Villa, organizing a library, adding to the collections of mouldings of ancient sculpture and founding a course in archaeology. He painted little: *L'Odalisque à l'esclave* (*Odalisque with Slave*) (1839, Cambridge, Massachusetts, Fogg Art Museum), *Antiochus et Stratonice* (1840, Chantilly, Musée Condé).

On his return to Paris in 1841 Ingres embarked on a series of society portraits to which he devoted endless care and which were highly successful: the *Comtesse d'Haussonville* (1845, New York, Frick Coll.), the *Baronne James de Rothschild* (1848, private coll.), *Madame Gonse* (1845-52, Montauban Museum), *Madame Moitessier*, standing (1851, Washington, N.G.) and seated (1856, London, N.G.) and the *Princesse de Broglie* (1853, New York, Metropolitan Museum, Lehman Coll.).

Ingres, whose fame continued to grow, received several important commissions for the decoration of monuments: *L'Âge d'Or* (*The Golden Age*), a vast mural for the Château de Dampierre (1842-9, unfinished); *L'Apothéose de Napoléon 1er*, ceiling of the Hotel de Ville in Paris (1853, destroyed in 1871; sketch in the Musée Carnavalet) and two series of cartoons for stained-glass windows. He also executed religious paintings: a *Vierge à l'hostie* (*Virgin of the Host*) (1841, Moscow, Pushkin Museum), *Jeanne d'Arc au couronnement de Charles VII* (*Joan of Arc at the Coronation of Charles VII*) (1854, Louvre), *Jésus au milieu des docteurs* (*Christ among the Doctors*) (1862, Montauban Museum), all of which have been accused of following unimaginatively in the footsteps of Raphael.

Yet Ingres had lost nothing of his creative vigour. Three nude scenes mark the high point of his art: *Vénus Anadyomène*, begun in 1808 in Rome, but not finished until 1848 in Paris (Chantilly, Musée Condé); *La Source* (*Spring*) (1856, Louvre); and, above all, *Le Bain turc* (*The Turkish Bath*) (1863, Louvre), which is the best of his later works.

His first wife having died in 1849, Ingres married for the second time at the age of 71. His new wife was Delphine Ramel, whose portrait, (1859), is in the Oskar Reinhart Collection at Winterthur. Ingres died in Paris on 14th January 1867.

The style of Ingres. Ingres's life, and consequently, his artistic career, were divided between Paris and Rome. Two major periods may be discerned, separated by the success of *Le Voeu de Louis XIII* at the 1824 Salon and that of the *L'Apothéose d'Homère* in 1827. The first was a phase of archaizing, anti-classical expressionism, the second classical and official. In fact, the two phases are linked by certain fundamental and permanent features of Ingres's art, as well as by the strength of his personality, and may be seen as an evolution, rather than a definite break.

As can be seen from his notebooks, from his early training in David's studio Ingres kept up the habit of seeking the subjects for his paintings from ancient history or literature and he found models in classical sculpture and in the works of Raphael and Poussin. But like certain of his fellow-students, Ingres was also aware of the prevailing pre-Romantic current, and he also became interested in the Middle Ages and in history, in Dante and Ossian, in the paintings of the Italian and Netherlandish primitives and in ancient Greek vases. At the same time he did not ignore such post-classical forms as the Hellenistic style of 16th-century Tuscan Mannerists.

Ingres was careful to work from the life: all his paintings were preceded by drawn studies of living models, whom he often made pose in the attitude of the statue or the painted figure that had inspired him in the first place. To his pupils he recommended truth and 'naïveté': not the passive reproduction of reality, but the enhancement of the individual character of the model, whether nude or in a straightforward portrait. From this doctrine resulted his deliberate stylization. He would accentuate a character, even exaggerate if need be, and introduce those 'deformities' (the neck of Thetis or of Francesca, the three 'extra' vertebrae of the *Grande Odalisque*) which the critics looked upon as faults, but which lend his models expressive qualities for which he willingly sacrificed perfect anatomical construction and realism. He lengthened proportions, gave them undulating curves and embellished his contours with arabesques, creating full, rounded forms from which he eliminated anything he considered to be mere detail. His smooth reliefs have neither shadows not obvious lights, but subtle passages among half-tints.

This tendency to stylize contours resulted in a certain geometrical element in the composition, which was to lead some 20th-century artists to claim Ingres as their inspiration. The audacity of some of Ingres's youthful works and his 'peculiarities' also occasionally won him the favour of Baudelaire, although the latter in general preferred Delacroix, who was more colourful, more poetic.

The works of Ingres's second period are calmer and in a more traditional classical style, but the essential features of his painting remained unchanged throughout his career. His hostility towards the official Paris art world never disappeared. In part this is explained by the total incomprehension with which it had greeted his youthful works but, more importantly, by Ingres's lifelong opposition to Neoclassicism, which was quite at odds with his own tendency towards expressiveness and the affirmation of individual character. Even though Ingres followed an official career he continued to have serious differences of opinion with his colleagues at the Academy right up until his death. To write him off as an academic painter is therefore unjustified.

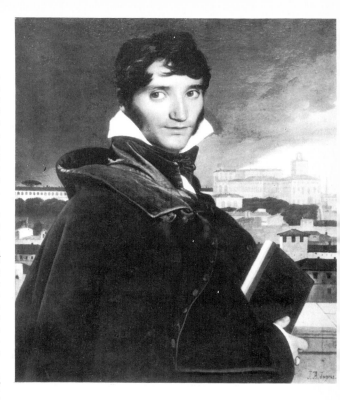

Ingres was above all a realist and an observer – he has been described as an 'eye' – and not a man of imagination. (His fidelity to his subject matter recently won him the respect of the advocates of the *nouveau roman*). These qualities did not rescue many of his historical paintings from failure – although Ingres thought of himself as a great historical painter – but served him marvellously in his nudes and portraits. In these two genres Ingres produced some of the world's masterpieces, not only among his paintings, but also among his innumerable pencil studies and black-lead portraits, which are among the most easily accessible of his works. A complex, baffling personality, plain-spoken and irritable, Ingres even now provokes widely differing opinions. D.T.

Inness
George

American painter
b.Newburgh, New York, 1825 – d.Bridge of Allan, Scotland, 1894

Inness has a particular importance in the history of 19th-century American painting. Although he was of the same generation as many of the painters of the Hudson River School, his style ran counter to the prevailing taste for the sublime. His slow climb to popularity as a landscape painter parallels the gradual acceptance in the United States of the innovations of the Barbizon School and foreshadows the subsequent overwhelming popularity of French Impressionism among American collectors.

The painter who was to reject the thunderous effects associated with Cole, Church and Bierstadt was born in the Hudson Valley at Newburgh, but at the age of five moved with his family to Newark, New Jersey. There, at the age of 14 he began drawing lessons, the same year that his father, a successful tradesman, installed him as the owner of a grocery shop. Inness gave

Ingres ▲
Portrait de François Marius Granet
Canvas. 72cm × 61cm
Aix-en-Provence, Musée Granet

this up to become an apprentice with a New York firm of map engravers, and from the age of 16 or 17 began to work seriously from nature. By the time he was 18, he had shown at the National Academy and also the American Art Union, before receiving any formal instruction from a known master – Regis Gignoux, in 1845.

A dry-goods auctioneer, Ogden Haggerty, is said to have interested himself in the youth's work and to have paid for his first trip abroad in 1847, when Inness briefly visited England and Italy. A second trip to Europe, including a long stay at Florence, followed in 1850-2, after which Inness achieved the status of Associate of the National Academy in 1853. It was, however, his third trip, in 1854, to France, where he first encountered the work of Corot, Daubigny, Rousseau and Courbet, that was the decisive experience for Inness. Now his style really began to change, and in 1857, he went to live for a while near Boston, a city whose artistic circles had been inspired with a genuine enthusiasm for the Barbizon style through the agency of William Morris Hunt.

Inness began to receive commissions for landscape portraits. He was familiar with the philosophy of Swedenborg, and his belief in the pantheistic quality of nature led him to find the quiet, the still and the intimate as significant as craggy mountains or sharp cliffs. He began to develop textures and patterns particularly suited to his unpretentious landscapes and gradually came to distrust painting that did not share his feeling for a poetic and intimate realism. Thus, he despised the Pre-Raphaelites, but equally disapproved of the Impressionists in the 1880s. The moralizing English artists he thought insincere and dull on account of their fanatical attention to detail, while the Impressionists transgressed common sense and

quiet good taste by their outrageous colours, which tried to outdo nature. To Inness nature was the model, and autumn was the season of greatest poetry. When he died in 1894, he was not perceived as a revolutionary, but rather as a faithful transcriber of nature in its calmer and more tranquil aspects. D.R.

Jawlensky
Alexej

Russian painter
b. Torschok, 1864 – d. Wiesbaden, 1941

Jawlensky gave up a military career in order to devote himself to painting and began his training at the St Petersburg Academy in 1889 before going on to Munich in 1896 to study with Anton Azbé, through whom he met Kandinsky. His early works are realist in style, but he soon came under the influence of Van Gogh (*Hyacinth and Fruit*, 1902, Basel, private coll.) and the Post-Impressionists, whom he discovered in France in 1905, a time when he also met Matisse.

Jawlensky founded the Neue Künstlervereinigung in 1909 with Kandinsky, and both artists spent the summers (starting from 1908) working at Murnau in the foothills of the Bavarian Alps. It was here that Jawlensky developed a highly original method of expression, a synthesis of Art Nouveau and borrowings from Matisse (in the aftermath of his Fauvist period), together with stylized effects derived from popular Bavarian painting and Russian icons (*Russia*, 1911, Bielefeld Museum; *Solitude*, 1912, Dortmund Museum). He con-

tinued to produce works in this vein until 1913, particularly during the Blaue Reiter period when his paintings were marked by their hieratic poses and vivid resonant colour (*Lady with the Blue Hat*, 1912-13, Mönchengladbach Museum).

After a visit to Bordighera in 1914, Jawlensky spent the war and post-war years at St Prex in Switzerland, where he experimented with a more abstract mode in his 'variations on a landscape theme' – 'songs without words', as he later described them (*Large-Scale Variation, Morning*, 1916, Paris, private coll.). These were followed by similar studies of the human face, which from now on dominated his work and was invested with a markedly religious significance (*Head of a Saint*, 1919, Stuttgart, Kunstkabinett).

After settling permanently in Wiesbaden in 1921, Jawlensky formed another group with Kandinsky, Klee and Feininger in 1924. Known as the Blauen Vier (Blue Four) in memory of the Blaue Reiter, it proved short-lived. Jawlensky continued his search for an ever more spiritual form of art, although he reverted to a comparatively figurative style in 1922-3 (*Open Eyes*, 1923, New York, M.O.M.A.), and completed his development with a long series of 'meditations' based on biblical themes. The paintings are smaller and more densely worked than hitherto, and are characterized by the placing of the faces, with their closed eyes, in broad, vertically hatched black bands that offer a minimum of landmarks to the eye (*Meditation*, 1930, Paris, private coll.). Around 1920 Jawlensky experienced the first signs of paralysis but continued painting until 1938. His catalogue, published by Clemens Weiler in 1959, lists 789 works.

Jawlensky, although continuously searching for a way of representing the non-material, never completely abandoned realistic allusion. His art is

 George Inness
Autumn Gold
Hartford, Connecticut, Wadsworth Atheneum

nonetheless typical of the basic conflict in modern painting between the abstract and the figurative. He is represented in Paris (M.N.A.M.) and in the Lyons Museum, as well as in most of the major German galleries: Dortmund, Düsseldorf (K.M.), Cologne (W.R.M.), Munich (Städtische Gal.), Stuttgart (Staatsgal.) and especially Wiesbaden (27 canvases) and Wuppertal (Von der Heydt Museum). M.A.S.

John
Augustus Edwin
English painter
b.Tenby, 1878 – d.Fordingbridge, 1961

The brother of Gwen John, who also became a distinguished artist, Augustus John was a man of strong personality and varied artistic talents: a painter of portraits, figure compositions, landscapes, and flowers, as well as being a fine draughtsman, an etcher and a lithographer. He studied at the Slade School from 1894 to 1898, and developed a spontaneous and brilliant style of drawing that won him immediate recognition as one of the most promising artists of his generation, and as Henry Tonks's leading pupil. As a student, John became something of a flamboyant figure, disguising his shyness behind a bohemian exterior. His impact on the Slade appears to have resulted from a radical change of personality which followed a bathing accident in the summer

of 1897, when he hit his head on a rock.

John began to exhibit at the New English Art Club in 1899 and became a member in 1903, the year of his first one-man exhibition, at the Carfax Gallery. By that time some of his paintings were quite accomplished, such as the portrait of *Estella Dolores Cerutti* (1902, Manchester, Art Gal.). After his marriage to Ida Nettleship in 1901, John felt the need for a steady income, and he took a position as a teacher of painting at an art school affiliated to University College, Liverpool; soon, however, his restlessness was reflected in an eccentric way of living.

The following years were probably the most important in John's life. He painted in Wales, Dorset and Ireland, and sometimes camped with gipsies, whom he admired and emulated. 'The absolute isolation of the gipsies seemed to me the rarest and most unattainable thing in the world', John once commented, and their rootless wanderings appealed strongly to his own passion for personal freedom and independence. His paintings of this period frequently depict those who apparently share this spirit: tramps, gipsies and peasants were recurrent subjects.

About 1905 John became interested in painting outdoor scenes with a light and rapid touch, as, for instance, in *Gipsy Encampment* (1905, private coll.), and it was a style that he was to develop in the following years. In 1906 he stayed in Paris, returning to England on Ida's death in 1907. He moved into residence with Dorelia McNeill in 1908, a year in which he made many fine drawings, both of Dorelia and of his sons. Several good portraits, such as *W.B. Yeats* (1907,

Augustus John ▲
The Blue Pool (1911)
Panel. 39 cm × 50 cm
Aberdeen Art Gallery

Alexej von Jawlensky ▲
Lady with the Blue Hat (1912–13)
Cartoon. 70 cm × 55 cm
Mönchengladbach, Städtisches Museum

Manchester, Art Gal.), also date from this period.

John spent some time abroad, with the help of John Quinn, the American collector, and in 1910 he painted at Martigues, a small French fishing town, which resulted in an exhibition of about 50 *Provençal Studies* at the Chenil Gallery. In 1911, the year in which he was elected to the Camden Town Group, he moved to the country, near Parkstone in Dorset, and painted another group of pictures in the 'Provençal' manner, again using his family as models. *The Red Feather* (c.1911, private coll.) is an attractive example. *Lyric Fantasy* (c.1910-15, London, Tate Gal.), a large and much more ambitious design, is far less spontaneous than the smaller paintings of the period, and was left incomplete: it was clearly influenced by the work of Puvis de Chavannes.

In 1916 John was rejected when he applied for military service and, apart from his work on the *Galway* cartoon (1916, London, Tate Gal.), also left incomplete, he produced little during the war.

In France at the Peace Conference in 1919, John painted many slick and slightly vacuous portraits. The glamorous *Marchesa Casati* (1919, Ontario, Art Gal.) and *Madame Suggia* (1920-3, London, Tate Gal.) are among the most notable of his post-war portraits of women, as is *Lady Adeane* (1929, Adeane Coll.), a work of a few years later. In 1928 John became a member of the Royal Academy, having been elected an Associate in 1921, which reflects the fact that – rather ironically – he was fast becoming part of the artistic establishment.

Some of the portraits of the 1930s, such as the later *W. B. Yeats* (1930, Glasgow, Art Gal.) and *Joseph Hone* (1932, London, Tate Gal.), are successful works, but on the whole neither the portraits nor the landscapes and flowerpieces that he had painted during the previous decade add much to his pre-war achievements.

John resigned from the Royal Academy in 1938 but was re-elected in 1940; the following year he was commissioned to paint the Queen, and in 1942 he was awarded the O.M. In 1948 he became President of the Royal Society of Portrait Painters, but resigned in 1953. He died without ever having quite fulfilled the promise of his early years. When his work went well, it appeared effortless and fresh, like the charming studies of 1910 and 1911, but when his enthusiasm fell away, John's paintings did not have the excellence of which he was capable. J.H.

Johns
Jasper

American painter
b.Allendale, South Carolina, 1930

After studying briefly at the University of South Carolina, Johns arrived in New York in 1949. In 1954 and 1955, when Abstract Expressionism was at its height, Johns painted a series of paintings of American flags and targets, some of which he exhibited in 1957 at the Leo Castelli Gallery where they attracted the attention of the art historian Robert Rosenblum.

In 1958, when Johns held his first one-man show at Castelli's, the flags and targets produced a storm of protest. The works reintroduced representation to American art, but were attacked as being a Neo-Dada manifestation.

Johns used the ancient technique of encaustic to change the nature of the surface of the canvas, and identified his images with the background, or field, thus asserting the formal priority of flatness while at the same time insisting on the significance of the image (*Flag on Orange Field*, 1957, Cologne, W.R.M.). Concentrating on a limited repertory of everyday, functional objects, he treated the art world to a dazzling display of painterly virtuosity (*Numbers in Color*, 1958-9, Buffalo, Albright-Knox Art Gal.; *Map*, 1961, New York, M.O.M.A.).

An important change took place around 1960 when Johns rejuvenated both his techniques and his subject matter, using a more broken type of execution which dissociated the image from the field (*Slow Field*, 1962, Stockholm, Moderna Museet; *According to What*, 1964, Los Angeles, Edwin Jauss Jnr. Coll.; *Edingsville*, 1965, Cologne, W.R.M., Ludwig Coll.). About 1960 also he made a now-legendary series of sculptures, some of them in bronze (*Beer Cans*, 1960, New York, Scull Coll.), which transposed the same theoretical problems as the earlier *Flags* and *Numbers* had dealt with into three dimensions.

More recently still, Johns has shown himself to be a print-maker of the first rank. An accomplished draughtsman, he has proved his subjects are invested with a different meaning when executed in a different manner (*Three Flags*, pencil, 1959, London, V. & A.). D.R. and J.P.M.

Jongkind
Johan Barthold

Dutch painter
b.Latrop, Overijssel, 1819 – d.Grenoble, 1891

Jongkind spent his childhood in Vlaardingen and, although he was originally destined for the legal profession, his love of drawing led him to choose art as a career. In 1837 he travelled to The Hague where he received instruction from the landscape painter Andreas Schelfhout. Between 1838 and 1842 he studied drawing at Massluis and in The Hague and in 1843 won a bursary which supported him for the next ten years.

He met Eugène Isabey in The Hague in 1845 and spent some time in the latter's studio in Paris

JOH

192

Jasper Johns ▲
Numbers in Color (1958–9)
Canvas. 168 cm × 125 cm
Buffalo, Allbright-Knox Art Gallery

the following year, and also in that of Picot. Until 1855 Jongkind drew most of his inspiration from Paris (numerous views of the *quais*, such as *The Breakwater*, 1853, Angers Museum; the *Quai d'Orsay*, 1852, Bagnères-de-Bigorre Museum) and from the Normandy ports such as Honfleur, Fécamp, Le Havre and Étretat that he visited after 1849. His watercolours and paintings reveal him as an accomplished craftsman in the Dutch landscape tradition, respectful of his subject but never overawed by it (*Le Pont Marie*, 1851, Paris, private coll.; *Étretat*, 1851, Louvre).

His lack of success at the Paris Exposition of 1855 made him decide to return to Holland where he lived in Rotterdam, then Klaaswall, and then Overschie until 1860. But he missed Paris and, encouraged by friends who were worried about the effect on his career of his absence in Holland, he returned to France. Between 1862 and 1866 he spent the summers in Normandy. In 1862 he produced his first etchings, *Six Views of Holland* (he left 27 engraved plates), and exhibited the following year at the Salon des Refusés. In 1864 he met Monet at Honfleur and the two men worked together. After 1860 his treatment grew lighter, his touch more fragmented, and he allowed his colours to separate spontaneously so as to suggest the vibration of light (*Effect of the Moon on an Estuary*, 1867, private coll.).

During his numerous journeys to Belgium, Holland, Normandy and the Nivernais area he painted principally in watercolour. Many of these works were designed as studies for further compositions, but increasingly he painted watercolours for their own sake (*Le Havre, Beach at Ste Adresse*, 1863, Louvre). He visited the Dauphiné region in 1873 and in 1878 moved to La Côte St André, Berlioz's birthplace. In 1880 he made a journey to the south of France (Marseilles, Narbonne, La Ciotat), and between 1881 and 1891 returned each winter to work in Paris.

By now watercolour had become his favourite medium; his very sure draughtsmanship, coupled with his ability to suggest swiftly and with intense accuracy both time and place, gained an extra dimension when allied to his fluid colours, in which white played a large part. His style became freer as he abandoned preliminary drawings and began using a reduced range of colours in which yellows and ochres predominated (*Snowscape in the Dauphiné*, 1885, private coll.). Jongkind's paintings have a freshness and vision which result from extreme subtlety of execution; his attitude towards nature makes him one of the precursors of Impressionism. During the last years of his life alcoholism led to psychological derangement; he died insane at Grenoble and was buried at La Côte St André.

His work is found chiefly in galleries in Holland (Rijksmuseum; Rotterdam, B.V.B.; The Hague, Gemeentemuseum) and France (Paris, Louvre and Petit Palais; Grenoble; Aix-les-Bains; Rheims), as well as in private collections. M.A.S.

Jordaens
Jacob

Flemish painter
b.Antwerp, 1593 – d.Antwerp, 1678

Jordaens spent his entire career in Antwerp where he became a pupil of Adam van Noort in 1607 and his son-in-law in 1616. He was received into the Antwerp Guild as a painter in tempera and watercolours in 1615. He enjoyed a successful career, receiving commissions from all over Europe, and was regarded in Antwerp as the natural successor to Rubens and Van Dyck.

Jordaens very soon acquired a personal style, although he was particularly influenced by Rubens and Caravaggio. In the latter, Jordaens found traits that corresponded closely to his own feelings; sharp, vigorous realism, ample rounded forms and lighting that brought out the richness of the colours (*The Holy Family*, 1616, Metropolitan Museum; *Adoration of the Shepherds*, c.1617, Grenoble Museum; *The Daughters of Cecrops*, 1617, Antwerp, Koninklijk Museum; *Allegory of Fertility*, Munich, Alte Pin.; *Crucifixion*, Rennes Museum; *The Temptation of the Magdalene*, Lille Museum).

These same paintings also reveal the influence of Rubens, whose work inspired Jordaens for many years – although his style was more Italian than Rubens's and he was probably Caravaggio's closest disciple in the Low Countries. His work always fluctuated between these two tendencies. Jordaens, who never went to Italy, was also interested in Bassano's and Elsheimer's experiments with light, as can be seen in his *Holy Family with St Anne* (c.1615-17, Detroit, Inst. of Arts).

Jordaens worked in Rubens's studio for over 20 years (between 1620 and 1640 approximately), although he was more of a collaborator than a pupil. He participated with Van Dyck in the great compositions in which Rubens was involved around 1620, including *Christ in the House of Simon* (Hermitage). After Van Dyck's departure for Italy in 1622, Jordaens became Rubens's closest associate and probably helped complete the 21 paintings commissioned for the Medici Gallery in Paris. In 1634-5 he worked on the elaborate gala decorations for the state entry of the Cardinal-Infante Ferdinand into Antwerp, and in 1636-8 on certain mythological com-

positions intended for Philip IV of Spain (*The Fall of the Titans*, Prado, signed by Jordaens but composed from a sketch by Rubens, now in Brussels, M.A.A.). After the death of Rubens in 1640 Jordaens was entrusted with the task of finishing two paintings, a *Hercules* and an *Andromeda*, for Philip IV, as well as the huge commission for Charles I of England, the *Story of Psyche*, in seven separate scenes.

During the course of this long collaboration with Rubens Jordaens simultaneously pursued his own career. With such works as *Pan and Syrinx* (Brussels, M.A.A.), *The Satyr and the Peasant* (Kassel Museum), *The Adoration of the Shepherds* (Stockholm, Nm; other versions in The Hague, Mainz and Brunswick museums) and the *Family Portraits* in the Hermitage and Brunswick Museum, Jordaens reached maturity as an artist.

His style found its happiest expression during the decade 1620-30. In his *Adoration of the Shepherds* (Mainz, Mittelrheinisches Landesmuseum) the idealized, graceful figure of the Virgin is surrounded by a robustly realistic group of shepherds in a work that juxtaposes two

Jacob Jordaens ▲
Christ Driving the Traders from the Temple
Canvas. 288 cm × 436 cm
Paris, Musée du Louvre

Johan Jongkind ▲
The Quai d'Orsay (1852)
Canvas. 32 cm × 51 cm
Bagnères-de-Bigorre, Musée Saliès

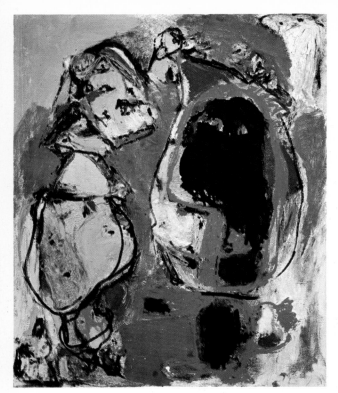

traditions, the Italian and the Flemish. In *The Arrest of Christ* (London, N.G.), and even more so in the *Allegory of Fertility* (c.1622, Brussels, M.A.A.), the forms are supple, the colours very light, the treatment less smooth than previously. *The Four Evangelists* (c.1622-3, Louvre), a masterpiece of Baroque religious art, combines mystical idealism with human realism, while *The Martyrdom of St Apollonia* (1628, Antwerp, Church of St Augustine; sketch in Paris, Petit Palais), a vast church painting, is clearly dominated by the influence of Rubens. *Christ Driving the Traders from the Temple* (Louvre), a rich hurly-burly of people and animals, is a fine example of Jordaens's pictorial vigour and his ease of execution. In his portraits, such as *Young Man with His Wife* (Boston, M.F.A.) and the *Portrait of a Man* (Washington, N.G.), Jordaens reveals an authority and a distinction close to those of Van Dyck.

Jordaens's later paintings, from 1630 onwards, have come in for a great deal of ill-founded criticism; for right up to the end of his career Jordaens continued to produce a number of works of the highest quality. *The Huntsman with Hounds* (1635, Lille Museum) remains one of his finest landscapes, with its echoes of both Rubens and the Italians. The ceiling that Jordaens painted for his own house around 1640 and which displays the *Signs of the Zodiac* is now installed in the Palais du Luxembourg in Paris. It uses perspective with a degree of virtuosity that rivals the boldest effects of Baroque illusionism. *The Education of Jupiter* (c.1635, Louvre) is more a genre painting than an allegory. Although the flesh textures are heavy and the forms rounded, as in *Susannah and the Elders* (Brussels, M.A.A.), Jordaens avoids any hint of coarseness, even in the somewhat crude colours he was then using.

A brutal realism is most in evidence in the painter's two favourite themes: *The Satyr and the Peasant* (apparently the earliest treatment in painting) (Brussels, Glasgow, Budapest, Leningrad and Munich museums) and *The King Drinks* (c.1638-40, Louvre). In other, similar paintings, such as *The Family Concert* (Antwerp Museum), Jordaens descends into vulgarity, as he does in the

version of *The King Drinks* in the Vienna Kunsthistorisches Museum. His religious paintings, overflowing with life and movement, and with their multiple perspectives, are close in spirit to the Baroque, as revealed in the tumultous *Last Judgement* (painted for the Furnes Town Hall, now in the Louvre), or *Jesus Among the Doctors* (1663, Mainz, Mittelrheinisches Landesmuseum).

From 1640 until his death the balance and Italian grace that distinguished one aspect of Jordaens's work (*Marsyas Chastised by the Muses*, Mauritshuis; *The Sleep of Antiope*, 1650, Grenoble Museum) were counterpointed by an equal emphasis on gigantic figures (*Neptune Abducting Amphitrite*, 1644, Antwerp, Rubens's House) or more conventional themes (*The Peace of Münster*, 1654, Oslo, N.G.). His use of colour remained clear and light in *St Ivo, Patron of Lawyers* (1645, Brussels, M.A.A.). The *Triumph of Prince Frederick-Henry of Nassau* for the Huis ten Bosch at The Hague (1652, sketches in Antwerp, Brussels and Warsaw museums) shows him moving towards Baroque immoderation, but at the same time there is a touching expressiveness in his last religious compositions: *The Ascent to Calvary* (Amsterdam, Church of St Francis Xavier) and *Christ Driving the Traders from the Temple* (1657, The Hague).

As a draughtsman Jordaens remains famous as much for his copies, made between 1630 and 1640, of the paintings and drawings of Rubens as for his own work. Unlike Rubens, whose graphic line was more refined, Jordaens started by positioning large areas of white and black and tracing the outlines of his forms, with a well-filled brush. He often used washes, and preferred the brush to the quill (*The Entombment*, c.1616, Prado; *Moses Producing Water from the Rocks*, c.1617, Antwerp, Print Room). He also executed many portrait studies in coloured chalk (Besançon Museum; Paris, Louvre and E.N.B.A.). In his employment of watercolour and gouache he displayed rare mastery (*Scenes from Country Life*, London, British Museum).

Jordaens also carried out a number of tapestry cartoons in tempera. Of these, *The History of Alexander*, a series of *Flemish Proverbs* and *The History of Charlemagne* were made up into tapestries several times during the 17th and 18th centuries. The Louvre has four of the original painted cartoons, and the museum at Besançon contains a number of fragments. P.H.P.

Jorn
Asger Oluf Jørgensen
Danish painter
b.Vejrum, 1914 – d.Aarhus, 1973

Jorn began his career as a painter in 1930 with small landscapes and portraits, and came to know of Kandinsky's work through the Bauhaus publications. In Paris, in 1936, he studied with Léger and then, the following year, under the direction of Le Corbusier (decoration of the Palais des Temps Nouveaux at the Exposition Universelle). After his return to Denmark these influences were succeeded by others more in accord with his own temperament, including those of his compatriot Jacobsen, Klee and Miró, as well as the engravings of Ensor.

During the Second World War Jorn founded

the magazine *Helhesten* in Copenhagen, together with Bille, Pederson and Jacobsen, whom he was to meet again in the 'Cobra' group. From then on his painting became spontaneous, dynamic and colourful (watercolours of the *Didaska*, 1944-5, Copenhagen, S.M.f.K.) and he also played a leading role in several avant-garde groups, including Cobra, from 1948 to 1951. In 1958 his book *Pour la forme: Ébauche d'une méthodologie des arts*, a collection of articles embodying Jorn's views on art, appeared in Paris.

Jorn was interested in all techniques, including engraving, ceramics and tapestries, and his work is distinguished by a constant search for new forms of expression. His early works were figurative and highly expressive, but he soon began to draw inspiration from the fantastic monsters of Scandinavian mythology. His association with the Cobra group opened new horizons and resulted in effervescent paintings in the mainstream of Expressionism (*Entry of Churchill into Copenhagen*, 1949-50, private coll.; *Letter to My Son*, 1956-7, private coll.). Through Cobra he was also led to take part in collective works and in 'word pictures', with Christian Dotrement (*La Chevelure des choses* [*The Long and the Short of It*], 1948).

His irreverent humour manifested itself at the expense of the uninspired old canvases which Jorn collected and painted over (*Modifications*, 1959; *Disfigurations* and *New Disfigurations*, 1961 and 1962). His aim was to evoke a poetic feeling for the interchange of the real with the unreal by the use of splashes of colour (*It's in the Air*, 1965, Paris, private coll.; *Calm Regard*, 1971, private coll.). After 1956 he spent a lot of time in Paris where he exhibited regularly, first at the Galerie Rive Gauche, then at the Galerie Jeanne Bûcher, where his last works were shown (collages, torn posters, gouaches).

Jorn's engravings match the quality of his paintings. His expressive *trouvailles* herald the work of Dubuffet and Alechinsky; he allowed his

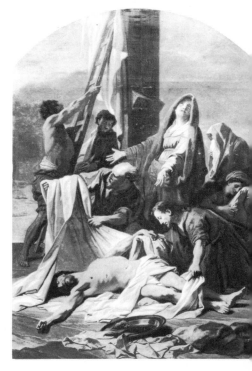

 Jean-Baptiste Jouvenet
Déposition de croix (1708)
Canvas. 292 cm × 193 cm
Pontoise, Church of St Maclou

▲ Asger Jorn
Anthropomorphic Rock
Canvas. 81 cm × 65 cm
Vienna, Museum des XX Jahrhunderts

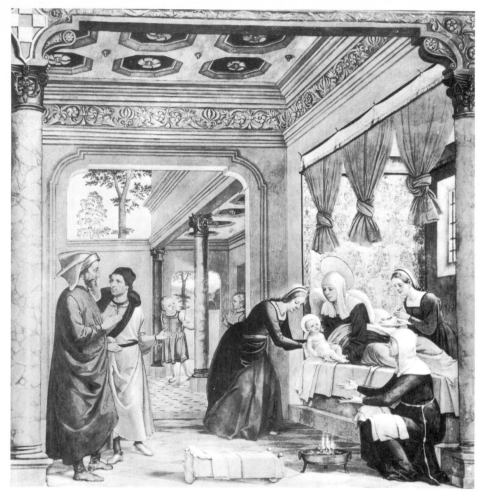

imagination free reign, refusing to subscribe to any dogma (*From Head to Foot*, 1966-7, ten coloured lithographs; *Safety Door*, 1971, nine drypoints; *Studies and Surprises*, 1971-2, twelve colour engravings on wood). He also produced vast decorative ensembles, as well as ceramics and tapestries (in collaboration with Pierre Wemaere), for Aarhus High School, and murals (1967-8) for a bank in Havana.

Jorn is well represented in Denmark: in Louisiana, outside Copenhagen, Aalborg, and especially in Silkeborg, richly provided for by the artist himself; and also in Vienna (Museum of the 20th Century) and Paris.　　　　　　M.A.S.

Jouvenet
Jean-Baptiste
French painter
b. Rouen, 1644 – d. Paris, 1717

Jouvenet was the principal member of a family of painters and sculptors based in Rouen, many of whom worked in Paris where Jouvenet himself arrived around 1661 to study under Le Brun. He collaborated with Le Brun on works at St Germain, the Tuileries and Versailles (Salon de Mars, 1673-4 and 1678; decor conserved, but repainted). In 1673 he painted *Jésus guérissant le paralytique* (*Jesus Curing the Paralytic*) (lost, but an engraving remains), and in 1675 he was received into the Académie (*Esther et Assuérus*).

Jouvenet is known to have been an admirer of Poussin, but his youthful work, inspired chiefly

by mythology, and now vanished, is little known. Traces of his early style, however, can be found in *La Famille de Darius* (*Family of Darius*) (Paris, Lycée Louis-le-Grand), *La Fondation d'une ville par les Tectosages* (*Founding of a City by the Tectosages*) (1684-5, Toulouse Museum), and *Le Départ de Phaëton* (*Departure of Phaëton*) (Rouen Museum), in which the lessons of Le Brun are translated into a more lyrical style.

Around 1685 Jouvenet took up religious painting (an *Annunciation*, Rouen Museum), a genre in which he became the leading practitioner in France. His more important works were painted for Paris churches: *Jésus guérissant les malades* (*Jesus Curing the Sick*) for the Carthusians (1689, Louvre); *Le Martyre de Saint Ovide* (*Martyrdom of St Ovid*) (1690, Grenoble Museum) and *Descente de croix* (*Descent from the Cross*) (1697, Louvre) for the Capuchins; four huge canvases (*La Pêche miraculeuse* [*The Miraculous Draught of Fishes*], *La Résurrection de Lazare* [*Resurrection of Lazarus*], Louvre; *Les Marchands chassés du Temple* [*The Traders Driven out of the Temple*], *Le Repas chez Simon* [*The Meal with Simon*], Lyons Museum) for St Martin-des-Champs (1703-6); copies for tapestries in 1711 (Lille, Arras and Amiens museums); and a *Magnificat* (1716) for Notre Dame. He also executed important works for provincial abbeys and churches: *Louis XIV guérit les scrofuleux* (*Louis XIV Curing the Scrofulous*) for the Abbey of St Riquier; *Christ au jardin des Oliviers* (*Christ in the Garden of Olives*) (1694, Rennes Museum) for St Étienne in Rennes; *L'Éducation de la Vierge* (*The Education of the Virgin*) (1699, Haramont Church) for Longpré Abbey; a *Deposition* (1708, St Maclou de Pontoise) for the Jesuits of Pontoise; *Le Centenier aux pieds du Christ*

(*The Centurion at the Feet of Christ*) (1712, Tours Museum) for Versailles; and *La Mort de Saint François* (*The Death of St Francis*) (Rouen Museum) for the Capuchins of Rouen.

Jouvenet also painted canvases on mythological subjects for the Trianon (two remain in position: *Zéphyre et Flore* [*Zephyr and Flora*], 1688-9; *Apollo et Thétys* [*Apollo and Thetis*], 1700-1) and for Marly and Meudon *Latone et les paysans de Lycie* (*Latonus and the Peasants of Lycia*, 1700-1, now in Fontainebleau). There were also vast decorations for the *parlement* at Rennes (1694-5, none preserved; sketch for *Le Triomphe de la justice* [*The Triumph of Justice*] in the Petit Palais in Paris), and others for the dome of the Invalides (1702-4, frescoes damaged; sketchs of *Les Douze Apôtres* [*The Twelve Apostles*] in Rouen Museum), for the chapel at Versailles (*Pentecôte* [*Pentecost*], 1709, preserved), and finally for the *parlement* at Rouen (destroyed; sketches for *Le Triomphe de la justice* in Rennes and Grenoble museums). The last years of Jouvenet's life were complicated by a creeping paralysis which forced him to paint with his left hand.

Jouvenet's art was founded on a vivid feeling for reality, particularly evident in his drawings (Stockholm, Nm) and in his portraits (*Raymond Finot*, Louvre), as well as on the use of rich textures coupled with simple colours; together these reintroduced fresh life into the classical tradition, to which he remained faithful all his life. He is represented by a fine collection of paintings, among them his *Self-Portrait*, and of drawings, in Rouen Museum.　　　　　　A.S.

Juan de Borgoña
Painter of French origin
active in Spain, 1494 – 1533

Borgoña is thought to have spent some time in Italy because of his evident knowledge of the art of Florence and Lombardy. In 1494 he is known to have been in Toledo but the frescoes he painted there have now disappeared. His first large-scale work was an altarpiece for Ávila Cathedral. A contract signed in March 1508 shows that he was employed to finish works begun here by Berruguete and Santa Cruz; five panels are attributed to him: an *Annunciation*, a *Nativity*, a *Purification*, a *Transfiguration* and a *Descent into Limbo*. The skilled, well-balanced composition, classical architecture and treatment of perspective reveal the influence of Florentine frescoes.

But it was in Toledo that Borgoña's talent first came to the fore. Between 1509 and 1511 he executed 15 frescoes in the chapterhouse of the Cathedral, dedicated to the Virgin (complete cycle from the *Meeting at the Beautiful Gate* to the *Assumption*) and to Christ (*The Descent from the Cross*, *The Entombment*, a *Resurrection* and a *Last Judgement*). The decoration was completed by a series of portraits of bishops and a floral decor for the vestibule. He expected further works for Toledo Cathedral (altarpieces for the chapels of the Trinity, the Epiphany and the Immaculate Conception), and in 1514 was commissioned to paint three large frescoes for the Moorish Chapel; those which depict the *Conquest of Oran* are somewhat monotonous in composition.

The art of Renaissance Italy, introduced into Castile by Borgoña, found only a limited response in his successors, Antonio de Comontes

▲ Juan de Borgoña
The Birth of the Virgin (1509–11)
Fresco in the chapterhouse
Toledo, Cathedral

and Pedro de Cisneros. The balance that Borgoña maintained between north European naturalism (due possibly to his French origins) and a taste (probably acquired in Italy) for strict organization of volumes and space places him on a level with such Spanish painters as Pedro Berruguete, Alejo Fernández and Johannes Hispanus. He also brings to mind certain Lombard painters such as Spanzotti and others from Provence (Lieferinxe) active towards the end of the 15th century. A.C.

Juan de Flandes
Netherlandish painter
b.1465(?) – d.Palencia, c.1519

Juan de Flandes is first mentioned in 1496 when he entered the service of Queen Isabella of Spain. Prior to this, nothing is known of his work; nor is it known how he came to the court, although Flemish painting was much in demand there. The first work that can be definitely attributed to him is a series of small-scale panels illustrating *Scenes from the Life of Christ and the Virgin*. These pictures come from an altarpiece painted between 1496 and 1504 for the Queen's Oratory, in collaboration with Michel Sittow. Of 47 paintings mentioned in the inventory made upon the death of Queen Isabella, 28 have been found. With three exceptions (Louvre; Washington, N.G.; United Kingdom, private coll.), which are the work of Sittow, these panels are all by Juan de Flandes. They are at present dispersed between the Royal

▲ Juan de Flandes
The Supper at Emmaüs
Wood. 21 cm × 15 cm (panel from the *Altarpiece of Isabella the Catholic*, 1496–1504)
Madrid, Museo del Palacio Real

Palace of Madrid (which has 15), and various galleries (Louvre; Washington, N.G.; London, N.G., and Apsley House; Detroit, Inst. of Arts; Vienna, K.M.; Berlin-Dahlem; and private colls.). A feature of these scenes is their pale colours, minute detail and the importance accorded to landscape.

After the death of Isabella in 1504 Juan de Flandes left the court and the following year signed a contract to decorate the altarpiece at the university chapel of Salamanca; of this work, the existence of which is borne out by documentation, only two half-length portraits of *Saints* (Apollonia and Mary Magdalene), executed in grisaille, survive. The altarpiece dedicated to *St Michael* (Salamanca, Diocesan Museum) dates from the same period.

Juan de Flandes's most important work, which is preserved *in situ*, is the great altarpiece for Palencia Cathedral (1505-6) of twelve *Scenes from the Life of Christ*. The fullness of the relief rivals the sculptural qualities and attempts at *trompe l'oeil* typical of Flemish realism – although the faces are sometimes almost contorted when the artist's northern temperament yields to Spanish pathos. Another great altarpiece in the same style was that carried out for the Church of S. Lazaro in Palencia; four panels (an *Annunciation*, a *Nativity*, *The Adoration of the Magi* and *The Baptism of Christ*) are in the National Gallery in Washington; the others (a *Visitation*, *The Garden of Olives*, *The Resurrection of Lazarus*, an *Ascension* and *Pentecost*) are in the Prado. *The Beheading of St John the Baptist* in the Geneva Museum and a delicate *Pietà* (Lugano, Thyssen Coll.) are also worth mentioning for the fact that they clearly reveal one of the artist's principal influences, that of Hugo van der Goes. Certain portraits of the royal family, in particular that of *Isabella the Catholic* (Madrid, Royal Palace) and that of a young girl (*Joanna the Mad?*) are in the Thyssen Collection in Lugano. A.C.

Justus of Ghent
(Joos van Gent, Joos van Wassenhove)
Flemish painter
active in Urbino, 1473-5

The name Justus of Ghent nowadays evokes an 'art-historical' problem. A number of works are associated with him but few scholars are in agreement about the attributions. It appears almost certain that Justus was one and the same as the Ghent painter Joos van Wassenhove, known to have been working between 1460 and 1469. Joos became a member of the Antwerp Guild in 1460, and of the Ghent Guild on 6th October 1464, and his name subsequently appeared in the Ghent archives several times, most notably in 1467 when he acted as guarantor for Hugo van der Goes. He appears to have been the protégé of the rich, middle-class Van der Zickele family, who made him a gift of money on the occasion of his departure for Italy, probably in 1469.

Documents from Urbino, dating from between 1473 and 1475, mention payments for a painting of the *Communion of the Apostles* to one 'maestro Giusto', who can be identified as Justus thanks to the evidence of Guicciardini and Vasari, both of whom mention one 'Justus of Ghent, who painted the communion painting for the Duke of Ur-

bino'. He would also appear to be the 'maestro solenne' whom Duke Federico of Urbino summoned from Flanders, and whom he commissioned to execute the portraits of famous intellectuals who frequented his *studiolo* and famous men of the past.

From this information Justus's work can be pieced together. *The Communion of the Apostles* (1474, Urbino, Ducal Palace) is unusual among Flemish paintings for its sweep and its monumental style. But it was probably unfinished, and only the two angels in the upper part of the picture have the texture and delicacy of north European painting. The work resembles to a certain degree, notably in the attitudes of the figures and their physical type, the triptych of the *Crucifixion* in the Church of St Bavon in Ghent, and it has often been suggested that Justus painted this latter work before he set off for Italy. Against this is the fact that the two works differ markedly from each other in spirit and in execution – so much so, in fact, that it is difficult to accept they are by the same hand simply because some of the details are similar.

The 28 portraits of *Famous Men* from Duke Federico's *studiolo* (Louvre; Urbino, Ducal Palace) are usually attributed to Justus, although they are mentioned in the early 17th century by Pablo de Céspedes as being the work of the Spanish painter Pedro Berruguete, who may have been working in Urbino around the time the portraits were executed. On the other hand, the monumentality of these half-figures suggests a wholly Italian style, and they have in the past been attributed by other authorities to Melozzo da Forlì. The problem is a difficult one to solve, although most critics tend to come down on the side of Justus of Ghent because of the uniformity of treatment, and a fidelity to the preliminary stage, as is revealed by infra-red photography. The portrait of the *Duke and his Son* (Urbino), which completed the decoration of the *studiolo*, is another painting whose authorship is disputed. It seems likely that the artist – Justus of Ghent or another – also executed the Duke's hands in Piero della Francesca's painting.

Similar in style are the two *Allegories of the Arts* (London, N.G.), the surviving paintings of an extensive series which probably came from a piece commissioned by the same patron. Here, however, the Italian characteristics are much more in evidence, especially in the emphatic foreshortenings. The same applies to a seriously damaged panel representing *Duke Federico Listening to a Humanist Lecture* (Royal Collection, Hampton Court). In the end, the personality of Justus of Ghent remains shrouded in mystery; caught between the influence of north and south, he upsets any overly rigid concept of schools and styles.

A.Ch.

Kalf
Willem
Dutch painter
b.Rotterdam, 1619 – d.Amsterdam, 1693

The master of the Amsterdam still life school, Kalf received his training under Hendrick Pot and early in his career was influenced by Rijckhals and by Cornelis Saftleven. He began by painting in the rustic style made fashionable by Adriaen van Ostade: *Cottage Interiors*; *Farmyards*

(Louvre; Strasbourg Museum; Berlin-Dahlem; Hermitage). The majority of these were painted in Paris where he lived between 1642 and 1646, frequenting the large Flemish colony in St Germain-des-Prés.

From 1643 onwards, however, Kalf also painted gorgeous still lifes showing gold or silver bowls (Cologne, W.R.M.; London, N.G.; Le Mans and Rouen museums) or weapons (Le Mans Museum), works characterized by a tasteful rendering of the subject and by harmonious and carefully chosen colours. He was particularly fond of offsetting the grey-browns of half-shadows with the golds, silvers and yellows of sudden flashes of light, a technique drawn from Rembrandt and his school. His name became linked with the style, which he persisted in after his return to Holland

around 1646 (he is known to have settled in Amsterdam by 1653). His usual subject matter consisted of gold and silver plate, glass, crockery or china, juxtaposed with more unusual objects such as shells or corals, spread out over luxurious rugs and painted in muted shades (Still Lifes: Rijksmuseum; Amiens Museum; Berlin-Dahlem; Rotterdam, B.V.B.; Copenhagen, S.M.f.K., 1678; Mauritshuis, 1658; and Paris, Netherlands Inst.).

Clearly reacting against the austere, monochrome still lifes of Claesz Heda, Kalf, together with Beyeren and Jan Davidsz de Heem, typified a new movement in Dutch painting around 1650 towards a more sumptuous and ostentatious form of art derived from Baroque ideas. His influence over such painters as Uriaan van Streeck, Van Hulsdonck, Janssens and Roestraten was so strong that their works have sometimes been mistaken for his. J.V.

Kandinsky
Wassily
French painter of Russian origin
b.Moscow, 1866 – d.Neuilly-sur-Seine, 1944

The birth of a vocation. Kandinsky began by studying law and economics, although the drawing, painting and music lessons he had received when younger inclined him towards art as a career. (He was later to confess that he had been too weak to believe that he had the right to renounce his other obligations.) In 1889 he was sent on a government mission to Vologda, where, as his diary reveals, he became as interested in the art, architecture and folklore of the peasants as in studying local laws, which was the official reason for his journey.

During that same trip his first entrance into an

isba (a house of the region) remained fixed in his memory: on seeing the popular images with their 'vivid, primitive' colours decorating the walls, he had the feeling he was 'walking into a painting'. Another decisive revelation was Monet's *Haystack*, before which Kandinsky, then attached to the faculty of law in Moscow (1895), felt 'obscurely that the subject (object) was missing from this work'. He was profoundly affected by the painting, whose every detail remained engraved in his memory; from then on the subject (or object; the hesitation is revealing) was gradually to lose its importance for him as the indispensable element of a painting. Little by little, Kandinsky began giving up his career as a lawyer until in 1896, when he was offered the chair at the University of Dorpat, he dropped out altogether to devote himself to painting.

Training. Having arrived in Munich towards the end of 1896, Kandinsky enrolled in the Azbé school. He found, however, that the school's drawing lessons did not interest him, and for a time he worked alone, notably on studies of landscapes, before following Franz von Stuck's classes at the Academy (1900) where his 'extravagant colours' earned him Von Stuck's disapproval. In 1910 he founded the Phalanx group (dissolved three years later) and for its first exhibition devised a poster that showed some affinities with Art Nouveau, then the dominant style in Munich. The following year he taught at the school connected with the group. Among his pupils was Gabriele Münter who became his companion until the outbreak of war in 1914.

Disillusioned by the unshakeable conservatism of Munich artistic circles, Kandinsky left Munich with Gabriele and started to travel: first to Venice, then Odessa and Moscow (1903), Tunis (1904), Dresden, Odessa once more, then Italy (1905), before settling for a year at Sèvres, near Paris. During this highly productive period Kandinsky was experimenting with various methods and techniques. His native city of Moscow often served as his inspiration, both in paintings done from memory and those from studies or sketches from life. The latter, executed in the old Schwabing area of Munich – where the intensity of light reminded Kandinsky of the colours of Moscow – disappointed him nonetheless, because they seemed to him to be merely a 'fruitless attempt to capture the power of nature'.

Of the paintings done from memory the 'romantic pictures', painted in his studio, remain in the mind: *Promenade* (1901, Zürich, Goldberg Coll.), *Old Town* (1903, Munich, Städtische Gal.) or *Panic* (1907). In style, they are both medieval and Russian, influences that can be seen again in his wood-engravings (146 between 1902 and 1912). Like his *Poems without Words* (twelve woodcuts, 1904, Moscow) and especially his *Xylographies* (five woodcuts, 1906, Paris), these are similar to his paintings as regards 'subject' but reveal a greater interest in colour for its own sake.

Murnau. After returning to Munich in 1908, Kandinsky settled in Murnau with Gabriele Münter. It was here that he made his 'leap into the abstract'. Returning to his studio one evening, he saw, in the half-light, 'a painting of indescribable beauty, imbued with an inner flame'. Seeing at first 'only forms and colours whose meaning was incomprehensible', he soon recognized one of his own paintings, standing on its side. The revelation made him realize that subjects were harming

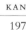

▲ Willem Kalf
Still Life with Goldsmith's Work
Canvas. 200 cm × 170 cm
Le Mans, Musée de Tessé

▲ Justus of Ghent
The Communion of the Apostles (1474)
Wood. 311 cm × 335 cm
Urbino, Palazzo Ducale, Galleria Nazionale delle Marche

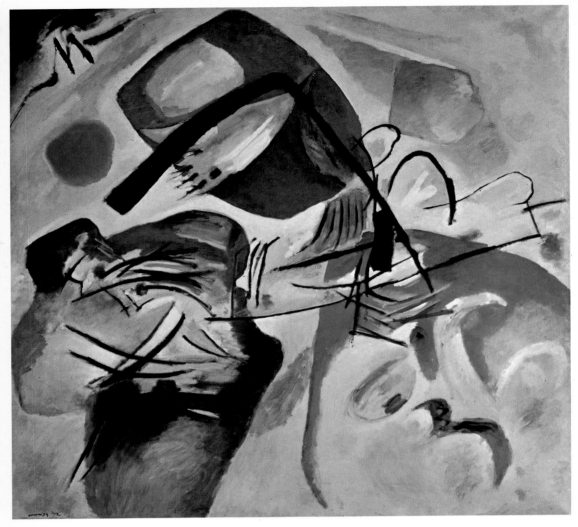

his pictures, and, in his search for a means of expression, he began gradually simply filling 'subjective' forms with colour, thus giving colour its proper expressive function (*Street in Murnau with Women*, 1908, Paris, Nina Kandinsky Coll.; *Landscape with Bell-Tower*, 1909, Paris, M.N.A.M.).

It was around this time that he took part in the exhibition of graphic art organized in Dresden by Die Brücke (1909); that same year, together with his friend Jawlensky, he founded the Neue Künstlervereinigung. But following fundamental differences over the very nature of art, he left the group and, still fighting against academicism, prepared the *Blaue Reiter* almanac with Franz Marc.

Abstraction. The almanac, which was finished in 1911, was first published in May 1912 after two epoch-making exhibitions in December 1911 and February 1912. Although he had prepared the ground for his opinions in his essay *Über das Geistige in der Kunst* (*Concerning the Spiritual in Art*), published late in 1911, Kandinsky nonetheless found himself a target for much criticism, for, as far as he was concerned, the painter always came before the theoretician. The 'inner need' of the artist, which he justified in his essay by quoting the anthroposophy of the Austrian philosopher Rudolf Steiner, led him increasingly to dispense with figurative elements. Coloured surfaces, distinct from subjective forms and edged in black, became 'signs' (*Improvisation III*, 1909, Paris, M.N.A.M.; *Sketch for Composition II*, 1909, New York, Guggenheim Museum). Then, by aban-

doning the tradition of spatial illusion, he affirmed the two-dimensional character of the canvas and at the same time the arbitrary nature of his space. Little by little the black outlines became autonomous graphic elements, in ever-increasing numbers, while the colours started to overflow the edges of the 'subject' (*Church*, 1910, Munich, Städtische Gal.; *Composition IV*, 1911, Düsseldorf, K.N.W.; *With the Black Arch*, 1912, Paris, M.N.A.M.; *Improvisation* [untitled], 1912, New York, Guggenheim Museum).

His first abstract watercolour (Paris, M.N.A.M.) dates from around 1910 and proved to be a perfect experimental medium for him. However, it was another year before he succeeded in completely detaching the subject from his oil paintings. From then on, while his *Impressions* were still expressive representations of nature, his *Improvisations*, and to an even greater extent his *Compositions*, were gradually turning into pure constructions of forms and colours.

In 1912 the gallery Der Sturm organized a retrospective exhibition of his work in Berlin where, in 1913, he exhibited in the German Autumn Salon. During that same year he published his autobiography, *Rückblicke* (*Reminiscences*), and a collection of poems illustrated with six woodcuts, *Klänge* (*Sounds*).

Return to Russia. When war broke out in 1914 Kandinsky returned to Moscow. Following the Bolshevik Revolution, he became a member of the arts section of the Commissariat for Intellectual Progress in 1918, taught at the Academy of

Fine Arts, and the following year founded the Museum of Culture in Moscow as well as 22 provincial museums. But after founding the Academy of Artistic Sciences in 1921 and seeing the initial enthusiasm for culture gradually becoming dissipated, he left Moscow with Nina de Andreevsky, whom he had married in 1917, and returned to Germany. In 1922 he was appointed to a teaching post at the Bauhaus, where Klee was already on the staff. Although Kandinsky's output during his period in Russia was not large (materials were hard to come by), he used the time to think out precisely his theory of the 'science of art' which he developed in Weimar.

The Bauhaus. Kandinsky's appointment to the Bauhaus marked a new phase in his work, characterized by what he himself termed 'lyrical geometricism'. He now felt that each form, each colour, together with its position within a space, had a precise function. He taught his pupils to 'observe precisely and present precisely not the exterior appearance of an object, but the elements of its make-up ...' He published some of his reflections in *Punkt und Linie zu Fläche* (*Point, Line and Surface*) in 1926 and in various theoretical studies.

His time at the Bauhaus was one of intense activity and one during which his genius was most appreciated. He developed a new association between three basic figures – circle, triangle and square – and a code of colours in which each line represented tension and each colour 'affirmed its dynamism' (*Composition VIII*, 1923, New York, Guggenheim Museum; *Yellow-Red-Blue*, 1925, Paris, M.N.A.M.; *Accent on Pink*, 1926, Paris, M.N.A.M.).

At Dessau, where the Bauhaus had moved in 1925, Kandinsky celebrated his 60th birthday. New nuances of colour started to appear in his work, while the geometry of his shapes either grew more pronounced (*Quadrat* [*Square*], 1927, Paris, Maeght Coll.; *Dark Point*, 1930, Paris, A. Bloc Coll.) or, alternatively, faded so that the space could be filled with suppler, more 'organic' forms (*Wickerwork*, 1927, Paris, Nina Kandinsky Coll.; *Pointed Black*, 1931, Basel, M. Hagenbach Coll.).

Continuing in the direction of a 'synthesis of the arts', Kandinsky designed the sets and costumes for a stage version of Mussorgsky's *Pictures from an Exhibition* (1928) and executed various large murals and ceramic panels for Mies van der Rohe's Music Room at the International Architectural Exhibition in Berlin (1931). In 1933 the Bauhaus, which had transferred to Berlin the previous year, was closed by the Nazis.

The 'third period': Neuilly. Kandinsky's move to Neuilly-sur-Seine with his wife saw the beginning of a 'third period', often viewed as marking a desire to return to a symbolic style. Shapes are generally smaller and the canvases are subdivided so as to bring closer together the various figures of the ideogram (*Sweet Nothings*, 1937; *Thirty*, 1937; both Paris, Nina Kandinsky Coll.). In his last canvases fluid shapes share the space with the artist's final, simplified geometric elements (*Joy*, 1939; *Tempered Impulse*, 1944; both Paris, Nina Kandinsky Coll.).

However great Kandinsky's prestige was during his lifetime, it was not until after the war that his true significance was appreciated. His influence became widely felt in the Nouvelle Abstraction movement, for which he had opened the

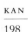 Wassily Kandinsky
With the Black Arch (1912)
Canvas. 196 cm × 186 cm
Paris, Musée National d'Art Moderne

way. The period prior to 1914 is well represented in Munich (Städtische Gal.), thanks chiefly to a bequest by G. Münter. The Musée National d'Art Moderne in Paris (15 canvases, 15 water-colours, donated by Nina Kandinsky), the German galleries (Cologne, Düsseldorf, Essen and Hamburg) and the American galleries (Los Angeles, Chicago, New York, M.O.M.A., and above all the Guggenheim Museum) all contain works by Kandinsky. E.M.

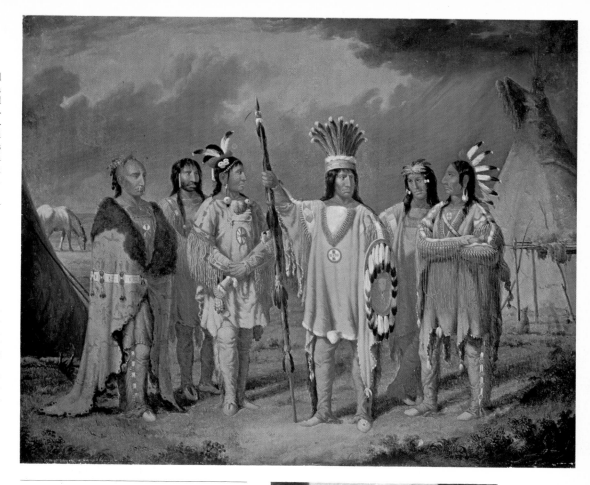

Kane
Paul
Canadian painter
b.Mallow, Co. Cork, 1810 – d.Toronto, 1871

Kane emigrated to Canada in 1818 or 1819 with his family. His father was a soldier under Lord Simcoe and the family resided in the garrison town of York, now Toronto. Kane's early interest in painting was encouraged by his first employer, William Conger, a furniture decorator, and he also received lessons from the art master at Upper Canada College. By 1834 Kane was working as a portrait painter. His wanderlust and adventurous spirit took him to Detroit in 1836, from where he hoped to accompany two Americans, Waugh and Bowman, to Rome. This plan was not realized, however, until 1841 when Kane sailed to Italy alone after travelling down the Mississippi to New Orleans, painting portraits as he went. After Italy Kane travelled to London where he visited the George Catlin Gallery of Indian paintings, an experience that determined the rest of his career. He returned to Canada in 1845 with the intention of painting and of opening a gallery similar to Catlin's.

The following year Kane was given permission to accompany a Hudson Bay Company expedition across Canada. He spent the next two years going from post to post across the country, sketching the Indians and their vanishing way of life. On the return trip Kane made side trips to the Pelouse River region to sketch the ceremonials of the Cree and Blackfoot Indians. He also recorded the annual buffalo hunt south of Fort Gary.

Upon his return to Toronto Kane exhibited 240 oil sketches at the Toronto City Hall in 1849. These brilliant oils, with their unfamiliar and fascinating subjects, proved extremely successful and Kane received many orders for paintings as a result. But his chief ambition was to paint a cycle of 100 canvases which would serve as a complete record of his trip, and he undertook commissions only to finance this project. One such commission, for a series of 12 paintings, came from the Ontario Legislature in 1851; one of these, *Blackfoot Chief and Subordinates*, shows a Blackfoot chief talking about his war victories with his fellow-tribesmen. The 100-work cycle was completed in 1856 and bought by Sir George Simpson; upon his death it was sold to the Royal Ontario Museum, Toronto.

Kane's work was seen abroad when he sent several canvases to the Exposition Universelle in Paris in 1855. He gained further recognition when his book, *Wanderings of an Artist among the Indians of North America*, was published in England in 1859. About this time his eyesight began to fail and in 1866 he was forced to give up painting when he became blind. A.G.

Kauffmann
Angelica Catherina Maria Anna
Swiss painter
b.Chur, 1741 – d.Rome, 1807

Daughter of a painter, Johann Joseph Kauffmann, Angelica made her own reputation as a painter, although from an early age she also displayed a talent for music and for languages. Her parents took her to Milan in 1754, Florence in 1757 and Rome in 1759 where she first achieved note for her portrait painting (*Portrait of Winckelmann*, 1764, Zürich, Kunsthaus). The Neoclassical currents which she found there, with their emphasis on seriousness and simplicity, were to affect her all her life. After a stay in Venice in 1764 she was taken up by Lady Wentworth, the wife of the English ambassador, travelled to England with her and was presented at court.

There is little doubt that Angelica's success was as much social as artistic. Her beauty, manners and singing voice, and her fluency in several languages impressed as much as her draughtsmanship and her understanding of the new Continental taste for Neoclassicism. It was certainly her person, rather than her works, which made the English painter Nathaniel Dance her permanently unrequited lover. She made a clandestine marriage with a person posing as the Swedish Count de Horn, but who was later revealed to be the Count's valet. Angelica extracted herself with a payment of £300 and later married, in 1781, the decorative painter Antonio Zucchi (1726–95).

While in England she achieved her own personal style, a colourful and decorative version of Neoclassicism. Her best painting is on a minor scale and often comprises small works let into

rooms designed by the brothers Adam (London, Courtauld Inst., 20 Portman Square and 30 Berkeley Square). She had considerable influence on Reynolds's conceptions, although she herself received greater inspiration from him. She was one of the original 36 members of the Royal Academy, nominated on its foundation in 1768, and Zucchi, her husband, was one of its associates. After they married they left London and took up residence in Rome, where they were to end their days.

Angelica's pretty style, which reflected her own personality with peculiar directness,

▲ Paul Kane
Blackfoot Chief and Subordinates (*c.*1851–6)
Canvas. 64 cm × 76 cm
Ottawa, National Gallery of Canada

▲ Angelica Kauffmann
Self-Portrait
Florence, Galleria degli Uffizi

achieved her great success. Her reputation was exaggerated beyond her achievements, mainly through the vast numbers of prints which disseminated her work. She herself engraved over 40 of her own compositions. A.Sm.

Kelly
Ellsworth

American painter
b.Newburgh, New York State, 1923

Ellsworth Kelly has been considered, along with Kenneth Noland and Frank Stella, as one of the leaders of the generation of American painters that succeeded the Abstract Expressionists, but his development differs markedly from the others because, from the beginning, he rejected the influence of the New York School and turned directly to a personal re-examination of European, and especially French, sources of contemporary art.

Kelly studied at the Boston Museum School with Carl Zerbe from 1946 to 1948, and then at the École des Beaux Arts in Paris from 1948 to 1954. In Paris he became fascinated with Byzantine art and began to experiment with pure colour in complex abstract spatial relationships through the use of collage. A friend of Arp, he was included in the Salons des Réalités Nouvelles and also showed at the Galerie Maeght. His first one-man show was in Paris in 1951 at the Galerie Arnaud. During these years Kelly was also deeply

interested in Matisse, and especially in Matisse's contour line and intense colour. Kelly was one of the few American artists at this time to understand the importance of Matisse's paper cutouts, and to examine the relationship of abstract pattern to the effects of nature, whether the structure of leaves and stems or the change in shadows falling across the open pages of a book.

Returning to the United States in 1955, Kelly began exhibiting regularly at the Betty Parsons Gallery and the Sidney Janis Gallery in New York. He became identified as a leading proponent of what was then called 'hard-edge' painting, because of his consistent emphasis on flat forms defined by sharply graded contours. Kelly balanced his interest in contour, often manifest in black-and-white paintings such as *Pole 1957* or *Rebound 1959*, with monochrome, but brilliantly coloured, canvases where slight alterations in the size of the stretchers caused the canvas literally to project into space. These slightly bulging works, with soft, subtle shadows, became the bases for the artist's investigation of sculpture.

In the black-and-white paintings especially, the meticulous and immaculate surface of the canvas forced an utter confounding of traditional figure-ground relationships. In yet other coloured works the juxtaposition of one painted panel against a series of similar size but different hues produced unexpected effects of slight projection or recession, depending as much on scale as placement.

In Kelly's work, including the painted aluminium sculpture he started to make in 1959, the smallest variation becomes impressively dramatic, and usually disturbing and challenging.

His ability to achieve complex effects with apparently simple means made him a principal influence on the following generation of American artists, the so-called 'Minimalists'. D.R.

Khnopff
Fernand

Belgian painter
b.Grembergen-lez-Termonde, 1858 – d.Brussels, 1921

Khnopff first studied under Mellery at the Brussels Académie, then under Moreau and Lefebvre in Paris in 1877. Co-founder in 1883 of Les Vingt, he was the first Belgian follower of Sâr Peladan, creator of the Salon de la Rose-Croix in Paris in 1892. An Anglophile and much influenced by the Pre-Raphaelites, Khnopff began contributing to the English magazine *The Studio* in 1894. Associated with the Symbolist poets, he became one of the leading exponents of Symbolism in Belgium.

The eclecticism of Khnopff's early works (*Listening to Schumann*, 1883, Brussels, M.A.M.) gave way to delicate, cold paintings, derived from allegorical and literary sources (*Art; Caresses; The Sphinx*, 1896, Brussels, M.A.M.; *I Lock My Door upon Myself*, Munich, Neue Pin.; *Sleeping Medusa*, 1896, pastel, private coll.). Realistic draughtsmanship, together with the severity of his setting, adds to the ambiguity of his symbols (*Portrait of the Artist's Sister*, 1887, Brussels, private coll.; *The Deserted Town*, drawing, Brussels,

▲ Ellsworth Kelly
Red Blue Green
Canvas. 213 cm × 346 cm
La Jolla Museum, California, Gift of Mr and Mrs Robert Rowan

M.A.M.). He also made use of photographs and the resultant pure objectivity contrasted with the incomprehensible nature of his settings (the seven young women of *Memories*, 1889, pastel, Brussels, M.A.M.). The result is representative of 1890s 'decadence'. Khnopff shares with other Symbolists an ambivalent view of women, looking on them both as celestial creatures and as sphinxes exercising a fatal fascination over men. In many respects his art foreshadows Surrealism.

<div align="right">M.A.S.</div>

Kirchner
Ernst Ludwig

German painter
b.Aschaffenburg, 1880 – d.Frauenkirch,
near Davos, 1938

Kirchner spent his childhood in Chemnitz and in 1901 entered Dresden technical college, then Hermann Obrist's art school in Munich (1903-4), before returning to Dresden. Earlier, in 1898, he had studied old German engravings in Nuremberg, particularly those of Dürer. In the ethnographical museum in Dresden he came across African and Oceanic carvings, which were to influence him profoundly. In 1905 he became co-founder of Die Brücke and emerged as the movement's dominant personality.

Kirchner displayed a precocious skill at wood-engraving (*Man and Woman*, series, *c*.1904; *Bathers*, *c*.1906), while his early paintings display the influence of Van Gogh, Munch and Divisionism (*Street in Dresden*, 1908, New York, M.O.M.A.). His skill at engraving, however, led him to produce unusually tense images in which areas of vivid colour were contained within austere and compact draughtsmanship (*Young Woman Seated: Fränzi*, begun in 1910, reworked in 1920, Minneapolis, Inst. of Arts). His graphic activity properly speaking (pen, pencil, chalk drawings and watercolours) was both intense and varied and revealed an ever-increasing dynamism, as in his paintings of cabaret and dance scenes.

Kirchner's Dresden period was distinguished by an eroticism and a feeling for nature inherited both from the Nabis and from Gauguin; he painted young models (*Dodo, Fränzi*), nudes in interiors (*Marcella*, 1909-10, Stockholm, Moderna Museet) or outdoors on the shore of the Moritzburg lake (*Four Bathers*, 1909, Wuppertal, Von der

Heydt Museum; *Nudes Playing under Trees*, 1910, Wuppertal, private coll.). His last work before he went to live in Berlin, the *Nude with Hat* (1911, Cologne, W.R.M.), was the most remarkable of a series of canvases executed during that year, and constituted a superb response by Kirchner to the style of Matisse during 1909-10.

In Berlin, in 1911, he came into contact with Cubism, of which he had known nothing while in Dresden, and this led him to elongate his forms and soften his use of colour, while at the same time the execution became less uniform. His paintings express the claustrophobia of city life but are animated, too, by either a latent or obvious eroticism in street and interior scenes (*Five Women in the Street*, 1913, Cologne, W.R.M.; *The Room in the Tower; Self-Portrait with Erna*, 1913, private coll.). The liveliness of inns and circuses still fascinated him (*The Circus Rider*, 1912, private coll.), while on the island of Fehmarn,

where he spent the summers between 1912 and 1914, he discovered the inspiration of the countryside (*Moonrise at Fehmarn*, 1914, Düsseldorf, K.M.).

Mobilized in 1915, he adapted badly to military life, suffered a nervous breakdown and was discharged. Powerful self-portraits reveal something of this period of crisis in his life (*The Drinker*, 1915, Nuremberg Museum; *The Artist as Soldier*, 1915, Oberlin, Allen Memorial Art Museum). That same year he executed one of his masterpieces, the woodcuts for Chamisso's *Peter Schlemihl*, the story of a man who sold his shadow to the Devil.

In 1917 he went to live at Davos in Switzerland and in 1923 settled at Wildboden, near Frauenkirch. This was a period of greater serenity for him and from it came Alpine landscapes and paintings of rustic figures (*Davos under Snow*, 1921, Basel Museum). His development, marked first by a somewhat tentative, lyrical abstraction (1926-9), then by an attempt at synthesizing decorative detail and expression (*Two Nudes in the Wood*, 1927-9, Frauenkirch, private coll.; *Two Lovers*, 1930, private coll.), proceeded uneasily in the face of the new developments in art, which were quite alien to his basic Expressionism. His last paintings, however, reveal a genuine rapprochement between figuration and the demands of colour and space (*Shepherds in the Evening*, 1937, private coll.).

His print *oeuvre*, among the most important of the early 20th century, changed little over the years. It comprises, according to the Dube catalogue (1967), 971 woodcuts, 665 etchings and 458 lithographs. The series of portraits and self-portraits on wood dated 1917-18 are of particular interest (*Henry van de Velde*, 1917; *Self-Portrait with Dance of Death*, 1918). As in his paintings, and probably to greater effect, Kirchner was inspired by the themes of nudes and lovers. Among

▲ Fernand Khnopff
I Lock My Door upon myself
Canvas. 72 cm × 140 cm
Munich, Neue Pinakothek

▲ Ernst Ludwig Kirchner
Young Woman Seated: Fränzi (1910–20)
Canvas. 79 cm × 89 cm
Minneapolis Institute of Arts

his lithographs is the extraordinary erotic series of 1911 (six lithos), worthy of the Japanese masters, and these were followed in 1915 by studies showing more specific practices (*Onanism, Sadism, The Breast Fetishist*).

Kirchner's influence survived the war and is particularly noticeable in the work of the Dutchman Jan Wiegers. In 1934 he met Klee and Schlemmer. The confiscation by the Nazis of 639 of his works in 1937 explains in part why he committed suicide some months later. Kirchner is represented in the majority of museums of modern art in Europe and the United States, as well as in several private collections. M.A.S.

Klee
Paul

Swiss painter
b.Münchenbuchsee, 1879 – d.Muralto-Locarno, 1940

Paul Klee's position in the development of 20th-century art is that of a wizard, beyond Cubism, Surrealism, Expressionism or abstraction. 'I cannot be grasped immediately,' he said in the epitaph he composed for himself, 'for I exist with the dead as much as with those who are yet unborn. A little closer to the heart of creation than is usual, yet not as close as I should like.' Music and poetry, 'primitive' lyricism and technical exactitude are aspects of his work which, alongside that of Picasso and Kandinsky, combines the major expressions of contemporary art, both in form and spirit.

Early years. Paul Klee's father, Hans, and his mother, Ida Maria Frick, were musicians, and it was to them he owed his talent as a violinist. Shortly after he was born the family moved to Bern where Klee studied arts and took a degree in classics in 1898. After hesitating between music and the visual arts, he enrolled at the Munich Academy where he studied under the painter Heinrich Knirr, the engraver Walter Ziegler, and in 1900, with Franz von Stuck from whom he learned anatomy. Klee, however, was not happy

 Paul Klee
Seneccio (1922)
Canvas on wood. 40 cm × 38 cm
Basel, Kunstmuseum

with this training and thought of turning to sculpture, but was dissuaded by his teacher Von Rührmann. He then spent the winter of 1901-2 in Rome in the company of the sculptor Hermann Haller, devoting his time to drawing, apart from visits to Naples and Florence. Back in Bern, where he remained until 1906, he earned a living as a musician in the city's orchestra and, in the hope of receiving commissions for illustrations, continued to work at his drawings and engravings and, from 1905 onwards, on watercolours 'under glass' – in fact he painted his compositions in reverse so that the final picture is viewed through the glass.

These early works reveal an intense effort to make his line less formal and academic in order to enhance its emotional content. Gradually he introduced chiaroscuro and experimented with colour, as in the portrait of his *Sister* painted in the style of Hodler (1903, Bern, Paul Klee Foundation) and in the landscapes 'under glass' (*Garden Scene, Watering Can, Cat, Red Chair*, 1905, Felix Klee Coll.). His drawings from this period are still marked by a symbolist approach not unlike that of Art Nouveau; space is organized in relation to linear structures only, but with such precision as to have led one critic to refer to Klee's 'watchmaker's attention to the measurable'. This feature is fundamental to Klee's art. The biting irony that Klee brought to his subject matter is a legacy of the difficult years in Bern and in its literary flavour occasionally recalls certain aspects of Surrealism (*Inventions*, exhibited in 1906 at the Munich Sezession: in particular, *Menacing Head*, 1905, Bern, Paul Klee Foundation).

Between 1905 and 1906 Klee visited Paris and Berlin, and, following his marriage to the pianist Lily Stumpf, settled in Munich where their son Felix was born in 1907. During his travels around Germany Klee had discovered Rembrandt (in Kassel) and Grünewald; a series of exhibitions in 1908 and 1909 also revealed to him Van Gogh and Cézanne (*the* painter as far as Klee was concerned), while at the same time he made an enthusiastic study of the engravings of Blake, Goya and Ensor. In 1910 the Bern Museum mounted its first exhibition of his works: 56 drawings, engravings and paintings 'under glass'.

The year 1911 was a decisive one: Die Blaue Reiter, whose theories confirmed his own experiments, was founded; he met Kandinsky, Marc, Jawlensky and Arp; and, finally, he discovered Cubism. In 1911 and 1912 he executed 26 grotesque illustrations for Voltaire's *Candide* (published in 1920, Bern, Paul Klee Foundation) and translated Delaunay's *Essai sur la lumière* after meeting the author, and Marc, while on a visit to Paris. The precise catalogue of his works that he began keeping in 1899 is an essential aid to the understanding of the output of this early period.

Tunis. Light and colour – which was frequently reduced to a monochrome (*Street with Carriage*, 1907, Cincinnati, Frank Laurens Coll.) – had so far played only a limited role in Klee's work; while his outlines were constantly interrupted by hatchings and scrapings, so as to give his work an Impressionist feel (*Munich, Central Station*, 1911, Bern, Paul Klee Foundation; *Sailing Boats*, 1911, New York, Kurt Valentin Coll.). But in 1914, together with Macke and Moilliet, he made a journey to Tunis, Hammamet and Kairouan that proved a revelation to him. On his return he wrote in his journal: 'Colour has me in its grip, I no longer need to pursue it . . . colour and I are at

one. I am a painter' (*Red and White Domes*, 1914, New York, Clifford Odets Coll.).

The war broke up Klee's circle: Kandinsky left for Moscow; Macke was killed in 1914 and Marc in 1916. Klee himself was mobilized, although he still managed to find some time to paint, and his reputation continued to grow. Discharged in 1918, he wrote, in 1920, an essay on the elements of graphic art that was included in his *Schöpferische Konfession*, his creative credo, published in the same year. To coincide with the publication by the Der Sturm Gallery of a volume of drawings, two monographs were devoted to him, and the Goltz Gallery in Munich organized an important retrospective , comprising some 362 exhibits.

The Bauhaus. In November 1920 Gropius invited Klee to join the teaching staff at the Bauhaus and he took up his position there the following year. These later years were increasingly productive. Ever since his experience of North Africa his horizons had broadened and he had become completely involved in a world of fantasy and formal abstraction. The geometrical shapes that he took over from Cubism helped to give his structures a greater purity of form; his design, now refined, rejected its reliance on chiaroscuro in favour of more precise motifs (ladders, parallels, arrows, etc.: *Rider Unhorsed and Bewitched*, 1920, United States, private coll.; *The Ideal Ménage*, 1920, Bern, Felix Klee Coll.), while his watercolours, vibrant and transparent, attained the crystalline clarity of manuscript illuminations.

Klee did not paint regularly in oil until after 1919, his occasional essays in the medium being based on ideas derived from Van Gogh, Cézanne, Delaunay or Cubism (*Little Girl with Pitchers*, 1910, Bern, Felix Klee Coll.; *Homage to Picasso*, 1914, Basel, private coll.). During the 1920s, however, he began to develop his own oil painting, finding in it a new expressive potential in which colours occurred according to the 'sonority' of the composition, in a play of vertical and horizontal lines; among these appeared simplified motifs – trees, birds, moons, hearts (*Town R*, 1919, Basel Museum; *The Women's Pavilion*, 1921, New York, Ralph Collin Coll.).

Klee's years as a teacher were also fruitful ones for him as an artist; exchanges with pupils and colleagues helped to enlarge his range and, in particular, to define what had before been wholly intuitive. (His lectures were published in the form of essays by the Bauhaus: *Wege des Naturstudiums* [*Ways of Studying Nature*] in 1923 and the important *Pädagogisches Skizzenbuch* [*Pedagogical Sketchbook*] in 1925.)

Forms were treated more and more for their own sake, as pure expression, with no presupposed content. But Klee's originality lay in his ability to elevate his objectivity, developing simple construction to such a degree that it becomes totally expressive – yet he preserved intuition as a foundation of his art. In 1920 appeared the first linear motifs drawn with a rule: parallel lines (*Chains*, 1920, Bern, Paul Klee Foundation); acute angles (*Mountain in Winter*, 1925, Bern, Rupf Coll.); perspectives (*Room with Occupants, Perspective View*, 1921, Bern, Paul Klee Foundation; *Italian Town*, 1928, Munich, Ida Bienert Coll.; *Main Road and Secondary Roads*, 1929, Cologne, private coll., on loan at the W.R.M.).

The study of tapestry opened his eyes to the qualities of grain and texture that could be achieved through the breaking-up and repetition of a theme, amounting to a type of calligraphy

which recalls certain oriental decorative themes (*Fresh Breeze in a Tropical Garden*, 1925, Basel, Doetsch-Benzinger Coll.; *Pastoral*, 1927, New York, M.O.M.A.). His ordered use of colour and his study of the intensity of tones led him in 1923 to the chessboard style (*Graduation of Colour from the Static to the Dynamic*, 1923, Berlin, private coll.), then, by breaking up the homogeneity of structures, he arrived at Divisionism (*Sunset*, 1930, Berlin, private coll.).

In 1924 Klee spent six weeks in Sicily and, the following year, accompanied the Bauhaus when it moved from Weimar to Dessau. From then on he spent his holidays travelling, visiting successively Italy, Portugal, Corsica, Brittany and Egypt. On the occasion of his 50th birthday the Flechtheim Gallery in Berlin, as well as the Museum of Modern Art in New York, organized a large retrospective exhibition of his works.

Last years. Klee eventually began to tire of teaching at the Bauhaus and in 1931 accepted a professorship at the Düsseldorf Akademie, a post taken away from him by the Nazis in 1933. He returned to Bern for good, already much weakened by the early stages of sclerosis, which was eventually to be responsible for his death. Preparations for an important exhibition in 1935 exhausted him, and 1936 was an almost entirely unproductive year.

His paintings now began to be filled with a profound anguish. His relationship with the world changed, his irony turned to sadness and intimations of death became ever-present. The face of the *Wise Man* (1913, Belp, Switzerland, private coll.), which conveys so much drama, gives way to a sort of archetype, a primordial image (*Fear*, 1934, New York, Rockefeller Coll.). Thus, in their 'primitive' childlike style, often linked with extreme economy of means, fruits, snakes, masks or arrows become the stuff of a true metaphysical vocabulary (*Full Moon in the Garden*, 1934, Bern, Rupf Coll.), a vocabulary which, after 1936, included hieroglyphics.

Klee was entering into his last phase: the subject became reduced little by little into a pure rhythmic exchange of signs, runes or ideograms depicted in broad strokes (*Signs in Yellow*, 1937, Belp, private coll.; *Project 1938* and *Death and Fire*, 1940, both Bern, Paul Klee Foundation). During his final months the image of death imposed itself with greater insistence (*Dark Voyage in a Boat*, 1940, Bern, Felix Klee Coll.) and in his last, child-like visions Klee discovered death in the happy themes of former years: *The Wardrobe* (1940) and *Still Life* (1940), his last painting (both Bern, Felix Klee Coll.). In 1946 a society set up the foundation which contains the greater part of his works, and which transferred to Bern Museum in 1952.

Klee's achievement. Klee's genius lay in his ability to transcend the formalism of the majority of modern movements in order to arrive at a core of energy that is the source of all creation. 'You must', he said 'be newly born.' From this arose a concept of art that was essentially dynamic. 'Formal creativity comes from movement, is itself movement that has been fixed, and is caught in movement.' This concept formed the basis of his life and teaching. But although the creative process lies below the level of awareness, a work does not automatically arise from the unconscious. It is the fruit of organic development which implies gestation, observation, meditation and finally mastery of technique; it leads to close

identification of the creative self with the universe. 'Art does not describe the visible; it makes things visible.' Klee saw art as something which excluded all naturalism although, being a life-giving force, the work of the artist might appear similar to that of nature.

With Klee the metamorphosis of shapes on canvas is comparable to variations on a musical theme and therefore takes on a metaphorical value. In fact, music is constantly present in Klee's work. A large number of paintings and of drawings are exact graphic transmutations of lines of music, together with their rhythmic harmonies, measures, colours and textures.

Klee's range has lost nothing of its grandeur.

Even more than the profound originality of his language and his infinite capacity for self-renewal, it is his moral strength and the ascetic authenticity he imposes on his work that impress today. By penetrating to the very source of inspiration, Klee's work has become the root and stock of contemporary art. Apart from the Paul Klee Foundation in Bern, the artist is represented in many public collections, notably in Düsseldorf (K.N.W., 91 paintings, watercolours and drawings), Basel Museum (30-odd paintings, including *Seneccio*, 1922), Paris (M.N.A.M.), Hamburg Museum, New York (M.O.M.A.), Buffalo (Albright-Knox Art Gal.) and Pasadena Museum.

B.Z.

Paul Klee ▲
Main Road and Secondary Roads (1929)
Canvas. 83 cm × 67 cm
Cologne, Private Collection, on loan to Wallraf-Richartz
Museum, Cologne

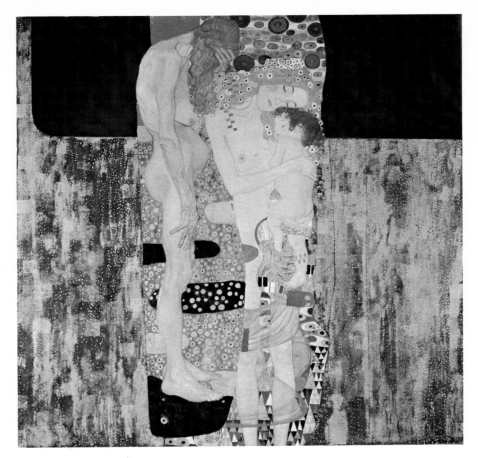

Klimt
Gustav

Austrian painter
b. Vienna, 1862 – d. Vienna, 1918

Klimt's art stems from two opposing tendencies in Austrian painting towards the end of the 19th century: traditional historical painting in its various forms (Rahl, Canon, Makart) and an Impressionism which was very close to the French school. Though symbolic paintings containing a number of figures recur throughout his career, it is, nevertheless, his monumental portraits and landscapes that together form the most important part of his output.

Beginnings. Klimt was trained at the Vienna School of Decorative Arts where he was a pupil of Ferdinand Laufberger. His first works are academic in style and full of naturalistic detail (ceilings and theatre curtains for Karlsbad, Reichenberg and Bucharest). At that time Klimt was collaborating with his brother Ernst and his fellow-pupil Franz Matsch, who also helped him with the decor of the Vienna Burgtheater (ceilings above the two great staircases, illustrating the history of the theatre).

The allegorical studies for the grand staircase of the Kunsthistorisches Museum mark the first appearance of one of the basic elements of Klimt's style: a precise definition of outline, allied to a decided taste for ornamentation, something which brings to mind the work of his Belgian contemporary Khnopff. His next commission was for two scenes (canvases now remounted) to be placed above the doors of the music room of a palace belonging to a patron of the arts, Nikolaus Dumba: *Allegory of Music* and *Schubert at the Piano* (1898-9). Traditional chiaroscuro is replaced in *Music* by a neutral, shadowless light, while the delicate silhouettes, with their light but strong contours, proved to be an enduring element in Klimt's art.

The same characteristics recur in his *Portrait of Sonja Knips* (1898, Vienna, Österr. Gal.), together with another feature peculiar to Klimt: an asymmetrical setting, somewhat Japanese in effect. These works are representative of the spirit of the Sezession, and of the Viennese interpretation of Art Nouveau; they reveal as well the importance of Klimt within the group, whose first president he was (1897-1905). He also collaborated in 1898 on *Ver Sacrum*, a review dedicated to the principal representatives of Symbolism.

Decorative cycles and landscapes. In 1894 Klimt was commissioned to paint three works for the ceiling of the main hall of Vienna University: *Philosophy*, *Medicine* and *Jurisprudence*. These were frequently modified until 1907, when they were finally completed. The provocative and despairing eroticism of these works created a scandal and Klimt was forced to remove them; they were destroyed at the end of the Second World War (studies in the Albertina). A return to asymmetrical composition can be seen in the allegories of *Philosophy* and *Medicine*. In both paintings a lightly inclined column stretches up to infinity; the column consists of a compact mass of human bodies that disappear into the edge of the composition. The illusionist rendering of bodies and

light, and the strangely muted colours, reach rare virtuosity in this work. *Jurisprudence*, the last of the three to be completed, differs in that the contours are more strictly defined.

The line was becoming Klimt's basic means of expression (typical, incidentally, of the ornamental intertwinings of the Art Nouveau painters) and imposed itself upon his last two murals: the *Beethoven Frieze*, painted for the Sezession building on the occasion of the inauguration of the statue of Beethoven by Max Klinger in 1902, and the mosaics for the dining-hall of the Stoclet Palace in Brussels (c.1905-9). The non-illusionist arrangement of the surfaces engenders an immediately perceptible rhythm; empty spaces alternate with dense masses of figures (*Beethoven Frieze*), human shapes barely emerge from the profusion of ornament (*Stoclet Frieze*).

This two-dimensional art, aiming at a close union of painting and architecture, is Klimt's main contribution to the revival of monumental art, and was something towards which Gauguin, Munch, Toorop and Hodler also worked at one time or another. Klimt applied these new principles of mural composition to some of his canvases, of which the most famous is *The Kiss* (1907-8, Vienna, Österr. Gal.), as well as in certain portraits (*Fritza Riedler*, 1906; *Adele Bloch-Bauer*, 1907; both Vienna, Österr. Gal.).

Klimt developed an interest in landscape around 1900. The first landscapes are still relatively realistic, but there then appears a deliberate fragmentation of the surface and a tendency towards asymmetrical composition. Colour is applied in pointillist touches, and the palette becomes richer, more intense. This new method endows Klimt's paintings in general and his landscapes in particular with an organic vitality which he subsequently attempted to conserve in his representation of nature (*The Park*, before 1910, New York, M.O.M.A.).

Klimt's style. Klimt carried this aim over into his allegorical works (*Hope*, 1903, Ottawa, N.G.; *The Three Ages of Women*, 1905, Rome, G.A.M.; *Death and Love*, 1911-13, Vienna, private coll.; *The Virgin*, 1913, Prague Museum; *The Fiancée*, 1917-18, unfinished, private coll.) and certain portraits. The rigorous symmetry of some of the larger portraits lends the characters a hieratic air that contrasts with the near-Impressionist effect of the brushwork (*Adele Bloch-Bauer II*, 1912, Vienna, 20th-Century Museum; *Baroness Elisabeth Bachofen-Echt*, 1914, Geneva, private coll.; *Friederike-Maria Beer*, 1916, New York, private coll.; *Fräulein Lieser*, 1917-18, unfinished, private coll.). To his earlier stylization Klimt now added motifs borrowed from medieval, Byzantine, oriental and exotic art. He continued to represent faces and hands naturalistically and these seem to be completely at odds with the surrounding abundance of objects.

A huge number of drawings, sketches and studies, all extremely spare, suggest a life lived to the full and reveal to what extent his vision of nature and the reproducing of it preoccupied Klimt. Yet his monumental paintings produce quite a contrary effect. Two opposing forces are involved here. One is a desire for complete freedom in relation to the subject, leading to the creation of a play with ornamental shapes, from the early allegories to the frieze for the Stoclet Palace: these varying works are symbolic in intent, the expression of an inaccessible world situated beyond reality and time. The other is an intense perception of nature, and a consequent awareness of the danger of uninhibited ornamentation.

In his last works Klimt attempted to reconcile these two tendencies, and the resulting equilibrium involved to some extent a return to nature: from then on the role of the idea, and of eroticism too, became less important. The last

Gustav Klimt ▲
The Three Ages of Woman (1905)
Canvas. 180 cm × 180 cm
Rome, Galleria Nazionale d'Arte Moderna

landscapes (*Litzlbergerkeller am Attersee*, 1915-16, private coll.) are distinguished by a feeling of calm and isolation.

The theme of the apple tree occurs three times in Klimt's work: in 1903 in *The Golden Apple Tree* (destroyed in 1945), where the ornamentation is tiny and intricate, prefiguring the Tree of Life in the *Stoclet Frieze*; around 1912 in *Apple Tree I* (Vienna, 20th-Century Museum), which reveals a light, almost tremulous structure; and finally in 1916 in *Apple Tree II* (Vienna, Österr. Gal.), a dark tree painted in sombre colours, standing before an avenue of stunted tree trunks.

A similar evolution is visible in one of the most important works from this late period, *The Mother with Two Children* (*c*.1900-10, private coll.), also known as *The Mother and the Emigrants*; the pale heads of the three sleeping figures, huddled in impenetrable darkness, seems to embody an infinitely tragic vision. This vision announced a new era, that of the Expressionism of Kokoschka and Schiele, whose art is directly related to that of Klimt. F.N.

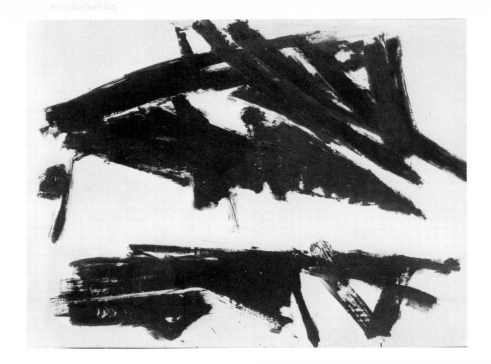

Kline
Franz

American painter
b.Wilkes-Barre, Pennsylvania, 1910 – d.New York, 1962

One of the leading painters of the New York school, Kline exercised an immense influence; he developed a vocabulary of instantly recognizable forms. His early training was at Girard College in Philadelphia and at Boston University (1931-5) under Bernard Adams, Stephen Spurrier and Frederick Whiting; but pursuing an interest in European Modernism, he spent two years in London (1937-8), working at the Heatherley School of Fine Art. Until the late 1940s, however, his work was semi-figurative, and the influence of Expressionist portraiture and even of American scene-painting were considerable.

Kline became the abstract painter most directly inspired by the city, especially by New York during its particular post-war phase of demolition and rebuilding. His monumental shapes seem to hint at an iconography of scaffolding and bridges, of buildings reduced to skeletons and scarred walls in the process of being torn down (*Collage*, 1947, New York, Noah Goldowsky Coll.).

He arrived at the stark simplicity of his style by enlarging the black brush drawings he had made on the pages of telephone directories; in translating these ideas to a large-scale format, however, although he retained and even enhanced the sense of speed, he actually executed his rough brush-strokes with great care, devoting as much attention to painted whites as to blacks (*Andes*, 1957, Basel Museum; *Rocker*, 1951, Dralus Theodore J. Eilild Jnr Coll; *Chief*, 1950, New York, M.O.M.A., named after a train). Until the mid-1950s his major paintings were exclusively in black and white; with the reintroduction of colour, especially around 1957, the space he created became more complex, denser, more evenly graded into an illusionistic space (*Yellow, Red, Green, Blue*, 1956, Baltimore Museum; *Horley Red*, 1960, New York, R.C. Sall Coll.; *Caboose*, 1961, Marlborough Gal.). He died in 1962 while still at the height of his powers. D.R.

Kneller
Sir Godfrey

Anglo-German painter
b.Lübeck, 1646 or 1649 – d.London, 1723

The son of the city surveyor of Lübeck, Kneller studied painting in the 1660s in Amsterdam under Ferdinand Bol and possibly Rembrandt. Pictures by him up to 1672 (e.g. *Elijah and the Angel*, 1672, London, Tate Gal.) show the influence of Bol. He then went to Italy but, after returning to Germany in 1675, settled in England in 1676, where he was taken up by John Banckes, a Hamburg merchant living in London. Through Banckes he met the secretary to the Duke of Monmouth, who introduced him to the Duke (a natural son of Charles II), who in turn recommended him to the King.

During this period Kneller tried his hand at the various portrait styles current in England, feeling his way forward in the process, helped in this by his Continental training, professionalism and speed of work. Soon after Lely's death in 1680 he was established as one of the two or three leading portraitists in the country. In 1688 he was made Principal Painter, jointly with John Riley, to William and Mary, becoming sole Principal Painter on Riley's death in 1691. From now on, at the head of a large studio, he was without a rival. He was knighted in 1692, made a baronet by George I in 1715 and, in 1711, elected Governor of the first Academy of Painting to be set up in London.

Despite these court honours and connections, however, and despite his production of a regular supply of state portraits, the most important part of Kneller's achievement consisted of his portraits of the nobility, intellectuals and men of affairs. This was partly because the monarchs he served after James II (1685-8) took little interest in painting but chiefly because, after 1688, the court was ceasing to be the focus of national life. The 'Glorious Revolution' of that year had given new, independent power to the aristocracy, which was able to seize it thanks to the rise of political parties, the increasing revenues from land and the growing trade of the City of London.

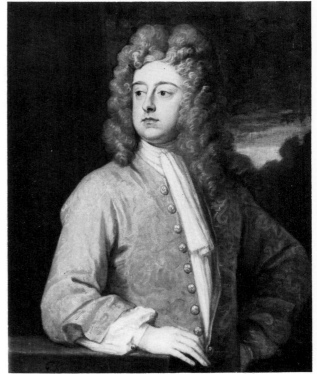

The full-length portrait, out of fashion in the age of Lely, was revived, and Kneller's typical aristocratic portraits are grand and grave, the men in full-bottomed wigs and wearing robes or armour, the women dressed in long flowing gowns made of masses of material. A Baroque column and curtain are frequent accessories, and colours, especially of backgrounds, are sombre to match the dark-panelled interiors in which the portraits were hung (*Duchess of Portsmouth*, 1684, Sussex, Goodwood House; *1st Duke of Shrewsbury*, *c*.1685-90, Herefordshire, Eastnor Castle; *4th Duke of Hamilton*, *c*.1705-10, Duke of Hamilton's Coll., on loan to Scottish N.P.G., Edinburgh).

In some ways more interesting are Kneller's

Franz Kline ▲
Andes (1957)
Canvas. 262 cm × 205 cm
Basel, Kunstmuseum

Sir Godfrey Kneller ▲
Francis, 2nd Earl Godolphin (*c*.1710)
Canvas. 91 cm × 71 cm
London, National Portrait Gallery

half-length portraits of writers and scientists, such as the poets *Dryden* and *Prior* (*c*.1698 and 1700, both Cambridge, Trinity College) and *Newton* (1702, London, N.P.G.). However, he is probably best known today for his series of portraits of more than 40 members of the Kit-Cat Club (*c*.1700-21, London, N.P.G.). This club comprised the leading Whig peers, politicians, soldiers, financiers, writers and scientists of the day who met for social evenings under the secretaryship of the publisher, Jacob Tonson. The portraits are simple yet varied in pose, of standard size (36 × 28 inches), each one known as a 'Kit-Cat', and show the sitter half-length with one or, less often, both hands visible.

With such a vast output it was inevitable that some of Kneller's work should be dull, but his portraiture, in contrast to Lely's, reveals a masculine strength and a power of delineating character that makes it of great interest as a social document in a period of growing national vigour.

M.K.

Købke
Christen

Danish painter
b.Copenhagen, 1810 – d.Copenhagen, 1848

Købke was the greatest figure to emerge from the 'golden age of Danish painting', a period during which painters such as Bendz, Hansen, Roed, Jensen, Lundbye and Købke himself were producing interior scenes, family portraits and landscapes that express a simple yet truthful vision of reality. The best of these works have a subtlety, derived from a precise observation of light, a refinement of colour and a sureness of setting that place them on a level with the best of European painting.

Købke was trained at the Copenhagen Academy between 1822 and 1832 and was a pupil of Eckersberg after 1828. Apart from a period

KØB
206

spent in Italy between 1838 and 1840, when he visited Rome, Naples and Capri, he lived on the outskirts of Copenhagen. He established a personal style with his first important work, *The Cast Room at Charlottenborg* (1830, Copenhagen, Hirschprung Coll.). It is characterized by lighting effects that make a play with the whites and animate the spaces, strict, although sometimes startling, composition, and an atmosphere of intimate tranquillity (*View from a Hayloft in the Ramparts of the Citadel of Copenhagen*, 1831, Copenhagen, S.M.f.K.).

Købke's portraits of friends (*Frederic Sodring*, 1832, *Marstrand*, 1836, both Copenhagen, S.M.f.K.; *H.E. Freund*, Copenhagen, Royal Academy) and his landscapes of the surroundings of Copenhagen (*The Bridge*, 1834, Copenhagen, N.C.G.) show the same warm but unobtrusive sensitivity, together with a fluent and precise touch. He painted *Frederiksborg Castle*, with its little bell-turrets standing out against the surrounding countryside, from several different angles (1835, Copenhagen, Hirschprung Coll.; 1836, Copenhagen, S.M.f.K.). He also provided the motifs for some large decorative panels (Copenhagen, Museum of Decorative Arts; preliminary sketch, Copenhagen, C.L. Davids Samling) and preceded these great works with studies, as he did for most of his major landscapes.

Around 1838 he came under the spell of Caspar David Friedrich's Romanticism and began celebrating the mysteries of a hazy dawn, or the effect of bare trees against back lighting (*Morning at the River's Edge*, 1838, Copenhagen, N.C.G.), or the poetry of expectation (*The Landing Stage on the Sortedam Lake*, 1838, Copenhagen, N.C.G.), a tendency which his journey to Italy fortunately lessened (1838-40, *The Castel dell' Ovo in Naples*, Copenhagen, N.C.G.). Between his return to Copenhagen and his premature death he produced some of his most moving landscapes: luminous views of country gardens (examples in Copenhagen, S.M.f.K.), and swift, simple sketches clearly painted from life, which reveal a miraculously sure eye and touch.

Of Købke's total output of slightly more than 200 paintings, most are today in the Copenhagen galleries (S.M.f.K., N.C.G. and Hirschprung Coll.). He is also represented in Stockholm, (Nm), Winterthur (Oskar Reinhart Coll.) and in the Louvre.

L.E.

Koch
Joseph Anton

Austrian painter
b.Obergieblen, Tyrol, 1768 – d.Rome, 1839

The son of a family of poor peasants, Koch entered the famous Karlsschule in Stuttgart in 1785. Fired with the ideals of liberty of the French Revolution, and dissatisfied with the traditional teaching of the school, he left after painting his first attempts at landscape in 1791. After a stay in Strasbourg he moved on to Switzerland (1791-4) where he was profoundly impressed by the grandeur of the Alps but where, for political reasons, he was unable to remain. He settled in Italy in 1794 and from 1795 onwards lived in Rome, where he much admired the work of Asmus Carstens, and finally, in 1806, married the daughter of an Italian peasant. In 1812 he left Rome for Vienna and,

despite his success there, returned in 1815 to Italy, his second homeland.

Koch depicted mainly the hills around Rome, in particular his wife's home village of Olevano. His strong personality expressed itself in an alliance of the classical spirit and a love of nature. He also executed some remarkable illustrations, in particular from the *Divine Comedy*, and it was from Dante, too, that he borrowed the themes for frescoes executed between 1827 and 1829 at the Casino Massimi in Rome.

His painting of the *Schmalribach Falls* (1811, Leipzig Museum) was inspired by studies made in Switzerland. This work, like his *Heroic Landscape with Rainbow* (Munich, Neue Pin.), shows his taste for the physical detail of the land and the action of the elements. Koch's vision of nature was a sharp one and his imaginary landscapes are filled with a natural grandeur and expressiveness, as in the biblical scene of *Noah's Sacrifice* (1813, Frankfurt, Städel. Inst.) or the dramatically picturesque *Macbeth with the Witches* (1829, Basel, K.M.). He brought a new look to landscape painting and exercised a profound influence over the evolution of this genre.

Koch is represented in most of the German and Austrian galleries; the most important collection of his drawings – almost 70 in all, including 50 based on texts by Dante – is in Vienna (Bibliothek der Akademie).

G. and V.K.

Kokoschka
Oskar

Austrian painter
b.Pöchlarn, 1886 – d. Vaud, Switzerland, 1980

A student at the Vienna School of Decorative Arts (1905-9), Kokoschka was dissatisfied with the training he received there. However, he composed two verse dramas during this period, *The Sphinx and the Scarecrow* and *Assassin, Hope of Women*, the poster for which (*Pietà*, 1908, Vienna, K.M.) is one of the masterpieces of the early Expressionist period. At first influenced by Romako and by Klimt (his first drawings of nudes) and particularly by the art of the Far East,

Kokoschka soon revealed his originality in drawings executed for his plays and in the paintings exhibited at the Vienna Kunstschau in 1908 and 1909. He collaborated in the work of the Viennese Ateliers (*Children Dreaming*, eight coloured lithographs, 1908), founded by Hoffmann in 1903.

In 1908 the architect Adolf Loos introduced him into artistic and literary circles whose personalities served as models for the famous series of 'psychological' portraits (1909-14), one of the most original creations of Viennese Expressionism. 'These people lived secure lives', Kokoschka later said, 'but they were all afraid. I could see it despite their very refined way of life, which verged on the baroque; I painted these people's portraits in their anxiety and their suffering.'

Until around 1910 line played an important role in his paintings (*Adolf Loos*, 1909, Berlin, N.G.; *Auguste Forel*, 1910, Mannheim Museum). The portrait of *Herwarth Walden* (1910, Minneapolis Inst. of Arts), to whom Loos had introduced him, and who asked him to contribute to *Der Sturm* in 1910 (he supplied numerous drawn portraits), is one of the great masterpieces of this period, in which needle-sharp precision of draughtsmanship heightens the seductiveness of the colour.

A visit to Switzerland in 1909 with Loos made Kokoschka aware of the grandeur of the Alps and he painted several landscapes, his first attempts at a genre to which he would later return in earnest (*Dent du Midi*, Zürich, private coll.). In Berlin, after 1910, Kokoschka rapidly became notorious and his private life was made even more public by his paintings (*Self-Portrait with Alma Mahler*, 1912, Hamburg, private coll.). A journey to Italy in 1913 revealed to him the Venetian old masters and Tintoretto in particular, and confirmed his sense of an evolution towards a more dynamic and pictorial method of expression (*Windesbraut*, [*The Tempest*], 1914, Basel Museum).

With the outbreak of war Kokoschka volunteered for the army. Seriously wounded in September 1915, he was nursed back to health in Dresden, where he remained from 1917 until 1924

after being appointed to the teaching staff of the Academy in 1919. He did further work for the theatre and also for the opera (*Job and The Burning Bush*, 1919, Max Reinhardt Theatre).

These years were marked by a change in vision as well as of technique; the paintings of 1917 and 1918 are distinguished by the density of their content, feverish speed of execution, and expressive pathos (*Self-Portrait*, 1917, Wuppertal, private coll); a more even treatment and expanses of vibrant colour characterize the works of the period immediately following (*The Slave Girl*, 1924, St Louis, private coll.). Many portraits, either watercolours, drawings or lithographs, date from the early 1920s and the range of interpretation is vast, with a tight definition and a free invention (*Gitta Wallerstein*, watercolour, c.1921, private coll.).

The Dresden years also saw Kokoschka's first coherent development as a landscape artist (*The Augustus Bridge with Steamer*, 1923, Eindhoven, Stedelijk Van Abbemuseum) and the consequent near-abandonment of Expressionism – although this still appears in his self-portraits and in the virulent animal studies (*The Mandrill*, 1926, Rotterdam, B.V.B.). From now on landscape became his favourite genre and one which he constantly enriched by frequent journeys (*Market in Tunis*, 1928-9, private coll.; *The Charles Bridge in Prague*, 1934, Prague Museum). These pictures are distinguished by their spacious and relaxed settings, their ever clearer colours and a light, sometimes impressionistic touch.

Between 1924 and 1931 Kokoschka spent a lot of time in Paris where he exhibited at the Galerie Georges Petit in 1931. He lived in Vienna from 1931 to 1934, and then Prague (1934-8). In 1938 he executed a poster in support of the Spanish Republicans. Much affected by the Nazi campaign against 'degenerate art', he fled to England in 1939, became a British subject in 1947, and in 1953 retired to Villeneuve on Lake Geneva. During these later years, besides landscapes, he painted vast compositions on classical themes (the *Thermopylae Triptych*, 1954, Hamburg, Faculty of Philosophy), while his style displayed the lyrical and decorative vivacity of the Austrian Baroque

(*The Thames from the Vickers Building*, 1961, London, private coll.).

Kokoschka's activity as decorator and lithographer went hand in hand with his work as a painter. In 1953 he furnished decor and costumes for productions of Mozart's *Magic Flute* and Verdi's *Ballo in Maschera*; he also produced a series of lithographs: *King Lear*, 1963; the *Odyssey*, 1963-5; *Saul and David*, 1966-8; *The Trojan Women*, 1971-2. A vast mosaic for the Church of St Nicholas in Hamburg was inaugurated in 1973 (*Ecce Homines*). In 1971 Kokoschka published his autobiography, *Mein Leben*; that same year the Vienna Belvedere devoted a retrospective to him, followed by an exhibition in Munich of his portraits from 1907 to 1970. He is represented in most of the major collections of Europe and the United States. M.A.S.

Koninck
Philips de

Dutch painter
b.Amsterdam, 1619 – d.Amsterdam, 1688

Trained by his brother Jacob in Rotterdam before 1649, Koninck was, to begin with, strongly influenced by Rembrandt, although there is no proof that he was ever the latter's pupil, as has sometimes been claimed. More significant was his marriage in 1641 to Cornelia Furnerius, niece of Abraham Furnerius, a talented landscapist who had been Rembrandt's pupil and whose style presents many analogies with that of Koninck. In 1641 Koninck settled in Amsterdam where, like a number of other artists at the time, he seems to have had a secondary occupation, in his case running a barge service between Amsterdam and Rotterdam.

Koninck's earliest surviving works are genre scenes and religious, mythological and historical pictures which reveal diverse influences, including those of Rembrandt (in the drawings), Maes and Steen (*Bacchus's Feast*, 1654, The Hague,

▲ Oskar Kokoschka
Portrait of Herwarth Walden (1910)
Canvas. 100cm × 68cm
Minneapolis Institute of Arts

▲ Philips de Koninck
A Landscape with Hawking Party
Canvas. 132cm × 160cm
London, National Gallery

Bredius Museum), and Bloot, Brouwer and such Rotterdam realists as Sorgh (*The Seamstress*, 1671, Hermitage). His portraits (*Self-Portrait*, 1667, Uffizi; *Portrait of Vondel*, 1674, Rijksmuseum), though noteworthy, are somewhat conventional in their blending of Rembrandt with Bol, or in their vision of the world, which is similar to that of Jan de Boen.

Koninck's drawings often emerge as rather vulgar pastiches of Rembrandt and it is only in his landscapes that the energy of his style is allied with breadth of vision. Koninck's true greatness lies in these landscapes, which make up almost half of his known output. His earliest known works in this genre date from 1647 (London, V. & A.) and from 1649 (Metropolitan Museum), and already display marked originality. In these vast panoramas the dark masses of vegetation are contrasted with the lightness of water or areas lit by the sun. There is a compelling poetry about these great spaces; few Dutch landscapes give such a feeling of immensity. Not that these views are of identifiable locales (the countryside of Gelderland inspired Koninck only in a vague and general way, and he utilized the same themes arbitrarily in one painting after another).

Unlike such other Dutch painters as Seghers, Rembrandt or Jacob van Ruisdael, Koninck always seems to efface himself before his scenes. He employed horizontals that look as though they are prolonged beyond the edges of the canvas, and the same realistic honesty can be seen in his use of green, blue, white and grey, enlivened sometimes by a few touches of red, which contrast strongly with the splendid golds and browns derived from Rembrandt and Seghers.

Koninck's concept of landscape thus appears as the end of a landscape tradition, inaugurated by Van de Velde and Van Goyen, that had led to a progressive lowering of the line of the horizon which allowed the sky an ever larger space. Koninck's work is a prime example of the great movement of the 1650s towards a more Baroque and lyrical art, expressed here as a genuine fascination with space, which is enlarged and deepened until it stretches beyond its physical

limits on the painting. This synthesis was without sequel (with the exception of certain echoes found in Ruisdael) since it was the Italianate style of landscape painting that dominated the second half of the century.

Koninck's landscapes are usually on a large scale (mainly measuring 4ft × 5ft). Among the finest of these are the paintings in the Copenhagen galleries (1654, S.M.f.K.), in the Rijksmuseum (particularly the acquisition in 1967 of a painting dated 1655 and formerly in the Earl of Derby's collection), in Oxford (Ashmolean Museum), in Rotterdam (1664, B.V.B.) and in London (N.G., four works). In some of the later landscapes (Wantage, Loyd Coll.; Rijksmuseum, 1676, and an undated landscape depicting a forest path near water) Koninck becomes less rigorous and contrasts the horizontal planes with great masses of trees in the foreground, with manifestly less success, as though he was yielding to the fashion for landscapes in the Italian style. J.F.

Konrad von Soest

German painter
b.Dortmund, c.1370 – d.Dortmund, after 1422

A master of the Westphalian School who worked in Dortmund, Konrad von Soest exemplifies the way that German painting was evolving around 1400, particularly in relation to the International Gothic style then popular in the West. Born in Dortmund about 1370, he married there in 1394, when he was clearly a citizen of the town; his name is further mentioned in the registers of 1413 and 1422. However, although there is more evidence about his life than there is for many of his contemporaries, detail is lacking.

Of his surviving works, the earliest seems to be a panel of *St Nicholas* (Church of St Nicholas in Soest), which was probably painted some time before 1400. It shows St Nicholas seated on a throne with St John the Baptist and St Catherine on his left and St John the Evangelist and St Barbara on his right. The stiffness of the draperies and the still clumsy modelling of the throne reveal Konrad's attachment to the Westphalian tradition, and although he was later to fall increasingly under the spell of Burgundian court art, he never completely abandoned his native style.

The panel of *St Nicholas* gives no clear indication whether or not he had seen the centres of Franco-Flemish art, but the later works leave no doubt about it. In these the technique has lost its stiffness and has become careful and elegant; there is a new suppleness about the draperies, which, together with the aristocratic-looking faces, are heightened by colouring of amazing subtlety. An early example of the new style is a panel showing *St Paul* (with *St Raineld* on the left) in Munich (Alte Pin.). It is the right-hand shutter from a portable altar, commissioned, immediately after 1400, by a noble family in Dortmund, named Berswordt.

The main work of this period, however, is the altarpiece of the high altar of Bad Wildungen, which is still in place. The work is inscribed with Konrad's name, one of the first occasions in Germany that the author of a work of art is thus mentioned. The inscription also bears a date, but it is hard to determine whether this should be

read as 1400 or 1404. This monumental altarpiece measures more than 24ft when it is open. The outer shutters, on which the inscription appears, are decorated with four large figures of *Saints*. Inside, 12 panels and a large central image tell the story of the life and Passion of Christ, from the *Annunciation* to the *Descent of the Holy Ghost* and *Christ as Judge*. One detail deserves attention: while the four scenes that take up the left-hand shutter form a whole, the story unfolds on a double row going from the central panel to the right-hand shutter and interrupted in its chronological continuity by the central picture, which represents *Calvary*. The scenes vary in quality, and certain details betray the hand of an assistant or show that the work was done in the studio, yet the altarpiece as a whole achieves a perfection and a delicacy of execution that is rare in Germany.

In contrast with contemporary altarpieces from the same region which are still steeped in the German medieval style of the 13th century, Konrad von Soest's style, born from contact with 'modern' Franco-Flemish painting, displays a marked originality. The *Niederwildungen Altarpiece* which links the German with the Burgundian aesthetic, is one of the most perfect expressions of International Gothic in Germany. The feeling of unreality that characterizes it stems from the extreme delicacy of its workmanship and from the painter's ability to sublimate reality. In their richly ornamented costumes of brocade and silk, the figures seem to have stepped out of a fairy-tale world. Their expressions are somewhat precious, the gestures of the hand rather studied. Detail is treated very carefully and precisely; the use of colour, in subtle gradations, is bright and exact.

A liking for attractive lines, for supple draperies, sumptuous clothes and fashionable costumes, characterizes Konrad's work. The spirit in which it is steeped, the various components, such as the architectural decor or the representations of hills, trees and bushes, show how open Konrad was to the influence of Western paintings. The arrangement of space, which Master Francke was to develop ten years later, was still only allusive in Konrad. The frail, ethereal outlines are without plasticity, products of an ornamental art without depth, in contrast with the *Altarpiece of St Barbara* made several years later by Master Francke.

The remains of a late work, the large altarpiece of Dortmund, which dates from about 1420 (*in situ*), is a brilliant demonstration of Konrad's artistic development. This altarpiece was taken down in the 18th century, and its panels were cut up and inserted into a Baroque frame. Of the central panel, representing the *Death of the Virgin* and reduced to two-fifths of its original size, only the main group survives. Three-quarters of the shutters that bear the *Nativity* and the *Adoration of the Magi* have been saved. The forms have gained in size and firmness, the composition is stricter and barer, the figures have a new majesty. Larger and more powerful, they take over the surface. The rich costumes of the kings, the faces and gestures, show Konrad's taste for a miniature-like fineness, but limpidity, calm and order are his main concern.

Konrad not only exercised a deep and lasting influence on Westphalian painting, but probably also on the art of northern Germany, as far as Cologne. His ascendancy was comparable only with that of Schongauer and Dürer a hundred years later. M.W.B.

▲ Konrad von Soest
Crucifixion (central panel of the *Altarpiece of the Passion*)
Wood. 158cm × 159cm
Bad Wildungen, Pfarrkirche

Krieghoff
Cornelius David

Canadian painter
b.Amsterdam, 1815 – d.Chicago, 1872

As a child Krieghoff moved with his family in 1820 to Düsseldorf where his father was employed as a wallpaper designer. Krieghoff studied painting at the Düsseldorf Akademie and then travelled through Europe earning his living as an artist and a musician. He developed a facility for languages and in his adult years spoke six languages fluently, as well as knowing Greek and Latin; his library reputedly contained 1,200 books.

About 1836 Krieghoff and his brother emigrated to New York and the following year he enlisted as an officer in the United States army. It may have been in New York that he met his future wife Louise, who was French-Canadian. Certainly it was their marriage which prompted his move to Quebec in 1840. Making a living was difficult, however, and in 1841 Krieghoff returned to the United States to teach painting and music in Buffalo. But the possibility of painting genre pictures of French-Canadian rural life attracted him. By re-working genre themes from European painting and giving them a French-Canadian flavour Krieghoff established a reputation and was able to return to Quebec to live and paint. His success was further guaranteed when he moved to Montreal in 1849 and joined the Montreal Society of Artists, thus acquiring a number of patrons.

Winter Landscape (1849) is a typical Krieghoff. It shows his wife Louise, her daughter Emily and her father Gautier in a sleigh at Longueil on the outskirts of Montreal, with Mount Royal in the distance. Krieghoff was highly skilled and able to impart an air of zest and vitality to these Canadian winter scenes. He was also very prolific and painted many works depicting people in sleighs on their isolated farms. He painted his patrons' favourite subjects repeatedly, varying minor details so that they all appeared slightly different.

The Habitant Farm (1856) is an important work from the period 1855-6 when Krieghoff painted a number of old farm dwellings around Quebec City. It shows a farmer returning from the market, laden with foodstuffs, and accompanied by a surprise visitor, the grandmother. Visitors to these lonely farms were rare, especially in winter, and she is greeted by the family with great excitement. There are often details of food in Krieghoff's paintings, and the pork, the molasses and the beans are all distinctly French-Canadian. This fidelity to detail and his ability constantly to change and add to detail was one of Krieghoff's strongest points as an artist.

Krieghoff twice revisited Europe to see the museums; once in 1854-5 and again in 1869. In 1868 he left Quebec City to live with his daughter in Chicago and he only revisited Montreal and Quebec City once, in 1871, before his death. A.G.

Kupka
František

Czechoslovak painter
b.Opočno, 1871 – d.Puteaux, 1957

The oldest of several children, Kupka was apprenticed to a saddler in Dobruška where his father was a secretary in the town hall. A highly sensitive young man, he was early influenced by his employer who initiated him into spiritualism and discovered in him a gift as a medium. But Kupka, who had no desire to become a saddler, left. A journey across eastern Bohemia impressed him with the richly Baroque art of the region, in particular the sculptures of Mathias Braun. On his return he attended the Jaroměř technical college where the painter Studnička introduced him to the work of Josef Mánes and prepared him for entry to the Prague Academy of Fine Art.

During his time in Prague from 1887 to 1891 Kupka discovered contemporary European painting, and continued to be fascinated by spiritualism. He then moved to Vienna where he followed courses at the Akademie. From this period date various portraits (*The Last Dream of the Dying Heine*, study, Prague Museum), Symbolist works painted in the academic style of the era. In 1894 he

spent a short time in London and rather longer in Scandinavia. In 1895 he arrived in Paris where he remained until his death.

To earn a living, Kupka gave drawing lessons to milliners and supplied satirical drawings to the newspapers. The cycles he executed in 1902 for *L'Assiette au beurre* (*Money, Peace*) were violent diatribes against the injustice and cruelty of man. Once he had achieved a certain measure of success he abandoned newspaper in favour of book illustration. Between 1904 and 1906 he illustrated Elisée Reclus's *L'Homme et la terre*; between 1905 and 1909 *The Song of Songs*, Leconte de Lisle's *Les Érinnyes*, Aristophanes's *Lysistrata* and Aeschylus's *Prometheus*, in which (particularly in the first two works) the influence of Alphonse Mucha may be discerned. He was still painting and, at the beginning of his time in Paris, he had experimented with Impressionism (*The Bibliophile*, 1896-8, Prague Museum).

Soon, under the influence of Odilon Redon, he began executing Symbolist canvases in which line predominated, and in which he occasionally sacrificed plastic expression to concept (*Defiance*, or *The Black Idol*, 1903, Prague Museum). After settling in Puteaux, where he was a neighbour of Jacques Villon, he participated in the Section d'Or. In 1905 he turned back towards Impressionism before moving closer to the Fauves. Between 1907 and 1910 he painted street scenes and prostitutes in Expressionist vein (*The Archaic*, 1910, Paris, M.N.A.M.)

Influenced by Reynaud's praxinoscope and by Marey's chronophotography, he attempted, long before Marcel Duchamp and the Italian Futurists, to translate movement and light. In 1909 he painted the picture that marked a turning-point in his art: the *Piano Keyboard – the Lake* (Prague Museum). For this work he divided his canvas into a series of narrow parallel bands which were those 'planes of colour' which formed the basis for his abstract canvases, painted from 1910 onwards but not exhibited until the 1912 Autumn Salon (*Madame Kupka among Vertical Lines*,

▲ Cornelius Krieghoff
The Ice Bridge at Longueil (1847–8)
Canvas. 58 cm × 74 cm
Ottawa, National Gallery of Canada

▲ František Kupka
Planes by Colours (1910–11)
Canvas. 110 cm × 100 cm
Paris, Musée National d'Art Moderne

1910-11, New York, M.O.M.A.; *Amorpha, Fugue for Two Colours*, Prague Museum; and *Vertical Planes*, 1912, Paris, M.N.A.M.).

The works caused a sensation. The titles, chosen by the artist himself, explain on the one hand the circular motifs, characterized by interrupting elliptical forms and by generally warm colours; and on the other the vertical motifs, defined with geometrical severity, and often cold colours. At the same time Kupka's interest in the natural sciences began to be reflected in such paintings as *Cosmic Spring I* (1913-19, Prague Museum). Kupka returned to his canvases many times during his career, constantly retouching them, and he did not date them until shortly before his death.

After serving with the forces in France during the First World War, Kupka took up his earlier work once more. In 1931 he joined the Abstraction-Creation movement and thus came into contact with painters working in the style of geometrical abstraction. He pared his paintings down, tending towards rigorous stylization, and painted a series of canvases and gouaches inspired by jazz and its syncopated rhythms: *Jazz-Hot No 1* and *Music* (1935, 1936; both Paris, M.N.A.M.). After being evacuated to Beaugency during the Second World War he returned once more to Puteaux and retouched old canvases (*Three Blues, Three Reds*, 1913-57, Paris, M.N.A.M.) and painted compositions with regular surfaces organized

into perpendicular planes in a non-illusionist space (*Autonomous White*, 1951-2, Paris, M.N.A.M.).

Kupka's numerous interests, music in particular, and his prodigious culture made him one of the eminent representatives of that modern spirit lauded by Apollinaire. Kupka gave the musical inspiration in his work a sometimes complex interpretation (see his *Creation in the Plastic Arts*, a theoretical essay written in French and published in a Czech translation in Prague in 1923). Alongside Kandinsky, Malevich, the Delaunays and Mondrian, he may be considered as one of the pioneers of abstract art – although his art was always that of a 'loner', and was not really recognized until after his death. A room in the Musée National d'Art Moderne in Paris is given over to him (the 163 paintings and drawings are largely the result of Mme Kupka's bequest of 1968), and this gallery and the Prague Museum between them contain the majority of his works. M.V.

Laer (Laar)
Pieter van
(also known as 'Il Bamboccio')
Dutch painter
b.Haarlem, c.1595 – d.Haarlem(?), 1642(?)

Van Laer's real name was Pieter Boddingh van Laer and he may have been a pupil of Esaias van de Velde in Haarlem. Around 1625 Van Laer travelled to Rome where he remained until 1639. While there he became friends with Herman van Swanevelt and Sandrart and also met Claude; he was to play a relatively important role among the boisterous group of foreigners working in Rome between 1630 and 1640, and more particularly among the community of northern painters who comprised the Schildersbent.

Van Laer's misshapen body (as revealed in the moving *Self-Portraits* in the Galleria Pallavicini

and the Uffizi) led to his being nicknamed 'Bamboccio', or 'chubby little fellow'. From this nickname came the name given to a new genre created by him in Rome, and which made him famous: the *bambocciate*, representing Roman street scenes (*The Pistol Shot*, Hermitage; *Italian Scene*, Uffizi; *Travellers with Horses before an Italian Inn*, Florence, Pitti; *Thieves before a Cave*, *Riders before an Inn*, Rome, Gal. Spada; *The Flagellants*, Munich, Alte Pin.). These pictures are filled with everyday types dressed in rags and wearing large, wide-brimmed hats, and are painted in thick, muted colours that reveal a mingling of Van Laer's Dutch training with the traditions of Caravaggio. The *bambocciate* sold extremely well in Rome and were imitated by a group of *bambocciati* that included Miel and Lingelbach.

The importance of Van Laer as a landscape painter has recently been rediscovered. He was the first Dutch painter whose landscapes were made up of groups of trees and hills of relatively large dimension, together with genre figures; the latter, large in relation to the surface, were painted fluently and with animation, and formed an essential part of the composition (*The Departure from the Hostelry*, *The Herdsmen*, (both Louvre; *Forges among Roman Ruins*, 1635, Schwerin Museum). He often depicted shepherds accompanied by their flocks or huntsmen with their dogs (*Shepherds and Washerwomen*, Rijksmuseum; *Ruins and Flock of Sheep*, Prado).

Van Laer was thus the creator of two new genres which were to enjoy considerable success in Holland after 1640 and to be imitated until the 19th century: the 'pastoral scene' and the 'hunting scene'. It was not only landscape painters in the Italian style, such as Berchem, Asselyn, Dujardin and Weenix, who drew inspiration from these genres introduced by Van Laer; artists who had in all probability never travelled south were equally influenced: Adriaen van de Velde, Dirck Stoop and Philips Wouwerman.

In 1639 Van Laer returned to Haarlem, passing through Amsterdam on the way. He may have influenced Dutch painters not only by the works he painted on his return, but also by the pictures he executed in Rome which were often bought at considerable expense in Italy and sent back to Holland. Van Laer set off on his travels once more in 1642, but his life beyond this point is not documented. A.Bl.

La Hyre
Laurent de
French painter
b.Paris, 1606 – d.Paris, 1656

After learning the rudiments of art from his father Étienne, who had been a painter in his youth, La Hyre completed his training in Paris in Georges Lallemand's studios. He also made a careful study of the decoration of Fontainebleau (as may be seen from his youthful work, *La Tuile* [The Tile], Paris, private coll.) and in addition must have profited from the advice of Quentin Varin, a friend of the family and former teacher of Poussin.

La Hyre's first important commission, *Visite du pape Nicolas V au tombeau de Saint François* (*Pope Nicholas V before the Body of St Francis*) (1630, Louvre), was executed for the Capuchin chapel of St Francis at Marais and combines Mannerist

▲ Pieter van Laer
The Flagellants
Canvas. 53 cm × 82 cm
Munich, Alte Pinakothek

▲ Laurent de La Hyre
La Mort des enfants de Béthel (1653)
Canvas. 97 cm × 129 cm
Arras, Musée Municipal

features and a classical sensibility. Two works carried out for Notre Dame, *Saint Pierre guérissant les malades de son ombre* (*St Peter Curing the Sick with his Shadow*) and *La Conversion de Saint Paul* (*The Conversion of St Paul*) (1635, 1637; both Notre Dame, Paris), confirmed his reputation. Baroque in character, with dramatic lighting reminiscent of Vouet or Blanchard, this latter work marks the end of the first phase of La Hyre's evolution.

From 1640 he executed decorative works (for the Hôtel Tallemant and the Hôtel Montoron), produced tapestry cartoons (a series on *La Vie de Saint Étienne* [*Life of St Stephen*] for the church of St Étienne-du-Mont in Paris, drawings in the Louvre), as well as *tableaux de cabinet* and altarpieces for newly constructed churches on behalf of the various religious orders. In 1648 he was one of the founder-members of the Académie.

These varied activities are typical of La Hyre's elected interests. A lover of music, and fascinated by mathematics and archaeology, he was representative of the Parisian society in which he lived. He began a reaction against the impetuousness of Vouet, at the same time making a determined effort to achieve elegance and serenity in his painting (*La Vierge et l'Enfant* [*Virgin and Child*], 1642, Louvre).

Landscape began to play an increasingly important role in his output; it was always supported by some architectural motif, depicted with a strict regard for accuracy, as in *La Naissance de Bacchus* (*The Birth of Bacchus*) (1638, Hermitage), one of the masterpieces of his classical maturity, and *Laban cherchant ses idoles* (*Laban Searching for Idols*) (1647, Louvre), in which the action is set in a calm, transparent landscape. Light colours discreetly sustain the gentle drama of *La Mort des enfants de Béthel* (*The Death of the Children of Bethel*) (1653, Arras Museum) or *Moïse sauvé des eaux* (*Moses Saved from the Waters*) (Detroit, Inst. of Arts). In the *Paysage au joueur de flûte* (*Landscape with Flautist*) (1647, Montpellier Museum) or the *Paysage aux baigneuses* (*Landscape with Bathers*) (1653, Louvre) the figures blur into the landscape, which becomes the subject of the painting. La Hyre's cool touch, and his sharpness, suggest the influence of the Flemish landscape painter Fouquières, who was living in Paris at this time.

La Hyre continued painting mythological scenes or themes from antiquity until the end of his life (*Hersé et Mercure*, 1649, Épinal Museum; *Cornélie* [*Cornelius*], Budapest Museum; *Allégorie de la paix et de la justice* [*Allegory of Peace and Justice*], 1654, Cleveland Museum), as well as large-scale religious compositions such as the *L'Apparition du Christ aux Maries* (*The Apparition of Christ to the Marys*) (Louvre), *La Descente de croix* (*The Descent from the Cross*) (1655, Rouen Museum), *L'Apparition du Christ à la Madeleine* (*Apparition of Christ to Mary Magdalene*) and *Les Disciples d'Emmaüs* (*The Disciples of Emmaus*) (1656, Grenoble Museum) which are remarkable for their dramatic power.

Only a few scattered works survive of his activity as a decorator: the *Allégorie de la Musique* (*Allegory of Music*) (1648, Metropolitan Museum) gives some idea of his output. From the same ensemble (probably from the Hôtel Tallemant) comes *La Grammaire* (*Grammar*) (1650, London, N.G.) and two *Putti* in the Magnin Museum in Dijon; two other pieces, *La Géométrie* (*Geometry*) (1649, Toledo, Ohio, Museum of Art) and *L'Astronomie* (*Astronomy*) (1649, Orléans Museum), may belong to the same work. The Bibliothèque Nationale in Paris possesses 40 or so very fine

engravings by La Hyre, who also executed numerous drawings in red chalk (*Saint Jean*, Louvre) and black chalk (*Les Trois Grâces* [*The Three Graces*], Montpellier Museum). La Hyre ranks among the greatest landscape painters of the 17th century. N.Bl.

Laib
Konrad

Austrian painter
b.Eislingen, near Nördlingen, c.1410 – d.after 1460

Laib is first mentioned in 1442 in Salzburg where, six years later, he acquired citizen's rights. His first known work (*c.*1440) is an *Altarpiece of the Virgin*, of which two panels survive: the *Nativity* (Freising Seminary) and *The Adoration of the Magi* (Cleveland Museum). The piece was intended for Salzburg and has links with the Salzburg tradition. Two triangular panels in Salzburg Museum of *St Hermes* and *St Primus* (*c.*1445) (probably organ doors originally from Hogastein) show signs of Netherlandish influence and are also close in outlook to the work of Konrad Witz and Hans Multscher.

Though there is no proof that Laib travelled to the Low Countries there can be no doubt that he had first-hand experience of the art of Verona and Padua, and particularly of the work of Altichiero. His great *Crucifixion* of 1449 is based on Altichiero's Paduan frescoes; it was exhibited in Salzburg Cathedral (now in Vienna, Österr. Gal.) and was painted by Laib in lieu of the tax to which he became liable after acquiring citizen's rights. The side-panels are now dispersed: those representing the *Annunciation* and the *Nativity* are in Padua (Palazzo Vescovile), while the *Death of the Virgin* is in Venice (Seminario Patriarcale); the outer wings depicted (left) *St Korbinian* (lower part in Padua) and (right) *St Florian*, of which Padua and Venice each possess half a panel.

◀ Konrad Laib
St Hermes
Wood. 129 cm × 71 cm
Salzburg, Salzburger Museum

St Maximilian dates from about 1450 (Bischofshofen), while another *Crucifixion*, painted for Graz Cathedral, is similar to the one in Salzburg; it is signed 'Laib' and dated 1457 (Graz, Diocesan Museum).

The triptych for the parish church of Pettau (Ptuj, Yugoslavia, Prokrajinski Muzej), Laib's last important work, is a curious mixture of the Germanic style of altarpiece, with shutters, and the Venetian icon. Open, the work reveals the *Death of the Virgin* and, on the side-wings, *St Jerome* and *St Mark*; closed, the *Crucifixion* in the centre, with, on the sides, *St Nicholas* and *St Bernard of Siena*. On the predella is a *St Veronica Presenting the Sudarium Carried by Two Angels*. A *Virgin and Child* (Munich, Alte Pin.) was completed soon after. Two frescoes from the Franciscan church in Salzburg, *The Agony in the Garden* and a *Man of Sorrows*, are also by Laib. W.B.

Lairesse
Gerard de

Flemish painter
b.Liège, 1641 – d.Amsterdam, 1711

Formerly referred to by the flattering title of the 'Dutch Poussin', Lairesse came from the artistic community of Liège where the influence of classical French and Roman art mingled with the Flemish Baroque of Rubens. The son of the painter Renier de Lairesse and the godson of Gerard Douffet, Lairesse became a pupil of Bartholet Flémalle, to whom he owed his passion for the classicism which was then the vogue in Paris. However, he did not visit the French capital and knew Poussin's work only through engravings.

In 1660 Lairesse painted in Aachen a *Martyrdom of St Ursula* (Aachen Museum), a work in which his rigid, somewhat theatrical classicism is already evident. In Liège itself he painted large mythological works: *Orpheus in the Underworld* (1662, Liège, Ansembourg Museum) and *The Marriage of Alexander and Roxane* (1664, Copenhagen, S.M.f.K.).

The classical elegance of his forms and the quality of his colours, particularly silvers and purples, came to the fore in *The Conversion of St Augustine* (Caen Museum) and in the *Baptism of St Augustine* (Mainz, Mittelrheinisches Landesmuseum), works which were painted for the church of the Ursuline convent in Liège. In 1664 he was forced to leave his native city because of a love affair, and sought refuge first in 's Hertogenbosch, then in Utrecht, before settling finally in Amsterdam in 1667. Here he enjoyed considerable success through his introduction of the classical style of Poussin, Le Brun and Raphael to Dutch painting.

Lairesse worked for the Statholder William of Orange, future king of England, and for Dutch high society, and decorated the Civil Chamber (Binnenhof), in The Hague with a series of seven vast compositions drawn from Roman history. He also carried out large decorative projects for the Soestdyck and Loo palaces, as well as painting allegorical decorations in grisaille which count among his very best works (Orléans Museum and Rijksmuseum). The virtuosity of his style reaches a peak in the *Bacchanalia* (Kassel Museum), *Antony and Cleopatra* (Rijksmuseum) and *The Assumption of the Virgin*, painted for Liège Cathedral (now in the Church of St Paul). The

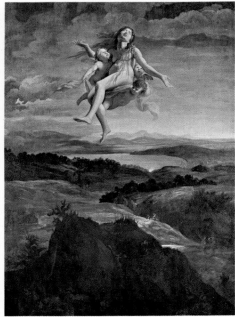

allegorical portrait of the *Duchess Mary of Cleves* (Amiens Museum) was modelled partly on Vouet and Le Brun.

Lairesse went blind in 1690, after which he organized conferences on painting and published several works dealing with aesthetics: *Grondlegginge der Teeken Kunst* (Amsterdam, 1701) and *Het Groot Schilderboek* (1707). This latter, translated into English as *The Art of Painting...*, in 1738, upheld the most intransigent kind of academicism, which in Lairesse's view only Poussin fully achieved. Rubens, like Rembrandt, was scarcely mentioned. Both as painter and theoretician Lairesse's fame lived on after his death and continued to grow, along with the taste for antiquity and Neoclassicism during the final decades of the 18th century. P.H.P.

Lam
Wilfredo

Cuban painter
b.Sagua la Grande, Cuba, 1902

A latecomer to the Surrealist movement, Lam brought to it an originality derived from his origins. He spent his childhood in Cuba where he began his artistic studies, later pursuing them in Madrid and Barcelona until the Spanish Civil War forced him to seek refuge in France in 1937. Introduced by Picasso to André Breton and the Surrealists, he was immediately drawn into their circle and it was with Breton that he travelled to the West Indies in 1941. After this, Lam travelled throughout the Pacific, South America and Europe.

His first exhibition was held in Paris in 1938 and, following his return to Cuba, he began to fill out his paintings more: intertwined vegetal shapes, concealing mythological figures, extend vertically against a dark background (*The Jungle*, 1943, New York, M.O.M.A., and Paris, M.N.A.M.; *The Astral Harp*, 1944, Paris, M.N.A.M.). These plant themes were followed after the war by broad spreads of less vivid colours (*Umbral*, 1950, Paris, M.N.A.M.; *Extra-Lucid*, 1950, Rotterdam, B.V.B.). Later his figures, set against a dark background, became increasingly simplified

(*Seated Woman*, 1954, New York, Mrs A. Gimbel Coll.), while, more recently still, the tapering, sharp-edged forms from the Cuban period have reappeared (*Figure*, 1965; *The Barrier*, 1968). Although Lam's work is similar in many respects to that of Central and South American Expressionists such as Tamayo, his free imagination and dreamlike profusion mark him as an authentic Surrealist. L.E.

Landseer
Sir Edwin

English painter
b.London, 1802 – d.London, 1873

Landseer showed his talent as a draughtsman before the age of six; by 1813 he had been awarded a prize by the Society of Arts, and in 1815 he exhibited for the first time at the Royal Academy. An early success was *Fighting Dogs Getting Wind* (1818, private coll.). He was elected to the Academy as an Associate as soon as he reached the qualifying age of 24, and he became a full Academician five years later, in 1831. Another example of his early work is *The Dog and the Shadow* (1822, London, V. & A.).

Like George Stubbs before him, Landseer in his paintings of animals showed a considerable knowledge of anatomy: he owned Stubbs's drawings for *The Anatomy of the Horse*, which were presented to the Academy after his death, and on one occasion he even dissected a lion. He was also fond of animal sports; as a boy he enjoyed the rather cruel pastimes of rat-killing and dog fights, and later in life he was an enthusiatic deerstalker.

In 1824 Landseer visited the Scottish Highlands with C.R. Leslie, Constable's biographer. On this occasion he met Sir Walter Scott at Abbotsford. The visit resulted in a series of paintings of stags and other Highland animals, such as *Chevy Chase* (1826, Birmingham, City Museum and Art Gal.), which was inspired by two Romantic sources: the literary work of Scott and the paintings of Delacroix.

Landseer, who quickly learned to move in the higher reaches of society, also painted portraits, including many of Queen Victoria, her family, gamekeepers, and pets. He was a favoured guest at Balmoral and was friendly with the Queen (who found him very handsome, though rather small); he had fine manners, was a good mimic and generally light-hearted although subject to bouts of depression. When Landseer died the Queen noted in her diary: 'I possess 39 oil paintings of his, 16 chalk drawings (framed), two frescoes, and many sketches'; her favourites were the small and freely painted landscapes and sketches.

Landseer's more sentimental paintings, such as the well-known *Dignity and Impudence* (1839, London, Tate Gal.), often show animals expressing human sentiments; they became extremely popular, particularly through the medium of engravings. Other paintings in the same manner include *High Life and Low Life* (1829, London, Tate Gal.), in which he contrasted an 'aristocratic' deerhound and a proletarian mongrel, and *The Old Shepherd's Chief Mourner* (1837, London, V. & A.), where the mourner is a dog. Until the 1840s, his paintings were frequently on wooden panels or millboard, with a gesso ground, but his later work is usually larger and on canvas.

In 1840 Landseer travelled abroad, because of ill-health, and painted some beautiful landscape studies, many of which he utilized in later pictures. Important works of the following years include the famous *Monarch of the Glen* (1851,

▲ Gerard de Lairesse
Antony and Cleopatra
Canvas. 74 cm × 95 cm
Amsterdam, Rijksmuseum

▲ Wilfredo Lam
The Jungle (1943)
Canvas. 240 cm × 228 cm
New York, Museum of Modern Art

▲ Giovanni Lanfranco
St Mary Magdalene carried away by the Angels
Canvas. 110 cm × 72 cm
Naples, Galleria Nazionale di Capodimonte

London, John Dewar and Sons Ltd.) and *Man Proposes, God Disposes* (1864, Egham, Royal Holloway College), which has an almost tragic grandeur. On the whole, however, the quality of his painting was variable during this period.

Having refused a knighthood once, Landseer accepted one in 1850; and in 1865, although he was formally elected, he declined the Presidency of the Royal Academy. Two years later he completed his main work as a sculptor, the four lions for the Nelson Memorial in Trafalgar Square, working from photographs and plaster casts. In 1869 his health broke down completely, and he went through periods of severe mental illness. He died four years afterwards, probably the most popular painter in the land, and was buried in St Paul's Cathedral. He left a considerable fortune, largely due to the immense number of engravings made from his works: by the year 1875 as many as 434 etchings and engravings had been made from his paintings, by 126 engravers. J.H.

Lanfranco
Giovanni
Italian painter
b. Terenzo, near Parma, 1582 – d. Rome, 1647

Lanfranco received his early training in Parma from Agostino Carracci, at that time painter to Duke Ranuccio Farnese, and acquired from him the basic principles of classicism. Following his master's death in 1602, Lanfranco left for Rome with his fellow-student Badalocchio, where they became part of the artistic circle around Annibale Carracci. Through Carracci's influence Lanfranco was commissioned to decorate with frescoes and canvases the Camerino degli Eremiti (so called because of the subject matter of the decorations) adjacent to the Farnese Palace.

These early paintings, now distributed between

▲ Sir Edwin Landseer
Dignity and Impudence (1839)
Canvas. 89 cm × 69 cm
London, Tate Gallery

the Church of S. Maria della Morte (Rome) and the Capodimonte (Naples), in their contrasts of light and shade and their free composition, reveal their debt to the naturalism of Caravaggio and his followers rather than to the principles of classicism. Certain areas of landscape – the background, for example, of *St Mary Magdalene Carried Away by the Angels* (Naples, Capodimonte) – are astonishingly realistic and quite different from the idealized vision of Annibale Carracci.

After Annibale's death in 1609, Lanfranco returned to Parma and, between 1610 and 1612, studied the work of Correggio, whose diffused luminosity and bold use of space fascinated him. However, a journey to Emilia reintroduced him to Annibale Carracci's youthful works, conceived while the artist was still under Venetian influence, and the brilliance of the colours allied to the animation of the whole impressed Lanfranco greatly. From this period date such works as *The Redemption of a Soul* (Naples, Capodimonte), *The Madonna, St Charles Borromeo and St Bartholomew* (Naples, Capodimonte) and *St Luke* (Piacenza, Collegio Notarile).

Lanfranco's essentially romantic temperament blossomed after his return to Rome in a series of religious works painted for various churches (*The Madonna, St Anthony and St James*, Vienna, K.M.). They are all characterized by a marked contrast between full, firm, naturalistic forms and intense lighting that seems to emanate from some supernatural source, but which nonetheless produces an effect of realism. From this contrast emerges a dramatic tension prefiguring the exciting climate of Baroque illusionism.

In fact it was Lanfranco who introduced this climate in his gigantic fresco for the dome of the Church of S. Andrea della Valle (*The Assumption of the Virgin*), the commission for which he took over from his friend Domenichino in 1625. Even his contemporaries were aware of the novelty of this painting, consisting of a mass of figures rising like a whirlwind and conceived as though it were a symphony 'in which the ensemble of tones forms the harmony'. Lanfranco's taste for bold, dynamic composition, reinforced by a study of Correggio and seen earlier in his vault for the Buongiovanni Chapel (1616-17, Rome, Church of S. Agostino), reaches a peak in this luminous dome. Lanfranco was to use it as his inspiration for similar works and it also served as a model for Pietro da Cortona and Baciccio in Rome and elsewhere.

Among the paintings Lanfranco executed at this period are *The Ecstasy of the Blessed Margaret of Cortona* (Florence, Pitti) and a series of canvases, now dispersed, that he painted around 1625 for the Church of S. Paolo fuori le Mura in Rome (Dublin, N.G.; Marseilles and Poitiers museums; Los Angeles, P. Getty Museum; and other colls.). By 1630 Lanfranco – together with Bernini in sculpture – was in the front rank of official art. His paintings were free from academicism but at the same time totally in tune with the ideology of a triumphant Catholic Church: after the struggles of the Reformation the Church needed a reasonably conservative artistic language in order to re-establish itself; it required something that would attract, not disconcert. It needed, too, a style that blended illusionist effects, fervour and spectacle, but with an easy gracefulness that would ensure it was universally understood.

Miracles, martyrdoms, celestial coronations and allegories of the virtues became Lanfranco's

themes from now on, together with the occasional mythological work. As a specialist in frescoes it was in Naples – the city that attracted all the best painters of the time – that Lanfranco found the most favourable opportunities for his decorative genius. The vast bare surfaces of the cupolas and pendentives in the Church of the Gesù (1634-5, of which only the *Evangelists* remain), the tribune and dome (*Martyr and Apostles*) of the Church of the SS. Apostoli (1638-46) and the dome (*The Glory of the Blessed*) of the Cappella del Tesoro in the Cathedral (1641-43) were all covered by a multitude of figures burning with a devout and sentimental fire which conquered the Naples school of painters and affected the course of painting from Giordano to Solimena.

Lanfranco returned to Rome in 1646 in order to carry out a fresco in the tribune to the Church of S. Carlo ai Catinari where 30 years earlier he had painted the altarpiece of the *Annunciation*, one of his masterpieces. He died before finishing the commission.

Lanfranco left works in a number of Italian cities apart from Rome and Naples and the towns of Emilia. His art was widely influential, particularly among such Italian painters as Anastasio Fontebuoni, Francesco Cozza and Giacinto Brandi, and with Simon Vouet and François Perrier in France. E.B.

Largillière
Nicolas de

French painter
b.Paris, 1656 – d.Paris, 1746

The son of a Parisian hat-maker, Largillière spent his youth in Antwerp where, after being trained by Antoine Goubaud, he was received into the guild of painters in 1672. Soon after this he travelled to England and was employed by Peter Lely. This double training as genre painter and as portraitist remained evident throughout his career. As a Catholic he was treated with suspicion in England and returned to Paris in 1682 where he received the patronage of a solid Flemish colony grouped around Van der Meulen.

In 1686 he was received into the Académie with his great *Portrait of Le Brun* (Louvre) in which his chief qualities are already in evidence. The portrait is an appropriately flattering and solemn depiction of its subject, containing symbols representing Le Brun's career, but it displays at the same time a brilliant technique and great power of psychological analysis.

Most of Largillière's career was devoted to portrait painting, but he was also commissioned to commemorate various events of Parisian life. He brought new life to the tradition of group portraits in the Dutch style (*Corps de ville délibérant...en 1687* [*City Council Deliberating...in 1687*], now lost; sketches in Amiens Museum, the Louvre and the Hermitage) and also associated the magistrates of Paris with various celestial apparitions (*Ex-voto à Sainte Geneviève* [*Votive Offering to St Geneviève*], 1696, Paris, Church of St-Étienne-du-Mont). He painted the occasional historical painting (*Moïse sauvé des eaux* [*Moses Saved from the Waters*], 1728, Louvre), together with a few landscapes (Louvre) and still lifes, broadly treated and with a simple use of colour; these were probably done fairly early in his career (Paris, Petit Palais; Amiens, Dunkirk and Grenoble museums).

Largillière's output of portraits was huge (1,500 according to contemporary sources), spread over 60-odd years. It is difficult to discern any clear evolution in his style, the more so since many of the portraits are still in private ownership. His clientèle, somewhat less aristocratic than that of his friend Rigaud, was drawn mainly from politicians, financiers and other members of the wealthy middle classes. In his youthful works, the setting, always comparatively simple, was similar to that used by the previous generation of French painters, and to this was added the distinction of the English portrait tradition derived from Van Dyck (*Précepteur et son élève* [*Preceptor and his Pupil*], 1685, Washington, N.G.).

Largillière's realism, enlivened by a sure dynamism of line, emerges clearly in his bust portraits, in which the background is reduced and simplified (*Pupil de Craponne*, 1708, Grenoble Museum). It can also be seen in his many portraits of artists (several *Self-Portraits*, 1711, Versailles; with his family, Louvre, replica at Hartford, Connecticut, Wadsworth Atheneum; portraits of *Jean Thierry*, Versailles; of *Norbert Roettiers*, Cambridge, Massachusetts, Fogg Art Museum; of *J.B. Forest*, 1704, Lille Museum; of *Thomas Germain and his Wife*, 1736, Lisbon, Gulbenkian Foundation) and in certain exceptional portraits of women, in which he often made use of a dominant shade, black, for such works as the famous *La Belle Strasbourgeoise* (*The Beautiful Lady from Strasbourg*) (1703, Strasbourg Museum), and white, as in the *Portrait d'Elizabeth Throckmorton* (1729, Washington, N.G.). But his women, displayed in flattering poses (*Mademoiselle Duclos*, Paris, Comédie-Française, and Chantilly, Musée Condé), are often devoid of psychological content, despite their verve. His best portraits of men, on the other hand, are taut studies quite without complacency. A.S.

La Tour
Georges de

French painter
b.Vic-sur-Seille, diocese of Metz, 1593 – d.Lunéville(?), 1652

Famous in his day, La Tour was utterly forgotten for over 250 years before being rediscovered in 1915 by Hermann Voss. Ever since, his reputation has continued to grow, aided in particular by

▲ Nicholas de Largillière
Portrait of Thomas Germain and his Wife (1736)
Canvas. 146 cm × 113 cm
Lisbon, Gulbenkian Foundation

▲ Georges de La Tour
St Sebastian Mourned by St Irene
Canvas. 160 cm × 129 cm
Berlin-Dahlem, Gemäldegalerie

▲ Georges de La Tour
Saint Joseph éveillé par l'Ange
Canvas. 93 cm × 81 cm
Nantes, Musée des Beaux-Arts

the much-publicized purchase by the Metropolitan Museum of *La Diseuse de bonne aventure* (*The Fortune-Teller*) in 1960 and the exhibition devoted to him in 1972 at the Orangerie in Paris.

La Tour was the second son of a baker, a trade which his mother's family also followed. However, he seems to have received a good education and to have profited when learning the basics of his craft from the brilliant artistic milieu which had sprung up in Lorraine, centred on Bellange. It seems possible that between 1610 and 1616 he visited Italy and felt there the influence of Caravaggio which superseded the Mannerist principles in which he had been trained. Certainly, in his home town after 1616 La Tour's style appears to be fully formed.

In July 1617 La Tour married Diane Le Nerf, a daughter of the Duke of Lorraine's finance minister, and descended from a noble family. After the death of her father the couple moved to his wife's town of Lunéville where La Tour was granted citizen's rights in 1620 and exempted from paying certain taxes, an honour normally reserved for the nobility. He soon became rich, and led the life of a country squire, clinging determinedly to wealth and privilege in a land which, from 1635 on, was to be cruelly ravaged by war, famine and epidemics.

Early on in his career, in 1623, La Tour had attracted the patronage of the Duke of Lorraine, and the renown that this brought him continued even when the duchy was occupied by French troops. La Tour became painter to Louis XIII and also enjoyed the personal esteem of the Govenor of Lorraine, the Maréchal de la Ferté, for whom he painted a *Nativity* (1644), a *St Alexis* (1648), a *St Sebastian* and a *Denial of St Peter* (1650; probably the painting in Nantes Museum). His works fetched high prices (600-700 francs or more).

La Tour appears to have been at the height of his fame when he fell victim to an epidemic on 30th January 1652, a few days after his wife and valet. His son Étienne, who had probably collaborated on his paintings from 1646 onwards, succeeded him as *peintre ordinaire du roi* in 1654 but, being a wealthy man, soon ceased to follow this commoner's occupation and rose rapidly in social circles (being received into the peerage in 1670), which probably explains why his father's work was so quickly forgotten.

Reassembled around the handful of signed canvases, some 75 La Tour compositions have been identified, of which 35 are accepted as original. They consist exclusively of religious or genre scenes; there are no mythological paintings, no portraits, no drawings. The numerous early copies (*St Sebastian mourned by St Irene*, 11 copies known, original lost) show how famous some of his works were.

Most of La Tour's paintings can be divided between daytime and night-time scenes. The first are notable for their cold, clear light, and a precise, swift, style (*Saint Jérôme pénitent* [*The Penitent St Jerome*], two original versions, Stockholm, Nm, and Grenoble Museum; *Le Joueur de vielle* [*The Hurdy-Gurdy Player*], Nantes Museum). The night scenes on the other hand make use of artificial lighting in order to exclude colour – normally only splashes of bright red bring life to the range of browns – and to reduce volumes to a few simple planes which have often led to these canvases being described as 'Cubist' (*Saint Sébastien*, original versions, Chapel of Bois-Anzeray, Eure, and Berlin-Dahlem).

Few of the paintings bear a definite date (*Saint Pierre repentant* [*The Repentant St Peter*], 1645, Cleveland Museum; *Le Reniement de Saint Pierre* [*The Denial of St Peter*], 1650, Nantes Museum) and this has led to disagreement among experts as to the precise chronology of the other, undated works. However, it is possible to distinguish a first period (1620-30), clearly marked by Caravaggesque realism and very close in style to, say, Baburen or Ter Brugghen (series *Christ et les douze apôtres* [*Christ and the Twelve Apostles*], two surviving originals and nine copies. Albi Museum; *Les Larmes de Saint Pierre* [*The Tears of St Peter*], lost, but engraved during the 18th century). It was not until the 1630s that La Tour moved towards a more personal realism (*Le Joueur de vielle*, Nantes Museum).

The upheavals in Lorraine (1635-42), and in particular the destruction by fire in 1638 of La Tour's early works, probably led the painter to move to Paris between about 1638 and 1642. Here, he painted some impressive daytime scenes (*La Diseuse de bonne aventure*, Metropolitan Museum; *Le Tricheur* [*Card-Sharp*], Louvre) and, more particularly, some night scenes (a *Saint Sébastien* was offered to Louis XIII). After his return to Lunéville in 1643 he produced his great series of night paintings, *Le Nouveau-né* (*The Newborn Child*) (Rennes Museum), *Saint Sébastien* (Bois-Anzeray and Berlin-Dahlem, probably 1649) and *Job raillé par sa femme* (*Job Mocked by his Wife*) (Épinal Museum). The last years were probably marked by increasing collaboration from his son Étienne and a return to already worked-on compositions (*Les Joueurs de dés* [*The Dice-Players*], Middlesbrough, Teesside Museums).

La Tour's range of subject matter was limited and he almost always repeated the themes of his Caravaggesque period of 1610 to 1620: they include *La Diseuse de bonne aventure* (Metropolitan Museum); *L'Enfant prodigue* (*The Prodigal Son*) or *Le Tricheur* (Louvre); *La Madeleine repentante* [*The Repentant Magdalene*] (several versions: Washington, N.G.; Louvre; New York, private coll.; and another engraved at the time) and *Le Reniement de Saint Pierre* (Nantes Museum). The years in Lorraine seemed to produce only a few additional themes (*La Découverte du corps de Saint Alexis* [*The Discovery of the Body of St Alexis*], one version, possibly original, in Nancy Museum) or studies of various individual types (*Le Joueur de vielle*). But instead of pushing this style in the direction of the picturesque, as did most of his northern contemporaries, La Tour renewed his links with the early followers of Caravaggio, like them finding in painting the best means of studying the soul of man.

La Tour kept his pictures down to essentials, and his world is surely the least cluttered of any great painter's. He excluded the anecdotal, subsidiary figures, buildings, description of interiors, landscape (no place allocated to nature; not a single plant, and only two or three animals); even accessories are reduced to the bare minimum (no haloes on saints, nor wings on angels), to the point where some of the figures are highly enigmatic (*Saint Joseph éveillé par l'ange* [*The Dream of St Joseph*], Nantes Museum). Even the most violent gestures are frozen into a kind of geometrical stasis (*La Rixe* [*The Brawl*], Los Angeles, P. Getty Museum) and the feeling of immobility and silence dominates his work (*La Femme à la puce* [*The Woman with the Flea*], Nancy Museum).

By apparently simple means, but often, in fact,

as a result of unexpected boldness (*Job raillé par sa femme*, Épinal Museum), he achieves an intensity surprising even among the followers of Caravaggio. Whether he is depicting human weakness and physical deterioration or, by contrast, the secret and fragile dignity of man's inner life, his works reflect both the stoicism of the era and the mysticism of Lorraine and must be ranked amongst the highest spiritual manifestations of the day. J.T.

La Tour
Maurice Quentin de

French pastel portraitist
b.St Quentin, 1704 – d.St Quentin, 1788

The official records of St Quentin show the artist's name as 'Delatour', and it was he himself who wrote it as three words, a practice which is now generally accepted. His talent for drawing became evident early on, when he began copying prints. In 1723, possibly as a result of an unfortunate affair with his cousin, he went to Paris and introduced himself to the engraver N.H. Tardieu, who helped him enter the studio of a mediocre painter named Jean-Jacques Spoëde. He was also advised by Louis de Boullogne and, in particular, Jean Restout, but in fact his training was devoted almost exclusively to drawing with pastel, a method which had recently become fashionable again thanks to Vivien and Rosalba Carriera. 'He advertised his services', wrote Mariette, 'as portrait painter; he did them in pastels, spent little time over them, did not tire his sitters; people found them lifelike and he was not expensive.'

The first extant dated portrait is that of *Voltaire* (1731), which is known only through an engraving by Langlois. After this, his works are better documented. He was 'recognized' by the Académie Royale in 1737 and 'received' in 1746 as 'painter of portraits in pastel', with his *Portrait of the Painter Restout* (Louvre). He took part in exhibitions at the Louvre, which the Director of the King's Buildings, Orry de Vignory, had just re-established after an interruption lasting 13 years. In 1741 he executed the large full-length portrait of *Président de Rieux* (Prégny, Rothschild Coll.), in 1742, that of the *Wife of Président de Rieux*, dressed in a ball gown (Paris, Musée Cognacq-Jay), and, astonishing in its accuracy, that of his friend the *Abbé Huber* (St Quentin Museum).

In 1743 came the first of the official portraits, that of the *Duc de Villars*, Governor-General of Provence (Aix-en-Provence Museum). In 1745 he showed at the Salon his portrait of *Duval de l'Epinoy* (Lisbon, Gulbenkian Foundation). The number of pastels sent by him to the 1748 Salon was 14, of which eight are conserved in the Louvre: among these are the portraits of the *King*, the *Queen*, the *Dauphin* and the *Maréchal de Saxe*. In 1750 he was named *conseiller* to the Académie Royale, and that same year an artist whom many critics like to compare with him, Jean-Baptiste Perronneau, was also admitted.

In 1751 La Tour executed the most 'finished' of his *Self-Portraits*, now in Amiens Museum. The artist's style, while losing some of its softness and charm, began at this time to gain in vigour and intensity. It was at the 1753 Salon that *Jean-Jacques Rousseau* (Geneva Museum) and *D'Alembert* (Louvre) were exhibited. With much ceremony the great portrait of *Madame de Pompadour*

(Louvre; 3 preliminary sketches, one of which expresses the decline of an era, St Quentin Museum) was shown at the 1755 Salon; it sold for 1,000 golden louis.

Among the figures portrayed by the artist in 1757, the following are worth mentioning: *Father Emmanuel* and *Mademoiselle Fel* (St Quentin Museum). The latter, a singer at the Opéra, was one of a number of actresses whose portraits La Tour made, and she was his companion for almost the whole of his life. La Tour's portraits won praise from Diderot. In 1761 he exhibited the *Dauphine*, Marie-Josèphe of Saxony (Louvre). From this time on he began to retouch his works, scrupulously and incessantly, which often made them both harder and heavier. The critics were beginning to lose interest, and he exhibited for the last time in 1773.

Fascinated by chemistry, geology and astronomy, a supporter of the philanthropic ideas of the *Encyclopédistes*, he drew up humanitarian projects, particularly on behalf of his native town, where he retired with his brother in 1784. He endowed the town with a maternity home and a refuge for elderly and infirm artisans, also a free art school, for whose future he richly provided, and which still flourishes today in the 18th-century-style building designed by Paul Bigot and built between 1928 and 1931. It contains 92 pastels by La Tour, half of which are sketches only. The painter also inaugurated three prizes, of which one is still awarded at the Académie des Sciences in Amiens, and another, for bust-length portraits, is also still in existence.

The high prices which La Tour's paintings fetched had made him an extremely rich man. His independent, authoritarian, irascible temperament gradually grew less controllable during his final years, until he went mad. He died intestate; his brother bequeathed to the town of St Quentin all the artist's works and studies, which make up the core of the city's museum. In the more successful portraits, which are supple and light, he sees, beyond a smile or a pout, to the model's inner character. His colour consists chiefly of blues and pearly grey, though pink often features. Accessories are carefully displayed though not in an over-fussy way, and they help define the character; backgrounds are beautifully composed in half-lights. La Tour invented a fixing agent for his pastels whose secret has not come down to us.

R.Pr.

Lawrence
Sir Thomas
English painter
b.Bristol, 1769 – d.London, 1830

The son of an unsuccessful innkeeper, Lawrence possessed a remarkable facility that led to his exploitation as a prodigy at an early age. In 1782 the family settled in Bath, where Lawrence's pastel portraits became popular amongst members of fashionable London society. In 1787 he moved to London where, apart from a few months' training at the Royal Academy Schools, he continued his practice, concentrating on oil painting.

In 1789 Lawrence exhibited *Lady Cremorne* (1789, private coll.) at the Royal Academy, and as a result secured a commission to paint a portrait of *Queen Charlotte* (1789, London, N.G.), which

was exhibited in the following year. Although this established his reputation as a society painter, it was his *Miss Farren* (1790, Metropolitan Museum), exhibited in the same year, that caught the popular imagination and, with its crisp brushwork and vivacious pose, revealed the way in which he was to develop Reynolds's style of portraiture. During the 1790s he rapidly became an accepted figure in both fashionable and artistic circles; he was made an A.R.A. in 1791, Painter-in-Ordinary to the King in 1792 on the death of Reynolds, and an R.A. in 1794, at the youngest age possible.

It was, however, also a period when his limitations became evident. For while he continued to paint portraits of an extremely high quality, such as *John Angerstein and his Wife* (1792, Louvre), he also became obsessed with painting in the 'grand manner' according to the precepts of Reynolds, producing works like *Satan Calling up his Legions* (1797, London, Royal Academy), in the manner of Fuseli. The theatrical portraits of Kemble, dating from the same period, show how lack of formal training seriously limited the depth of his expression.

For a time these preoccupations, as well as financial pressure caused by living persistently beyond his means, made the quality of his portraits erratic, and he too often covered up hasty work by facile brushstrokes. After 1800, however, there is a notable sobering in his style. Abandoning history painting, he concentrated on developing the compositional possibilities of portraiture, as can be seen in the *Francis Baring* group (1807, private coll.). With the death of his rival Hoppner in 1810 his position as the leading English portraitist was unchallenged, and he enjoyed the favour of the Prince Regent, whose portrait he painted several times.

In 1815 he was knighted as part of a plan to send him to the Continent to paint the portraits of the rulers responsible for the downfall of Napoleon. The plan did not mature until 1818, when he visited Aachen, Vienna and Rome (*Portrait of Pius VII*, 1819, Windsor Castle). After his return to England in 1820 he was elected President of the Royal Academy on the death of Benjamin West. His personal charm had made him accepted throughout the courts of Europe and his brilliant style had established him as the

prime portrait painter in Europe. In his later works there is sometimes a tendency towards sentimentality, as in *Master Lambton* (1825, private coll.), but it was also a time when he managed to come to terms with his own art most successfully, producing works like *Lady Blessington* (1822, London, Wallace Coll.), in which form and treatment unite in a perfect blend of charm and sophistication, and the sympathetic *John Nash* (1827, Oxford, Jesus College).

He exhibited at the Paris Salon of 1824, together with other English artists, and scored a great success, and when Delacroix came to London he was sufficiently impressed by Lawrence to paint a portrait in his style (*Baron Schwiter*, London, N.G.). He took a lively interest in the works of other artists, possessing an unrivalled collection of old-master drawings, and being approachable to even the youngest and least distinguished of his contemporaries. His own career had a success rarely paralleled, but his work, despite its brilliance, never quite lives up to its promise. In a well-known phrase of Benjamin Haydon, 'Lawrence was suited to the age, and the age to Lawrence', for although he imbued his portraits of fashionable personalities with romantic overtones, these rarely do more than flatter the sitter, and seldom manage to achieve any great depth of psychological penetration.

W.V.

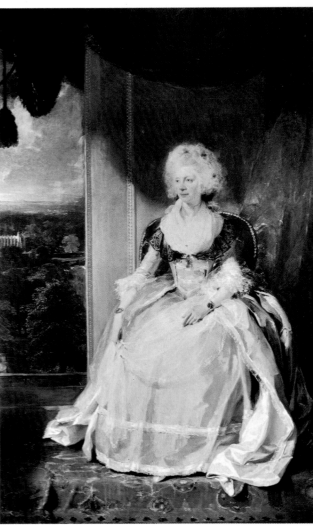

▲ Maurice Quentin de La Tour
Portrait de Duval de L'Épinoy (1745)
Pastel. 119 cm × 92 cm
Lisbon, Gulbenkian Foundation

▲ Thomas Lawrence
Portrait of Queen Charlotte (1789)
Canvas. 239 cm × 147 cm
London, National Gallery

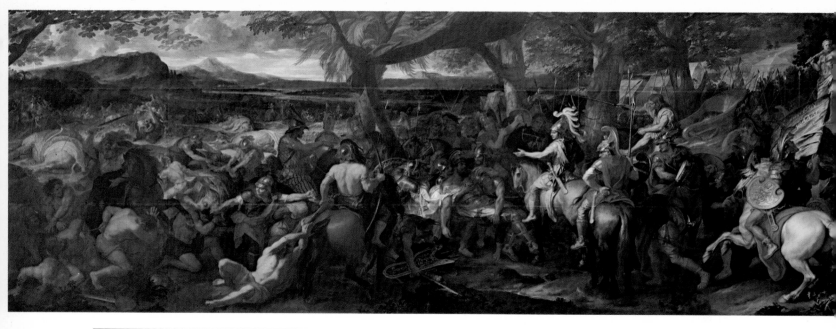

Le Brun
Charles

French painter
b.Paris, 1619 – d.Paris, 1690

The son of a sculptor, Le Brun was a highly talented child who became a protégé of Séguier, the Chancellor, at a very early age. He entered Vouet's studios around 1634 and rapidly assimilated the various styles of the day, as revealed in his designs for engravings. He also painted for Richelieu (*Hercule et Diomède*, 1641, Nottingham Museum; sketch in Paris, private coll.) and for the Guild of Painters and Sculptors (*Le Martyre de Saint Jean L'Evangéliste* (*The Martyrdom of St John the Evangelist*) (1642, Paris, Church of St Nicolas du Chardonnet).

In 1642 he travelled to Rome in the company of Poussin, who acted as his supervisor during his time in the city. He studied the works of classical antiquity, as well as Raphael, the Carracci, Domenichino and, probably, the decorative work of Pietro da Cortona, and produced paintings such as *Horatius Cocles* (Dulwich College Art Gal.), *Mucius Scaevola* (Mâcon Museum), and *Le Christ mort sur les genoux de la Vierge* (*Dead Christ in the Lap of the Virgin*) (Louvre).

Against Séguier's advice he left Rome and, after a brief stay in Lyons (where he probably painted *Caton mourant* [*Death of Cato*], Arras Museum), returned to Paris in 1646 where, still under the Chancellor's protection, he rapidly built up a clientèle. He twice painted May offerings for Notre Dame (*La Crucifixion de Saint André* [*The Crucifixion of St Andrew*], 1647, sketch in Northampton, Spencer Coll.; *Le Martyre de Saint Étienne* [*The Martyrdom of Saint Stephen*], 1651).

Most of Le Brun's commissions under the regency of Anne of Austria were either for religious paintings or for ceiling decorations. The former include *Le Repas chez Simon* (*Meal with Simon*) (Venice, Accademia), *Christ servi par les anges* (*Christ Served by Angels*) (*c.*1653, Louvre) and *Le Silence* (1655, Louvre), distinguished by their calm dignity and the masterly way in which Le Brun has captured expressions. Early decorations of the time include works for the Hôtel de la Rivière (1653, Paris, Musée Carnavalet),

Psyché enlevée au ciel (*Psyche Carried up to Heaven*) (Louvre, Petit Cabinet du Roi, now destroyed) and the Galerie d'Hercule at the Hôtel Lambert, all of which are richly inventive and often coupled with relief stucco on the vault, but avoid excessive foreshortening. The *Portrait of Chancellor Séguier* on horseback (Louvre), justifiably one of Le Brun's most popular works, also probably dates from this period (*c.*1655).

Le Brun's masterpiece is the decoration of the Château of Vaux-le-Vicomte for Nicolas Fouquet (1658-61). Here he was given the opportunity to display his talent in both buildings and gardens, painting walls and ceilings, designing sculptures and tapestries (which were made up at Maincy), as well as providing ideas for fêtes and spectacles.

At about this time Le Brun painted for Louis XIV *La Tente de Darius* (*The Tent of Darius*) (1660-1, Versailles), which served as a manifesto for academic art; composed in the form of a frieze, sober and classical in style, in which the attitudes and facial expressions of the protagonists illustrate the action, the work was much admired. He entered the service of the King and was confirmed as *premier peintre du roi* in 1664. He also occupied a leading place in the Académie, of which he was a founder-member, and when Colbert, for whom he also worked, asked the Académie to draw up the rules of art, Le Brun emerged as a most eloquent speaker. Painting, he maintained, was an art which addressed itself primarily to the intelligence, and was not, as so many believed, merely something to please the eye.

Appointed Director of the Gobelins factory in 1663, Le Brun supervised the training of the workmen, and the control he exercised over the production of furniture and tapestries contributed to the unity of the Louis XIV style throughout the royal residences. He produced cartoons for the series of *Les Quatre Eléments* (*The Four Elements*) and *Les Quatre Saisons* (*The Four Seasons*), as well as for *Les Mois* (*The Months of the Year*) (also known as *Les Maisons royales* [*The Royal Houses*] and *L'Histoire du roi* (*The History of the King*).

La Tente de Darius was followed around 1673 by four further paintings inspired by the legend of Alexander: *L'Entrée à Babylone* (*The Entry into Babylon*), *Le Passage du Granique* (*The Crossing of the Granicus*), *La Bataille d'Arbelles* (*The Battle of Arbela*) and *Alexandre et Porus*; other subjects were also sketched out. The immense canvases (Louvre) which served as cartoons for the Gobelins

tapestries were later to take their place in a cycle of epic paintings and it is probably their format, and the impossibility of finding a suitable place to exhibit them, that prevented the finishing of the original project.

The Galerie d'Apollon in the Louvre, intended as a more obvious glorification of Louis XIV, likewise remained unfinished when the King left Paris for the new palace of Versailles. Versailles, however, gave Le Brun the chance to demonstrate his artistic ideals: the staircase of the Ambassadors (1674-8, now destroyed), the Hall of Mirrors (1679-84; sketches in Auxerre, Troyes, Compiègne and Versailles museums), the Halls of Peace and War (1685-6) and his supervision of the decoration of the state rooms and the Château de Marly all embody an aesthetic that glorified absolutism – an example that was to be followed by the kings and courts of all Europe.

After Louvois succeeded Colbert in 1683 Mignard, Le Brun's rival, became the chief beneficiary of royal patronage. Deprived of important commissions, Le Brun spent the remaining years of his life painting medium-sized religious works on themes such as the *Passion of Christ* (Louvre; Troyes and St Étienne museums); these mark a return to the tradition of Poussin and to the idea of meditation on a narrative theme.

Le Brun introduced into France a style that owed much to Poussin's classicism and to the Italian Baroque, and which could be adapted to the different requirements of ceiling paintings, tapestries or historical tableaux. His authoritarianism, for which he has often been criticized, was the inevitable consequence of artistic superiority. The art of engraving served to make his work more widely known and his influence stretched well beyond the limits of his country and his epoch.

J.M.

Léger
Fernand

French painter
b.Argentan, 1881 – d.Gif-sur-Yvette, 1955

Early years. After studying architecture for two years in Caen (1897-9) Léger went to Paris and worked as an architect's draughtsman. On the completion of his military service in 1903 he

▲ Charles Le Brun
Alexandre et Porus
Canvas. 470 cm × 1264 cm
Paris, Musée du Louvre

applied successfully to the École des Arts Décoratifs but failed to gain a place at the École des Beaux Arts, enrolling there instead as an independent pupil of Léon Gérôme, then of Gabriel Ferrier. He also frequented the Académie Julian while continuing to work for an architect and a photographer.

Léger's first paintings, dating from 1904-5, were Impressionist in style (*Le Jardin de ma mère* [*My Mother's Garden*], 1905, Biot, Fernand Léger Museum) or, more rarely, in Fauve vein, such as the lively *Self-Portrait* (Paris, private coll.). Most of these early canvases were destroyed by the artist himself, who described them as '*Léger avant Léger*', after seeing the 42 paintings by Cézanne exhibited at the 1904 Autumn Salon. Cézanne's influence is evident in the geometric Corsican landscapes that Léger painted in the winter of 1906-7 and in the ink studies of nudes (1905-8, Biot, Fernand Léger Museum).

Cubist period. The Cézanne retrospective at the 1907 Autumn Salon further influenced Léger who wrote : 'Cézanne taught me the love of forms and volumes and made me concentrate on drawing'. The *Compotier sur une table* (*Table with Fruit-Dish*) (1909, Minneapolis, Inst. of Arts) shows how much he had taken from Cézanne; in contrast, *La Couseuse* (*The Seamstress*) (1909, Paris, private coll.), an austere painting, without depth, is highly personal in style.

At La Ruche (c.1908-9) Léger became friendly with Delaunay, Max Jacob, Apollinaire, Maurice Raynal and particularly with Blaise Cendrars who dedicated to him his famous poem *Construction*. In 1910, he attracted the attention of the dealer Kahnweiler who offered him space in his gallery, where Braque and Picasso were already exhibited.

Nus dans la forêt (*Nudes in the Forest*) (1909-10, Otterlo, Kröller-Müller) was, according to Léger, a 'battle of volumes' brutally overlapping one another; its syncopated rhythms, bathed in a cold light, affirm a rule of plasticity which is 'at the antipodes of Impressionism'. Elsewhere, the influence of Delaunay may be discerned in *La Noce* (*The Wedding*) (1911, Paris, M.N.A.M.) and in certain urban landscapes (*Les Toits de Paris* [*The Rooftops of Paris*], 1912, Biot, Fernand Léger Museum) with their more highly coloured accents and a musical fluency of areas between planes (still that of Cézanne).

By contrast, a new element, bearing the promise of great future development, appears in the *Femme en bleu* (*Woman in Blue*) (1912, Basel Museum); the theme is distributed in flat, geometrical areas to create a purely plastic and abstract composition. That same year (1912) saw Léger's first one-man exhibition at the Kahnweiler Gallery (where the following year he was offered an exclusive contract) and his participation in the 'Knave of Diamonds' exhibition organized by Malevich in Moscow.

In 1913 and 1914 Léger travelled to Germany; he attended two conferences at the Wassilieff Academy in Berlin during which he spelled out the underlying principles of his aesthetic: 'the intensity of contrasts', of colours and of forms. In 1913 he developed this final reference back to Cézanne until it gave way to abstraction in the homogeneous and masterly suite, *Contrastes de formes* (*Contrasts of Forms*) (Paris, M.N.A.M.; New York, M.O.M.A.; Düsseldorf, K.N.W.). Then, in 1914, he created from this experiment a new figurative order translated via a restrained range of colours (blue, white, red, yellow and

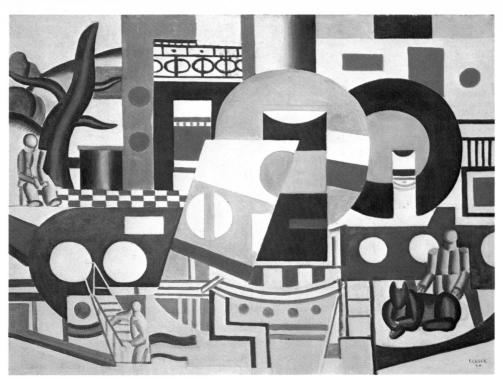

green), spread in luminous volumes and geometrical planes, which could be adapted either to landscapes (*Maisons dans la forêt* [*Houses in the Forest*], Basel Museum), or to still lifes (*Nature morte à la lampe* [*Still Life with Lamp*], New York, private coll.), or to figures (*Femme en rouge et vert* [*Woman in Red and Green*], Paris, M.N.A.M.).

The war years (1914-18). Léger was mobilized on 2nd August 1914. Between July 1915 and December 1916 he executed a series of sketches from the life, (Biot, Fernand Léger Museum) showing the daily existence of his comrades in the army camp. These formed the basis of *L'Homme à la pipe* (*Man with a Pipe*) (1916, Düsseldorf, K.N.W.) and the monumental *Partie de cartes* (*Card Party*) (Otterlo, Kröller-Müller), painted towards the end of 1917 in hospital where Léger was recovering from being gassed at the front near Verdun. This canvas, which Léger was later to describe as the 'first painting for which I deliberately chose a subject from my own time', is a tightly composed work, crowded with figures of soldiers whose mechanical outlines give them the appearance of robots. The painting concludes the earlier experimental period and makes a decisive change in Léger's ideas and sensibility.

Machines and the human figure, 1918-23. 'I was dazzled by the sight of a 75 cannon breech opened to the sun', wrote Léger; 'it taught me more about plasticity than all the museums in the world. Once back from the war I continued to use what I had felt at the front.' In fact, for several years Léger was an enthusiastic exponent of the use of machines, with all their power and beauty, as part of the daily routine. Two paintings stand out in this 'mechanical' period. These are *Disques* (1918, Paris, M.A.M. de la Ville), in which gaily contrasting circular areas of colour (evoking Delaunay's chromatic circles) are arranged around the movement of a driving-rod; and *La Ville* (*The Town*) (1919-20, Philadelphia, Museum of Art), in which Léger celebrates the urban world in more lyrical fashion; the dynamic intertwining of sharp planes, the perfect autonomy of colour and the introduction of stencilled letters

transpose a banal universe into an imposing vision in which even small figures have a place. The vast composition, *Éléments mécaniques* (*Mechanical Elements*) (1924, Paris, M.N.A.M.; sketches from 1917 on), sums up these experiences.

Enriched by his wartime experiences, Léger began to reintroduce figures into his paintings in 1918, at first in timid counterpoint to his ever-present machines (*Le Remorqueur* [*The Tugboat*], 1918, private coll.; other versions: 1920, Grenoble Museum; 1923, Biot, Fernand Léger Museum), then in a more equal relationship (*Le Typographe* [*The Typographer*], second stage, 1919, Munich, Neue Pin.), until finally figures took on an archetypal value in the monumental *Mécanicien* (*Mechanic*) (1920, Ottawa, N.G.) and later in *L'Homme au chandail* (*Man with a Sweater*) (1924, Paris, private coll.). But the artist warned that his human figures were included 'not for emotional reasons, but solely in plastic terms, and are submitted to the geometrical order which regulates machines and the urban environment'. Thus, up until 1923, Léger treated the parallel themes of the city, work and leisure; people figure in *Paysage animé* (*Landscape with Figures*) (1921, Paris, private coll.) or, in more intimate fashion, in complex interiors (*Le grand Déjeuner* [*The Large Meal*], 1921, New York, M.O.M.A.; *Femme et enfant dans un intérieur* [*Interior with Woman and Child*], 1922, Basel Museum). The last work on this theme is the impressive *La Lecture* (*Reading*) of 1924 (Paris, M.N.A.M.).

Decorative works and Purism. Rectilinear and asymmetrical architectural shapes served as the background for Léger's urban views as well as for his figure studies; they were the common denominator and serve as a reminder that, from 1921 on, Léger was in contact with the artists of De Stijl, including Van Doesburg and Mondrian, whose writings had been published the previous year. Neo-Plasticism now seemed to him to represent 'total liberation, a necessity, a means of disintoxication'. In fact it helped Léger to become aware of his vocation for murals, and its influence over the great abstract compositions of 1924-5, which he referred to as 'illuminating walls',

proved a determining one (*Composition murale*, 1924, Biot, Fernand Léger Museum). For the Decorative Arts Exhibition in 1925 he decorated, with Delaunay, the entrance hall to a French pavilion and executed his first murals for Le Corbusier in the Pavillon de l'Esprit Nouveau.

Léger had long been interested in the world of the theatre; one of his most important works dates from 1923 when he designed the decor and costumes for de Maré's ballet *La Création du monde*, inspired by Baoulé and Bushongo African art, with music by Milhaud and a libretto by Cendrars.

In 1924 Léger opened an independent studio with Ozenfant, Laurencin and Exter; its influence was to spread across the world. That same year, probably influenced by ideas already exploited in Abel Gance's film *La Roue* (1921; to which he and Cendrars contributed), he made the first film without scenario, *Ballet mécanique*, with photographs by Man Ray and Dudley Murphy, and music by Antheil. Between 1924 and 1927 objects began to occupy a dominant place in his paintings. Compositions in close-up, inspired by the cinema, were now stripped down and more rigorously constructed. His work displays a synthesis of elements taken from De Stijl, the Bauhaus and Russian Constructivism and from his contact with the founders of Purism – although he queried the influence of the latter on his painting (*Accordéon* [*Accordion*], 1926, Eindhoven, Stedelijk Van Abbe Museum; *Nature morte au bras* [*Still Life with Arm*], 1927, Essen, Folkwang Museum).

Objects in space. After 1928 Léger progressively detached himself from Neo-Plasticism but remained faithful to the two great constants of his art, object and contrast. He now thought in terms of a dynamic space (circular composition), renewed his iconography, and established new links between motifs. His *Joconde aux clés* (*Mona Lisa with Keys*) (1930, Biot, Fernand Léger Museum) was, for Léger, the 'most daring painting from the point of view of contrasting objects'.

At the same time canvases such as the *Feuille de houx* (*Holly Leaf*) (1930, Paris, Gal. Leiris; pencil in 1928, Paris, private coll.) and *Papillon et fleurs* (*Butterfly and Flowers*) (1937, private coll.) illustrate the world of plants and animals. The root, used at first as a linking motif, was later treated for its own sake (*Racine noire* [*Black Root*], 1941, Paris, Gal. Maeght; *Racine rouge et noire* [*Red and Black Root*], ceramic, Chicago, Art Inst.). To the *Joconde aux clés* may be linked *Marie l'acrobate* (*Marie the Acrobat*) (1933, private coll.) and *Adam et Ève* (1935-9, Düsseldorf, K.N.W.); in these paintings Léger opposes various abstract elements and figures in a perfect demonstration of his

◄ Wilhelm Leibl
Women Spinning (1892)
Canvas. 65 cm × 74 cm
Leipzig, Museum der bildenden Künste

principle that: 'Major art always has two opposing themes in counterpoint.'

In 1935 Léger left, with Le Corbusier, for his second visit to the United States (the first having been in 1931 to New York and Chicago); on this occasion the Museum of Modern Art and the Art Institute organized his first American exhibition.

The experience of the 1936 Popular Front had a profound effect on Léger and influenced him towards vast, realistic scenes. In 1936 he designed the decor and costumes for Lifar's ballet *David triomphant* and the decor of the Vélodrome d'Hiver, and also painted the *Transport des forces* in honour of science, for the Pavilion of Discovery at the Paris Exposition. This rich period culminated in his vast *Composition aux deux perroquets* (*Composition with Two Parrots*) (1935-9, Paris, M.N.A.M.; studies in 1933 and 1937 in Biot, Fernand Léger Museum), the antithesis to *La Ville* (*The Town*) of 1919, according to Léger, and the beginning of his evolution towards the theme of figures in space.

American period (1940-5). After a third visit to New York (September 1938-March 1939; decor of the apartment of Nelson A. Rockefeller Jr), Léger left France in October 1940 and went into a five-year voluntary exile in the United States where he taught at Yale University. Before embarking at Marseilles he went swimming with some of the young dockers in the port. He later explained that 'it was these divers who gave rise to all the others, the acrobats, the cyclists, the musicians', and, in fact, his *Plongeurs sur fond jaune* (*Divers on Yellow Background*) (1941-2, New York, M.O.M.A.) inaugurated a series of variations on 'men in space'.

American night life, with its glittering lights, filled Léger with enthusiasm, and he began dissociating colour from drawing in his paintings, creating an 'elastic surface' in his *Plongeurs polychromes* (*Polychrome Divers*) (1942-6, Biot, Fernand Léger Museum) and *La Danse* (*The Dance*) (1942, Paris, Gal. Leiris). This process was taken up again in two works painted at the end of 1954: *La Grande Parade* (*The Great Parade*) (New York, Guggenheim Museum), on the theme of the circus, 'a world of circles in action' which he had first entered in 1918 (*Le Cirque* [*The Circus*], Paris, M.N.A.M.); and *La Partie de campagne* (*The Picnic*) (St Paul-de-Vence, Maeght Foundation), clearly foreshadowed by a wash-drawing of 1943 (Chicago, Johnson International Gal.).

Léger's American experiences also show in his paintings of cyclists, which have a powerful popular appeal (*La Grande Julie*, 1945, M.O.M.A.), while he was equally aware of the conflict between nature and the spread of large urban concentrations (*Adieu New York*, 1946, Paris, M.N.A.M.).

Return to France, 1945-55. On his return to France Léger's feeling for contemporary reality developed into a need to express political and social awareness. He joined the Communist Party and became associated with a straightforward, easily comprehensible style of painting that treated 'great' subjects in which figures predominated. *Les Loisirs* (*Leisure*), begun in the United States in 1943, became transformed into *Hommage à David* (1948-9, Paris, M.N.A.M.), which finished the series on cyclists in symbolic, realistic, happy and popular style. *Le Campeur* (*The Camper*) (1954, Biot, Fernand Léger Museum), like *La Partie de campagne*, bears wit-

ness to Léger's success in communicating directly through art. *Les Constructeurs* (*The Engineers*) (1950, Biot, Fernand Léger Museum) illustrates another aspect of daily life, that of work.

From 1949 onwards in Biot, Léger, together with his former pupil Roland Brice, began to experiment with ceramics, as well as with mosaics and stained glass. His preoccupations with monumental art and with colours and contrasts still remained, as may be seen in such works as the mosaics for the façade of the church at Assy (1949), stained glass for churches at Audincourt (1951) and Courfaivre, Switzerland (1954), and for the University of Caracas (1954), as well as the sculptures, mosaics and ceramics for Gaz de France at Alfortville (1955). Ceramics, with their striking colours and brilliant surfaces, offered Léger new possibilities for sculpture and multicoloured reliefs (*La Fleur qui marche* [*The Walking Flower*], 1950, Paris, M.N.A.M.; *Les Femmes au perroquet* [*Women with Parrot*], 1952, Biot, Fernand Léger Museum).

The Fernand Léger Museum, founded by Nadia Léger and Georges Bauquier, was inaugurated at Biot in 1960, and taken over by the state in 1967. It contains a major collection of drawings, gouaches, paintings, mosaics and ceramics spanning the whole of Léger's career. The building and its Mediterranean site provide a perfect setting for the work of an artist who considered himself to be 'the primitive of a future age'. A.Ba.

Leibl
Wilhelm

German painter
b.Cologne, 1844 – d.Würzburg, 1900

Leibl received his early training from the Polish painter Hermann Becker between 1861 and 1864, and then, in the latter year, attended the Munich Academy where he met Hirth, Haider and Sperl. Between 1866 and 1868 he was taught by Arthur von Ramberg, and by Piloty in 1869. His first important work, *Frau Gedon* (Munich, Neue Pin.), was exhibited at the Munich International Exhibition where he also saw Courbet's paintings and was deeply impressed by them. That same year he met Courbet and followed him to Paris where he executed *The Cocotte* (Cologne, W.R.M.). Back in Munich between 1870 and 1873, he met Schuch and Trübner in 1871 and the following year painted his first large-scale composition featuring several figures: *The Dinner Party* (Cologne, W.R.M.).

From 1873 onwards Leibl lived in various villages round Munich. The finely detailed realism of *The Village Politicians* (1876-7, Winterthur, Oskar Reinhart Coll.), an early representation of a peasant interior, marks the achievement of Leibl's mature style. It was followed between 1878 and 1882 by *Three Women in Church* (Hamburg Museum), one of his finest canvases, but *The Poachers*, painted between 1882 and 1886, was destroyed by the artist following its cool reception in Paris (fragment in Berlin, N.G.).

Peasant life inspired numerous portraits and genre paintings, marked by an absence of anecdotalism that stemmed from Leibl's study of the Dutch painters, notably Rembrandt and Ter Borch. In Munich he opposed the school of his-

torical painters such as Piloty, with the result that he attracted increasing hostility from public and critics alike. From around 1874 until 1886 he continued in a realistic vein, producing minutely executed, technically perfect paintings, even when he was working on a large scale. During the 1880s his Bavarian peasant interiors with figures made up the greater part of his output.

The later period was marked by a broader treatment (*Women Spinning*, 1892, Leipzig Museum). He often painted the portrait of his friend *Sperl* as well as those of such artists as *Trübner, Schuch* (Munich, Neue Pin.), *Thoma* and *Eysen*, who belonged to the same group of painters as himself. Together with Menzel he remains the most famous representative of German realistic painting of the 19th century. Most of his works today are in the Wallraf-Richartz Museum in Cologne, while others are to be found in Hamburg and in the Neue Pinakothek in Munich. H.B.S.

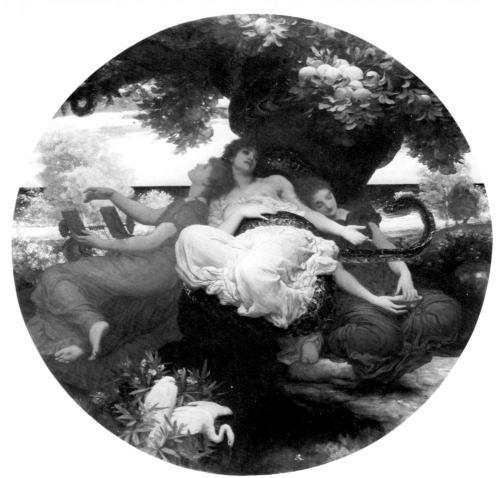

Leighton
Frederic (Baron Leighton of Stretton)

English painter
b.Scarborough, 1830 – d.London, 1896

The only son of a wealthy doctor, Leighton, from the age of ten, was brought up on the Continent, where the family travelled for the sake of his mother's health. He received a broad, liberal education in many European cities, including Berlin, Munich, Frankfurt, Florence and Rome. By the age of ten he was already familiar with the intricacies of classical legend. He studied for a while at the Accademia delle Belle Arti in Florence, but soon left for Frankfurt where he resumed his general education. When he was 17 he left school and enrolled at the Städelsches Institut, which combined a museum and an art school. In 1848 and 1849 Leighton visited Brussels and Paris but returned to Frankfurt in 1850 to study under J.E. von Steinle, the Austrian Nazarene painter, whom he later referred to as his only real master. Late in 1852 he went to Rome.

Thackeray, who met Leighton in Rome, remarked to Millais that he had met 'a versatile young dog called Leighton, who will one of these days run you hard for the presidency of the R.A.' Indeed, while he was in Rome Leighton painted the picture that gave the first intimation of his future success: *Cimabue's Madonna Carried in Procession through the Streets of Florence*, which was shown at the Royal Academy in 1855 and caused a sensation. It was purchased by Queen Victoria and remains in the Royal Collection.

Leighton returned to settle in London in 1859, after a three-year sojourn in Paris. Although he painted such fine pictures as *May Sartoris* (c.1860, Fort Worth, Kimbell Art Museum), the following years were somewhat uncertain and uneasy, for Leighton was still struggling to find his way. In 1864 he exhibited *Dante in Exile* (private coll.) and *Golden Hours* (private coll.), and he was elected to the Academy as an Associate Member. During the 1860s Leighton gradually abandoned his tightly controlled German technique for a more 'classical' style, which can be seen in his first important nude painting, *Venus Disrobing* (1867, private coll.). He also became increasingly interested in classical themes, which he incorporated into works such as *The Syracusan Bride* (c.1865-6, private coll.).

In 1866 Leighton went to live in his splendid new house at 2 Holland Park, Kensington, which was soon famous for its 'Arab Hall', and for Leighton's social and musical gatherings. That year also marked the completion of his wall-painting in Lyndhurst Church, *The Parable of the Wise and Foolish Virgins*. In 1868 he became a full Academician, and departed on his first voyage to the Middle East, where he painted such pictures as *Temple of Phylae, Looking up the Nile*. In 1877 he exhibited his first piece of sculpture, *Athlete Struggling with a Python* (London, Tate Gal., on loan to Leighton House).

After the death of Sir Francis Grant in 1878, Leighton succeeded him as President of the Royal Academy, and, following normal practice, he was knighted. Leighton was handsome, learned, socially charming, and a fine linguist, besides being an excellent administrator, so he filled the office with considerable distinction. Nevertheless, he continued to paint prolifically, and his enthusiasm for classicism grew apace. He conceived of 'beauty' as a distinct and identifiable ideal: 'It is the intensification of the simple aesthetic sensation through ethic and intellectual suggestiveness that gives to the Arts of Architecture, Sculpture and Painting, so powerful, so deep and so mysterious a hold on the imagination.' Important works of these years include *The Bath of Psyche* (1890, London, Tate Gal.) and *The Garden of the Hesperides* (1892, Port Sunlight, Lady Lever Art Gal.). It is interesting that many paintings of Leighton's final years, such as *Flaming June* (1895, Puerto Rico, Museo de Arte de Ponce), show a new richness of colour and design, and reveal a sensual core behind his classical academicism.

In 1895 Leighton's health failed, and he died shortly afterwards, on 24th January 1896, the day following his elevation to the peerage. His last words were: 'Give my love to the Royal Academy.' J.H.

Lely
Sir Peter

Anglo-Dutch painter
b.Soest, Westphalia, 1618 – d.London, 1680

The son of a Dutch army officer named Van der Faes who was in Germany when the artist was born, Lely is recorded in Haarlem in 1637 as a pupil of Frans Pietersz de Grebber. He took or was given the nickname of 'Lely' (often spelt and pronounced 'Lilly' in England in the 17th century) after a house called 'In de Lelye' in The Hague owned by his father. He arrived in England in the 1640s (at the latest by 1647), in the middle of the Civil War between King and Parliament, and was taken up by a group of noblemen of moderate views led by the Earl of Northumberland.

Lely's earliest certain works, dating from 1647, are portraits of the King's younger children, then in Northumberland's care (Sussex, Petworth House; Middlesex, Syon House). Lely's figure style here owed much to Van Dyck (as in a sense it always did), pictures by whom were in Northumberland's collection, but his landscape backgrounds are more Dutch in feeling, and his own distinctive breadth of handling, rich pigment and colour, and assured decorative sense are already in evidence. During this period he experimented

▲ Frederic Leighton
The Garden of the Hesperides (1892)
Canvas. 169 cm × 169 cm
Port Sunlight, Lady Lever Art Gallery

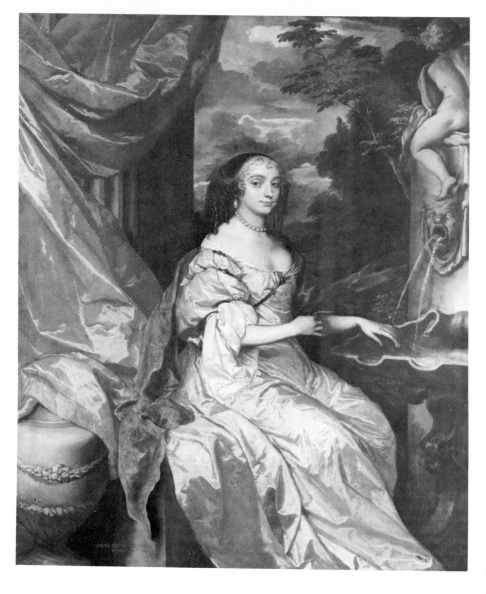

with a series of pastoral and mythological scenes in a Dutch style (London, Courtauld Inst. Galleries; Chatsworth, Devonshire Coll.), but these did not succeed in an England wedded to portraiture, and thereafter he confined himself to portrait painting.

During the Commonwealth (1649-60), and despite a general lessening of activity in the arts, Lely built up the largest portrait practice in the country. In or about 1653 he painted Cromwell (who is said to have asked to be represented 'warts and all'; several versions of this portrait exist). In 1656 he re-visited the Netherlands. Lely came into his own, however, with the Restoration of Charles II in 1660, and his name is now mainly associated with the years following that event. In 1661 he was granted an annual salary of £200, to be paid 'as formerly to Sr Vandyke'. Nevertheless, his chief patrons were not so much the King himself, whom he rarely painted, as his brother, the Duke (later James II) and Duchess of York.

In his sumptuous portraits of society women Lely mirrored the atmosphere of sensuality, cynicism and artificiality, as also the preoccupation with manners and fashion, which prevailed at court under the Restoration. It was *de rigueur* to try to look as much as possible like the King's current mistress, and Lely clearly encouraged this, for which he was criticized by outside observers. The series of ten 'Windsor Beauties', painted during the 1660s for the Duchess of York (Hampton Court, Royal Coll.), epitomizes this side of his work. A more robust side is, however, seen in his portraits of the admirals who had defeated the Dutch under the command of the Duke at the Battle of Sole Bay in 1665 (Greenwich, National Maritime Museum), in which the physique, if not the character, of each sitter is skilfully individualized.

Lely's strengths and limitations as a painter are obvious enough. With his brilliant colour sense, dexterity in handling dress materials and gift for flattery, he made portraiture almost into a branch of decoration. He is probably the most Baroque of English portrait painters. At his best he is bold, at his worst his execution is tired, either because of lack of concentration or the use of studio assistants. He made a large fortune, part of which he spent on forming one of the finest collections of old-master drawings in Europe in the 17th century. M.K.

Lemoyne
François

French painter
b.Paris, 1688 – d.Paris, 1737

A pupil of Louis Galloche from 1701 until 1713, Lemoyne was admitted to the Académie in 1718 with his *Hercule et Cacus* (*Hercules and Cacus*) (Paris, E.N.B.A.; preliminary drawing in the Louvre; sketch in Compiègne Museum). Unlike his contemporary Watteau, he followed a conventional career, becoming a teacher at the Académie in 1733 and being appointed *premier peintre du roi* in 1736.

His first canvases are painted in the warm colours inherited from Jouvenet and Galloche and include a series, *Épisodes de la vie du Christ* (*Episodes from the Life of Christ*) (1715-20; some

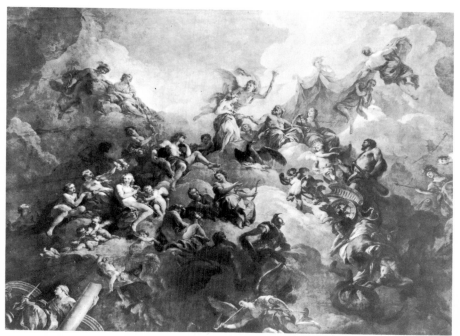

▲ François Lemoyne
L'Apothéose d'Hercule
Ceiling of the Salon d'Hercule (1733–6)
Versailles, Musée National du Château

▲ Sir Peter Lely
Anne Hyde, Duchess of York
Canvas. 182 cm × 144 cm
Edinburgh, Scottish National Portrait Gallery

canvases at Sens, Musée du Palais Synodal), and *Olympe* (*Olympus*), a sketch for the decoration of the ceiling of the Hôtel de Nevers (now the Banque Royale) (1718, Paris, Musée des Arts Décoratifs). But the influence of Sebastiano Ricci, whom he met while the latter was in Paris, and of Pellegrini, together with a visit to Italy in 1723, led him to develop a light palette in which yellows and pinks predominate. Constantly broken up, these lent a smoother and more vibrant finish to his canvases: *Hercule et Omphale* (*Hercules and Omphale*), painted in Rome (Louvre); *La Transfiguration* (1723, Paris, Church of St Thomas d'Aquin).

Lemoyne's next projects were at Versailles (*Céphale et l'Aurore* [*Cephalus and Aurora*], 1724, Hôtel de Ville; paintings for the Cathedral) and for a number of Parisian churches (*La Glorification de la Vierge* [*The Glorification of the Virgin*], 1731-2, much repainted, Church of St Sulpice). These works show him evolving towards the use of broad masses of colour, applied with a delicate touch. At the same time he received two commissions for the Château of Versailles: an allegorical composition for the Salon de la Paix (*Louis XV donnant la paix à l'Europe* [*Louis XV Bringing Peace to Europe*], 1728-9), and the ceiling of the Salon d'Hercule (1733-6; sketch at Versailles). These are still in the decorative tradition of the *grand siècle*, but less complex in their composition, as well as being less austere and less monumental, and clearly influenced by contemporary Venetian art.

The French decorative tradition of the 17th century, as manifest in the works of Le Brun, as well as Italian decorations, such as those of Correggio, formed part of Lemoyne's background. It was his knowledge of Rubens, however, that inclined him towards lighter paintings such as the oval in the Salon de la Paix, in which the grouping is reminiscent of that in Rubens's Medici cycle in the Luxembourg Palace. Rubens's influence is also clearly visible in *Le Repos des chasseurs* (*Huntsmen's Rest*) (Munich, Alte Pin.; preliminary drawings in Stockholm, Nm, and in the Metropolitan Museum), where the clothes, 'in the Spanish style', are borrowed directly from Rubens.

A final source of inspiration was the art of Bologna and, in particular, the work of Albani, evident in such drawings and smaller compositions (formerly attributed to Watteau) as *Enfants tirant à la cible* (*Children Shooting at a Target*) (private coll.; engraved in colour by Jean Robert and by N.C. de Silvestre) and *Enfants jouant avec les attributs d'Hercule* (*Children Playing with the Symbols of Hercules*), a theme taken up again in the Hercules ceiling.

Without being a mere imitator, Lemoyne, thanks to his wide culture, was able to continue the French decorative tradition, adapting its grandeur and monumentality to the taste of the court of Louis XV, and introducing to it a lighter and easier style. This, together with the *fêtes galantes* of Antoine Watteau and his followers, was to culminate in the elegance and grace of his pupils Boucher and Natoire towards the middle of the 18th century.

Lemoyne's pleasurable style belies the tenor of his personality, particularly in the 1720s when he became increasingly weighed down by the work commissioned from him for the Salon d'Hercule. Ultimately his feelings of persecution were to prove fatal; he stabbed himself and died from his wounds on 4th June 1737. C.C.

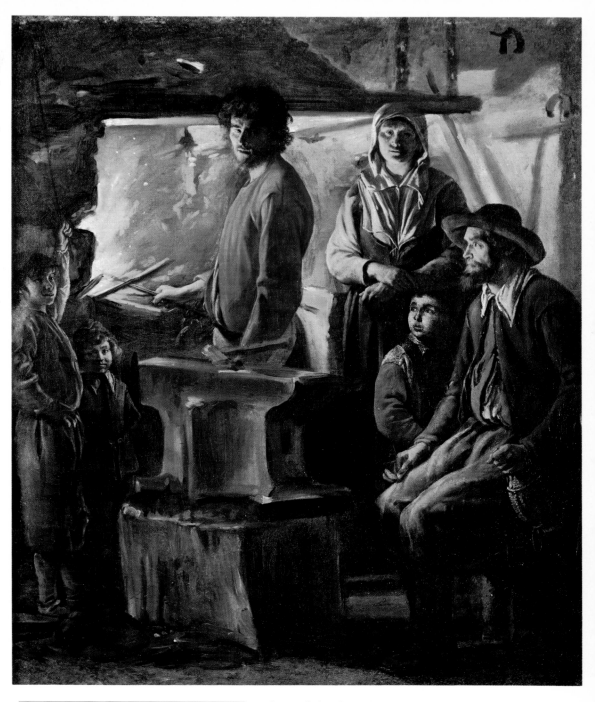

Le Nain
Antoine
b.Laon, c.1600 – d.Paris, 1648
Louis
b.Laon, c.1600 – d.Paris, 1648
Mathieu
b.Laon, 1607(?) – d.Paris, 1677

French painters

Virtually forgotten after the end of the 17th century before being restored to public attention by the novelist Champfleury in the mid-19th century, the Le Nain brothers are now ranked among the top flight of French painters. And yet piecing together their lives and works has led to a series of problems. All three were born in Laon, but of the dates of birth accepted until recently, only that of the youngest, Mathieu (1607), though approximate, seems at all likely; those of Antoine (1588) and Louis (1593), coming as they do from doubtful sources, should be brought forward.

The brothers seem to have spent their childhood in a reasonably comfortable and enlightened home, though they remained in direct contact with the local peasantry. Their father Isaac, who came from a family of farm labourers and winegrowers near Laon, had acquired an official position at the local salt depot (1595) and also owned several houses, vineyards, meadows and woods in Laon and the surrounding districts.

Of the five Le Nain brothers, the three youngest followed a trade which was not entirely out of place in Laon where, around the Cathedral and

▲ Le Nain (brothers)
La Forge
Canvas. 69 cm × 57 cm
Paris, Musée du Louvre

the religious houses, there existed a fairly active artistic circle. For one year the brothers were taught by a painter passing through Laon, after which they travelled to Paris to pursue their studies. Choosing not to follow the slow, costly road towards becoming guild painters and sculptors, they moved to St Germain-des-Prés, where Antoine was admitted as master painter in 1629 and where he and his brothers settled in the Rue Princesse. They remained in Paris from that time onwards, although they never completely severed their links with Laon, where they had family and property.

The studio in which the three brothers worked so closely together rapidly made a name for itself. In 1632 they obtained from the City of Paris the commission for the portraits of the *Municipal Magistrates* (now lost); and some time before 1643 Mathieu painted the portrait of *Queen Anne of Austria* (also lost). The Le Nain brothers were chosen to decorate the Lady Chapel at St Germain-des-Prés (the ensemble disappeared at the time of the Revolution) and to execute the altarpieces of the four chapels of Notre Dame (of which one, a *Crucifixion*, dated 1646, is lost). Their success is borne out by the literature of the day (Du Bail, 1644; Scudéry, 1646). In 1648 all three were admitted to the Académie at its inception. But Louis and Antoine died suddenly soon after. Louis was buried on 24th May and Antoine on the 26th.

Mathieu, who had been named residual legatee by an act of 1646, was now alone and the possessor of a considerable fortune. Of a military bent, he became in 1633 a lieutenant in a Parisian company and, after having probably served in the royal army itself, took the title of 'Sieur de La Jumelle'. He aimed for a high place in Parisian society, which was at odds with his métier as a painter. He continued to paint for a while (*Portrait de Mazarin* [*Portrait of Mazarin*], donated to the Académie in 1649, now lost; the *Martyre des Saints Crépin et Crépinien* [*Martyrdom of Sts Crispin and Crispian*], 1654, Laon, Église des Cordeliers, lost), but ceased to be *peintre ordinaire du roi* and in 1662 was awarded the Order of St Michel, which was almost equivalent to a peerage. His desire to forget his former condition as a commoner meant that he did nothing to keep the memory of his brothers alive, something which largely explains why, particularly after his death on 20th April 1677, the name of Le Nain was so quickly forgotten.

The brothers' work can be pieced together by tracing some 15 canvases, all signed and dated, and all originating between 1640 and 1647. For a long time these paintings were looked upon as the work of provincial painters taught by a travelling Flemish artist. They were believed to have come to the capital relatively late in their careers and to have tried unsuccessfully to persuade the Parisian public to accept their over-realistic peasant inspiration. This failure was supposed to have led to inept attempts at *grande peinture* and portrait painting, before finally leading Mathieu into total decadence.

This view, coloured by the romanticism of the 19th century, is little borne out by the facts. The three brothers seem, on the contrary, to have made a swift impression in Paris by virtue of their religious paintings and, in particular, by their portraits. Around 1640, when Vouet's pupils began to have more influence, and a taste for the burlesque as well as for peasant scenes became popular with high society, the brothers probably tried to maintain their success by devoting a large part of their output to *bambocciate* interpreted in the French style; at the same time they painted group portraits, which until then in France had consisted only of votive offerings and official portraits. Following the example of Dutch painters they transformed these into genre scenes by reducing them in size: such clever innovations would appear to have enjoyed a large measure of success in Parisian society.

Their *grande peinture* remains little known. One allegorical figure, probably intended to decorate a chimneypiece, the surprising *Victoire* (*Victory*) in the Louvre, and two mythological canvases (*Bacchus et Ariane* [*Bacchus and Ariadne*], Orléans Museum; *Vénus dans la forge de Vulcain* [*Venus in Vulcan's Forge*], 1641, Rheims Museum) suggest that they had only a mediocre knowledge of composition, but made up for this by their freshness of outlook and sensitive inspiration. The remaining religious works reveal the same faults and the same qualities: the series *La Vie de la Vierge* (*Life of the Virgin*), probably painted around 1630-2 for one of the chapels of the Petits Augustins in Paris (four paintings found out of six, including *L'Adoration des bergers* [*The Adoration of the Shepherds*] in the Louvre), does not yet reveal the mastery found in the altarpieces for Notre Dame (two found out of four: *Saint Michel dédiant ses armes à la Vierge* [*St Michael Dedicating his Arms to the Virgin*], Nevers, Church of St Pierre; *Nativité de la Vierge* [*Birth of the Virgin*], Paris, Notre Dame, formerly Church of St Étienne-du-Mont).

In those canvases where the composition is less complicated a monumental simplicity of form highlights the brothers' realistic vision and contained emotion (*Repos de la Sainte Famille en Égypte* [*Rest on the Flight into Egypt*], private coll.; *La Madeleine repentante* [*The Repentant Magdalene*], private coll., probably a variation of a canvas depicting the same subject, 1643, now lost), while a series of medium – or small-scale works, containing numerous figures, may be classed with the genre paintings. Sometimes these are of high quality (*L'Adoration des bergers* [*The Adoration of the Shepherds*], London, N.G.), sometimes they are so mediocre in treatment as to appear to be the work of imitators or pupils (the existence of two apprentices is attested by contracts of employment).

Only a very few portraits survive which are certainly by the Le Nain brothers, and they vary both in format and in style: *Le Marquis de Trévilles* (1644, private coll.); *Dame âgée* (*Old Lady*) (copy of an original dated 1644, Avignon Museum); and *Homme en buste* (*Bust of a Man*) (Puy Museum). Better known are the group portraits, which are dominated by a series of works treated as genre paintings; they include the series based on the *Corps de garde* (*Guard-House*) (1643, Louvre) and the five paintings formerly in the Seyssel Collection, including *Les Joueurs de trictrac* (*Backgammon Players*) (Louvre) and *Danse d'enfants* (*Children's Dance*) (Paris, private coll.). Among these is a composition which is heavier, less relaxed and closer to the Dutch models, *La Réunion d'amateurs* (*Reunion*) (Louvre), and certain small-format works, clumsy in composition, more realistic in observation and curiously impressionistic in technique: *Réunion de famille* [*Family Reunion*) (1642, Louvre); and *Portraits dans un intérieur* (*Portraits in an Interior*) (1647, Louvre).

But the paintings by the Le Nain brothers which place them beyond the ordinary are those depicting peasant scenes. Here the diversity of treatments and quality still surprise. Two vast canvases, which should immediately be singled out from the others, contain all that is best in their art: *Famille de paysans* (*Peasant Family*) (Louvre) and *Repas de paysans* (*Peasants' Meal*) (1642, Louvre). The power of the construction in bas-relief, the soberness of the colours, in which browns and greys are highlighted only by a few touches of brighter colour, the sureness of treatment, which is both simple and firm: all these qualities heighten the sincerity of observation, which excludes the picturesque along with the cruel. There is a depth of psychological perception in the depiction of a few contemporary peasants that catches the spirit of the peasant soul for all time.

Some of these surprising qualities reappear in small-scale interiors such as *La Visite à la grand-mère* (*The Visit to Grandmother*) (Hermitage) or *La Famille heureuse* (*The Happy Family*) (also known as *Le Retour du baptême* [*The Return after the Baptism*], 1642, Louvre). *La Forge* (*The Forge*) (Louvre) adds to these qualities a study of lighting rendered with a skill and boldness of touch that are quite exceptional. The majority of subjects and themes are closely linked with the standard Flemish repertoire; but their psychological depth probably derives from the Caravaggesque tradition (*Les Joueurs de cartes* [*The Card Players*], Aix-en-Provence Museum; *La Rixe* [*The Brawl*], 1640(?), Springfield, Massachusetts, Museum).

Very different from these is another series of interior scenes, small in size, painted on wood or copper and generally depicting groups of children, which reveal a naïve observation and sometimes a heavy, rather inept touch; the best example of this is *Le Vieux Joueur de Flageolet* (*Old Tin-Whistle Player*) (1644, Detroit, Inst. of Arts). In contrast to these interiors is the surprising series of open-air peasant scenes. In some of these the motif is dominant (*La Charrette* [*The Cart*], 1641, Louvre), others are pure landscapes (*Paysans dans un paysage* [*Peasants in a Landscape*], Hartford, Connecticut, Wadsworth Atheneum); but in most cases these two aspects are balanced (*La Laitière* [*The Milkmaid*], Hermitage). The clear colours of these paintings and their unusually bold handling – freedom of touch, realistic and unconventional depiction of the landscape, the silvery atmosphere – seem to establish an unexpected link between Fouquet and Corot.

The task of attribution presents further difficulties. Quickly plagiarized, the Le Nain brothers' work became overlaid in the 18th century with false attributions. Some of these are now identified as the work of Michelin; more difficult, however, is identification of the 'Master of the Cortèges', painter of *Le Cortège du boeuf gras* (*Cortège of the Fatted Ox*) (private coll.) and *Le Cortège du bélier* (*Cortège of the Ram*) (Philadelphia, Museum of Art), original in their frieze composition. Equally problematic is the identity of the more austere painter of the *Voyageurs dans une auberge* (*Travellers at an Inn*) (Minneapolis, Inst. of Arts); or even the mediocre author of a number of outdoor scenes, often highly vulgar in intent and frequently attributed, for no good reason, to Mathieu in his later years (*Le Repas villageois* [*Village Meal*], *L'Abreuvoir* [*Drinking Trough*], both Louvre).

In addition, the attribution of the works between the three brothers has been a long-standing problem. It becomes somewhat less important if the supposed age gap (19 years between Antoine and Mathieu) is narrowed. The solution proposed by Paul Jamot (*Les Le Nain*, 1929) still seems the

most likely: small-scale, picturesque paintings of children and small group portraits should be attributed to Antoine; to Louis should be attributed peasant scenes, along with credit for profound psychological insight and a wholly modern feeling for landscape; while to Mathieu should go such elegant group portraits such as *Les Joueurs de tric-trac*. But this division is not without a number of difficulties, and cannot be applied to all the known works (full-length portraits, mythological and religious paintings). Nor does it take into account the constant collaboration between the brothers; most of the major works, apart from the portraits, appear to be the work of several hands.

The works produced by the studio are remarkably diverse yet at the same time have a profound degree of unity. Each in their own way, all three brothers deserve a share of the credit for having incarnated the ideal of elegance and light towards which Parisian painting between 1630 and 1650 was moving. There is a simplicity of composition, established over distinct planes, a subdued but clear use of colour, a carefully wrought atmosphere and a balance between psychological insight and expression, between the observation of the 'natural' and elegance of form. Whereas such painters as La Hyre and Le Sueur looked to the Italian tradition in developing style, the Le Nain brothers – as far as portraits and genre scenes are concerned, in which French production remained closely linked with the Flemish tradition – arrived at a wholly original expression which, at least in its final form, seems almost unique in 17th-century European painting. J.T.

Leonardo da Vinci

Italian painter
b.Vinci, near Florence, 1452 – d.Cloux, near Amboise,1519

Both as artist and scientist (his interests included hydraulic engineering, anatomy and botany as well as music), Leonardo da Vinci has become the prime symbol of the Italian Renaissance. He marks the watershed between the quattrocento art of the Pollaiuoli and Botticelli and the High Renaissance style of Raphael and Titian. His career is generally divided into four main periods: 1452-81, formative years in Florence; 1482-1500, first period in Milan; 1500-16, maturity; 1517-19, final years in France.

Formative years. Leonardo's apprenticeship took place in Florence where his presence is documented after 1469 in the workshop of Andrea del Verrocchio, with such artists as Botticelli, Perugino, Domenico Ghirlandaio, Cosimo Rosselli and Filippino Lippi. The earliest paintings which are definitely his (the angel in Verrocchio's *Baptism of Christ*, Uffizi; the portrait of *Ginevra Benci*, Washington, N.G.) reveal him as inheritor of the plastic and graphic tradition of Florentine painters like Antonio Pollaiuolo and Verrocchio, and are imbued with the Florentine culture of Lorenzo the Magnificent and Marsilio Ficino.

He was the illegitimate child of a notary, Ser Piero, and a peasant girl, Caterina. His numerous aspirations, his literary and philosophical ambitions, and his technical and scientific curiosity remained with him all his life, as is evidenced by

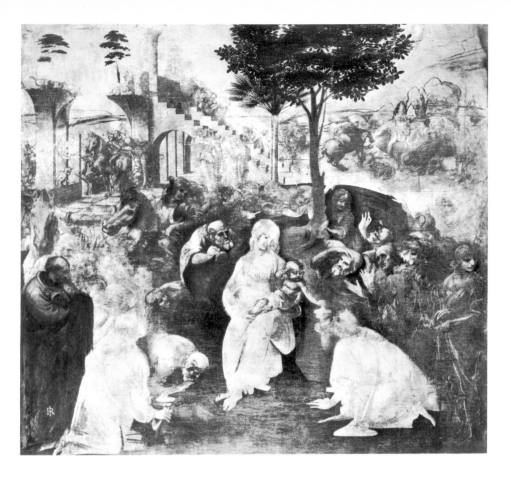

his notebooks. The Florentine period ended with *The Adoration of the Magi* (1481-2), executed for the Church of S. Donato a Scopeto (now in the Uffizi), a work which in style and subject matter shows a profoundly new treatment thanks to a dramatic expressiveness based on movement and a new emphasis on gesture and facial expression. The work remained unfinished when Leonardo was called to Milan by Duke Lodovico Sforza, Il Moro (1482). Since its underpainting is visible, it allows art historians insight into Leonardo's tonal method of execution, at odds with the exclusively linear approach of his contemporaries.

First Milan period. During his first stay in Milan Leonardo's painting was enriched by what he learned from local art, which by tradition paid great attention to the problems of light and which had recently (thanks to Bramantino) begun to assimilate the great lessons in perspective taught by the Renaissance. Vasari recalls Leonardo's friendship with Bernardino Zenale, whose complex character has recently come in for closer study; and although the influence of Leonardo on the style of Zenale is obvious, it is also very likely that, under the influence of the master from Treviso, Leonardo was led to think more deeply about the problems of chiaroscuro and aerial perspective. This at least is suggested by the masterpieces of this period in Milan: *The Virgin of the Rocks* (Paris, Louvre) and *The Last Supper* (1497, Milan, Church of S. Maria delle Grazie).

The disastrous state of preservation of the fresco (due partly to Leonardo's technical experiments) is not such as to prevent the viewer from appreciating the still-life studies (something rather unusual in Florentine art) and the centralized perspective, cleverly emphasized by contrasts in light and shade. It is evident that Leonardo is continuing the experiments with facial

expressions, gestures and movements that he had begun in *The Adoration of the Magi*, and exploring the problems of balance encountered in *The Virgin of the Rocks*, yet the main attribute of the work is its achievement of great drama and its depiction of a particular time of day – evening.

Of the gigantic *Equestrian Statue* (c.1490) to Francesco Sforza, father of Lodovico Il Moro, which was to have been Leonardo's most important Milanese work, only a few splendid drawings remain (Windsor Castle). After the fall of Lodovico (1499) and the conquest of the Duchy of Milan by Louis XII, the model of this life-size statue was used as a target by the French halberdiers and was subsequently completely destroyed.

Leonardo left Milan in order to escape from the upheavals that followed in the wake of the conquest. He went first to Mantua where he made a drawing of *Isabella d'Este* (1500, Louvre), then to Venice and Florence. He next spent a year (1502) in Romagna as Cesare Borgia's military architect. But on his return to Florence in 1503 he started work on the cartoon for the *Battle of Anghiari* which was to have made a pair with Michelangelo's *Battle of Cascina* in the Palazzo Vecchio. The work was never finished and the cartoon (completed in 1505) was later destroyed. However, we have some idea of the work, thanks to partial copies (one by Rubens, Louvre) and the preliminary drawings (Budapest Museum; Venice, Accademia; British Museum; Windsor Castle).

In the central episode, the *Battle for the Standard*, Leonardo deploys all his knowledge of human and equestrian anatomy, of foreshortening and of composition, and his skill at conveying impetuous movement as well as violent passions. It is impossible to guess how much importance 'atmosphere' could have had in this work, although there are suggestions in certain autograph

▲ Leonardo da Vinci
The Adoration of the Magi
Wood. 246cm × 243cm
Florence, Galleria degli Uffizi

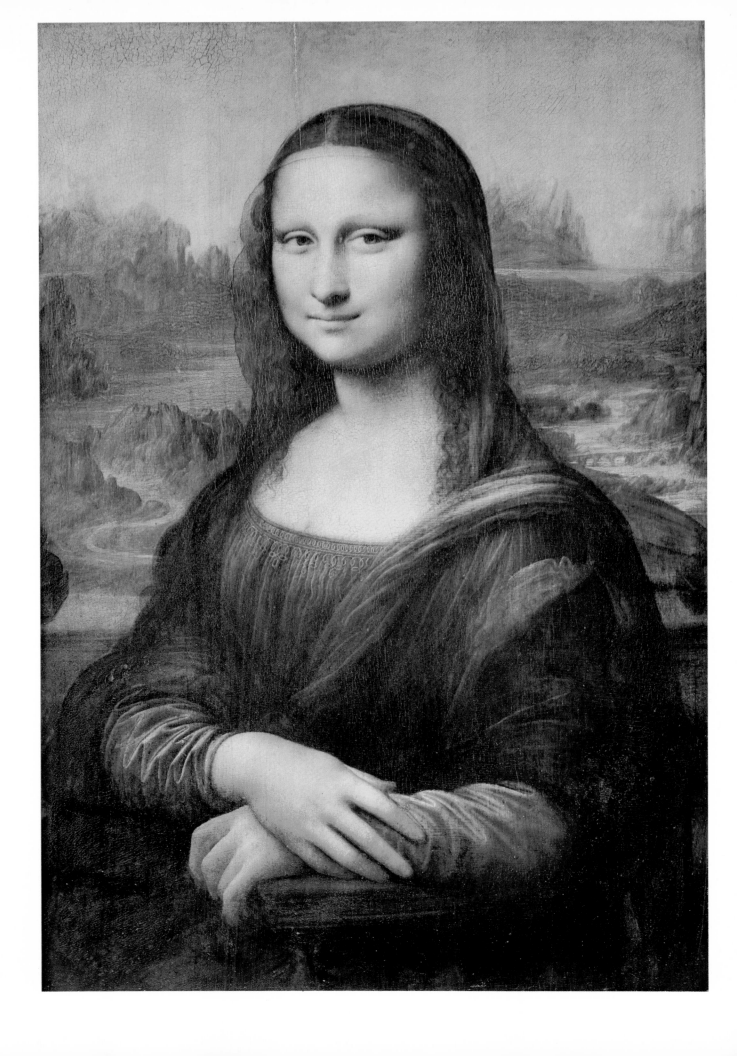

sketches and in particular in the written descriptions made by Leonardo himself in one of his famous notes. It was probably around this time, too, that he painted the portrait of *Mona Lisa* (Louvre), wife of Francesco di Bartolommeo del Giocondo.

Second stay in Milan. In 1506 Leonardo returned to Milan, this time in the service of Charles II of Chaumont, the Maréchal d'Amboise, nominated by Louis XII as Governor of the Duchy of Milan. It is assumed that Leonardo then worked on the second version of *The Virgin of the Rocks* (London, N.G.). In September 1507 differences with his brothers on the question of the succession of their uncle Francesco led him to return to Florence where he lived for about six months with Piero Martelli.

In July 1508 Leonardo returned to Milan where he remained until September 1513. He devoted a large part of these five years to studying geology, at the same time as preparing the *Equestrian Statue of Gian Giacomo Trivulzio* (drawings in Windsor Castle) and working on the portrayal of the *Virgin and Child with St Anne* (Louvre), a painting for which he had already drawn a preliminary cartoon (that in the National Gallery, London, is undocumented and shows an earlier development of the theme) and which he kept in his own home, without ever completely finishing it, until his death.

On 24th September 1513 Leonardo left Milan with his pupils Melzi and Sali, stopped over in Florence in October and, on 1st December, arrived in Rome to enter the service of Giuliano de' Medici (brother of Pope Leo X), who gave him lodgings in the Vatican belvedere. Under the protection of the '*magnifico Giuliano*', who was fascinated by philosophy and alchemy, Leonardo was able to devote himself to his technical and scientific studies.

Leonardo in France. After the death of his patron (17th March 1516) Leonardo accepted the hospitality offered to him by Francis I at the Manor of Clos-Lucé, near Amboise in France. Here it was that Cardinal Luigi d'Aragona, came to visit him in October 1517 while travelling through Europe with his secretary Antonio de Beatis who noted in his *Diary* that they had seen at the painter's home 'an infinite number of books, all in the vernacular', and three paintings: the *Mona Lisa*, *The Virgin and Child with St Anne* and a *St John the Baptist*, unanimously accepted as the artist's last autograph work (Louvre). There is a story that he died in the arms of Francis I on 2nd May 1519. He was buried in the cloister of the church at Cloux, but his remains were dispersed during the Thirty Years' War, and his tomb has disappeared. G.P.

Le Sueur
Eustache

French painter
b.Paris, 1616 – d.Paris, 1655

Equally notable as a painter of historical canvases and as a decorative artist, Le Sueur led an uneventful life that never took him far from the centre of Paris, for, unlike many of his contemporaries, he never travelled to Italy. The son of a

wood turner, he became an apprentice around 1632 in the studio of Vouet where he met Le Brun and Mignard. A study of the works of Raphael, the drawings in the royal collections, the prints of Marcantonio Raimondi and the decorations at Fontainebleau completed his training.

His early years were made easier by Vouet who, in 1637, entrusted him with a commission for eight paintings illustrating the *Hypnerotomachia Poliphilii* or *Dream of Poliphilus* by Colonna, which were later reproduced in tapestry. Of this ensemble, completed around 1645, four paintings survive (Le Mans and Rouen museums; Dijon, Musée Magnin; Vienna, Czernin Coll.). In 1644 he began decorative works for the President of the French treasury, Lambert de Thorigny, for whom Le Vau had built a house on the Île St Louis. Several important pieces survive, notably the ornamental panels (private coll., Château de La Grange) and the ceiling of the *Cabinet de l'Amour* (five panels in the Louvre), and they reflect to some degree Vouet's dynamic style, although the draughtsmanship is lighter and more restrained, and the colour rich and fresh. The portraits dating from this time are more personal (*Réunion d'amateurs* [*Reunion*], Louvre; *Portrait de M. Albert*, 1641, Guéret Museum).

Several other canvases inspired by Vouet, and indeed often attributed to him, are worth mentioning: *Diane et Callisto* (Dijon, Musée Magnin); *La Résurrection du fils de la veuve de Naïm* (*The Resurrection of the Son of the Widow of Naim*) (Paris, Church of St Roch); *L'Ange Raphaël quittant Tobie* (*The Angel Raphael leaving Tobias*) (Grenoble Museum; originally, like another painting in the Louvre depicting the life of Tobias, in the Hôtel de Fieubet); *La Résurrection de Tabitha* (*The Resurrection of Tabitha*) (Toronto Museum).

The *Cabinet des Muses*, also in the Hôtel Lambert, and executed when work was started again about 1647-50, shows, in its ample treatment of figures and draperies, the classical influence of Poussin, who was in Paris between 1640 and 1642. Five panels depicting the *Muses* and the ceiling canvas (*Phaéton*) are in the Louvre. The panel of the *Three Muses, Clio, Euterpe and Thalia*, in particular, is a typical example from this time of transition, and is characterized by the supple rhythms of the lines and the fresh harmony of the colours. By now Le Sueur's reputation was established, and in 1648 he became one of the founder-members of the Académie.

Between 1645 and 1648 Le Sueur executed an important series of 22 paintings for the cloister of the Carthusians. The series, which relates the principal episodes in the *Life of St Bruno*, exemplifies a personal style that is the fruit of much

reflection and of a study of Poussin's classicism. *La Mort de Saint Bruno* (*The Death of St Bruno*) (Louvre) is depicted with a seriousness animated by psychological insight and realism. The severity of the inspiration and the discreet harmonies are reminiscent of Zurbarán. An understanding, and noble use, of perspective are chiefly responsible for the grandeur of *Saint Bruno écoutant Raymond Diocre prêchant* (*St Bruno Listening to the Preaching of Raymond Diocre*) (Louvre). The same solidity appears in *Saint Paul à Éphèse* (*St Paul at Ephesus*) (1649, Paris, Notre Dame), commissioned by the Goldsmiths' Guild for the May offering at Notre Dame.

For the Royal Bedchamber in the Louvre Le Sueur executed an *Allégorie de la Monarchie française* (*Allegory of the French Monarchy*), as well as providing decorations for the bathroom of the Queen Mother. These works disappeared at the end of the 18th century.

From 1650 onwards Le Sueur's art began to move in a new direction, particularly in his religious and easel paintings, for which he borrowed subjects from the Old and New Testaments, or from ancient Greek history. He was greatly impressed by Raphael's tapestry cartoons and by his compositions for the Vatican Loggie, and started to develop a cold but quite remarkable style in such paintings as *L'Annonciation* (1652, Louvre), *Jésus chez Marthe et Marie* (*Jesus in the House of Martha and Mary*) (Munich, Alte Pin.) and *La Présentation au Temple* (*Presentation in the Temple*) (1652, Marseilles Museum) – though these are still lit by bursts of colour. In the great *Adoration des bergers* (*Adoration of the Shepherds*) (1653, La Rochelle Museum) a beautifully modulated line unites the figures, whose expressions and poses nonetheless remain precise and lifelike. The art of the Renaissance period no doubt inspired the tondo of *La Descente de la croix* (*Descent from the Cross*) (Louvre; part of the same altarpiece as the admirable *Christ portant sa croix* [*Christ Bearing His Cross*].

A similar inspiration distinguishes Le Sueur's final works, four paintings executed in 1654 for the Abbey at Marmoutiers, among them *L'Apparition de la Vierge à Saint Martin* (*Apparition of the Virgin to St Martin*) and *La Messe de Saint Martin* (*St Martin's Mass*) (both Louvre; the other two paintings are in Tours Museum). After painting for the Church of St Gervais in Paris *Saints Gervais et Protais amenés devant Astasius* (*Sts Gervase and Protase Led before Astasius*) (Louvre), Le Sueur left unfinished his *Martyre des Saints Gervais et Protais* (*Martyrdom of Sts Gervase and Protase*) (Lyons Museum). The work was in fact completed after his death by his brother-in-law Thomas Goussey.

◀ Leonardo da Vinci
Portrait of Mona Lisa, known as La Gioconda
Wood. 77 cm × 53 cm
Paris, Musée du Louvre

▲ Eustache Le Sueur
Christ bearing His Cross
Wood. 61 cm × 126 cm
Paris, Musée du Louvre

Le Sueur also left a large and remarkable collection of drawings (most are in the Louvre, but many other larger museums have examples). They served as preliminary studies for his paintings, and were often executed in red chalk and also, following Vouet's example, in charcoal with white highlights, on grey paper.

Very much imitated, Le Sueur nonetheless left no known pupils. Referred to as the 'French Raphael' and greatly admired during the 18th century, when he was considered Poussin's equal for his 'tenderness', a quality then much appreciated, he remains one of the most sensitive of the painters working in Paris at that time. A very pure sense of harmony, together with a solidly based learning, represent the development of French classicism before the advent of Le Brun.　　　N.Bl.

Leu
Hans, the Younger

Swiss painter
b.Zürich, c.1490 – d.1531 at the Battle of Gubel

The most remarkable representative of Late Gothic art in Zürich, Leu wandered through Germany between 1507 and 1513 and very probably worked with Dürer in Nuremberg and with Hans Baldung at Freiburg-im-Breisgau. By 1514 he was active in Zürich where his output was considerable, despite a somewhat disorganized life-style that led him backwards and forwards between the battlefield and the courtroom. Basel Museum houses his best works, including the famous *Orpheus Charming the Animals* (1519), the *Fantastic Landscape* and the *Passion of Christ* (1522), as well as four woodcuts dating from 1516, among them *St George Fighting the Dragon*, and a large number of drawings. Among these last should be mentioned the *Baptism of Christ* (1513, British Museum) and *St Sebastian* (1517, Nuremberg Museum).

Although Leu's unsettled existence brings to mind that of Urs Graf or Nikolaus Manuel Deutsch, he differed from them in not being a painter of battles and military life. His themes were mainly religious or mythological, and although they were never particularly brilliantly executed, they are nonetheless remarkable for

their interpretation, which is poetically intimate and mysterious, not to say bizarre. But Leu's great originality lies in the landscapes, both drawn and painted, which he executed from 1513 onwards. Like Altdorfer and Hirschvogel, he liked to imagine fantastic locales, romantic chains of jagged mountains with wild vegetation, all of which went to make him one of the masters of 16th-century landscape.　　　B.Z.

Lewis
Percy Wyndham

English painter
b.at sea, 1882 – d.London, 1957

Lewis was born on board his father's yacht, off Nova Scotia. He was at the Slade School from 1898 to 1901, and then travelled abroad for eight years, spending some time in various cities, but staying mainly in Munich and Paris. He returned to London in 1909, presumably aware of the new ideas of Cubism, as his own work of the following years clearly reveals their influence. In 1911 he exhibited with the Camden Town Group, and his work was included in the second Post-Impressionist Exhibition organized by Roger Fry in the following year.

A controversial exhibition of Futurist art was held in London in March 1912, accompanied by lectures given by Marinetti who worked with great gusto to spread the somewhat violent ideology of the movement. Marinetti's views soon became known, and to some extent shared, by London's artistic avant garde. Lewis, for example, declared that 'England has need of these foreign auxiliaries to put her energies to rights, and restore order'. Soon, however, Lewis changed his opinions, and referred to 'the café-philosopher, Marinetti, with his epileptic outpourings in praise of speed and force'.

In fact Lewis's work and ideas were more influenced by Futurism than he cared to admit. His drawings for *Timon of Athens*, of 1913-14, show mechanistic and angular figures set in geometrical

landscapes, and they have a sense of furious energy that parallels the work of the Italians. *Planners* (or *Happy Days*) of the same year (London, Tate Gal.) is completely abstract, and is, for that reason, among the most significant developments in English art at that date. In 1913 Lewis's work was included in the Post-Impressionist and Futurist Exhibition held at the Doré Gallery, and he also exhibited with the New London Group.

Lewis was full of revolutionary fervour and was determined to destroy the complacency that beset British culture. He took several lines of polemical attack. Having joined Fry's Omega Workshops in July 1913, he had left by October, and he set up a rival organization called the 'Rebel Art Centre'. It was a short-lived foundation, and it disintegrated shortly before Lewis published the first issue of *Blast: Review of the Great English Vortex* in June 1914. To Lewis the concept of the 'vortex' referred to the idea of a still centre from which an artist, committed to full involvement in contemporary life, could look out upon the hectic rush and flux around him. Ezra Pound, however, who suggested the term in 1913, defined it in the first issue of *Blast* as a point of maximum energy 'from which, and through which and into which, ideas are constantly rushing'.

In 1915 a second issue of *Blast* was published, and the Doré Gallery put on the only London Vorticist exhibition (another was held at the Penguin Club, New York, in 1917). 'Vorticism', like 'vortex', is a difficult term to define: Lewis described some of the main characteristics of the style as 'activity, significance and essential movement', but the word can also be used to represent the varied ideas of a group of artists as different as Lewis, Gaudier-Brzeska, David Bomberg, William Roberts, Jacob Epstein and Ezra Pound.

After the onset of war, Lewis's friends and fellow-artists were soon separated, and the momentum of Vorticism was halted. In 1916 Lewis joined the army, and in 1917 he became an official war artist, attached to the Canadian Corps headquarters. His war paintings, which are bold, hard, but only partially successful, include *A Canadian Gunpit* (1918, Ottawa, N.G.) and *A Battery Shelled* (1919, London, Imperial War

▲ Hans Leu the Younger
Orpheus charming the Animals (1519)
Canvas. 58 cm × 51 cm
Basel, Kunstmuseum

▲ Percy Wyndham Lewis
Ezra Pound (1939)
Canvas. 76 cm × 102 cm
London, Tate Gallery

Museum). In 1919 Lewis held a one-man exhibition at the Goupil Gallery in London, and, attempting to re-establish the Vorticist movement, he founded 'Group X' in 1920. However, their single exhibition showed that the old fervour had disappeared.

Lewis's later portraits, although less purely Vorticist, are among his finest achievements. Many of them depict prominent literary figures of the time, such as *Edith Sitwell* (1923-35, London, Tate Gal.), *Ezra Pound* (1938, London, Tate Gal.) and *T.S. Eliot* (1938, Durban, Art Gal.). Lewis was himself a notable author whose novels include *Tarr* (1914), *The Apes of God* (1930) and *Self-Condemned* (1954). It is likely, indeed, that he will be remembered as much for his literary gifts as for his work as a painter. J.H.

Liberale da Verona

Italian
b.Verona, c.1445 – d.Verona, 1529

After executing his first miniatures in Verona in 1465 for the Church of S. Maria in Organo, Liberale moved to Tuscany. Between 1467 and 1469 he illuminated four *Antiphonals* (Chiusi, Museo dell' Opera del Duomo) for the Monastery of Monte Oliveto Maggiore, which blend Paduan tradition with Tuscan innovations. From his northern Italian training Liberale acquired the supple and fluid graphic facility, rich in arabesques, that is the hallmark of his style. His originality emerges in the 14 famous Graduals (1470-6), executed for the library of the Piccolomini of Siena. In these large pages, all of them masterpieces of 15th-century Italian illumination, traces

▲ Liberale da Verona
The Adoration of the Magi
Wood. 147 cm × 82 cm
Verona, Cathedral

of Late International Gothic are still evident, side by side with the strong, incisive Florentine line as practised by such artists as Botticelli or the Pollaiuoli.

All Liberale's work in Siena is similar to, and often closely linked with, that of another miniaturist, Girolamo da Cremona. For a long time this made attributions to these two artists very difficult, but Liberale is now credited with several important works formerly attributed to Girolamo and executed during the course of visits to Rome (*The Virgin and Child between Sts Benedict and Francis*, Church of S. Francesca Romana), and to Viterbo. *Christ and Four Saints* (1472, Viterbo Cathedral) is probably Liberale's masterpiece. The troubled figure of Christ stands on a podium and is thrown into relief through the modelling of the robes.

Other works now attributed to Liberale include: two *Scenes from the Life of St Peter* (Berlin-Dahlem and London, private coll.); *The Rape of Helen* (Avignon, Petit Palais) and *The Rape of Europa* (Louvre); a *Nativity* (New Haven, Yale University Art Gal.); *The Draughts Players* (Metropolitan Museum and private coll.).

According to Vasari, Liberale returned to Verona in 1482. He travelled to Venice in 1489, the date when he painted an altarpiece of the *Madonna Enthroned with Four Saints* (East Berlin, Bode Museum), before returning to Verona where he continued to paint steadily and prolifically right up until his death. The works from this latter period include: a *Pietà* (Munich, Alte Pin.); a *St Sebastian* (Milan, Brera), in which the influence of Mantegna is discernible; a *Nativity* (Boston, Gardner Museum); numerous *Madonnas* (Turin, Gal. Sabauda; London, N.G.; Stockholm, University; Grenoble and Kraków museums); *The Adoration of the Magi* (Verona, Duomo); *The Deposition from the Cross* (Verona, Castel Vecchio); and a predella depicting scenes from the *Life of the Virgin* (Verona, Archbishop's Palace). The frescoes (1490) in the Bonaversi Chapel in the Church of S. Anastasia in Verona represent some of his most significant works.

Liberale's poetic, fantastic imagination, and his sharpness and tormented expressiveness were recognized by Vasari, who admired his capacity for portraying 'smiles as well as tears'. This 'expressionism', to use a modern term, isolated him from the classical climate of Verona at this period. He thus seems much closer to certain north European painters and in particular to those of the Danube School. L.C.V.

Lichtenstein
Roy

American painter
b.New York, 1923

Lichenstein studied briefly with Reginald Marsh at the Art Students League in 1939, and for the next three years pursued a normal academic course at Ohio State College. His education, interrupted by service in the Second World War, was completed at Ohio State College, and he taught there until 1951. From that date until 1957 he lived in Cleveland, and thereafter taught at New York State University before settling in New York itself.

Since 1951 most years have seen a one-man ex-

hibition by Lichtenstein in a New York gallery. When Lichtenstein's painting first claimed wide attention, in 1960-1, it was because his work was diametrically opposed to the then dominant Abstract Expressionist School. He employed banal subject matter derived from advertising and the mass media, and seemingly copied from sources so obvious that everyone knew them (*Like New*, 1961, New York, R. Rosenblum Coll.); his techniques, too, seemed to derive from mass-production. His large paintings would reproduce the screen of dots familiar to all newspaper readers (*Whaam*, 1963, London, Tate Gal.).

Lichtenstein's art was calculated in the extreme, leaving no room for the personal gestures and sensual paint effects to which everyone had become accustomed. His renditions of comic strips and paintings based on Erle Loran's diagrams of portraits by Cézanne, or paintings by Picasso (*Portrait of Mme Cézanne*, 1962, Los Angeles, I. Blum Coll.) were seen as bitter satires on the most meretricious elements of American life, the consumer society of television sets and washing-machines. Yet within the limits of this subject matter Lichtenstein displayed remarkable concern for classic modes of composition and a brilliant sense of colour. He had adhered to the flat pattern as few American artists have done since the 1930s.

Since 1964 narrative has been less important in his art; he has turned increasingly to landscape themes which give a freer rein to his feeling for elegant design: landscapes, abstract compositions and take-offs of Abstract Expressionism (*Large Painting 6*, 1965, Düsseldorf, K.N.W.), sometimes compositions based on Art Deco (*Modern Painting with Two Circles*, 1967, Japan, Nagakoa Museum), pictures of mirrors (1971) and rather complex still lifes (*Still Life with Crystal Glass, Lemon and Raisins*, 1973, private coll.).

Many of his drawings are self-sufficient works, independent of any paintings (six variations, becoming progressively more abstract, on the theme of *Bull*, 1973; variations on the theme of the *Artist's Studio*, 1974). Lichtenstein has also turned his talents to prints, his style adapting itself perfectly to lithography and silk-screen (*Rouen Cathedral*, 1969). The parallel between Lichtenstein's formal organizational schemes and those of the younger abstract (Minimal) artists has often been noted, but his true importance lies in the new complex relationship between the banal subject and the sophisticated abstract structure which he, as a protagonist of Pop Art, helped to reintroduce into American art. D.R. and J.P.M.

▲ Roy Lichtenstein
Large Painting 6 (1965)
Oil and magma. 234 cm × 327 cm
Düsseldorf, Kunstsammlung Nordrhein-Westfalen

Limbourg
(the brothers)
Pol, Herman and Jehanequin de
active early 15th century, before 1416

All our knowledge of the work of the Limbourg brothers stems from a discovery by L. Delisle who, towards the end of the 19th century, set out to identify the author of the famous book *Les Très Riches Heures* which was in the possession of the Musée Condé at Chantilly after being acquired in 1855 by the Duc d'Aumale. Delisle based his research on, and wrote an article about,

the final inventory of the collections of Jean, Duc de Berry, drawn up in 1416. In this the manuscript, which remained unfinished on account of the death of the Duke and of his painters, but which was later completed by Jean Colombe for Charles de Savoie, was described as: 'Several books of "*très riches heures*" made by Pol and his brothers, most richly told and illuminated.' This mention, when linked with other documentary sources, became a determining factor in the piecing-together of the careers of the Limbourg brothers.

Pol, Herman and Jehanequin de Limbourg came from an artistic family which had its origins in Gelderland, and on which recent researches have shed new light. Their father, Arnold, was a sculptor and their uncle was Jean Malouel, painter

to the Duke of Burgundy, Philip the Bold. A document dating from 1399 reveals the presence of two of the brothers, Herman and Jehanequin, then 'young children', in the studio of a Parisian goldsmith. By 1402 their reputation was sufficiently established for Philip the Bold to engage them in his exclusive service in order to illuminate a 'very fine and notable Bible'. It is possible that this first commission (which was interrupted by the death of the Duke in 1404) was in fact the *Bible moralisée*, the first three books of which are by the Limbourg brothers (Paris, B.N.).

Although there are no supporting documents, it seems probable that the three brothers moved into the service of Jean de Berry soon after the death of their first employer. In any case it is known that in 1405 they illuminated for the Duc de Berry a charter, which has now disappeared. But it is not until 1409 that there occurs a number of mentions of favours granted to the Limbourg brothers, particularly to Pol who seems to have been the most gifted of the three, from their new patron. Gifts of homes, the title *valet de chambre*, and valuable presents recompensed their work for the Duke. These favours continued until 1416, the year of Jean de Berry's death, probably preceded some months earlier by those of the Limbourg brothers themselves.

The Limbourg brothers' most important works, the *Belles Heures* (New York, Cloisters) and the *Très Riches Heures* (Chantilly, Musée Condé), date from the time of the patronage of Jean de Berry. To these should be added various illuminations in the two other books of hours previously executed for the Duke, as well as a painting in the *Petites Heures* (Paris, B.N.) of the Duke setting out on a journey and illustrations to the prayers to the angels and to the Holy Trinity in the *Très Belles Heures de Notre Dame* (Paris, B.N.).

With the exception of the *Très Riches Heures*, which definitely dates from between 1413 and 1416, the chronology of the works remains unclear. It would seem that even the *Belles Heures*, generally reckoned to date from between 1410 and 1413, but the style of which is clearly closer to that of the *Bible moralisée* in the Bibliothèque Nationale than to the *Heures* at Chantilly, should be ascribed to an earlier period. The place which these *Belles Heures* occupy in the 1416 inventory shows that they were finished by 1409. It is likely that the pages added to the *Très Belles Heures*, and also the *Livre d'heures* in the Seilern collection in London, were executed at around the same time, whereas the more mannered paintings of the *Petites Heures* would seem to date from late in the brothers' careers.

Even in their earliest works the style of the Limbourg brothers appears as profoundly original; nothing produced by the studios of illuminators of Paris at that time can truly be compared with what came from their hands. Perhaps their situation as painters (it is not impossible that Jean de Berry employed them from time to time to paint monumental works) explains their comparative isolation; in any case, it is with the very rare easel paintings that have survived from this era, in particular those attributed to their uncle Jean Malouel and to Henri Bellechose, that their art reveals the closest affinities. The constituents of this art include acute powers of observation inherited from their northern forebears, together with a monumental sense of composition quite plainly acquired from Italian art,

▲ Limbourg (brothers)
Le Voyage des Rois mages
29 cm × 21 cm (illumination for the *Très Riches Heures du duc de Berry*)
Chantilly, Musée Condé

which they could have studied in the collections of Philip the Bold and Jean de Berry without the need to travel to Italy. The diversity of these Italian sources – Siena, Florence, northern Italy – seems to confirm this view.

What is unique in the works of the Limbourg brothers, apart from the almost fairytale quality of their colour, is their ever-increasing skill in representing nature in its various aspects. This is what makes their final masterpiece, the *Très Riches Heures*, a monumental achievement of European painting, free from most of the features of the International Gothic style, yet one of its most refined expressions. Like most books of hours, the *Très Riches Heures* contains a calendar. In this case it is illustrated by 12 miniatures, each showing scenes typical of the time of year. These illustrations have become justly famous for their observation of the ways of both upper and lower classes, for their architectural portraits, and for their visions of landscapes and animals which stand at the beginning of the history of western European landscape art. F.A.

Liotard
Jean Étienne

Swiss painter
b.Geneva, 1702 – d.Geneva, 1789

Liotard spent the greater part of his life abroad. After serving an apprenticeship with the miniaturist Daniel Gardelle he left Geneva for Paris in 1723 and became the pupil of Jean-Baptiste Massé. In 1736 he travelled to Rome where he made the acquaintance of William Ponsonby, the future Lord Bessborough, and together they set off for Constantinople in 1738. On his return in 1742, Liotard brought back with him a series of travel sketches (Paris, Louvre and B.N.); many are in red chalk, and all are notable for their combination of charm and precision. An indefatigable traveller, Liotard lived in Vienna for a time (1743-5) where he painted his most celebrated pastel, the portrait of Fräulein Baldauf (*Maid Carrying Chocolate*, *c*.1745, Dresden, Gg). On his return to Paris he was presented at court in 1749 by the Maréchal de Saxe, whose portrait he had just painted. Although he exhibited several times at the Académie de St Luc, he suffered a number of rebuffs from the Académie itself, and was never admitted.

In 1754 Liotard left France for London and Holland, and in 1757 he settled in Geneva. He was now rich and famous and became a fashionable portrait painter, executing commissions from all the town's notables, as well as from visiting foreigners. Several pastel portraits executed at this time count among his best. His style had become more rigorous, his draughtsmanship more precise; the portrait of *Madame d'Épinay* (*c*.1759, Geneva Museum), which was admired by both Flaubert and Ingres, is perhaps the most perfect example.

Back in Vienna in 1762 Liotard executed a three-pencil drawing of the eleven *Children of Maria Theresa* (Geneva Museum). After further periods in Paris (1770-2) and in London, where he exhibited successfully at the Royal Academy, he paid a last visit to Vienna before returning to Geneva in 1778. His *Portrait of the Artist in Old Age* (1773, Geneva Museum), with its subtle interplay

of light, blended colours and spontaneity of touch, is an uninhibited work that displays a boldness unusual for Liotard. During the last years of his life, after his retirement to Confignon, near Geneva, he painted restrained but ingenious still lifes (Geneva Museum and Salmanowitz Coll.) that rival those of Chardin as masterpieces of the genre. He also executed an astonishing *Landscape* with a view of the mountains near his studio (Rijksmuseum).

Liotard's art was opposed to French 18th-century painting, with its verve, grace and charm. His vision, sometimes disconcerting in its independence and originality, was a source of both strength and weakness. His taste for analysis and observation and his independence led him to despise contemporary fashions. He stripped his pictorial language to its essentials, refusing to make concessions that might tend to beautify his models. His first, indeed his only, preoccupation was with what was 'real' – hence his nickname 'the painter of reality'. His sensitive use of colour reveals a masterly understanding of tone values. His pastels lack the psychological insights of La Tour, or the extreme refinement of those of Perronneau, but compensate by a scrupulous rendering of reality. R.L.

Liotard is represented by an important collection of pastels, oils and drawings in the Geneva Museum; the Rijksmuseum also has a fine series of pastels (*Woman Reading*, 1746).

Liotard was also author of the *Traité des principes et des règles de la peinture* (*Treatise on the Principles and Rules of Painting*) (Geneva, 1781). His conception of painting as the 'immutable mirror of all that is most beautiful in the universe' was strongly opposed to the *peinture de touches* of his contemporaries and led him to affirm that 'you see no brushstrokes in the works of nature, which is a very good reason for not putting them in your paintings'. He rebelled and fought against opinions that he considered wrong, and against the naïveté of those who had 'no knowledge of the principles of art'. G.P.

Lippi
Filippino

Italian painter
b.Prato(?), 1457(?) – d.Florence, 1504

After the death of his father Filippo, who was his first teacher, Filippino, then aged 12, entered Botticelli's workshop. His early works, painted around 1478-82, are very close in style to those of Botticelli, with their elongated, refined figures and elegant melancholy. These include *Scenes from the Life of Esther* (now distributed between the Louvre, the Musée Condé at Chantilly, the National Gallery in Ottawa and the Horne Museum in Florence); *Three Archangels with Tobias* (Turin, Gal. Sabauda); *The Adoration of the Magi* (London, N.G.); *Scenes from the Story of Virginia* (Louvre) and those from the *Story of Lucretia* (Florence, Pitti). Botticelli's influence, in fact, was so strong that Berenson attributed all these paintings, together with a few portraits, to a hypothetical artist named 'Amico di Sandro' (i.e. 'Friend of Sandro [Botticelli]').

Around 1484-5 Filippino completed the frescoes for the Brancacci Chapel (Florence, S. Maria del Carmine), left unfinished 50 years previously by Masaccio on his death. But before this task, the young Filippino, frightened perhaps by the impressive grandeur of the model left by Masaccio, turned to a new style that resulted, in the end, in superficial, episodic work, lacking in the sensitivity of his earliest paintings. Two tondi of the *Annunciation* (*c*.1483, San Gimignano Museum) are distinguished by a more tormented and nervous line and metallic colours. Meanwhile Hugo van der Goes's *Altarpiece* arrived in Florence and Lippi, like other painters of the time, was struck by the naturalistic elements of the work, which soon became famous.

Round about this time he began to receive really important commissions. In 1486 he began work on an altarpiece (*The Madonna Enthroned*

▲ Jean Étienne Liotard
View of the Landscape around Geneva, from the Artist's Studio
Pastel. 45 cm × 58 cm
Amsterdam, Rijksmuseum

with Sts John the Baptist, Victor, Bernard, and Zenobius) for the Sala degli Otto di Pratica in the Palazzo Vecchio (now in the Uffizi). At about the same time he painted *The Vision of St Bernard* for the Pugliese family chapel (Florence, Church of La Badia) and a *Virgin and Child Enthroned with Saints and a Donor*, still on the altar of the Nerli Chapel in the Church of S. Spirito. In the latter is a perspective of Florence, opening out beyond the portico that frames the holy group, which equals the finest landscapes of European painting.

Between 1489 and 1493 Filippino was in Rome painting scenes from the *Life of the Virgin* and of *St Thomas Aquinas* in the Caraffa Chapel of the Church of S. Maria sopra Minerva. His contact with classical remains inspired in him a taste for exuberant decoration, featuring friezes, grotesques and bizarre headdresses – for where the masters of the early quattrocento had respected the laws and proportions of classical art, to the painters of the late 15th century the ancient world served as a pretext for nostalgic evocation and fantasy. *The Adoration of the Magi* (1496, Uffizi) was painted for the monks of the Scopeto convent who had earlier commissioned a painting of the same theme from Leonardo. The grouping and complicated poses of the figures centred around the Holy Family in Lippi's painting may have been inspired by Leonardo's rough sketches for the work (now in the Uffizi), which he never completed.

After the turn of the century Lippi also accepted commissions in other cities: for the Church of S. Domenico in Bologna he painted in 1501 *The Mystic Marriage of St Catherine*; and at around the same time he sent to Genoa his *Altarpiece of St Sebastian* (now in the Palazzo Bianco). In 1503 he completed for the Strozzi Chapel (Florence, Church of S. Maria Novella) the fresco cycle *Scenes from the Lives of St Philip and St John the Evangelist*, commissioned in 1487. Here, he abandoned his tormented figures in favour of an extravagant decorative vein, borrowed from classical art, in which architectonic perspectives tend to be lost. The rhetoric, however, does not quite swamp certain remarkable figures and details, which retain Lippi's usual imaginative force. His premature death interrupted his work on *The Coronation of the Virgin* for the Church of S. Girolamo alla Costa (now in the Louvre), which was finished by Berruguete, and a *Deposition* for the Church of the Annunziata (Florence, Accademia), completed by Perugino in 1505.

A representative of Florentine painting at the end of the quattrocento, Lippi anticipated, as did Piero di Cosimo, some of the bizarre fantasy which the Mannerists were later to translate into more sophisticated intellectual language. M.B.

Lippi
Fra Filippo
Italian painter
b.Florence, 1406 – d.Spoleto, 1469

Filippo was a lay brother at the Carmelite abbey in Florence at precisely the time when Masaccio was painting his scenes from the *Life of St Peter* in the Brancacci Chapel and the *Sagra* (now destroyed) in the adjoining cloister. He soon left the abbey and led an eventful life (although the story of his abduction by the 'Moors' and his captivity in 'Barbary' are probably a figment of Vasari's imagination). On the other hand, the historian should probably treat more seriously a mention of a stay by Filippo in Naples, where he would have discovered a Netherlandish cultural milieu, which would explain detailed passages in his youthful work. In 1456, while painting in Prato Cathedral, he persuaded a nun from the Convent of S. Margherita to abscond with him; from this union, subsequently legalized by Pope Pius II, who absolved the two fugitives from their vows, came a son, Filippino, also to become a painter.

Filippo's taste was formed in the Gothic ambience, but he was able to appreciate the work being done in the Brancacci Chapel where the latest Gothic refinements of Masolino were juxtaposed with the violent and dramatic world of Masaccio. In Filippo's first works, the fresco of the *Reform of the Carmelite Rule*, formerly in the Carmelite cloister (1432-3), and the *Trivulzio Madonna* (Milan, Castello Sforzesco), the influence of Masaccio can be seen in the full, heavy figures, although, from the first, Filippo rejected Masaccio's rigorous perspective and his severe and dramatic manner. His humanity found expression in a series of cheerful rustic figures that awoke an instant response from the Florentine public of the early 15th century, which until then had been disconcerted by the spare, rational language of the early Renaissance.

In 1434 Filippo went to Padua but nothing is known for certain about his time there. Probably he was not yet in a position to introduce with authority the new style of the Renaissance, something that was left to Donatello to do during his ten-year stay in that city. On his return to Florence, Filippo painted in 1437 the *Tarquinia Madonna* (Rome, G.N.), the work in which he draws closest to Masaccio, although the rapport between figures and their surroundings, so carefully calculated in Masaccio, is quite missing in Filippo. His Virgin is a massive figure that looms

menacingly over the foreshortened perspective of the room.

Increasingly, from now on, Filippo was influenced by Fra Angelico, most notably in his employment of clear, luminous colours. In 1437 the Barbadori family commissioned an altarpiece depicting the *Virgin and Child between St Frediano and St Augustine with Angels* (Louvre; predella with *St Frediano Changing the Course of the River, Annunciation of the Death of the Virgin* and *St Augustine* in the Uffizi). The linear rhythms of these paintings, especially noticeable in the robes of the flanking angels, are an increasingly prominent feature of Florentine art generally, stemming from Andrea del Castagno and the linear solutions devised by Donatello.

Filippo's most significant works from this period are *The Coronation of the Virgin* (1441, Uffizi) and the two *Annunciations* (Florence, Church of S. Lorenzo; Rome, G.N.), where Fra Angelico's rarefied and spiritual atmosphere assumes a worldly, concrete character, more in line with Filippo's own temperament, both as a man and as an artist. In 1452 he was entrusted with the decoration in fresco of the choir of Prato Cathedral and chose as his theme *Scenes from the Lives of St John the Baptist and of St Stephen*, completing the cycle in 1464. From 1452 also dates the Bartolini tondo (Florence, Pitti), with the *Virgin and Child and Scenes from the Life of the Virgin*. Certain details, such as the Virgin's veil and the face of the basket-carrier, anticipate the subtleties of line of Botticelli who was in fact to become a pupil of Filippo.

Filippo's later works, painted after 1455, such as *The Virgin and Child Held Aloft by Two Angels* and *The Virgin Adoring the Child with St Hilarion* (both in the Uffizi), reveal an often rather indiscriminate mingling of widely disparate influences, from the fragile sensitivity of Fra Angelico's figures to Masaccio's solidly weighted forms, and even include certain Gothic features such as the splintered rocks of the *Virgin Adoring the Child with St Bernard*, painted for Lorenzo Tornabuoni (Uffizi). Filippo died in Spoleto where, with his young son Filippino, he had gone to paint the *Scenes from the Life of the Virgin* for the choir of the Cathedral. The weaknesses of this, Filippo's last work, are in large measure a result of his heavy reliance upon assistants, in particular Fra Diamante.

Filippo achieved a full 15th-century degree of realism in terms of perspective and figure style. He perpetuated, however, the gentle psychology of the more 'Gothic' painters (e.g. Fra Angelico). His art is founded on fusion of the decorative colour and pattern in the works of the latter with the illusionism of the former. M.B.

▲ Filippino Lippi
Esther and Ahasuerus
Wood. 47 cm × 138 cm
Chantilly, Musée Condé

Liss
Johann
German painter
b.Oldenburg, c.1597 – d.Venice, 1630

After living in the Low Countries between 1615 and 1619, Liss had by 1621 settled in Venice where he remained until his death, except for a visit to Rome in 1622. Trained first by the Haarlem painter Goltzius, then by Pieter Bruegel and Buytewech, as well as in the Dutch Caravaggesque method of Jordaens, Liss introduced to Venice, which was then going through a period of artistic stagnation, a new north European concept of painting.

He produced mainly figure paintings, and because he was constantly reworking the same theme, the various phases of his evolution are hard to chronicle accurately. One obvious characteristic of his work, however, is his transformation, under the influence of the 16th-century Venetian masters, of the luminous qualities of Caravaggio (the theme of the *Soldiers' Banquet* in the Nuremberg Museum is directly borrowed from the Italian master) into a method of painting in which forms dissolve and blur. His Venetian genre paintings, whose subject matter sprang from his way of life, if one accepts Sandrart's testimony (*The Brawl*, Innsbruck, Ferdinandeum; *The Wedding*, Budapest Museum; *The Prodigal Son*, Vienna, Akademie; *The Game of Morra*, Kassel Museum), date for the most part from his early years in the city and depict groups of people, Flemish in feeling, set in the Venetian gardens typical of Fetti, and bathed in Titianesque light.

Liss's themes are extremely varied, and alongside these genre paintings religious and mythological scenes occupy an important place in his output. They include: *The Satyr and the Peasant*

(Berlin-Dahlem; Washington, N.G.); *The Fall of Phaeton* (London, Mahon Coll.); *Judith* (Vienna, K.M.; London, N.G.); *Moses Saved from the Waters* (Lille Museum); and *The Toilet of Venus*, a masterpiece of vivid colour representing the goddess surrounded by her attendants and seated on a throne impressively draped with silks (Uffizi; Pommersfelden, Schönborn Coll.).

One of the distinguishing features of Baroque art is its imposing synthesis of preceding styles. Among the works of Liss that conform to this definition are *The Vision of St Paul* (Berlin-Dahlem) and *The Inspiration of St Jerome* (Venice, Church of S. Nicolò da Tolentino). These paintings blend with extreme virtuosity a celestial vision of ecstasy and the sensuality of real life. The irrational and the transcendental are expressed by luminous spaces, but the saints are imbued with a wholly material presence, conveyed by the dynamism of the painting and by a diagonal composition where all is bathed in iridescent light. The diagonal, a typically Baroque device, was used to suggest movement, and dominates the entire composition, from the dark

areas reserved for the world on earth, to the sparkling crown, symbol of celestial glory. This pictorial language, with its light touch and extraordinary rhythm, has something about it that is typical of the 18th century.

During the first two decades of the 17th century Liss brought new life to Venetian painting, thus opening the way, along with Fetti and Strozzi, to such masters as Tiepolo and Piazzetta. His career was short, but during it he sought to create a synthesis of northern expressive power, the majestic forms of Caravaggio and the Roman painters, and the Venetian harmony of colour, a blend which found its most perfect expression in his luminous visions. G.A.

Lochner
Stephan
German painter
b.Meersburg, c.1410 – d.Cologne, 1451

In October 1520 Dürer, who was on his way to the Low Countries, stopped in Cologne and noted in his diary that he had paid 'four Weisspfennig' in order to obtain permission to view a painting by 'Maister Steffan zu Cöln' in the chapel of the Town Hall. From this it is possible to establish that the author of these panels, transferred to the cathedral in 1810, was none other than Stephan Lochner. In this way, Cologne's most distinguished 15th-century painter emerged from anonymity. His name appears for the first time in the account books of Cologne for 1442, and for the last time in 1451, the year of the Black Death, when he probably died. His repeated re-election to the town council reveals how high was his prestige among his fellow-citizens. One document mentioning him under the name of 'Stephan of Constance' suggests that he was born in that region.

Even today his artistic development remains obscure. He was probably trained in Upper Swabia, where he was born, but no precise facts are to hand to support this hypothesis, and by the time his name appears in Cologne he had already adopted that city's pictorial style. It is quite likely that he settled there some time during the 1430s, after a journey to the Low Countries from which he returned imbued with the art of Van Eyck, and especially that of the Master of Flémalle.

Although none of his works is signed, two of them are dated. These are the two leaves of an altarpiece representing the *Nativity* (with the *Crucifixion* on the reverse; Munich, Alte Pin.) and *The Presentation in the Temple* (with *St Francis Receiving the Stigmata* on the reverse; Lisbon, Gulbenkian Foundation), and another *Presentation* (Darmstadt Museum), which was the centrepiece for the main altar in the church of the Teutonic Knights. The works date back respectively to 1445 and 1447 and make it possible to establish a chronology.

Lochner's surviving works are now thought to begin with a *St Jerome* (Raleigh, North Carolina Museum) and an altarpiece of the *Last Judgement*, formerly in the Church of St Lorenz in Cologne (central panel with scene of the *Judgement*, Cologne, W.R.M.; interior faces relating the *Martyrdom of Six Apostles*, Frankfurt, Städel. Inst.; exteriors each displaying three standing

◀ Johann Liss
The Fall of Phaeton
Canvas. 128 cm × 110 cm
London, Mahon Collection

Saints, Munich, Alte Pin.). For a long time there was hesitation about attributing *St Jerome* to Lochner, but it was precisely the Netherlandish features which led to its being included among his early works.

The dismantled altarpiece showing the *Last Judgement* is slightly later. The division of the wings into six distinct scenes is still in accordance with medieval tradition and brings to mind the altarpieces of the early 15th century. The central image, too, consists of the juxtaposition of individual scenes. However, in details, Lochner enriched the Cologne School by his use of many original touches. The small figures have a new freedom and move easily and with spirit. The human figure, whether nude or in profile, viewed from behind, or in movement, had never before been represented in this way in Cologne. Each detail is rendered with equal attention, but the contrast between the richness of realistic features resulting from intelligent observation of nature, and the lack of cohesion of the whole, suggest that this triptych was one of Lochner's first works, probably executed around 1435–40.

The great "*Three Kings Altarpiece*" (*Das Dombild*), attributed to Lochner on the basis of Dürer's statement, must therefore have been executed shortly after 1440 (Cologne Cathedral). The central panel represents the *Adoration of the Magi*; on the interiors of the wings are the city's patron saints, *St Ursula* and *St Gereon*, together with their attendants. The outside is devoted to the *Annunciation*, in an interior with a wooden ceiling and walls hung with brocades. Lochner depicts this scene with great restraint, and the theme is easily understood, thanks to the clear disposition of the characters. Nothing here recalls the hesitant attempts at perspective or at conveying a feeling

of space such as characterized the triptych of the *Last Judgement*. Renouncing all ancillary detail, Lochner limits himself to essentials, and he remained faithful to this principle in the central panel, in which the monumental feeling and austere style are even more in evidence. Objects, figures and costumes are depicted with great care, in a pleasing style, rich in individual features, but unity of composition remains the dominant preoccupation. From now on composition took pride of place over detail, which remained subordinated to the whole.

The *Altar of the Patron Saints* led directly to *The Presentation in the Temple* (1447, Darmstadt Museum). In its layout the latter is very close to the central panel of the preceding triptych.

Compared with the paintings of Witz or of Multscher, Lochner's art was not innovatory. In fact, he approached the problems which preoccupied these two masters – problems such as the suggestion of space and the representation of landscape – rather timidly. Too attached, probably, to the traditions of the Cologne School, he appears to have considered these questions as taking second place to craftsmanship, colour and feelings of piety. He developed the 'soft style' of International Gothic and was eager to characterize to extremes the costumes and individual features of his figures. A subtle use of colour confers lightness and a feeling of smooth solemnity on his paintings; no foreshortening or sharp gestures disturb the calm, introspective atmosphere.

Although Lochner remained close to the Cologne traditions, expressed, for example, by the Master of St Veronica, he also frequently stepped beyond these bounds. Turning away from the kind of dislocated composition which had been in favour by then for several centuries,

he rediscovered the art of composition on large surfaces and with ample forms.

The Virgin in the Rose-Bower (Cologne, W.R.M.), his last work, in which he mingles his own ideal with the Cologne tradition, is a fine example of his technique. Seated on the grass with her head lightly inclined, the Virgin forms the centre of the composition. Around her angelic musicians, softly playing their instruments, convey the solemn calm and introspection which envelop the scene, and one finds here the same language as that used in the previous century by the Master of St Veronica. M.W.B.

Longhi
Pietro
Italian painter
b. Venice, 1702 – d. Venice, 1785

After serving an apprenticeship with Balestra, as evidenced by the somewhat unsuccessful frescoes of the *Fall of the Titans* in the Palazzo Sagredo, Venice (1734), Longhi went to Bologna where he became a pupil of Crespi. Impressed by Crespi's modern, unselfconscious style, in which novelty of subject was allied to rich, dense treatment and remarkable colour effects, he altered his own style completely. He became a *peintre de moeurs*, depicting in small, familiar scenes, with a hint of caricature, the daily life of the people of Venice, whether aristocracy, peasantry or bourgeoisie. Longhi thus existed within a wide cultural context that was not only Italian (with Crespi, Ceruti and Ghislandi) but more widely European because of the affinities of his style with the English 'conversation pieces' and the paintings and prints of Watteau and Boucher. Venetian painting at the time was characterized by and concerned with the world of reality, in the *veduta* (view) as in the portrait, which was once more back in fashion. Longhi's painting may be compared with the comedies of Goldoni, which gave a lively picture of Venetian society on the eve of its disintegration.

Among Longhi's first works, painted when he was in his thirties, is a series of *Shepherds* and *Shepherdesses* (Bassano Museum; Rovigo, Pin. del Seminario) which clearly reveal the influence of Crespi with their gleaming colours and cold lighting. The *Concert* (Venice, Accademia) of 1741 is the first dated scene of Venetian life; already a masterpiece in its subtle depiction of people and its cleverly orchestrated composition, the work is

Stephan Lochner ▲
The Presentation in the Temple
Wood. 139 cm × 126 cm
Darmstadt, Hessisches Landesmuseum

Pietro Longhi ▶
The Presentation
64 cm × 53 cm
Paris, Musée du Louvre

full of delicate, pale colours, exquisitely refined.

Critics have remarked that during the 1750s Longhi alternated dense, rapid brushstrokes, à la Crespi, with a lighter style, closer to the fluid and transparent colours of Rosalba Carriera. From this period come scenes which may be grouped in series, such as *The Life of a Lady*, among which are a *Toilet* (Venice, Accademia), marked by an acute, elegant power of observation, and *The Presentation* (Louvre), constructed with a skilled and delicate blending of tones. Alongside these scenes of aristocratic life are those showing ordinary citizens: *The Pancake Seller* (Venice, Ca' Rezzonico), a work of sparkling vivacity; and episodes of street life, such as the *Tooth Extractor* (Brera), which verge on satire.

Until 1770 Longhi's style remained fairly uniform, so that it is difficult to place his works in any definite chronological order. His observation of reality became closer, sharper, and his search for new subjects led to a biting, lively sense of fantasy. From 1751 comes the famous *Rhinoceros* (Venice, Ca' Rezzonico) in which the faces in the crowd take on the power of individual portraits. Of the various 'series', that of the *Sacraments* (Venice, Gal. Querini-Stampalia) is inspired by Crespi's work on the same theme. It here becomes a chronicle of daily events, observed with ironic detachment and translated into a delicate, pale range of colours. An outdoor setting characterizes seven hunting scenes (among which is *The Hunt in the Valley*, Venice, Gal. Querini-Stampalia), painted for the Barbarigo family, probably between 1760 and 1770. The colours of these small paintings have a new intensity and the play of light and shade creates a twilight atmosphere. Longhi observes with a satirical eye, as in *The Arrival of the Lord of the Manor*, who is saluted by peasants, or in *The Lord Embarking*, in which each character is sharply observed.

After 1770 Longhi's artistic development seemed to cease, yet during his last years he still managed to produce some astonishing works. Now he preferred to centre his interest on the individual (*The Michiel Family*, Venice, Gal. Querini-Stampalia). His study of humanity became more profound and almost gives the impression of a real documentary of Venetian 18th-century society.

Among the galleries that hold works by Longhi, the Venetian collections (the Ca' Rezzonico, the Galleria Querini-Stampalia and the Accademia) have pride of place by virtue of the 'series'. The National Gallery, London, and the Metropolitan Museum also contain examples of Longhi's work. F.d'A.

Loo
Charles André van (Carle)

*French painter of Flemish descent
b.Nice, 1705 – d.Paris, 1765*

The second son of Louis-Abraham, Van Loo joined his older brother Jean-Baptiste in Turin in 1712, then went to Rome to become a pupil of Benedetto Luti. After returning to Paris in 1719 he painted his first religious compositions (*La Présentation au Temple* [*The Presentation in the Temple*], 1725, Lyons, Church of St Jean) and was awarded the Prix de Rome in 1724, which enabled him to return to study in Rome. He ar-

rived there in 1727, at the same time as Boucher, and stayed until 1732 (*L'Apothéose de Saint Isidore*, 1729, Rome, Church of St Isidore; sketch in Hamburg Museum). Between 1732 and 1734 he was in Turin where he worked for the King of Sardinia (11 paintings of *Jérusalem délivrée*, 1733, Turin, Palazzo Reale; *Le Repos de Diane* [*The Repose of Diana*], 1733, Château de Stupinigi), as well as executing commissions for religious paintings (*La Cène* [*The Last Supper*]; *La Multiplication des pains* [*The Miracle of the Loaves and Fishes*], 1733, Turin, Church of S. Croce; preparatory sketch in Arras Museum).

Van Loo returned to Paris in 1734 and was elected to the Académie the following year with *Apollon faisant écorcher Marsyas* (*Apollo Flaying Marsyas*) (Paris, E.N.B.A.). From then on he had a brilliant official career that culminated in his appointment as Principal Painter to the King in 1762 and as Director of the Académie in 1763, posts he retained until his death. In 1749 he was made Governor of the École des Élèves Protégés and played an important educative role in the lives of his pupils, amongst whom were Fragonard and Brenet.

Van Loo was, with Jean François de Troy and Natoire, one of the principal exponents of the 'grand style'. He worked for the King: *Chasse à l'ours* (*Bear Hunt*) (1736), *Chasse à l'autruche* (*Ostrich Hunt*) (1736; both Amiens Museum); *Halte de chasse* (*Rest on the Hunt*) (1737, Louvre); and three *Allégories des Arts* (1745, Paris, B.N., Cabinet des Médailles), and for the Gobelins tapestry works: *Thésée vainqueur du taureau* (*Theseus overcoming the Minotaur*) (1746, Nice Museum; another version in Besançon Museum), as well as carrying out private commissions: *Jupiter et Junon, Mars et Vénus, La Toilette de Vénus* and *Castor et Pollux* (1737, Paris, Hôtel de Soubise, today in the Archives Nationales). Above all, he worked for churches: *Le Lavement des pieds* (*Christ Washing the Disciples' Feet*) (1742, Le Mans Museum); four pictures of *La Vie de la Vierge* (*The Life of the Virgin*) (1746-51, Paris, Church of St Sulpice); and six pictures of *La Vie de Saint Augustin* and *Le Vœu de Louis XIII* (*Vow of Louis XIII*) (1748-53, Paris, Church of Notre-Dame-des-Victoires).

Van Loo also painted many genre scenes, and was one of the earliest painters to depict his subjects in fancy dress, Turkish or Spanish: *Le Pacha faisant peindre sa maîtresse* (*The Pacha having his Mistress Painted*) (1737, London, Wallace Coll.); *Une Sultane prenant le café* (*A Sultana Taking Cof-*

fee), *Une Sultane travaillant à une tapisserie* (*A Sultana Working at her Tapestry*) (1755, Paris, Musée des Arts Décoratifs); and *Conversation espagnole* (*Spanish Conversation-Piece*) (1755, Hermitage).

Van Loo was held in high esteem by his pupils (Doyen, Lépicié, Lagrenée the Elder) and was the rival of Boucher, who was not appointed *premier peintre* until after Van Loo's death. One of the most gifted historical painters of the 18th century, he suffered from the vogue for David, and was even challenged during his own lifetime (Vien, David's teacher, showed his *Marchande d'Amours* [*Seller of Cupids*] in 1763). Carle van Loo was no less skilful as a painter of pleasing and decorative compositions, than as the creator of the imposing large-scale works, too long ignored, which are one of the glories of French rococo.

C.C. and J.V.

Lorenzetti
Ambrogio

*Italian painter
active 1319–47*

Ambrogio Lorenzetti was one of the greatest masters of the first generation of Sienese painters of the trecento. His career developed alongside that of his brother Pietro, who was probably his elder, and with whom he maintained good relations despite his exceptionally independent character and the originality of his own stylistic ideas. But he shared with his brother an interest in the work of the Florentine school, seen from the point of view of the Sienese tradition.

The *Virgin and Child* in the Church of S. Angelo at Vico l'Abate (near Florence), dated 1319, is probably Ambrogio's earliest work. It allies the various formal elements native to Sienese culture, such as elegance of line, and those of Florentine painting, which sought to depict volumes in space. Documents reveal that Ambrogio was in fact in Florence in 1321, and the influence of Florentine models is clear in works generally attributed to this artist's first period, from 1320 until about 1330; the two versions of the *Virgin and Child* (Brera; Metropolitan Museum); the two *Crucifixes* (Siena, P.N.; Montenero sull' Amiata, Church of S. Lucia); and the frescoes depicting the *Martyrdom of the Franciscans at Ceuta* and *St Louis of Toulouse before Boniface VIII* (Siena, Church of S. Francesco). In the last

Charles van Loo ▲
Le Départ de Renauld (1733)
Canvas. 50 cm × 106 cm
Turin, Palazzo Reale

the space is boldly used in the manner of a Florentine painter descended from Giotto or Maso di Banco, but with a far more realistic touch. Some critics consider that these frescoes belong to the cycle executed for the cloister of the Abbey, probably dating from 1330-1, whereas others believe them to be older.

The year 1332 saw a change in Lorenzetti's style with his *Virgin and Child between St Nicholas and St Proculus* (Uffizi). This triptych may be identified as one of the works executed that year for the Church of S. Procolo in Florence. As Lorenzetti's draughtsmanship developed, so he freed himself from the influence of Florentine art. He may even have begun to influence Florence in his turn, both by his subtle, realistic power and by his use of space (almost prefiguring the International Gothic school's interest in the very close and very distant, an interest which was to become almost the exclusive province of the northern European painter). Florence may have benefited, too, from the psychological thread which links the images in Ambrogio's works.

All these features were blended into a highly coloured humanity, which looks almost 'modern' in style, perhaps because of the realism of the gestures and the wholly secular gaiety derived from the demands of the narrative and an ornamental use of *trompe l'oeil*. It is from this point of view that the four *Scenes from the Life of St Nicholas* (Uffizi) should be judged, along with the surprising *Allegory of the Redemption* (Siena, P.N.), often attributed to his brother Pietro. Other notable works include the panels of a polyptych taken from the Church of S. Petronilla (including, among others, *The Virgin and Child*, *St Mary Magdalene*, *St Dorothea*; Siena, P.N.) and the frescoes of the chapel in Montesiepi (*Maestà*, the *Annunciation*, *Scenes from the Life of St Galgano*), in which all Ambrogio's inventive force appears in his use of inner surfaces to simulate space.

Henceforth withdrawn into himself, he found expression in a deeper sensitivity, as in the great *Maestà* of Massa Marittima (Municipio), or in the fresco of the *Maestà* in the sacristy of the Church of S. Agostino (Siena), or, among the works generally reckoned to date from before 1340, in the astonishing polyptychs in the Asciano Museum (formerly in the Badia di Rofeno; centre, *St Michael Fighting the Dragon*) and of Roccalbegna (churches of S. Pietro and S. Paolo), in which the depictions of *St Peter* and *St Paul* rival

the highest achievements of the Italian trecento. All these works bear comparison with Lorenzetti's famous frescoes of the *Allegory of Good and Bad Government*, painted between 1337 and 1339 (Siena, Palazzo Pubblico).

Nothing survives of the frescoes executed in 1335 by Ambrogio and his brother Pietro Lorenzetti on the facade of the Church of S. Maria della Scala (Siena) representing *Scenes from the Life of the Virgin*. From the great fresco depicting the *Virgin in Majesty*, painted in 1340 in the loggia of the Palazzo Pubblico, there remains the central group with the *Virgin and Child*, a work which makes possible the dating of such later works as the *Madonna del Latte* of the Seminario (Siena) or the little portable altarpiece with the *Virgin in Majesty, Saints and Angels* (Siena, P.N.), with its use of perspective, surprising for the era, and its admirable freshness of colour.

In 1340, after the departure of Simone Martini for Avignon, Pietro and Ambrogio Lorenzetti became Siena's most highly regarded painters and took on increasingly ambitious works. From 1342 comes *The Presentation in the Temple* for Siena Cathedral (now in the Uffizi), a work which forms a climax to Ambrogio's experiments with perspective. His pictures are marked by a richness of ornamentation and a worldly luxury which were to serve as a model to Sienese painters for almost a century. Thus, the *Annunciation* (1344, Siena, P.N.), formerly in the Palazzo Pubblico, presents such assured perspectives, monumentality in the figures and elegant originality of draughtsmanship that it synthesizes all the experiments undertaken by this sensitive, refined artist throughout a career notable equally for learning and bold innovation. Lorenzetti is worthy in all respects of his reputation as one of the highest representatives of Italian Gothic humanism. C.V.

Lorenzetti
Pietro

Italian painter
active 1305(?) – 45

Pietro Lorenzetti was probably born some ten years or so before his brother Ambrogio but there is no certainty that a document of 1305 relates to

this painter. Like Simone Martini, he grew up at a time when the artistic climate was dominated by Duccio's mature output, but unlike these two artists, he manifested an extremely dramatic, passionate temperament. After difficult beginnings and considerable efforts to free himself from the tradition of Duccio, he soon began to look towards Giotto, from whom he took the profound divisions of space, while adapting them to the traditional language of Siena. His most significant work in this respect is the triptych with the *Virgin and Child between St Francis and St John the Baptist*, painted in fresco (Assisi, Basilica of S. Francesco, Lower Church), but the coherence of these beginnings is equally apparent in the succeeding works, all dating from between 1310 and 1320. Among the most characteristic are *The Virgin and Child with Angels* and the *Crucifix* (Cortona Museum); the polyptych representing the *Virgin and Child and Saints* (now split up: Church of Monticchiello; Florence, Horne Huseum; Le Mans Museum); the *Virgin in Majesty* (Philadelphia Museum, Johnson Coll.); and a small *Crucifixion and Saints* (Cambridge, Massachusetts, Fogg Art Museum).

These works enable us to follow the evolution of Lorenzetti's powerful style, and reveal his preoccupation with problems that are wholly modern in their concern to express pathos or tragic eloquence. Even when he draws inspiration from the violent elements in the sculptures of Giovanni Pisano, his natural talent is accompanied by a deep expression of feeling, rendered by colours whose tones are alternately brilliant and deep. He is thus able to transform the aristocratic tradition of Siena into a realistic and human style of representation, whose freedom is highlighted by an even wider choice of theme and by a vigour that is both plastic and formal.

These experiments culminated in the fine frescoes of the Lower Church of S. Francesco, Assisi (which some critics, however, attribute to Pietro's workshop), and also the *Scenes of the Passion* (from *The Entry of Christ into Jerusalem* to *The Ascent of Calvary*) and the great polyptych of *The Virgin and Child with Saints* (still on its original site on the high altar of the Pieve in Arezzo), commissioned in 1320 and his first dated work. These paintings mark the beginnings of Lorenzetti's mature period, when he produced works of the large-scale inventiveness demanded by the art of the fresco, on themes of pathos or tragedy,

Ambrogio Lorenzetti ▲
The Allegory of Good Government (1337–9)
Fresco
Siena, Palazzo Pubblico

Pietro Lorenzetti ▶
The Birth of the Virgin (1342)
Wood. Triptych. 187 cm × 182 cm
Siena, Museo dell'Opera della Metropolitana

powerful in their intensity. Therein lies the dominating theme which unites the frescoes of the left transept in the Lower Church of Assisi.

By its sheer size and spiritual grandeur, the great *Crucifixion* dominates the other scenes in this transept. The artist surrounded the scene of suffering on the Cross with a confused and variegated crowd of worshippers, soldiers and horsemen, as though the howling mob from Cimabue's *Crucifixion* had been transported into a theatrical setting. This masterpiece influenced not only Sienese painting but much of the art of the period by its tremendous innovations in setting, expressiveness and iconography. The other frescoes in the cycle are no less admirable and include the *Scenes from the Passion* after the death of Christ (from the *Deposition* to the *Resurrection*), and *The Stigmatization of St Francis*.

From 1329 comes the altarpiece formerly in the Carmelite church (Siena, P.N.), which, particularly in its astonishing predella (*Scenes from the Lives of the Carmelite Monks*), reveals Lorenzetti's encounter with the new post-Giottesque school of Florentine painting, and more precisely with the work of Maso di Banco. Here, the prophetic fervour of the Assisi frescoes is toned down, and the work reveals an admirable composition, more ornate and worldly, and displaying severe, almost classical, colours and proportions.

The three panels of the polyptych (dated 1332) representing *St Bartholomew*, *St Cecilia* and *St John the Baptist* (formerly in the Pieve di S. Cecilia at Cremola; Siena, P.N.) reveal a marked affinity with works which were formerly attributed to a hypothetical painter, close to Lorenzetti in style, who was conventionally known as the 'Master of the Dijon Triptych' (this work is now in Dijon Museum). From this group the *Virgin and Child* of the Loeser Collection (Florence, Palazzo Vecchio) should be singled out, along with its accompany-

ing panels (now in the Metropolitan Museum; formerly Assisi, Mason-Perkins Coll. and private coll.) and the small paintings depicting the *Virgin and Child Surrounded by Saints* (Baltimore, Walters Coll.; Milan, Poldi-Pezzoli Museum; Berlin-Dahlem), *Christ before Pilate* (Vatican), or the small panel with *St Sabinus before the Governor* (London, N.G.), which should be linked to the great altarpiece, begun in 1335, for Siena

Cathedral, the central panel of which consisted of the *Birth of the Virgin*, dated 1342 (Siena, Museo dell'Opera della Metropolitana).

The superb *Virgin in Majesty* (1340, Uffizi), formerly at Pistoia, and the polyptych describing *Scenes from the Life of the Blessed Humilitas*, certainly executed after 1332 (Uffizi; two panels in Berlin-Dahlem), conclude Lorenzetti's stylistic evolution, which was concentrated on a neo-Giottoesque study of the synthesis of forms and of colours. The art of Pietro Lorenzetti had a profound influence, which was prolonged by his numerous followers and imitators (Nicolò di Segna, the Master of San Pietro d'Ovile). As with Simone Martini, it may safely be said that for a long time after Lorenzetti's death, no Sienese artist remained unaffected by the imprint of his incomparable poetic personality. C.V.

Lorenzo Monaco

Italian painter
b.Siena(?), c.1370 – d.Florence, c.1425

Lorenzo Monaco received his training in Florence. He must have been living there well before 1390, the year in which his presence is recorded at the Camaldolese monastery of S. Maria degli Angeli where he made his vows the following year. The activity of his early years has been reconstructed by means of stylistic analogies with his later works. Research has revealed an artist who, following the stimulating, innovatory example of Spinello Aretino, sought to deepen and reinforce the somewhat antiquated tradition of Giotto and linear fantasy which characterized Florentine art at the end of the century. Tormented yet inspired by religious feelings, Lorenzo at first hesitated over his choice of figurative sources; Agnolo Gaddi's elegance of colour and line may be seen in the *Nobili Predella* (1387-8,

Lorenzo Monaco ▲
The Adoration of the Magi (1420–2)
Wood. 115 cm × 170 cm
Florence, Galleria degli Uffizi

Louvre) and in the *Altarpiece of S. Gaggio* (Florence, Accademia), and the severe monumentality of Andrea Orcagna in *The Agony in the Garden* (Florence, Accademia).

Lorenzo's taut draughtsmanship, the perfect vehicle for his troubled sensibility, acquired new rhythmic vitality from his contact with the Camaldolese school of miniaturists, as appears in his decoration of three manuscripts dated 1394, 1395 and 1396 (*Corali*, *5*, *8* and *1*, Florence, Laurenziana Library). The works that followed, including his only two documented paintings, the *Monte Oliveto Altarpiece* (finished in 1410, Uffizi) and *The Coronation of the Virgin* (1414, Uffizi), show a swift evolution, partly in reaction against the early works of Ghiberti and partly under the influence of the International Gothic style. The contorted line and the fantastic freedom of invention of the new figurative mode were cautiously incorporated into the *Altarpiece* (1404) for Empoli Cathedral and were later fully assimilated in two panels now in the Louvre, *Agony in the Garden* and *The Three Marys at the Sepulchre*, as well as in the Florence *Annunciation* (Accademia), completed in 1410.

The increasingly dramatic content of his inspiration led to a sort of heightened formality which reaches a climax in the *Coronation of the Virgin* mentioned above, and in the *Crucifixion* of the same year (Florence, Church of S. Giovannino dei Cavalieri). There is an intensely spiritual significance in the gentle, arched outlines of the elongated figures, the vividly contrasting colours, and the arbitrary interplay of light on the sinuous folds of fabrics. Added to this there is an attempt at psychological depth in the accentuated facial expressions. Gradually, religious meditation becomes reverie until, in compositions like the *Scenes from the Life of St Onophrius and St Nicholas of Bari* (Florence, Accademia) or the *Journey of the Three Kings* (drawing, Berlin-Dahlem), it is transformed into fairy-tale.

During the last phase of Lorenzo's activity his style gradually became calmer, while, at the same time, he began to experiment with plastic and spatial values. From *The Adoration of the Magi* (1420-2, Uffizi), in which he seeks to integrate a mass of figures into a sad, mysterious landscape, he moved on to the slightly forced monumentality of the frescoes of the Bartolini Chapel (Florence, Church of S. Trinità), and finally, in the panel of the *Annunciation* in the same building, to a quite unexpected delight in nature that reveals affinities with Gentile da Fabriano (who was in Florence in 1423). Lorenzo influenced,. either directly or indirectly, all those minor painters who, unaware of Masaccio's revolutionary innovations, kept the Gothic tradition alive in Florence. None of them, however, inherited his intimate power of mystical sincerity. G.R.C.

Lorenzo Veneziano

Italian painter
active Venice, 1357-72

The *Lion Polyptych* (Venice, Accademia), the first dated work (1357-9) by Lorenzo Veneziano, reveals an artist who was already formed. Before this time he had probably worked among the entourage of Paolo Veneziano (several works have been attributed to this early, undocumented,

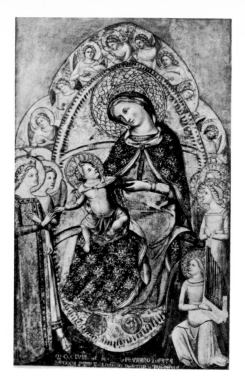

period) and may have made a trip to Verona around 1350. The *Lion Polyptych* (an *Annunciation* and numerous *Saints*) reveals an attempt to break free from the rigid, figurative Byzantine style, such as would have been derived from Paolo Veneziano, and to seek a more varied formal articulation. There is a tendency towards the Gothic and the unconventional, for Lorenzo was well aware of movements elsewhere in Europe, as well as of Bolognese realism. These courageous attempts single out Lorenzo as one of the innovators in Venetian painting during the second half of the trecento.

This urge to break with Byzantine art is also evident in *The Mystic Marriage of St Catherine* (1359, Venice, Accademia), with its sinuous rhythms, its lighter colours, and naturalistic atmosphere that brings to mind Tommaso da Modena. It is less pronounced in the polyptych (*The Death of the Virgin with Saints*) in Vicenza Cathedral (1366), which retains a generally Byzantine presentation, together with certain almost oriental stylistic elements, and in which aspirations towards a new style are limited to frail, rather precious, Gothic lines.

Gothic touches are mingled with the Byzantine in a later polyptych, now dismantled, which displayed, in the centre, *The Presentation of the Keys to St Peter* (1370, Venice, Correr Museum), and on the sides, four *Saints* (Berlin-Dahlem). However, the brilliant ,predella, also at Berlin-Dahlem (*Scenes from the Lives of St Peter and St Paul*), animated by a narrative freshness and acute observation of nature, reveals a new and original sensitivity. It bears witness to the assimilation of non-Italian influences and also confirms the close links existing with Bologna and Lorenzo's own presence in that city. (He is known to have painted, in 1368, a polyptych, now split up [two panels in Bologna, P.N.], for the Church of S. Giacomo in Bologna.)

In the polyptych of the *Annunciation* of 1371 (Venice, Accademia) the figures are painted with a more consistent physical density and are placed in a flowering meadow of the type beloved by the more precious exponents of the International Gothic. A new vigour and a more fantastic spirit appear in another triptych: *The Resurrection of*

Christ (Milan, Castello Sforzesco), *St Peter* (1371) and *St Mark* (Venice, Accademia).

During his last active period Lorenzo abandoned his former interests and confined himself to the search for subtle and graceful elegance, something he achieved particularly in the *Virgin and Child* (1372, Louvre). His Gothicism at this time is notable for its soft, refined images and for certain whimsical architectonic elements. The polyptych of *S. Maria della Celestia* (Brera), with the *Virgin and Child and Angels* surrounded by eight *Saints*, is complicated by the introduction of windows and pinnacles which, together with the tiny figures, form an infinitely precious decorative ensemble. With this final work Lorenzo Veneziano's style attained a Gothic dimension already imbued with the 'courtly' spirit which, as it brought to an end his career, opened up in Venice the new chapter of the International Gothic style. F.Z.B.

Lotto
Lorenzo

Italian painter
b.Venice, 1480 – d.Loreto, 1556

Although Lotto's career as an artist unfolded on the periphery of Venetian 15th-century painting, it nonetheless represents an important and fascinating chapter in the history of art. His work was closely linked with the vicissitudes of an unsettled life, spent largely away from Venice while the artist travelled to Rome, Bergamo and The Marches.

Lotto's unconventional personality became evident early on in the works he painted at Treviso between 1498 and 1508, so much so that it is not always easy to identify the sources of his inspiration. Between the two works now in Naples (Capodimonte), a *Madonna with St Peter Martyr* (1503) and the *Portrait of Bishop Bernardo de' Rossi* of 1505 (also the panel depicting an *Allegory* in the National Gallery, Washington), may be placed two fresco *Pages* from the Onigo monument (Treviso, Church of S. Niccolò).

In 1506 Lotto executed, for the first time, monumental altarpieces such as the *Madonna and Saints* for the Church of S. Cristina at Tivarone (near Treviso) and the *Assumption* for Asolo Cathedral (in S. Maria Assunta, near Treviso), following the *St Jerome* (Louvre), a subject to which he returned several times. In 1508, during his first period in The Marches, he painted the *Recanati Polyptych* (Recanati, Pin.) and the *Madonna with Two Saints* (Rome, Borghese Gal.).

All these works were the outcome of a formative period during which he was influenced first by Giovanni Bellini, then by Antonello da Messina (through the works of Vivarini) and then by Dürer (who was in Venice between 1505 and 1507). He remained unaffected by Giorgione and Titian, and developed a highly personal language, characterized by sharp, nervous forms and by a 'polyphonic' and anti-tonal range of colours.

His stay in Rome, during which he is recorded, in March 1508, as having executed works in the stanze of the Vatican (disappeared), was to result in a notable change of style towards a purely 16th-century manner. This development, which first appeared in paintings executed in The Marches (*Transfiguration*, Recanati, Pin.; *Entomb-*

▲ Lorenzo Veneziano
The Mystic Marriage of Saint Catherine (1359)
Wood. 95 cm × 58 cm
Venice, Galleria dell'Accademia

ment, 1512, Jesi, Pin.), became more evident in the first works that Lotto painted in Bergamo (the *S. Stefano Altarpiece*, 1516, now in the Church of S. Bartolomeo; predella at Bergamo, Accad. Carrara), where he arrived towards the end of 1512. There is an enrichment of form that reveals a broader grasp of space. To the Raphaelesque features were added, during this fruitful period in Bergamo, elements of the Lombard-Leonardesque style which increased Lotto's expressive potential (*Madonna*, 1518, Dresden, Gg), while a new use of light furthered his ability to convey pathos (*Christ Bidding Farewell to His Mother*, Berlin-Dahlem). He was developing, too, a growing interest in the painting of Altdorfer and of Grünewald.

Such varied sources of inspiration during this period – perhaps Lotto's best – did not detract from his own special brand of poetry: a very pure and luminous use of colour (*Altarpieces* at the churches of S. Bernardino and S. Spirito, 1521, Bergamo); the intimate, gentle atmosphere of the sacred scenes (1523, *The Mystic Marriage of St Catherine*, Bergamo, Accad. Carrara; *Nativity*, Washington, N.G.); the human quality of the portraits, deriving from their realism and psychological penetration (*Agostino and Niccolò della Torre*, 1515, London, N.G.; *Portrait of 'Messire' Marsilio and His Wife*, 1523, Prado); and, above all, the freshness of observation and visual sincerity. All these make Lotto an important precursor of Caravaggio. Added to all this is a narrative skill which, already evident in 1517 in *Susannah at the Bath* (Florence, Contini-Bonacossi Coll.), finds notable expression in 1524 in the frescoes for the Suardi Chapel at Trescore, Bergamo (*Scenes from the Life of St Barbara, St Catherine, St Mary Magdalene* and *St Clare*), paintings which are, in addition, freer, richer in invention and more popular in style.

After returning to Venice towards the end of 1525, Lotto continued to work for Bergamo, sending cartoons (now lost) for the marquetry of the Church of S. Maria Maggiore, a work which occupied him between 1524 and 1532, as well as devotional pieces for the various churches of the province (*Polyptych* for the Church of SS. Vincenzo e Alessandro, at Ponteranica, one of his most accessible works, rich in features reminiscent of Grünewald; the *Assumption* in the church at Celana, 1527). In Venice he lived with the Dominicans of SS. Giovanni e Paolo. The *Portrait of a Dominican*, full of sensitivity and gentleness (1526, Treviso Museum), possibly represents the Abbey's bursar, Master Marcantonio Luciani.

Lotto worked intensively, especially in the Marches where he periodically sent works for the churches (*Madonna and Child with St Joseph and St Jerome*, 1526; *Annunciation*, now in the Jesi Pin.). In Venice contact with the dominating figure of Titian did nothing to impair the profound independence of his vision; on the contrary, during the next few years his originality reached its highest point in such works as the *Annunciation* painted for the Church of S. Maria sopra Mercanti in Recanati, a curious interior scene treated in luminous style, *The Adoration of the Shepherds* (Brescia, Pin. Tosio Martinengo), and the *Altarpiece of St Nicholas in Glory* (1529, Venice, Church of the Carmini), in which the landscape, remarkable for its feeling for nature, both idyllic and dramatic, is one of Lotto's most successfully poetic works, but whose acid, clashing colours were not appreciated by his contemporaries in Venice.

Towards 1530 he was back in The Marches where, in 1531, he painted the *Crucifixion* for the Church of S. Maria in Telusiano, Monte San Giusto (near Fermo) and, in 1532, *St Lucy before the Judge* (Jesi, Pin.), another key work, full of novel invention and solutions, whose expressiveness is translated by a cold range of colours. Rich in lighting effects, it is a work which is particularly carefully executed in the very free narrative passages of the predella. During these years Lotto's portraits gained in psychological depth and in stylistic balance: *Portrait of a Young Man in his Studio* (Venice, Accademia); *Portrait of Andrea Odoni* (Hampton Court Royal Collection); and *Portrait of a Gentleman* (Rome, Borghese Gal.).

The last phase of Lotto's career reveals a deepening religious awareness but at the same time a diminished creative serenity which corresponds to the spiritual crisis that tormented the artist over the years. Lotto's notes in his account books, from 1538 until the year of his death, are valuable as evidence of the tribulations of a life soured by material privation, professional dissatisfaction and frequent displacements; they also shed light on his later paintings. After supposedly ending his stay in The Marches with the altarpiece of the *Madonna of the Rosary*, dated 1539 (Church of S. Domenico, Cingoli), Lotto returned to Venice in 1540 and two years later painted *The Distribution of St Anthony's Alms*, still full of life and powerful observation, for the Dominicans of SS. Giovanni e Paolo.

Between 1542 and 1545 Lotto stayed in Treviso with his friend Giovanni del Saon, then lived in various parts of Venice from 1545 until 1549. The portraits executed during the 1550s are distinguished by more faded colours and a play with shades that denote an awareness of the example of Titian: *Portrait of Febo da Brescia, Portrait of Laura da Pola, Portrait of an Elderly Gentleman with Gloves* (all Brera), and *Portrait of a Man with a Crossbow*

(Rome, Capitoline Gal.). This affinity with Titian, which is also evident in altarpieces such as the *Madonna and Saints* (formerly in the Church of S. Agostino at Ancona, now in the Church of S. Maria della Piazza, Ancona) and the *Assumption with Saints* (Mogliano Church, near Fermo), certainly painted in Venice, is characteristic of Lotto's last authenticated paintings.

After finally settling in The Marches in July 1549, tired and ill, he further exhausted himself by continuing to paint prolifically. The quality, however, was mediocre, with one exception: a *Presentation in the Temple*, painted in the Santa Casa of Loreto where, after being admitted as a lay brother, he died. In its reduced range of colour, and free-hand line, this, Lotto's last work, displays a degree of modernity that confirms the genius of an artist who was one of the most unusual and attractive to emerge from 16th-century Italy. F.Z.B.

Louis
Morris

American painter
b.Baltimore, 1912 – d.Washington, D.C., 1962

Louis attained fame and became influential only at the moment of his untimely death in 1962. He trained as an artist at the Maryland Institute between 1929 and 1933, and spent most of his life far from New York, the centre of artistic activity. Although his home was in Washington, D.C., he took part peripherally in the Abstract Expressionist movement, following the painting of Jackson Pollock with keen interest. Through his friendship with another Washington painter, Kenneth Noland, Louis met the influential critic Clement Greenberg on a trip to New York. Greenberg interested himself in Louis's work and arranged for it to be hung in 1954 at an exhibition entitled 'New Talent' which he was preparing for the Kootz Gallery.

Louis had already adapted the large-scale format of Abstract Expressionism, but his paintings around 1954 were made by staining the canvas with colour, so that hues overlapped in veils of lyrical beauty. He sought effects so strong, and an emotional intensity so unequivocal, that even the largest available scale was insufficient. He was thus led to create an image with no beginning or ending, an image that theoretically transcended physical size. It was a brilliant spectrum of pure colour that appeared to have its origin beyond

Lorenzo Lotto ▲
Apollo asleep, and the Muses
Canvas. 45 cm × 75 cm
Budapest, Szepmuvezeti Muzeum

Morris Louis ▲
Alpha pi (1961)
Canvas. 260 cm × 449 cm
New York, Metropolitan Museum, Arthur H. Hearn Fund

the edges of the canvas, and either swept through it or came to a sudden stop within the confines of the canvas. These vertical and diagonal 'stripe' paintings of his last years were seen as a genuine departure from the two dominant wings of Abstract Expressionist painting in the 1950s, 'gesture' and 'field' painting.

Together with these intense works Louis also executed numerous lyrical paintings where bands of colour, more hesitant, swept diagonally across the canvas from both upper corners, rolling off the edge at the bottom centre; these are known as the 'unfurled' paintings. Louis unwittingly became the inspiration for a school of painters, the 'Washington Colour Painters'. Besides Kenneth Noland, the work of Gene Davis and Thomas Downing is outstanding and appears to owe much to Louis's preoccupation with colour.

D.R. and J.P.M.

Lowry
Laurence Stephen

English painter
b.Manchester, 1887 – d.Mottram-in-Longdendale,
Cheshire,1976

Lowry attended school in Manchester and in 1904 joined a firm of chartered accountants as a clerk. From 1905 to 1915 he studied during his free time at the Municipal College of Art, Manchester, under Adolphe Valette who was an important influence on his early development as a painter. Lowry joined an insurance company in 1907, and two years later he moved to Pendlebury, in Salford, with his parents. In 1910 he became a rent collector and clerk with the Pall Mall Property Company in Manchester, for whom he worked until his retirement in 1952. The paintings of these early years, such as the portraits of his parents (Salford, Museum and Art Gal.), have,

however, little bearing on his mature style.

In 1915 Lowry began to take drawing and painting classes at the Salford School of Art (which he continued to attend, infrequently, until 1925), and about the same time he became interested in depicting the industrial environment in which he lived. Among the more distinctive pictures of this period are works such as *Coming from the Mill* (*c.*1917, Salford, Museum and Art Gal.) and *Manufacturing Town* (1922, private coll.). During the following years Lowry's paintings were shown at several open exhibitions in Manchester, as well as at the Paris Salon; and in 1930 *An Accident* was bought by the Manchester City Art Gallery.

Many of Lowry's industrial landscapes are a composite of reality and imagination; the artist himself sometimes referred to them as 'dreamscapes'. His stylized figures, usually small and anonymous, are simple and loosely structured, and are painted without shadows, which, Lowry pointed out, 'only mess up the composition'. By 1932, when he first exhibited at the Royal Academy, most of Lowry's paintings had these characteristics. They also frequently conveyed a sense of loneliness, which is particularly strong in pictures such as *The Empty House* (1932, Stoke-on-Trent, City Museum and Art Gal.). Two years later he became a member of the Royal Society of British Artists.

In 1939 a one-man exhibition at the Lefevre Gallery in London marked the beginning of a wider recognition for Lowry, which was consolidated by the purchase of *Dwellings, Ordsall Lane, Salford* by the Tate Gallery. He continued to paint in the same manner throughout the war, as can be seen in *Going to Work* (1943, London, Imperial War Museum). After the war he exhibited regularly with the Manchester Group from 1946 to 1951. He moved in 1948 to Mottram-in-Longdendale where he lived for the rest of his life.

In paintings like *The Cripples* (1949, Salford, Museum and Art Gal.) another aspect of Lowry's artistic personality can be seen: his fascination

with the grotesque, which sometimes found expression in bitterness and disillusion. On the whole, however, Lowry continued to work in his familiar style during the next two decades, exhibiting industrial scenes full of small bustling figures, as well as a number of desolate landscapes and seascapes. *The Mill – Early Morning* (1961, National Westminster Bank) and *The Notice Board* (1971, Manchester, the Manchester Club) are good examples of the work of his later years. He was elected to the Royal Academy as an Associate in 1955, and became a full Academician in 1962.

A solitary man, who largely painted at night after a full day's work, Lowry developed an intuitive talent that was nurtured by his simple life-style, but his apparent naïveté was quite deliberate. He viewed life in a detached manner, usually without much comment, although many paintings reveal his quiet melancholy. 'Had I not been lonely', the artist remarked. 'I should not have seen what I did.' His artistic style, like his life, unfolded clearly and uneventfully.

J.H.

Lucas van Leyden
(Lucas Hugensz)

Dutch painter
b.Leiden, 1489 or 1494 – d.Leiden, 1533

Born, according to Van Mander, 'with a pencil and engraving tool in his hand', Lucas van Leyden is, by virtue of the variety and range of his work, one of the foremost painters of the first half of the 16th century.

Son and pupil of Huygh Jacobsz, he entered the studio of Cornelis Engelbrechtsz in 1508 and began painting small-format genre pictures, such as *The Fortune-Teller* (Louvre). He was equally precocious as a graphic artist: in 1508 he engraved on copper *Mohammed and the Monk*, a skilfully organized work that makes full use of the contrasts between light and shade. His youthful works, such as *Potiphar's Wife* (Rotterdam, B.V.B.), are frequently small genre paintings with the figures depicted from the waist up. As for prints, in 1509 he executed a series of nine copper engravings representing the *Passion of Christ*, in which he made a study of poses and developed a taste for psychological analysis.

Lucas particularly enjoyed engraving on copper, but he also executed woodcuts. Between 1511 and 1515 he illustrated *The Garden of the Soul* and decorated the *Missale ad verum cathedralis ecclesiae Traiectensis ritum* with 42 vignettes representing the saints. The work was first published by Jan Seversz in Leiden. In 1513-14 he made a group of seven woodcuts which are known collectively as the 'great series on women' (*Adam and Eve, Samson and Delilah, Herodias's Feast, Virgil Suspended in a Basket, Solomon Adoring the Idols, The Queen of Sheba before Solomon, Aristotle and Phyllis*).

Parallel to these illustrations, he engraved in copper in 1510 the *Standard-Bearer*, inspired by the style of Dürer whose work he knew through prints, and in 1512 a series of five engravings recounting the *Story of Jacob*, in which the carefully executed composition and the complicated robes with their rumpled folds reveal the unmistakable influence of the Antwerp Mannerists. From the same period comes his series of 13 engravings representing *Christ and the Apostles*.

His career as an engraver continued with the *Triumph of Mordecai* (1515), *Esther before Ahasuerus* (1518), and *The Evangelists*.

In 1520 he began learning the technique of etching and executed the *Portrait of the Emperor Maximilian I*, an exact copy of Dürer's 1519 woodcut. All these works reveal his continued attempts to resolve certain problems of composition, movement and expression. For him, anything served as a pretext for depicting genre scenes, even if the subject came from the Old or New Testaments. *The Betrothed* (*c*.1519, Strasbourg Museum) and the *Portrait of a Woman* (*c*.1520, Rotterdam, B.V.B.) are among the rare paintings he executed at this time.

In 1521, while Lucas was in Antwerp, he met Dürer who executed his portrait in silverpoint (Lille Museum). Even before 1521 Lucas had known Dürer's work and admired it and the meeting in Antwerp allowed the two men to exchange ideas. In 1521 Lucas engraved on copper a series of 14 prints known as the *Little Passion*, inspired by the suite executed by Dürer between 1507 and 1513.

Back in Leiden, Lucas abandoned engraving to some extent in order to concentrate on painting. His diptych of the *Virgin and Child and Mary Magdalene* (Munich, Alte Pin.) dates from 1522 and reveals the artist's interest in landscape. Next came the triptych of the *Adoration of the Golden Calf* (Rijksmuseum), a work of the most refined colouring, peopled with a skilfully organized throng of figures. A masterpiece of pictorial Mannerism, the painting succeeds in realizing all the promises inherent in the art of Lucas's master Engelbrechtsz. After 1526 Lucas became interested in nudes: in 1529 he engraved six plates drawn from the *Story of Adam and Eve*, influenced by

Marcantonio Raimondi and others devoted to mythological subjects (*Venus and Cupid*, 1528, Rijksmuseum).

Lucas's masterpiece is the famous triptych of the *Last Judgement* (1526–7, Leiden Museum), a devotional painting executed in memory of Claes Dirck van Swieten for the Church of St Peter in Leiden, and carefully preserved from the 16th-century iconoclasts by the people of Leiden themselves, who quickly became aware of the exceptional interest of this altarpiece. *Heaven* (with, on the reverse, *St Peter*) and *Hell* (with *St Paul* on the reverse) frame the *Last Judgement*, painted in beautiful, rich, pale, colours, lightened by large areas of white light. The central scene, which is carried over on to the wings, involves relatively few figures, but Lucas studied them particularly carefully and paid great attention to the links between the groups by making play with the difference between the pale bodies and the dark ground.

An artist of international reputation, much praised by Vasari as the worthy rival of Dürer, Lucas van Leyden was better known as a graphic artist than as a painter. Relatively few of his paintings survive, but the ease and assurance of his brushwork, the strident and deliberately unrealistic colours, the precision and acuity of the genre scenes reveal one of the earliest realists in the modern sense of the word. However outnumbered by his engravings, these are works to command attention in their own right. A brilliant technician and precocious artist, Lucas was always highly sensitive and receptive to new ideas while retaining his originality. He opened up his own particular path between the Gothic and the Renaissance and only his premature death prevented him from exploring it to the full. J.V.

Luini
Bernardino

Italian painter
b.Luino (?), c.1485 – d.Milan (?), 1532

Luini's training and early works are still a matter for dispute. It has been suggested that early on he may have visited Florence and Rome, and there met Raphael whose *Entombment of Christ* (Rome, Gal. Borghese) he copied; but the attribution of the copy to Luini has yet to be confirmed (Venice, private coll.). Equally, the authorship of the *Madonna and Child with Saints*, in the Musée Jacquemart-André in Paris, dated 1507 and signed 'Bernardinus Mediolanensis', is still open to question. Only the fresco of the *Virgin with Saints*, painted at Chiaravalle Abbey in 1512 in the Lombardy tradition of Foppa and Bergognone, and including certain traces of the *sfumato* of Leonardo

da Vinci, can provide a definite starting point.

Luini was a prolific painter whose ample plastic rhythms are derived from Bramantino. His best work was done in Milan: the great cycles of frescoes in the chapel of Corpus Domini in the Church of S. Giorgio al Palazzo (1516), in the chapel of S. Giuseppe in the Church of S. Maria della Pace (re-erected at the Brera), in the Villa Rabbia alla Pelucca (Brera; Louvre; Chantilly, Musée Condé), in the Palazzo Rabbia in Milan (divided between the Bode Museum in East Berlin and the National Gallery, Washington), in the Oratory of Greco Milanese (Louvre), and in the Besozzi Chapel at the Church of S. Maurizio, his masterpiece, on which he worked until 1530.

At the same time Luini painted a large number of rather sentimental *Virgins* (Louvre; Hermitage; Brera; London, Wallace Coll.; Naples, Capodimonte), to which he owes the fame accorded him by the 19th-century Romantics. Though following the style of Leonardo with considerable *sfumato* effects, these works are marked particularly by the art of Solario. Among the best are: the *Deposition* in the Church of S. Maria della Passione in Milan; the Brera *Annunciation*; the *Pietà* (1516) of the Church of S. Giorgio al Palazzo, Milan; *St Jerome* (Milan, Poldi-Pezzoli Museum); the *Polyptych* (1523) of the Church of S. Magno at Legnano; and the *Torriani Polyptych* (formerly in Turin, Di Rovasenda Coll.; predella, Los Angeles, Norton Simon Foundation). Luini's more monumental and rational late style is represented by the frescoes of the Church of S. Maria degli Angeli in Lugano (1529-30) and those in the sanctuary at Saronno (1525-32) which clearly reveal an affinity with the art of Gaudenzio Ferrari. M.R.

MacDonald
James Edward Harvey

Canadian painter
b.Co. Durham, 1873 – d. Toronto, 1932

At the age of 14, in 1887, MacDonald emigrated to Canada from England with his family. Two years later he was an apprentice at the Toronto Lithography Co., while attending Saturday classes at the Central Ontario School of Art and Design. William Morris and English Art Nouveau were two early influences on MacDonald's design work. He was able to see examples of Art Nouveau in the English periodical *The Studio*, which first appeared in 1893. This influence can be seen in his early book cover designs from around 1900. The appeal of English design took MacDonald back to England in 1903, and he remained there until 1907 working as a designer for Carlton Studios. Being able to see painting exhibitions, such as the important Impressionist exhibition at the Grafton Galleries in 1905, must have been a considerable stimulus, for he returned to Canada determined to be a full-time painter. However, financial necessity forced him to work as an illustrator for *The Grip* until 1911, after which he was able to survive as a freelance designer and realize his ambition.

In 1910 MacDonald visited the remote Georgian Bay area of the Canadian North, and the light and landscape impressed him so deeply that he set out to convey this atmosphere in paintings that would appear uniquely Canadian. *Tracks and*

Traffic (1912) is an early urban landscape showing the railway yards and gas storage tanks on the Toronto lakefront. In spite of the bleakness of the winter scene, by using a palette knife to build up a surface of mauve, yellow and orange against the white of the snow, MacDonald succeeds in conveying an effect of light and colour.

In January 1913 MacDonald visited Buffalo to see an exhibition of Scandinavian art, in the company of the painter Lauren Harris. The work he saw there made a deep impression; he particularly liked the way Art Nouveau designs had been adapted to depict the Scandinavian landscape. The effect of this experience is seen in *The Tangled Garden* (1916), which shows the back of the artist's house in North Toronto. The distinct linear stylization of the sunflowers, which were a characteristic feature of English Art Nouveau, gives a strong definition to the foreground, while the garden behind dissolves in a profusion of simple masses of rich colour. By using two different styles for the two areas of the garden the painter creates a sense of space and distance. It is an attempt to suggest pattern, texture and colour in landscape, with a strong emphasis on design.

From 1918 to 1920 MacDonald made an annual autumn visit to Algoma with Lauren Harris and A.Y. Jackson. The brilliant colours of the autumn foliage, the clear light and the linear rocky formations of the rolling hills provided him with the effect he had been seeking. Each time he made countless sketches and then returned to Toronto in the winter months to work these sketches into large paintings. *Leaves in the Brook* (1919) reflects the bold and demanding quality of this landscape. The colour is bright and intense, and the shapes of the rocks and the running brook form swirling curves across the picture surface. In *Forest Wilderness* (1921) the rock formations of the hills and the forest in the valley are also depicted in this stylized way. In all of these paintings there is a strong emphasis on the horizontal parallel picture planes, which are broken only by gentle diagonals of natural details in the landscape.

With the Algoma landscapes MacDonald made a significant contribution to a distinctively Canadian style of painting. He shared this achievement with seven painters known as 'The Group of Seven' who came together in 1920 with the hope of gaining recognition for their work, which was being ignored in conservative art circles in Toronto. Lauren Harris and A.Y. Jackson were also members of the group.

In 1921 MacDonald joined the teaching staff of the Ontario College of Art. Until his death in 1932 he continued to seek the basic monumental structure and repetitive shapes in nature and extended his travels from Northern Ontario and Quebec to Nova Scotia and the Rocky Mountains in British Columbia in search of new landscapes.
 A.G.

Macke
August

German painter
b.Meschede, 1887 – d. Western Front, 1914

Macke's childhood was spent first in Cologne, then in Bonn. Between 1904 and 1906 he attended the Düsseldorf Academy of Fine Art and the School of Decorative Arts. He made his first visit to Paris in 1907 and subsequently became Corinth's pupil in Berlin (1907-8) where he met Bernard Koehler, the uncle of his future wife and a collector with an interest in French painting. It was on his advice that Macke returned to Paris in 1908. Back in Bonn after a year's military service (1909) he made the acquaintance of Marc (January 1910) who introduced him to Kandinsky in Munich. Macke joined the ranks of the Blaue Reiter and his contact with older painters, whose work was already well advanced, hastened his own artistic development.

His first works were in a modified impressionistic and realistic style, but he learnt from his study of Matisse (who had an exhibition in Munich in 1910) to give dabs of colour their own autonomy, in such a way as to express form (*Tablecloth with Hyacinths*, 1910, private coll.). *The*

▲ James MacDonald
The Tangled Garden (1916)
Board. 122 cm × 152 cm
Ottawa, National Gallery of Canada

Chemin de fer (The Railway) (1873, Washington, N.G.), En Bateau (On the River) (1874, Metropolitan Museum) and Argenteuil (1874, Tournai Museum). But in 1874, when his friends decided to exhibit together, Manet withdrew, leaving Monet as the group's most important figure. Influenced by Zola's Naturalism (he had painted the author's Portrait in 1868; Louvre, Jeu de Paume), and by Maupassant, he executed a series of canvases: Nana (1877, Hamburg Museum); La Serveuse de bocks [The Waitress] (1878, London, N.G.); Chez le Père Lathuile (At Old Lathuile's) (1879, Tournai Museum); Dans la serre (In the Conservatory) (1879, Berlin, N.G.) and Le Bar des Folies-Bergère (1881, London, Courtauld Inst. Gal.) in which the expression of visual sensation is pushed to its limits. In some of these works it is possible to speak of the abolition of the subject, so brilliantly improvised is the treatment of faces and atmosphere.

In Le Bar des Folies-Bergère exhibited at the 1882 Salon, he succeeded in capturing, not without a touch of melancholy, the charm of life in Montmartre, to which he had long been attached. By now, in fact, he was confined to his house in Rueil, ill, painting views of his garden (Berlin, N.G.) or still lifes with flowers. He received a succession of visits from women friends whose sharply detailed portraits he drew in pastels (Louvre; Dijon Museum; Washington, N.G.). He died after an operation on 30th April 1883.

Towards the end of his life Manet had become a friend of Mallarmé. He illustrated a number of his works, notably his translation of Poe's The Raven and his more important poems, such as L'Après-midi d'un faune. He also painted his Portrait (1876, Louvre, Jeu de Paume) which, though small in format, ranks among his greatest masterpieces. J.La.

Mantegna
Andrea

Italian painter
b.Isola di Carturo, near Vicenza, 1430/1 –
d.Mantua, 1506

Ever since the 16th century critics have praised Mantegna for his masterly draughtsmanship, his truthful naturalism, his technical ability, his study of colour and, above all, his astonishing foreshortening. These virtues place him among the group of highly skilled artists who, during the Renaissance, attempted to express nature in terms of perspective, and space by the use of clearly defined volumes.

Padua. Mantegna is mentioned for the first time in 1441 in documents in Padua as apprentice and adoptive son of the painter Francesco Squarcione with whom he travelled to Venice in 1447, but whose excessive tutelage he soon threw off. An altarpiece (destroyed in the 17th century) for the Church of S. Sofia, Padua appears to have been Mantegna's first signed and dated work, executed in 1448 when he was 17. After a visit to Ferrara the following year, he established his reputation with the decoration of the Ovetari chapel in the Eremitani Church in Padua, where he continued to work until 1456.

During this period his importance grew as one by one other painters – Giovanni D'Alemagna, Antonio Vivarini and Pizzolo, his close collaborator – died or left the city. Mantegna's mastery asserted itself in his *Scenes from the Lives of St Christopher and St James*, impressive for its hard, taut style, the power of the drawing and for

▲ Édouard Manet
Le Bar des Folies-Bergère (1881)
Canvas. 96cm × 130cm
London, Courtauld Institute Galleries

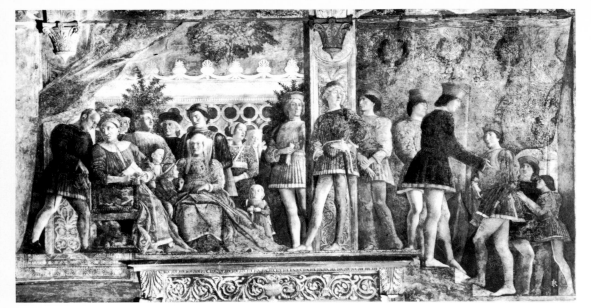

the imaginative use of perspective. Unfortunately, this work was almost completely destroyed during the Second World War: only the *Assumption*, *The Martyrdom* and the *Bearing of the Body of St Christopher* remain more or less intact. In 1453 he received a commission for the Church of S. Giustina of Padua for a *Polyptych of St Luke* (Brera), a work still in the Late Gothic tradition which he had learnt from Antonio Vivarini.

The following year he put his name to a *St Euphemia* (Naples, Capodimonte), which prefigures the *Altarpiece of S. Zeno* (Verona), the masterpiece of his early period, commissioned in 1456 but not finished until after 1460. Mantegna executed this ensemble consisting of six panels in a frame carved in the form of an aedicule. The artist designed the aedicule himself and drew inspiration from the work of Donatello who had executed a sculptural altar for the Church of S. Antonio in Padua. The *Virgin and Child* surrounded by groups of *Saints* is conserved *in situ*; the three paintings from the predella have been replaced by copies; the *Crucifixion* is now in the Louvre, and the *Agony in the Garden* and the *Resurrection* are in Tours Museum. The whole possesses a remarkable unity, the architectural features and the sculpted motifs forming a homogeneous ensemble. Mantegna had a window to the right of the building specially opened, in order to allow this real source of light to be lined with the supposed lighting of the painting, which was positioned on the main altar.

Mantua. In 1453, through his marriage to Nicolosia Bellini, the daughter of Jacopo and sister of Gentile and of Giovanni, the painter had become a member of the most powerful family of painters in Venice. And when, in 1456, Lodovico Gonzaga first wrote to him asking him to enter his service, he was addressing himself to a well-established and financially secure artist. Mantegna's move to Mantua in 1459 marked a decisive stage in his career and he remained official painter to the Mantuan court until his death.

His early Mantuan works are not well known. His *St Sebastian* (Vienna, K.M.) is often attributed to this period. It is signed in Greek and reveals a preoccupation with space and perspective, with its checkerboard floor, an echo of Piero della Francesca. The Italian art historian Longhi places the painting later, from around 1470. Some critics have seen in the 'triptych' of the Uffizi (*Ascension*, *Adoration of the Magi*, *Circumcision*), which is an

assembly of different works, the vestiges of a work much admired by Vasari in this chapel when he travelled to Mantua in 1565 and which is supposed to correspond to a work mentioned in 1464. In 1463 and 1464 Mantegna directed the building works at the ducal residences of Cavriana and Goito. He was at that time in close contact with the humanists, particularly Felice Feliciano. It was during this period that the curious archaeological journey to Lake Garda took place, the aim of which was to look for inscriptions and remains from antiquity, something which is highly revealing of Mantegna's interests.

Two short stays in Tuscany are documented in 1466 and 1467 at which time the *Uffizi Triptych* may have been executed for a member of the Medici family. The most important work to emerge from this confused period is the *Camera degli Sposi* (*The Bridal Chamber*), of the Ducal Palace at Mantua, the theme of which is the glorification of the reigning family. The decoration of the room was conceived in the form of a pavilion in which the ceiling, in *trompe-l'oeil*, appears open to the sky. Around the walls are scenes of courtly life, framed by heavy tapestries. It is thought that the work, which was finished by 1474, took between four and ten years to paint. Mantegna brought to this masterpiece an entirely new decorative system, which had nothing in common with his Tuscan predecessors and foreshadowed the kind of illusionist perspective which was to impress Bramante, Correggio and Leonardo. Like similar contemporary cycles from northern Italy (Ferrara, Schifanoia Palace), group portraits and other paintings celebrate life at the palace, but in a coherent setting, complete with pilasters and antique-style medallions. What is created is an illusionist decor taking in the entire room. It is dominated by the astonishing *trompe-l'oeil* ceiling showing a circular balcony with figures leaning over it, a theme which was later to prove very popular.

Between 1480 and 1490 Mantegna, now directing a busy studio, executed a variety of works under the patronage of the Gonzagas, including tapestry cartoons, *cassoni* (marriage chests) and designs for gold and silver ware. Of the paintings from this period, foreshortened *Dead Christ* (Brera) may originally have been in the Mazarin gallery in Rome. Other works from this period include a *St Sebastian*, donated to the church of Aigueperse on the occasion of the marriage of a member of the Bourbons (1481, Louvre); several

portraits; *The Madonna with Angels* (Brera), and *The Presentation in the Temple* (Berlin-Dahlem), in which the similarities between Mantegna and Giovanni Bellini become much more obvious. Some are painted with an attention to detail which highlights the most subtle effects of light: *The Virgin of the Stonecutters* (Uffizi), the *Christ on a Tomb Supported by Two Angels* (Copenhagen, S.M.f.K.).

The series of nine great canvases representing the *Triumph of Caesar* (Hampton Court) illustrates the last phase of Mantegna's art. These are masterpieces in the mythological style, unusually decorative. Instead of his normal range of austere colours, the artist here opted for a rich variety, admirably served by the sureness of the draughtsmanship. In 1492, when the series was not yet finished, engravings of it were already being sold. The work was purchased by Charles I in the 17th century.

Last Period. In 1489 Mantegna travelled to Rome where he worked for Pope Innocent VIII on the decoration of the little chapel of the Belvedere, which has now disappeared. Back in Mantua in 1490 he was commissioned by the new rulers, Francesco and Isabella d'Este, to produce a number of works: the decoration of their new residence at Marmirolo; *The Madonna of Victory* (1496), which commemorated the victory of the Duke over the French at Fornova; the *Trivulzio Madonna* (1497, Milan, Castello Sforzesco), harmonious in composition but also revealing a certain technical weakness.

This last period also saw the decoration of the studiolo, a small room situated in one of the towers of the palace for which Isabella wished to collect paintings by the best living Italian artists. Preceding Perugino and Lorenzo Costa, Mantegna executed the *Parnassus* commissioned in 1496 and hung in position in 1497, *The Triumph of Virtue*, positioned opposite the *Parnassus* in 1502, and *Comus*, finished by Costa. All three were transferred to the Louvre after being acquired by Cardinal Richelieu before 1630.

Of greater significance are the admirable monochromes on biblical subjects in simulated bas-relief dating from the years 1490-1500 (Cincinatti Museum; Dublin, N.G.; Vienna, K.M.; Louvre; London, N.G.). Mantegna treated these with astonishing precision and care and showed his complete accord with Renaissance thinking; he created a language for the myths of antiquity, his dry, hard forms producing a clarity and balance that are wholly classical. Among the best of his last compositions are the *Sacra Conversazione* (Dresden, Gg) and *The Virgin and Child between St John and St Mary Magdalene* (London, N.G.).

Style and influence. Although Mantegna's art appears to have its roots deeply embedded in the love for antiquities of his master in Padua, Squarcione, the presence in Padua between 1430 and 1460 of Tuscan artists such as Andrea del Castagno, Uccello, Filippo Lippi and Donatello played a crucial role in his development. Piero della Francesca travelled to Ferrara in 1449 and the *St Luke Polyptych* seems, with its fresh colours, to suggest a meeting between the two artists. In Ferrara, Mantegna also came into contact with the painting of Rogier van der Weyden.

Then it was the turn of the Venetians: the notebooks of drawings left by Jacopo Bellini must certainly have influenced the young Mantegna, while his exchange with Giovanni Bellini led to a

 Andrea Mantegna
The Family and Court of the Duke of Mantua
Fresco from the Camera degli Sposi
Mantua, Palazzo Ducale

softening of his art. In Mantua too, Mantegna found a climate of archaeological erudition, and his journeys to Tuscany may have given him an interest in the engravings of Benozzo Gozzoli. He was probably too deeply entrenched in his personal vision of antiquity to be much affected by his first contact with Rome. This seems to be supported by the stylistic unity of the series of the *Triumph of Caesar*, executed both before and after his visit to the city. Towards the end of his life, Mantegna seems to have become more withdrawn, and to have taken no account of the new generation of Leonardo da Vinci, Giorgione, Michelangelo and Raphael.

Though important, Mantegna's pictorial activity is difficult to define because of the disappearance of several decorative cycles, and the poor state of preservation of some of his easel paintings. As for his graphic output, this was a field in which Mantegna excelled and in which he was often more sincere than in his more formal pieces. During the 18th century, some 50 engravings were attributed to him but today only seven are known, of which six are mentioned by Vasari: two *Bacchanals*, two parts of a *Battle of the Sea-Gods* (c.1470), a *Deposition*, a *Madonna and Child* similar to the painting in the Poldi-Pezzoli Museum in Milan (c.1475), and *Christ Resurrected between St Andrew and St Longinus* (c.1488). Among Mantegna's noblest works is a drawing of *Judith* (Uffizi, 1491), which belonged to Vasari.

Mantegna was a solitary figure who defies classification. His paintings are often solemn, cold and cerebral, with an intellectual tension that is rarely relaxed, but they are often full of a tragic power. More than any other painter, he influenced the art of northern Italy, from Padua, to Venice to Ferrara and even as far as The Marches. On the level of pictorial technique he was a pioneer: his *St Euphemia* (1454) is the earliest-known Italian work of art to be painted on canvas. Vasari noted that Mantegna's great experience of working on canvas enabled him to produce the series of the *Triumph of Caesar* in this medium rather than as a fresco. Finally, it was largely through his engravings that the Italian Renaissance reached Germany. C.M.G.

Manuel Deutsch
Niklaus

Swiss painter
b.Bern, 1484 – d.Bern, 1530

Deutsch's father, Emmanuel Allemann, was an apothecary from Chieri in Piedmont, and it was his Christian name that Deutsch adopted as his own surname following his marriage in 1509 to Katarina Frisching. He retained the German rendering of his name only for the composition of his monogram: a dagger surmounted by the initials 'NMD'. Elected to the Swiss Council in 1512, he spent several years in Italy with mercenary troops. On his return to Bern he indulged in a period of prodigious creative activity before rejoining the army of Albrecht von Stein in 1522. Wounded in the hand during the siege of Novara, he was present at the defeat of La Bicoque and returned to Switzerland for good. After being appointed a magistrate in Cerlier in 1523, he became increasingly involved in political, diplomatic and religious disputes and painted less

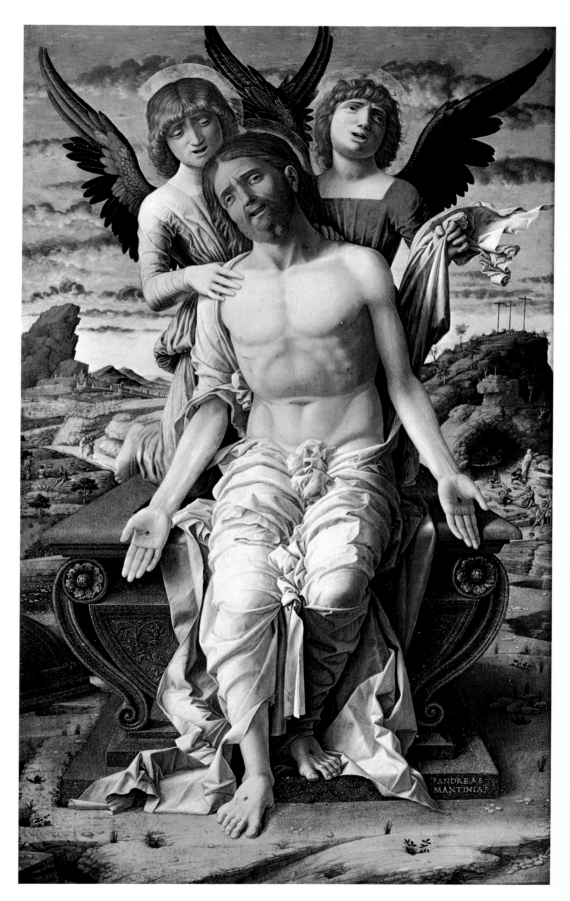

▲ Andrea Mantegna
Christ on a Tomb Supported by Two Angels
Wood. 83 cm × 51 cm
Copenhagen, Statens Museum for Kunst

and less. In 1528 he was elected to the Inner Council.

Nothing is known about how or where he was trained, but his artistic education appears to have been perfunctory. Around 1508 he executed the first of his works to have survived: a few drawings and paintings on glass on martial themes in the style of Urs Graf (mainly in Basel Museum). During his early years, financial hardship forced him to accept commissions indiscriminately, notably the painting on the vault of the choir of Bern Cathedral and the famous *Dance of Death* for the Dominican monastery, which we know only through poor copies by Albrecht Kauw (1649, Bern, Historical Museum). These works, executed around 1515-16, paved the way for the most prolific phase of his brief artistic career.

Poetic, inventive and sensitive, he suffered from his lack of training and never developed a true artistic independence. His style was heterogeneous, developed from a multiplicity of experiments in technique, materials and subject matter. He made his first attempts under the shadow of Hans Fries's Gothic expressionism (*St Luke Painting the Virgin* with, on the reverse, *The Birth of the Virgin*, Bern Museum). Composition, colours, treatment and space are all derived from Fries but, instead of the traditional sculpted decor, Deutsch introduced motifs gleaned from Italy such as cupids, winged heads and garlands, and was thus, to some extent at least, an innovator.

As with Hans Leu, landscape took on a greater importance over the years. A work such as *Pyramus and Thisbe* (Basel Museum) mixes realism and fantasy in an impressionist vision that is more atmospheric than topographical and is important in that it is painted on canvas. Elsewhere,

the painter's lack of skill in rendering perspective gives his works the appearance of tapestries, as in the *Judgement of Paris* (Basel Museum), in which the decor of sombre foliage, painted without depth, serves to push back the coloured figures in the foreground. Deutsch's masterpiece is a *Beheading of St John the Baptist* (c.1520, Basel Museum). A wild nocturnal setting, pierced by flashes of lightning, echoes the dramatic intensity of the action, while the work as a whole has a spirituality reminiscent of Dürer or Grünewald.

His drawings, influenced first by Dürer then by Baldung, are very important, especially those in silverpoint in the sketchbooks now in Basel Museum. They include drawings on religious and Renaissance themes, as well as of ordinary people, soldiers and landscapes sketched from life with great freedom and biting humour, sometimes evocative of the careless calligraphy of Urs Graf. Of Deutsch's wood-engravings, only one series of illustrations on the theme of the parable of the *Wise and Foolish Virgins* (c.1518, Basel Museum) has survived.

Around 1522 Deutsch gave up painting in order to become a popular poet and propagandist for the Reformation. He wrote a morality play, *The Pope and his Clergy*, which was performed in 1522, and in the same year, produced a satire *Richard Malice, Seller of Indulgences*. Protestant iconoclasm undoubtedly influenced his decision to stop painting but at the same time plunged this fervent proselyte into a certain confusion, as is suggested by the title of his *Complaint of the Poor Idols Thrown out of the Churches and Chapels and Burnt*, the expression of one of the many contradictions which were apparently inherent in this era of violence and poetry. B.Z.

Maratta spent most of his life in Rome where he entered the studio of Andrea Sacchi while still a young man, remaining there until the painter's death in 1661. With the exception of two visits to The Marches in 1650 and 1672, he lived in the city until his death. Until about 1650 he continued under Sacchi's influence, as can be seen in the two frescoes of the Church of S. Giovanni in Fonte in Rome, painted after cartoons by Sacchi (1648) and in the *Monterotondo Altarpiece*. A later painting for the church of Camerano, however, shows a return to earlier sources, notably to the preciosity of Albani and the vibrant colours of Titian.

In 1650 he established his reputation with *The Adoration of the Shepherds* (Rome, Church of S. Giuseppe dei Falegnani). In the passage from an essentially pictorial and colouristic vision towards a more linear and intellectual concept is clearly visible and abstract reflexes are substituted for creative vigour. This was the result of the exchange of ideas that went on in Sacchi's studios where Bellori and Poussin also met.

But this idealizing tendency did not prevent Maratta, between 1654 and 1666, from using the Baroque language of Lanfranco in his frescoes for the Church of S. Isidoro Agricola in Rome: a *Nativity* and *Flight into Egypt* in the Capella di S. Giuseppe (1653-55); *The Triumph of the Cross, The Crowning with Thorns* and *The Agony in the Garden* in the Capella di Crocefisso (1657). The same tendencies appear, too, in the altarpiece painted for the Barberini family in 1660: *S. Rosalia among the Plague Victims* (Florence, Corsini Coll.).

As a disciple of Bellori he would not wholly abandon himself to the Baroque, but at the same time he was drawn, through Lanfranco, towards the greater sensitivity and lyricism expressed in a diffused chiaroscuro derived from Correggio. It was at this time that he produced two of his finest works, *The Virgin and Child with S. Francesca Romana* (1656, Ascoli Piceno, church of S. Angelo Magno) and *St Augustine* (1655, Rome, Church of S. Maria dei Sette Dolori), and also began work on the series of the *Apostles* for Cardinal Barberini.

After the death of Sacchi, Maratta became more open to such Baroque stylistic devices as foreshortening and diagonals, and, under the influence of Pietro da Cortona, modified the pathos evident in the S. Isidoro compositions to move towards a more colourful and decorative mode. This, in any case, was called for by the nature of his commissions, which included a number from Pope Alexander VII for large-format works: the *Nativity* in the Quirinal (1657), the *Visitation* at the Church of S. Maria della Pace and, later, the paintings for Siena Cathedral (1661-4), *St Bernard and Victor IV* (1656-8, Rome, Church of S. Croce in Gerusalemme) and *Augustus Making a Sacrifice to Peace* (1661, Lille Museum) for Louis XIV's secretary of state. At this time, too, Maratta began to paint secular subjects (*Summer*, 1659, Ariccia, Palazzo Chigi), which were to become more numerous towards the end of his life.

Maratta's synthesis of past and present, his linking of Raphael, the Carracci, Lanfranco and Pietro da Cortona turned him into one of the

foremost painters in Rome, making it impossible for anyone to follow the Baroque tendencies of Gaulli after 1670. His huge output dominated Roman art at the end of the 17th and the beginning of the 18th centuries: altarpieces in Rome (*Death of St Francis Xavier* at the Gesù; a gigantic *Madonna* in the Vatican: *The Virgin and Child between St Charles Borromeo and St Ignatius*, 1685, Church of S. Maria in Vallicella) and elsewhere (*The Immaculate Conception*, 1664, Ancona, Church of S. Agostino); fresco decorations (ceiling, the *Triumph of Clemency*, Rome, Palazzo Altieri, c.1676); cartoons for St Peter's (1677-89) and for Urbino Cathedral (after 1707); secular decorations (*Birth of Venus*, 1680, Frascati, Villa Falconieri; *Apollo and Daphne*, Brussels, M.A.A.; *Romulus and Remus*, 1692, Potsdam, Sans-Souci).

There was a constant trend towards a more intellectual form of art, from which all lyricism had been banished, and a predilection for colour, visible in *The Death of the Virgin* (Rome, Villa Albani), a new version of the theme already treated by Sacchi and not without reference to Poussin's *Death of Germanicus*. Elsewhere in his secular compositions, Maratta alternated between gracefulness and a coldness that prefigured Chiari and Mengs, and at the same time allowed an important role to landscape, sometimes borrowing from Dughet (*Diana and Actaeon*, Chatsworth, Duke of Devonshire's Coll.).

Nor should it be forgotten that Maratta was one of the greatest portraitists of 17th-century Italy. After starting in naturalistic vein (*Portrait of Fra Luca Wadding*, known from an engraving) he developed a somewhat aristocratic formula, exemplified by the refinement (reminiscent of Van Dyck) of the *Portrait of Maria Maddalena Rospigliosi* (Louvre). Many foreshadowed Rigaud and Largillière in their theatricality, such as the portraits of *Cardinal Cybo* (before 1650, Marseilles Museum) or *Pope Clement IX* (Vatican). Together with his *Self-Portrait* (c.1675, Brussels, M.A.A.), they give a foretaste of the partly historical, partly allegorical and worldly portrait which was to be all the rage in Regency France.

The S. Fernando Academy in Madrid and the Düsseldorf Kunstmuseum each house a large collection of Maratta's drawings. S.De.

Marc
Franz
German painter
b.Munich, 1880 – d.Verdun, 1916

Marc was a student at the Munich Academy between 1900 and 1903, the year when he first spent some months in Paris. In 1906 he travelled to Greece before returning to Paris in 1907. At this time he was strongly influenced by Van Gogh and was painting figures and studies of landscapes and animals in thick impasto and a range of pale colours (the *Haystacks*, 1909, Münster Museum). His interest in animals (horses and deer in particular) dates from the drawings he made in 1905 and was reinforced by sketches made in the Berlin Zoo and by his friendship with the Swiss animal expert Jean Nietslé. Marc himself, in 1908, explained in a letter to Reinhart Piper that he chose animals as his subject-matter because of their immediate reference to the pantheistic communion with nature that he sought.

His meeting with Kandinsky and his joining (1911) the New Association of Artists in Munich freed him from the constraints of realism. After 1909 Marc spent the summers in Sindelsdorf, in the Bavarian Alps, where he worked on large, vividly coloured landscapes with horses. Red and blue, the dominant colours in these compositions, had clear symbolic overtones for the artist, blue signifying virility, and red, passion. The bold curves of the settings recall the Jugendstil, but rejuvenated through a study of the work of Kandinsky (*Horse in a Landscape*, 1910, Essen, Folkwang Museum; *Small Yellow Horses*, 1912, Stuttgart, Staatsgal.). With Kandinsky, Marc was the founder and one of the leading lights of the Blaue Reiter, and was caught up in the rapid developments of the movement, although these affected only the form, not the spirit of his work.

The decorative lyricism of Marc's earlier compositions with figures (*Two Nudes in an Arcadian Landscape*, 1911, Düsseldorf, K.M.) disappeared after 1912, the year in which he discovered Cubism and Futurism while on a visit to Delaunay in Paris. He abandoned the arabesque in favour of a more analytical draughtsmanship characterized by broken lines (*The Tiger*, 1912, Munich, Städtische Gal.). Futurism showed him a new way of suggesting movement by situating objects within strong oblique lines (*In the Rain*, 1912, Munich, Städtische Gal.).

Marc also retained a great deal from Delaunay, and developed a new synthesis, a calmer and more lyrical style in which colour is spread methodically across planes of equal value, so as to compose themes that can still be read figuratively (*Deer in the Forest II*, 1913-14, Karlsruhe Museum). But his *Little Composition I* (1913, Bern, private coll.), is devoid of all figurative allusion and is more precise in its reference, more dynamic in style, with its Delaunay-type 'windows'. It foreshadows the *Battling Forms* (1914, Munich, Neue Pin.), a violent mixture of contrasting colours which, painted just before the outbreak of war, betrays a disquiet that was not normally part of Marc's temperament. His last works were a series of abstract drawings executed at the front.

Marc's work, although it embodied all the technical innovations of his day, and moved with ease from the figurative to the abstract, has its origins (via the Symbolism of the late 19th century) in the pantheistic nostalgia characteristic of Germany at that time and, more particularly, in its romanticism. The complete catalogue of his work (totalling 917 pieces in all) includes 240 oil paintings, 251 watercolours and pastels, and 63

engravings (executed after 1908), of which one is an etching, and 25 are woodcuts. He is represented in several German and American museums: Düsseldorf (K.M., *The Foxes*, 1913), Essen (*Bull Lying Down*, 1913), Hamburg (*The Monkey's Procession*, 1911), Mannheim, and Stuttgart (*Four Cats Playing*, 1913), Munich and Hagen (*Composition III*, 1914); New York (Guggenheim Museum, *The Yellow Cow*, 1911), Minneapolis (Walker Art Centre, *Large Blue Horses*, 1911), as well as in Basel (*The Fate of the Animals*, 1913).

M.A.S.

Margarito d'Arezzo
Italian painter
active 13th century

It is not known for certain whether Margarito was painting during the first or the second half of the 13th century, although a document dated 1262 probably relates to him. *The Madonna and Child Enthroned* (Montelungo, near Arezzo, Church of S. Maria) was probably painted by Margarito in 1250, and is generally accepted to be the last of the works attributable to him. All of these were probably executed between 1230 and 1250, and in the

Franz Marc ▶
Deer in the Forest II (1913-14)
Canvas. 110 cm × 100 cm
Karlsruhe, Staatliche Kunsthalle

Carlo Maratta ▲
The Virgin and Child between St Charles Borromeo and St Ignatius (1685)
Canvas. 380 cm × 200 cm
Rome, S. Maria in Vallicella

following order: *St Francis*, signed (Arezzo Museum); antependium of an altar (*The Virgin and Child Enthroned, with Scenes from the Nativity and the Lives of the Saints*), signed (London, N.G.); *Madonna with Four Scenes from the Life of the Virgin* (Church of S. Maria delle Vertighe at Monte S. Savino, near Arezzo); finally, the S. Maria de Montelungo *Madonna*.

If this order is correct, it would explain the similarities between Margarito and certain Florentine painters of the period, such as the Master of Bigallo. Margarito must have had some influence on the Florentines; at least, this is more likely than the thesis that they had an influence over him. The Byzantine models towards whom the painter turned were not those who were to enjoy a great vogue in Florence during the second half of the 13th century and whose work is characterized by a complicated, mechanical linearism. His preference for formal simplification, his expressive vivacity, his taste for ornamentation and rich fabrics, reveal his knowledge of works from antiquity of popular origin going back to the time of the Copts and Syrians of the Palaeo-Christian era. Vasari was particularly interested in Margarito and attributed to him, apart from his activity as a painter, a role as archi-

tect, but this is a matter which modern research has yet to corroborate. B.T.

Martin
John
English painter
b.Haydon Bridge, 1789 – d.Isle of Man, 1854

Martin was one of twelve children, of whom only four survived; at least two of his brothers were very eccentric, and John himself later acquired the nickname of 'Mad Martin'. When he was 14 he was apprenticed to a coachbuilder in order to learn heraldic painting, and shortly afterwards he became the pupil of a Piedmontese artist, Boniface Musso, who had settled in Newcastle. Musso later moved to London and was followed by Martin, who began to work as a china painter with Musso's son.

In 1811 Martin had a painting accepted by the Royal Academy, and in 1812 his *Sadak in Search of the Waters of Oblivion* (Southampton, Art Gal.) caused much comment. Like most of his work, it is Romantic and melodramatic, and its effect depends on the striking colouring and on the disparity of scale between the figure and the fantastic landscape. *Joshua Commanding the Sun to Stand Still upon Gideon* (London, United Grand Lodge Museum), painted four years later, made him famous, and by 1817 he was successful enough to have been appointed 'Historical Landscape Painter' to Prince Leopold and Princess Charlotte. *Belshazzar's Feast* (private coll.), painted in 1821, from which several engravings were made, became one of the most famous and popular pictures of the age. It is a theatrical scene with colossal architecture and crowds of small figures, unified by heightened effects of chiaroscuro. Martin painted many other works of similar conception, including *The Destruction of Herculaneum* (1822, Manchester City Art Gal.), and *The Seventh Plague* (*c*.1823, Boston, M.F.A.).

Martin's engravings, such as his illustrations to the Bible and to Milton's *Paradise Lost*, were also well known. His interest in the technique was partly brought about by his desire to reach a wider public, and partly because he felt that his paintings were not well displayed at the Royal Academy. He nurtured a prolonged grudge against the Academy, supposedly initiated by an unfortunate incident when an Academician spilt varnish over one of Martin's paintings at the 1814 exhibition.

His success was revived with *The Coronation of Queen Victoria* (London, Tate Gal.), which was painted in 1839. He subsequently produced other works which were more akin to his earlier style, including *The Assuaging of the Waters* (1840, Edinburgh, Church of Scotland), as well as a large number of watercolour landscapes. Being something of an inventor, he became obsessed with ideas for improving London's water and sewage systems, and although his schemes caused him financial trouble, his walks around the city provided him with ample opportunities to paint the local scenery.

The three huge *Judgement* paintings, inspired by the Book of Revelation, were regarded as his masterpieces when they were exhibited a year after his death, and they were sent on a tour of England and America that lasted about 20 years. The first, *The Great Day of His Wrath* (1851-3, London, Tate Gal.), is reminiscent of Francis Danby's *The Opening of the Sixth Seal* (Dublin, National Gallery of Ireland), a painting which itself had been influenced by Martin some 25 years before. The second, *The Plains of Heaven* (1853, United Kingdom, Frank Coll.), is a contrasting scene of overly sweet serenity, while *The Last Judgement* (1853, United Kingdom, Frank Coll.), which is, in fact, the largest of the group, is an attempt to combine both disaster and lyricism in an apocalyptic crescendo.

In 1853 Martin suffered a seizure that left him speechless and with a paralysed right hand. Believing that abstinence might be a remedy, he ate only the smallest amounts of food, and moved to the Isle of Man to recuperate, but he died there the following year.

During his lifetime Martin was considered by many to be one of the greatest geniuses of all time, but even before he died his reputation had greatly diminished. His work was called 'meretricious' and 'mechanical', and the more obvious faults in his drawing and colouring were generally criticized. It is only recently that there has been a renewed interest in his flamboyant form of English Romanticism. J.H.

▲ John Martin
The Great Day of his Wrath (1851–3)
Canvas. 198 cm × 303 cm
London, Tate Gallery

▲ Margarito d'Arezzo
The Virgin and Child Enthroned, with Scenes from the Nativity and the Lives of the Saints
Wood. 92 cm × 182 cm
London, National Gallery

Martini
Simone

Italian painter
b.Siena, c.1284 – d.Avignon, 1344

Simone Martini was almost certainly the pupil of Duccio at a time when the latter was working on the *Maestà* for Siena Cathedral. However, Martini's earliest signed work, a fresco on the same theme, painted in 1315 (Siena, Palazzo Pubblico), contains but a few traces of Duccio's teaching. This vast composition shows the influence of French Gothic art, particularly in the architectural features of the Virgin's throne. The angels and saints under a canopy gathered around the Virgin and Child give to the whole an aura of courtly ceremony. It seems likely that Martini came into contact with northern art at such an early age through the miniatures, metalwork and ivories of the Île de France, which were famous and widely distributed throughout the larger Italian cities.

An important event from this period was Martini's contact with King Robert of Anjou at Naples, who awarded him the title of *miles* (knight) on 23rd July 1317, a title which carried with it a great deal of money. His dealings with the court of Robert of Anjou probably went back even further, though the date 1317 is the most likely one for the great altarpiece representing *St Louis of Toulouse Crowning King Robert* (Naples, Capodimonte), since the canonization of the Franciscan saint, brother of the King, had taken place that year. What is more, if this work is compared with the *Maestà* of 1315, the evolution of Martini's style corroborates the dating of 1317. The predella of the Naples altarpiece, depicting five episodes from the life of the saint, reveals the close attention paid by the artist to a rational interpretation of the Tuscan discoveries of the day, in particular those of Giotto, without abandoning all reference to the spirit and taste of Gothicism outside Italy.

The interpretation is further developed in the cycle of frescoes for the chapel of St Martin in the Lower Church of Assisi (probably Martini's most perfect achievement, and one of the high points of Gothic art). The frescoes for the chapel (*Scenes from the Life of St Martin*), for which Martini also designed the stained-glass windows, had been commissioned by Cardinal Gentile da Montefiore, who died in Tuscany in 1312. The dealings of this prelate with the house of Anjou explain why Martini was chosen to illustrate the legend of the former Bishop of Tours, and to exalt Louis of Toulouse to the rank of saint. These scenes of courtly life and of secular activities are based on ideas that are essentially Tuscan and above all, 'Giottoesque'.

Even a glance at Martini's work reveals how much importance he accorded to the definition of space, to architectural structures and to a calm and balanced rhythm in many of the compositions: *The Dream of the Saint, The Saint Meditating, The Dedication, The Dedication of the Chapel by Cardinal Gentile*. He brought a new optical depth and elegance to the language of Gothic art, prefiguring the International Gothic style. It was perhaps this perfection of stylistic balance between such widely differing influences that led critics to ascribe a later date to the frescoes

(between 1320 and 1330) whereas now it seems far more likely that the work was completed by around 1317.

With the polyptych (the half-length *Virgin and Child*, surrounded by numerous *Saints* and *Prophets*) executed for the Church of S. Caterina in Pisa (Pisa, M.N.) in 1319, and the two *Orvieto Polyptychs* (Opera del Duomo; the one donated by Monaldeschi is dated 1320) we are back on more certain ground chronologically. These works confirm the artist's precocious stylistic maturity; *The Holy Martyr* (Ottawa, N.G.), which was a part of one of the Orvieto polyptychs, is the most striking example. The painting of *St Ladislas* (Altomonte, Church of S. Maria della Consolazione) probably dates from 1326. This unique and finely detailed work is one of the few to have survived from this period.

Not until 1328 is there another dated work by Martini. This was the great commemorative fresco for Guidoriccio da Fogliano, which decorates a wall of the Sala del Mappamondo in the Palazzo Pubblico in Siena. The inspiration of

this work is highly original. It shows the Sienese *condottiere* riding through the countryside, outlined against a vast landscape of hills, castles and military camps which commemorate the conquest of the fortresses of Montemassi and Sassoforte. This clearly secular, equestrian scene sheds an idealized light on the daily life of the time. The altarpiece of the *Blessed Agostino Novello* (showing the saint himself and, on either side of him, four *Scenes from his Life*; Siena, Church of S. Agostino) is also thought to date from around 1328. It is a vivid and serene narration of miraculous deeds, showing close affinities with the Giottoesque art of Florence as well as with the contemporary discoveries of Lorenzetti.

In 1333, Simone Martini's name and that of his brother-in-law Lippo Memmi appeared on the great altarpiece of the *Annunciation* (flanked by S. *Ansano* and S. *Giulietta*), formerly in the chapel of S. Ansano in Siena Cathedral (Uffizi). The two saints are generally considered to be the work of Memmi, while the *Annunciation* itself, a work of unbelievable refinement and rhythmic abstraction,

▲ Simone Martini
St Martin Renouncing Arms
Fresco from the chapel of St Martin
Assisi, Basilica of San Francesco

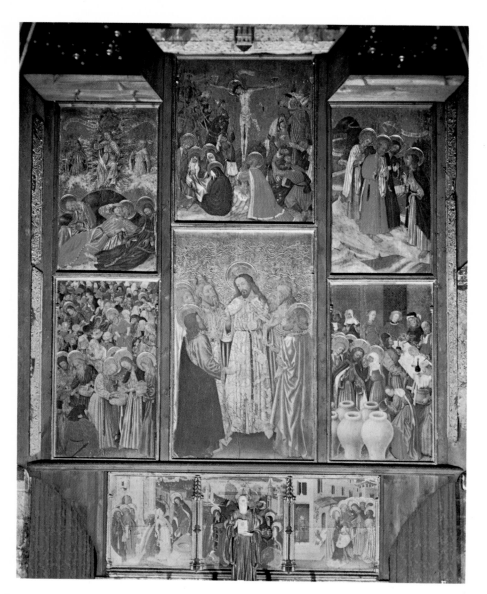

Apart from Lippo Memmi and his brother Donato (of whom no individual works are known), he had a number of collaborators and exercised a direct influence over several pupils (the Master of the Madonna of the Palazzo di Venezia, the Master of the Strauss Madonna, Ceccarelli) and followers (the Master of the St George Codex, Barna da Siena).

His influence continued beyond 1350 (Lippo Vanni, Andrea Vanni, Niccolò di Ser Sozzo Tegliacci). In fact his themes (the *Annunciation* served as a model for countless artists) and the refined elegance of his technique had a considerable effect on the whole of the Siena school well into the 15th century. There are obvious traces of his style in Pisa, Lucca, Naples and in Provence (the Master of the Aix panels, Giovannetti). L.E.

Martorell
Bernardo

Spanish painter
active Barcelona, 1427–52

Martorell is documented between 1427 and 1452, when he was one of the most sought-after painters in Barcelona, the successor to Borrassa. Only one of these documents, dated 1437, refers to a surviving work, the *Altarpiece of St Peter of Púbol* (Gerona Museum), but stylistic comparisons reveal him as the author of a group of works formerly attributed to 'the Master of Saint George'.

With the exception of the *St George Altarpiece* (Chicago, Art Inst.; Louvre), to which Martorell owed his provisional name, the best of his paintings – altarpieces made up of numerous panels illustrating the Life of Christ or of the Saints – are still to be found in Catalonia. They reveal a highly individual personality, probably the most original in Spain at that time. Martorell was almost certainly trained by Borrassa but he enriched this teaching with studies of more 'modern' sources: the Paris miniaturists (and particularly the Master of Boucicaut and the Limbourg brothers), Burgundian sculptors and the younger painters of the Netherlandish School, as well as the art of Tuscany and Lombardy. Without sacrificing anything of the Gothic taste for the arabesque, or of poetic, ornamental fantasy, he sought to give it a new balance by introducing a new way of expressing volumes, by blending unity of light with dramatic intensity, even with psychological observation, opening the way to Jaime Huguet.

The works attributed to Martorell on stylistic grounds are relatively numerous and span the different periods of his career. To the first phase belongs the *St George Altarpiece* (before 1435), of which the Chicago Art Institute possesses the centre section (*St George Fighting the Dragon*) and the Louvre the four wings. These depict the saint judged by Diocletian and his court, then dragged on his back to his martyrdom, his feet attached to the horse's rump, through a crowd held back by armed men. From the *Altarpiece of St Eulalia and St John the Baptist* (Vich Museum) five episodes in rustic settings survive: in one, St Eulalia, half-naked, is attached to a St Andrew's cross and surrounded by executioners. The *St Vincent Altarpiece* (Barcelona, B.A.C.), originally in Menarguens, not far from Tarragona, carries the coat-of-arms of the Poblet monastery. In it the saint is

the epitome of Gothic stylization for generations of Sienese artists, is by Martini.

The leading part played by Martini in the development of Gothic painting does not stop here; it acquired a new dimension thanks to the works produced during his later years at the court of Avignon in Provence where he arrived with his brother Donato around 1340. During the ensuing four years he completed a series of paintings in which the discoveries of Gothic abstraction are softened by a tender feeling for reality.

The small portable altarpiece probably executed for Napoleone Orsini (who died in Avignon in 1342), most of the panels of which were found in Dijon in 1826, is full of vivacity and pathos. The scenes represent the *Ascent to Calvary* (Louvre); the *Crucifixion*, the *Deposition*, the *Annunciation* (all Antwerp Museum); and the *Entombment* (Berlin-Dahlem). The wing from a diptych depicting the *Christ discovered in the Temple* (Liverpool, Walker Art Gal.) dates from 1342. With this work Simone Martini's career came to an end, but at a high level of attainment, for the paintings must rank among the most influential works of art in Provençal culture.

The frescoes painted by Martini on the portal of Notre Dame des Doms (*Christ Giving Benediction*, the *Virgin of Humility Adored by Cardinal Stefaneschi*) have largely disappeared, but the extraordinary sinopia (reddish-brown pigment) remains. The fresco representing *St George Slaying the Dragon* is lost. The lighter aspect of the painter's work is best seen in the miniatures (*Allegory of Virgil with Aeneas*), painted by Martini for a manuscript of Virgil belonging to Petrarch (Milan, Ambrosiana), rather than in the graphically literal memento conserved in the Vatican library.

A number of other works are occasionally attributed to Simone Martini. They include: a *Madonna* from Lucignano (now in Siena, P.N.); the *Polyptych* in the Gardner Museum in Boston; the *Crucifix* in the Church of the Misericordia at S. Casciano in Val di Pessa; a polyptych with panels dispersed as follows: a *Madonna* (Cologne, W.R.M.), three *Saints* in the Fitzwilliam Museum, Cambridge, and a *Saint* in a private collection; *St John the Evangelist* at the Barber Institute of Arts, Birmingham; and a diptych with the *Virgin and the Angel of the Annunciation* (Hermitage; Washington, N.G.).

 Bernardo Martorell
Altarpiece of the Transfiguration (1449–52)
Wood.
Barcelona Cathedral

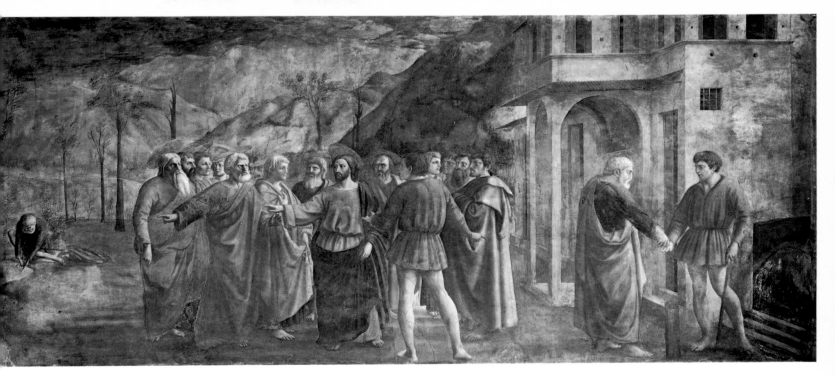

flanked by various episodes from his life, his trial
and the tortures he endured, the cross and the
rack, before his death; in this last, his delicately
modelled body rests on a bright red couch. A
triptych, the centre panel of which is dedicated to
the *Descent from the Cross* (Lisbon, M.A.A.),
reveals Martorell's interest in perspective, which
he often enhances by placing the figures at differ-
ing levels.

The great *Altarpiece of St Peter of Púbol*, Mar-
torell's only documented painting, was under-
taken as the result of a contract in 1437. The
centrepiece shows the apostle on a throne in his
pontifical robes, carrying the tiara, and depicted
in the tradition of the great Catalonian altarpieces.
Kneeling at his feet are the donors: Bernardo de
Corbera, with his wife Margarita de Cam-
pollouch on the left and, to the right, their son.
They have the appearance of being painted from
life, and are undoubtedly portraits. There is an
intense vitality about these figures in their ample
robes, and the gesture of the mother presenting
her son to be blessed by the Pontiff is full of
feminine sensibility.

Martorell's masterpiece, however, is the *Altar-
piece of the Transfiguration* (1449-52, Barcelona
Cathedral), commissioned by the bishop, Simó
Salvador, whose coat-of-arms decorates the
upper section of the frame. In the centre appears
the tall figure of Christ, gently dominating the
two apostles placed symmetrically in the
foreground. Three other figures, more distant,
blur into a brilliant golden background. The
upper section, in which reds predominate, con-
tains the *Crucifixion* with, on either side, the
Glorification of the Saviour and the *Order of Silence
Given to the Three Chosen Apostles*. On the wings
may be seen the *Multiplication of the Loaves* and the
Wedding at Cana. The predella consists of the *Des-
cent from the Cross*, a picturesque scene of exorcism,
and the *Meeting between Christ and the Woman of
Samaria*, in which a meandering road is framed by
medieval city walls. The persuasive serenity of
Christ is in contrast with the woman's surprise as
she turns towards him; here psychological insight
is added to plastic values.

Other works which have been attributed to
Martorell are in public collections in Palma and

Vich. His studio is also recognized as having also
been responsible for book illuminations. M.Bé.

Masaccio
(Tommaso di Giovanni)

Italian painter
b.San Giovanni Valdarno, Arezzo, 1401 –
d.Rome,1428

The name by which one of the greatest painters of
the quattrocento is known is in fact a nickname.
Although the ending *–cio* in Italian is usually
pejorative, Vasari noted that in his case it does not
indicate 'that he was bad, since he was goodness
itself, but refers rather to the carelessness of some
of his settings'.

In January 1422, when he was just 20 years old
(his birthday was on 21st December, St Thomas's
day, whose name he was given), Masaccio, who
had probably been in Florence for some time,
joined the brotherhood of the *Medici e Speziali* to
which many Florentine painters belonged. His
masters during his extremely precocious for-
mative years were not the normal painters of the
Late Gothic period, whether Tuscan or otherwise,
although some of the most elegant and osten-
tatious masters of the style were working in
Florence between 1422 and 1426, from the Master
of the Bambino Vispo to the great Gentile da
Fabriano. They were, in fact, the two greatest
representatives of the Tuscan Renaissance in
architecture and in sculpture, Brunelleschi and
Donatello.

It was from Brunelleschi that Masaccio ac-
quired the solid perspectives he used in the fresco
of the *Trinity* in the church of S. Maria Novella.
The new consciousness of the human figure,
which Donatello exalted in his statues for the Or-
sanmichele and for the campanile of the Cathedral
(*St George, Jeremiah, Habakuk*), was translated by
Masaccio into pictorial terms in the realistic
figures surrounding Christ in the scene of *The
Tribute Money* or in the solemn apparition of *St
Peter* in other scenes of the Brancacci chapel cycle.

And if Masaccio studied the work of any single
painter, it was certainly that of Giotto.

Masaccio and Masolino. Masaccio probably
met Masolino, a compatriot and his elder by
around 20 years, soon after his arrival in Florence.
He twice collaborated with him: on the altarpiece
of the *Virgin and St Anne* for the church of S. Am-
brogio (now in the Uffizi) and on the cycle of
frescoes commissioned from Masolino in 1424 for
the chapel in the church of S. Maria del Carmine
in Florence. However, Masolino was not Masac-
cio's master in the generally accepted sense of the
word.

Even in his earliest works Masaccio revealed
himself utterly at odds, both by training and tem-
perament, with the tender, delicate world of Late
Gothic art of which Masolino, Starnina and
Lorenzo Monaco were the greatest represen-
tatives in Florence in the early quattrocento. It
was Masolino, in fact, who, in the works
executed by the two artists in collaboration, had
to endure the provoking superiority of his young
companion who imposed upon him a new vision
of perspective and of humanity. In the S. Am
brogio altarpiece the group of the *Virgin and Child*
was painted by Masaccio, who should have taken
second place. The group asserts a strong physical
and moral presence, and is lit by a natural light
falling from the left, whereas the figure of *St Anne*
herself, painted by Masolino, timidly stretches a
hand over the Virgin, who is surrounded by a
fragile and graceful corona of angels about the
throne. The figure of only one of the angels (the
second from the right) reveals by its deeper
colouring and more incisive gestures the new,
assured style of Masaccio.

When, after the end of the 19th century, a new
interest in the history of art developed, the per-
sonalities of the two masters who had worked on
the Brancacci chapel were still shrouded in mys-
tery, to such an extent that a large proportion of
the works of Masolino were still attributed to
Masaccio. It was not until 1940 that the Italian art
historian Longhi established the clear distinction
between the two artists and drew attention to the
part played by Masaccio in the *Virgin and St Anne*
altarpiece and in the Brancacci chapel frescoes. He

▲ Masaccio
The Tribute Money
Fresco from the Brancacci Chapel
Florence, S. Maria del Carmine

noted how the rigorous view of perspective imposed on Masolino, as in *The Resurrection of Tabitha* or *The Curing of the Sick Woman*, in the background of which is an exact representation of a Florentine street, was the direct result of Masaccio's newly discovered sense of realism.

To distinguish the two personalities it is enough to compare the two scenes painted on the pilasters on either side of the entrance to the Brancacci chapel. In *The Temptation of Adam and Eve* by Masolino, Adam and Eve are tender creatures, caressed by the light, unaware of being involved in any sort of drama, or of having committed a sin. In *Adam and Eve Expelled from the Garden of Eden*, however, Masaccio depicts a drama full of humanity, expressed by the weeping figure of Eve, her face, contorted with misery, contrasted with the shame of Adam who, head bowed, covers his face.

The chronology of Masaccio's works, all of which were executed within a fairly short space of time (between 1422 and 1428) is still a matter of controversy. Most of the problems centre on how long he spent working alongside Masolino on the Brancacci chapel. According to Longhi, Masaccio was already working for Masolino in 1425 and left for Rome with him that same year. The start of work on Masolino's *Triptych*, painted for the Church of S. Maria Maggiore in Rome, probably dates from this time, and in it the presence of Masaccio emerges in one of the wings depicting *St Jerome and St John the Baptist* (now in London, N.G.). Back in Florence, Masaccio probably returned alone to the decoration of the chapel, as Masolino had been called to Hungary into the service of Pippo Spano. Masaccio interrupted his work on the cycle once more to return a second time to Rome, where he died shortly after his arrival. Other authorities date his presence in the Brancacci chapel from 1426 or 1427, after the return of Masolino from Hungary.

In the Brancacci chapel, Masaccio's hand may be seen in the architectural background of *The*

Resurrection of Tabitha, The Baptism of the Neophytes, The Cripple Cured by the Shadow of St Peter, The Distribution of Alms, The Tribute Money, and *Adam and Eve Expelled from the Garden of Eden.* The artist left unfinished the decoration of the lower tier: the scenes with *St Peter Enthroned* and *The Resurrection of the Son of Theophilus* were completed by Filippino Lippi between 1480 and 1490.

The chapel suffered a number of vicissitudes over the course of centuries. During the 17th century an unfortunate attempt at renovation narrowly missed destroying the work completely. It was saved thanks to the intervention of the Grand Duchess Vittoria della Rovere, mother of the reigning Grand Duke Cosimo III, to whom the various art academies had addressed themselves with the request that she should halt the destruction of what was already considered the very foundation of the Florentine Renaissance. The work was mutilated between 1746 and 1748 during the course of partial restoration, when the vault and some lunettes were lost, but it was miraculously spared in 1771 when fire totally destroyed the rest of the church.

Other works. The only one of Masaccio's works that may be dated with certainty (1426) is the polyptych painted for the Carmelite church in Pisa. It was dismantled during the 17th century and the remaining panels are now dispersed. The central section (*The Virgin and Child Enthroned with Angels*, London, N.G.) is among the artist's most famous compositions. Gothic rhythms and ogival frame vanish in favour of the large figure of the Virgin seated on a simple square throne, while the Child picks the fruit from a bunch of grapes. The same applies to the *Crucifixion* (Naples, Capodimonte) in which the vivid red of Mary Magdalene's robe dominates the intensity of the scene. The predella (Berlin-Dahlem) represents the *Martyrdom of St Peter* and the *Martyrdom of St John the Baptist*, the *Adoration of the Magi* and *Scenes from the Lives of St Nicholas and St Julian* (studio work). Four pilaster *Saints* (Berlin-Dahlem) survive, and two of the *Saints* from the upper part of the work (Pisa, M.N.; formerly in Vienna, private coll.).

Masaccio's lost works include the famous *Sagra del Carmine* (c.1422), painted in the cloister of the church of that name. It depicted the consecration of the church in 1422, a ceremony in which Florence's most important citizens, along with a number of Masaccio's painter friends, par-

ticipated. *St Ivo* (formerly in the Church of La Badia in Florence), which Vasari admired for its bold effects of foreshortening, is also lost. In many cases Masaccio's activity remains obscure, particularly on the question of his possible contribution to the great fresco of the *Crucifixion* in the Church of S. Clemente in Rome, which was completed by Masolino with *Scenes from the Life of St Catherine of Alexandria*.

Masaccio's style was not easy to grasp: dry, pared down to essentials, violent and intense. The public at that time was still too used to, and fascinated by, the pleasing divagations of the Late Gothic to appreciate Masaccio fully, and both during his lifetime and after his death he was misunderstood. But the public slowly grew aware of his immense stature, and he is now recognized as one of the most influential painters not only in the Renaissance but in the whole history of painting.

M.B.

Maso di Banco

Italian painter
b.Florence, first half of the 14th century

The identification of Maso has been among the most complicated problems faced by art historians over the past 50 years. But the work has provided an opportunity for studying and distinguishing a number of other painters. Among the pupils of Giotto after Stefano and Taddeo Gaddi, Ghiberti mentions Maso whom he praised highly and to whom he ascribes, among other works, the frescoes of the Bardi di Vernio chapel in the Church of S. Croce in Florence. Further, a number of documents mention a 'Maso di Banco' who can be identified as Ghiberti's Maso, since the papers also concern the S. Croce frescoes, over which the painter quarrelled with his clients in 1341.

Vasari on the other hand seems never to have heard of Maso, and attributes to 'Giottino' the works which Ghiberti maintains were by Maso. This 'Giottino' is now believed to be Giotto di Maestro Stefano who became famous later in the century, and can therefore be distinguished from Maso who belonged to an earlier generation. To complicate the problem further, documents on the subject of works variously ascribed to either Maso or Giottino, mention a painter named

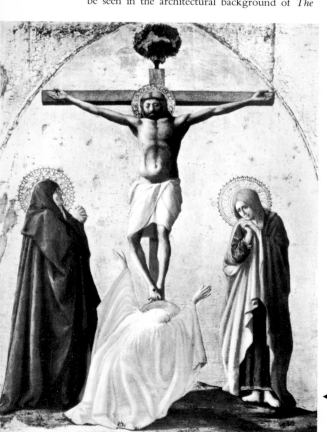

◄ Masaccio
The Crucifixion
Wood. 83cm × 63cm
Naples, Galleria Nazionale di Capodimonte

▲ Maso di Banco
Scenes from the Life of St Sylvester: Pope Sylvester Bringing the two Magi back to Life
Fresco for the Bardi Chapel
Florence, Church of S. Croce

'Stefano', without giving further details. After all this confusion, the respective works of these three artists were finally separated by Offner in 1929. Maso emerged as a figure in his own right and a coherent, unified catalogue was finally established.

In order to identify the works of Maso, the Bardi di Vernio frescoes in the S. Croce were compared with other pieces. The frescoes represent *Scenes from the Life of St Sylvester* and the *Resurrection of a Member of the Bardi Family*, and around these has been assembled a stylistically coherent group of paintings consisting of the lunette painted *al fresco* with the *Coronation of the Virgin* (also at S. Croce, Opera del Duomo), a polyptych split between Berlin-Dahlem (*Madonna:* further panels destroyed in 1945) and the Metropolitan Museum (*St Anthony of Padua*), and a further polyptych (*Madonna* and *Four Saints*) at the Church of S. Spirito in Florence. To these should be added a small portable triptych (New York, Brooklyn Museum), *The Madonna of the Girdle* (Berlin-Dahlem), *The Coronation of the Virgin* (Budapest Museum), and *The Death of the Virgin* (Chantilly, Musée Condé). These last three small panels were probably originally part of the tabernacle of the Sacred Girdle at Prato Cathedral. Finally, certain fragments of frescoes should be mentioned, with the heads of saints and of angels in the window embrasures of the chapel of Castel Nuovo in Naples (1329-32), and also other fragments (*Heraclius Carrying the Cross to Jerusalem*) at the Church of S. Francesco in Pistoia.

Maso occupies an important place among the pupils of Giotto, the more so in that his activity was almost certainly confined to the first half of the 14th century. He must, indeed, have had a profound effect on the formation of such painters as Giottino, Giovanni da Milano, Puccio di Simone, Giusto de' Menabuoi and Nardo di Cione. Further, instead of the cultural influence which Siena was always assumed to have exercised over Florence, it is more likely that it was Maso who influenced the Lorenzetti brothers, and Pietro in particular. Maso's paintings possess two fundamental qualities: a fuller exploitation of Giottoesque volumes, and the subtle radiance of his colours, which are so vibrant with light that he has been described as 'the Piero della Francesca of the trecento'. P.P.D.

Masolino
(Tommaso di Cristofano Fini)
Italian painter
b.Panicale in Valdesa, c.1383 – d. c.1440

It is possible that Masolino was a goldsmith in his youth and, according to Vasari, he was the 'best worker in bronze'. Certainly it was to him that Ghiberti turned while working on the south door of the Baptistery in Florence. He was not admitted to the guild of the *Medici e Speziale* in Florence until 1423, the year in which he added his name to the *Madonna of Humility* (Bremen Museum), a work which bears few similarities to Ghiberti. In fact he uses a suppler, broader line, a freer construction, less calculated and less academic than Ghiberti's. But his qualities as a painter emerge particularly in his use of delicate but intense colours, and of textures which grow

denser in the shade, then blur and soften in lighter areas in order to avoid too heavy an insistence on the difference between light and shade. At the same time, he knew how to convey the essential quality of things, as Giovanni da Milano had before him.

This colourful, tender vision had its origins in the International Gothic style as practised in Tuscany by Lorenzo Monaco and to an even greater extent by artists such as the Master of the Strauss Madonna, the Master of the Bambino Vispo and the Master of 1419. It also included certain features new to Florence, such as the fantasies of Arcangelo di Cola (who came to Florence in 1419) and Gentile da Fabriano (1422).

On 2nd November 1424 Masolino finished the fresco decoration for the chapel of the Confraternity of the Cross (or of S. Elena) in the Church of S. Agostino d'Empoli, of which today only the sinopia (reddish-brown pigment) remains, together with a few decorative fragments and the *Saints* from the intrados of the entrance arch. In a lunette from another part of the church, important remains of a *Madonna and Child with Two Angels* and the fragments of a group of *Young Girls at Prayer* seem to pre-date the decoration of the chapel and even the Bremen *Madonna*. Because of its obvious similarities with Lorenzo Monaco and

the Master of the Bambino Vispo, the *Madonna* from the Contini-Bonacossi collection in Florence (now in the Palazzo Vecchio), with its exceptionally broad range of colours, both vivid and delicate, would appear to be even earlier. It undoubtedly represents the high point of Florentine painting in the International Gothic style.

The *Heads* which survive from the chapel of the Cross at S. Agostino d'Empoli, on the other hand, are very similar to the Bremen *Madonna*, although a few of them reveal a more synthetic and more sharply defined chiaroscuro that recalls the earlier collaboration between Masolino and Masaccio on *The Virgin with St Anne* (Uffizi). In this latter work the monumentality of the Madonna and the massive form of the Child reveal the hand of an artist impatient to bring his new ideas to fruition, and unconcerned with Masolino's careful experiments within the framework of the Gothic tradition. It has been established that Masaccio painted the figures of the Madonna, the Child and the angel in the top right-hand corner, while Masolino was responsible for St Anne and the other angels.

With the aid of this identification it has been possible to clarify the respective contribution of each artist to a further collaboration between them, the decoration of the Brancacci chapel in

▲ Masolino
The Feast of Herod
Fresco
Castiglione Olona, Varese, Baptistery

the Church of S. Maria del Carmine in Florence, commissioned by Felice Brancacci from Masolino, shortly after the former's return to Florence in February 1423. During the 18th century, the vault was unfortunately repainted and a huge altar was installed against the rear wall. To Masolino may be attributed *The Temptation of Adam and Eve* on the pilaster to the right of the entrance. The *Resurrection of Tabitha* (except for the square and the buildings in the background) and *The Sermon of St Peter* on the rear wall. *Adam and Eve Expelled from the Garden of Eden* on the left-hand pilaster by the entrance, and *The Tribute Money* (with the exception of the head of Christ) on the left wall, as well as *The Baptism of the Neophytes*, are the work of Masaccio. Compared to his colleague, Masolino (whose dealings with the Church of S. Maria del Carmine are proven by documents dated 1425) seems to give his figures a more ample and monumental stature and to highlight their volume by the deliberate use of

chiaroscuro. But he failed to achieve the desired effect and the shading of the faces looks more like sunburn.

He undoubtedly obtained his best effects in the fresco of the *Pietà*, even though it is a little heavy (now in the museum of the Collegiate Church of Empoli) and in the *Carnesecchi Triptych* of the Florentine church of S. Maria Maggiore, of which only the right-hand panel depicting *St Julian* (Florence, Seminary) now survives, although there is a panel from the predella in Montauban Museum. Here, Masolino uses a more filtered, diffuse chiaroscuro (clothing, head of the Christ-Child, left hands of the Virgin and of St Julian) and the result suggests a gentler, mellower Masaccio. The triptych was almost certainly in position by 1426 and must have been executed before 1st September 1425, when Masolino left for Hungary.

Masolino returned to Italy in July 1427. Between 1427 and 1431 he finished in Rome the

frescoes in a chapel in S. Clemente (*Scenes from the Lives of St Catherine and St Ambrose, Annunciation, Crucifixion, Evangelists, Doctors of the Church*) and the double-sided triptych for the Church of S. Maria Maggiore.

But here too the presence of Masaccio complicates analysis of the work. In fact, he was responsible for *Sts Jerome and John the Baptist* (London, N.G.) in the polyptych and probably had a hand in the execution of the soldiers in the bottom left-hand corner of the S. Clemente *Crucifixion*. A certain difference in style between the sections executed by Masolino himself suggests that he and Masaccio had already paid a visit to Rome in 1425. The *Crucifixion* ensemble is exceptionally sober and deep compared with the other scenes, such as that showing the *Beheading of St Catherine*, which reveals a marked tendency towards the anecdotal. The panel of the polyptych with *St Matthias and a Pope* (St Liberius?) (London, N.G.) is closer in style to the frescoes of the Brancacci

chapel than to the refined, elegant central scenes of the S. Maria Maggiore altarpiece (*The Assumption*, *The Foundation of S. Maria Maggiore*; Naples, Capodimonte).

This hypothesis is further strengthened by the fact that in April of 1425 Cardinal Castiglione, who commissioned works from Masolino and who was the titular cardinal of the Church of S. Clemente, passed through Florence. In Rome, too, he was associated with Cardinal Brancacci, the brother of Felice, who had commissioned the decorations for the chapel of S. Maria del Carmine. After executing around this time *The Madonna of Humility* (Munich, Alte Pin.) and the two *Annunciations* (Washington, N.G.), in 1432 Masolino painted for the Church of S. Fortunato in Todi, a fresco of the *Madonna between Two Angels*, which is close in style to the admirable fresco cycle in the Baptistery of Castiglione Olona (*Scenes from the Life of St John the Baptist, Evangelists, Doctors of the Church, God the Father*). These were certainly carried out before those of the vault of the collegiate choir (*Scenes from the Life of the Virgin*), finished by Paolo Schiavo and by Vecchietta, probably after the death of the painter.

Here, such elements as the influence of the late International Gothic, the experience of Masaccio, a sure knowledge of perspective and the new outlook of Gentile da Fabriano are blended into a cheerful and colourful vision of men and of things, of architecture and landscape, depicted in a range of clear, vivid colours. The artistic heritage left by Masolino served as a basis for a revised version of Masaccio's aesthetic, as applied later by Domenico Veneziano and Piero della Francesca. L.B.

Master of the Aix Annunciation

French painter
active c.1445

This anonymous artist is known through a single work, the triptych commissioned by Pierre Corpici, a cloth manufacturer of Aix, for the Church of St Sauveur in Aix, and executed between 1443 and 1445. The triptych, now dispersed, represents in the centre the *Annunciation* (Aix-en-Provence, Church of La Madeleine); on the left-hand panel (now cut) is the *Prophet Isaiah* (Rotterdam, B.V.B.) with, beneath it, a *Still Life* (Rijksmuseum); on the right-hand panel is the *Prophet Jeremiah* (Brussels, M.A.A.); and on the reverse of the two closed shutters is *Christ Appearing to the Magdalene*.

The Master is a painter in the Netherlandish style; the concept of the whole and the realistic portrayal of the figures are derived from Van Eyck and above all from the Master of Flémalle. He was probably trained in Burgundy, for the style of the draperies, with their heavy folds, and the monumentality of the figures reveal the influence of Sluter. This northern basis is profoundly modified by a Provençal interpretation of forms and of light, in such a way that the contrast of light brings out the volumes, which are reduced to their essentials. Affinities with the *Coeur d'amour épris* indicate that the painter was working in the entourage of King René, whom he may well have accompanied to Naples. Unsuccessful

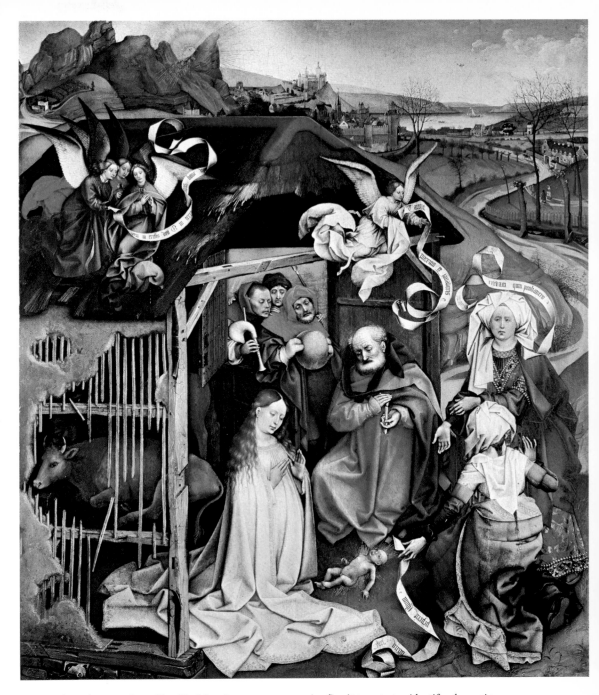

attempts have been made to identify this painter with the Master of Flémalle, Colantonio, Jean Chapus, Bartholomew d'Eyck and Guillaume Dombet. Of these, only d'Eyck, painter and illuminator to King René between 1447 and 1476, seems at all possible. N.R.

Master of Flémalle

Flemish painter
active 1410 – c.1440

The work of this painter, who is sometimes also known as the Master of Merode or the Master of the Mousetrap, centres around two panels of a triptych (Frankfurt, Städel. Inst.) which came from the Château of Flémalle near Liège (not, as has been claimed, from the monastery, since this

never existed). Attempts to identify the artist have led to bitter controversy, which still flares up from time to time. Of the three names that have been put forward – those of Jacques Daret, Rogier van der Weyden and Robert Campin – the last-mentioned seems the most likely, and, indeed, many authorities accept the identification as beyond doubt, despite the absence of documentary proof. If, in fact, the Master was Campin, then he was a painter from Tournai in whose studio Rogier van der Weyden and Jacques Daret worked between 1426 and 1432.

A triptych (London, Seilern Coll.) seems to be the artist's earliest work: comprising an *Entombment* and a *Resurrection*, with a donor kneeling at the foot of Golgotha. It is an involved composition distinguished by fine silhouettes, very graceful and Gothic, and a continuity of volumes accentuated by the heavy, massive folds of the draperies.

The originality and power of the painter are

▲ Master of Flémalle
Nativity
Wood. 87 cm × 70 cm
Dijon, Musée des Beaux Arts

particularly evident in his mature works. The panel depicting the *Bad Thief* (Frankfurt, Städel. Inst.) is the upper fragment of the right-hand panel of a great triptych devoted to the theme of the *Deposition*, a work whose form is known through an old copy in the Walker Art Gallery, Liverpool. The figure on the cross is brutal in its realism, with its stretched muscles and atrocious wounds. The whole is accentuated by the staccato rhythm of the contours, which stand out against a gilt background. Expressiveness is carried to the point of ugliness, and is evident in the faces of the other two figures, which are all the more striking for the powerful modelling that gives them an almost sculptural quality. The two Flémalle panels are similar in character: the figures of the *Virgin and Child* and *St Veronica* are placed on a lawn sprinkled with symbolic flowers and in front of a damask cloth that isolates them in a restricted space. There is an expressive vigour about them which also animates the grisaille of the *Trinity* on the reverse of the *St Veronica* panel.

In small works, the monumental character gives way quite naturally to quality of expression. One panel of the triptych in the Prado illustrates the difference in genre. On the reverse, *St James the Great* and *St Clare*, worked in grisaille like statues in niches, are similar to the larger figures, but give a foretaste of a more refined method of execution. *The Marriage of the Virgin* is depicted with a characteristic richness of detail. The work is alive with figures, some of whose faces are twisted into grimaces bordering on the grotesque.

This taste for the anecdotal showed no sign of weakening in what are presumed to be the later works, but, here, inessentials are stripped away to arrive at a more synthetic vision. The *Nativity* in Dijon Museum contains one of the first northern landscapes. Care has been taken to unify the figures placed before the stable in the background, partly by the artifice of a winding road, partly by the even spread of the light. The sparse trees lining the road are picked out by a white light which is singularly evocative of winter days in the Low Countries and the whole constitutes a decisive step forward in the new realism.

The same vision lies behind the section of the collection of the Princesse de Merode (New York, Cloisters). The scene shows an interior in which each detail is carefully analysed; everyday objects are treated with a poetic insight, even though their inclusion would in any case be justified on symbolic grounds. In the right-hand panel, St Joseph is depicted as a simple carpenter working in his shop, which opens out on to the town square. On his workbench, alongside familiar objects, is a mousetrap. *The Virgin with the Firescreen* (London, N.G.) shows the Virgin suckling her Baby, seated on a bench against the chimney-piece; she is protected from the heat of the fire by a wicker screen which forms a sort of natural halo about her.

This same love of intimate scenes led the Master of Flémalle to depict on one shutter of a small diptych in the Hermitage the Virgin seated and warming herself near the fire, with the Child naked on her knees. Linked to this composition is a representation of the *Trinity*, conceived according to a formula which is sometimes referred to as the 'Throne of Grace': God the Father, seated on his throne, holds the dead Christ in his arms, while the dove of the Holy Spirit perches on Christ's shoulder. Another version, more or less the same size and on the same theme (Louvain Museum), is perhaps also by the Master of Flé-

malle, or at least from his studio, but it has been seriously damaged. Both these works are variations on the composition painted on the reverse of the *St Veronica* of Frankfurt.

On a small panel, now in Aix-en-Provence Museum, the painter represented, in a composition he frequently returned to, the *Virgin and Child* seated on a throne in the sky, with her feet on a crescent-shaped moon, according to the vision of the Apocalypse. Here, a monk kneels on the ground between St Peter and St Augustine.

Several portraits have been attributed to the Master of Flémalle. Among these are a pair showing a *Man* and *Woman* (London, N.G.), a *Musician* (private coll.), and *Robert de Masmines* (two versions, one at Berlin-Dahlem, the other in Lugano, Thyssen Coll.). They are striking for the attention paid to the faces, and the precision of the detail. The latest surviving work, and the only one to be dated, is a triptych of which only the wings remain (Prado). Commissioned in 1438 by Heinrich Werl, provincial head of the Franciscan friars of Cologne, it shows the donor being presented by St John the Evangelist to the figure of St Barbara who sits reading. This is a more supple, less violent work with a more refined light and more delicate relief, which reveals the influences of the painter's contemporaries, together with that of the younger artists, Jan van Eyck and Rogier van der Weyden.

The compositions of the Master of Flémalle were held in high esteem and were frequently copied. Some, in fact, are only known through copies. Among these are: *The Virgin and Child in an Apse*, a *Mass of St Gregory*, *The Adoration of the Magi*, *The Vengeance of Thomyris*, *Jael Slaying Sisara*, *St Luke painting the Virgin*, a *Virgin and Child with Saints and Donors*, and a *Crucifixion*. This powerful art could never be classed among the youthful work of Rogier van der Weyden unless one assumes a radical change of spirit at some stage of his life. There is no attempt in these works to match Rogier's finesse or the harmony of supple, well-balanced lines. The Master of Flémalle is a plastic artist constantly seeking a more powerful means of expression. His forms are depicted in cross-hatched rhythms which exclude all real grace and take on a brutal, peasant

look. His contribution was essential to the development of Netherlandish realistic painting in the 15th century. A.Ch.

Master of Heiligenkreuz
active first half of the 15th century (?)

This extremely important painter, one of the most typical exponents of the International Gothic style, owes his name to a diptych (*c.*1410) formerly in the Cistercian monastery of Heiligenkreuz near Vienna, representing the *Annunciation* and the *Mystic Marriage of St Catherine*. The scenes are bounded by exquisitely delicate architecture in the form of a parapet, behind which may be seen the figures of, on the left, the *Apostles Paul and James* and, on the right, *St Barbara* and *St*

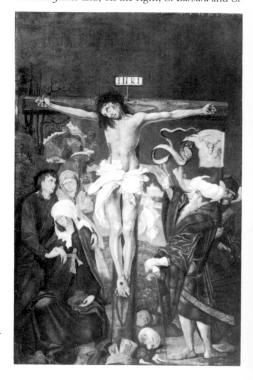

Master of Heiligenkreuz ▲
The Annunciation. The Mystic Marriage of St Catherine
Diptych. 72 cm × 43 cm (both panels)
Vienna, Kunsthistorisches Museum

Master M.S. ▶
The Crucifixion
Wood. 145 cm × 91 cm
Esztergom, Kereszteny Muzeum

Dorothy with, on the reverse, the *Virgin and Child and St Dorothy* (Vienna, K.M.).

There is much discussion concerning the origins of both painter and diptych. Some French experts believe the work to be Austrian; the Austrians, on the other hand, believe it to be French. The painter has been variously supposed to have been influenced by the art of the Viennese court, or to have belonged to the Paris school (possibly, even, to have been by André de Paris, mentioned in documents as being in Vienna between 1411 and 1434), or to have been one and the same as the painter of the *Grandes Heures de Rohan* or to have been of Provençal origin.

A further theory that this little altarpiece formerly decorated the surrounds of the choir of the chapel at Heiligenkreuz is without foundation, since the painting does not figure among the monastery's assets before the 19th century, when it may have been acquired from a private collection or been given as a bequest. So the fact that this diptychs was found in an Austrian Cistercian monastery is no help at all in determining the origins of the painter, or the school to which he belonged.

The hand of the painter may also be recognized in two panels from a diptych, today divided between Cleveland Museum and the National Gallery, Washington, and representing the *Death of the Virgin* and the *Death of St Clare*. It is equally probable that these paintings were not originally destined for the Convent of the Poor Clares at Eger where they were discovered, but that they were acquired at some stage by the order. Whatever his origin the master represents the expressionist side of the International Gothic style and is therefore comparable to Master Francke.

W.B.

Master of the Housebook
(formerly known as the Master of the Amsterdam Cabinet)
German painter
active late 15th century – d.after 1505

South German painting towards the end of the 15th century was dominated by the influence of the Master of the Housebook, so named after a book he illustrated with pen drawings (Wolfegg Castle, Prince von Waldburg Coll.). At the same time, the large number of engravings by this artist in the Print Room of the Rijksmuseum formerly earned him the name of the Master of the Amsterdam Cabinet. Nothing is known of his life; he has been variously identified as Erhard Reuwich of Utrecht, as Nikolaus Nievergalt of Worms, and as a great many others besides, but nothing has yet been proved. According to recent research it seems probable that his art is derived from the Upper Rhine region, and that this was probably where he served his early apprenticeship.

The Master of the Housebook is credited with a series of paintings of powerful realism and fine, clear arrangement, including the *Passion Altarpiece* (*c*.1475, panels divided between Freiburg-im-Breisgau Museum, Berlin-Dahlem, and Frankfurt, Städel. Inst.); a *Lamentation* (*c*.1480, Dresden, Gg); *The Lovers* (*c*.1480, Gotha Museum); and such graceful paintings as *The Virgin and Child* (Munich, Alte Pin.). But although these works are distinguished by their rare quality, it was in

his engravings that the Master's true genius and originality lay. He was the equal of Schongauer as one of the most strikingly individual line-engravers of the 15th century. His metal cuts (around 90 of them) are still Gothic in flavour, and display individuality and great spontaneity. The nine *Scenes from the Life of the Virgin* (of which only five are by his hand) are his last work; with a near-perfect clarity, they comprise a synthesis of all his influences to that time. S.D.

Master M.S.
Central European painter
active c.1500

The work of this artist consists of a *Deposition*, dated 1495 (Warsaw Museum), an *Adoration of the Magi* (Lille Museum) and, notably, six panels of a great altarpiece, now divided up, which formerly

decorated the high altar of the Slovak parochial church of Banská Štiavnica: a *Visitation* (Budapest Museum), a *Nativity* (Church of Svaty Anton, Czechoslovakia), *The Agony in the Garden*, a *Carrying of the Cross*, a *Crucifixion* and a *Resurrection* (all Esztergom, Kereszteny Muzeum). The last bears the monogram M + S and the date 1506, and it was assumed that the letters stood for a certain Master Sebastian who died in Banská Štiavnica in 1507, but this is a hypothesis that now seems unlikely.

Initially identified, by virtue of the expressionist character of his art, with Jorg Breu the Elder (who worked in Krems around 1500), Master M.S. was then considered to have been his pupil and, therefore, a member of the Danube School. But, in fact, his work bears no relation to that of this school, as is proved by the date of a recently discovered painting by Breu, whose work is also much inferior to that of Master M.S. It is possible that the Master had some connection with Kraków.

Despite the presence of a few Italian traits and

Master of the Housebook ▲
The Lovers (*c*.1480)
Wood. 114 cm × 80 cm
Gotha, Schlossmuseum

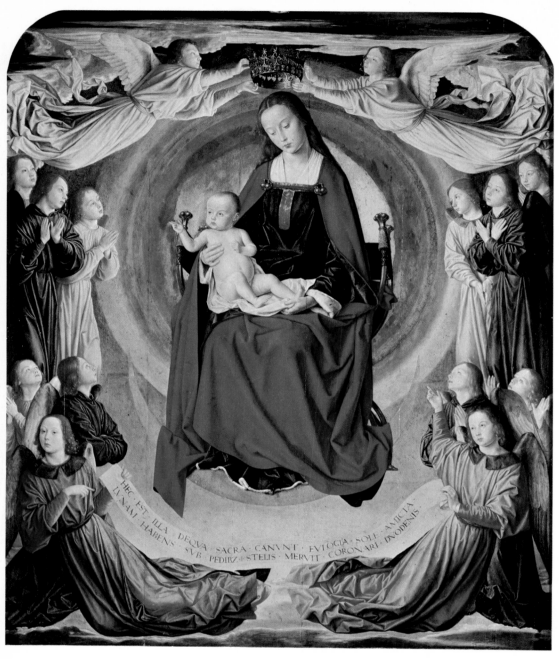

Young Princess), very probably Margaret of Austria, then betrothed to Charles VIII (Metropolitan Museum, Lehman Coll.). In 1492-3 the artist painted for the Duke and Duchess of Bourbon a small triptych; the central panel has been lost but the wings represent *Pierre II de Bourbon avec saint Pierre* and his wife *Anne de France avec saint Jean l'Évangéliste* (Louvre). Behind this there was originally, before the panel was cut up, his daughter Suzanne, then aged one or two, and known as the *L'Enfant en prière* (*Child Saying her Prayers*) (Louvre).

In 1493, the Duke of Bourbon had a miniature painted for Charles VIII; this was the frontispiece of a version of the *Statuts de l'ordre de Saint-Michel* (Paris, B.N.). In 1494 the artist executed a portrait of the *Dauphin Charles-Orland* (Louvre) which was sent to Charles VIII during his Italian campaign. From between 1490 and about 1495 come the two panels cut from the edges of a long altarpiece, whose central section has disappeared: *La Rencontre à la porte dorée* (*The Meeting at the Golden Gate*) (London, N.G.) and *L'Annonciation* (Chicago, Art Inst.). Around 1498 the Duke and Duchess of Bourbon commissioned a large triptych for Moulins Collegiate Church: in the centre is the *Virgin in Glory* surrounded by angels; on the wings are *Saint Pierre présentant Pierre II de Bourbon* and *Sainte Anne présentant Anne de France et sa fille Suzanne* (on the reverse of the wings is an *Annonciation* in grisaille). Finally, the portrait, *Un Donateur présenté par saint Maurice* (*Donor presented by Saint Maurice*) (Glasgow, Art Gal.), must date from about 1500, as must *La Vierge allaitant* (*Virgin Suckling the Child*) (Paris, private coll.) and the stained glass for the Popillon family in Moulins Cathedral. The absence of works later than about 1500 leads to the supposition that the artist died during the first decade of the 16th century.

From these works it seems probable that the Master of Moulins worked in central France, in particular in the service of the family and court of the dukes of Bourbon (he was, in fact, known as the 'Painter to the Bourbons' when he was rediscovered early in the 20th century). His early works suggest that he must have been trained in the Netherlands on account of the naturalism of his portraits, as well as his method of executing landscapes, and certain formulae of composition and iconography. He was strongly influenced by Hugo van der Goes's later works, from which he borrowed not only the cold clear colours and the sharp draughtsmanship apparent in his own early works, but also the dense modelling, certain facial types and the general appearance of the figures – features he retained throughout his career.

The authority of Hugo was, however, tempered in him with sensitivity; his basic naturalism soon acquired a delicacy and feeling for balance characteristic of French art at that time. From his contact with the work of Fouquet and the Master of Jacques Coeur, he acquired a more abstract vision of form, a sculptural feeling for volumes, and a classical taste for monumental poise in his composition, while as court painter he knew how to give his works an aristocratic dignity and refined elegance that made him one of the greatest artists of the Late Gothic and of the early northern Renaissance.

Various attempts to identify the Master of Moulins have failed owing to the lack of any documentary evidence. The Bourbon archives relating to the late 15th century have unfortunately been destroyed. At one time there was a move

borrowings from the engravings of Dürer, his art remains resolutely backward-looking, although this does not prevent him from having been one of the greatest central European painters of his time. He was master of a particularly supple technique, similar to that of the greatest Flemish painters of the late 15th century, a draughtsman who was as sensitive to the expressive value of the line as to the charm of an arabesque, a brilliant colourist with an ability to distribute his colours over the entire surface of the painting. P.V.

Master of Moulins

French painter
active 1480–1503/4

This anonymous artist owes his name to his principal work, the *Triptych of the Virgin in Glory Surrounded by Angels* in Moulins Cathedral. In the

field of French 15th-century painting his is the largest and most important work to have been preserved. This ensemble has been built up largely on the basis of stylistic criteria, for no documentation exists either of the artist or his work. As a rule some 15 paintings are attributed to the Master of Moulins, as well as a stained-glass window, one miniature and one drawing. Thanks to the number of identifiable portraits that figure in his work it is possible to establish an approximate chronology of his output.

It is generally agreed that the Master's early work dates back to around 1480-3 when he was in Burgundy painting the *Nativity* commissioned by Cardinal Rolin (Autun Museum). The portrait of *Cardinal Charles de Bourbon* (Munich, Alte Pin.) also probably dates from around this time. From 1490 comes the presumed portrait of *Madeleine de Bourgogne, dame de Laage, avec Sainte Madeleine* (Louvre), *La Vierge aux anges* (*Virgin with Angels*) (Brussels, M.A.A.), the drawing depicting the profile of a young girl (Louvre), and, about 1490-1, the *Portrait d'une jeune princesse* (*Portrait of a*

 Master of Moulins
The Virgin in Glory surrounded by Angels
Wood. 157 cm × 142 cm (central panel from the *Triptych of the Bourbons*)
Moulins, Notre Dame Cathedral

MAS

262

to identify him with Jean Perréal, the most famous painter of the day, who was supposed to have been in contact with a number of models for portraits attributed to the Master of Moulins; but recent research seems to disprove this theory. A second hypothesis, based on the bold interpretation of a text and in scant accord with historical facts, would have him be Jean Prévost, the glass-painter of Lyons Church (known only through documents from 1471 to the time of his death in 1503-4). A final suggestion is that the Master was Jean Hey, a painter of Netherlandish origin who is mentioned as being among the greatest artists in France at that time and of whom one painting, dated and signed, is known: *Ecce Homo* (1494, Brussels, M.A.A.). Basic similarities of style, and the donor of the work, Jean Cueillette, treasurer to the Duke of Bourbon, make the identification almost certain. N.R.

Master of René d'Anjou
French painter
active c.1440-70

The drawings and miniatures from three manuscripts may be attributed to one artist known, from the name of his employer, as the Master of René d'Anjou: *Le Devis d'un tournoi* (Paris, B.N.), written by King René about 1455 and illustrated around the same date; *Le Coeur d'amour épris* (Vienna, B.N.), also written by the King, in 1457, and illustrated about 1465, but unfinished; finally, the *Teseide* of Boccaccio (Vienna, B.N.), probably translated before 1462 by Louis de Beauvau, friend and adviser to King René (the end part of this manuscript was illuminated by another artist, after 1470).

The Master's style is exceptionally homogeneous and personal. It was that of a northern man; geometric perspective held no interest for him and he constructed his spaces out of colour and light, giving the whole a mixture of dream and reality. Although his work was still influenced by Van Eyck, it was exceptional in the use it made of light. The artist transformed court cos-

tumes into so much still life, in which light and shade carve out folds of the most extraordinary complexity.

In the *Coeur d'amour épris* (*The Heart Lost in Love*), his masterpiece, he depicted the landscapes of Anjou and Provence with a realism that derives from the play of light: at dawn, the rays of the rising sun send out long shadows over the dewy grass; fire shines over the figures in an interior; night envelops the sleeping horsemen in deep blue light. This magical role played by light is less prominent in the Anjou landscapes and in the Teseide miniatures, and it may well have been the specific quality of the light of Provence that inspired the painter. The *Coeur d'amour épris* was probably his last work and it displays, too, a mastery of colour.

Even within the limited framework of these miniatures the monumental aspect of the painter's simple, clear art is evident. This is not so much the work of an illuminator as of an artist capable of working on all levels, in this case by reducing easel paintings to the dimensions of miniatures. Hence the suggestion that he was also the anonymous painter of the Aix *Annunciation*, in which, in fact, may be found the same faces, the same draped fabrics, the same play of light, the same concept of space.

Other miniatures have been linked with the Master's name. Someone in his entourage must have finished miniatures sketched out by him, or completed series he had already begun. Among the latter may be classed the miniature depicting the *Pas de la bergère* (*Dance of the Shepherdess*, Paris, B.N.), illustrating a text by Louis de Beauvau from about 1449, and bearing the arms of his brother Jean. The same applies to certain miniatures, now detached from the manuscript, on the subject of the *Mortifiement de vaine plaisance* (*Mortification of Vain Pleasure*; Metz, Bibliothèque Municipale) for which the text was written by King René in 1455. In these miniatures the sure touch of the Master is lacking, together with his own particular manner of drawing a drapery, a profile or a hand, and his brushstrokes are not there. Certain quirks of style are present, but they are exaggerated.

King René inherited a *Book of Hours* from his family (British Museum) to which he had five miniatures added, but the attribution of these to

this Master raises serious difficulties: they are not all by the same hand, and only one among them (*Les Armes du roi René* [*The Arms of King René*]) because of its skilful use of light, could possibly be the work of the Master. It seems more likely that the work is somewhat earlier in date and was produced by a studio whose head (the artist who here painted *Le Roi mort*) and his assistants had been trained in Germany.

Who was the Master of King René? Where did he come from? All that is known is that for at least 20 years he worked exclusively for King René, and illustrated only his texts. According to one hypothesis, based on an oral tradition that is probably Neapolitan in origin, the King himself was a great painter. But no contemporary French source mentions this possibility. Even so, an ever greater number of works is attributed to the King, all varying greatly in style, and even including the paintings of Quarton and Froment.

Nothing in the archives either confirms or refutes the idea that René may have been a painter, although it is easy to believe that he may have been an amateur. However the *Annunciation* altarpiece could well be the work of the person who was responsible for the miniatures, and it is difficult to imagine the King painting an altarpiece for his own draper, Pierre Corpici. The altarpiece and miniatures mentioned above are of such high quality that they simply cannot have been the work of an amateur, however talented.

It is known, however, that between 1447, at the earliest, and 1471, a painter lived under the King's roof, and even worked in his rooms, as well as forming part of his entourage; this painter was Bartholomew d'Eyck. The artist's mother came from Maaseyck in Limbourg and had married as her second husband a certain Pierre du Billant, who also came from 'the country of Germany'. This Pierre du Billant was painter, embroiderer and valet to King René from 1440-1 until 1470. Unlike Bartholomew d'Eyck, who lived close to the King, Du Billant had a studio and he was often entrusted with political missions in Provence. Until 1471, the probable date of death of these two Franco-German painters, King René only employed other painters on a temporary basis, and they were never a part of his household. All the works attributed to the Master of King René suggest a Flemish training, and all were executed between approximately 1443 and 1470. When he died, Bartholomew left certain works unfinished, as is attested by a letter from his widow, and at this point another illuminator entered into the King's service. There are therefore a number of good reasons for identifying the Master of King René as Bartholomew d'Eyck. F.W.

Master of Rohan
(also known as the Master of the Grandes Heures de Rohan)
French illuminator
active first half of the 15th century

This anonymous artist derives his name from a manuscript, the *Grandes Heures de Rohan*, so called from the arms of the family which it carries (Paris, B.N.), although it is not known for whom the manuscript was originally intended. A number of other exceptional works have been linked with this manuscript and therefore to one

▲ Master of René d'Anjou
At Fortune's Fountain
29 cm × 20 cm (illumination for the *Coeur d'amour épris*)
Vienna, Österreichische Nationalbibliothek

working in western France and in Brittany who had something of his style but nothing of his spirit, he left no followers, and his genius remained isolated during his lifetime. N.R.

Master of the St Bartholomew Altarpiece

German painter
active c.1475 – c.1510

The principal representative of Late Gothic painting in Cologne, the Master was named after his most important work, the *St Bartholomew Altarpiece*. Nothing is known about the life of this anonymous artist, who was probably of Netherlandish origins, and settled in Cologne about 1480 where he probably died.

Thanks, however, to his extravagant style, it has been possible to identify with near-certainty most of his works, which have a technical perfection that rules out the presence of collaborators. Among the artist's first works are: *The Book of Hours of Sophia van Bylant* (c.1475, Cologne, W.R.M.); an *Altarpiece of the Virgin*, now dispersed (*Adoration of the Shepherds*, Paris; Petit Palais; *Adoration of the Magi*, Munich, Alte Pin.; *The Death of the Virgin*, destroyed, formerly in Berlin; *The Meeting of the Magi*, and an *Assumption*, Great Britain, Lulworth Castle, Weld Coll.; *St Anne, the Virgin and Child*, Munich, Alte Pin.; *St Gregory's Mass*, Cologne, W.R.M. All these paintings are imbued with Flemish influences and marked by borrowings from Dieric Bouts and Rogier van der Weyden.

The Virgin with the Walnut (Cologne, W.R.M.), a work in the tradition of the Cologne Madonnas, and *The Descent from the Cross* (Louvre; another version in Garrowby Hall, Halifax Coll.), a free and brilliant interpretation of a theme already treated by Rogier van der Weyden (Prado), are in a transitional style that leads to the works of the painter's maturity. These are the great altarpieces of *St Thomas* and the *Crucifixion* (executed for the chapterhouse of St Barbara in Cologne, 1490-1500, both now in the W.R.M.), and the *Baptism of Christ* in the National Gallery, Washington.

Towards the end of his career, in about 1500-10, the Master carried out the imposing *St Bartholomew Altarpiece*, formerly in the Church of St Colomba. This splendidly coloured work (Munich, Alte Pin.) consists of *Seven Saints* arrayed before a rich backcloth of brocade. In the centre is *St Bartholomew*, flanked by *St Agnes* and *St Cecilia*, with a *Kneeling Carthusian* at his feet; on the right-hand panel are *St Catherine* and *St James the Less*; on the left are *St John the Evangelist* and *St Margaret*.

An independent and highly original artist, the Master of St Bartholomew had neither pupils nor followers. During a period when European painting was undergoing profound changes, he remained faithful to the spirit and forms of the Gothic tradition. He is believed, with some reason, to have been profoundly influenced by the spiritual atmosphere of the Carthusian monastery in Cologne, which was famed for its intense religious and artistic activity, and to which he remained close.

His refined colours and his taste for the exotic and the bizarre, as well as the intense and symbol-

painter – or rather, to one studio working under his direction, for autographed pages by the Master are rare.

It is likely that the Master of Rohan began his career around 1410 in Paris alongside the Master of Bedford, illustrating secular books, but at this time he appears to have specialized in the commercial production of books of hours, of mediocre quality. Around 1420 he entered the service of the Anjou family and executed four inspired books of hours: the *Grandes Heures de Rohan*, the *Heures de René d'Anjou* (Paris, B.N.), the *Heures dites 'd'Isabelle Stuart'* (*The so-called 'Hours of Isabella Stuart'*) (Cambridge, Fitzwilliam Museum) and the *Heures à l'usage d'Angers* (*Book of Hours for the use of Angers*), from the former Martin Le Roy collection. One painting on wood is also attributed to him: this is a fragment of an *Annunciation* (Laon Museum).

The Master of Rohan's work varies greatly in quality, and displays a complete indifference to all

the technical problems – plasticity, space, narrative – that preoccupied his contemporaries in their search for greater realism. His rather flat compositions, set against the abstract backgrounds characteristic of the preceding century reveal terraced landscapes, and incoherent use of architecture and disproportionate figures. His sole concern was to express his own interior vision, his profound anguish in the face of the pathos of life and death, in scenes, which, in their originality and inventiveness, seem to bear no relation to traditional iconography; they are among the greatest masterpieces of Christian inspiration.

Because he was more concerned with the afterlife than with the world, he is difficult to classify. Nothing is known of his origins, though he may have been Spanish, or, more likely, from the north Netherlands, then the heart of religious expressionism. He was an artist too old-fashioned in technique, and far too personal in inspiration, to form a school. With the exception of a few pupils

MAS

264

Master of Rohan ▲
Death before its Judge
29 cm × 21 cm (illumination for the *Grandes Heures de Rohan*)
Paris, Bibliothèque Nationale

Master of the St Bartholomew Altarpiece ▲
The Baptism of Christ
Wood. 106 cm × 170 cm
Washington, D.C., National Gallery of Art, Samuel H.
Kress Collection

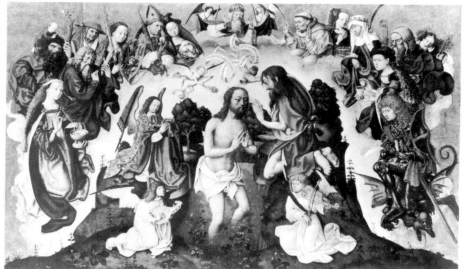

ic nature of his work, may derive from this association. Almost certainly trained in the Low Countries (probably in Utrecht) and, to be more precise, in illumination (his first known work is an illumination for a manuscript), the Master of St Bartholomew brought to Cologne a highly sensitive draughtsmanship, an appreciation of the most complex forms, and a feeling for expressive gestures. This blend of graphic refinement and decorative richness and the spiritual intensity of his inspiration, make him one of the last great Gothic painters. S.D.

Master of the St Veronica

German painter
(active c.1410-20)

Named after his principal work, the Munich *St Veronica* (Alte Pin.), which came from the Church of St Severinus in Cologne and was probably originally the door to a reliquary, the Master is an important artist. Formerly he was identified with Master Wilhelm of Cologne, mentioned in the city's archives between 1358 and 1378 and later. Other unsuccessful attempts have been made to identify him with Wynrich von Wesel, Johann Eckard, Johann Platvoys and Willam von Berghuysen.

One of the treasures of German art and one of the most typical examples of the International Gothic style, the *Veronica* would appear to have been painted around 1410. The saint with her graceful, lightly inclined head, presents the miraculous shroud on which is imprinted the face of Christ, her solemn serenity contrasting with the tragic, powerful face of Christ. Groups of small angels, lively and attractive, positioned in the lower corners, give this composition its great harmony.

Nothing is known for certain about this painter. Apart from this valuable painting, with its limpid colours, he is generally credited with *The Virgin of the Sweet Pea* (Cologne, W.R.M.), the wings of which represent, on the inside, *St Catherine* and *St Barbara*, with *Christ Mocked* on the outside. A further example of the *Veronica* (London, N.G.) has been much discussed, but it is probably an earlier work by the same hand, rather than a copy of the Munich version. On the basis of these paintings, other works have been attributed to the Master, notably a small

Crucifixion with numerous figures (Cologne, W.R.M.), a vast altarpiece representing *Christ on the Cross between the Virgin, St John and Seven Apostles* (Cologne, W.R.M.), *Christ in Agony between the Virgin and St Catherine* (Antwerp Museum), and a small portable triptych representing the *Virgin Surrounded by Saints* (Kreuzlingen, Kisters Coll.).

The Master was the most important painter in Cologne in the early 15th century before Lochner. A number of important works from this period were formerly attributed to him, including the *Wasserfass Calvary* and an altarpiece of the *Holy Family*; both of these are now thought to be by independent masters who have been named after the works. S.D.

Master Theodoric

Czech painter
active third quarter of the 14th century

Theodoric worked in Prague at the court of the Emperor Charles IV; in a deed of 1359 he is styled *malerius imperatoris*. In the register of the painters' guild (*c.*1365) he is released from paying the annual subscription, and a charter of Charles IV (dated 28th April 1367) eulogizes Theodoric's work in the chapel in the imperial castle at Karlstein, and exempts him from paying the land tax on his property at Morina.

The decoration of the chapel was probably undertaken for its second consecration on 9th February 1365 by Archbishop Jan Očko of Vlasim, and would have been completed in 1367. It represents the total extant work of Theodoric who was responsible for the arrangement of the entire project. The upper part of the wall is covered with 129 painted panels in several rows representing the entire celestial army: saints, popes, evangelists, archbishops, abbots and hermits. Their half-length or head-and-shoulder portraits, strong and calm, and those of ordinary people, their faces delicately modelled in a new manner by light and shadow, are imbued with a spiritual fervour. The style of modelling led to the so-called 'soft style'. They stand out strongly against their backgrounds, which are of gold or richly decorated.

Little is known of the beginnings of Theodoric's art. He began painting about 1350 and was directly in contact with the studio of the Master of Genealogy of the Luxembourgs who introduced

western realism into Bohemia. Italian influence is plain, derived from Tommaso da Modena, from Venice, and from northern Italy. Among the works which most closely resemble the severe and realistic art of Theodoric are the *Votive Painting of the Archbishop Jan Očko of Vlasim*, a *Dormition* (Brno, Gal. Moravia) and the *Mulhausen Altarpiece* (1385, Stuttgart, Staatsgal.). The leading figure in Bohemian painting in the 1360s, Theodoric linked the painters of earlier generations to the Master of Třeboň, who owes much to his influence. J.Ho.

Master of the Třeboň Altarpiece

Czech painter
active c.1380-90

The Master of the Třeboň Altarpiece belonged to a group of artists working for the court at Prague, and takes his name from the great altarpiece, probably intended for the Church of St Giles at the Augustinian monastery at Třeboň. However,

Master of the St Veronica ▲
The Virgin of the Sweet Pea
Wood. 53 cm × 34 cm (central panel)
53 cm × 14 cm (side panels)
Cologne, Wallraf-Richartz Museum

Master Theodoric ▶
St Matthew
Wood. 115 cm × 94 cm
Prague, Národní Galerie

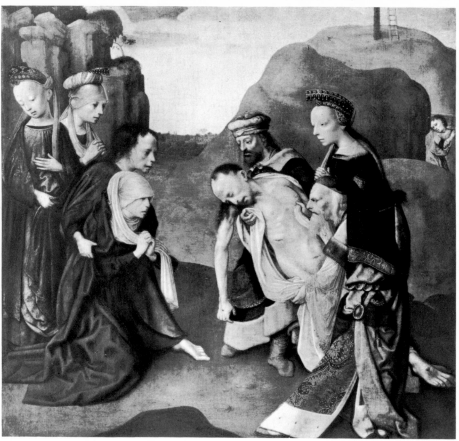

only three panels of this work remain: *The Agony in the Garden*, an *Entombment*, and a *Resurrection* (*c.*1380, Prague Museum), all of them decorated on the reverse with the figures of saintly men and women.

The artist's work is imbued with the spirit of the Augustines and reveals, besides, a number of influences that include the work of his immediate predecessors in Bohemia (painting in Karlstein Castle, by Master Theodoric, and in Prague Cathedral and the monastery of Emmaus), as well, possibly, as the art of northern Italy and of France.

Whatever the case, he remains the greatest of the Czech, or rather Bohemian Gothic painters. His ability to suggest space and depth is matched by a skilled modelling of form based on deep shadows, something used here for the first time. He also displays a new tendency towards greater expressiveness. The Master was one of the creators of a Bohemian and central European variation on the International Gothic style, which prefigures the Late Gothic period in these parts of Europe. Among the works leading up to the *Třeboň Altarpiece* are a panel representing *Our Lady of Sorrows* (before 1380, Cirkvice church) and the *Roudnice Madonna* (after 1380, Prague Museum), which are similar to the *Madonna* from the Church of Holy Trinity (Hluboká, Aleš. Gal.) and those at Vyšší Brod and Wroclaw.

Among the artist's studio works are: an *Adoration* (after 1380, Hluboká Castle); *The Virgin of Ara Coeli* (after 1380, Prague Museum), the earliest known example of a painting of which the frame is decorated with pictures, a characteristic of Bohemian panel painting during the first half of the 15th century; and the *Crucifixion* of the chapel of St Barbara, near Třeboň (after 1380, Prague Museum). *The Virgin between St Bartholomew and St Margaret* (Hluboká Castle) was

executed by the painter's collaborators, as was the Vyšší Brod *Crucifixion* (end of the 14th century, Prague Museum). His influence may be seen in the *Pähl Altarpiece* (end of the 14th century, Munich, Bayerisches Nationalmuseum) and in the *Grüdziadze Altarpiece* (*c.*1400, Warsaw Museum), spreading out from Bohemia to the neighbouring centres of Nuremberg, Bavaria and Silesia. J.Ha.

Master of the Virgo inter Virgines

Netherlandish painter
active late 15th century

The name refers to an artist whose *oeuvre* is grouped around a painting in the Rijksmuseum representing *The Virgin among Virgins*. That he was active in Delft has been established both by the similarity of his style to that of various illuminations in grisaille, typical of the Delft studios of that time, and by drawings he made to illustrate books published chiefly in that town.

His art is characterized by faces whose dramatic intensity verges on caricature. His female figures, including those appearing in the painting from which he derived his name, are graceless and have flat faces with sharp features. The sharpness of his style catches the viewer by surprise in scenes such as this, which might have been wholly charming, or in *The Adoration of the Magi* (Berlin-Dahlem), which turns a composition of the Haarlem school into a work full of pathos.

On the other hand, it is a style well suited to the rendering of themes of despair, such as *The Deposition* (Liverpool, Walker Art Gal.), a work full

of agony, or *The Lamentation* (Belgium, Enghien Hospital), or even *The Entombment* (St Louis, Missouri, City Art gal.), curiously composed in two groups separated by a gap in the landscape. It dominates the greatest surviving work by this painter, the *Triptych of the Crucifixion* (Barnard Castle, Bowes Museum), which consists of a *Carrying of the Cross*, a *Crucifixion* and a *Deposition* linked by an agitated crowd whose twisted robes accentuate the passionate nature of the work. The Master's art is well served by a sober palette consisting chiefly of browns and greys, but given warmth and vibrancy by a few bright touches, such as vivid red or acid green.

The work at present attributed to this painter is so varied that there is more than a possibility that it includes paintings by several hands, probably all from Delft, and therefore similarly influenced. The same may well apply to the woodcuts, which are numerous, figuring in some 15 works published between 1483 and 1500 by Jacob van der Meer, Christian Snellaert and Eckert van Homberch in Delft, and also by Gheraet Leu in Antwerp. All represent Dutch 15th-century art at its most astringent. A.Ch.

Master of Vyšší Brod

Czech painter
active c.1350

The Master of Vyšší Brod probably came from Prague and was the author of the nine paintings of an altarpiece, now dismembered, representing *Scenes from the Life and Passion of Christ*. This work, finished before 1350 (Prague Museum), came from the Cistercian monastery at Vyšší

 Master of the Třeboň Altarpiece
The Resurrection
Wood. 132 cm × 92 cm
Prague, Národní Galerie

▲ Master of the Virgo inter Virgines
The Deposition
Wood. 54 cm × 54 cm
Liverpool, Walker Art Gallery

Brod in southern Bohemia, and may have been executed for Peter I of Rozmberk who died in 1347. This is one of the most remarkable examples of panel painting in the Middle Ages, characterized by a synthesis of northern linear and rhythmic concepts, linked with Italian influences in the spatial forms. The work may have been influenced by Giotto and Duccio, and there are similarities with the panels of the Klosterneuburg altarpiece (1331).

To the Master of Vyšší Brod are attributed the *Annunciation*, the *Nativity* and perhaps also *The Adoration of the Magi* and the *Resurrection*; the other episodes are probably by his studio collaborators. *The Descent of the Holy Spirit* is distinguished by a more supple modelling and more dynamic treatment, foreshadowing the future development of Czech painting.

Grouped around the *Vyšší Brod Altarpiece* and within its stylistic purview are, first, the *Vysehrad Madonna*, (after 1350), which in its turn influenced the *Zbraslav Madonna* and the *Strakov Madonna* (after 1350, Prague Museum), then the *Kladsko Madonna*, painted for Archbishop Arnost of Pardubice (Berlin-Dahlem), the *Kaufmann Crucifixion* (Berlin-Dahlem), and the *Veveri Madonna* (before 1350, Prague Museum). Some later works also remain faithful to the tradition of the Master of Vyšší Brod: the *Karlsruhe Diptych* (before 1350, Karlsruhe Museum), the '*Rome' Madonna* (c.1360), Prague Museum), *The Virgin between St Catherine and St Margaret* (c.1360, Hluboká and Vlatovon) and *The Agony in the Garden* (in the *Codex Flores decretalim Magistri Johannis de Deo*, Wilhering Monastery, Austria). The work of the Master of Vyšší Brod was of crucial importance in the development of panel painting. Similarities of form to the work of one of the creators of Czech sculpture, the Master of the Michle Madonna, are also evident.　　　　　　　　　　J.Ha.

Matisse
Henri
French painter
b.Le Cateau-Cambrésis, 1869 – d.Nice, 1954

The birth of a vocation. The son of a grain merchant, and destined to follow his father as head of the business, Matisse attended the college at St Quentin before studying law at the University of Paris (1887-8). After working as a solicitor's clerk (1889) he began painting in 1890 (copies of chromos) during a period of convalescence following an operation for appendicitis. He then decided to devote himself full-time to painting and attended the school of Quentin-Latour before returning to Paris in 1892.

He enrolled at the Académie Julian in order to prepare for entrance to the École des Beaux Arts and at the same time attended evening classes at the École des Arts Décoratifs where he met Albert Marquet. Gustave Moreau noticed him while he was drawing and offered him the use of his studio (March 1895), at the same time waiving the entrance requirements to the Beaux Arts. Moreau's teaching, in which a free interpretation of the old masters played an important part, helped Matisse to express his own personality. At the same time, the young artist also made the acquaintance of Rouault, Camoin, Manguin and the Belgian painter Evenepoel.

Matisse's first paintings evoke the hazy atmosphere and poetic objectivity of the Nabis (*La Liseuse* [*Woman Reading*], c.1894, Paris, M.N. A.M.), but the firmness of his composition, one of the constants of his art, was already in evidence. In 1896 he spent the summer at Belle-Île in the company of Émile Wéry and there met the Australian John Russell. A friend of Rodin and collector of the works of Émile Bernard and of Van Gogh, Russell had worked with Van Gogh ten years previously and offered Matisse two of his drawings. Thanks to these new contacts, Matisse's style acquired a greater ease and his palette grew gradually lighter (*Le Tisserand breton* [*The Breton Weaver*], 1896, Paris, M.N. A.M.; *La Desserte* [*The Dinner Table*], 1897, privatecoll.). In these the colours are richly orchestrated but the emphasis on decoration still shows the influence of Moreau. Russell introduced him to the work of Rodin, from whom he drew inspiration for his early sculptures, and to Camille Pissarro, who pointed out to him the dangers of the over-use of white, a major defect in *La Desserte*.

Before Fauvism. In 1898 the artist married and spent a short while in London studying Turner, before setting off for Corsica which was Matisse's first contact with the Mediterranean. His numerous landscapes are marked by a broad treatment and an Impressionism tinged with the example of Van Gogh (*L'Arbre* [*The Tree*], 1898, Bordeaux Museum).

The following year, the essay by Signac entitled *De Delacroix au Néo-Impressionisme*, published in the *Revue Blanche*, interested Matisse because of its comments on colour and brushstrokes. He left the Beaux Arts after the death of Moreau and in February 1899 went to live at No. 19 Quai St Michel, where he remained until 1907. Following their teacher's advice, he and Marquet alternated their studies from nature (at Arceuil and in the Luxembourg) with reinterpretations of older works.

A sumptuous 'pre-Fauvism' came into his painting around 1899 with the production of still lifes and nudes in deep cobalt blues, emerald greens, oranges and purples. The latter were executed chiefly in a small studio in the Rue de Rennes where Eugène Carrière frequently came to make corrections, and which was often visited by Derain and other painters. These powerfully constructed works, simple in their plastic strength, reflect the lessons in modelling that Matisse was attending at the time, and astonished his friends by the boldness of the foreshortening and the freedom of their colour harmonies (*Nu à l'atelier* [*Nude in the Studio*], London, Tate Gal.). Despite limited financial means, Matisse bought Japanese prints and hangings, a plastic cast by Rodin and, at Vollard's, *Three bathers* by Cézanne (Paris, Petit Palais), as well as a *Tête de garçon* [*Head of a Boy*] by Gauguin.

Meanwhile, his own work was gaining in originality and he was becoming aware of the work of other late 19th-century innovators. He was, however, forced to work with Marquet on the decoration of the Grand Palais for the 1900 Exposition Universelle, while his wife ran a clothes shop. In 1901 he exhibited at the Salon des Indépendants and that same year, during the Van Gogh retrospective at the Galerie Berheim-Jeune, Derain introduced Vlaminck to him.

The period around 1901-3 saw the appearance of a new austerity: colours were muted and

surfaces, rigorously conceived according to the rectangle of the painting, obeyed a rhythm not unlike that of Cézanne (*Notre-Dame en fin d'après-midi* [*Notre Dame in the Late Afternoon*], 1902, Buffalo, Albright-Knox Gal.). Some of the sculptures that Matisse produced during this period are not dissimilar to those of Rodin and Bayre.

Fauvism. The year 1904 marked certain decisive experiments. After exhibiting at Vollard's in June (this was his first one-man exhibition), Matisse spent the summer at Signac's house in St Tropez and, on his advice, executed a number of Divisionist works with his customary methodical intelligence. *La Terrasse de Signac à Saint-Tropez* (1904, Boston, Gardner Museum) represents the sum of all that he had learned so far: a Japanese-style setting (with Mme Matisse posing in a kimono); small branches forming decorative arabesques, balanced by the weight of the wall of the house and a variety of brushwork techniques. A great economy of effect is the feature *par excellence* of Matisse's art at this stage and shows how far systematic Divisionism could lead him. *Luxe, calme et volupté* (1904, Paris, private coll.), exhibited at the Salon des Indépendants in 1905 and bought by Signac, reveals a flagrant clash between line and colour but its theme of uninhibited joy and the serenity of nature is significant in Matisse's development. Divisionist methods also enabled him to exploit to the full the sensuous and emotional qualities of each brushstroke (*Nu à l'atelier*, 1904-5, Paris, M.N.A.M.).

Strengthened by the new experiences of 1905 and 1907, Matisse gave way to more audacious interpretations during the brief paroxysm of Fauvism, producing highly diverse landscapes as well as portraits and other compositions. He spent the summer of 1905 at Collioure where he stayed with Derain and produced a number of sketches and studies for *La Joie de vivre* (1906, Merion, Pennsylvania, Barnes Foundation).

The little *Pastorale* (Paris, M.A.M. de la Ville) marks an important stage in Matisse's development. In this graceful arabesque, still painted in comparatively dense textures, and in light but sober colours, the contours of the nudes are free from any hint of stiffness. *La Fenêtre ouverte à Collioure* (*The Open Window, Collioure*) (1905, New York, John Hay Whitney Coll.) and *La Femme au chapeau* (*The Woman with a Hat*) (San Francisco, Walter A. Maas Coll.), exhibited at the 1905 Autumn Salon, reveal an exceptionally

Master of the Vyšší Brod ▲
The Resurrection
Wood. 95 cm × 85 cm
Prague, Národní Galerie

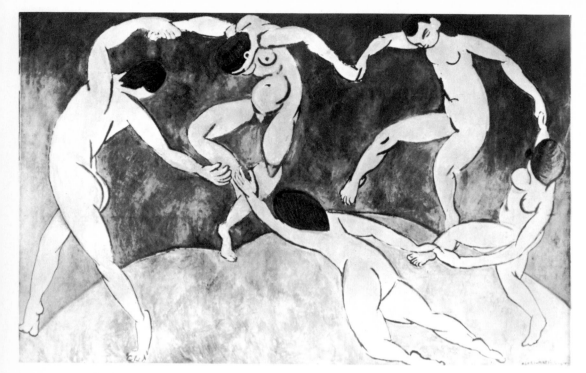

and sensitivity reaches a point of extreme acuity in *La Fenêtre bleue* (*The Blue Window*) of 1911 (New York, M.O.M.A.), executed at Issy-les-Moulineaux, where the painter had been living since 1909. The landscape, viewed from a window, and the relevant angles of the building are reduced to geometrical, though never arid, elements, and are invested with areas of blues clearly punctuated by ochre and green (busts, vase, lamp) and by the two red splashes of the flowers. The three paintings known as the 'Moroccan triptych', bought by Morosov (1912, Hermitage; Moscow, Pushkin Museum), aim at a more relaxed style, marked by a Mediterranean light so that the colour suggests the form, a résumé of Matisse's recent experiments.

In 1914 Matisse rented another studio at No. 19 Quai St Michel. In 1917, before his discovery of Nice and his surfeit of sunshine, he had, as at the start of his career, undergone a period of austerity. Deeper harmonies and bold simplifications suited his new mood and he produced works parallel to those of synthetic Cubism. Alongside studio paintings with a view of the exterior (*Le Bocal de poissons rouges* [*The Goldfish Bowl*], 1914, Paris, M.N.A.M.), he created other works in which the various motifs, happily set within curves on a vast black background – black was the 'colour of light' according to Matisse – are pure signs, always identifiable (*Les Marocains* [*The Moroccans*], 1916; *Les Coloquintes*, 1916; both New York, M.O.M.A.). *La Porte-fenêtre à Collioure* (*French Window at Collioure*) (1914, private coll.) goes even further: the details of the window are dispensed with, and only essential areas of colour remain in evidence, something which was later to be taken up by Newman, Reinhardt and Rothko. During these same years Matisse, in his sculpture, pursued a similar objective in attempting to bring planes as close as possible to reliefs (*Dos* [*Back*], 1916-17), an aim which is also visible in *La Leçon de piano* (*The Piano Lesson*) (1916, New York, M.O.M.A.).

Nice. Matisse moved to Nice in 1921. The presence of Renoir in Cagnes in 1918 and the general post-war climate, once more pervaded by the easy familiarity of everyday life, resulted in a return to a more accessible realism. The *Intérieur à Nice* (*Interior at Nice*) (1917-18, Copenhagen, S.M.f.K.), in which the palm tree and the light of southern France occupy a still discreet but revealing place, was one of several transitional works between his recent Parisian output and that of the 1920s. These paintings feature bright interiors in which a nude or semi-nude 'odalisque' makes an effective and decorative impact on the scene. Some are lightly elliptical in the style of Bonnard (*Intérieur à Nice*, 1921, Chicago, Art Institute), and entirely absorb the feminine presence. In others the modelling of the torso creates a tangible plasticity which stands out from the decorative surroundings and recalls the powerful stylized classicism of Matisse's sculptures of this period.

The *Figure décorative sur fond ornemental* (*Decorative Figure on an Ornamental Background*) (1925, Paris, M.N.A.M.), the title of which explicitly states the painter's intentions, shows the effigy of a woman that derives partly from Negro art, together with motifs from Islamic art. After the intimate sensuality of the first odalisques, this work is very much in tune with the art of the mid-1920s, a synthesis of the various aesthetic trends of the early part of the century which

lively creativity. But whereas the landscapes are carried along by an unmistakable decorative rhythm, the face of the *Femme au chapeau*, in green, ochre and mauve, has a new expressive vigour which is seen again in the *Portrait à la raie verte* (*Portrait with a Green Stripe*) (1905, Copenhagen, S.M.f.K.) and in *La Gitane* (*The Gipsy*), with its Expressionistic touches (1906, St Tropez, Musée de L'Annonciade). These figures, constructed over broad planes of deep colours (green, violet, indigo, midnight blue) foretell a return to a more tightly executed representation of form and discipline of touch as exploited in 1905 by Matisse with the greatest freedom.

A new meeting was to hasten this development. While he was at Collioure Matisse made the acquaintance of Maillol who introduced him to Daniel de Monfreid at whose house he saw Gauguin's last paintings. In 1906 he also began to take an interest in Negro art. From this time on, the reorganization of the surface, which was rendered more supple by the play of arabesques that were at the same time decorative and expressive, was to play a major part in Matisse's work. The year 1906 also saw three woodcuts and his first lithographs, in which he employed techniques very close to those he had introduced into painting, at least in spirit (*Nu bleu* [*The Blue Nude*], 1907, Baltimore, Museum of Art; *Luxe 1*, 1907, sketch and drawings in Paris, M.N.A.M.; final version in Copenhagen, S.M.f.K.).

Definition of an aesthetic. By 1907, the year of the Cézanne retrospective at the Autumn Salon, Fauvism had been through its finest period and Picasso had painted *Les Demoiselles d'Avignon*. Matisse's fame was now growing, particularly among foreign buyers such as Stein, Shchukin and Morosov, and he was looked upon as one of the leading names in French painting. In 1908, on the recommendation of these collectors, he opened a school in his Paris studio in the Rue de Sèvres, which attracted Americans, Germans and Scandinavians in particular. In the same year he published his *Notes d'un Peintre* in the *Grande Revue* – important for a full understanding of his art. In it, he maintained that if expression is the aim of art it should be achieved by the layout of

the painting, not by the direct display of emotional content as in Van Gogh or the German artists of Die Brücke. The painting's 'essential lines' should be studied, and this eminently harmonic aspect should, according to Matisse, provide modern man with classical enjoyment.

La Musique and *La Danse*, commissioned by Shchukin in 1909 (now in the Hermitage), are excellent illustrations of this dictum: 'Three colours on a large panel of dancers: the blue of the sky, the pink of the bodies, the green of the hill' (interview for *Les Nouvelles*, 12th April 1909). To the supple circle of nude dancers correspond the interrupted lines of the musicians, who are more sharply defined. In 1910 he visited the Munich exhibition with Marquet, spent the winter of 1910-11 in southern Spain and the beginning of the following year in Morocco, where he returned in 1913. Apart from his large decorative panels, the studio paintings, figures, landscapes and still lifes executed between 1909 and 1913 (Moscow, Pushkin Museum; Hermitage) reveal a considerable variety of methods, both plastic and colouristic, all of them equally decisive in their application.

The expressionism of *La Gitane* reappears in *L'Algérienne* (*The Algerian Girl*) (1909, Paris, M.N.A.M.), but in watered-down fashion. This figure, treated in strong, sober areas of colour abruptly outlined in black, evokes the technique of wood-engraving and is not without similarities to the nearly contemporary works of Kirchner. The same applies to the nudes executed during the course of the summer of 1909 at Cavalière (*Nu, paysage ensoleillé* [*Nude in a Sunny Landscape*], San Francisco, private coll.; *Nu rose* [*Pink Nude*], Grenoble Museum). Certain still lifes make use of an arrangement and a touch which are still reminiscent of Cézanne (*Nature morte aux oranges* [*Still Life with Oranges*], 1912, former Picasso Coll.) whereas others (such as the interior scenes) develop the theme in a succession of flat tones very carefully arranged in relation to the surface of the canvas, and on which are inscribed particular motifs (*La Famille du peintre* [*The Painter's Family*], 1911, Hermitage; *Les Poissons rouges* [*Goldfish*], 1911, Berlin, private coll.).

The subtle Matissian balance between rigour

 Henri Matisse
La Danse (1910)
Canvas. 260 cm × 391 cm
Leningrad, Hermitage

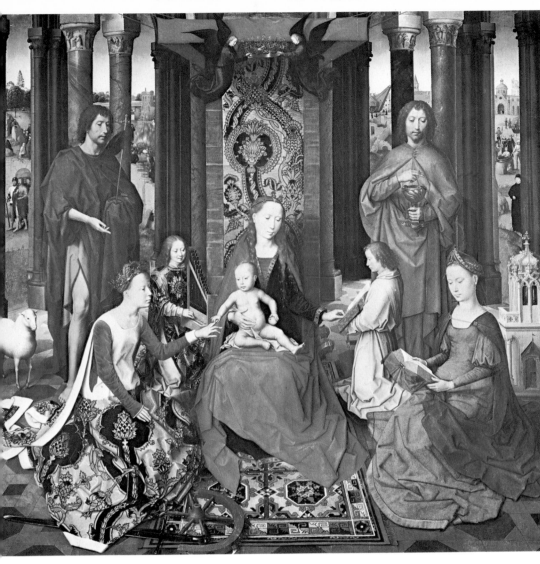

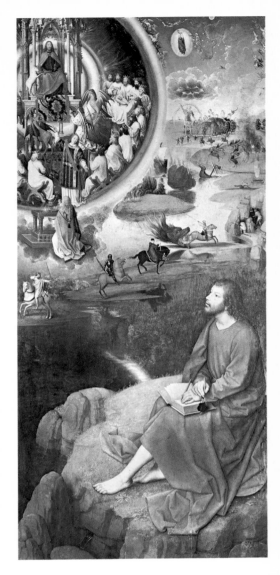

position of which is very close to that of Van der Weyden's triptych in Vienna. The small diptych in the Alte Pinakothek, however, is more personal in style: the grace of the angelic musicians surrounding the Virgin (left-hand panel), with their rather fixed smiles, is typical of Memling, whereas the precisely painted reflections in the armour of *St George*, who presents the donor (right-hand panel) suggest an attempt to imitate Van Eyck. A panel showing *Scenes from the Passion of Christ* (Turin, Gal. Sabauda), probably executed for the Florentine merchant Portinari about 1470, illustrates Memling's seductive talent as a story-teller. The painting becomes one great image, in which the fresh and lively colours invite the eye to read the numerous scenes in succession.

The triptych in the National Gallery, London, (centre, *The Virgin and Child with Donors, Angels and Saints*; wings, open, the two *Sts John*; wings, closed, *St Christopher* and *St Anthony*) was his first masterpiece. It was probably painted in about 1477 for Sir John Donne of Kidwelly who appears on the central panel with his wife and daughter. This rigorously symmetrical composition blends borrowings from Rogier van der Weyden with the preciosity of Van Eyck in a style which is now drier than that in his earlier work. A *Donor Presented to the Virgin and Child by St Anthony* (Ottawa, N.G.), dated 1472, is very similar to this work.

From 1473 comes the artist's famous triptych of the *Last Judgement* (Gdańsk, Marienkirche; now

in Gdańsk Museum) with, on the reverse, the *Virgin* and *St Michael*. Commissioned by the Florentine merchant Jacopo Tani, it was seized while it was being transported by sea and was presented to the Marienkirche in Gdańsk. The composition was inspired by the triptych by Rogier van der Weyden in the Hospices de Beaune, but differs from it chiefly by the anecdotal treatment of the resurrection of souls and their subsequent fate. From the same period comes a further triptych inspired by Van der Weyden. *The Adoration of the Magi* (Prado; left-hand wing, *The Nativity*; right-hand wing, *The Presentation in the Temple*). The same theme was taken up again in 1479 in a more powerful version painted for Jan Floreins (Bruges, Hôpital de St Jean).

Memling's later career is marked by only a small number of dated works. In 1479 came the great triptych of the *Mystic Marriage of St Catherine* (Bruges, Hôpital de St Jean); in 1480, the *Portrait of a Woman as Sibyl Sambeth* (Bruges Museum) and the panel depicting *Scenes from the Life of Christ* (Munich, Alte Pin.); in 1484, *The Moreel Triptych* (Bruges, Hôpital de St Jean); in 1487, the diptych with *The Virgin and Child and Martin van Nieuwenhoven* (Bruges, Hôpital de St Jean), a *Donor* (Uffizi), a panel from a triptych of which another wing, *St Benedict*, is also in the Uffizi, and of which the centrepiece was almost certainly the *Virgin* in the Berlin-Dahlem; finally

in 1489 came the famous *Reliquary of St Ursula* (Bruges, Hôpital de St Jean). In this last work, Memling's talent as illustrator comes to the fore, bringing him closer to the illuminators. It appears, too, in the small-scale religious panels: *Triptych of the Resurrection* (Louvre), *Triptych of the Virgin* (Vienna, K.M.) and *Diptych of the Virgin among Virgins* (Louvre).

In his large-scale altar-paintings (such as the *Triptych of the Passion*, 1491, Lübeck Museum) Memling sought to achieve the majesty of Rogier van der Weyden but this taste for detail, together with his vivid and varied use of colour, stood in the way of monumentality. This is particularly the case in the *Triptych of the Virgin and the two Sts John* (Bruges, Hôpital de St Jean), which is nonetheless one of the painter's finest works. Even the great panels depicting *Christ Surrounded by Angel Musicians* (Antwerp Museum), which probably once formed organ doors, have nothing of the plastic vigour of their models in the *Mystical Lamb* and remain purely decorative.

Memling's portraits were the most powerful works of his maturity. Whether following Rogier's formula of diptychs (*Diptych of Martin van Nieuwenhoven*) or Van Eyck's almost frontal representation in *trompe-l'oeil* (*Sibyl Sambeth*), or whether composing his figures in family groups (*Altarpiece of Jacques Floreins*, Louvre), he brought an exactitude and a precision to his portrayals that made his sitters appear full of life. For this genre

273

Hans Memling ▲
The Mystic Marriage of St Catherine (1479)
Wood. 172 cm × 172 cm (central panel from the *Triptych of the Virgin and the two Sts John*)
Bruges, Hôpital de St Jean

Hans Memling ▲
St John on Patmos
Wood. 172 cm × 79 cm (right-hand panel from the *Triptych of the Virgin and the two Sts John*)
Bruges, Hôpital de St Jean

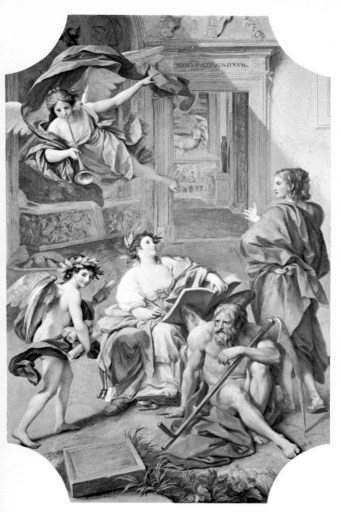

was back in Rome again in 1752. In 1761 he painted for Cardinal Albani, Winckelmann's patron, the *Parnassus* fresco, inspired by paintings from antiquity that had recently been discovered at Herculaneum. The same year he accompanied the Bourbon King Charles III to Spain and remained in Madrid for about ten years, where he executed frescoes for the Royal Palace as well as numerous portraits: *Charles III of Spain* (Copenhagen, S.M. f.K.; Prado); *Charles IV* (Prado); *Ferdinand of Bourbon* (Naples, Capodimonte; Prado); *Maria Luisa of Parma* (Prado; Metropolitan Museum). In 1769 he finished a vast *Ascension*, begun in Dresden in 1752 (Dresden, Gg; studies and preparatory drawings in the Prado).

On his return to Rome in 1770 (*The Adoration of the Shepherds*, Prado; study in Weimar Museum) he was appointed head of the St Luke Academy and executed a fresco in the Sala dei Papiri in the Vatican for Pope Clement XIV. He was recalled to Madrid in order to paint the fresco of the *Apotheosis of Trajan* (1776, Royal Palace), but his poor health forced him to request permission to return to Rome where he arrived in 1777.

As a leading interpreter of the rationalized form of Baroque that was to lead to Neoclassicism, Mengs in his day was looked upon as a new Raphael and in intellectual circles was regarded as the greatest living painter. His allegorical frescoes display both Baroque and Neoclassical tendencies, but his portraits are perhaps more serious and carefully thought out and reveal an interesting spiritual evolution. During his early years, under the guidance of his father, he studied central European portraitists such as Adler and Kupecky, then, in Dresden, Liotard's brilliant pastels, before moving on to Roman portraitists such as Benefial. Finally, he exploited with discernment the English style of portrait painting, foreshadowed by Pompeo Batoni, but infused by Mengs with his own particular brand of sentiment in the pre-Romantic vein.

As a theoretician and art historian, Mengs owes his fame to his *Gedanken über die Schönheit und*

den Geschmack in der Malerei (*Studies on Beauty and Taste in Painting*, Zürich, 1762-88, dedicated to Winckelmann) and to the collection of his *Works*, which were widely translated. In them, he emerges as a mediocre theoretician but a fine critic, with a deep knowledge not only of the 'three greats' (Raphael, Correggio and Titian) but of the whole modern pictorial tradition of the West. His *Letter to Don Antonio Ponz* (1776) on the collection of paintings in the Royal Palace in Madrid is a good example of his critical insight.

Mengs was a friend and collaborator of Winckelmann, who initiated him into the stylistic analysis of the works of antiquity, and who was in turn influenced by those of his friend. G.P.

Menzel
Adolf Friedrich Erdmann von
German painter
b.Breslau, 1815 – d.Berlin, 1905

With the exception of a few journeys to Paris (1855, 1867, 1868), to Verona (1880, 1881, 1882) and study trips to Austria and southern Germany, Menzel, from 1830 onwards, passed his entire life in Berlin where, in 1832, he became manager of the printing works founded by his father, Carl Erdmann Menzel. Almost wholly self-taught, he owed his early successes to his wood-engravings: particularly to the 200 illustrations he contributed between 1840 and 1842 to Franz Kugler's *Life of Frederick the Great*. He prepared for these engravings and others dealing with the history of Prussia by thorough historical research. Between 1849 and 1856 he painted scenes of the life of Frederick the Great, notably *Frederick at Dinner with His Friends at Sans Souci* (1850, formerly in Berlin, now destroyed), *The Flute Concert* (1852, Berlin, N.G.) and *Frederick the Great at Hochkirch* (1856, formerly in Berlin, now destroyed). After 1861 he painted various episodes from the life of the Emperor William I, but by that time problems of technique and anecdotal interpretation were more important to him than the glorification of monarchy.

Menzel's realism, from which all sense of pathos has been excluded, is evident in these historical paintings (*The Salute of William I to the Army*, 1871, Berlin, N.G.), but even more so in his landscapes and interiors, of which the most famous are *The French Window* (1845, Berlin, N.G.) and *The Artist's Sister with a Candle* (1847, Munich, Neue Pin.) and in such genre scenes as the *Théâtre du Gymnase in Paris*, 1856, Berlin, N.G.

This gift of precise observation is also visible in his vast graphic output, where it is enlivened by the vivacity of his temperament; no object appears to him to be unworthy of attention (*Casts on the Wall of the Studio*, 1872, Hamburg Museum). There are several thousand drawings by him in the National Gallery, Berlin. His style forms part of a realistic tradition that belonged specifically to Berlin in the 19th century, and which he extended. Through his totally objective view of reality, he was the north German equivalent of Leibl and prefigured Liebermann. He is particularly well represented in Berlin (N.G.) and also in the majority of German museums (Düsseldorf, Hanover, Mannheim, Cologne, Munich) and at Winterthur, Oskar Reinhart Collection. H.B.S.

he avoided the rigorous draughtsmanship of Van der Weyden, preferring a more delicate texture and more supple poses. Among his best portraits are those of *Tommaso and Maria Portinari* (Metropolitan Museum); *Willem* and his wife *Barbara van Vlaenderbergh* (Brussels, M.A.A.); an *Old Man* (Berlin-Dahlem) and *His Wife* (Louvre); a *Young Man* (London, N.G.); a *Man with a Medal* (Antwerp Museum); a *Young Man* (Lugano, Thyssen Coll.), with a *Vase of Flowers* painted on the reverse of the panel; and a *Man Praying* (Mauritshuis).

Memling's art was extremely popular towards the end of the 19th century when it was considered to be the highest expression of 15th-century Flemish painting. Now that the works of Van Eyck and of Rogier van der Weyden are better known, he is more rightly seen as a brilliant emulator of their style. A.Ch.

Mengs
Anton Raffael
German painter and theoretician
b.Aussig, Bohemia, 1728 – d.Rome, 1779

The son of Ismael Mengs, court painter to Augustus III of Saxony, Mengs paid his first visit to Rome in 1741. On his return to Dresden he was appointed 'painter to the Chamber' (1745) but set off again the following year for Rome where, in 1748, he married an Italian girl, a model at the Academy. He returned to Dresden in 1749 but

▲ Anton Raphael Mengs
An Allegory of History
Canvas. 126 cm × 80 cm
Bassano, Museo Civico

▲ Adolf von Menzel
The Artist's Sister with a Candle (1847)
Cartoon. 46 cm × 32 cm
Munich, Neue Pinakothek

Metsu
Gabriel

Dutch painter
b.Leiden, 1629 – d.Amsterdam, 1667

Metsu was probably a pupil of Dou in Leiden and was one of the founder members of the Leiden Guild of Painters in 1648; he remained in the town until 1651, but by 1657 had settled in Amsterdam. As precocious and talented as he was prolific, Metsu painted a great diversity of subjects in styles that were equally varied but sometimes too eclectic, a feature that makes it difficult to date his work precisely.

Dou's influence is evident in Metsu's many pictures of smokers, hunters or servants, subjects to which he returned throughout his career (*The Chemist*, Louvre; *The Huntsman*, 1661, Mauritshuis). The coldness and clarity of these fine paintings were tempered, especially during the 1650s, by a warmth of tone derived from Steen, as well as from Knupfer and Jan-Baptist Weenix whose influence appears in Metsu's important *Woman Taken in Adultery* (1653, Louvre), a beautiful essay in the Italian style. The series of *Blacksmith's Shops* with their highly successful lighting effects (*The Interior of a Smithy*, London, N.G.) is based on Steen.

It was during these years that Metsu produced his best works, delicate genre scenes in which tables, fabrics and objects serve as a pretext for exercises in pictorial virtuosity. The faces and poses of his figures reveal a profound understanding of psychology, while the gritty treatment of some of the painting recalls the works of Vermeer. A light chiaroscuro animates the Feasts, Musical Gatherings and Letter Scenes, themes that abound among the genre paintings of Vermeer's contemporaries. The most successful examples of Metsu include: *The Meal* (Rijksmuseum); the *Man Writing a Letter* (Montpellier Museum), which is remarkable for its candlelit effects; *A Young Woman Seated Drawing* (London, N.G.), strongly influenced by Ter Borch; *The Tipsy Woman* and *The Apple Peeler* (both in the Louvre, dated *c*.1655), admirable for the treatment of the red tablecloth; and *Alms* (Kassel Museum), in which the landscape has the same evocative mellowness as the famous *Amsterdam Herb Market* (Louvre).

Metsu later lost this simplicity and delicacy, but in compensation found a harder and more precise style, more complicated in its decoration, (*The Visit*, 1661, Metropolitan Museum). Certain transitional works, however, also date from around this time, works that are highly reminiscent of Vermeer in their clear harmonies and firm construction: for example, *The Sick Child* in Amsterdam (Rijksmuseum), or *A Man and a Woman Seated by a Virginal* (London, N.G.), as well as the famous canvases belonging to the Beit collection at Blessington, *The Letter Written* and *The Letter Received*. The same qualities reappear in a group of pictures strongly influenced by Ter Borch, including the two *Ladies*, one writing, the other at the virginals (Paris, Petit Palais), the astonishing *Noli me tangere* (1662, Vienna, K.M.) and *Woman at a Virginal* (Rotterdam, Van der Vorm Museum), which are comparable to the best interior scenes of Pieter de Hooch, Jacobas de Vrel and Janssens.

During the 1660s, however, Metsu began to overload his surfaces with an excessive amount of detail (*Woman and Man Selling Poultry*, 1662, Dresden, Gg) in canvases which were once again in the style of Leyden. The relative decline of his art from this time on is visible in the *Couple Eating a Meal* (1667, Karlsruhe Museum), although his tremendous skill to some degree compensates for his lack of inventiveness. In contrast, his two surviving still lifes, *The Dead Cockerel* (Prado) and the *Still Life with Herring* (Louvre) realize to perfection a certain ideal of poetic calm, something always sought after by Dutch painters. J.F.

Metsys
Quentin

Netherlandish painter
b.Louvain, 1466 – d.Antwerp, 1530

Metsys (whose name is often rendered as Massys or Matsys) was the son of a tinsmith, and until the age of 20 followed his father's occupation. He is first mentioned in 1491 on the occasion of his enrolment as a painter in the Antwerp Guild. He was probably trained in Louvain, perhaps alongside the sons of Dieric Bouts, but his early years remain obscure, since no known works are dated prior to 1509.

A *Virgin and Child* (Brussels, M.A.A.) is probably one of Metsys's earliest works. The presentation of the figures on a throne, richly Gothic in style, marks a backward-looking tendency, and the familiar sentimental pose of the Child reading a book in His mother's arms is in the direct tradition of Gerard David. The colours are all half-tints, broken up with brilliant shades drawn from the tradition of 15th-century painting. A *Lamentation* (private coll.), the composition of which was inspired by that by Petrus Christus, also appears to be an early work.

In 1509 Metsys completed the *St Anne Altarpiece* (Brussels, M.A.A.) for the Church of St Peter in Louvain, which had been commissioned from him in 1507. This large-scale triptych (closed: 224 cm × 219 cm) represents, in the centre, *The Holy Kindred* and, on the interior face of the wings, the *Annunciation to Joachim* and the *Death of St Anne*, while the outside depicts *Joachim Distributing his Goods among the Poor* and the *Rejection of Joachim's Offering*. The figures are grouped on the wings in a sort of shallow frieze and stand out as impressive silhouettes that have led the work to be compared to a tapestry. The tones are subtly harmonized within a range of highly characteristic translucent half-tints. A vast landscape unfolds in the background without disturbing the unity of the groups of figures. If the taste for sumptuous brocades, heavily draped folds and even the type of people are derived from the 15th-century tradition, the setting and the modelling reveal the influence of Italian art.

In 1508, when this monumental work was still not completed, Metsys received a commission for

▲ Gabriel Metsu
The Amsterdam Herb Market
Canvas. 97 cm × 83 cm
Paris, Musée du Louvre

lucent quality of the pictorial content is obtained by thin layers, almost glazes, of transparency over a white ground. It has sometimes been supposed that a pupil of Metsys, Edward the Portuguese, may have collaborated in this work, but this is no more than speculation.

Metsys's love of the archaic is clearly revealed in *The Money-Changer and His Wife* (1514, Louvre), which in its taste for *trompe l'oeil* and the precosity of its treatment displays a return to Van Eyck. Other works, however, reveal an increasing interest in Italian painting. The settings and poses in the related portraits of *Erasmus* (Rome, N.G.) and *Pieter Gilles* (Longford Castle, England) are as natural as those in *The Money-Changer*, but the atmosphere is more subtle. The influence of Leonardo appears in a *Virgin and Child* (Poznan Museum), inspired by *The Virgin and St Anne*; the same source may also be discerned in the treatment of the *Rattier Virgin* (1529, Louvre), or the *Magdalene* (Antwerp Museum). It may, too, have led to the tendency towards caricature in *The Old Man* (1514, Paris, Musée Jacquemart-André), the so-called '*Ugly Duchess*' (London, private coll.) and even indirectly to such genre scenes as *The Elderly Gallant* (Washington, N.G.) or *The Usurer* (Rome, Gal. Doria-Pamphili) from which Marinus van Reymerswaele drew inspiration in his turn.

None of this excluded a return to older themes, dramatically interpreted, as for example the *Crucifixion* (Vaduz, Liechtenstein Coll.), in the tradition of the followers of Van Eyck; a *Deposition* (Louvre), based on a composition by Rogier van der Weyden and *The Adoration of the Magi*; (1526, Metropolitan Museum) which derived from Gerard David. The importance that Metsys attached to landscape has led to the suggestion that Patenier may have collaborated in some of the works. This seems likely in *The Temptation of St Anthony* (Prado), which has been attributed to each of these artists in turn. The art of Metsys unites the traditions of the Netherlandish 15th century with the new wave of Italian realism.

A.Ch.

an altarpiece for the carpenters' altar in Antwerp Cathedral (Antwerp Museum). Finished on 26th August 1511, this second triptych is even larger than the *St Anne* altarpiece (closed: 8 ft 11 in. × 9 ft 3 in.). A *Lamentation* takes up the central section. *The Martyrdom of the Two Sts John* is featured on the inside faces of the wings, and the same saints reappear in grisaille on the outside. The central panel resembles the *St Anne Altarpiece*, with delicately modelled figures standing around the scene at Golgotha, and expresses vividly a feeling of grief. The wings, on the other hand, reveal an outward-looking character unusual for this artist and contrast strongly with the centre. The figures form part of a cluttered, animated composition, their faces contorted by emotion to the extent that they almost become caricatures.

Around the same time Metsys probably executed a third important altarpiece for the Convent of the Madre de Deus in Lisbon. Dedicated to the *Seven Sorrows of the Virgin*, the work is notable for its central panel (Lisbon, M.A.A.), which is one of the first representations of the Virgin to show the heart pierced with swords. Six secondary panels have survived, including a *Flight into Egypt* (Worcester, Massachusetts, Museum). The whole is marked by the care taken to give the figures an important role in an atmosphere which at the same time softens their outlines. The trans-

MIC

276

▲ Quentin Metsys
The Holy Kindred (1509)
Wood. 224 cm × 219 cm (central panel from the *St Anne Altarpiece*)
Brussels, Musée d'Art Ancien

▲ Piotr Michalowski
Don Quixote
Canvas. 62 cm × 46 cm
Kraków, Muzeum Narodowe

Michalowski
Piotr
Polish painter
b.Kraków, 1800 – d.Krzyztoporzyce, 1855

Michalowski was a wealthy landowner from Gahai who, after studying at Kraków and Göttingen universities, took personal charge of his estates and became active in political and social affairs. A connoisseur of art, he made frequent journeys throughout Europe and it was during a stay in Paris (1832-35) that he entered Charlet's studios, while at the same time studying Spanish and Flemish art, and also the works of Géricault, in the galleries.

Michalowski's paintings of horses and of scenes from the Napoleonic and Polish wars (*Battle of Somosierre*, Warsaw Museum) are well known, as too are his portraits (several likenesses of Napoleon) and studies of peasants (*Don Quixote*, Kraków, Muzeum Narodowe) and of beggars, a genre in which he displayed a remarkable psychological insight. His works have a liveliness and an expressive realism which, together with the technical assurance of his broad, sketchlike

treatment, his synthetic forms, harmonious and bold composition (especially in his pictures of horses), make him one of the most important representatives of the European Romantic movement. He is represented in most of the Polish galleries, notably in Warsaw Museum, which contains a fine collection of his works. W.J.

Michelangelo
(Michelangelo Buonarroti)

Italian sculptor, painter and architect
b.Caprese, near Arezzo, 1475 – d.Rome, 1564

Early years in Florence. Michelangelo was apprenticed to Ghirlandaio in 1488 at a time when the latter was engaged on the fresco cycle for the choir of the Church of S. Maria Novella, Florence, and it is not impossible that the young Buonarroti learnt the rudiments of his craft by collaborating on this work. He did not stay long with Ghirlandaio and by the following year had transferred to the school of S. Marco where he was able to study antique statues belonging to the Medici and to work as a sculptor under the direction of Bertoldo di Giovanni.

From his early pictorial activity there survives a group of pen drawings after the great masters of the 14th and 15th centuries (Louvre; Munich, Graphische Sammlung; Albertina) and a small painted panel after an engraving by Schongauer depicting the *Temptations of St Anthony*, mentioned by Vasari, which has yet to be positively identified. Even after the death of Lorenzo the Magnificent (1492), which obliged him to leave the S. Marco School, Michelangelo continued to prefer sculpture and anatomical studies to painting; the earliest reference to a painting occurs during his first stay in Rome (1496–1501), when he executed *The Stigmatization of St Francis* for the Church of S. Pietro in Montorio, of which no trace remains.

The 'Battle of Cascina' and the 'Doni Tondo'. During the spring of 1501, Michelangelo returned to Florence where he attended a public exhibition of Leonardo da Vinci's cartoon *St Anne with Virgin and Child*. He was fascinated by the complicated intertwining of the bodies, and made a drawing from this work, now in the Ashmolean Museum in Oxford; the pen strokes are supple and irregular, so as to preserve the fluid contours of Leonardo. At this time Leonardo was Florence's leading painter and it was to him that the rulers of the city entrusted the decoration

of the Council Chamber in the Palazzo Vecchio. However, in the autumn of 1504, part of this decoration, the *Battle of Cascina*, was handed over to Michelangelo who had already established his reputation in Florence with his statue of *David*. He settled the iconography by confining the battle to the middle ground of the painting, while in the foreground Florentine soldiers surprised by the Pisans on the banks of the river arm themselves hastily. This new solution allowed him to exploit to the full his anatomical knowledge and to celebrate the vitality and beauty of the human body in movement. Michelangelo's cartoon for the painting was destroyed early on (1515–16) and there remain only some mediocre copies of parts, together with a number of Michelangelo's drawings (British Museum; Florence, Casa Buonarroti) and others of doubtful attribution (Oxford, Ashmolean Museum; Albertina; Uffizi).

The young male nudes of the cartoon for the *Battle of Cascina* reappear in the painting depicting the *Holy Family* and known as the *Doni Tondo* (Uffizi), commissioned to commemorate the marriage of Agnolo Doni to Maddalena Strozzi (celebrated between the end of 1503 and the beginning of 1504) but executed some time later on, and already revealing links with the earlier Sistine scenes. The distant model for this painting is still undoubtedly the Leonardo cartoon of *St*

▲ Michelangelo
The Prophet Isaiah; Josias; The Delphic Sibyl
Ceiling fresco for the Sistine Chapel
Vatican

Anne with the Virgin and Child, but, in Michelangelo's *tondo*, the link between the figures appears more complex. The anecdotal nature of the Holy Families painted up till now in Florence gives way to the sacred and solemn feeling of a classical rite, in which the naked young athletes take part with an abstracted air. This was an intellectual solution, classical in inspiration, to the representation of the myth of Christianity, and it was to serve as a model for all 16th-century painting.

Michelangelo in Rome: the Sistine Chapel.

Michelangelo's work in Florence was interrupted at the beginning of 1505 by Pope Julius II who summoned him to Rome. The relationship between these two leading figures of the early Roman cinquecento was never an easy one and before long Michelangelo, angered by objections to his project for the Pope's tomb, left Rome and returned to Florence. The two men were reconciled soon after and Michelangelo began work on the frescoes for the Sistine Chapel in the Vatican on 10th May 1508. The initial project involved only the redecoration of the vault, previously studded with stars, but after a time Michelangelo was authorized to decorate the areas around the lunettes and spandrels. Some of the first drawings for this project have survived (British Museum; Detroit, Inst. of Arts); they allowed for the dividing up of the vault into regular squares enclosed by cornices and cartouches.

But the eventual solution was far more complex, for it aimed to remodel, from the spatial point of view, the surface to be painted. On the twelve corbels (five on either wall, plus one at

 Michelangelo
The Crucifixion of St Peter (1546–50)
Fresco from the Pauline Chapel
Vatican

each end) that punctuate the walls of the room are painted the thrones of the *Prophets* and *Sibyls*, framed by jutting pilasters. Above these are seated the *Ignudi* (nude figures), which hold bronze shields and occupy the central section of the vault. The pilasters of the two longer walls are linked by transverse arches, which frame the spaces occupied by rectangular compositions of *Biblical Scenes* (these are smaller or larger, depending on whether or not they correspond to sections including *Ignudi*).

Starting from the altar the scenes are: *God Separates Light from Darkness*, *The Creation of the Stars and Planets*, *The Separation of the Waters*, *The Creation of Adam*, *The Creation of Eve*, *Original Sin*, *The Sacrifice of Noah*, *The Flood*, *The Drunkenness of Noah*. The four double spandrels are occupied by *The Brazen Serpent*, *The Crucifixion of Haman*, *Judith and Holofernes* and *David and Goliath*. In the triangles between the thrones and in the lunettes on the faces of the walls are *The Ancestors of Christ*. The remaining spaces are filled with the *Ignudi*. The superhuman athletes of the *Doni Tondo* are here multiplied and invade the great vault of the Sistine Chapel, dominating it by their physical presence.

Only the scenes executed at the start of the project (those involving Noah) still show the equilibrium of classical influence; by the time the *Ancestors* were being painted, a superhuman, colossal race of beings had emerged. The *Prophets* and *Sibyls* anxiously consult books and gigantic scrolls, interrupt their reading, surprised and troubled by a sudden thought, or retreat, terrified, like Jonas, before the revelation of divinity.

In the triangles of the vault and around the lunettes of the walls are the families of the *Ancestors*, as though in limbo, condemned to a sombre, melancholy life. The sharp and strident range of colours in the central scenes, which are based on pale, metallic tones, becomes darker and more changeable, as though illuminated by sudden, sinister lights.

Drawings by Michelangelo which may be linked with the Sistine Chapel are rare, and in certain cases there is a possibility that surviving drawings were, in fact, executed much earlier in his life, and simply used as a matter of convenience for the Sistine Chapel. To those already mentioned in London and Detroit should be added two magnificent red-chalk drawings for the *Libyan Sibyl* (Oxford, Ashmolean Museum; Metropolitan Museum), the charcoal profile of *Zacharias* in the Uffizi and the drawings for the head of the *Prophet Jonas* and the figure of the *Mother of Ozias* in one of the lunettes, both in the Casa Buonarroti in Florence.

The Sistine Chapel was officially reopened to the public on 31st October 1512.

Return to Florence. After finishing this task, Michelangelo returned to working on the tomb of Julius II and devoted himself to other sculptures. The new pope, Leo X, requested that he work in Florence on the facade of the Church of S. Lorenzo (1516) and on the Medici tombs destined for the new sacristy of the same church (1520). Michelangelo was later given the commission (1523) for the project for the Biblioteca Laurenziana. Commissions from the Medici family kept him in Florence until 1534, the year in which Clement VII died.

Sculptural and architectural activity predominated to such an extent that mentions of paintings are extremely rare, and even his drawings of figures are few in number. The best-known drawings from these years are those done for his young friend Tommaso Cavalieri, which were intended to be used by the young man as models to teach him the art of draughtsmanship. The chosen themes are either allegorical or mythological in character: *The Fall of Phaeton*, *The Abduction of Ganymede*, *The Punishment of Tityos*, a *Bacchanal of Putti* and 'The Archer'. Michelangelo's line had by now grown heavier and thicker, and the physical type of the athlete that appeared in his work up to and including the Sistine Chapel paintings had now given way to fleshier figures, prefiguring those which were to appear in *The Last Judgement*.

The Last Judgement. On his return to Rome, Michelangelo, at the request of Pope Paul III, took up a project which had probably first been mooted by Pope Clement VII: the decoration of the wall above the altar in the Sistine Chapel. Preparation of the surface took several months, and it was not until the spring of 1536 that Michelangelo was able to start this work, which he completed on 18th November 1541. No architectural features inhibit the spread of the figures over this enormous surface. The ranks of the elect swell around the figure of Christ whose gesture conveys irreversible judgement. The damned, situated in the bottom right-hand corner, are tragically stricken and precipitated towards Charon's dark ship and the mouth of Hades. The colours are vivid and uniform: the brown of the flesh dominates and stands out in sinister fashion against the cobalt blue of the background. *The*

Last Judgement was seen by Michelangelo as a storm that descends on a population of giants and threatens to annihilate them.

For this work, too, only a small number of drawings remain, among which is one charcoal sketch of particular importance (Florence, Casa Buonarroti) because it shows Michelangelo's original plan for the work before it became gradually enlarged.

The religious crisis which tormented Michelangelo, evident in the apocalyptic vision of the *Last Judgement* as well as in his literary output at this time, was due in some measure to his close relationship with Vittoria Colonna, whom he first met in 1536 or in 1538, and whom he continued seeing until her death in 1547. For her, Michelangelo executed drawings on religious subjects, of which only a few rare examples survive. *Christ on the Cross* (*Cristus vivens*) is lost, but it is known through copies in the British Museum and in Windsor Castle; however, a red-chalk drawing, meticulously finished and representing the so-called 'Madonna of Silence' (London, Duke of Portland's Coll.), still survives. Michelangelo also drew for Vittoria Colonna a *Christ and the Woman of Samaria*, known only through an engraving.

The Pauline Chapel and the late drawings.
The decoration of Pope Paul III's chapel in the Vatican was also executed within the new framework of Michelangelo's religious preoccupation. The completion of the first fresco took from July 1542 until July 1545 (this was probably *The Conversion of St Paul*) and that of the second fresco, with *The Crucifixion of St Peter*, from March 1546 until the beginning of 1550. In *The Conversion of St Paul*, as in the *Last Judgement*, Christ appears in majesty, enveloped by a cloud of naked male figures drawn by his presence, whilst the mortals below seem dumbstruck at this unexpected event. Michelangelo does not appear noticeably to have modified his style since *The Last Judgement*, except that the colours are now lighter and gentler.

More novel in style is the fresco depicting the *Crucifixion of St Peter*. The martyrdom of the Prince of Apostles unfolds almost in slow motion, in a dreamlike atmosphere. The volcanic hill on which the Cross is erected in the foreground rises in highly irrational perspective. The scenes seem to continue beyond its boundaries, both at the sides and below with the soldiers and other bystanders continuing to advance weightily but as though hesitating slightly. There is no violence in this martyrdom, simply the implacable accomplishment of a fate determined at the dawn of time.

So far no drawings for the *Conversion of St Paul* have been identified while for the *Martyrdom of St Peter* only a few charcoal sketches on a sheet of architectural studies (Haarlem, Teyler Museum) are known. However, although retouched and damaged, there is in Naples (Capodimonte) a fragment of a cartoon used by Michelangelo for the soldiers in the bottom left-hand corner.

Once he had finished the decoration of the Pauline Chapel, Michelangelo devoted himself almost exclusively to architectural works for St Peter's, the Capitol, the Farnese Palace and the Church of S. Giovanni dei Fiorentini. His sculptures were reduced to tormented contemplations on the theme of the *Pietà* (there is a moving drawing in the Ashmolean Museum, Oxford, with variations prefiguring the *Rondanini Pietà*).

The intelligence and intense religious passion that animated Michelangelo's last years are most in evidence in a number of the drawings on sacred themes. The group of drawings with *Christ Expelling the Moneylenders from the Temple* (three studies in charcoal in the British Museum; other sketches of details, also in charcoal, on a sheet at the Ashmolean Museum, Oxford) is still close in style to the *Martyrdom of St Peter*. Being no longer constrained by the minutely detailed finish so dear to Vittoria Colonna, Michelangelo attacked the theme boldly, superimposing his second thoughts and variations on his original concept.

Another theme upon which he meditated deeply towards the end of his life was that of *Christ on the Cross between the Virgin and St John*, of which there are numerous charcoal drawings in the British Museum, Windsor Castle, the Louvre and the Ashmolean Museum. The contours of the bodies seem to palpitate, blending into an almost tangible chiaroscuro. This group of drawings is similar to two charcoal studies for an *Annunciation* (British Museum) and the double charcoal study for *Christ Bidding His Mother Farewell* (Cambridge, Fitzwilliam Museum). The last drawings of figures by Michelangelo are probably the Ashmolean Museum's *Annunciation* (dating from between 1556 and 1561) and the *Virgin and Child* in the British Museum (both in charcoal). The final images of his visionary imagination are probably the *Rondanini Pietà*, on which he was working during the last days of his life, and the drawings for the *Porta Pia*, executed after 1561, which even then struck Vasari as being 'extravagant and very beautiful' (Florence, Casa Buonarroti; Windsor Castle; Haarlem, Teyler Museum).

Michelangelo's influence as a painter was spread by engravings made from his works, both paintings and drawings. In his own century, the ceiling of the Sistine Chapel was seen as an example of a type of painting which was in direct opposition to the spontaneous 'painterly' works being developed in Venice by the young Titian. This 'sculptural' style, with its metallic finish, was of great importance to Bronzino and Pontormo while the figure style was crucial to Sebastiano del Piombo (whom Michelangelo helped with drawings), Daniele da Volterra and others. G.R.

Michelino da Besozzo

Italian painter
documented between 1388 and 1445

Michelino's first dated work is the illumination for the book containing *The Funeral Elegy of Gian Galeazzo Visconti* of 1403 (Paris, B.N.), which is contemporary with his four drawings of *Apostles* now in the Louvre. The fresco of the *Crucifixion* from the Church of S. Salvatore sopra Crevenna (near Erbe), however, certainly antedates these works, but the fragment of a fresco in the church of Viboldone (*St Laurence*), which has been attributed to Michelino, was probably painted by another artist with a similar style. In these early works, Michelino appears as a follower of Giovannino de' Grassi, but his line is less sharp and the modelling softer because of his use of fine tonalities and golden highlights.

In 1410 Michelino is known to have been in Venice, where Gentile da Fabriano was also living, but by whom he was not much influenced.

More important was his contact with Stefano da Zevio; both artists drew closer to the Austro-Czech school, and, more generally, to the Gothic mode. Apart from the *Virgin in the Rose Garden*, attributed to Stefano, the best example of these affinities is the *Mystic Marriage of St Catherine*, signed 'Michelinus fecit' (Siena, P.N.). Its supple figures, with their two-dimensional definition over a golden background, convey a feeling of gentle humanity.

To this same stylistic period belongs the drawing of the *Adoration of the Magi* (Albertina), formerly attributed to Pisanello. The miniatures for the *Book of Hours* in Avignon Library, Michelino's masterpiece of illumination, are works of supreme elegance of line and colour, in which the influence of Stefano da Zevio, evident in the figures of the saints, mingles with the Lombard style of de' Grassi. The same character emerges from the *Libretto degli Anacoreti* (Rome, Print Room) which, however, would seem to be a studio piece, closer perhaps in style to the work of Michelino's son Leonardo, who painted the frescoes in the Church of S. Giovanni a Carbonara, Naples, in about 1430-40.

Among the works of Michelino's maturity are a *Book of Hours* for the Bodmer Library at Cologny, near Geneva, a *Marriage of the Virgin* (Metropolitan Museum), and frescoes on secular themes for the Palazzo Borromeo, Milan (fragments in the Rocca di Angera). There are signs in the frescoes of an attempt to adapt the International Gothic tradition to a more spatial and more vigorous narrative style that certainly also takes into account the work of Masolino at Castiglione d'Olona, and, more particularly, of his landscapes in the Palazzo Castiglione. M.R.

Michelino da Besozzo ▲
The Mystic Marriage of St Catherine
Wood. 75 cm × 57 cm
Siena, Pinacoteca Nazionale

Mignard
Pierre

French painter
b.Troyes, 1612 – d.Paris, 1695

After being apprenticed to Jean Boucher in Bourges, Pierre Mignard studied the decorations of Fontainebleau, before entering Vouet's studio in Paris as a protégé of the Maréchal de Vitry. He became a friend of the painter and writer du Fresnoy and, in 1635, joined the latter in Italy where he was to spend more than 20 years. His activity during this time remains obscure, although he seems to have earned his living less from his great religious compositions such as *St Charles Borromeo* (Narbonne) which combined the style of Bologna with that of Pietro da Cortona, than from his devotional paintings (the famous *Virgins*, the 'mignardes', known only through engravings by de Poilly, or through mediocre examples) and his portraits, of which only two survive, both of them late works: *Un Dignitaire de l'ordre de Malte* (*A Dignitary of the Order of Malta*), dated 1653 (Malta, S. Anton Palace) and *Portrait d'homme* (*Portrait of a Man*) (1654, Prague Museum). He visited Venice in 1654 and met Albani in Bologna, but would appear to have been less influenced by him than by Domenichino.

On his return to France in 1657 he established a reputation for his portraits of women, some of them extremely flattering (the *Duchess of Portsmouth*, 1682, London, N.P.G.), for various ceilings (all disappeared) for the larger Parisian hôtels, and for his great fresco composition for the dome of the church of Val-de-Grâce (1663). His colours were now tinged with grey (according to some sources this was because he used inadequately slaked lime in his mortar) but the clear, rigorous organization of the sky in this latter work, peopled with some 200 figures, is still arresting. It is the only great vault painted in 17th-century France to have survived.

Mignard then set himself up as a rival to Le Brun and was put in charge of the Académie de

MIG

280

▲ Pierre Mignard
Portrait d'homme (1654)
Canvas. 118 cm × 98 cm
Prague, Národní Galerie

St Luc, which was at odds with the Académie Royale. Although he had long been excluded from royal commissions, he was eventually asked to carry out certain large decorations: first, for the Duc d'Orléans at St Cloud (1677-80, destroyed, but partly engraved by de Poilly) where the ensemble was completed by a *Pietà*, painted for the chapel of the Château in 1682, now in the Church of Sainte Marie Madeleine de Genevilliers); then for Monseigneur, the King's brother, at Versailles (1683-4); and finally for Louis XIV himself.

In 1685 he painted the ceilings of the Petite Galerie at Versailles (engraved by Audran) and of the two adjoining rooms, all of which were unfortunately destroyed. Their loss is all the more unfortunate in that Mignard considered them to be his most important works. Supported by Louvois, Mignard gradually supplanted Le Brun, whom he fought openly. Their rivalry resulted in works such as a *Carrying of the Cross*, which Mignard offered to the King in 1684 (Louvre), and *The Family of Darius* (1689, Hermitage), a counterpart of Le Brun's painting on the same theme, and the work which brought Mignard his great fame.

After Le Brun's death in 1690, Mignard, now in his seventies, took over his commissions and titles and set himself to produce an incredible volume of work. He executed several projects for the decoration of the church of Les Invalides (drawings in the Louvre), undertook two ceilings for the Petit Appartement of the King at Versailles (fragments in Grenoble, Lille, Toulouse and Dinant museums and in Fontainebleau) and painted a series of religious works, notable for their refined colours: *Christ et la Samaritaine* (*Christ and the Woman of Samaria*) (1690, Louvre; an earlier version at the Raleigh, North Carolina, Museum); *Christ au roseau* (*Christ with the Reed*) and *Christ entre les soldats* (*Christ among the Soldiers*) (1690, Toulouse and Rouen museums); *Sainte Cécile* (1691, Louvre); and *La Foi* (*Faith*) and *L'espérance* (*Hope*) (1692, Quimper Museum). He died while putting the finishing touches to his

Autoportrait en Saint Luc (*Self-Portrait as St Luke*) (Troyes Museum).

Most of the extant works (including almost all of the 300-odd drawings, now in the Louvre) date from the last years of Mignard's long life. He remains famous for his portraits, although the majority of those attributed to him are either of doubtful origin, or are copies which accentuate the defects of the originals: shapes are sometimes too round and soft, or the atmosphere too complacent. Although the quality of the draughtsmanship is high, only a few of the portraits seem to us today to have escaped from unfortunate stylistic conventions. Those that do are memorable for the richness of their ensembles (*La Famille du Grand Dauphin* [*The Family of the Grand Dauphin*], Versailles), their depth of sentiment (*Fillette aux bulles de savon* [*Young Girl Blowing Bubbles*], known as *Mademoiselle de Blois*, Versailles) or their realism (portraits of *Madame de Maintenon*; 1691, Louvre; of *Tubeuf*; 1663, Versailles; and of *Colbert de Villacerf*; 1693, Versailles).　A.S.

Millais
Sir John Everett

English painter
b.Southampton, 1829 – d.London, 1896

Millais entered the Royal Academy Schools in 1840, winning several medals at a prodigiously early age. His first canvases were conventionally academic, but after meeting Holman Hunt and Rossetti he became one of the founders of the Pre-Raphaelite Brotherhood. His *Lorenzo and Isabella* (1848, Liverpool, Walker Art Gal.), exhibited at the Royal Academy in 1849 as one of the test-pieces of the movement, aroused mild praise, but his *Christ in the House of his Parents* (1850, London, Tate Gal.), which concentrated on realism rather than medievalism, was greeted with hostility, notably by Dickens, and his reputation was only saved by the timely defence of Ruskin.

After this he soon became successful with works like *Ophelia* (1852, London, Tate Gal.), which demonstrated his amazing technical virtuosity, and, never a man of intellectual pretensions, gradually drifted away from his early ideals. He subsequently painted works aimed at popular sentiment such as *The North-West Passage* (1874, London, Tate Gal.), which brought him ample material rewards, including an income of £30,000 a year, a baronetcy in 1885, and the Presidency of the Royal Academy in 1896. However, even though these late paintings have little artistic merit they show great technical accomplishment, which raises his portraits in particular to an unusually high standard.　W.V.

▲ John Everett Millais
Autumn Leaves (1856)
Canvas. 104 cm × 74 cm
Manchester, City Art Gallery

Millet
Jean François

French painter
b.Gruchy, 1814 – d.Barbizon, 1875

Early years. Born into a peasant family at a hamlet near Cherbourg, Millet was a precocious child who tempered his peasant life with studies in the Latin classics and art, before working with the

painters Mouchel and Langlois in Cherbourg from 1833 to 1837. With the aid of a municipal scholarship, he moved to Paris where he worked for a time in the studio of Paul Delaroche.

By 1840 he was making his living as a painter of portraits, and had one accepted in the Salon that year. The earliest portraits (*Autoportrait* [*Self Portrait*], 1841; *Pauline Ono*, 1841; both Cherbourg Museum) are in a provincial Neoclassical manner with crisp contrasts of light and dark, and sculptural modelling. Millet's fondness for Spanish painting led to a progressive softening to his portrait style. From 1843 to 1846 he produced his greatest portraits in a *manière fleurie*, in which the colours are applied in separate flake-like strokes to form rich and sensuous surfaces, based, however, on a sturdy substructure (*Pauline Ono*, 1843, and *Armand Ono*, both Cherbourg Museum; *Deleuze*, Brême Museum; *Antoinette Hébert*, United States, private coll.; *Officiers de Marine* [*Naval Officers*], 1845, Rouen and Lyons Museums).

He spent much of his time in Cherbourg and, after the death of his first wife, lived for several months in Le Havre in 1845 before returning to Paris. In addition to portraits he was now painting bucolic scenes in a style that owed much to his contemporary Diaz and to the tradition exemplified by Prud'hon and Correggio. Back in Paris in late 1845, Millet turned to fresh subjects, while at the same time developing a new style. A new-found admiration for Poussin and Michelangelo, which was not incompatible with a respect for Delacroix's energetic *contrapposto* and foreshortenings, is evident in a variety of subjects notable for more sculptural and more heroic forms than those of the *manière fleurie*.

From 1846 to 1848 portraits became fewer (commissions were undoubtedly harder to find in the capital) and he found inspiration instead in religious and mythological themes such as *Saint Jérôme*, *Hagar*, and *Oedipe détaché de l'arbre* (*Oedipus Unbound from the Tree*) (Salon of 1847), together with nudes and genre scenes. His nudes, both oils and drawings, are extraordinarily handsome and are among his greatest works. Such genre subjects as women feeding chickens or forlorn fisherwomen led to his first heroic peasant figure, *Le Vanneur* (*The Winnower*) (destroyed; variants in Louvre), shown at the Salon of 1848. Like other artists Millet was profoundly affected by the 1848 Revolution, and from then on peasant life, reflecting the new triumph of the common man, displaced all other subjects in his art. With the fee from a government commission he was able to settle in Barbizon in late 1849, and he remained there the rest of his life, with only occasional visits to his native Normandy and to the Auvergne.

Peasant subjects and social ideals. The heroic figures of his *Semeur* (*Sower*) (Philadelphia, Provident Bank) in the Salon of 1850-1 brought Millet great notoriety, and his successive contributions to the Salon, including *Le Repas des moissonneurs* (*The Harvesters' Meal*) (1853, Boston, M.F.A.), *Le Greffeur* (*The Grafter*) (United States, private coll.), *Les Glaneuses* (*The Gleaners*) (1857, Louvre), *La Mort et le bûcheron* (*Death and the Woodcutter*) (rejected in 1859, Copenhagen, S.M. f.K.) and *L'Homme à la houe* (*The Man with the Hoe*) (1863, San Francisco, private coll.), became major elements in the social, as well as the artistic history of the Second Empire. Millet's work had a radical function because for the bourgeois critic

the peasant was a reminder of 1848 and of the contemporary misery of dislocated village life.

Millet was associated in the public mind with Courbet as the creator of a new naturalism that rivalled the established styles of classicism and Romanticism. Although he was a fatalist, and not at all a socialist, Millet's desire to depict man's unceasing struggle for existence was grafted on to a period of profound social upheaval, attendant upon the massive transfer of the rural population to the expanding industrial cities. After 1865, however, the laborious rural life he represented became associated with a widespread nostalgia for non-industrial subjects, and there began then the rise to popularity that made him after his death one of the most famous artists of the century.

In the early 1850s Millet's paintings and drawings were full of powerful images of men and women at work in field and forest, their figures knotted in tension. These give way in the later years of the decade to more monumental forms in calm poses, recalling Poussin and the classical tradition. Two or more figures are placed in the harmonic rhythms of a frieze-like order against the flat plains of the Brie, their monumentality residing in a noble, almost primitive simplicity of visual statement, the essence of which lies in the sculptural archetypes they form. Their eloquence belongs to the grand French tradition which disdains the trivial in favour of the basic visual construction.

In the 1850s Millet also executed many drawings and paintings on a more modest scale than his Salon pictures. His domestic interiors look to the Dutch tradition and to Chardin in their essential dignity of presentation and in their simplicity of structure. The drawings are perhaps finer than the paintings: the rich greys and velvety blacks formed by the ever-moving strokes of black crayon create surfaces that give power to the images and an evocative mystery to their subject. Later,

Seurat, Redon, Pissarro and Van Gogh were to build upon these drawings of Millet.

Later works. A series of major shifts occur in Millet's art in the 1860s. Until then he had been almost exclusively a painter of the human figure, but he now turned increasingly to landscape, partly as a result of his long association with Théodore Rousseau. Together they were the chief figures in what came to be known as the Barbizon School. Millet's landscape paintings show the open farmland near Barbizon (*L'Hiver aux corbeaux* [*Winter with Ravens*], 1862, Vienna, K.M.) and, more frequently, the villages and hilly pastures along the coast of his native Cotentin (*Hameau Cousin*, Rheims Museum; *L'Église de Gréville* [*The Church at Gréville*], 1871-4, Louvre), with an impressive scale and moral intensity that imply the presence of man and his care-laden relationship with nature. His most notable landscape drawings date from his visits to Vichy between 1866 and 1868; these tiny ink drawings and watercolours are miracles of sensitivity and evocation.

Another part of the great change of the 1860s was Millet's development of large pastels, independently from his paintings. From 1865 onwards he produced superb pastels of landscapes and peasants, regarded by many as his greatest achievement (Boston, M.F.A.), exploiting as they do his singular gift for drawing. Over a preliminary drawing in black chalk he drew his colours in separate strokes that retain their independence (heralding Van Gogh), all the while building the blocky, condensed forms that mark his style.

Millet's pastels were produced at a time when he was at last enjoying considerable material success, with steady purchases putting him beyond the poverty of his early years. With the Légion d'Honneur in 1868 came a grudging official

▲ Jean-François Millet
L'Hiver, Les bûcheronnes
Canvas. 78 cm × 97 cm
Cardiff, National Museum of Wales

recognition, and commissions for paintings kept him occupied. He spent the period of the Franco-Prussian War at the Commune in Cherbourg, and produced some of his finest landscape paintings there. His remaining years in Barbizon were rich in activity in all media, including powerfully lyrical landscapes (*Le Coup de vent* [*The Gust of Wind*], Cardiff Museum), the extraordinary *Chasse aux oiseaux* (*Bird hunt*) (1874, Philadelphia, Museum of Art), and the great series *Les Quatre Saisons* (*The Four Seasons*) Louvre; Boston, M.F.A.; Cardiff Museum and Metropolitan Museum). His declining health prevented him from carrying out an official commission in 1874 to decorate the Panthéon, and he died at Barbizon on 20th January 1875.

Millet's art sprang from a life-long absorption in Virgil, La Fontaine and the Bible, expressed in a proud nostalgia for rural nature, and in forms that transposed creative impulses from the past, emanating both from classical French sources and from Dutch and Flemish tradition, especially from Bruegel. His rôle was to pass these impulses on to Pissarro, Van Gogh, Seurat and Rivera embodied in forms that reveal the relevance of history and of moral intensity, as well as the vigour and beauty of one of the finest talents of the 19th century. R.L.H.

Miró
Joan
Spanish painter
b.Barcelona, 1893 – d.Palma de Majorca, 1983

The son of a goldsmith and clockmaker, Miró discovered a talent for drawing at an early age (his first works date from 1901). He enrolled in a commercial college in 1907 but at the same time followed courses at the Lonja school of fine art in Barcelona. Following a period of employment as a book-keeper during 1910, he became ill and, in 1911, spent some time convalescing at his parents' farm near Montroig in Catalonia, an area which was to become one of his greatest sources of inspiration. He then decided to devote himself full-time to painting and attended the Francisco Gali Academy in Barcelona where he found the liberal teaching stimulating. He came to know various Catalan artists at this time, among them his future collaborator, the ceramic artist Llorens Artigas.

Early years. In 1912 the Dalmau Gallery in Barcelona held an exhibition of Impressionists, Fauvists and Cubists and, four years later, Vollard organized a vast exhibition of French art in the city. These opposing influences are evident in Miró's work between 1916 and 1919. A relatively brief period of decorative Fauvism, sometimes referred to as Catalan (*North-South*, 1917, Paris, private coll.), was followed by the more vital influence of a synthetic, free Cubism, applied in particular to the portraits (*Portrait of Ricart*, 1917, private coll.). But more decisive and revealing of the artist's original temperament are the landscapes executed at Montroig, Cambrils, Prades and Ciurana, and especially those of Montroig between 1918 and 1919. Described as *détailliste* they evoke the naïveté of the Douanier Rousseau. A precise draughtsmanship governs the theme, the two-dimensional space is that of synthetic

Cubism, and sharp, cold colours prefigure Miró's later Surrealist works (*Montroig, Church and Village*, 1919, private coll.). In Barcelona, Miró made the acquaintance of Maurice Raynal and Picabia, exhibited for the first time at the Dalmau Gallery in 1918, and left in the spring of 1919 for Paris where he joined Picasso.

From 1920 onwards, Miró worked in Montroig in the summer and spent the winter in Paris where his studio neighbour in the Rue Blomet was André Masson. Despite these new contacts, he continued to follow his own inspiration. *The Nude at the Mirror* (1919, Düsseldorf, K.N.W.), drawn with cruel precision, announces the dissolution of reality before interior tensions, as do the still lifes and landscapes painted at this time. In *The Farm* (1921-2, private coll.) and *The Farmer's Wife* (1922-3, Paris, private coll.) certain details free themselves from immediate references and become purely plastic signs within a smooth space. Introduced by Maurice Raynal, Miró's first exhibition in Paris took place in April-May 1921 at the Galerie La Licorne.

Surrealism. The amount of time he spent with writers and artists belonging to the Surrealist movement confirmed Miró in his transition towards that dreamlike, semi-fantastic, semi-familiar universe that was uniquely his. A proliferation of motifs, vividly coloured and linked by arabesques, still distinguishes *Ploughed Earth* (1923-4, New York, Guggenheim Museum) and *Harlequin's Carnival* (1924-5, Buffalo, Albright-Knox Art Gal.), but *Motherhood* (1924, private coll.) with its exemplary economy of means and the subtle mechanism of its sexual symbolism brought him well and truly into his Surrealist period (1925-7).

Spontaneous invention replaced the careful and methodical style of the preceding period, although the blobs and arabesques, set against vividly mobile backgrounds, that characterize this new style are, in fact, cunningly interlinked (*Head of a Catalan Peasant*, 1925, private coll.; paintings on the theme of the *Circus Horse*). On the other hand, the paintings executed during his summer stays at Montroig (1926 and 1927) are more poetic and harmonious and sometimes humorous and tender, such as the *Dog Barking at the Moon* (1926, Philadelphia, Museum of Art), a thoroughly accomplished expression of his style.

Miró went on to exploit this personal figuration after his experience of Surrealism. The three *Dutch Interiors* (1928) and the *Imaginary Portraits* (1929) are the outcome of a complicated genesis: starting from drawn studies or from outside sources, he effected a complete transformation of the original subject matter, as in the painting by Jan Steen that formed the basis for *Dutch Interior II* (Venice, Peggy Guggenheim Foundation). In the *Portraits* the composition of the background is in large zones of flat colour, following a tenet of contemporary abstraction (*Portrait of Mrs Mills in 1750*, private coll.).

Collages, too, figured largely during this same period (exhibited at the Galerie Pierre in 1930 and 1931). The characteristic elements of Miró's style are present, but the manipulation of different textures and different objects (wood, metal, string, paper) stimulated a deeper knowledge of the chosen material, always in a spirit of great austerity. These superficially repellent works led Miró to describe himself as the 'assassin of painting', and the oil paintings which followed these collages are among the most abrupt and schematic

of all Miró's output (*Head of a Man I*, 1931, private coll.). Between 1929 (the year of his marriage) and 1936, he spent considerable periods of time in Catalonia and Montroig. In 1932 an exhibition of his work was held by Pierre Matisse in New York, with whom he remained in contact from then on.

His first attempts at lithography (developed mainly after the war) date from 1930, and he made his first etching in 1933 (*Daphnis and Chloe*). The theme of woman reappeared in his paintings from 1931 onwards, but was treated in an almost entirely abstract style. In 1931, in paintings made on wood, the forms are more structured, and arabesques and splashes of fine deep colours are in rhythm with the delicacy of the backgrounds. 'Compositions' alternated with paintings of figures that equal the creations of Picasso on the same theme in their lyrical and violent expressiveness (*Seated Woman*, 1932, New York, private coll.). Sustained by an abundant graphic output (watercolours, gouaches, nudes drawn at La Grande Chaumière in Paris, 1937), the so-called 'savage' pictures of 1937-8, small in format, reflect the Spanish Civil War in their sense of anguish. The war eventually forced Miró into exile in France until 1940. *The Reaper*, a painted mural (now disappeared) for the Spanish pavilion at the 1937 Exposition Universelle in Paris, derived from the same aesthetic, as did the *Head of a Woman* (1938, Los Angeles, private coll.), and is both its fiercest and its most complete expression.

This period, still relatively little known, but which probably represents one of the high points of European expressionism, came to a fairly rapid end. Miró's art began to open out into a sort of airy poetry, particularly during his stays in Varengeville, the heart of Surrealism, where André Breton had earlier conceived his poetic novel *Nadja*. It was here that Miró began the series of 23 *Constellations*, finished at Palma, Majorca, and in Montroig in 1941. Preceded by small paintings on sackcloth, these are among Miró's finest and most imaginative works, full of precise and poetic motifs. There is a hint of oriental influence in the richly orchestrated backgrounds, derived, perhaps, from a study of the art of Spanish North Africa, an influence that was to reappear a few years later in Miró's ceramics (*The Escape Ladder*, 1940, New York, private coll.).

New techniques. In 1942 Miró returned to Barcelona. Between then and 1944 he devoted himself to working on paper, exploiting what he had learned from the *Constellations*, but with a lighter touch. Among the themes that dominate this period are those of *Woman*, *Bird* and *Star*. In 1944 Miró took up lithography once again, and also began collaborating with the ceramic artist Artigas. Three years later he travelled to the United States in order to execute a mural for a hotel in Cincinatti and in 1950 carried out work for Harvard University. Miró's style adapted with ease to the monumental and the experience he gained led him soon afterwards to execute some large-format paintings.

Arabesques frequently appear in his easel paintings, and links with the pictorial space are modified by the role of coloured areas, at the whim of a fertile invention. Thus in 1949-50, 'slow' pictures alternate with 'spontaneous' pictures, the former comprising a series as perfect as the *Constellations*. The attention which Miró

devotes to his drawing and to the tactile and chromatic quality of the background, as well as to the equilibrium composed of these two elements, is brought into play only in the larger-format works, and according to a broader rhythm (*Figures in the Night*, 1950, New York, private coll.). The latter, all blobs and splashes, fashioned from a variety of materials, foreshadows works produced between 1952 and 1954, in which gritty areas and opaque lines stand alongside rougher, almost rustic graphic features.

This simplification culminates in the ceramics executed with Artigas between 1954 and 1959, and in the mural panels in the same material for the Unesco building in Paris (1958) and for Harvard (1960). Miró's paintings, on the other hand, with the exception of periodic returns to older patterns, are distinguished after 1960 by a new investigation of immense, often monochrome spaces, only just brought to life by the movement of the brush or by a few symbolic accidentals. Although he demonstrated, with great success, his ability to reconcile the experiments of his younger contemporaries (tachism, expression of total space, destruction of supports) with his own personal style (*Sourire de l'étoile à l'arbre jumeau de la plaine*, private coll.), his naïve grace and exquisite craftsmanship are more often found in his small-format works (studies of *Heads*, 1974, dominated by a rich use of blacks).

Ceramics continued to preoccupy the artist, together with sculpture (painted marble and bronzes; *Labyrinth*, 1968, St Paul-de-Vence, Maeght Foundation). On two occasions he designed settings for the ballet: in 1926 *Romeo and Juliet* for the Ballets Russes, in collaboration with Max Ernst; and in 1932 for Massine's *Jeux d'enfants*. He also produced tapestry cartoons, while his engravings (etchings, wood-engravings and lithographs) were exhibited in 1974 in Paris, following an important retrospective exhibition.

Miró's art was of an exceptional fecundity and diversity, and his originality cannot be over-estimated. Freedom of interpretation, allied to a continuing search for fresh sources of inspiration, had ever since Montroig, given substance to his work throughout a career that was one of the most exemplary among modern artists. A Miró Foundation, the work of the architect Luis Sert, who was responsible for the Maeght Foundation at St Paul-de-Vence, has been set up at Montjuich near Barcelona; it contains over 100 canvases donated by the artist, as well as his entire output of lithographs and sculptures.

Miró is represented in all the large galleries and private collections in Europe and the United States. M.A.S.

Modigliani
Amedeo

Italian painter
b.Leghorn, 1884 – d.Paris, 1920

Born into a family of Jewish origins, Modigliani endured a difficult childhood and adolescence because of ill health. In 1898 he entered the art school at Leghorn where he was a pupil of Guglielmo Micheli, a minor artist pursuing the tradition of the *macchiaioli*, and in 1902 continued his studies in Florence and the following year in Venice. A cultured man and a lover of poetry

(particularly that of Dante and D'Annunzio), Modigliani soon realized that in order to fulfil himself he would need to devote himself entirely to art.

He moved to Paris late in 1905 or early in 1906 and went to live in the Rue Caulaincourt in Montmartre, close to the Bateau-Lavoir. His early paintings reveal a mild interest in Cubism, then in its infancy, and suggest a certain affinity with Steinlen, Lautrec and Picasso's Blue Period (*La Juive* [*The Jewess*], 1908, private coll.). Towards the end of 1907 he met his first patron, Dr Paul Alexandre, whose portrait he painted several times. He exhibited at the Salon des Indépendants in 1908.

In 1909 he returned to Leghorn for a brief visit; his *Le Joueur de violoncelle* (*The Cellist*) (private coll.), in which line is already more important than brushwork or colour, reveals the main features of his future development. Of greater importance was his meeting that year with the sculptor Brancusi, and his move to Falguière's studios in Montparnasse. Until 1913 sculpture dominated Modigliani's output, and he only executed some 30 or so paintings. He abandoned sculpture partly because of the cost of the materials and partly for health reasons. He left 25 works (Paris, M.N.A.M.; Washington, N.G.), almost all of them heads, and most of them unfinished, which reveal influences from antiquity as well as from the Baoulé art of the Ivory Coast (multiple varia-

tions on the theme of the caryatid; New York, Guggenheim Museum; Paris, M.N.A.M.). This experience with sculpture, before he gave himself over entirely to painting, was important, for it gave him the ability to convey ample volume at a single sweep.

In 1916 Modigliani made the acquaintance of Leopold Zborowski, who helped publicize his works, and of Paul Guillaume (*Portraits of Paul Guillaume*, Paris, Musées Nationaux, Walter Guillaume Coll.; Milan, G.A.M.), who bought paintings from him from 1915 onwards. A liaison with the English poetess Beatrice Hastings, however, dragged him into an increasingly wild lifestyle. When he took up painting again he flirted briefly with Divisionism, which he sometimes exploited rather clumsily (*Portrait of Frank Burty Haviland*, c.1914, Milan, Mattioli Coll.), but elsewhere managed to integrate with an ample, supple graphism (*Portrait of Diego Rivera*, 1914, São Paulo Museum). During 1915-16 he painted portraits of his friends which reveal the influence of Cubism in their rigorous composition, broad planes, and precise draughtsmanship (*Head of Kisling*, 1915, Milan, Jesi Coll.; *Portrait of Max Jacob*, c.1916, Düsseldorf, K.N.W., Cincinnati Museum).

It was towards the end of this period that Modigliani appeared most completely master of his style in works notable for their deft arabesques, economy of means and generally sober

colours (ochres for flesh, browns, greys and blacks, with blue or green highlights), which, however, grew lighter during the last two years of his life (*The Servant*, 1916, Zürich, Kunsthaus). He was particularly successful in combining schematic reduction with the expression of the often powerful personality of his models (*Portrait of Blaise Cendrars*, 1917, Rome, private coll.; *Portrait of Chaim Soutine*, 1916, Washington, N.G.).

From around 1916-17, nudes appear more frequently in his work; they were almost always drawn first, and Modigliani respected reality in his drawings even more than in his portraits. His classical temperament reveals itself above all in his search for the rhythm of the lines of a body (*Nu couché* [*Reclining Nude*], *c.*1917, Milan, Mattioli Coll.). He softened the plasticity of contours and renounced the interior hierarchy of volumes in order to improve continuity (*Nu accroupi* [*Crouching Nude*], 1917, Antwerp Museum; *Grand nu* [*Large Nude*], *c.*1917, New York, M.O.M.A.; *Elvira*, 1919; Bern, private coll.).

His meeting with Jeanne Hébuterne in 1917 helped him to regain something of his former stability, and both Jeanne, and another young woman, Lunia Czecowska, inspired some of the finest works of his later years. Although the Mannerist characteristic of elongating the lines (of the neck in particular) became more general in his compositions, they also reveal an extremely subtle feeling for decorative effect and expression (*Jeanne Hébuterne accoudée à une chaise* [*Jeanne Hébuterne Leaning on a Chair*], 1918, New York, private coll.; *Le Maillot jaune* [*The Yellow Sweater*], 1919, New York, Guggenheim Museum; *Portrait of Lunia Czecowska*, 1919, Milan, private coll.; *La Bohémienne* [*The Bohemian Girl*], 1919, Washington, N.G.; *Marie*, 1919, Basel, private coll.).

In other works the influence of Cézanne is evident (*Le jeune apprenti* [*The Young Apprentice*], Paris, Musées Nationaux, Walter Guillaume Coll.; *Le petit paysan* [*The Little Peasant*], 1918, London, Tate Gal.; *Le Garçon à la veste bleue* [*Boy in a Blue Jacket*], 1919, Indianapolis Museum). Modigliani moved to Nice (1918-19) in an attempt to improve his health, but it was already too late to counteract the effects of tuberculosis

and overindulgence. He died in the Hôpital de la Charité on 24th January 1920; the following day Jeanne Hébuterne committed suicide.

Modigliani's was essentially a southern, classical genius, founded upon his talent for draughtsmanship and the expression of plastic values. In spite of this he was able to integrate with ease into his work the experiments of the early 20th century. Like many of his contemporaries, he found his sources in older European and African art, but unlike them he aimed through his portraits and nudes to give a modern aspect to reality, and not to define a new conception of art. M.A.S.

Mondrian
(Pieter Cornelis Mondriaan, known as Piet)

Dutch painter
b.Amersfoort, 1872 – d.New York, 1944

Together with Kandinsky and Malevich, Mondrian is considered as one of the pioneers of abstraction. His profound influence on the art of the 20th century derives as much from his writings on theory as from his painting.

After deciding at an early age to dedicate himself to painting, Mondrian studied for a teaching diploma, in order to please his father, who was a teacher. But after graduating in 1892 he gave up teaching and enrolled at the Amsterdam Academy where he was a pupil of August Allebé for three years. Between 1895 and 1897 he attended evening classes, earning his living during the day by painting portraits and making copies from the old masters in local museums.

Apart from this enforced activity he often painted out of doors, on the banks of rivers or broad polders, producing landscapes that were still highly academic in style (*Mill by the Water*, *c.*1900, New York, M.O.M.A.; *Landscape near Amsterdam*, *c.*1902, Paris, M. Seuphor Coll.). Coming as he did from a Calvinist family, Mondrian, before entering the Academy, had been uncertain whether to choose art or the Church as a career.

When, in 1899, he met the young theosophist Albert van den Briel, the latter's ideas affected him profoundly, with the lasting result that he became a member of the Dutch Theosophical Society ten years later. It was inevitable that these theories, and the study of them, should occupy an important place in Mondrian's artistic development.

After a short visit to Spain he travelled through Brabant where he decided to settle. He moved to the little village of Uden in January 1904, and it was then that a great change began to appear in his compositions. 'A certain equilibrium of architectonic division struck me in the farms of Brabant', he later wrote in *Natural Reality and Abstract Reality*. This could be ascertained by aligning and repeating forms and identical elements (segments of roofs or of trees), and this balance was also often reinforced by the use of colour, described as 'expressionist': deep blue used in conjunction with mauve, for example (*Evening Landscape*, *c.*1904; *Farm at Nistelrode*, *c.*1904, The Hague, Gemeentemuseum).

Mondrian returned to Amsterdam in 1905 and began to sell a few canvases, although he still had to teach in order to make ends meet. He completed such important compositions as *The Red Tree* (1909-10) and the more structured *Forest near Oele* (1907-9; both in The Hague, Gemeentemuseum), in which vertical and horizontal lines now opposed each other, and colours were left unmixed.

In 1908 he paid his first extended visit to Domburg, in Zeeland, where he made the acquaintance of Jan Toorop and of his *circle* of painters, to whom he probably owed two important features in his work: his lighter use of colour and the divisionism of certain canvases (*Lighthouse at Westkapelle*, *c.*1910, The Hague, Nieuwenhuisen Segaar Coll.). But during this first period in Zeeland he did not limit himself to any particular process. Stylization interested him to begin with (*Dune V*, 1909-10, The Hague, Gemeentemuseum), then the schematic arrangement of forms. A first series of trees, finishing with *The Silvered Tree* (1911, The Hague, Gemeentemuseum), separated him from the 'synthesism' of the Nabis, to which his attention had been drawn by Sluyters. With hindsight, one can discern the diminution of curves in favour of horizontal and vertical strokes, but these are more often than not interrupted by oblique lines which did not finally disappear until 1914. From this period, too, dates the triptych of the *Evolution* (1910-11, The Hague, Gemeentemuseum), in which theosophical symbolism is linked with the 'rigidity of lines'.

After an exhibition at the Stedelijk Museum in Amsterdam of the Modern Art Circle (which he had founded with Sluyters, Toorop and Kickert), Mondrian arrived in Paris, probably in January 1912. For over two years he worked alone in his studio in the Rue du Départ, but he was nonetheless deeply affected by Picasso's Cubism, which he was then discovering for the first time. Pursuing his variations on the theme of the tree (*Apple Tree in Blossom*, *c.*1912, The Hague, Gemeentemuseum), he accorded a primary importance to graphic elements, relegating colour to second place in the style of the Cubist grisailles. A *Nude*, a *Female Figure* and the two *Still Lifes with Jar of Ginger* (1912, The Hague, Gemeentemuseum) confirm this development and the growing dominance of right angles.

Then, abandoning all three-dimensionality, Mondrian began reducing objects within his com-

▲ Amedeo Modigliani
Reclining Nude (1917)
Canvas. 60 cm × 92 cm
Milan, Mattioli Collection

positions to the point where only the organization of the lines in relation to the surface of the canvas has any relevance (*Composition No. 7*, 1913, New York, Guggenheim Museum; *Oval Composition*, 1913, Amsterdam, Stedelijk Museum). Shortly before leaving Paris he reintroduced colour for its own sake into his work, most notably in his *Oval Composition in Pale Colours* (1913) and *Composition No. 9 (Blue Facade)* (1913; both New York, M.O.M.A.). From now on, two lines of research preoccupied him; the division of the canvas and the distribution of coloured planes. But the level of abstraction he achieved did not satisfy him. Summoned back to Holland, where his father was dying, he soon began his search for a 'universal pictorial language'.

After his return to Domburg he took up earlier themes (church exteriors, the sea), but this time he treated them according to plus and minus signs, with a horizontal-vertical rhythm expressing the unity of the universal principles of masculine and feminine, of the spiritual and the material (*Church Facade*, 1914, New York, Harry Holtzman Coll.; *Pier and Ocean*, 1914, New York, M.O.M.A.). A meeting in 1916 with Bart van der Leck who painted in unified planes of pure colour proved decisive: 'My technique,' Mondrian later wrote, 'which was more or less Cubist, and therefore more or less pictorial, came under the influence of his precise method.'

At the same time as he finished his *Composition with Lines* (1917, Otterlo, Kröller-Müller), and with it his plus-minus series, Mondrian began to paint in broad spreads, utilizing rectangular, sometimes overlapping planes of pure colour (*Composition No. 3 with Colour Planes*, 1917, The Hague, Gemeentemuseum), but the limits were henceforth precise, even underlined by small, broad black strokes, which were also to be found dotted about the surface of the canvas (*Composition in Blue B*, 1917, Eindhoven, Stedelijk Van Abbe Museum). The following year he took an important step with *Composition, Coloured Planes with Grey Contours* (1918, Zürich, Max Bill Coll.), in which black or grey lines join up with one another, encircling each coloured plane; the painting was 'open', making it look like the fragment of a larger ensemble.

Meanwhile, Mondrian had come into contact with Van Doesburg who was preparing the avantgarde review *De Stijl*, of which the first edition appeared in October 1917. The painter Juszr, the architects Oud, Wils, Van't Hoff and Rietveld as well as the sculptor Vantongerloo, became associated with this magazine, in which Mondrian's articles, published between 1917 and 1922, constituted the basic doctrinal element.

In 1918 Mondrian inaugurated his series of diamond-shaped compositions with *Composition, Diamond with Grey Lines* (1918, The Hague, Gemeentemuseum), in which a double system of perpendicular lines determined modules. In later canvases these were used to add a more balanced rhythm (*Composition, Planes of Pale Colours with Grey Lines*, 1919, Otterlo, Kröller-Müller). But this balance must never entail symmetry, which shatters the whole system of the linking of opposites, the basis of the theories which Mondrian revealed in 1919-20 in *Natural Reality and Abstract Reality*, then again under the name of 'Neo-Plasticism': the opposition of the so-called primary colours (red, blue, yellow) with non-colours (black, grey and white); the opposition of the horizontal with the vertical; and of equivalent dimensions with one another.

Mondrian returned to Paris in 1919, after which he gradually perfected a system of thick perpendicular black lines, usually of unequal width, which determine the structure of planes of pure colour, the importance of which *vis-à-vis* the canvas varies according to the colour. He executed almost 70 paintings within twelve years, some of which display important variations: the reduction of coloured surfaces, accompanied by their extension towards the edges of the canvas (*Composition with Red, Yellow and Blue*, 1921, The Hague,

Gemeentemuseum); the use of 'non-colours' alone (*Composition in Black and White*, 1926, New York, M.O.M.A.); and variation of the thickness of the black lines (*Composition with Black Lines*, 1930, New York, J.L. Senior Jr Coll.). Each of these innovations reappears in a modified form in the artist's later works. A new cycle was begun in 1932 with the introduction of two closely set parallel lines crossing the entire surface of the canvas (*Composition B with Grey and Yellow*, 1932, Basel, Muller-Widman Coll.).

▲ Piet Mondrian
Composition with Red, Yellow and Blue (1921)
Canvas. 80 cm × 50 cm
The Hague, Gemeentemuseum

After the publication of his *Neo-Plasticism* in 1920 Mondrian participated in numerous group exhibitions in Paris, The Hague, Amsterdam and London. In 1922 the Dutch Art Circle organized a retrospective of his work at the Stedelijk Museum in Amsterdam and, in November of the following year, he exhibited with the De Stijl group at the Léonce Rosenberg Gallery where he met Michel Seuphor, his first biographer. Following disagreement over the 'elementarist' theories of Van Doesburg, Mondrian left the De Stijl group in 1924.

In 1929 he joined the group Cercle et Carré founded by Seuphor and Torres-Garcia, then in 1932 became associated with the Abstraction-Création group, consisting largely of the remaining members of the earlier organization. In the same year he created a new cycle of paintings (multiplication of parallel black lines), following it in 1933 by a key work: *Composition with Yellow Lines* (The Hague, Gemeentemuseum). In this four coloured lines of varying thickness cross, without intersecting, a space in the shape of a white diamond. Mondrian now had at his disposal all the elements which were soon to emerge in his combined method, though it was to be another nine years before he fully perfected the synthesis.

After the series of diamond-shaped compositions came those consisting of increasingly close lines in which the use of colour is considerably reduced, and sometimes banished to the edge of the canvas (*Composition II with Red and Blue*, 1937, Paris, M.N.A.M.). In September 1938, conscious of impending war, Mondrian left Paris for London where he began vast compositions with numerous lines (*Trafalgar Square*, 1939-43, New York, J.L. Senior Jr Coll.; *Place de la Concorde*, 1938-43, New York, H. Holtzman Coll.). But the majority of these were not finished when he left London and the Blitz and sought refuge in New York.

He arrived in the artistic capital of the United States in September 1940 and found he was well received and, indeed, much sought after. He exhibited at the Dudensing Gallery (January 1942 and March 1943), while the press hailed him as 'one of Europe's greatest refugees'. In New York, which seems to have made a considerable im-

pression on him, he modified his combinations, adding a few coloured lines around the edges of the canvas to the grids of black lines (*New York*, 1941-2, New York, private coll.) until the grid became composed of coloured lines only (*New York City I*, 1941-2, New York, Sidney Janis Gal.).

Deriving from this principle, Mondrian's later works, with their syncopated rhythms, like the dances from which they took their name, include clearly visible modifications: small squares of different colours appear in the intersections, whereas in the margins grey or yellow rectangles are placed over other rectangles in blue or red (*Broadway Boogie-Woogie*, 1942-3, New York, M.O. M.A.). Finally, the unfinished *Victory Boogie-Woogie*, 1943-4, Meriden, Connecticut, B. Tremaine Coll.), a development of the previous canvas, is criss-crossed by lines composed of squares.

Mondrian died of pneumonia on 1st February 1944 and his posthumous fame was immediate and considerable. Retrospectives of his work were mounted by the New York Museum of Modern Art in 1945, by the Stedelijk Museum in Amsterdam in 1946, and by the Basel Museum in 1947. It was not until 1969 that Paris paid homage to this artist with a retrospective in the Orangerie. The Gemeentemuseum in The Hague, the Stedelijk Museum in Amsterdam and the Museum of Modern Art in New York contain the greater part of his works. E.M.

Monet
Claude
b.Paris, 1840 – d.Giverny, 1926

Early years. Monet was educated at the college of La Meilleraye in Le Havre and while still quite young earned a reputation for his skill at caricature (several of these drawings are now in the Chicago Art Institute). Around 1858 he met Boudin, whose works did not impress him much to begin with, but who encouraged him to paint from nature. Later, Monet was to point to

Boudin's love of art and independence as the determining factor in his own decision to become a painter.

Recognizing his son's talent, Monet's father asked the municipality of Le Havre in 1858 for financial support to enable the boy to study in Paris. The still life which accompanied the request was turned down, but Monet had already left for Paris in May 1859 without waiting for a reply, in order to catch the exhibition at the Palais de l'Industrie, which was due to close in June. At the Salon he admired Daubigny, Corot, Rousseau and Monginot (the painter of still lifes and animals) who put his studio at Monet's disposal. Meanwhile, in opposition to his father's wishes, Monet refused to enter the École des Beaux Arts, and his allowance was cut off. He frequented the Atelier Suisse where he probably met Pissarro who was then working in the style of Corot.

After his son's two years of military service (1861-3, spent in Algeria), as a condition of allowing him to devote his life to art, Adolphe Monet insisted that he enter the studio of an established painter. After a short stay at Le Havre where he worked with Boudin and Jongkind, who exerted a profound influence over him, Monet entered Gleyre's Paris studio in 1862 after an introduction by a relative, Toulmouche.

Development of Impressionism. It was at Gleyre's that Monet met Bazille, Lepic, Renoir and Sisley. Throughout the years 1862-4, Monet and Bazille worked together in Chailly (near Barbizon) as well as at Honfleur (with Boudin and Jongkind), settling in Paris in 1865 in the Rue de Furstenberg where they were once again in contact with Pissarro and Cézanne. In April Monet returned to Chailly intending to paint a vast canvas, a *Déjeuner sur l'herbe* 'in the spirit of Manet, but actually painted out of doors'.

Courbet helped him financially and gave him advice, which sometimes irritated Monet. However, in this case, he followed Courbet's suggestion and altered his canvas, with the result that it no longer pleased him; he decided against entering it for the Salon and left it rolled up in his studio. It was later remounted (the main part is now privately owned in France; the left-hand section is in the Jeu de Paume and there is a sketch in the Pushkin Museum in Moscow).

Freed from Courbet's teachings, Monet painted in the open air, and, using a luminous range of colours over light backgrounds, executed a large canvas representing several young women, for whom the only model was, in fact, Camille Doncieux (of whom he also made portraits) in his garden at Ville d'Avray (*Femmes au jardin* [*Women in the Garden*], Louvre, Jeu de Paume). Bazille came to his help by buying this vast work for 2,500 francs, payable in monthly instalments of 50 francs. In 1870 Bazille's father exchanged this painting with Monet, for the portrait of his son painted by Renoir. Renoir then gave *Femmes au jardin* back to Monet, and the work was acquired by the State in 1921.

The period up to late 1870, when he settled in Argenteuil, was spent variously in Paris (*Le Quai du Louvre*, The Hague, Gemeentemuseum), Sainte-Adresse (*Terrasse à Sainte-Adresse*, Metropolitan Museum), Le Havre (*Navires sortant des jetées du Havre* [*Ships Leaving the Quays at Le Havre*], accepted for the 1868 Salon after introduction by Daubigny), Étretat and London, where he arrived in September 1870 (canvases refused by the Royal Academy). During this

▲ Claude Monet
Déjeuner sur l'herbe (1866)
Canvas. 130 cm × 181 cm
Moscow, Pushkin Museum

time Camille Doncieux gave birth to Monet's son Jean. In Argenteuil he converted a boat into a studio and plied the Seine as far as Rouen, so as to capture the various subtle variations of atmosphere (*Chasse-marée à l'ancre* [*Coasting Lugger at Anchor*], Louvre, Jeu de Paume).

The period at Argenteuil represented the culmination of the Impressionist movement. Several of the young artists of the day such as Manet, Renoir, Sisley and Caillebotte came there to paint and exchange ideas and discoveries. In 1874 they decided to unite and exhibit their paintings at the Galerie Nadar. One of Monet's pictures, painted in 1872, *Impression, soleil levant* (*Impression, Sun Rising*) (Paris, Musée Marmottan), aroused sarcastic comment from the critic Leroy, who derisively coined the term 'impressionistic'. Monet's views of Argenteuil include *Le Pont* (*The Bridge*), *Les Régates* (*The Regattas*), *Voiliers* (*Sailing-boats*), *Le Déjeuner* (*The Lunch*, Louvre, Jeu de Paume) and *L'Été* (*Summer*, Berlin, N.G.).

On 24 March 1875 Durand-Ruel organized a sale at the Hôtel Drouot of 73 paintings, including 20 by Monet. The sale was a failure, and Monet's increasingly desperate financial situation forced him to apply for help to his friends Manet, Caillebotte, de Bellio and Zola.

For an exhibition at the Galerie Durand-Ruel in 1876 Monet supplied 18 canvases, including *Mme Monet en costume japonais* (*Mme Monet in Japanese costume*) (Boston, M.F.A.). That same year he went to Mongeron where Ernest Hoschedé bought several of his landscapes, including some painted in his grounds (*Les Dindons* [*The Turkeys*], Louvre, Jeu de Paume).

Back in Paris Monet was captivated by the architecture of the Gare St Lazare and executed several studies of this great iron framework seen through the smoke. For the first time he repeated the same subject, under different lighting conditions. At the 1877 exhibition at Durand-Ruel's he presented 30 canvases, of which seven were views of *St Lazare* (Louvre, Jeu de Paume; Paris, Musée Marmottan; Chicago, Art Inst.; Cambridge, Massachusetts, Fogg Art Museum). In March 1878 Camille gave birth to a second son, Michel. Ernest Hoschedé, now bankrupt, was forced to sell his collection of Impressionist paintings at the Hôtel Drouot where Monet's canvases fetched absurdly low prices.

Vétheuil. It was Manet who, by buying some of Monet's work, made it possible for the artist to settle at Vétheuil on the banks of the Seine in 1878. Some of the numerous views that Monet painted of this little village and its surroundings (Buffalo, Albright-Knox Art Gal.; Boston, M.F.A.; Paris, Musée Marmottan) were included in the fourth Impressionist exhibition in 1879. On the advice of Renoir he submitted two canvases to the Salon, one of which was accepted.

Camille died at Vétheuil on 5th September 1879, leaving Monet helpless with grief. More out of a desire to be by himself after her death than from a wish to detach himself from the group (as was claimed by Degas, who accused him of being a traitor), he organized his own exhibition at La Vie Moderne in June 1880. However, he took part in the seventh Impressionist show in 1882, with 32 canvases, landscapes and still lifes, which were favourably received by the critics.

In 1883 Monet went to live in Giverny, and in this year Durand-Ruel organized exhibitions of the works of the group in Boston, Rotterdam, London and Berlin. From 1883 to 1890, he travelled from his base in Giverny to the South of France, Normandy and Brittany, painting in all the locations he visited. (*Étretat, Belle-Île*, Louvre, Jeu de Paume; Paris, Musée Marmottan; *La Manne Porte, Étretat*, Metropolitan Museum). He participated in the fourth, fifth and sixth Expositions Internationales de Peinture.

In 1886 Durand-Ruel presented 'three hundred works in oil and pastels by the Impressionists of Paris'. Monet was also represented at the Exposition des Vingt in Brussels. From a short visit to Holland he brought back a few canvases depicting fields of tulips. At Giverny he painted some decorative panels for which Suzanne Hoschede was his model (*Femme à l'ombrelle* [*Woman with a Parasol*], Louvre, Jeu de Paume).

In 1888 he entered into a contract with Theo van Gogh, and in the same year stayed at the Château de la Pinède at Antibes (*St Jean-Cap-Ferrat*, 1888, Boston, M.F.A.; *Vue de la Salis*, France, Mrs Frank J. Gould Coll.). The year 1889 was notable for a big retrospective that he and Rodin organized at the Galerie Georges Petit; the 65 canvases that Monet exhibited were a great success. Part of the year was spent at Fresselines and Crozant, and Monet also took the initiative in raising subscriptions in order to donate Manet's *Olympia* to the State. Between 1890 and 1894 he began meeting his Impressionist friends once more, this time at the Café Riche in Paris.

Les Nymphéas (The Waterlilies). Monet, who had now been living at Giverny for seven years, bought his house in 1890; there was a large garden attached, which he filled with rare plants and flowers, and a lake with waterlilies, over which he built a little Japanese bridge. He found here the subject matter for his experiments with 'instantaneity', something which led him to undertake a great series on a single subject. At Durand-Ruel's in 1891 he exhibited 15 canvases depicting haystacks (*Meules*) and poplars (*Peupliers*) on the banks of the River Epte, and various aspects of *Rouen Cathedral*. In July 1892 he married Alice Raingo, the widow of Ernest Hoschedé. In 1894 Cézanne came to live at the inn at Giverny and, in February 1895, Monet left for Norway where he spent several months as the guest of Queen Christiana (*Mont Colsaas* [*Mount Colsaas*], Louvre, Jeu de Paume; Paris, Musée Marmottan).

Between the 10th and 31st May 1895 he exhibited 49 canvases at Durand-Ruel's, including the 20 views of Rouen Cathedral and eight canvases painted in Norway.

At the Galerie Georges Petit in 1897 he exhibited a series of studies of the *Nymphéas* (*Waterlilies*). In 1900 he visited London, where he was often to return, to paint a succession of canvases of the Thames. On his return, 37 of these were exhibited at Durand-Ruel's. From a journey to Venice in 1908 he brought back 29 canvases which were shown in 1912 at the Galerie Bernheim: *Le Palais ducal* (*The Ducal Palace*) (New York, Brooklyn Museum); *Le Grand Canal* (*The Grand Canal*) (Boston, M.F.A.). The 48 landscapes with water which make up the *Nymphéas*, painted between 1904 and 1906, and exhibited at Durand-Ruel's between 5th May and 5th June, were highly successful.

On 19th May 1911 Monet's second wife Alice died at Giverny. His stepdaughter Blanche Hoschedé-Monet, who was herself a painter, supported Monet by her presence and love until his death.

In 1914 Monet had a large airy studio built in the grounds at Giverny in order to paint huge canvases on the theme of the *Nymphéas* (some of these are now in the Musée Marmottan in Paris). In November 1918, at the instigation of the prime minister, Clemenceau, he decided to donate to the nation several of these canvases, in the form of a vast decorative work. The Orangerie at the Tuileries was chosen as their site. Monet designed the settings of these panels in the ground-floor rooms and signed the paintings over on 12th April 1922. The execution of this immense project was delayed while Monet underwent a cataract operation, but

▲ Claude Monet
Les Nymphéas. Reflets Verts (detail)
Canvas. 197 cm × 847 cm
Paris, Musée du Louvre

it was completed before he died on 5th December 1926. It was unveiled on 17th May 1927.

The majority of the studies for the *Nymphéas* were shown at the Galerie Katia Granoff in 1956 and 1957. Since then, critics have tended to consider Monet as one of the precursors of lyrical abstraction, and in particular of the 'abstract landscape'. All the world's great galleries contain works by Monet: among the most important collections are those in the Louvre (Jeu de Paume, 56 canvases), the Metropolitan Museum (30 canvases), the Musée Marmottan (75 canvases bequeathed by the artist's son in 1968 or deriving from the de Bellio Collection), the Museum of Fine Art in Boston (over 30 canvases) and the Chicago Art Institute (over 30 canvases.) H.A.

Mor
(Anthonis Mor van Dashorst)
Dutch painter
b.Utrecht, 1517 – d.Antwerp, 1576

Mor was a pupil of the famous painter Jan van Scorel in Utrecht, and later settled in Antwerp where he was admitted to the guild in 1547. He became a protégé of Antoine Perrenot, Archbishop of Arras, and the future Cardinal Granvella, who introduced him to the court in Brussels. Here, Mor painted a *Portrait of Granvella* (1549, Vienna, K.M.), as well as portraits of the *Duke of Alba* (1549, New York, Hispanic Society) and of the future *Philip II* (Althorp, Spencer Coll.). In 1550 he was sent by Mary of Hungary to Portugal to execute portraits of the Hapsburg family. He appears to have travelled through Italy as far as Rome where he was able to study portraits by Titian and Bronzino.

It was probably in Genoa that he painted, in 1550, the full-length portrait of *Maximilian of Austria*, the future Emperor, who had married the sister of Philip II; the portrait of the latter, dated 1551, was executed in Spain (both are in the Prado). In 1552 the presence of Mor in Portugal is

attested by surviving documents. He spent some further time in Madrid where contact with the austere atmosphere of the Spanish court influenced his development as an artist. He perfected a kind of portrait that was to be admired and copied throughout the courts of Europe: a sober style, devoid of decorative draperies and embellished by a minimum of accessories, but for this reason all the more authoritative and fascinating. Mor's models look out impassively, without revealing the slightest feeling. From this first stay in the peninsula come the portrait of *Queen Catherine of Portugal*, sister of Charles V (Prado), and the admirable *Portrait of the Lady with the Jewel* (Prado), which, in spite of its severity, has certain Mannerist touches.

In 1553 Mor was back in Utrecht where he and his wife Metgen bought a house. The following year he was sent to London on the occasion of the marriage of Philip II to Mary Tudor. The latter's portrait (1554, Prado), devoid equally of flattery and malice, is a masterpiece of truthfulness in the grand manner. In 1555, the year of the abdication of Charles V, Mor painted in Brussels the moving portrait of the *Young Prince of Orange in Armour* (Kassel Museum), with his dreamy though lively expression, as well as the charming portrait of *Alessandro Farnese*, an eleven-year-old page-boy, who stands proudly with his hand on the hilt of his dagger (1557, Parma, G.N.).

From this same period dates the portrait of *Philip II* in armour, painted to commemorate the victory of St Quentin. Several versions of this work are in existence. Between 1558 and 1559 Mor finally managed to return to his house in Utrecht and to find time to paint a *Self-Portrait* in which he depicts himself clothed in black satin and seated at his easel, palette and paintbrush in hand, aware of his importance, though not unduly proud (1558, Uffizi). This was also the era of the middle-class portrait, in more relaxed style, such as those of the musician *Jean Lecocq and his Wife* (1559, Kassel Museum).

In August 1559 Mor set sail for Spain with the King, but he stayed for one year only, during which time he painted the moving portrait of *Pejeron, the Count of Benavente's Fool* (Prado) and that of the *Infanta Juana*, sister of Philip II and young widow of the Prince of Brazil (1559, Prado). In 1560 he was back in Utrecht where he met once more his master Jan van Scorel, whose elderly features he captured in the form of a medallion in *trompe l'oeil* (1560, London, Society of Antiquaries). From this same period dates the *Portrait of Cardinal Granvella's Dwarf* (Louvre) and that of a *Goldsmith* (1564, Mauritshuis).

Utrecht was to be the artist's home from then on, but he nonetheless continued in his capacity as official portrait painter. He painted the new ruler of the Low Countries, *Margaret of Parma* (Berlin-Dahlem), the fourth wife of Philip II, and the young *Anne of Austria* (1570, Vienna, K.M.). These portraits alternate with figures of lawyers and businessmen (*Thomas Gresham and his Wife*, Rijksmuseum) in which the style is now flexible, and the psychology more penetrating. In 1568 and 1569 Mor once more spent several months in London, as is attested by the dates of certain English portraits.

After 1570 no more is heard of him, although some months before his death he executed at one sitting the portrait, full of life, of his friend the numismatist *Hubert Goltzius* (1576, Brussels, M.A.A.). His field of activity corresponded to the countries over which Spain held an influence. The

portraits of important figures of his time reflect a scrupulous observation conveyed in taut style. He exerted a considerable sway over Frans Pourbus the Elder, Adriaen-Thomas Key and the Spaniard Sánchez Coello. G.M.

Morales
Luis
Spanish painter
b.Badajoz, c.1515-20 – d.Badajoz, 1586

Morales's first dated work, *The Virgin with the Bird* (1546), was painted for the parish of the Conception in Badajoz. For four years he executed minor works for the cathedral there. He is thought to have served his apprenticeship in Seville in the studio of Pedro Campaña, as well as visiting Italy – which would account for certain affinities with Beccafumi and Sebastiano del Piombo. Morales's reputation was high around 1560 and in the years following the Bishop of Badajoz, Juan de Ribera, commissioned numerous works from him. According to tradition Morales was employed on the decoration of the Escorial, but his art displeased Philip II. In spite of this, he was awarded a pension in 1581, which was continued until his death.

Morales's range of subjects was limited to renderings of the *Virgin and Child*, *Pietà* and the *Passion of Christ*. The backgrounds are neutral and the landscape suggested in a summary fashion. He also initiated the style of painting the face of the Virgin in a clearly defined oval, with heavy eyelids.

His first period was very much in the Italian style: *The Madonna of Purity* (Naples, Church of S. Pietro Maggiore), and the two paintings of the *Holy Family* for the collegiate church at Roncesvalles and for Salamanca Cathedral reveal close

Mor ▲
Portrait of a Goldsmith
Wood. 118 cm × 90 cm
The Hague, Mauritshuis

Luis Morales ▲
Pietà
Wood. 124 cm × 94 cm
Madrid, Real Academia de Bellas Artes de San Fernando

links with Lombard painting; some versions of *The Virgin and Child* (Prado; London, N.G.; New York, Hispanic Society) derive their inspiration from Luini.

The dramatic character which appears in the *Pietà* of Badajoz Cathedral and which characterizes the works after 1560 is due to the influence of Netherlandish art, known through the intermediary of the Portuguese painters, or from engravings: *Pietà* and *Ecco Homo* (both Madrid, S. Fernando Acad.); *Virgin and Child* and *St John the Baptist* (both Lisbon, M.A.A.) from the altarpiece of the Church of S. Domingo at Evora. Morales's achievement lay in his reinterpretation in terms acceptable to Spanish piety of the themes and forms of the Italian Renaissance, executed in a dry precise style, which was, however, animated by a brilliant use of colour. A.C.

Morandi
Giorgio
Italian painter
b.Bologna, 1890 – d.Bologna, 1964

Morandi worked exclusively in Bologna where he attended the Academy of Fine Arts between 1907 and 1913. He began to produce etchings in 1912 and to paint the following year; the subjects he treated at this time, landscapes around Bologna and still lifes, were to preoccupy him throughout his career. A study of Giotto in Assisi and Padua in 1914 lent new depth to his earlier pictorial experiments, which he developed into a personal and poetic style.

Standing outside all cultural movements and schools, Morandi rigorously exploited his chosen themes, which he reduced to their essentials. Only his first works reflect a fleeting adherence to the metaphysical theories on painting of de Chirico or Carrà, or to the purism of the Valori Plastici group with whom he exhibited in Berlin in 1921. The paintings from this era, and in particular the still lifes of 1916 (private coll.) and of 1918 (Milan, Jesi and Jucker Coll.; Hermitage), highlight his search for a new order: forms are simplified and reduced to archetypes (cylinders, cones, spheres); there is a rigorous frontal representation; while the space is stripped of all descriptive elements.

Despite the abstraction ever-present in his themes, which nonetheless always retain their identity, landscapes and still lifes take on, after 1918, a more deeply poetic atmosphere. Bottles, jars, vases of flowers, views of the countryside around Grizzana (a village in the Apennines near Bologna) constitute the themes of a familiar world (*Landscape*, 1925, Milan, Jesi Coll.).

In 1930 Morandi was appointed Professor of Engraving at the Bologna Academy, and that same year was represented in the Venice Biennale. The 1939 Rome Quadriennale devoted an exhibition entirely to him, in which around 50 of his works were shown. While living in Grizzana during the Second World War he executed a series of landscapes, using the countryside of Emilia as his theme, and these have been compared to Corot's Italian landscapes (*Landscape*, 1941, Caracas, private coll.). His first major one-man exhibition took place at the Fiore Gallery in Florence in 1945, and there have been several subsequent ones. L.M.

Moreau
Gustave
French painter
b.Paris, 1826 – d.Paris, 1898

After training for two years in the studio of François Picot, Moreau abandoned this somewhat arid course of study in order to work alone, producing paintings in the manner of Delacroix (*La Légende du roi Canut* [*The Legend of King Canute*], Paris, Musée Gustave Moreau). In 1848 he made the acquaintance of Chassériau whom he admired for his taste for orientalism and his poetic elegance. The young artist was profoundly influenced by this friendship, which was to affect all his later work (*La Sulamite*, 1853, Dijon Museum); Chassériau was the only master from whom he never dissociated himself.

After Chassériau's death in 1856, Moreau spent two years in Italy studying and copying the works of the old masters, in particular those of Carpaccio, Gozzoli and Mantegna. He was struck, too, by the effects of Perugino's smoothness, the languid charm of Leonardo da Vinci and the powerful harmony of Michelangelo's figures. He also absorbed elements of the linear Florentine style, and the Mannerist canon.

On his return to Paris he exhibited successively at the Salon *Oedipe et le Sphinx* (*Oedipus and the Sphinx*) (1864, Metropolitan Museum), *Le Jeune Homme et la Mort* (*The Young Man and Death*) (1865) and the famous *Jeune Fille thrace portant la tête d'Orphée* (*Young Thracian Girl Carrying the Head of Orpheus*) (1865, Louvre). He had by now won over the art critics and an intellectual and cultivated minority among the public. But he also aroused derision among others who failed to understand his work, and thereafter he refused to exhibit regularly at the Salon.

Notwithstanding, he took part in the 1878 Exposition Universelle and achieved success with a number of works, including *Salomé dansant devant Hérode* (*Salome Dancing before Herod*) (1876, New York, Huntington Hartford Coll.) and *L'Apparition* (watercolour, 1876, Louvre). After 1884, profoundly saddened by the death of his mother, he lived only for his art. His illustrations for the *Fables* of La Fontaine, commissioned by his friend Antony Roux in 1881, were exhibited in 1886 at the Galerie Goupil.

After these years of solitary activity, he was elected to the Académie des Beaux Arts in 1888 and appointed professor in succession to Élie Delaunay in 1891. He was thus forced to abandon his isolated existence in order to devote himself to his pupils. Although some of them, including Sabatte, Milcendeau and Mazence, developed along traditional lines, others soon revealed their independence. The symbolism of René Piot, and the religious expressionism of Rouault or of Desvallières nonetheless owe a lot to Moreau and despite their revolutionary spirit, young Fauves such as Matisse, Marquet and Manguin thoroughly absorbed Moreau's teachings about colour.

Throughout his career Moreau attempted to express the inexpressible. His craftsmanship was sure, but his numerous preparatory pencil sketches seem cold and severe, since he took no interest in the living model and real life to him was but a means to an end. He painted in smooth impasto with enamel-like highlights and trans-

parent glazes. Colours, on the other hand, were mixed on the palette in order to obtain unusual shades: blues and reds that gleam like jewels, or pale golds and russets. This skilfully composed amalgam of colours is sometimes heightened even further by the use of wax (*Saint Sébastien*, Paris, Musée Gustave Moreau).

In his watercolours, Moreau allows himself complete freedom and ease of movement, playing freely with the effects produced by diluted colours. But he was dominated by his ceaseless quest, on both an intellectual and a mystical level, for legend and the divine. Fascinated by the world of antiquity, both religious and literary, he sought to extract the quintessence from it. He became excited first by the Bible and the Koran, and then by Greek, Egyptian and Oriental mythology. He often mixed them up, uniting them in fairy-like evocations of universal significance: *Salomé dansant devant Hérode* is eastern in its Babylonian decor, with its single lotus flower, while Hercules seduces the *Daughters of Thestius* (Paris, Musée Gustave Moreau) in the fabulous halls of some Assyrian palace. Sometimes his lyricism is overdone, as in *Le Cavalier* (*c*.1855) or *Vol des anges suivant les Rois mages* (*Flight of Angels Following the Magi*); sometimes he accentuates the hieratic immobility of his figures, as in *Hélène* or *L'Ange voyageur* (*The Voyaging Angel*) (all these works are in the Musée Gustave Moreau). Only paintings on Christian themes reveal a greater austerity of expression (*Pietà*, 1867, Frankfurt, Städel. Inst.).

Moreau exalted the hero and the poet as beautiful, noble, pure, and almost always misunderstood (*Hésiode et les Muses*, 1891, Paris, Musée Gustave Moreau). Despite his own happy relationship with his mistress, a profound misogyny emerges from the ambiguous and subtle images of women that fill his canvases, their charm often depicted as enigmatic and cruel. Far removed in spirit from the tender pity of the young Thracian girl wondering at the dead face of Orpheus, are the insidious *Chimères* (*Chimeras*) (1884, Paris, Musée Gustave Moreau) that surround the anguished figure of the man and the perverse Virgin; in *Salomé* (1876, Paris, Musée Gustave Moreau, study) the figure of the preacher is lost among undulating arabesques. Only the figure of *Leda* (1865, Paris, Musée Gustave

decors, hallucinatory palaces with marble colonnades and heavy embroidered hangings, as well as landscapes filled with craggy cliffs and twisted trees standing out against pale distant backgrounds in the manner of Grünewald. He liked the glint of gold, of jewellery and minerals, among which fabulous flowers grow.

Gustave Moreau's visions held a strong appeal for the Symbolist poets who were pursuing similar fantasies – Mallarmé or Henri de Régnier for example – and they also attracted André Breton and the Surrealists. But they troubled aesthetes such as Robert de Montesquiou and writers such as Jean Lorrain, Barrès and Huysmans who, in *À rebours* in 1884, partly based his character Des Esseintes on Moreau. All saw in these luxuriant, mysterious fantasies the expression of idealistic thoughts and of a sensual and exalted personality. Joseph Péladan even tried, though without success, to draw him into the frenetic circle of the Rose Croix. Gustave Moreau was however less ambiguous than his reputation would suggest. A shy man, he dealt only with problems that had already been overcome and was interested only in posthumous recognition.

In 1898 Moreau bequeathed to the State his studio at 14, Rue La Rochefoucauld, and all the paintings in it; Georges Rouault became the first curator of this collection. The studio, with its vast, unfinished paintings, its refined watercolours and countless drawings, reveals better than any other means the vibrant sensitivity of their author and of his aesthetic, which was very much that of the *fin de siècle*. T.B.

Moretto
Alessandro Binvicino
Italian painter
b.Brescia, c.1498 – d.Brescia, 1554

Moretto's entire career was spent in his native city of Brescia, and his style reflects its geographical situation midway between Lombardy and Venice, with their distinctive artistic traditions embodied in the work of Foppa and that of Giorgione and the young Titian, respectively. In 1516 he was working for Ferramola, a local painter, whose feeling for plasticity survives in his own work. His friendship with Romanino must already have been well established by this time, for in 1513 they had travelled to Padua together to carry out the *S. Giustina Altarpiece*. A recently discovered work, the *Madonna and Saints* (1520, Belluno, Church of S. Gregorio delle Alpi), reflects a direct knowledge of Venetian painting. From then on the artist was to enjoy a considerable measure of fame in the Veneto, although his first works, in fact, evoke the atmosphere of Lombardy and are bathed in a poetic light borrowed from Foppa (*Christ among the Animals*, Metropolitan Museum; *Christ and the Woman of Samaria*, Bergamo, Accad. Carrara).

Moretto's serenity and a deep feeling for the reality of things (the still life of the *Christ in the House of the Pharisee Simon* in the Church of S. Maria Calchera in Brescia, or the figures of the bystanders in the *Fall of Simon Magus* in the Church of Corpus Christi in Brescia have been seen as heralding Caravaggio), coupled with a noticeable tendency towards classical order, separate him from the tormented romanticism of

Moreau) is less equivocal, and becomes a symbol of communion between god and beast.

But Moreau kept coming up against the impossibility of translating exactly his visions and his impressions. He was unable to complete several large-scale works because of scruples, discouragement, or sheer lack of artistic strength. *Les Prétendants* (*The Suitors*) (1852-98, Paris, Musée Gustave Moreau), with its excessively involved style, and *Les Argonautes* (*The Argonauts*) (1897,

unfinished, Paris, Musée Gustave Moreau) are pictures whose complicated symbolism almost turns them into visual puzzles. That the latter remained unfinished is a measure of Moreau's continual dissatisfaction.

However he did finish the astonishing *Jupiter and Semele* (Paris, Musée Gustave Moreau), and the series of sketches he made in order to capture the dream-like poses of the figures are often admirable. For he knew how to create fantastic

 Gustave Moreau
Jupiter and Semele
Canvas. 213 cm × 118 cm
Paris, Musée Gustave Moreau

Romanino with whom he executed the decoration of the chapel of the Holy Sacrament in the Church of S. Giovanni Evangelista (completed in 1524). Romanino had transmitted to Moretto his taste for sumptuous colours; equally, Moretto had inspired the older painter with his feeling for stable forms. Gradually, however, he drew further away from Romanino and introduced a calmer climate into his works, which bear the imprint of authentic naturalism (*Nativity*, Brescia, Pin. Civica 'Tosio-Martinengo').

In spite of this, there is a certain monotony about his style, especially in his large altarpieces, with their static two-tiered compositions, their frequently repeated backgrounds of landscape or buildings and their recurring physical types. Most people prefer his portraits, in which he plays skilfully with the textured effects of fabrics and in which he captures his sitters in a mood of peaceful contemplation (*Man*, London, N.G.; *Lady*, Vienna, K.M.; *A Cleric*, Munich, Alte Pin.; *An Old Man*, c.1565-70, Bergamo, Accad. Carrara). As a portraitist he had a considerable influence on his pupil Moroni.

Moretto is well represented in Brescia Museum, as well as in the churches and private collections of the town and the region. The National Gallery in London has a fine collection of his work, while other masterpieces to be found outside Brescia include *The Entombment* (Washington, N.G.), *Christ by the Pillar* (Naples, Capodimonte), the organ shutters in the Church of S. Maria in Valvendra at Lovere, and *St Justina* (Vienna, K.M.), one of the artist's most poetic creations. C.M.G.

Moroni
Giovanni Battista
Italian painter
b.Albino, Bergamo, c.1525 – d.Albino, 1578

Little is known about Moroni's life but he is thought to have visited Trent, Parma and Venice. He was trained in Brescia in Moretto's studio and never wholly freed himself from this influence in his religious paintings, which are to be found in many of the churches in Bergamo. The balanced compositions, somewhat wooden figures and dryness of expression explain the lack of success of these religious works, in which he nonetheless often displays a feeling for reality that marks him out as one of the most successful exponents of Lombard poetic naturalism (*The Last Supper*, 1568, Romano Lombardo, Church of S. Maria Assunta).

As a portraitist, on the other hand, Moroni enjoyed considerable fame (even Titian did not hesitate to advise the councillors and governors of Venice living in Bergamo to have their likenesses painted by him). For the grandeur of Moretto's portraits he substituted a feeling of intimacy and a narrative quality which give a particular charm to his works. His first full-length portraits, against a background of ruins or landscape (*A Gentleman*, Milan, Ambrosiana; *G. G. Grumelli in Pink*, 1560, Bergamo, Palazzo Moroni; *The Knight with Wounded Foot*, London, N.G.) are clearly derived from Moretto. From Lotto Moroni drew a finely attuned psychological penetration.

In his maturity he succeeded in fusing background and subject, and in capturing a particular-

ly harmonious pictorial atmosphere. In his later works he caught the innermost personality of his model with a perspicacity that places him on the level of the Dutch portraitists of the 17th century. His immense production is well known, and many of the works are dated. He is particularly well represented at the Accademia Carrara in Bergamo (over 15 portraits, including those of *Isotta Brembati Grumelli* and of *Paolo Vidoni Cedrelli*, 1576), in the National Gallery in London, in the Brera, Milan, and in various collections in Bergamo. His masterpiece is, without doubt, the famous *Tailor* (London, N.G.). Finally, one little-known aspect of Moroni's work should be mentioned. This was his interest in the painting of the Renaissance which led him to make copies of a *Madonna* by Giovanni Bellini (Bergamo, private coll.) and *The Calumny of Apelles* (now lost) by Mantegna (Nîmes Museum). C.M.G.

Morrice
James Wilson
Canadian painter
b.Montreal, 1865 – d.Tunisia, 1924

The son of a wealthy Scottish-born merchant, who collected paintings as a pastime, Morrice trained to be a lawyer. His family, however, soon realized his keen interest in art and, in 1890, he was sent to Paris to study painting, where he was to remain for most of his life. Like many other foreign students, Morrice enrolled at the Acadé-

mie Julian, and, although he did not remain there long, he formed lasting friendships with other painters studying there, including the Australian Charles Conder and the Americans Maurice Prendergast and Robert Henri who later formed part of the group known as 'the Eight'. Morrice used to visit them in New York on his annual visits to Canada, which lasted until 1914, and there is a marked similarity between his work and that of Prendergast.

It is difficult to date Morrice's work before 1905. He remained at the Académie Julian only a few months before taking private tuition from Henri Harpignes. Harpignes had close ties with Whistler, and Whistler's influence can be detected in his teaching and consequently in Morrice's work from the 1890s. Harpignes encouraged his pupil to paint on small wooden panels known as *pochades*, and Morrice never lost his liking for these panels, which comprise the bulk of his output. The early ones are very Whistlerian in style, and Whistler, who knew Morrice, thought highly enough of his work to invite him to submit his work to the International Society in London, which was an exhibiting body founded in 1898 with Whistler as President.

Morrice's subjects were intimate views of Parisian life, similar to those painted by Bonnard and Vuillard, together with small landscapes of Fontainebleau and Bois le Roi and the seaside villages in Normandy and Brittany where he went to sketch with Conder and Prendergast. Like Whistler and many other artists of the period, Morrice also visited Venice, in the company of the Canadian painter Maurice Cullen. *Venetian Girl* (Ottawa, N.G.) is a work which

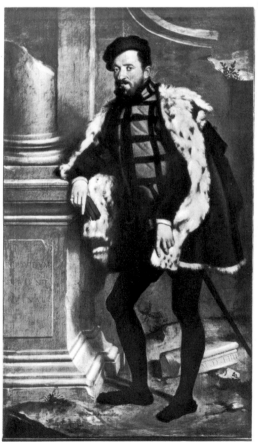

▲ Giovanni Battista Moroni
Portrait of a Gentleman (1554)
Canvas. 185 cm × 115 cm
Milan Pinacoteca Ambrosiana

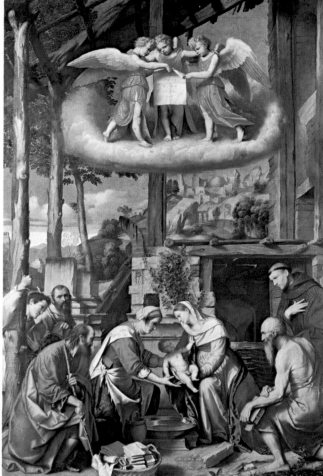

Alessandro Moretto ▲
Nativity
Canvas. 412 cm × 276 cm
Brescia, Pinacoteca Civica 'Tosio-Martinengo'

survives from this trip; many of the panels are painted with a sparkling mosaic technique.

Besides showing at the International Society, Morrice also exhibited at the Société Nationale des Beaux Arts, the Autumn Salon and the Société Nouvelle. In spite of this success his work was never recognized in Canada, although he continued to exhibit there and painted many Canadian snow scenes. *The Ferry* (1909, Ottawa, N.G.) exemplifies the neo-intimist technique that Morrice adopted after 1905. He painted in thin washes, allowing the canvas to show through, and concentrated on the decorative effect of pattern and the sensation of colour. These snow scenes, which helped to make Morrice's reputation in Paris in the first decade of the century, were painted *en plein air*, and Morrice often complained that the tubes of paint became stiff at 30° below zero.

After 1908 or 1909 Morrice met Matisse and became interested in the rhythmical possibilities of strong Fauve colour. He followed Matisse to Tangiers in 1911-12 and again in 1912-13. *Algiers Road Scene*, with its thin washes of Fauve colour, is very similar to a Matisse from the same period.

A highly sophisticated *bon vivant* Morrice had a wide circle of friends in France, including Whistler, Verlaine, Rodin, Picasso, Matisse and the Irish painter Roderic O'Conor. He was the model for characters in several novels, including Somerset Maugham's *Of Human Bondage* and Arnold Bennett's *Buried Alive*.

After spending the war in London, Morrice returned to Brittany and designed a composition for the Canadian war memorial. From there he travelled to Tunisia, Canada and the West Indies and died in Tunisia on 23rd January 1924. A.G.

Morse
Samuel Finley Breese

American painter
b.Boston, 1791 – d.New York, 1872

Morse, artist, professor, inventor, man of business and cultural affairs, represents the quintessential

James Morrice ▲
The Ferry (1909)
Canvas. 61 cm × 81 cm
Ottawa, National Gallery of Canada

early-19th century American idea of the artist, that is, a man who painted passably good portraits, but who is chiefly remembered as the inventor of the electric telegraph. Like C.W. Peale, who aspired to natural science, or Robert Fulton, the painter who invented the steamboat, or Rufus Porter, the rural stencil decorator who founded the *Scientific American*, Morse himself embodied his society's basic values, which led him to the conclusion that his country was not yet ready for high art. Thus Morse's greatest accomplishment, apart from his inventions, was his establishment of a National Academy of Design, an institution that he hoped would secure the necessary conditions for fine art to flourish in America.

Morse was born at Charlestown, Boston, the son of a Congregational minister, and the grandson, on his mother's side, of the President of the College of New Jersey (Princeton). At the age of 14 he entered Yale where he studied under Benjamin Silliman and graduated in 1810. Silliman was the nephew-in-law of Col. John Trumbull, against whom Morse was to lead a revolt by young artists in 1825 when he challenged the authority of the American Academy of Fine Arts of which Trumbull was President. In 1811 Morse left for England to study under the aging Benjamin West. He worked closely with the Royal Academy until 1815, and acquired the standard portrait techniques of his day. He was influenced, too, by the sombre genius of Washington Allston and a painting and sculpture of 1813, *The Dying Hercules*, both show Allston's influence – although the fact that Morse invented a marble-carving machine to aid in the realization of his conception is revealing of his many-sided genius.

Returning to the United States in 1816 Morse painted portraits in New England for 15 dollars a time, then married, and tried his fortune in South Carolina from 1819 to 1822. In 1821, bowing to the realities of American culture, he painted *The Old House of Representatives* (Washington, D.C., Corcoran Gall.), intending to send the work, which comprised 86 portraits, on tour. The project was a failure as there was no public interest in it. In 1824, however, he settled in New York and entered a competition against Sully, Rembrandt Peale, and Inman for the commission

to paint the portrait of Lafayette. Winning this established his reputation and ensured him a regular supply of important portrait commissions. Yet he longed to do more effective public work.

In 1829, following the death of his wife, Morse returned to Europe for three years. Here, he conceived the idea of painting a huge picture of the Salon Carré at the Louvre, reproducing all the masterpieces that hung in that famous chamber. The picture was intended to show America the advantages of such a collection, but once again the United States tour was a failure. Morse returned to New York and occupied himself with the affairs of the National Academy, which was at once a training ground, an exhibition centre for contemporary artists, and what Morse saw as the potential nucleus of a much-needed museum. In 1835 Morse was named Professor of the Literature of the Arts of Design at New York University. While there, he built and tested in 1835-6 the first telegraph. He also introduced the daguerrotype to the United States, thus establishing the basis for the portrait photography that would destroy the market for low-price painted portraits.

Morse was an accomplished, even felicitous painter, especially in more informal works, such as *The Muse–Susan Walker Morse* (1835-7), a portrait of his daughter drawing. The occasional landscape, such as *Apple Hill* (Metropolitan Museum), shows him not insensitive to the transcendental language of landscape in the spirit of Cole and Doughty, and has special significance as representing the region of Cooperstown, New York, site of many of the novels of J. Fenimore Cooper. D.R.

Moser
Lukas

German painter
active first half of the 15th century

Moser was the author of an *Altarpiece of St Mary Magdalene* now in the church of Tiefenbronn near Pforzheim in the Black Forest, and dating from 1432 (not from 1431 as was previously thought). An inscription on the frame states that the work is by 'Lukas Moser, painter of Weil' (probably referring to Weilderstadt, where the artist's studios are thought to have been situated).

The altarpiece, whose unusual shape is explained by its destination (it was substituted for a fresco on the wall of the southern arm of the transept, under an arch) is executed on oak (exceptional in southern Germany) and covered in parchment. Certain sections have been gilded and others, such as the sea, painted in silver leaf. The work has suffered only two alterations: one about 1525, when the statuary of the chest was replaced by *The Apotheosis of the Magdalene*, which is still there today, and which involved increasing the height and the addition of a small decorative frieze on the top of the movable wings as well as on top of the fixed panels; and the other in 1891 when the installation of a new exterior frame involved the loss of part of the inscription. The remaining parts have been repainted, but without alteration to the shape of the letters or the meaning of the words.

When closed, the altarpiece reveals scenes from

the legend of *The Magdalene*: to the left (fixed panel) *The Sea Voyage*; in the centre (two movable panels) *The Sleep of the Saints on their Arrival in Marseilles* and above, across a window, *St Mary Magdalene Appearing to the Wife of the Prince*; on the right (fixed panel) is *The Last Communion of the Saint in the Cathedral at Aix*. Inside the movable wings are *St Martha* (left) and *St Lazarus* (right): both figures stand against a background of gold on a floor composed of clouds, stars and a multitude of monsters – an allusion perhaps to their evangelizing in Provence. On the still visible lunette, the Magdalene is shown drying the feet of Christ during the meal with Simon; the predella has *Christ with the Wise and Foolish Virgins*.

The work is of high pictorial quality, unequalled in Germany at this time. It is difficult to determine where its author received his training – possibly in the Lower Rhine region – but certain iconographic peculiarities and points of style show him to have been fully acquainted with the most recent developments in Netherlandish art, and particularly with the works of the Master of Flémalle. These include the symbolism in the figures on the portal and the unfinished state of Aix Cathedral; the fact that the same architectural composition is employed in two different scenes (*The Arrival in Marseilles* and the *Communion*); the rendering of water in a manner comparable to that found in the most up-to-date miniaturists of

the time; and the attention devoted to the effect of light (as, for example, the shadow of a ring upon a wall). However, the treatment of forms is still very close to the style of the preceding generation.

The famous inscription 'Cry out, art, cry out and wail! No one wants you now' on the frame has led to considerable comment. It seems less likely to have been the protest of a traditional painter against innovation in art, than of an artist aware of his worth and his modernity in a milieu still unable to appreciate his work. P.V.

Mostaert
Jan
Dutch painter
b.Haarlem, c.1475 – d.Haarlem, 1555-6

For a long time Mostaert was known under the name of 'the Master of Oultremont' (the name attached to the triptych depicting the *Descent from the Cross*, now in Brussels, M.R.B.A.). Early documents mentioned his presence in Haarlem in 1498 where he was the pupil of Jacob Jansz van Haarlem, a painter about whom very little is known, and who is perhaps identifiable as the

Master of the Brunswick Diptych. In 1507 he is mentioned for the first time as Dean of the Haarlem Guild, a position he occupied again in 1543. Between 1519 and 1529 he was painter to the Regent Margaret of Austria, whose court was at Malines. The Haarlem archives prove however that he never lived for any length of time outside his native town.

Mostaert's work is always balanced, moderate and refined, and is made up of religious subjects, a few landscapes and a number of portraits. Among

Samuel Morse ▲
The Dying Hercules (1813)
Canvas. 245 cm × 181 cm
New Haven, Connecticut, Yale University Art Gallery

Lukas Moser ▲
The Sea Voyage
Wood. 135 cm × 57 cm (panel from the *Altarpiece of St Mary Magdalene*, 1432)
Tiefenbronn, parish church

the best of these are *Joost van Brockhorst* (Paris, Petit Palais) and the portraits of men in Berlin, Copenhagen and Brussels, as well as that of a *Young Man* (1520–5, Liverpool, Walker Art Gal.). All these likenesses are remarkable for their air of wisdom, and the use of subtle colours. The gloves are painted in silky grey, very much in the style of Geertgen tot Sint Jans and the Haarlem landscape school with, in the background, the knots of small, agitated figures characteristic of this painter.

The strange *East Indies Landscape* is extremely novel (1542, Haarlem, Frans Hals Museum); one of the first evocations of the New World, it is singularly fresh in its naïve inaccuracy. The influence of Patenier may be seen again in the *Landscape with St Christopher* (Antwerp, Mayer van den Bergh Museum), painted towards the end of Mostaert's career. In his religious paintings, the example, though in more softened form, of Geertgen, is clearly visible; *Head of St John the Baptist* (Rijksmuseum), a work overladen with detail; *The Adoration of the Magi* (Rijksmuseum); a fine series on the *Ecce Homo* (London, N.G.; Verona, Castel Vecchio; Burgos Museum); *The Tree of Jesse* (Rijksmuseum) of such naïve and poetic charm that it was long considered to be by Geertgen himself.

The key work around which the paintings attributed to Mostaert have been grouped is the so-called *Oultremont Triptych* with a *Descent from the Cross* on the central panel, painted for Albrecht van Adrichem of Haarlem (Brussels, M.A.A.). Typical also of the Mostaert's slightly old-fashioned charm is his *Holy Family* in Rome (Palazzo di Venezia) and his triptych of *The Last Judgement* (c.1515) in Bonn Museum.

The work of Jan Mostaert as a court painter conveys a seductive impression of luxurious elegance and dreamlike poetry despite, or perhaps because of, its apparent uniformity and latent conservatism, which was to prolong the school of Haarlem and the influence of Geertgen well into the 16th century. J.V. and J.F.

Munch
Edvard

Norwegian painter
b.Lyten, 1863 – d.Ekely, 1944

The son of a doctor, Munch was profoundly affected by the death of his mother and of two of his sisters (the source of a number of paintings of death-bed scenes). After his father had moved to Christiania (now Oslo), he entered the local technical college in 1879), becoming associated a few

years later with the Norwegian outdoor school of Naturalist painting, which included Hans Heyerdahl and Christian Krogh (who was also his teacher in 1882), as well as with artistic and literary circles in Christiania.

Munch began by painting portraits of his friends and relations in a realistic style, softened by a timid Impressionism (*Portrait of the Artist's Aunt*, 1884, Oslo, private coll.). In 1885 he paid his first visit to Paris, which seems to have made little impression on him. Soon after, he painted *The Sick Child* (1885-6, Oslo, Munch Museum), in which the use of a single dominant colour, and above all the atmosphere, prefigure Picasso's Blue Period. The work was significant of Munch's morbid state of mind, largely due to his surroundings in which sickness, pain and death were ever-present, bringing irredeemable solitude to people, even when in love. Women were for Munch often objects of revulsion as much as of attraction and ended up by incarnating a negative, destructive force (*Vampire*, c.1893, Oslo, Munch Museum; *The Young Girl and the Heart*, 1896, etching). In 1889 Munch was awarded a travelling scholarship and he moved to Paris which was to be his home until 1892. He frequented Léon Bonnat's studio, saw the Gauguin exhibition at the Café Volpini and was considerably influenced by Impressionism (*Rue La Fayette*, 1891, Oslo, Ng).

Back in Oslo, he exhibited successfully and was invited to Berlin by the Verein der Berliner Künstler, where he presented 55 works which revolutionized that city's artistic life (1892). He decided to remain in Berlin, and this was to be the start of the most important period of his career. He made the acquaintance of Strindberg, learned the techniques of etching and drypoint (1894), then lithography and wood-engraving (1896), and came under the influence of Max Klinger, Rops and Vallotton. Once he had assimilated Impressionism, his development tended towards a highly expressive concentration of form, saturated with generally dull colours (*Evening in Karl-Johann Street in Oslo*, c.1892, Bergen, private coll.). The tension in this last work, representing the 'solitary crowd', is accentuated in *Anguish* (1894, Oslo, Munch Museum) and attains its culmination in *The Scream* (1893, Oslo, Ng). Certain pictures remain relatively realistic (*The Next Day*, 1894-5, Oslo, Ng), as do some of the engravings (*The Kiss*, aquatint and drypoint, 1895), but this characteristic is generally lacking. Later works on the same theme, in which economy of means is taken to its furthest limits are *Madonna*, 1895-1902, lithograph, and *The Kiss*, 1902, wood-engraving.

Munch returned to Paris in 1896 and exhibited at the Galerie Art Nouveau (with brief commentaries on the paintings by Strindberg). He also worked on the series *The Frieze of Life* (originally entitled *Eighteen Scenes from the Modern Life of the Soul*), exhibited in 1897 at the Salon des Indépendants. *The Dance of Life* (1899-1900, Oslo, Ng) is a resumé of this series and reveals a deeply pessimistic view of humanity; in it, the inflexions of the Jugendstil and Gauguin's Synthetism blend with the stylizations resulting from Munch's experience with wood. Munch also collaborated at the Théâtre de l'Oeuvre and designed the programme for Ibsen's *Peer Gynt*.

The ten years from 1898 were restless ones for Munch, during which he spent periods in Germany, Norway, France and Italy, culminating in a nervous breakdown in 1908. To this graphic work, which comprised an important part of his

▲ Jan Mostaert
Portrait of a Young Man (1520–5)
Wood. 96 cm × 76 cm
Liverpool, Walker Art Gallery

studied in Vienna with Rahl and Piloty, then at the Munich Academy with Alexander Wagner and Franz Adam, a period during which he was particularly attracted by the art of Rembrandt. Passing through Paris in 1867 he discovered, too, the social realism of Courbet. After 1868 he completed his training in Düsseldorf in Knaus's studio where he came to know László Páal. At the Salon des Artistes Français in 1870 he showed his famous *Last Day of a Condemned Man in Hungary* (1870, Budapest, M.N.G.), which won him the gold medal and universal acclaim. There followed numerous realistic canvases in thick impasto and a subdued range of blacks, browns and greys, relieved by touches of pure white or vivid red: *The Lint-Makers* (1871, Budapest, M.N.G.), *The Village Hero* (1875, Cologne, W.R.M.), or the *Women with the Milk Churn* (1873, Budapest, M.N.G.).

In 1872 Munkácsy settled in Paris and spent some time in Barbizon in 1874 where he executed landscapes in subdued but beautiful colours (*Dusty Road*, 1881; *Avenue of Chestnut Trees*, 1886, both Budapest, M.N.G.). He married a French woman, Cécile Papier, widow of the Baron de Marches and, now closely involved with Goupil and Sedelmeyer, lived for many years the opulent worldly life of the successful painter in Paris. He executed some typically Parisian canvases in these surroundings and, under the influence of Makart, abandoned realism to some extent. Like Wilhelm Leibl, he drew closer to Impressionism, but devoted himself primarily to historical and religious works, very vigorous in character, though occasionally somewhat theatrical (*Christ before Pilate*, 1881, Budapest, M.N.G.). For the Parliament buildings in Budapest he executed a huge decorative composition, *The Taking of Hungary by the Magyars in 896* (Reception Chamber of the President's Council). He died at Endenich, near Bonn, in a lunatic asylum. D.P.

Murillo
Bartolomé Esteban

Spanish painter
b.Seville, 1618 – d.Seville, 1682

Orphaned at a very early age, Murillo was apprenticed to Juan del Castillo but must also have known the work of Zurbarán, then at the

output between 1896 and 1898, were now added oppressive interpretations of landscape (*Summer Night on the River Bank*, c.1902, Vienna, K.M.) or more light-hearted works (*Dance on the River Bank*, 1900-2, Prague Museum; *Port of Lübeck with Steamer*, 1907, Zürich, Kunsthaus). In 1908 Munch returned to live in Norway and in 1916 he settled in Ekely. The frescoes commissioned from him by Oslo University (1909-15), despite their ambitious programme and symbolic intentions (*Alma Mater*, *The Mountain of Mankind*), indicate an orientation towards a more descriptive, even realistic art, as can already be seen in the etchings (1902) and contemporary canvases on the theme of work (*Workers Returning Home*, 1915, Oslo, Munch Museum). A few paintings, however, display great boldness, where forms dissolve into motifs treated for their own sake, in a sort of expressive abstraction (*Children in the Street*, 1910, Oslo, Munch Museum). Munch's style changed little after this, admitting only, alongside the established severity of his style, some which are more relaxed (*Brigitte Olsen Seated on a Bed*, 1925-8, Oslo, Munch Museum). Towards the end of his life, the artist executed a number of *Self-Portraits*, full of pathos, returning again and again to the question of his own fate (*The Nocturnal Vagabond*, 1939, Oslo, Munch Museum).

In his engravings, the themes of love and death, of women and couples, inspired many fine works,

from *Death and the Maiden* (drypoint, 1894), with its macabre eroticism worthy of Baldung, to the nostalgic *Encounter in the Universe* (coloured wood engraving, 1899), and the representations of stages in the lives of women (*Puberty*, etching, 1902), and the later, less pessimistic, more genuinely human series (*The Bite*, etching, 1913; *Towards the Forest*, coloured wood engraving, 1915). His last version of *The Kiss* was engraved on wood in 1943. Munch's influence, as the precursor of Expressionism, was very strong in Germany, particularly over Die Brücke. The artist is well represented in Oslo (Ng and Munch Museum), Germany (Berlin, N.G.; Cologne, W.R.M.; Hamburg), Switzerland (Zürich) and the United States (Boston, M.F.A.). M.A.S.

Munkácsy
Mihály (Michael Lieb)

Hungarian painter
b.Munkacs, 1844 – d.Endenich, near Bonn, 1900

After a difficult and unhappy childhood, Munkácsy received his first lessons from a travelling painter, Alexis Szamossy, and then in 1863 worked in Budapest with Anton Ligeti. He next

▲ Edvard Munch
The Scream (1893)
Canvas. 91 cm × 73 cm
Oslo, Nasjonalgalleriet

▲ Munkácsy
Dusty Road (1881)
Canvas. 96 cm × 129 cm
Budapest, Magyar Nemzeti Galeria

religious paintings on such themes as the *Holy Family*, the *Virgin and Child* and the *Immaculate Conception*, works that earned him a tremendous reputation during his lifetime and were still admired during the 18th and 19th centuries. At times his delicacy was carried to the point of sentimental affection in response to the conventional middle-class piety of the time; and the fact that these works were distributed in their hundreds in the form of popular prints means that they tend now to be looked upon with disdain. But it must be said that from a strictly technical point of view, they figure among the most successful and free of Murillo's works, and, more generally, among the authentic masterpieces of the Baroque genius.

Contemporary taste, however, is more in tune with Murillo's genre paintings and portraits. The famous pictures of children, such as *The Young Beggar* (c.1650, Louvre) and *The Watermelon Eaters* (Munich, Alte Pin.), have a vivacity rare in 17th-century Spanish art. They combine an affectionate view of a sometimes cruel reality with the joyous vitality of the picaresque world and an incomparable technical virtuosity. *The Ragged Boy* has sometimes been quoted as the direct ancestor of the sunny paintings of the 19th century. Portraits that can definitely be attributed to Murillo are rare: *Andrés de Andrade* (Metropolitan Museum), *Nicholas Omazur*, the *Horseman* (known also as *The Jew*; Prado), *Self-Portrait* (c.1665, London, N.G.). In spite of this, he may be looked upon as a successful disciple of Van Dyck, whose refined elegance he shares, although he is always more sober, more austere, more Spanish, owing to his use of severe colours, in which strongly contrasting blacks and whites soften into delicate flesh-tints.

To Murillo the landscape artist are attributed a few remarkable views (*Landscape*, Prado), although these present problems of authorship and it is certain that the Basque painter Iriarte, about whom little is known, collaborated in these works.

Murillo trained a number of pupils and collaborators, and it is still difficult to gauge precisely the extent of their contribution to his work. Often, they assimilated the models and ideas of their master only superficially, and they are primarily responsible for the discredit that attached to Murillo during his later years. However, his style of composition continued to dominate painting in Seville until well into the 18th century, while even in the 19th century there were some not unskilful imitators of his art.

A.E.P.S.

height of his fame, and of Ribera, who was well represented in the collections of Seville. The influence of these two painters is clear in his youthful works.

The first important commission he received, in 1645, was for the *Franciscan Cycle* for the convent of that order in Seville, a series of eleven paintings, now dispersed: *The Angels' Kitchen* (1646, Louvre), *San Diego of Alcalá* (Madrid, S. Fernando Acad.), *The Death of St Clare* (Dresden, Gg). Alongside a certain clumsiness of composition and a treatment of light that is still tenebrist, there appears a characteristically bitter view of the reality of daily life and an almost medieval concept of religion, in which objective truth and miracles mingle quite naturally and ingenuously.

Murillo's marriage in 1648 marked the beginning of a happy and productive period in his life. During these early years his style developed according to the current trend towards tenebrism (*The Last Supper*, 1640, Seville, Church of S. Maria la Blanca; *The Holy Family with a Bird*, Prado). The next ten years, however, saw his style grow more fluent, as well as suppler and lighter. The sureness of his composition, the diffusion of light and the use of increasingly rich colours reveal not only a knowledge of Venetian and Flemish models (particularly Anthony van Dyck) but also of the Flemish-influenced painting

of Genoa, which he was able to study in Seville.

In 1658 Murillo travelled to Madrid where he studied the royal collections and came into contact with Velázquez. During the years 1665-6 he carried out for the Church of S. Maria la Blanca in Seville a decorative ensemble that ranks as one of his masterpieces, both for its delicacy and sureness of touch and for the beauty of its warm, golden tones, tinged with greys and silvers in the distant landscape (now dispersed; *The Dream of the Patrician* and *The Explanation of the Dream by Pope Liberius*, Prado). In 1665, too, he undertook the series of figures of *Saints* commissioned from him by the Capuchins of Seville (Seville Museum).

In 1668 he worked on the great *Immaculate Conception* for the cathedral and the series of busts of *Saints* for the sacristy. Between 1671 and 1674 he carried out, in collaboration with Valdes Léal, an ensemble of paintings for the Charity Hospital in Seville, notably *Moses Striking the Rock* and *St Isabella of Hungary*, works which are among the most representative of his maturity. In 1681 he began a cycle for the Capuchin monks of Cadiz, left uncompleted after an accident from which he died some months later.

Apart from the series for the various monasteries, which can be dated with certainty, Murillo, a highly prolific artist, also left numerous

Nash
Paul

English painter
b.London, 1889 – d.Boscombe, 1946

After a short period at the Chelsea Polytechnic, Nash studied at the Slade School from 1910 to 1911. Unlike many of his contemporaries there, he resisted the influence of the Post-Impressionist Exhibition organized by Roger Fry in 1910, and his earliest drawings were quite Romantic in spirit, such as *Angel and Devil* (1910, London, V. & A.). They were largely inspired by the work, both literary and pictorial, of D.G. Rossetti and William Blake. Gradually Nash turned to more

NAS

296

 Bartolomé Murillo
The Young Beggar (*c*.1650)
Canvas. 137cm × 115cm
Paris, Musée du Louvre

realistic subject matter, drawing from nature and painting landscapes that were usually unpeopled, but full of atmosphere. His first one-man exhibition, of watercolours, was held at the Carfax Gallery in 1912.

When war broke out Nash joined the Artists' Rifles, and in 1916 he was commissioned in the Hampshire Regiment. The following year he was sent to the Ypres salient, but returned home after four months, as the result of an accident. However, the fruit of those months were the drawings that were shown at the Goupil Gallery, and he was soon sent back to the front as an official war artist. He held another exhibition of war drawings at the Leicester Galleries in 1918, and from April to early in 1919 he worked on *Menin Road* (London, Imperial War Museum), a painting commissioned by the government. The paintings of this period combine detached realism with a growing sense of abstract design: among the most impressive is *We are Making a New World* (1918, London, Imperial War Museum).

From 1918 to 1928 Nash illustrated books, designed scenery for the theatre, and was briefly a teacher of design at the Royal College of Art. He was also widely recognized as a watercolourist of a high calibre. After a serious illness in 1921 he began a series of pictures of Dymchurch beach on the Kent coast. The broad, angular vision that marks these lonely and bleak views can be seen in *Dymchurch Steps* (1922-4, Ottawa, N.G.).

Towards the end of the decade Nash struggled to move beyond the apparent stagnation that threatened to halt the full expression of his powers. The Dymchurch paintings had already hinted at the possibilities of abstraction, and in *The Shore* (1923, Leeds, City Art Gal.) Nash reduced the formal elements of the picture even further, which heightened the effect of the bright, clear colouring. In 1928, under the influence of Giorgio de Chirico (who had held an exhibition in London that year), Nash decided to attempt to reveal 'the reality of another aspect of the accepted world, this mystery of clarity that was at once so elusive and so positive.' This contact with Surrealism stimulated his imagination and generally opened a way in which he could advance.

From 1928 to 1938 Nash travelled a good deal in Europe and in America, and in 1932 he completed his most important book illustrations, for Sir Thomas Browne's *Urn Burial* and *The Garden of Cyrus*. In 1933 he founded Unit One, a group of 'imaginative painters and designers', and during the following years he held further exhibitions, as well as doing commercial work. Ill health compelled Nash to seek a more salutary environment, and he moved house several times before settling in Hampstead. Meanwhile, his interest in Surrealism continued to develop but without the disturbing undertones of de Chirico or the continental Surrealists. Nash, whose sensibility was more literary and English, concerned himself with the contemplation of megaliths, stones, flowers and trees. He tried to set his subjects in dramatic relationships that would uncover something of their true individuality.

Nash was still not well when the Second World War began. Once more he became a war artist, this time attached to the Air Ministry. But even under such changed conditions his style remained the same: his colouring was bright and clear, and his personal vision was strong enough to withstand the lesser pressures of his experience of the later war. Few of the war paintings have the desolation of some of his earlier works. Among

the most notable is *Totes Meer* (*Dead Sea*) (London, Tate Gal.), which shows a tangled mass of German aeroplanes lying in a dump near Oxford.

Paul Nash did not long survive the end of the war. His last paintings were of sunflowers and landscapes, which, like several symbolic pictures in earlier years, dealt with the concepts of regeneration and renewal. J.H.

Nattier
Jean Marc
French painter
b.Paris, 1685 – d.Paris, 1766

Nattier was the son of the portraitist and painter at the Académie, Marc Nattier, and younger brother of Jean Baptiste Nattier, a historical painter who was admitted to the Académie in 1712 (*Joseph et la femme de Putiphar*, Hermitage). Noticed by Louis XIV, who authorized him to draw and have engraved Rubens's *Marie de Médicis* series (1700-10), he worked for Peter the Great in Holland and Paris (1717) before being admitted to the Académie in 1718 with *Persée changeant Phinée en pierre* (*Petrification of Phineas and of his Companions*) (Tours Museum). With Watteau he then devised paintings of the King and the Regent for Crozat (1721) and collaborated with J.B. Massé on engravings after decorations in the Grande Galerie at Versailles (1723-53).

Early on, however, Nattier began specializing in portraits. His first likenesses recall the art of Raoux with their play of light and shimmering materials, but his draughtsmanship is surer (*Mlle de Lambesc sous la figure de Minerve* (*Mademoiselle de Lambesc beneath the Figure of Minerva*), 1732, Louvre). He soon became the favourite painter of the House of Orléans, working on the decoration

of the Temple (1734-48), whose Head Prior was Jean Philippe, Chevalier d'Orléans. Of a series of commissions dating from the 1740s, the two portraits of the two younger sisters of the Comtesse de Mailly, mistress of Louis XV, *Mme de Flavacourt* and *Mme de la Tournelle* (duplicates in Marseilles Museum) were much admired at court.

After this he became official painter to the royal family (*Marie Leszczinska*, 1748, Versailles) and more particularly to the royal princesses (*Mme Henriette en Flore*, 1742, Versailles; *Mme Adélaïde en Diane*, 1745, Versailles; allegorical portraits of the King's daughters, commissioned by the Dauphin, 1751, São Paulo Museum). One of the most brilliant portraitists of the century, Nattier gave all his models a sweet, if somewhat effeminate expression that verges on the insipid, particularly in his portraits of men, although the portraits are more than redeemed by the delicate modelling of the features, and by the profusion of silks and decorative features.

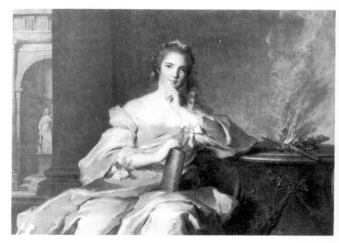

Despite certain defects, Nattier holds the attention because of his greater sensitivity to the human face. The importance of the sitter, whether a member of the court or the royal family, fades into insignificance, and what emerges is a gentleness, elegance and happiness tinged with melancholy that reflect the feeling of a society in which the role of women was growing. His work has affinities with the writings of Jean Jacques Rousseau and prefigures such portraits of sensibility as those by Greuze and Vigée-Lebrun.

Some of Nattier's best portraits are to be found in the Louvre (*Portrait d'un commandeur de l'ordre de Malte* [*Portrait of a Commander of the Order of Malta*], 1739; *La Comtesse Tessin*, 1741; *La Duchesse de Chaulnes en Hebé*, 1744; *Mme de Sombreval en Erato*, 1746) and particularly at Versailles (*Mme Louise*, *Mme Victoire*, 1748; *Isabelle de Parme*, 1752; *Mme Henriette jouant de la basse de viole*, 1754; the *Duc de Bourgogne*, 1754; *L'Artiste et sa famille* [*The Artist and his Family*], 1761). Other notable portraits are in the Musée Condé at Chantilly (*Mlle de Clermont*; *La Princesse de Condé*); at Amiens Museum (*J.B. Louis Cresset*); at the Musée Jacquemart-André in Paris (*La Marquise d'Antin*, 1738); at the Royal Academy in Copenhagen (*Tocqué*, 1762); at the Stockholm Nationalmuseum (*La Marquise de Broglie*, 1742; *La Duchesse d'Orléans en Hébé*, 1744); at the Wallace Collection in London (*Mlle de Clermont au bain* [*Mademoiselle de Clermont in her Bath*], 1733; *La Comtesse de Tillières*, 1750; *Mlle de Châteaurenard*, 1755); at the Metropolitan Museum (*Mme de Marsollier et sa fille* [*Madame de Marsollier and her Daughter*], 1749); and at the National Gallery, Washington (*Joseph Bonnier de La Mosson*, 1745; *Mme de Caumartin*, 1753). C.C.

Newman
Barnett

American painter
b.New York, 1905 – d.New York, 1970

Newman may be considered a pivotal figure in the new American style that emerged after 1945. Together with Mark Rothko and Clyfford Still he represents the non-gestural wing of the New

Barnett Newman ▲
Who is afraid of red, yellow, blue? (III)
Canvas. 244 cm × 511 cm
Amsterdam, Stedelijk Museum

York School, or Abstract Expressionism. Until the 1960s, however, his presence was not dominant, but in the work of artists like Morris Louis, Kenneth Noland and a host of followers for whom vertical stripes, or the edge of the picture, assume crucial importance, the strict forms and impressive scale of Newman's manner have exercised a profound influence. As early as 1955, in an essay entitled 'American-Type Painting' in the *Partisan Review*, Clement Greenberg coined the term 'field painting' to denote the distinction between the painterly, sensual abstraction of Pollock, De Kooning and Gorky, and the emphatic surface flatness best exemplified by Barnett Newman. 'The limiting edges of Newman's larger canvases', Greenberg wrote, 'act just like the lines inside them: to divide but not to separate or enclose or bound; to delimit, but not limit.'

The formal characteristics of Newman's style began to crystallize between 1946 and 1948. An untitled ink drawing in the collection of B.H. Friedman is one of the earliest vertically oriented sheets where an almost central image both divides and unites the surface plane. *Onement I* (1948, New York, Annalee Newman Coll.) is the first realized work where an orange stripe, now centred, gives the impression of totally irresistible motion. In the succeeding years Newman's format grew larger and his use of pure colour became more intense, with the result that the stripes heightened the bordering fields, often so large that they totally engulf the spectator. He broke the rectangularity of the surface, even as he asserted its primacy; yet, the vertical cut in the rectangle is also a connection between the parts. It is, in addition, an internal assertion of the picture's edge, thereby establishing an analogy that as one part is to another, so the bounded whole is to the wall.

It would be a profound error to regard Newman's painting in purely formal terms. There can be no doubt that the artist himself conceived of his work in terms that approach the symbolic. Like those of other major artists of his generation, his titles are often a metaphor for his intentions, and his intentions are complex, intellectual and poetic. 'Onement' – and there are, to date, at least six works with this title – symbolizes harmony, totality, completeness. Thomas Hess, the artist's biographer, calls attention to the fact that the word 'onement', which is no longer used in English, is, in fact, an older form of 'atonement'.

Other titles reflect the deep spiritual significance at the core of the artist's ambition: *Covenant*, *Abraham*, *Concord*, *Cathedra*. More often than not, the work rings with biblical resonance. The exhibition Lawrence Alloway prepared in 1966 for the Guggenheim Museum, entitled 'Stations of the Cross', made this abundantly clear, even to those younger artists who admired Newman's paintings perhaps more for their appearances than for their essential meaning. Whatever their considerable technical merit, brilliance of colour, vastness of scale, Newman's paintings have at their heart the urge to create an entire metaphysic. Sometimes profound, occasionally pretentious or posturing, the efforts of this singular artist are likely to be remembered for a long time.

Newman's last works include compositions in the form of isosceles triangles (*Chartres*, 1969, estate of the artist). He also executed sculptures, for the most part in steel (*Here I*, 1962; *Here II* and *III*, 1965; *Broken Obelisk*, 1963-7; *Zim-Zum*, 1969), a model for a synagogue (1963), and lithographs (*Cantos*, 1963-4, Paris, M.N.A.M.). A retrospective exhibition of his work was held in New York in 1972 and was subsequently staged in London, Amsterdam and Paris. He is represented in numerous public and private collections, notably in New York (M.O.M.A. and A. Newman Coll.), Los Angeles (*Onement VI*, Weisman Coll.), Basel (*Day Before One*, 1951), London (*Adam*, 1951-2, Tate Gal.) and Stockholm (*Tertia*, 1964, Nm). D.R. and L.E.

Nicholson
Ben

English painter
b.Denham, 1894 – d.London, 1982

The son of the painter William Nicholson and his wife, Mabel, sister of James Pryde and herself a painter, Nicholson briefly studied at the Slade School, London, and travelled abroad between 1911 and 1914, visiting Italy and the United States. His early work was influenced by Cézanne and by Cubism, and the landscapes and still lifes of the 1920s are stylistically related to the work of Christopher Wood and of his first wife,

Winifred Nicholson (*Banshead*, 1925, London, private coll.; *Cumberland Landscape*, 1930, London, Hepworth Coll.). Contacts with artists in Paris in 1932-3, and especially with Mondrian, turned Nicholson to a pure classical form of abstract art. As well as paintings with rectangles of primary colours, Nicholson made at the time of his second marriage to the sculptor Barbara Hepworth many low reliefs, carved with squares and circles and usually painted white (*Relief in White*, 1934, London, Tate Gal.). Active in the abstract art movements of the 1930s, including *Abstraction-Création*, Nicholson was a founder-member of *Unit One*, 1933, and one of the editors of *Circle*, 1937.

From 1939 to 1958 he lived at St Ives in Cornwall and allowed landscape and still-life motifs to enter his work (*Still Life [Rock]*, 1949, London, private coll.), though never abandoning abstract painting (*Painting, Version I*, 1942, Ramsden Coll.) and relief-making altogether. After he moved to Switzerland, his work again became more severely abstract, although drawings and prints in particular are frequently based on still-life or landscape subjects (*Swan Goose*, 1961; *Amboise*, 1965).

Nicholson had many exhibitions all over the world from 1922 onwards, including retrospectives at The Tate Gallery, London, in 1955 and 1969. He won the first prize at the Carnegie International, Pittsburgh, in 1952, the first Guggenheim International Prize in 1956, and the painting prize at São Paulo in 1957. As one of the best-known of contemporary British painters, Nicholson is represented in most museums of modern art throughout the world, but especially in the Tate Gallery. A.Bo.

Nicolau
Pedro

Spanish painter
b.Barcelona; active 1390-1408

One of the most famous exponents of the International Gothic style, Nicolau was active during the heyday of the Valencia school, at a time, between the end of the 14th century and the beginning of the 15th, when the city was one of the European centres of the style. He is comparatively easy to place in a historical context, in contrast with the authors of most of the remarkable altarpieces of this time, who remain anonymous for lack of convincing contemporary records.

Pedro Nicolau ▲
The Annunciation
Panel from the *Altarpiece of the Virgin*
Bilbao, Museo Provincial de Bellas Artes

Nicolau's one documented work is the *Sarrión Altarpiece*, dated 1404 (central panel of the *Virgin* destroyed in 1936; side-panels in Deering Coll.), around which have been grouped other paintings in similar style. An exquisitely refined and elegant draughtsman, and a delicate colourist who used a range of blues, pinks and greys, Nicolau depicted a type of Virgin seated on a throne, surrounded by a choir of angelic musicians, that originated in the work of Lorenzo Zaragoza. The fragile grace of these figures evokes those of the contemporary school of Cologne, a type very much in favour in Valencia. The scenes on the side-panels illustrate the *Seven Joys of the Virgin*, and their narrative ease, together with certain iconographic details, reveals a knowledge of Sienese models.

In the other altarpieces attributed to this artist (*Altarpiece of the Virgin* in the church of Albentosa, Teruel; *Altarpiece of the Virgin* in Bilbao Museum), the narrative vitality of the complex scenes is combined with a quasi-Germanic expressionism, an almost Mannerist feeling about the poses, and a liking for complicated lines resulting from his contact with Andrés Marzal de Sax, his collaborator on several occasions before 1404. Many of the Valencia altarpieces of the first decades of the 15th century bear the marks of Nicolau's style. The names of some of his collaborators are known, and many artists came under his influence: Jaime Mateu, his nephew, Gabriel Marti (*St Nicholas Altarpiece*, Albal church), Gonzalo Pérez, presumed author of the remarkable *Altarpiece of the Family of Marti de Torres* (Valencia Museum), the Master of Burgo de Osma (*Altarpiece* in the Louvre), Miguel Alcañiz, and others such as the Master of Ollería. A.E.P.S.

Nolan
Sidney

Australian painter
b.Melbourne, 1917

Nolan's preoccupation with mythic themes, both national and universal, has been identified as the central feature of his work. His treatment of the outlaw Ned Kelly, for which he is best known, exemplifies his attitude to this type of subject matter, in that Kelly's stature as hero is constantly brought into question. Nolan remains engaged yet equivocal. Kelly was both a bush-ranging murderer and a protester against class domination and police brutality. In him the two aspects are so curiously mixed that, while he cannot be held up as an official national hero, nevertheless he occupies a key place in popular Australian mythology. Nolan's ambiguous stance reflects the contentious nature of the subject, and is expressed in the whimsical, wry mood of many of these paintings, in the *faux-naif* immediacy of the imagery, and in the deliberate abandonment of the conventions of scale and illusionistic perspective in order to depict more directly the essential elements of the scene. Nolan eschews narrative elaboration in favour of a naive directness; a quasi-hieratic presentation supersedes representation.

Similarly, in his treatment of other themes such as Gallipoli (a military defeat paradoxically celebrated as an example of national valour), Leda and the Swan, and the Crucifixion, the lyrical mood undercuts the weightiness of the theme,

preventing any possibility of rhetoric or portentousness. In dealing with myth Nolan manages both to uphold it and to question it, as if meaning can only be distilled ironically and self-consciously.

Although by no means a narrowly national painter (he has lived abroad, principally in London, since 1953), in his approach to his subject matter Nolan has been largely influenced by the milieu in which he forged his artistic identity. Born to a working-class family of Irish descent, he left school at 15 to work for a firm of commercial signmakers. Between 1934 and 1938 he was employed in the design department of a hat factory while simultaneously, if sporadically, attending art classes from which he claims to have derived little benefit. By the late 1930s he was devoting most of his time to painting, supporting himself by a series of casual jobs. He also wrote poetry, and until the late 1940s, in fact, his interest was equally divided between painting and writing. Indeed, many ideas for his paintings resulted from word sketches rather than from pictorial notation. In his paintings the subject is always paramount; style is the means to its realization, not the principal concern in itself. Yet Nolan is in no sense a literary painter: the themes are evoked, never described.

Nolan's first one-man show in 1940 consisted entirely of abstract work, but this was soon succeeded by landscape and urban scenes treated in a whimsical, mock-heroic manner. With Albert Tucker and Arthur Boyd, his contemporaries, Nolan stood firmly against all academic teaching, seeking instead a vitality that derived from a direct, spontaneous and instinctive response to the subject, freed from the inhibiting effects of conventional training. Unlike his immediate predecessors, such as Drysdale, who had imbibed a sound technical training in Melbourne art schools before submitting themselves to the influence of international modern art in the form of the School of Paris, often travelling there to study, Nolan and his friends developed their styles without venturing abroad, more influenced by Surrealist precepts than by specific idioms.

Technically, they experimented freely with unorthodox materials and methods – Nolan's paintings during the 1940s were mainly executed with ripolin (an imported enamel paint) on masonite board. Whilst they were unwilling to celebrate overtly their Australian milieu in the way Drysdale, for example, had, nevertheless they did respond to the contemporary preoccupation with the question of national identity. The means they evolved for coming to terms with this unique world involved the introduction of myth.

Ben Nicholson ▲
Poisonous Yellow (1949)
Canvas. 124 cm × 162 cm
Venice, Galleria Internazionale d'Arte Moderna di Ca'Pesaro

In Nolan's work this burgeoned in the Kelly series of 1947-9. His interest in the theme was aroused by reading a historical interpretation of the events, and he followed this up with further background reading, then a visit to some of the sites around Glenrowan. The resulting series of 25 paintings were quickly executed. This procedure becomes typical of Nolan's approach to subsequent themes, including Gallipoli and the Greek myths. His introduction to the idea came from reading, followed by personal experience of the background, with the paintings emerging not as a literal or illusionistic account but as lyrical or poetic evocation. A hallmark of Nolan's best work is the freshness and vitality that result from the peculiar potency of the imagery expressed with a remarkable facility in handling.

Thus Nolan has succeeded in devising a way of dealing with themes that might otherwise have seemed of little relevance to the contemporary world. In his more recent work the detail is reduced so that forms appear to float in nebulous space or are embedded in fields of resonant colour, evoking an ethereal world; contemplation is the essence of the works. In his latest paintings Nolan has continued to explore a range of mythic themes, while reducing his means even more stringently to opaque fields of sonorous colour which almost engulf the shadowy imagery. L.C.

Nolde
(Emil Hansen)
German painter
b.Nolde, 1867 – d.Seebüll, 1956

Nolde adopted the name of his native town in 1902. Between 1884 and 1889 he learned wood

sculpture at Flensburg before working in Munich, Karlsruhe and Berlin. He taught at the school of industrial art at St Gallen in Switzerland where he executed watercolours of mountains (1894-6) for picture postcards in a humorous and expressive style, as well as designs for masks in the form of powerful caricatures (Seebüll, Nolde Foundation). He returned to Munich, was a student of Hölzel in Dáchau and began to execute etchings (1898-9) and some very fine watercolours, a

medium in which he always excelled (*Portrait of a Young Girl*, 1898, Seebüll, Nolde Foundation).

In Paris between 1899 and 1900, he was impressed by Rembrandt, among the old masters, and by Manet among more recent artists and worked at the Académie Julian. He then travelled to Berlin and Copenhagen before settling in 1903 on the island of Alsen. He exhibited at Dresden in January 1906 and became associated with Die Brücke, but broke away from them the following year. Kirchner, in particular, admired his etchings and he began to engrave on wood in 1906, then on stone in 1907.

His painting at this period, and especially his landscapes, were executed in a thick and colourful impasto, and reveal an impressionism influenced by Van Gogh (*Pinks, Reds and Yellows*, 1907, Cologne, W.R.M.). His treatment grew lighter and more diversified after 1909-10, when he undertook the famous series of paintings on religious and biblical themes, a work in which ecstatic fervour is mingled with a brutal sensuality (*Pentecost*, 1909, Berlin, N.G.; *The Golden Calf*, 1910, Seebüll, Nolde Foundation; *Christ with the Children*, 1910, New York, M.O.M.A.; *The Legend of Mary the Egyptian*, triptych, 1912, Hamburg Museum; *Life of Christ*, 1912, nine paintings, Neukirchen über Niebüll; *Simeon and the Women*, 1915, private coll.).

He treated the theme of the dance, both in its religious and secular associations (*Wild Dance of Children*, 1909, Kiel Museum), emphasizing the element of frenzy, the shape of the dancer, the frail limbs and breasts with enormous red nipples (*Dancers with Candles*, 1912, Seebüll, Nolde Foundation; wood-engraving, 1917; *Dancer*, 1913, colour lithograph). Other paintings were devoted to urban scenes (*At the Café*, 1911, Essen, Folkwang Museum). In 1910 Nolde executed a very fine series of wood-engravings and also etchings inspired by the port of Hamburg. In 1910-11 came a series of pictures on the themes of the sea, to which he returned at regular intervals. He visited Ensor in Ostend in 1911 and

 Sidney Nolan
Convict in Swamp
Polyvinyl acetate on masonite. 124 cm × 151 cm
Adelaide, The Art Gallery of South Australia, A.R. Ragless
Bequest

▲ Emil Nolde
Tropical Sun (1914)
Canvas. 70 cm × 104 cm
Seebüll, Nolde-Museum

in 1913 accompanied the Külz-Deber anthropological expedition to New Guinea, from which he brought back drawings, watercolours and paintings (*Tropical Sun*, 1914, Seebüll, Nolde-Museum).

Back in Germany in 1914, Nolde lived first in Alsen (until 1917), then in Berlin. By now his style was established and changed little thereafter. But he began using colour with greater confidence, choosing richly contrasting blues and yellows, oranges and violets. Sometimes he treated his subject matter realistically (*Brother and Sister*, 1918, Seebüll, Nolde Foundation) but at others he opted for a more stylized approach (*The Sinner*, 1926, private coll.). His last engravings, such as the *Fire Dancer* of 1921, are still full of incisive vigour, although a new element of gracefulness makes its appearance (*Bather*, 1925). After 1929 he painted a great many watercolour studies of flowers and landscapes, often with figures. In 1926 he spent the summer at Seebüll, near the Danish frontier, where he returned frequently before settling there in 1941.

Particularly badly treated (as was Kirchner) by the Nazis, in 1941 he was forbidden to paint. During this unhappy period he was, however, able to produce a number of small watercolours of landscapes and figures – 'unpainted paintings' as he called them – in which his imagination was given free rein (*Couple in a Yellow Light*, Seebüll, Nolde Foundation). After 1930 his best canvases were devoted to studies of flowers in exuberant colours and to broadly composed marine views that display a serene vision and an intimate feeling for natural phenomena (*Sunflowers*, 1932, Detroit, Inst. of Arts; *Poppies*, 1942, and *Light View of the Sea*, 1948, both Seebüll, Nolde Foundation). Such works further enlarged the scope of German Expressionism, to which he had already contributed so largely prior to 1918.

Between 1896 and 1951 Nolde produced 1112 paintings, 231 etchings, 197 wood-engravings and 83 lithographs. Nearly all the engravings date from prior to 1926, except for four last woodcuts in 1937. The Seebüll house, transformed into a museum in 1957, provides the best setting for an understanding of the work of Nolde, who is also represented in the more important European (Basel, *Twilight*, 1916; Paris, M.N.A.M., *Still Life with Dancers*, 1914) and American galleries.

M.A.S.

O'Keeffe
Georgia

American painter
Prairie, Wisconsin, 1887 – d.Santa Fe, 1986

The best-known American woman painter, Georgia O'Keeffe was educated at the Chatham Episcopal Institute in Virginia and, determined to study art, returned to the Mid-West to work at the Chicago Art Institute School in 1905-6 under John Vanderpoel. Restless and almost continuously on the move, O'Keeffe also sampled the instruction of William Merritt Chase at the Art Students League in New York in 1907-8, worked briefly as a commercial artist in Chicago (1910-11), studied design at the University of Virginia (1912) and finally came under the influence of the remarkable Arthur Wesley Dow at Teachers' College, Columbia University, between 1914 and 1916. If Dow gave O'Keeffe the

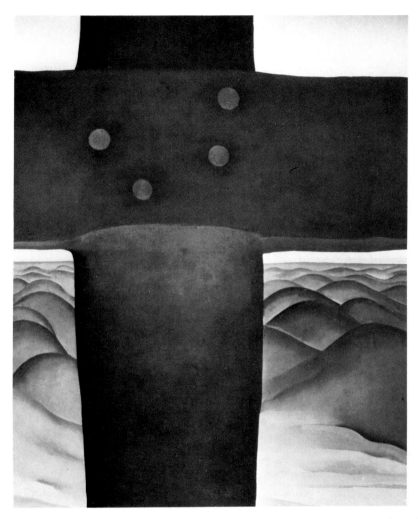

courage to pursue her instincts towards abstraction, Teachers' College gave her the credentials to pursue an independent life and still have time to paint.

She became a supervisor of school art in the area of Amarillo, Texas, and worked, in 1916-17, at the West Texas Normal School near Canton, Texas, a remote part of the prairie, where her first nature abstractions were created in watercolour. These were unique for their time, far bolder than the most advanced work of any other American in breaking with the conventions of representation. Executed in complete artistic isolation, paintings such as those of light dawning on the Texas plains were conceived in order to capture the singular emotion generated by visual phenomena, not to reproduce directly a state of mind.

O'Keeffe showed her work to the pioneering American photographer, Alfred Stieglitz, whose Gallery 291 in New York was at that time the only outpost of the international avant-garde in the United States. Stieglitz promptly gave her a one-man exhibition in 1917, and exhibited her work regularly from then onwards. In 1918 she moved to New York and took a leading place in the sophisticated circle that surrounded the photographer, whom she married in 1924. From this period date her landscapes of the Lake George region, where the Stieglitz family had a summer home, and her contacts with the group of Marin,

Hartley, Dove and Demuth associate her with the American Precisionist style that assimilated Cubism to the subject matter of New York. Her most dramatic paintings of the New York skyscrapers date from the 1920s, canvases that by their isolation of detail and freedom from human anecdote demonstrate an affinity with the work of another American photographer, Paul Strand.

During these years of growing recognition, O'Keeffe exerted as much influence on Stieglitz as he did on her by his effective management of her career. His decision to rename his gallery 'An American Place' and to cease exhibiting the work of modern European painters appears to have been in part a response to O'Keeffe's insistence that modern American art had come of age. In 1929 O'Keeffe created a second residence near Abiquiu, New Mexico, and embarked on the series of pictures associated with the desert of the American South-West, for which she is best known. Themes of rocks and skulls, of mountains and flowers, alternate in her work throughout the next 30 years. In the late 1940s, following the death of Stieglitz, she moved permanently to the South-West after having established Stieglitz collections at both the Metropolitan Museum of Art in New York and the Art Institute of Chicago. She became one of the most esteemed of American painters, receiving honorary degrees from the University of Wisconsin in 1942 and from Harvard University in 1973.

D.R.

▲ Georgia O'Keeffe
Black Cross, New Mexico
Canvas. 100 cm × 76 cm
Art Institute of Chicago, Art Institute Purchase Fund

but, even though he introduced the new concepts of the Renaissance into the art of Brussels, he was nonetheless a traditionalist. For the novelty of his art, which consisted largely of borrowings from Italy, resided only in externals like exuberance of movement, profusion of decoration, Mannerist poses and foreshortenings.

Unlike Quentin Metsys, Van Orley did not succeed in renewing the art of the Middle Ages. Instead, he continued to borrow from the Renaissance without ever completely assimilating its essential elements. He appears to have acquired his Italianism not from visiting Italy, but indirectly through contact with those who, like Jacopo de' Barbari, admired the works of antiquity and of the Italian Renaissance. Nor should the part played by drawings and engravings after the best-known Italian masters be underestimated, for these were widely available in Flanders.

The traditional origins of Van Orley's art are obvious in his earliest works, in which the subject is anecdotal, the composition disorganized, the treatment hesitant and the architectural decor fantastic, in the style of the Mannerists of 1520. A good example of this is the *Triptych of St Thomas and St Matthew*, designed for the chapel of the Carpenters and Masons in Brussels (central panel bearing the monogram and arms of the artist, Vienna, K.M.; side-panels, Brussels, M.A.A.). More important is the *Portrait of Georg van Zelle*, Charles V's doctor. This painting (1519, Brussels, M.A.A.) illustrates the new concept of the art of the portrait in the 16th century. The model is represented in direct manner, almost head-on, in his normal surroundings. Warm, intense colours recall the Italian Primitives, but the setting is utterly modern.

In 1520 Van Orley was paid for his *Altarpiece of the Cross*, executed for the brotherhood of the Holy Cross, established in the Church of St Walburga at Furnes. The centre section of this altarpiece has now disappeared, but the two wings in the Galleria Sabauda in Turin and the Musées Royaux des Beaux Arts in Brussels may once have formed part of it. The important triptych of *The Virtue of Patience* (Brussels, M.A.A.) was completed in 1521. The artist, who seems to have been proud of this work, signed each part with his initials, dated it twice and added his coat-of-arms.

The altarpiece was commissioned by Margaret of Austria, who had instructed Van Orley to base his painting on her poem on the virtue of patience, in which she praised the resignation of Job and of Lazarus who, despite adversity, had not lost faith. Although Van Orley had set out to create a dramatic work such as had never before been attempted by Flemish artists, he succeeded only partially for, instead of a feeling of tragedy, he produced unco-ordinated movements, posed attitudes and a multitude of purely fantastic architectural ornaments.

The Holy Family (1521, Louvre) was conceived in the same style, as was the *Holy Family* in the Prado (1522). In 1525 Van Orley executed *The Last Judgement* (Antwerp Museum), which seems to have been a not entirely successful attempt to resolve the problems of nudes in motion. After his appointment to the court he appears to have composed chiefly cartoons for tapestries and stained-glass windows, and he became the most important Flemish decorator of the period. He furnished the designs for the tapestries of the *Hunts of Maximilian* (Louvre). To him are also attributed the invention of the series of the *Victory of Pavia* (Naples, Capodimonte) and the *History*

Orcagna
(Andrea di Cione)

Italian painter
active 1343-68

Orcagna was the principal exponent of developments in the course of Florentine painting as outlined by Giotto and his disciples during the first half of the 14th century, but it was a new direction which was marked by a certain impoverishment and, in fact, by a kind of reaction. In his most important work, the *Altarpiece* in the Strozzi chapel in the Church of S. Maria Novella in Florence, dating from 1357 (*Christ in Glory Surrounded by Saints*), the rigorously symmetrical organization of figurative elements has an almost heraldic effect. There is a noticeable tendency to reduce everything to rigid profiles or strictly frontal representation, schematizations of the solemn and synthetic forms of Maso di Banco, the great disciple of Giotto, on whom Orcagna relied for inspiration.

The vertical presentation of the ornate pavement and the absence of any architectonic structure reveal Orcagna's lack of concern with the problems of spatial representation and a return to a neo-medieval figuration and hieratic view of transcendental concepts. This style influenced the entire school of Florence until Lorenzo Monaco. However, in the predella of the S. Maria Novella polyptych (*Mass of St Thomas*, *Vocation of St Peter*, *Death of the Emperor Henry*, *Redemption of his Soul*), as well as in certain fragments of the frescoes in

the Church of S. Croce (*Triumph of Death*, and *Hell*, Florence, Opera di S. Croce), these backward-looking elements are balanced by a solemnity worthy of Maso. L.B.

Orley
Barent van

Netherlandish painter
b.Brussels, c.1488 – d.Brussels, 1541

Van Orley was the pupil of his father Valentin, who worked first in Brussels and then in Antwerp. After 1515 he was in the service of Margaret of Austria and, in 1518, succeeded Jacopo de' Barbari as official court painter. It was in this capacity that he executed numerous portraits of the imperial family and of various dignitaries. He met Dürer during the latter's voyage to the Low Countries in 1520. In 1527 Orley and several members of his family were implicated in a trial brought against a number of artists from Brussels who had attended the preachings of the reformer Jacques van der Elst. He fell into disfavour but, after the death of Margaret of Austria, the new ruler of the Low Countries, Mary of Hungary, took him back into her service.

Although Van Orley dominated painting in the southern Netherlands during the first half of the 16th century, his renown, like that of Frans Floris, for example, seems to have been exaggerated by his contemporaries. He was certainly a prolific artist and admirable decorative painter

Orcagna
Christ in Glory surrounded by Saints (altarpiece from the Strozzi chapel)
Wood. 160 cm × 296 cm
Florence, Church of S. Maria Novella

tion, Buckingham Palace) or *The Traveller's Rest* (1671, Rijksmuseum) are even further removed from Brouwer's powerful expressiveness.

The spirit and jovial atmosphere of the famous *Village Violin-Player* (1673, Mauritshuis) were taken up by Van Ostade's numerous pupils and imitators, including Cornelis Dusart, who finished several of his works, as well as by Cornelis Bega, Michiel van Musscher and Richard Brakenburgh. Greatly admired during the 18th century, Van Ostade was sometimes considered as the equal of Rembrandt, and his popularity continued into the 19th century. P.H.P.

Oudry
Jean Baptiste
French painter
b.Paris, 1686 – d.Paris, 1755

Oudry was the son of the painter Jacques Oudry who became Director of the Académie de St Luc in 1706. Oudry received his first lessons from Michel Serre, a cousin of Rigaud and painter of the royal galleys at Marseilles. In 1707 he entered Largillière's studios where he began copying Flemish and Dutch works and made a particular study of colour harmonies, a practice which he brought to the point of virtuosity in his famous *Le Canard blanc* (*The White Duck*) (1753, Marquess of Cholmondeley Coll.).

Oudry was received into the Académie de St Luc in 1708 with a painting of *St Jerome* (lost) and between 1709 and 1715 painted a number of religious works (*Saint Pierre délivré de prison* [*St Peter Freed from Prison*], 1713, Schwerin Museum). He also executed portraits that reveal his indebtedness to Largillière (*Le Comte* and *La Comtesse de Castelblanco*, c.1716, Prado; *Portrait d'un chasseur* [*Portrait of a Huntsman*], Champaign, University of Illinois, Krannert Art Museum). From 1719

of Jacob (Brussels, M.A.A.). In his decorative projects, Van Orley always neglected synthesis to some extent in favour of detail, but in general they attained a greater grandeur of organization and more naturalness of movement than his paintings. He executed the designs for the stained glass positioned in 1537 and 1538 in the transept of the Cathedral of St Michel in Brussels, and the pieces produce an impressive effect within their monumental surroundings. W.L.

Ostade
Adriaen van
Dutch painter
b.Haarlem, 1610 – d.Haarlem, 1685

A genre painter who specialized in scenes of peasant life, Van Ostade also left a few portraits, while his engravings and his watercolour drawings are equally notable. Over 900 paintings are attributed to him, mainly small in size and painted on wood. According to Houbraken, Van Ostade entered the studio of Frans Hals about 1627, where he was a fellow-student of Adriaen Brouwer. Though the influence of Hals is hard to detect, the example of Brouwer was a determining factor in Van Ostade's work, with the result that he established his reputation as an outstanding interpreter of peasants brawling or carousing: *The Farmyard* (Copenhagen, S.M.f.K.); *Interior of an Inn* (1631, Louvre); *Peasants at the Inn* (Mauritshuis); *The Brawl* (1637, Hermitage). These early

works, painted in a range of simple colours, animated by aggressive figures, were directly inspired by the style and subjects of Brouwer. In 1634 Van Ostade was admitted to the Haarlem Guild and became its Dean in 1662. He did not leave Haarlem again, except for a brief journey to Amsterdam in 1657, where he got married.

After about 1640 he returned to the style of chiaroscuro favoured by Rembrandt and adopted the same golden tones: *The Studio* (Rijksmuseum); *School Interior* (1641, Louvre); *Interior with Peasants* (Brussels, T. Meddens Coll.); and *The Violin Player* (1648, Hermitage). All are bathed in a pale light and reveal a subtle use of very fine halftones. Van Ostade's palette is characterized by a cold yellow, turning almost to brown, as well as by shades of orange tinged with pink, lilac or brown. *The Peasants' Brawl* (1656, Munich, Alte Pin.), *The Merry Drinkers* (Mauritshuis), the *Interior of an Inn* (1653, London, N.G.) and *The Concert* (1655, Hermitage) derive their vivid animation from the diversity of their colours and the multiplicity of their poses. Two *Family Portraits* (1654; Louvre and The Hague, Bredius Museum), with their dominating blacks and browns, are notable for their avoidance of the excess of fantasy and vulgarity to which Van Ostade sometimes descends.

After about 1660 chiaroscuro appears less often, and the artist's technique becomes smoother and finer. From this last period *The Alchemist* (1661, London, N.G.), *The Dutch Tavern* (1663, Brussels, M.A.A.) and *Peasants at the Inn* (Mauritshuis) seem to draw closer to the picturesque style of Jan Steen or of Metsu. *The Artist's Studio* (1663, Dresden, Gg), *The Inn* (London, Royal Collec-

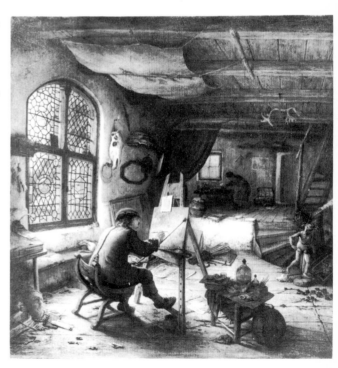

▲ Adriaen van Ostade
The Artist's Studio (1663)
Wood. 38 cm × 35 cm
Dresden, Gemäldegalerie

▲ Barent van Orley
The Death of the Wicked Rich Man (central panel from the triptych of *The Virtue of Patience*) (1521)
Wood. 176 cm × 184 cm
Brussels, Musée d'Art Ancien

dates the picture for which he was received into the Académie Royale as a historical painter, *L'Abondance avec ses attributs* (*Abundance with its Attributes*) (Versailles, Grand Trianon). At the same time he painted the personal testimony, unique among his work, *L'Hôtel-Dieu après l'incendie* (*The Hôtel-Dieu after the Fire*) (1718, Paris, Musée Carnavalet).

But from the start of his career Oudry was drawn towards still lifes (*Nature morte avec des insectes* [*Still Life with Insects*], 1712, Agen Museum), and he was soon considered as the equal of Desportes, whose brilliant compositions he copied, grouping together animals, flowers and musical instruments (*Nature morte avec un singe et un violon* [*Still Life with Monkey and Violin*], 1719, Stockholm, Nm). His first compositions inspired by the theme of the hunt date from 1721. These are the two versions of *Le Retour de chasse* (*The Return from the Hunt*) in the Wallace Collection, London, and *Le Chevreuil mort* (*The Dead Roebuck*) in the Schwerin Museum, which are among his finest paintings. The following year Oudry executed his first hunting scene, *La Chasse au loups* (*The Wolf Hunt*) (1722, Ansbach, Residenz), followed by *L'Hallali du cerf* (*The Death of the Stag*) (1723, Stockholm, Royal Palace). These early successes earned him an important commission for the three *Grandes Chasses* for Chantilly (two in the Musée Condé, Chantilly, one in Rouen Museum).

Presented to the young Louis XV by the Marquis de Beringhen, he was appointed *peintre ordinaire de la vénerie royale* and given lodgings in the Louvre. In 1726 he exhibited 26 of his best works in the Grands Appartements at Versailles, and in 1734 was appointed director of the tapestry works at Beauvais. An excellent administrator, he reorganized the manufacturing side of the firm, which enjoyed a spectacular revival thanks to him. He also furnished cartoons for *Les Chasses nouvelles* (*The New Hunts*) (1727), for *Amusements champêtres* (*Pastoral Amusements*) (1730), for Molière's *Comédies* (1732), for Ovid's *Metamorphoses* (1734), for *Verdures fines* (1735) and for La Fontaine's *Fables* (1736).

But it was for the Gobelins that Oudry created his finest tapestry cartoons, the *Chasses de Louis XV* (sketches in the Nissim de Camondo

Museum in Paris; cartoons executed between 1733 and 1745, of which eight are at Fontainebleau and one in the Louvre). The design was worked only twice (1736-47, Compiègne; 1742-53, Florence, Pitti). Oudry probably owed this royal commission, to which he brought an elegant perfection of composition and a rare nobility of decor, to the success of his *Chasse à vue de Saint-Germain* (*Hunt at St Germain*) (1728, Toulouse Museum), presented to the King in 1730. At the same time he was executing for the various royal residences door-surrounds and decorative panels, including the *Fables* of La Fontaine for the Dauphin's quarters at Versailles (1747).

The patronage of admirers such as the Marquis de Beringhen and Comte Tessin earned him numerous private commissions. Schwerin Museum, thanks to the Duke of Mecklenburg-Schwerin's enthusiasm, houses a comprehensive collection of Oudry's pictures and drawings. Returning several times to the same subject, Oudry painted numerous *Hunts and Hounds with Game* (Louvre; Stockholm, Nm; Schwerin Museum), 'portraits' of the *King's Hounds* (Fontainebleau), and *Exotic Animals* (Schwerin Museum).

Oudry's work clearly reflects his interest in the picturesque and decorative aspects of art (*Le cerf qui se mire dans l'eau* [*The Stag Reflected in the Water*], 1747, Versailles), while showing his knowledge of values, of the play of light and of perspective. As a landscape painter, although he did not always succeed in freeing himself from convention (*Paysage des cinq sens* [*Landscape of the Five Senses*], Versailles), Oudry was among the leading practitioners of his age (*Paysage avec chasse au loup* [*Landscape with Wolf Hunt*], 1748, Nantes Museum). His later works reveal a great admiration for the landscapes of Berchem (*Le Printemps* [*Spring*], 1749, Louvre), as well as an interest in illusionism (the famous *Canard blanc*).

His love of accuracy sometimes led him to almost obsessive experiments with *trompe l'oeil*: *Un Lièvre et un gigot* (*Hare and Leg of Mutton*) (1742, Cleveland Museum); *Nature morte au faisan* (*Still Life with Pheasant*) (1753, Louvre); or the surprising *Têtes de cerf* (*Stags' Heads*) in the Hunting Rooms at Fontainebleau. It was in a similar spirit that he painted canvases for fixed decors, such as

the great *Nature morte au gibier* (*Still Life with Game*) (San Francisco, Palace of the Legion of Honour), intended to be set in the panelling of a dining room, or *La Tabouret de lacque* (*The Lacquer Stool*) (Paris, private coll.), painted to cover a chimney breast.

Oudry left a number of drawings, more or less closely linked to his paintings and tapestry models, all very carefully executed with washtint or gouache highlights on coloured paper (*Le Héron* [*The Heron*], Louvre; *Combat d'onagres en plein air* [*Wild Asses Fighting*], Cambridge, Massachusetts, Fogg Art Museum). Other studies of animals are in watercolour (*Album d'oiseaux* [*Album of Birds*], Cambridge, Massachusetts, Fogg Art Museum). He frequently executed very well finished drawings as though they were original works, taking up again various elements from his paintings (*Tête de chien* [*Head of a Dog*], Schwerin Museum). His preliminary drawings for the *Chasses royales* (Louvre, Hermitage) are of equally refined technique. His talent as a draughtsman may be seen in the 273 drawings illustrating the great edition of the *Fables* of La Fontaine (1729-34, private coll.) and in the 38 drawings intended as engravings (Oudry himself engraved a dozen or so) to illustrate Scarron's *Roman comique*.

C.C. and M.D.B.

Overbeck
Friedrich

German painter
b.Lübeck, 1789 – d.Rome, 1869

The leading figure, together with Cornelius, of the Nazarene Group, Overbeck began his training with Joseph Peroux in Lübeck at the age of 16, before, in 1806, entering the Vienna Akademie where he came under the influence of Eberhard Wächter. In 1809, together with Franz Pforr, who became his close friend and whose portrait he painted in 1810 (Berlin, N.G.), and other artists, he founded the Lukasbund, which was opposed to academic classicism. That same year he and other members of the guild travelled to

 Jean Baptiste Oudry
Strange Set of Antlers of a Stag Killed by the King on 3 July 1741 (1741)
Canvas. 114 cm × 67 cm
Fontainebleau, Musée National du Château

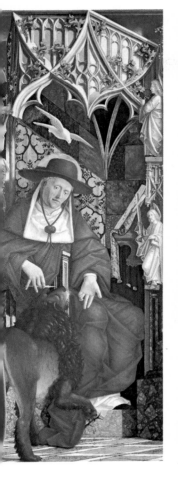
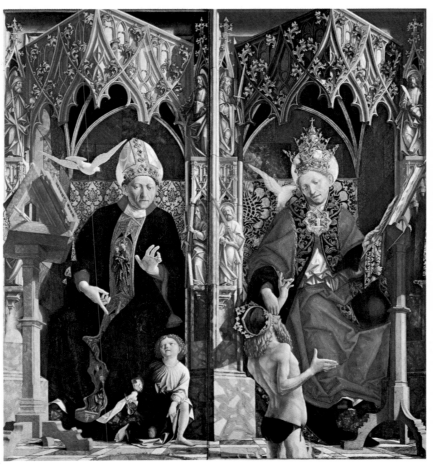
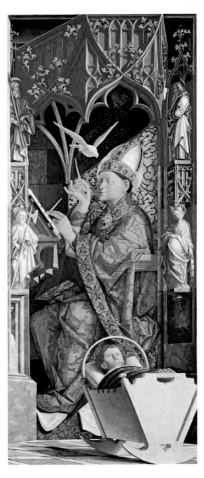

Rome where they lived in the deserted convent of S. Isidoro on the Pincio. From then on, with the exception of a journey to the Rhineland in 1831, Overbeck remained in Italy until his death.

He collaborated with other Nazarenes on the frescoes in the Casa Bartholdy (1816–17, now in East Berlin, N.G.) and in the Casino Massimi in Rome (1817–27). In 1829 he executed for the exterior façade of the Portiuncula chapel in the pilgrimage church of S. Maria degli Angeli, near Assisi, a fresco of the *Miracle of the Rosary of St Francis*. Other important works include: *Italia and Germania* (1811–28, Munich, Neue Pin.; sketch in Schäfer Coll. at Schweinfurt); *Christ's Entry into Jerusalem* (finished in 1824, formerly in Lübeck, Marienkirche, destroyed in 1942); and *The Triumph of Religion in the Arts* (1840, Frankfurt, Städel. Inst.). Most of his drawings are today in the Nationalgalerie, East Berlin.

Overbeck's style was very similar to that of the Early Renaissance masters, in particular that of Fra Angelico, Perugino and the young Raphael, but a certain uniformity distanced him from his models, and during his last period, ended up as schematic formalism devoid of character. Alongside the portraits (*Self-Portrait with Bible*, 1809, Lübeck, Behnhaus; *Portrait of the Artist's Family*, 1820–30, Lübeck, Behnhaus), religious themes predominated in his work (*St Sebastian*, Berlin, N.G.; *The Marriage of the Virgin*, Poznan Museum; *The Doubt of St Thomas*, Schweinfurt, Schäfer Coll.). His influence on the religious painting (much of it mediocre) of the second half of the 19th century was immense. H.B.S.

Pacher
Michael

Austrian painter and sculptor
b.Neustift, nr Brixen (Bressanone), c.1435 –
d.Salzburg, 1498

The origins of Pacher's style are to be found in his native country, deriving partly from the Master of St Sigmund (now identified as Jacob Sunter) but mainly from the Master of Uttenheim, probably a relation of Pacher's, from whom he received his early training. From the altarpiece by Hans Multscher in Sterzing (Vipiteno) (1456–9), Swabian in origin and the most modern work of art in the vicinity, Pacher learned about recent developments in Netherlandish and north German painting. This makes it unlikely that he travelled to the Upper Rhine around 1470, as has been suggested.

Pacher's youthful works include *The Coronation of the Virgin* (c.1460, Munich, Alte Pin.) and *The Virgin and Child* (fragment of a *Flight into Egypt*, c.1470, Basel Museum). The dating of the altarpiece in the Church of St Laurenz of Pustertal (Pusteria) presents problems. The sculpted parts apparently date from 1462, but the wings, and in particular the *Legend of St Lawrence* (Vienna, K.M.; Munich, Alte Pin.), presuppose a knowledge of the frescoes of Mantegna in the Ovetari Chapel in Padua, which suggests a considerably later date, around 1482–4.

From 1467 on Pacher was in charge of a painting and sculpture studio at Bruneck. In 1471 he received his first important commission, for the *Gries (Bolzano) Altarpiece* (1471–c.1475), the wings of which have disappeared. In the same year he became contracted to the Abbot of Mondsee, Benedikt Eck, for the *St Wolfgang Altarpiece*, although the work was not begun until after the completion of the *Gries Altarpiece*. In the interval he probably visited Italy, for Italian elements feature strongly in the *St Wolfgang Altarpiece* (1481). The treatment of the figures and the mastery of perspective reflect the example of Mantegna and of Jacopo Bellini. In accordance with traditional iconography, the four paintings from each side of the richly sculpted case illustrate scenes from the *Life of The Virgin*. The first panel contains eight scenes from the *Life of Christ* and, when the altarpiece is completely closed, four scenes from the *Legend of St Wolfgang* are visible. The paintings on the outside wings were carried out by Michael's brother Friedrich.

Pacher next received the commission for the *Altarpiece* of the church at Neustift (before 1483, now in Munich, Alte Pin.). Its four panels show the *Fathers of the Church* and four scenes from the *Legend of St Wolfgang* when the shutters are closed. About this time Pacher paid a third visit to Italy where he had the opportunity of seeing Donatello's high altar in the Church of S. Antonio in Padua. That this made a great impression on him is clear from the predella of *Scenes from the Life of St Thomas à Becket*, carrying on the reverse the symbols of the *Evangelists*

◀ Friedrich Overbeck
Olynda and Sophronias at the Stake
Fresco from the Tasso Chamber (1817–27).
200 cm × 500 cm
Rome, Casino Massimi

▲ Michael Pacher
The Four Fathers of the Church
Wood. 212 cm × 200 cm (central panel)
216 cm × 91 cm (side panels)
Munich, Alte Pinakothek

(Graz, Landesmuseum Joanneum). In 1484 he moved to Salzburg to carry out a commission for an altarpiece in the parish church (now the Franciscan church), the only surviving parts of which are a *Flagellation*, *The Marriage of the Virgin* and a panel representing a *Scene from the Life of Joseph in Egypt* (all in Vienna, Österr. Gal.).

These paintings and one panel representing the *Virgin between St Michael and a Bishop* (*c*.1490, London, N.G.) are the last of Pacher's mature work. His art is a synthesis of local traditions and the prevailing styles of western Europe and Italy. Exposed to such cross-currents, he might have become an undistinguished follower of one or other, but instead the situation encouraged the flowering of his genius. Pacher assimilated foreign influences while remaining a Gothic master. W.B.

Palma Vecchio
(Jacopo Negreti)

Italian painter
b.Serinalta, nr Bergamo, c.1480 – d.Venice, 1528

The earliest mention of Palma shows that he was living in Venice from 1510, and he probably had some difficulty adjusting to the atmosphere of the city after the narrowness of his provincial background. After a start painting banal works in the manner of Bellini, he flirted briefly with the style of Carpaccio, before finally settling for the example of Titian. The altarpiece of *The Virgin and Child with Three Saints* in the Church of S. Elena in Zerman (Treviso) is an early attempt to assimilate Titian's style, and also that of Giorgione (as exemplified in his Castelfranco altarpiece) – for Palma at this stage was clearly unable to avoid the poetic influence of Giorgione, and something of his dreamlike feeling is also evident in *The Two Nymphs* (Frankfurt, Städel.

▲ Palma Vecchio
La Bella
Canvas. 100 cm × 88 cm
Lugano, Thyssen-Bornemisza Collection

Inst.), as well as in the vibrant so-called *Portrait of Ariosto* and *The Shepherd's Family* (Philadelphia, Museum of Art). All the same, Palma remained Lombard in his vivid, brilliant use of colour, broadly spread in dense areas, recalling the work of Lotto.

In the end, however, it was the influence of Titian that determined the character of his painting. Palma was unable to accept completely the subtle disquiet of Giorgione, or the heroic vision of Titian. His placid rustic temperament was more at home in depicting the kind of serenely sensual beauty that has no overtones of mystery. He often returned to the theme of the *Sacra Conversazione*, which was well suited to his unruffled temperament. *The Virgin between St Barbara, St Justine and Two Donors* (Rome, Gal. Borghese) belongs to his youth and reveals the influence of Lotto in its fresh colours. The *Sacra Conversazione* in the Thyssen Collection (Lugano), on the other hand, comes from a period when the influence of Titian was strong, and there is an obvious connection between this work and the Titian version known as the Balbi *Sacra Conversazione* (Reggio Emilia, Magnani Coll.), particularly in the figure of the donor and in the bowed, tense attitudes of the figures. The theme which Titian rendered dramatically becomes with Palma a serene vision, a meeting of mature women and young girls, set out against a vast background of hills and villages, bathed in clear light, and far removed from that feeling for atmosphere and for the time of day which permeates Titian's painting.

Palma's portraits, too, are characterized by this predilection for opulent figures and temperaments devoid of inner drama. The subject in the *Portrait of a Young Girl* (Vienna, K.M.) spreads her full shoulders within a shady nook, displaying her white décolletage and the flowing gold of her sleeve. In *The Three Sisters* (Dresden, Gg) broad masses of colour are disposed within a space engendered by the figure themselves. In the semi-nude *Portrait of a Woman* (Milan, Poldi-Pezzoli Museum) light flows from the gold of the hair to reveal the ample bust, dazzling white shift and red clothing of a creature well satisfied with her own beauty. In the portrait known as *La Bella* (Lugano, Thyssen-Bornemisza Coll.) Palma appears to be competing with Titian.

But having attained a poetic, individual expression, Palma's imagination tended to crystallize into fixed formulas which are close to academicism. When he attempted to escape from

this and pursue new styles, in particular, after 1520, that of Titian, his work appears forced (*The Adoration of the Magi*, Brera, and certain altarpieces in Venice). On the other hand, just before his death, he appeared to discover a new nobility and psychological penetration (in which can be seen something of Lotto) in the two portraits of *Francesco* and *Paola Querini* (1528, Venice, Querini-Stampalia Gal.), which he left unfinished.

Palma's major works include: the Giorgione-like *Country Concert* in the Crichton-Stuart Collection (Ardencraig, Scotland); the *Sacra Conversazioni* (Vicenza, Church of S. Stefano; Naples, Capodimonte; Prague Museum; Vaduz, Liechtenstein Coll.; Venice, Accademia); *The Adoration of the Shepherds* (Louvre); *St Barbara* (Venice, Church of S. Maria Formosa); *Adam and Eve* (Brunswick, Herzog Anton Ulrich Museum); *Venus* (Cambridge, Fitzwilliam Museum); and *Diana and Callisto* (Vienna, K.M.). This last-named gallery, like the Dresden Gemäldegalerie, the Berlin-Dahlem and the Hermitage, owns a fine collection of works by Palma. M.C.V. and L.E.

Palmer
Samuel

English painter
b.London, 1805 – d.London, 1881

Palmer is now mainly remembered for the visionary landscapes he produced early in his career. He displayed a precocious talent as a landscape draughtsman but his interests changed when he met John Linnell, who introduced him to the works of Dürer and Van Leyden and arranged a meeting with William Blake in 1824. These influences turned him against the 'modern art of effects' towards a pastoralism with strong medieval and idealistic overtones. His *A Rustic Scene* (1825, Oxford, Ashmolean Museum) is one of a series of drawings he made at this time which reveal these sources and also the effect of contemporary Christian nature-mysticism upon his thought. They are in a highly wrought linear style, with great emphasis on textural definition, and are mostly accompanied by texts from such writers as Milton and Virgil emphasizing the primal life-giving properties of nature.

▲ Samuel Palmer
Cornfield by Moonlight with the Evening Star (*c*.1830)
Watercolour. 19 cm × 30 cm
London, Lord and Lady Clark Collection

While these remained central to his art, his vision was enhanced after 1825 by a closer contact with nature, the result of frequent visits to the Kent village of Shoreham, where he made his home from 1827 to 1832. He was joined there at various times by fellow-artists like Edward Calvert and George Richmond who shared his enthusiasm for Blake and 'primitivism', an interest that led them to call themselves 'the Ancients'. The development of Palmer's style can be seen in works like *A Hilly Scene* (c.1826, London, Tate Gal.), where his linearity is enriched by a jewel-like use of tempera, a change that leads towards the softer, more glowing works at the end of this period, like *The Magic Apple Tree* (1830, Cambridge, Fitzwilliam Museum). An element of near-fantasy, too, appears in some of his moonlit landscapes, such as *Cornfield by Moonlight with the Evening Star* (c.1830, London, Clark Coll.).

In the early 1830s the group began to disintegrate, at the same time as Palmer's ideal of a pastoral society was attacked by the movement for Parliamentary Reform. He left Shoreham, and for a time toured Cornwall and Wales, producing nostalgic pictures based on his memories of Shoreham (*The Sleeping Shepherd*, 1833-4, Manchester, Whitworth Art Gallery). This gradual decline of his visionary powers culminated in his trip to Italy in 1837-9, after which he became a painter of competent and innocuous water-colours.

His work is to be found in London (British Museum, V. & A., Tate Gal.); Cambridge (Fitzwilliam Museum); Oxford (Ashmolean Museum); Carlisle (City Museum); Manchester (City Art Gal.; Whitworth Art Gal.); Edinburgh (N.G.); Philadelphia (Museum of Art); Melbourne (N.G.); Ottawa (N.G.); and Princeton (University Museum). W.V.

Panini (Pannini)
Giovanni Paolo
Italian painter
b.Piacenza, 1691 – d.Rome, 1765

Panini's first lessons were from the celebrated stage-designers, the Bibiena family, and he retained a taste for the theatrical during the whole of his career in Rome, where he settled in 1715. There he was at first the pupil of Luti, whose Maratta-like classicism influenced him only briefly (canvases on religious subjects in the Louvre, the Prado and in Budapest Museum). His frescoes in Rome for the Villa Patrizi (1719-25) were followed by works in the various palaces, including the Quirinal and the Alberoni, but it was as the indefatigable recorder of the life and monuments of Rome that he quickly achieved international renown.

Though this activity may seem to place him among the *vedutisti* (painters of views) of 18th-century Rome, he, in fact, went beyond the limits of the genre – limits which by then were already fairly rigidly established. He strove, on the one hand, to recapture the freedom of vision which had characterized the precursors of the *vedutisti* during the preceding century, while on the other he participated in those 'proto-Romantic' tendencies which were to lead to Piranesi. The follower of Codazzi in his *rovine*

ideate – apparently realistic compositions which, in fact, were arbitrary groups of ancient ruins peopled by small figures, painted in a graceful rococo style – Panini was not unaware of the work of such landscape artists as Bloemen and Locatelli and, in the analytical precision of his realistic *vedute* (*Castel Sant'Angelo*, 1744, Potsdam, Sans-Souci), of the experiments of Vanvitelli.

Whether invented or copied from life, his compositions, some of which are huge, often have that feeling of being 'documentaries' of life within the framework of ancient and modern Roman monuments (*Piazza del Quirinale* and *Piazza S. Maria Maggiore*, 1742, Rome, Quirinal); they remain among the most attractive examples of the period.

An exceptional scenographer, Panini was always able to invest his views with a feeling of space. The monumental effects he achieved contrast with the animation of the little figures peopling the scenes. He painted ceremonies (*Visit of Charles III to St Peter's*, 1745, and *Visit of Charles III to the Quirinal*, 1746; both Naples, Capodimonte); feasts (*Celebrations in the Piazza Navona*, 1729, Louvre); and theatrical scenes (*Banquet for the Marriage of the Dauphin*, 1747, Louvre). He also produced representations of collections in museums, both real (*Gallery of Cardinal Valenti Gonzaga*, Hartford, Connecticut, Wadsworth Atheneum) and imaginary (*Ancient Rome* and *Modern Rome*, Louvre), in which vast spaces are accompanied by a faithful reproduction of styles.

Panini's output was considerable. His paintings, which are now to be found in a great many European and American galleries, were widely popular, especially in France, a country with which Panini had close links – he became a member of the Paris Academy of Painting and Sculpture in 1732. G.R.C.

Paolo Veneziano
Italian painter
b.Venice, before 1300 – d.Venice, c.1360

The dominant figure in Venetian art during the first half of the 14th century and the true founder of the Venetian school, Paolo Veneziano was an original, complex and enigmatic personality.

An analysis of certain of Paolo's works shows that, despite some opinion to the contrary, the Byzantinism which was for long held to be his distinguishing feature is characteristic only of the works of his maturity. His early paintings, in fact, reveal a Romanesque influence which was linked to the flowering of the 'Greek style' as it appeared in Venice under the sophisticated culture of the Palaeologues during the first half of the 14th century. There is evidence of an awareness of Giotto modified by the Riminese school, and of a definitely Western feeling for plasticity and decoration. These techniques, barely perceptible in the painted sections of the *Altarpiece* in the Church of S. Donato at Murano (1310), stand out plainly in the altar frontal illustrating the *Story of the Blessed Leone Bembo* (1321), now in the Church of S. Biagio at Dignano (Vodnjan). The painting is enlivened by vibrant colours and an acute eye for detail and awareness of perspective.

Paolo's art then entered an eclectic phase, during which it displayed both Eastern and Wes-

tern influences. These are apparent in *The Coronation of the Virgin* (1324, Washington, N.G.); the side-panels of the triptych of *St Clare* with various Saints (1328-30, Trieste, Pin.); the *Madonna with Two Donors* (Venice, Accademia), painted according to Byzantine principles but with sweeping linear rhythms that are decidedly Gothic; and the altar-frontal of *St Lucy* in the Bishop's palace at Veglia (Krk), which interprets an orientalized theme in descriptive and dynamic terms.

It was not until much later, possibly during the fourth decade of the century, that Paolo freed himself from this 'Romanesque Byzantinism', as it has been called. The first work to display his firm commitment to the neo-Greek art of the Palaeologues is the central panel of the great polyptych formerly in the Church of S. Vicenzo, Vicenza, showing the *Dormition of the Virgin* (fragments, Vicenza Museum). Dating from 1333, this is an important work, the first to bear Paolo's signature, and one which has only recently been recognized as belonging to his later period. In it, Byzantine convention does not rule out a certain Gothic bias or a hint of expressiveness in the somewhat rigid countenances of the saints.

These same characteristics can also be found in a series of small portable altarpieces in which Paolo's workshop may have collaborated (the small *Triptych* in Parma, G.N.; others in Worcester, Massachusetts, Art Museum; Washington, N.G.; Avignon, Petit Palais), as well as the more important *Polyptych* in the Tbilisi Museum, USSR, all painted during the same decade. *The Virgin and Child* of Merate (1340, private coll.) marks another stage in the artist's development. Paolo went on to paint a series of works on the same theme.

Paolo's influence in Venice is confirmed by the number of official commissions he received, including those from the Doge Andrea Dandolo for the Ducal Palace and the Basilica of St Mark. One such was for the cover of the *Pala feriale* or 'working altar frontal', so called because it was used during the 'ordinary' days to cover up the *Pala d'oro*, which was reserved for special feast days. The *Pala feriale* is dated 22nd April 1345 and is signed by Paolo and his sons Luca and Giovanni. This was the beginning of a family collaboration, and in many works it is impossible to tell the work of the three artists apart, so similar are their methods. It has been suggested that one of the sons painted the brilliant lower section of *Scenes from the Life of St Mark* because of the marked

Giovanni Panini ▲
The Visit of Charles III to the Quirinal (1746)
Canvas. 123 cm × 173 cm
Naples, Galleria Nazionale di Capodimonte

'Greek style', courtly, rigid, almost abstract, is enriched once more with a delicate, stylized Gothic ornamentation, and an exquisite imagery. With *The Coronation of the Virgin* (New York, Frick Coll.), dated 1358 and signed by both Paolo and Giovanni, an authentic masterpiece with a depth of Gothic inspiration, clear brilliant tones and perfectly balanced composition, Paolo Veneziano reached the end of his career. His unique vision, uniting East and West, provides a distinguished beginning to the long history of Venetian painting. F.Z.B.

Paret y Alcázar
Luis
Spanish painter
b.Madrid, 1746 – d.Madrid, 1799

In 18th-century Spain it was Paret who, next to Goya, attracted most attention from the critics. A solitary and cultivated man, he led his contemporaries in his understanding and absorption of French influences.

Until recently Paret's father was believed to have been a Catalan but it is now known that he was the descendant of an old French family from the Dauphiné region. His marriage to Paret's mother, Maria Alcázar, took place in Madrid in 1745 when he was aged 20. Their son, having learned the rudiments of drawing from a French goldsmith, Duclos, who had settled in Madrid, was sent at the age of ten to the Academy of San Fernando where he became a pupil of Antonio González Velázquez. He failed the examinations but in spite of this was able to go on to Rome, and spent the next three years in Italy.

On returning home in 1766 he came to the notice of the artist-diplomat Charles de la Traverse, who had connections with the Parisian art world. After Paret's early successes in Madrid (his *Masked Ball* in the Prado shows an already mature talent – although one influenced by Tiepolo) nothing is known of him for two years, but it seems likely that he spent some time in France.

Between 1770 and 1775 Paret executed his most brilliant genre paintings, full of shimmering colours and a kind of nervous vigour. He received some commissions from the court (*The Royal Carrousel at Aranjuez*, 1770, Prado; *Charles III Dining in front of the Court*, Prado; *Puerta del Sol*, 1773, Havana Museum). One of his very best, *The Antique Shop* (1772, Madrid, Lazaro Galdiano Museum), seems to show an acquaintance, perhaps indirect, with Watteau's *L'Enseigne de Gersaint*.

After these promising beginnings, Paret's career was now marred by an incident quite unconnected with his art. In 1774, while in the service of the Infante Luis, he was accused of having helped Luis in his illicit love affairs and was exiled to Puerto Rico. Pardoned after three years, he returned to Spain but was exiled from the capital and made his home at Bilbao, where he married in 1780. That same year, as an admission piece to the Academy, he submitted his curious *Diogenes's Circumspection* (Madrid, San Fernando Academy).

After the Infante's death in 1785 Paret was allowed back to Madrid and commissioned to paint views of the Cantabrian ports, which he did in the style of Vernet. For some time he continued

contrast between the architectural motifs and evidence of Emilian influence in this section and the Byzantinism of the upper part. However, it should be remembered that Paolo's early work showed similar hybrid traits.

The two vigorous panels of *Scenes from the Life of St Nicholas* (Florence, Pitti, Contini-Bonacossi Donation) also display the same mixture of styles. They probably once formed part of an altarpiece made for the Ducal Palace by Paolo in 1346, and destroyed by fire in 1483. There is a Gothic flavour to the *Madonna* (1347) in the parish church of Carpinetta (Cesena) which reappears in the three-panelled *Polyptych* in the Church of S. Giacomo in Bologna (evidence of Paolo's connection with the city). Parts of this latter work, for example *St George Killing the Dragon*, reach absolute perfection of style and execution. The lively narrative manner and varied expressions of the saints, drawn with a nimble and flowing ease, followed an iconographic plan which was to become the mark of Paolo's work from now on, and recall the *Polyptych* of Chioggia in the Oratory of S. Martino (1348), reconstructed with panels from various sources.

A more pronounced Byzantinism appears around the middle of the century and lends weight to the theory that Paolo had paid a visit to Constantinople. It is especially apparent in the large *Polyptych of St Francis and St Clare* (Venice, Accademia), a complicated work that is a perfect example of the blending of Byzantine rhythms and decoration with the Western, and especially the Bolognese tradition. The outstanding originality of this neo-Byzantinism is the measure of Paolo's genius as an artist. A further example is the polyptych in the Collegium of Pirano, showing the *Virgin and Child with Eight Saints* (1354), at one time attributed to a 'Master of Pirano' but now known to be Paolo's work. However, the power of invention is not quite so lively, and there is some recourse to facile academic formulas – possibly the work of students called in to help cope with the growing number of commissions.

This tendency is again noticeable in the *Polyptych* in the Convent of S. Eufemia at Arbe (Rab) and in that in the Louvre; but in the Polyptych depicting *Saints* in S. Severino (Pin. Communale), recently reattributed to Paolo, the

 Paolo Veneziano
The Coronation of the Virgin
Wood. 98cm × 63cm
(central part of the *Polyptych of St Francis and St Clare*)
Venice, Galleria dell'Accademia

to live in the north, executing an important series of religious paintings for the church of Viana in Navarre (1786), as well as a number of commissions for landscapes (*St Sebastian* and *Bilbao*, both Madrid, Royal Palace; *Fuenterrabía*, Caen Museum). These are remarkable, both for the way in which Paret has captured the feeling of space and light, and for his groupings of the peasants, fishermen and sailors who people his canvases.

Paret returned to the court where he lived in semi-ostracism, watching Goya reign supreme as the leading painter of the day. From that time until his death Paret produced only one really important picture, *Oath of Ferdinand VII as Prince of the Asturias* (1792, Prado), and lived in seclusion, concentrating on academic work. He also devoted himself with great success to illustration.

Paret's relatively early death has led one writer to deplore the small use he made of his talent. Yet in the Spain of his day Paret was exceptional, both for his culture (he spoke French and English, and had translated Lucian from the Greek) and for the diversity of his talents, producing genre scenes, landscapes, portraits and religious paintings as well as illustrating Cervantes and Quevedo. In his personal life he exemplified the Madrid gentleman of his day: kind, easygoing, popular and elegant. Although he was more influenced by France than was Goya, Paret's gaiety and charm were very much his own.

A.C. and P.G.

Parmigianino
(Francesco Mazzola)
(also known as Parmigiano)

Italian painter
b.Parma, 1503 – d.Casalmaggiore, 1540

Parmigianino was the son of a successful painter, Filippo Mazzola. He lost his father while he was still a child and was brought up by his uncles, Michele and Pier Ilario Mazzola, who were also painters. The boy showed an extraordinary precocity, producing his first canvas, a *Baptism of Christ*, when he was only 14; this may be the

painting now in Berlin-Dahlem. His first frescoes, still to be seen in the Church of S. Giovanni Evangelista in Parma, reveal the influence of Correggio and, in their dynamic colour and forceful composition, of Anselmi and Pordenone.

The earliest work which may reliably be attributed to Parmigianino is *The Mystic Marriage of St Catherine* (1521, Bardi, Church of S. Maria). It has an elegance and delicacy which show his prodigious skill as a draughtsman, and was the first of a series of religious paintings (*The Rest on the Flight into Egypt*, London, Seilern Coll.; *St Catherine*, 1523-4, Frankfurt, Städel. Inst.; *The Holy Family*, 1524, Prado). In 1523 Count Galeazzo Sanvitale (of whom Parmigianino painted a magnificent portrait; Naples, Capodimonte) commissioned him to decorate the boudoir of Paola Gonzaga at Fontanellato. These exquisite frescoes, showing *Diana and Actaeon*, rival Correggio's *Camera di San Paolo*.

In 1524, leaving unfinished his work in the choir of the Church of S. Maria della Steccata, Parmigianino went to Rome, taking with him several of his canvases, including his *Self-Portrait in a Convex Mirror* (Vienna, K.M.), a masterpiece of Mannerism. There is little documentation of this important period in Parmigianino's life, although it is known that he made copies of classical works and studied Michelangelo and especially Raphael at first hand. He met Perino del Vaga, Sebastiano del Piombo and Rosso, with whom he worked in a palazzo in the Via Giulia. He painted small delicate pictures, including new versions of *The Mystic Marriage of St Catherine* and *The Rest on the Flight into Egypt* (Rome, Palazzo Doria), and probably some portraits (*Lorenzo Cybo*, 1524-6, Copenhagen, S.M.f.K.), as well as the monumental *Vision of St Jerome* (1526-7, London, N.G.).

The sack of Rome forced Parmigianino to flee to Bologna, where for three years (1527-30) he was extremely active. His *St Roch* (Basilica of S. Petronio) delighted Vasari with its learned use of arabesques, and was the first of a series of more ambitious works such as the great *Madonna with St Margaret and Other Saints* (1528-9, Bologna, P.N.) or *The Madonna and Child, the Infant St John, the Magdalene and St Zacharias* (c.1530,

Florence, Uffizi) with its delicate landscape background. He also painted *The Conversion of St Paul* (1527-8, Vienna, K.M.) and *The Madonna of the Rose* (1528-30, Dresden, Gg), a strange mixture of sensuousness and refinement. His contemporaries saw the genius of Raphael coming to life again in Parmigianino's works.

In 1530, in Bologna, Parmigianino took part in the coronation celebrations of the Emperor Charles V, and painted his portrait from memory (formerly Great Britain, Richmond, Cook Coll.). Many other portraits date from this time (to be found today in Florence, Uffizi; Rome, Gal. Borghese; Naples, Capodimonte; Parma, G.N.; Vienna, K.M.; Hampton Court). That same year, hearing that Correggio had left Parma, Parmigianino returned to his native city, by now at the peak of his career. Brilliant draughtsman, exquisite colourist, and endowed with an original mind, he was destined for greatness, but his neurotic personality made him increasingly restless, and an incessant quest for perfection of form (*Amor*, 1531-4, Vienna, K.M.) caused him to leave many of his most beautiful works unfinished, including *The Madonna with the Long Neck* (c.1535, Florence, Uffizi).

This gradual change in his character partly explains his quarrel with the chapter of S. Maria della Steccata where he worked for some years (1530-4) on an ambitious series of frescoes for the vault. The numerous drawings that have survived show elegant female figures placed in harmonious symmetry, almost abstract in their rhythmic execution. The portraits Parmigianino did at this time also express great spiritual insight and something of his own mental anguish (*The Count and Countess of San Secondo*, 1532-5, Prado; and especially his strange *Antea*, 1535-7, Naples, Capodimonte). After about six years the artist had made very little progress on his Steccata frescoes, and had to flee to Casalmaggiore to

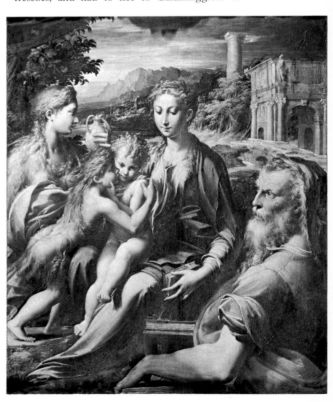

▲ Luis Paret y Alcázar
Charles III Dining in front of the Court
Canvas. 50 cm × 64 cm
Madrid, Museo del Prado

▲ Parmigianino
The Madonna and Child, the Infant St John, the Magdalene, and St Zacharias (c. 1530)
Wood. 96 cm × 73 cm
Florence, Galleria degli Uffizi

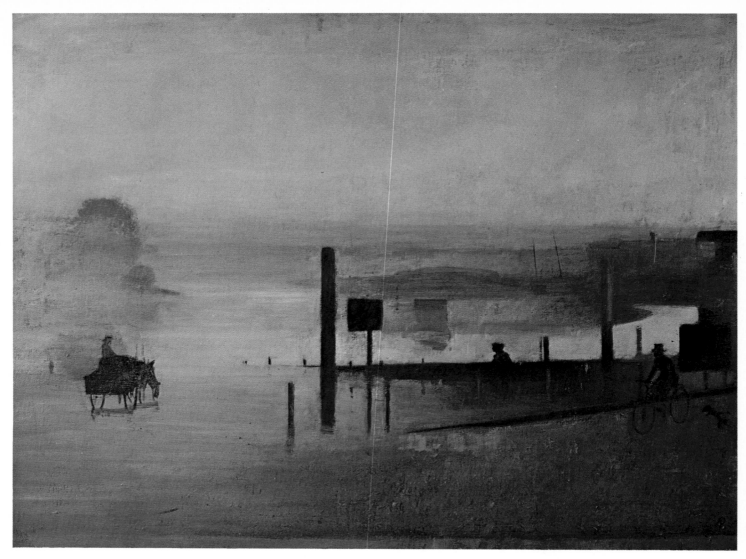

escape imprisonment for default. He did not give up his quest for perfection, eventually stripping his work to the bare essentials (*Madonna and Child with St Stephen, John the Baptist and a Donor*, Dresden, Gg; *Lucretia*, Naples, Capodimonte).

He died prematurely at Casalmaggiore in his 37th year, having changed from the gentle, elegant person he used to be, to an unkempt, wild man because, says Vasari, of his obsession with alchemy. His influence, which was enormous, remained. He was one of the most sensitive of the Mannerist painters, and his splendid drawings, as engravings, carried his fame far and wide. There is a superb collection in the Louvre and others in the Parma National Gallery, the Devonshire Collection, Chatsworth, Derbyshire, the Uffizi, the Albertina, the British Museum, Windsor Castle and Budapest Museum. S.B.

Pasmore
Victor

*English painter
b.Chelsham, Surrey, 1908*

The son of a medical practitioner, from 1926 until 1938 Pasmore worked as a clerk for the London County Council, painting in his free time and taking some lessons at the Central School. He

began exhibiting his pictures at mixed exhibitions and contributed to 'Objective Abstractions' at the Zwemmer Gallery in 1934. His early work was often experimental in character, showing signs of both Fauvist and Cubist influence.

In 1937 Pasmore, with his friends William Coldstream and Claude Rogers, opened a teaching studio which was soon to become known as the 'Euston Road School'. The term was also applied to the painting of the three teachers, describing a straightforward realist approach to both style and subject matter, as, for example, in Pasmore's *Parisian Café* (1938, Manchester, City Art Gal.) and *The Flower Barrow* (1938–43, Adelaide).

Pasmore continued to paint during the Second World War, although he spent some time in the army and in prison as a conscientious objector to military service. He began part-time teaching at Camberwell in London in 1943, and taught from 1949 until 1953 at the Central School. There he made a comprehensive study of the theoretical writings of painters, taking a particular interest in Cézanne, Seurat and, later, Klee. His own painting reflects the results of these studies, especially noticeable in a series of large paintings of the River Thames at Chiswick where Pasmore was then living (London, Tate Gal.; Ottawa, N.G.). These pictures became increasingly abstracted, and in 1948 Pasmore painted his first completely abstract pictures since the experiments of the 1930s. Choosing such basic forms as the square

and the spiral, Pasmore at first seemed to be looking for their symbolic properties, and the spiral form was developed into the wave and snowstorm pictures of 1949–52 (London, Tate Gal.).

At the same time, however, Pasmore was using collage, and this led him into making wooden relief constructions. For a time, from 1954 to 1956, he produced only reliefs, using wood and plastic materials and paint. Meanwhile, in 1954, he had moved to Newcastle as Master of Painting at the University, and until 1961 was a very influential teacher. He also became consultant architectural designer for the new town of Peterlee in County Durham, and this provided him with the opportunity of extending his ideas into the social environment.

In the 1950s and early 1960s Pasmore was very active as a theorist, and his work was widely known in Europe, notable exhibitions being held at the Venice Biennale in 1960 and at the Tate Gallery in 1965.

In 1966 Pasmore moved to Malta, though keeping his house in London. He continued to produce both paintings and relief constructions, developing formal ideas but growing increasingly interested in the introduction of irrational elements, and proclaiming a symbolic content for his work. The creation of a self-sufficient personal morphology, and the constant insistence on transformation, shows Pasmore's late work to be a logical extension of certain basic abstract and Surrealist ideas of the mid-20th century. A.Bo.

 Victor Pasmore
The Quiet River: the Thames at Chiswick (1942–4)
Canvas. 76 cm × 102 cm
London, Tate Gallery

Patenier (Patinir, Patinier)
Joachim
Netherlandish painter
b.Dinant or Bouvignes, c.1480 – d.Antwerp, 1524

Biographical information on the most seminal of Netherlandish landscape painters is extremely scarce and the first positive mention of his name occurs only in 1515 when he is recorded as a master of the Antwerp Guild. His name appears next to that of Gerard David who joined the guild in the same year and may have been Patenier's master in Bruges before his settling in Antwerp – a theory which appears to be borne out by the subject matter of certain of Patenier's works such as a *Baptism of Christ* and by his use of a pointillist technique to highlight foliage.

In the course of his visit to Antwerp in 1520 Dürer became friendly with Patenier. The records in his diary say how he borrowed Patenier's paints and employed one of his pupils, in exchange for some engravings and a drawing, as well as a painting by their German contemporary Hans Baldung. Dürer also bought Patenier's *Lot and his Daughters*. On 5th May 1521 he was at Patenier's wedding to his second wife Jeanne Nuyts, and later made two portraits of her, one of which could be the drawing in silverpoint now in the Weimar Museum.

Quentin Metsys was another painter who had strong links with Patenier. He painted some of the figures in Patenier's *Temptation of St Anthony* (Prado; 1574 inventory) and was appointed guardian to the artist's daughters on his death. This probably occurred in 1524, as Jeanne Nuyts is styled 'widow of Joachim Patenier' in a deed dated 5th October 1524.

Famous in his lifetime, Patenier was acknowledged by Guevara, Philip II's artistic adviser, to be one of the greatest of the Netherlandish masters. In 1521 three of his works were recorded as being in the Grimani Palace, Venice. Many paintings by pupils or imitators have been wrongly attributed to Patenier. In fact, no more than a score of works are indisputably by his hand, including *The Flight into Egypt* (Antwerp Museum), *The Baptism of Christ* (Vienna, K.M.), *St Jerome* and *The Temptation of St Anthony* (both Prado). Of these only a few are signed, notably two of his youthful works.

While following the tradition of Van Eyck, Patenier seems to have been influenced by Bosch (his senior by 30 years) in the way in which he depicts landscape from a bird's-eye view. As with Bosch, the figures in the foreground seem to be detached from their surroundings, the religious subject matter being only a pretext for the depiction of a marvellous world of fantasy. Like a true man of the Renaissance, Patenier directed his talents to landscapes at a time when the discovery of new lands and distant places was everywhere arousing passionate interest.

Into his boundless universe Patenier puts tiny figures preoccupied with the familiar actions of their everyday lives. His pictures are full of naturalistic details. In *St Jerome* (Louvre) a little dog is shown leaping after a bird in flight, while in the background of *Rest on the Flight into Egypt* (Prado) the realistic details of the harvest are matched by the adoration of the god Baal, which serves as an excuse for the inclusion of fantastic edifices surrounded by jagged rocky cliffs.

Patenier's imaginary landscapes re-create and bring together in one varied scene the natural elements of the countryside around Antwerp and the cliffs near Dinant, washed by the Meuse. But his fantastic rocky crags are also the legacy of a Christian symbolism, still widespread at the beginning of the 16th century.

The aerial perspective of his compositions is designed in a succession of three coloured planes: thus, in the version of *St Jerome* in the National Gallery, London, the eye is caught first by the saint's blue robe standing out against the warm brown of the rocks behind him. A second plane, showing a valley between the rocks, is painted in cool luminous tones; and, finally, the eye comes to rest on the mountains in the hazy distance. Using a whole gamut of greys for the rocks and a delicate pink for the rooftops, Patenier emphasizes this scheme with great subtlety. The tiers slip away towards a rather high skyline, a well-tried technique used by Bruegel and Seghers.

Patenier limited himself to a small number of themes grouped around a few *sujets prétextes*, which, however, were always religious: *The Flight into Egypt* (Prado; Vienna, K.M.; Antwerp Museum; Berlin-Dahlem); *The Baptism of Christ* (Vienna, K.M.; Metropolitan Museum); *St Jerome* (Vienna, K.M.; Prado; London, N.G.; Louvre; Metropolitan Museum; Karlsruhe Museum); *St Christopher* (Escorial); *The Temptation of St Anthony* (Prado); *The Burning of Sodom* (Rotterdam, B.V.B.; Oxford, Ashmolean Museum); and two rarer subjects, *The Vision of St Hubert* (private coll.) and *The Journey across the Styx* (Prado).

This last-named painting (also known as *Heaven and Hell*) stands apart from the rest of Patenier's work, which is generally serene in mood. In depicting the medieval idea of the 'chosen' and the 'damned' Patenier created a surprisingly secular picture in which, between a celestial kingdom in the tradition of Van Eyck

and a flaming inferno reminiscent of Hieronymus Bosch, a vast, deep-blue river stretches as far as the eye can see towards new horizons. Equally striking is the violent expressionism of *The Burning of Sodom*, painted in browns and reds, with its phantasmagorical rocky crags grouped against the background, without regard to the rules of perspective.

Patenier knew nothing of Italian painting. His methods, his pure colours, and his blending of fantasy with precise factual detail make him the heir to the 15th century. Nevertheless, he imposes a new and unfamiliar vision on the Middle Ages, and heralds Bruegel. His pupils, such as Quentin Metsys, and his many imitators upheld his ideas throughout the 16th century. They were renewed by Herri met de Bles, Lucas Cassel, Joos de Momper, Jan Bruegel the Elder and Gillis van Coninxloo. H.L. and M.D.B.

Peale
Charles Willson
American painter
b.Queen Annes County, Maryland, 1741 –
d.Philadelphia, 1827

No career exemplifies so well the curious position of the artist in Colonial, Revolutionary and early Federal America as that of Charles Willson Peale. One of the principal artists of the Revolution and one of the few to have painted Washington from life, he was the effective head of three generations of family artists and was responsible for the founding and operation of America's first successful museum. He was equally involved in the establishment of the Pennsylvania Academy of the Fine Arts. The names he gave his many

Joachim Patenier ▲
The Baptism of Christ
Wood. 60 cm × 76 cm
Vienna, Kunsthistorisches Museum

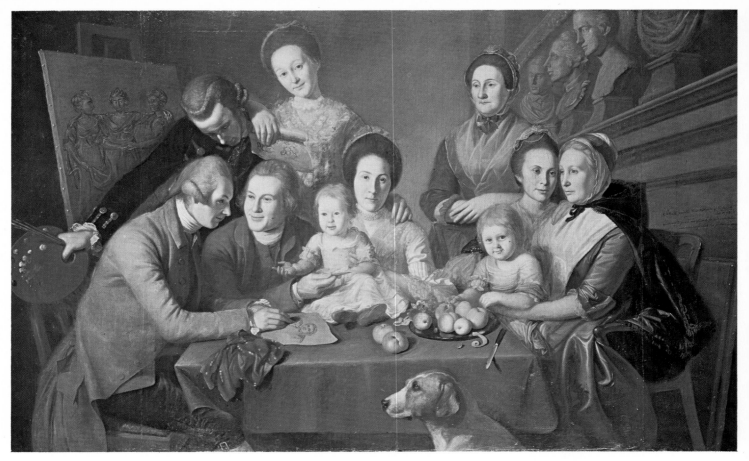

offspring, including Raphaelle (1774–1825), Angelica Kauffman (1775–1883), Rembrandt (1778–1860), Rubens (1784–1865) and Titian (1799–1885) demonstrate Peale's genuine enthusiasm for the old masters. Yet, by the names he assigned to the children of his second marriage, Linnaeus and Franklin, as well as through the contents of his museum, Peale hinted at a practical truth for his epoch: he had a low opinion of painting and regarded it merely as a trade, unless at the service of science. His ideal perhaps was the French artist-naturalist, Charles Alexandre Lesueur, whose portrait he painted in 1818.

Peale began life as a saddler's apprentice in Annapolis, Maryland (his younger brother, the miniaturist James Peale, began as a cabinetmaker). After studying painting briefly with John Hesselius (1763) and working in Boston with Copley (1765), Peale joined Benjamin West in London from 1767 to 1769, where he was the third American (preceded by Matthew Pratt and Abraham Delaunoy) in a long stream of pupils from the New World. Like any American artist of his time Peale was dependent on portraiture for a livelihood, but he had the great good fortune to paint George Washington from life seven times, the first at Mount Vernon in 1772 and the last at Philadelphia in 1795.

Peale settled in Philadelphia shortly before the Revolution and served in the Continental army as a captain until 1778. In order to secure further orders for portraits he conceived the idea of displaying his army portraits in the painting room of his Philadelphia house. This led to the development of Peale's museum, but the art which had served initially as an advertisement for the painter was never destined, in his mind, to serve other than an ancillary role. Peale was basically interested in science and natural history, and his museum move – as it became successful, and

filled with 'specimens' – first to Philosophical Hall in 1794, and then to Independence Hall, the Old State House, in 1802. There it remained until 1827, the admission fees providing a steady source of income for various members of the Peale family.

Peale's best paintings reflect the artist's infatuation with science. *The Artist in his Museum* (1822, Philadelphia, Pennsylvania Academy of Fine Arts), a self-portrait, shows him inviting the viewer to penetrate beyond the visual to partake of the wonders of general inquiry. The lively *Staircase Group* (1795, Philadelphia, Pennsylvania Museum of Art), a portrait of his sons Raphaelle and Titian, has the sharply observed quality that stems from a man fascinated by optics and perspective. His most famous painting, *Exhumation of the Mastodon* (1806, Baltimore, Peale Museum), was for Peale the record of a scientific discovery of great moment. It was exhibited in his museum as a document, simultaneously with the bones of the mastodon.

Raphaelle Peale, Charles Willson's eldest son, established a branch museum in Baltimore. An artist who wanted to be an inventor, he is best known for his profile silhouettes. Rembrandt Peale, the second son, was the favourite pupil of his father and began as an assistant in the family portrait factory. He took the mastodon skeleton on a London tour, but also developed an increasing interest in pure art during a visit to the Continent in the early 1800s. His staple was the idealized 'porthole' portrait of George Washington. Rubens Peale, the third son, was trained as a naturalist but in effect became the family museum administrator until he sold out to Barnum in 1837 and took up painting. The saga of the Peale family is far more the history of the early American conception of what an artist should be, and what artistic institutions were

required in the young republic, than it is of individual styles or of unusually penetrating attitudes towards life expressed in purely visual terms. D.R.

Pellegrini
Giovanni Antonio
Italian painter
b.Venice, 1675 – d.Venice, 1741

The revival of Venetian painting which took place during the 18th century owes much to Pellegrini who, together with Ricci and Amigoni, first gave it impetus. His position is the more significant and original in that he was active throughout Europe as the creator of an entirely new form of decoration. More often abroad than at home, he brought to many of the European courts, including London, Bavaria, Paris and Vienna, a style that was distinguished by lightness and gaiety, and by delicate glowing colours. His sketches are thought to be amongst the most brilliant made anywhere in Europe in his time.

His early works bear the mark of his native Venice where he was able to study the flowing, polished Baroque style of Liberi as well as the daring later discoveries of Giordano. Pellegrini was a pupil of Sebastiano Ricci, who had brought back from central Italy at the end of the 17th century many decorative innovations and had developed a light and luminous style of painting. Pellegrini's style remained individual and consistent throughout his career. Everything lay in the ease and the sensitivity with which he softened his brushstrokes to produce hazy and indefinite outlines. The result was purely decorative figures

Charles Willson Peale ▲
The Peale Family
New York, New-York Historical Society

which seemed to be weightless and unposed, and whose ephemeral existence he had succeeded in capturing in fresh silvery colours.

Pellegrini's earliest known works were painted for the Scuola del Cristo in Venice, following a visit to Rome in 1701; they already show the kind of transparent fluidity normally associated with pastel. From 1708 Pellegrini was in London with Marco Ricci, and painted at Kimbolton Castle for Lord Manchester a series of *Roman Triumphs* which literally glow with light. At Castle Howard he painted several ceilings (many of which were destroyed in the Second World War) where the influence of Ricci can be clearly seen, although the figures, in their shimmering costumes, lend his frescoes an airiness and vivacity which is completely rococo. Pellegrini's third great set of decorations was for Narford Hall, Norfolk.

In 1713 he set off for Düsseldorf where, in Bensberg Castle, he painted a ceiling and 14 large canvases which are now in Schleissheim Castle. In these paintings the allegory and myth are stripped of the classical ostentation demanded by Pellegrini's court patrons, and instead the pictures evoke a graceful frivolity comparable to the silvery notes of a minuet. The episodes unfold without any dramatic tension, and even without narration, giving the impression more of a princely gala. Following this, Pellegrini stayed in The Hague where, for the Antwerp Guild of Brewers, he painted *The Four Elements*, an airy and flexible work.

In 1719 Pellegrini returned to England where he produced a remarkable *Deposition* (Sarasota, Ringling Museum), a dynamic and complex painting, in which the softly merging colours eliminate all hard outlines, so that the figures appear in an evanescent, pellucid atmosphere. The following year he was in Paris where he painted a magnificent ceiling for the Bank of France which, although now destroyed, remains part of the history of French painting in the 18th century. In 1724 he painted an important series of murals of *Hercules and the Hesperides* for Prince Schönborn at Pommersfelden. Outstanding for their delicate colouring and their inventiveness, these constitute one of the most joyous masterpieces in painting.

Three years later Pellegrini was in Venice where he painted a fresco for the cupola of the Salesian Church. But his powers were now on the decline. Here, as with the commissions begun later in Paris (where he was admitted to the Académie in 1733) and for Mannheim Castle (*c.*1737), his outlines tended to harden and his colours to become dull and heavy as he experimented with the balance of light and shadow. It was as though he found himself unable to respond when faced with the emerging talents of Piazzetta and Tiepolo, who from now on came to occupy a dominant position in the favours of the public. F.d'A.

Pereda
Antonio de

Spanish painter
b.Valladolid, 1608 – d.Madrid, 1678

The son of an artist, Pereda was brought up in his native town before being apprenticed to Pedro de las Cuevas in Madrid. Here he found patrons at the court, notably the great Italian architect Crescenzi. In 1635 he collaborated with Carducho, Velázquez and Zurbarán in the decoration of the Royal Salon in the new palace at Buen Retiro (*The Relief of Genoa* in the series *Spanish Victories*, now in the Prado). The subject of the painting makes it unique in Pereda's output, as he afterwards withdrew from the court and worked only for convents and churches, producing huge altarpieces, such as *St Augustine and St Theresa at the Feet of the Virgin and St Joseph* (1640, Carmelite Convent, Toledo) and *The Marriage of the Virgin* (1643, painted for the Capuchins at Valladolid, now in Paris, St Sulpice). These are noteworthy more for the brilliance of their colouring than for their sense of personal involvement, but he also painted a number of extremely small works. The single figures in *Ecce Homo* (1641) and *St Jerome Penitent* (1643), both in the Prado, combine a faultless sense of colour learned from the Venetians with a firm line and a sober but vigorous realism that recalls the tenebrism of Ribera.

By contrast, Pereda was very fond of painting still life – rich materials, fruit and flowers, cooking utensils bathed in warm, soft light (1650-1, Lisbon, M.A.A.; Hermitage) – and Palomino declared that no other painter could surpass Pereda in this genre. Pereda also painted moral allegories which, like their counterparts, the Dutch 'vanitas' paintings, stressed the fugitive nature of life and the deceptiveness of worldly glory. Some of his greatest works are in this genre, notably *The Dream of a Young Nobleman* (Madrid, San Fernando Academy) and *The Angel and Human Vanities* (Vienna, K.M.).

During his final years Pereda modified his style to take account of the Baroque forcefulness that Madrid embraced about 1660. His conversion, however, was superficial. His last altarpieces (*Miracle of the Portiuncula*, 1664, Valladolid Museum; *The Deposition*, Marseilles Museum; *Portrait of St Dominic Consigned to the Monk of Soriano*, Madrid, Cerralbo Museum) are far from being conventional works. A.E.P.S.

Permeke
Constant

Belgian painter
b.Antwerp, 1886 – d.Ostend, 1952

The son of Henri Permeke, a marine painter, Permeke spent his early years in Antwerp until the family moved to Ostend in 1892. Enrolled as a free pupil at Ghent Art School in 1904, he was taught by Jean Delvin and made the acquaintance of Gustave de Smet and Frits van de Berghe. After completing his military service he settled in the village of Laethem-St Martin in the spring of 1909, and lived there until 1912. During these three years Permeke experimented with various techniques then still popular in Belgium, and which derived from Impressionism and Symbolism. Soon, however, encouraged by the Expressionist painters De Saedeleer and Servaes, who were living in the village, he made his first attempt at synthesis, *Winter in Flanders* (1912, Antwerp Museum), a landscape with figures which marks a deliberate effort to express an affinity with the land. Later canvases on the themes of the sea and motherhood, painted at Ostend

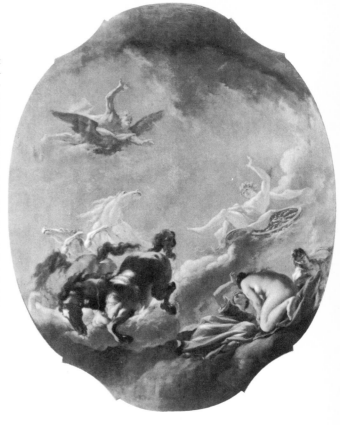

between 1912 and 1914, display similar Expressionist tendencies (*Motherhood*, 1913, Rotterdam, B.V.B.). By now, too, his talent for drawing was equally developed (*The Artist's Mother*, charcoal, 1913, Jabbeke, Permeke Museum).

Called up in 1914, Permeke was badly wounded during the siege of Antwerp and was evacuated to England. It was while he was convalescing in Devon, first at Chardstock and then at Sidford, that he began work on his huge figure paintings, *The Stranger* (1916, Brussels, M.A.M.), *The Butcher* (1916, Brussels, private coll.) and *The Cider Drinker* (1917, Basel, private coll.). Although later seen as manifestations of Flemish Expressionism, these works, with their curved and rounded forms which seem to make up part of the background, are still partly Symbolist in spirit. The landscapes that Permeke painted in Devon are very different. The range of warm tones from red to gold that give the canvases a look almost of imprecision may owe something to Turner's

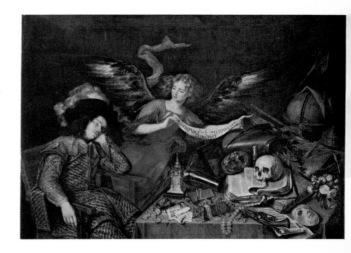

Giovanni Pellegrini ▲
The Fall of Phaeton (ceiling)
Saint Jean-Cap Ferrat, Musée Île-de-France

Antonio de Pereda ▲
The Dream of a Young Nobleman
Canvas. 152 cm × 217 cm
Madrid, Real Academia de Bellas Artes de San Fernando

influence (*Harvest in Devon*, 1917, Ypres Museum).

From 1919 to 1929 Permeke spent most of his time at Ostend where he devoted himself principally to marine painting. Gradually, however, he turned to rural themes and spent long periods in the hinterland at Astene (1922-4) and then at Jabbeke, where he settled permanently in 1929. Cubism and Negro art, which he discovered at exhibitions in Antwerp and Brussels in 1920, strongly influenced his style. He felt a great affinity with fishermen, peasants and farmers and used them as subjects for a number of charcoal studies of varying sizes. At the same time he was producing high canvases which freely integrate the principles of modernism and the School of Paris and state them with an unyielding honesty: *Fiancés* (1923, Brussels, M.A.M.); *Brown Bread* (1923, Ghent, private coll.); *Brother Sailors* (1923, Basel Museum); and *Man with a Basket* (1925, Ostend Museum). His palette remained sombre even though the subject matter had lightened considerably since the start of his career.

Between 1926 and 1928 Permeke was absorbed by the development of form, with a tendency to favour the two-dimensional at the expense of tonal values (*Peasant Family with a Cat*, 1928, Bruges Museum). His move to Jabbeke in 1929 saw the start of the six most fruitful years of his career. His paintings of farmsteads and the Flemish countryside make use of a clearer, more varied palette (*The Sow*, 1928, Brussels, private coll.; *Autumn Landscape*, 1931, Antwerp Museum), while his great figure paintings display a lyric fusion of line and colour (*Motherhood*, 1929, Ostend Museum). Several works such as *The Sower* (1933, Jabbeke, Permeke Museum), *Peasant*

Raking the Soil (1934, Antwerp Museum) and *The Potato Eater* (1935, Brussels, M.A.M.) represent a northern tradition of the painter close to the soil, with explicit overtones of Bruegel and Van Gogh, and are probably Permeke's most personal assertions. From around 1935-6 Permeke became interested in sculpture. During the Second World War he drew mostly nudes and was always a remarkable exponent of this art form. His last years were occupied with portraits and with landscapes which richly evoke the whole atmosphere of Flanders. The extraordinary tonal values and unity of some of these (Deurle Museum; Brussels, M.A.M.) made a strong impression on the artist de Staël when he was in Belgium.

Permeke's art is one of the most powerful representational syntheses of his age, harnessing its technical innovations and spiritual currents to produce works of deep humanity. He is represented in many Belgian museums: a fine salon in Antwerp is dedicated to him, and at Jabbeke the Permeke Museum has an enormous collection of his drawings and paintings of all periods. His works can also be seen at the Musée National d'Art Moderne in Paris, at the Stedelijk Museum in Amsterdam, in London at the Tate Gallery, and at galleries in Basel, Prague and São Paulo.

M.A.S.

Perronneau
Jean-Baptiste
French painter
b.Paris, 1715 – d.Amsterdam, 1783

Perronneau began his training under Natoire, and for a number of years, until 1744, his work – such as the *Quatre Éléments* (*The Elements*) produced in collaboration with Aveline – closely resembled that of Natoire and Boucher. He became a pupil of Laurent Cars at Orléans, and painted his portrait some years later, in 1750 (Ann Arbor, University of Michigan Museum of Art; a pastel version is in the Louvre). During his time at Orléans he met Desfriches who obtained for him many commissions for portraits. Another strong influence on Perronneau's early works was Nattier, notably in *La Petite Fille au chat* (*Girl with a Kitten*) pastel, 1743, London, N.G.) and in one of his greatest works, *Madame de Sorquainville* (1749, Louvre), the composition of which resembles Nattier's *Marie Leszczinska* (Versailles), which had been exhibited at the Salon the previous year. In 1753 Perronneau was admitted to the Académie with portraits of *Adam l'Aîné* (*Adam the Elder*) and *J.B. Oudry* (both Louvre).

Perronneau's use of pastel led him to be compared with his contemporary Maurice Quentin de La Tour. Like his rival, Perronneau painted head-and-shoulder or three-quarter-length portraits (rarely full-length) against a neutral background with a minimum of accessories. The aim of such portraits as *Normant du Coudray* (1766, Paris, Musée Cognacq-Jay) seems to have been aesthetic rather than descriptive. However, unlike La Tour, Perronneau had a difficult life. He applied several times for accommodation in the Louvre without success; and he had, too, to content himself with a middle-class clientèle, either from the provinces or from abroad (*Daniel Jousse*, Orléans Museum; *Mademoiselle Courrégeoles*, 1768, Bor-

deaux Museum). This partly explains the ceaseless travelling which took him across Europe in search of work, including journeys to Holland (in 1754, 1755, 1761, 1771, 1772, 1780 and 1783), Italy (1759), England (1761), Russia (1781) and Poland (1782).

Perronneau's portraits, like those of La Tour, are distinguished by psychological penetration, but a less mellow technique and the occasional use of strong colours (remarkably similar to the style of contemporary English portraitists) add a touch of uncompromising realism. This slightly unpolished look of his portraits explains the reluctance of the court to commission him, and why he tended to rely on male sitters, who, in fact, elicited his best work (*Abraham van Robais*, 1767, Louvre). Here, Perronneau is closer in feeling to Chardin, with a sense of intimacy, a marvellous use of light and shade and of reflection breaking up his colour masses, which made him a colourist unrivalled even by La Tour.

He is well represented in the Louvre, and at the Orléans Museum which has a particularly fine selection of his works, as well as in London, (N.G.), Boston (M.F.A.), Chicago (Art Inst.), Detroit (Inst. of Arts), the Hermitage (*L'Enfant au livre* [*Child with a Book*]), Copenhagen (S.M.f.K.) and the Rijksmuseum; and at the museums of Geneva, Tours and St Quentin (his portrait of *Maurice Quentin de La Tour*).

C.C.

Perugino
(Pietro Vannucci)
Italian painter
b.Città della Pieve, c.1448 – d.Fontignano, 1523

A pupil of Verrocchio, Perugino was enrolled in the Guild of St Luke in Florence in 1472. Verrocchio's influence is plain in his early work, with its concise and uncluttered draughtsmanship, and its use of chiaroscuro, as in the paintings of the

▲ Jean-Baptiste Perronneau
L'Enfant au livre
Canvas. 63 cm × 52 cm
Leningrad, Hermitage

▲ Constant Permeke
Motherhood (1929)
Charcoal and oil. 180 cm × 90 cm
Ostend, Musée des Beaux-Arts

Virgin in the Musée Jacquemart-André, Paris, Berlin-Dahlem, and the National Gallery, London. The young Perugino collaborated in the *Crucifixion with St Jerome and St Anthony* for the Church of SS. Maria e Angiolo at Argiano, while studying under Verrocchio, and also contributed the predella, *The Birth of St John the Baptist* (Liverpool, Walker Art Gal.), and to Verrocchio's altarpiece *The Madonna di Piazza* for Pistoia Cathedral (after 1474).

His connections with Verrocchio and his Florentine followers gave Perugino a lively interest in the use of space and the effect of light, a legacy from Piero della Francesca. Both Piero and Domenico Veneziano worked at Perugia and the influence of their architectural fantasies and luminosity is clearly evident in *The Life of St Bernardino,* now on display there in the Galleria Nazionale. Dating from 1473, the *Scenes* were probably executed from Perugino's preliminary sketches, but only *The Miracle of the Healing of the Youth of L'Aquila* and *The Healing of a Young Girl* appear to have been actually painted by him.

Perugino's constant aim was to achieve harmony and balance. These qualities are already apparent in his *St Sebastian between Two Saints* (1478, fresco, Church of S. Maria, Cerqueto). But the best example is the fresco showing the *Giving of the Keys to St Peter* (1481-2, Vatican, Sistine Chapel). Here, Perugino broke away from the doctrines of Piero della Francesca: his friezes of figures placed on various levels against an architectonic perspective are very different from Piero's geometrical characters surrounded by vast spaces. Perugino also collaborated with Pinturicchio on the Sistine Chapel frescoes depicting *Moses Journeying in Egypt* and the *Baptism of Christ.* There is a hint of Pinturicchio's style in the busy pictorial landscape background of Perugino's *St Jerome* (Washington, N.G.), but it was undoubtedly Flemish art which inspired the closely observed misty countryside of the beautiful *Galitzine Triptych* – a *Crucifixion* flanked by *St Jerome* and *St Mary Magdalene* (Washington, N.G.). It is worth remembering that the triptych by Hugo van der Goes, now in the Uffizi, which was commissioned by the Portinari family, probably reached Florence around 1483.

With the *Albani Torlonia Polyptych* (*Nativity* with *Saints*, 1491, Rome, Torlonia Coll.) a new rhythmical relationship appears between the two separate parts of the composition – the figures and the architectural setting – placed symmetrically around a central motif. This arrangement, which achieved universal popularity during the next five years, at a time when Perugino was working mainly in Florence, can be seen in such works as *The Virgin Enthroned between St John the Baptist and St Sebastian* (1493, Uffizi), *The Virgin Appearing to St Bernard* (Munich, Alte Pin.) and the *Pietà* (Uffizi). The tripartite fresco of the *Crucifixion* in the Church of S. Maria Maddalena dei Pazzi in Florence marks, however, another stage in Perugino's treatment of space: the appearance of a rhythmic, everyday landscape with broad, not altogether solid, fields, completely lacking in architectural perspective. The way in which the figures are arranged, often posed in untidy rows in the foreground of the picture, has been compared to the style of Andrea della Robbia in his ceramic altarpieces. Further examples of this technique are *The Virgin with Saints* (Bologna, P.N.), the *Ascension* in the centre of the polyptych for the church of S. Pietro at Perugia (Lyons Museum; the predella is in Rouen Museum), the murals of

the Collegio del Cambio, Perugia (completed in 1500), and the *Assumption* for the Abbey of Vallombrosa (1500, Florence, Accademia).

Towards the end of the 15th century the young Raphael came to Perugino's studio, and collaborated with him on the predella of the *Fano Altarpiece* (Fano, Church of S. Maria Nuova). At Raphael's instigation Perugino began to employ a more slender and more brilliant line than in previous years: see, for example, the two *Prophets* in the polyptych of S. Pietro (Nantes Museum), the *Pietà* in the Clark Art Institute, Williamstown, and the vault of the Collegio del Cambio.

For the next 20 years Perugino's art kept its languid and elegant harmony of line, but his style had become anaemic and his inspiration had dried up. The change is evident in such works as *The Adoration of the Magi* (1504, Città della Pieve, Oratory of S. Maria dei Bianchi); *The Combat between Love and Chastity* for the studiolo of Isabella d'Este (1505, Louvre); Perugino's work on the polyptych (now dismantled) showing the *Deposition* (Florence, Accademia), the *Assumption* (Florence, Church of the Annunziata) and *Saints* (Altenburg, Lindenau Museum and private coll.), which was begun for the Church of the Annunziata in Florence by Fra Filippino Lippi (1504-7); the vault of the Vatican chamber (*c.*1507) where Raphael and his students later painted the *Fire in the Borgo;* the fresco showing the *Nativity* at the Church of S. Francesco in Montefalco; and the frescoes in the Church of S. Maria delle Lacrime at Trevi (1521).

Perugino's significant work was accomplished by the close of the 15th century. He was one of the most important figures of the late quattrocento because of his role-transmitting classicism throughout Umbria (through Raphael), Tuscany (Fra Bartolommeo) and northern Italy (Francia and Costa). For his own part, Perugino chose not to follow the movement to whose birth he had contributed so much by his ceaseless quest after grandeur and dignity. C.D.B.

Among Perugino's most important works are: the tondo of the *Virgin with Saints and Angels, Apollo and Marsyas* and *St Sebastian* (all in the Louvre); *The Lamentation* (1495) and the *Mary Magdalene* (both Florence, Pitti); the fragments of

a *Polyptych of the Certosa of Pavia* (London, N.G.); the *Resurrection* (Vatican); *The Marriage of the Virgin* (Caen Museum); and several outstanding portraits: *Francesco delle Opere* (1494), *Don Biagio Milanesi* and *Don Baldassare di Antonio di Angelo* (all in the Uffizi). L.E.

Piazzetta
Giovanni Battista
Italian painter
b.Venice, 1682 – d.Venice, 1754

The dramatic tension in the work of Piazzetta, a powerful and original personality in the Venetian art world of the 18th century, suggests that he was a tenebrist in the tradition of Caravaggio. At the same time he was a lively innovator: his pictures, full of a heavy impasto and bathed in light, show him moving gradually away from the Baroque towards the fluidity and grace of the rococo.

After being taught for a while in Venice by Antonio Molinari (an undistinguished member of the tenebrists) Piazzetta moved to Bologna where, around 1703, he studied with Crespi who taught him how to apply his paint lavishly in order to obtain a lively and radiant effect, and also encouraged his taste for a developed chiaroscuro. Employing a bold sweeping brush, Piazzetta turned out dramatic, forceful pictures characterized by daring contrasts between sombre tonal values and reddish highlights. One of his most typical works is *St James Led to Martyrdom* (1717, Venice, Church of S. Stae), where the two protagonists stand out strongly against the dramatic contrasts of light and shadow. His palette is typical of the period, with browns, terracotta and soft reds lending a warm, almost burning tonality to the picture.

In the third decade of the century Piazzetta rediscovered the richness of clearer, more iridescent colours. Between 1725 and 1727 he painted *The Virgin Appearing to St Philip Neri* (Venice, Church of S. Maria della Fava; preliminary sketch, Philadelphia, Museum of Art), in which

his paint seems almost to catch fire with the effect of the light. *The Glorification of St Dominic*, his only major decorative work, probably dates from this time (Venice, Church of SS. Giovanni e Paolo). This great painted vault recalls Crespi's decorations in the Palazzo Pepoli in Bologna. The composition is in the form of a spiral. The imposing grey and white figures of the Dominicans leaning on a balustrade are shown in brilliant foreshortening. Within a spiral of angels St Dominic is being carried up to the heavens, where, in the centre of the picture, the Virgin, bathed in light, waits to greet him. The altarpiece showing the *Guardian Angel with St Louis Gonzaga and St Anthony of Padua* (Venice, Church of S. Vidal) is also of this period, as is the *Supper at Emmaus* (Cleveland Museum). *The Ecstasy of St Francis* (Vicenza Museum) was executed around 1732. This bold yet touching work is enlivened by unexpected rays of light which mould the figures under a night sky.

With the *Assumption* (Lille, Musée Wicar) Piazzetta's technique underwent a marked change, with the dark tones of his earlier works now giving way to a more graceful and delicate style. This was the period of Piazzetta's *lumière solaire*, and this calmer and less turbulent style, with its realistic tonal values, came to mark a series of more intimate and naturalistic paintings, the forerunner of which is *The Standard-Bearer* (Dresden, Gg). Piazzetta took his themes from the Old Testament and treated them as genre subjects: thus *Rebecca at the Well* (Brera) becomes a simple family scene, serene and natural, painted in warm greys and subtle tones of violet. The same elements characterize the 'sylvan idylls' (*Pastoral*, Chicago, Art Inst.; *Idyll by the Seashore*, Cologne, W.R.M.) and *The Fortune Teller* (Venice, Accademia), with their lively expressive faces and figures painted in a rich gamut of purples and browns.

At the start of the 1750s Piazzetta's art began to decline. The extremes of chiaroscuro begin to look unreal and detract from all spontaneity,

giving a certain harshness to the painting. Yielding to popular demand Piazzetta took up historical themes (*The Death of Darius*, Venice, Ca' Rezzonico; *Mucius Scaevola*, Venice, Palazzo Barbaro); but his inventive powers failed him and the paintings seem merely theatrical and grandiloquent. The power and originality of his drawing, however – notably nudes, and drawn in black on grey or blue paper and highlighted with white – have never been called into question. There is a representative collection of Piazzetta's drawings at Windsor Castle. F.d'A.

Picabia
(François Marie Martinez-Picabia)
French painter
b.Paris, 1879 – d.Paris, 1953

In 1894, to show off the precocious talent of his son, Picabia's father sent one of the boy's canvases to the Salon. Not only was the painting, *Vue des Martigues*, accepted, but it won a prize. The next year Picabia entered the École des Arts Décoratifs, but was more interested in attending classes at the Louvre or at the Académie Humbert where he worked beside Braque and Marie Laurencin. In 1897 he came under the sway of Impressionism after discovering the works of Sisley and his interest grew the following year when he met the Pissarro family. This marked the beginning of an extremely fertile period which lasted for ten years and resulted in hundreds of paintings in an Impressionist style calculated to appeal to the public.

Picabia's first one-man exhibition at the Galerie Haussmann in 1905 was a triumph. The works on show were in the tradition of the *pur luminisme impressionniste* and revealed nothing of the experiments going on with plasticity at the time

(*L'Église de Moret* [*The Church at Moret*], 1904, Milan, private coll.).

Gradually, however, Picabia came to question the plastic values to which he owed his growing success. In 1908 a meeting with Gabrielle Buffet – whom he was later to marry and who encouraged him in his pursuit of new trends in painting – completed the break with Impressionism, his private income making it possible for him to live without having to depend on commissions.

The next phase in Picabia's career was remarkable for the diversity of his experiments. Although he was particularly drawn to abstract art, he took an almost equal interest in Cubism and Fauvism (*Caoutchouc* [*India-rubber*], *c*.1909, and *Paysage* [*Landscape*], 1909, both Paris, M.N.A.M.; *Les Régates* [*Regattas*], 1911, Paris, private coll.). But the most important influence in his career was Marcel Duchamp, whom he met around 1911 when he was already married to Gabrielle Buffet. Both men found themselves opposed to doctrinal Cubists such as Gleizes and Metzinger who strongly disapproved of some of the work done by the other two, particularly Duchamp's nudes which they believed were unsuitable subjects for Cubism. Through Duchamp, Picabia was able to meet Apollinaire and shortly afterwards, in October 1912, organized an exhibition in Paris for the Section d'Or (*Danses à la source* [*Dances at the Spring*], 1912, Philadelphia Museum of Art).

Between January and May 1913 Picabia visited the United States where he acted as the spokesman for the Cubist paintings on exhibition at the Armory Show in New York. The experience affected him deeply: interviews with the press, lectures where he was surrounded by millionaire anarchists – all created an atmosphere in which his boisterous character blossomed. New York bowled him over with its colours and rhythm, and its love of jazz and sport which inspired him to paint a series of watercolours (*New York*, 1913, watercolour and gouache, Paris, M.N.A.M.;

▲ Giovanni Battista Piazzetta
Idyll by the Seashore
Canvas. 195 cm × 146 cm
Cologne, Wallraf-Richartz Museum

▲ Picabia
L'Enfant carburateur (1919)
Oil and gold leaf on wood. 126 cm × 101 cm
New York, Guggenheim Museum

Chanson nègre [*Negro Song*], 1913, Metropolitan Museum). On his return to Paris he developed these into huge oil paintings where only the shapes and colours allowed the viewer to perceive 'another' reality, by freeing the picture from its dependence on 'objective' external subjects (*Je revois en souvenir ma chère Udnie* [*I Recall through Memory My Dear Udnie*], c.1914, New York, M.O.M.A.; *Catch as Catch Can*, 1913, Philadelphia Museum of Art; *Udnie*, 1913, Paris, M.N.A.M.).

It was around this time that Apollinaire produced this theory of Orphism. In Picabia's work, however, what might be termed 'mechanomorphic' elements were beginning to appear. The role of the machine, that 'daughter without a mother', became ever more prominent until his paintings came to resemble the simple working drawings of an engineer (*Voilà la femme* [*Behold the Woman*], 1915, Paris, private coll.; *Voilà la fille née sans mère* [*Behold the Daughter Born without a Mother*], 1916-17, Alès, private coll.).

On the outbreak of war Picabia was called up and in 1915 was sent on a mission to Cuba, stopping at New York on the way. Here he remained for nearly a year. He was reunited with Duchamp and several other friends with whom he collaborated on the avant-garde review *291*. After several months of wild living he put aside his brushes for a while and wrote the first of his *Cinquante-Deux Miroirs* (*Fifty-Two Mirrors*), published in Barcelona in 1917.

Picabia made a very brief visit to Cuba to carry out his 'mission', then left for Barcelona with his wife in August 1916. Here he found Gleizes, Marie Laurencin and the 'poet-boxer' Arthur Cravan, with whom he brought out another review which, in memory of *291*, was called *391*. Four numbers appeared in Barcelona, during which time he slowly began to take up drawing again (*Novia*, 1917, and *Flamenca*, 1917, in *391*, Nos 1 and 3).

In March 1917 Picabia set sail for New York for the last time. He stayed for six months and revived *391*, which was Americanized for three editions. With Duchamp, he participated in the first Independents' Exhibition in New York, but following a nervous breakdown returned to Europe, and during his treatment in Switzerland began a correspondence with Tristan Tzara, originator, in Zürich, of Dada. Making a sudden recovery, Picabia returned to Paris in March 1919, and was soon joined by Tzara. Within six months Dada had conquered Paris: scandalous demonstrations and revolt in the arts, literature and politics were all conducted with outrageous panache.

Picabia, meanwhile, continued to paint his pictures of machinery (*L'Enfant carburateur* [*The Carbonizing Child*], 1919, New York, Guggenheim Museum; *Pompe à combustible* [*Combustible Engine*], 1919-22, watercolour, private coll.). In 1922 he turned to collage (*Chapeau de paille* [*Straw Hat*], 1921-2, Paris, M.N.A.M.; *Centimètres*, 1924-5, Milan, private coll.). His return to figuration (*Nuit espagnole* [*Spanish Night*], 1922, private coll.) coincided with a number of undisplayed experiments with abstraction (*Volucelle II*, 1922, private coll.).

Numerous exhibitions followed in quick succession. Then, in May 1921, when the 14th issue of *391* was appearing, Picabia suddenly gave up Dadaism. In July, he produced a special number of the magazine called *Pilhaou-Thibaou*, which

was a violently anti-Dada manifesto. At the same time he renewed his friendship with André Breton and with the nascent Surrealist movement. This phase lasted until 1924, when he moved to Mougins in the Midi and began painting the 'monsters' (*Femme à l'ombrelle* [*Woman with a Parasol*], 1924-5, private coll.)

Picabia remained at Mougins for the next 20 years, where, after creating the scenario and decor for the ballet *Relâche*, with music by Satie, for the Swedish Ballet, he collaborated with René Clair in a film, *Entr'acte*.

The year 1927, or thereabouts, saw the beginning of a new period, that of his 'transparencies' (*Sphinx*, 1929, Paris, M.N.A.M.), which continued until about 1930, after which he painted in a more or less conventional manner: portraits, landscapes and nudes (*Suzy Solidor*, 1933, Milan, private coll.). In 1937-8 he produced several abstract paintings.

Picabia finally left the Midi in 1945 to return to Paris with Olga Mohler, whom he had married in 1940. The move led to yet another new development in his painting which he called 'Surirrealism', the first results of which he exhibited in 1946. Three years later the Drouin Gallery presented an important retrospective exhibition of his work: the catalogue was called *491*.

Mixing with younger artists such as Hartung, Soulages and Atlan finally led Picabia to abstraction (*Danger de la force* [*Danger of Strength*], 1947-50, Paris, Picabia Estate). In 1948, together with Hartung, Wols, Mathieu and Bryen, he showed works which are among the earliest examples of *non-figuration psychique*, and can be regarded in some ways as an outcome of Surrealism, to which he had contributed in the beginning. In 1948 the Musée National d'Art Moderne in Paris acquired *Udnie*. Picabia painted very little after 1951.

Picabia's restless personality, his constantly changing opinions and affections, and his love of women, fast cars and streamlined boats undoubtedly masked a deeper concern: the need to reconcile the chronic apprehensions which periodically tortured him with his uncontrollable urge for freedom of action. It was this therapeutic function that his painting must have fulfilled. It gave him, he said '*le plaisir d'invention*', imposing transitoriness on order of any kind. E.M. and L.E.

Picasso
Pablo Ruiz

Spanish painter
b.Málaga, 1881 – d.Mougins, 1973

Formative years. In spite of suggestions that Picasso's mother was of Jewish origin, the family was, in fact, pure Spanish, of middle-class Andalusian origins. His father, José Ruiz Blasco (Picasso was his mother's name), was an uninspired painter, a teacher at the School of Fine Arts in Málaga, then at the grammar school in La Coruña, before finally settling in Barcelona where Picasso joined him in September 1895. It was there that his real artistic training began. Although he spent several months in the winter of 1897-8 studying in Madrid, his precocious talent had gained little or nothing from the academic atmosphere of the capital (*Homme à la casquette* [*Man with a Cap*], 1895, Picasso Estate). The artis-

tic climate of Barcelona, however, dominated by the extraordinary personality of the architect Gaudí, was wide open to outside influences: those of Art Nouveau, Beardsley, Munch and northern Expressionism generally; less so French painting and the Impressionists, apart from Steinlen and Toulouse-Lautrec whose influence can be seen in Picasso's early works such as *Danseuse naine* (*The Dwarf Dancer*) (1901, Barcelona, Picasso Museum).

The Catalan artists whom Picasso met regularly at the Café Els Quatro Gats discovered, through El Greco, Zurbarán and medieval Catalonian sculpture, a more savage and passionate Spain than that approved by official art education. This provincial and romantic intelligentsia was profoundly affected by social problems and by the violence of anarchism. Picasso seemed deeply aware of the material and moral wretchedness of the prostitutes and alcoholics who haunted the cabarets and brothels in the Barrio Chino, which provided him with the models and themes for his Blue Period (1901-5).

Blue Period and Rose Period. In 1900 Picasso visited Paris for the first time, and joined his closest friend Isidro Noñell, the Catalan painter. He returned to Paris the following year, and again in 1902, and finally settled there in 1904. In spite of the Parisian flavour of some of his canvases at that time (*La Femme au verre d'absinthe* [*The Woman with the Glass of Absinthe*], 1901, private coll.; *The Tub*, 1901, Washington, Phillips Coll.; *Au Lapin agile*, 1905, private coll.) his work remained essentially Spanish.

Alone in Paris, Picasso went through his international apprenticeship and assimilated with disconcerting ease many different influences: Toulouse-Lautrec and Gauguin (*La Vie* [*Life*], 1903, Cleveland Museum); Eugène Carrière (*Mère et enfant au fichu* [*Mother and Sick Child*], 1903, Barcelona, Picasso Museum); Puvis de Chavannes (*Maternité au bord de la mer* [*Mother and Child by the Sea*], 1902, private coll.). He was as much inspired by the Nabis (*Arlequin accoudé* [*Harlequin Leaning on his Elbow*], 1901, private coll.) as by Greek art (*Abreuvoir* [*Watering Trough*], drypoint, 1905) and pure Hispanic tradition (*Le Vieux Guitariste* [*The Old Guitarist*], 1903, Chicago, Art Inst.; *Portraits de Mme Canals*, 1905, Barcelona, Picasso Museum).

The paintings of his Blue Period (so called because of their prevailing colour) showed, against a timeless background, a destitute section of humanity, emaciated by hunger and overwork (*The Couple*, 1904, Ascona, private coll.; *La Repasseuse* [*Woman Ironing*], 1904, New York, Guggenheim Museum; *Le Repas frugal* [*The Frugal Meal*], etching, 1904.

The Rose Period, which followed, evoked less bitterly, and with clearer tonal values, but with the same sense of involvement and in the same style, the world of the circus – mountebanks, actors, vagabonds (*Famille d'acrobates au singe* [*Family of Acrobats with Monkey*], 1905, Göteborg Museum; *Acrobate à la boule* [*Young Girl on a Ball*], Moscow, Pushkin Museum; *Les Bateleurs* [*The Jugglers*], Washington, N.G.; *Enfant et saltimbanque assis* [*Seated Circus Performer with Boy*], 1906, Zürich, Kunsthaus).

Towards primitivism. Until 1906 Picasso's painting was spontaneous and personal, unconcerned with purely plastic problems and current

In the process perspective vanished, colours became almost monochrome and, even though the initial aim of Cubism had been to convey the feeling of reality, of the weightiness of masses, in a more convincing manner than by traditional processes, the canvases were often reduced to incomprehensible riddles. In an attempt to restore a sense of reality, Picasso and Braque introduced *trompe l'oeil* effects and constructed collages from pieces of newspaper (*Aficionado*, 1912, Basel Musem) and a whole variety of materials – cloth, corrugated cardboard, string, fragments of cork and matchboxes (*Bouteille de vieux marc, verre, journal* [*Bottle, Glass and Newspaper*], 1912, Laugier Coll.).

These collages led Picasso on to reconstitute the facets of the Cubist prism into large planes arranged in flat compositions, as though the pictures had no depth and were almost abstract (*Violon et guitare* [*Violin and Guitar*], 1913, Philadelphia Museum of Art, Arensberg Coll.). In other works he reinterpreted in a humorous and relaxed manner the experiments of the years 1910-13 (*Portrait de jeune fille* [*Portrait of a Girl*], 1914, Paris, M.N.A.M.). Picasso's real Cubist period was over by the early months of the First World War, which separated him from Braque with whom he had quarrelled. Nevertheless, until 1921, Picasso continued to make use of certain Cubist techniques in some of his major works (*Trois musiciens* [*Three Musicians*], 1921, Philadelphia, Museum of Art).

After the War: return to figuration. In 1917 Jean Cocteau persuaded Picasso to accompany him to Rome to create the sets for a ballet, *Parade*, for which he had written the scenario to music by Satie. Picasso's collaboration with Diaghilev's Ballets Russes (sets and costumes for *Tricorne*, 1919, and *Pulcinella*, 1920) reawoke his feeling for decoration and made him turn back to the characters in his earlier works (*Arlequin* [*Harlequin*], 1913, Paris, M.N.A.M.). His famous drop-curtain for *Parade* marked a return to realism, to elegant, punctilious and precise drawing (which was attacked as being 'Ingresque'), to monumental figures inspired by classical art (*Trois Femmes à la fontaine* [*Three Women at a Fountain*], 1921, New York, M.O.M.A.) and sometimes treated in a robust, straightforward style (*Flûtes de Pan* [*The Pipes of Pan*], 1923, Picasso Estate).

The euphoric and conservative climate of postwar Paris, Picasso's marriage to the middle-class Olga Kokhlova, and his material success, partly explain this temporary and, moreover, relative conversion, since he continued to paint startling still lifes in the Cubist idiom (*Mandoline et guitare* [*Guitar and Mandolin*], 1924, New York, Guggenheim Museum). In addition to the series of giants and bathers, the paintings inspired by Roman classicism (*Femme en blanc* [*Woman in White*], 1923, New York, M.O.M.A.) and the many portraits of his wife (*Portrait of Olga*, pastel, 1923, Picasso Estate) and of his son (*Paul as Pierrot*, 1925, Picasso Estate) are among the most fascinating works that Picasso ever produced – even if their slightly facile classicism and their air of pastiche disconcerted the avant-garde of the day. These works marked the first appearance of Picasso's curiosity about the styles of the past, translated with amazing skill into a modern and personal language – a trend which became more pronounced with the passage of time and was common to many artists, particularly Stravinsky, between the wars.

theories. From 1905, perhaps under the influence of Cézanne, he began to give greater simplicity and weight to masses – less so in his first attempts at sculpture (*Le Fou*, 1905) than in 'Hellenistic' paintings such as *Jeune Homme nu conduisant un cheval* (*Boy Leading a Horse*) (New York, M.O.M.A.). But the break with the decorative mannerism of his early works took place during a stay at Gosol in Andorra in the summer of 1906. It was here that his conversion to the emotive and formal primitivism which he continued to use at intervals for the rest of his life occurred.

On his return, in a burst of intense activity, he painted the *Portrait of Gertrude Stein* (1906, Metropolitan Museum) and the uncouth and monstrous *Femmes nues* (*Nudes*) (New York, M.O.M.A.), as well as working throughout the winter on *Les Demoiselles d'Avignon* (1907, New York, M.O.M.A.), an extremely complex semi-abstract work in which the influence of Cézanne mingles with that of Iberian and Negro sculpture

(undoubtedly among the main sources of Cubism despite Picasso's denials). This was followed by *Nude with Drapery*, (1907, Hermitage).

Cubism. From 1907 to 1914 Picasso worked so closely with Braque that it is impossible to isolate the contributions that each made to the development of Cubism. After a 'Cézannian' period which reached its peak with the *Portrait of Clovis Sagot* (spring 1909, Hamburg Museum), Picasso accentuated the reduction of forms to geometric solids (*Usine à Horta de Ebro* [*Factory at Horta de Ebro*], summer 1909, Hermitage), distending and breaking up masses (*Portrait of Fernande Olivier*, 1909, Düsseldorf, K.N.W.) and shattering them into planes and small facets that disintegrated into spatial depth, itself analysed as a solid, tending to reduce the plane of the picture (*Jeune Fille à la mandoline* [*Girl with a Mandolin*], 1910, Roland Penrose Coll.; *Portrait of D.H. Kahnweiler*, 1910, Chicago, Art Inst.).

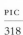 Pablo Picasso
Les Flûtes de Pan (1923)
Canvas. 204 cm × 174 cm
Picasso Estate

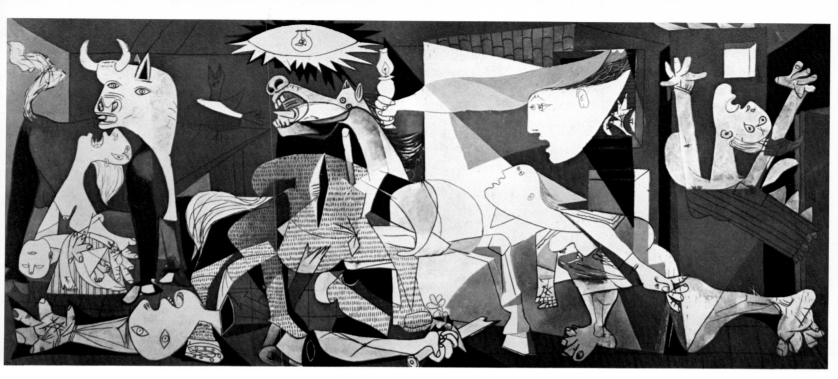

Contact with Surrealism. In 1925 Picasso entered one of the most complex and disturbed periods of his career. Following the sensually elegant works of the early 1920s, *La Danse* (*Three Dancers*) (London, Tate Gal.) heralded a new mood in which repulsive and violent distortions of the models produced an effect of dream-like unreality. Stemming from the Surrealist poets, the trend appears in certain drawings (*Torse* [*Torso*], 1933, private coll.) and also in Picasso's own poems, written in 1935, and in a play, *Le Désir attrapé par la queue*, dating from the war years. For several years Picasso's imagination seemed to be peopled only by monsters: slashed and mangled creatures (*Baigneuse assise* [*Seated Bather*], 1929, New York, M.O.M.A.), howling with anguish (*Femme dans un fauteuil* [*Woman in an Armchair*], 1923, Picasso Estate), or horribly swollen and deformed (*Baigneuse* [*Bather*], drawing, 1927, Picasso Estate), evoking images of metamorphosis and erotic aggression (*Figures au bord de la mer* [*Figures by the Sea*], 1931, Picasso Estate).

Despite several works in a calmer mood which are important landmarks in this period of stylistic confusion (*Jeune Fille devant une glace* [*Girl in front of a Mirror*], 1932, New York, M.O.M.A.), it is women who seem to be the chief victims of the artist's savage whims. Picasso's marriage was turning out badly, which may have accounted for this, although when, in 1932, he met the young Marie-Thérèse Walter, her unaffected beauty immediately inspired several works which quite straightforwardly express a peaceful and utterly fulfilled sensuality (*Le Miroir* [*The Mirror*], 1932, Picasso Estate). Mlle Walter was also the model for some serene busts and heads which Picasso made that year at Boisgeloup, a property he had bought in 1930.

From 1930 to 1934 Picasso expressed himself chiefly through sculpture, possibly because he found more vitality in the medium: busts and female nudes, some of them inspired by Matisse (*Femme couchée* [*Woman Lying Down*], 1932), animals, and small Surrealist figures (*Homme au bouquet* [*Man with Bunch of Flowers*], 1934). More important were the constructions in metal in semi-abstract, semi-realist shapes, sometimes

created with refuse and junk, which he carried out with the help of his friend, the Spanish sculptor Julio González (*Construction*, 1931). Alongside these curious and subtle forms the engravings which Picasso made to illustrate Ovid's *Metamorphoses* (1930) and the *Lysistrata* of Aristophanes (1934) demonstrated the enduring inspiration that he found in classical art.

Minotaurs and *Guernica*. Following two long visits to Spain in 1933 and 1934, Picasso became increasingly drawn to the theme of the bullfight, which he interpreted through its literary associations: that of the Minotaur was stressed in a series of exquisite engravings made in 1936 (the *Minotauromachie*. This image of the bull as despoiler and murderer ended Picasso's Surrealist period but remained the central subject of *Guernica*, his most famous work. (The painting, the property of the Spanish Republican Government, is lodged in New York at the Museum of Modern Art.) He took only a few weeks to finish it after German aircraft had completely destroyed the little Basque village and killed many of its inhabitants, and the painting was Picasso's declaration of his political commitment. His anguish at the barbarism which was spreading across Europe, and his horror of war and of fascism, although not openly expressed in his work, gave it a funereal and agonized tonality (*Pêche de nuit à Antibes* [*Night Fishing at Antibes*], 1939, New York, M.O.M.A.) and an intense bitterness and irony which was absent only from the portraits of children (*Maïa et sa poupée* [*Portrait of Maïa with a Doll*], 1938, Picasso Estate).

Once again, women were the victims of this indiscriminate fury, and one woman in particular: Dora Maar, who had been his companion since 1936 and whose troubled beauty he never hesitated to caricature and distort (*Femme qui pleure* [*Weeping Woman*], 1937, London, Roland Penrose Coll.). The artist's misogyny had never been so fierce: women appear wearing absurd hats (*Femme assise coiffée d'un chapeau en forme de poisson* [*Seated Woman with Hat in the Shape of a Fish*], 1942, private coll.), the faces are seen in profile, haggard and disjointed; or with grotesquely bloated and distended torsoes (*Nu se coiffant* [*Nude*

Dressing Her Hair], 1940, private coll.); or like clowns gathering their rags and tatters about them (*Aubade*, 1942, Paris, M.N.A.M.). Even animals were not spared this satirical massacre (*Chat dévorant un oiseau* [*Cat Devouring a Bird*], 1939, private coll.).

The German occupation of France did nothing to restore Picasso's peace of mind. He remained in Paris between 1940 and 1944, producing a flow of portraits, sculptures (*Homme au mouton* [*Man with a Sheep*]) and still lifes which powerfully evoked the wretchedness of the times (*Nature morte au crâne de boeuf* [*Still Life with Ox's Skull*], 1942, Düsseldorf, K.N.W.).

After the War. With peace came relaxation. His *Charnier* (*The Charnel House*) (1944-5, New York, Walter Chrysler Coll.) is Picasso's last tragic work, and although it publicized his adherence to communism in the autumn of 1944 he showed no inclination to embark on a series of great historical works, which was what, perhaps, his political acquaintances were hoping for (*Massacre en Corée* [*Massacre in Korea*], 1951, Picasso Estate). The white dove which illustrated the poster for the congress of the World Peace Movement in Paris in 1949 is probably the greatest proof of his involvement, and also helped to make him a legend throughout the world.

Picasso's post-war work, however, was that of a happy man. He was living with a young woman, Françoise Gilot, whom he had met in 1945, and who had two children by him. He was inspired to paint many vigorous and charming family groups (*Maternité à l'orange* [*Mother and Child with Orange*], 1951, Picasso Estate). He left Paris and discovered the pleasures of the Midi – sun, sea and sand – settling first at Vallauris (1948), then at Cannes (1955). In 1958 he bought the Château of Vauvenargues and retired finally to the farmstead of Notre Dame de Vie at Mougins in 1961. The works of the years 1945-55 have a marked Mediterranean flavour, a feeling of idyllic paganism, and show, also, a renewal of inspiration from classical sources – characteristics which are most readily seen in the paintings and drawings from the end of 1946 in the Picasso Museum at Antibes (*Joie de vivre*).

Pablo Picasso ▲
Guernica (1937)
Canvas. 351 cm × 782 cm
New York, Museum of Modern Art

But Picasso's work at this period is most notable for his experiments with new media and his surrender to a zestful decorativeness. He turned out large numbers of engravings and lithographs (nearly 200 major works between November 1945 and April 1949), as well as an enormous collection of posters, woodcuts and lino-cuts, pottery, ceramics and sculpture. In the autumn of 1947 he began working at the Madoura factory at Vallauris, where, always fascinated by technical problems and enthusiastic about manual work, he made with his own hands plates, decorated dishes, anthropomorphic jugs and animal statuettes (*Centaure*, 1958). Some of these display, perhaps, a rather self-conscious archaism, but they are, nevertheless, always full of charm and wit.

The sculptures of this period are the most important since the days at Boisgeloup (*Femme enceinte* [*Pregnant Woman*], 1950). Those, such as *Chèvre* (*Goat*) (1950) and *Guenon et son petit* (*She-Monkey and Child*) (1952), which were created out of chance materials (the goat's belly is made from an old wicker basket) are considered to be masterpieces of *l'art de l'assemblage*.

In 1953 Françoise Gilot and Picasso parted. Picasso went through a serious emotional crisis, evident in the series of remarkable drawings which he made between the end of 1953 and the end of the following year. They express, with characteristically disconcerting irony, his bitterness against old age and his scepticism regarding even painting itself.

In 1954 he met Jacqueline Roque and married her in 1958. She was the inspiration for some fine portraits (*Portrait de Jacqueline aux mains croisées* [*Portrait of Jacqueline with Folded Hands*], 1954, Picasso Estate).

The works of Picasso's last 15 years are hard to analyse both because of their diversity and their uneven quality, in spite of undeniable successes (*Atelier de Cannes* [*Studio at Cannes*], 1956, Picasso Estate). The rebirth of Spanish inspiration is interesting (*Portrait d'un peintre d'après le Greco* [*Portrait of a Painter, after El Greco*], 1950, private coll.), as is that of the bullfighting theme, possibly because the growing popularity which bullfighting enjoyed in the Midi had turned Picasso into an enthusiastic *aficionado*. This inspired a Goyaesque set of drawings and wash-drawings under the title, *Romancero du picador* (1959-68), in which Picasso's gifts as a story-teller are given full rein.

But probably the most remarkable manifestation of Picasso's complex personality – his permanent dissatisfaction, his cultural hunger, his pride, his uncertain equilibrium between a nostalgia for the past and an even more provocative modernism – is the series of works produced after the war, in which he reinterpreted great paintings of the past: *Les Demoiselles des bords de la Seine* (*Women by the River Seine*), after Courbet (1950, Basel Museum); *Les Femmes d'Alger* (*Women of Algiers*), after Delacroix (1955); *Les Ménines* (*Las Meninas*), after Velázquez (1957); *Déjeuner sur l'herbe*, after Manet (1960). Some of these are very beautiful paintings but, in general, critical opinion has remained cool towards them.

It is far too early to pass judgement on all Picasso's huge output, but it is certain that no painter before him has so completely dominated his age, imposing his whims and moods on it, yet at the same time finding in it his inspiration and managing to be always ahead of it in his most fruitful discoveries.　　　　　　　A.F.

Piero della Francesca
(Piero de' Franceschi)

Italian painter and mathematician
b.Borgo San Sepolcro, c.1416 – d.Borgo San Sepolcro, 1492

Early years. Piero della Francesca is the greatest Italian painter of the quattrocento; his employment of geometric perspective is the earliest and most systematic in the history of painting.

He is first mentioned on 7th September 1439 as assistant to Domenico Veneziano in painting frescoes for the Church of S. Egidio in Florence (now lost except for a few fragments). In 1442 he became a town councillor at his birthplace, Borgo San Sepolcro in Umbria, following its annexation by Florence in 1441. In 1445 a confraternity in the town, the Compagnia della Misericordia, commissioned Piero to paint an altarpiece with *Our Lady of Mercy* at the centre, *Saints* on the side-panels and pilasters, and the *Annunciation* and the *Crucifixion* in the upper tier (Borgo, Pin.). Piero, who worked slowly, may not have finished it until 1462, for it was not paid for until that year. The plasticity of the earlier parts of the work shows strong affinities with Masaccio.

It was probably round about 1445, too, that Piero began work for Federico II of Montefeltro, who became Duke of Urbino that same year. From the three figures grouped in the foreground it seems that Piero's *Flagellation of Christ* (Urbino, G.N.) may allude to a plot in 1444 that led to the murder of the Duke's half-brother. Stylistically it has strong links with *St Jerome* (Venice, Accademia), almost certainly executed for Girolamo di Agostino Amadi during a journey that Piero made to the north of Italy in about 1449, when he may also have painted some frescoes at Ferrara for Lionello d'Este.

In 1451 Piero signed the fresco showing *Sigismondo Malatesta and his Patron Saint* (Rimini, Malatesta Chapel) which repeats the scheme of the painting in Venice. The medallion-like profile of Malatesta, however, and the distant view of the castle framed in an 'oculus' (bull's-eye window) resemble the great *Diptych of the Duke of Urbino* (Uffizi), in which Federico da Montefeltro and his wife are shown in profile against a sweeping landscape. On the reverse is the *Triumph* of husband and wife, spread out before another vast scene of mountains, rivers and valleys. Authorities differ as to whether the painting shows the Duke's first or second wife: if the first, then the picture dates from between 1450 and 1457; if the second, then it must have been painted between 1460 and 1466. Stylistically, the later dating appears more likely.

The S. Francesco frescoes. The wall decoration of the choir of the Church of S. Francesco in Arezzo (Tuscany) is Piero della Francesca's masterpiece and one of the monuments of the Italian Renaissance. The work, on which he was engaged from 1452 to 1459, is a fresco cycle showing the *Legend of the True Cross*, and represents the completion of a commission left unfinished by Bicci di Lorenzo at the time of his death in 1452. Bicci di Lorenzo had completed the frescoes on the vault, the entrance wall and the intrados of the arch, and to these Piero added the scenes on the three main sections of the side walls of the chapel.

It is not known whether Piero or his patron, a rich middle-class citizen of Arezzo, chose the subject. The theme was a popular one with the Franciscans, and there is a similar cycle by Cenni di Francesco in the Franciscan church at Volterra, not far from Arezzo, dating from 1410. Nor is it known whether the sequence of events in the frescoes divided, according to tradition, into three sections on each wall was decided by Piero or Bicci, although it was certainly Piero who grouped the scenes out of chronological order in order to attain symmetry and a sense of interval. The story, in consequence, becomes a reinterpretation in terms of the symbolism current among the Tuscan humanists of the time with whom Piero was linked.

It has been suggested that the frescoes are an act of homage to the 15th-century bourgeois donor, or an allegory of human destiny or of major stages in the history of mankind from biblical times up to 15th-century urban life. All these theories remain unproven. On the other hand, the mathematical precision of perspective with which each episode is contructed plainly shows that Piero sought an intellectual unity of form and space, rather than a formal one. The reintroduction of humanity into the abstract language that perspective was in danger of becoming proved of incalculable importance for painting throughout Italy, and even beyond the Alps, for more than half a century.

The most famous pictures in the cycle, *The Visit of the Queen of Sheba to King Solomon* and *The Dream of Constantine*, exemplify two of Piero's principal characteristics as an artist: his use of full Mediterranean sunlight, in which people and architecture are grouped in rigorous, classical symmetry, hierarchical and impressive; and 'night-pieces' borrowed from northern sources. Here, the solemn and thoughtful tone is without precedent, even in Piero's career.

Later works. On 4th October 1454 Piero undertook to paint the polyptych for the high altar of the Church of S. Agostino at Borgo San Sepolcro (which he did not finish until 1469). The surviving fragments are housed in various collections: the central part, possibly a *Madonna*, has never been found; on the left-hand panel, *St Augustine* is in Lisbon (M.A.A.) and *St Michael* in London (N.G.). They were painted with the help of assistants. The right-hand section, *St Andrew*, is in the Frick Collection, New York, and *St Nicholas of Tolentino* is in Milan (Poldi-Pezzoli Museum). Of the saints which formerly decorated the pilasters, only *St Monica* (New York, Frick Coll.), from the left-hand pilaster, and *St Apollonia* (Washington, N.G.) and an *Augustinian Saint* (New York, Frick Coll.), both from the right, survive. The *Crucifixion* from the centre of the predella is now in the John D. Rockefeller Collection (New York). It has suffered some damage.

Piero probably visited Rome some time before 1455 during the reign of Pope Nicholas V. A document shows, too, that he was in the service of Pope Pius II on 12th April 1459. Of all the work he did in Rome, however, only a fresco depicting *St Luke the Evangelist* (Church of S. Maria Maggiore) survives, although he undoubtedly had a strong influence on artists such as Antoniazzo Romano, Lorenzo da Viterbo and Melozzo da Forlì.

In 1466, on 20th December, Piero was asked to supply a standard (now lost) for the confraternity of the Nunziata at Arezzo, showing the *Annuncia-*

tion. A year later he was again in public office in Borgo, but in 1468 was forced to leave the town because of the plague. He took refuge at Bastia where he finished the standard. A paper dated 1469 shows that he was host to Giovanni Santi, the father of Raphael, in Urbino. During the years immediately following Piero spent more and more time at Borgo where he painted many frescoes (now lost) for the chapel of the Madonna of Badia (a bill for payment is dated 13th April 1474). He also supervised the detachment and transportation of the *Resurrection of Christ* fresco in the Palazzo Communale (then known as the Palazzo de' Conservatori) to a new site in the same building (1474).

During this period Piero took an increasing interest in Flemish art. This may have been due to the arrival of Justus of Ghent (Joos van Wassenhove), summoned to Urbino by Federico da Montefeltro. This new desire on Piero's part to compete with the optical refinements of northern art is evident in the altarpiece now in the Galleria Nazionale at Perugia (*Virgin and Child* between *Four Saints*: above, the *Annunciation*; on the predella, *Scenes from the Lives of St Anthony of Padua, St Francis and St Elizabeth*) and reached fruition in *The Madonna of Senigallia* (Urbino Museum). The light that filters through the windows defines the space and gilds the atmosphere, framing the left-hand angel in a natural aureole of hair. This work is one of the outstanding syntheses of perspective and mathematical perfection of the quattrocento.

The altarpiece showing the *Madonna and Child, Angels, Saints, and Federigo da Montefeltro* (Brera) is thought to date from 1472–4. *The Madonna and Child with Angels* (Williamstown, Virginia, Clark Art Inst.) is probably from the same period. Here, the more fluid composition, the lateral positioning of the focal point and the raised skyline all soften the frightening impassivity of the sacred figures in earlier works, in particular that of Christ, as in the *Baptism* (London, N.G.), the *Flagellation* (Urbino Museum) and the *Resurrection* (Borgo San Sepolcro, Pin.). The hieratic poses are more familiar and from now on evoke the *sacre conversazioni* of Bellini and his followers.

In 1478 Piero was once more called to Borgo where the confraternity of the Misericordia commissioned a fresco of the *Madonna* (now destroyed). From 1480 to 1482 he was head of the powerful confraternity of St Bartholomew at Borgo. On 22nd April 1482 he rented a house with a garden and a well at Rimini, a fact which suggests that he spent some time in the town, although there is no supporting evidence for this. He made his will on 5th July 1487, naming his brother, or if he predeceased him, his sons, as his heirs. Some time after 1486 he lost his sight and died at his birthplace on 12th October 1492.

Piero was the author of various treatises, believed to have been written during his last years. The *De prospectiva pingendi* (before 1482) was followed by the *De quinque corporibus regularibus*, dedicated to Guidobaldo della Rovere, Duke of Urbino. Piero's third treatise, on mathematics, *Del abaco*, is still unpublished. Among other important works that can be attributed to Piero are *St Jerome* (Berlin-Dahlem), the *Madonna del Parto* (fresco in the chapel of the cemetery at Monterchi), *Hercules* (fresco, Boston, Gardner Museum) and a *Nativity* (London, N.G.).

Piero della Francesca's influence was considerable. It was felt by such painters as Bartolommeo

Piero della Francesca ▶
The Dream of Constantine
Fresco in the Choir
Arezzo, Church of S. Francesco

della Gatta, Signorelli and Perugino, and by others working in the cities in which he stayed – Florence, Ferrara, and especially Rome. Piero was the discoverer of a new vision, lucid and solemn, achieving mathematical perfection with the precise definition of volumes in space, a sense of interval, and a new treatment of light. Perugino and Raphael profited from this lesson; Antonello da Messina and Giovanni Bellini owe the maturing of their art to him; and even the work of Fouquet and Quarton displays some affinity with the ideals of which Domenico Veneziano and the young Piero della Francesca were the initiators. G.P. and L.E.

Piero di Cosimo
(Piero di Lorenzo)
Italian painter
b.Florence, c.1462 – d.Florence, 1521

There is little information about Piero di Cosimo's life. He is known to have studied with

 Piero della Francesca
Resurrection of Christ
Fresco. 225 cm × 200 cm
Borgo San Sepolcro, Pinacoteca Communale

Cosimo Rosselli when he was 18 and to have adopted his master's name. Around 1481 he accompanied Rosselli to Rome as his assistant in painting the frescoes in the Sistine Chapel. After returning to Florence he remained there until his death. None of his paintings is signed or dated, and there are no contemporary references to them apart from those by Vasari. Although some of these works had disappeared and others were hard to identify with certainty, art historians in the latter half of the 19th century began the task of raising Piero from the neglect into which he had fallen at the end of the 17th century because of his inventive anti-classicism.

About 50 paintings are attributed to Piero, of which about ten are altarpieces and the remainder devotional paintings for private patrons, decorations for furniture destined for Florentine palazzi and portraits (*Simonetta Vespucci*, Chantilly, Musée Condé). Piero's work reflects the course of Florentine painting at the end of the 15th and beginning of the 16th centuries. The imprint of Filippino Lippi is plain in some early works, dating from around 1480, such as the altarpiece for the church at Montevettolini (near Pistoia) showing the *Virgin and Child* (Stockholm,

Swedish Royal Coll.), as is the well organized structural sense of Ghirlandaio in the *Pugliese Altarpiece* (centre panel in St Louis, City Art Museum). Van der Goes's naturalism may be seen in *The Visitation* (Washington, N.G.) and the influence of Signorelli in *Mythological Scenes: Forest Fire* (Oxford, Ashmolean Museum) and two *Hunting Scenes* (Metropolitan Museum).

The works painted at the end of the century show signs of Leonardo's use of colour (the Tedaldi *Immaculate Conception*, Uffizi) and of the classicism of Fra Bartolommeo, another of Rosselli's pupils (*St Mary Magdalene*, Rome, G.N.). The devotional paintings of this period, commissioned by private patrons, increasingly show the influence of the young Raphael in the placing of the figures against backgrounds of open countryside. Towards the end of his life Piero was affected by the neo-Leonardo style fashionable with young artists born at the end of the 15th century, and was especially influenced by the work of Andrea del Sarto, his former pupil (the *Madonna*, Tulsa Museum, Kress Coll.; *The Holy Family*, Venice, Cini Coll.).

Piero's susceptibility to such diverse influences would appear to lay him open to the charge of eclecticism, but this, in fact, has no foundation, for his brilliant imagination and originality reworked the impressions he received from the world around him. The feature common to all his work and apparently varied inspiration is his predilection for natural themes, revealed by the close attention he paid to light, and by his realistic, anti-academic interpretations of both secular and religious subjects (altarpiece of *The Mystic Marriage of St Catherine and Saints*, Florence, Ospedale degli Innocenti; *The Madonna with the Dove*, Louvre).

Above all, Piero imbues his secular works with a special character, fantastic, elegiac, comic or full of pathos, which cannot be found among any of his Florentine contemporaries (*Mythological Scenes*, Oxford, Ashmolean Museum, and New York, Metropolitan Museum; *The Death of Procris*, London, N.G.; *Venus and Mars*, Berlin-Dahlem; *Hylas and the Nymphs*, Hartford, Connecticut, Wadsworth Atheneum; *The Battle of the Centaurs and the Lapiths*, London, N.G.; *Bacchic Scene*, Cambridge, Fitzwilliam Museum, and its companion piece, *The Discovery of Honey*, Worcester, Massachusetts, Art Museum). The Berlin-Dahlem *Venus and Mars* once formed part of Vasari's collection. His biography of Piero is one of the most vivacious and engaging of his *Lives*.
 M.B.

Pietro da Cortona
(Pietro Berrettini)
Italian painter and architect
b.Cortona, 1596 – d.Rome, 1669

Brought up in Cortona by the Florentine Andrea Commodi, Pietro accompanied him in 1612 to Rome at a time when the artistic life of the city, during the reign of Pope Paul V, was rich in contrasts and many different styles. To begin with, Pietro was too busy making drawings from Trajan's Column and other classical remains, or from Raphael or Polidoro, to be aware of other influences such as the Caravaggists. However, he soon broke out of his restricted circle and through Cassiano dal Pozzo, secretary to Cardinal Fran-

cesco Barberini, acquired that taste for classical antiquity which was to mark his work for the rest of his life. He learned, too, of the change that painting had undergone between 1620 and 1630, particularly with the appearance of Lanfranco's Baroque manner.

After painting two frescoes in the Villa Arrigoni (now called the Villa Muti) at Frascati (*c.*1616) he demonstrated his adherence to the new Roman High Baroque in three works painted some time before 1624: *The Sacrifice of Polyxena* and *The Triumph of Bacchus* (Rome, Capitoline Gal.), and *The Oath of Semiramis* (London, Mahon Coll.), as well as in frescoes for the gallery ceiling of the Palazzo Mattei (before 1625: *Scenes from the Life of Solomon*). All Pietro's works display his gift for breathing life into his flamboyant mythological world and creating a convincing atmosphere, thanks to the examples of Rubens and, above all, Titian. The latter's influence dominated Rome from 1621, the date of the arrival of the Ludovisi *Bacchanals*. Pietro was one of the first practitioners of the neo-Venetian style, as exemplified in his *Triumph of Bacchus*, which was to play such an important part in the development of Poussin.

But it was the frescoes for the Church of S. Bibiana, Rome (1624–6), commissioned by Pope Urban VIII, which brought real fame to Pietro. From that time on he was intensely active. Between 1627 and 1629 he was engaged on decorating the chapel and the long gallery in the Villa Sacchetti at Castel Fusano (his rivalry with Andrea Sacchi, who worked under him, probably dates from this time). His most famous work during these years is *The Rape of the Sabines* (1629, Rome, Capitoline Gal.), a masterpiece of the Roman High Baroque, in which two opposing principles are at work: an atmosphere vibrant with passionate emotions, and underlying it, a classicism derived from Raphael. There is in addition a new awareness of nature. Pietro also painted altarpieces (*St Bernard Offering the Rule to the Virgin*, 1626, Toledo, Ohio, Museum of Art; *The Virgin with Four Saints*, 1628, Church of S. Agostino, Cortona), which reflect the sense of hierarchy of the Counter-Reformation.

A leading member of the Academy of St Luke from 1634 to 1638, Pietro da Cortona was at the height of his powers when he painted the ceiling of the Palazzo Barberini between 1636 and 1639. This *Allegory of Divine Providence and Barberini Power* was inspired by the Gallery of the Palazzo Farnese and created an astounding illusion of the ceiling being a vast open sky in which the painted figures hovered like celestial beings in the heavens. In embodying this idea of divine investiture in pictorial terms Pietro also created a picture to serve 17th-century absolutism. This was the period of his academic dispute with Sacchi about composition and the restriction of the number of figures. At the same time he was beginning to move away from the Baroque. These two tendencies are opposed in the Palazzo Barberini paintings and are thrown into relief by Sacchi's paintings of *Divine Wisdom* in an adjoining room (1629–33). Baroque in atmosphere, it is classical in the limited number of figures.

At the invitation of Ferdinand II, Duke of Tuscany, Pietro made three visits to Florence. On the first of these, in June 1637, he began decorating the Pitti Palace with frescoes of the *Four Ages of the World* in the same neo-Venetian style as the Barberini ceilings. After their completion in 1641, he began work on the *Planets* rooms in the Pitti, using white and gold stucco for the first time, but by 1647 he had only managed to finish the rooms of Venus, Jupiter and Mars, leaving the room of Apollo to be completed by his pupil, Ciro Ferri, who also painted Saturn's room.

Returning to Rome for the last time in 1647 during the pontificate of Innocent X (Pamphili), Pietro decorated the cupola of the Chiesa Nuova (a more up-to-date version of Lanfranco's decor for the Church of S. Andrea della Valle) and the gallery ceiling in the Palazzo Pamphili (*The Story of Aeneas*, 1651–4). In this, the greatest achievement of his final years, Pietro adapted his style to the flowery Baroque of Borromini, the architect of the gallery. Returning to the system of division into sections, and using paler colours, he gave unity to the whole series by renouncing stucco and by painting one continuous sky behind all the different scenes. At the same time he designed the cartoons for the cupola of the right-hand nave of St Peter's (1652) and painted the *Sacrifice to Diana* (1653, Palazzo Barberini).

Towards the end of his life Cortona expanded his already immense activities to include architecture and devoted only a small part of his time to painting. He acted merely as the director for the decoration of the gallery of the Montecavallo Palace, as well as the apse of the Chiesa Nuova, and left the decoration of the Quirinal entirely to painters of the 'classical Baroque' school. In his last decorative work, the vault of the nave in the Chiesa Nuova (*Vision of St Philip Neri during the Building of the Church*, 1664–5), he created a new illusion: this was to separate the decorative section from the pictorial section by depicting a kind of open window in the ceiling. In this he anticipated Tiepolo. He showed the same gift for fresh ideas in his altarpieces, for example that in the Church of S. Carlo ai Catinari (*St Charles Carrying the Sacred Nail to the Plague-Stricken*, 1607), which is painted with great technical freedom.

Devoting himself to the service of the rich and powerful — his career spanned the reigns of six popes — Pietro da Cortona was the painter of the Church triumphant and of absolutism. He is the founder of an art whose heirs include Le Brun, Luca Giordano and Tiepolo. S.De.

Piero di Cosimo ▲
The Death of Procris
Wood. 65 cm × 183 cm
London, National Gallery

Pietro da Cortona ▲
The Silver Age (1637–41)
Fresco in the Sala della Stufa
Florence, Palazzo Pitti

Piranesi
Giovanni Battista

Italian etcher and draughtsman
b.Mogliano di Mestre, nr Venice, 1720 – d.Rome, 1778

Piranesi received his preliminary training in Venice where, after deciding to devote himself to architecture, he studied with various architects and stage designers and also learned perspective from an engraver, as was usual at the time. He would almost certainly have been influenced by the neo-Palladian atmosphere in which Venetian architecture was developing, as well as by his acquaintance with Bibiena, whose *Architettura Civile* had been published in 1711. In 1740 he went to Rome as draughtsman to the Venetian ambassador and, after studying in various studios specializing in etching and engraving, decided to concentrate on engraving, a medium to which henceforth he devoted himself to the exclusion of all others. He also practised architecture, but this was always a secondary occupation and served mainly as an outlet for expressing the principles in his engravings. In 1743 he published his *Prima Parte di Architetture e Prospettive*, an essentially Venetian work, with its large plates showing imposing structures, prompted by memories of his apprenticeship with the stage designers.

That same year, on returning to Venice, Piranesi is thought to have worked in the studio of G.B. Tiepolo. He was certainly influenced by Tiepolo, as also by Marco Ricci and Canaletto, finding in the work of all three of his Venetian contemporaries an affinity with his own love of the fantastic and concern for the subject matter. It is of interest that Piranesi, who was to become one of the most significant figures in Roman culture in the 18th century, should have found the sources of his vision in Venetian art.

Still in Venice in 1744, he began working on his ideas for the *Prisons* and the *Caprices*, and prepared the plates the following year in Rome, although it was 1750 before they were published, under the title of *Invenzioni Capricci di Carceri*. In 1745 he tackled for the first time the theme of the *veduta* (view) with 27 small scenes of Rome, published by Amidei as a collection of prints. While he was giving his visionary genius free rein with the fantasies of the *Prisons*, he was also facing the problems of portraying nature according to the rules of realism that governed the *veduta*. The conflict here between Piranesi the poet, attracted by the spontaneous charm of the imaginary and fantastic, and Piranesi the scholar, submitting to the demands of objectivity, henceforth sets its mark on all his work and imbued it with that power of suggestion which would make him famous throughout Europe.

The 30 plates of *Antichità Romane dei Tempi della Repubblica*, published in 1748, are the first fruits of this conflict. In this work he vigorously opposed Winckelmann's theories and reasserted the myth of classical Rome with all the force that only an impassioned imagination could produce. In Piranesi the struggle in which the theorist engaged with his contemporaries goes hand in hand with the fight undertaken by the artist against his own times, which were destroying and plunging into oblivion the old civilizations.

Piranesi's etchings, in which he had made startling technical advances, were both a means of expression and an instrument of propaganda which enlarged the controversy to international proportions. Reviving the past by recording ancient monuments uncovered by excavation and the majestic ruins which gave an indication of life at that time, compiling an index, and setting up archaeological reconstructions were tasks which obsessed Piranesi during the last 30 years of his life. It took him all of this time to complete the last two books of *Views*, begun in 1748 and published in the year of his death.

Meanwhile he had produced the four volumes of *Le Antichità Romane*, published in 1756, and a second edition of *Carceri d'Invenzione*, engraved and published in 1760-1, with even more dramatic and tormented illustrations. He also published his most important theoretical treatise, *Della magnificenza ed architettura dei Romani*, illustrated with 38 plates which eloquently propounded his thesis that the Romans owed little or nothing to the Greeks in matters of architecture.

He combined speleology with archaeology in his *Descrizione e disegno dell'Emissario del Lago Albano* (1762-4), the nine plates of which allowed him to link realism with the mysterious and subterranean chasms of his dreams. He widened his field of research to the towns of Cori (*Antichità di Cora*, 1764) and Paestum (*Différentes Vues de l'ancienne ville de Pesto*, 1778). He put together collections of his prints, *Diverse Maniere d'adornare i cammini ed ogni altra parte degli edifizi* (1769) and *Vasi, Candelabri, Cippi, Sacofagi, Tripodi, Lucerne ed Ornamenti Antichi* (1778), which were to become the most important reference works throughout Europe on classical archaeology and the Neoclassical movement in art.

Through the force of his own personality Piranesi came to occupy a special role in the European culture of the 18th century. Totally opposed to the rococo frivolity of the time, he refuted the simplistic ideals in which archaeology seemed to be fixed just at the moment when it was becoming a scientific discipline. The philosophical scope of his work brought new life to historic concepts and inspired succeeding generations.

With Tiepolo, Piranesi was one of the most superb draughtsmen of the 18th century. His drawings, usually in pen and wash, sometimes in red chalk, are often detailed preliminary studies for his etchings. Executed with great liveliness and sensitivity, the drawings, like engravings, play with wonderful contrasts of light, achieved by the careful placing of deeply inked-in masses and finely drawn details. With the unerring eye of a visionary, Piranesi would seize the least gesture of a tiny figure lost in the midst of a vast landscape, and give it life. Collections of these spectacular works are to be found in Hamburg, Copenhagen, Berlin-Dahlem, the Uffizi, the École Nationale des Beaux Arts in Paris, and the British Museum. G.R.C. and L.E.

Pisanello
(Antonio Pisano)

Italian painter
b.Pisa(?), before 1395 – d. c.1455

The exact date of Pisanello's birth remains unknown, but it is thought to have been only shortly before 1395, the year he left his birthplace, Pisa, following the death of his father. He was brought up in Verona, where he came into contact with the delicate art of Stefano da Verona which almost certainly gave him his feeling for rhythmic fluidity of line. The presence in the Veneto of Gentile da Fabriano between 1414 and 1418 was also important for Pisanello's development. Two works attributed to Pisanello, the *Madonna with the Quail* (Verona, Castel Vecchio) and the four panels representing *Scenes from the Life of St Benedict* (three in the Uffizi; one in Milan, Poldi-Pezzoli Museum), show the influence of these two artists—Stefano in the former, Gentile in the latter. In two of the scenes, the *Miracle of the Broken Platter* and *St Benedict Exorcizing a Monk* (both Uffizi), the arrested gestures, the delicacy of the architectural backgrounds and the range of clear, jewel-like colours, create an atmosphere of rare poetry.

Pisanello's name first occurs in connection with the frescoes in the great council chamber of the Doge's Palace in Venice (1415-22), on which

▲ Piranesi
Imaginary Prison Interior
Drawing. 17cm × 23cm
London, British Museum

Gentile had already begun work. These important frescoes (now destroyed) bore witness to Pisanello's growing reputation. He worked with Gentile da Fabriano again, this time in Florence in 1422-3, on the famous *Adoration of the Magi* (Uffizi).

On his return to Verona in 1426 he painted the fresco of the *Annunciation* above the memorial monument to Nicolò Brenzono in the Church of S. Fermo Maggiore. In this richly Gothic setting Gentile's influence is apparent in the elegantly fragile and slightly weary Madonna, but the firm line and the refinement of the angel's flight are typical of Pisanello. His final collaboration with Gentile was on the frescoes (now destroyed) for St John Lateran in Rome, and he continued working on these, following the death of Gentile in 1427, until 1432.

After this date Pisanello's numerous journeys and commissions from the courts of northern Italy are well documented. In 1432 he made a drawing of the Emperor Sigismund of Bohemia (Louvre) who was travelling in Italy at the time, and this could have been the preliminary sketch for the portrait now in Vienna (K.M.), which has been attributed to the artist. Pisanello did little work in the Veneto, and spent only brief periods in Verona, but he did paint a fresco there for the Church of S. Anastasia: his famous *St George and the Princess* (1433-8). This fresco is filled with minute detail. Pisanello's love of precision is testified to by the number of sketches he left. The two figures illustrating the 'courtly' fashion are shown, rapt and impassive, as though transfixed in the act of saying farewell, like characters in a book of chivalrous tales. The feeling of inevitability and the disquieting atmosphere which hover over the scene are accentuated by the fabulous deserted city, crowned with turrets, which dominates the background, and by mysterious figures who seem to play no part in the central drama: soldiers, hunting dogs, and corpses suspended from gibbets.

The Vision of St Eustace (London, N.G.), conceived more as a hunt in a princely park than as a miraculous visitation, dates from roughly the same period. With small regard for spatial depth Pisanello has assembled, as on a page in a sketchbook, a whole collection of wild animals and hunting hounds. Deep in the leafy shade of the woods, an elegant knight stands motionless, his profile towards us, a perfect example of the sophisticated world of the late Middle Ages.

In 1438, while Pisanello was in Ferrara for the ecclesiastical council, he executed the portrait of the Byzantine Emperor John VIII Palaeologus. Moved by the importance of his sitter, he decided to revive a technique popular in the ancient world and accordingly struck a portrait medal of him, the first in his long and distinguished career as a medallist. Although inspired by classical models, the medals are Gothic in spirit, with their fantastic imagery decorating the reverse. Pisanello treated his metal in such a way as to achieve pictorial effects superior even to those in his paintings. And it was not mere chance that made him choose to sign his medals '*Opus Pisani pictoris*'.

The ten years when Pisanello was living in Ferrara were an eventful time, much of it spent in travels between the courts of Mantua, Verona, Milan and Venice. It was also the period when he produced his most important works, such as *St Jerome* (London, N.G.) (probably by Pisanello, although normally attributed to Bono da Ferrara) and the magnificent portrait described as an *Este*

Princess (Louvre), who could be either Margherita Gonzaga or Ginevra d'Este. The minutely detailed profile, as firmly delineated as on a medallion, stands out against a background strewn with butterflies and wild flowers, so that it almost takes on the significance of a heraldic symbol.

In 1441 Pisanello painted a portrait of *Lionello d'Este* (Bergamo, Accademia Carrara) in competition with Jacopo Bellini and, several years later, a last panel, *The Virgin and Child with Sts George and Anthony Abbot* (London, N.G.). In this painting, the only one that Pisanello ever signed, two symbols of the dying Middle Ages confront each other against a background of forest, irrationally reduced to the size of a copse: the elegant and knightly saint and the unkempt, bearded monk.

Some recently discovered frescoes in the Ducal Palace at Mantua are believed to have been painted by Pisanello around 1447 during his stay at the court of the Gonzagas. Although the series is incomplete – there are considerable gaps in the pictures – this is one of the greatest discoveries to be made for many years in quattrocento art. Taken from the Arthurian legends, the cycle is one of the most sumptuous illustrations of 'courtly' Gothic. Across three sides of the room a vast scramble of horsemen is shown entangled in picturesque confusion. Knights-errant stand beneath the walls of a fortified castle while their ladies watch the battle. Some of the undamaged parts of the frescoes, such as a lady looking on at the fighting, and a group of dead or wounded armoured knights, can bear comparison with any of Pisanello's other major works.

In 1449 Pisanello was in Naples at the court of Alfonso of Aragon and it was here that he began his great series of drawings, silverwork and medals, including that of Inigo de Avalos. After 1450 there are no more records of his activity and it is presumed that he died some time between 1450 and 1455.

Throughout his career Pisanello drew: sketches for compositions, careful studies from nature (portraits, animals, costume), and also finished drawings in which he showed himself to be one of

the great draughtsmen of his time. The Vallardi Codex, acquired by the Louvre in 1856 from the merchant Giuseppe Vallardi, contains an important collection of his sketches and drawings, which display the remarkable range of his inspiration. Other collections are in Milan, Vienna and the British Museum.

Pisanello was among the most sought-after painters of his day, a cause of dispute to the most powerful courts in Italy, and an object of respect to poets and scholars for his skill in interpreting nature and for the detailed concern he brought to reality. Because of this refinement and his particular brand of realism he has been seen as a forerunner of the Renaissance. In fact, however, Pisanello, the artist of a world of refinement, adhered almost without thinking to the enchantment of the Gothic dream. His work embodies the fundamental contradiction of the International Gothic style: the juxtaposition of a meticulous surface realism with that urge towards the fantastic, outside and beyond reality, that characterizes the waning of the Middle Ages.　　L.C.V.

Pissarro
Camille

French painter
b.St Thomas, West Indies, 1830 – d.Paris, 1903

Born of a Creole mother and a Portuguese father on the island of St Thomas in the Antilles, which at that time was Danish territory, Pissarro was sent to school in Paris in 1842, returning home to work in his father's shop in 1847. In 1853 he ran away to Venezuela with the painter Fritz Melbye, in order to devote himself to art, but his father accepted his vocation and sent him back to Paris to study painting. Arriving in 1855 at the time of the International Fair, he discovered the work of Courbet, Ingres and, particularly, Corot, whom he met and visited several times. Pissarro studied in turn with Anton Melbye, at the École des Beaux Arts and at the Académie Suisse, where he

Pisanello ▲
St George and the Princess (1433–8)
Fresco
Verona, Church of S. Anastasia

met Monet and others who were later to become associated as Impressionists.

At this period Pissarro was mainly painting tropical landscapes, but he also worked in the open air in the countryside just outside Paris; a landscape of Montmorency was exhibited in the Salon in 1859. In 1860 he was introduced to Ludovic Piette, who became one of his closest friends, and whose family often entertained him at their country house at Montfoucault in Brittany until Ludovic's death in 1877. Pissarro did not suffer the disapproval of the official art world because, although he had been hung at the Salon des Refusés in 1863 and rejected in 1867, he regularly exhibited at the Salon from 1864 to 1870.

His early landscapes show the influence of Corot, whose follower he was until 1865, and also of Courbet, from whom he derived the breadth and full colouring which earned him Corot's disapproval. Pissarro often used a palette knife and his *Still Life* (1867, Toledo, Ohio, Museum of Art) is executed in a style that was to influence Cézanne. He went to live at Pontoise in 1866, moved to Louveciennes in 1869, and applied himself to painting the surrounding countryside with an affection that is evident in *La Route à Louveciennes* (*The Road at Louveciennes*) (1870) and *Diligence à Louveciennes* (*Coach at Louveciennes*) (1870; both Louvre, Jeu de Paume), as well as in *La Route de Versailles à Louveciennes* (*The Road from Versailles to Louveciennes*) (1870, Zürich, Bührle Coll.). The figures in the foreground of this latter painting are rare in his works.

During the war of 1870 he took refuge, first with Piette, then in London, where he was reunited with Monet and met Durand-Ruel, who bought two of his canvases. In London he discovered the English landscapists and became particularly interested in Constable. On returning to France he found that his home had been ransacked by the Germans, who had used the large number of paintings, between two and three hundred, that he had left behind, as duckboards in the mud of the garden.

Pissarro settled at Pontoise, working also at Osny and Auvers. This was a fruitful time for him. By now he was the complete master of his art and from 1874 he began experimenting with Impressionist techniques and joining in Impressionist demonstrations, although disagreements remained deep. He shared the Impressionist fascination with the effect of light on water (*La Seine à Marly* [*The Seine at Marly*], 1871, Great Britain, private coll.; *L'Oise aux environs de Pontoise* [*The Oise near Pontoise*], 1873, Williamstown, Virginia, Clark Art Inst.), but it was the changing aspects of the sun and of nature that most interested him, and he set out to capture these in a rich gamut of colours based on browns, greens and reds.

Among the best works from this period are: *La Route de Rocquencourt* (*The Rocquencourt Road*) (1871, New York, private coll.); *L'Entrée du village de Voisins* (*The Entrance to the Village of Voisins*) (1872) and *La Route de Louveciennes* (*The Louveciennes Road*) (1872; both Louvre, Jeu de Paume); *La Route de Gisors à Pontoise, effet de neige* (*The Road from Gisors to Pontoise under Snow*) (1873, Boston, M.F.A.); *Moisson à Montfoucault* (*Harvest at Montfoucault*) (1876), *Potagers, arbres en fleurs* (*Orchard in Blossom*) (1877) and *Les Toits rouges* (*The Red Roofs*) (1877; all Louvre, Jeu de Paume).

Apart from the full colour and precise observation, the most striking aspects of Pissarro's work are his firmness of handling and accented brushwork, and the firm, clear tonal definitions of the forms, which strongly influenced Cézanne. The two artists often worked together and Pissarro encouraged the other man to work in the open air. Pissarro had a kindly and gentle nature, and was always ready to advise and help his friends. (It was said of him by Mary Cassatt that he was such a good teacher that he could teach stones to draw.) He was one of Gauguin's first teachers, and invited him to take part in the fifth Impressionist exhibition in 1880.

Pissarro had a large family and often experienced great hardship, particularly in 1878 when, for the first time, his natural optimism was shaken. Around this time he became very interested in etching, along with Degas and Mary Cassatt, and his high regard for exact observation often meant that his plates went through ten or more processes. His lithographs were mostly produced at Éragny, where he installed a hand-press.

A fairly successful exhibition put on by Durand-Ruel allowed Pissarro to buy a house at Éragny. Towards the end of 1885 he met Signac and Seurat and, being interested in all new techniques, he began to experiment with pointillism. He showed these paintings at the eighth Impressionist exhibition in 1886, alongside those of his new friends. He continued to use pointillist techniques for some years (*Femmes dans un clos* [*Women in an Enclosure*], 1887, Louvre, Jeu de Paume; *L'Île Lacroix, Rouen, effet de brouillard* [*The Island of Lacroix, Rouen, Fog*], 1888, Philadelphia, Museum of Art), but these canvases did not find any buyers and soon Pissarro was in financial difficulties again, exacerbated by eye trouble which almost destroyed his sight. The slowness of pointillist methods also aroused his impatience and around 1890 he gave them up to return to his spontaneous style, which was nevertheless enriched by his experiments.

A large retrospective exhibition at Durand-Ruel's in 1892 was very successful, and Pissarro began to specialize in painting series, generally townscapes. His frequent visits to Rouen and Dieppe resulted in works such as *Le Grand Pont, Rouen* (1896, Pittsburgh, Carnegie Inst.); *Le Pont Boieldieu à Rouen, soleil couchant* (1896, Birmingham, Museum of Art); and *L'Église Saint-Jacques à Dieppe* (*The Church of St Jacques at Dieppe*) (1901, Louvre, Jeu de Paume). But the most important series were those he painted in different parts of Paris, and exhibited from 1893. These are views with steep perspective, looking down from the windows of Pissarro's various lodgings – for by now his eyesight was too poor for him to work out of doors. The paintings are of the busiest streets of the capital: first of the Rue St Lazare in 1893, and again in 1897, and then the grands boulevards (*Boulevard des Italiens, Paris, matin, effet de soleil*, 1897, Washington, N.G.). Another group of pictures, looking towards the Louvre, contrasted with the 'Boulevard' series, and showed a different side of Paris (1897-8).

He then turned to the Place du Théâtre Français and the Avenue de l'Opéra for his subject matter: *Place du Théâtre-Français, printemps* (1898, Hermitage); *Place du Théâtre-Français, effet de pluie* (1898, Minneapolis, Inst. of Arts). The Tuileries and the Carrousel occupied him during 1899-1900, as seen from an apartment at 204 Rue de Rivoli: *Le Carrousel, matin d'automne* (*Le Carrousel, Morning in Autumn*) (1899, private coll.); *Bassin des Tuileries, brumes* (*Lake in the Tuileries, Misty Weather*) (1900, private coll.).

The following winter he stayed in the Place Dauphine, facing the Pont Neuf and the Louvre,

 Camille Pissarro
Les Toits rouges. Coin de village, effect d'hiver (1877)
Canvas. 54 cm × 65 cm
Paris, Musée du Louvre, Galerie du Jeu de Paume

where he painted *Vue de la Seine prise du terre-plein du Pont-Neuf* (*View of the Seine from the Rampart of the Pont Neuf*) (1901) and *Le Monument Henri IV et le pont des Arts* (1901; both Basel, Staechelin Foundation). These series differ greatly from similar series by Monet because, unlike Monet, Pissarro was not concerned with depicting the same view at different times of the day, but with showing it from different viewpoints. His range of colours, too, besides being subtle, was also very much richer. Pissarro was moving into the Boulevard Morland when he died, on 13th November 1903.

Pissarro's art is central to Impressionism, of which he was the most faithful champion. His output was enormous and extremely diverse: oil painting, drawings, watercolour, gouache, pastel, etching and lithography. His works are dispersed throughout the world, but major collections are to be found in the Louvre (Jeu de Paume), in England (London, N.G., Tate Gal.; Oxford, Ashmolean Museum), where his son Lucien (d.1944) had made his home and left certain bequests, and in the United States (Metropolitan Museum). N.B.

Poelenburgh
Cornelis van

Dutch painter
b.Utrecht, c.1590 – d.Utrecht, 1667

Poelenburgh was trained in Utrecht by the painter Abraham Bloemaert. After spending some years in Italy (1617–c.1625) he returned to Utrecht and, apart from a short period in England in 1637, never again left the city. While in Italy he worked in Florence (some of his small paintings are today in the Pitti Palace) and also Rome where he was one of the founders of the Society of Netherlands Painters, the Bentvueghels.

Poelenburgh's first dated painting is *Landscape with Ruins and Cattle Dealers* (1620, Louvre). Like most of his work at this time, it shows a landscape peopled with small figures: shepherds or peasants with their animals posed amidst imaginary ruins. Poelenburgh borrowed this theme from the Antwerp painter Paul Bril, who was working in Rome around 1580, but he treated it with great originality. The work of Bril and his school, before 1620, is characterized by a dislike of empty space and by a composition based on diagonals which has affinities with Mannerism. After 1620 Poelenburgh freed himself completely from this influence.

The composition of Poelenburgh's paintings is simple and uncomplicated. He also led the way in recording accurately the effect of strong sunlight on colours. This light, so typical of Italy, fascinated the northern painters, and Poelenburgh achieved a most subtle play of light and shadow, bringing out gradations of tone by delicate nuances of colour. Despite this meticulous technique his early works are full of freshness and spontaneity. His artful use of reflected light was influenced by the German painter Elsheimer, although otherwise their work has little in common. The paintings executed by Poelenburgh during his Italian period anticipated the great Italianate landscape painters of the Low Countries (Breenbergh, Jan Both, Asselyn, Berchem) as much in subject matter as in technique.

On his return to Utrecht Poelenburgh turned to mythological themes (*Diana and Actaeon*, Prado) and religious subjects (*The Annunciation to the Shepherds*, Gray, France, Baron Martin Museum; *The Adoration of the Magi*, Geneva Museum; *The Angel Leading the Shepherds*, London, Apsley House), and his handling gained a new assurance and fluidity.

His landscapes with bathing nymphs, sometimes pursued by satyrs (Rijksmuseum), brought him tremendous popularity and were much imitated. Later, his reputation suffered through a number of mediocre canvases, but the paintings made at the end of his life have a particular charm by virtue of their finish and brilliant enamel-like colouring (*The Glorification of St Catherine of Alexandria*, Utrecht Museum). A.Bl.

Poliakoff
Serge

French painter of Russian origin
b.Moscow, 1906 – d.Paris, 1969

After studying for a short time in Moscow (his studies were interrupted by the October Revolution), Poliakoff left Russia in 1919 and spent some time in Constantinople, Sofia, Belgrade and Berlin, before settling in Paris in 1923. In 1930 he became a student at the Académie de la Grande Chaumière, supporting himself by playing the guitar in Russian cafés. He spent two years in London at the Slade School, returning to Paris in 1937, where he met Kandinsky, and Robert and Sonia Delaunay. Through their influence he discovered tone values and the specific qualities of colour, while from Freundlich he learned chromatic contruction. In 1938 he produced his first abstracts which were shown at the Salon des Indépendants in 1945. His first one-man exhibition, held at the same time at the Galerie l'Esquisse, brought him to the notice of the Parisian public, and from then on he contributed regularly to the Salon des Réalités

Nouvelles and the Salon de Mai. His second one-man show in 1947, held at Denise René's, was followed by many others in Paris and in several other countries.

After the war Poliakoff helped launch the Nouvelle Abstraction movement, in reaction against the geometric restriction of the previous ten years. He relied almost entirely on colour, delimiting large masses in vivid, sometimes overlapping tones. However, in 1946, after being complimented on producing paintings that were as colourfully variegated as a Bokhara rug, he became aware that his work was in danger of declining into mere decoration and turned towards 'embellished asceticism', disciplining himself to sombre colours (*Composition abstraite* [*Abstract Composition*], 1950, New York, Guggenheim Museum; *Composition rouge* [*Red Composition*], 1954, New York, Shapiro Coll.).

To accentuate the juxtaposition of planes, Poliakoff gradually began to use closely related colours, orange and pink next to red, a green beside a blue (*Composition*, 1958, Kiel, W. Koch Coll.; *Composition abstraite*, 1961, St Gall, H. Strehler Coll.). He decentred his canvas,

Serge Poliakoff ▲
Composition (1954)
Canvas. 89 cm × 116 cm
Lille, Musée des Beaux-Arts

Cornelis van Poelenburgh ▲
Landscape with Ruins and Cattle Dealers (1620)
Copperplate. 40 cm × 55 cm
Paris, Musée du Louvre

abandoning traditional spatial depth and rejecting the illusion of the third dimension (*Composition*, 1961, Switzerland, Heerbrugg, H. Stoffel Coll.; *Composition*, 1963-4, private coll.; *Triptyque*, 1967, private coll.). Although he sometimes allowed himself to be trapped by his own chromatic games, he remains, nevertheless, one of the greatest of the post-war colourists. His last works are less complicated and show, to some degree, the influence of Minimal Art.

Poliakoff is well represented at the Musée National d'Art Moderne in Paris (nine paintings were listed in 1972), at the Museum of Modern Art in New York, at the Tate Gallery in London, and at galleries in Lille, Grenoble, Nantes, Basel, Hamburg, Vienna and Liège, as well as in private collections all over the world. E.M.

Pollaiuolo
(Pollaiolo, Pollajuolo)
Antonio
b.Florence, c.1431 – d.Rome, 1498

Piero
b.Florence, c.1443 – d.Rome, 1496

Italian painters and sculptors

Nephews of a poulterer (*pollaiolo*) in the market in Florence, Antonio and Piero Pollaiuolo owed their names to this relationship. Antonio, the elder and more gifted of the two brothers, was also a goldsmith and engraver, crafts he continued to practise even when he became one of

◄ Pollaiuolo
Martyrdom of St Sebastian
Wood. 291 cm × 202 cm
London, National Gallery

the most famous Florentine painters of his day. He carried out important commissions for the baptistery of the S. Giovanni, including shrines, silver crosses and bookbinding. His finest work as a craftsman was his contribution, in 1457, to the famous silver reliquary in Florence (now in the Opera del Duomo). In 1466, again for the cathedral baptistery, he made sketches for the embroidery of the baptistery ornaments showing *Scenes from the Life of John the Baptist* (Florence, Opera del Duomo).

His output of major paintings was small, comprising: *The Assumption of St Mary the Egyptian* (Church of S. Maria de Staggia); the two *Portraits of a Woman* in profile (Berlin-Dahlem; Milan, Poldi-Pezzoli Museum); *Tobias and the Archangel* (Turin, Sabauda Gal.); the altarpiece with *Sts Vincent, James and Eustace* for the Church of S. Miniato al Monte (now in the Uffizi), begun in 1467; the badly damaged frescoes in the Villa della Gallina, Florence, showing naked figures dancing, a cycle related perhaps to the only engraving known to be by him, *The Battle of the Nudes*; two small paintings depicting the *Labours of Hercules* (Uffizi); a large painting of the *Martyrdom of St Sebastian* (London, N.G.), which, according to Vasari, was completed in 1475; *David* (Berlin-Dahlem); and, among his last works, *Apollo and Daphne* (London, N.G.) and *The Rape of Deianira* (New Haven, Connecticut, Yale University Art Gal.).

His most famous sculptures were produced during these same years: a bust of a *Warrior* and *Hercules and Antaeus* (both Florence, Bargello), and two funerary monuments at the Vatican, the tomb of Sixtus IV (1484-92) and that of Innocent VIII (finished 1498), which he executed with his brother.

It is not known where Antonio received his training and it is therefore possible that he may have taught himself by working with the goldsmiths, engravers and enamel workers of the city. Both brothers' painting, however, has strong affinities with that of Andrea del Castagno and the sculpture of Donatello, especially with that of his last period. Piero is believed to have studied under Castagno, and both brothers were excellent anatomists, who delighted in depicting violent physical action.

Antonio's work, like that of Leonardo and the young Michelangelo, is a summary of all the trends in Florentine art in the second half of the 15th century. He analysed the human body with pitiless clarity, using a clear, incisive line, and with a nervous strength translated probably from his work as a goldsmith and engraver. In this respect, the most striking examples of his genius include the acute observation shown in his famous female profiles; the surging movement in the bodies of the *Labours of Hercules*; the violent energy underlying the figures in the frescoes of the Villa della Gallina; and the mathematical and perspective devices latent in the figures of the martyr and the archers in the great *St Sebastian*.

Piero, more than ten years his brother's junior, developed in his wake. From the age of 18 he collaborated with Antonio on three large canvases showing the *Labours of Hercules* (now lost), which were commissioned by Piero de' Medici for a palazzo in the Via Larga, as well as on the decoration of the chapel of the Cardinal of Portugal in the Church of S. Miniato al Monte. The rather faded figure of St Eustace in the altarpiece of the chapel (Uffizi) is known to be by him, as are some works in the papal tombs in Rome. He also

owed his few personal commissions to his brother's fame: the *Virtues* for the backs of the seats of the Tribunale della Mercatanzia, now in the Uffizi (the *Fortitude* is the work of Botticelli); and the altarpiece, *The Coronation of the Virgin*, for the Church of S. Agostino at San Gimignano (1483). Piero's work cannot stand comparison with that of his brother: the vitality and intensity of Antonio's line is tempered and weakened, the forms are more rigid and wooden, and the tone values deadened, with consequent loss of pictorial unity. M.B.

Pollock
Jackson

American painter
b.Cody, Wyoming, 1912 – d.East Hampton, Long Island, 1956

The fifth son of a struggling farming family, Pollock was frequently on the move in his youth because of the failure of his father's enterprises. The family moved successively from Wyoming, to California, to Arizona, then back to California, where they settled in 1924 at Riverside, a town near Los Angeles. Here Pollock went to school for a time, before moving into the growing city in 1928, where he began to study art and to associate with artists. In 1929 he moved to New York to join an older brother, Charles, already an art student, and enrolled at the Art Students League in a course given by Thomas Hart Benton. He became interested at this period in the mural work of the Mexican painters, Orozco, Siqueiros and Rivera. Pollock's friendship with Benton remained close even after he ceased to study with him. During the Depression in New York, Pollock was desperately poor, often ill and already by 1936-7 suffering from alcoholism. Nevertheless, he took part in in the Federal Art Project and began to learn something about modern European painting, both abstract and Surrealist.

In 1941 Pollock met a student of Hans Hoffmann, Lee Krasner, who was to become his wife, and who introduced him to the circle of young artists later to become the leaders of Abstract Expressionism: Motherwell, Baziotes and Matta, all of them strongly oriented towards Surrealism. At that time, in the early years of the war, many European artists whose reputation to the young Americans was almost legendary had sought refuge in New York, among them Mondrian, Ernst and Masson. André Breton, too, was in New York.

This influx of great artists led Peggy Guggenheim to establish a gallery, in part a museum, in part commercial. Her 'Art of the Century' Gallery opened late in 1943, as part of her programme to encourage young experimental painters. Pollock was asked to exhibit and, fascinated by his work, she gave him a yearly contract in return for ownership of a substantial part of his output. At the same time she commissioned from him a mural for her New York town house. This painting, now in the collection of the University of Iowa, was Pollock's first really large-scale work, and is a key example of his fusion of European modernism with the scale and new space that were to be characteristic of his own style.

At this time, too, the critic Clement Greenberg

began to write articles underlining the importance of Pollock's work. Before the mural Pollock had painted some interesting and individual works such as *The She-Wolf* (1943, New York, M.O. M.A.) and *The Guardians of the Secret* (1943, San Francisco Museum) but the very titles of these hint at their fundamental reliance on Surrealism, with its intentions and associations drawn from the unconscious. The forms were powerful, yet retained an affinity with those of Picasso and Masson, the two artists from the School of Paris who, together with Miró, most strongly influenced Pollock. With the mural, however, almost 20 feet in length, a new, pulsating rhythm entered and dominated his work. Densely painted, charged with energy, it created the space of the new American painting.

In the years that followed Pollock developed steadily (although he was always a very uneven painter), while gradually forsaking traditional techniques for his own well-known, often misinterpreted methods. Eschewing easel painting, he laid his canvas on the studio floor and poured out the paint, flicking it with a stick from the cans. Thus, he himself was within the space of the painting, and the very motion of his body was incorporated into the dense and ever more intricate compositions which he wove.

A certain amount of Surrealist automatism was seen as being involved in this method, broadly interpreted in the light of Harold Rosenberg's theory of Action Painting as meaning that the painting was the record of the process of the picture's creation, reflecting the whole of the artist's physical and mental, his conscious and unconscious make-up. Yet this element can be exaggerated if it is taken to suggest that Pollock was not firmly in control of his paintings – although he certainly permitted, and even encouraged minor accidents. The edges of his paintings are clear evidence of the care with which he organized the beginning and end of his work, but the struggle between control and freedom which

animates the picture surface cannot be missed by the spectator. Indeed, it is one of the most potent forces in Pollock's art.

Among Pollock's greatest works are his *Arabesque Number 13* (1948, New York, R.B. Bahr Coll.); *Lavender Mist Number 1* (1950, New York, Ossorio-Dragon Coll.); and above all, *One* (1950, New York, M.O.M.A.). In *One*, and also in the Metropolitan Museum's *Autumn Rhythm* (1950), Pollock's linear delicacy reached its height, and he created a deep space of infinitely soft gradations. Less successful is a work like *Out of the Web Number 7* (1949, Stuttgart, Staatsgal.), where, overworking the intricate overlays, he struggled to rescue the painting by cutting out flat patterns, scraping down to the masonite. In 1951 the strain that these creations imposed upon the artist began to take its toll. He returned to a black-and-white figuration reminiscent of Picasso, and the works of this period are a more virtuoso rendering of images akin to those he created in 1942-3. In 1956, without having resolved the crises engendered by the clash of figurative and abstract elements inherent in his style, he was killed in an automobile accident at East Hampton, Long Island.

Since his death Pollock's reputation, founded on his position as the most representative of the Action painters and, in general, as the symbol of the triumph of American painting after the Second World War, has never ceased to grow. His continuing fame is signalled by the prices fetched by his canvases, which may equal those paid for an old master.

The Museum of Modern Art in New York held two important retrospective exhibitions of Pollock's work in 1956 and 1957. He is well represented in New York (Metropolitan Museum; M.O.M.A.; Guggenheim Museum; Lee Krasner-Pollock Coll.), Los Angeles, Venice (Peggy Guggenheim Foundation), London (Tate Gal.), Paris (M.N.A.M.) and Rome (G.A.M.) and in many American galleries. D.R.

Pontormo
Jacopo da
(Jacopo Carrucci)
Italian painter
b.Pontormo, 1494 – d.Florence, 1556

After Raphael and Michelangelo, Pontormo remains the dominant personality of Florentine painting in the period around 1520. To Fra Bartolommeo's classicism he opposed his own personal style – tense, uneasy, unexpected and, sometimes, bizarre.

Having come to Florence early in his career, he may have known Leonardo, but was, at all events, greatly influenced by him. After studying with Piero di Cosimo and Albertinelli, he was apprenticed to Andrea del Sarto (1512-14), whose narrative style and ordered rhythms he copied (fresco of the *Madonna and Four Saints*, c.1514, originally in the Church of S. Ruffillo, now in the Church of the Annunziata; *Visitation*, 1514-16, fresco in the atrium of the same church). Between 1515 and 1516 he decorated four panels for the Borgherini family, in collaboration with Andrea del Sarto, Bacchiacca and Granacci (*The Story of Joseph*, London, N.G.).

Soon after, he painted his first altarpiece, for the Church of S. Michele Visdomini in Florence, departing from the conventional framework of the *sacra conversazione* by superimposing long, subtly undulating curves (*Madonna and Five Saints*, 1517-18). The growing influence of Michelangelo, with his emphasis on contour, is particularly apparent at this period in Pontormo's drawing, inspired by the nudes in *The Battle of Cascina*. He may even, perhaps, have visited Rome to study the ceiling of the Sistine Chapel before his documented journey there in 1539.

Through the patronage of Cardinal Ottaviano de' Medici, Pontormo was asked to help decorate

▲ Jackson Pollock
Autumn Rhythm (1950)
Canvas. 266 cm × 525 cm
New York, Metropolitan Museum of Art, George A. Hearn Foundation

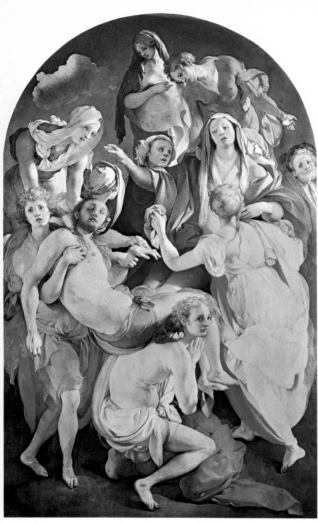

the great entrance hall of the Villa at Poggio a Caiano. The series, commissioned by Pope Leo X in memory of his father Lorenzo the Magnificent, was carried out by Andrea del Sarto, Franciabigio and Pontormo, who was responsible for two opposite lunettes pierced by a bull's-eye window (oculus) in the centre. On the death of Leo X the work was left unfinished. Pontormo had completed only one of the lunettes (*Vertumnus and Pomona*) but it is one of his happier works, a masterpiece of Florentine Mannerism, full of fantasy and elegant arabesques.

In the Carthusian monastery of Galluzzo, near Florence, Pontormo executed a cycle of frescoes on the theme of the *Passion* (1522–4), to which he later added a canvas, *The Supper at Emmaus* (1525, Uffizi; the whole series, greatly dilapidated, has been detached and replaced with copies by Jacopo da Empoli). The influence of Dürer's prints is unmistakable and has often been remarked upon, but the work as a whole is also noteworthy for its dramatic power, its contorted forms, and high degree of linear tension. The same tension can be seen in the altarpiece of the *Deposition* in the Church of S. Felicità in Florence (*c*.1526–7). Neither tomb nor cross is shown, but only hallucinatory, weightless figures whose grief is expressed in tender gestures. The work's remarkable harmonies are complemented by an exquisite decoration in fresco of the *Annunciation* and the *Evangelists*.

The *Visitation* in the Church of S. Michele on the outskirts of Florence (*c*.1528) features four figures instead of the customary two, set against an architectural background and forming an un-

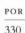
dulating unit painted in tones of faded red and yellow. Restless rhythms, unstable figures and broken lines are again found in *The Legend of the Ten Thousand Martyrs*, painted for the Spedale degli Innocenti in Florence (*c*.1529–30). Michelangelo's influence still underlies the whole concept. The portrait of *Alessandro de' Medici* (*c*.1525, Lucca Museum) is the first of series showing elongated, lissom figures in complicated poses silhouetted against neutral backgrounds (*Portrait of a Halberdier*, *c*.1527, New York, Chauncey Stillman Coll.). Apart from preparatory sketches, no trace remains of Pontormo's decorations for the villas of Careggi (1535–6, for Alessandro de' Medici) and Castello (*c*.1537–43, for Duke Cosimo). Painted across the walls of the partly open loggias in the entrance courtyard, they showed allegories of the *Virtues* and the *Liberal Arts*.

Around 1545–9 Pontormo supplied cartoons for two tapestries of the *Story of Joseph* (Rome, Quirinal Palace) as part of a series of 20 scenes commissioned by Duke Alessandro for the Palazzo Vecchio, in which Bronzino and Salviati also collaborated. The tapestries reveal the monumental character of Pontormo's late style, which reached its apogee in the great undertaking of his last ten years, a commission from the Medici family for the frescoes in the Church of S. Lorenzo (1546–56). Painted on two levels on the three walls of the choir, they were left incomplete by Pontormo and were finished by Bronzino.

The frescoes were destroyed during the 18th century, but the general layout of the whole work is known from old descriptions (for example, by Vasari) and from Pontormo's diary (Florence, B.N.), which contains references to S. Lorenzo in the two years before his death. A series of some 30 preparatory sketches, mainly executed in black chalk (most in the Uffizi), is all that remains of Pontormo's last masterpiece. Groups of astonishingly entwined nudes connect the various scenes of the *Fall*, the *Flood* and the *Resurrection*. In their breadth of vision the frescoes resemble Michelangelo's work in the Sistine Chapel, and project a plastic force and dramatic tension which were completely beyond the comprehension of his contemporaries.

Pontormo was an isolated figure among the artists of his day. His individuality, akin to that of Rosso, rules out any ideas of a studio. He had some imitators, such as Naldini and Morandini, but few pupils, with the exception of Bronzino, whose mannered techniques prolonged the *maniera fiorentina* well into the 16th century. Certain works of Jacopino del Conte, Vasari and Salviati, with their echoes of Pontormo's style, only serve to emphasize the level of his achievements.

F.V.

Pordenone
Giovanni Antonio
Italian painter
b.Pordenone, c.1483 – d.Ferrara, 1539

Pordenone probably received his training in the town of Tolmezzo, an artistic backwater. His master is presumed to have been one Gianfrancesco da Tolmezzo, who painted in the illusionistic style of Mantegna, a style that Pordenone copied in his first dated work (1506), a triptych

painted in fresco (*St Michael, St Valerian and John the Baptist*) in the Church of S. Stefano in Valeriano. A visit to the court of Ferrara in 1508 in the company of Pellegrino da San Daniele was the first of the many journeys that Pordenone made throughout Italy in the course of his career, all of which enriched his complex art with strands from different cultures.

The influence of Melozzo da Forlì and of Signorelli, whose work Pordenone came to know in the course of a visit to Loreto, affected the frescoes (now destroyed) for the Church of S. Salvatore in Colalto (1508–11). The altarpiece of the *Virgin and Child with Four Saints* (1511, for the same church, but now in Venice, Accademia) is in a more 'modern' style. The more positive role allotted to colour reveals Pordenone's sensitivity to the Venetian school and in particular to Giorgione and the young Titian. However, Giorgione's influence, plainly visible in the two altar-paintings on the theme of the *Virgin and Child with Four Saints* in the churches of Susegana and Vallenoncello and that in Pordenone Cathedral (*Our Lady of Mercy*, 1511), is confined chiefly to the formal aspect. Pordenone's natural bent was for simple realism rather than idealization.

After a stay in Umbria, during which he painted a fresco of the *Virgin with St Gregory, St Jerome and the Donor Pentesilea Baglioni* for the church of Alviano near Terni, in 1516 Pordenone made a journey to Rome which proved decisive to his development. Under the influence of Raphael, Pordenone drew closer to the 'grand manner', evident in the frescoes he undertook for the parish church of Rorai Grande (*The Evangelists, the Virgin and St Thomas*) and for the Malchiostro Chapel (*Augustus and the Sibyl; The Visitation; Adoration of the Magi; Saints*), as well as those in Treviso Cathedral (1520) – which also show traces of Leonardo. But the impact of the Roman style, this

time of Michelangelo, in their marked plasticity and intensification of chiaroscuro, shows even more strongly in the Cremona Cathedral frescoes of the *Passion of Christ* (1520-2). The dynamism of the figures, however, is the antithesis of Renaissance art and merges with the Mannerist current. This impressive and moving work, rich in innovations, won for Pordenone the title of *pictor modernus*.

From now on, for the rest of the decade, Pordenone's painting developed in open opposition to the Venetian tradition. The violent contrasts of light, the bold foreshortenings and *trompe-l'oeil* effects, and the impetuous passion found in *The Assumption*, *The Conversion of St Paul* and *The Fall of Simon Magus*, painted on his return to Friuli in 1524 as the organ shutters of Spilimbergo Cathedral, are repeated in the Venetian works, such as *St Christopher and St Martin* (1528, Church of S. Rocco). Pordenone's breakaway from Renaissance ideas gave him a decisive role in the development of Venetian Mannerism during the 1530s and a particular influence on the orientation of Tintoretto. But Pordenone became increasingly overshadowed by Titian, his great rival, and left Venice for Emilia. At Cortemagggiore he gave further proof of the vitality and assurance of his art in his dramatic *Entombment* (Franciscan church) and *Immaculate Conception* (Pallavicini Chapel, now in Naples, Capodimonte).

Later, other influences, especially that of Parmigianino, added an element of refinement to Pordenone's work. A new stylistic balance and a more relaxed narrative style, based on a calmer observation of reality, appear in the remarkable frescoes (*Scenes from the Life of the Virgin and St Catherine*) in the Church of the Madonna di Campagna in Piacenza (1531). After a stay in Genoa (*c*.1532) and another in Friuli (*The Holy Trinity*, Cividale Cathedral) Pordenone returned to Venice, where he remained from 1532 to 1538, working with more success. The altarpiece of *S. Lorenzo Giustiniani*, painted for the Church of S. Maria dell'Orto (now in Venice, Accademia), is a new affirmation of his late style which, at the very end of his working life, he adapted to illustrative or pathetic themes (*Noli me tangere*, Cividale Cathedral). Summoned to Ferrara in 1538 by Ercole II, Pordenone died there a year later, poisoned, it was said, by rivals.

Comparison with his contemporary and rival, Titian, has in the past prejudiced a true evaluation of Pordenone's importance as an artist. But in the context of Venetian painting as a whole, he not only demands recognition as the leader of the Friuli school, but the nobility and originality of

his 'provincial' style single him out as one of the most remarkable representatives of the complex culture of the first half of the 16th century in Italy.

F.Z.B.

Potter
Paulus

Dutch painter
b.Enkhuizen, 1625 – d.Amsterdam, 1654

Paulus Potter was one of the most famous landscape and animal painters in 17th-century Holland. He was taught by his father Pieter in Amsterdam and came under the influence of Claes Cornelisz Moeyaert. In 1646 his name is listed as a member of the Guild of St Luke in Delft. One of his first paintings is the overrated life-size *Young Bull* (Mauritshuis), dating from 1647, an unskilful piece of work in its exaggerated treatment – although the landscape in the background is fresh and beautifully luminous. The drawings of the same period, such as *Stags Fighting* (1647, Rijksmuseum), show the freedom of line and the acute observations of which Potter was capable.

In 1649 Potter settled at The Hague, staying with the painter Jan van Goyen. From this period dates his finest work, characterized by delicately changing light effects. Among the most famous canvases of this period are: *Horse Tethered at a Cottage Door* (1649, Louvre); *Study of a Cow* (1649, Hermitage); *Cattle in a Field* (1649, Turin, Gal. Sabauda); *Horses at Pasture* (1649, Rijksmuseum); *View of the Woods of The Hague* (1650, Louvre); *Countryside with Animals* and *Cows at Pasture* (both 1651, Rijksmuseum). Potter, however, was unsuccessful at The Hague, and moved on to Amsterdam in 1652. It was here that his last works were painted: *Meadow* (1652, Louvre); *Animals at Pasture* (1652, Mauritshuis); *Departure for the Hunt*

(1652, Berlin-Dahlem); and *Piebald Horse* (1653, Louvre).

Potter was equally noteworthy as an engraver, both for the brio of his technique and the amazing variations of tone that he achieved. He was the real founder of the animal-painting genre peculiar to Dutch art in the 17th century (in a strange painting in the Hermitage he depicts animals ruling over man). In his early works he portrayed animals against sketchy backgrounds. Later he worked towards a subtle affinity between animals and nature. His delicate, accurate and poetic art, despite a sadly short career, exercised a highly beneficent influence on such later animal painters as Adriaen van de Velde and Aelbert Cuyp. J.V.

Poussin
Nicolas

French painter
b.Les Andelys, 1594 – d.Rome, 1665

Early years. Poussin received his first instruction in painting from Quentin Varin who visited Les Andelys in 1612 and encouraged the young man to become an artist. The same year Poussin left for Paris, probably stopping for a short time in Rouen, where he is said to have worked in the studio of Noël Jouvenet, grandfather of Jean. After brief and unsatisfactory periods of training under the portrait painter Ferdinand Elle and Georges Lallemand from Lorraine, Poussin seems to have set up independently, working partly in Paris and partly in the provinces, executing whatever commissions he could get.

Little is known of his activities during the years after his arrival in Paris, but he certainly worked in the south-west, probably at the Château de Mornay, near Niort, and also at Lyons and Blois. He was settled in Paris by 1622, when he obtained commissions from the Jesuits and from the

POU

▲ Paulus Potter
Horses at Pasture (1649)
Wood. 23 cm × 30 cm
Amsterdam, Rijksmuseum

Nicolas Poussin ▲
L'Empire de Flore
Canvas. 131 cm × 181 cm
Dresden, Gemäldegalerie

Archbishop of Paris and collaborated with Philippe de Champaigne on decorative work in the Luxembourg (all lost). At the same time he met the Italian poet Marino who encouraged him and commissioned him to make drawings illustrating the *Metamorphoses* of Ovid (Windsor Castle) and probably also his own poems.

First stay in Rome. During these years Poussin made two abortive attempts to visit Rome. On one occasion he got as far as Florence and then for reasons unknown turned back but he finally reached Rome in the spring of 1624 after spending a short time in Venice on the way. His one Italian friend, Marino, had left for Naples where he was to die the following year, but he had given the artist introductions to connoisseurs in Rome who were to become Poussin's best patrons. Of these the most powerful was Cardinal Francesco Barberini, nephew of the newly elected Pope, Urban VIII, for whom he painted *La Mort de Germanicus* (*The Death of Germanicus*) (1628, Minneapolis, Inst. of Arts). But even more important from Poussin's point of view was the Cardinal's secretary, Cassiano dal Pozzo, a great enthusiast for the arts, with a keen interest in the study of antiquity and contacts with men of learning all over Europe. It was under his influence that Poussin was to mature and to become the 'learned' painter who appealed to the connoisseur – the *peintre philosophe*.

It was about this time, too, that Poussin began to reveal his talents as a draughtsman. Even during his lifetime his drawings were collected by his friends, particularly by Pozzo and Cardinal Camillo Massimi, whose albums are now in the Royal Library at Windsor Castle. The Louvre has a magnificent collection of the sketches Poussin made for his landscape paintings and other compositions.

During his first years in Rome, however, Poussin appears as a quite different kind of artist and even a different character from what he was later to become. He was fiery and impetuous. His life seems to have been fairly wild, and he was involved in several brawls with members of the anti-French faction. At the same time he made an attempt to establish himself as a painter of large religious works, even succeeding in 1627 in obtaining a commission to paint an altarpiece for St Peter's (*Le Martyre de Saint Érasme* [*The Martyrdom of St Erasmus*], Vatican). This picture, however, met with a cool reception and in 1630 Poussin suffered a further rebuff in failing to win the competition for the decoration of a chapel in the Church of S. Luigi dei Francesi, which was given instead to Charles Mellin. At the same time he became gravely ill. On his recovery he married Anne, the daughter of a French cook and restaurant proprietor called Jacques Dughet, who had looked after him during his illness, and whose brother, Gaspard, was to become a pupil of Poussin.

About this time he seems to have embarked on the course which he was to follow both in his life and in his art for the rest of his career. He gradually withdrew from the competitive world of public art in Rome and concentrated on the production of small canvases intended for the private houses of a modest but devoted group of collectors, of whom the most important was Pozzo. These works were sometimes on conventional religious themes (*Le Triomphe de David*) [*The Triumph of David*], Prado, and London, Dulwich College Art Gal.; *L'Annonciation* and *Le*

Massacre des innocents [*The Massacre of the Innocents*], Chantilly, Musée Condé; *Lamentation sur le Christ mort* [*Lamentation*], Dublin, N.G., and Munich, Alte Pin.), but the most personal treated poetical subjects of a rather unusual kind. Some are simple allegories, such as *L'Inspiration du poète* [*The Poet's Inspiration*] (Louvre and Hanover Museum).

Others deals with melancholy themes, such as the frailty of human happiness (*Les Bergers d'Arcadie* [*The Arcadian Shepherds*], Chatsworth, Duke of Devonshire's Coll.; *Narcisse* [*Narcissus*], Louvre) or the futility of wealth (*Midas*, Ajaccio Museum and Metropolitan Museum). Some have more erudite allusions as allegories of death and resurrection (*Diane et Endymion* [*Diana and Endymion*], Detroit, Inst. of Arts; *Mort d'Adonis* [*Death of Adonis*], Caen Museum; *L'Empire de Flore* [*The Kingdom of Flora*], Dresden Gg; and *Le Triomphe de Flore* [*The Triumph of Flora*], Louvre). At this period Poussin's style is dominated by his admiration for Titian, whose *Bacchanals* he studied and copied at the Villa Ludovisi in Rome.

By about 1635 Poussin's fame had begun to spread and had reached Paris, probably through paintings sent as presents by Cardinal Barberini to Richelieu. In 1635-6 Poussin began two canvases commissioned by the latter which were to hang in a place of honour in the Château de Richelieu which was then in course of construction (*Le Triomphe de Pan* [*The Triumph of Pan*], Gloucestershire, Morrison Coll., and *Le Triomphe de Bacchus* [*The Triumph of Bacchus*], known from a copy in Kansas City Museum). During the next few years the links with France became closer and in 1639 Poussin received an invitation to come to Paris to work for Louis XIII and for Richelieu. The artist showed great reluctance to leave Rome and it was only when he received positive and almost threatening orders to do so that he finally set out for Paris, where he arrived in the last days of 1640.

Just prior to this journey to Paris Poussin had begun for Pozzo a series of paintings representing the *Seven Sacraments* (five in Belvoir Castle, Duke of Rutland Coll.; one destroyed; the *Baptism* in Washington). In these works a new solemnity appears expressed by a style much more considered than in the freely painted compositions of the early and middle 1630s. The compositions are simpler and more static. The colours are cooler, the handling is smoother, and the figures show the effect on the artist of his study of ancient Roman sculpture. The last of the series, the *Baptism*, was taken by Poussin to Paris and not finished until well on in the year 1642.

Paris: 1640-2. The visit to Paris was from Poussin's point of view a disaster. After a short period of happiness resulting from the enthusiastic reception given to him by the King, the Cardinal and the Surintendant des Bâtiments, Sublet des Noyers, Poussin realized that the tasks which he was called upon to execute were wholly uncongenial to him: large altarpieces (*Institution de l'eucharistie* for St Germain, *Miracles de Saint François Xavier* for the Novitiate of the Jesuits, both in the Louvre), large allegorical paintings for Richelieu (*Temps révélant la Vérité* [*Time Revealing Truth*], Louvre; *Le Buisson ardent* [*The Burning Bush*], Copenhagen, S.M.f.K.) and above all the decoration of the Long Gallery of the Louvre (never completed and later destroyed).

His difficulties were increased by the intrigues of Vouet and the other painters who felt that their positions were threatened by Poussin's presence

in Paris. Eventually he escaped to Rome where he arrived towards the end of 1642. Although in theory he had only gone back to fetch his wife, it is clear that he had no intention of returning and this was made easier for him by the death of Richelieu, followed within a few months by that of the King.

The visit to Paris was a failure from the official point of view but it enabled Poussin to consolidate his contacts with certain French collectors who were to be his best patrons in his later years. Of these the most important was Paul Fréart de Chantelou, secretary to Sublet des Noyers, to whom Poussin wrote a series of letters which provide the most intimate and vivid picture of the artist's personality.

Second stay in Rome: Christianity and Stoicism. During the ten years after his return to Rome Poussin established himself as one of the leading figures in European painting and produced the series of works on which his reputation rested for two centuries after his death. The most famous of these was the second series of canvases representing the *Seven Sacraments*, painted for Chantelou between 1644 and 1648 (Duke of Sutherland's Coll., on loan to N.G., Edinburgh).

In these paintings the solemnity already noticeable in the first series is intensified. The compositions are monumental, based on a severe symmetry and perfect lucidity of spatial planning. The figures have the gravity of marble statues; the colours are clear, even hard, the gestures are explicit, and all inessentials are eliminated. The conception of the series is also original because Poussin deliberately set out to depict the subjects in accordance with the doctrines and liturgy of the Early Christian Church, a plan in which he was helped by his learned friends in Rome and also by the study of the sarcophagi and frescoes which had recently been revealed by the excavation of the Catacombs.

These grave Christian compositions are paralleled by a series of paintings dealing with pagan subjects. Directly inspired by Stoic philosophy, in which Poussin himself believed and which is reflected in his letters and in the conduct of his life, the paintings are of stories taken from Plutarch's *Lives* (*Les Funérailles de Phocion* [*The Funeral of Phocion*] Great Britain, Lord Plymouth's Coll.; *Les Cendres de Phocion* [*The Ashes of Phocion*], Great Britain, Lord Derby's Coll.; *Coriolan* [*Coriolanus*], (Andelys Town Hall) or on themes with elevated moral lessons, such as *Le Testament d'Eudamidas* (Copenhagen, S.M.f.K.), even if taken from non-Stoic writers. Like many of his contemporaries, Poussin saw no difficulty in reconciling the ethics of Stoicism with the doctrines of Christianity.

The landscapes. During the 1640s Poussin experienced the revelation of the beauty of nature. In his earlier works landscape is simply a background for his figure groups, although it often reflects the mood of the subject, but now it takes on a quite new importance. Sometimes, as in the two paintings illustrating the story of Phocion, the stately, almost sculptural trees and the classical town in the background are used by the artist to underline the grandeur of the hero's character. In *Diogène* (*Diogenes*) (Louvre) the luxuriant vegetation expresses the philosopher's ideal of nature as the source of all the good things necessary to man's happiness. In the mysterious *Paysage avec*

un homme tué par un serpent (*Landscape with a Man Killed by a Snake*) (London, N.G.) there is no explicit theme, but the landscape expresses the mysterious forces of nature, more powerful than man.

This feeling for the mystery and the overwhelming power of nature is the outstanding characteristic of the landscapes which Poussin painted in the last years of his life. In *Orion* (Metropolitan Museum) humanity is nothing and even the giant Orion himself is dwarfed by the great oaks among which he moves. Here Poussin intended an allegory referring to the cyclical processes of nature – in this case the source of clouds and rain, the fertilizing forces in nature – probably suggested to him by the writings of the poet-philosopher Tommaso Campanella. Similar allusions occur in *La Naissance de Bacchus* (*The Birth of Bacchus*) (Cambridge, Massachusetts, Fogg Art Museum) and in his last work, *Apollon et Daphné* (*Apollo and Daphne*) (Louvre). In fact, in these last paintings Poussin seems to have followed a strange thread in the development of Stoicism in late antiquity, when writers like Macrobius turned the myths of Greece and Rome into allegories of the processes of nature and started a tradition of symbolism which was taken up at the time of the

Renaissance – although rarely with the fervour and poetic understanding shown in Poussin's last works.

Late works. These dream-world allegorical landscapes are perhaps the most moving of Poussin's late works, but he did not abandon the painting of religious subjects. His last figure paintings in some ways continue the works of the 1640s but they have a remote detachment and a monumental calm which are altogether distinctive (*Sainte Famille* [*Holy Family*], Hermitage and Sarasota, Ringling Museum; *Mort de Saphire* [*Death of Sapphira*], Louvre; *Repos de la Sainte Famille en Égypte* [*The Rest on the Flight into Egypt*]. In *Les Quatre Saisons* (*The Four Seasons*) (Louvre), painted for the Duc de Richelieu between 1660 and 1664, Poussin creates a synthesis of all the elements of his late style. The settings show the beauty of nature. The biblical narrative is now combined with allusions to the medieval ideas of type and anti-type and also, probably, to classical mythology. *Le Printemps* (*Spring*) is dominated by Apollo as well as by God the Father, the heroine of *L'Été* (*Summer*) is not only Ruth but Ceres; the clusters of grapes in *L'Automne* (*Autumn*) are the symbol of Bacchus as much as of the blood of

Christ; and the snake in *L'Hiver* (*Winter*) belongs as much to Hades as to the Old Testament Flood. Once again the synthesis of Christianity and pagan belief is complete.

When Poussin died in 1665 he was revered in artistic circles but he was neither loved nor imitated. He was not loved partly because his character was hard and unbending and he was far from charitable in his comments on other artists. Further, he had become a kind of hermit, aloof from Roman society, seeing only a few very intimate friends, and wholly devoted to his art. He was not imitated because, unlike all his Roman contemporaries, he never used assistants and never established a studio. Moreover, in his isolation he had evolved a style which was designed solely to satisfy his own delicate sensibility and that of a few close admirers and which in fact ran quite contrary to current taste in Rome.

Reputation. In Paris, and particularly in the Académie Royale de Peinture et de Sculpture, his name ranked second only to that of Raphael and he was the model set up before all the young students, to whom his works served as the subjects of lectures on the nature of art. In spite of this, even Le Brun and his fellow academicians

▲ Nicolas Poussin
Paysage avec Polyphème
Canvas. 150 cm × 193 cm
Leningrad, Hermitage

failed to understand the real qualities of Poussin's last works. Soon, moreover, the situation was to change. The defenders of colour as opposed to drawing and the partisans of the Moderns against the Ancients challenged the supremacy of Raphael and Poussin and pressed the claims of Rubens and the Venetians in their stead, with the result that by 1700 the more inventive artists working in Paris had moved on to a very different conception of painting which was, in fact, quite opposed to Poussin's ideals.

With the change of taste in the later part of the 18th century, however, Poussin's fortunes rose

once more, and Vien and, above all, his pupil David recognized and proclaimed his genius. Among artists of the next generation it was natural that Ingres should have named him as one of his gods, but it is revealing of the ambiguous relationship between classicism and Romanticism at this stage that Delacroix should have manifested almost equal enthusiasm for him and should have written one of the most perceptive essays in his honour. He continued to be revered by the followers of Ingres, but he was a much more fertile influence on artists such as Degas and Cézanne, who made no attempt to imitate his style but applied the principles underlying his art to the problems which were real to them and relevant to the art of their time. A.F.B.

Preti
Mattia
(also known as Il Cavaliere Calabrese)
Italian painter
b. Taverna, 1613 – d. Malta, 1699

Preti received his early training in Naples under Battistello at a time, the beginning of the 17th century, when painting in the south was flourishing, following the tradition of Caravaggio. Thoroughly grounded in this tradition, the young Preti arrived in Rome in 1630 where his first contacts with the artistic life of the city inclined him towards the 'northern' Caravaggism of Valentin, Serodine and Stomer (*Concert*, Alba Town Hall). The neo-Venetian style, however, proved equally influential and Preti completed his development through Testa, Mola and Poussin between 1630 and 1640 (*Triumph of Silenus*, Tours Museum; *Story of Moses*, Montpellier Museum).

This duality between the Caravaggesque and neo-Venetian styles gradually gave way in Preti's work to a marked taste for Emilian painting, in particular that of Lanfranco and Guercino. The change appears in the broad layout of the composition and the vigorous treatment of light in the fresco of *Scenes from the Life of St Andrew* in the Church of S. Andrea della Valle, painted between 1650 and 1653. But the frescoes depicting *Paradise*

in the cupola of the Church of S. Biagio in Modena (1653–6) represent Preti's best work. Here the influence of Pietro da Cortona may be seen in Preti's attempt to make the solidity of the forms more flexible by establishing a rapport in spatial terms between matter and light.

Preti's second stay in Naples (1656–60) marks a renewal of his earlier inspiration: reflections on the art of Ribera and on Battistello's luminism, together with the persisting influence of the neo-Venetian style, gave birth to such remarkable works as the cycle of paintings, *Scenes from the Life of St Catherine and St Peter Celestine*, in the Church of S. Pietro in Maiella. But, for Preti, the high peak of this period was his discovery of Giordano. It is to Giordano that Preti owes his development of impasto surfaces and his rapid and succinct brushwork, and it is Giordano's outspoken Baroque taste that appears in such works of Preti as *Belshazzar's Feast* and *Absalom's Feast* (both Naples, Capodimonte), as well as in *The Return of the Prodigal Son* (Naples, Palazzo Reale) and in the sketches for the *Ex-Voto of the Plague of 1656* (Naples, Capodimonte).

Preti worked in Malta from 1660 until his death. These 40 years of activity outside Italy cut him off almost totally from any new movement in art. In this provincial atmosphere his ideas crystallized into a calm academicism, evident in the huge decorative undertaking of the Church and Oratory of St John in Valletta and in the *Baptism of Christ* (Valletta Museum).

Preti's output was very considerable. The Museo Nazionale di Capodimonte, Naples, houses a major collection of his works, and others remain in the churches of Naples and Taverna, and in Malta. In addition, his paintings can be found in most of the Rome galleries and in a large number of other collections throughout the world: the Gemäldegalerie, Dresden; the Prado; the Dayton, Ohio, Art Institute; the Toledo, Ohio, Museum of Art; the museums of Grenoble, Le Mans, Chambéry and Lyons; the Kunsthistorisches Museum, Vienna; the Brera, Milan; and the Accademia Albertina in Turin. L.E.

Primaticcio
Francesco
Italian painter, active in France
b. Bologna, c.1504 – d. Paris, 1570

A pupil of Innocenzo da Imola in Bologna, then of Bagnacavallo, both of them followers of Raphael, Primaticcio spent his most formative years in Mantua after 1526 as Giulio Romano's assistant. The *Cabinet of Apollo* (drawing, Turin, Royal Library) in the Ducal Palace and *The Triumph of the Emperor Sigismund* (1530) in the Palazzo del Tè are attributed to him. Other influences at this period were Correggio and Parmigianino.

In 1532 he entered the service of Francis I at Fontainebleau, in place of Giulio Romano. On his arrival he found Rosso already installed, his reputation established and with a salary far higher than his own. Primaticcio was commissioned to decorate the King's Bedchamber (1533 and 1535, *Story of Psyche*, known by a drawing, Louvre), and from some copies of his designs it is possible to imagine his decorations in stucco and fresco, elegantly symmetrical, and very different from

▲ Francesco Primaticcio
The Holy Family
Slate. 43 cm × 31 cm
Leningrad, Hermitage

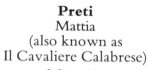

▲ Mattia Preti
Absalom's Feast
Canvas. 204 cm × 296 cm
Naples, Galleria Nazionale di Capodimonte

Rosso's varied and dynamic style. Also at this time Primaticcio began work on the Queen's Bedchamber, of which only the fireplace remains (1534-7).

In 1535 he was working on the Porte Dorée, the main entrance to the Château of Fontainebleau in the 16th century (*Scenes from the Story of Hercules*), and on the Pomone Pavilion with Rosso (1532-5, destroyed; drawing of the *Gardens of Pomona*, Louvre). He was beginning, too, the decoration of the lower gallery (1535-42) on the ground floor of the Poesles Pavilion (now vanished; drawing, Louvre).

The sudden death of Rosso in 1540 gave Primaticcio the chance to develop his own ideas for the decoration of Fontainebleau. On his return to the château from a visit to Italy in search of antiques for the royal collection, he began by completing Rosso's unfinished work. Either at this time or earlier, he decorated two small rooms (now removed) opening on to the middle of the Francis I gallery with a *Danaë* – now placed in the centre of the gallery (drawing, Chantilly, Musée Condé) – and with a *Semele* (lost). He then painted the King's Closet (1541-5; destroyed). The fireplace is known by some sketches (*Forge of Vulcan*, Louvre) and the decoration on the wardrobes is also recorded in drawings (the *Virtues*, Louvre and private coll.).

At the same time Primaticcio was painting six compositions for the entrance hall of the Porte Dorée (1543-4, still in place). The decor of the Duchesse d'Étampes's Bedchamber (1541-4), although disfigured by a staircase in the reign of Louis XV and by some unfortunate 19th-century modifications, can still be seen in part. The large stucco figures that punctuate the frescoes give a rhythmic symmetry to the whole. Primaticcio's magnificent preliminary sketches for the frescoes, on the theme of the *Masquerade at Persepolis*, can be seen in the Louvre.

He next decorated in fresco the grotto in the Jardin des Pins (1543, destroyed) with subjects painted in perspective (*Minerva, Juno*; drawings, Louvre) and followed this with what was formerly one of the marvels of Fontainebleau, *L'Appartement des Bains* (1541-7, now gone) on the ground floor of the Francis I gallery. These contained masterpieces from the royal collections, surrounded by stucco and painted decorations (*Story of Callisto*; drawings, Louvre and British Museum).

This intense activity – interrupted in 1543 and 1546 by journeys to Italy, where Primaticcio probably came under new influences, especially that of Perino del Vaga – was made possible only by the collaboration of a team of assistants, some of whom were first-class artists. Primaticcio also directed a casting foundry where bronze casts were made of the treasures brought back from Italy, and a tapestry studio (*Tapestry after the Gallery of Francis I*, Vienna, K.M.). He was then at the height of his powers and in undisputed command of everything concerning the art and decoration of the palace. Personal assistant to the King, in 1544 he was appointed Abbé of St Martin-ès-Ayres, near Troyes. The King's death in 1547, and the appointment of Philibert de l'Orme as Controller of Buildings, undermined his power for a short time, and the death or departure of some of his assistants may have influenced him towards new concepts of decoration where stucco no longer had a place.

In 1541 he undertook the decoration of the *Galerie d'Ulysse* (now gone), and he worked on his project almost until his death, in collaboration

with Niccolò dell'Abbate. The gallery took its name from the 58 compositions with which the partition walls were decorated, while the vaulted ceiling, with its 15 bays decorated with grotesques, was painted with a variety of subjects, presented in a bold and highly effective foreshortening (numerous drawings and engravings still exist). Between 1552 and 1556 Primaticcio completely decorated the ballroom in fresco with mythological subjects on the walls and between the windows. He was again helped by dell'Abbate, who had become his most important assistant.

These royal commissions did not prevent Primaticcio from working for private clients (the Ferrara town house, 1548; the Guise Chapel – drawings in the Louvre, and at Chantilly, Meudon and Montargis). He supervised a studio at Nesles (sculptures carried out by German Pilon and his workshop: *Monument of the Heart of Henry II*, Louvre; *Tomb of Henry II*, St Denis), and also did some architectural work on the Belle Cheminée wing at Fontainebleau. He submitted ideas for entertainments and *entrées* (series of drawings: *Masquerade at Stockholm*, Stockholm, Nm), as well as designs for enamels and silvers. Two of the most important works of his last years were the additional decorations (1570) for the Duchesse d'Étampes's Bedchamber, and, at the same period, similar additions, on subjects drawn from the *Iliad*, to the King's Bedchamber (lost; copies by Belly and Van Thulden; sketches in the Louvre). All these paintings were executed by Niccolò dell'Abbate.

Overburdened with commissions, Primaticcio could paint little himself and few paintings can be attributed to him with certainty. They include *The Holy Family* (Hermitage) and *Ulysses and Penelope* (Toledo, Ohio, Museum of Art). *The Rape of Helen* (Barnard Castle, Bowes Museum) seems to be a studio work. It is difficult to form an opinion about the *Évanouissement d'Andromaque* (Providence, Rhode Island, Museum) because of its condition. Most of Primaticcio's work has been lost or badly preserved, and it is only through his numerous sketches and drawings that his style is known (important collection, Louvre; Albertina; Stockholm, Nm). Executed in pen and wash, or with red chalk highlighted with white, they display an elaborate grace and are full of the poetic mannered invention of a great decorator. Engravings of his work spread his fame widely throughout Europe, while his long career and widely diverse talents exerted a decisive influence on French art, particularly during the 18th century. S.B.

Prud'hon
Pierre Paul
French painter
b.Cluny, 1758 – d.Paris, 1823

In 1773 the Bishop of Cluny sent Prud'hon to Dijon to become the pupil of Devosge, whose own work was modelled on that of Bouchardon and Greuze, an influence that can be seen in Prud'hon's early sketchbooks. Between 1780 and 1783 he continued his studies in Paris where he met the engravers Wille and Pierre and won the Prix des États de Bourgogne. On the strength of this he went to Rome in 1784, remaining there for five years and painting his first great decorative work,

La Gloire des Condé, in imitation of Pietro da Cortona's ceiling in the Barberini Palace (1786-7, Dijon Museum). Cortona's figures, however, are softened by a delicacy of shading and a hazy atmosphere learned from Leonardo and Correggio – models whom Prud'hon favoured throughout his career.

During the Revolution, both in Paris and near Gray in the Franche-Comté (1794-6), Prud'hon showed himself an ardent Republican (*Cadet de Gassicourt*, 1791, Paris, Musée Jacquemart-André; *Saint Just*, 1793, Lyons Museum) and he soon began to receive official commissions for great political and patriotic allegories such as *La Sagesse et la Vérité descendant sur la Terre* (*Wisdom and Truth Descending to Earth*) (1799, Louvre), *Le Triomphe de Bonaparte* [*The Triumph of Bonaparte*) (1800, preparatory sketch in Lyons Museum), *Diane implorant Jupiter* (*Diana Beseeching Jupiter*) (Louvre ceiling) and *La Justice et la Vengeance divine poursuivant le Crime* (*Justice and Divine Vengeance Pursuing Crime*) (1808, Louvre; from the Palais de Justice, Paris).

For a new society, greedy for pleasure after the upheavals of the Revolution, Prud'hon revived the 18th-century decorative tradition, notably in his allegorical decor for two rooms in the town house of the banker Lanoy (1799). Now broken up, the decorations portrayed graceful figures symbolizing the arts, riches, pleasure and philosophy, accompanied by the passage of the hours and the seasons (preparatory painted sketches in the museums of Montpellier and Châteauroux).

To earn a living Prud'hon undertook bread-and-butter work such as book illustration and drawing for engravers. He illustrated *La Nouvelle Héloïse* with vignettes which are still close in feeling to the 18th century, but his pictures for *Daphnis et Chloé* have a sensuality that looks forward to

Pierre-Paul Prud'hon ▲
Vénus et Adonis (1812)
Canvas. 245 cm × 172 cm
London, Wallace Collection

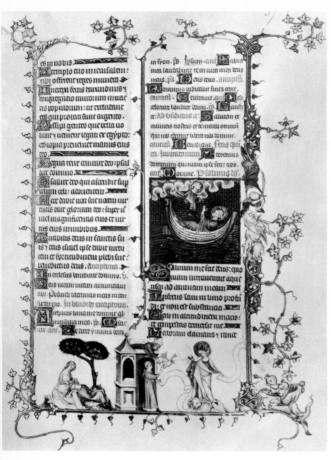

environment. Neoclassic, precursor of Romanticism, still greatly attached to the 18th century, he worked in conflicting styles, each marked by a freshness and a personal charm that set him apart from the art of his time. A continuing element in his work, however, is the strong influence of Leonardo and the school of Correggio, evident in the light radiating from the midst of his figures and the delicate arabesques delineating the pattern of the composition, as in *Vénus et Adonis*, painted in 1812 for Marie-Louise to hang in the Tuileries (London, Wallace Coll.).

This same sensuous charm, achieved by the soft modelling of the forms and an air of mystery that appears, for example, in the smile of the *Jeune Zéphyr se balancant au-dessus de l'eau* (*Young Zephyr Hovering above the Water*) (1814, Louvre), is strengthened by the play of moonlight (*Enlèvement de Psyché* [*Psyche Carried Off*], 1804-14, Louvre) and a misty atmosphere and lowering skies which foreshadow Romanticism (*La Justice et la Vengeance divine poursuivant le Crime*). Added to this was a taste for antiquity, for composition in bas-relief and for classical forms softened only by delicate transitions of tone, quite different from the clear colours of the followers of David. *Le Triomphe de Bonaparte*, although it is only a sketch, differs from the rest of Prud'hon's work in its swifter brushstrokes, greater energy, bolder colour contrasts and total absence of tenderness.

It is through this drawing that Prud'hon's importance as a decorator can be assessed: projects for ceilings, murals, medals, displays for celebrations, votive pillars and designs for furnishings. His decoration for a salon at the Sorbonne, *Le Séjour de l'Immortalité* (*The Abode of Immortality*) (large drawing on bluish paper, Chantilly, Musée Condé), prefigures the work of Ingres. Prud'hon was also commissioned to carry out decorations on the occasion of Napoleon's coronation and his marriage to Marie-Louise, and in celebration of the Treaty of Tilsit. Unfortunately nothing remains of these but a set of drawings and two painted sketches, one of which, *Les Noces d'Hercule et Hébé* (*The Marriage of Hercules and Hebe*), is in the Louvre. It was also Prud'hon who was asked by the city of Paris to design a cradle for the King of Rome, as well as the silver-gilt toilet-set for Marie-Louise, which was part of the city's wedding-gift. The drawings for these reveal an ornamentist of rare invention and verve.

C.C. and M.D.B.

Pucelle
Jean
French illuminator
active in Paris, c.1320-1333

Pucelle's name is chiefly associated with three works, of which two were collaborations: the *Bréviaire de Belleville* and the *Bible de Robert de Billyng* (Paris, B.N.); the third, '*un petit livret d'oraisons que Pucelle enlumina*' ('*a small book of hours illuminated by Pucelle*'), is by his own hand and was commissioned between 1325 and 1328 by Charles IV for his wife Jeanne d'Évreux (today identified with a little *Book of Hours* in New York, Cloisters). The output from Pucelle's studio, however, was far greater than was formerly believed, and consisted mainly of books commissioned by rich patrons: *The Breviary of Blanche*

of France, *The Book of Hours of Jeanne of Savoy*, *The Psalter of Queen Bonne of Luxembourg*, *The Book of Hours of Jeanne II of Navarre* and *The Book of Hours of Yolande of Flanders*.

It is interesting to note the similarity of style between Pucelle's art and the translucent enamels decorating the base of the famous silver-gilt *Virgin* known as the '*Vierge de Jeanne d'Évreux*' (1339, Louvre). The *Bréviaire de Belleville* and the *Heures de Jeanne d'Évreux* are the most characteristic of Pucelle's works and show him to be one of the foremost craftsmen of his day.

The most striking elements of Pucelle's style are the strength of his imagination and the freedom of his invention, both in his miniatures and in the marginal decorations. He fills these with grotesque figures full of exuberance and humour, which suggest an acquaintance with the 13th-century manuscripts of northern France and Flanders. Above all, he shows an awareness of the work of Master Honoré and his school; his concern for detail, the subtlety of his design, his careful study of anatomy and psychology – all reveal a strong Parisian influence. Moreover, Pucelle's technique surpassed that of his predecessors. In the *Heures de Jeanne d'Évreux* he used a black outline, dark stippling and light-red lines shaded with red chalk and vivid colours.

His most important discovery, however, was tinting in grisaille enriched with colour, an innovation which, because of its greyish monochrome effect, permitted him to achieve an overall decorative unity on the page and to give a lively plasticity to his figures. The technique may have owed something to contemporary stained glass, or Pucelle may have known of the discoveries of Giotto. Whatever the case, Italian influence is apparent in both his iconography and his style: certain architectural details and structures, for example, are repeated. Some scenes even appear to be taken from Duccio's *Maestà* and transposed into French Gothic art. These new methods of creating illusion in painting by the use of perspective and chiaroscuro were much admired by Pucelle. He made an attempt to place his figures, sometimes rather clumsily and uncertainly, in three-dimensional settings resembling doll's-house interiors, and to exaggerate their foreshortening.

Such new techniques would have been impossible without some knowledge of Italian art, and Pucelle may at some point have visited Italy. But gradually these Italian characteristics became less obvious. The manuscripts of Pucelle and his school show that the master and his most gifted pupils had assimilated even earlier stylistic elements to arrive at a rational, analytical, elegant and decorative synthesis which is wholly Parisian in its narrative ingenuity and naturalistic outlines, and which probed deeply into human experience.

J.P.S.

Puvis de Chavannes
Pierre
French painter
b.Lyons, 1824 – d.Paris, 1898

Born into a respectable middle-class family in Lyons, Puvis was given a solid classical education, after which, attracted towards painting, he spent a year as the pupil of Henri Scheffer. After

Romanticism. In spite of incurring the hostility of David and his followers, and of being excluded from the Institute until 1816, he became the favourite painter of the imperial family. He portrayed the *Roi de Rome* (sketch in the Louvre) and the *Impératrice Joséphine* (*The Empress Josephine*) (1805, Louvre), preparatory sketch in the Musée Jacquemart-André, Paris) and designed the furniture offered as a wedding present by the city of Paris to the new Empress, Marie-Louise. Under the Restoration he painted very little, confining himself to portraits and religious works (*Christ en croix* [*Christ on the Cross*], 1822, commissioned by Metz Cathedral; Louvre) which expressed his inner disquiet.

Neurotic by nature, Prud'hon was not helped by his liaison (1803-21) with his pupil Constance Mayer, whose eventual suicide was the indirect cause of his own death. But his sensitivity and his innate sympathy for others bore fruit in his work, especially in his portraits, which encompass an astonishing range of character: the liveliness of *Devosge* (Dijon Museum); the exquisite mystery of *Mme Anthony* (1796, Lyons Museum), painted in delicate pinks and blues, and white; the serene and melancholy sensitivity of *Monsieur Anthony* (1796, Dijon Museum); the sadness of the *Self-Portrait* of Dijon (Musée Magnin); and the refined sensuality of *Mme Jarre* (1822, Louvre). The gentle, romantic gravity that is the hallmark of all his portraits possibly reached perfection with his portrait of the *Empress Joséphine*, where the supple charm of the silhouette contrasts with the uneasiness of the gaze. His portraits of the Anthonys are comparable to those by David of the Sériziats, but the play of light lends them a subtle and secret poetry that is lacking in David's brilliant silhouettes.

Prud'hon's other paintings reveal the complexity of his own cultural background and that of his

PUC

336

▲ Jean Pucelle
La Barque de Saint Pierre. Samson et Dalila. La Confirmation, La Force.
Illuminated decoration from the *Bréviaire de Belleville*
24 cm × 17 cm
Paris, Bibliothèque Nationale

studying briefly with Delacroix and Couture, in 1852 he set himself up in a studio in the Place Pigalle and joined forces with his friends Bida, Ricard and the engraver Pollet to engage the services of a model. His eclectic training is apparent in his early works: his portraits have the sombre tonality of Couture; his romantic canvases display the intense blues and reds of Delacroix (*Jean Cavalier au chevet de sa mère mourante* [*Jean Cavalier Playing the Luther Chorale for his Dying Mother*], 1851, Lyons Museum); while some of his genre paintings even achieve Daumier's expressionist pathos (*Leçon de lecture* [*Reading Lesson*], Brouchy, private coll.). But Puvis was also a great admirer of Chassériau whose frescoes on the staircase of the Cour des Comptes inspired his interest in murals. In 1854 he completed his first series of murals, *Le Retour de l'enfant prodigue* (*The Return of the Prodigal Son*) and *Les Quatre Saisons* (*The Four Seasons*), for his brother's dining-room at Brouchy.

During this period Puvis was refused eight times by the Salon but, undeterred, he submitted two large panels, *Concordia* and *Bellum*, in 1861, and these were accepted. After *Concordia* (or *La Paix*) had been bought with official funds for Amiens Museum, he immediately presented its companion piece and, two years later, *Le Travail* (*Work*) and *Le Repos* (*Rest*). To complete the group he created his *Ave Picardia Nutrix* (1865), a hymn to the rustic pleasures of the ancient province of Picardy, and his *Pro Patria Ludus* (1880–2).

In 1869, for the Palais de Longchamp at Marseilles, he painted two beautiful murals of the Phocaean city, *Messalia, colonie grecque* (*Massilia, Greek Colony*) and *Marseille, porte de l'Orient* (*Marseilles, Gateway to the Orient*). In 1874 he attempted religious themes for the first time in two works for the Hôtel de Ville at Poitiers: *Charles Martel sauvant la chrétienté par sa victoire sur les Sarrasins* (*Charles Martel Saving Christianity by his Victory over the Saracens*) and the even greater *Sainte Radegonde écoutant une lecture du poète Fortunat* (*St Radegund Listening to the Poet Fortunatus Reading*), which displays a profound understanding of the medieval mind. The novel nature of these compositions provoked a mixed response from the critics, ranging from abuse to enthusiastic acceptance.

By this time Puvis had gained confidence and now aimed at achieving perfect harmony between the flat plane of the wall and his decoration. He rigorously suppressed all three-dimensional effects, relying on the use of soft flat tones and monochromes, the balance of different areas of colour and his rhythmic line in an attempt to reproduce something of the effect of Giotto and the 15th-century Florentine fresco painters – although he used vast canvases pasted to the wall and not the wet plaster of the true fresco.

He produced, in succession, his three masterpieces for the museum at Lyons, the Sorbonne and the Panthéon. In his *Bois sacré cher aux poètes et aux Muses* (*Sacred Grove, Beloved of the Arts and the Muses*), commissioned by the city of Lyons in 1883 for the Palais des Arts, he expressed some of his deepest beliefs. The mural shows the Muses entrusting the young poet and artist with the most sublime secrets of the spirit, and Puvis complemented this delicate allegory with his *Vision Antique*, a painting of serene melancholy, and with his *Inspiration chrétienne*, in which he rendered homage to Fra Angelico.

For the great amphitheatre of the Sorbonne he developed the theme which he had already

touched upon in his *Inter Artes et Naturam* (1890, Rouen Museum) to produce a work notable for the rhythmic balance of the composition and the solemn beauty of its figures. *L'Enfance de Sainte Geneviève* (*The Childhood of St Geneviève*), commissioned in 1874 for the Panthéon, is probably his most monumental work.

In these three works Puvis achieved a tranquil solemnity and a simple grace which made him one of the greatest decorative painters of the late 19th century. But he sometimes intermingled a little of the purifying emotion that nature inspired in Rousseau, and in fact revealed himself as a sensitive landscape painter, surrounding his allegories and pastoral idylls with scenes of meadows, valleys and forests which evoke the countryside of the Île-de-France, the soft hills of Picardy and the misty pools of the Lyonnais.

After finishing *Les Muses inspiratrices acclamant le génie messager de la lumière* (*The Inspiring Muses Acclaim Genius, Messenger of Light*) (1894–6) for the public library in Boston, he accepted an official commission for a second series of decorations for the Panthéon showing the life of St Geneviève. Deeply affected by the death of his wife, Princess Marie Cantacuzene, his long-time support and inspiration whom he had only recently married in 1897, he spent several months finishing *Sainte Geneviève veillant sur Paris endormi* (*St Geneviève Keeping Watch over Sleeping Paris*), which he depicted in a precise monochromatic composition of soft blues and greys.

Most of Puvis's large collection of drawings are housed at the Louvre, the Petit Palais in Paris, and at the Lyons Museum. These are all preparatory studies for the huge murals, sometimes sketches of poses and attitudes and sometimes more finished work, untiringly redrawn in the search for perfection. He also executed easel paintings, which were much criticized by his admirers, such as Albert Wolff, and, paradoxically, highly praised by Huysmans, to whom Puvis's frescoes meant very little.

Besides some beautiful portraits which are already modern in their abstraction (*Portrait de Mme Puvis de Chavannes*, 1883, Lyons Museum), Puvis painted many pictures of a Symbolist nature, which nevertheless carry a clear, pictorial message. *Le Sommeil* (*Sleep*) (1867, Lille Museum) and *L'Été* (*Summer*) (1873, Chartres Museum)

lack the contrived simplicity of his two paintings of *L'Espérance* (*Hope*) (one in the Louvre) which appeal through their freshness and naïveté. His *Jeunes Filles au bord de la mer* (*Young Girls beside the Sea*) (*c*.1879, Louvre) are shown in Hellenic poses against a sulphurous sky and stormy sea. *Le Fils prodigue* (*The Prodigal Son*) (1879, Zürich, Bührle Coll.) expresses the moral destitution of a man who has renounced his ideals.

Le Pauvre Pêcheur (*The Poor Fisherman*) (1881, Louvre), one of the most controversial works of his career, seems today one of the earliest manifestations of French Symbolism. Both the style and subject matter of the work affected Picasso: only a short distance separates *Le Pauvre Pêcheur* from the man in *Tragédie* (*Tragedy*) (Washington, N.G.). T.B.

Quarton or Charreton
Enguerrand

French painter
active in Provence, c.1444 – c.1466

The name Quarton (or Carton) by which the painter was known in Provence is a Latinized version of the French Charreton or Charretier (but not Charenton as he is sometimes wrongly called). He was born in Picardy around 1415 or earlier, so probably received his training between 1430 and 1440. Judging by the many Gothic elements in his work, Quarton's style was formed in northern France. The monumental quality of his paintings and of certain of his symbols is derived from cathedral sculpture, but there is also ample evidence of the influence of Van Eyck, Campin (the Master of Flémalle) and Rogier van der Weyden. During the 1430s Picardy lay in the sphere of influence of Burgundy and such contacts must have been readily available.

The realism that Quarton absorbed from these sources makes him a 'modern' artist in the middle of the 15th century, sensitive to outward forms, to the lineaments of a face or landscape, as well as to the new-found fascination of city life. Quarton, however, always kept this wealth of detail within the bounds of a vision of form that derived

▲ Puvis de Chavannes
L'Hiver (1891–2)
Fresco
Paris, Hôtel de Ville

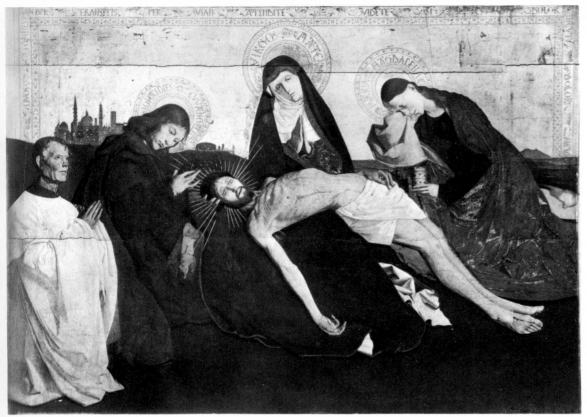

as much from northern France as from the Midi. From the secular Gothic tradition he had inherited his ability in the handling of imposing and expressive arabesques. Provence gave him its special quality of light and landscape, which resulted in sketchy outlines accentuated by short shadows, with the simplified masses broken up into facets.

Quarton was never in Italy despite the many parallels with the work of Domenico Veneziano, Uccello and Castagno, with whom, in fact, he had no direct connection. He was affected by the type of Italian art that had been 'translated' in Provence – that of the time of Simone Martini and Matteo Giovannetti, from whom he borrowed several motifs. The likeness of some details in his work to Tuscan art is explained by his contact with the paintings he saw in the houses of the numerous Florentine bankers and merchants who had settled in Provence. In Provence he came face to face with a painter who, like himself, came from the north and had been formed by the art of Van Eyck and the painters of Tournai, but had also been influenced by the Midi to the point of being the founder of the Provençal 'cubist' style. This was the Master of the Altarpiece of the *Annunciation*, which was executed at Aix between 1443 and 1445, the exact time when Quarton was staying in the city.

All this receptivity tends to prove that Quarton was relatively young when he came to Provence. He is heard of in 1444 in Aix, two years later in Arles, and the next year in Avignon, where he stayed until 1466, after which there is no more mention of him. The date of his death is unknown, but details exist of seven contracts made between him and various clients: nobles, rich merchants, clergy and fellow-artists. They all concern large altarpieces including predellas (1446-7, 1452, 1453-4, 1461, 1462-4 and 1466) as well as a processional banner (1457-8). Two of the paintings described have survived, and allow, by comparison, two other non-documented works to be safely attributed to the artist.

The altarpiece *La Vierge de miséricorde (Our Lady of Mercy)* (Chantilly, Musée Condé) was commissioned in 1452 in Avignon from Quarton and Pierre Villate by Pierre Cadart, Seigneur du Thor, in the diocese of Limoges. He wished his deceased parents to be portrayed at the feet of the Virgin in company with their patron saints, the two Saints John. The contract also mentions a predella but without specifying a subject. Doubts about whether the Chantilly panel was the combined work of the two artists or of Quarton alone have been resolved by the painting's similarities to Quarton's *Couronnement de la Vierge (Coronation of the Virgin)*. It is therefore presumed that Villate executed the least important part of the altarpiece, the lost predella. The Chantilly painting is impressive by virtue of the grandeur of its composition and a dominant rhythm.

The contract for *Le Couronnement de la Vierge* (Hospice of Villeneuve-lès-Avignon) is the most detailed to survive for a medieval work of art. It was drawn up in 1453 between Quarton and Jean de Montagnac, Canon of St-Agricol d'Avignon and chaplain of the church of the Charterhouse of Villeneuve. The work, destined for the altar of the Holy Trinity at the Charterhouse, must have been finished in September 1454. It could not have included a predella, and the dais specified in the contract is lost. The plan was extremely ambitious. It evoked the Christian order of the universe in its entirety: Paradise with the saints and the elect, Purgatory, the world, showing the two holy cities of Rome and Jerusalem and their grandest monuments, and, finally, Hell. The Holy Ghost was to be represented in the form of a dove, and there was to be no difference between the Father and the Son, according to the dogma of the Council of Florence in 1439.

Some changes of detail were left to the painter, according to his artistic sensibility and the requirements of balance and three-dimensional harmony. In 1449, during an illness, Montagnac made a will requesting a work showing him as donor with St Agricola, before the Virgin, to be placed by his tomb in the church of the Charterhouse. On recovering he cancelled this commission and instead went on a pilgrimage to Rome and then Jerusalem. The *Couronnement* is therefore a commemoration of this journey.

For the altarpiece Quarton drew on his memories of the cathedral sculpture of northern France: the lower portion displays a panoramic view of the Earth and the subterranean world which represents Purgatory, while Hell is shown in the predella. A real lintel supports the tympanum, dominated by the Holy Trinity. In the 15th century the style forged by the Master of the Aix *Annunciation* and by Quarton is one of the great styles of Latin Europe, on a level with that of Tuscany and of Spain and Portugal.

No known document corresponds to the altarpiece *La Vierge à l'Enfant entre Saint Jacques et Saint Agricol avec un couple de donateurs (The Virgin and Child between St James and St Agricola with Two Donors)* (Avignon Museum), which is probably incomplete. Its origin is unknown and the armorial bearings have worn away so that the donors cannot be identified. The colour, the density, the tautness of the faces, and the sunken eyes, the characteristic Virgin, the hands, the directional hatching, however, all point to Quarton's brush. If the bishop is St Agricola, particularly venerated in Avignon, the picture may well date from Quarton's early days in the city, around 1447-50.

The subject matter of the *Pietà de Villeneuve-lès-Avignon* (Louvre) (in particular the way St John takes off the crown of thorns) and also its composition influenced the Tarascon *Pietà*, painted about 1456 (Paris, Musée de Cluny), which proves that it is earlier than that date. It is almost certainly intended for the Charterhouse of Villeneuve, and certain features of the work, such as the composition, the figure of Christ, and the delineation of the eyes, hands and rocks, point to Quarton's authorship. The dirt now covering the painting has completely changed the colour, which is in fact quite clear and austere, and has also altered the forms by adding a false chiaroscuro. The work's donor, a canon wearing an amice, bears a striking resemblance to the portrait of Montagnac which appears twice in Quarton's *Couronnement de la Vierge*. It is therefore reasonable to suppose that Montagnac, on returning from his pilgrimage, decided to recommission the votive painting portraying himself as donor, which was to have been placed by his tomb in the Charterhouse.

The *Couronnement de la Vierge*, painted as an altarpiece, did not take the place of the votive painting (it was not put beside the donor's tomb, and depicts him very discreetly as a tiny praying figure). By comparison, the *Pietà*, with the orientalized Jerusalem and the donor-canon in the foreground, can claim to be a really new and 'up-to-date' version of the 1449 project, conceived after the pilgrimage. Following the examples of the Master of Flémalle, Van Eyck and Rogier van der Weyden, the donor is not portrayed as an archaic figurine but on the same scale as the sacred personages. The *Pietà* would have been painted between 1454 and 1456.

Its attribution to Quarton places him among the very greatest painters of 15th-century Europe. In France he can be ranked with Fouquet. Both painters responded to contact with the Mediterranean of Italy and Provence by an affirmation of their Frenchness. Their synthesis of quasi-Flemish realism and quasi-Italian Mannerism is more

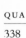 Enguerrand Quarton
Pietà de Villeneuve-lès-Avignon
Wood. 162 cm × 218 cm
Paris, Musée du Louvre

spontaneous and subtle than that of Antonello da Messina, who of all southern European painters perhaps bears the closest resemblance to Quarton.

Ch.S.

Raeburn
Sir Henry

Scottish painter
b.Edinburgh, 1756 – d.Edinburgh, 1823

Raeburn's father was a yarn boiler, but Raeburn himself started training to be a goldsmith. His first contact with the world of art and artists was when he met David Martin, a portrait painter who had been a pupil of Allan Ramsay. One of his earliest masters was David Deuchar, a specialist in etching and miniatures, who gave Raeburn an hour's training in the evening after the day's work. It is also probable that Raeburn studied the style of such painters as Romney and Reynolds from the mezzotints of their work.

He went to Rome in 1785, meeting Gavin Hamilton there, and returned to Edinburgh in 1787, establishing himself as a portrait painter with immediate success. He was proclaimed Miniaturist to the Queen in Scotland. Only after some considerable time did he endeavour to make contact with the artistic society of London, exhibiting at the Royal Academy for the first time in 1792. The work he chose was *Boy with a Rabbit*, his diploma piece (London, Royal Academy). He became an Academician in 1815.

Edinburgh was hostile to London standards of taste, and Raeburn's lack of interest in the English capital probably increased his popularity and repute at home. Knighted by George IV during his visit to Edinburgh in 1822, he was declared King's Limner in Scotland in 1823.

He was a prolific portraitist (about 1,000 works are attributed to him) but his works are seldom dated. His style expunged detail and relied on free brushwork and bold contrasts of light and shade (*Sir John and Lady Clark*, *c*.1790, Blessington, Beit Coll.).

Raeburn often used poses developed by London artists, but in a simplified, more stark form (*Mrs Barbara Murchison*, 1793, Budapest Museum). At

Enguerrand Quarton ▲
Le Couronnement de la Vierge (1453–4)
Wood. 183 cm × 220 cm
Villeneuve-lès-Avignon, Musée de L'Hospice

Henry Raeburn ▶
Sir John and Lady Clark (*c*.1790)
Canvas. 145 cm × 206 cm
Blessington, Beit Collection

times their Scottish costume gives them an exotic air (*Colonel Alastair Macdonell of Glengarry*, 1812, Edinburgh, N.G.).

Raeburn was known as 'The Scottish Lawrence', which distinctly underestimates his rather independent achievement. His work is not well known outside Scotland, which accounts for his lack of a truly international reputation. The National Gallery of Scotland, Edinburgh, has 40 portraits including a masterpiece, *The Rev. Robert Walker Skating on Duddingston Loch* (1784). Glasgow Art Gallery has 12. He is also represented in London (Courtauld Inst. Galleries and Tate Gal.).

J.N.S.

Ramsay
Allan

Scottish painter
d.Edinburgh, 1713 – d.Dover, 1784

Ramsay, a major portraitist of the 18th century, was brought up in a literary milieu and learned to draw at the Academy of St Luke in his native city, before studying briefly with Hysing in London in 1734. He spent the years 1736 to 1738 in Rome and Naples with Francesco Imperiali (the master of Pompeo Batoni) and Solimena. Portraits of this period, such as *Samuel Torriano* (1738, Berwickshire, Mellerstain, Binning Coll.) and *Francis, 2nd Duke of Buccleuch* (1739, Dumfries, Drumlanrig Castle, Buccleuch Coll.), show Ramsay's characteristic grace, even at this early date.

By 1739 Ramsay had settled in London, although he made fairly frequent visits to Scotland during the following years. Thomas Hudson was his main rival in the field of portraiture, and in 1746 Ramsay made a gift of the full-length *Dr Mead* to the Foundling Hospital, following Hudson's example. The picture was painted in the 'grand style' typical of many of Ramsay's early works, in which he posed his sitters in a classical manner. For example, *Norman, 22nd Chief of Macleod* (1748, Dunvegan Castle, Macleod Coll.) is reminiscent of the *Apollo Belvedere*.

In his portrait of the *7th Earl of Wemyss and his Wife* (c.1746, Gosford, Wemyss Coll.) the two heads were painted on separate canvases and inserted into a larger one, which points to the fact that, like Hudson, Ramsay was then making constant use of the services of drapery painters such as Van Aken. He also had recourse to sensitive and highly accomplished drawings, particularly of costumes and hands. Another aspect of Ramsay's style in the 1740s is evident in several of his female portraits, such as *Jean Nisbet* (1748, Forglen House, Abercromby Coll.), which is painted with notable simplicity.

In the early 1750s Ramsay showed increasing interest in landscape settings, as in *William, 17th Earl of Sutherland* (1753, Dunrobin Castle, Sutherland Coll.), and also in strong characterization, which he expressed, for instance, in the early portrait of *Hume* (Edinburgh, Gunn Coll.). Ramsay soon found himself competing with Reynolds, who returned from Italy in 1753, but he was clearly sufficiently well established in London to feel able to make a second trip to Rome in 1754, where he drew at the French Academy and made studies of Domenichino's frescoes at the Church of S. Luigi dei Francesi.

While in Rome he generally scrutinized the

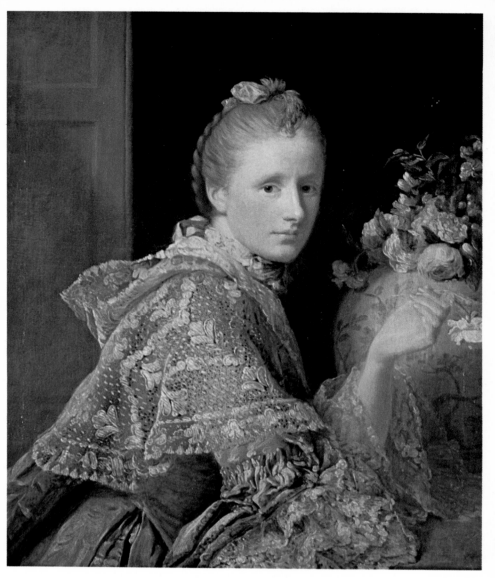

work of the Italian masters, searching for qualities of grace and finesse which he could develop in his own paintings. The finest of Ramsay's works of these years, and possibly his masterpiece, is the *Portrait of the Artist's Wife* (Edinburgh, N.G.). This picture of Ramsay's second wife (Anne, his first, died in 1743, and he eloped with Margaret Lindsay in 1752) is painted with great intimacy, and shows, in its delicacy, the influence of French portraiture.

On his return from Italy Ramsay was as successful as before. The years from 1754 and 1766 were marked by his greatest achievements in full-length portraiture, which were largely due to the 3rd Earl of Bute's commission, in 1757, of *George III as Prince of Wales* (Mount Stuart, Bute Coll.). The painting re-established the elegant court tradition of Van Dyck and so pleased the Prince that, when he came to the throne in 1760, Ramsay was appointed Painter-in-Ordinary to the King, in preference to Reynolds. This was regarded as the highest possible honour for an artist. He painted the King and Queen in coronation robes – a picture that was frequently copied by Ramsay's assistants – but the finest portrait of the period is *John Stuart, 3rd Earl of Bute* (1758, Mount Stuart, Bute Coll.), painted a few years earlier. It is refined and elegantly posed, as is the more arrogant, but equally distinguished, portrait of *Lady Mary Coke* (1762, Mount Stuart, Bute Coll.).

In 1766 Ramsay painted a portrait of *Rousseau* (Edinburgh, N.G.) and a second one of *Hume* (Edinburgh, National Portrait Gallery of Scotland) which are remarkable for their incisive sense of character. After that year his interest in painting appears to have waned, and he never exhibited at the Royal Academy, which was founded in 1768. Increasingly, Ramsay turned to literary matters, writing books and essays on subjects as diverse as 'Ridicule', and an *Inquiry into the Principles of English Versification*. He was a member of Samuel Johnson's circle, included Hume and Horace Walpole amongst his friends, and was in correspondence with Voltaire and Diderot. By the time of his death he was almost forgotten as a painter.

J.H.

Raphael
(Raffaello Santi or Sanzio)

Italian painter and architect
b.Urbino, 1483 – d.Rome, 1520

Early years. Not very much is known for certain about Raphael's early training. Vasari believed that he was a pupil in the very busy studio of his father, the painter Giovanni Santi (*d*.1494), before

▲ Allan Ramsay
Portrait of the Artist's Wife (1754–5)
Canvas. 76 cm × 64 cm
Edinburgh, National Gallery of Scotland

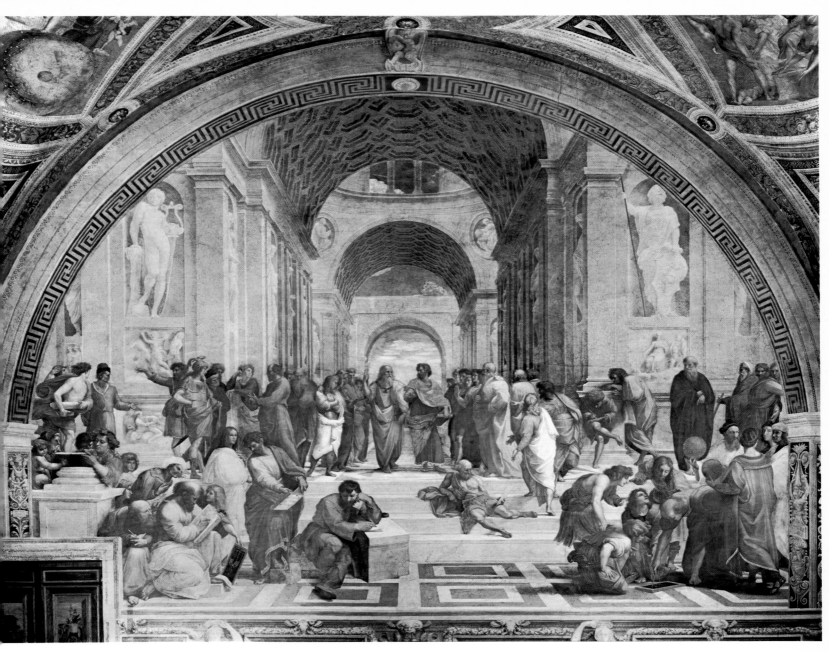

being sent on to Perugino, but this seems implausible as Raphael was just 11 when his father died. If, in fact, Raphael did spend some time studying under Perugino it was probably between 1499 and 1500, but in any case not later than December 1500.

The only early works definitely attributable to Raphael are three altarpieces for the churches of the Città di Castello. Of the first, *The Coronation of the Blessed Nicholas of Tolentino*, only fragments survive, showing *God the Father and the Virgin* (Naples, Capodimonte). At Brescia (Pin. Civica 'Tosio Martinengo') there is an *Angel*, and some preparatory sketches are in Lille Museum. The contract, dated 10th December 1500, refers to Raphael as the workshop master, together with Evangelista da Pian di Meleto, who had been his father's assistant. The second altarpiece represented the *Crucifixion with St Jerome* and was completed in 1503 (London, N.G.; the predella panels of *Scenes from the Life of St Jerome* are in Lisbon, M.A.A., and at Raleigh, North Carolina, Museum). The third is the famous *Marriage of the Virgin (Lo Sposalizio)* of 1504 (Milan, Brera).

The Coronation of the Virgin (Vatican), painted for the Church of S. Francesco in Perugia, is also often thought to date from before 1500. But the preparatory sketches (Oxford, Ashmolean Museum; British Museum; Lille Museum) make this theory hard to accept and upset the chronology of the earlier works.

These four great works and several similar paintings, like the *Solly Madonna* (Berlin-Dahlem), show a Raphael completely dominated by Perugino. It is only in *The Marriage of the Virgin*, in which the composition takes its inspiration directly from Perugino's painting on the same theme (Caen Museum), that the animation of the figures and a new concept of spatial depth indicate the direction that the art of Raphael was taking. It is likely that the allegorical *Vision of a Knight* (London, N.G.) and *The Three Graces* (Chantilly, Musée Condé) also belong to this period. The second of these works may have some connection with Raphael's visit to Siena to assist Pintoricchio with the frescoes for the Biblioteca Piccolomini. The classical original of *The Three Graces* had been sent to Siena by the Borghese in 1502 and, if

the diptych had been a commission from the Borghese, this could have been executed in Siena while Raphael was there in 1502-3.

Florence: 1504-8. Raphael probably arrived in Florence in the autumn of 1504, and remained there until 1508. He did not spend all his time in the city, however, but on several occasions left it in order to carry out commissions in Umbria. These included the fresco *The Glory of the Trinity* (1505-8, Perugia, Church of S. Severo) and three altarpieces which must have been painted in Perugia. The *Colonna Altarpiece* (Metropolitan Museum), comprises *The Virgin and Child with the Young St John and Four Saints*; in the lunette, *God the Father*; on the predella, *The Agony in the Garden* (other panels from the predella are the *Ascent to Calvary* in the National Gallery, London, and the *Pietà* in the Gardner Museum, Boston). The *Ansidei Altarpiece* consists of *The Virgin and Child with St John the Baptist and St Nicholas* (London, N.G.). The third altarpiece is the *Entombment* (1507, Rome, Gal. Borghese; predella showing the *Theological Virtues*, Vatican).

▲ Raphael
The School of Athens (1509–10)
Fresco in the Stanza della Segnatura
Vatican

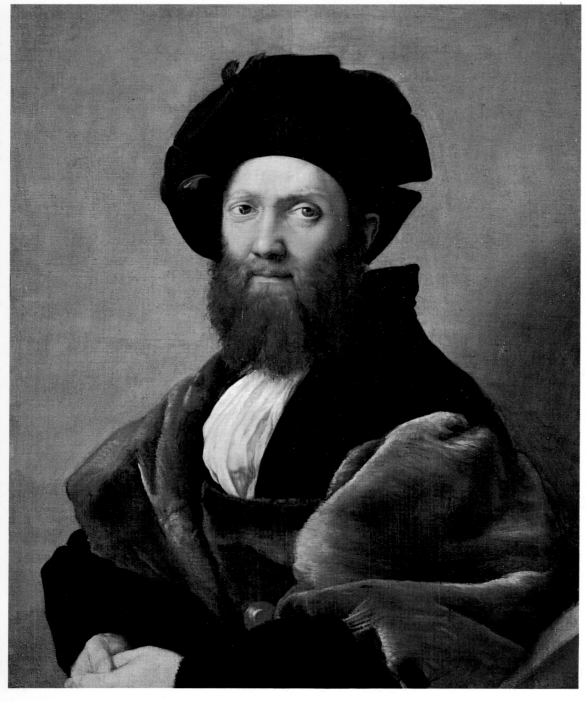

Rome, probably towards the end of 1508. This marked the beginning of a period of intense activity during which Raphael commanded the services of numerous pupils and assistants and organized a large and efficient workshop. During these years in Rome, when the Renaissance reached its peak, Raphael worked mostly in the Stanze, a series of comparatively small rooms in the Vatican that he and his pupils decorated for Julius II (1503-13) and Leo X (1513-1521). Each series of decorations have a unity and a stylistic synthesis, and in each Raphael found a new, classically poised balance.

Chronologically the series began with the Stanza della Segnatura (1508-11), the Stanza d'Eliodoro (1511-14), the Stanza dell'Incendio (1514-17), the tapestry cartoons designed to be hung in the Sistine chapel (cartoons, United Kingdom, Royal Collection, on loan to London, V.&A.), the Stanza dei Palafrenieri (1517, destroyed), the Vatican Loggie (1517-19), where the direct participation of Raphael himself in the decoration is debatable, and the Sala di Constantino, which was entirely decorated by Raphael's assistants Giulio Romano and Giovanni Penni (1520-4), after the master's death.

During the last years of his life, in fact, Raphael devolved more and more work on to his assistants, particularly Giulio and Penni, because of the overwhelming number of commissions he received. His activities included not only paintings and frescoes but also that of architect of the new St Peter's, a position to which he was appointed in 1514 on the death of Bramante.

The Stanza della Segnatura is a masterpiece of serenity and recalls many aspects of Umbria, especially in the *Disputation concerning the Blessed Sacrament*, the first of these great decorations, together with the *School of Athens*, to be completed. In the Stanza d'Eliodoro Raphael is more dramatic, exploiting to the full the classical style in the theme of divine intervention on behalf of the Church. The violent and colourful episodes show the *Expulsion of Heliodorus from the Temple* and *Attila halted by Leo the Great*. In *The Liberation of St Peter* and *The Miracle of the Mass at Bolsena* the artist makes full use of the effect of light in space.

In the Stanza dell'Incendio the general effect is less harmonious and satisfying, with a lack of control that is not evident in the other Stanze. This is in spite of the spectacular nature of the compositions, particularly *The Coronation of Charlemagne* and *The Fire in the Borgo*. The work, however, was carried out almost entirely by Raphael's assistants. The seven tapestry cartoons representing the *Acts of the Apostles* combine a new, powerful language with an increased severity in drawing, while the works done for the Loggie, showing the development of the 'grotesque' in antiquity, are masterpieces of purely decorative art.

The Chigi commissions. The Sienese banker Agostino Chigi (1465-1520), a leading figure in Roman society, was, after the popes, Raphael's greatest patron. For his house on the outskirts of Rome, built by Peruzzi, Raphael painted the fresco *The Triumph of Galatea* (1511, Rome, Farnesina). He also undertook the decoration of two chapels, that of S. Maria della Pace (where he painted *The Sibyls*, 1514, and designed a *Resurrection* for an altar) and the Chigi funerary chapel in the Church of S. Maria del Popolo, for which he furnished the architectural drawings, as well as

Meanwhile, Florentine art played a decisive part in the maturing of Raphael's style. The series of *Madonnas* and *Holy Families* of this period shows how the still completely Umbrian style of the little *Conestabile Madonna* (1504[?], Hermitage) had been replaced by an inflexible classicism derived from the study of Leonardo, the young Michelangelo and Fra Bartolommeo: the *Madonna del Granduca* (1504, Florence, Pitti), where Leonardo's influence is particularly evident in the dark background; the small *Cowper Madonna* (1504-5, Washington, N.G.); the *Madonna del Prato* (1507, Vienna, K.M.); the *Madonna with the Goldfinch* (*Madonna del Cardellino*) (1507, Uffizi); and *La Belle Jardinière* (1507, Louvre).

The *Canigiani Holy Family* (1507-8, Munich, Alte Pin.), the large *Cowper Madonna* (1508, Washington, N.G.) and the *Casa Tempi Madonna* (1508, Munich, Alte Pin.) mark the completion of

Raphael's development, at the end of which he emerged as one of the greatest painters of the Italian High Renaissance.

During this youthful period Raphael also produced a *St Michael* and a *St George*, both judged very precocious works (*c*.1501, Louvre), although some art historians now believe that these date from rather later, about 1505. The *St George* in the National Gallery, Washington, is certainly later than the one in the Louvre. Several portraits from this period also survive, notably those of *Angelo* and *Maddalena Doni* (Florence, Pitti), in which the influence of the *Mona Lisa* is strongly in evidence (see also the drawn version in the Louvre of the *Lady with the Unicorn* in the Gal. Borghese, Rome).

Rome: the Vatican decorations (1508-20).
Summoned by Pope Julius II, Raphael arrived in

▲ Raphael
Portrait of Balthazar Castiglione (*c*. 1515)
Canvas. 82 cm × 67 cm
Paris, Musée du Louvre

designing mosaics for the cupola (*God and the Planets*, 1516), and for the statue of *Jonah* sculpted by Lorenzetto. His work on the two chapels remained unfinished but another decorative ensemble, the ceiling in the Loggia di Psyche in the Farnesina (1517), remains, in spite of some clumsiness in execution by his helpers and the ravages of time, one of the most exquisite and brilliant illusionist decorations of the Renaissance.

Religious paintings, altarpieces, portraits. During his twelve years in Rome, Raphael also continued to produce religious works, altarpieces and portraits. *The Madonna of Foligno* (1511-12, Vatican), the beautiful *Sistine Madonna* (1513-14, Dresden, Gg), *St Cecilia* (1514, Bologna, P.N.), the *Virgin with the Fish* (c.1514, Prado) and *The Carrying of the Cross* (1517, Prado) constitute an impressive collection of altarpieces. Of great intensity and emphatic tone values, these works display an increasing complexity that reached its apogee in the sublime *Transfiguration* (1517-20, Vatican). Raphael left this painting incomplete on his death and Giulio Romano, his most important pupil, added the finishing touches so that it could be carried on his master's catafalque.

In his religious paintings Raphael abandoned the simple and relaxed naturalism of the Florentine school for more animated and exaggerated compositions. The most striking examples are the *Madonna with the Diadem* (Louvre), the *Alba Madonna* (Washington, N.G.) and, particularly, the *Madonna della Tenda* (Munich, Alte Pin.), where the complex harmonies of the figures are unrivalled. In the *Holy Family of Francis I*, (1518, Louvre) Raphael's style achieves monumental proportions.

Raphael put the same qualities of imagination and strength into his portraits, where, each time, he found a new solution (*Portrait of a Cardinal*, Prado; *Julius II*, London, N.G.; *Lorenzo de' Medici*, New York, private coll.). His most notable portraits are, without doubt, the *Portrait of Baldassare Castiglione* (c.1515, Louvre), the perfect portrayal of a gentleman and a humanist, and the *Portrait of a Young Woman*, called '*La Donna Velata*' (c.1516, Florence, Pitti), which is its feminine equivalent. The sitter is believed to have been the painter's mistress. *Raphael and his Fencing-Master* (c.1518, Louvre; the identification of the fencing-master in the foreground is not certain) and *Leo X and Two Cardinals* (1518-19, Uffizi) show the final style employed by Raphael in portraying two or three people together.

The drawings. Raphael is probably as renowned for his drawings as for his painting. It is in his drawings that he expresses himself most personally and directly, and they have been collected avidly by museums and connoisseurs throughout the world. The Ashmolean Museum, Oxford, Windsor Castle, the British Museum, the Louvre, the Uffizi, the Albertina, and the museums of Lille, Frankfurt and Bayonne house the most important collections. Raphael also has a place in the history of engraving even though he himself was not an engraver, but worked in collaboration with Marcantonio Raimondi, who has passed on some works of Raphael's that would otherwise have remained unknown, for example, the beautiful *Judgement of Paris*. The spread of Raphael's work through engravings helped to establish his importance, which it is impossible to overestimate.

A full appreciation of the art of Raphael is not easy, and has been made more difficult by

the inevitable comparisons made with Michelangelo – comparisons that were also made by their contemporaries. Raphael's infallible sense of balance, the measured rhetoric seen in the gestures of his figures and his own self-effacing character have all tended to suffer in modern eyes from the comparison; but they go hand in hand with a prolific invention that is without equal. The astonishing power to assimilate and adapt simultaneously, united with sheer genius, makes Raphael's work a synthesis of the High Renaissance and the ultimate expression of humanism in art. H.Z.

Rauschenberg
Robert

American painter
b.Port Arthur, Texas, 1925

Rauschenberg studied at the Kansas City Art Institute (Missouri) and with Joseph Albers at Black Mountain College in North Carolina where he met the composer John Cage. His first one-man show was at the Betty Parsons Gallery, New York, in 1951, following which he spent two years travelling in Italy and North Africa. On his return to New York he became increasingly absorbed by collage, which, for him, produced a rich juxtaposition of diverse subjects. Between 1953 and 1955 he introduced such *objets trouvés* as rope, stuffed birds and wallpaper into his work, mingling them with painted images and giving them the name of 'Combine Paintings'. The title of one of them, *Rebus*, suggests the metaphorical way in which they should be read.

Rauschenberg's style grew out of American Expressionism, but his introduction of layers of content attacked traditional concepts of abstraction (*Red Painting*, 1953, New York, Guggenheim Museum). In many ways, Rauschenberg's revolution, similar to John Cage's musical theories and anticipating one of the main tenets of Marshall McLuhan, is reminiscent of the 'simultaneity' which was debated in Paris by Barzan, Delaunay, Apollinaire and the Italian Futurists.

The 'combine paintings' underwent a transformation after 1960. The artist henceforth used

silk screen to a considerable extent in order to bring to his canvas images from everyday life in America – for example, of President Kennedy (*Retroactive I*, 1964, Hartford, Connecticut, Wadsworth Atheneum) or of the parachutist who reappears often at the moment when the war in Vietnam is intensified (*Creek*, 1964, New York, private coll.). Silk-screen was also used to render likenesses of famous examples of fine art – Velázquez's *The Rokeby Venus* (in *Bicycle*, 1963, New York, private coll.) and Rubens's *Toilet of Venus* (in *Tracer*, 1964, United States, private coll.). These images in silk-screen are heightened by energetic passages in paint. The coexistence of the two techniques side-by-side, and often overlapping, directly exposes Rauschenberg's view that 'Painting exists simultaneously in relation to both art and life. I try to locate my work in the gap between the two.'

Later he moved into more abstract researches, notably with *Revolvers* (1967), which comprises large circular plaques of perspex covered with imagery whose movement reinforces the impression of simultaneous perception. Subsequently he renounced painting for constructions based on something other than real life – *Venetian Series*, *Early Egyptian Series* (1973). The initiator, with Jasper Johns, of the American version of Pop Art, Rauschenberg won the major prize at the 1964 Venice Biennale. D.R.

Redon
Odilon

French painter
b.Bordeaux, 1840 – d.Paris, 1916

A contemporary of the Impressionists, Redon stood apart from the spirit of his age in order to develop an independent, intensely personal style. His work made little impact until about 1890, but after this date he became recognized as one of the most original personalities of the 19th century, an explorer of new paths in drawing, engraving, painting and decorative art. His *Journal* and his *Notes*, which were published together in 1922 under the title of *À soi-même*, also mark him as a writer of some significance.

▲ Robert Rauschenberg
Charlene (1954)
Combine painting. 192 cm × 361 cm
Amsterdam, Stedelijk Museum

fertile period, that of *Les Noirs*, the name he himself coined for the profusion of charcoal drawings and lithographs that chiefly occupied him until 1895. The choice of charcoal on tinted paper, derived from his study of Corot, is an indication of Redon's desire to move away from Romanticism towards a more indeterminate and ambiguous, and hence more suggestive mode of expression. In his own words, it meant 'living within the realm of the equivocal, the realm of two- and three-fold appearance, or the shadow of appearance'.

To increase the rate of production of his drawings Redon worked regularly with printers and developed an amazing mastery of the black-and-white technique of lithography (181 are listed in the 1913 catalogue). Between 1879 and 1899, in addition to single works such as the well-known *Pégase captif* (*The Captured Pegasus*) (1889), Redon produced 13 albums of lithographs, the most important being *Dans le rêve* (*Dreams*) (1879), *Origines* (*Beginnings*) (1883), *Hommage à Goya* (1885), the three series of *La Tentation de Saint Antoine* (*The Temptation of St Anthony*) (1888, 1889 and 1896) and *L'Apocalypse* (1899).

The visions of Goya and Gustave Moreau, and the discovery, thanks to the microscope of his great friend the botanist Clavaud, of the mysteries of the infinitesimal, led Redon into a new dimension. *Les Noirs* now appear as landmarks of a spiritual journey to the borders of the conscious and the unconscious. Redon had a rare capacity for putting 'the logic of the visible world at the service of the invisible' and of being able to express visually his obsessions.

Redon described the genesis of these visionary works as follows: 'My most fruitful way of working, the most important in my development, has been to make a direct copy from nature, carefully reproducing objects with all that is most minute, special and random about them. After trying to make an exact drawing of a pebble, leaf, human hand or any other living or inorganic object I begin to feel a mental seething; I need to create, to let my imagination run riot.'

His development can be seen in *Les Noirs*, from the haunted and pathetic charcoal drawings prior to 1885: *Tête d'Orphée sur les eaux* (*Head of Orpheus on the Waters*) (Otterlo, Kröller-Müller), to the more secretive and interiorized works of the 1890s, such as a *Chimère* (*Chimaera*) (Louvre), and on to those works where the chiaroscuro is sufficiently powerful even to suggest colour in the black tones, substituting for form and arabesque: *Le Pavot noir* (*Black Poppy*) (Almen, Bonger Coll.), *Sommeil* (*Sleep*) (Louvre).

Paintings and pastels. Redon's imagination spurred him on to new experiments with paint and pastel. He had, in fact, already copied the great masters, executed portraits, including his own (1867) (Paris, A. Redon Coll.), painted flower studies (Karlsruhe Museum; Almen, Bonger Coll.) and the landscape around Peyrelebade. But all these works, which he called *Studies for the Author* and kept in the studio, barely skim the surface of his real *oeuvre*.

After 1890 Redon attempted to make the change from *Les Noirs* to colour, using oils again (*Les Yeux clos* [*With Closed Eyes*], 1890, Louvre) and charcoal reinforced with pastel (*Vieil Ange* [*Old Angel*], Paris, Petit Palais). In 1900 colour finally triumphed. His remarkable collection of pastel portraits dates from this time (*Madame Arthur Fontaine*, 1901, Metropolitan Museum; *Jeanne*

Chaire, 1903, Basel Museum; *Violette Heymann*, Cleveland Museum), as well as highly coloured versions of mythological themes and religious subjects. Redon's work in colour is typified by his delicate paintings of flowers, which have an exceptional freshness and luminosity (Louvre; Petit Palais; Bonger Coll.; Hahnloser Coll; A. Redon Coll.).

An isolated figure in his own time, Redon was a fruitful influence on later generations of artists. Émile Bernard and Gauguin acknowledged their debt to him. The Nabis, Bonnard, Vuillard, Maurice Denis and many others were his friends.

He became interested in decorative art after receiving a number of commissions (Château de Domecy, Yonne, 1900-3; Chausson town house, Paris, 1901-2; Fontfroide Abbey, near Narbonne 1910-14). After 1905 he found in the theme of Apollo's chariot the ultimate expression of his mysterious and symbolic art (Paris, Petit Palais; Bordeaux Museum). Some of his final works were in watercolour. R.B.

Rembrandt
(Harmensz van Rijn)
Dutch painter
b.Leiden, 1606 – d.Amsterdam, 1669

Training. The name 'Rembrandt' was originally only a Christian name, from which comes the signature 'RH' (Rembrandt Harmenszoon, 'Rembrandt, son of Harmen'), often used by the artist. Rembrandt's father, a miller, added to his name the words 'van Rijn' as an allusion to his mill near the Rhine.

Rembrandt was the youngest but one of nine children and much younger and more gifted than his brothers. He was sent to the Latin school in Leiden and then, at the age of 13 to the university. However, he soon gave up his studies in order to train under Jacob Isaacsz Swanenburgh, a much respected citizen of Leiden, although a not particularly talented painter. Swanenburgh was a traditionalist who had travelled in Italy and painted 'noble' subjects, and his teaching was, in effect, a continuation of the humanism of the Latin school and Leiden University. His importance for Rembrandt was that from the start he directed his pupil towards historical themes.

From Leiden Rembrandt went to Amsterdam to Pieter Lastman's studio, where he stayed for six decisive months, being introduced to early Baroque and the work of Caravaggio. (He was to remain devoted to Lastman's memory and made a large collection of Lastman's drawings.) He is said, too, to have spent some time with Jacob Pynas, although in all probability the artist in question was Jan Pynas rather than Jacob (see Jan Pynas's *Raising of Lazarus*, 1615, Philadelphia, Museum of Art). Even so, the association with Rembrandt remains conjectural.

Early years in Leiden. Around 1625, on his return to Leiden, Rembrandt seems to have set up his own studio, an enterprise that the absence of a guild of painters in Leiden at that time may have facilitated. At least two important pictures appear to bear this out: *The Martyrdom of St Stephen* (1625, Lyons Museum) and *The Justice of Brutus* (1626, Leiden Museum). Both are rough, challenging works in which the artist plagiarizes Last-

 Odilon Redon
L'Armure (1891)
Drawing (charcoal and crayon). 50 cm × 36 cm
New York, Metropolitan Museum of Art

man whilst trying honestly, but without skill, to move away from his easy, flowing style which he found too superficial and facile. The anti-academic Rembrandt is already breaking through, searching for a new and convincing mode of expression.

In the famous *Balaam* (Paris, Musée Cognacq-Jay) and *Tobit and Anna* (on loan to the Rijksmuseum), painted in 1626, and *David Presenting the Head of Goliath to Saul* (1627, Basel Museum) Lastman's influence is still dominant, but soon afterwards more concentrated works begin to appear, with more emotional content and subtlety, reflecting the influence of Pynas. The aggressive polychrome of the earliest works gives way to a series of harmonies in brown and to a play with the effects of light and shade that result in a mysterious chiaroscuro.

Rembrandt's ability to portray human emotions shows a striking advance in *The Denial of St Peter* (1628, Tokyo, Bridgestone Museum), *The Flight into Egypt* (1627, Tours Museum) and *Samson and Delilah* (1628, Berlin-Dahlem), culminating in the *Christ at Emmaus* (Paris, Musée Jacquemart-André) and *The Presentation in the Temple* (1631, Mauritshuis). His natural realism, the forthright expression of his fantastic vision, quickly made his reputation. At this time (1613) chiaroscuro had never been handled so subtly and with such ease, nor in a spirit so far removed from Caravaggio.

The repertoire of the historical painter in the 17th century was not limited to pure narration, yet from the beginning Rembrandt developed this type of painting to the full. His taste for psychological expression, the technical virtuosity that struck his contemporaries so forcibly, and his uncompromising realism and expressionism were in keeping with such subjects. Compared with that of other artists of his time, his work is less descriptive and simple, more touching and true to life.

He brought the same intensity to historical and genre subjects and during this period in Leiden produced many pictures of philosophers or of apostles meditating in half-lit interiors, but always powerfully drawn (*A Man Seated Reading in a Lofty Room*, London, N.G.; *St Paul in Prison*, 1927, Stuttgart, Staatsgal.; *Jeremiah*, 1630, Rijksmuseum; *St Anastasius*, 1613, Stockholm, Nm). Rembrandt's favourite exercises, however, were his self-portraits (museums in Kassel, Stockholm, Munich, Liverpool, Boston) and his studies of old men and women with lined, eloquent features, often sitters who were close to him personally (*Old Man in a Bonnet* ['Rembrandt's Father'], Mauritshuis; *The Artist's Mother*, London, Buckingham Palace, Royal Coll.; *Old Man Wearing a Cap* ['Rembrandt's Father'], Innsbrück Museum).

Throughout this prolific period in Leiden Rembrandt worked in close collaboration, perhaps sharing a studio for a time, with another extremely gifted young townsman, Jan Lievens, who was not to fulfil his early promise. However, at this time, Lievens was so outstanding and there was such an affinity between the two, that it can be difficult to distinguish their respective work (for example, the enigmatic *Herod's Feast*, Raleigh Museum, attributed to each artist in turn), especially as they had both been trained by Lastman.

If Lievens was judged superior with regard to invention, formal beauty and grandeur, Rembrandt was more intuitive and gave more psychological depth to his sitters. If Lievens paint-

ed more accurate portraits, Rembrandt was incomparable in depicting history because he knew how to invest his subjects with life, and, while Lievens chose to paint life-size, Rembrandt showed a wonderful skill in small formats and said far more in much less space.

First years in Amsterdam. After June 1631 Rembrandt, encouraged by his success, settled in Amsterdam at the home of the art dealer Hendrik van Ulenborch, cousin of his future wife Saskia (the marriage took place in 1634). His success as a portrait painter of the wealthy bourgeoisie grew rapidly. Out of 50 paintings dated 1632-3, 46 are portraits, or studies of heads. One of the most famous is the so-called *Anatomy Lesson of Dr Tulp* (1632, Mauritshuis), a masterpiece of group portraiture, which was very fashionable in Holland at that time. It shows the members of the Amsterdam Guild of Surgeons.

All the portraits of the 1630s display a keen observation and a pictorial finesse which reveal the artist's affinity to Van der Helst and de Keyser as much as to Van Dyck or Rubens. At this time Rembrandt occupied a position as a fashionable society painter that he had never had in Leiden. His works, subtle and lifelike, were usually executed on a pale grey background. They were often oval in shape, sometimes in an ambitious format and painted in pairs (likenesses of *The Preacher Johannes Ellison* and his wife *Maria Bockenolle*, 1634, Boston, M.F.A.; *Marten Soolmans* and his wife *Oopjen Coppit*, 1634, Paris, A. de Rothschild Coll.; *Jan Pellicorne and his Son Casper* and *Susanna van Collen, Wife of Jan Pellicorne and her Daughter*, London, Wallace Coll.).

These paintings arrest the eye by the amazingly direct gaze of the sitter, and the great plasticity obtained by simplification of the harmonies of black and white, and light and shade. Always dignified and well-finished, they are striking both for

the affluence and skilful understanding of their settings, and a smoother and more supple treatment than Rembrandt ever achieved in Leiden. The entire composition, the studied rhythm and the symbolism of the hands, one of which is often out of sight, and the turn of the head, suggest a vital mobile presence, purely Baroque in essence.

Among the greatest successes of this 'aristocratic' portraiture are: *The Merchant Nicolaes Ruts* (1631, New York, Frick Coll.); *Fashionably-dressed Couple in an Interior* (1633, Boston, Gardner Museum); *Maerten Looten* (1632, Los Angeles, County Museum of Art); the poet *Jan Hermansz Krul* (1633, Kassel Museum), symbolically represented at the entrance to a porch; the *Fashionably-dressed Man* (1633, Cincinnati Museum) and the *Young Woman* (Metropolitan Museum), as well as the *Seated Man* and its companion *Portrait of a Woman* (Vienna, K.M.), which closely follows Van Dyck; *A Man in a Polish Costume* (1637, Washington, N.G.) and *Maria Trip* (1639, Rijksmuseum), who is represented in a painted *trompe-l'oeil* frame, Mannerist in style, after the *Amalia van Solms* (1632, Paris, Musée Jacquemart-André).

The Baroque tendencies which, in Rembrandt's work, characterize the formal society paintings of the 1630s, are just as evident in his numerous self-portraits and in the paintings of Saskia, notably in the sumptuous dresses and exotic oriental costumes, of which he had a huge collection. Thus, Rembrandt depicts himself wearing ornaments, gold chains (Louvre, 1633 and 1634), and gorgets (Uffizi, Berlin-Dahlem, Mauritshuis), helmets (1634, Kassel Museum) and superb plumed hats (Berlin-Dahlem – a picture which perhaps is the counterpart of the smiling *Saskia*, wearing a similar hat in Dresden, Gg; 1635, Vaduz, Liechtenstein Coll.; Mauritshuis; 1639, Dresden, Gg – a curious picture in which the artist is hanging up a dead bittern).

▲ Rembrandt
The Blinding of Samson by the Philistines (1636)
Canvas. 236 cm × 302 cm
Frankfurt, Städelsches Kunstinstitut

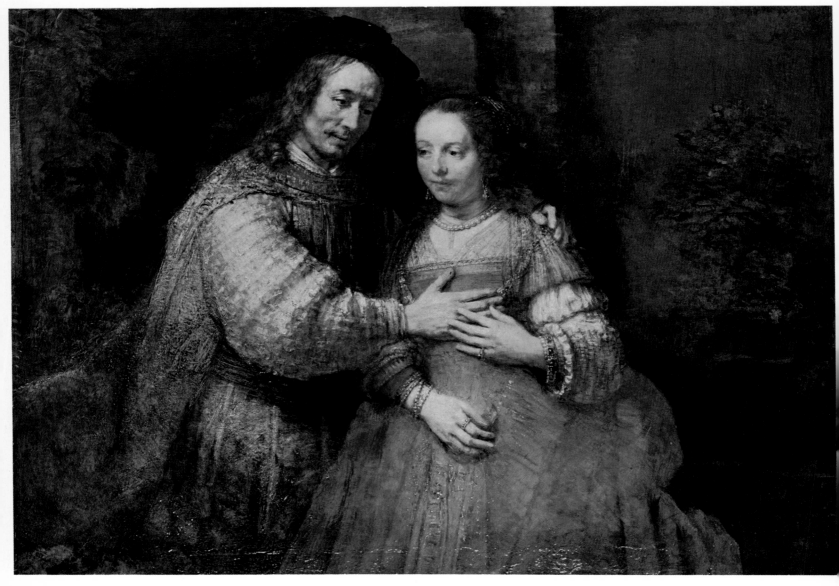

Thus Saskia, swathed in a delicate veil (1633, Rijksmuseum; Washington, N.G.), becomes, by the donning of a magnificent red beret, a fascinating and remote dream-figure in the charming likeness at Kassel where Rembrandt returns to painting in profile. The poetic transmutation of Saskia's face was best accomplished by the oblique rendering of *Saskia as Flora* (1634, Hermitage; 1635, London, N.G.). The master reached the height of his Baroque bravura in the famous *Double Portrait* (Dresden, Gg).

As a historical painter, Rembrandt in Amsterdam continued in the same brilliant vein as he had previously in Leiden, producing *The Scholar* (1634, Prague Museum) and *King Uzziah Struck by Leprosy* (Chatsworth, Duke of Devonshire's Coll.), which are in the direct tradition of the 'old people' at Leiden. But, as with his portraits, his methods became more ingenious and ambitious. His light-effects, which are spectacular, grew less harsh and more subtle. The richness of the accessories and the picturesque models – often Jews from the ghetto in Amsterdam where the artist lived – clearly show the effects of the proximity of the well-to-do, such as his cousin-in-law Van Ulenborch. In short, the 'Baroque' rivalry between himself and Rubens and the Italians, was renewed.

One of Rembrandt's rare official commissions

dates from the 1630s – the series of five paintings of *Christ's Passion* (Munich, Alte Pin.) carried out for Prince Frederick Hendrik of Orange. Two pictures were delivered in 1633 (the *Raising of the Cross* and the *Descent from the Cross*). The other three paintings were finished between 1636 and 1639, the *Ascension* and the *Resurrection* being among the most animated of all Rembrandt's works, depending largely on the use of chiaroscuro to obtain unreal and magical effects in the tradition of Elsheimer. A powerful Baroque rhetoric and a monumental format characterize *The Holy Family* (c.1635, Munich, Alte Pin.), *The Sacrifice of Isaac* (1635, Hermitage) and especially the tumultuous and realistic *Blinding of Samson* (1636, Frankfurt, Städel. Inst.), which shows the technical and psychological enrichment that Rembrandt brought to the use of chiaroscuro.

At the time when Honthorst and other followers of Caravaggio were moving towards a dignified and dispassionate classicism, Rembrandt was searching for an ever more vivacious depiction of life. *Samson Posing the Riddle to his Wedding Guests* (1638, Dresden, Gg), *Belshazzar's Feast* (London, N.G.), like the *Sophonisba* (also called *Artemisia*) in the Prado (1634), are also linked to these great heroic religious works.

However, Rembrandt also remained attached to the small scale reminiscent of his Leiden

period: *The Toilet of Esther*, (1633, Ottawa, N.G.); *The Adoration of the Magi*, (1632, Hermitage – now known to be by his hand); *The Flight into Egypt*, in the manner of Elsheimer (1634, London, Wharton Coll.). Such works show that he had lost none of his facility in highlighting the details of faces in a crowd, in treating every object with meticulous care, and in depicting interiors in minute detail.

But a warm brown tonality, an increasing tendency towards intimate and personal narration, and an enveloping spatial depth gradually began to characterize his work from 1636 onwards: the *Visitation* (1640, Detroit, Inst. of Arts); *The Parable of the Labourers in the Vineyard* (1637, Hermitage); *Tobias and the Angel* (1637, Louvre); *Noli me Tangere* (1638, London, Buckingham Palace, Royal Coll.); the touching *Susannah* (1637, Mauritshuis); the mysterious *Scholar in a Room with a Winding Stair* (Louvre) – all these works amply demonstrate these developments. So, too, does *The Preaching of St John the Baptist* (Berlin-Dahlem) with its sweeping landscape background that takes on almost cosmic dimensions.

The same lyrical quality of landscape is found again in the imposing *Baptism of the Eunuch* (1636, on loan to Hanover Museum). In 1636-8 Rembrandt began to concentrate more on landscape painting: *Landscape with Stone Bridge* (Rijks-

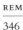 Rembrandt
The Jewish Bride (*c.* 1660)
Canvas. 121 cm × 166 cm
Amsterdam, Rijksmuseum

museum); *Landscape with the Good Samaritan* (1638, Kraków, Czartorysky Museum); *Stormy Landscape* (Brunswick, Herzog Anton Ulrich Museum) are all remarkable for the eloquence of the light, which is both concentrated and dynamic. Here again, Rembrandt demonstrated his originality by turning his back on naturalistic depiction of landscape in order to use it to express moods and states of mind, imbuing it with poetic dimensions.

Secular subjects, especially those taken from mythology, inspired Rembrandt to some of his finest work, in which he gave free rein to the power of his imagination, still under the stimulus of the Baroque aesthetic of his early period. Themes from classical mythology resulted in such paintings as *The Rape of Proserpina* (Berlin-Dahlem), *The Rape of Europa* (1632, New York, Klotz Coll.), *The Rape of Ganymede* (1635, Dresden, Gg) and *Diana with Scenes from the Stories of Actaeon and Callisto* (1632, Westphalia, Germany, Rheda Castle), an almost unknown masterpiece. Rembrandt's finest achievement remains the *Danaë* (1636, Hermitage), his most beautiful odalisque, a superb example of the linking of humanity with poetry, which is so much his own.

From the time that he settled in Amsterdam, Rembrandt, as his success increased, acquired a large circle of pupils: Jacob Backer, Willem de Poorter and Jan de Wet (1631-2); then Flinck, Bol, and Eeckhout; later Heerschop, Verdoel, Furnerius, the genial Carel Fabritius and Van der Pluym. There was also Hoogstraeten, who wrote interestingly about his teacher; possibly the two Konincks (Philips and Jacob), Victors and Horst; Doomer, the Germans Paudiss and Ovens, and Bernhardt Keil, the Danish 'Monsù Bernardo' who, himself, had an atelier later and who, in Italy, supplied Baldinucci, one of Rembrandt's 17 biographers, with information on this artist's life; Nicolaes Maes, Renesse, Drost and, during the very last years, Leupinius and Aert de Gelder.

All these artists were very gifted and are closely associated with Rembrandt's output. Sometimes he touched up his pupils' work to sell for his own profit (as with the *Sacrifice of Isaac*, 1636, Munich, Alte Pin., clearly inscribed 'Revised and improved by Rembrandt'). In this way he must have earned considerable amounts. Another sign of his prosperity is his activity as a collector. His interests ranged over a wide field: arms, armour, paintings and drawings (mostly from Italy), engravings, sculptures, rich materials and exotic curiosities. Many of these objects were used as 'props' in his paintings. Their accumulation was a fundamental part of Rembrandt's nature, as well as his dealings in his pupils' work. An entire part of his output is directly influenced by his collections; for example, his 'Orientals'.

Early maturity. In 1639, at the height of his powers and fame, Rembrandt paid 13,000 florins for a huge house in the Breestraat (the present Rembrandthuis), but the difficulty of keeping it up and paying his bills gave him constant anxiety. In 1641 Saskia gave birth to their son Titus; she died the year after. This was the start of a period of continuing ill-fortune for Rembrandt. Around 1643 Geertghe Dircx, Titus's nurse, became his mistress, but in 1649 she left him, suing for breach of promise, after having been supplanted by a young servant, Hendrickje Stoffels. In her will Saskia had stipulated that Rembrandt could continue to use her dowry only so long as he did not remarry, so he was unable to legalize his liaison with Hendrickje.

During this decade Rembrandt turned increasingly to religious subjects, treated with more intense effects of light. Henceforth, light justified the painting, inundating and animating the interiors, and defining the forms, while the handling, making use of a heavy impasto, gradually developed a robust, gritty texture. At the same time Rembrandt's desire to organize the space in his paintings grew stronger and he began to devise compositions that are undeniably Italian in feeling, deriving from his love of Giorgione, Palma and Titian. *Christ at Emmaus* (1648, Louvre) is close to Veronese, *The Young Girl at a Window* (1645, London, Dulwich College) recalls Jacopo Bassano, and the sublime etching of the *Three Crosses* (1653) demonstrates the influence of Mantegna.

The famous and dazzling group portrait *The Night Watch*, although painted in 1642, looks back to the brilliant style of the 1630s. The true Rembrandt of the 1640s emerges in works in which depth of thought and feeling are allied with an intense luminism: the *Holy Family* (c.1646, Kassel Museum), famous for the *trompe-l'oeil* deception of the frame and curtain; *Bathsheba* (1643, Metropolitan Museum); *The Adoration of the Shepherds* (1646, London, N.G.; Munich, Alte Pin.). The masterpiece of this period, in terms of humanity and formal monumentality, as well as in its glowing 'Venetian' colour, is the *Emmaus* in the Louvre (1648).

Rembrandt's engravings during this decade, such as *The Three Trees* (1643) or The *100-Guilder Print* (c.1649), display great technical freedom. In the portraits the frequent recourse to the use of *trompe-l'oeil* effects is very evident: hands which seem to move towards the viewer as in *The Mennonite Minister Cornelis Anslo in Conversation with a Woman* (1641, Berlin-Dahlem), or in *Agatha Bas* (1641, London, Buckingham Palace, Royal Coll.), or the central figure of *The Night Watch* (1642), his elbows resting on the balustrade in a pose openly taken from Titian (see also *Self-Portrait*, c.1634 London, Wallace Coll.; *Nicolaas van Bambeeck*, Brussels, M.A.A.).

During these years Rembrandt's interest in landscape increased, although by now he had moved far beyond simple naturalism. The grandiose and visionary manner of the *Three Trees*, the *Landscape with a Castle* (Louvre) and the *Landscape with a Coach* (London, Wallace Coll.) foreshadows his exquisite *River Landscape with Ruins* (Kassel Museum) and shows affinities with the painting of Claude.

The 1650s. The works of the following decade display the same radiant maturity together with the hint of a new 'heroic' manner. It is the period of the greatest masterpieces: *Bathsheba* (1654, Louvre); *Aristotle* (1653, Metropolitan Museum); 'The Polish Rider' (c.1655, New York, Frick Coll.); *The Slaughtered Ox* (Louvre); and the biblical figures after Michelangelo: *Jacob with the Angel* (1660) and *Moses Throwing down the Tablets of the Law* (1659) (both, Berlin-Dahlem).

The works of the 1650s are unequalled in the splendour of their technique, especially in the interplay of the thickly painted golds and reds to which Rembrandt became increasingly addicted, from the deeply penetrating portrait of *Jan Six* (Amsterdam, Six Coll.) to *The Blessing of Jacob* (Kassel Museum). His growing ambition to make his mark on his era as a historical painter and as the leader of a new school led to the production of large-scale works and of 'moral' portraits – figures

with a literary or symbolic connection, drawn from the heroic or legendary world of antiquity, and typical of the cultural demands of the Baroque age: *Alexander, Aristotle, Homer, Flora, Lucretia, Cupid and Jupiter and Mercury visiting Philemon and Baucis*.

An incident which occurred in 1654 with the Portuguese merchant Diego Andrada (Rembrandt refused to alter a portrait judged to be a poor likeness) stands out as symbolizing the true nature of Rembrandt's struggle during what were difficult years materially and on which biographers are inclined to dwell: bankruptcy in 1656; the sale of his house in 1658; legal action against Geertghe; co-habitation with Hendrickje Stoffels, censured by the Reformed Church in 1654, with consequent sanctions against the girl in the form of her being forbidden to take communion.

Final period. During his final years Rembrandt became increasingly liberated, original and bold, and the works of this period constitute the apotheosis of his art: *The Syndics of the Clothmakers' Guild* (*The Staal Meesters*, 1662) and *The Jewish Bride*, c.1660 (both Rijksmuseum); *Homer* (Mauritshuis), and the many self-Portraits, some worked on with a palette knife, (Louvre; Kenwood, Iveagh Bequest); *The Return of the Prodigal Son* (Hermitage); the *Virgin* (Épinal Museum); and the *Family Group* (Brunswick, Herzog Anton Ulrich Museum).

Through lyricism, and an exceptional harmony between form and content, Rembrandt, at the end of his life, seems to have reached the very limits of painting and to speak a new language which goes beyond that of art. Subjects and treatment do not differ appreciably from those of the preceding years. Religious themes still predominate. Besides the works already mentioned there were many other masterpieces: *The Denial of St Peter* (Rijksmuseum); the *Circumcision* (Washington, N.G.); *The Disgrace of Haman* (Hermitage) and *Simeon in the Temple* (1669, Stockholm, Nm), one of Rembrandt's last works and left incomplete, but nonetheless overwhelming in its effect.

Classical subjects, treated mainly as 'moral' portraits, continued to fascinate Rembrandt, as can be seen in *Homer* (1663, Mauritshuis), *The Suicide of Lucretia* (1664, Washington, N.G.; 1666, Minneapolis, Inst. of Arts), *Juno* (New York, private coll.) and the moving and mysterious *Woman with a Carnation* (Metropolitan Museum).

The works of these final years include the celebrated *Conspiracy of Julius Civilis* (Stockholm, Nm) and the last *Self-Portrait*, full of penetrating self-analysis (Cologne, W.R.M.). The incredible gaping mouth, fixed in a thick golden impasto, reveals in both subject and technique Rembrandt's fundamental nonconformism. This explains the growing importance, in the last works, of the flat tonal values, the impasted surfaces, the accented relief of form and the use of the reed for tracing thick strokes in drawing. A certain heaviness in the treatment appears as a result, although, in fact, Rembrandt was no longer setting out to please, and neglected details in the costumes, moving further and further away from everyday life towards a wonderful world of his own imagining.

A totally liberated painter with his life in ruins (he had to leave his beautiful house for a lodging in the Rozengracht 1661), Rembrandt in his declining years was, however, never cut off from

the public. He remained a respected master, and even later critics of classical bent, such as Lairesse, Hoogstraeten and Houbraken, admitted that Rembrandt was a great original rather than merely old-fashioned.

Around 1661-2 he received his greatest official commission (apart from *The Night Watch*) from the Town Hall of Amsterdam: *The Conspiracy of Julius Civilis*, proof of his undiminished powers. The gigantic canvas (15ft × 15ft) shows Rembrandt's talent as a decorative painter in the Italian style, and although, shortly after it was hung in the new Town Hall, Rembrandt took the painting back and put it aside in his studio (it was finally replaced by a picture by Juriaen Ovens), this does not necessarily mean that the work had been repudiated. The inventory taken after his death proves that he was able to partially reconstruct his collections. But he had the misfortune to lose Hendrickje in 1663 and in 1668 Titus, who had just married in the previous year, also died.

The task of distinguishing Rembrandt's work from that of his pupils and imitators has been largely successful and has led to more than 600 surviving pictures being attributed to him (without taking into account all the lost works known only through inventories or catalogues). In addition there are about 300 recognized etchings, while the drawings are numbered in thousands. Outside Holland important collections of his work exist in New York, London, Leningrad and Kassel. J.F.

Reni
Guido

Italian painter
b.Bologna, 1575 – d.Bologna, 1642

Together with Domenichino and Albani, Reni studied painting with the Fleming Denys Calvaert. He then turned to the Carraccis, who had opened a new school about 1595, and in so doing determined the course of his future development. From the start, however, he went his own way in the new climate of naturalism foreshadowed by the Carraccis in reaction against Mannerism at the end of the 16th century.

Of an intransigent and aristocratic disposition, Reni did not look to nature for his models, as had Annibale and Lodovico Carracci, but chose instead to follow the cult of beauty and grace originating in the work of Raphael. Reni, in fact had been enthralled by Raphael's *St Cecilia* in the Church of S. Giovanni in Monte at Bologna, and had been inspired by it to execute his first important altarpiece, *The Coronation of the Virgin* (Bologna, P.N.). He also made an exact copy of it, which later found its way to Rome, to the Church of S. Luigi dei Francesi. Slow and retiring by nature, Reni was a long time in freeing himself of the influences that stood in the way of his full development as an artist. The frescoes for the Oratory of S. Colombano, in which he collaborated with other pupils of the Carraccis, still show a certain formal restraint.

In 1602 Reni travelled to Rome to study the works of Raphael and classical sculpture. He encountered, too, the work of Caravaggio, and this proved significant in that it led him to experiment with Caravaggio's style without abandoning his own conventional ideals. *The Crucifixion of St Peter* (1603), painted for the Church of S. Paolo alle Quattro Fontane (Vatican), was his first important work. Going beyond the naturalism of Caravaggio, admired for his luminescence and pictorial values, Reni affirmed his personal vision of painting as representation purged of all ugliness and vulgarity.

From this time, his uncertainty vanished and he became successful in both Bologna and Rome, spending his time in each city in turn. Freed now of all outside influence, he perfected an expressive language using classical linear rhythms and translucent, exquisitely delicate tone values that resulted in a flow of masterpieces. *The Martyrdom of St Andrew* for the Church of S. Gregorio al Cielo, Rome (1608), is a large fresco where the influence of Raphael blends perfectly with a very contemporary feel to the landscape background. The *Scenes from the Life of the Virgin* in the Chapel of the Annunciation in the Quirinal (1611) are notable for their art of charming intimacy. *Samson Victorious* and *The Massacre of the Innocents* (1611, Bologna, P.N.) are major landmarks in 17th-century classicism, and are admirably constructed, with their juxtaposition of colour and rhythmical accentuation. *Aurora*, the decorative fresco on the ceiling of the Casino Rospigliosi in Rome (1614), is a most touching evocation of Raphael's classicism, created a century earlier.

In 1614, at the height of his success, Reni finally settled in Bologna. This decision may have been forced on him as the result of some disagreement with the papal curia, or it might have stemmed from a need for greater independence, which was easier to find in the provinces. This return to his birthplace coincided with a considerable enrichment of his art.

The great and severe altarpiece of the *Mendicants* (Bologna, P.N.), constructed in two parts (the *Pietà* and the *Patron Saints of Bologna*) like a quattrocento painting, bears witness to a spiritual crisis resolved poetically. From his *Crucifixion* for the Capuchin church (1616, Bologna, P.N.) to *The Labours of Hercules* (Louvre), from the *Annunciation* (Genoa, Church of S. Ambrogio) to *Atalanta and Hippomenes* (Naples, Capodimonte), the tension increased to such a degree that it became difficult to sustain within the limits of the classical balance that Reni had set himself. In fact, after 1620, he allowed himself moments of grace and elegance, and of theatrical sentimentality, which alternated with works of great spiritual intensity. Thus his pictures of famous women (*Cleopatra, Lucretia, Semiramis, Salome, Judith*) all display the amorous langour for which he became famous, but which was also his greatest weakness.

At the same time he produced many religious canvases of excessive piety. While working on these paintings he conceived new images whose unearthly beauty gave birth to a light which seemed increasingly unreal. Gradually his palette lightened, acquiring iridescent reflections (*The Virgin and Child Surrounded by Angels and the Patron Saints of Bologna* (1631-2, Bologna, P.N.). This degree of poetic exaltation led to the use of increasingly clear and silvery colours, which, however, were allied to a feeling of unease. The intense spirituality of some of his works led his contemporaries to mistake them for rough drafts: *St Sebastian* (Bologna, P.N.); *St John the Baptist* (London, Dulwich College Art Gal.); *Madonna and Child with St John* (Florence, Longhi Foundation); *Lucretia, Young Girl with a Coronet* and *Cleopatra* (all Rome, Capitoline Gal.) and a *Flagellation* (Bologna, P.N.). Through these beautiful compositions, for so long misunderstood, Reni freed himself from the uniformity of the classical painters of the 17th century and established himself as one of the greatest and most purely lyrical artists of his age. E.B.

Renoir
Pierre Auguste

French painter
b.Limoges, 1841 – d.Cagnes-sur-Mer, 1919

Youth. Renoir spent his childhood in Paris. Early on he displayed a gift for music which was en-

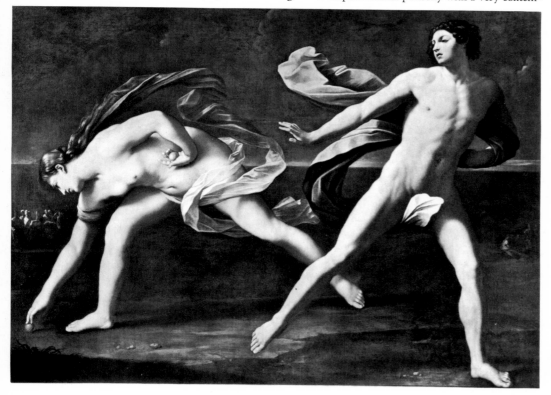

◀ Guido Reni
Atalanta and Hippomenes
Canvas. 206 cm × 297 cm
Naples, Galleria Nazionale di Capodimonte

couraged by Gounod, but his parents, recognizing the boy's even greater talent for drawing, apprenticed him to a porcelain-painter in 1854. Here Renoir remained for four years, attending classes in the evening at a school for drawing and decorative arts in the Rue des Petits Carreaux. When the porcelain-painter's workshop closed down Renoir was employed by his brother, an engraver of medals, to colour coats-of-arms. He went on to decorate fans with pictures of gallants and their ladies, and subsequently painted blinds and awnings. Eventually he saved a little money and was able to devote all his time to painting.

Renoir was admitted to the École des Beaux Arts in 1862, and then enrolled at the Académie Gleyre, where he met Bazille, Monet and Sisley. Together they took to painting out of doors in the forest of Fontainebleau, and it was here, in 1863, that Renoir met Diaz who advised him to lighten his palette.

Renoir's first submission to the Salon in 1864, *Esmeralda dansant avec sa chèvre* (*Esmeralda Dancing with her Goat*), was accepted, but later Renoir destroyed the painting, thinking it too sombre and academic. He then fell deeply under the influence of Courbet, having met him at Marlotte near Fontainebleau. This influence is evident in his first large-scale composition, *Auberge de la mère Anthony* (*The Inn of Mère Anthony*) (Stockholm, Nm), rejected by the Salon in 1866, and also in one of his first nudes *Diane chasseresse* (*Diana, the Huntress*) (1867, Washington, N.G.), rejected by the Salon in 1867. Meanwhile Renoir was painting portraits to good effect, catching the sitter's personality: *Bazille* (1867, Louvre, Jeu de Paume), those of the *Sisley Family* (1868, Cologne, W.R.M.) or the *Femme à l'ombrelle* (*Woman with a Parasol*) (1867, Essen, Folkwang Museum), hung in the Salon in 1868.

Impressionism. However, it was Impressionism that was to free Renoir from these various influences. From 1869 when he painted *La Grenouillère* (Winterthur, Oskar Reinhart Foundation) in company with Monet, he became obsessed with the study of reflections on water, and began adding small accents of colour to replace the drawing. The two painters continued along these lines after 1870 at Argenteuil where they painted regattas and a variety of landscapes. But Renoir, unlike his friends, had not abandoned the human form, where he also tried to apply Impressionist principles.

He was comparatively successful with *Parisiennes habillées en Algériennes* (*Parisian Women Dressed as Algerians*) (1872, Tokyo, N.M. of Western Art), in which he was obviously influenced by Delacroix, and with his *Cavaliers au bois de Boulogne* (*Horsemen in the Bois de Boulogne*) (1872, Hamburg Museum), rejected by the Salon in 1873 but shown at the Salon des Refusés. His true brilliance emerged only in *Madame Monet étendue sur un sofa* (*Madame Monet Reclining on a Sofa*) (1872, Lisbon, Gulbenkian Foundation) and in *La Loge* (*The Box*) (1874, London, Courtauld Inst. Galleries) as well as *La Danseuse* (*The Dancer*) (1874, Washington, N.G.), the two latter paintings being shown with four other canvases and a pastel at the first Impressionist Exhibition.

After this his development quickened, and from 1876 he applied his Impressionist principles to portraits, with which he was again successful, showing 15 paintings at the second Impressionist Exhibition in 1876. This was a lucky year for Renoir. He rented a studio in the Rue Cortot in

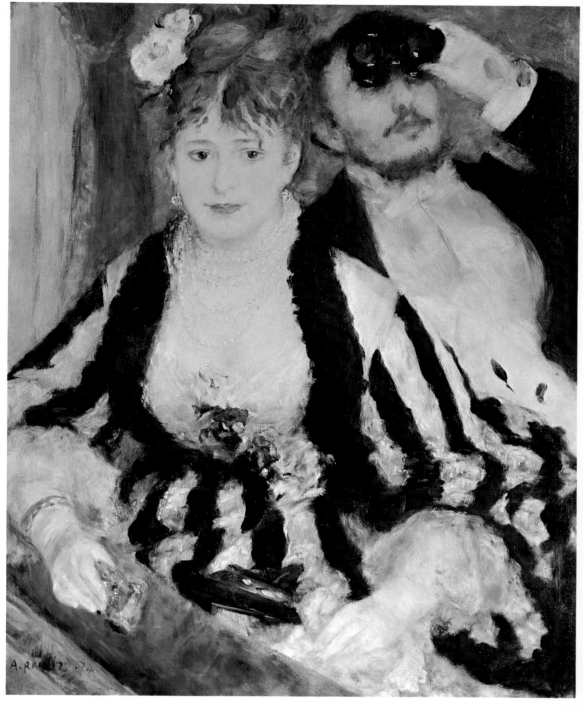

Montmartre where he produced some of his most famous works, such as *Le Moulin de la Galette, La Balançoire* (*The Swing*), *Torse de femme au soleil* (*Nude in Sunshine*) (all Louvre, Jeu de Paume), and *Sous la tonnelle* (*Under the Arbour*) (Moscow, Pushkin Museum). In all these different canvases, which he exhibited in 1877 at the third Impressionist Exhibition, Renoir aimed at capturing the effect of light filtering through trees on to figures in the shade (which, the critics said, make them resemble corpses). It was also at this time that Renoir became acquainted with the publisher Georges Charpentier and was frequently invited to his glittering salon, where he met the leading political, literary and artistic figures of the day.

To earn a living he had to undertake many commissions, including works of decorative art and a number of portraits of mothers with their

children: *Mlle Georgette Charpentier* (1876, private coll.); *L'Enfant à l'arrosoir* (*Child with a Watering-Can*) (1876, Washington, N.G.); *Mme Georges Charpentier* (1876-7, Louvre, Jeu de Paume); *Portrait de Mlle Jeanne Samary* (1878, Hermitage), and the magnificent *Portrait de Mme Charpentier et de ses enfants* (1879, Metropolitan Museum). These last two portraits were shown at the 1879 Salon, Renoir refusing to show at the fourth Impressionist Exhibition, no doubt in the belief that this would compromise his success with Parisian society, which accepted him as a brilliant portraitist.

He displayed less worldliness but equal brilliance in his paintings of the habitués of small suburban bistros and in his *Portrait d'Alphonsine Fournaise* – wrongly called *À la Grenouillère* – (1879, Louvre, Jeu de Paume). He took no part

▲ Auguste Renoir
La Loge (1874)
Canvas. 84 cm × 65 cm
London, Courtauld Institute Galleries

again in the fifth Impressionist Exhibition of 1880, showing instead two canvases at the Salon, *La Femme au chat* (*Woman with a Cat*) (1880, Williamstown, Clark Art Inst.) and *Pêcheuses de moules à Berneval* (*Fishing for Mussels at Berneval*) (1879, Merion, Barnes Foundation). These were painted during a holiday at Wargemont, near Dieppe, where he was staying with the diplomat Paul Bérard, whose guest he often was during the summer.

It was perhaps this double life, both fashionable and commonplace, that prompted him to go to Algeria for a time for a rest, from the beginning of March to 15th April 1881. He returned with several paintings of Algerian women and vividly coloured landscapes: *Champs de bananiers* (*Fields of Banana Trees*), *Ravin de la femme sauvage* (*Ravine of the Wild Woman*), *Fête arabe à Alger* (*Arab Fête at Algiers*) (all Louvre, Jeu de Paume).

The 'harsh style'. On returning to France, Renoir suffered a breakdown and, at the end of October 1881, went to Italy for several months. He stayed in Milan and Venice, where he produced several paintings of gondoliers and of the Basilica of St Mark, before going on to Florence and Rome. The art of Raphael came as a revelation which was to influence his style from then on, and which led to what he called his *manière aigre* or 'harsh style'. It could equally well be termed his Ingres period, where drawing took precedence over colour and his painting shows a sharper definition of form. This ascendancy of drawing is already evident in *Les Parapluies* (*The Umbrellas*) (*c*.1879, London, N.G.) as well as in *La Baigneuse blonde* (*The Blonde Bather*) (1881, Williamstown, Clark Art Inst.) but it was not until 1883 that the new method reached its peak.

During this same Italian visit Renoir went to Naples and Pompeii and stayed in Sicily long enough to produce a hasty portrait of *Richard Wagner* (1882, Louvre, Jeu de Paume). On his return to France he stayed at L'Estaque where he worked with Cézanne, then departed again for Algeria (March-April 1882). Meanwhile the seventh Impressionist Exhibition was held in Paris, with 25 paintings by Renoir, including his *Déjeuner des canotiers* (*The Rowers' Lunch*) (1880-1, Washington, Phillips Coll.), in which he portrayed Aline Charigot, his future wife.

During the Ingres period Renoir continued to paint the human form: *Danse à Bougival* (1883, Boston, M.F.A.); *Danse à la ville* (1883) and *Danse à la campagne* (1883; both Paris, Durand-Ruel Coll.). He also painted landscapes and seascapes during his many trips to the Channel Islands (September 1883), the Normandy and Brittany coasts, the Côte d'Azur and La Rochelle (summer, 1884). The most representative work in the *manière aigre* remains *Les Grandes Baigneuses* (*The Bathers*) (1884-7, Philadelphia, Museum of Art), inspired by Girardon's *Bain de Diane* (*Diana's Bath*) (Versailles). The canvas was painted in the studio and Renoir prepared for it with numerous studies, drawings, and sketches in both crayon and sanguine (Nice Museum; Louvre).

'Pearly period'. Renoir went through another period of depression in the autumn of 1888. Finding his compositions too dry he destroyed many of his canvases and adopted a new method called the 'pearly' method, gradually giving up his linear style to make the most of a more supple technique based on half-tones of pink and white: *Les Jeunes*

Filles au piano (*Young Girls at the Piano*) (1892, Metropolitan Museum; Louvre, Jeu de Paume). Towards the end of his life Renoir used mainly professional models, except for his servant Gabrielle. Almost all the nudes he painted bore the title 'Bather': *Baigneuse assise sur un rocher* (*Bather Seated on a Rock*) (1892, Paris, private coll.); *Baigneuse endormie* (*Sleeping Bather*) (1897, Winterthur, Oskar Reinhart Foundation); *Grande baigneuse écartant sa chevelure* (*Bather Letting down her Hair*) (*c*.1904-6, Vienna, K.M.); *Baigneuse aux cheveux longs* (*Bather with Long Hair*) (Paris, Musées Nationaux, Walter Guillaume Coll.).

The artist's sensuousness has never been more beautifully expressed than in his portrayals of these buxom young women with their soft pearly flesh. At the same time he extended his range to include pictures of children, but not only those of the well-to-do. Renoir painted his own sons, Pierre (*b*.1885), Jean (*b*.1894), but mostly Claude, called Coco (*b*.1901), in spontaneous poses taken from everyday life: *Gabrielle et Jean* (1895, Paris, Musées Nationaux, Walter Guillaume Coll.); *La Leçon de lecture de Coco* (*Coco's Reading Lesson*) (*c*.1906, Merion, Barnes Foundation).

Cagnes-sur-Mer. In 1903 Renoir moved to Cagnes and from then on a certain change in his work became apparent. The figures that he painted in his untended garden, planted with olive trees, had a sculptural quality, while red became the dominant colour, increasing in strength with the artist's approach to old age. It was also the predominant colour in his still lifes: *Les Fraises* (*Strawberries*) (Bordeaux Museum); *Nature morte aux pommes* (*Still Life with Apples*) (Nice Museum); *Roses dans un vase* (*Roses in a Vase*) (Louvre, Jeu de Paume). Most of these works were small in size. One of the painter's peculiarities at this time was his habit of painting many different subjects, all very small, on the same canvas. The minute studies to be found on the market are often pieces from canvases that have been cut up.

By now Renoir's hands were completely paralysed by arthritis and his brushes had to be placed between his fingers. Yet, his creative genius was as strong as ever. Encouraged by Ambroise Vollard to try lithography and engraving, Renoir made several portraits of him, and took up sculpture with the same verve, being helped by his assistants, who modelled the clay, adding or removing it as Renoir directed.

About 15 pieces were cast, among them *Venus Victrix* (Cagnes, Maison des Collettes) and *Le Jugement de Paris* (plaster cast in the Louvre, Jeu de Paume). Included in the intensely active period at Cagnes, where Renoir worked mostly on small pictures, *Les Baigneuses* (*c*.1918, Louvre, Jeu de Paume) is exceptional. It is one of his last great compositions before his death.

Renoir worked far more quickly than his fellow Impressionists and his pictures from the beginning were eagerly sought after. As a result they are to be found today all over the world and in many private collections. The most important large collections are in the Louvre (Jeu de Paume), the Metropolitan Museum, the National Gallery in Washington, the Barnes Foundation in Merion, the Clark Art Institute in Williamstown (U.S.A.) and the Hermitage. N.B.

Repin
Ilya Lefimovich
Russian painter
b.Chuguyev, Kharkov, 1844 – d.Kuokkala (now Repino), 1930

Born into a family of Ukrainian settlers. Repin received his first drawing lessons from an icon painter in the Kharkov region. He arrived in St Petersburg in 1863, and attended the school of drawing attached to the Society for the Encouragement of Fine Arts where his teacher was Kramskoi, a founder of the Peredvizhniki group. The following year Repin was admitted into the Academy and studied there until 1871, when he won a scholarship to France. However, it was two years before he left for Paris, where he worked until 1876, interrupting his stay with journeys to Italy. He was in Paris in 1874 for the first Impressionist Exhibition, which interested him from a technical viewpoint but seemed otherwise quite meaningless. This is why the theme of his admission painting for the Academy, executed while he was abroad, was that of an old Russian fairy story, *Sadko*, which the painter filled with symbols.

On his return to Russia Repin settled in Moscow, where the way of life was more to his taste and more favourable to the production of

Ilya Repin ▶
The Procession in the Region of Kursk (1880–3)
Canvas. 175 cm × 280 cm
Moscow, Tretiakov Gallery

authentic Russian painting. It was there that, in the company of Polenov, Surikov and Vasnetsov, he joined the circle of Savva Mamontov while still remaining closely linked with Kramskoi and the Peredvizhniki, with whom he regularly exhibited. He returned to St Petersburg in 1882, travelled (Holland, Spain, 1883), exhibited, frequented the company of painters, musicians, writers and the nobility, and became successful. Connected with the Mir Iskusstva group from its foundation, he took part in the first exhibition organized by Diaghilev and became a member of the editorial committee of the review founded in 1898. However, in spite of a mutual admiration a rupture occurred between Repin, the supporter of didactic realism, and the group, whom Repin accused of dilettantism.

Repin found himself at a crucial moment in his career. His desire to instruct resulted in a meticulous attention to detail in his genre painting and his historical scenes, but the epic inspiration was lacking. His inconstancy regarding his subjects made him fill notebooks with sketches that were never developed, and many paintings conceived at this time were never finished or even begun, despite the advice of Tolstoy, who saw in him the pictorial executor of his own ideas. However, as a studio director of the Fine Arts Academy after 1894, Repin was very successful and in great demand as a teacher because he allowed the utmost freedom to individual development. But, disgusted by academic routine against which he was helpless, in spite of promises of reform, he gave up official teaching in 1907 and retired finally to his estate at Kuokkala, where he had mostly lived after painting his famous *Solemn Session of the Council of State* (1901-5, Leningrad, Russian Museum). His last public appearance in St Petersburg was for the celebration of his jubilee in 1917.

An excellent draughtsman with a great pictorial gift, Repin left, besides many sketchbooks, vigorous canvases notable not only for the expressive realism characteristic of the Peredvizhnikis, but equally for a deeply Russian sentiment. His attachment to his native country motivated both his first great painting, the famous *Boathaulers of the Volga* (1872, Leningrad, Russian Museum), seen as an indictment of the loss of personal liberty, and *Sadko* (1876, Leningrad, Russian Museum) with its Symbolist overtones. Repin was not given to fantasy and *Sadko* seems on the face of it to stand outside the main body of his work. However, he himself explained the legend's symbolic content: just as Sadko, plunged into the strange Kingdom of the Sea, chooses from among the beautiful creatures of the world who file past him a young Russian girl, so Repin, alone in the alien world of the West, clings to his dream of Russia.

The search for psychological expressiveness constantly breaks through. The most famous examples are *The Procession in the Region of Kursk* (1880-3), *The Return of the Exile* (1884). *Ivan the Terrible before the Body of his Son* (1885; all Moscow, Tretiakov Gal.) and *The Zaporogian Cossacks* (1891, Leningrad, Russian Museum, copy in Moscow, Tretiakov Gal.). Some excellent portraits of his contemporaries, such as *Mussorgsky* (1881), *Tretiakov* (1883) and *Tolstoy* (1887; all Moscow, Tretiakov Gal.), complete a varied *oeuvre*, which received the seal of official recognition with the *Solemn Session of the Council of State* and continues to be highly esteemed today in the USSR. B. de M.

Restout
Jean II

French painter
b.Rouen, 1692 – d.Paris, 1768

Restout's father, Jean Restout I, was a painter from Caen who had moved to Rouen where he married the sister of Jean Jouvenet. The latter became the godfather and teacher of his nephew Jean II. About 1707 Restout left Rouen for Paris, the city where he was to make his career. In 1720 he was admitted to the Académie with his *Alphée et Aréthuse* (Rouen Museum), eventually becoming Director in 1760.

Restout's work includes mythological paintings, very close in feeling to Boucher, in which elegant female forms are paired with bronzed male figures – although Restout's colours are simpler and less unrealistic than Boucher's (Sopraporta, Hôtel de Soubise, 1736-8, now in the National Archives; *Histoire de Psyché* [*Story of Psyche*], 1748, Versailles). The main part of his output, however, consisted of religious paintings. He continued Jouvenet's work, as may be seen in his tapestry cartoons of the *New Testament* (*Baptême du Christ* [*Baptism of Christ*], 1733, Louvre), as well as in several early paintings (*Saint Paul et Ananie* [*St Paul and Ananias*], 1719, Louvre; *Guérison du Paralytique* [*Healing of the Paralytic*], 1725, Arras Museum; *Mort de Sainte Scholastique* [*Death of St Scholastica*], 1730, and *Extase de Saint Benoît* [*Ecstasy of St Benedict*] (both Tours Museum); *Pentecôte* [*Pentecost*], 1732, Louvre).

Like his uncle, Restout had the gift of breathing life into large-scale architectural compositions by virtue of his acute observation – a quality that is also manifest in his portraits: *M. du Basset, Chartreux de Gaillon* (1716, Rouen Museum); *Abbé Tournus* (c.1730, one copy in Vire Museum);

and the *Portrait de Jean-Bernard Restout* (1736, Stockholm, Nm).

However, his style differs fundamentally from that of Jouvenet. The elongated figures, of which he was so fond, with their disproportionately small heads emerging from swirling draperies, sometimes recall the art of Bernini: *Saint Hymer dans sa solitude* (*St Hymer in Solitude*) (1735) and *La Charité de Saint Martin* (*The Charity of St Martin*) (both Calvados, St Hymer's Church); *Présentation de la Vierge* (*Presentation of the Virgin*) (1735, Rouen Museum). Restout's visionary talent and realism are expressed in a very free technique, a light and supple laying on of paint in which greys and pinks often predominate: *Le Triomphe de Mardochée* (*The Triumph of Mordecai*) (1755, Paris, Church of St Roch); *La Purification* (1758, Paris, Church of St Roch, sketch in Rouen Museum).

. A highly regarded teacher, Restout wrote an *Essai sur les Principes de la Peinture* (finally published 1863, Caen) which is interesting for its inclusion of the precepts of Jouvenet, La Fosse and Largillière. In spite of his originality, Restout was little imitated, except by mediocre provincial artists such as Wampe. A.S.

Reynolds
Sir Joshua

English painter
b.Plympton, Devon, 1723 – d.London, 1792

After receiving a classical education from his father – a clergyman-schoolmaster and former Fellow of Balliol College, Oxford, whose library included books on the theory of painting – the young Reynolds went to London to study art in 1740, announcing on his departure that he 'would rather be an apothecary than an *ordinary* (i.e. portrait) painter'. However, his chosen master was the fashionable portraitist Thomas Hudson, and it is a mark of Reynolds's character that he always sought the most prudent path to success. He knew that portraiture was the only reliable way for an English artist to make a living. His early style shows the influence of Hudson, Rembrandt and Van Dyck.

He worked in London and Devon from 1743 to 1749, then sailed for Italy in the ship of Commodore (later Admiral) Keppel, whose portrait he painted several times in this and later years – most notably in 1753-4 after returning to London, when his full-length portrait of Keppel (now Greenwich, National Maritime Museum) made his reputation as the leading English painter. While in Italy he spent two years in Rome studying classical antiquity, Raphael and Michelangelo, at a time when it was rare for visiting artists to take a serious interest in the past.

He left Rome in May 1752, passing through Florence, Bologna and Parma on his way to Venice, where he stayed only three weeks but made an unusual number of sketches of paintings by the great Venetian Renaissance masters. It was from Titian above all (although also from artists who belonged broadly to the Titianesque tradition, such as the Carracci, Rubens and Rembrandt) that Reynolds learnt the technical side of his art – his brushwork and treatment of light, shade and colour. Though extolling the superiority of form to colour in his theoretical writings, he remained a 'painterly' painter, with his roots in

the Baroque past, and he despised the work of his foreign contemporaries.

Within two years of settling in London in 1753, where he lived until his death in 1792, he had well over a hundred sitters and was already employing assistants to paint draperies, among them Giuseppe Marchi, whom he had brought with him from Rome. At this stage of his career he charged 12 guineas for a head, 24 guineas for a half-length portrait, and 48 guineas for a full-length portrait. By 1782 his prices had risen to, respectively, 50, 100 and 200 guineas – double the rate of his nearest rival, Gainsborough.

Typical sitters of the 1750s included Lord Cathcart (The Trustees of Earl Cathcart), the Duke of Grafton (Oxford, Ashmolean Museum) and Lord Ludlow (Woburn Abbey, Duke of Bedford's Coll.), all depicted in the Venetian taste.

In the next few years he began to respond to Ramsay's more delicate style, after the latter's return from his second visit to Italy in 1757, and produced a series of tender and intimate portraits, mainly of women, of which perhaps the finest is *Georgiana, Countess Spencer and her Daughter* (1759–61; Althorp, Northants., Earl Spencer's Coll.).

Meanwhile Reynolds had also developed a formal manner, prompted by the inception of public exhibitions. To the first Society of Artists exhibition in 1760 he sent four works, including a full-length portrait of the *Duchess of Hamilton* (Port Sunlight, Cheshire, Lady Lever Art Gallery). She appears in the long, loose 'classical' dress (under her peeress's cloak) that Reynolds often favoured in the 1770s and leans on a sculptured relief of the Judgement of Paris. This was a type of portrait that admittedly had precedents in the 16th and 17th centuries but which Reynolds used as a means of raising portraiture through its classical associations 'far above its natural rank' (as he put it later in his *Discourses*).

Throughout the 1760s the two styles, the formal and the intimate, continued side by side in Reynold's work (although the division between

them was never hard and fast) and the great 'portrait gallery without walls' that he created of the English 18th-century aristocracy, officer corps and intelligentsia began to emerge. He commanded an astonishing variety of pose, and his output included portraits of children and groups as well as individual sitters. With the first exhibition of the Royal Academy in 1769 he made a further effort with the classical, or historical, style and contributed four female portraits, all with allegorical overtones, their poses being taken from Correggio, Albani, Guido Reni and Guercino. This style dominated his art in the 1770s, culminating in *The Three Daughters of Sir William Montgomery as 'The Graces adorning a Term of Hymen'* of 1773 (London, Tate Gal.), of which he wrote to the sitters' father, who had ordered the picture, that '[The subject] affords sufficient employment to the figures, and gives an opportunity of introducing a variety of graceful historical attitudes.'

Reynolds had been unanimously elected President of the Royal Academy on its foundation in 1768, although he had never found real favour with the King (it was almost his only material failure). In 1769 he gave the first of 15 *Discourses*, which he delivered at the Academy, usually on prize-giving day, between this year and 1790. In these lectures, afterwards printed, he expounded, commented on and amplified the tradition of orthodox academic art-theory as it had been derived from classical literature and developed by Continental writers since the Renaissance. In so doing he sought to give English art a much-needed intellectual foundation, to raise the social status of the English painter and to encourage a more catholic, better-informed taste among patrons.

He succeeded in at least the second of these aims, but the central theme of the *Discourses* – that history painting in the pure, noble style, based on mastery of form, created by Michelangelo and Raphael, is superior to all other types of art – never found a very clear or powerful echo in English painting, for a variety of reasons. In some ways Reynolds's most enduring contribution as a writer on art lay in his critical asides, notably on his contemporary and opposite, Gainsborough, in whose honour the 14th *Discourse* was delivered after his death in 1788.

In 1781 Reynolds visited Flanders and Holland, where he took extensive notes – a journey that deepened his interest in Rubens. Several portraits of the 1780s reflect the latter's influence (*Lady Lavinia Spencer*, 1782, Althorp, Earl Spencer's Coll.), although the most explicit tribute Reynolds paid to Michelangelo – *Mrs Siddons as 'The Tragic Muse'* (1784, San Marino, California, Huntington Museum and Art Gal.) – also belongs to this decade. In addition, most of his rare – and surprisingly unclassical – pure history paintings are of the same period (*Macbeth and the Witches*, 1789, Petworth, Sussex, Lord Egremont's Coll.). Despite experiments with unsound pigments and media that have caused the ruin of many pictures, his late work shows no decline in invention.

There is little doubt that Reynolds is the most important single painter in the history of the English School, although more through his prestige, his authority, his breadth of culture and his connections, than through his actual work. Almost all his virtues have their corresponding defects – he was moderate but also devious, ambitious but also snobbish, intelligent but also arid, generous to his rivals but only when they were dead.

Nevertheless, he 'institutionalized' English painting, giving his 19th-century successors a standard both to look up to and to react against.

He is well represented in British galleries, in Edinburgh and Glasgow, but especially in London: six paintings in the National Gallery, notably the portraits of *Anne, Countess of Albemarle* (1757-1759) and of *Lord Heathfield, Governor of Gibraltar* (1787); some 20 works in the National Portrait Gallery and 32 in the Tate Gallery; and several in the Royal Academy, including two *Self-Portraits*. Some of his masterpieces, however, are still in private hands, such as *Master Crewe* (1776, O'Neill Coll.) and the portrait of George IV when he was *Prince of Wales* (1783, Lord Brochet's Coll.) M.K.

Ribalta
Francisco
Spanish painter
b. Solsona, Lérida, 1565 – d. Valencia, 1628

This great painter, founder of the Valencian tenebrist school, was a Catalan, as the recent discovery of his baptismal certificate at Solsona proves. He was trained in Castille in the artistic ambience of the Escorial. His earliest known works, including a *Crucifixion* (1582, Hermitage), reveal his connexion with the Italians Zuccaro and Tibaldi, and also with Cambiaso and Navarrete el Mudo (whom he copied freely in his series of the *Martyrdom of St James*; Escorial, Church of Algemesi). He married in Madrid in 1596 and his son Juan was born there the following year, but 1599 found him in Valencia where he spent most of the rest of his life. He may have visited Italy some time between 1616 and 1620 (the only period of his life of which there is no record), perhaps in order to study the work of Caravaggio

▲ Sir Joshua Reynolds
Portrait of Nelly O'Brien
Canvas. 126 cm × 100 cm
London, Wallace Collection

▲ Francisco Ribalta
Christ Embracing St Bernard
Canvas. 158 cm × 113 cm
Madrid, Museo del Prado

(signed copy of *The Crucifixion of St Peter*, Rome, private coll.).

He painted some important series in and around Valencia, notably the altarpieces for the church of Algemesi (1603–4; partially destroyed in 1936), and some large oils for the College of the Patriarch founded by Archbishop Juan de Ribera (*Vision of St Vincent Ferrier*, 1604; *The Last Supper*, 1606, for the high altar). He also painted some excellent portraits of the Archbishop (College of the Patriarch). But his masterpieces were the paintings executed for the Capuchin monastery, a contract having been signed in 1620 (*St Francis Ill, Comforted by an Angel*, Prado; *St Francis at the Feet of Christ Crucified*, Valencia Museum; *Christ Embracing St Bernard*, Prado), and the altarpiece for the Charterhouse of Porta-Coeli (1625, Valencia Museum).

In all Ribalta's later work the uncertain realism of his early style develops into a broad, frankly Baroque naturalism that incorporates elements from Caravaggio and the Venetian school, as well as a liberal interpretation of the living model. Ribalta created some of the most noble and austere works in all Spanish painting (*Sts Peter, Paul and Bruno* in the altarpiece of Porta-Coeli, Valencia Museum). He had an important workshop and many pupils, in the first rank of whom was his son Juan. His influence on Valencian painting was immense. A.E.P.S.

Ribera
José de

Spanish painter
b.Jativa, Valencia, 1591 – d.Naples, 1652

There is now some doubt whether Ribera trained in Valencia with Ribalta, as has always been believed. At all events, he left Spain for good at an early age and settled in Italy. Here he visited Parma and Bologna, where Lodovico Carracci praised his work, and before 1615 was in Rome. He is mentioned as one of the most important artists to adopt the style of Caravaggio, as well as leading a hectic and unconventional life. In 1616 he settled in Naples and married the daughter of a modest local painter, Azzolini. From then on, thanks to the patronage of successive Spanish viceroys, he became the most famous and sought-after artist in the city, and remained so almost until the end of his life. He was nicknamed *Spagnoletto* because of his small stature. His children's dates of birth between 1617 and 1636 are recorded, and many works are accurately dated from 1621 until his death.

Ribera was elected to the Accademia di San Luca in Rome before 1626, the year in which he signed his nickname to the *Drunken Silenus* (Naples, Capodimonte). In the last years of his life, following the anti-Spanish revolt of Masaniello (1647), his success declined, possibly because of ill health and his slowness in executing his work – although his output may also have been affected by the scandal attendant on the seduction of his daughter by Don Juan José of Austria, an illegitimate son of Philip IV. In spite of this, Ribera made two portraits of him, one engraved, the other painted in 1649 (Madrid, Royal Palace).

Nothing is known of Ribera's beginnings as an artist, since his first dated pictures go back only to 1626. Prior to this only a number of etchings have

survived, but these are of such a quality as to place him as the most important of Spanish engravers and one of the best in Europe of the Baroque age. His etchings (*St Jerome; The Poet; Drunken Silenus*) are notable both for the firmness of the line and the beauty of the chiaroscuro, which avoids the excessive contrasts to be seen in some of his early paintings. His earliest surviving works follow Caravaggio closely, despite certain affinities with the Bolognese school and especially with his rival Guido Reni (*Calvary*, commissioned by the Duke of Osuna, Viceroy of Naples, for the Collegiate Church of Osuna, Seville.)

Ribera's taste for tenebrism and violent effects of light burst out of his early works (*St Sebastian*, 1628, Hermitage; *Martyrdom of St Andrew*, 1628, Budapest Museum). But the subtle line of Caravaggio was transformed: Ribera's composition took on an extraordinary monumentality as he used his paint with a compact density which showed up every hair, every wrinkle and wart with an astounding veracity. Probably no artist has carried this art of representing the tactile reality of objects and beings so far, and making the spectator feel it so concretely. His paintings of penitent saints and philosophers of antiquity, represented as picaresque beggars (*Archimedes*, 1630, Prado; *Diogenes*, 1637, Dresden, Gg), as well as sensuous allegories (*The Blind Sculptor or Touch*, 1632, Prado; *Hearing*, 1637, London, private coll.), are all characteristic of this tenebrist method.

After 1635, however, a considerable change came over Ribera's work. His palette grew lighter and his composition, without losing its harsh monumentality, acquired more freedom, perhaps influenced by the Flemish masters whose works Ribera came to know through the collections in Naples, and by a thorough study of the Venetian school. The change can be seen in his imposing *Immaculata* (1635) painted for the Viceroy Monterrey (Salamanca, Agustinas Recoletas) or in *The Triumph of the Magdalene* (1636, Madrid, San Fer-

nando Academy) and *The Martyrdom of St Bartholomew* (1639, Prado).

The mythological paintings of this period have a warm and brilliant sensuality: *Apollo and Marsyas* (1637, Naples, Museo di S. Martino; Brussels, M.A.A.); *Death of Adonis* (1637, Rome, G.N.). The isolated figures of his saints still have the same air of devotion (*The Penitent Magdalene*, Prado; *St Paul the Hermit*, 1640, Prado; *St Agnes*, 1641, Dresden, Gg). But the composition reveals a new skill in the way that Ribera places his figures without loss of balance, while retaining their individuality and his dense rich range of colour (*Virgin of Pity*, 1637, Naples, Carthusian Monastery of S. Martino; *Holy Family with St Catherine*, 1648, Metropolitan Museum; *Adoration of the Shepherds*, 1650, Louvre).

Some of Ribera's last works show a return to tenebrism (*St Jerome*, 1652, Prado) but rendered with a more delicate touch, which models the forms, and with a greater refinement in the use of colour. A restrained gamut of greys (*The Miracle of St Donatus*, 1652, Amiens Museum) competes with a majestic opulence that brings to mind the great Venetians (*Communion of the Apostles*, 1652, Naples, Carthusian Monastery of S. Martino).

An exceptional ability to capture and translate reality made Ribera a powerful portrait painter (*A Jesuit*, Milan, Poldi-Pezzoli Museum) and, on occasion, a cool observer of human deformities, with the curiosity of a naturalist (*Woman with a Beard*, Toledo, Lerma Foundation; *The Club Foot*, 1642, Louvre).

Ribera is one of the greatest figures of the Baroque age. His personality affected both Italian and Spanish art, since the evolution of his rich and complex style was one of the starting points of the Neapolitan school, while the numerous works that found their way to Spain had a comparable influence on a considerable number of Spanish painters. An echo of his art can be found even in the work of certain 19th-century French realists, such as Bonnat or Ribot. A.E.P.S.

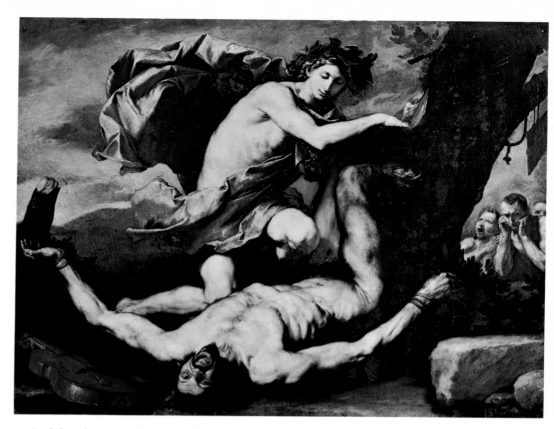

▲ José de Ribera
Apollo and Marsyas (1637)
Canvas. 185 cm × 226 cm
Naples, Museo di San Martino

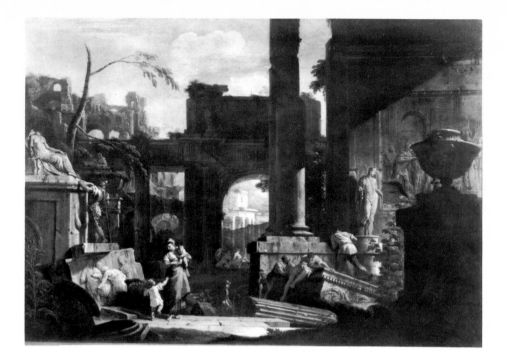

Ricci
Marco

Italian painter
b.Belluno, 1676 – d.Venice, 1730

A nephew of Sebastiano Ricci, Marco introduced landscape painting to Venice in the 18th century. His training at first inclined him towards the 17th-century styles, but his vision, which was always very objective, imbued his subjects with a lively sensitivity and a keen feeling for atmosphere. He was constantly lightening his palette to achieve sunlit effects that could, at times, resemble the work of Canaletto. After several experiments which reveal a personal acquaintance with Neapolitan art, Marco painted some interesting seascapes (particularly that in the Pinacoteca Nazionale, Bologna) in which Magnasco's influence is predominant. His pictorial sense was already well developed, together with a highly personal freedom of handling.

In 1708 Ricci accompanied Pellegrini to London where he stayed until 1716, although he returned to Italy between 1710 and 1712. He worked on stage scenery, and this interest is reflected in the arrangement of certain paintings, such as the *Landscape* in the Venice Accademia, where there is a strong play of contrasts between the dark mass of trees in the foreground and the intense lighting behind.

A trip to Rome in 1720 was of great importance in Ricci's artistic development. He knew Pannini's paintings of ruins, at that time very fashionable, and his *Landscape with Ancient Ruins* (Vicenza Museum), painted in collaboration with his uncle Sebastiano, who put in the small figures, is witness to Pannini's influence. A keen observer, Ricci demonstrates in his *Winter Landscape* (Ca' Rezzonico, Venice) a gift for seizing the passing moment with a spontaneous stroke of his brush. Between 1720 and 1730 he redoubled his efforts to capture the effects of sunlight, and during his final years often used gouache or tempera on copper with which he obtained a clearer and more delicate rendering.

He also used this technique in his *Farmyard* (London, Buckingham Palace, Royal Coll.)

where, under a very clear sky, sunlight filters through the leaves of a vine-arbour, throwing long shadows on the wall. In one of his last works, *Imaginary Landscape* (1728, London, Buckingham Palace), the new juxtaposition of ruins and a Baroque monument strike the eye with sudden, surprising clarity.

Marco Ricci was also an outstanding etcher; 33 landscape engravings survive, in which he uses the same themes as in his paintings and pursues the same quest for light, striving unceasingly to make it more vibrant and more dramatic.

Marco Ricci's paintings and gouaches are to be found in the galleries of Venice, Belluno, Bassano, Trieste, Vicenza, Padua, Bologna (P.N.), Warsaw, Kassel, Dresden (Gg), the City Art Gallery in Leeds, and the Barber Institute of Arts in Birmingham. F.d'A.

Ricci
Sebastiano

Italian painter
b.Belluno, 1659 – d.Venice, 1734

An outstanding personality in 18th-century Venetian art, Sebastiano Ricci was one of the initiators of the bright and pretty rococo style which, from its beginnings in the early years of the century, spread throughout Europe. Ricci had an eclectic and particularly receptive temperament and, during his long training, assimilated all that was new in late 17th-century art (*Nocturnal Vision* or *The Dream of Aesculapius*, Venice, Accademia). His style remained personal and was characterized by a vibrant use of paint and a very free handling of forms in an atmosphere which glows with light.

After studying in Venice with Mazzoni and Cervelli, he moved to Bologna and then to Parma at the behest of Duke Ranunccio Farnese, where he executed works which were clearly influenced by the Bolognese school (*Scenes from Roman History*). Between 1685 and 1687 he decorated in fresco the Oratory of the Madonna del Serraglio, near Parma. His elegant and mannered forms are classical in feeling, but his velvety gradations of

colour clearly derive from Correggio. Ricci next went to Rome, where he made the acquaintance of Pietro da Cortona and Baciccia whose decorative genius influenced him towards a more fluid and supple style.

After a stay in Milan, Ricci returned to the Veneto at the start of the 18th century with a greatly enlarged and up-to-date vision. A study of the work of Veronese now led him to brighten his palette and to seek an increase in luminosity through the juxtaposition of blue and white tones. Several of the light, clear canvases of this period are now in the University of Parma.

The rococo and the Venetian tradition are to be found hand-in-hand in the paintings of this period (ceilings of the Church of S. Marziale, Venice, before 1705). His compositions are bold but strongly foreshortened; his bright colours spread light on to backgrounds of unblemished sky. In Florence he executed decorations (1706-7) in the Palazzo Maruccelli-Fenzi (fresco: *Apotheosis of Hercules*) and the Pitti Palace (*Diana and Actaeon*; sketch, Orléans Museum). These mark a new stage in Ricci's artistic development in which his quick, light rhythm, narrative ease and lightness of touch produced his own, wholly personal, decorative rococo style. In 1708 he painted a *Madonna with Saints* for the Church of S. Giorgio Maggiore, Venice. Here, the forms are broken up by short, rapid brushstrokes, while the colours are clear and limpid – a technique that Ricci continued to develop. The delicately rococo aspect of his method defined itself more precisely while he drew nearer to Veronese.

It was because of his Venetian background that Ricci played such an important role in the formation of a European style at the start of the 18th century. Between 1712 and 1716 he was in London with his nephew Marco. His decoration of Burlington House (now the Royal Academy) was more striking than anything he had done before, the forms seeming to dissolve in a moving atmosphere. The work remained unfinished, however. His greatest achievement in England was the *Resurrection*, painted in the apse of the chapel of Chelsea Hospital. On his way home, he stayed in Paris where he was received into the Académie. Once back in Venice he did not leave there again.

Two paintings (*Solomon Worshipping the Idols* and the *Repudiation of Hagar*, 1724, Turin, Sabauda Gal.), suffused with a silvery light in a continuous vibration of forms, are examples of his deepening study of the chromatism originated by Veronese. Between about 1726 and 1734 Ricci painted a series (now in Hampton Court) for the British Consul in Venice, Smith, using a method that seems to make the subject sparkle out from the canvas. Of his last works one of the most important is *St Gregory* (Church of S. Alessandro della Croce, Bergamo), marking the final stage of the development of a picturesque, totally uninhibited artistic language. F.d'A.

Rigaud
(Hyacinthe Rigau y Ros)

French painter
b.Perpignan, 1659 – d.Paris, 1743

After moving to Montpellier at the age of 14, Rigaud was first apprenticed to Paul Pezet, then

 Marco Ricci
Landscape with Ancient Ruins (Figures by Sebastiano Ricci)
Canvas. 204 cm × 274 cm
Vicenza, Museo Civico d'Arte e Storia

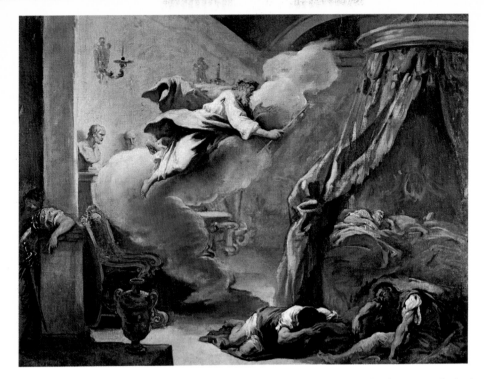

with a remote, refined expression. The fame of many of his models and their connection with Versailles have caused Rigaud to be underrated. He is, in fact, the creator of an original genre, that of the 'portrait of pomp' which was to be spread throughout the European courts of the first half of the 18th century. This style of portrait, of which those of Philip V and Louis XIV are the most celebrated examples, owes much to the Genoan and English works of Van Dyck, perhaps also to 16th-century Florentine art, and certainly to Pourbus and Philippe de Champaigne. But Rigaud's contribution is of the utmost importance, and he played a major role in the history of French portraiture. J.P.C.

Riley
Bridget
English painter
b.London,1931

Bridget Riley studied at Goldsmith's College and at the Royal College of Art in London from 1949 until 1955. Among her contemporaries at the Royal College were Frank Auerbach, Peter Blake, Robyn Denny and Richard Smith. Her early work was realist in character, analytical, but extremely tentative, reflecting her own uncertainties. For a time she stopped painting altogether, taught children, and then began part-time work as a commercial illustrator for the J. Walter Thompson advertising agency, which continued spasmodically until 1964.

From 1958, however, she became particularly interested in the ideas of the painter-teachers Victor Pasmore, Harry Thubron and Maurice de

to Antoine Ranc, who introduced him to the art of Van Dyck. At 18 he went to Lyons and finally arrived in Paris in 1681 where he enrolled at the Academy and in 1682 won the Prix de Rome with his *Cain bâtissant la ville d'Enoch* (*Cain Building the City of Enoch*). However, he gave up the idea of studying in Italy on the advice, it is said, of Le Brun, in order to devote himself to portraiture. He worked with François de Troy and with Nicolas de Largillière, and soon made a reputation in this field. It was, however, with a painting of the *Crucifixion* that he was made an associate of the Académie in 1684. In 1700 he was elected a full member with two portraits of the sculptor *Desjardins* (one in the Louvre, painted 1692) and from that time climbed up the ladder of an academic career, finally becoming Director of the Académie in 1733.

Rigaud's clientele of bankers and financiers grew swiftly, but his reputation suddenly blossomed when, in 1688, he painted *Monsieur*, the brother of Louis XIV, and the following year his son *Philippe d'Orléans*, the future Regent. The King himself sat for Rigaud: portrait of *Louis XIV in Armour* (1694, Prado) and *Louis XIV in Coronation Robes* (Louvre), which is still Rigaud's most famous painting. A perfect emblem of the French monarchy, it was painted in 1701 shortly after the portrait of *Philip V of Spain* (1700, now at Versailles), which was unanimously admired. Following this Rigaud executed brilliant official portraits of the young *Louis XV* in 1717, and again in 1730 (both Versailles).

Rigaud painted over 400 pictures. He kept an account book which has luckily survived (Paris, Bibliothèque de l'Institut) and has helped the art historian to identify his models and date the paintings. His clientèle soon spread outside France: portrait of the *Elector Augustus III* (Dresden, Gg); portrait of *Count Sinzendorf* (Vienna, K.M.). The etchers Edelinck and Drevet helped to circulate Rigaud's work. Often he was so overburdened with commissions that he had to have recourse to collaborators to help in the least important sections of his huge portraits. The portrait of *Bossuet* (Louvre) was painted with the aid of Sevin de La Penaye. At other times he had one of his famous contemporaries paint a small part only, for

example, Joseph Parrocel, who put in the background of the battle in the portrait of the *Duke of Burgundy* (1704, Versailles).

Rigaud is happiest with dazzling and sumptuous portraits against the rich backgrounds that were his speciality: *J.A. Morsztyn and his Daughter* (1693, Cherbourg Museum); *The Marshal Charles-Auguste de Matignon* (1708, Karlsruhe Museum); *Pierre Cardin Le Bret and his Son* (Melbourne, N.G.); *President Hébert* (Washington, N.G.); *Cardinal Dubois* (1723, Cleveland Museum); *Noël Bouton, Marquis de Chamilly* (Pasadena, Norton Simon Foundation); *Cardinal Fleury* (Budapest Museum); *The Financier Antoine Paris* (1724, London, N.G.). His canvases aim at decorative splendour and pictorial magnificence, as in the portrait of the *Marquis de Dangeau* (1702, Versailles), where the sitter is shown in his theatrical costume of Grand Master of the Order of St Lazarus, and in the comically over-ornamented portrait of *Gaspard de Gueidan Playing the Bagpipes* (1735, Aix-en-Provence Museum).

But a more relaxed Rigaud, more of a 'painter' and therefore closer to us, occasionally reveals himself: his portrait of *Marie Serre* (1695, Louvre), for example, is an astounding double portrait of his mother seen in profile and in three-quarters view. Rigaud here produced a work, stripped to its essentials, psychologically penetrating and exceptionally intimate. Portraits of his family, often half-length, can show another world of relaxed people, without ceremony or solemnity: his brother-in-law *Lafitte with his Wife and Daughter* (c.1694, Louvre), the fluent painterly brushwork combining tones of pink and grey. The family appears in other portraits, official and 'posed': *The Léonard Family* (1693, Louvre) or *The Judge's Family* (1699, Ottawa, N.G.), magnificently arranged and enriched by picturesque accessories – fruit, flowers and animals.

His broad and vigorous style and the way he dwelt on his models' nobility of posture, pageantry and splendour explain Rigaud's success. A painter who loved crumpled and scintillating draperies, curtains shimmering in strong contrasts of light and shadow, he orchestrated these luxurious elements around the theme of a face, both proud and amiable, often half-smiling,

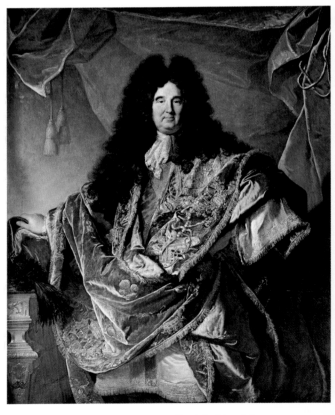

Sebastiano Ricci ▲
Nocturnal Vision (Dream of Aesculapius)
Canvas. 62 cm × 100 cm
Venice, Galleria dell'Accademia

Hyacinthe Rigaud ▲
Portrait du Marquis de Dangeau (1702)
Canvas. 162 cm × 130 cm
Versailles, Musée National du Château

Sausmarez, who were showing in art schools at Newcastle and Leeds how the kind of teaching first developed at the Bauhaus could be adapted for English use. Their systematic investigations of shape, colour, tone and space accorded with Bridget Riley's own experiments. In 1960 she began teaching at Hornsey with de Sausmarez, but she quickly realized that it was in abstract painting and not in teaching that she could best express her ideas.

Large black-and-white abstract pictures, exploiting simple optical effects, were first exhibited at Victor Musgrave's Gallery One in London in 1961. Although similar work had been produced in Paris by Vasarely for some years, Riley's painting was immediately recognized as being independent and personal; it also existed at a more searching and perceptive level. Her contact at this time with the Gestalt psychologist Anton Ehrenzweig no doubt greatly enriched the artist's understanding of the perceptual and optical implications of her new work.

Success for Bridget Riley came very suddenly in the early 1960s. By 1965 she had featured in a number of major international exhibitions, culminating in 'The Responsive Eye' at the Museum of Modern Art in New York: an example of her work was chosen for the catalogue cover of this exhibition. Her 'Op Art' became so fashionable that it was, to the artist's chagrin and without her permission, adapted for use in window display and textile design. Important exhibitions followed, for example at the Venice Biennale in 1968, where she won the painting prize, and at the Hayward Gallery in London in 1971.

Bridget Riley's earliest paintings had no tonal variation: they were in black and white only, and were based on the repetition and adaptation of regular shapes in ways that seemed to deny the flatness of the picture. From 1964 onwards the artist began to use a range of grey tones in her work. This line of development is exemplified in the set of four screen prints of 1968, *Nineteen Greys*.

In 1967 she introduced colour in the *Cataract* series of paintings, and throughout the 1970s her most typical work has consisted of vertical or horizontal bands of variegated colour. The paintings are carefully designed by the artist, and immaculately executed on a large scale with the help of assistants. They have continued to demonstrate the inexhaustible variety of a wholly modern but classical art. A.Bo.

▲ Bridget Riley
Search (1966)
Board. 90 cm × 90 cm
University of Manchester, Whitworth Art Gallery

Riopelle
Jean Paul
Canadian painter
b.Montreal,1923

In 1944 Riopelle left the École du Meuble where he was studying in Montreal to devote himself entirely to painting. To begin with he was influenced by traditional art, which he eventually abandoned. In 1946 he took part, with F. Leduc, in the first exhibition of 'Automatistes', instigated by P.E. Borduas in Montreal. He visited Paris, where he exhibited in 1947, and then New York, where he was reunited with some of his fellow artists at the International Surrealist Exhibition.

In 1948 he left America to settle in Paris. His friendship with Leduc continued and he met Georges Mathieu; André Breton and his circle were among his admirers. Riopelle's paintings were hung with those of Wols, Bryen, Mathieu and Ubac in the exhibition 'L'Imaginaire'. More anxious to express himself in action than in literary discussions, Riopelle moved completely away from the Surrealists, and settled with his family at St Mandé.

Between 1948 and 1954, he went through a very difficult period. After his break with representational art in 1946, he substituted a more monumental vision of nature for the early nocturnal landscapes crossed by a thin network of light. After experimenting with tachism, which he thought shallow, he developed another technique about 1950-1, which he called 'controlled drops' (*égoutture dirigée*) (*Composition* (1950-1, private coll.). This was to lead to a more perfect mastery of his palette. To paint directly applied with the tube Riopelle now preferred a palette knife which, in the style of Cézanne, changed the canvas into a coloured interplay of impasted mosaics: *Chevreuse* (*Young She-Goat*) (1954, Paris, M.N.A.M.). The landscape is worked up through planes of colour which mingle together: *Pavane* (*Pavan*) (1954, Ottawa, N.G.); *Rencontre* (*Meeting*) (1956, Cologne, W.R.M.).

Later, by breaking his mosaic structure he reintroduced the calligraphic networks of serpentine blue, mauve and black veins: *Lunes sans l'autre* (1967, private coll.). At the same time his interest in sculpture led him to re-create in his painting more representational forms. The surface becomes broader, the paint is thickly impasted and stands up in lumps: *Dédorés* (1968, private coll.); *Poule d'eau* (*Moorhen*) (1970, private coll.). Frequent visits to the far north (1970-1975) were the source of works of recent years. He found inspiration in the games played by the Eskimos with string, and in natural events: *Fonte* (*Thaw*) (1973). Riopelle's work is hung in most important Canadian museums and art galleries and also in Paris (M.N.A.M.), Cologne (W.R.M.), London (Tate Gal.) and New York (M.O.M.A.). H.N.

Robert
Hubert
French painter
b.Paris, 1733 – d.Paris, 1808

Robert received his first drawing lessons from Michel-Ange Slodtz. In 1754 he arrived in Rome in the retinue of the French ambassador, the Comte de Stainville. A great admirer of Pannini (25 of whose paintings he subsequently acquired), of Piranesi and of Locatelli, Robert met Fragonard in 1756 and the Abbé de St Non in 1759, the year he was granted a place as *pensionnaire* at the Académie. In 1760 Robert and Fragonard, with their young patron St Non, journeyed to Naples and Sicily, and then on to the Villa d'Este to work together. Robert's drawings in sanguine of the formal gardens and ruins have an airiness and fluid line (*Parc* [*Park*], *Vue du Capitole* [*View of the Capitol*], Louvre) that contrasts with the hastily but exactly drawn little figures. There is an originality about them that seems lacking in, say, Vernet's picturesque descriptions (*Cascade de la villa Conti à Frascati*, Besançon Museum). On the other hand, the few engravings left by Robert show that he lacked both the patient meticulousness of St Non and the mastery of Fragonard.

In 1765 Robert returned to Paris, with an established reputation as a landscapist and decorative artist. He triumphed at the Salon of 1767, notably with his admission piece for the Académie, *Port du Rome* (1766, Paris, E.N.B.A.). Until 1775 he continued to make use of the drawings he had brought back from Italy as the basis for decorative works for various Parisian patrons such as the Marquis de Montesquiou.

But from 1770, as the fashion for English landscape gardens spread through France, Robert began to draw series of views in and around Paris (*Incendie de l'Opéra* [*Fire at the Opera*], 1781, Paris, Musée Carnavalet) and was commissioned to redecorate the Bains d'Apollon at Versailles (*Vue du Tapis vert, Vue des Bains d'Apollon*, 1777, Versailles). Designer of the King's gardens (1778), he also worked at the park in Compiègne and probably also at Méréville for the financier Laborde. The series of pictures of the life of *Mme Geoffrin*, (1772, Paris, Veil-Picard Coll.) date from this period and reveal a talent for intimate scenes close to that of Chardin whose *Dame cachetant une lettre* (*Lady Sealing a Letter*) (now lost) he once owned.

From 1770 until his death he painted a superb series of views of Paris, describing, modifying, varying, bringing together, amassing or suppressing as the inspiration took him, buildings and characters, details and proportions, in works where fantasy passed for reality. Many examples of these are to be found in the Musée Carnavalet: *Démolitions du pont Notre-Dame et du Pont-au-Change*, 1786-8; *Une Frise du Pont Royal*, 1789, Épinal Museum.

The ancient monuments of France next engaged his interest: (*Le Pont du Gard; L'Intérieur du Temple de Diane à Nîmes; La Maison carrée, les Arènes et la tour Magne à Nîmes; L'Arc de triomphe et l'amphithéâtre de la ville d'Orange*; all 1787, Louvre), which formed the series *Antiquités du Languedoc*, commissioned for the Château de Fontainebleau. In 1784 he was made keeper of Louis XVI's pictures but continued to paint his landscapes of Italian ruins (*L'Ancien Portique de Marc Aurèle* and the *Portique d'Octave à Rome servant de marché aux poissons* [*Portico of Octavius at Rome with a Fish Market*], 1785, Louvre, on loan to the French Embassy, London).

During the years preceding the Revolution he painted a series of imaginary views of rooms in the Louvre, including the great *Vues de la Grande Galerie* (Louvre), shown at the Salon of 1796. In spite of welcoming the Revolution with his *Fête de la Fédération* (1790, Versailles), Robert spent some time in prison, during which period he occupied himself with decorating plates. On his release he was appointed, together with Fragonard, to the commission of the Conservatoire, then of the Louvre (1795-1802).

In the second half of the 18th century Robert's work represents one of the most brilliant examples of the type of architectural painting brought back into favour by Pannini. Here he was helped by his friendship with Fragonard, who encouraged him to use clear, sweeping impasto with a very fluid touch to create compositions in which picturesque details were subordinated to the overall effect (*Portique en ruine* [*Ruined Portico*]; *Pêcheur et laveuses* [*Fisherman and Washerwomen*], 1783, Louvre). Also, even though his imagination led him to create landscapes from very lifelike elements, Robert never achieved the sense of fantasy that makes Fragonard a forerunner of the Romantics. Robert, in fact, is perhaps one of the last painters of the 18th century whose sensitivity and elegance were relatively little affected by the new spirit of Rousseau and Greuze.

Robert is particularly well represented in the Hermitage (which, following the example of such once great families as the Shuvalovs, Galitzins and Stroganovs, seems to have acquired many works during his lifetime), as well as in the Valence Museum, which houses all the drawings in sanguine (Veyrenc Coll.). C.C.

Roberti
Ercole d'Antonio de'
Italian painter
b.Ferrara, c.1450 – d.1496

Roberti was the pupil and collaborator of Francesco del Cossa, and it seems probable that the latter, on abandoning the decoration of the Palazzo Schifanoia in Ferrara, took Roberti with him to Bologna in 1470. After working with Cossa on the Griffoni altarpiece for the Basilica of S. Petronio there (*c*.1473) – he painted the predella and the pilasters – he returned to Ferrara to finish the altarpiece for the Church of S. Lazzaro, which Cossa had also left incomplete. He stayed with Cossa in Bologna until the latter's death around

1478 and then, the following year, joined his brother Polidoro, who had a workshop in Ferrara. In 1481 there is a record of a payment for an altarpiece for the Church of S. Maria in Porto, near Ravenna, while some time before 1486 he painted in fresco the Garganelli chapel in the Church of S. Pietro, Bologna. The predella of *Scenes of the Passion*, painted for the Church of S. Giovanni in Monte, also dates from this time, as well as the frescoes of the Palazzo Bentivoglio, Bologna (lost).

Before 1486 he was back in Ferrara, where he was appointed court painter to the Este family by Ercole I. The next year he accompanied Cardinal Ippolito d'Este to Hungary. Various payments are recorded between 1486 and 1494 for his work for the Este family: the Duchess Eleanora of Aragon, Isabella and Beatrice Alfonso, and Ippolito d'Este. In 1495 the works in the Church of S. Maria, Vado, directed by the architect Biagio Rossetti, were carried out from his plans.

Although the fresco decoration of the Palazzo Schifanoia is largely the work of Cossa, it is now known that Roberti was mainly responsible for the panel dedicated to *September* (upper part, *The Forge of Vulcan*, *The Triumph of Lust* and *The Loves of Venus and Mars*; centre part, *Allegories of the Three Decans of September*; lower section, *Borso d'Este Surrounded by his Courtiers*. Ercole's harsh and forceful style of painting reflects the influence of the great Ferrarese painter Tura, although it is married with an exceptional delicacy of interpretation and an extraordinary vivacity. Without completely renouncing the influence of Piero della Francesca, as interpreted by Cossa, Roberti succeeded in creating a more nervous, uneasy world, unstable and fascinating.

Even more than in *September*, these characteristics are evident in the predella showing the *Miracles of St Vincent Ferrer* (Vatican), which forms part of the great Griffoni altarpiece whose main panels (London, N.G.; Brera) are by Cossa. The predella was certainly conceived by Cossa and painted under his direction by Roberti, but the narrative episodes of which it consists display Roberti's own personal and sensitive style. For the decoration of the pilasters Roberti also produced eight small panels representing saints, of which seven are now dispersed in various galleries (Louvre; Rotterdam, B.V.B.; Ferrara, P.N.) and private collections (Venice, Cini).

The great altarpiece of the Church of S. Lazzaro, Ferrara (destroyed in Berlin, 1945) was one of Roberti's most important early works. Its theme of the *Virgin and Child Enthroned with Four Saints* was realized from a rough sketch by Cossa, whose stylistic peculiarities may be seen in the cherubs on the Virgin's throne, while the complex composition reflects the influence of Tura. The beautiful *trompe-l'oeil* friezes (imitating bas-reliefs) that decorate the base of the throne are, however, completely characteristic of Roberti's own style. A comparison of the S. Lazzaro altarpiece and the Portuense altarpiece painted for the Church of S. Maria in Porto, near Ravenna (Brera) shows clearly the profound evolution undergone by Roberti's art in only a few years.

In the Portuense altarpiece (*The Virgin and Child Enthroned with Two Male Saints and Two Female Saints*) Roberti reached the greatest heights in composition, developing the solemn and dignified theme of the *sacra conversazione* to its furthest limits. As a frame he used the interior of a large, perfectly balanced temple and set the sacred group on a high pedestal. By a stroke of genius he let the

Last Supper, the *Adoration of the Shepherds*, the *Pietà* and *The Gathering of the Manna* (all London, N.G.); *St Michael* (Bologna, P.N.); *Madonna with Child* (Berlin-Dahlem); *Brutus and Portia* (formerly Richmond, Cook Coll., now in Cambridge, Fitzwilliam Museum), and *The Wife of Hasdrubal* (Washington, N.G.).

Roberti's influence in Bologna was even stronger than that of Cossa, and was a major factor in the evolution of Bolognese painting. Francia, and especially Lorenzo Costa, were among those on whom he exercised a particular influence. He has now been identified as one and the same as Ercole Grandi, although it was for long believed that they were two separate artists. c.v.

Romney
George

English painter
b.Dalton-in-Furness, Lancs, 1734 – d.Kendal,
Westmorland, 1802

The son of a Lancashire cabinet-maker, Romney first studied under the itinerant portrait painter Christopher Steele from 1755 to 1757. His early portraits, such as *Col. George Wilson of Abbot Hall, Kendal* (1760, private coll.), are close to those of Steele and of Arthur Devis, a fellow-Lancastrian. In 1762 Romney moved to London where, in 1763, he gained an award from the Society of Arts for his *Death of Wolfe*. He visited Paris in 1764, where he met Joseph Vanet. He exhibited *The Death of King Edmond* in London the following year.

As a portraitist he achieved maturity with the likenesses of *Sir Christopher and Lady Sykes* (1786, private coll.) and of *William Beckford* (Upton House, Bearsted Coll.). His portraits presented an ideal image of contemporary society, less imaginative than that of Gainsborough and Reynolds whose prices he could not rival. His portraits concentrate less on psychology and more on costume and background landscapes which qualify his sitter's status. The *brio* of his execution brought him considerable renown. His reputation today is founded in the series of

distant horizon be glimpsed through the base of this construction, taking up once more a motif which he had barely outlined in the S. Lazzaro altarpiece.

Of equal dramatic intensity are the tragic and hallucinatory *St John the Baptist* (Berlin-Dahlem), which anticipates the Mannerists, and the two-part predella of the *Agony in the Garden and Betrayal* and the *Ascent to Calvary* (Dresden, Gg) that Roberti created for the Church of S. Giovanni in Monte, Bologna. It included in its centre the wonderful *Pietà* (Liverpool, Walker Art Gal.). In this work the formal breadth of the Portuense altarpiece is allied with complex inventiveness and crystalline pictorial arrangement. These qualities reappear in a *Mary Magdalene* (Bologna, P.N.), a

fragment of a *Calvary* and a few remains of the frescoes of the Garganelli chapel (now in the sacristy of the church, together with some copies of the *Calvary*), as well as in *The Death of the Virgin* (Sarasota, Ringling Museum; Avignon, Petit Palais).

Other works of Roberti that deserve mention include: *St Jerome Penitent* (London, Barlow Coll.); the profile portraits of *Giovanni II Bentivoglio* and of his wife *Ginevra Sforza* (both Washington, N.G.); a profile *Portrait of a Young Man* (formerly Böhler Coll.) and a *Madonna with Child* (Chicago, Art Inst.). All these date from his early period. From his second period date another portrait of *Giovanni II Bentivoglio* (Bologna, University); a series of small panels showing the

▲ Ercole de' Roberti
Virgin and Child Enthroned with Four Saints
Wood. 323 cm × 240 cm
Milan, Pinacoteca di Brera

▲ George Romney
Portrait of Peter and James Romney
Canvas. 110 cm × 85 cm
Washington, D.C., Paul Mellon Collection

portraits he made of Emma Hart whom he met in 1782 and who was to become Lady Hamilton in 1791. He painted her in many different guises – as a shepherdess, and also as *Miranda* (about 1786, Philadelphia, M.A.) and engaged in banal pursuits (*Spring*, 1782-6, Kenwood, Iveagh Bequest). At times his portraits have an air of classicism which reveals his talent for history painting (*Lady Louisa Stormont*, 1776, private coll.).

In Italy during 1773-5, Romney met Fuseli in Rome, copied the works of Raphael and Michelangelo and visited Venice, Florence, Bologna, Parma and Genoa. On his return to London he became connected with London literary society which was dominated by William Hayley. He made a multitude of drawings based on the antique works he had encountered in Italy, drawings which, with their attractive freedom of hue, are now valued as some of the first Neoclassic works by an English artist.

He is famous primarily as a portraitist and his work is well represented in London galleries and throughout Britain. In the United States, Boston, New York and Washington have examples, the Mellon Collection has fine paintings (*Peter and James Romney*), as does the Huntington Library, San Marino, California. His drawings are mainly conserved in the British Museum, the Victoria and Albert Museum and at Cambridge, Fitzwilliam Museum. J.N.S.

Rosa
Salvator

Italian painter and etcher
b.Naples, 1615 – d.Rome, 1673

Of exceptional talent, being equally good at engraving, poetry and music. Salvator Rosa was the creator of a particular landscape style where the natural scene was linked to a feeling of dreamlike melancholy. He began his painting career in Naples, although most of his life was spent in Florence (1640-9) and Rome, where he finally settled in 1649.

Aniello Falcone was an early influence, as can be seen in *The Battle* (1637, London, Mostyn Owen Coll.), in which the scene is painted from life without attempts at idealization or glorification. In Rome Rosa became connected with the *Bamboccianti* who specialized in small paintings of peasants and low life. He studied mainly with Van Laer, concentrating on everyday subjects and common scenes, such as the *Bambocciata* (formerly Di Castro Coll., Rome). Large-scale works, such as *Doubting St Thomas* (Viterbo Museum), reveal the influence of Ribera in their almost macabre tenebrism (Rosa may, in fact, have been Ribera's pupil).

In 1639-40 Rosa turned decisively towards classicism, already familiar in Naples through the works of Reni, Domenichino and the geometric paintings of Codazzi. But it was Rome, where the 'antique' classicism of Poussin prevailed over the Baroque, that taught Rosa most about the 'poetic' depiction of nature. His preference for a certain type of classical landscape is seen in two paintings of 1640: *Seascape* and *Hermione Carving the Name of Tancredi* (Modena, Pin. Estense). Both pictures clearly demonstrate the principle that truth should be subordinated to the ideal of beauty or to an idealized representation of nature.

However, Rosa never wholly committed himself to the idea of a perfectly arranged classical landscape. He included in his paintings figures of ordinary people while his natural tendency towards the picturesque gave animation to, and sometimes even dissipated, the 'ideal' design. In the ensuing years, however, in the learned and academic circles he frequented in Florence, he drew nearer to the classical style, as seen in 1645, in works which have a new nobility of content: *The Philosophers' Forest* (Florence, Pitti). Side by side with his classicism he experimented with another style based on ugliness, even repulsiveness, in which esoteric themes were dominant (*Sorcery*, Florence, Corsini Coll.).

Towards 1650 Rosa abandoned his earlier, serene approach and depicted nature in a more lively and disturbed fashion. *St John the Baptist Preaching* and *Baptism in the Jordan* (Glasgow Art Gal.) are the most characteristic works of this period.

The growth of Rosa's reputation (Magnasco and Marco Ricci followed his style) stemmed from his development of a style of anticlassical landscape painting, the romantic counterpart to Claude. It was a style that was to earn an ever-increasing popularity, culminating in the work of the 19th-century Romantic painters.

Rosa (who was also an etcher and a draughtsman) was a prolific artist. His landscapes (marine paintings, historical, biblical and mythological scenes) can be seen in: Florence (Pitti); Paris (Louvre); Chicago (Art Inst.); London (N.G.); Liverpool (Walker Art Gal.); Melbourne (N.G.); Rome (G.N.); Detroit (Inst. of Arts); Chantilly (Musée Condé); Vienna (K.M.); and Hartford, Connecticut (Wadsworth Atheneum). His 'battles' are in the Louvre, the Vienna K.M., the Pitti Palace, the Cleveland Museum and Apsley House in London. Rosa also painted portraits: *Self-Portraits* (London, N.G.; Metropolitan Museum); *Portrait of Lucrezia* (Rome, G.N.); *Portraits of Men* (Sarasota, Ringling Museum; Hermitage), and allegories; the *Sibyl* (Hartford, Wadsworth Atheneum; Rome, G.N.).

The themes of his figure compositions include: witchcraft (*Saul*, Louvre; *Sorcerers*, Althorp House, Spencer Coll.); philosophical allegories: (*Democritus Meditating*, Copenhagen, S.M.f.K.; *Humana Fragilitas*, Cambridge, Fitzwilliam Museum); scenes from the Old and New Testaments: (*Jonah*, Copenhagen, S.M.f.K.; *The*

Prodigal Son, Hermitage; *Jeremiah*, *Daniel* and *The Raising of Lazarus* all Chantilly, Musée Condé; *Job*, Uffizi); and classical antiquity: (*Death of Attilius Regulus*, Richmond, Virginia, Museum; *The Building of Thebes*, Copenhagen, S.M.f.K.; *Glaucus and Scylla*, Brussels, M.A.A.; *Ulysses and Nausicaa*, Hermitage). N.S. and L.E.

Roslin
Alexandre

Swedish painter active in Paris
b.Malmö, 1718 – d.Paris, 1793

After training in Stockholm under Georg Engelhardt Schröder, Roslin went abroad in 1745. He worked first in Bayreuth, then Italy, before settling in Paris in 1752, where he was to remain for the rest of his life. Between 1774 and 1778 he visited Stockholm, St Petersburg, Warsaw and Vienna. In Paris he was taken under the wing of Boucher and the court and soon made his name as a portraitist with an aristocratic and wealthy clientèle. In 1753 he became a member of the Académie. His early works show the influence of Schröder's Baroque style, but once he had moved to Paris he fell under the spell of Boucher and slipped easily into the rococo: *The Baroness de Neubourg-Cromière* (1756, Stockholm, Nm) is a portrait whose textures display a very practised hand.

Later, his art became more austere and his palette more strongly accented: *Joseph Vernet* (1767), *The Lady with a Fan* (1768), and *Gustav III and his Brothers* (1771, all Stockholm, Nm). In his

Alexandre Roslin ▶
Self-Portrait
Canvas. 112 cm × 79 cm
Malmö Museum

Salvator Rosa ▲
Democritus Meditating
Canvas. 344 cm × 214 cm
Copenhagen, Statens Museum for Kunst

final works his sitters have an air of deep melancholy: *Carl von Linné* (1775, Stockholm, Vetenskapsakedemien). The Louvre contains his portraits of *Dandré-Bardon* and *Étienne Jeaurat*.

In 1759 Roslin married Marie-Suzanne Giroust (the model for the celebrated *Lady with a Fan*), herself a miniaturist and pastellist, and a pupil of La Tour. She was received into the Academy in 1771 with an excellent pastel of *Pigalle* (Louvre). The Nationalmuseum in Stockholm is rich in Roslin's work. L.E.

Rossetti
Dante Gabriel
English painter and poet
b.London, 1828 – d.Birmingham, 1882

The son of an Italian émigré professor, Rossetti developed precociously in a highly gifted family (his sister Christina was a poet and his brother William an art critic). By 1847 he had already written his famous poem *The Blessed Damozel*, which reveals the romantic nature of his vision. Meanwhile he was training as a painter, first at Sass's and then at the Royal Academy Schools. In 1848 he apprenticed himself to Ford Madox Brown, but although Brown's medievalism aroused his enthusiasm he soon lost interest in the technical precision that accompanied it. He then shared a studio with his fellow-student Holman Hunt and, together with Millais, they founded the Pre-Raphaelite Brotherhood, Rossetti's first picture in this manner. *The Girlhood of the Virgin Mary* (1849, London, Tate Gal.) is more mystical and primitive than the works of his confrères, relating more closely to the eclecticism of the German Nazarenes than the naturalism of the other Pre-Raphaelites.

After the attack on the Pre-Raphaelites in 1850 he ceased to exhibit and, apart from a few works like *Found* (begun 1854, Wilmington, Delaware, Art Centre, Bancroft Coll.), his only direct comment on contemporary society, concentrated mainly on watercolours. In these he became increasingly mystical, creating a personal iconography around Dante and other literary sources. Elizabeth Siddal, his favourite model, whom he met in 1850 and married in 1860, was incorporated in this world, and when she died in 1863 he painted *Beata Beatrice* (1864, London, Tate Gal.), in which Dante's vision is combined with his own vision of his wife being transported to Heaven.

His style, which had always lacked the precision of the other Pre-Raphaelites, was now becoming increasingly sensuous, but at the same time as he was moving away from his early associates he was influencing the development of William Morris and Burne-Jones, whom he had met at Oxford in 1856. He supervised the medievally inspired *Oxford Union Frescoes* (1858), and later executed work for the firm of Morris & Co. After the death of his wife, Morris's wife, Jane Burden, became the inspiration of his idealized female forms (*La Pia de' Tolomei*, 1881, Kansas, University of Kansas Museum of Art), and it is these that are commonly associated with the 'Pre-Raphaelite' type of beauty.

During the last years of his life, Rossetti became a recluse, keeping up few contacts outside the Morris circle. As a painter he never achieved

any great level of competence, and his work owes its strength to the originality and power of his vision, even though he tended towards sentimentality in his later years. Owing far more to Romantic sources than the other Pre-Raphaelites, he was the main inspiration of Late Victorian romanticism. W.V.

Rosso
Giovanni Battista
b.Florence, 1494 – d.Paris, 1540

By nature independent and critically minded, Rosso was a great admirer of Michelangelo and made drawings of the latter's *Battle of Cascina*. He worked under Andrea del Sarto, and joined the Guild of Florentine Artists on 26th February 1516. After executing some decorative commissions he joined Andrea del Sarto and his assistant Franciabigio in decorating the cloister of the Church of the Annunziata with the *Assumption of the Virgin*, a fresco remarkable for its light and colour (1517). The work of Bandinelli helped him to develop his draughtsmanship to a high degree of accuracy (*Skeletons*, 1517, Uffizi). The following year he completed a *Madonna with Four Saints* (1518, Uffizi) for the Church of S. Maria Novella, which, according to Vasari, alarmed the chapter with its innovations.

The Deposition (1521, Volterra Museum) marks a step towards the Mannerist style of his next works, with their abstract construction and highly coloured lyricism (*Madonna with the Two Sts John*, 1521, parish church of Villamagna, near Volterra). During his second period in Florence, Rosso, now recognized and admired, painted an altarpiece for the Dei family (*Madonna with Ten Saints*, 1522, Florence, Pitti), but in spite of its more classical inspiration the work aroused little response – as perhaps, too, did the curious *Virgin with the Angels* (Hermitage). However, *The Marriage of the Virgin* (1523, Florence, Church of S. Lorenzo), with its wonderful balance of line and colour, was universally praised. Several of Rosso's portraits, too, probably date from this time: *Man with a Helmet* (Liverpool, Walker Art Gal.), *Young Man* (Naples, Capodimonte), and – the most abstract of all his works – *Moses Defending the Daughters of Jethro* (Uffizi).

In 1523-4 Rosso was in Rome where he had the opportunity of viewing the masterpieces of Michelangelo and Raphael and of meeting such younger artists as Perino del Vaga and Parmigianino, with whom he collaborated on a palazzo in the Via Giulia. In the Cesi chapel (Church of S. Maria della Pace) he decorated a lunette in fresco (*The Creation of Eve* and *Original Sin*, drawings, Uffizi and Edinburgh, N.G.) and made drawings for engravers (*Gods and Goddesses in Niches*, several original drawings in Besançon Museum and at Lyons, Musée Historique des Tissus; *The Labours of Hercules*, engraved by Caraglio) under the influence of Bandinelli, the Roman school (*The Rape of the Sabines*) and Dürer (*Fury*). The highly controversial *Challenge of the Pierides* (Louvre) is also attributed to this time, but his masterpiece, only recently discovered, is *The Dead Christ* (Boston, M.F.A.).

The sack of Rome forced Rosso to leave the city. He journeyed to Perugia, Borgo San Sepolcro (a *Deposition* for the orphanage), Città di Cas-

▲ Giovanni Battista Rosso
The Dead Christ
Wood. 133 cm × 104 cm
Boston, Museum of Fine Arts

▲ Dante Gabriel Rossetti
Ecce Ancilla Domini (1850)
Canvas. 72 cm × 42 cm
London, Tate Gallery

tello and Arezzo where his friend, the humanist Pollastra, gave him ideas for subjects for four cartoons for the vault of the Church of S. Maria delle Lacrime. Rosso began to draw much more at this time. He returned to Borgo to complete a *Transfiguration* begun in 1528 (Città di Castello Cathedral). In 1530 he went to Venice and was host to Aretino who recommended him to the French king Francis I, sending him Rosso's drawing of *Mars and Venus* (Louvre).

Appointed his chief painter by Francis I, Rosso was entrusted with the task of carrying out decorations at the Château of Fontainebleau. Most of his work there has vanished. The *Pavillon de Pomone*, carried out in collaboration with Primaticcio (1532-5), is now destroyed (known by an engraving by Fantuzzi, and a drawing, *Vertumne et Pomone*, Louvre), as is the high chamber of the *Pavillon des Poesles* (1538-40) and the *Galerie basse* (1541-50). Only the *Galerie François I* remains (1534-40), much altered over the centuries but still retaining above the panelling of Scibec de Carpi, 12 impressive frescoes dedicated to Francis I (completed by Primaticcio's *Danaë*). The framework of stucco in which they are set has tremendous ornamental variety, either underlining or complementing the main theme of the fresco. Among all these motifs (garlands, putti, masks), one of them, the strapwork (so-called because it imitates the coils of bands of leather) met with remarkable success, thanks to its publication by engravers.

Rosso also made a copy of Michelangelo's *Leda* for the King (cartoon, British Museum), but the only original work that definitely dates from this time is the *Pietà* of Ecouen (Louvre), executed for the Constable of Montmorency (date very controversial, *c*.1534 or *c*.1537-40). Rosso may also have painted (*c*.1540) a *Holy Family* (Los Angeles, County Museum of Art) while he was in France. Engravings have preserved records of several lost works (*Judith*), masquerade costumes, and designs for silversmiths (Fantuzzi, Boyvin). Unfortunately nothing is known of Rosso's plans for the triumphal entry of Charles V nor of his miniatures for the King. A very few drawings have been saved from this period – preparations for compositions now lost (*Pandora*, Paris, E.N. B.A.) or even sculptures (*Design for a Tabernacle*, British Museum).

Rosso died, on 14th November 1540, probably from natural causes, although Vasari claims that he committed suicide. One of the greatest Florentine Mannerists, he also founded the School of Fontainebleau. An exceptional decorative artist, he brought to Fontainebleau a completely new style and repertory of decoration. Helped by engravings, his work, especially in the realm of ornamentation, exercised a profound influence throughout Europe. S.B.

Rothko
Mark

American painter of Russian origin
d.Dvinsk, 1903 – d.New York, 1970

Born in Russia in 1903, Rothko arrived in the United States in 1913, and grew up on the West Coast, in Portland, Oregon. After two years studying liberal arts at Yale (1921-3), he moved to New York to become an artist. He worked with

Max Weber briefly at the Art Students League (1926) and his painting for the next ten years, like much of the art of that time, was oriented toward social themes, with expressionist overtones. He worked on the Federal arts project (Works Progress Administration) during the Depression, and it was not until the late 1930s and early 1940s that his work began to display elements of autonomous surrealism. In 1945 he exhibited at Peggy Guggenheim's Art of this Century Gallery, and over the next years his canvases grew larger and the abstract shapes within them became more simplified, until by 1949-50 he had arrived at the wall-sized painting typical of the Abstract Expressionist school in New York.

Barnett Newman, Clyfford Still and Jackson Pollock were also producing paintings on a similar scale by 1950, but Rothko had reduced his forms to large fields, into two or three rectangles painted in luminous colours with soft, velvety textures. These shapes, however, and their edges, are blurred so that the apparent geometric simplicity is belied by the interpenetration of colours from different fields. The areas of colour never quite touch, and the imposing effects thus produced induce a contemplative mood in the spectator. Along with Gottlieb and Newman, Rothko declared his adherence to the 'importance of the large shape because it has the impact of the unequivocal.' He was the subject of an important retrospective exhibition at the Museum of Modern Art in New York in 1961.

Rothko committed suicide in his studio in New York in 1970. He is represented in most of the big American museums, notably in the Museum of Modern Art in New York (*Number 10*, 1950; *Number 118*, 1961), as well as in the Musée National d'Art Moderne in Paris (*Dark over brown Number 14*, 1963), in Basel Museum, in Düsseldorf and at the Tate Gallery in London (particularly the admirable series of eight canvases painted during 1958-9 on a brownish red background). D.R.

Rouault
Georges

French painter
b.Paris, 1871 – d.Paris, 1958

Rouault's artisan origins (his father was a cabinet-maker) and his early training gave him a feeling for craftsmanship that was to last throughout his life. In 1885 he began an apprenticeship in stained glass with a restorer of old windows, Hirsch, at the same time attending evening classes at the École des Arts Décoratifs. In 1890 he decided to devote himself entirely to painting and, in the next year, enrolled at the École des Beaux Arts under Élie Delaunay, who was succeeded in 1892 by Gustave Moreau, for whom Rouault had a

▲ Mark Rothko
Red, White, Brown (1957)
Canvas. 252 cm × 207 cm
Basel, Kunstmuseum

forwarded by a newfound interest in engraving, which he took up at the suggestion of the dealer Vollard (Series of *Miserere* and *Guerre*). After Rouault had held two one-man exhibitions at Druet's (1910-11), Vollard bought up the artist's entire output and became his exclusive dealer. At the same time Rouault began to evolve a new style: the static and synthetic component becomes stronger and clearer, emphasizing the motif. The image and the symbol appear as opposite poles in the complex of interactions (*Vieux Clown*, 1917, Athens, private coll.). From 1920 to 1937 the engravings took precedence over painting: *Miserere*, the *Réincarnations du père Ubu* by Vollard (etchings and wood-engravings, published 1932); *Maîtres et petits maîtres d'aujourd'hui* and *Souvenirs intimes* (lithographs, 1926); *Petite Banlieue* (lithographs, 1929); and lithographs for Baudelaire's *Les Fleurs du Mal* in 1926. In 1938 Rouault made several more etchings and xylographs for his own text, *Cirque de l'étoile filante*, and in 1939 for André Suarès's *Passion*.

All this work in the field of black and white was not without its effect on Rouault's activity as a painter. He developed a velvety modulation of tones, ranging from the deepest black to the purest white (although the latter is rare) and corresponding to a planned harmony of colour – blue, yellow, green and ochre – applied with a thick impasto. The balance between formal decorative abstraction and expression (a perennial problem resolved by Rouault according to his own lights) is reached in his *Apprenti ouvrier* (*The Apprentice Workman*) (1925, Paris, M.N.A.M.).

After 1930 the Christ-figure in his numerous paintings of *Ecce Homo* becomes deeply identified with the secular figure of *Pierrot*, both of them creatures exposed to derision. The symbolic range of these images is all the more effective because it avoids the focussing of attention, or only manifests it through an enduring, almost Byzantine fixity (*Véronique*, 1945, Paris, M.N.A.M.; *Tête de Christ* [*Head of Christ*], 1938, Cleveland Museum). Landscapes, too, provided Rouault with an outlet for his continuing spiritual quest. Taken up again many times after long periods of neglect, they were in a state of permanent metamorphosis (*Fuite en Egypte* [*The Flight into Egypt*] c.1940-8, Paris, private coll.; *Fin d'automne* [*The End of Autumn*], 1948-52, New York, private coll.).

During his last period (1950-8) Rouault increasingly found his desire for perfection and hence for a completed work at odds with his patient craftsmanlike method of working. This explains why he destroyed so many of his works, as, for example, at the end of the Vollard lawsuit. Vollard had been steadily stockpiling Rouault's canvases for 30 years, and after his death Rouault became involved in a long lawsuit with his heirs to recover the works, many of which he considered to be unfinished.

The court finally decided in favour of the moral right of the artist over his uncompleted works, and Vollard's heirs were ordered to return the unfinished paintings. It is believed that they managed to keep back many of the canvases but several hundred were returned. Rouault, in the presence of a court official and a photographer, burned 315 paintings. Rouault felt, and also succeeded in conveying, as no one else, the irreducible strain between the physical nature of painting as an act and its function as a medium for expressing the ineffable, but was nevertheless forced to create so that the work could be born.

profound admiration. He was put forward for the Prix de Rome by Moreau in 1893 and again in 1895, and then, on Moreau's advice, left the Beaux Arts. Three years later he became the first Curator of the Moreau Museum.

Two important steps in his career were his visits to the Benedictine Abbey of Ligugé (Vienne) where he met Huysmans and where the religious feeling that underlies the whole of his work was fostered and his part in founding the Autumn Salon (1903), which helped to bring him wider recognition. Round about this time Rouault freed himself from the academicism of his training while retaining the solid foundation of draughtsmanship that he had learnt. He took as his subject matter the wretched world of those outside society, of prostitutes and clowns, whose plight could touch the most hardened social conscience.

Adapting the lessons of Moreau to his own ends, Rouault used watercolour, sometimes strengthened with pastel or gouache, to obtain magisterial effects – effects that are repeated in the breadth and fluidity of his oils. His palette acquired a corrosive austerity: blues predominated but were eclipsed by livid pinks and mordant ochres, heightened by black. His expressive intensity stays near the surface without breaking through his subjects' integrity (*Clown tragique*

[*Head of a Tragic Clown*], 1904, Montreux, private coll.), but sometimes with a new-found boldness transposes it (*Nu se coiffant* [*Nude Doing her Hair*], 1906, Paris, M.A.M. de la Ville; *Au miroir* [*Prostitute at her Mirror*], 1906, Paris, M.N.A.M.).

Inspired by Léon Bloy's book *La Femme pauvre*, Rouault's *Monsieur et Madame Poulot* (Hem, Nord, private coll.) was shown at the Autumn Salon of 1905. The work stood apart from the Fauve paintings surrounding it both by virtue of its feeling for human realities and through its style, which offered analogies with Picasso's pre-Cubist works. Rouault's completely personal development soon separated him from all contemporary art and '-isms'. From 1906 he became interested in ceramics and the need to unite expressiveness and decoration. The characteristic dark outlines of his figures were already in evidence, balanced by areas of brilliant colour that they enclosed (*Baigneuses* [*Woman Bathers*], 1907, Hem, private coll.). Begun in 1908, the collection of *Juges* (*Judges*), counterpointed by paintings showing the poverty of the back streets, were in a more satirical vein, verging on caricature. This exposure of pharisaism was echoed in the despairing pathos of Rouault's early watercolours.

Gradually, however, Rouault came to neglect watercolour in favour of oils, which he used exclusively from 1918 onwards. The process was

▲ Georges Rouault
Nu se coiffant (1906)
Gouache, watercolour and crayon. 71 cm × 55 cm
Paris, Musée d'Art Moderne de la Ville

In the field of decorative art he designed, in 1929, the sets and costumes for Diaghilev's ballet *The Prodigal Son* (music by Prokofiev) and in 1945 was commissioned to design five stained-glass windows for the church at Assy (Haute Savoie). From 1949 he gave the sketches of his enamels to the abbey at Ligugé. His style easily adapted to these decorative techniques, particularly to stained glass. The frame of his paintings was of great importance to him and had to be as rich in texture as the paintings themselves. They were painted by Rouault in the style of medieval borders.

Rouault is well represented in Paris (M.N.A.M. and especially M.A.M. de la Ville), as well as in many great public and private collections throughout the world. His centenary was celebrated in 1971 by a large retrospective exhibition at the Musée National d'Art Moderne in Paris, where his unfinished works were also on view (nearly 200 donations to the French nation). These revealed a new side to his genius, and showed that, at a certain level, he can be compared to Daumier. M.A.S.

Rousseau
Henri ('le Douanier')
French painter
b.Laval, 1844 – d.Paris, 1910

The fourth child of a tinsmith in Laval, Rousseau as a youth was awarded prizes for both art and music at his local lycée. He found employment with a solicitor in Angers, but was jailed for a month for abusing professional confidences. To escape from the scandal he joined the army as a volunteer, although he was never in Mexico despite the frequent allusions he later made to his army service there. His life was narrow and uneventful. Married in 1869, starting as a clerk,

he became an agent second-class in the Municipal Customs Service of Paris (hence his nickname 'le Douanier'), remaining there until 1885. A 'Sunday' painter, in 1884 he was authorized to work as a copyist in the national collections.

In 1886, under the auspices of Signac, he succeeded in having some of his paintings accepted by the Salon des Indépendants and, until his death, exhibited there every year, with the exception of 1899 and 1900. It was to this Salon, in fact, that he owed much of his subsequent career and notoriety. In 1888 his wife died, having borne him seven children. He remarried in 1899.

After retiring from the Customs Service in 1885 he settled down to paint in earnest. The painting he showed at the Salon des Indépendants in 1894, *La Guerre* (*War*) (Louvre, Jeu de Paume), exemplified his highly original technique and his particular style of Modern Primitivism. His fellow-citizen from Laval, Alfred Jarry, introduced him to Rémy de Gourmont, publisher of *L'Ymagier* who, in 1895, reproduced Rousseau's painting in his review. In 1897 Rousseau showed his famous *Bohémienne endormie* (*Sleeping Gypsy*) (New York, M.O.M.A.), which he vainly tried to persuade the mayor of Laval to buy. At this time he was playing in an orchestra on the Left Bank and, to eke out a living, gave painting and music lessons.

On the death of his second wife, in 1903, Rousseau moved to the Rue Perrel in the working-class district of Plaisance, where he made portraits of neighbouring tradesmen after taking their measurements with a ruler. His first exotic painting, *Éclaireurs attaqués par un tigre* (*Scouts Attacked by a Tiger*) (Merion, Barnes Foundation) was hung at the Salon des Indépendants in 1904. The next year Rousseau was admitted to the Autumn Salon, exhibiting with the Fauves and sending in a large panel, *Lion ayant faim* (*The Hungry Lion*) (private coll.).

This marked the end of his obscurity. Jarry introduced him to Robert Delaunay, and they became friends, while Delaunay's mother com-

missioned the *Charmeuse de serpents* (*Snake Charmer*), exhibited at the Autumn Salon of 1907 (Louvre, Jeu de Paume). In December of that same year, however, he was sent to prison for passing a bad cheque, even though he had been the innocent victim of a swindler. To exonerate himself he displayed his paintings, of which he was proud, and which convinced the authorities that he was not responsible for his actions, so he was released.

He was not as yet taken very seriously, although he was an object of interest to a number of artists, as well as to Wilhelm Uhde, his first biographer (1911). In 1908 Picasso gave a great luncheon for Rousseau in his studio, an occasion that is still remembered, and increased Rousseau's notoriety. Rousseau himself also entertained, giving musical evenings in his studio at which he played his own compositions. In 1904 he had even published a waltz, *Clémence*, in memory of his wife. Dealers began to buy his work, chiefly Vollard and Brummer. At the Salon des Indépendants in 1909 he exhibited his *Muse inspirant le poète* (*Muse Inspiring the poet*) (Basel Museum), which portrayed Marie Laurencin and Guillaume Apollinaire.

Despite his artistic success, his difficult private life made his last years very unhappy. In 1910 he died alone in the Necker hospital. The following year his friends Delaunay and the moulder Queval bought him a burial plot. On his tombstone Apollinaire wrote a famous poem, which Brancusi later incised in the stone. In 1947 his remains were transferred to the Parc de la Perrine at Laval.

Rousseau's art is complex and its interpretations are numerous. Many of his works, especially those painted before 1900, have been lost. Through his friend Clément, a painter at the Salon, he came to know such leading academic painters as Cabanel, Bouguereau and Gérôme, for whom he expressed admiration. He even asked Gérôme for advice about his painting, and it is possible that he would have liked to be compared with them.

Jarry's friendship involved him with the avantgarde, and he also attracted the attention of Gauguin and Degas (although their admiration contained some reservations), and later, of Picasso and Delaunay. In spite of this, Rousseau felt himself to be very remote from Impressionism and modern trends.

Rousseau's work falls into a number of categories. First come his portraits, together with scenes of everyday life: his self-portraits (1888-90, Prague Museum); *Une noce à la campagne* (*A Country Wedding*) (1905, Paris, Musées Nationaux, Walter Guillaume Coll.); *Portrait de Loti* (Zürich, Kunsthaus); *La Carriole du père Juniet* (*The Cart of Père Juniet*) (1908, Paris, Musées Nationaux, Walter Guillaume Coll.).

A second genre includes scenes of Paris, showing the quais along the Seine. The suburban streets with little figures, idlers, fishermen, have a profound and idyllic poetry: *Un soir de carnival* (*Carnival Evening*) (1886, Philadelphia, Museum of Art); *Promenade dans la forêt* (*Walk in the Forest*) (between 1886 and 1890, Zürich, Kunsthaus); *Vue du parc Montsouris* (*View of the Parc Montsouris*) (1895, Paris, private coll.); *Bois de Boulogne* (1898, formerly H. Siemens Coll.).

A third category is that of his collective scenes: patriotic (*Centenaire de l'Indépendance* [*Centenary of Independence*], 1892, Düsseldorf, Voemel Coll.); military (*Artilleurs* [*Artillerymen*], *c.*1893, New

◀ Henri Rousseau
La Charmeuse de Serpents (1907)
Canvas. 167 cm × 189 cm
Paris, Musée du Louvre, Galerie du Jeu de Paume

York, Guggenheim Museum); *Représentants des puissances étrangères venant saluer la République en signe de paix* [*Representatives of Foreign Powers Saluting the Republic with the Sign of Peace*] exhibited 1907, Picasso Coll.); and sporting (*Joueurs de football* [*Football Players*], 1908, New York, Guggenheim Museum).

The genre, however, that won him commissions and fame, and which he developed towards the end of his life into huge paintings, was the exotic: *Le Repas du lion* [*The Lion's Meal*] (1907, Metropolitan Museum); *Flamants* (*Flamingoes*) (1907, New York, Payson Coll.); *Nègre attaqué par un jaguar* (*Negro Attacked by a Jaguar*) (1909, Basel Museum); *Singes dans la forêt vierge* (*Monkeys in the Virgin Forest*) (1910, Metropolitan Museum); *La Cascade* (*The Waterfall*) (1910, Chicago, Art Inst.).

Rousseau's inspiration for these works came, in fact, not from his imaginary journey to Mexico, but from magazine illustrations and visits to the Jardin des Plantes. For all this, he was well aware how to evoke the exotic through his fantastic vision of lush, forest backgrounds, and by his immediate feeling for the esoteric life of animals (he admitted to being terrified of the wild beasts he painted). Yet the slightly careless, sometimes hurried, aspect of some of his canvases is undeniable. A final category, that of his flower paintings, is distinguished by delicate tonal values and purity of line.

The clarity of Rousseau's forms marks a reaction, parallel to that of Gauguin, against the hazy masses of the Impressionists, while the subtlety of his tonal range is akin to that of the 15th-century Primitives. He resembles them, too, in the sincerity and gentleness of his imagination, qualities that link him to a tradition of popular, anonymous painting, of which he was the first powerfully individual exponent. His influence had been considerable and has led to the emergence of a group of 20th-century 'Primitive' or 'Naïf' painters. L.E.

Rowlandson
Thomas

English watercolourist and caricaturist
b.London, 1756 – d.London, 1827

Rowlandson was the son of a London merchant whose speculations in the textile industry eventually led him to bankruptcy. The young Thomas was then raised by his uncle and aunt, attended Dr Barwis's school, and enrolled at the Royal Academy Schools in November 1772. Rowlandson visited France in 1774, the year before he first exhibited at the Academy, and probably made further trips in 1778 and in the early years of the next decade. The few surviving drawings that date from before 1780 have a sense of rococo elegance and reveal a debt to Mortimer in their hatched and stippled technique. Between 1780 and 1783 Mortimer's influence diminished, and Rowlandson developed his own method of laying thin tints of watercolour over an ink drawing, a practice that was initiated by topographical artists such as Paul Sandby.

Success first came to Rowlandson with his drawing of *Vauxhall Gardens* (1784, London, V. & A.) and with a series of caricatures made during the Westminster election of 1784. From then on-

wards Rowlandson produced annually a large number of prints and drawings. In 1786 he exhibited five drawings at the Royal Academy, including *The English Review* and *The French Review* (Windsor, Royal Coll.), two of his most ambitious and carefully drawn compositions. He also exhibited at the Academy in 1787 for the last time. By then his artistic style was already mature, and Rowlandson subsequently saw little need to change either his subject matter or his manner of expressing himself. Although he was aware of the innovative ideas of his contemporaries, Rowlandson chose to disregard them.

In 1787 he made another trip to France, where he is supposed to have indulged an inveterate passion for gambling and high living. When his widowed aunt died in 1789, leaving him a considerable sum of money, he spent it all and went into debt. He appears, nonetheless, to have been otherwise very scrupulous in his financial dealings. Rowlandson's enjoyment of the racier aspects of 18th-century life is comically mirrored in his drawings, such as *A Gaming Table at Devonshire House* (1791, Metropolitan Museum).

During the 1790s Rowlandson continued to visit the Continent, on one occasion in the company of Matthew Mitchell, a wealthy banker who had become his chief patron. About 1797 Rowlandson began his association with Rudolph Ackermann, whose 'Repository of Arts' in the Strand was then a lively and popular meeting-place for artists. He drew hundreds of designs to illustrate works published by Ackermann, as well as making numerous drawings that were etched and sold as prints.

The various editions of *The Tours of Dr Syntax*, published in 1812 and the following years, were extremely successful and marked the peak of Rowlandson's popularity. Initially, he took some sketches to Ackermann who felt that they might be suitable for publication in his new *Poetical Magazine*, if appropriate verses could be found to match them. Rowlandson then sent a monthly illustration to William Combe who wrote the accompanying narrative. *The Tour of Dr Syntax in Search of the Picturesque* proved to be such a success that the individual prints were issued together as a book and were followed by two other series: *Dr Syntax in Search of Consolation*, published in 1820, and *Dr Syntax in Search of a Wife*, published in the

following year. The illustrations were etched by Rowlandson, finished in aquatint, and then coloured by hand, in imitation of his original watercolours.

Rowlandson made frequent copies and close variants of his drawings. Indeed, he sometimes drew in printer's ink and ran the drawing through a press with a sheet of damp paper on top of it, thus producing a print, which he then retouched. His style, which was calligraphic and full of curves and arabesques, altered only slightly during his career, which sometimes makes his work very difficult to date.

In 1814 Rowlandson probably visited Paris again, and after 1820 he spent a while in Italy. In his final years, prior to a serious illness in 1825, he became interested in classical art and in anatomy. He died unmarried.

Rowlandson's caricatures do not show the social concern or moral indignation of Hogarth or Gillray, and his portrayal of everyday life lacks accuracy and realism, for he exaggerated and adapted to suit his own purposes, but his detached and humorous observations convey a view of the late 18th century that is tolerant, amusing and often scandalous. J.H.

Rubens
Sir Peter Paul

Flemish painter
b.Siegen, Westphalia, 1577 – d.Antwerp, 1640

Life. Peter Paul Rubens was born in Siegen where his family lived in exile, having fled from Antwerp to escape religious and political persecution. Around 1587, after his father's death, his mother returned to Antwerp with her children. After attending the Latin School of Rombaut Verdonck, Rubens, at the age of 13, became a page in the service of the Countess of Lalaing before being apprenticed, perhaps first of all to Tobias Verhaecht, and then to Adam van Noort and Otto van Veen. In 1598 he was made a member of the Painters' Guild in Antwerp. He went to Italy in 1600 where he became court painter to the Duke of Mantua, Vicenzo Gonzaga, remaining

▲ Thomas Rowlandson
A Gaming Table at Devonshire House (1791)
Pen and watercolour on paper. 31 cm × 44 cm
New York, The Metropolitan Museum of Art,
Harris Brisbane Dick Fund, 1941

with him until the end of his stay in Italy. In 1601 the Duke sent him to Rome to copy some pictures and in 1603 on a mission to Philip III of Spain. After his return to Mantua early in 1604 Rubens did not leave the city again until the end of the following year. He may have visited Genoa in 1606.

The illness and death of his mother brought Rubens home to Antwerp in 1608 from Rome. He quickly found two powerful patrons in Nicolas Rockox, who was several times Burgomaster of Antwerp, and the Archduke Albert, Governor of the southern Netherlands. At the end of 1609 Rubens married Isabella Brandt, daughter of the lawyer Jean Brandt (*Rubens and Isabella Brandt*, 1609-10, Munich, Alte Pin.; *Isabella Brandt*, Washington, N.G.), and in 1611 he bought a house on to which he built a studio. Here, Rubens led a hard-working and well-regulated life, rising at four o'clock each morning, and then, after attending Mass, beginning work. He painted until five in the afternoon, and then went riding.

His first wife, who died in 1626, bore him three children: Claire-Sereine, who died when she was twelve, Albert and Nicolas. Between 1625 and 1630 Rubens was involved in diplomatic missions between Spain and England, and later between the Spanish Netherlands and Holland, until 1633. Charles I of England knighted him for his diplomatic achievements in 1629, and he was also ennobled by the King of Spain.

In 1630 he married the 16-year-old Hélène Fourment, the eldest daughter of a rich tapestry merchant. He painted many portraits of his second wife (*Hélène Fourment*; Lisbon, Gulbenkian Foundation; Munich, Alte Pin.; Vienna, K.M.; Louvre), while her sister Suzanne provided the model for the famous '*Chapeau de paille*' painting in the National Gallery, London, Hélène bore him five children and the last ten years of his life were extremely happy. Rich, famous, and with a young and beautiful wife and loving children, Rubens lived out the lofty dream he had immortalized in his art.

Rubens's rôle in Antwerp. Antwerp, which had been the centre of international commerce during the 16th century, lost its prosperity with the closing of the River Scheldt. At the moment when Rubens's genius was flowering a long period of internal troubles was coming to an end, but the threat of war was not completely dispelled. In art, too, this was a time of stagnation. The leading painters of the time did not rise above a purely regional style derived from Mannerism or Caravaggism, both borrowed from Italy, but marked, too, by the beautiful mode of execution characteristic of the Flemish pictorial tradition.

Rubens's vitality and fertility contrasted sharply with the lack of vigour of his contemporaries. By the sheer magnetic force of his genius he created an atmosphere favourable to the flowering of the talents of Van Dyck, Jordaens and countless others. Although he did not form a school in the accepted sense, his influence was such that nearly all Flemish painters working on a large scale benefited from his style and technique. He was the creator of Flemish Baroque and of the artistic climate of the Antwerp School. The movement's development was stimulated by the Counter-Reformation. Commissions for the churches increased, some of them to make good paintings lost during the religious conflicts.

Soon after his return from Italy, Rubens, through the power and originality of his style, became recognized as the leading figure of the Antwerp School. Most of the Flemish painters around him owed him a great deal. Some, like Van Dyck, Jordaens, Snyders and Van Thulden, were his pupils, or, at some time or other, like 'Velvet' Bruegel, collaborated with him. The role of his studio, however, must not be overestimated. Certainly, in some extremely large works Rubens was helped by his pupils, especially between 1610 and 1620. Conversely, for the decorative ensembles, he must have called in collaborators, but these were often independent artists who worked to his rough drafts. Nevertheless, the most important of these large-scale compositions are entirely by Rubens's hand. And if the output is enormous this is entirely due to the fertility of his imagination, the rapidity and assurance of his execution, and the ardour of his creative genius.

The evolution of Rubens's style. Rubens's *oeuvre* is enormous. It is difficult to compile a complete catalogue, the more so because his pupils, collaborators and colleagues were so inspired by his style that it is not always easy to distinguish between the master's own work and that of his followers. Rubens's talent matured very slowly, and he found his definitive personal style only after his return from Italy. Those youthful works executed before his departure have not all been identified with absolute certainty. During his stay in Italy he set out to equal the great masters by a sweeping composition, rapid execution and a pronounced chiaroscuro.

He yielded, too, to the temptation of Caravaggism (*The Entombment of Christ*; the National Gallery, Ottawa, is based on the painting in the Vatican by Caravaggio). This is most obvious in the major works of this period: *The Crowning with Thorns* (1602, Grasse Hospital); *The Apostles* (Prado); *The Adoration of the Shepherds* (Fermo, Church of S. Filippo Neri; sketch in the Hermitage); the *Equestrian Portrait of the Duke of Lerma* (1603, Prado); *The Baptism of Christ* (Antwerp Museum) and the *Transfiguration* (Nancy Museum), both painted 1604-6; and *The Virgin Adored by the Saints* (1606-8, Grenoble Museum). This last picture already shows signs of Rubens's mature style in its glowing colours and the richness of the tone values.

Between 1610 and 1611, Rubens painted *The Raising of the Cross* for Antwerp Cathedral, an immense triptych, where for the first time, he revealed his daring. The work was completely new in its dynamic intensity, powerful forms and the sure and rapid handling. But already, in *The Descent from the Cross*, the centre of another triptych painted 1611-14 for the same cathedral, Rubens had begun to relax this paroxysm of movement in favour of more harmoniously balanced forms, full of a noble grandeur. The pallor is of the body of Christ, accentuated by the blinding whiteness of the winding-sheet. An easel painting, *The Prodigal Son* (*c*.1612, Antwerp Museum), enchants by its picturesque and realistic rendering, by the effects of the light and by the brilliant and fluid handling. This work is comparable to *Winter* in the British Royal Collection (the pendant to *Summer*), which, however, excels it in its evocation of atmosphere.

In 1615, while he was working on *The Fall of the Damned* and the little *Last Judgement* (both Munich, Alte Pin.), Rubens reached the peak of

his dramatic style and, indeed, of his career. Here he evoked the drama of a human sea in which the individual, caught up in the overwhelming movement, melts away into limitless and undefined space. In the same vein, and at around the same time, came *The Battle of the Amazons* (Munich, Alte Pin.). Here again, the figures dissolve in the general atmosphere, forming part of a tumultuous fray developed with such an intoxicating rhythm that the formal and pictorial skill is forgotten. The *Abduction of the Daughters of Leucippus* (1618-20, Munich, Alte Pin.) ingeniously introduces movement into a composition which, at first sight, seems static.

From now until the end of his life Rubens never stopped trying to perfect this gift for giving spontaneity and the impetus of life itself to his immense decorative works. Thus, his great religious compositions are animated by a vitality equal to that of his easel paintings and preparatory sketches. This broad improvisation can be seen, too, in dramatic works like the '*Coup de Lance*' (1620, Antwerp Museum), as well in such religious paintings as *The Adoration of the Magi* (1624, Antwerp Museum), *The Virgin Adored by the Saints* (1628, Antwerp, Church of St Augustine), *The Martyrdom of St Lievin* (Brussels, M.A.A., usually dated from 1635), and *The Ascent to Calvary* (1636-7, Brussels, M.A.A.). They recall the triumph of faith, but are also a wonderful hymn to the joy of living.

The innumerable secular works of the artist's mature years mostly pay homage to the life of people close to the earth. This intoxication with sheer animal life bursts forth in the turbulent *Country Fair* in the Louvre (1635-6). The sensuality which there releases itself with an orgiastic abandon, assumes a courtly aspect in *The Artist and his Wife in the Garden* (1631, Munich, Alte Pin.) and in the exquisite *Garden of Love* (1635, Prado); while a playful and ironic feeling is

Sir Peter Paul Rubens ▲
Hélène Fourment with two of her Children (1635–8)
Wood. 113 cm × 83 cm
Paris, Musée du Louvre

▲ Sir Peter Paul Rubens
Abduction of the Daughters of Leucippus (1618–20)
Canvas. 222 cm × 209 cm
Munich, Alte Pinakothek

evident in the perfect masterpiece, *Hélène Fourment with Two of her Children* (1635-8, Louvre).

During his last years Rubens produced many masterpieces. His landscapes, often full of dramatic inspiration, emphasize the power of nature, at once destructive and generative. The *Landscape with Rainbow* (Munich, Alte Pin.), the *Landscape with a View of Steen* (London, N.G.; Vienna, K.M.), the *Landscape with Muddied Cart* (Hermitage), all dated 1636, and the landscape showing *Philemon and Baucis* (1638-40, Vienna, K.M.) share the same vital spirit as that in the *Virgin with Saints* at the Church of St Jacques in Antwerp (1636-8) or in the magnificent nudes in *Andromeda* (Berlin-Dahlem), the *Judgement of Paris* (1638-9, Prado) and *The Three Graces* (1638-40, Prado).

The great decorative works. Rubens's great decorative works were carried out from a series of beautiful oil sketches. His works in this genre were immense, and it was normal for him to enlist the aid of collaborators who worked from his drafts. These *esquisses* were not so much rough sketches as models to show to clients, and for the assistants to follow. They were all very free in handling, the colour touched in with an extremely limpid effect, and perfect examples of the natural impulse of his genius. Rubens's major decorative works include:

1617-18: designs for a series of tapestries representing in seven scenes the *Story of Decius Mus*. The commission came from the *gentiluomini* of Genoa. Today the paintings are housed in the gallery of the Princes of Liechtenstein at Vaduz.

1620: decoration of the ceiling of the *Jesuit Church* in Antwerp (39 pictures, destroyed by fire, 1718). The sketches are among Rubens's most beautiful and reveal the virtuosity of his foreshortening, a triumph of Baroque illusionism (Louvre; museums at Gotha, Quimper and Prague; Vienna, Akademie; London, Seilern Coll.).

1621-2: cartoons for a set of twelve tapestries showing the *History of the Emperor Constantine* for Louis XIII (tapestries at the Mobilier National, Paris, and Philadelphia, Museum of Art; sketches mostly in the Wallace Coll., London, and in a private collection in Paris).

1621-5: decoration for the *Galerie Marie de' Medici*: 22 pictures intended to ornament one of the wings of the Luxembourg Palace in Paris, now in the Louvre (set of sketches in Munich, Alte Pin., the Hermitage and the Louvre).

1625-8: designs for 15 very large tapestries of *The Triumph of the Eucharist*, commissioned by the Archduchess Isabella for the Convent of the Carmelites in Madrid (most of the large sketches in the Prado).

1627-31: beginning of the decoration for the *Galerie Henri IV*, commissioned by Marie de' Medici for another wing of the Luxembourg Palace. The project was not carried out (two large compositions broadly sketched out at the Uffizi; sketches at Bayonne Museum and the Wallace Coll., London).

1629-34: decoration for the ceiling of the Banqueting House in Whitehall for Charles I: nine paintings showing the glorification of James I (most of the sketches in the Hermitage, the Louvre, the B.V.B. at Rotterdam, Antwerp Museum and Brussels, M.A.A.).

1630-2: set of eight tapestries on the *Story of Achilles* (set of sketches in Rotterdam, B.V.B.; two large sketches in Pau Museum).

1635: *Decoration for the City of Antwerp on the Occasion of the Joyful Entry of the new Governor-General of the Low Countries, the Archduke Ferdinand of Austria*: sketches (mostly at the Hermitage, and museums at Antwerp and Bayonne), and other large paintings for 43 theatres and triumphal arches.

1637-8: *Decoration for the Torre de la Parada*: sketches (a set in Brussels, M.A.A.; Prado; Bayonne Museum; Rotterdam, B.V.B.) for 112 paintings on the *Metamorphoses* of Ovid to ornament 25 rooms in Philip IV's hunting lodge.

Rubens and the Baroque. Rubens's study of the great Italian decorative artists during his years in Italy led him, on his return to Antwerp, to abandon the meticulous painting sacred to the Flemish pictorial tradition, and which his contemporaries employed even on works of enormous size. His newfound Italianism, however, was in its turn, to be translated into a northern Baroque, to which he brought a new strength through the intensity of his palette, the dynamism of his design, and the brio of his execution. The vision and understanding of this Baroque artist par excellence are unstable and shifting. He created a world, harnessed to the essence of real forms, but reworked by an elemental and impetuous rhythm. The constantly changing light affects the tone values, playing a very important part in the picture by moving in the direction of the strong outlines of the composition.

Rubens's forms are characterized by an equal concern for breadth and vitality. For his figures he created an ideal human type – men of heroic aspect and women full of sensuality. Their delineation, which is above all pictorial, does not have clear-cut outlines, but is completely integrated into the light surrounding it. Even Rubens's drawings have this potentially pictorial character.

The tone values are obviously the fundamental part of the picture. The warmth and richness of his colours cast a particular spell over the artist's works, conceived mostly in golden tones, although in some compositions the tonality is silver. Flat colour is used only in the foreground of his large compositions, to produce a startlingly decorative effect. Scattered everywhere, the changing gradations of colour give an impression of transience to the surrounding atmosphere. Rubens achieved his rich colouring thanks to his dazzling technique, based on the economic use of a gamut of primary and complementary colours, in all no more than about six.

In his maturity the master stopped using the Italianate chiaroscuro in favour of glowing colours and more light. Moreover, this luminosity was strengthened by the juxtaposition of pure colour and the optical effect which resulted. He also used complementary colours in a judicious contrast, with the intention of heightening the lustre of his palette, and his paintings provide ample evidence of his audacious methods, cultivated systematically only from the 19th century. W.L.

Ruisdael
Jacob van
Dutch painter
b.Haarlem, 1628/9 – d.Amsterdam or Haarlem, 1682

The son of Isaak van Ruisdael, Jacob probably frequented his uncle Salomon's studio in Haarlem and benefited from his teaching. There is no record of any further training, but in 1646, at the age of about 18, he was already signing paintings (example in the Hermitage), and from 1648 he is entered in lists of the Haarlem Guild of Painters. (The story that he had undergone sufficient training in medicine to operate skilfully on patients in Amsterdam thus appears improbable.) Various works, both drawings and paintings, testify to frequent journeys to Alkmaar, Egmond-aan-Zee and the region near the German border-Bentheim, Rhenen, Cleves – where he was able to find his favourite subjects.

In about 1656-7 he settled in Amsterdam, as did many other Haarlem artists, notably his cousin Jacob Salomonsz (1666) and the landscape artist Allart van Everdingen (1657), so close to him in his 'Romantic' inspiration (waterfalls and mountainous forests). By 1657 Ruisdael had moved to Amsterdam, and in 1660 he testified that Hobbema 'served and learned with me for some years'. His poverty and final destitution appear to be a legend exploited with complacent satisfaction in the 19th century: in fact, his pictures were sold at high prices, he was in demand as an art expert, and the will that he drew up in favour of his father – who himself knew chronic financial worries and was often in his son's debt – implies a certain affluence in the son. Against this, it is possible that Ruisdael was in poor health, as seems to be indicated by the fact that the will was prematurely drawn up in 1667. In 1682 he was still living in Amsterdam and probably died there, but was buried in Haarlem on 14th March.

The works of his early years, between 1646 and about 1650, are distinguished by a meticulous technique, especially in the rendering of foliage, and, in fact, are conceived in an essentially graphic spirit, rather like engravings. The family fondness for such subject matter as sand dunes with a few trees, or the openings to forest glades, or marshes surrounded by trees and bushes, is already apparent in early works. Something of Salomon's fanciful depiction of trees is visible, as well as the influence of his own father and, more especially, of Vroom, with his equally graphic 'Elsheimerian' method of delicately silhouetting foliage against the light of a clear sky. Ruisdael's few etchings all appear to date from this first period, and show residual traces of Mannerism, recalling the sylvan 'caprices' so loved by Roelandt Savery or Gillis van Coninxloo. Alongside Vroom's powerful influence, there are signs of some rapport with the exactly contemporary works of Guillam Dubois and Jan van der Meer the Elder (compare the latter's *The Path*, 1648, Mauritshuis).

This first style is austere and precise, lacking in boldness perhaps, but with a definite poetic charm in its revelation of the abundance of nature. Among the best of these early works are the landscapes of 1646-7 (Hermitage; Munich, Alte Pin.), the famous *Thicket* (Louvre), and especially *The Edge of the Marsh* (Budapest Museum), with its compelling image of the dead tree, white beneath its stripped bark, catching the light. Other fine examples from this first period are to be found in Leipzig (1648), Copenhagen (1646), the Mauritshuis (1648), Cambridge, Fitzwilliam Museum (1648) and Vienna (Akademie).

To this harmonious and crowded vision, where Ruisdael appears spellbound by detail, there succeeded a more ambitious and general conception. Better structured, with large masses and strong backgrounds through which the painter sought to

deepen the horizon, such paintings were fully developed by the 1650s. The style is an imposing one, precise and penetrating in execution and design, and is already evident in the important *River Landscape* (1649, Edinburgh, N.G.). In the many paintings of Bentheim Castle (1651, Raveningham, Great Britain, Bacon Coll; 1653, Blessington, Ireland, Beit Coll.) it reached its height. The journeys which Ruisdael made at this time with Berchem to the countryside near the German frontier were probably connected with this new 'noble' and 'heroic' stage in his career. The number of architectural motifs (bridges, water mills, locks, castles) increased, being important to the balance of the painting and to the harmony sought between man and nature.

All Dutch painting of the period, from Rembrandt and Philips de Koninck to the Italianists (Both, then, Berchem and Dujardin), aimed at this expressive conception, which was both calm and uplifting, and close in spirit to the quests for the 'ideal' of Claude and Dughet. Many fine examples of this balanced, powerful style – the painter's best – exist, notably in: the Wallace Collection, London; the Herzog Anton Ulrich Museum, Brunswick; Berlin-Dahlem; the Frick Collection, New York (1654); the Mulhouse Museum; and the Ashmolean Museum, Oxford. Also from the 1650s comes the famous *Jewish Cemetery* (Dresden, Gg; another version in Detroit), an amazing dialogue between the symbols of death and the elements of life, which delighted Goethe as a thinker and poet, as much as an artist and visionary.

After 1653 dated works become rare, which makes it difficult to establish a chronology. The artist's style also varied according to the theme. In general, he tended towards finer, warmer, less gloomy tone values. He used seascapes and urban views as pretexts to depict effects of cloudy skies connected with his life in Amsterdam. In his many paintings of *Cascades* and *Torrents* flowing into gorges, where Everdingen's influence is apparent, Ruisdael still remained attached to a dark palette and a dramatic lyricism. But the style of the figures who sometimes appear in these landscapes allows certain works to be dated approximately from the beginning of the 1660s, such as the celebrated *Mill at Wijk* (Amsterdam, Rijksmuseum), a perfect example of the interplay of clouds and light.

From 1660 Ruisdael became interested in a more panoramic landscape, in which the spatial depth was increased by the emphasis on the horizontal, and where contrasts of light were used. These recall the magisterial scenes of Koninck. Examples are the *Views of Beverwijk* (Munich, Alte Pin.), or examples of the vast plain of Haarlem (Rijksmuseum; Mauritshuis; Zürich, Kunsthaus); the *Shore at Egmond-aan-Zee* (London, N.G.) or *Scheveningen* (Chantilly, Musée Condé), as well as the *Cornfields* where the yellow of the grain forms a luminous point of focus, strong and convincing in its simple realism (Lille Museum; Metropolitan Museum; Rotterdam, B.V.B.). His greatest masterpiece *The Burst of Sunshine* (Louvre), dated about 1670-5 or some time soon after 1660 (this last date seems more likely), and the comparable *Mountainous Landscape* (Hermitage), share a quality of poetic emotion.

In these mature years, in his landscapes of forests and fens he was more forceful in his arrangement of the ornamental interplay of living or dead tree trunks (a tree with whitened bark thrown diagonally across the foreground is a

favourite and typical motif, which was later exploited by Wynants). His paintings of marshes in the National Gallery, London, the Hermitage and Berlin-Dahlem, with a very fine leaning tree, an elegant architectonic revival of a Mannerist theme in the manner of Savery, are perfect illustrations of Ruisdael's qualities of gravity and reflection. Finally, there are some rare winter landscapes, generally late works, which have a very delicate harmony of tone in perfect accord with the atmosphere of intense melancholy that pervades them. Overall, however, Ruisdael's late works show some decline in quality resulting from constant repetition of themes, such as the cascades, that had proved particularly successful. J.F.

Runge
Philipp Otto

German painter
b.Wolgast, 1777 – d.Hamburg, 1810

In 1795 Runge came to Hamburg in order to join his brother Daniel in a commercial career, but the artistic ambience he found in the city decided him instead to become a painter. After studying drawing in Hamburg he became a student at the Copenhagen Academy from 1799 to 1801, where he was a pupil of Jens Juel. He then went to Dresden where he met Anton Graff and became friendly with the poet Ludwig Tieck, who made a deep impression on him. Pencil portraits and sketches for figure compositions in the Neoclassical style of Carstens and Flaxman have survived from these early years. The masterpieces of his Dresden period are the four engravings, *The Times of Day*, the theme of which, enriched by his own emotional and subjective approach and religious experiences, here takes on unprecedented dimensions. The human figure is made the symbol of natural elements, and a harmonious relationship between man and nature is born. This new concept of landscape was to become his principal theme. He dreamed of repeating these compositions as murals.

In 1803 Runge returned to Hamburg and began painting, chiefly portraits, in preparation for his new idea of animated landscapes. He took his models mainly from his family. In 1805 he painted *We Three* (destroyed 1931), a seminal work in the history of the romantic *Freundschaftsbild*, showing Runge, his wife and his eldest brother (drawing, Berlin, Print Room) and the *Young Perthes* (Weimar Museum), then in 1806, *The Hülsenbeck Children* (Hamburg Museum). He worked at Wolgast during 1806-7, painting the *Double Portrait* of his parents and two religious pictures: *Rest on the Flight into Egypt* and *Christ on the Water* (all three, Hamburg Museum). Settling once again in Hamburg in 1807, he took up the theme of *The Times of Day* and painted a version of *Morning* (Hamburg Museum). He began a new composition on the same subject in a much larger format, but failed to complete it (*Morning*, 1809, Hamburg Museum). During the last two years of his life Runge wrote a treatise on his theory of colour.

The brevity of his life prevented him from realizing all his artistic projects. Most of his paintings are portraits, which remain the most direct expression of his craft, but to which Runge himself attached only secondary importance. The influence of Graff is evident, but he also took his inspiration from English painters of the late 18th century, although the forms in his own work are more firmly modelled, the composition more austere and the colours more brilliant. There is a certain affinity, too, with the intensity of German Romantic portraits, especially in the portraits of children, where Runge displays a profound feeling for the mind of the child.

Although Runge was, with Friedrich, the outstanding German Romantic painter of the early part of the century, he had relatively little influence on his contemporaries. Schinkel, however, took up the innovations he introduced into landscape painting, while traces of his style can still be found in Hamburg art. Most of his work is housed in the Hamburg Museum: this includes paintings, engravings, *The Times of Day*, drawings and illustrations for *Ossian*. The Nationalgalerie in East Berlin has a collection of his drawings. H.B.S.

Jacob van Ruisdael ▲
The Jewish Cemetery
Canvas. 142 cm × 189 cm
Detroit, Institute of Arts. Gift of Julius de Haas

Andrea Sacchi ▶
The Vision of St Romuold (*c.*1631)
Canvas. 310 cm × 175 cm
Rome, Pinacoteca Vaticana

Ruysdael
Salomon van

Dutch painter
b.Naarden after 1600 – d.Haarlem, 1670

Brother of Isaack van Ruisdael and uncle of the great Jacob van Ruisdael (the signed paintings show this difference in spelling), Salomon, like them, specialized in landscapes. He was taught by an unknown master, probably in Haarlem, but was certainly recorded in the Haarlem Guild of Painters in 1623. A Mennonite, he seems to have occupied a prosperous position in Haarlem, to judge from the taxes he paid and the expenses for his wife's funeral in 1660. His earliest attested works, dated 1626 and 1627, show the joint influence of Esaias van der Velde and Molyn, two landscape painters who, with Van Goyen, introduced the 'monochrome' naturalist trend. Both had links with Haarlem. Van der Velde was there until 1618, Molyn throughout his career. The influence of Van Goyen, evident in Salomon's painting, led to claims that he had been Van Goyen's pupil, and the works of the two painters, at least in the beginning, were often confused.

Like Van Goyen, Ruysdael, especially during the 1630s, was fond of painting river banks, or canals, with placid waters in which trees and houses were reflected. After 1640 he added panoramas of sand dunes, or roads whose interest lay in the delicate silhouettes of a few trees in the background. The depiction of foliage, in imitation of Van Goyen, is achieved with tiny strokes of paint, and the same liquid colours are used in a gamut of even grey-green and browns, but his technique is generally more mechanical and monotonous than Van Goyen's.

Curiously, their development was inversely

parallel: Van Goyen, in general, tended towards the use of a near monochrome, warmed, however, by a yellowish-brown tone. Salomon's trees were drawn with a sinuous line and the figures and animals handled delicately, with great animation and attention to detail. His drawing was less hasty than that of Van Goyen (possibly as a result of Van der Velde's influence), and he also depicted his landscape in an even, cold, greyish light. But, especially after 1640, his colours became more lively and his tonal range wider, notably in the blues, which grew clearer. The trees, too, are given more prominence, standing out against the background.

His later works, such as the beautiful and fantastic landscape *Ruins of Egmond Abbey* (1664, La Fère Museum), assume certain dramatic and decorative characteristics which invite comparison with the Italianists Berchem, Both and Moucheron. A distinct and significant tendency to enlarge his format and an increasing monumentality in the composition can be seen from about 1650. Several unusual still lifes date from these last years. One of the most remarkable, only recently discovered, is the fascinating *Turkeycock* (1661, Louvre), which is completely rococo in handling and close in feeling to the contemporary works of Van Aelst, Lelienbergh or Jan Baptist Weenix (another of Salomon's still lifes is at the Bredius Museum, The Hague).

Ruysdael's works, often signed and dated, are to be found in most major collections: principally Stockholm, Philadelphia, Vienna, Ottawa, Melbourne, Leningrad and the Louvre. J.F.

Sacchi
Andrea

Italian painter
b.Nettuno, near Rome, 1599 – d.Rome, 1661

A pupil of Albani in Rome and then Bologna, Sacchi was in Rome from 1627, chiefly employed by the Great Cardinal Antonio Barberini. His career was marked by many important commissions: *The Vision of St Isidore* (1622, Rome, Church of S. Isidoro): *Allegory of the Four Seasons* (*c.*1626-9), frescoes in the Villa Chigi (today the Villa Sacchetti) at Castelfusano, decorated mainly by Pietro da Cortona; *Birth of the Virgin* (*c.* 1628-9, Prado).

The *Divine Wisdom* (1629-33) in the Barberini Palace (the ceiling of the Sala del Mappamondo) is a key work of Roman art, painted at a time when the great dispute between the relative importance of 'disegno' and 'colore' was at its peak. The work shows that Sacchi, after subjects which were frankly Baroque, had acquired a new mastery of 'purified' Baroque, involving simpler and more controlled effects than those of Bernini and Pietro da Cortona. Refined tone values without violent contrasts, a reassuring tranquillity in the poses, great clarity of composition, with broad and harmonious rhythms: everything was less feverish and sparkling than the great decors of Cortona. Rome in the 1630s was a theatre of experiment and discovery in which Sacchi played a leading role. His celebrated *Vision of St Romuald* (*c.*1631, Vatican) dates from these years as does his *Hagar and Ishmael in the Wilderness* (1631, formerly Florence, Corsini Coll., now Cardiff, National Museum of Wales).

After 1635 Sacchi travelled throughout northern Italy (Bologna, Venice, Parma, Modena) and his palette was variously influenced by the schools of Bologna and Venice. A member of the Accademia di S. Luca, he was elected Principal in 1656 but refused to accept the honour. He worked in the Church of S. Giovanni in Fonte (*Life of St John the Baptist*, 1639-49); he painted a *Death of St Anne* (1648-9, Rome, Church of S. Carlo ai Catinari), a *St John the Baptist in the Wilderness* (*c.*1650, Fabriano, Church of S. Niccolò), and a *Dream of St Joseph*, which was one of his final commissions (1652, Rome, Church of S. Giuseppe a Capo le Case).

Sacchi also painted some of the greatest portraits of his period: those of *Pope Urban VIII* and *Cardinal Francesco Barberini* are lost, but those of *Monsignor Merlini* (Rome, Gal. Borghese), the singer *Pasqualini* (Althorp, Spencer Coll.), and a *Cardinal* (Ottawa, N.G.) have survived. His drawings, often studies of shimmering draperies, enlivened by shining highlights and intense black shadows, are numerous (Louvre; Darmstadt Museum; some beautiful series at Düsseldorf and at Windsor Castle).

Sacchi's importance, for long considered to be only secondary, is now fully recognized by the critics, who refute previous accusations of coldness and dogmatism and stress the authority of his composition, the nobility of his drawing, and the dramatic richness of his palette. His influence was important in the formation of Poussin who worked in his studio after 1631, the year of Domenichino's departure for Naples. Sacchi was

Philipp Runge ▲
The Hülsenbeck Children (1806)
Canvas. 131 cm × 143 cm
Hamburg, Kunsthalle

Salomon van Ruysdael ▲
The Landing Stage (1635)
Wood. 73 cm × 109 cm
Paris, Musée du Louvre

monochrome theme of Dutch painting. His cool, subtle choice of colours is taken mainly from the whites and beiges. In other respects, the scientific exactitude of his architectural paintings, the limpidity of the atmosphere, the precision and clarity of his formal language, lend a quasi-abstract quality to his work. J.V.

Salviati
Francesco
Italian painter
b.Florence, 1510 – d.Rome, 1563

The son of a weaver of Florentine velvet, Salviati adopted as his surname that of the cardinal who was his first patron when he arrived in Rome in 1531. He belonged to the generation that succeeded Pontormo, Giulio Romano, Rosso and Perino del Vaga, and he is a brilliant example of the second phase of Mannerism, together with Primaticcio, Bronzino and Daniele da Volterra. He was a childhood friend of Vasari, with whom he studied the works of the masters of the previous generation in Florence, and later in Rome. His attitude was influenced by his work in the studio of Andrea del Sarto and by the art of Rosso, as can be seen in his first studies in red chalk. Like many Florentine artists he completed his studies under a goldsmith and retained a taste in his pictures for the complicated shapes of metal objects.

Like many of his contemporaries, too, he often helped design the temporary decorations used in parades. In 1535 he executed several paintings in monochrome for a triumphal arch put up in Rome for the visit of the Emperor Charles V. But as early as 1532 he had also painted in Rome an important *Annunciation* for the Church of S. Francesco a Ripa. In 1537 Pier Luigi Farnese, the son of Pope Paul III, commissioned him to design decors for celebrations, and he remained in the family's service until 1544. A stay in Venice (1539–40), where he worked for the Patriarch (ceilings showing *Apollo and Psyche*) and where he also painted a *Deposition from the Cross* for the Church of Corpus Domini, Viaggiù (now in the Church of the Virgin of the Rosary), awakened his interest in large decorative works.

Parmigianino's influence is clearly evident in Salviati's *Holy Families*, and in the great painting of *Charity* (in the Uffizi). He was also a prolific portrait painter (Rome, Gal. Colonna; Vienna, K.M.), although in neither of these genres did he outshine his contemporaries. Rather, it is as one of the greatest decorative artists of the period 1540-60 that his name is remembered. In 1544 Duke Cosimo I de' Medici brought him to Florence to decorate the audience chamber in the Palazzo Vecchio. These great compositions of the *Story of Camilla* abound in allegorical figures, natural elements and trophies, arranged with a masterly touch. They have, too, an epic and fantastic spirit. The later Roman decorations at the Farnese Palace (*The Farnese Family in State*), and especially those in the Sacchetti Palace, can take their place in the first rank of this art form, so characteristic of the 16th century.

Around 1550 Salviati was strongly attracted to the monumental style of Michelangelo (paintings in the Oratory of Gonfalone). According to Vasari, Salviati visited France between 1554 and

very close to Duquesnoy, himself a great friend of Poussin. He was also Carlo Maratta's master: through these men his genius was continued in art throughout the whole of the 17th century. J.P.C.

Saenredam
Pieter Jansz
Dutch painter
b.Assendelft, 1597 – d.Haarlem, 1665

Saenredam's father Jan Pietersz Saenredam was an engraver who taught his son the rudiments of his craft before sending him to the studio of Frans de Grebbe in 1612. In 1622 Saenredam was enrolled in the Guild of St Luke in Haarlem, and in 1626 produced his first painting: *Christ Expelling the Merchants from the Temple* (London, private coll.).

Saenredam, however, is known chiefly for his paintings of churches, and his acquaintance with several architects such as Jacob van Campen, the greatest of Dutch classical architects, may explain the austerity and severe lines of these works. His 56 known paintings are of a mathematical precision, and were usually preceded by elaborate sketches and very accurate drawings, with the perspective projection fully worked out. About 140 of these are known at the present time.

Saenredam travelled throughout the Low Countries to study the essential characteristics of the monuments he drew. In 1632 he visited 's Hertogenbosch where he made drawings of the *Interior of St John's Cathedral* (British Museum; Brussels, M.A.A.). He returned to Assendelft, then went to Alkmaar (*c*.1634) and Haarlem (1635-6), where he painted the *Church of St Bavon* (Rijksmuseum; Paris, Netherlands Inst.; Warsaw Museum). In 1636 he journeyed to Utrecht where he drew *St Martin's Cathedral* (Utrecht, Municipal

Archives; Paris, B.N.), the *Church of St James* (Rotterdam, B.V.B.; Utrecht, Municipal Archives), the *Church of St John* (Hamburg Museum) and the *Church of St Mary* (Haarlem, Teyler Museum; Utrecht, Municipal Archives; Paris, Dutch Inst.).

One of his most productive periods was during his stay in Amsterdam (1641) where he painted national historical monuments in opposition to the Italianate trend of the time. From this period date drawings representing the *Old Town Hall in Amsterdam* (Haarlem, Teyler Museum; Amsterdam, Muncipal Archives, Fodor Coll.), which were preparatory sketches for the large, luminous view of the same building (1641-57, Rijksmuseum). Also in 1641 he painted the *Interior of St Mary's in Utrecht* (Rijksmuseum), a work of great austerity, and in 1642, *St James's Church in Utrecht* (Munich, Alte Pin.). The following year he executed a *View of the Pantheon* (New York, private coll.) from drawings made in Italy by Maerten van Heemskerck (Berlin-Dahlem).

In 1644 he travelled to Rhenen and drew the *Nave* and the *Tower of the Church of St Cunera* (Rijksmuseum). One of his most famous works, the *Interior of the Odulphuskerk in Assendelft* (Rijksmuseum), a veritable symphony of ochres, whites and greys, dates from 1649. Then he produced a series of views of Haarlem that included the *Nieuwe Kerk* (1650-5), built a short while before by his friend Jacob van Campen (drawings in Haarlem, Municipal Archives; Rotterdam, B.V.B.; painting in Haarlem, Frans Hals Museum). Saenredam returned to Alkmaar in 1661, where he painted the *Church of St Lawrence* (Rotterdam, B.V.B.; drawings, Albertina and Paris, Dutch Inst.). In Utrecht (1663) he painted *St Mary's Square* (Rotterdam, B.V.B.); the preparatory sketch is in the Teyler Museum in Haarlem.

Saenredam's church interiors, more severe than those of Emmanuel de Witte, are typical of the

 Pieter Saenredam
Interior of the Odulphuskerk in Assendelft (1649)
Wood. 50 cm × 76 cm
Amsterdam, Rijksmuseum

Francesco Salviati ▶
Bathsheba Calling at David's House
Fresco
Rome, Palazzo Sacchetti

1555, but no work from this journey has survived.

His neurotic, restless temperament, his prolific imagination, his refined and cultivated tastes, and his romanticism, allied Salviati to Caravaggio, whose true heir he was. His fertile talent was also exercised in book illustrations, designs for tapestries, and for gold or silverware. It represents the quintessence of the Italian Mannerist style and its craft. C.M.G.

Sánchez Cotán
Fray Juan
Spanish painter
b.Orgaz, 1561 – d.Granada, 1627

A narrative painter, with the piety and sensitivity of a Primitive, as well as an early pioneer of tenebrism at the beginning of the golden age of Spanish painting, Sánchez Cotán is one of the masters who still most intrigues modern critics. Trained in Toledo with Blas del Prado, an artist famous for his still lifes, Cotán began by painting altarpieces (now lost) as well as several *bodegones* (*Vegetables and Game*, 1602, Madrid, Duke of Hernani's Coll.). These last have been identified from the will that Cotán drew up in 1603 when, in his forties, he decided to renounce the world and enter the Carthusian monastery of Paular. From here, in 1612, he was sent to the monastery in Granada, where he ended his days, universally beloved and considered as a saint.

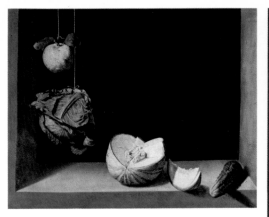

Cotán was a prolific artist whose work, carried out exclusively for his monastery, reached its peak about 1615 in the cycle of eight great narrative paintings on the themes of the foundation of the order by St Bruno, and the persecution of the monks in England by the Protestants, which he carried out for the cloister of the Granada monastery. He also decorated the chapterhouse, the refectory, several chapels (*The Last Supper*, episodes from the *Passion, Immaculate Conceptions*), and for the monks' cells painted scenes showing the Virgin garlanded with flowers, and green landscapes with solitary figures.

Today these compositions are divided between the monastery and the Granada Museum. Although there is an archaic air to them, they also reveal a keen interest in the treatment of light volumes, and in some respects are comparable with certain works by the Italian Cambiaso whom Cotán knew at the Escorial (*Virgin Waking the Infant Child*, Granada Museum). The monastic themes, even the scenes of martyrdom, have a peaceful rhythm, and are treated with a profound piety and a naive freshness (*Vision of St Hugh*, in which Christ, the Virgin and the angels are building the walls of the future monastery; *St Bruno and his Companions before St Hugh*; *The Virgin of the Rosary with the Carthusians*).

Cotán's still lifes, both before and after he became a monk, are of exceptional quality. Their austerity, their almost musical rhythm, the strict distribution of volumes and shadows (*Inn at Cardon*, Granada Museum; *Melon, Pumpkin, Cabbage and Quince*, 1602, San Diego, Timken Art Gal.) evoke the metaphysical preoccupations of the Neopythagoreans, as in Spanish mystical literature, which gives a transcendental meaning to everyday reality.

In spite of his retreat from the world, Cotán's influence remained strong. According to Palomino, Carducho visited him in Madrid to see his works before painting his great Carthusian cycles in the Paular. It is also possible that Zurbarán visited Granada. There is an obvious spiritual relationship between his religious works and Cotán's. The direct influence of Cotán's *bodegones* is evident in younger painters, such as Felipe Ramirez (*Cardoon, Flowers and Grapes*, 1628, Prado) and Blas de Ledesma. A.E.P.S.

Saraceni
Carlo, called Veneziano
Italian painter
b.Venice, c.1580 – d.Venice, 1620

At the end of the 16th century Saraceni left Venice for Rome where, after a short apprenticeship with

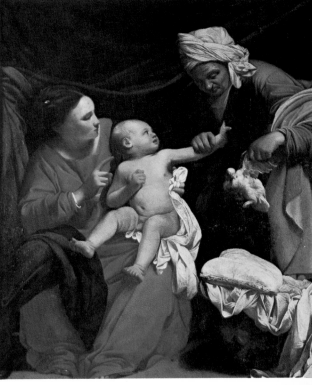

a late follower of the Venetian academic tradition, Camillo Mariani of Vicenza, he became part of the dissolute and boisterous circle of which Caravaggio was the leader and the idol. The *Rest on the Flight into Egypt* (1606, Frascati, Hermitage of the Camaldolites) is an example of how Saraceni's Caravaggism was moderated by his Venetian background to produce harmonious effects of light and, in his early works, a more intimate and touching vision than that associated with Caravaggio's dramatic temperament.

Saraceni was sufficiently closely related to the Caravaggesque circle for his works often to be confused with those of Gentileschi and even more so with those of Elsheimer, who had retained from his northern origins an idyllic feeling in his landscapes that awoke a similar response in Saraceni. The *Mythological Scenes* (Naples, Capodimonte), painted on copper, were for many years attributed to Elsheimer before being correctly assigned to Saraceni. The scenery is, in fact, typical of Elsheimer, with its dazzling and tranquil watery reflections, and compact leafy masses, painted in tones ranging from dark greens to pale greys.

The *Virgin and Child with St Anne* (*c.*1610, Rome, G.N.) marks Saraceni's transition to works of a greater serenity in which the Caravaggism, interpreted in a neo-Giorgionesque style, takes on the subtle lyricism that is Saraceni's most notable attribute. The enchantment of moonlight and the silent contemplation of *St Roch Tended by the Angel* (Rome, Gal. Doria-Pamphili), the mysterious suggestive power of *Judith Displaying the Head of Holofernes* (Vienna, K.M.) are further examples of Saraceni's Venetian background and Giorgionesque style, which, in the nocturnal effects in the Vienna painting surpass the chiaroscuro even of Gerrit van Honthorst. However, Saraceni's adherence to the techniques of Caravaggio is more in evidence in *The Martyrdom of St Erasmus* (Gaeta Cathedral) and in *The Martyrdom of St Agapetus* (Palestrina Cathedral). Between 1616 and 1617 he worked on frescoes in the Quirinal with Tassi and Lanfranco.

SAR

371

Fray Juan Sánchez Cotán ▲
Melon, Pumpkin, Cabbage and Quince
Canvas. 64 cm × 81 cm
San Diego, Timken Art Gallery

Carlo Saraceni ▲
The Virgin and Child with St Anne (*c.*1610)
Canvas. 155 cm × 130 cm
Rome, Galleria Nazionale d'Arte Antica

Saraceni's final period of activity in Rome produced *The Martyrdom of St Lambert* and the *Miracle of St Benno*, 1618 (Rome, Church of S. Maria dell'Anima), which saw a distinct return to the early style of Caravaggio. For all this, the more that Saraceni managed to free himself from his devotion to Caravaggism the more his art benefited. Inclined to intimism and tranquillity, he is an elegiac interpreter of what, for Caravaggio, was drama and violence. The despairing sadness of Caravaggio's *Death of the Virgin* (Louvre) becomes no more than a sigh in Saraceni's *St Charles Giving Communion to a Plague Victim* (Cesna, Church of the Servi). The light which, full of unexpected contrasts in the painting in the Louvre, emphasizing the masses, here diffuses itself like a mist and blurs the outlines instead of defining them.

In 1619 Saraceni returned to Venice with an outstanding pupil, Jean-Le-Clerc, from Nancy. Although Venice was still held fast in the Mannerist tradition and was no longer open to revolutionary ideas in the same way as in the past, Saraceni's genius was fully recognized there. His last work, *St Francis in Glory* (Venice, Church of the Redentore), painted in a sombre and homogeneous range of colours, is a sober view of his intensely human and vulnerable world. In the *Alliance of the Doge Enrico Dandolo with the Crusaders* (Venice, Doge's Palace) the composition is by Saraceni, while the figures are the work of Le Clerc, who completed and signed this large canvas after his master's sudden death. He also finished the brilliant altarpiece of the *Annunciation* for the Church of S. Giustina at Belluno.

M.C.V.

 John Singer Sargent
Ena and Betty, Daughters of Asher and Mrs Wertheimer (1901)
Canvas. 185 cm × 131 cm
London, Tate Gallery

Sargent
John Singer
American painter
b.Florence, 1856 – d.London, 1925

Sargent was the second child of an expatriate Philadelphia doctor, Fitzwilliam Sargent, whose wife, Mary Newbold Singer, was convinced that life in the United States was intolerably provincial. The family, while not poor, was obliged to take advantage of bargain rates at the various European spas, which perhaps accounts for Sargent's aspirations to succeed in the best social circles. He gave evidence of being a gifted draughtsman from earliest youth, keeping sketchbooks which recorded the family travels. In Rome in 1868 his first instructor was a German-American landscape painter named Carl Welsch. By 1870, when he enrolled in the Accademia di Belle Arti in Florence, the venerable American sculptor Hiram Powers had predicted a glowing future for the young artist.

By 1874 Sargent was ready to enter the École des Beaux Arts in Paris but soon transferred to the private studio of Carolus Duran, a fashionable Parisian portraitist, whose elegance and dashingly fluid manner made an indelible impression on his student. Although he developed a close friendship with Monet, admired Whistler and Mary Cassatt, and was even asked to join the Impressionist group, Sargent consciously opted for establishment art, undoubtedly because it provided the most assured avenue to worldly success.

In this decision he could not have been disappointed. By the time he was 22, he had gained an honourable mention in the Salon of 1878, guaranteeing exemption from further submissions before the jury. Then his strategy became clear: it was safely to establish his reputation and then, from a plateau of security, to practise those innovations which, he must have protested to himself, he always realized determined the true value of modern painting. Thus, in the late 1870s and early 1880s his landscapes increasingly demonstrate how well he understood Impressionism, yet it was an Impressionism in part only, and in portrait backgrounds, always sacrificed to the exigencies of a society portrait.

In turn Sargent absorbed with splendid facility each of the fashions that French and English painting offered during the 1880s and 1890s. His understanding of the importance of Spanish subjects, first introduced by Manet and Baudelaire in the early 1860s, was fulfilled in his *El Jaleo* (1882, Boston, Isabella Stewart Gardner Museum), which was again a great critical success. The preparation of this work led Sargent to make a thorough study of Velázquez which correspondingly enriched his portrait manner. From about 1882-3, when he painted *The Boit Children* (Boston, M.F.A.), his most remarkable work, Sargent's career as a fashionable portraitist began to develop rapidly.

The portrait of *Madame Pierre Gautreau* (Metropolitan Museum), exhibited at the Salon of 1884, secured his fame with a scandal, for the model was a well-known professional beauty, and her candid worldliness had been exploited by Sargent in his daring manner. For a brief instant it seemed that the notoriety thus won might backfire and drive away clients, but a timely move to England and the admiration of Henry James

secured a steady stream of sitters. In 1887, when Sargent received the invitation to paint the portrait of Mrs Henry Marquand, and travelled to America to do it, his clientèle expanded to its widest and most appreciative extent. Typically, Mrs Jack Gardner of Boston then wished to have her own portrait painted in the pose of the notorious Mme Gautreau. There followed a second visit to the United States in 1890, and Sargent produced more than 40 portrait commissions.

He had, meanwhile, met Charles Follen McKim of the architectural firm of McKim, Mead and White, and was given a major commission for murals in the new Boston Public Library. These decorations now consumed his energy, for he saw in them an opportunity to escape from what he knew was the tedious routine of a successful society portraitist. He settled on an ambitious scheme – the origins of Western religion and the rise and triumph of Christianity.

Nothing is more revealing of the fundamentally bourgeois nature of his values than the pretentiousness of his subject matter, fully in accord with the tastes of the Boston brahmins who applauded the results and commissioned yet more work for the library, and ultimately for the new Museum of Fine Arts. Sargent was all the rage. In one year, 1897, he was elected to the National Academy in New York, the Royal Academy in London, and made an officer of the Légion d'Honneur in Paris.

With high society clamouring to be painted, basking in his fame as the most brilliant of American turn-of-the-century painters, Sargent characteristically determined to abandon the compromising activity of portraits and devote himself to what he truly believed in; that is, apart from the Boston decorations, he would paint only for himself. But it was too late. No matter how prodigious his talent and technical virtuosity, no matter how much he had absorbed from the innovations of the Post-Impressionists and the Neoclassical simplifications of Puvis de Chavannes, his murals demonstrate a fundamental intellectual shallowness.

In only one area, beginning around 1900 and lasting until the end of his life, did Sargent consistently transcend the years of compromise in order to achieve worldly success. This was in watercolour sketching, particularly in direct studies after nature. These often casual small sketches preserved what the Princeton art historian Frank J. Mather called the 'zest of a beginner', and eloquently demonstrate what a remarkable artist Sargent almost was.

Although he never set foot in the United States until he was 21 (and then only to maintain his American citizenship) and spent his entire life on the Continent and in England, Sargent nevertheless represented the very ideal of the American artist of the early 20th century. This is because he was so successful, because his work sold so well, and finally because his fame had been secured through official channels in Europe. His career was crowned by the 1922 mural decorations executed for the Widener Memorial Library at Harvard.

He died in April 1925 in London, and achieved the distinction of a memorial service in Westminster Abbey. The following year, memorial exhibitions were staged by the Royal Academy in London and the Metropolitan Museum in New York.

A.Bo.

and a panel with *St Martin Sharing his Cloak with the Beggar* (Siena, Chigi-Saracini Coll.). Here, the mingling of subtle calculation and an ingenuous imagination reflect the advances in perspective made by the Tuscan school. Other versions of the *Virgin and Child* (Siena, P.N.: Grosseto Museum; Washington, N.G.) and an exquisite predella, part of an unidentified polyptych, depicting the *Agony in the Garden*, the *Kiss of Judas* and the *Ascent to Calvary* (Detroit, Inst. of Arts), also date from the fourth decade of the century. Sassetta's synthesis of the influence of Fra Angelico, Masolino and Uccello with an imaginative Gothic world is one of the most original in Tuscan art.

In 1437 Sassetta was commissioned to execute a large altarpiece of *St Francis* for the Church of S. Francesco in Borgo San Sepolcro, but he did not complete it until 1444. It represents the *Virgin Enthroned between St Anthony and St John the Evangelist* (Louvre), the *Blessed Ranieri Rasini* and *St John the Baptist* (Settignano, Berenson Coll.), and, on the reverse, *Eight Scenes from the Life of St Francis* (seven in London, N.G.; one at Chantilly, Musée Condé) surrounding *St Francis in Glory* (Settignano, Berenson Coll.). Only two panels survive from the predella showing the *Miracle of the Blessed Ranieri* (Berlin-Dahlem; Louvre). This is undoubtedly Sassetta's masterpiece, the fruit of a career and of an art that reflect the ideals of a dying civilization. The stories of St Francis are exalted as in a mystic and courtly legend.

Sassetta died in Siena of an illness, caught, it was said, while working out of doors on frescoes for the Porto Romano. Of these only *The Glory of the Angels* in the vault has survived. C.V.

Amongst those Sienese painters most directly influenced by Sassetta are Sano di Pietro, Pietro di Giovanni d'Ambrogio, and the Master of the *Osservanza* triptych, some of whose works are still attributed to Sassetta, especially the famous series of panels illustrating the *Life of St Anthony* (Washington, N.G.; Metropolitan Museum, Lehman Coll.; New Haven, Connecticut, Yale University Art Gal.; Berlin-Dahlem). L.E.

Sassetta
Stefano di Giovanni
Italian painter
b.Siena, c.1395 – d.Siena, 1450

Sassetta was the leading figure in the school of Siena at the time of the Florentine Renaissance. The altarpiece of the *Eucharist* (1423-6) painted for the Cappella dell'Arte of Lana is his earliest known work. It is now in separate pieces. The panels of the predella are in Budapest (*St Thomas at Prayer*). Other parts are in the Bowes Museum, Barnard Castle (*a Holy Communion*), the Vatican (*St Thomas before the Crucifix*), a private collection (*Miracle of the Consecrated Host*) and in the Pinacoteca Nazionale, Siena (*The Last Supper, St Anthony Beaten*), which also has eight *Saints* from the pilasters and two *Prophets* from the pinnacles. The *Angel* and the *Virgin* from the *Annunciation* of the pinnacles are now, respectively, at the Massa Marittima Museum and Yale University Art Gallery.

St Anthony Abbot, in a private collection in Italy, is the only surviving large panel. In this work the artist employs a method which, by translating perspective through rhythm, encloses the supple Gothic cadences in a fragile three-dimensional framework. Its 'modernity', however, consists in providing only a clear, limpid setting for the most abiding medieval dreams. This profound difference from the humanist and rational position of the Florentines marked all Sienese painting throughout the century.

Between 1430 and 1433 Sassetta executed the great altarpiece for Siena Cathedral, dedicated to the *Madonna of the Snows* (Florence, Pitti, Contini-Bonacossi Donation). His art was becoming increasingly subtle, an original synthesis of the strict rules of perspective established by the Florentine school, and the poetic unreality of a guileless vision. The predella, which depicts the *History of the Founding of S. Maria Maggiore in Rome*, is an especially fine example of Sassetta's art, where the light of the new age opens up the concentric heavens of medieval cosmology.

From this time on there was no painter in Siena who did not owe something to Sassetta who, for his part, followed with interest the cultural progress of his epoch and that of Florence in particular. If the central motif of *The Virgin and the Angels* in the polyptych of the Church of S. Domenico in Cortona still bears an extremely delicate Gothic stamp, the precise construction of the four lateral figures of the *Saints*, and the serene tonal harmonies, derive from Fra Angelico, whose mystical spirit also corresponded to that of Sassetta.

The Adoration of the Magi (Siena, Chigi-Saracini Coll.) and the little panels showing the *Procession of the Magi* (Metropolitan Museum), which surmounted the original polyptych, where the brilliance and luxurious taste of Gentile da Fabriano is reflected, likewise reveal a contrast in their basic elements, together with a strict unity of style. This gives rise to the belief that this polyptych predates *The Madonna of the Snows*, which itself was painted shortly before the surviving parts of a *Crucifix* with *The Virgin and St John*

▲ Stefano Sassetta
Altarpiece of the Madonna of the Snows (1430-3)
Wood. 241 cm × 223 cm
Florence, Palazzo Pitti, Contini-Bonacossi Donation

Savery
Roelandt
Flemish painter
b.Courtrai, 1576 – d.Utrecht, 1639

Savery was the younger brother of the landscape painter Jacob Savery, whom he accompanied to Amsterdam around 1591. During his time in the city he would almost certainly have come under the influence of Gillis van Coninxloo. In 1604 he was in Prague in the service of the Emperor Rudolf II and discovered the work of other Flemish artists such as Aegidius Sadeler, Joris Hoefnagel and Spranger. The Emperor commissioned him to travel throughout the Tyrol to make drawings, which were then engraved by Sadeler and Matham. Many of these engravings have survived (Albertina; Paris, Netherlands Inst.; Louvre; Stockholm, Nm; Berlin, Print Room). He was also given the chance to draw from nature, studying the animals in the Emperor's zoological gardens.

His works include *The Sacking of a Village* (1604, Courtrai Museum), *Hungarian Troopers on the March* (Louvre), *Interior of a Stable* (1615,

von Gütersloh, 1918, Minneapolis Inst. of Arts; *The Family*, 1918, Vienna, Österr. Gal.). Both Schiele and his wife died in the Spanish influenza epidemic of 1918 that spread across Europe.

A major exponent of Austrian Expressionism, between Klimt and Kokoschka (whose 'psychological portraits', painted at the same time as his own, show a less probing cruelty), Schiele went beyond the eroticism of Die Brücke by his implacable refusal to make concessions, and his lucid appraisal of others and of himself. He is well represented in Vienna, especially at the Österreichische Galerie and the Albertina.

M.A.S.

Rijksmuseum), a number of flower paintings, crammed with exquisite detail (Utrecht Museum), animal paintings (Rotterdam, B.V.B.; Antwerp Museum) and pictures of village fairs. For the most part, however, he painted fantastic landscapes inspired by the Tyrol, and peopled with both wild and domestic animals and birds (Vienna, K.M.; Hermitage; Rijksmuseum; Munich, Alte Pin.; museums in Prague, Brussels, Hamburg, Hanover, Courtrai, Ghent, Verviers and Hampton Court). Sometimes these served as the setting for a biblical or mythological scene: *Elijah Fed by the Ravens* (1634, Rijksmuseum); *Noah's Ark* (Dresden, Gg; Warsaw Museum); *The Earthly Paradise* (East Berlin, Bode Museum; Vienna, K.M.) and *Orpheus Charming the Beasts* (Louvre; Antwerp Museum; Göttingen Museum; Mauritshuis; Vienna, K.M.).

After Rudolph II's death in 1612 Savery spent several years in Vienna, Munich and Salzburg before returning to the Low Countries. In 1617 he was in Amsterdam and Haarlem, and the following year settled in Utrecht, where he died mad in 1639. His pupils were Willem van Nieulandt, Gillis de Hondecoeter and Allart van Everdingen.

J.L.

Schiele
Egon
Austrian painter
b. Tully, 1890 – d. Vienna, 1918

Schiele studied at the Academy of Fine Arts in Vienna from 1906 to 1909, meeting Gustav Klimt in 1907. His early works were greatly influenced by Klimt and there was a mutual admiration be-

tween the two artists. In 1908 Schiele exhibited at Klosterneuburg, and in 1909 at the International Kunstschau in Vienna. He worked at Krumau in Bavaria in 1911 and then at Neulengbach, before settling in Vienna in 1912. He was a very gifted draughtsman and the major part of his work was done in pencil, watercolour and gouache. He began as a painter of landscapes and portraits marked by the Jugendstil, but his originality became apparent in 1909.

Schiele was obsessed by his own face (double and triple self-portraits) and particularly by his body, as he was by those of his models, who were often very young. The treatment is sharp, and nervous, with strident colours (*Seated Male Nude*, pen and gouache, 1910, Vienna, private coll.; *Nude Man with Widespread Legs*, 1914, pencil and gouache, Albertina). The accent is on the genitalia, the cadaverous faces, the widespread and stretched fingers, the poses of lovers welded together in the final spasm (*Self-Portrait with Spread Fingers*, 1911, Vienna, Historisches Museum der Stadt; *Two Lovers*, 1913, private coll.).

More authentically than with Munch, love and death are linked in Schiele's world. Certain complicated poses are borrowed from sculptors such as Minne and Rodin, and some themes from Munch (*Dead Mother I*, 1910, Vienna, private coll.) and from Van Gogh (*Sunflowers*; *The Artist's Room in Neulengbach*, 1911, Vienna, Historisches Museum der Stadt), but the two-dimensional composition and the touch, both frail and taut, have a very personal effectiveness. His biting and provocative eroticism, the outlet for a despairing loneliness, earned the artist three weeks in prison (April-May 1912), which had a profound effect on him (*Self-Portrait as a Prisoner*, pencil and watercolour, 1912, Vienna, Albertina).

Some of his landscapes reveal the same sterile tension as the nudes (*Autumn Tree*, 1909, Darmstadt, Hessisches Landesmuseum; work done in autumn, 1912). Some, showing a quieter realism, are reminiscent of those of Hodler (*Four Trees*, 1917, Vienna, Österr. Gal.). A fairly large number, inspired by the old town of Krumau, have a geometric composition and colouring that anticipate the poetics of Klee (*Windows*, 1914, Vienna, Österr. Gal.; *Landscape at Krumau*, 1916, Linz, Neue Gal. der Stadt).

Schiele married in 1915, and this change in his situation shows in his work, in which his eroticism softens (*Reclining Woman II*, 1917, Vienna, private coll.). After guarding prisoners for a short time during the war he was able to continue painting in his Vienna studio. His reputation grew after 1912. His last works are close to Klimt in their sense of greater volume and their concern with a less abused reality (*Portrait of Albert Paris*

Schlemmer
Oskar
German painter
b. Stuttgart, 1888 – d. Baden-Baden, 1943

After a short apprenticeship in a marquetry workshop (1903-5), Schlemmer entered the School of Arts and Crafts in Stuttgart, where he joined Otto Meyer-Amden and Willi Baumeister before following the courses of Landenberger and Hoelzel at the Academy. The discovery of Cézanne, and above all, of Seurat, in Berlin (1911) proved a decisive influence. Appointed to the staff of the Bauhaus by Gropius, he was in charge of the stone sculpture studio and mural painting, then the theatrical studio until 1929, an activity which soon confirmed his affinity with painting. Professor at Breslau Academy in 1929, then at the School of Fine Arts in Berlin in 1932, he was dismissed the following year by the Nazis on account of his so-called 'degenerate' tendencies. Working alone, then in a lacquer factory, he retired to southern Germany, where he lived until his death.

From his early Post-Impressionism, Schlemmer, because of his interest in scenic problems, soon passed through a Cubist phase (*Houses*, pencil and watercolour, 1912), towards a severe form of abstraction that converted natural shapes to their static semblance (*Dancer*, 1922-3, Stuttgart, Tut Schlemmer Coll.; *Guests*, 1923, Darmstadt, Stroher Coll.). The essential aim of his art was the placing of figures in space, or, to use his own expression, to depict the 'plastic quality of man' in basic poses: vertical, horizontal, seated and walking positions (*Römisches*, 1925, Basel Museum; *Entrance to the Stadium*, 1930, Stuttgart, Staatsgal.). His figures dwindle to diagrammatic silhouettes, and the composition is regulated according to a play of purely geometric contrasts, based on the sculptural characters of the subjects and their affinity with space (*The Staircase of the Bauhaus*, 1932, New York, M.O.M.A.; *Heroic Scene*, 1936, Stuttgart, Tut Schlemmer Coll.).

During his last years Schlemmer's geometricism became less clearly defined, but more atmospheric and psychological (*The Designer*, 1942, Mannheim, Emil Frey Coll.; *Window* series, 1942, Stuttgart, Tut Schlemmer Coll.). As well as important murals (notably for the Folkwang Museum, Essen, 1928-30), Schlemmer created many sets and costumes for the theatre and opera. He is represented in galleries in Basel, Breslau, Dessau, Essen, Hanover, Duisburg, Cologne, Frankfurt, Munich, Saarbrücken, Stuttgart and New York (M.O.M.A.).

B.Z.

◄ Egon Schiele
The Family (1918)
Canvas. 150 cm × 160 cm
Vienna, Österreichische Galerie

▲ Roelandt Savery
Landscape with Birds
Wood. 58 cm × 108 cm
Prague, Národní Galerie

Schmidt-Rottluff
Karl

German painter
b.Rottluff, near Chemnitz, 1884 – d.West Berlin, 1976

From 1897 Schmidt-Rottluff studied in Chemnitz where he met Heckel in 1901. They met again in Dresden, where Schmidt-Rottluff was studying architecture, and together took part in the foundation of Die Brücke in 1905. Schmidt-Rottluff's early wood-engravings display the influence of the Jugendstil, as well as evidence that he possessed a sound technique (*Lady with a Hat*, 1905). In 1906 he took up lithography, and his first pictures reveal the vigorous Impressionism practised at the time by Nolde, with whom he went to Alsen in the same year (*Windy Day*, Hamburg, private coll.). In 1909 he devoted himself mainly to watercolours (*Dangast Landscape*, Hamburg, private coll.).

These varied experiments, as well as his mastery of wood-engraving (*Two Women*, 1910, Kiel Museum), soon helped Schmidt-Rottluff to develop a style full of concise simplifications, where the colour is spread in vigorous contrasting areas that assert the flatness of the picture plane (*Reading*, 1911, Munich, private coll.; *Portrait of Rosa Shapiro*, 1911, Berlin-Dahlem, Brücke Museum). This search for an expressive synthesis is best illustrated in the landscapes painted during visits to Norway and the Baltic coast (*Lofthus*, 1911, Hamburg Museum; *Sun in the Pines*, 1913, Bornemisza, private coll.).

In Berlin, where Schmidt-Rottluff settled in 1911, his friendship with Feininger and the growing influence of Negro art helped define his style, which, although now more naturalistic, laid great stress on the outline. The theme of women bathing is a recurring one in the works of this period (*Four Women Bathing on the Beach*, 1913, Hanover, private coll.; *Woman with a Necklace*, 1914, wood-engraving, Stuttgart, Staatsgal.). His first one-man exhibition took place in the Gürlitt gallery in 1914.

Mobilized in 1915, he was still able to carry out

engravings and began (1917-8) a series of wood-cuts on Old Testament subjects, masterly works, strictly arranged, in which the dense areas of black dominate the light zones (*Christ and the Woman Taken in Adultery*, 1918; *The Prophetess*, 1919). He also produced sculptures which openly plagiarized the African plasticity of Kirchner and Pechstein. He travelled to Italy in 1923, and to Paris in 1924. In 1928 and 1929 he stayed in Tessin. From 1928 to 1932 he spent his summers in a Pomeranian fishing-village.

The period of calm that began in 1922 was marked by great graphic activity (woodcuts, lithographs, etchings, watercolours) which remains, after that of the Die Brücke period, the best of Schmidt-Rottluff's work (*Peasant Hammering his Scythe*, 1924, etching; *Moon over the Village*, watercolour, 1924, Düsseldorf, K.M.). The theme of the *Town in the Mountain* recurs in his engravings between 1922 and 1926. From then on, both in his engravings and his paintings – in which the colour is always dominant – he treated the motif with a freedom which paid more attention to reality, although sometimes he reverted to stylization (*The Walk*, 1923, Berlin-Dahlem, Brücke Museum; *Dunes with a Dead Tree*, 1937, Kiel, private coll.).

In 1941 the Nazi government forbade him to paint at all and he was placed under police supervision. The last survivor of the group, in 1967 he founded a Die Brücke Museum in Berlin-Dahlem. He is represented in most German galleries, especially in Berlin (N.G., Brücke Museum, 61 works), as well as in London (Tate Gal.) and New York (M.O.M.A.). M.A.S.

Schnorr von Carolsfeld
Julius

German painter
b.Leipzig, 1794 – d.Dresden, 1872

Son of the painter and engraver Hans Veit Schnorr von Carolsfeld, Julius was a pupil at the Academy in Vienna from 1811, where he came especially under the influence of Joseph Anton Koch and Ferdinand Olivier. In 1817 he painted his first important work, *St Rock Distributing Alms* (Leipzig Museum). In the same year he went to Italy and joined the Nazarenes in Rome in the decoration of the Casino Massimo (1818). A journey to Sicily in 1826 marked the end of his stay in Italy where, besides the frescoes illustrating scenes from *Orlando Furioso* in the Ariosto bedchamber in the Casino Massimo, he had made landscape drawings in the Alban and Sabine hills, and some pencil drawings. Among his surviving paintings are *Carla Bianca von Quandt* (1819-20, Berlin, N.G.). *The Marriage at Cana* (1819, Hamburg Museum) and the *Holy Family and the Family of St John* (Dresden, Gg).

In 1827, at the request of Ludwig I of Bavaria, he settled in Munich to decorate the King's residence with murals illustrating the *Legend of the Nibelungen*, the *Story of Charlemagne, Barbarossa* and *Rudolf of Hapsburg*. At the same time he taught at the Academy. In 1846 he was made Director of the Dresden Gallery and also a professor at the Academy. His *Bible in Pictures*, decorated with 240 illustrations, appeared in 1860. In this work Schnorr showed his mastery of

drawing and the art of composition better than he had done in the frescoes, which lacked lyricism. His finest works were produced in his youth, especially his drawings, which are among the most notable examples of German art in the early part of the 19th century. The Print Room in Dresden possesses the most important collections of Schnorr's drawings, of which examples can also be seen in Berlin (N.G.). H.B.S.

Schönfeld
Johann Heinrich

German painter
b.Biberach, 1609 – d.Augsburg, 1682/3

After serving his apprenticeship in Memmingen, Schönfeld worked from 1627 to 1629 as a journeyman in Stuttgart. From there, like most German painters of the time, he went to Italy, travelling through Basel. He spent some ten years in Italy (*c.*1630-40), a period that proved decisive for his art. His first works, in the Mannerist

tradition of Goltzius, Müller and Valckenborch, were soon followed by paintings in which Schönfeld established his personal style. In Rome, where he was in the service of Prince Orsini, Schönfeld showed little taste at first for monumental religious compositions, taking his inspiration instead from Elsheimer and his circle and from the style of the Italian Mannerists. It is not known how long he stayed in Rome, the only indication being a note in the archives of 1633 in which the name of a certain Giorgio Belcampo Teutonico, that is, Schönfeld, appears as the sponsor of a German. It provides no indication that he was then in the city.

Schönfeld moved on to Naples where a circle of artists had formed. His association with them had a most beneficial effect on the young German as they opposed to the monumental painting, then so esteemed in Rome, a more intimate variant, with poetic themes and a subtle tonal range, expressed in vast panoramas, richly atmospheric and painted in the smallest format. Naples, where Schönfeld remained for several years, introduced new tones to his art. Works such as *The Triumph of David* (Karlsruhe Museum), *The Victory of Joshua in Gibeon* (Prague, Castle Gal.) or *Solomon Anointed by Zadok the Priest* (Stuttgart, Staatsgal.) show quite strongly the influence of the Neapolitan painters of battle scenes, Aniello Falcone, Salvator Rosa and Domenico Gargiulo. The two magnificent *Seascapes* (Rome, Pallavicini Gal.), as well as the two versions of the *Flood* (Vienna, K.M.; Kassel Museum; the latter, so far attributed to De Loutherbourg, is certainly by Schönfeld) can only have been conceived in Naples. Personal contact seems to have existed between Schönfeld and Cavallino, his junior by 13 years, whose paintings with their delicate transitions of tones, pronounced chiaroscuro and picturesque rendering of atmosphere, show many affinities with the works of the German master. It is not known, however, to what extent the one influenced the other.

Schönfeld seems to have discovered the art of Jacques Callot (whose influence appears in the organization of the composition, and in the frieze-like formats, and in the slenderness of the figures) through his fellow-countryman, the Strasbourg painter and engraver, J.G. Baur. Schönfeld, most of whose paintings were conceived in Italy, produced some poetic fables and pastorals, scenes from classical antiquity and from Graeco-Roman mythology, biblical narratives and bucolic paintings, enlivened by many figures.

As much by his choice of themes as by the transparency of his colours, which bring out

dappled reflections and violet shadows, Schönfeld appears as one of the precursors of 18th-century painting, anticipating elements of composition that are purely rococo: slender silhouettes stand out from the whole, outlined against a delicate grey background. In the atmosphere's silvery coldness the light-coloured zones are opposed to the dark masses, suggesting depth. In these solemn scenes of ruins, powerful contrasts invite the eye to plunge into the depth of the painting. As in Roman friezes, processions of figures march past (*The Triumph of Venus*, Berlin-Dahlem; *The Train of Bacchus*, Naples, Capodimonte; *The Triumph of David*, Karlsruhe Museum). Alongside the lively, triumphal processions, Arcadian idylls echo classical frescoes in which the figures are in harmony with the surrounding countryside.

One of the most important themes of Baroque art, that of the futility of earthly things, occupies an important place in Schönfeld's work. Dead animals, burning candles, irridescent soap bubbles, hour-glasses and ruins are not simple accessories, but allegories symbolizing time, and the transience of all things. To these themes Schönfeld adds treasure-seekers and the scenes of carnage so popular with his contemporaries for their sombre intensity. Ancient tombs and sarcophagi, symbols of past grandeur, are represented as broken and profaned.

Schönfeld is one of the few well-known German artists of the 17th century to have returned to his native land. After spending more than 15 years in Italy, he went back to Germany at the end of the Thirty Years War. Precise information is lacking on his activity from the time of his arrival in Stuttgart around 1627-9 until 1651, when he painted the *Holy Trinity* in the Church of Biberach. An inscription on the back of his *Jacob and Rachael at the Fountain* (Stuttgart, Staatsgal) suggests that in 1647 he was director of the Count of Brühl's gallery in Dresden, but this cannot be taken as proof. It is only after 1652, the date when he settled in Augsburg, and was given the freedom of the city, that his works begin to be dated.

His creative genius seems to have weakened progressively after his return from Italy. To satisfy the many commissions from convents and churches in southern Germany, he turned mainly to altarpieces in which he showed great virtuosity without, however, recapturing the power of expression of his youthful works. The influence that Schönfeld, one of the greatest religious painters of the 17th century, exerted over his followers in Augsburg, Johann Heiss, Isaak Fisches and Johann Spillenberger, was due mainly

to his use of classical formulae. Curiously, in spite of his anticipation of many elements of the rococo, Schönfeld, apart from his influence on the young Maulbertsch and Kremerschmidt, did not decisively influence the future course of German painting. G.A.

Schongauer
Martin

German painter and engraver
b.Colmar, c.1450 – d.Breisach, 1491

The last representative of Rhineland mysticism, Schongauer was the greatest painter in Germany before Grünewald, Holbein and Dürer. His father, Caspar, a goldsmith in Augsburg, moved to Colmar in 1440 or later, where Schongauer seems to have received his early training in his father's workshop. He then took lessons from the masters of the guild, which he himself then joined. He appears to have spent the year 1465 at Leipzig University, possibly studying for the priesthood. His name occurs several times in the land register of Colmar, although he never seems to have become a burgher of the city. Around 1488 he moved to Breisach where he was appointed the town's official artist the following year.

Among his earlier attributed works are three drawings dated 1469, notably that of *Christ in Glory* (Louvre), which so closely resembles Rogier van der Weyden's *Christ at the Last Judgement* (Hospices de Beaune) that it must be a copy. It is quite possible, in fact, that the two masters met. Certainly, Schongauer, as the result of his early training, was so familiar with the contemporary Flemish school that Vasari took him for a pupil of Rogier. The Netherlandish master's monumental style is so strikingly reflected in Schongauer's early works that a certain rigidity of technique is apparent.

Few paintings by Schongauer have survived. The most famous is the *Madonna of the Rose-Bower*, 1473, Colmar, Church of St Martin). An early copy (Boston, Gardner Museum) shows that the panel was cut on all four sides, eliminating the figure of God the Father and the dove of the Holy Ghost. Schongauer here developed his sense of the flatness of the picture plane. His early days as a goldsmith's apprentice, and Rogier's example, both made him aware of linear problems. Without sacrificing the theme, he split up and studied the figures and elements of the decor in their minutest detail. His supple line, pared to essentials, imparts an expressive plasticity to the faces. From the Virgin, one of the most beautiful in German art, plunged deep in thought, her head slightly turned, there emanates a silent, inner peacefulness, which infuses the entire picture. The lacy pattern of the foliage and the subtle play of colour soften the rather severe monumentality.

Among the few other authenticated paintings to have survived, is the *Orliac Altarpiece* (Colmar Museum), named after the donor, Jean d'Orliac. Like the *Madonna of the Rose-Bower*, the three panels (*Annunciation*, *Adoration* and *St Anthony and the Donor*) display a spiritual exaltation embodied in a serene and idealized beauty that is in striking contrast to the banal emotions of most German Late Gothic painting at this time. Schongauer also painted three small panels, a *Holy Family* (Vienna, K.M.), a *Nativity* (Munich, Alte

◀ Johann Schönfeld
The Triumph of David
Canvas. 115 cm × 207 cm
Karlsruhe, Staatliche Kunsthalle

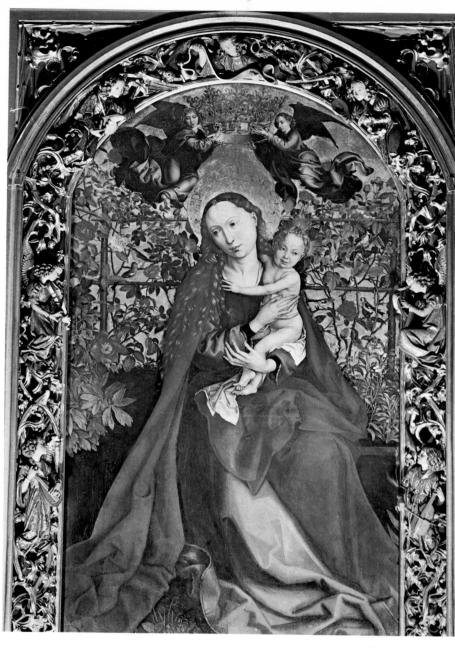

16th century fell under his influence in varying degrees. But this was the final flicker of a great conflagration. The Renaissance and the Reformation brought many changes and Schongauer's fame died soon after him. However, in his day, many artists were influenced by his passionate expression of medieval spirituality. B.Z.

Schwitters
Kurt
German painter
b.Hanover, 1887 – d.Ambleside, England, 1948

After studying at the schools of fine art in Hanover, Dresden and Berlin, in 1914 Schwitters began work as an academic portrait painter, at the same time painting abstract canvases and submitting to the successive influences of various avant-garde movements: Expressionism, Fauvism, Cubism and Die Blaue Reiter (*Snow-Covered Houses*, 1918, Hanover Museum). In 1918 he suddenly gave up the traditional materials of painting, in favour of the rubbish of city life: handbills, tram-tickets, bits of rag, scraps of paper, jam-jar lids, string, corrugated cardboard. These collages in which, unlike the Cubist *papiers collés*, there was no pictorial element in the true sense, he named *Merz*, after the letters on a fragment of paper advertising a bank – *Kommerz-und Privat-bank* – which was stuck in the centre of one of his collages.

The first *Merz* exhibition was held in 1919 in Berlin, under the aegis of *Der Sturm*, by Klee and Molzahn, and it was *Der Sturm*, which, that same year, also printed Schwitters's first *Merz* poem *Anna Blume*. In spite of Huelsenbeck's hostility towards him in 1920 Schwitters took part in Dada activities, and was particularly close to Raoul Hausmann, Arp and Hannah Höch. The collages he made at this time gave an impression of spontaneity and of 'objective chance', but were nonetheless constructed according to the shapes and colours of the rubbish he used (*The 'And' Picture*, 1919, private coll.; *Merz Picture, 14.6 schwimmt*, 1921, New York, Rothschild Coll.).

In 1921, together with Hausmann, Schwitters carried out a lecture tour in Czechoslovakia before waging a 'Dada campaign' in 1922 with

Pin.), and an *Adoration of the Shepherds* (Berlin-Dahlem) that are true translations into paint of his engravings.

The authenticity of the altarpiece for the Dominican church (Colmar Museum), however, is now very much in doubt. On the other hand, parts of a wall-painting of the *Last Judgement*, discovered in 1931 on the west wall of Breisach Cathedral, are undoubtedly by Schongauer. Despite the poor condition of the painting his meticulous drawing can still be made out, full of the dramatic intensity that made him unique throughout the Rhineland during his day. Grouped around the usual 'Deity' are Moses and the Old Testament saints. Above is God the Father amongst angels who hold the instruments of the Passion. Below, angels with trumpets awaken the dead. As in a triptych the composition continues along the lower parts with the hosts of the saved and the damned, terminating at the base in a barrier of flame.

Schongauer left 115 engravings and about 100 drawings, some half of which have been lost but are known by contemporary copies. Schongauer was one of the first to sign his works (he used the monogram 'MS' with a cross having a semi-circular cross-piece). His output covered various religious themes: *The Life of the Virgin, The Passion, The Parable of the Foolish Virgins*, of which the greatest examples are in the British Museum. Acutely penetrating, with a subtly balanced play of rhythmic line and interwoven colour that shows the realism of such painters of the Upper Rhine as the Master E.S. or the Master of the Playing Cards (*The Censer*, British Museum), his style flowered freely in the atmosphere of spiritual tension that characterizes most of his compositions: *Noli me tangere* (British Museum), *The Carrying of the Cross* (British Museum).

Schongauer's work brought him resounding success, but although widespread, it was also short-lived. Dürer, unaware of his death, travelled from Colmar (1492) expressly to see him. Vasari records how Michelangelo, fascinated by Schongauer's technical mastery, copied his *Temptation of St Anthony*. Baldung, Dürer, Grünewald, Bosch and Holbein – all the German and Swiss masters at the beginning of the

Martin Schongauer ▲
The Madonna of the Rose-Bower (1473)
Wood. 200 cm × 115 cm
Colmar, Church of St Martin

Kurt Schwitters ▶
Merz 378 (1922)
Collage
Essen, Folkwang Museum

Theo van Doesburg. To publicize his works and ideas he made use, until 1923, of the periodicals favourably disposed towards Dada: *Der Sturm*, *Der Marstall*, *Der Sweemann*, but soon founded his own review, called *Merz*, in which he reproduced several of his works (*Mz 600*, Leiden, 1923, Hamburg Museum; *Mz 26·48*, Berlin, 1926, Paris, private coll.). In line with Dada precepts, *Merz* soon opened its columns to the Bauhaus, to De Stijl and to Mondrian's Neo-Plasticism, thus marking the break with the international Dada.

Classed as a *Kulturbolschewik* after Hitler came to power, Schwitters fled to Norway in 1937, then to England in 1940, never ceasing to work on his *Merzbilder* according to the principles he had laid down in 1919. An abstract influence became apparent in his last pictures (*With a Slit*, 1942-5, London, Lord's Gal.), but it was not a decisive influence in the rediscovery of his work by the 'New Dada' and the 'New Realist' painters of the 1960s.

Schwitters is represented mostly in Düsseldorf (K.M.W.); the Hamburg Museum; Essen (Folkwang Museum); the Hanover Museum; New York (M.O.M.A. and Guggenheim Museum); Stockholm, (Moderna Museet); London (Tate Gal.); Los Angeles (County Museum of Art); and Newcastle University (unfinished *Merz Structure*).

E.M.

Scorel
Jan van

Netherlandish painter
b.Schoorl, near Alkmaar, 1495 – d.Utrecht, 1562

Scorel studied in Alkmaar until he was 14, and was then apprenticed to Cornelis Buys in Haarlem, and then to Jacob Cornelisz van Oostsanen in Amsterdam. He spent a short period with Gossaert in Utrecht between 1515 and 1518, and then travelled to Germany, staying in Cologne, Speyer, Strasbourg, Basel and Nuremberg, where, according to Vasari, he met Dürer. In Carinthia, in 1520, he worked on a triptych for the parish church of Obervillach (preserved in the church) for Count Frangipani. He then continued his journey as far as Venice, where he came under the influence of Giorgione and Palma Vecchio. He painted some portraits: an *Italian* (Stuttgart, Staatsgal.) and a *Venetian* (Oldenburg Museum). Set against a light background, these display a keen realism and light tone values, very close to the Italian tradition.

From Venice he went on a pilgrimage to Jerusalem in order to make studies for biblical pictures – sketches of costumes, landscapes and archi-tecture to help him to reproduce the local colour more faithfully. He made many drawings in Jerusalem before going to Cyprus and Rhodes. Towards 1522 he returned to Rome, arriving during the pontificate of the Dutch Pope, Adrian VI, who came from Utrecht. Greatly favoured by the Pope and made inspector of the Belvedere, he remained in Rome until 1524, becoming acquainted with the work of Raphael and Michelangelo. He visited Utrecht in 1523, and in 1525 returned to the Low Countries for good, opening a studio in Utrecht where he stayed until his death.

Between 1525 and 1526 he painted two series of twelve *Portraits of the Confraternity of Jerusalem in Utrecht* (Utrecht Museum), a third series in 1535, and, between 1527 and 1528, twelve *Portraits of the Confraternity of Jerusalem in Haarlem* (Haarlem, Frans Hals Museum). This was the origin of the Dutch 'collective' portrait. Already Scorel was developing one of his most characteristic effects: the model, very studied, is captured in a typical pose and bathed in a clear light that throws the forms into relief. Around 1524-5 he painted the *Altarpiece of Herman van Lochorst* (Utrecht Museum), the central panel of which shows the *Entry into Jerusalem*, with a view of the town in the background. This is obviously inspired by the memory of his pilgrimage to the Holy Land.

 Jan van Scorel
The Dispute of St Stephen
Wood. 234 cm × 73 cm (Panel of the polyptych of the Abbey of Marchiennes)
Douai, Musée de la Chartreuse

▲ Jan van Scorel
The Stoning of St Stephen
Wood. 219 cm × 151 cm (Central panel of the polyptych of the Abbey of Marchiennes)
Douai, Musée de la Chartreuse

▲ Jan van Scorel
The Burial of St Stephen
Wood. 234 cm × 82 cm (Panel of the polyptych of the Abbey of Marchiennes)
Douai, Musée de la Chartreuse

He was made a canon of the Chapter of St Mary in Utrecht in 1528, although this did not prevent him from living with Agatha van Schoonhoven, by whom he had six children, and of whom he painted an excellent portrait (1529, Rome, Gal. Doria-Pamphili). This is one of his most successful and beautiful works, notable for its range of browns and the strength of its three-dimensional effects. In the same genre as this painting is the no less famous portrait of the *Little Scholar* (*c*.1531, Rotterdam, B.V.B.).

Towards 1533 Scorel painted *The Presentation in the Temple* (Vienna, K.M.), in an Italianate architectonic setting, and a *Magdalene* (Rijksmuseum), set before a landscape divided into the traditional three planes. In this solemn and delicate work, bathed in light, the shadows project and define the modelling. Between 1536 and 1538 Scorel worked in Breda Castle, and in 1540 collaborated in the decorations for the celebration of the Emperor Charles V's entry into Utrecht.

It was around 1540-1 that Scorel worked on one of his most famous altarpieces, recently discovered and restored: the *Marchiennes Polyptych* (Douai Museum), commissioned by Jacques Coene, Abbot of Marchiennes. This complex and huge construction comprises two movable folding shutters attached to a central panel. Separated for a long time, the various parts have now been reassembled in the museum at Douai. The work depicts the lives of *St James the Great* and *St Stephen*: the figures are almost life-size. The sumptuous background of ancient monuments is evidence of the archaeological knowledge acquired by the artist during his stay in Rome. The expressiveness of the picture comes, not from the faces, but from the elongation of the figures, which are bathed in a strong light that brings out the sharpness of the colours.

The reappearance of this altarpiece is of great importance, all the others mentioned by Van Mander having been destroyed by the Calvinist iconoclasts in 1566. This, and the one in the church of Breda, are the only two to survive to this day. Scorel's relations with the French abbey (confirmed by part of the *Polyptych of the Eleven Thousand Virgins, c.*1540, recently taken to Douai Museum) are explained by the economic connections between the abbeys of the Douai region and the Chapter of Utrecht.

In 1542 Scorel, very much in the style of Michelangelo, painted a *St Sebastian*, taken from a figure in the *Last Judgement* (Rotterdam, B.V.B.). He followed this around 1541-3 with an altarpiece for the church at Breda, of which the centre panel shows the *Discovery of the True Cross by St Helena and the Emperor Constantine* and the *Queen of Sheba Visiting Solomon* (Rijksmuseum). In 1552 he worked on decorations for the entry of Philip II into Utrecht, and restored Van Eyck's *Polyptych of the Lamb of God*. Scorel also worked for the Abbey of St Vaast, although no trace of what he did there survives.

Famous in his own time, he was one of the first to bring the Italian influence to the Low Countries; as such, his importance is enormous. But even more, his work, so strongly original, is very typical of the fundamental tendency towards expressionism of the artists of the northern Low Countries. With its harsh light, brusque movements, and almost strident colours, his style proved the starting-point for a whole school of painters: Heemskerck, Cornelius Buys II, Dirck Jacobsz, Jan Swart, Vermeyen and Anthonis Mor may all be seen as Scorel's direct descendants. J.V.

Sebastiano del Piombo
(Sebastiano Luciano)
Italian painter
b.Venice (?), c.1485 – d.Rome, 1547

A birthdate of about 1485 is suggested by Vasari's statement, that Sebastiano was aged 62 when he died in 1547. He was probably born in Venice itself, but there are no certain facts about his early life and we know nothing about the circumstances in which he became a painter. Nonetheless, it is now generally agreed that Sebastiano carried out two major works in the years before his move to Rome in 1511. One is the organ shutters in the Church of S. Bartolomeo al Rialto, which clearly date from early in the period after his emergence as an independent artist. The other is the picture for the high altar of the Church of S. Giovanni Crisostomo, painted towards the end of the Venetian activity. To these two works may well be added a third, *The Judgement of Solomon* (Great Britain, Bankes Coll.), a picture still sometimes attributed to Giorgione.

Each of these three works is of outstanding quality and inventiveness. The inner sides of the S. Bartolomeo shutters, representing *St Louis* and *St Sinibaldus*, show the young Sebastiano's deep sympathy with Giorgione's style of about 1506. They share the lyrical qualities of the older artist, but possess a technical virtuosity in the handling of paint entirely Sebastiano's own. The outer sides are far more heroically conceived. Possibly influenced by the presence of Fra Bartolommeo in Venice in 1508, they show Sebastiano's own innate predilection for the qualities of dramatic action and emphatic plasticity which are so characteristic of his work done after the move to Rome.

The Judgement of Solomon, which is unfinished, is the most ambitious of the Venetian works. It combines asymmetry of composition with an exceptionally complex (and even symbolic) use of colour. The S. Giovanni Crisostomo altar is the most mature of the large Venetian pictures. It exemplifies the artist's quest for simplified and monumental shapes, and a taste for colour less violent than that in the early Titian. Close in character is a small painting of *Salome* (London, N.G.) dated 1510.

Sebastiano's move to Rome early in 1511, one of the most decisive events of his career, was prompted by an offer of employment by the banker Agostino Chigi. One of the artist's first tasks in Rome was to undertake fresco decoration in a room in Chigi's newly built villa, the Farnesina. Sebastiano's chief piece of decoration there was a series of lunettes illustrating episodes from Ovid's *Metamorphoses*, which must be counted among his least successful works. The character of the commission was probably alien to him for, in striking contrast to Titian, Sebastiano painted very few mythological subjects, and his lack of sympathy with fresco painting subsequently led him to develop for himself an oil technique for mural painting.

At about the same date, Sebastiano painted one of his most remarkable portraits, of *Ferry Carondelet Dictating to his Secretary* (Lugano, Thyssen Coll.). Other works in this portrait series, done between 1511 and 1520, include the *Portrait of a Young Man* (Budapest Museum), the *Portrait of a Young Man with a Violin Bow* (Paris, Rothschild Coll.), the *Portrait of a Young Woman* (Berlin-Dahlem) and the group portrait, dated 1516, of *Cardinal Sauli and Three Companions* (New York, Kress Coll.).

Sebastiano arrived in Rome when Michelangelo was finishing the first half of the Sistine Chapel ceiling. At a date soon after that work's completion in 1512, he became a close friend of Michelangelo, and we know, both from Vasari and from the evidence of surviving drawings, that Michelangelo made drawings to help the younger artist with his commissions. The first fruit of this artistic co-operation was Sebastiano's *Pietà* (Viterbo, Museo Civico), painted for a chapel in Viterbo and almost certainly finished by 1515. Vasari's statement that Michelangelo made a cartoon for the two figures is confirmed by the character of the picture's design (one drawing by Michelangelo connected with the picture survives in the Albertina, Vienna). The picture is in fact a remarkable alliance of central Italian *disegno* and rich Venetian colour and tone, with a dark landscape that still clearly proclaims Sebastiano's Venetian origins.

Two other major results of the co-operation with Michelangelo date from the second half of the same decade. They are the Borgherini chapel in the Church of S. Pietro in Montorio, Rome, and *The Raising of Lazarus* (London, N.G.). Drawings by Michelangelo done to help Sebastiano with both commissions survive, although Michelangelo's intervention was greater in the case of the Borgherini chapel decoration, of which the altarpiece, painted by Sebastiano in oil on the wall, representing the *Flagellation of Christ*, became a landmark in 16th-century Roman art. *The Raising of Lazarus*, more ambitious and less successful, was, like Raphael's *Transfiguration*, ordered by Cardinal Giulio de' Medici and was painted in direct competition with Raphael's picture.

After Raphael's death in 1520, Sebastiano's position as a portrait painter was unchallenged in Rome. And from 1520 to 1527, when the sack of the city led to the temporary end of all artistic activity there, he executed a series of portraits in many respects more remarkable than those of the previous decade. This series includes the now ruined portrait of *Pietro Aretino* (Arezzo, Palazzo Pubblico), the *Portrait of a Man* (Houston, Texas, Kress Coll.), the *Portrait of Andrea Doria* (Rome, Palazzo Doria), and the *Portrait of Clement VII*

(Naples, Capodimonte). Each of these pictures represents an aspect of a new monumental portrait style which seems to have no precedents. A new dramatization in the characterization of the sitters (almost all of whom were leading personalities of the age) is combined with a new pictorial breadth. As a result, a painting such as that of *Pope Clement VII* seems to relate as much to Michelangelo's Sistine ceiling *Prophets* as to previous High Renaissance portraiture.

Sebastiano was involved in the dispersal of Roman society which was provoked by the sack of the city. By March 1528 he was with the depleted Papal court at Orvieto and a few months later he was in Venice. But he was one of the first artists to return to Rome and was at work there by June 1530 or earlier.

The view is widely held that, after he received the sinecure Papal office of the Piombo in 1531, Sebastiano painted very little. This emphasis on his lack of activity in the decade of the 1530s, found already in Vasari's *Life*, has almost certainly been exaggerated. There can be no doubt that Sebastiano resumed his career as one of the foremost portrait painters in Italy in this decade, and from this period there can be dated with certainty the *Portrait of Baccio Valori* (Florence, Pitti), the portraits of *Clement VII* in Vienna, Parma and Naples, the *Portrait of Cardinal Rodolfo Pio* (Vienna, K.M., datable after December 1536) and the *Portrait of Cardinal Reginald Pole* (Hermitage, datable after December 1536). Stylistically, the impressive *Portrait of a Lady* (Great Britain, Radnor Coll.) also belongs to the second half of the decade. These later portraits are not uniform in style but the general trend is towards a more relaxed and ideal style, less heroic than that of the 1520s.

In the early 1530s Sebastiano began to employ slate as a support for his easel pictures, and several of the portraits listed above, together with a majority of the subject pictures of this period, are painted in this way. In many of the subject pictures (almost invariably religious in theme) there is an ever-increasing pursuit of massive and simplified forms, where all incidental detail is eliminated. Examples of this style are the large mural altarpiece of the Chigi chapel in the Church of S. Maria del Popolo, the *Christ Carrying the Cross* (Hermitage), the *Christ Carrying the Cross* (Budapest Museum) and the *Pietà* painted for the Chapel of Francisco de los Cobos at Ubeda in Spain. For the figure of the dead Christ in this picture Michelangelo supplied a drawing (Louvre). Two works which must be placed very late in Sebastiano's career are a large (now dismembered) mural of

the *Visitation* (once in the Church of S. Maria della Pace, Rome; three large fragments now in the Duke of Northumberland Coll.) and the *Madonna del Velo* (Naples, Capodimonte). This last work well exemplifies Sebastiano's *ultima maniera*, which embraces the greatest delicacy of execution, a highly idealized sense of form, and a very cool range of colour. M.H.

Segantini
Giovanni
Italian painter
b.Arco di Trento, 1858 – d.Schafberg, 1899

Segantini's first works, following his training at Brera Academy (1876-8), are in a naturalistic style that derived from Millet and his European followers (*Ave Maria at Sea*, 1882, Zürich, private coll.). A meeting with Vittore Grubicy in 1880 later led him (1887-8) to adopt, although not exclusively, the techniques of Divisionism, which resulted in a lightening of his palette and a greater emphasis on rhythm and geometrical elements (*Young Shepherdess Knitting*, 1887-8, Zürich, Kunsthaus; *Two Mothers*, 1890, Milan, G.A.M.). From 1890, following Previati, he threw himself enthusiastically into Symbolism, which, both as regards his choice of subjects and the intensified use of arabesque, dominated his later works. He was influenced also by the Pre-Raphaelites, and by the Viennese Sezession (*The Angel of Life*, 1894; *Love at the Springs of Life*, 1896; *The Goddess of Love*, 1894-7, all Milan, G.A.M.; *The Punishment of Lust*, 1897, and *The Wicked Mothers*, both Zürich, Kunsthaus).

The Alpine landscape remained his favourite theme and was often used as the background of his compositions. In other works Segantini remained attached to realism (*Spring Pasture*, 1896, Brera), sometimes in studies of light that used the division of tones (*Portrait of Carlo Rota*, 1897; *Portrait of Mme Casiraghi Oriani*, 1899), and sometimes by adding a new feeling of decorative rhythm, or mystical and symbolical allusions (*Hay Harvest*, 1891-9; the *Triptych of the Alps*, 1886-99, St Moritz, Segantini Museum). Segantini's work, some of which is in the Segantini Museum, St Moritz, is also represented in galleries in Basel, Zürich, Leipzig, Munich, Berlin, Vienna, Hamburg, Wuppertal, Brussels, The Hague and Liverpool (*The Punishment of Luxury*). A.M.M.

Giovanni Segantini ▶
The Wicked Mothers (1897)
Cardboard. 40 cm × 73 cm
Zürich, Kunsthaus

Seghers
Hercules Pietersz

Dutch painter and etcher
b.Haarlem, c.1589-90 – d.Amsterdam, c.1635

Little is known about the life of Seghers, and the few documents that do refer to him shed no light on his personality. He is mentioned as a pupil of Gillis von Coninxloo in Amsterdam until the latter's death in 1607. At the public sale of his master's estate, he bought a landscape referred to as a 'rocky landscape'. The choice of this subject, rarely painted by Coninxloo, seems to indicate that Seghers had already determined his path. He was received into the Guild of Painters in Haarlem in 1612 and in 1615 married Anneken van der Brugghen who was 16 years his senior. The couple settled in Amsterdam where Seghers bought a house on the Lindengracht in 1619, the memory of which is preserved in one of his etchings (*View from the Window of Seghers's House*).

Seghers enjoyed a certain fame in his lifetime, as is shown by the mention of his paintings in the estate inventories of his contemporaries Louys Rocourt, Herman Saftleven and Jacob Marell. In 1656 Rembrandt owned eight of his paintings, one of which was probably *The Mountain Landscape* (Uffizi), and in 1621 a work by Seghers was offered to the King of Denmark. Two others are mentioned in the collection of the Prince of Orange (1632). According to Hoogstraeten, however (1678), Seghers was misunderstood by his contemporaries and died alone in poverty. This falsehood can be attributed, perhaps, to the lack of interest which Hoogstraeten felt for his work, whose originality he could not comprehend.

The paintings. Of the 11 paintings recognized as by Seghers, none is dated, and only four seem to have been signed (*The Valley*, Rijksmuseum; *River Valley*, Rotterdam, B.V.B.; *View of Rhenen*, Berlin-Dahlem; *Two Windmills*, Fareham, Norton Coll.). They are mainly landscapes, as (with a few exceptions) were the lost paintings, described in old documents. The paintings which have survived do not form a continuous series, so that it is almost impossible to draw up a chronology of Seghers's work. It is usually supposed that the fantastic landscapes came before the realistic paintings of actual places. The two earliest surviving paintings are *The Valley* (Rijksmuseum) and the *Mountain Landscape* (Ijmuiden, Kessler Coll.), which reflect the imaginary landscapes of Joos de Momper that Coninxloo must have made known to his pupil. A feeling of anguish emerges from these valleys, surrounded by masses of steeply sloping rocks with, in the foreground, a dead tree. The human figure is almost totally absent.

The small *River Landscape with a Waterfall* (Westphalia, Herdringen Castle, mentioned in 1627 [?]) may have been painted later. The same treatment is found here: a thin execution and a palette in which greys and greens dominate, lightened in places by a touch of red or blue.

With the *Mountain Landscape* (Uffizi), once attributed to Rembrandt, Seghers reveals the extent of his genius. An arid foreground, bathed in light, is prolonged on the right of the picture by the rising mass of sheer mountains, which completely dominates the horizon, while on the left a vast green valley stretches endlessly, the outlines of trees leading the eye into the far distance. Rem-

brandt, who may once have owned this work, probably reworked it, adding, on the left, a horse-drawn carriage and two peasants, thus introducing a human dimension not found in Seghers's other paintings. The originality of the composition lies in the juxtaposition, on a single canvas, of great, arid mountains with a spreading fertile plain, and the dramatic tension which results from this.

Seghers took up this design again in three other surviving paintings: *River Valley* and *River Valley with Houses* (Rotterdam, B.V.B.), and *Houses and Village in a River Valley* (formerly New York, Historical Soc.). Like the Uffizi *Landscape*, the *River Valley* (Rotterdam) is painted on canvas stuck on wood, a method favoured by Seghers. In the three works the same trees and bushes are depicted, their foliage conveyed by the placing of small circles and dabs of paint, while in the distance, there appears a large lake against which silhouettes of sailing ships stand out. The *River Valley with Houses* (Rotterdam) is especially significant because the houses, which the painter could actually see from his window in Amsterdam, are placed in an imaginary setting, a method which was also employed by other contemporary painters such as Salomon van Ruysdael and Aelbert Cuyp.

The four surviving urban or rural landscapes (as opposed to views of mountain or river valleys) are in a very different spirit: *Brussels, View from the North* (Cologne, W.R.M.); *Two Windmills* (Fareham, Norton Coll.); *Village by a River* (Berlin-Dahlem); and *View over Rhenen* (Berlin-Dahlem). These three last pictures represent panoramic landscapes in which a steeple or windmill stands out above an almost flat horizon. Seghers painted these in an exaggeratedly elongated format, thus accentuating the endless extent of the flat country in which he lived, and it is perhaps to him that the real credit for having

created this typically Dutch landscape should go.

Among the paintings referred to in old catalogues, the disappearance (after 1853) of a larger than life-size *Skull* is particularly regrettable.

The engravings. Only a small number of impressions (183) by Seghers have survived, made from 54 different plates. Seghers, who did not employ an etcher, made only a few pulls of each state, introducing modifications each time. It is therefore a small production for such a long career, although many engravings may have been lost. The subjects of these works are more varied than those of the paintings: storms, studies of boats, trees and a rearing horse; still lifes of books and a skull: views of ruins, streets, wooded landscapes, mountains and plains. All these themes were used by Seghers's contemporaries, but he treats them with a boldness that leads almost to abstraction, if one can imagine that in a 17th-century context.

More so than the paintings, the engraved landscapes vary widely in style from imaginary valleys and fantastic mountains (the most numerous) to realistic views of plains and villages. However, by varying the techniques of engraving Seghers succeeded in creating an imaginary setting from a naturalistic landscape. From one print to the next, for example, the *Ruins of Rijnsburg Abbey* progresses from a faithful representation to a magic image. In the *Mountain Landscape with Ship's Rigging* the implacable character of the enormous rocks that dominate the small village lying in a deep valley is accentuated by the network sketched by the ship's rigging – the remains of another composition that the artist only partially effaced.

Steep rocks, dead trees, isolated villages, sometimes scarcely visible, formed one of his favourite subjects, and from it he made engravings in a large format, notably *Mountain Valley*

Hercules Seghers ▲
River Valley with Houses
Canvas. 70 cm × 86 cm
Rotterdam, Museum Boymans-van Beuningen

with *Four Trees*, *Landscape with Fenced Fields* and *Rocky Landscape with Waterfalls*. The same threatening atmosphere pervades both versions of his *Tempest at Sea*, showing sailing ships struggling hopelessly against the elements.

Besides landscapes Seghers made various studies of trees in a natural setting (*Large Tree*), or against a neutral abstract ground (*Two Trees*; *Mossy Tree*). The first of these has many similarities with other landscapes, but a refined poetry, close to Asiatic art and without any equivalent in Western art, emanates from the colourful prints of the *Two Trees* and the *Mossy Tree*.

The *Three Books* is one of Seghers's most interesting etchings. Once again he succeeded in creating a dramatic tension by playing only on the proportions and arrangement of three books.

The varied printing techniques used by Seghers played an essential role in each print and allowed him to obtain infinite variations from one plate. The polychrome effects of certain engravings seem especially to have interested Seghers, and he ended by making oil paintings of them, particularly those that were varnished, such as a print of *The Great Ruin of Rijnsburg Abbey*, traced in yellow on paper painted black, with the sky retouched in green, and the stones with red.

The two largest collections of Seghers's engravings are in the Rijksmuseum (Print Room) and in Paris (B.N., Print Room). The engravings did not have a wide influence in the 17th century, except on the work of Johannes Runscher. In painting, only Frans de Momper was deeply influenced by his landscapes. However, Segher made a profound impression on both Rembrandt and Philips de Koninck. M.D.B.

Seurat
Georges

French painter
b.Paris, 1859 – d.Paris, 1891

The artistic development of the man who was considered to be the leader of the Neo-Impressionists was entirely traditional. After working in a municipal art school (at the expense of his studies at the lycée) where he drew all the time, working from illustrations or paintings, or sometimes plaster casts, in 1877 Seurat enrolled at the École des Beaux Arts. Not only did his parents not oppose this move, they even helped him, so that he was free of all financial worry. From 1879 he rented a studio with Aman-Jean whom he had met at the local art school. The two friends worked together in the same style and studied contemporary art, visiting the fourth Impressionist Exhibition in May 1879. At the Beaux Arts Seurat saw the new (1872-3) copies of Piero della Francesca's murals, actually executed on the spot at Arezzo.

He worked from the life, and studied classical art and the works of the old masters. His professor, Henri Lehmann, a follower of Ingres, helped to train him according to the principles of Ingres, and one of Seurat's earliest known works, *Angélique au rocher* (*Angelica on the Rock*) (London, private coll.), is in fact, partially copied from Ingres's *Roger délivrant Angélique* (*Roger Saving Angelica*) in the Louvre, where he was a frequent visitor. An avid reader, Seurat spent much of his time in libraries, studying engravings and reproductions, and poring over treatises on painting. He studied Chevreul's theory of colour, the opinions of Delacroix from his diaries, and the ideas of Corot and Couture. He never stopped researching into the theory of colour and painting, even during his military service at Brest between November 1879 and November 1880, when he studied Sutter's ideas on the phenomena of vision.

In 1881, back in Paris, he read the works of Rood, and worked on his own, slaving away at drawing. He studied volumes, and the play of light, and finally arrived at an alliance of forceful line and soft shadow that later led Signac to remark of his drawings that it would be possible to paint from them without another look at the model. Some of Seurat's works are so smooth and velvety that they appear to derive directly from the tradition of Rembrandt. He had often exhibited his drawings, and it was one of these, the *Portrait d'Aman-Jean* (Metropolitan Museum),

▲ Georges Seurat
Un dimanche après-midi à l'île de la Grande Jatte
(1886)
Canvas. 205 cm × 308 cm
Art Institute of Chicago

accepted by the judges at the Salon of 1883, that enabled him to exhibit there for the first time. The Louvre and the Museum of Modern Art in New York have some fine collections of Seurat's drawings.

Seurat's talent as a painter developed more slowly than as a draughtsman. In his early works, he followed the Barbizon tradition, especially in his subject-matter. From 1881 to 1883 he made so many studies of country scenes and peasants at work (New York, Guggenheim Museum; Glasgow, Art Gal.; Washington, Phillips Coll.) that it appeared as though he were preparing to paint in the style of Millet, who closely influenced him. He also came under the influence of the Impressionists whose technique he adopted and, from 1883, their themes, especially those showing the banks of the Seine. His first important painting, *Une baignade à Asnières* (*Bathers at Asnières*) (London, N.G.), rejected by the Salon in 1884, was hung the same year at the Indépendants. This is a work of high originality, even though it still shows many influences – including those of Puvis de Chavannes and Pissarro, especially in the simplification and 'monumentalization' of the forms. Certain new principles appear, imbibed from his reading and his study of Delacroix.

Un dimanche après-midi à l'île de la Grande Jatte (*Sunday Afternoon on the Island of La Grande Jatte*) (1886, Chicago, Art Inst.) was the fruit of two years' work, and a perfect demonstration of Seurat's developed method. For such large compositions he made notes from life, either in the form of squared drawings or of paintings executed very rapidly on small wooden panels; in effect, thumbnail sketches. In his studio he worked on either small panels or large canvases. From these extensive studies he finally elaborated his own theory of division, based on the intermingling (but not actual mixing) of primary colours to give a clearer effect of a secondary colour than if it had been mixed on the palette. The colours were put on to the canvas in small spots, their size varying with the size of the canvas and the distance at which the spectator would stand to 'see' the desired colour. Seurat declared that he had had this aim in view since he first picked up a paintbrush. In his own words he was looking for 'a formula for optical painting'.

In 1884 he became friendly with Signac, who, absorbed by the same problems, was destined to become in the course of his long life the most zealous follower of Divisionism. A group formed around them that included Camille Pissarro and his son Lucien, Dubois-Pillet, Luce and Angrand. Neo-Impressionism astounded the Parisian public and earned the disapproval of most critics, although it made a strong appeal to people of an experimental cast of mind. Félix Fénéon explained its scientific foundation to readers of *Vogue*, while Gustave Kahn linked it to the theories of Symbolist writers. It spread as far as Belgium where it found supporters such as Van Rysselberghe, Henry van der Velde and Finch.

While frequenting literary and artistic circles, Seurat continued to work tenaciously. Durand-Ruel showed some of his paintings in New York, and also in Brussels where he had been invited by the Groupe des XX. Various Parisian galleries opened up to him: the Galerie Martinet, the Théâtre Libre, the premises of the *Revue Indépendante*. He was admitted to the last Impressionist Exhibition and contributed regularly to the exhibitions at the Salon des Artistes Indépendants where he showed some of his most important

works: *Un dimanche après-midi à l'île de la Grande Jatte* in 1886, *Les Poseuses* (*The Models*) (Merion, Barnes Foundation) and *Parade de cirque* (*Circus Show*) (Metropolitan Museum) in 1888, *Le Chahut* (Otterlo, Kröller-Müller) and *Jeune Femme se poudrant* (*Young Woman Powdering Herself*) (London, Courtauld Inst. Galleries) in 1890, and *Le Cirque* (*The Circus*) (Louvre, Jeu de Paume) in 1891.

He also showed landscapes which, in addition to his large figure compositions, made up an important part of his output. It was chiefly in his marine paintings that he joined a keenly observant eye for nature to the rhythmic design of the picture. According to his usual method he began by painting directly from the subject – he had spent summers by the sea – and later finished the work in his studio. In this way he painted, in 1885, his views of *Grandcamp* (London, Tate Gal.; New York, Rockefeller Coll.); in 1886, of *Honfleur* (Otterlo, Kröler-Müller; Prague Museum; New York, M.O.M.A.; Tournai Museum); in 1888, of *Port-en-Bessin* (Minneapolis, Inst. of Arts; St Louis, Missouri, City Art Gal.; Otterlo, Kröller-Müller; Louvre, Jeu de Paume; New York, M.O.M.A.); in 1889, of *Crotoy* (Paris, Niarchos Coll.; Detroit, Inst. of Arts); and in 1890, of *Gravelines* (London, Courtauld Inst Galleries; Otterlo, Kröller-Müller; New York, M.O.M.A.; Indianapolis Museum).

He experimented with the psychological effect of structural lines in the composition, a problem that was already preoccupying him in his *Baignade à Asnières* and *La Grande Jatte*. He was looking for a 'logical, scientific and pictorial system' that would provide a basis for harmonizing the lines of a composition in the same way that he was able to harmonize the colours. He was fascinated by the work of the scientist, Charles Henry, the author of an *Esthétique scientifique*, in which he aimed to establish the connection between the expressive values of line and colour. Seurat, in his constant search for a scientific basis for his art, studied these aesthetic theories of Henry's attentively and used them in his compositions. In *Parade* the horizontals dominate, giving an impression of repose, while *Le Chahut* and *Le Cirque* are constructed on diagonals which suggest gaiety and urgent movement.

Hung at the Salon des Indépendants in 1891, *Le Cirque* was still unfinished, and has remained so. Only a few days after the opening of the exhibition Seurat was struck down by a sudden illness and died. His loss was deeply felt in the world of art. So strong was his personality that he had made his mark even on those who opposed his theories, such as Teodor de Wyzewa, who described Seurat as 'an admirable example of a race that I had supposed finished; the race of theoretician-painters, uniting the practice to the idea and the imaginative unconscious to the thought-out endeavour' and compared him in this respect to Leonardo, Dürer and Poussin. From 1892 in Paris (at the *Revue blanche* and at the Salon des Indépendants) and in Brussels (in the Groupe des XX) retrospective exhibitions of Seurat's art achieved a degree of success. In 1899 Signac dedicated his book *D'Eugène Delacroix au Néo-Impressionisme* to the memory of Seurat, and hailed him as the originator of the optical mixture in painting.

His theories were equally interesting to students of Divisionism – Gaetano Previati in Italy, Curt Herrmann in Germany – as well as to those to whom art implied construction and syn-

thesis, such as Le Corbusier and Ozenfant (*L'Esprit nouveau*) and Severini (*Du Cubisme au Classicisme*). Seurat's artistic concepts influenced the Fauves and the Cubists, the German Expressionists and the Italian Futurists, and some of his ideas reappeared among the artists in the De Stijl movement and among the members of the Bauhaus. Both through his paintings and his theories Seurat played an important role in the evolution of modern art. M.T.F.

Shahn
Ben

American painter
b.Kaunas, 1898 – d.New York, 1969

American painter, print- and poster-maker, strongly identified with the Social Realist movement of the 1930s and 1940s, Shahn was born in Kaunas (formerly Kovno), Lithuania, and emigrated with his family to Brooklyn, New York, in 1906. At the age of 15 he became a lithographer's apprentice, completing his secondary education at night school. The experience with lithography, his direct knowledge of printing techniques and the mass audience reached by the medium must be counted as among the decisive influences on his development. (He continued to work as a lithographer until 1930.)

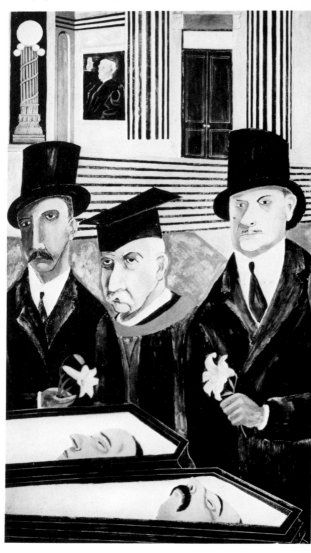

Ben Shahn ▶
The Passion of Sacco and Vanzetti (1931–2)
Canvas. 215 cm × 130 cm
New York, Whitney Museum of Art, Gift of Edith and Milton Lowenthal

In the spirit of highly motivated emigrants to turn-of-the-century America, Shahn pursued his higher education at City College, New York, and at New York University between 1919 and 1922, before entering the National Academy of Design in 1922. In 1925 he made his first trip to Europe, returning again for two years between 1927 and 1929 to absorb what he considered the principal innovations of French modernism. These, to Shahn, were found in the work of Dufy and Rouault rather than in formal abstraction, for he was above all sensitive to the social content of art. Painting that did not manifest a concern for the condition of the mass of the people did not seem to him to be a valid contemporary expression.

Shahn's first major exhibition took place at Edith Halpert's Downtown Gallery in April 1930. His work was characterized by a keen feeling for flat design, simplified figural references, and subtle colour. He was a master of tempera and gouache. In the United States he was clearly identified with 'modern' art in the sense that he eschewed the conventional subject matter of high art and embraced distortion and modification of representational elements for expressive purposes. The following year he began the series for which he is most famous, 23 gouache paintings and two large panels depicting the Sacco-Vanzetti case (New York, M.O.M.A.), culminating in the trial and condemnation of the two accused anarchists. Shahn's burning social conscience was coolly controlled in these works, in which both caricature and flat design were combined with references to late quattrocento painting in a sophisticated way.

The best-known of these panels, depicting the investigatory tribunal that exonerated the government for its handling of the Sacco-Vanzetti case, was exhibited at the Harvard Society of Contemporary Art in 1932. The painting caused a scandal because President Lowell of Harvard was clearly depicted as a collaborator in the execution of the two Italian immigrants. The same year the Sacco-Vanzetti panels were shown at the Museum of Modern Art, thereby identifying both Shahn and Social Realist art as components of modernism.

Shahn was employed by Diego Rivera to work as an assistant on the *Man at the Crossroads* fresco commissioned for the R.C.A. building at Rockefeller Centre, New York, and subsequently covered over because it pilloried John D. Rockefeller. His art thrived on controversy. He painted a series on the case of the union leader Tom Mooney, and during 1933-4 was deeply involved with the Public Works Administration, not only as a muralist but also as a photographer. The many documentary pictures he took in the service of the Farmers' Security Administration (F.S.A.) are conserved at the Library of Congress and at the Fogg Museum, Cambridge, Massachusetts. Of his murals, the most famous are the fresco for the Federal housing project in Roosevelt, New Jersey (1935-1938), and for the Bronx Central Annexe Post Office (1938-9). This last was carried out in collaboration with his wife, the noted illustrator Bernarda Bryson.

Because of his clearly articulated liberal, not to say radical, sympathies, Shahn's career was not all plain sailing. In 1939-40 a mural project on the four freedoms, commissioned by the Public Buildings Administration for the post office at St Louis, Missouri, was rejected. He did, however, secure the commission for the murals in the main corridor of the Federal Security Building in Washington, D.C. (1940-2), and the Office of

War Information commissioned posters from him, although only two were published. From about the middle of the war, he began increasingly to be offered and to accept commercial assignments, sometimes from the left-wing organizations with which he was identified, such as the C.I.O., but also from commercial concerns like the Container Corporation of America, the Columbia Broadcasting System, and *Fortune* and *Time* magazines.

The climax of Shahn's career was probably in 1956 when he was appointed Charles Eliot Norton lecturer at Harvard University and delivered the lectures entitled *The Shape of Content*. While the Harvard appointment and his acceptance of it vindicated the university from its implied collusion in the Sacco-Vanzetti affair, by the mid-1950s Shahn was considered by the younger generation of New York School artists to be an exponent of aesthetic conservatism, no matter how progressive his politics had been. He died before his work could be re-evaluated in the context of a renewed interest in socially conscious art.

<div style="text-align: right">D.R.</div>

Sheeler
Charles

American painter and photographer
b.Philadelphia, 1883 – d.Dobbs Ferry, New York State, 1965

In 1900 Sheeler entered the Pennsylvania School of Industrial Art, an institution founded, together with a museum, in the wake of the Centennial Exposition of 1876, and modelled on Cole's philosophy of the collaboration between school and museum as developed in the early days of the Victoria and Albert Museum in London. Sheeler learned applied design, studying the classical orders of ornament in a logical and meticulous fashion. By 1903, however, he had become more ambitious and entered the much older Pennsylvania Academy of the Fine Arts. As a student, he worked for a time under William Merritt Chase, learning to master the dazzling brushwork that was the hallmark of sophisticated painting at the turn of the century in the United States.

Around 1906 Sheeler became friendly with Morton Schamberg, a former architecture student at the University of Pennsylvania, and the two shared a studio in Philadelphia. Schamberg was more adventurous in his tastes than Scheeler, and no doubt conditioned his friend to be receptive to modern French painting, which he encountered for the first time during an extended European trip in 1908-9. In Paris he was certainly impressed by Cézanne and Matisse, but it is doubtful if he saw any work by Picasso or Braque. Nevertheless, the trip was decisive and he abandoned the method of working from nature in the manner of Chase, claiming that henceforward he had to start from scratch, trying to plan his work in advance, and aiming to introduce a cerebral element into his canvases.

About this time (1912) Sheeler turned to photography as a means of earning a living, taking on assignments largely from Philadelphia architects. The junction between his early training, his new European ideas, and his means of livelihood was now established, but the implications were not borne home to him until after he

had seen the Armory Show at New York in 1913. Now Sheeler began to be more actively involved with the developing New York art world, receptive to European modernism. He participated in the Forum Show and in the famous 1917 exhibition of the Society of Independent Artists. He became friendly with Walter Conrad Arensberg, with Marius de Zayas, and with the European painter-refugees from the war, Duchamp, Picabia and Gleizes. De Zayas gave him an exhibition at his Modern Gallery in 1917, and his photography increasingly assumed the aspect of independent creative work – indeed leading his painting.

When Schamberg died in 1918 Sheeler moved to New York, and there began to explore the visual possibilities of the city's buildings in film (in collaboration with Paul Strand), photography and painting. By the mid-1920s the characteristic, crisp, patterned vocabulary of Sheeler's mature style emerged. The lessons of architecture were applied to pattern-making not only in landscape or seascape, but even in portraiture. His most famous painting, *Upper Deck* (1929, Cambridge, Massachusetts, Fogg Museum), provides an inventory of those elements that subsequently became identified with the concept of 'American Precisionism', a feeling of careful planning and crisp observation of detail, so that the accumulated individual forms assume predominance over the context and the work looks more abstract than it actually is. In *Home Sweet Home* (1931) the cut-off composition and combination of simplified patterns are so emphatic as to flatten out the picture plane and make the work appear primarily as an exercise in pure design. This painting also reflects the modern American artist's deliberate linking of pre-industrial and vernacular design with a feeling for technology in a satisfying, if austere, harmony.

Sheeler's work continued to develop in the 1940s and 1950s, and he did not hesitate to transcend the exigencies of realistic depiction by introducing lines and colours that were emphatic rhythmic repetitions rather than imitations. Yet, at heart, he remained a realist. In this respect he is properly grouped with those Americans associated with the first cautious response to European modernism – with O'Keeffe, Demuth, Marin, Spencer and Crawford. In 1959 he suffered a stroke which disabled him, and in 1965 a second stroke ended his life.

<div style="text-align: right">D.R.</div>

Sickert
Walter Richard

English painter
b.Munich, 1860 – d.Bathampton, 1942

Sickert, a leading figure in English art during his lifetime, was possibly the most important English painter since Turner. His long and active career lasted from 1881 to 1942, and his prolific output includes landscapes, portraits, music-hall and theatre scenes, intimate interior scenes and still lifes.

Sickert was the son of Oswald Adalbert Sickert, a painter and illustrator of Danish descent, and of an English mother. The family settled in England in 1868. From 1877 to 1881 Sickert worked as an actor, and in 1879 he met Whistler, as well as making his first trip to Dieppe. He studied at the Slade School from 1881

to 1882 under Alphonse Legros, but left to become Whistler's pupil and assistant. The American influenced Sickert in several ways: by his social and artistic independence, by his liking for dark tones and subdued colouring, and through his connections with the French Impressionists. Under his instruction, Sickert painted low-keyed, tonal landscapes and portrait studies, and worked straight from the subject, using thin washes of paint, as, for example, in *La Plage* (1885[?], Manchester, City Art Gal.).

In 1883 Whistler sent him to Paris in order to accompany a picture that was to be exhibited at the Salon, and gave him a letter of introduction to Degas. The meeting with Degas was the first of many, and was to prove an important turning-point for Sickert, for although his admiration for Whistler lessened over the years, Degas remained an ideal for most of his life. Under the influence of Degas Sickert extended the range of his subject matter and began to paint more structured pictures. Thus, for instance, the motif and composition of *The Laundry Shop* (1885, Leeds, City Art Gal.) owe much to Whistler, but the deliberate construction could be said to be due to the influence of Degas.

From 1887 to 1890 Sickert painted a number of music-hall scenes, which are close in conception to Degas's *café-concerts*. They include such works as *Gatti's Hungerford Palace of Varieties, Second Turn of Katie Lawrence* (c.1887-8, Sydney, Art Gal. of New South Wales) and *Little Dot Hetherington at the Bedford Music Hall* (c.1888-9, Great Britain, private coll.). *The Gallery of the Old Bedford* (c.1894, Liverpool, Walker Art Gal.) is a later example of these scenes and one of the finest. Sickert ignored the stage on this occasion, and turned instead to depict a motley group of young men in the audience.

Sickert began to travel abroad from 1894 on-

wards, spending summers in Dieppe and Venice and painting portraits in London during the remainder of the year. Several of his portraits, notably those that were not commissioned, are of very high quality: *George Moore* (c.1891, London, Tate Gal.) and *Aubrey Beardsley* (1894, London, Tate Gal.) are both convincing portrayals, approached in differing ways that are suited to the subjects. In 1898 Sickert went to live in Dieppe and Venice and did not return to live in London until 1905, although he sent back paintings for exhibition at the New English Art Club, which he had joined in 1888. Dieppe, for Sickert, was largely a source of landscape subjects, such as *St Jacques' Facade* (c.1899-1900, Manchester, Whitworth Art Gal.). But while he was in Venice Sickert became more interested in figure painting. He subsequently spent a year in Paris, during which time he painted a series of nudes and theatrical scenes.

Changes in Sickert's style gradually became evident on his return: he adopted a method of painting in dots and patches, like a mosaic; he developed a thicker manner of handling the paint; and many of his pictures are more solidly constructed. These characteristics can be seen in works such as *Mornington Crescent Nude* (1908, Adelaide, Art Gallery of South Australia) and his self-portrait *The Juvenile Lead* (1907, Southampton, Art Gal.). Now settled in London, Sickert worked with an informal group of artists who had become dissatisfied with the New English Art Club. Among them were Walter Russell, Harold Gilman, Spencer Gore and William and Albert Rothenstein.

In 1908 he supported the foundation of the Allied Artists' Association. Three years later he founded the Camden Town Group, with Gore, Gilman and Charles Ginner, exhibiting with them at the Carfax Gallery and in 1913 they merged

with the larger London Group. The best paintings of this 'Camden Town period' come closest to realizing Sickert's own aims, and he was able to utilize what he had learned from Whistler, Degas, Bonnard and Vuillard to depict anecdotal and unprepossessing subjects in a very painterly manner. *L'Ennui* (c.1914, London, Tate Gal.) is possibly the greatest work in the series: its scale and fine composition, as well as its powerful atmosphere make it one of the most imposing of Sickert's paintings.

During the war Sickert spent much of his time teaching, writing and etching, but his move to Envermeu in 1919 brought him back to more consistent painting. In 1920 he went to Dieppe again, where he stayed until 1928, painting at the harbour cafés and at the Casino. He also started work on the portrait of *Victor Lecour* (1922-4, Manchester, City Art Gal.), one of the finest and most powerful of Sickert's postwar pictures. After 1924 Sickert began increasingly to rely on photographs as the basis of his paintings: for example, he painted a full-length portrait of *Edward VIII* (1936, Fredericton, New Brunswick, Beaverbrook Art Gal.) without sittings, using press photographs instead. He also employed Victorian illustrations as sources for his *Echoes*, a series of anecdotal paintings. The quality of Sickert's work at this time was more erratic than hitherto.

Sickert was President of the London Group and of the Royal Society of British Artists. He was elected as an Associate of the Royal Academy in 1924, and became a full Academician in 1934, although he resigned in the following year. In 1934 he moved from London to Thanet, and to Bathampton in 1938. He lived just long enough to know of the important retrospective exhibition that was held at the National Gallery, London, in 1941. J.H.

Charles Sheeler ▲
Home Sweet Home (1931)
36 cm × 29 cm
The Detroit Institute of Arts

Walter Richard Sickert ▲
Ennui (c.1914)
Canvas, 152 cm × 112 cm
London, Tate Gallery

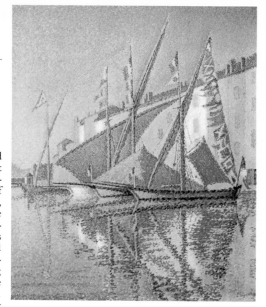

Signac
Paul

French painter
b.Paris, 1863 – d.Paris, 1935

The son of well-to-do parents, Signac devoted himself entirely to painting from 1882. Apart from a brief spell in a 'free' studio, he was self-taught, and early on came under the influence of the Impressionists (*Route de Gennevilliers*, 1883, Louvre, Jeu de Paume). In 1884 he took an active part in the creation of the Société des Artistes Indépendants where he met Seurat. He showed his paintings at the society's first exhibitions and remained one of its most faithful and active members until his death. Out of 18 of his works hung at the final Impressionist Exhibition, several were shown a few weeks later at the Indépendants. Some – such as *La Berge, Asnières* (Paris, Signac Coll.) – reveal him as a disciple of Impressionism. Others – *Embranchement de Bois-Colombes* (*Branches and Doves*) (Leeds, City Art Gal.); *Modistes* (*Milliners*) (1885-6, Zürich, Bührle Coll.) – show him as an innovator employing, under Seurat's influence, the technique of Divisionism.

He continued to use this method, finding his subjects along the banks of the Seine, in Brittany and on the shores of the Mediterranean. He applied the theories of 'the rhythms and measures of line and colour' of the scientist, Charles Henry, in some of his canvases. In 1890 he made a portrait of *Félix Fénéon* 'sur l'émail d'un fond rythmique de mesures et d'angles, de tons et de teintes' ('based on the texture of a rhythmic ground of intervals and angles, of tones and of tints'), in which the curvilinear design was inspired by a Japanese kimono (Switzerland, Josefowitz Coll.).

Soon after Seurat's death in 1891 Signac visited St Tropez for the first time, and from then on, until about 1911, spent part of each year there, painting. An excellent navigator, he was very fond of sailing, a recreation that took him from Rotterdam to Istanbul and helped him to depict the life of the ports. Towards 1896 his technique changed, following the rules of Divisionism less strictly, with broader brushstrokes that gave some of his canvases the appearance of mosaics. He was immensely interested in the work of younger artists, and it was beside him in 1904, in St Tropez, that Matisse took up Neo-Impressionism.

From 1913 Signac spent long periods at Antibes, although he always kept a studio in Paris. As well as landscapes and portraits, he painted still lifes, scenes of everyday life (*Dimanche parisien* [*Sunday in Paris*], 1890; *Femme se coiffant* [*Woman Combing her Hair*], 1892, private coll.) and many decorative compositions, in particular *Femmes au puits* (*Women at the Well*) (1892, private coll.) and *Au temps d'harmonie* (*In a Time of Harmony*) (1894, Montreuil Town Hall), which is a positive manifesto of his concept of an ideal anarchist society. Highly conscious and deliberate in his oil-paintings, he revealed his sensitivity in his watercolours (Louvre, Besançon and St Tropez museums), in which he expressed himself with complete freedom. A hard worker, and endowed with enormous vitality, he threw himself wholeheartedly into the life around him.

Signac's part in the formation of the Neo-Impressionist group was considerable. Besides acting as a link between Pissarro, Seurat and the Symbolist writers, he established friendly relations with those Belgian painters who formed a second group of Neo-Impressionists. Vice-President in 1903 of the Artistes Indépendants, becoming President in 1909, he earned the respect of the Fauves and Cubists.

He was also a writer and his book *Jongkind* (1927) contains a treatise on watercolour painting. His *D'Eugène Delacroix au Néo-Impressionisme* (1889) remains the standard work on Divisionism. He also had considerable importance for the next generation, and it has been said that his doctrine of colour helped the Fauves, his asceticism the Cubists and his rational analyses Matisse. In his detachment from nature and his obsession with pure painting and with colour, he was close to Delaunay and Kandinsky, the fathers of abstract art.

Signac's works are in art galleries in Baltimore (*Quai de Clichy*, 1887), Besancon (*Voile jaune* [*Yellow Sail*], 1904; and watercolours), Essen, Grenoble, The Hague (Gemeentemuseum, *Cassis*, 1889), Liège, Melbourne (N.G., *Gazomètres de Clichy*, 1886), Moscow (Pushkin Museum, *Saint-Briac*, 1890), New York (Metropolitan Museum), Otterlo (Kröller-Müller; several canvases, including *Déjeuner*, 1887), Paris (M.N.A.M., Petit Palais), St Tropez (which he helped to found), Wuppertal (Von der Heydt Museum, *Port de Saint-Tropez*, 1893), and also in many private collections. M.T.F.

Signorelli
Luca

Italian painter
b.Cortona, 1445 – d.Cortona, 1523

Trained in the studio of Piero della Francesca, Signorelli inherited his master's strict sense of composition and his taste for the monumental, which he kept throughout his life. From his earliest works only some fragments of frescoes have survived, painted in 1474 in Città di Castello. His links with Piero's art are so strong that it has even been proposed to regroup around these frescoes other works (paintings of the *Virgin*, Boston, M.F.A.; Oxford, Christ Church; Venice, Cini Coll.) that in conception, if not actual execution, are pure Piero. However, the state of the remaining fragments is so bad that it is impossible to be absolutely sure of their author.

Signorelli's formative years remain obscure. From 1479 his work on the frescoes in the church which contains the Santa Casa at Loreto shows him undergoing new influences, notably that of contemporary Florentine painting, with its stress on outline and violent movement, totally opposed to the poetry of Piero della Francesca. It would seem, although it is far from sure, that the first person to introduce Signorelli to this new art was Bartolomeo della Gatta, who collaborated with him in Loreto and profoundly influenced his later development. Signorelli was, in addition, very greatly influenced by the brothers Pollaiuolo and by Verrocchio, as can be seen in the angelic musicians in the vault, and in the dramatic synthesis of the *Conversion of St Paul* on the sacristy walls.

An almost contemporary date has been established for the two panels in the Brera (the *Flagellation* and the *Virgin and Child*), which have the same characteristic linear vigour, and may owe their conception to Piero. In Signorelli's great fresco in the Sistine Chapel, *The Death and Testament of Moses* (1480-1), the question of Bartolomeo della Gatta's collaboration again arises. Bartolomeo's influence is once more discernible in the altarpiece for Perugia Cathedral (*The Virgin Enthroned among the Saints*, 1484), but elsewhere Signorelli appeared to be reaching full maturity. In his ever-increasing attention to the anatomical definition of the nude (showing traces of Pollaiuolo), and by a taut and vibrant line linked to a powerfully three-dimensional chiaroscuro, he achieved the miraculous pictorial harmony that makes of man the protagonist of the universe. He also achieved his greatest works.

Modern criticism tends to diminish the range of Signorelli's art, and would cast doubts on the traditional belief that he was the forerunner of Michelangelo. Nevertheless, by consciously rejecting all the subtleties that Florentine culture could offer him, as well as in the austere paring down of his compositions to articulated backgrounds and solid masses, Signorelli undoubtedly opened up new possibilities beyond the range of 15th-century traditions. This is especially true of the painting formerly in Berlin (now destroyed) of the *Education of Pan*, which, because of the severity with which it treated mythological themes, was considered, wrongly, to be an anti-Botticelli affirmation. Many other paintings produced between this period and the end of the century belong to this same tradition, and are among Signorelli's happiest productions. Works such as the *tondo* of the *Virgin and Child* (Uffizi), the *Virgin Enthroned Among the Saints* (Volterra Museum) the *tondo* of the *Holy Family* (Uffizi) anticipate the solutions of the early 16th century.

Although their impact was weakened by the work of assistants, the frescoes in the cloister of Monteoliveto Maggiore, showing scenes from the life of St Benedict, still bear remarkable witness to Signorelli's ability to synthesize, and his forceful plasticity. With the fresco cycle in the chapel of S. Brizio in Orvieto Cathedral (begun 1447 by Fra Angelico) Signorelli reached the peak of his art – although the signs of stylistic decline are also becoming apparent. Executed between 1499 and 1504, this cycle suffers from a lack of balance in its composition, while the very boldness of its conception has resulted in weaknesses in execution. The iconographic scheme planned

▲ Paul Signac
Le Port de Saint-Tropez (1893)
Canvas. 56 cm × 46 cm
Wuppertal, Von der Heydt Museum

by Fra Angelico, who had begun work in the vault, involved a series of frescoes depicting the *Saved and the Damned*, following the example in the Strozzi chapel in the Church of S. Maria Novella. Signorelli added two scenes depicting the *End of the World* and the *Coming and Fall of Anti-Christ*, the latter, apparently, in homage to Savonarola. On the plinth the first 11 cantos of Dante's *Purgatorio* are depicted in monochrome. Despite its weakness of execution, the cycle has a spirituality that is well in keeping with the art of 15th-century Italy.

A growing heaviness in the forms, together with the stress laid on anatomical analysis, which had already begun to show in the Orvieto frescoes, increasingly impaired Signorelli's production. Although he was still capable of imposing effects in his *Deposition* for Cortona Cathedral (1502), by finally giving way to suggestions that he follow Raphael and lighten his palette, he only stressed the contrast, always a feature of his work, between the hardness of outline and the effect of colour.

Although his studio was always very active and he had many pupils, he did not have any outstanding successors. At the end of his life he had come to represent a conservative and provincial tradition that was quickly submerged by the great developments in central Italy from the beginning of the 16th century. G.R.C.

Sisley
Alfred

English painter
b.Paris, 1839 – d.Moret-sur-Loing, 1899

Although he was born in Paris and spent most of his life in France, Sisley was British by birth. His father, who was the director of an export company in Paris, sent him to London to learn commerce (1857-61), and during this period Sisley often visited the galleries to see the works of Constable, Bonington and Turner. Returning to Paris in 1862 he enrolled in Gleyre's studio to study painting. There he became friendly with Bazille, Monet and Renoir. Until 1870 he was able to live in comfort thanks to his father's support. After Gleyre's studio closed in 1864 he spent the winter in Paris, letting his poorer friends, such as Renoir, stay with him. In the summer he went to the country where, influenced by Corot, he could paint landscapes. He joined Monet at Chailly, and painted with Renoir along the banks of the Seine, then at Marlotte, near Fontainebleau.

His early landscapes (*Rue de village à Marlotte*, [*Village Street at Marlotte*], 1866, Buffalo, Albright-Knox Art Gal.; *Vue de Montmartre prise de la cité des fleurs* [*View of Montmartre*], 1869, Grenoble Museum) are sombre in tone, but display a detailed construction and a taste for broad areas of sky and ample spaces. In his still lifes (*Héron aux ailes déployées* [*Heron with Wings Spread*], 1867, Louvre, Jeu de Paume) his subtle harmonies of tone are apparent.

Being shy and rather solitary, Sisley did not often go to the Café Guerbois where his friends gathered around Manet. In 1870 he lightened his palette and began to use broken touches and strokes of juxtaposed colours. *Péniches sur le canal Saint-Martin (Barges on the St Martin Canal)* (1870,

Luca Signorelli ▲
The Resurrection
Fresco
Orvieto Cathedral, Capella di S. Brizio

Alfred Sisley ▲
L'Inondation à Port-Marly (1876)
Canvas. 48 cm × 61 cm
Rouen, Musée des Beaux-Arts

Winterthur, Oskar Reinhart Foundation), is an example, showing how he depicted reflections on the surface of water by rapid strokes in the style begun by Monet and Renoir at La Grenouillère.

Ruined by the war of 1870, Sisley spent a precarious existence and he went to live at Louveciennes near Paris. He painted landscapes, usually broken by the receding perspective of a road or lane (*Louveciennes, le chemin de Sèvres*, [*Louveciennes, the Sèvres Road*], 1873, Louvre, Jeu de Paume), and recording the effect of the changing seasons in the same place, as in *Louveciennes en automne* (*Louveciennes in Autumn*) (1873, Tokyo, private coll.) and *Louveciennes en hiver* (*Louveciennes in Winter*) (1874, Washington, Phillips Coll.).

At the first Impressionist Exhibition he showed five landscapes. He was helped by dealers such as Durand-Ruel and Duret, and by the baritone Jean-Baptiste Faure, who took him to London in the summer of 1874. He painted boat-races (*Régates de Molesey* [*Regatta at Molesey*], Louvre, Jeu de Paume), in which the movement and animation are unusual for his compositions, and also numerous views of the English countryside (*Pont à Hampton Court* [*Hampton Court Bridge*], Cologne, W.R.M.).

From Louveciennes he moved to Marly, where he painted views of the horse-pond in front of his house and became the chronicler of the village, as in the *Forge à Marly* (1875, Louvre, Jeu de Paume), an interior scene unusual in his work, or *L'Inondation à Port-Marly* (*The Flood at Port-Marly*) (1876, Louvre, Jeu de Paume; Rouen Museum) shown at the second Impressionist Exhibition together with seven other canvases. In 1877 he took part in the third Impressionist Exhibition with 17 paintings, but met with small success and did not exhibit for some years thereafter. He moved to Sèvres in 1877, but soon returned to Louveciennes where he painted out of doors a great deal, concentrating on the changing sky. Always well balanced, these sensitive works show a light, delicate handling (*Neige à Louveciennes* [*Snow at Louveciennes*], 1878, Louvre, Jeu de Paume).

After 1880 Sisley went to live near Moret-sur-Loing, then in Moret itself, becoming more and more isolated. Under Monet's influence he modified his technique, broadening his brushstroke and working his surfaces more heavily. In a different spirit from Monet but using a similar technique, he began a series on the surrounding countryside, at first near St Mammès: *La Croix blanche à Saint-Mammès* (*The White Cross at Saint-Mammès*) (1884, Boston, M.F.A.); *Saint-Mammès et les coteaux de la Celle, matin de juin* (*Saint-Mammès and the Slopes of La Celle, June Morning*) (1884, Tokyo, Ishibashi Coll.); *Saint-Mammès* (1885, Louvre, Jeu de Paume).

Then he painted mainly views of Moret: *Le Pont de Moret – Effet d'orage* (*The Bridge at Moret-Storm*) (1887, Le Havre Museum); *Meules de paille à Moret – Effet du matin* (*Haystacks at Moret – Morning*) (1891, Melbourne, N.G.); *Canal du Loing* (1892, Louvre, Jeu de Paume); *L'Église de Moret après la pluie* (*The Church at Moret, after Rain*) (1894, Detroit, Inst. of Arts). A one-man exhibition at Durand-Ruel's in 1883 and another at Georges Petit's in 1897 did not bring Sisley much success, and he continued to live in miserable circumstances. Attacked by cancer, he stopped painting in 1897, and it was only after his death that his reputation began to grow.

Sisley is one of the great figures of the Im-pressionist movement. A fervent disciple of out-door painting and clear tone values, like Corot and Pissarro he loved the countryside of the Île-de-France. His work, however, differs from theirs in its concern for composition and an almost monumental balance, contrasting with the quiet familiarity of his chosen sites. A.P.P. and N.B.

Sittow
Michel (also called Master Michiel)
Painter of Estonian origin
b. Tallinn, formerly Reval, 1469 – d. Tallinn, 1525

Originating from Reval, the Hanseatic town linked to the commercial cities of the North Sea, and himself the son of an artist, Sittow was apprenticed at Bruges in 1484. He probably entered the studio of Memling whose influence, freely interpreted, was to remain with Sittow throughout his life (*Virgin and Child*, Berlin-Dahlem). In 1492 he appeared in Spain (perhaps after a stay in France with the Master of Moulins) in the service of Queen Isabella for whom he painted, in collaboration with Juan of Flandes, several scenes for an altarpiece showing the Life of Christ and the Glorification of the Virgin (*The Assumption*, Washington, N.G.; *The Coronation of the Virgin*, Louvre). The only attested examples of his religious works, these little panels reveal his contacts with the Flemish miniaturists, such as the Master of the Hours of Dresden as well as great originality in the use of colour and light, and a feeling for space.

Sittow seems next to have entered the service of various princes connected with the royal house of Spain; Philippe the Handsome in Flanders (1504-6); possibly Catherine of Aragon in London (1505); then, after some time at Reval (1507-14), with Christian II of Denmark in Copenhagen (1514); Margaret of Austria at Malines (1515); and the future Charles V in Flanders (1516). Sittow went back to Reval in 1518, where he ended his career (shutters for the altarpiece of *St Anthony* for the Church of St Nicholas).

A painter of different styles, he has left some beautiful portraits. Well-balanced and interpreted with attention to detail, with heavily worked paint, the colour sustained and brilliant, they reveal that in the movement towards the sources of Flemish painting around 1500, Sittow was looking to the art of Van Eyck. In addition, however, his cosmopolitan career resulted in a combination of technique and a Flemish feeling for observation, with the Latin taste for highlighted forms, stylization and three-dimensional force that he admired in Dürer (*The Knight of Calatrava*, Washington, N.G.; *Catherine of Aragon*, Vienna, K.M.; *Portrait of a Lady as the Magdalene*, Detroit, Inst. of Arts). N.R.

Smith
Richard
English painter
b. Letchworth, 1931

Richard Smith studied at the Luton and St Albans schools of art and then from 1954 to 1957 at the Royal College of Art. Here he met Peter Blake who was to become a lifelong friend. In 1959-61 and again in 1963-5 he lived in New York. In 1968 he bought a house in Wiltshire, but he has continued to make many teaching visits to the United States.

Richard Smith belongs to the first generation of English painters to look to New York rather than to Paris for cultural contacts. Profoundly affected by the exhibition of American painting held at the Tate Gallery in 1956, his early painting was Abstract Expressionist in character. He was also interested in the discussions held at the Institute of Contemporary Arts by the Independent Group in the late 1950s, but his fascination with pop culture – especially Hollywood musicals, rock music, and new product design – did not at first directly alter his painting. From 1960, however, the forms and colours in Smith's paintings began to reflect cigarettes and cosmetic advertisements, and in 1963 he broke away from the two-dimensional picture format to incorporate a box or carton shape into his pictorial design.

Smith remained concerned with shape and colour for its own sake, and did not persist with references to advertisements and packaging. Instead he pursued a more formal exploration of shaped canvases, showing, for example, at the Kasmin Gallery, London, in 1967, a sequence of twelve panels, *A Whole Year in Half a Day*, in which the shape and colour change in a progressive sequence. Later work showed a preoccupation with surface, and this led Smith to dispense with the stretcher, so that from 1972 many of his works have been 'kite' paintings. Here he has rejected the bulky three-dimensional construction of the mid-1960s for something that is collapsible, like a tent.

Smith was awarded the Grand Prix at the 1967 São Paulo Bienal and had important one-man exhibitions at the Venice Biennale in 1970 and at the Tate Gallery in 1975. Though he has kept a close relationship with New York painters of his own generation, as well as with English Pop artists, his own work has retained a detachment from current fashion, evincing a fastidious and classical concern with the traditional pictorial issues of colour, texture, form and composition. A.Bo.

Snyders
Frans

Flemish painter
b.Antwerp, 1579 – d.Antwerp, 1657

Snyder's meetings with the artists who came regularly to his father's inn may have played some part in his choice of career. In 1593 he became a pupil of Pieter Bruegel the Younger and a friend of his brother Jan 'Velvet' Bruegel. Elected a master in 1602, he was enabled to go to Italy through Jan Bruegel's generosity, as appears from Snyder's correspondence with Cardinal Borromeo who became his patron in Milan, following a stay in Rome. Returning to Antwerp a year later, Snyders specialized in still life and attracted the attention of Rubens, who, between 1611 and 1616, employed him to paint the still life parts of his hunting pictures. In 1611 he married Margueretha de Vos, the sister of the artists Cornelis and Paul (over whom at this time, he had great influence). A member of the Guild of Romanists in Antwerp in 1619, he was made Dean in 1628. He became rich and famous, as attested by the portraits painted of him by Van Dyck (New York, Frick Coll.), the admiration of his contemporaries, the commissions he received, and the wealth of his collections.

In his earliest known work, *Game, Fruit and Vegetables* (1603, Brussels, private coll.), he imposed a new interpretation on a theme inherited from Pieter Aertsen and Joachim Beuckelaer. Without modifying the principle of large-format still life, he substituted for the massive heaps of objects more decorative compositions. His travels in Italy and the influence of Rubens helped him to enlarge his concepts. Rubens even furnished him with subjects such as *Philopoemen, General of the Achaeans, Recognized by an Old Woman* (Louvre). By transposing Rubens's breadth and impetuosity into his still lifes, Snyders affirmed his own originality. He ennobled his subject and brought it to life with a touch of the Baroque, opposing a dynamic vision to the descriptive tendency, but losing nothing in clarity or in monumental clearness, to which his tonal range contributed (*Still Life with Cat*, East Berlin, Bode Museum; *Still Life: Lady with a Parrot*, Dresden, Gg).

Through Rubens, Snyders enlivened his palette,

and if from his Italian experience he retained a taste for an extended colour range, he never forgot the balance of the composition. This he generally organized around a light central feature: a swan with outspread wings (*The Larder*, Brussels, M.A.A.), or a piece of linen, or sometimes the dead, white flesh of poultry; while to underline the horizontals he often employed large planes of vermilion, such as a carpet along the forefront of the picture, lobsters or joints of meat. He emphasized the volumes by juxtaposed colours, rather than by a single basic tone.

He painted many hunting scenes (Brussels, M.A.A.; Ghent Museum; Brera; Dresden, Gg), as well as still lifes of flowers and fruits (Turin Museum; Stockholm, Nm; Brussels, M.A.A.) and animal studies (*The Birds' Concert*, Hermitage; *Three Hunting Hounds*, Brunswick, Herzog Anton Ulrich Museum). An innovator in his ideas, in his technique Snyders was careful, exact and conventional, as shown by the huge numbers of carefully worked-out sketches, transposed with no alterations on to the canvas.

In spite of the numerous copies of his works, he had few imitators (he enrolled only three pupils, of whom Nicasius Bernaerts alone has left any impression). However, his lyricism affected not only his contemporaries, Paul de Vos, Arthur Claessens, Adriaen van Utrecht and Jan Fyt, but also such 18th-century French artists as Oudry and Desportes, as well as the Genoese, Castiglione.

Of the many known works by the artist, about 60 are signed. Snyders is especially well represented at the Prado and the Hermitage (notably four paintings for the Archbishop of Ghent; *Vegetables*; *Fruit*; *Game*; *Fish*). H.L.

Solimena
Francesco (occasionally called l'Abate Ciccio)

Italian painter
b.Nocera, 1657 – d.Barra, 1747

Solimena's style was formed on that of Luca Giordano and he was, with him, the leading Baroque painter in Naples. He received his early training

from his father Angelo in the naturalistic tradition of Guarino, but soon fell under Giordano's influence. He collaborated in many works with his father (cupola of Nocera Cathedral) before, around 1680, painting frescoes for the Church of S. Giorgio in Salerno (*Scenes from the Lives of St Thecla, St Archelaa and St Susannah*). These frescoes, and those which he painted soon after in the choir of the Church of S. Maria Donnaregina in Naples (*St Andrew and St Augustine, St Matthew and St Januarius, Victory of St Francis, Scenes from the Life of St Francis*) comprise his best early work.

His personality was already asserting itself in his search for a possible fusion between Giordano's chromatism and Mattia Preti's neo-Caravaggesque plasticity, to which he added the audacity of Lanfranco's illusionist perspective. This extension of Giordano's tendency towards a more liberal interpretation of the structural function of light led to a complete breakup of conventional description.

Solimena's evolution took him from the large frescoes (*Scenes from the Life of St Paul*; a ceiling, *Virtues and Angels*) in the sacristy of the Church of S. Paulo Maggiore (1689-90), by way of the *Scenes from the Life of St Nicholas of Bari* in the Church of S. Nicola alla Carità (Naples, 1697; he had previously painted for this church two of his finest altarpieces: *St Francis de Sales, St Francis of Assisi and St Anthony of Padua* and the *Virgin with St Peter and St Paul*) to the vast output of easel paintings and altarpieces of this period.

All these works are severely and forcefully constructed, and display a light and colouristic style; they synthesize all the elements of the Neapolitan pictorial tradition. In the early works, which reveal the influence of Preti, there is a tendency towards a 'classicist' eloquence. At the end of the century he had some contact with Roman artistic circles, notably with those influenced by Maratta's classical tendencies. At this time he also took an interest in the classical sources of the Emilian school, from Domenichino to Reni.

This rationalist return to 'good taste' which had its literary equivalent in the Arcadian movement of the 18th-century, was typical of the whole of Solimena's output from the beginning of the century to about 1730-5. The entire period is distinguished by a unity of tone that derives from an unquestioning, formal purism. Thus, although it was an intensely productive period, it was also rather monotonous. Solimena received many

commissions for churches in Naples (Gesù Vecchio, S. Anna dei Lombardi, S. Maria di Donnalbina, S. Domenico Maggiore, Girolamini, Charterhouse of S. Martino) and for Neapolitan purchasers and for regional churches (Aversa, Monte Cassino, Capua).

He also produced many works for the great houses of Italy and Europe (*Allegory for Louis XIV*, 1700, Hermitage; *The Abduction of Orythia*, 1700, Rome, Gal. Spada; *Rebecca and Jacob, Rebecca and Eliezer*, Venice, Accademia; *Deborah and Barak, Judith*, Cornigliano, Villa Bombrini; four canvases on biblical subjects, Turin, Gal. Sabauda; important series of pictures in Vienna (K.M.; Belvedere; Harrach Coll.); and an *Annunciation* (1733, Venice, Church of S. Rocco).

His best works during this period were the frescoes, particularly the one in the portal of the church of Gesù Nuovo, Naples, showing *Heliodorus Chased from the Temple* (1725; oil painting, Louvre). During this period Solimena greatly influenced such local painters as De Mura, Bonito and Celebrano, a circumstance that was to be the origin of the academicism of Neapolitan painting in the 18th century, and which came to flower in the Neoclassical style.

After 1732-3, however, Solimena unexpectedly returned to the tenebrism of his early maturity, and produced some of the finest portraits in the history of Neapolitan painting, thanks to the intensity of his palette and to his penetrating psychology: *Self-Portrait* (Naples, Museo di S. Martino); *Portrait of a Knight of the Order of St Januarius* (Naples, Gaetani Coll.); and the *Portrait*

Francesco Solimena
The Massacre of the Justinians at Chios
Canvas. 275 cm × 163 cm
Naples, Galleria Nazionale di Capodimonte

of the *Princess Imperial of Lusciano* (Naples, Pisano Coll.).

Solimena influenced not only the painters of his time, but also the sculptors and architects. Apart from those named, a vast number of his paintings are to be found in churches throughout the region of Naples and in the Museo Nazionale di Capodimonte and in the San Martino Collection, as well as in other museums and galleries (Brera; Rome, G.N.; Dresden, Gg; Budapest Museum; London, N.G.; Liverpool, Walker Art Gal.; Oxford, Ashmolean Museum; Cleveland Museum; Metropolitan Museum; Mauritshuis; Prado; Escorial; museums at Chambéry, Ajaccio, Montargis, Toulouse, Le Havre and Córdoba). The Albertina, the British Museum and the San Martino Museum also house large collections of Solimena's drawings. N.S.

Soulages
Pierre

French painter
b.Rodez, 1919

Roman monuments and the engraved dolmens and menhirs from the region of Rodez were the first artistic works to capture the attention of Pierre Soulages. When he was 18 he discovered modern painting at an exhibition of Cézanne and another of Picasso, while on a visit to Paris. During the war he worked on the land near Montpellier, and returned to Paris in 1946 to take up painting.

In 1947 his work was shown at the Salon des Surindépendants. Withdrawn into himself and rebelling against outside influences, he soon developed his own powerful form of abstraction, which attracted attention at his first one-man exhibition (1949, Paris, Gal. Lydia Conti). At the start of his career he often painted on paper stained with walnut juice, petrol or oil (paintings on paper, 1946-63, hung in 1963, Gal. de France).

From the beginning he discovered a means of expression that reflected his temperament, and thereby made a clean sweep of pictorial tradition. His imagination brought a new three-dimensional structure to the picture, in which the impression of line in space is essential to the deliberately calligraphic effect. Soulages soon resorted to the palette knife, then to the spatula, and finally to the rubber sole of his shoe, in place of the brush (*Peinture, 23 octobre 1960*, Paris, private coll.). This technique, in basing the three-dimensional effect on the act of painting itself, gives to every canvas the appearance of a monolithic whole, and recalls certain methods of Far Eastern art that Soulages instinctively adopted, guided by the needs of his own sensibility (*Peinture, 22 septembre 1961*, Paris, private coll.).

Soulages designed the sets and costumes for *Heloïse et Abélard* by Roger Vaillant (1949), and for Graham Greene's *The Power and the Glory* (1951). He has also done fashion drawing. In 1952 he took up etching and in 1957 lithography. In the course of his evolution he has considerably softened the severity of his composition. If he always has in the forefront of his mind, the format and central pivot of his canvas, he also stresses the effects of depth and rhythm (*Peinture no. 4, 9 janvier 1970*, private coll.), sometimes by the simple contrast of black and white, sometimes, although

less commonly, by the use of such colours as blue and green (*Peinture, 27 avril 1972*, private coll.).

Soulages is represented in galleries throughout Europe, notably in Paris (M.N.A.M.), Rouen, Nantes, Grenoble, Düsseldorf, Hanover, Essen, Hamburg, Mannheim, Bielefeld, Cologne, Rotterdam, Oslo, Berlin (N.G.), London (Tate Gal.), Copenhagen (S.M.f.K.), Helsinki, Vienna (20th Century Museum), Zürich and Turin (G.A.M.), as well as in many American collections, including the Museum of Modern Art and the Guggenheim Museum in New York. D.V.

Soutine
Chaim

French painter of Lithuanian origin
b.Smilovich, near Minsk, 1893 – d.Paris, 1943

The son of poor Jewish parents, Soutine spent his youth in conditions of grinding poverty. While living in Minsk in 1907, he met Kikoïn who taught him how to draw. Three years later he attended the School of Fine Arts at Vilna. Soutine arrived in Paris in 1913 and lived first in Montparnasse with Chagall and Modigliani (who painted his portrait), then at the Cité Falguière with the sculptor Mietshaninoff, and Lipchitz. He studied with Cormon, and spent hours in the Louvre. He was particularly fascinated by Rembrandt, Corot, Chardin, Fouquet, Cézanne and Courbet. Van Gogh was a painter he stubbornly refused to understand, partly because he could see a certain similarity in their respective fates. His first paintings (views of the Cité Falguière, 1914; still lifes) were in a vein of strict realism and the technique was still clumsy (*Fourchettes, c.*1916, Paris, private coll.), but he soon found himself, lightening his palette and beginning to use magnificent glowing reds (1917-18) and, a little later, Veronese green and silver-white (*Self-Portrait*, 1917, New York, Henry and Rose Pearlman Foundation).

Soutine's career hardly allows for the idea of evolution. At the beginning he was slightly influenced by Chagall (*Portrait of a Nurse, c.*1916, Los Angeles, County Museum of Art) and by Modigliani, whose influence appears in the rather unusual degree of self-discipline in some of the portraits (*Portrait of Maria Lani*, 1929, New York, M.O.M.A.; *La Polonaise*, 1930, private coll.). The role played by *shtetl* ('small-town') Hebrew culture in Soutine's aesthetic, where emotion and expression dominate, has been noted by one critic.

Soutine chose his models with the utmost care. He had great difficulty as he never let them rest, hated professional models and preferred peasants and children, who could not keep still. If there was a mutual empathy between Soutine and his model, a whole series of paintings would result. He was also very particular about the tools of his trade; he used brushes only once. Modigliani recommended him to Zborowski, and it was at his suggestion that Soutine went to the Midi, to Cagnes and Vence (1918), to Céret (1919), and to Cagnes again after going back to Paris in 1922.

During this very important period of his career Soutine had many setbacks but also produced a succession of masterly landscapes and still lifes: tumultuous networks of colour, where the impasto alternated with a more fluid handling (*Escalier rouge* [*Red Stairway*], 1923, Paris, private coll.; *Paysage de Cagnes* [*Landscape at Cagnes*], c.1923,

the Pre-Raphaelites, another early influence. In 1915 Spencer enlisted in the Royal Army Medical Corps, and later served as an infantryman.

In 1919, after the end of the war, Spencer returned to his native Cookham, to which he was always very attached. He lived there for the next few years and worked on a painting of *Travoys Arriving with Wounded at a Dressing-Station, Smol, Macedonia* (London, Imperial War Museum), which had been commissioned as an official war painting. From this period stem some of Spencer's finest works, including *Christ's Entry into Jerusalem* (1920, Leeds, City Art Gal.) and *The Disrobing of Christ* (1922, London, Tate Gal.). Spencer subsequently wrote of the 'state of sureness' that he felt before the war and until 1922 or 1923, which enabled him to visualize Heaven in the streets of Cookham, and to imagine the events of Jesus's life being enacted there. This unique vision of suburban life being transformed by the presence of Christ began to weaken shortly afterwards, as Spencer seemed gradually to lose the freshness and innocence of his convictions. He wrote: 'I knew in 1922-23 that I was changing or losing grip or something. I was, I feared, forsaking the vision and I was filled with consternation. All the ability I had was dependent on that vision.'

In 1925 the artist married Hilda Carline, and in 1926 he completed the ambitious *Resurrection* (London, Tate Gal.), which he exhibited at the Goupil Gallery in 1927. In the same year Spencer first went to Burghclere to begin work on the decoration of the Oratory of All Souls, a memorial chapel built to house his war designs. The paintings there are based on his experiences during the war. They show scenes of everyday life in the army, with landscapes of military encampments and, on the altar wall, a *Resurrection of Soldiers* (1928-9), one of the most striking of his

Los Angeles, private coll.); [*Colline à Céret* [*View of Céret*], c.1921, New York, private coll.). Soutine later disowned these works, which were discovered in Paris in 1923 by Dr Albert Barnes, who bought many of them, thus suddenly drawing attention to Soutine.

After 1925 Soutine had a number of different studios in Paris, and stayed in Indre, Provence and at Châtelguyon (1928) where he met Madeleine and Marcel Castaing, who became his most devoted admirers and friends. He then stayed in Bordeaux with Élie Faure, who began the Soutine bibliography (1929). In 1927 Henri Bing organized the first exhibition of his collected work. Between about 1923 and 1930 some themes were painted in several versions, distinguished by different dominant tonalities: white for the *Pâtissiers* (*Pastrycooks*) (various collections; Musées Nationaux, Walter Guillaume Coll.); white and red for the *Enfants de chœur* (*Choirboys*) (various collections; Musée Nationaux, Walter Guillaume Coll.); vivid vermilion for the *Chasseurs* (*Huntsmen*) (Paris, M.N.A.M.) and the three interpretations of *Le Boeuf écorché* (*Carcass of Beef*) (1925; Amsterdam, Buffalo, Grenoble) after the work by Rembrandt.

Blue and green were kept for still lifes with turkeys and ducks (Soutine liked them to be getting high and would keep them for days until the flesh had taken on a livid tint). The ochres and pinks were for fish such as skate (Cleveland Museum). A natural affinity with people who were physically or socially his inferiors influenced Soutine's choice of model (*Déchéance*, [*Degeneration*] 1920-1, Avignon Museum), and resulted in some very touching and poignant portraits of children (*Fillette à la robe rose* [*Girl in a Red Dress*], 1920, Paris, private coll.; *Charlot*, c.1931-2, Paris, private coll.).

After 1930, spending the summer in the country with the Castaings at Lèves near Chartres, Soutine experienced a period of peace and was inspired by Courbet to paint animal studies (*L'Âne* [*The Ass*], 1934, Paris, private coll.). Between 1935 and 1939 he often painted near Auxerre (*Jour de vent à Auxerre* [*Windy Day, Auxerre*], 1939, Washington, Phillips Coll.), and during the war lived at Champigny-sur-Veuldre. Under the stress of events his natural anxiety took

over. His last landscapes again showed the dramatic lyricism of Céret, and are amongst his most beautiful works (*Après l'orage* [*After the Storm*], 1939-40, Paris, private coll.).

His studies of women and children are equally numerous, inspired by Rembrandt (*Femme entrant dans l'eau* [*A Woman Wading*], 1931, Paris, private coll.), or Courbet, or revealing an unexpected pastoral mood (*Deux Enfants assis sur un tronc d'arbre* [*Two Children Seated on a Tree-Trunk*], 1939, Paris, private coll.). His discreet and unpublicized romantic life may account for the fact that he painted only one nude, prudish and flurried (1933, New York, private coll.). From 1937 until she was sent to a concentration camp at the start of the war, he lived with Gerda, a young German girl whom he called 'Garde' because, he said, he was 'guarding' her. In reality it was she who ceaselessly ministered to his ill-health.

Soutine left few drawings, studies of heads in which a broken and shifting line evokes an image at once precise and ephemeral (Paris, private coll.). He is represented in art galleries on both sides of the Atlantic, and in many important private collections. M.A.S.

Spencer
Sir Stanley

English painter
b.Cookham, 1891 – d.Taplow, 1959

Spencer was one of the most idiosyncratic English painters of this century and possessed a religious sensibility that was imaginative and occasionally visionary. After winning a scholarship to the Slade School, he studied there from 1908 to 1912 under Henry Tonks. In his final year Spencer exhibited *John Donne Arriving in Heaven* at Roger Fry's Second Post-Impressionist Exhibition at the Grafton Gallery, and he won a prize for *The Nativity* (London, Slade School of Fine Art). Both pictures show the influence of Post-Impressionism, but the delicate detail in a drawing of a *Fairy on the Waterlily Leaf* (1910, Cookham, Spencer Gal.) reveals Spencer's interest in

many interpretations of the 'Last Day' theme. He completed the chapel in 1932, the year when he became an Associate of the Royal Academy. As a whole the paintings show war as a possible means of salvation and man's trials as opportunities to learn to understand suffering and death. Later, Spencer planned a 'Church-House' that would house works dedicated to the central theme of the 'Last Day', when the 'Coming of the Apostles' would redeem the life and activities of Cookham. The project was never realized, although many individual paintings were completed.

The 1930s were a somewhat trying period in Spencer's life. Involved in a complex emotional relationship with Hilda and with Patricia Preece, whom he married after his divorce from the former, Spencer was, in his own words, 'making big demands on life at the time, and had to paint far more than I would have wished'. Many of his best-known paintings were completed at this time, such as Sarah Tubb and the Angels (1933, Karmel Coll.), Separating Fighting Swans (1934, Leeds, City Art Gal.) and Hilda, Unity and Dolls (1937, Leeds, City Art Gal.). He resigned from the Royal Academy in 1935 when St Francis and the Birds (1935, London, Tate Gal.) and The Dustman (1934, Newcastle, Laing Art Gal.) were rejected by the hanging committee. Late in 1938, alone in London, Spencer began his Christ in the Wilderness series, in which he made some of his most moving statements about his own sense of loneliness.

The following year, after the outbreak of war, the artist was commissioned to paint pictures of Glasgow shipyards by the War Artists Advisory Committee, and made the first of several trips to Lithgow's Yard, Port Glasgow. In 1942 he returned to Cookham where he continued to work on the shipyard paintings. Two years later he began a Resurrection series, which occupied him until 1950, and which grew to a scale comparable to the Burghclere chapel sequence.

In 1950 Spencer rejoined the Academy and became an Academician. Two years afterwards he started a large number of preliminary drawings for a series of paintings related to the theme of Christ Preaching at Cookham Regatta. The fact that he prepared about 60 before beginning to paint

the pictures indicates his increasing interest in drawing and composition, and a corresponding disenchantment with the painterly realization of his ideas. The Marriage at Cana (1953, Swansea, Glynn Vivian Gal. and Museum) refers both to his marriage with Hilda, and to his longing to engage in a second marriage with her. His devotion to Hilda culminated in works such as Love on the Moor (1949-54, Cambridge, Fitzwilliam Museum), in which Hilda is depicted as a statue of Venus on Cookham Moor. His last images of her remained unfinished at the time of his death. A.Bo.

Spilliaert
Léon

Belgian painter
b.Ostend, 1881 – d.Brussels, 1946

Self-taught, except for a short period at Bruges Academy, Spilliaert began painting in 1900, and for the whole of his career used watercolour, Indian ink, gouache, pastel and crayon, almost to the exclusion of any other medium. His first works already display a poetic and highly personal symbolism (Contemplation, c.1900, Brussels, Bibliothèque Albert 1er). In 1903-4 he worked for the publisher Edmond Deman, and became part of the circle of the Belgian literary Symbolists, Hellens, Verhaeren and Maeterlinck, who often provided him with inspiration. He lived in a studio on the quayside at Ostend. In 1904 he paid his first visit to Paris, and thereafter returned regularly during the winter to exhibit at the Salon des Indépendants (1909, 1911 and 1913).

A complicated man, he was placed by his art at the intersection of many contemporary movements. Some of his works, two-dimensional and influenced by Japanese art, seem to belong to the Nabis by their sly observation of daily life, although their handling is more edgy and spare (Coup de vent [Gust of Wind], 1908, Brussels, private coll.; Baigneuses [Bathers], 1910, Brussels, M.A.M.). His striking compositions, and his

taste for the unusual and unexpected, led to Spilliaert being regarded as the forerunner of Surrealism (Le Vertige [Dizziness], 1908, Ostend Museum; Galerie royale à Ostende [The Royal Galleries at Ostend], 1908, Brussels Museum; Digue et kursaal d'Ostende [Jetty and Kursaal at Ostend], 1908, Brussels, private coll.). Some subjects, borrowed from the Realist tradition, emerge as Expressionist themes akin to those of Munch (Buveuse d'absinthe [Absinthe Drinker], 1907, watercolour and gouache, Ostend, private coll.), and elsewhere, others, of synthetic figures, foretell those of Permeke (Fiancés, c.1907, Brussels, private coll.).

Spilliaert lived in Brussels from 1917 to 1921, and settled there permanently in 1935. He kept in touch with his Paris acquaintances Paul Guillaume, Coquiot, and Zborowski, and with the clientèle he had built up. He continued to be inspired by the port of Ostend (many seascapes in pastel or gouache; and bathers), without losing interest in other themes, which he handled with the same expressive verve (Ali Baba et les quarante voleurs [Ali Baba and the Forty Thieves], c.1927, gouache, Brussels, private coll.).

Stanley Spencer ▲
The Resurrection, Cookham (1923–6)
Canvas. 274 cm × 549 cm
London, Tate Gallery

Léon Spilliaert ▶
Le Vertige (1908)
Canvas. 100 cm × 70 cm
Ostend, Musée des Beaux-Arts

In 1937 Spilliaert discovered the countryside around Fagnes in the Ardennes, returning there many times to make studies of trees in which the detailed drawing and atmospheric effect have a magic realism (*Coupe-feu* [*Avenue*], 1944, Ostend Museum; *Troncs de hêtres* [*Beech Trunks*], 1945, watercolour and Indian ink, Brussels Museum). He is represented in many Belgian art galleries, notably in Ostend and Brussels. M.A.S.

Spranger
Bartholomeus
Flemish painter
b.Antwerp, 1546 – d.Prague, 1611

A pupil of Jan Mandijn from 1557 to 1559, then of Cornelis van Dalem from 1560 to 1565, Spranger was trained as a landscape painter. In 1565 he went to Rome via Paris, Lyons, Milan and Parma, where he worked in the studio of Bernardino Gatti. He lived mainly in Rome from 1566 to 1575, being employed by Cardinal Farnese to decorate his castle at Caprarola, and by Pope Pius V. He probably visited Venice before leaving Italy for Vienna, where he entered the service of the Emperor Maximilian II in 1575. The beginning of 1581 saw him in Prague, and in 1584 he was made court painter to Rudolf II. Meanwhile, he had married in 1582 Christine Müller, the daughter of a Prague jeweller. Through the Emperor's favour he was ennobled in 1595 and was able to make a 'triumphal' tour through Dresden, Cologne, Amsterdam, Haarlem and Antwerp (with Hans von Aachen) in 1602.

As court painter Spranger was mostly occupied with allegorical or mythological subjects, in which he proved himself to be one of the greatest representatives of late international Mannerism at the end of the 16th century. Several of his early landscapes (Karlsruhe, Budapest), some religious paintings (*The Three Marys at the Tomb*, Vienna, K.M.; a *Lamentation*, Munich, Alte Pin.; *The Adoration of the Magi*, London, N.G.) and a *Self-Portrait* (Vienna, K.M.), show the greatly varied talent of this prolific artist. He is known to have painted a series of small landscapes of Rome, of which two, still showing Van Dalem's influence, have survived: *Mountainous Landscape with a Hermit Reading* and *Mountainous Landscape with a Group of Beggars* (1569, Karlsruhe Museum). A *Landscape with St George Killing the Dragon* (Budapest Museum) appears to have been painted at the end of his period in Rome, and to have been influenced by Giulio Clovio.

Two religious works, both painted in Rome, have remained in Italy: *The Martyrdom of St John the Evangelist* (Rome, Church of S. Giovanni at Portalatina) and a *Last Judgement* (Turin, Gal. Sabauda), which was painted on copper for Pius V and inspired by Fra Angelico's painting of the same subject (Berlin-Dahlem). But it is in his paintings for Rudolf II, executed in Prague, that Spranger's originality is really evident. He often took as his theme pairs of figures (*Mars and Venus, Venus and Adonis, Vulcan and Maia*, Vienna, K.M.), whose improbable mannered poses and the importance attached to the nude creates an atmosphere of refined eroticism, emphasized by unusual colours where a green or an indefinite orange cuts across the shaded tones of grey, as in the *Allegory of Justice* (Louvre). The mythological

compositions show a taste for artificiality (especially in the effects of light) and an obvious effort to reject the distinct arrangements of classicism (a deliberate imbalance is given to the figures), resulting in a composite style that combines picturesque realism in certain of the details (armour, jewels) with the unreality of the composition as a whole.

It is to his early Flemish training that Spranger owes his success with the small paintings on copper (*Hercules and Omphale* and *Vulcan and Maia*, Vienna, K.M.), in which the colours glow with the clarity of enamel. His taste for exquisite and refined detail is most obvious in his early Prague works: helmets, bucklers, shields, richly decorated swords, sculpted pieces, jewellery and pieces of gold- and silverware (*Mars and Venus* and *Ulysses and Circe*, Vienna, K.M.). From this time dates *Hercules and Dejanira*, Vienna, K.M.), painted with a turbulent sensuality, where the corpse of the centaur Nessus, seen in striking

foreshortening, lies at the feet of the entwined couple.

One of Spranger's strangest paintings, *Cupid and Psyche* (Oldenburg Museum), probably dates from a little later. The artist has painted in grisaille a richly sculpted decorative foreground, framing a window through which the main action of the painting may be seen taking place. Although it occupies only a small part of the canvas, the extraordinary arabesque formed by the two figures of Psyche and Cupid, with Psyche trying to hold back Cupid who is in flight, is compelling.

In these numerous mythological compositions, often taken from Ovid, the smoothly curved forms, the slightly elongated faces (*Sine Cerere et Baccho friget Venus*, 1590, Graz; *The Revenge of Venus*, Troyes Museum) gradually give way to more ample figures, especially in the luxurious female nudes that the artist always puts in the foreground of his pictures (*Glaucus and Scylla*,

Bartholomeus Spranger ▲
Hermaphroditus and Salmacis
Canvas. 110 cm × 81 cm
Vienna, Kunsthistorisches Museum

St Mary Magdalene and *Judith Giving the Head of Holofernes to a Servant* (Louvre), pen drawings heightened by wash and white gouache, are two of his greatest drawings and show a spontaneity not to be found in his paintings.

From the 1580s, thanks to the engravings of Sadeler, and then of Goltzius, his work became more widely known. He had enormous influence on the Academy at Haarlem (Goltzius, Cornelisz van Haarlem, Wtewael, Bloemaert, Van Mander) and maintained direct links with F. Sustris's circle in Munich. The founding of an academy in Prague with Heintz and Aachen likewise helped to spread the elegance and refinement of Mannerism across Europe. M.D.B.

Staël
Nicolas de

French painter of Russian origin
b.St Petersburg, 1914 – d.Antibes, 1955

Nicolas de Staël was the son of Baron Vladimir Ivanovich de Staël-Holstein, a general in the army of the Tsar, and governor of the Fortress of St Peter and St Paul, who owned lands between Finland and eastern Russia. The family was distantly related to the famous French letter-writer, Mme de Staël. In 1919 the child Nicolas emigrated with his family to Ostrów in Poland. Following the death of his father in 1921 and of his mother in 1922, De Staël was brought up in an institution especially created for Russian émigré children in Brussels.

He ran away, being unable to bear even their light discipline, and was adopted by a M. Fricero, who was also of Russian origin. After a solid classical education he studied at the Académie Royale des Beaux Arts in Brussels from 1932 to 1933. At about this time he visited Holland where he discovered Rembrandt, Vermeer, Hals, Philips de Koninck and Seghers. He then made his first journey to the Midi in France and, on his return, went to Paris where he visited the Louvre and also discovered the work of Cézanne, Matisse, Braque and Soutine who remained his ideals and examples. He supported himself by painting stage sets.

On his return to Brussels he worked as an assistant to a decorative painter. In the summer of 1935 he went to Spain and in June of the following year travelled to Morocco where he remained for over a year, until August 1937, drawing and painting with dedicated fervour. He met another painter, Jeannine Guillou, who became his constant companion. Together they travelled to Algeria, then to Italy, and finally reached Paris in May 1938. Living in dire poverty, they nonetheless continued to paint. De Staël made copies of Chardin and Delacroix in the Louvre.

When war was declared he enlisted in the Foreign Legion and was sent to Tunisia. In September 1940 he was demobilized and settled in Nice. His daughter Anna was born in 1942, and to support his family De Staël, who demonstrated enormous reserves of energy, accepted any form of work, while continuing to paint still lifes and *Portraits of Jeannine* (1939, 1942, Paris, private coll.). He kept company with Surrealist and abstract painters and endlessly discussed the question of his figurative approach, which he was gradually finding increasingly irksome. He began by relying on a freely invented line to organize space in

his new pictures. This marks the real beginning of his *oeuvre*.

Returning to Paris in September 1943, in April 1944, with Kandinsky, Magnelli and Domela, he took part in an exhibition of abstract art, organized, in spite of the German occupation, by the little Galerie l'Esquisse where, the following month, he held his first one-man exhibition. Having already formed a close friendship with Braque, he met, through an exhibition at the Galerie Jeanne Bucher that same year, the painter Lanskoy, another Russian, who became a devoted and life-long friend. Engaged in the same experiments, Lanskoy confirmed for De Staël that the pictorial qualities he so much admired in Braque were not incompatible with abstract art, as long as contact with reality was not lost. This was certainly De Staël's own intuitive idea, from which he never departed, and through which he was to be finally reconciled to nature.

Gradually art lovers and collectors became interested in his work, as did the dealers: the collector Jean Bauret encouraged him by buying several canvases, and in October 1946 the dealer Louis Carré signed a contract with him. The death of Jeannine in February of that year, however, had left De Staël in utter despair, but, during a visit to the Mediterranean, he met Françoise Chapoutou, whom he married in May, and by whom he had three children. At the beginning of 1947 he settled in the Rue Gauguet in a large studio near Braque, and began painting enormous canvases. An American dealer Theodore Schempp, who lived in the same house, introduced his work to the United States, while in Paris the connoisseur Jacques Dobourg appointed himself De Staël's champion. In April 1948 De Staël became a French citizen.

His first 'abstract' period was characterized by a subjectivity showing great tension and force in an entanglement of broken and contrasted lines, in which the many layers of superimposed paint formed a heavy impasto (*La Vie dure* [*The Hard Life*], 1946, Paris, Louis Carré Coll.; *De la danse* [*Concerning Dancing*], 1946, Paris, private coll.). From 1949 the structure grew gradually larger, while at the same time the contrasts of light and shade gave way to more luminous and colourful harmonies, divided into firmly articulated areas, more often than not worked up with a palette knife or spatula, to produce a canvas with great bands of colour crossing it (*Composition*, 1950, London, Denys Sutton Coll.; *Rue Gauguet*, 1949, Boston, M.F.A.).

Later on De Staël, by small juxtaposed strokes in check patterns, composed vibrant paintings such as the series of *Compositions* of 1951, which reached their peak in the *Toits de Paris* (*Paris Roof-Tops*) of January 1952 (Paris, M.N.A.M.), in which the suggestion of a motif is more distinct. Soon after objects begin to make their appearance: bottles, apples, hastily executed landscapes, executed in broad horizontal bands that declared De Staël's intention of mastering their physical aspect without sacrificing the freedom of the conception. Progressively, themes from nature took over but without resulting in a total submission. Above all, what was in question for De Staël was to merge the act of painting as closely as possible with his life.

Without ceasing to paint with growing intensity and tenacity, he took up engraving in 1951 with the same enthusiasm, executing a series of 14 large woodcuts for René Char's *Poèmes*. He himself conceived all details of printing and presenta-

Venus and Adonis, and *Hermaphroditus and Salmacis*, all Vienna, K.M.). *Susannah and the Elders* (Schleissheim Castle) is a perfect example of this development. The naked form of Susannah, tilted backwards in an attitude of revulsion, takes up almost half the canvas, from which Spranger has excluded all extraneous detail. His *Vanity* in Wavel Castle, Kraków is simply a pretext for a beautiful study of a naked child, the subject being indicated merely by the presence of a skull and an hour-glass.

Spranger's few religious paintings also reveal his liking for nudes with undulating curves (*Lamentation*, Munich, Alte Pin.) and his taste for the picturesque (*The Adoration of the Magi*, London, N.G.).

A fluent draughtsman, Spranger made many studies in black chalk and in pen and ink that display broad but sensitive handling: *Pegasus* (Brunswick, Herzog Anton Ulrich Museum); *Jupiter*, *Mars*, *Vulcan* and *Pluto* (Windsor Castle).

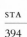 Nicolas de Staël
Le Lavandou (1952)
Canvas. 192 cm × 96 cm
Paris, Musée National d'Art Moderne

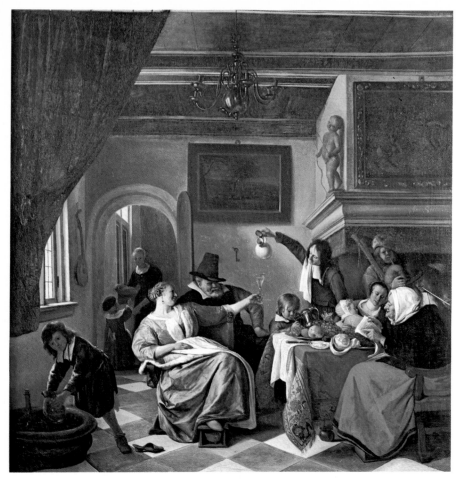

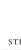

led by his friend Pierre Granville, as well as in Paris (M.N.A.M., *Le Lavandou*, 1952), Antibes Museum, Oslo (Sonje Henie–Niels Onstad Foundation); Zürich (Kunsthaus); London (Tate Gal.) and particularly in galleries in the United States: Chicago (Art Inst.), Minneapolis (Walker Art Centre); Los Angeles (County Museum of Art), Cincinnati, Toledo and Milwaukee. R.V.G.

Steen
Jan
Dutch painter
b.Leiden, 1625 or 1626/7 – d.Leiden, 1679

By virtue both of the quality and the extent of his output, Jan Steen figures as one of the most prominent members of the Dutch school during the 17th century. A pupil of Nicolaes Knupfer in Utrecht, of Adriaen van Ostade in Haarlem, and of Jan van Goyen at The Hague, he married Van Goyen's daughter in 1649 and settled in The Hague for the next five years. In 1654 he moved to Delft, where he ran a brewery, and in 1656 to Warmond, a small village near Leiden. From 1661 to 1676 he was in Haarlem, and finally, from 1670 until his death, in Leiden where he was President of the Guild of St Luke (1671-3) and Dean in 1674. He also kept a tavern.

Steen was a painter of the mainstream of life: peasant scenes, treated humorously and sometimes licentiously. However, in some of his paintings such as *Bad Company* (Louvre), a didactic element appears: men are shown as blind to their own vices and become the instruments of their own misery. Steen often illustrated proverbs after this fashion, a tradition handed down from Bruegel (*As the Old Ones Sing, the Little Ones Twitter*, Montpellier Museum).

Steen was extremely prolific, and today there are major collections of his work in London (N.G; Wallace Coll.; Apsley House), the Rijksmuseum and the Mauritshuis. More significant than Metsu or Ter Borch, Steen shows himself a master of irony, as well as of picturesque and popular realism. His religious paintings are treated in exactly the same spirit as his divertissements and with a contemporary Dutch background: *The Feast of Ahasuerus* (Hermitage); *Moses Striking the Rock* (Philadelphia, Museum of Art); *Samson and Delilah* (Cologne, W.R.M.); *The Return of David* (Copenhagen, S.M.f.K.); *Jesus and the Elders* (Basel Museum), notable for its strange crepuscular effect; *Jesus Expelling the Traders from the Temple* (1675, Leiden Museum); *The Marriage of Tobias and Sarah* (1677, Brunswick, Herzog Anton Ulrich Museum); *The Disciples at Emmaus* (Rijksmuseum).

Apart from his portraits (*Bakker Oostwaard and his Wife*, Rijksmuseum; *Marguerite van Goyen at the Lute*, Mauritshuis; *Self-Portrait*, Rijksmuseum; *Self-Portrait at the Lute*, Lugano, Thyssen Coll.), he also produced a number of works in which only a few figures are depicted (*The Sick Woman*, Philadelphia, Museum of Art; Edinburgh, N.G.; Rijksmuseum; Mauritshuis; Hermitage; London, Apsley House; *Two Men and a Young Woman Making Music on a Terrace* and *A Young Woman Playing a Harpsichord to a Young Man*, London, N.G.; *The Harpsichord Lesson*, London, Wallace Coll.; *Woman Eating Oysters*, Mauritshuis; *The Morning Toilet*, 1663, London, Buckingham

tion of this magisterial work, which was exhibited at the end of the year at the Galerie Jacques Dubourg. Later he illustrated other books, including *Ballets-Minute* by Pierre Lecuire (1954), to which he contributed 20 illustrations.

In the spring of 1952 a floodlit football match between France and Sweden inspired him to produce many small studies and large oil paintings notable for their striking forms and joyful primary colours (*Grands Footballeurs* [*Football Players*], 1952, Paris, private coll.). At this time, too, he painted several still lifes of flowers and pursued this realist theme with paintings of the Normandy coast at Honfleur and Dieppe, and studies of skies in the region of Paris. Meanwhile, he followed up the 'footballers' with a number of paintings in very large format: *Le Lavandou*, (1952, Paris, M.N.A.M.); *Musiciens* (*The Musicians*) (1953, Paris, private coll.) after seeing a jazz concert with Sydney Bechet, and *Bouteilles dans l'atelier* (*Bottles in the Studio*) (1953, private coll.).

Henceforth he travelled more often to the Midi, to Le Lavandou and La Ciotat, as well as to Italy and Sicily, and painted many elemental landscapes in startlingly vivid colours, almost extempore (*Agrigento*, 1954, Beverley Hills, California, private coll.; *Port de Sicile* [*Sicilian Harbour*], 1954, Ottawa, N.G.; *Martigues*, 1954, Winterthur Museum). He also returned to still lifes, as well as painting corners of his studio and subjects that were new to him: female nudes and figures on horseback (*Nu couché* [*Nude Lying Down*], 1954, Paris, private coll.; *Cavalier rouge*, [*Red Horseman*], 1954, Paris, private coll.).

Also at this time he attempted to lighten his painting by substituting washes and scumbling for the brushstrokes and the trowel, so that he ended up with different levels in the structure of his canvas. (*Nu gris de dos* [*Nude with a Grey Back*], 1954; *Coin d'atelier fond bleu* [*Corner of a Studio in Dark Blue*], 1955; the *Fort d'Antibes*, 1955; all Paris, private colls.). The light of the Midi led him to evolve a personal, luminous treatment in his paintings of boats and seascapes of 1954-5, although for him this was merely another stage in his evolution. In the autumn of 1953 he bought a 17th-century château, Le Castellet, in the fortified village of Ménerbes in the Vaucluse, then, in September 1954, went to live alone in Antibes in a studio facing the sea. There, physical exhaustion and an attack of deep depression drove him to suicide on 16th March 1955.

In less than a dozen years De Staël had produced a fantastic output: the 1968 catalogue of his works records 1,059 canvases, to which must be added the innumerable working drawings that he made for all his paintings, as well as wood-engravings or etchings, lithographs and collages. The first retrospective exhibition of his work was held in Paris (M.N.A.M.) in 1956, and the second was presented successively in 1965 and 1966 in Rotterdam (B.V.B.), Zürich (Kunsthaus), then in the United States (Boston, M.F.A.; Chicago, Art Inst.; New York, Guggenheim Museum), and in 1972 at the Maeght Foundation at St Paul-de-Vence. These posthumous exhibitions affirmed on an international scale the dedication to his art of the most powerful creator of his generation in the post-war Paris school, over which he exercised great influence through his success in breaking down the barrier between abstract and figurative painting. His last, unfinished, canvas, *L'Immense Concert* (*Boundless Harmony*), can be seen at the Musée National d'Art Moderne in Paris.

De Staël is represented by an outstanding collection of pictures in Dijon Museum, assemb-

▲ Jan Steen
As the Old Ones Sing, the Little Ones Twitter
Canvas. 87 cm × 71 cm
Montpellier, Musée Fabre

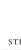

STE

395

Palace; and *The Alchemist*, Frankfurt, Städel. Inst.).

Most of his paintings, however, are of lively gatherings at table: *The Christening Feast* (1664, London, Wallace Coll.); *The Bean King* (1668, Kassel Museum); *Flemish Feast in an Inn* (1674, Louvre); *Merrymaking in a Tavern* (London, Wallace Coll.); or of wedding celebrations: *Village Wedding* (1635, Rotterdam, B.V.B.); or of people at play: *Skittle Players* (London, N.G.); or reeling after a good supper or too much to drink: *The Drunken Woman* (Mauritshuis).

Steen brought to such popular scenes, in a tradition inherited from Brouwer, an inexhaustible invention and humorous sparkle, as well as a mordant observation and a theatrical feeling for arrangement. Together with Adriaen van Ostade, Cornelius Dusart, Jan Miensz Molenaer and Cornelis Bega, he is one of the most significant figures to paint in this genre. J.V.

Stefano da Zevio
(or da Verona)

Italian painter
b.Verona, 1374 – d.Verona, after 1438

Information about the life and work of Stefano is scanty, and only one of his pictures is dated (*The Adoration of the Magi*, 1435, Brera). He seems to have been trained in the Lombard school of miniaturists (Michelino da Besozzo had travelled in the Veneto in 1410) and in the Venetian region. The *Madonna of the Rosebush* (Verona, Museo Civico) is generally thought to be an early work. The subject is one of the 'cult' themes of the north European painters: that of the walled garden in which the privileged sit in tranquil isolation – the 'gardens of Paradise'. Stefano treats this theme in a very personal and completely Italian way: the figures, lost in their dream, give a feeling of illusion to the scene. They are placed obliquely in the enclosure of a rose-garden against a gold background featuring languid angels with intertwined wings. The work reveals the fundamental quality of Stefano's style: an extremely delicate harmony of line and feeling, where all reference to reality dissolves.

The same jewel-like quality is found in the little choir of angels in the *Nativity*, his fresco for the Chapel of S. Fermo (Verona), and in the panels of the *Madonna and the Angels* (Rome, Gal. Colonna), one of the highest expressions of International Gothic in Italy. Here the angelic musicians are harmoniously grouped around the foot of the throne, encircling the Virgin like an aureole.

The Brera *Adoration of the Magi* seems to have been painted much later. It nevertheless shows an affinity with Michelino da Bessozzo, and also with the International Gothic miniaturists. The imagery associated with this subject, rich in characters, costumes and exotic animals, is recaptured with a broad lyricism and an exquisite delicacy, while the linear rhythms twist and untwist from the foreground to the background. Stefano's frescoes in the Church of S. Eufemia in Verona have not survived the passage of time and few other works are known. They include, however, a beautiful collection of drawings (Louvre, Albertina, Uffizi) that reveal Stefano as one of the greatest draughtsmen of his day, and one who was to be emulated by Pisanello during the second decade of the 15th century. L.C.V.

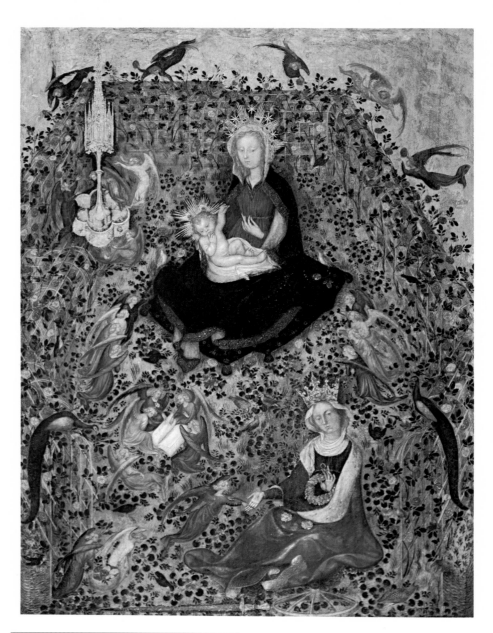

Stella
Frank

American painter
b.Malden, Massachusetts, 1936

Frank Stella, a leading American painter, identified in the 1960s with formalism, was born the son of a doctor. He attended Phillips Academy, Andover, a distinguished private school, and entered Princeton University in 1954, where he was influenced by the art historian William Seitz and the artist-in-residence Stephen Greene. During his time at Princeton, the peak period of interest in Abstract Expressionist painting, Stella had already begun to move away from the prevailing concern of the New York School with gestural abstraction. He manifested his future direction not only by his emphasis on geometric regularity of design, but in his academic

work, producing an essay on Hiberno-Saxon manuscripts, the first instance of his almost scholarly passion for early and remote examples of abstract art. In 1959 he exhibited professionally at the Tibor de Nagy Gallery, New York, and immediately attracted the attention of museum curators and critics. In the same year the Museum of Modern Art acquired its first example of his work, *The Marriage of Reason and Squalor*.

No work is more revealing, however, of the intentions of the young artist and of the critical climate of formalism that was to make of him one of its principal heroes than the small collage he executed in 1959, *The First Post-Cubist Collage* (New York, Baker Coll.). A square, composed of four sheets, the work is indeed a collage, but Stella suggests by the arrogant and humorous title that it is the first work where the visual interest resides wholly in the activity on the surface. The implication is clear both as regards the artist's acceptance of Clement Greenberg's definitions of Cubism and the ordained direction of abstract art,

▲ Stefano da Zevio
Madonna of the Rosebush
Wood. 129 cm × 95 cm
Verona, Museo Civico

from shallow space to the total realization of the complete independence of the work of art as a created, flat entity; and the briefly dominant notion that such an achievement – genuinely abstract art – was only occurring around 1960 in the United States. Therefore, all interest resides in pattern, structure and colour. Stella began with monochrome painting (black), moved on to irridescent, metallic paints that enabled him to establish linear movements without the assistance of painted lines, and did not hesitate to follow the internal logic of his formulas to their conclusion in irregularly shaped canvases.

In 1965 the pictorial attitude that Stella exemplified, stripping formal manipulation from the mythic content it had carried for such of his predecessors as Barnett Newman, received critical canonization in the exhibition 'Three American Painters', organized by Michael Fried for the Fogg Museum at Harvard. Stella's art continued to flourish, gathering force and complexity with the addition of colour and further variations on geometric shapes, as evidenced by the 'protractor' series in the late 1960s of which *Agbatana III* (1968, Oberlin, Ohio, Allen Memorial Art Museum) is an example. His passion for Islamic art and architecture became increasingly apparent. He sought that ultimate fusion of structure and meaning discoverable in the vaults of the Isfahan mosques. Moreover, this adventure unfolded in fertile and often humorous pictorial dialogue with other American painters, notably Jasper Johns, for whom Stella clearly has the highest regard, although the work of the two painters might have appeared diametrically opposed during the 1960s.

With the decline of formalism in the 1970s, Stella's work has lacked the critical support it enjoyed earlier, but it continues to expand even as it includes now emphatic signs of the once expunged gesture, as well as the traditional symbols of a self-conscious draughtsman, the triangle and the French curve. D.R.

Stoskopff
Sebastian

Alsatian painter
b.Strasbourg, 1597 – d.Idstein, Nassau, 1657

The son of George Stoskopff, a diplomatic courier in Strasbourg, Stoskopff received some early training with the miniaturist and engraver Frédéric Brentel, who must have contributed to the sharp observation of reality of the man who became a specialist in still life. In 1614 George Stoskopff asked the Strasbourg Council to place his son with a master painter and the following summer he began training with the Walloon artist Daniel Soreau, a refugee at Hanau-Frankfurt. When Soreau died, Stoskopff, who was then 22, took over his studio for a time. Soreau's son, Pierre, and Joachim von Sandrart, a former pupil of Soreau, continued working at the studio.

The Thirty Years' War caused Stoskopff to leave Hanau in 1621 for Paris where he discovered the works of such famous contemporaries as Rubens, Vouet, Callot, Bosse, Baugin, Linard and, possibly, Rembrandt. He was in Venice in 1629, where he met Sandrart, but returned to Paris where he seems to have established himself in the Flemish Protestant circle of 'realist' painters, living in St Germain-des-Prés.

In 1641 he went back to Strasbourg and in the following year produced a '*fort belle peinture*' for the Council Chamber. On 21st September 1646 he married Anne-Marie Riedinger, daughter of the master goldsmith Nicolas Riedinger, who was by another alliance already his brother-in-law. Among Stoskopff's many admirers and patrons in Strasbourg, the most notable was Count Jean de Nassau-Idstein who in 1655 invited the artist to his residence at Idstein where he worked until his death. Some mystery surrounds this. There have been suggestions that he was murdered, or, alternatively, that he may have died from overindulgence in alcohol.

Apart from a number of portraits, Stoskopff's art is devoted almost entirely to still lifes painted in the style of the Flemish and Dutch schools: the 'orderly disorder'. He also acquired a touch of Caravaggism, either by direct contact with Italy, or through Honthorst. His two stays in Paris placed him in contact with the Second School of Fontainebleau (*The Five Senses*, 1663; *The Four Elements*; Strasbourg Museum). His severe and rather barren studies of composition in Paris were supplanted on his return to Strasbourg by his evocation of an atmosphere that combines *trompe-l'oeil* with chiaroscuro (*Basketful of Glasses*, Strasbourg Museum).

There is a fine collection of Stoskopff's works in Strasbourg Museum, and he is further represented in Munich (*Still Life*, Alte Pin.), in Rotterdam (B.V.B.), and in Saarbrücken Museum. A recent survey has produced a catalogue of 70 works, although some of these are of doubtful attribution. V.B.

Strigel
Bernhard

German painter
b.Memmingen, c.1460 – d.Memmingen, 1528

Court painter to the Emperor Maximilian I, of whom he produced many studies (*Portrait of Maximilian*, 1504, Berlin Museum; *Maximilian and his Family*, Vienna, K.M.), Strigel was not identified by name until 1881. Prior to this date he was known as 'the Master of the Hirscher Collection' (the Freiburg Coll. contains portraits assembled under this name), and some of his works were attributed to Holbein or Amberger. Working chiefly at Memmingen, he was in Vienna in 1515 and again in 1520, and at Innsbruck from 1523 to 1525.

During his training Strigel was influenced by Bartolomäus Zeitblom and at first seemed to be attached to the Gothic tradition. However, in the *Altarpiece of St Stephen of Mindelheim* (c.1505; the panels are divided between the German Museum at Nuremberg and Schloss Donzdorf) he shows a lively narrative style that in no way detracts from the firmness of the outlines. An intuitive and sensitive artist, he has left a truthful record of the Swabian aristocracy of his day, thanks to his subtle likenesses and expert use of light (*Portrait of Hieronymus Haller*, 1503, Munich, Alte Pin.). But his greatest claim to originality lies in having anticipated even the Netherlands painters in his creation of the group portrait, his most significant work in this genre being the standing, life-size portrait of *Konrad Rehlinger and his Eight Children* (1517, Munich, Alte Pin.).

Among his best portraits are those of a *Woman*

Sebastian Stoskopff ▲
Vanitas Still Life (1641)
Canvas. 125 cm × 165 cm
Strasbourg, Musée de l'Œuvre-Notre-Dame

Frank Stella ▲
Agbatana III (1968)
Canvas
Oberlin, Ohio, Allen Memorial Art Museum

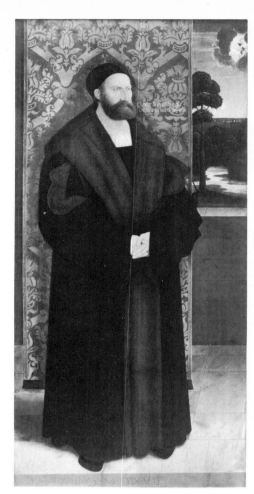

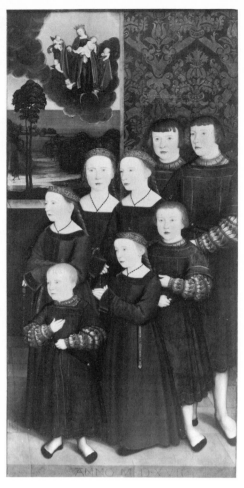

(Metropolitan Museum) and of *Hans Rott and his Wife Margaret Vohlin* (1527, Washington, N.G.), as well as *Portrait of Sibylla von Freyberg* (Munich, Alte Pin.). York Art Gallery has the *Sleeping Halberdier*, which, like three other similar panels in the Alte Pinakothek in Munich, seems to have been part of an altarpiece of the *Resurrection*.

Like those in Berlin, Munich, Vienna and Nuremberg, the museums of Basel, Karlsruhe, Stuttgart, Innsbruck, Memmingen and Sigmaringen also have works by Strigel.　　A.C.S.

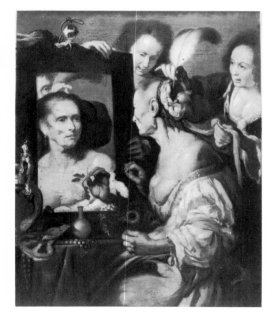

▲ Bernardo Strozzi
Old Woman at the Mirror
Canvas. 135 cm × 109 cm
Moscow, Pushkin Museum

Strozzi
Bernardo (called 'Il Cappuccino')

Italian painter
b. Genoa, 1581 – d. Venice, 1644

Strozzi's master was Pietro Sorri, a Mannerist painter from Siena who was in Genoa from 1595 to 1597. After becoming a Franciscan friar at the age of 17, Strozzi painted small devotional pictures, but his career did not really begin until after 1610 when he was allowed to leave the convent to support his widowed mother and practise his art. It is known that he decorated in fresco the Palazzo Centurione de Carpanetto at San Pier d'Arena (1623-5), and that in 1629 he painted the altarpiece (*The Virgin and Child with St Lawrence, St John and Angels*) in the Church of the Istituto Sordomuti in Genoa. When his mother died in 1630, he was imprisoned (so the story goes) for refusing to return to the convent, and eventually departed for Venice where he lived for the rest of his life.

His powerful and original style was formed between 1610 and 1630. From the beginning Strozzi showed himself a Mannerist rather than a realist painter, a follower of Paggi, but even more of Barocci, whose *Crucifixion* (1596) is in the Church of S. Lorenzo in Genoa. His early works (*St Catherine*, Hartford, Connecticut, Wadsworth Atheneum; *The Dead Christ*, Genoa, Accad. Ligustica; *Violinist*, Genoa, Gal. di Palazzo Bianco) are distinguished by angular drapery, a sharp palette, and an unreal and abstract feeling. Little by little, however, from 1615, this style gave way

▲ Bernhard Strigel
Portrait of Konrad Rehlinger and his Eight Children
(1517)
Wood. 209 cm × 101 cm and 98 cm (2 panels)
Munich, Alte Pinakothek

to a greater naturalism under the pressure of several combined influences. The one, predominant in Genoa, of the lesser Flemish masters (the Van Wael brothers, Jan Roos), is clear in the *Adoration of the Shepherds* (Baltimore, W.A.G.) and in the *Cook* (Genoa, Gal. di Palazzo Rosso), and is close to that of Aertsen and Beuckelaer. Another, the Lombard influence, was strong in Genoa around 1618 because of the presence of Giulio Cesare Procaccini (who painted the *Last Supper* for the Church of the Annunziata). It is also likely that the appearance of Gentileschi in Genoa in 1621 (an *Annunciation* in the Church of S. Siro) played some part in Strozzi's increasing interest in the play of light and shade evident in the three paintings for the Church of S. Annunziata del Vastato (*The Feast at Emmaus, The Denial of St Peter, Joseph Recounting his Dream*).

But it was above all the influence of Rubens and his *Miracle of St Ignatius* (1620, Genoa, Church of S. Ambrogio) and also that of Van Dyck (in Genoa from 1621 and 1627) that enabled Strozzi to blend these different stylistic elements in a manner at once dense and free. His palette lightened, his tone values now ranged from warm to flamboyant, while his brushstrokes developed an inimitable *brio*. This mature style, which was later developed further in Venice, can be seen in the preparatory sketches for *Paradise* (Genoa, Accad. Ligustica), a fresco that Strozzi painted in 1625 for the Church of S. Domenico, Genoa (destroyed), in *Joseph Recounting his Dream* (Genoa, Pallavicini Coll.) and in the *Altarpiece of the Istituto Sordomuti* (1629).

These are works, full of atmosphere and executed in intense colours, that brought new hope to Genoese art, and had a particular influence upon De Ferrari. Among Strozzi's most important Genoese works are the 'Roman' frescoes in the Palazzo Centurione de Carpineto at San Pier d'Arena, and a beautiful collection of portraits (Turin, Gal. Sabauda; Brera; Genoa, Gal. Durazzo Giustiniani and G.N. di Palazzo Spinola).

In Venice (1630-44) Strozzi's first sight of Veronese's works (which inspired the *Supper at the House of Simon* at the Accademia, and the *Abduction of Europa* in the Poznán Museum), together with those of contemporaries such as Fetti and Liss, confirmed him in the direction he had already started to take in Genoa towards a changing play of colour and a more fluid touch. However, while Fetti and Liss worked in the 'petite manière' for private commissions, Strozzi received large official orders. He became one of the leading portrait painters in the city and made his mark on Venetian official style. He decorated the ceiling of the Marciana Library (*Allegory of Sculpture*, 1635) and painted the portrait of the *Doge Francesco Erizzo* (1631, Vienna, K.M.).

Strozzi was one of those rare artists who was able to continue the tradition of 16th-century Venice while transforming it into a Baroque idiom. *The Martyrdom of St Sebastian* (Venice, Church of S. Benedetto) and *St Lawrence Distributing Alms* (Venice, Church of S. Niccolò dei Tolentini) evoke Titian and Veronese, but also Ribera and Rubens. The best of Strozzi's Venetian works are *Minerva* (Cleveland Museum), *The Parable of the Wedding Guests* (Uffizi), and *An Allegory of Fame* (London, N.G.), while outstanding portraits include those in the National Gallery, Washington, Toulouse Museum, and the Museo Correr and the Palazzo Barbaro Curtis in Venice.

Strozzi, with Fetti and Liss was the third in the trio of foreign artists who brought new life to Venetian painting, introducing a freedom of spirit unknown to Venetian painters at that time, paralysed as they were by the lingering tradition of the 16th century. Among those most influenced by him was Maffei. He was also a great draughtsman (examples in Genoa, Palazzo Rosso) and the complexity of his artistic background is particularly evident in his graphic work.

Strozzi's output was enormous (approximately 500 paintings) and can be seen in most European and American art galleries. S.De.

Stuart
Gilbert Charles
American painter
b.North Kingstown, Rhode Island, 1755 –
d.Boston,1828

After almost two centuries, the best-known painter of the young American republic remains Gilbert Stuart. Although he painted George Washington from life only three times, his idealization of the first President so conformed with the expectations of early 19th-century society that he thus imposed the image of the 'Athenaeum' portrait on posterity's notion of the father of the republic.

Stuart was the son of a Scottish immigrant who operated a snuff mill until about 1761, when it failed. The family moved to Newport, a rich and cosmopolitan town, then the fifth in size in Colonial America. A Scottish painter, Cosmo Alexander, visited Newport in 1769 and gave lessons to the 14-year old Stuart, subsequently taking him as an apprentice on a painting trip through the Southern colonies, and then, in 1771, to Edinburgh. Unfortunately for Stuart, Alexander died and he was obliged to return to Newport, his training scarcely complete. He secured several portrait commissions in Newport, executing them in Alexander's stock manner, but he knew that if he were to succeed, another trip to Europe was necessary, this time to London, to work under Benjamin West. Stuart left Newport in 1775, just after the Battle of Bunker Hill signalled the beginning of Revolutionary hostilities, arriving penniless in London in November of that year.

West was incredibly kind to Stuart. Indeed, had it not been for West's interest, and the equally generous friendship of a boyhood companion from Rhode Island, the medical student, Benjamin Waterhouse, it is doubtful if Stuart would have survived. By 1777, however, he was living in West's house, and by 1780 he was being entrusted with important sections of the history paintings West was executing for Windsor Castle. To contrast Stuart's portrait of *James Ward*, later his engraver (1779), with a Newport painting such as the portrait of *John Bannister* (1774, Newport, Redwood Library) offers a vivid insight into how rapidly Stuart absorbed the elegant portrait convention of London.

By 1782 he had surpassed his master, West, at least in the fashionable techniques of portraiture, and at the Royal Academy exhibition of 1782, where his *Skater* (Washington, N.G.) was shown, he earned such a favourable reception that he was able to embark on an independent career. He was

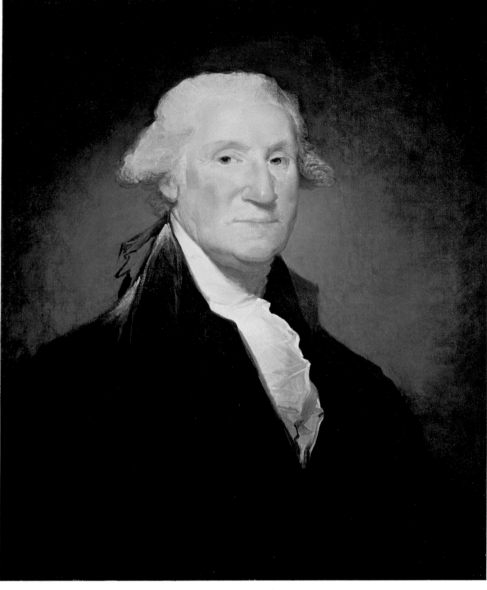

a successful portrait painter and something of a man of fashion at a time when Reynolds, Gainsborough and Romney were at the peak of their powers, and he borrowed from all of them poses, colouring, fluent brushwork and luminosity. A certain blandness in mood and characterization of his sitters seemed only to contribute to his success. He married in 1786 and in 1787 moved to Dublin where his charm and skill earned him commissions to paint most of Dublin society. For six years he enjoyed a life of ease and extravagance but, after accumulating serious debts, he left for America to escape from his creditors.

From the moment he arrived in the United States in the spring of 1793, he made his mark. His social graces, his English reputation, and his genuine dash as a painter coincided with an immense need on the part of the American society to be recorded in the most optimistic light. Stuart's rich and glowing style fitted the bill exactly, and the three versions of Washington's portrait he created in 1795 and 1796 ensured his reputation for the rest of his life. Of these, the 'Vaughan' version was the first, dating from the spring of 1795. Stuart made two copies of the 'Lansdowne' likeness in April 1796. It is full-length and shows Washington holding a sword with one hand, but gesturing in a pacific, open-handed manner with

the other. The name 'Lansdowne' derives from Lord Lansdowne, negotiator of the American peace treaty, to whom Senator William Bingham of Philadelphia, who had commissioned the portrait, presented the second version. The third Washington portrait is the most famous: the 'Athenaeum' likeness, also painted in 1796. It was retained by Stuart until his death, and from it he made many replicas during the next 30 years. Here Washington has the look of an elder statesman, noble, serene, beyond political passions. Although it was not a good likeness according to most contemporary observers, it rapidly became the preferred history-book image.

Stuart moved to Boston in 1805, having spent two dull years in Washington, the raw Federal city growing up on the banks of the Potomac. The production of his last quarter-century is relaxed and easy. Although he broke no new ground, his standards for portraiture had become generally accepted, and he exerted a considerable influence on younger American painters, especially Waldo and Sully, and the largely self-taught John Neagle. All sought to achieve the easy fluidity of technique that Stuart had learned in London, and also to match his fame, for he was the first to embody the concept of the successful American artist. D.R.

▲ Gilbert Stuart
George Washington (1795)
74 cm × 60 cm
Washington, D.C., National Gallery of Art, Andrew Mellon Collection

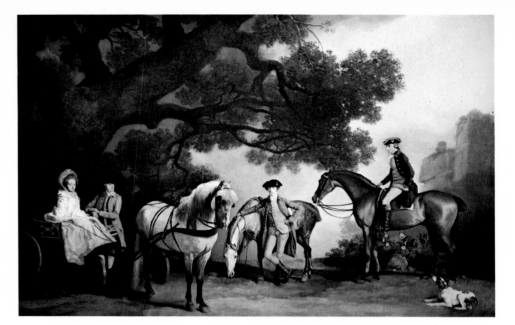

Stubbs
George

English painter
b.Liverpool, 1724 – d.London, 1806

Stubbs worked briefly under Hamlet Winstanley after 1741 and first practised as a portrait painter in the north of England. He worked in Wigan in 1744, then in Leeds, and at York from 1745 to 1752, returning to Hull and Liverpool before his visit to Italy in 1754. Meanwhile he was studying anatomy and gave a series of lectures on this subject at York Hospital in 1746. His visit to Italy convinced him 'that Nature was and always is superior to Art', but his lion and horse subjects were probably inspired by an antique sculpture of a horse attacked by a lion, then in the Palazzo Senatorio in Rome. He studied the anatomy of the horse in Lincolnshire from 1756 to about 1759, and made drawings for a work entitled *The Anatomy of the Horse*, which was published in 1766. He engraved the plates himself.

He settled in London in 1759 or 1760 and began by exhibiting at the Society of Artists. His picture of the *Duke and Duchess of Richmond Watching Horses Exercising* (1760-1, private coll.) is a typical example of his work, in which people and horses are depicted in harmony with one another in an English landscape. He was not made a founder-member of the Royal Academy because he was considered only a horse painter, but he became an A.R.A. in 1780 and an R.A. in 1781. He was subsequently expelled for not complying with the rules of the Academy. In the 1790s he enjoyed the patronage of the Prince of Wales and in 1802 he advertised his 'Comparative anatomical exposition of the structure of the human body with that of a tiger and a common fowl', begun in 1795 and published in parts, 1804-6, but never completed. A continual experimenter, he found a means of using enamel colours, first on copper and later on ceramic plaques.

Stubbs approached the painting of horses through the study of their anatomy, showing that he was of the same scientific bent as his contemporary, Joseph Wright of Derby, and his horses are always accurately drawn. His *Mares and Foals without a Background* (1762, private coll.) shows a method of composition, which involved painting the horses first and then filling in the background afterwards (the background may have been omitted at the suggestion of Charles, 2nd Marquis of Rockingham, for whom the picture was painted). *The Reapers* (1785, London, Tate Gal.), part of a rustic idyll series, demonstrates his love of the country and its seasons. His best works exhibit a flowing composition of gently curving lines, although he did tend to see his pictures, not as a whole, but as the accumulation of a number of parts. J.N.S.

Subleyras
Pierre

French painter
b.St Gilles-du-Gard, 1699 – d.Rome, 1749

France occupies an exceptional place in the artistic life of Rome in the 18th century, and Subleyras was among those who contributed greatly to this. Born in the same year as Chardin, he is, too, a painter of silence, of curtailed movement and suppressed emotion, but his particular interest is in large religious and mythological paintings. Son of a minor painter at Uzès, he was trained in Toulouse under Rivalz. The few canvases to have survived from this period – mainly the five medallions in the ceiling of the Church of the Pénitents-Blancs (today in Toulouse Museum) and three of their preparatory sketches in the museum at Maite and at Birmingham City Art Gallery – show an artist deeply affected by the tradition of the Toulouse school, one of the most brilliant outside Paris. The artist's first portraits date from this time: *Mme Poulhariez et sa fille* (1724, Carcassonne Museum); *Le Sculpteur Lucas* (Toulouse Museum).

In 1724, possibly with the help of a grant from the town council of Toulouse, Subleyras went to Paris. The following year he competed for the Grand Prix de l'Académie with *Le Serpent d'airain* (*The Brazen Serpent*) (Nîmes Museum), which opened the doors of the Académie de France in Rome to him. In 1728 he left Paris for good. Like Poussin – and the likeness does not end there – he was 30 when he arrived in Rome, and already master of his art. The French Academy's director at this time was Vleughels, and Subleyras's progress, which was especially rapid in his portrait painting, may be followed in various letters written by Vleughels to the head of the Beaux Arts, the Duc d'Antin, who with other patrons secured permission for Subleyras not only to remain in Rome, but also to live in the Palazzo Mancini, home of the French Academy, where he remained until 1735.

Subleyras's first important secular commission was the *Remise au Prince Vaini de l'ordre du Saint-Esprit par le duc de Saint-Aignan* (*Presentation to Prince Vaini of the Order of the St Esprit by the Duc de St Aignan*) (Paris, Musée de la Légion d'Honneur). In the same year, 1737, he painted his equally important *Repas chez Simon* (*Christ in the House of Simon*), commissioned by the Order of St Jean-de-Latran for the Convent of Asti in Piedmont (Louvre). From this time on, for the remaining twelve years of his life, Subleyras, through various religious orders, received several important commissions for churches not only in Rome, but all over Italy (for the church of St Cosmas and St Damian in Milan, for example, he painted *Saint Jérôme* in 1739, and in 1744 *Christ en croix entouré de la Madeleine, de Saint Philippe Neri et de Saint Eusèbe* [*Christ on the Cross Surrounded by the Magdalene, St Philip Neri and St Eusebius*], today both in the Brera), and even in France (Toulouse and Grasse).

In 1739 he married the miniaturist, Maria Felice Tibaldi, daughter of the composer Tibaldi. As well as making miniatures of her husband's paintings, for example the *Repas chez Simon* (1748, Rome, Gal. Capitoline), she also collaborated in his works. The famous painting in the Vienna Akademie shows, gathered together in the *Atelier du peintre* (*Studio of the Painter*), pictures that the artist and his family had actually painted, hung all over the walls.

In 1740 Subleyras met Cardinal Valenti Gonzaga who recommended him to Pope Benedict XIV. Subleyras painted the Pope's official portrait in the following year (several versions, including one at Chantilly, Musée Condé). Benedict's patronage brought Subleyras a commission to paint *Saint Basile célébrant la messe de rite grec devant l'empereur Valens, arien* (*The Mass of St Basil*) for St Peter's (today in Rome, Church of S. Maria degli Angeli). Proof that Subleyras's reputation could match that of Vouet, Poussin and Valentin is that he was the only French painter commissioned to carry out work in St Peter's.

Before finishing this huge canvas in 1748, however, he painted some of his most beautiful works: *Le Miracle de Saint Benoît* (*The Miracle of St Benedict*) (for the Olivetans of Perugia; today in Rome, Church of S. Francesca Romana); *Saint Ambroise absolvant Théodose* (*St Ambrose Absolving Theodosius*) (for the same order; now in Perugia, G.N.); *Saint Camille de Lellis adorant la croix* (*St Camilla of Lellis Adoring the Cross*) (church of Rieti); *Le Mariage de Sainte Catherine* (*The Marriage of St Catherine*) (Rome, private coll.; sketch in Northampton, Massachusetts, Smith College); and his masterpiece, *Saint Camille de Lellis conjurant l'inondation* (*St Camilla of Lellis Abating the Flood*), one of the most exquisite paintings of the 18th century (Rome, Museo di Roma).

On 26th January 1748 *Saint Basile* was unveiled at St Peter's and proved a triumph, establishing Subleyras's reputation without question. With Jean-François de Troy, then Director of the French Academy in Rome, he was regarded as the leader of the Roman School. But he was already in the grip of illness and, despite a recuperative

▲ George Stubbs
The Melbourne and Milbanke Families
Canvas. 101 cm × 147 cm
London, National Gallery

journey to Naples in 1747, Subleyras died in Rome at the age of fifty.

Above all a historical painter, the ambition of all artists of his day, Subleyras also painted still lifes (Toulouse Museum), genre subjects, executed with a freedom and lightness of touch (illustrations for La Fontaine's *Contes*), portraits (*Don Cesare Benvenuti*, Louvre; *Le Bienheureux Jean d'Avila* [*The Blessed John of Ávila*], Birmingham, City Art Gal.), scenes from mythology and nudes (*Caron* [*Charon*] Louvre; the exceptional *Nu de femme* [*Female Nude*], Rome, G.N.).

His touch was delicate, meticulous and recognizable anywhere. But it was his palette above all that set him apart. Subleyras loved three colours, which he used with great distinction: black, white (two studies of the *Deacon* for the *Messe de Saint Basile* [*Mass of St Basil*] in Orléans Museum), and especially a delicate pink.

An outstanding artist whose work is often very moving, Subleyras maintained his reputation undimmed into the second half of the 18th century, and he remains among the leading artists of his era. P.R.

Sutherland
Graham

English painter
b.London, 1903 – d.Menton, 1980

While a student at Goldsmith's College, London, Sutherland specialized in print-making, a subject which he taught in the early part of his career. Only in 1935 did he begin to paint in oil, one year after his first stay in Pembrokeshire. In 1936 he exhibited together with the English surrealists. Inspired by the theory of the *objet trouvé*, he painted a series of Welsh landscapes which immediately marked him as a neo-romantic in the vein of Piper and Paul Nash. His relationship with nature, both mystic and pantheistic, which found its inspiration in Blake and Samuel Palmer, is the keynote of his work at this time. Its poetic intimacy was typical of the contemporaneous movement in England (*Entry to a Foot-path*, 1939, London, Tate Gallery).

In 1937 Sutherland installed himself at Trottiscliffe, a village in Kent, although from 1947 he spent part of each year in France. His later work was more forceful in colour. Specific objects and abstract forms were sometimes isolated and took on an almost human appearance. Sutherland also painted a series of portraits (retrospective exhibition at National Portrait Gallery, London, 1978), his first commission being for *Somerset Maugham* (1949, London, Tate Gal.). Other notable examples show *Winston Churchill* (now destroyed), *Adenauer, Edward Sackville-West* (1949, private coll.) and *Helena Rubinstein*. His religious works include the large *Crucifixion* (1946) for St Matthew's Church in Northampton, the huge tapestry of *Christ in Glory* (1954–57) destined for the new Coventry Cathedral, and a *Crucifixion* for the Church of St Aidan at East Acton. He had several retrospective exhibitions throughout Europe and in the USA. In 1976 Sutherland made a gift to the nation of 200 of his oils, watercolours, lithographs and sketches, which are housed at the Graham Sutherland Foundation, Picton Castle, Dyfed, Wales. Most British galleries have examples of his painting. In recent

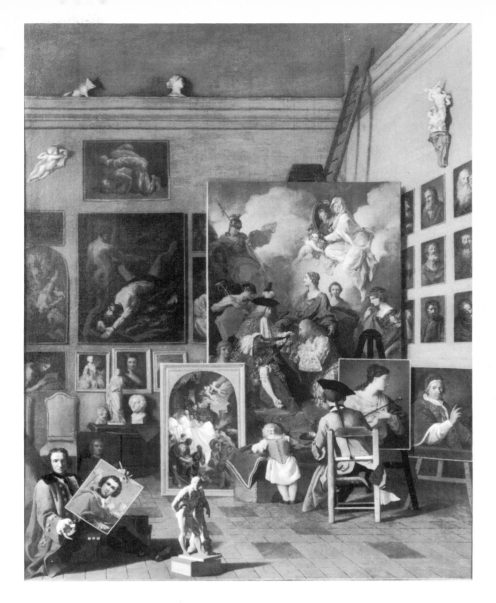

years his early prints have become much sought after – a reflection of the sway in the 1970s towards figurative art with a poetic, materialistic quality. A.Sm.

Sweerts
Michael

Flemish painter
b.Brussels, 1624 – d.Goa, 1664

Neither completely Flemish, nor Dutch, but above all 'Roman', Sweerts was a typical representative of those groups of north European artists active in Rome in the 17th century, and pursuing, for the most part, the realistic art of the *bambocciate*. As such his name appears from 1646 as an associate member of the Academy of St Luke in Rome and regularly, from 1646 to 1651, in the archives of the Church of S. Maria del Popolo, as a resident in the famous Via Margutta.

However, the painter seems to have left Italy some time after 1654, because, in 1656, he was offered the post of director of a school of drawing in Brussels and apparently accepted it. In 1659 he was received into the Brussels Guild of Painters

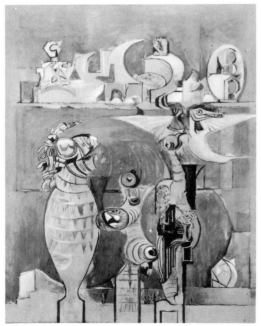

▲ Pierre Subleyras
L'Atelier du peintre
Canvas. 127 cm × 99 cm
Vienna, Gemäldegalerie der Akademie der bildenden Künste

▲ Graham Sutherland
The Origins of the World (1951)
Canvas. 424 cm × 327 cm
London, Tate Gallery

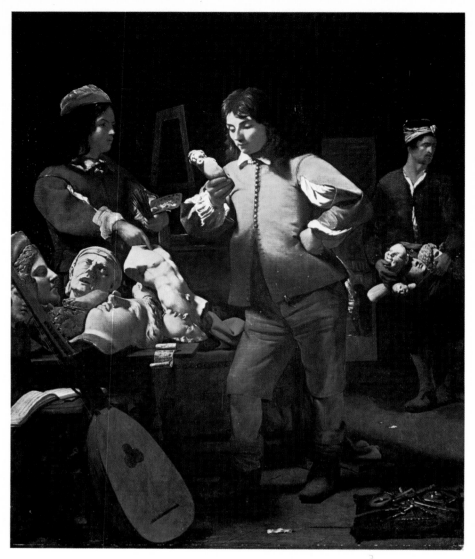

their fastidiousness and icy delicacy, set him between Dujardin (compare Sweert's amazing monochrome portraits at the Allen Memorial Museum, Oberlin, and the Rijksmuseum) and Ter Borch (to whom *The Go-Between and the Young Man* was once attributed; recently acquired by the Louvre).

It is perhaps not too much to claim that the crystalline purity of his colour, together with his extraordinary and exquisite tone values, place Sweerts at not too great a distance from Vermeer. With La Tour, Le Nain and Caravaggio, his reputation has benefited from the return to favour of realist painters in the last 50 years. J.F.

Szinyei-Merse
Pál

Hungarian painter
b.Szinye-Ujfalu, 1845 – d.Jernye, 1920

A pupil of Mezei, Szinyei-Merse later studied in Munich under Wagner and Piloty. Escaping from the grip of academicism his talent soon flowered, notably in the realist portraits he painted of his family (*Tsigmond Szinyei-Merse*, 1867; *István and Béla*, 1868). Two canvases (*Linen Drying*; *The Swing*), executed during the summer of 1869, at the same time at Monet and Renoir were painting their versions of *La Grenouillère*, already showed a feeling for Impressionism. Alone, and with no encouragement in Munich, Szinyei-Merse, however, hesitated to persevere with this style. His portraits of his sister *Ninon* (1870) and of the *Young Couple* are, in fact, regressions. But his masterpiece, *The Picnic Luncheon* (1873), constitutes a specifically Hungarian and definitive solution to the problems of open-air painting, quite independent of French Impressionism. The work aroused general indignation and outrage and Szinyei-Merse, discouraged, retired to Jernye where he painted nothing but portraits of his wife (*Lady in a Purple Dress*, 1874).

Around 1882 he tried to revive a feeling for contemporary art, but two exhibitions of his work in Vienna and Budapest were again unfavourably received. After executing several open-air studies (*The River*, 1883; *Snow Thawing*, 1884) he gave up painting. It was only in 1894 that he again took heart after a young painter had admired *The Picnic Luncheon*. The best of his paintings were shown during the festival to mark Hungary's millennium, held in Budapest in 1896. The young painters of Nagybánya, familiar with French Impressionism, now discovered these early manifestations of Hungarian Impressionism. There were more exhibitions (Paris, 1900; Munich, 1901; Berlin, 1910; Rome, 1911), which were, at last, successful. This belated appreciation gave the artist back his confidence and strengthened his creativity.

His last works are the masterpieces of an art self-made in maturity, with a quiet lyricism (*Autumn Landscape*, 1900; *Thuya*, 1912; *The Colour of Autumn*, 1914). The main part of his output is in the National Gallery of Hungary, Budapest, with the exception of some paintings in American collections (*Mother with Child*, 1869; *The Bathing Pavilion at Starnberg Lake*, 1872). Sharing the problems of the French Impressionists, Szinyei-Merse succeeded in solving them through his own personal means of expression.

and, the following year, presented them with a *Self-Portrait*. In 1661, in Amsterdam, he met the French Lazarists and, being very religious, offered himself as a lay brother for their missionary work. He joined a Monseigneur Pallu in Paris in November 1661, and together they left for Marseilles in January of the following year. As early as July, however, in a letter written from Tabriz in Persia, Pallu complains of Sweerts's incessant quarrels with his travelling companions and his unsuitability as a missionary. After the inevitable falling-out Sweerts went to the Jesuits in Goa, feeling, with some justification, very bitter towards Pallu. However, he continued to paint throughout his years with the mission. The cause of his death is uncertain.

It is not known where Sweerts received his training, as his earliest works date back only to his time in Italy (*Soldiers Playing Dice*, 1645 or 1649, Louvre; *Draughtsmen*, Rotterdam, B.V.B.). They reveal a perfect understanding of the genre of Pieter van Laer and, to a lesser degree, of Cerquozzi and Miel, painters who were working in Rome before Sweert's arrival. His themes and style did not develop very noticeably, except towards the end of his time in Brussels and Holland.

His favourite subjects were: young students being given drawing lessons from the antique (Rijksmuseum; Rotterdam, B.V.B.; Detroit, Inst. of Arts; Haarlem, Frans Hals Museum); scenes inside gambling dens (Louvre; Rijks-

museum; Lugano, Thyssen Coll.); and popular Italian themes treated with a seriousness and realism that prefigures Corot's Italian figures (*The Beggar* and *The Goddaughter*, Rome, Gal. Capitolina; *The Beauty at her Dressing-Table* and *Old Drunkards*, Rome, Academy of St Luke; *The Goddaughter*, Gouda Museum; *Mother Delousing her Child*, Strasbourg Museum).

He also painted several large collective scenes such as the series of *Five Works of Mercy* (Rijksmuseum), and notably his curious and ambitious compositions of *Bathers* (Strasbourg Museum), *Wrestlers* (Karlsruhe Museum), and the *Plague in Athens* (formerly Cook Coll., Richmond), which may be seen as related to the classical projects he encouraged during his time at the Brussels academy.

Sweerts's originality, apart from that of the large pictures mentioned above, lies in his use of dramatic chiaroscuro and subdued, subtly matched colours, particularly a cold blue, and strong variations of browns and greys. This tonal range reinforces most effectively the rather dated realism of his style, which is both solemn and tinged with sadness.

In his final period, giving up his Italian themes, Sweerts again laid stress on technical perfection in small studies of children's heads, often pendants (Stuttgart, Staatsgal; Rotterdam, B.V.B.), and in ravishing genre pictures (Louvre; Lübeck Museum). These brought him back to the 'aristocratic' tradition of Dutch painting and, by

Michael Sweerts ▲
The Studio (1652)
Canvas. 71 cm × 58 cm
Detroit, Institute of Arts

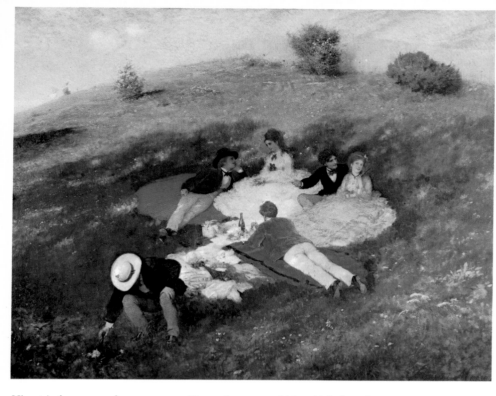

His art is the source of contemporary Hungarian painting, born of an original spirit, independent of foreign influence. The tradition was continued by the painters of Nagybánya and of Post-Nagybánya.

D.P.

Tanguy
Yves

American painter of French origin
b.Paris, 1900 – d.Woodbury, Connecticut, 1955

Son of a master mariner, Tanguy himself served in the merchant service in 1918. He did his military service at Lunéville in 1920 at the same time as Jacques Prévert, and together the two young men in 1922 found themselves in Montparnasse, where they lived by their wits, and discovered Surrealism in Adrienne Monnier's bookshop. In 1924, freed from financial cares, Tanguy began to paint. A canvas of de Chirico's, seen in the window of the dealer Paul Guillaume, had made a strong impression on him, and he fell under de Chirico's influence, as well as that of Max Ernst. He also made the acquaintance of André Breton and, linked henceforth to the Surrealists, he withdrew from their circle only on the eve of the Second World War.

Genèse (*Genesis*) (1926, Mouans-Sartoux, Marcel Duhamel Coll.) and the works reproduced in *La Révolution surréaliste* after June 1926, such as *L'Orage* (1926, Philadelphia, Museum of Art, Arensberg Coll.) or *On sonne* (1927), are the results of Tanguy's 'automatic' method. Later, the figures and the bizarre animals began gradually to disappear and Tanguy's canvases acquired their special characteristics: the light assumes a milky, opaque quality; a deserted plain is separated from the sky by a soft, blurred horizon; and amorphous figures with insect-like feelers, and flower stalks, mill about against this lunar background. The hallucination of limitless space takes us into an ambiguous and bitter-sweet

world in which the stillness of this petrified flotsam evokes the day following the holocaust. In *L'Envol des ducs* (1929, Jacques Ullmer Coll.) the skyline is clearly defined, while *L'Inquisiteur* (1929) and the *Ruban des excés* (1932), reproduced in the 11th issue of *La Révolution surréaliste*, also date from this period.

In 1938 the artist met the American Kay Sage, a painter who believed in Surrealism, and when war was declared Tanguy joined her in New York. From 1941 they lived together at Woodbury (Connecticut) and Tanguy became an American national in 1948. His work entered its middle period: he produced *Vers le nord lentement* (1942); *Divisibilité indéfinie* (1942, Buffalo, Albright-Knox Art Gal.); *Le Palais aux rochers de fenêtres* (1942, Paris, M.N.A.M.); and *Mer close, monde ouvert* (1944). The passing influence of Tachism appeared in *Nombres réels* (1946, private coll.) and *Multiplication des arcs* (1954, New York, M.O.M.A.), in which an inorganic mob overrun the plain. Tanguy's last work was *Nombres imaginaires* (1954).

Tanguy is represented in most important galleries of modern art, notably in Paris (M.N.A.M.), New York (M.O.M.A.), Chicago (Art Inst.), Basel Museum, London (Tate Gal.), Buffalo (Albright-Knox Art Gal.) and Helsinki (Ateneum), as well as in many private collections.

R.P.

Tàpies
Antoni

Spanish painter
b.Barcelona, 1923

Tàpies discovered contemporary art while he was studying law and, from 1934, became interested in drawing and painting. Deeply affected by the Civil War and its accompanying atrocities, he fell ill and took up painting during his convalescence. In 1946 he produced several heavily impasted

works, together with collages made of string, paper and cardboard reminiscent of the work of Miró. In 1948 he joined a group of writers and painters in Barcelona in founding the review *Dau al Set*, exhibited for the first time at the Barcelona Salón de Octubre, and made the acquaintance of Miró. This was the start of his fruitful 'Surrealist' period, with many works showing the influence of Klee, Ernst and Miró: smooth-textured paintings in a gamut of warm colours in which the motifs borrowed from the repertoire of these painters (suns, moons, crosses, draughtboards, geometric forms, landscapes and dreamlike figures) stand out against backgrounds marked by the play of light and shade (*Desconsuelo Lunar*, 1949; *Parafaragamus*). In 1949 Tàpies took up aquatint engraving, a technique which he used brilliantly and which won him a prize at the

Pál Szinyei-Merse ▲
The Picnic Luncheon (1873)
Canvas. 128 cm × 161 cm
Budapest, Magyar Nemzeti Galeria

Antoni Tàpies ▲
Large Square (1962)
Canvas. 195 cm × 130 cm
Cuenca, Museo de Arte Abstracto Español

Yves Tanguy ▲
Demain, on me fusille (1928)
Canvas. 61 cm × 50 cm
Helsinki, Ateneumin Taidemuseo

Ljubljana Biennale in 1967. His first one-man exhibition took place in Barcelona in 1950 at the Galerias Laietanes.

A grant from the French government enabled him to work in Paris, where he later spent much of his time. It was here that he discovered 'Raw Art', pioneered by Dubuffet, Fautrier, Michaux and Wols. After *Dau al Set* had ceased publishing in 1951, Tàpies toyed briefly with geometric forms, before returning to his early experiments with paint, impasto and 'scratching'. He mixed sand, pulverized marble, latex and powdered colour with his paint in order to obtain the effects that, from then on, were to characterize his work–for example his efforts to convey the texture of old walls (*Rojo*, 1955; *Negro y ocre*, 1955). The paint was sometimes deeply incised, or wrinkled, heavy and as though about to run, or grooved with wavy lines and manipulated very much in the style of Dubuffet. Following this came large, almost empty spaces, marked only by a few touches or impressions, deep incisions or 'cuts', revealing a base of a different colour (*Crackled White and Grey on Brown*, 1961, Barcelona, private coll.; *Large Square*, 1962, Cuenca Museum). Tàpies's first one-man exhibition in New York was held in 1953 at the Martha Jackson Gallery, and in Paris in 1956 at the Galerie Stadler.

It sometimes seems that Tàpies is tempted to paint representational objects, although he is not a representational painter. His forms are more openly defined until they eventually appear as the central theme of the 'picture' (*Curtain of Fire with Violin*, 1956, Barcelona, private coll.; *Packing-Case with Red Shirt*, 1972, Paris, private coll.; *Wood and Easel*, 1970, Paris, private coll.). Besides these works, Tàpies has also created figurative allusions, monumental details that take up almost the entire space of the canvas, and assume a fascinating ambiguity (*Paint in the Shape of an Armpit*, 1968, Palma, Joan Miró Coll.). After

settling in Switzerland at St Gall in 1962, he was given many public commissions by the town (mural in the theatre, 1972). In 1970 he took up sculpture, and has also published *The Practice of Art* (Barcelona, 1970). He is represented in most major galleries of modern art and in many private collections. G.B.

Teniers
David, the Younger

Flemish painter
b.Antwerp, 1610 – d.Brussels, 1690

Son and pupil of David Teniers the Elder, Teniers was famed as a genre painter, but also produced many portraits, landscapes and historical paintings. Several thousand pictures have been attributed to him, and his virtuosity was prodigious. Many tapestries, Flemish and French, and large sets of engravings, helped to make his work known to a wide public and to spread his influence up to the end of the 18th century.

Teniers became a Master in Antwerp in 1632–3. In 1637 he married Anna Bruegel, the daughter of Jan 'Velvet' Bruegel and a pupil of Rubens. Dean of the Academy of St Luke in Antwerp in 1645–6, Teniers worked for Prince William of Orange, the King of Spain and the Archduke Leopold Wilhelm, Regent of the Netherlands, whose service he entered as court painter in 1651 when he may have made his home in Brussels. His large fortune enabled him to buy the manor house of Dry Toren (the Three Towers) in 1662.

Teniers was commissioned to produce small copies of 244 Italian paintings belonging to the Archduke for an album of engravings which appeared in 1660 under the title of *Theatrum Pictorium Davidis Teniers Antwerpiensis*. Leopold Wilhelm's

successor, Don John of Austria, kept Teniers on as court painter, and his efforts to obtain a title of nobility finally succeeded in 1680. After his wife died in 1656 he married the daughter of the Secretary of the Council of Brabant. He was one of the founders of the Academy of Fine Arts in Antwerp, which opened in 1665. His success continued until his death.

In his early works (c.1633) Teniers followed the traditional style of Francken in his genre scenes (*The Guard Room*, Rome, Palazzo Corsini), but with a warmer and more varied chiaroscuro, and a greater awareness of space in the organization of his composition. He soon became a painter of middle-class life (*Company at Table*, 1634, Berlin-Dahlem; *The Covetous Man*, London, N.G.; *The Five Senses*, Prado) and of popular scenes (*Inn Scene*, 1634, Mannheim Museum). He has also been credited with a number of still lifes in a restrained gamut of greys: *Books and a Globe* (Brussels, M.A.A.); *Violin, Mappa Mundi and Book* (Rouen Museum). The fantastic Mannerism of Joos de Momper inspired his first landscapes and his *Temptations of St Anthony* (Antwerp, Mayer van den Bergh Museum; Louvre; Prado; Dresden, Gg).

Between the years 1634 and about 1640 Brouwer, with his popular subjects and tavern scenes in measured colours, had some influence on Teniers's work; it can be seen in such painting as *Drinkers in a Tavern* (Rome, Gal. Borghese), painted in chiaroscuro highlighted with red and blue, *Inn Scene* (1634, Mannheim Museum), *The Tavern* (Louvre), *Herdsmen* (Rome, Gal. Corsini) and *The Card-Players* (Rijksmuseum). In all these paintings Teniers confined himself to a down-to-earth realism.

In his third period (1640–50), which is considered to be the peak of his career, Teniers lightened his palette considerably with luminous, golden tones and took as his subjects village fêtes, travelling fairs and landscapes; these last were enlivened by the influence of Rubens. Their pastoral, idyllic style accounts for the success of such pictures as *A Corner of the Village at the Day's End* (Cologne, W.R.M.), *Rustic Repose* (Rome, Gal. Doria-Pamphili) and *The Shepherds' Hut* (Rome, Palazzo Corsini).

Part of Teniers's official duties was to make smaller copies of other painters' works (London, Seilern Coll.; Althorp, Spencer Coll.; Louvre). He also painted mythological themes: *Cupids as Alchemists* (Frankfurt, Städel. Inst.). He was equally at home with small easel paintings (Prado; Munich, Alte Pin.), and one of his finest works is *The Archduke Leopold Wilhelm in his Gallery in Brussels* (Vienna, K.M.), which today has considerable historical interest. Teniers started the fashion for interiors in which the personages are monkeys or cats dressed as humans (Brunswick, Herzog Anton Ulrich Museum; Hermitage), a genre which remained popular into the following century.

In the last decade of his life Teniers's palette darkened, with brownish tones predominating, and his handling became heavier. He untiringly repeated his favourite themes: *The Alchemist* (1680, Munich, Alte Pin.); *Village Fair* (Vienna, K.M.; Prado). In these latter, however, more figures now appear: *Fête of the Crossbowmen of St Sebastian in the Grande Place, Antwerp* (Hermitage). He often painted himself surrounded by his family out in the open air (Berlin-Dahlem; London, Buckingham Palace, Royal Coll.), portraits that prefigure the 18th century.

 David Teniers the Younger
The Archduke Leopold Wilhelm in his Gallery in Brussels
Canvas. 123cm × 163cm
Vienna, Kunsthistorisches Museum

Teniers enlarged and brought new life to Flemish genre painting. His art lacked the pathos of Brouwer, but opened the way to many followers, the best of whom are Gillis van Tilborch and David Ryckaert.

Most of the world's more important museums and art galleries have complete series of paintings by Teniers, among them the National Gallery in London and the Prado, both of which have large collections. P.H.P.

Tiepolo
Giambattista
Italian painter
b.Venice, 1696 – d.Madrid, 1770

The art of Tiepolo. No critical examination of the personality and work of Tiepolo can afford to ignore the social and intellectual climate in which he developed. If this is true for all artists, it is par-

ticularly so in the case of a painter who, to this day, is still eulogized and denigrated by turns, labelled alternately a reactionary or an innovator.

Early years. In Venice the young Tiepolo worked in the studio of Gregorio Lazzarini, but was soon attracted by the work of Bencovich and Piazzetta who did not favour the excesses of a dramatic chiaroscuro and preferred the pale tones of the rococo. From this period (*c.*1720) date *Our Lady of Carmel* (Brera) and *The Martyrdom of St Bartholomew* (Venice, Church of S. Stae), both showing great forcefulness, with the figures standing out in a three-dimensional precision typical of Tiepolo's linear clarity.

His first important decorative fresco dates from around 1725: the ceiling of the Palazzo Sandi in Venice (*The Power of Eloquence*). The impetuous energy of the young painter is already evident in its composition, while the very light tone shows traces of Veronese. Another important ceiling that Tiepolo painted at this time was his *Deification of St Theresa* for the Church of the Scalzi in Venice.

It was in his fresco cycle for the Archbishop's Palace at Udine (1727-8), however, that the novelty of Tiepolo's art, far removed from the dark painting of Piazzetta, made its impact, with its fluid rococo arabesques and the personal dynamism and boldness of its construction and, above all, the bright luminosity of the clear open skies, painted as the background behind most of the figures. The decoration (scenes and characters from the *Old Testament* on the stairs, and in the salon and gallery of the palace) is, in fact, the first complete realization of an absolutely new approach where natural light becomes the protagonist of the picture. At this time Tiepolo also painted a set of enormous canvases on themes from Roman history for the Palazzo Dolfin in Venice. Today these are shared between the Kunsthistorisches Museum in Vienna, the Hermitage and the Metropolitan Museum.

Maturity. Tiepolo's reputation was made and commissions came in with dizzying speed, both from Venice and outside. He worked in Milan in the Palazzo Archinto (*Triumph of the Arts*, ceiling

▲ Giambattista Tiepolo
Apollo presenting Beatrice of Burgundy to Frederick Barbarossa
Würzburg, Residenz, Fresco on the ceiling of the Kaisersaal

destroyed in 1943) and in the Palazzo Dugnani-Casati (1731, *Story of Scipio*), where his scenographic experiments were to prove invaluable for his later work. In the decoration for the Cappella Colleoni at Bergamo (1732-3, *Scenes from the Life of St John the Baptist*) and for the Villa Loschi-Zileri (1734), near Vicenza, the allegorical figures show a courtly classicism that is not, however, lacking in drama or intimist feeling.

Other great decorative works of this period were the frescoes in honour of St Dominic on the ceiling of the Church of S. Maria dei Gesuati in Venice (1737-9). One of Tiepolo's masterpieces dates from 1743: the ceiling of the Scuola dei Carmini, Venice, showing in the centre *Our Lady of Carmel Appearing to the Blessed Simon Stock*, and notable for the astonishing originality of the Virgin's white robe set against a luminous sky. Tiepolo now began to work with the architectural painter Mengozzi-Colonna who designed and painted for him the architectural perspectives framing pictures or frescoes. The *chef-d'oeuvre* of their collaboration is the decorative series in the Palazzo Labia, Venice (1747-50), depicting *Antony and Cleopatra* (preparatory sketch in Stockholm University). The architectural background opens on to the sky and frames a superb composition, with the figures dressed in sumptuous 18th-century costumes, and the whole moving in rhythmic progress across and beyond the picture plane. Here, decoration and the representation of the grandeur, real or imaginary, of the patron's family give the painter occasion for the most intricate artistic interplay.

Würzburg. In the same spirit Tiepolo and his two sons, Giandomenico and Lorenzo, went to Würzburg at the invitation of the Prince-Bishop, Karl Philipp von Greiffenklau, to decorate the Kaisersaal (salon) in the Residenz at Würzburg with *Scenes from the Life of Frederick Barbarossa*. Painted after 1750, the work is grandiose and solemn in its combination of painting with white and gilded stucco. Even more magnificent is the *Olympus* (sketch at Stuttgart, Staatsgal.) above the great staircase of the palace, where the multicoloured throngs of figures, massed on all sides of the ceiling, leave open an airy sky bathed in light. Here, the imagination of Tiepolo transforms myth and reality into a cosmology at once pagan and sacred.

Returning to Venice at the end of 1753, Tiepolo was increasingly in demand as an illustrator of state occasions for the republic or the noble families of the city. There followed the decorations for the Church of the Pietà in Venice (1754-5); for the Villa Valmarana, near Vicenza (1757; rooms with *Iphigenia*, *Orlando Furioso*, the *Iliad*, *Jerusalem Delivered*, the *Aeneid*); for the Ca'

Rezzonico in Venice (1758); for the Palazzo Canossa, Verona (1761, *Triumph of Hercules*); and for the Villa Pisani at Strà (1761-2, *Deification of the Pisani Family*; sketch in Angers Museum). Tiepolo's technique continued to lighten, his brushstroke became more rapid and nervous, his light intensified, and his composition grew more carefree and experimental. The tragic episodes depicted in the Villa Valmarana, with their melancholy figures, were succeeded by the dizzy foreshortening on the ceiling at Strà.

Spain. In 1761 Charles III summoned Tiepolo to Madrid to decorate in fresco the new royal palace. The painter again took his sons on this journey, from which he was never to return. His Spanish production appears to be affected by an inner disquiet, which had sometimes dimmed the brilliant fantasies of some of his previous works. One of the causes was the prevailing atmosphere of Neoclassicism, represented by Mengs, who was the foremost artist in Madrid at that time, and who intrigued against Tiepolo and criticized the 'frivolity' of his works (which, in fact, did not earn general approbation).

Tiepolo's inclination towards a touching intimacy had already appeared in such works as the fine *St Thecla Delivering Este from the Plague* (1759, Este Cathedral), which pointed to a withdrawal into himself on the part of the artist. In a number of portraits the ostentation of the ceremonial garments does not disguise the animation in the subject's features, and bears witness to Tiepolo's fondness for realism. In the Royal Palace Tiepolo painted three ceilings: *The Deification of Aeneas*, *The Magnificence of the Spanish Monarchy* and *The Apotheosis of Spain* (completed in 1764). His capricious and inventive genius could still create splendid compositions – although he was trying out new ideas, abandoning strict perspective in favour of broken lines and fragmented motifs – but here the light in the skies has faded, and purplish clouds have gathered against the opaque backgrounds.

A new spirit is shown in a group of altar paintings executed between 1767 and 1769 for the Church of the Convent of Aranjuez (sketches mostly in London, Seilern Coll.), today divided between the Prado and the Royal Palace, Madrid. They are composed of solitary figures of saints in empty, realistically depicted landscapes, painted with a new simplicity and psychological awareness, while, in *The Flight into Egypt* (Lisbon, M.A.A. and private coll.), Tiepolo achieves an intimate and mystical effect by the originality of his colours and his broken, nervous line.

Apart from this 'official' work, Tiepolo left many sacred and secular paintings in a much smaller format, as well as preparatory sketches for

the large decorative works. Among his early mythological paintings are four in the Venice Accademia, notable for the play of sharp contrasts of light and shade, and the brilliant *Temptation of St Anthony* (Brera), painted about 1725 but recalling the works of Sebastiano and Marco Ricci (especially of the latter, in the rapid brushstrokes of the background). *Hagar in the Wilderness* and *Abraham and the Angels* (Venice, Scuola S. Rocco) are characteristic of Tiepolo's religious works, stamped with a light and airy sensuousness, and are products of the period following his first stay in Milan (1733). From about 1736 dates *Jupiter and Danaë* (Stockholm University), where the myth is given a humorous twist and secularized with a marvellous fantasy.

One of Tiepolo's finest portraits is that of *Antonio Riccobono* (*c.*1745) in the Accademia dei Concordi in Rovigo. The painter has captured his sitter's uneasy and questioning nature, seen in a moment of unexpected relaxation; the intimate character of the picture is stressed by the sombre tonal range of browns. There is a marked contrast between this painting and the 'official' *Portrait of an Attorney* (*c.*1750, Venice, Gal. Querini-Stampalia), with his cloak flowing around the canvas in spots of glorious colour, while Tiepolo's caustic wit comes out in the sharp analysis of the features.

Especially important is the graphic work of Tiepolo, both drawings and etchings (the latter include the 24 *Scherzi* and the 10 *Capriccii*; no precise date). For Tiepolo, drawing was not necessarily a part of a painting: it was an end in itself. His large output of drawings (1,500 at least) is now mostly in London (V.&A.), at the Horne Museum in Florence, the Print Room in Stockholm and the Museo Civico in Trieste, as well as in other major international collections.

In the early drawings the outline of his figures is fluid and his use of wash produces incredible effects. Towards 1730 the line became more incisive and energetic, as exemplified by the many sketches for the Milan frescoes and those for the Villa Loschi, and they end in misty arabesques, as in the studies for *Cleopatra*. In Tiepolo's German period the drawings are sharper and richly shaded, while those of the next period (preparatory sketches for the Villa Valmarana) have an extraordinary translucence. The line becomes very quick and 'scratchy' and the figures have a majestic gravity. The decade 1740-50 was Tiepolo's most fruitful period as a draughtsman. His drawings of dogs and landscapes show his widespread interests, while the *Caricatures* and the *Punchinello* series (Milan, Castello Sforzesco; Trieste, Museo Civico) reflect his fantastic imagination and a caustic streak that contrasts with the laudatory style of his official commissions. F.d'A.

Tiepolo
Giovanni Domenico

Italian painter
b.Venice, 1727 – d.Venice, 1804

Tiepolo was the son of Giambattista Tiepolo, and for a long time his work was considered as a reflection or continuation of his father's art. But modern critics have reassessed his output and recognized him as a painter in his own right and, by his affinity with his own times, a chronicler of

that epoch in his genre paintings. Pupil and assistant to his father, Giovanni Domenico followed his style in his early works, although, in some of the Würzburg paintings (1751–3), such as *Alexander and the Daughters of Darius* (Detroit, Inst. of Arts), he was already distinguishing himself by a quicker and more vivacious handling. His father's influence persisted in the decorations for the Church of SS. Faustino and Giovita (Brescia), executed on his return from Germany, whereas in his easel paintings of the same time, such as *The Healing of the Blind* (1753, Los Angeles, Loewi Coll.), the grouping of the figures in the foreground gives an original dramatic rhythm to the picture. In the nocturnal *Adoration of the Shepherds* (Stockholm, Nm) the painter reveals a highly personal sensitivity in his treatment of light.

In 1757 Tiepolo was called on to assist his father in the fresco decoration in the Villa Valmarana (Vicenza). Given the guest room to paint, he was at last able to display his individual talent. Great narrative freedom and a subtly sardonic vein are typical of these genre scenes, such as *The Mountebank* or *The New World*, with their delicate, diaphanous landscape backgrounds. In the rooms of the Gothic Pavilion, or in the pastoral scenes, his down-to-earth treatment of episodes from aristocratic or peasant life is underlined by a new approach to contrasting effects. The same curiosity about contemporary reality is evident in a series of easel paintings depicting carnival scenes and social life in Venice (the *Burchiello*, Vienna, K.M.).

During his time in Spain Tiepolo seemed to inherit his father's final legacy in the more intimate rendering of feeling and in the hatching that characterizes *The Preaching of John the Baptist* (Treviso Museum). His last important official work, carried out in 1789, was the ceiling of the Palazzo Contarini in Venice, where he reused old decorative schemes at the request, perhaps, of his patrons. These have a cold feeling and do not attain his usual elegant subtlety of design, except in the monochromes.

After this, Tiepolo retired to his villa at Zianigo, decorating it with frescoes in between carrying out two commissions. Taking unconventional subjects, which he treated with a melancholy and an almost cruel irony, his frescoes showed *Punchinello*, *Satyrs* and *Centaurs* (the series has been reassembled in the Ca' Rezzonico, Venice), and furnish a last tragi-comic picture of a world on the brink of collapse, where only Punchinello's masque will survive. F.d'A.

Tintoretto
(Jacopo Robusti)
Italian painter
b. Venice, 1518 – d. Venice, 1594

Early years. Although he was Venetian by birth (his name is derived from the profession of his father Giovanni Battista, a dyer of silk), and lived all his life in Venice (only a visit to Mantua in 1580 is recorded), from the beginning Tintoretto painted in a style so different from that of his native region that its origins must be looked for outside Venice. These probably include the influence of such provincial painters as Bonifazio de' Pitati and Pordenone, and all the new figurative currents, Tuscan, Roman and Emilian, entering Venice in the third decade of the century in the wake of Sansovino and Aretino (1527), and later, of Salviati and his pupil Porta (1539), as well as through the circulation of varied engravings. In Venice itself Tintoretto's apprenticeship with Titian was short-lived and was terminated as a result of the immediate rivalry between the master and his over-gifted pupil.

▲ Tintoretto
Susannah and the Elders
Canvas. 146 cm × 193 cm
Vienna, Kunsthistorisches Museum

fluence of Veronese: *Assumption of the Virgin* (Venice, Church of S. Maria Assunta); six *Scenes from the Old Testament* (Prado); and *Journey of St Ursula* (Venice, Church of S. Lazzaro dei Mendicanti). Tintoretto exploited an original, more intimate vein in a *Last Supper* in the Church of S. Trovaso, Venice, which is stamped with religious fervour and executed in a popular style deriving from a simple observation of nature.

Maturity. Arrived now at his full maturity, Tintoretto launched out into a phase of immense boldness. From 1562 to 1566, the time of his second period of work with the Scuola di S. Marco, he produced three canvases. In two of these, behind the 'theatrical' action which takes place in the foreground of the picture, there open up striking architectonic perspectives. His talent for bravura appears in the amazing luminosity of the arches of the galleries in the *Discovery of the Body of St Mark* (Brera) and in the deserted immensity of the square in the *Removal of the Body of St Mark* (Venice, Accademia). The third picture, *St Mark Rescuing a Slave* (Venice, Accademia), is remarkable for the dramatic restlessness of the crowded composition, with its violent movement and bold foreshortening. In this same decade he painted two enormous canvases, *The Adoration of the Golden Calf* and *The Last Judgement*, for the apse of the Church of the Madonna dell'Orto, preceding these by the organ shutters (*The Presentation of the Virgin in the Temple; The Vision of St Peter; The Martyrdom of St Paul*) for the same church. The work was completed in 1556.

The Scuola di S. Rocco. Having impetuously entered in 1564 for the competition for the decoration of the Scuola di S. Rocco, Tintoretto, in the same year, began the cycle of paintings which, after several intervals, was to be completed in 1567 and remains the supreme testimony to his art. The work, which Tintoretto executed *con furia* (it is in the spontaneity and the extraordinary rapidity of the brushstrokes, more than in the sometimes dizzying movement of the figures, that the dynamic force of his art rests), begins in the Sala dell'Albergo (1564–7) with the spectacular canvases on the ceiling and the walls: *The Passion of Christ*, comprising most notably the 16ft-high *Crucifixion* and *Christ before Pilate*.

Simultaneously with the work in the Scuola di S. Rocco, Tintoretto engaged in a variety of other projects. But the same powerful emotion, springing from his visionary effects of light (*St Roch in Prison*, 1567, Venice, choir of the Church of S. Rocco) or the rhetorical force of the action (*The Last Supper*, Venice, Church of S. Paolo), is evident in the best works of this period. These include, too, a number of portraits, a genre in which he showed himself extremely sensitive, capable of grasping and depicting with an unfailing truth all the aspects of reality, however harsh. This is especially so in his treatment of the old, whom he handles with a vibrant humanity (portraits of *Alvise Cornaro*, Florence, Pitti; *Vincezo Morosini*, London, N.G.; a *Venetian Senator*, Prado).

In 1576 Tintoretto began his second cycle at the Scuola di S. Rocco, this time for the Sala Grande, finishing it in 1588 (*The Bronze Serpent, Moses Striking Water from the Rock, The Gathering of the Manna* and other Old Testament scenes on the ceiling; scenes from the *Life of Christ* on the walls). In these paintings Tintoretto reaches the poetic apogee of his art, and displays complete

Tintoretto's early works conformed to the Mannerist tradition by their observance of certain rules laid down by Parmigianino, by their narrative style and by their accord with the ideas of Andrea Schiavone, as evident in the *Virgin and Child with Six Saints* (New York, private coll.), the 14 ceiling panels of *Mythological Scenes* (Modena, Pin. Estense), the six *Old Testament Scenes* (Vienna, K.M.) and *Apollo and Marsyas* (Hartford, Connecticut, Wadsworth Atheneum).

This early Emilian influence, also to be seen in *Jesus among the Elders* (c. 1542, Milan, Museo del Duomo), led Tintoretto to develop a great admiration for Michelangelo (noticeable especially in his works of the late 1540s and involving a more decided definition of form) – an admiration that has given rise to the theory that Tintoretto went to Rome in 1547. There is no record of such a journey, but it is worth noting that Michelangelo's art was well known in Venice at this time, through the spread of drawings and engravings. Later, Tintoretto owned and studied a collection of plaster casts by the master.

This wide cultural awareness finally crystallized into an amalgam of stylistic trends: elongated forms, a dynamic articulation, linear arabesques linked to a forceful plasticity, all translated into a completely personal language and animated by an original handling of light. In addition, there is a new conception, both physical and symbolic, of spatial depth, and an achievement of the 'spectacular' through preliminary

rough sketches and arrangements using small wax figures. This method of creating a painting is characteristic of the *Last Supper* (Venice, Church of S. Marcuola), the *Washing of the Feet* (1547, Prado), and especially of the *Miracle of St Mark Rescuing a Slave*, painted in 1548 for the Scuola di S. Marco (Venice, Accademia), a revolutionary masterpiece of Tintoretto's youth, acclaimed since it was first shown, and which has recently been restored to its former splendour. This work marks the beginning of Tintoretto's connection with the religious confraternities, patrons who were to provide him with a constant supply of work, in which he adapted his art to popular beliefs, transforming them by his own unique brand of poetry.

In *St Rock Healing the Plague Victims* (1549, Venice, Church of S. Rocco) the subjugation of colour to chiaroscuro produces the feeling of a miracle and marks the first step towards Tintoretto's conquests of the problem of light. From 1550 to 1552 his contact with the Venetian art of the day shows in the way he adapted his style to that of Titian and in the new feeling for landscape that appears in *Scenes from the Old Testament* for the Scuola della Trinità (of which three, *The Creation of Animals, Original Sin* and *The Death of Abel*, are now in the Accademia), culminating in such masterpieces as *Susannah and the Elders* (Vienna, K.M.) and *St George Rescuing the Princess* (London, N.G.), with their sparkling colours. From 1553 to 1555 he begin lightening his palette under the in-

▲ Tintoretto
The Removal of the Body of St Mark
Canvas. 398 cm × 315 cm
Venice, Galleria dell'Accademia

mastery of the Mannerist style. The fantastic effects of light emphasize the vertiginous space, contrasts of scale, receding diagonals and dramatic compositions, and fuse the separate parts together. A strong moral feeling, however, biblical in inspiration, underlies the drama, and is identified with the 'historic' disclosure of the event.

Final period. From 1580 the number of his commissions made it necessary for Tintoretto to use collaborators, who, in the Sala Grande, worked under his personal direction. But most other works of this period show a decline in quality because of the actual painting of large parts of the compositions by assistants. The four *Allegories* in honour of the Doges of Venice in the Sala dell' Anticollegio in the Doge's Palace (completed in 1577) are by Tintoretto's own hand, and have a serenity and expressive flexibility typical of the artist. However, in the eight scenes depicting the *Splendour of the Gonzagas*, commissioned by Guglielmo Gonzaga a little before 1579 and finished in

May 1580 (Munich, Alte Pin.), the enormous amount of work done by assistants is disagreeably obvious, despite the important contribution of Domenico, Tintoretto's son.

Tintoretto used the same solution in the decoration of the Doge's Palace (oil paintings for the Sala del Senato and the Sala del Maggior Consiglio), which is why his genius is more evident in the *modello* autograph of his *Paradise* (Louvre) than in the vast final version (1588). But in the series of eight canvases painted between 1583 and 1587 in the lower hall of the Scuola di S. Rocco Tintoretto again displays his inventiveness, reviving his luminist technique to produce the delicate expressionism of the *Scenes from the Life of the Virgin*. In his *St Mary Magdalene Reading* and in *St Mary the Egyptian* the figures dematerialize in unexpected rays of light and reflections that make the entire fabulous landscape vibrate. Tintoretto painted without ceasing until his death, and in the magnificent *Last Supper* in the Church of S. Giorgio Maggiore left the final statement of his supremely poetic vision. F.Z.B.

Titian
(Tiziano Vecellio)
Italian painter
b.Pieve di Cadore, 1488 or 1489 – d.Venice, 1576

The second of the five children of Gregorio Vecellio, a notary from Cadore, Titian was born in 1488 or 1489 according to Dolce (1557) and Vasari (1568). Modern authorities accept these dates in preference to the earlier traditional dates of between 1473 and 1483 derived from other sources because they correspond more conveniently to the evolution of the 'Titianesque' style. Dolce claims that Titian was only nine years old when he arrived in Venice to begin his apprenticeship with Sebastiano Zuccato. The early rudiments mastered, he moved on to the studio of Gentile Bellini. However, Gentile's 'dry and outmoded manner' was not to his taste and he soon found himself in greater sympathy with the

▲ Titian
Shepherd and Nymph (1570–6)
Canvas. 149 cm × 187 cm
Vienna, Kunsthistorisches Museum

more modern style of Giovanni Bellini who collaborated in the same studio.

Titian and Giorgione. The year 1508 was decisive in Titian's early career, for it was then that he and Giorgione were commissioned to decorate in fresco the Fondaco dei Tedeschi. Giorgione was to paint the main front facing the Grand Canal, while Titian was to do the wall giving on to the Merceria. Only a few fragments survive of this work (today in the Accademia and at the Soprintendenza ai Monumenti, Venice), and the rest must be seen in the engravings made by Zanetti in the 18th century. If these few scraps are any proof, Titian's real teacher was Giorgione, who impressed on him his way of suggesting forms rather than stressing them, as well as conveying his feelings about nature. But it is also true that from the beginning the pupil differed from the master, whose contemplative lyricism he did not share, or his indifference to earthly reality.

Endowed with a dramatic temperament and considerable nervous energy, Titian put the lessons of 15th-century naturalism to good use in the frescoes for the Scuola del Santo in Padua (*The Miracle of the Newly Born Child, St Anthony Healing a Young Man, The Jealous Husband*), executed in 1511. In these scenes he organizes his space into a rhythmic composition that stresses a succession of volumes enveloped in bold, contrasting colours. 'Real' men and women act out their passions against a landscape treated as a stage-set, in a space where they are the masters, rather than in the mysterious atmosphere of Giorgione.

Some of Titian's works, displaying a progressive detachment from Giorgione, are thought by today's critics to be earlier than 1508-11, or at least contemporary. Four panels from chests have survived from Titian's early years: *The Birth of Adonis* and *The Forest of Polydorus* (Padua, Museo Civico); *Endymion* (Merion, Pennsylvania, Barnes Foundation); and *Orpheus and Eurydice* (Bergamo, Accad. Carrara). Already an obvious sensitivity to effects of space and colour is visible, alien to Giorgione, and Titian

can be seen exploring new themes and the 'constructive' use of colour. From this first period also date a *Circumcision* (New Haven, Connecticut, Yale University Art Gal.), a *Flight into Egypt* (Hermitage), *Jacopo Pesaro Presented to St Peter by Pope Alexander VI* (Antwerp Museum) and a *Virgin and Child with St Anthony of Padua and St Roch* (Prado), so like the work of Giorgione that it seems deliberate.

Titian's portraits, in contrast to those of Giorgione, which are full of pathos, are strongly characterized: *Gentleman Leaning on a Book* (Washington, N.G.); and the *Lady* (London, N.G.). In his *Portrait of a Man with a Blue Sleeve* (London, N.G.) the presentation, which is still Giorgionesque, is simplified by the employment of several large planes: the fullness of a sleeve, the puffed-out satin clothes, the projection of the image by the sharp division of the balcony. The wood-engraving of the *Triumph of the Faith* (*c*.1511; the first of five editions is in the Print Room at Berlin-Dahlem) represents a climax in Titian's reaction against Giorgione's influence. But in October 1510 Giorgione died; his other rebellious pupil, Sebastiano del Piombo, left for Rome, and Giovanni da Udine and Morto da Feltre went to central Italy. This period gave birth to works in which the demarcation line between the hands of the two artists is hard to distinguish. *The Outdoor Concert* (Louvre) seems to have been completed by Titian after being left unfinished by Giorgione, while the *Noli me tangere* (London, N.G.), *The Concert* (Florence, Pitti), *The Allegory of Human Life* (Edinburgh, N.G.), *The Bohemian Girl* (Vienna, K.M.) and the *Carrying of the Cross* (Venice, Scuola di S. Rocco) are all full of a Giorgionesque feeling.

Classicism. After the *Baptism of Christ* (*c*.1512, Rome, Gal. Doria-Pamphili) and the *Sacra Conversazione* (*c*.1513, Reggio Emilia, Magnoni Coll.) Titian's art is characterized by a new figurative feeling and the search for that serene and majestic beauty emblematic of the Renaissance. Representative of the new trend are: a series of *sacre conversazioni* (Munich, Alte Pin.; Edinburgh, N.G.; London, N.G.); *Salome*

(Rome, Gal. Doria-Pamphili); *Flora* (Uffizi); the *Young Woman at her Toilet* (Louvre); and *Divine Love and Profane Love* (Rome, Gal. Borghese). This last is one of the highest peaks of Titian's classicism and, in the peaceful harmony of the landscape and beauty of the figures, one of the supreme expressions of Renaissance art. An equal harmony is typical of other *sacre conversazioni* (Prado; Dresden, Gg), as well as *Christ and the Widow's Mite* (Dresden, Gg), the *Virgin with the Cherries* and *Violante* (both Vienna, K.M.).

In the enormous altarpiece of the *Assumption* for the Church of S. Maria Gloriosa dei Frari in Venice, commissioned in 1515 and erected in the church on 20th March 1518, Titian's classicism gave way to a naturalism and a passion that the Venetians, unprepared for such boldness, found disconcerting. This ardour is somewhat abated in the three paintings for Alfonso I d'Este: *The Worship of Venus* and *The Andrians* (1518-19, Prado), and *Bacchus and Ariadne* (1523, London, N.G.). Between 1518 and 1520 Titian painted an *Annunciation* for Treviso Cathedral; in 1520 he signed and dated a *Virgin and Child Appearing to Sts Francis and Blaise and to the Donor Alvise Gozzi* (Ancona Museum), and between 1520 and 1522 the *Averoldi Polyptych*, in five panels, for the Church of S. Nazaro e Celso, Brescia. In all these works, and especially in the *Resurrection of Christ* in the Averoldi altarpiece, Titian's regard for Raphael and Michelangelo is perceptible in the dramatic intensity of feeling and the vigorous accents.

A deep awareness of the model's psychology and a simplified structure are typical of the portraits of *Vicenzo Mosti* (*c*.1523-5, Florence, Pitti), the *Man with a Glove* (*c*.1523-4, Louvre) and *Federico Gonzaga* (after 1525, Prado). In contrast, *The Virgin and the Pesaro Family* (1519-26, Venice, Church of S. Maria Gloriosa dei Frari) is very complicated, with its lofty effects of monumental architecture and perspective stretching into infinity. Although Raphael was the inspiration behind the *Entombment* (*c*.1523-5, Louvre), the way in which light is used gives the work a restlessness that is Titian's own. Unfortunately another major work, the *Martyrdom of St Peter*, is lost. Painted by Titian for the Church of SS. Giovanni e Paolo, and completed on 27th April 1530, it was enthusiastically described by Vasari and Aretino, and brought to an end the figurative period that had begun with the Frari *Assumption*.

The *Virgin with the Rabbit* (Louvre) and the *Virgin and Child with St John the Baptist and St Catherine* (London, N.G.), both from 1530, are more calm in their flexibility and modelled landscapes. This glorification of feminine beauty is more spontaneous, and even homely, in the *Portrait of a Young Woman in a Furred Gown* (*c*.1535-7, Vienna, K.M.) and in the *Bella* (*c*.1536, Florence, Pitti).

European fame. Titian's fame was at its height: Renaissance rulers and nobles saw themselves through his art, and therein realized their most sublime aspirations. The artist's relations with the court of the Este family were succeeded in 1523 by a new connection with the Gonzaga court, and with Francesco Maria della Rovere. In 1530 Titian had his first meeting with Charles V in Bologna; three years later, in the same town, the Emperor made him a Palatine count and a knight of the Order of the Golden Spur. He invited the artist to the court at Augsburg between 1548 and 1550, and again in 1550-1. This lofty patronage is

▲ Titian
The Entombment (*c*.1523–5)
Canvas. 143 cm × 205 cm
Paris, Musée du Louvre

evidence of Titian's intense activity as a portrait painter, a genre that satisfied his taste for realism. The paintings of *Charles V* (*c.*1532-3, Prado), of *Cardinal Ippolito de' Medici* (1533, Florence, Pitti), of the *Duke* and the *Duchess of Urbino* (1538, Uffizi), of *Francis I* (1538, Louvre) and of *Alfonso d'Avalos* (1536-8, Paris, Ganay Coll.) met all his clients' demands for pomp and majesty.

The pronounced naturalism in the *Presentation of the Virgin in the Temple* (1534-8, Venice, Accademia) and in the *Venus of Urbino* (1538, Uffizi) gave way in Titian's works to the Mannerism which had been introduced into Venice during these years by Salviati and Giorgio Vasari, and which must already have made an impression on Titian during the time he had spent in the Mantua of Giulio Romano. The three-dimensional tension peculiar to Mannerism characterizes the 12 *Portraits of Roman Emperors* (begun in 1536 for the Sala di Troia of the Palazzo Ducale in Mantua, then lost, and today known only by the engravings of Sadeler) and is also evident in *Alfonso d'Avalos Addressing his Soldiers* (1540-1, Prado), *The Crowning with Thorns* (*c.*1543, Louvre) and *Ecce Homo* (1543, Vienna, K.M.), and in three ceilings – *The Sacrifice of Abraham, Cain and Abel,* and *David and Goliath* – for the Church of S. Spirito in Isola (1542; now in the sacristy of the Church of S. Maria della Salute, Venice).

In the realm of the portrait this tension is resolved by the energy Titian employed to capture the personality of his sitters, who appear variously as prudent, cunning, arrogant or devout (*Ranuccio Farnese,* 1541-2, Washington, N.G.; *Pope Paul III,* 1546, Naples, Capodimonte; the *Doge Andrea Gritti,* Washington, N.G.; *Charles V at the Battle of Mühlberg,* Prado; *Charles V Seated,* Munich, Alte Pin.; *Antoine Perrenot de Granvelle,* 1548, Kansas City, W.R. Nelson Gal. of Art; *Philip II,* 1551, Prado; *Votive Painting of the Vendramin Family,* 1547, London, N.G.).

Last period. The years after 1550 show no slackening in Titian's creative activities. He executed simultaneously works for Venice (*Pentecost,* 1555-8, painted for the Church of S. Spirito, now in the Church of S. Maria della Salute; *The Martyrdom of St Lawrence,* finished in 1559, Venice, Church of the Gesuiti; *Wisdom,* for the ceiling of the antechamber of the Biblioteca Marciana, after 1560) and for Ancona (*Christ on the Cross with the Virgin, St Dominic and St John,* 1558, Church of S. Domenico). To please the curious tastes of Philip II of Spain, he painted the famous 'poesie', a series of erotic pictures on mythological themes (*Danaë,* 1554, and *Venus and Adonis,* 1553-4, both in the Prado; *Diana and Actaeon* and *Diana and Callisto,* 1556-9, exhibited at Edinburgh, N.G.; *The Death of Actaeon, c.*1559, London, N.G.; *The Rape of Europa,* 1562, Boston, Gardner Museum). He also treated religious subjects (*St Margaret,* 1552, Escorial, 1567, Prado; *The Entombment,* 1559, Prado; *Agony in the Garden,* 1562; *The Martyrdom of St Lawrence and St Jerome,* 1565, Escorial). The expressiveness of all these works derives from the way in which the forms seem to dissolve as though by a process of self-combustion.

Titian had now reached the last phase of his activity: the representation of a naturalistic vision where the already eroded classical ideal no longer interested him. He developed a style which paid small regard to contour or plasticity: very free in handling, and almost harsh, where people and nature were painted in splashes and clots, slashes

almost, of colour, the outlines softened, the highlights modulated, sometimes with a smudged finger. From this smoky disaggregation of the paint golden lights loom out in the *Annunciation* (1566, Venice, Church of S. Salvatore); a crackling impasto in *Venus Binding the Eyes of Cupid* (1560-2, Rome, Gal. Borghese), in *St Sebastian* (*c.*1570-2, Hermitage) and in *The Crowning with Thorns* (Munich, Alte Pin.); a rosy light in *Tarquin and Lucretia* (1570-1, Cambridge, Fitzwilliam Museum), which is even more striking in the alternate version in Vienna (Akademie); a melancholy, turbulent sky in *Shepherd and Nymph* (1570-6, Vienna, K.M.); and a great fire which bathes in purple *The Scourging of Marsyas* (1570-6, Kroměříž Museum).

This 'magic impressionism' is also characteristic of Titian's last portraits: *Francesco Venier* (1554-6, Lugano, Thyssen Coll.); *The Antiquary Jacopo Strada* (1567-8, Vienna, K.M.); *Self-Portrait* (1568-70, Prado), painted for his children to remember him by, where, from the heavy impasto, a spectral, unearthly figure stands out. Titian died in Venice of the plague in his house at Birri on 27th August, 1576, leaving unfinished a *Pietà* (Venice, Accademia), a complex, troubled work which was intended for his vault in S. Maria Gloriosa dei Frari and which was completed by his follower Palma Giovane. M.C.V.

Tobey
Mark

American painter
b.Centerville, Wisconsin, 1890 – d.Basel, 1976

After attending Hammond High School for a short time, Tobey worked at various trades in Chicago, where his family lived, and finally became a fashion artist, first in Chicago, then in New York. He was tempted to become a society portrait painter, but decided to earn his living as a decorative artist in order to be free to paint.

Tobey's conversion, around 1918, to Zen Buddhism proved the spritual point of departure for his art. His beginnings as a self-taught painter, oscillating between traditional art and experiments with spatial rhythms, lasted for several years, during which he moved from place to place. Around 1922 he left New York to return to Chicago, then spent two years in Seattle where he taught drawing at the Cornish School. In 1925 he went to Paris and joined the American colony in Montparnasse. A Mediterranean cruise proved an opportunity to visit Bahaist shrines (Acre, Sinai). Paris, however, disappointed him, and he returned to the United States in the summer of 1926. He divided his time between New York and Seattle where he again took up teaching.

In 1930 Tobey went to England where he taught at Dartington Hall, and stayed for seven years, interrupted by several trips. He visited Mexico in 1931 and in 1932 returned to the Near East. In 1934 he left for China where he met a friend from Seattle, the Chinese artist Ting Kwei, who initiated him into the techniques of Chinese calligraphy and wash, with which he tried new experiments. However, it was in Japan, where he went next, that a painter monk in a Zen monastery revealed to him the cosmic significance of interrupted calligraphic lines in space.

After his return to the United States, Tobey's

experiments, based on Chinese calligraphy, finally blossomed into what he called 'white writings'. The first example was *Broadway* (1936, New York, M.O.M.A.), which was followed by a series of paintings in the same style. Some were descriptive, others purely rhythmical. In 1944 Tobey had his first one-man exhibition in New York at the Maryan Willard Gallery, and he exhibited there each year from then on, while his reputation grew. It was during this time that his talent was recognized by Jeanne Bûcher who helped to make him known in Paris. Soon he gave up white writing for a new, sombre style, which he pursued until 1953, when white reappeared as the dominant element in his painting.

If Tobey's observations of nature always inspired him and made him reject the abstract as having no affinity with life, he liked to vary the means and style of his pictorial writing in an effort to discover the secret connections between his own inner impulses and the rhythms of the universe. He recognized the influence of the Far East when he named some of his 1957 works 'sumi' (the Japanese term for wash and Indian ink): *Sumi Still Life: Calligraphy in White* (Seattle, O.D. Seligman Coll.).

Tobey achieved equal recognition in the United States, where he was awarded the national prize of the Guggenheim Foundation in 1957 and elected to the American Academy of Arts in 1958, and in Europe, where, the same year, he won the Grand Prix for painting at the Biennale in Venice. He settled in Basel in 1960, where he led a solitary existence devoted entirely to work (*Sagittarius Red,* 1963, Basel Museum; *Drum Echoes,* 1965, private coll.; *Six Impromptus on Omar Khayyám,* 1970, watercolour). He is mainly represented in New York (M.O.M.A. and Metropolitan Museum). London (Tate Gal.) and Paris (M.N.A.M.). R.V.G.

▲ Mark Tobey
August Excitement (1953)
Canvas. 122 cm × 71 cm
New York, Museum of Modern Art

Toorop
Johannes Theodorus (called Jan)

Dutch painter
b.Poerworedjo, Java, 1858 – d. The Hague, 1928

After training in Delft, Amsterdam (1880-1) and Brussels (1882), Toorop settled in The Hague in 1888. His early works are in the style of the Impressionists, but two visits to England in 1884 and 1886 introduced him to Blake and the Pre-Raphaelites, and his contact in Paris in 1889 with Rops and Redon made him into an enthusiastic disciple of the Symbolists. With Thorn-Prikker he became one of the principal Symbolist painters in Holland. His essentially graphic, stylized and recherché art reveals the influence of Beardsley (*The Three Fiancées*, 1893, Otterlo, Kröller-Müller; poster for *Delftsche Slaolie*, lithograph, 1895, Amsterdam, Stedelijk Museum).

After 1900 Toorop returned to a simpler but more colourful style that combines Neo-Impressionism with the example of Van Gogh (*Canal near Middelburg*, 1907, Amsterdam, Stedelijk Museum). He played an important part in European and Dutch art at the end of the 19th century and contributed greatly to the evolution of Mondrian. After being converted to Roman Catholicism, he developed a new style, full of religious symbolism, decorative and monumental, where the mark of Cubism is perceptible (*The Flight into Egypt*, Amsterdam, Stedelijk Museum). He executed the stained-glass windows for the Church of St Joseph at Nijmegen. Toorop is represented in galleries in The Hague, Amsterdam and especially at Otterlo. L.E.

Toulouse-Lautrec
Henri Marie Raymond de

French painter
b.Albi, 1864 – d.Château de Malromé, Gironde, 1901

The painter's father, the Comte Alphonse de Toulouse-Lautrec Monfa, married his first cousin, Adèle Tapié de Celeyran, and these close blood ties were possibly one of the causes of their

child's weak constitution. The boy was born at Albi but spent his childhood in Paris and at the Château de Celeyran in the Aude, in the aristocratic family atmosphere in which honour, glory, courage and a passionate fondness for fox-hunting prevailed. But, like his father, his elder brother and both his uncles, Henri de Toulouse-Lautrec loved to draw.

In 1878, after breaking both legs, he was attacked by an incurable bone disease, which resulted in his being a dwarfish cripple. He was given lessons by René Princeteau, a talented animal painter, and a friend of his father. Very soon Henri, following his teacher's example, was painting frisky horses (*Artilleur sellant son cheval* [*Artilleryman Saddling his Horse*], 1879, Albi Museum) and 'portraits' of horses and dogs, very sensitive studies of heads (*Cheval blanc Gazelle* [*White Horse Gazelle*], 1881, Albi Museum). The *Mail-Coach* in the Petit Palais, Paris (*Alphonse de Toulouse-Lautrec Monfa conduisant son mail-coach à Nice*, 1881), is the most famous example of his already very free handling.

Influenced by the light, clear colours of Manet and the Impressionists, Lautrec painted a portrait of his mother (*La Comtesse de Toulouse-Lautrec à Malromé*, 1883, Albi Museum) which, in its solid composition and simplification of planes, expresses the tender thoughtfulness of the model. He painted Alfred Stevens in the same fashion (*Pose du modèle*, 1885, Lille Museum).

Having enrolled at the École des Beaux Arts in 1882, after getting his baccalaureate, he studied in turn in the studios of Bonnat and Cormon, where he became friendly with Émile Bernard, Anquetin, Francois Gauzi and particularly Van Gogh, whom he often visited between the years 1886 and 1888. Like Van Gogh, he was interested in pointillism and made a superb pastel portrait of him (1887, Amsterdam, M.N.V. Van Gogh) in which he used vigorous hatching similar to his famous friend's technique. For a time, under the influence of his academic masters, Lautrec adopted a more traditional manner and a darker palette (*Jeune Fille aux cheveux roux* [*Young Girl with Red Hair*] 1889, Zürich, private coll.).

Around 1890 he abandoned Impressionism and joined the independent painters such as Renoir, Zandomeneghi and the Nabis. Through them he met their friends, notably the Natanson brothers, founders of the *Revue blanche*, but he remained hostile to theories and schools. His admiration for Degas was his real teacher: following the master's example, he gave priority to the expressive power of drawing and composition, and, like Degas, unceasingly adapted his technique to his subject matter. If Raffaëlli and Forain fired him to discover and depict the lives of the poor in Montmartre, it was still Degas to whom he owed his penetrating observation of Parisian mores and the choice of his 'modern' subjects (*La Blanchisseuse* [*The Laundress*], 1889, Paris, private coll.). Like Degas, he painted the world of cabarets and brothels, but without cruelty or contempt.

A dwarf, grotesque and suffering, Toulouse-Lautrec was full of kindness and understanding. After living for many years in Montmartre he moved to the Champs-Élysées, but returned each evening to drink and draw in the bars, the low music-halls and the brothels, where a place was always kept for him. He also often went, accompanied by his cousin, Dr Tapié de Celeyran, to the Moulin Rouge, the Rat Mort, or the dances at the Moulin de le Galette or the Élysée-Montmartre. He knew the Chat Noir of Salis and

Aristide Bruant's Le Mirliton, and was a very frequent visitor to the Divan Japonais, the Scala and the Ambassadeurs.

He knew the stars of these nocturnal entertainments, and drew and painted them with an indulgent veracity that made them larger than life. Above all he admired the Cancan dancers, Grille-d'Égout, Rayon-d'Or, Nini Patte-en-l'Air, Trompe-la-Mort, and, more than any other, La Goulue, with her red hair piled high (*Au Moulin-Rouge, entrée de la Goulue* [*At the Moulin Rouge: Entrance of La Goulue*], 1892, New York, M.O.M.A.). Ceaselessly, he studied the reckless rhythm of the dance, the upraised legs, the swirling petticoats (*La Troupe de Mlle Églantine*), Turin, private coll.). He also made drawings of Valentin le Désossé, the Negro dancer Chocolat, and Jane Avril, his favourite, whose mannerist elegance in black stockings he reproduced perfectly (*Jane Avril dansant*, c.1891-2, Louvre, Jeu de Paume).

He was interested in prostitutes and made many studies in the Rue des Moulins. He depicted these women in unstudied attitudes, immodest and disillusioned, transforming them by a strange lyricism and irony (*Au salon de la rue des Moulins*, 1894, Albi Museum). After 1892 Lautrec became interested in famous singers: May Belfort, dainty in pink muslin (*May Belfort*, 1895, Cleveland Museum), Polaire or Yvette Guilbert, whose pointed nose and long black gloves he immortalized. He likewise caught the spangled, melancholy charm of the Cirque Fernando where he studied the circus-riders, the acrobats and the clowns. He made several paintings of the large and sparkling figure of the *Clownesse Cha-U-Kao* (*Female Clown Cha-U-Kao*) (1895, Louvre, Jeu de Paume). An ardent 'first-nighter' at the theatre, he used popular actors as one of the principal themes of his lithographs (*Réjane et Galipaux dans 'Madame Sans-Gêne'*, 1894, lithograph). He adored the dramatic gestures of the elder Coquelin, Leloir and Sarah Bernhardt.

The movement and colour of the Vélodrome Buffalo Cycling Track also enchanted him (*Coureur cycliste* [*Racing cyclist*], 1894, Louvre, Cabinet des Dessins), and he was one of the first to put the bicycle on the map by celebrating the racing-cyclist Zimmermann.

Always under the influence of the art of Degas, Lautrec experimented with the arbitrary division of the canvas, and created dynamic areas of empty space (*M. Boileau au café*, 1893, Cleveland Museum). But he was not interested in three-dimensional effects and chiaroscuro, and preferred to use areas of flat colours and arabesques to convey rapid movement and emphasize the design. He was influenced by Japanese prints, but also by his own discovery (after 1892) of Cranach and the Primitives. His colour remained rich, with vivid greens and reds, blue shadows and a strange, artificial luminosity. His art was strong, lucid and unified (*Au Moulin-Rouge*, 1892, Chicago, Art Inst.).

He painted on tracing paper (*Artilleur et femme* [*Artilleryman and Woman*], 1886, Albi Museum) and on unprepared wood panels (*La Modiste* [*The Milliner*], 1900, Albi Museum), but more often on unprimed cardboard where the neutral grey or buff tone formed the background to his picture (*Femme au boa noir* [*Woman with Black Boa*], 1892, Louvre, Jeu de Paume). He used wet colours that soaked into the cardboard: with his brush he drew the outlines of his composition (*Femme qui tire son bas* [*Woman Putting on her Stocking*], 1894, Albi Museum), then painted in his figures very wet

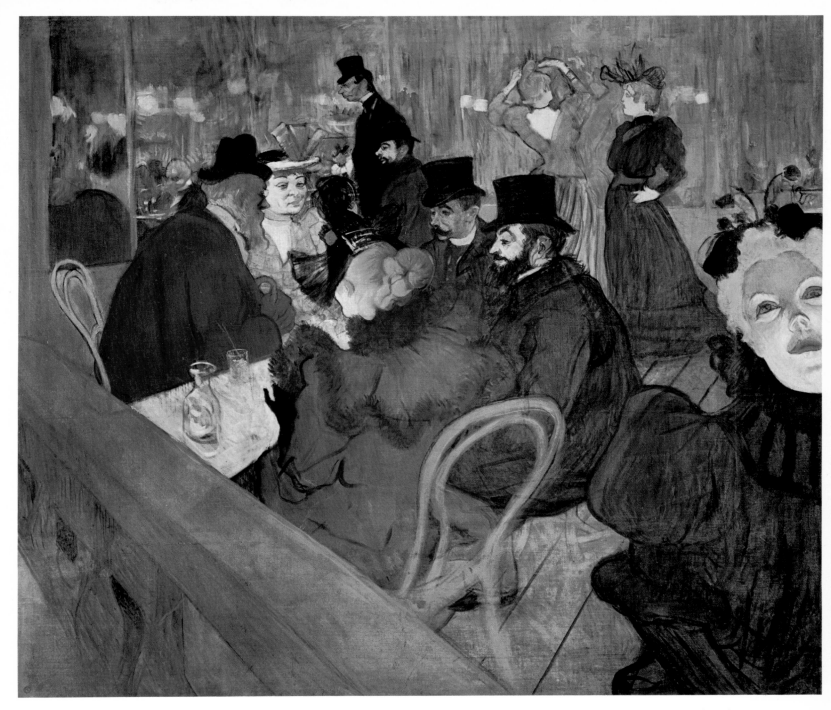

(*Marcelle*, 1894, Albi Museum), sometimes with highlights of light gouache (*Missia Natanson*, 1895, Paris, S. Niarchos Coll.). This technique, originating with Raffaëlli, was frequently used by the Nabis.

Lautrec was a superb draughtsman: his stroke, sure and rapid, suggested whole situations (*Au lit* [*In Bed*], *c.*1896, London, Courtauld Inst. Galleries). Around 1884 he illustrated Victor Hugo for Cormon. He never stopped drawing: in notebooks, on tablecloths, on any scrap of paper; and his drawing became more defined, selective, distorted, studied, expressing the psychology of his model. His self-portraits were insolent caricatures.

His audacious drawing, his bold arrangements, his feeling for composition and his taste for a 'Japanese' simplicity made him the master of the poster. When new mechanical printing methods

made it possible to print posters in four colours, Chéret and Bonnard adopted this technique, and in their wake Toulouse-Lautrec, at one stroke, created a revolutionary style of advertising poster. His *Au Moulin-Rouge, la Goulue* (1891), where the gawky, 'Chinese' shadow of Valentin le Désossé stands out, and his *Aristide Bruant dans son cabaret* (1891) caused a sensation. The best of the series were *Aristide Bruant aux Ambassadeurs* (1892), the *Divan japonais* (1892), *Jane Avril au Jardin de Paris* (1893), the *Revue blanche* (1895), and the *Troupe de Mlle Églantine* (1896). To the dynamic ease of the design and movement, he added a superb play of colour, in emphatic clashes of orange and blue, red and black.

Lautrec showed a comparable decorative audacity in the many lithographs he executed from 1892. He was deeply affected by the Japanese prints of Hiroshige and Utamaro, where

he found what he had already admired in the French 18th century: wit in the study of mores, a taste for women and an ironic eroticism (*Elles*, 1896). Alone, he integrated the flat tints and stylization with the Art Nouveau of Europe, and in a sense, prefigured the Sezession. From 1892 to 1899 Toulouse-Lautrec produced over 300 lithographs. An observant worker, he scrupulously examined the grain of the stone, the quality of the paper, the number of proofs. He repeated all his favourite themes: the circus, the racecouse, the Vélodrome, the theatre. Sometimes Lautrec illustrated journals and magazines: *Le Mirliton*, *Le Courrier francais*, *Paris-illustré* and *Le Rire* published his satirical sketches (*Alors vous êtes sages?*, 1897, Albi Museum).

After his first exhibition in 1893, at the Galerie de la Maison Goupil, he was wildly admired, and by 1895 his reputation as a great artist was made.

▲ Henri de Toulouse-Lautrec
Au Moulin-Rouge (1892)
Canvas. 123 cm × 140 cm
Art Institute of Chicago

In this year he painted the famous decoration for La Goulue's booth at the Trône fair, a rapid evocation, harsh, but inspired, of a brutish and stupid world (Louvre). Gradually, although reasonably ambitious, he began to drink more and more. This continued intemperance brought on his first attack of delirium tremens in 1899, and he had to go into a clinic at Neuilly, where he drew from memory, using coloured pencils, a series of circus drawings, of which 22 were published by Manzi and Joyant in 1905 (*Au cirque, le salut* [*Greetings to the Circus*], 1899, Hofer Coll.). But he would not stop drinking. In 1899 he painted some fine works, including *Au Rat-Mort* (London, Courtauld Inst. Galleries). After his first attack of paralysis he gave up his studio and went to live with his mother at the Château de Malromé in the Gironde, where he died in 1901.

His mother gave all the works she had collected to the museum at Albi: paintings, drawings and engravings that immediately confirmed Lautrec's fame and the importance of his work. The power of his draughtsmanship and the precision of the flat planes of colour influenced the Nabis, Gauguin and the young Picasso; the harshness of his palette with its blue and green shadows foreshadowed, from 1895, the boldness of the Fauves and the Expressionists. T.B.

Troost
Cornelis

Dutch painter
b.Amsterdam, 1697 – d.Amsterdam, 1750

Troost was the most justifiably famous Dutch painter of his day. A pupil of Arnold Boonen, who painted many group portraits, a genre also practised by Troost (*The Anatomy Lesson of Professor Roell*, 1729; *The Regents of the Aalmoezeniersweeshuis*, 1729; *The Guild of Surgeons*, 1731; all Rijksmuseum), he worked mainly in Amsterdam. In his genre scenes, which are close to Hogarth and Longhi in spirit, he casts an amused and satirical eye on the social mores of 18th-century Holland.

Works like *The Inspectors of the Collegium Medicum* (1724, Rijksmuseum), *Reunion of Friends at the House of Biberis* (series of five paintings, Mauritshuis), *The Bashful Lovers* (1738, Mauritshuis), *The Flouted Husband* (1739, Mauritshuis) and *Blind-Man's Buff* (Rotterdam, B.V.B.), which displays traces of French *fêtes galantes*, show his meticulous, refined technique – although he

▲ Cornelis Troost
Blind-Man's Buff
Canvas. 60 cm × 74 cm
Rotterdam, Museum Boymans-van Beuningen

sometimes mixes pastel with gouache to singular effect (examples in the Rijksmuseum Print Room, and Haarlem, Teyler Museum). Troost painted some excellent portraits: *Jan Lepeltak* (1729, Rijksmuseum), *Jeronimus Tonneman and his Son* (1736, Dublin, N.G.) and the *Self-Portraits* (1720, Haarlem, Frans Hals Mus.; 1737, Rijksmuseum; 1745, Mauritshuis) and intimist genre scenes in which he continues the tradition of Pieter de Hooch (*The Garden*, Rijksmuseum). J.V.

Trumbull
John

American painter
b.Lebanon, Connecticut, 1756 – d.New Haven, Connecticut, 1843

John Trumbull, the foremost documentary artist of the American Revolution, was born into the highest stratum of Colonial society; the son of the Governor of Connecticut, he was also the brother of Joseph Trumbull, first Commissary-General of the Continental army. At the age of four he lost the sight of his left eye in an accident, but this defect, to which many of the visual peculiarities of his later and larger paintings can be attributed, never caused him to hesitate in his choice of a career. He was a member of the Harvard class of 1773 and while in Boston began to develop both his taste and talent for painting. Here he first encountered the engravings of Piranesi and the paintings of Copley, and read Hogarth's treatise on beauty – representing the taste of 20 years earlier.

On graduating Trumbull returned to Lebanon where he was briefly a schoolmaster. In 1775 he accepted a commission in the Continental army. He fought in the Rhode Island campaign, but resigned his commission in the middle of the Revolutionary War to go to London to study with Benjamin West (1780). Here he was imprisoned briefly in retaliation for the hanging of Major André. He returned to America before the end of the war, only half-trained, yet nevertheless the first American painter to have received both a classical university education and experience in the studio of an acknowledged master.

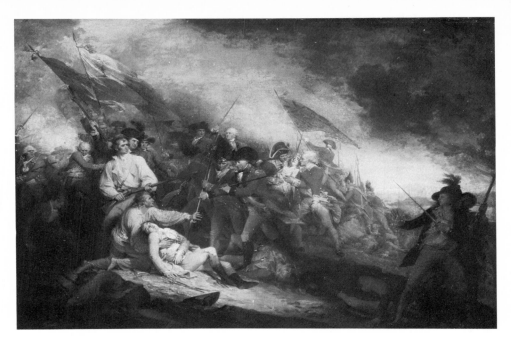

In 1784 Trumbull returned to London to resume his studies with West and also attended the Royal Academy Schools. Two years later, at West's suggestion and with the encouragement of Thomas Jefferson, he began his series of paintings of American history. This was the period of his greatest and most successful activity, as seen in his painting of *The Death of General Warren at the Battle of Bunker's Hill* (1786, New Haven, Connecticut, Yale University Art Gal.). Although clearly inspired by West's work – notably *The Death of Wolfe* – Trumbull brought to the painting of contemporary history a verve and feeling of verisimilitude that stemmed from his presence at many of the events he chose to interpret. He was also strongly influenced by Copley's *The Death of Major Peirson* (London, Tate Gal.) which was on public exhibition in London at the time of his second visit and fired him with the ambition to excel as a painter of national history. Despite the urging of Edmund Burke that he should study architecture, Trumbull kept to his ambition, even though the bulk of his early work consisted of portraiture, miniatures (which include some of his finest work), medals, badges and even, on occasion, maps.

To extend his experience with history painting, Trumbull visited Paris frequently between 1787 and 1789, and the influence of David is apparent in *The Death of General Montgomery in the Attack on Quebec, 31 December, 1775* (1786, New Haven, Connecticut, Yale University Art Gal.). He also travelled extensively in America in order to obtain likenesses of the leading figures of the American Revolution. The original version of his *Declaration of Independence* (1786-97, New Haven, Connecticut, Yale University Art Gal.), like many of his ambitious works of this decade, is a rigorous and successful painting, far different from the wooden replica of it that he executed in 1818 for the rotunda of the United States Capitol, where it was installed only in 1824.

With the dawning of the new century, Trumbull's activities took on a more institutional and less individual flavour. Although he continued to paint-portraits and replicas of his history paintings, he was mainly concerned with establishing the American Academy of Fine Arts, which was founded in 1802 in New York. Trumbull was the effective head of the Academy until it closed in the 1830s. It contained his personal collection and

▲ John Trumbull
The Death of General Warren at the Battle of Bunker's Hill June 17, 1775 (1786)
64 cm × 86 cm
New Haven, Connecticut, Yale University Art Gallery

embodied his hopes for creating a training-patronage relationship with American artists – a relationship that never materialized, in large part because of Trumbull's own snobbery. In 1825 young artists led by Morse walked out and established the new National Academy of Design.

Through his family and social connections Trumbull had secured the commission for the historical paintings in the United States Capitol, but the work attracted little admiration or respect from the young. With the collapse of the American Academy, the ageing artist returned to Connecticut to live in the home of his nephew-in-law, Benjamin Silliman, who held a chair of science at Yale. Silliman persuaded Yale to accept the entire Trumbull collection in exchange for a 6,000-dollar annuity, and the Neoclassical gallery opened in New Haven in 1832 (designed by Trumbull) was the first art gallery in the United States connected with an institution of higher education, and the first devoted totally to the fine arts that endures to the present. Trumbull's influence on another relative, Daniel Wadsworth of Hartford, Connecticut, led directly to the establishment of the Atheneum in Hartford in 1842, the first public art museum in America. D.R.

Tura
Cosmè or Cosimo

Italian painter
b.Ferrara, c.1430 – d.Ferrara, 1495

Tura is mentioned in Ferrara in 1452 in connection with some decorative works, but he must already have been well known, for his name occurs the previous year as arbiter in a valuation of works of art. There is no further mention of him in Ferrara until 1456 and during this period he was probably in Padua and Venice, where he would have had the opportunity of studying Donatello and Mantegna.

From 1457 he was a painter at the court of Ferrara where he carried out a variety of decorative commissions, including the Duke's studiolo (1460-2) in Castello Belfiore, a work that had already been started by Pannonio, Maccagnino and Galasso, and ten panels (1465-7, now lost) for the library of the Mirandola castle. In 1469 he was engaged by Duke Borso d'Este to decorate his residence, Delizia di Belriguardo, completing the work (now lost) in 1472. He went to Venice in 1469 to buy colours, and to Brescia to see the frescoes of Gentile da Fabriano in the Broletto. The same year he received payment for the organ shutters of the Cathedral (*Annunciation*; *St George and the Princess of Trebizond*), which still exist. In 1471 he was made portrait painter at the Este court where he produced many portraits (now lost), including those of *Duke Ercole and his Daughter Lucrezia, Alfonso d'Este* and *Beatrice d'Este*. In 1486 he gave up his court appointment and retired to a keep in the city wall where, until his death in April 1495, he continued to work with a painter called Teofilo.

The small *Virgin with Child* (Washington, N.G.), painted shortly after 1450, marks the beginning of his work, Although it is undoubtedly by his hand, it differs from the rest of his production by the imagination and ornamental pungency of the Late Gothic style in which it is painted. This characterizes the floral motifs of the

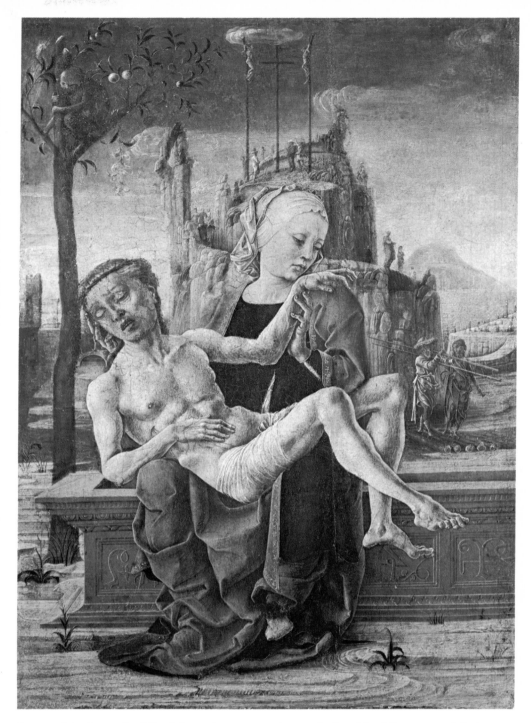

frame and background of floral decoration, as well as the figures themselves, whose supple tenderness was not to be seen again, with certain exceptions, in Tura's typically austere style.

The Allegory of Spring (London, N.G.), which was probably part of the Belfiore decoration, is significant in this respect. Here, Tura already reveals Paduan sources and uses them to produce a brittle figure style and distant, cold psychology. The architecture of the throne on which Spring sits illustrates Tura's taste for extravagant decoration with a refined surreal elegance. The artist never moves away from the basic formulas, even when his nervous, harsh style shows a more complex and disturbed state of mind, as seen in the *Pietà* in the Correr Museum, Venice. This is such an original interpretation of the subject that it suggests a direct relationship with the surrealist

and expressionist spirit of German art. It is thus clear that Tura took suggestions from Mantegna, and developed in them a complex personality. Tura's style varied little throughout his career and was marked by a search for the highest degree of stylization and by an intensely dramatic feeling.

The organ shutters for Ferrara Cathedral date from 1469 (now Ferrara, Museo del Duomo) and represent, on one side, *St George and the Dragon*, and on the other, the *Annunciation*. In the latter rational perspective is obvious, but the other panel shows Tura's imagination at its most capricious: the princess flees, while the knight and the dragon form a single group invested with almost heraldic elegance. In the background steep crags, on which buildings and small figures are visible, recall Mantegna, but with a note of magic resulting from the dark colouring and flaring contrasts.

▲ Cosmè Tura
Pietà
Wood. 48 cm × 33 cm
Venice, Museo Correr

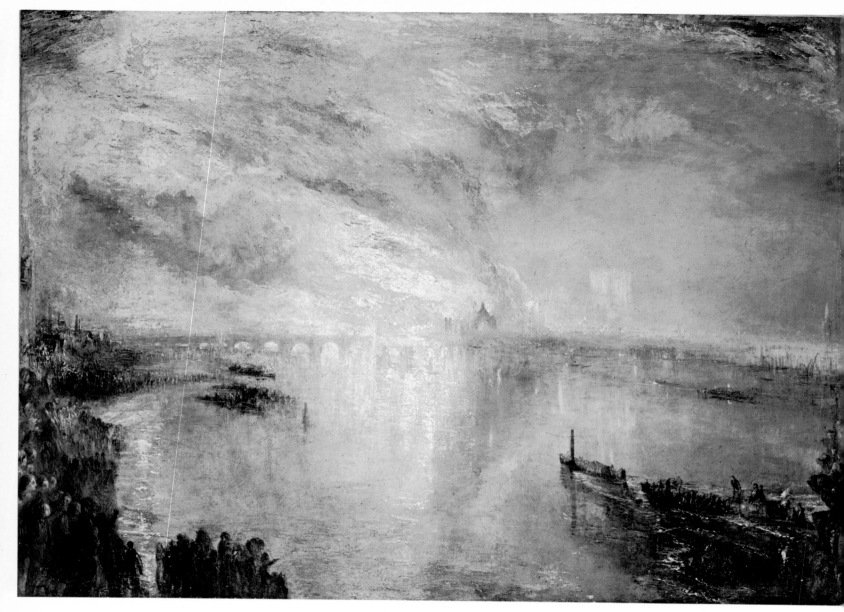

The *Roverella Polyptych*, formerly in the Church of S. Giorgio in Ferrara, was Tura's most important work, and most of it still exists. The central part with the *Virgin and Child and the Angel Musicians*, a work which combines drama and ornaments is in the National Gallery, London. Also in S. Giorgio's at one time was the *Polyptych of St Maurelius*, of which two tondi from the predella remain (*Arrest* and *Martyrdom of St Maurelius*, Ferrara, P.N.). *St Anthony of Padua* (1484, Modena, Pin. Estense) is an important later work, whilst the *Virgin Enthroned and Saints* (Ajaccio, Fesch Museum) shows the last phase of Tura's activity.

Among Tura's other works are the *Madonnas* of the Accademia, Venice, and the Galleria Colonna, Rome; three tondi of the *Circumcision* (Boston, Gardner Museum), *The Adoration of the Magi* (Cambridge, Massachusetts, Fogg Art Museum) and *The Flight into Egypt* (Metropolitan Museum), which may once have formed part of the predella of the *Roverella Polyptych*; *St Jerome* (London, N.G.); three small panels from the same altarpiece including a *Virgin of the Annunciation* (Rome, Gal. Colonna); and a series of *Saints* originally part of several polyptychs: one with *St Christopher* and *St Sebastian* (Berlin-Dahlem), another with *St Nicholas of Bari* (Nantes Museum) and *St Louis of*

Toulouse (Metropolitan Museum), and a third with *St Anthony of Padua* (Louvre) and *St Dominic* (Uffizi). There are drawings by the artist in Berlin-Dahlem, Rotterdam (B.V.B.), London (British Museum) and Florence (Uffizi).

Tura's influence was important in the development of Cossa and of Ercole de' Roberti. His work marks the beginning of a complete renewal of art in Ferrara, which became one of the main centres of the Renaissance in northern Italy. R.R.

Turner
Joseph Mallord William
English painter
b.London, 1775 – d.London, 1851

One of the greatest of English painters, Turner, by virtue of his expressive range and varied subject matter, offers a strong contrast to the intimate personal art of the only contemporary equal to him, Constable. His private life remains obscure, and there is little to relate it to the remarkable developments in his art.

The son of a barber, Turner attended the Royal Academy Schools regularly from 1789 to 1794, and intermittently thereafter until 1799. He studied at the same time under the topographer Thomas Malton. He also began to make annual tours in parts of Britain, a habit that was to regulate his production even in later life. His work, however, had not progressed much beyond the 18th-century tradition of his master before he commenced employment by copying works for Dr Monro in about 1795. Through this he not only profited from the tonal refinements of the watercolours of J. R. Cozens that he copied, but he also met Thomas Girtin. Concurrently, they developed a greater technical freedom, most notably in the abandonment of a monochromatic base, as can be seen in works like *Old London Bridge* (1796–7, British Museum)

In 1796 Turner exhibited an oil painting, *Fishermen at Sea* (c.1796, London, Tate Gal.), at the Royal Academy, and from this time oil painting rapidly became the most important part of his *oeuvre*, although he still used watercolour extensively, especially on his Continental tours. His early oil paintings owe a debt to the 18th-century concept of the picturesque, although they are more naturalistic and at times, as with

 Joseph Mallord William Turner
The Houses of Parliament on Fire (1835)
Canvas. 92 cm × 123 cm
The Cleveland Museum of Art, Ohio, John L. Severance
Collection

Coniston Fells (c.1798, London, Tate Gal.), almost Wordsworthian.

With his rapid acceptance in official art circles, however (he was made an A.R.A. in 1799, at the youngest possible age, and an R.A. in 1802), Turner seems to have become more concerned with historical landscape. He was certainly strongly aware of the classical hierarchy of pictures, as can be seen in the subdivisions of the *Liber Studiorum* (the volumes of engravings of his works that were published sporadically from 1807 to 1819), and he frequently appended quotations to his exhibited works, mainly from the poet Thomson and, after 1813, from his own incomplete poem, *Fallacies of Hope*. While his *Aeneas and the Sibyl* (c.1798, London, Tate Gal.) shows the influence of English classical landscape painters like Wilson, his *Fifth Plague of Egypt* (c.1800, Indianapolis Museum) is more in the European tradition, and his *Tenth Plague of Egypt* (c.1802, London, Tate Gal.) reveals his absorption of Poussin's methods of composition.

The Treaty of Amiens in 1802 enabled Turner to travel abroad for the first time, and he experienced the dramatic grandeur of the Alps, as well as seeing the huge numbers of art treasures that Napoleon had amassed in Paris. On his return to England, he combined a new breadth of expression with contemporary themes, notably in *The Shipwreck* (c.1805, London, Tate Gal.), in which he made use of his own naturalistic observation and the power of classical compositional techniques. A sign of his growing confidence and reputation is seen in the opening of his own gallery in 1804, to supplement the works he contributed to public exhibitions.

In 1807, however, this development as a historical landscape painter became less marked. Perhaps because of the success of Wilkie, he exhibited genre scenes of rustic England, like the *Country Blacksmith* (c.1807, London, Tate Gal.), and in the next few years he painted several rural subjects, culminating in *Frosty Morning* (c.1813, London, Tate Gal.), while making numerous studies of the English countryside, like *The Thames near Walton Bridges* (c.1807, London, Tate Gal.), that are close in spirit to Constable's oil sketches. Nevertheless, he did not abandon his more ambitious canvases, and produced contemporary historical works like *The Battle of Trafalgar* (1806-8, London, Tate Gal.) and dramatic history paintings such as *Snowstorm: Hannibal Crossing the Alps* (c.1812, London, Tate Gal.) in which his personal experience of a storm is restated in heroic terms. After this he returned to a closer emulation of classical landscape painters, in particular Claude, as can be seen in *Crossing the Brook* (c.1815, London, Tate Gal.) where he seeks to outdo his light effects with a technical freedom that brought the criticisms of incoherence, first levelled against him at the time of *The Shipwreck*, once more into prominence.

Turner's first visit to Italy in 1819 increased this tendency, as can be seen in the great translucent Venetian watercolours like *S. Giorgio from the Dogana* (1819, British Museum), although oil paintings like *Rome, from the Vatican* (c.1820, London, Tate Gal.) reveal more of his rather uncritical awe of the cultural heritage of Rome. In the 1820s he managed to combine these elements more successfully, using them creatively rather than eclectically, as in the *Bay of Baiae* (c.1823, London, Tate Gal.), in which the light of Claude is greatly augmented and the classical system of recession is rephrased in more complex diagonals.

His *Ulysses Deriding Polyphemus* (c.1829, London, N.G.) is in many ways the culmination of this development, and his use of bright blues, reds and browns indicates the beginning of an abandonment of tonal structure in his large works. Surprisingly the change took place first in the genre pictures that he had begun to paint at this time.

The secure patronage Turner enjoyed from the 3rd Lord Egremont meant that he spent a great deal of time at Petworth House from 1829 to 1837, and there he executed studies and paintings with an unprecedented abstraction of light and colour, such as *Music at Petworth* (c.1830, London, Tate Gal.). These were never exhibited in his lifetime, and it was only gradually that his large works achieved a similar freedom. The burning of the Houses of Parliament in 1834 not only inspired several pictures, but also set off a series of paintings of violence and fire in which he could use greater extremes of colour, leading to works where colour has a strong emotive power, as in *The Fighting Téméraire* (c.1838, London, N.G.), and the final freedom from tonal painting that occurs in *The Slave Ship* (c.1840, Boston, M.F.A.).

Turner's pictures were now becoming arranged compositionally around 'vortexes', in which the picture emanates from a central structure in a series of sweeps, as in *Snowstorm at Sea* (c.1842, London, N.G.), and he experimented with more new forms, such as squares and octagons. His development was always deliberate. His lectures as Professor of Perspective at the Royal Academy, which had ended in 1828, showed his strong concern with painting theory, while his Petworth development had been symbolized in *Watteau Study by Fresnoy's Rules* (c.1831, London, Tate Gal.). Now he painted *Light and Colour: Goethe's Theory* (c.1843, London, Tate Gal.), showing how his reading of Eastlake's translation of Goethe's *Treatise on Colour* had encouraged his emotive use of colour. Gradually this attitude led to greater abstraction and his final pictures are rather overworked and clumsy.

It is the works of the mid-1840s that attract most attention today, both as the logical development of Turner's style and because of their affinity with certain modern movements in abstract art. His contemporaries, however, found these incomprehensible, although his apologist Ruskin interpreted works like *The Slave Ship* with great insight. For while Turner, even in his most extreme works, depended ultimately on naturalistic observation, it was a naturalism far removed from the minute works of the Pre-Raphaelites or the later analytical style of the Impressionists, being inspired not by primitivism or realism, but by the profound grandeur and perception of a romantic temperament. w.v.

Uccello
Paolo
(Paolo di Dono)

Italian painter
b.Florence, 1397 – d.Florence, 1475

Treated offhandedly by Vasari because he preferred to study the problems of perspective rather than to draw people and animals (although it was from his love of birds that he got his name), Paolo Uccello is today one of the most discussed

artists of the quattrocento. Regarded by some as one of the founders of the Renaissance, he has been relegated by other critics to the limbo of conceptual artisans. The Cubists were the first to restore him to public attention, followed by the Surrealists who saw him as a 'lunar' painter. It is in fact possible to view certain aspects of *The Battle of San Romano* in a 'Surrealist' light: the precise delimitation of planes, the frozen movements, the disquieting awareness of the glittering warriors sealed in their armour. Uccello's rendering of *The Flood*, too, appears to be deliberately enigmatic.

Similar ambiguities seem to arise when it comes to reconstructing his career, even from the small corpus of undisputed works. These comprise: the fresco of an *Equestrian Monument for Sir John Hawkwood* (1436), four *Heads of Prophets* (1443) and cartoons for the stained-glass windows of the cupola of Florence Cathedral showing the *Nativity* and the *Resurrection* (1443-5; all Florence Cathedral); the fragmentary cycle of frescoes in *terra verde* and colour of *Scenes from Monastic Legends* in the cloister of the Church of S. Miniato al Monte, outside Florence (1447-55); *Noah's Ark*, Florence, Church of S. Maria Novella, Chiostro Verde; three paintings showing different events from *The Battle of San Romano* (c.1456, Uffizi, Louvre and London, N.G.); the *Nativity* fresco in the Church of S. Martino alla Scala, Florence; two versions of *St George and the Dragon* (Paris, Musée Jacquemart-André, and London, N.G.); *The Hunt by Moonlight* (Oxford, Ashmolean Museum); *The Profanation of the Host* (1467-9, Urbino, N.G.).

Although all these works have in common a certain showy display of the art of perspective, it seems incredible that the *Story of Noah*, with its sculptural monumentality, should be by the same hand as the elegant *Hunt by Moonlight*; or that the *Hawkwood Monument*, recorded in 1436 (but which seems to bellong to the same period as *The Battle of San Romano*, later by perhaps 20 years), should lead straight on to Neo-Gothic compositions in which there is no noticeable attempt to deal with the problem of perspective, such as the stained glass of the Church of S. Maria del Fiore.

It seems, then, that this notorious preoccupation with perspective is not the true common denominator of Uccello's works; that it is necessary to look into the painter's general attitude towards figurative art, which he treated as a complicated intellectual game full of the most intoxicating subtleties. In *The Flood*, for example, with a disarming indifference to the catastrophic proportions of the disaster, Uccello dispassionately arranges his figures as though they were chess pieces, and at the same time secularizes the Old Testament story, taking away its dramatic content. The frozen aloofness of Shem in the foreground is made absurd by the frantic figure clinging to his ankles. The young man in the cask, the despairing woman on the back of a buffalo who realizes that the animal is drowning beneath her, and the giant and his club are so many enigmas, but they are bordering on the comic.

Masaccio's sense of physical reality, contained by the strict rules of perspective, here becomes merely a game. Everything conveys the impression that perspective, in Vasari's words, was a very 'lovely thing' because it only represented an intellectual entertainment. The vast, unifying spaces of Masaccio, Brunelleschi or Piero della Francesca are quite different from the complicated game of enclosed spaces in *The Battle of San*

IOANNES·ACVTVS·EQVES·BRITANNICVS·DVX·AETATIS·S
VAE·CAVTISSIMVS·ET·REI·MILITARIS·PERITISSIMVS·HABITVS·EST

PAVLI·VGIELLI·OPVS

▲ Paolo Uccello
Equestrian Monument for Sir John Hawkwood (1436)
Fresco
Florence, Basilica di S. Maria del Fiore

Romano, or the double line of flight in the *Nativity* (Florence, Chuch of S. Martino alla Scala), or again, the lines of the contrasted horizon in *St George and the Dragon* (Paris, Musée Jacquemart-André).

All this explains why experts have considered Uccello's use of perspective to be more or less derived from empirical precepts of the Middle Ages in optics or *perspectiva*. However, it must be remembered that Uccello's greatest experiments in perspective were quite late: *The Battle of San Romano* could not have been painted before 1450 and probably dates from around 1456; the remains of the S. Miniato al Monte frescoes could not have been earlier than 1447 and probably date from 1455, the year in which the painter was in this area. Almost all the surviving works, therefore, seem to belong to the second half of the century, a time when Florentine art was already searching for something new. This explains why Uccello found no followers in Florence.

The facts of Uccello's life provide an important key to an understanding of his work. Born several years before Masaccio, he was very young when he worked beside Ghiberti (who at that time was still 'Gothic') on the north door of the Baptistery in Florence in 1407 (he was in fact listed amongst Ghiberti's assistants in two contracts relating to the door). While Masaccio was in Florence creating his new naturalistic style (1425-30), Uccello was in Venice where the memory of Gentile da Fabriano still lingered, and where, thanks to Pisanello's early works and the enormous activity of Niccolò di Pietro, Zanino di Pietro and Jacobello del Fiore, the International Gothic style was flourishing.

Uccello returned to Florence in 1431 with his reputation as yet unestablished, for in 1432 the council responsible for the fabric of the Cathedral made enquiries in Venice about his capabilities as a mosaicist before engaging him. Worse was to come: his fresco for the *Hawkwood Monument* failed to please and he had to repaint it. Nor had he been mentioned as its author in Alberti's *Treatise on Painting* (1436), even though all the great painters of the time were listed. What is more, in 1438, Domenico Veneziano, in a letter written from Perugia, did not discuss Uccello at all, although he knew about younger artists such as Fra Angelico and Filippo Lippi.

One of the most difficult problems for the art historian is that of Uccello's activity during these years prior to the middle of the century. Some historians are inclined to attribute an important collection of works to him, including the frescoes for the chapel of the Assumption in Prato Cathedral (not including the lower part by Andrea di Giusto) and the three panels of the Quarata predella showing *St John on Patmos*, the *Adoration of the Magi and the Saints* (Florence, Seminario Maggiore) and the *Adoration of the Infant Jesus with Three Saints* (Karlsruhe Museum). However, the identity of the painter of these varied works still causes controversy, and they have been in turn attributed to hypothetical masters: the 'Master of Prato', the 'Master of Quarata' or the 'Master of Karlsruhe', or even to the Florentine artist Giovanni di Francesco. It is undeniable, however, that there are strong likenesses between the paintings and that the influence of Domenico Veneziano emerges in all of them, sometimes interpreted in a more ample and luminous style, as in the Prato frescoes, sometimes more contorted and allusive, as in the Karlsruhe painting. Although the strong Gothic resemblances abound,

the interest in perspective is not very pronounced.

Some of these works show an affinity with the stained glass in Florence Cathedral; the Prato frescoes show similarities with the *Heads of Prophets* in the Cathedral, just as the Quarata predella does with *St George and the Dragon* in London, and the Karlsruhe *Nativity* with the frescoes in S. Miniato, which themselves are strongly influenced by Domenico Veneziano.

These difficulties of attribution are increased by the problem raised by the *Hawkwood Monument*: it is difficult to reconcile the advanced treatment of perspective in the fresco with such an early date (1436), since it is associated with the series of works – including the *Annunziata* predella – which bear a later date (*c*.1452). One possibility is that Uccello almost entirely repainted the *Monument* at the same time that Andrea del Castagno was creating the monument for Niccolò da Tolentino (1456). Stylistic considerations lend strength to this supposition, given the perfect affinity between this fresco and *The Battle of San Romano*. The many-faceted personality of Uccello raise questions, too, in connection with the first scenes from the *Life of Noah* in S. Maria Novella. That these frescoes (today in very bad repair) are by the master has never been in question. There is no trace, however, of the sharp and over-refined traits that made Paolo Uccello one of the strangest painters of the Florentine Renaissance. L.B.

Utrillo
Maurice

French painter
b.Paris, 1883 – d.Dax, 1955

Utrillo was born in Montmartre, the illegitimate child of Suzanne Valadon, herself a talented painter and a model for such artists as Renoir and Toulouse-Lautrec. In 1891 he was given his name by a family friend, Miguel Utrillo y Molins, an artist who was well known in Barcelona and whom Utrillo never met. He soon took to delinquency and drink, but was found employment in a bank, where he at first gave satisfaction, but from which he was later dismissed because of his outrageous sense of humour. Repeated scandals resulting from drunkenness led to his being sent to hospital in an attempt to cure his addiction. In 1902 an unusually perceptive doctor advised his mother to let him learn to paint, and from 1903 to 1906 Utrillo painted in the suburbs around Paris and in Montmartre, in a sombre and impasted style which attracted the attention of the dealer Clovis Sagot and several connoisseurs.

After 1907 Utrillo lightened his palette and, from around 1910, began using a lot of white in his paintings, which earned the name 'white period' for his activity until 1915. The dealer Libaude, in 1909, sought to establish the sole right to his paintings in return for a modest monthly sum. Through him Utrillo came to know Francis Jourdain, Élie Faure, who was a fervent admirer, and Octave Mirbeau. From 1909 Utrillo exhibited at the Autumn Salon and at the Indépendants. However, he had little contact with other painters and spent his unhappy life between the Belle Gabrielle cabaret and the Casse-Croûte bistro. Following an attack of delirium tremens in 1912, Utrillo spent two months in a clinic at Sannois, and afterwards went to Brittany and to Cor-

sica where he did a great deal of painting. His first collective exhibition took place in 1913.

Around 1914, under his mother's influence, his technique began to develop towards a more colourful, linear style close to *Cloisonnisme*. In 1916 he was shut away at Villejuif with dangerous lunatics, then in the asylum at Picpus. An exhibition at the Galerie Lepoutre in 1919 brought him great critical and financial success, but from then on his family kept him under surveillance and took advantage of him. After two exhibitions at the Galerie Weill, he was offered a contract by the Galerie Bernheim-Jeune, and suddenly found himself the most fashionable artist of the day. Despite all this, Utrillo remained unstable, attempted suicide, and was taken by his mother to the Château de St Bernard in Ain, where, from 1923, he spent every summer. He designed the sets for *Barabao*, staged by Diaghilev's Ballets Russes, and in 1928 was awarded the Légion d'Honneur. In 1935 he married Lucie Pauwels. At this time the dealer Paul Pétridès acquired exclusive rights over Utrillo's output.

In 1948 Utrillo designed sets for Charpentier's *Louise* at the Opéra Comique, and in 1955 two panels, each 9ft high, were commissioned by the Hôtel de Ville to decorate the Salle de la Commission des Beaux Arts. Utrillo's talent, however, had greatly declined at the same time as he was acquiring an international reputation (exhibition in New York, 1939; a room at the Venice Biennale in 1950). Fake Utrillos flooded the market, giving rise to resounding scandals.

His painting cannot be classified with a stylistic label. Some critics have tried to place him with the naïve painters because of the minute detail in his drawing and his popular forms, but these characteristics do not appear until relatively late in the more colourful canvases. Utrillo was, in effect, self-taught, having received advice only from his mother and from a painter called Quizet, a solitary like himself, with whom he painted in the streets. (It was not until later, when his talent waned, that he began to copy postcards.) His early style was akin to that of the Impressionists, and he looked in particular to Sisley. However, his subjects were always limited to urban views of Montmartre or the Paris suburbs and to some provincial churches and buildings. His originality lies in his conception of space, with steeply rising and descending perspectives, the curving lines of streets and the volumes of houses creating, parallel with Cubism, an exceptionally vital style.

The other side of his art, however, displays a poignant expressiveness: the leprous walls of the slums, the hallucinatory repetition of black windows, the emptiness of roads and pavements. In his early period he achieved startling effects with the flight of streets across the canvas, the rising impetus of a church steeple, the despairing nakedness of certain forgotten corners of the suburbs. His 'white' style, more airy, is especially representative of his views of Montmartre, and he could elicit an astonishing poetry from such everyday sights as the *Lapin Agile* restaurant (1910, Paris, M.N.A.M.) or the Sacré-Coeur, as well as from suburban churches. He could also capture the grandeur of such buildings as *Notre-Dame de Chartres* with a serene power that no other artist has yet attained.

The Musée National d'Art Moderne in Paris has a fine collection of Utrillo's works. He is also well represented in the Musée d'Art Moderne de la Ville, and in most large galleries in Europe and the United States. L.E.

Valdés Leal
Juan de

Spanish painter
b.Seville, 1622 – d.Seville, 1690

The son of a Portuguese goldsmith, Fernando de Niza, Valdés Leal adopted the name of his Andalusian mother for professional purposes. He studied in Córdoba where his family had settled, and where he must have known Antonio del Castillo who strongly influenced his first paintings. He was equally interested in the work of the elder Herrera, whose energetic style corresponded to his own temperament (*St Andrew*, 1649, Córdoba, Church of S. Francisco). Married in Córdoba in 1647, he returned to Seville before 1656. The most important achievement of this youthful period was the large cycle depicting the *Life of St Clare*, painted in 1653-4 for the Convent of the Poor Clares at Carmona (now divided between Seville Museum and a private coll.). There are numerous instances in these paintings of Castillo's influence, but Valdés Leal's own personality asserts itself in the forceful dynamism of certain pictures such as *Assault on the Convent by the Moors* (Seville Museum).

In 1657 the Hieronymite Convent of Buenavista (near Seville) commissioned Valdés Leal to execute a series of paintings devoted to the *Life of St Jerome* and to important figures in the Hieronymite Order, which he completed in the years following. The scenes from the life of the saint are remarkable for the richness of their colouring, while, despite some careless drawing, the figures of the order (today dispersed between the Prado and collections in Seville, Dresden, Le Mans, Grenoble and Barnard Castle) are notable for their strongly individual characterization (*Brother Atanaso de Ocaña*, Grenoble Museum; *Brother Juan de Ledesma*, Seville Museum).

In 1658 Valdés began a huge altarpiece for the Carmelite Convent at Córdoba (*Elijah in the Chariot of Fire, Elijah and Elisha in the Desert*, busts of the saints, and severed heads of martyrs). Baroque in spirit, the work displays a very uneven execution. In 1660 Valdés helped to found the Seville Academy and was made President in 1664. The same year he went to Madrid where he was able to study the royal collections and meet painters of the Madrid school. As a result several works by Madrid artists have been wrongly

▲ Maurice Utrillo
Rue du Mont–Cenis
Canvas. 45 cm × 63 cm
Moscow, Pushkin Museum

attributed to him, evidence of the consanguinity of styles. In 1671, in honour of the canonization of St Ferdinand, Valdés painted the ceremonial decorations for Seville Cathedral. The next year he worked with Murillo in the Charity Hospital in Seville founded by Don Miguel de Mañara (whose portrait he painted). Here he produced his famous *Triumph of Death*, a masterpiece of macabre and almost morbid realism, as well as the two enormous and equally gruesome canvases, *Sic Transit Gloria Mundi* and *In Ictu Oculi*.

Between 1674 and 1676 he painted a series showing the *Life of St Ignatius* (Seville Museum), a hastily executed work, very unevenly painted, and often careless in its handling, but which shows, nevertheless, great powers of invention.

A contemporary of Murillo, Valdés Leal reveals a sensitivity diametrically opposed to that of his compatriot. Completely indifferent to physical beauty and to the seduction of the flesh, his art is defined by a very personal emotional and dramatic style. Capturing movement and tension (*The Road to Calvary*, Seville Museum; *The Liberation of St Peter*, Seville Cathedral) interested him far more than balance or harmony. His paintings on the life of the Virgin, for example, are outstanding for their plasticity but never aspire to the beauty or elegance of those by Murillo or Antolinez (*Virgin of the Goldsmiths*, Córdoba Museum; *Assumption of the Virgin*, Washington, N.G.; the *Immaculata*, 1661, London, N.G.). On the other hand, Valdés displayed an exceptional talent for translating the solid reality of things. He left some very fine still lifes on 'vanitas' themes (*Allegory of Vanity*, 1660, Hartford, Connecticut, Wadsworth Atheneum).

Given to excess, egoistic, violent, Valdés Leal left no followers, with the exception of his son,

who completed his father's decorative scheme in the Hospital of the Venerables in Seville. A.E.P.S.

Valenciennes
Pierre Henri de

French painter
b.Toulouse, 1750 – d.Paris, 1819

A pupil of both Despax and Bouton in Toulouse, Valenciennes later went on to Paris to the studio of Doyen (1778). Essentially, however, he was a self-taught landscape painter who visited Italy on a number of occasions (1769, 1777, 1781) and also the Near East (1782-4), returning with many sketchbooks (Paris, Louvre and B.N.). He was received into the Académie (*Cicéron découvrant le tombeau d'Archimède* [*Cicero Discovering the Tomb of Archimedes*], 1787, Toulouse Museum), and after that exhibited regularly at the Salons. What he saw as the inadequacy of the Dutch landscape tradition led him to publish his own aesthetic theories: *Éléments de perspective pratique à l'usage des artistes, réflexions et conseils sur le genre de paysage* (Paris, 1800), in which he proclaimed the grandeur of landscape as depicted by Poussin, in intimate communication with the human drama unfolding before it.

Valencienne's own large-scale compositions, although somewhat cold in feeling, stem from the same humanist concept, more concerned with the union of the ideal with nature than with producing visual impressions (*Ancienne Ville d'Agrigente* [*The Ancient City of Agrigentum*], 1787, Louvre; *Colloque d'Archelaüs et de Sylla* [*Archelaus and Sulla*], 1819, Toulouse Museum). In contrast, his *Études peintes* (150 in the Louvre) of Italian landscapes and his drawings show a freshness of feeling and a concern for atmosphere and the play of light (*Étude de ciel au Quirinal* [*Study of the Sky over the Quirinal*], Louvre), as well as for precise composition and for the minute depiction of detail (*Sous-bois* [*Woods*], Louvre). By this great investigation into nature, which was to serve him later in more complicated works such as the *Villa Borghese* (Louvre) and the *Paysage avec figures* (*Landscape with Figures*) (Barnard Castle, Bowes Museum), Valenciennes edged landscape painting towards Neoclassicism, at the same time foreshadowing the more sensitive and vibrant compositions of the 19th century. Many of his works, in fact, appear to prefigure Corot's Italian landscapes. C.C.

Valentin
(Valentin de Boulogne)

French painter
b.Coulommiers, 1591 – d.Rome, 1632

Valentin spent his working life in Rome where he is known to have arrived before Vouet, that is, by 1614. 'Moïse', to give him his Roman nickname, was never to leave the city where he died at the age of 41. His career is marked by few dates: the recently rediscovered *Samson* (Cleveland Museum) dates from 1627, and a large *Allegory of Rome* (now in the Villa Lante, Rome), painted for Cardinal Francesco Barberini, nephew of Pope

Urban VIII, from the following year. A short time later Valentin received, in place of Albani, a commission for a large painting for St Peter's, which was completed in 1630: *The Martyrdom of St Processus and St Martinian* (Vatican), which was a pendant to Poussin's *Martyrdom of St Erasmus*, hung the previous year. On his death Valentin was given the title of *pictorum gloria*, and the artistic world of Rome, especially the Germans and Scandinavians, attended his funeral.

Valentin left about 50 canvases in which he experimented with all genres: allegory and portrait (Queen Christina of Sweden owned the *Portrait of the Cavaliere dal Pozzo*); mythology (*Hermione with the Shepherds*, Munich, Alte Pin.); biblical scenes (*Judgement of Solomon*, Louvre and Rome, G.N.; *Sacrifice of Isaac*, Montreal Museum; *Judith and Holofernes*, Malta, Valletta Museum; *Jesus Expelling the Money-Lenders from the Temple*, Rome, G.N.; *The Last Supper*, Rome, G.N.); and genre painting (two *Concerts*, Louvre; also the *Meeting in a Tavern* and a *Fortune-Teller*). In all these works, however, the same models seem to reappear: models who, following the example of Caravaggio, are taken from daily life but whom Valentin endows with a melancholy and a dignity that are all his own. This still and solemn world, with its silent characters set against a dark background, is the noblest and most classical reinterpretation of Caravaggio's precepts. P.R.

Vallotton
Félix Édouard

French painter of Swiss origin
b.Lausanne, 1865 – d.Paris, 1925

A member of the Protestant middle class of Lausanne, Vallotton decided at the age of 17 to devote himself to painting and enrolled at the Académie in Paris. After three difficult, lonely years he exhibited for the first time at the Salon

▲ Juan de Valdés Leal
The Triumph of Death
Canvas. 220 cm × 216 cm
Seville, Hospital de la Caridad

◀ Pierre de Valenciennes
Étude de ciel au Quirinal
Oil on paper. 25 cm × 33 cm
Paris, Musée du Louvre

des Artistes Français a portrait that revealed his obvious admiration for Holbein (*Portrait de M. Ursenbach*, 1885, Zürich, Kunsthaus). In the Louvre he diligently copied Leonardo, Antonello da Messina and Dürer, but above all he admired Ingres: it is said that he burst into tears when he saw *Le Bain turc* (*The Turkish Bath*). In 1893 his *Bain au soir d'été* (*Summer Evening Bathers*) (Zürich, Kunsthaus), exhibited at the Salon des Indépendants, caused a scandal by its cold eroticism, its smooth technique and its tortuous design. In the same year he exhibited with the Nabis, his friends from the Académie Julian, but only really joined the group in 1897.

During this period Vallotton produced many wood-engravings (a technique which he had been using since 1891), and these quickly brought him international success when they appeared in *Le Courrier français* and *Le Rire* from 1894, and in *La Revue blanche*, the Chicago *Chap Book* and the Munich *Jugend* the following year. The naïve, 'pure' art of these engravings, which appealed to the Nabis and Alfred Jarry, was based on simplification of forms and suppression of naturalism.

Vallotton, by a clear division of black and white masses and other methods of simplification, forcefully conveys a bitter, cruel vision of the world, whether in his portraits (illustrations in the *Livres des masques* of Remy de Gourmont) or in those pictures that display his sympathy for the anarchist movement and his violent reaction against contemporary bourgeois society (*La Manifestation* [*The Manifestation*], 1883; *Sauvons Rome et la France* [*Let Us Save Rome and France*], 1893; *L'Exécution* [*The Execution*], 1894; *Le Train de plaisir* [*The Train of Pleasure*], 1903, Paris, B.N., Cabinet des Estampes).

The paintings of Vallotton's youth (*La Cuisinière* [*The Cook*], 1892; *La Malade* [*The Invalid*], 1892; both A. Vallotton Coll.), like those of the Nabi period (*Bon Marché* triptych, 1898, Switzerland, private coll.) or the later works (*Self-Portrait*, 1923, Bern Museum), all have an almost photographic realism, achieved by a smooth technique, and an honest rendering of the ugliness

and ridiculousness of humanity, which turns to a morbid delight. 'He only enjoys bitterness', Jules Renard wrote of him.

Vallotton left several pieces of writing, the best being a novel, *La Vie meurtrière*, full of a cold observation, wounded sensitivity and lonely bitterness that help to explain the painting. His nudes are sometimes painful studies of housewives, but they can achieve a most eloquent, chilling eroticism (*Baigneuses* [*Bathers*], 1912) and, by their hallucinatory naturalism, they foreshadow Surrealists such as Delvaux or Magritte, and sometimes Balthus (*L'Enlèvement d'Europe* [*The Rape of Europa*], 1908, Hahnloser Coll.).

Vallotton is represented in the Musée National d'Art Moderne in Paris (*La Troisième Galerie au Châtelet* [*The Third Gallery, Châtelet*], 1895; *Le Dîner* [*The Dinner*], 1899; *La Partie de poker* [*The Poker Game*], 1902; *Mme Vallotton*; *La Roumaine* [*The Roumanian Woman*], 1924), in the museums of Besançon, Bagnols-sur-Cèze, Albi, Grenoble, Lille, Lyons, Nantes, Nice, Rouen, Strasbourg, Basel, Bern, Lausanne and Neuchâtel, and in the Kunsthaus in Zürich, the Ghez Foundation in Geneva, and the Neue Pinakothek in Munich. F.C.

Van Dongen
Kees

French painter of Dutch origin
b.Delfshaven, near Rotterdam, 1877 – d.Monte Carlo, 1968

After working in the malthouse managed by his father, Van Dongen studied at the Rotterdam Academy (1895). He drew for the *Groene* and the *Rotterdamsche Nieuwsblad* (1896), and his studies of port scenes and prostitutes printed in the newspaper caused a scandal. In his first paintings he made use of similar themes, executed in a boldly formalized style and strong in colour (*La Chimère-pie* [*The Chimera-Magpie*], 1895, private

coll.; the *Zandstraat à Rotterdam*, c.1897, private coll.). In July 1897 he moved to Paris and lived in Montmartre where he later (1906-7) worked as a host in the Bateau Lavoir. He exhibited at Père Soulier's (near the Cirque Médrano) and at Le Barc de Boutteville (1898), where he saw works by the Nabis, and also contributed watercolours to a number of journals, including a series on prostitutes in 1901. He met Fénéon, through whom he was published in the *Revue blanche* in 1903 and who persuaded Vollard to devote an important exhibition to Van Dongen the following year.

After going through a short phase of Divisionism (*Le Boniment* [*The Puff*], 1904, Paris, private coll.), he lightened his palette under the influence of the Nabis, so that by the time that Fauvism, in which he took part, had exploded upon the Parisian art scene his style was already formed: a bold but refined harmony, rapid strokes compensating for areas of a more regular execution, and a sensuality of face and pose in his models (*Anita*, 1907, Monaco, private coll.). In 1905 he began a very beautiful series of nudes (*Torse* [*Torso*], private coll.), while his constant visits to the Cirque Médrano inspired him to paint in 1906 and 1907 a series of pictures which have a very uniform quality: clowns, acrobats, ballerinas (*Le Maillot blanc* [*The White Tights*], 1906, private coll.). In 1908 he collaborated with the ceramicist Metthey; he also exhibited in Düsseldorf at the instigation of Kahnweiler, and then in Dresden, where he sent drawings to the exhibition organized by Die Brücke. His work at this time shows that he was closer to the Expressionists than to the Fauves (*Au Bois de Boulogne* [*In the Bois de Boulogne*], 1907-8, Le Havre Museum).

A contract with the Galerie Bernheim-Jeune (1909-15) was the mark of Van Dongen's growing success. He went to Spain and Morocco (1910-11) and returned with some fine canvases painted in a very fresh style (*Femmes à la balustrade*] [*Women on the Balustrade*], c.1911, St Tropez Museum), or in a breezy, witty fashion (*Les Fellahs* [*The Fellaheen*], 1911, Paris, M.N.A.M.). Decorative compositions, worked in large areas of flat colour, began to appear in 1911 (*Rouge et jaune* [*Red and Yellow*], *Rouge et bleu* [*Red and Blue*], private coll.) and, probably helped by a visit to Egypt in 1913, evolved towards a hieratic, two-dimensional style (*Femme au pigeon* [*Woman with Pigeon*], 1913, Paris, private coll.; *Rythmes*,

▲ Valentin
The Martyrdom of St Processus and St Martinian
(1630)
Canvas. 113 cm × 192 cm
Rome, Pinacoteca Vaticana

▲ Félix Vallotton
La Malade (1892)
Canvas. 74 cm × 100 cm
Lausanne, Vallotton Collection

▲ Kees Van Dongen
Femmes à la balustrade (c.1911)
Canvas. 81 cm × 100 cm
St Tropez, Musée de L'Annonciade

c.1918, private coll.; *Quiétude*, 1920, private coll.).

His friendships with the Marquise Casati from 1913 and, more importantly, with Léo Jasmy from 1916 until 1932, directed his painting towards the sophisticated style which made him so successful after the war. In this, an amalgam of the formal portrait and the poster, the composition is steadier, the female models are reduced to long rhythmic verticals (*La Vasque fleurie* [*The Flowery Basin*], 1917, Paris, M.A.M. de la Ville), and the colour, although still vivid and carefree, loses something of its refinement. Van Dongen became the painter of the celebrities, both of society and the demi-monde, in Paris and in Deauville. His long series of portraits, cruelly true to life, are reminders of a particular section of society that existed between the wars (*Boni de Castallane*, 1922, private coll.; *The Dolly Sisters*, 1925, Paris, private coll.). His activity as a portraitist lasted a long time, but after 1930 a more truthful and also more conventional outlook appeared in his work (*Utrillo*, 1948, private coll.; *Brigitte Bardot*, 1954, private coll.).

It was in his soberly executed landscapes, painted during the same period, that Van Dongen rediscovered the happy and accurate expression of such earlier paintings as *Petit Âne sur la plage* (*Little Donkey on the Beach*) c.1930, St Tropez Museum). His work, of which the best was painted before 1920, remained in essence faithful to the spirit and the methods of a Fauvism inclining towards Expressionism, all in the course of an evolution which remained indifferent to the transmutations of contemporary art.

Van Dongen became a French citizen in 1929, and in 1959 he settled in Monaco in a villa called the Bateau Lavoir. Apart from his paintings, he produced lithographs for *Les Lépreuses* by Montherlant (1946), Voltaire's *Princesse de Babylone* (1948) and *La Révolte des anges* by Anatole France (1951), whose portrait he painted in 1917. He was also the author of a number of books: *La Hollande, les femmes et l'art* (Paris, 1927); *La Vie de Rembrandt* (Paris, 1927); and *Peindre, conseils pratiques* (Paris, 1937). Van Dongen is well represented in Paris (M.N.A.M.), St Tropez, Grenoble, Montpellier, Geneva, New York (M.O.M.A.) and in many Dutch art galleries.

M.A.S.

Vasarely
Victor (Viktor Vasarhelyi)
French painter of Hungarian origin
b.Pécs, 1908

Vasarely was trained in Hungary, first at the Pololini-Volkmann Academy, then at the Bauhaus in Budapest in 1929. Settling in Paris in 1931, he worked in advertising and publicity and, from 1936 to 1944, produced an important graphic *oeuvre*. In 1944 he helped to found the Galerie Denise René, which opened with his first exhibition. A collection of portraits (*Self-Portrait, Antonin Artaud*) painted in 1946 demonstrate post-Cubist preoccupations, but after 1952 (the Denfert period) Vasarely turned to abstraction. Colours became fewer, and this elegant and supple line played a dynamic part in the compositions. A holiday at Belle-Île-en-Mer in 1947 helped formulate Vasarely's feelings about nature, to which he adhered thenceforward: 'Les langages

de l'esprit ne sont que les supervibrations de la grande nature physique'. The 'Crystal Period' (Gordes, Vaucluse, 1948) rests on the same transition from reality to synthesis.

Vasarely's development of Op Art was neither sudden nor accidental, but the culmination of continuous experiment, first evident in such early works as the *Étude bleue* (*Blue Study*) (1930), where he employed the special tone values of Klimt, following a method of dynamic surface organization. The series of *Zèbres* (*Zebras*) (1932–42) defined the spirit of his later work. From then on Vasarely was to abandon all his previous themes, passing from easel painting to the decoration of walls and huge spaces, introducing new materials (aluminium, glass) with the ultimate aim of integrating his works with architecture: examples are his work at the university city of Caracas, including a mural in honour of Malevich, compositions in ceramic and thin plates of aluminium made by the construction group of Jean Ginsberg (in Paris, buildings in the Boulevard Lannes, Avenue Versailles and Rue Camou), polychrome sculpture at Flaine (Haute Savoie), and tapestries woven at Aubusson.

Vasarely has also produced important graphic work: *Chelle* (1949), *Album Vasarely* (1958), *Album III* (1959), *Constellations* (1967). Because he is both painter and sculptor, he is, above all, a worker in three dimensions, a producer of colour and space. He is dedicated to the creation of a mural space enlivened by optical effects, the abandonment of easel painting, and aims to renew the Renaissance tradition which aspires to a total art. He has played an important role in all manifestations of contemporary art and has achieved worldwide recognition.

Vasarely lives in the Château de Gordes, where, in June 1970, he opened his '*musée didactique*', a collection of some 550 works tracing his evolution. A foundation was opened in 1976 at Aix-en-Provence in the house, the Jas de Bouffan, where Cézanne had lived. The artist is represented in the principal galleries of modern art including those in New York (M.O.M.A. and Guggenheim Museum), Paris, Amsterdam, Buffalo, São Paulo and Vienna (20th-Century Museum).

J.J.L.

▲ Victor Vasarely
Mindanao (1952–5)
Canvas. 161 cm × 129 cm
Buffalo, Albright-Knox Art Gallery

Velázquez
Diego Rodríguez de Silva
Spanish painter
b.Seville, 1599 – d.Madrid, 1660

The outstanding painter of the Spanish school, Velázquez displayed personal qualities of integrity and courtesy that matched his genius as an artist and won him the respect of his employer, Philip IV, as well as of his contemporaries. Outside his art his life was mostly uneventful and was marked by an untroubled rise in his profession that recalls that of his great contemporary Rubens. Three major events marked the stages of his career: his installation in Madrid (1623) after his beginnings in Seville; and two periods in Italy, the first from August 1629 to January 1631, the second from January 1649 to June 1651.

The years in Seville. Diego Rodríguez de Silva Velázquez (he later reversed the order of his names, as did many artists of the time) was born in Seville on 6th June 1599, of noble parents. His father was Portuguese, originally from Oporto, and his mother came from Seville. At the age of 12, because of his precocious talent, he was apprenticed to Pacheco, a transitional painter who alternated between an outdated Mannerism and a timid realism, but who nonetheless was an excellent teacher, a humanist and a theorist of his art, in whose studio all the best painters and poets of Seville foregathered. Velázquez, his favourite pupil, became an independent master of the Guild of Painters in 1617, and the next year married Pacheco's daughter Juana. The marriage was a happy one and produced two daughters, who were born in 1619 and 1621.

The influence of Pacheco in the works of this period is scarcely noticeable. Far more in evidence is that of Herrera, from whom Velázquez had taken lessons, of Montañés, the master of polychrome wood sculpture, and above all the tenebrism and naturalism of Caravaggio, which had conquered the younger generation in Seville. Velázquez's first works are *bodegones*, scenes of homely subjects, which show eggs, fish, pitchers or wine flasks and generally also include characters splendidly observed in the manner of Aertsen or Beuckelaer; *The Waterseller of Seville* (London, Apsley House, Wellington Coll.); *Old Woman Frying Eggs* (Edinburgh, N.G.); *The Musicians* (Berlin-Dahlem); *Three Men at Table* (Hermitage).

Sometimes the subjects were sacred, such as the *Christ and the Pilgrims of Emmaus* (Chicago, Art Inst.) or *Christ in the House of Martha and Mary* (London, N.G.). These are paintings seen in a strong light, the volumes powerfully expressed, almost as though they were carved out of wood. The portraits achieve the same degree of success, in almost sculptural relief (*La Venerable Madre Jerónima de la Fuente*, Prado), as do the religious works: the *Immaculate Conception* (London, N.G.); the *Investiture of St Ildefonso with the Chasuble* (1622–3, Seville, Archbishop's Palace); and especially the magnificent *Adoration of the Magi* (1619, Prado).

Velázquez at the court. Pacheco, who admired his son-in-law, looked to the all-powerful Duke of Olivares, himself from Seville, to introduce Velázquez to the King and the court. After one

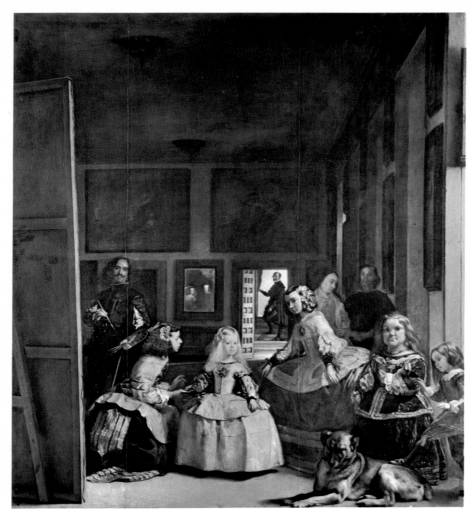

the *Coronation of the Virgin* and the *Hermits* (the composition is taken from engravings by Dürer). In a secular vein, his mythologies are conceived in a very modern, even cynical style: *The Forge of Vulcan* (in fact, 'Vulcan being told by Apollo of Venus's infidelity'), *Mars* (a comic version of Michelangelo's sculpture of Lorenzo de' Medici) and *Venus at her Mirror* (the so-called *Rokeby Venus*; London, N.G.), which is a completely *madrileño* version of antique or Renaissance models, portrayed with a unique grace.

In addition, from 1635 to 1636 Velázquez was occupied with two great decorative works, in which history and the portrait met. For the Salón de Reinos at Buen Retiro (the state drawing-room in the new palace) he produced equestrian portraits of Philip III, Philip IV and the heir-apparent Baltasar Carlos, painted in a manner very close to Rubens, but set against the panoramic background of the mountains and forests of Guadarrama, and *The Surrender of Breda*, which formed part of a series devoted by all the King's painters (including Maino and Zurbarán) to recent Spanish victories. It is a masterpiece of rhythmic composition, a noble work that depicts the homage rendered by the conquerer to his courageous foe. In the hunting-lodge at Torre de la Parada, in which Rubens painted his great mythological series, Velázquez drew portraits of the King, his queen, his brother and his son, as hunters accompanied by their dogs, and 'picaresque' but majestic interpretations of *Aesop* and *Menippus*.

A third group is that of the *hombres de placer* (*Don Juan of Austria*, *Pablo de Valladolid*), painted between 1632 and 1649, and depicted in the sombre finery of their court dress: figures that are sometimes haunted, always impressive in their vulnerable humanity. Velázquez's production was never large and he did not have an organized studio. His chief collaborator was Juan Bautista Martínez del Mazo, who became his son-in-law in 1634 and whose large painting (Vienna, K.M.) depicts the *Family of Velázquez* in his home. Mazo, a very competent painter, collaborated to a considerable degree in such large panoramic works teeming with figures as *The Royal Hunt at Aranjuez* (London, N.G.) and the *View of Saragossa* (Prado), painted in 1647. The numerous copies of portraits attributed to Velázquez are probably by Mazo.

Apart from his work for the King, Velázquez painted many 'official' portraits – the *Duke of Olivares* (1638, Prado), the *Duke of Modena*, who visited the Madrid court (Modena, Pin. Estense), the *Count of Benavente* (Prado) – and others, less formal, but all revealing an amazing appetite for life, in which the influence of the Venetians and El Greco is sometimes apparent: his wife *Juana Pacheco*, the sculptor *Montañés* and the *Lady with a Fan* (London, Wallace Coll.). Nor must the 'portraits' of more humble sitters be forgotten, showing as they do Velázquez as an animal-painter of the highest order: *The White Horse*, recently rediscovered (Madrid, Royal Palace), and the *Head of a Stag* (Madrid, Casa Torres Coll.).

Second Italian journey, and the final years. In 1649 Velázquez was given permission to return to Italy to buy paintings and antiques for the royal collection. He embarked at Málaga with the embassy travelling to Trento to escort the new queen, Mariana of Austria. Philip IV, now a widower after the death of Isabel of Bourbon, was to marry this young niece. After 20 years

unsuccessful visit in 1622 (although he did execute a fine portrait of Góngora), Velázquez returned to Madrid the following year with his father-in-law. Through the intervention of Olivares he was commissioned to paint an equestrian portrait of the King and, an unprecedented triumph, to show it to the public in front of the Church of S. Felipe el Real. In October he moved into the court as court painter, forbidden to undertake any commissions except from the King, and housed in the palace, where Philip IV liked to watch him at work. He portrayed the monarch full-length and head and shoulders, in armour and in court dress, as well as his brother, the Infante Don Carlos (1625-8, Prado). Henceforth, almost all his works were destined for the Spanish royal family. Mostly assembled today at the Prado, they form a unique mirror of his development despite the loss of many famous canvases, such as *The Expulsion of the Moors by Philip III*, in the fire at the Alcázar in 1734.

First journey to Italy. In 1628 Rubens, on a diplomatic mission to Philip IV, became friendly with Velázquez who invited him to the Escorial. This was a decisive meeting, directing the young painter towards humanism and mythology, which he had already been able to study in the Venetian paintings in the royal collections, and inspiring the journey to Italy. After painting *Los Borrachos* (*The Drunkards*) (1629, Prado) – a rather unsuccessful depiction of Bacchus as a bibulous country lad, surrounded by drunken peasants – Velázquez received grudging permission from the King to go to Italy. He stayed in Venice, where

he found 'the best of painting', in Ferrara and in Rome, where, through the favour of Cardinal Barberini, he was able to work alone and freely in the Vatican stanze, while staying at the Villa Medici. It seems doubtful, despite the opinions of some modern art historians, whether, in fact, the two paintings of the *Gardens of the Villa Medici* (Prado), which anticipate Corot, date from this journey rather than the second. The only undisputed Roman work is the huge painting in the Escorial, *Joseph's Coat Brought to Jacob*. Velázquez finished his journey in Naples where he visited Ribera and painted a portrait of Queen Maria of Hungary, sister of Philip IV (Prado).

Maturity. After his return to Madrid, Velázquez did not venture far afield during the next 18 years, except to accompany his royal patron to Aragon during the campaign against the Catalan revolt (1644). Italy had taught him the 'grand manner', loosened his drawing and expanded his vision. The figures in his paintings henceforth lose their rigidity and appear posed in an airy space, filled with the harmonious greys, ochres and greens that are so characteristic of his style.

He explored many levels of painting with an equal degree of success. For his narrative paintings, which he painted infrequently, he often turned for inspiration to foreign engravings or classical statues. The most important of his religious works are: the two paintings of *Christ on the Cross* in the Prado (the small *Christ* in a landscape is dated 1631; the large *Christ*, offered to the Convent of St Placido 'for the sins of the King', was possibly inspired by the *Christ* of Zurbarán),

▲ Velázquez
Las Meninas (1656)
Canvas. 318 cm × 276 cm
Madrid, Museo del Prado

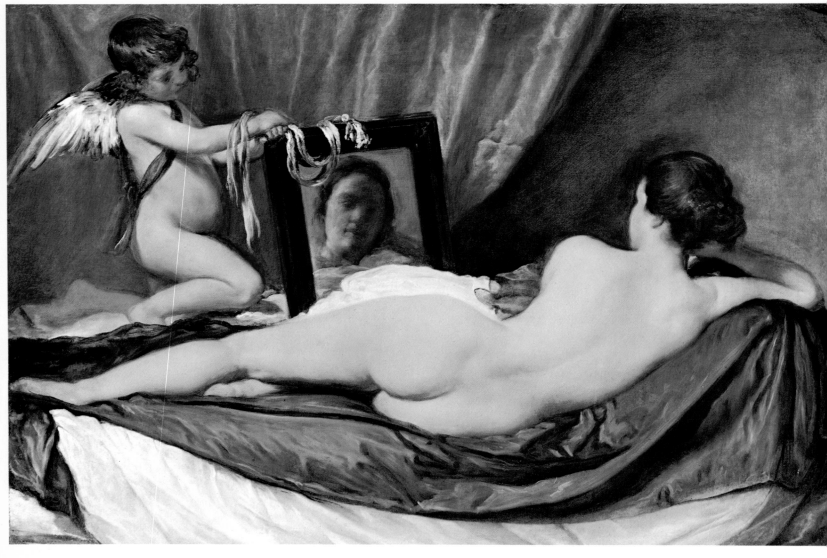

Velázquez again saw northern Italy, Rome and Naples, to be welcomed this time as a person of great consequence. In Rome, after he had painted *Juan de Pareja* (Metropolitan Museum), the portrait of *Pope Innocent X* (Rome, Gal. Doria-Pamphili), a sumptuous harmony of reds exhibited at the Pantheon and universally admired, gained him admission in 1650 to the Academy of St Luke. Velázquez stayed on in Italy, despite the despatch of orders recalling him, until a command from the King himself forced him to return to Spain.

His arrival back in Madrid opened a new phase in his career. Named '*aposentador*' (in charge of accommodation at the court), Velázquez conscientiously assumed his heavy duties. After an interminable enquiry into the 'purity' of his blood, and into whether any of his family had been engaged in trade, the King in 1659 created Velázquez a knight of the Order of Santiago, an unprecedented honour for an artist. The following spring the marriage of the Infanta Maria Theresa to Louis XIV involved him in a tiring journey to the frontier at Irún to prepare accommodation for the court and the meeting of the two sovereigns. Velázquez returned in June, exhausted after the festivities, and succumbed to a violent attack of fever. After several days of illness he died. His wife survived him by less than a week. The inventory which was taken after his death confirmed his wealth, the richness of his fur-

nishings and his wardrobe, and his large collections of jewels, books and various *objets d'art*.

Few in number, his final works showed a renewal of themes and style: the young queen and the children born of the royal marriage were given predominance. Velázquez treated these fragile and rather expressionless creatures, stiff and aloof in their fine attire, as harmonies in colour in which the pale rose and silvery greys of dresses and ornaments blend with the carmine of curtains and the subdued gold of consoles and mirrors. For broken contours he substituted a play of vibrant touches, shading, modelling and blending realism with atmosphere. From this stems the magical aspect of an enclosed world where everything is suggested rather than expressed, where objects and their reflections dissolve; hence, too, the outstanding attractiveness of some of the portraits in the Prado (*Queen Mariana*, the *Infanta Margarita Maria with a Rose*) and those sent to the Austrian branch of the Habsburgs, which have passed to the Kunsthistorisches Museum in Vienna (the *Infanta Margarita with a Muff*, the *Infante Philip Prosper*).

Two large canvases may be seen as the epitome of Velázquez's work. *Las Meninas* (*The Maids of Honour*) (1656, Prado) shows us the royal family in daily life, grouped around the small Infanta and her maids of honour, and the dwarfs, playmates for the children. *Las Hilanderas* (*The Spinners*) is possibly later, and transposes the myth of

Arachne, the over-gifted spinner persecuted by the goddess Minerva, to the royal tapestry workshop at Santa Barbara, with the workers toiling in the foreground. The reality and myth melt together in sober colours to give the soft effect of a tapestry.

The poetic, slightly mysterious universe of this the last of Velázquez's paintings has had a great attraction for our modern age, appearing to foreshadow as it does the Impressionist art of Monet and Whistler. Their immediate predecessors, however, saw in him a luminous and epic realist, an artist to 'make the scales fall from the eyes', whom Manet, in Madrid, called 'the painter of painters'. So Velázquez, after exercising a vital influence on the brilliant Madrid school that followed him (Carreño, Claudio Coello), after freeing Goya from his early academicism, became the inspiration and guide for the creators of modern art from the Impressionists to de Staël. P.G.

There are over 50 canvases by Velázquez in the Prado, including almost all his masterpieces. The artist is also represented by a fine collection of pictures in London (N.G.) and royal portraits in Vienna (K.M.). Other important paintings are to be found in Barcelona, Berlin-Dahlem, Budapest, Dresden (Gg) Munich (Alte Pin.), Orihuela, Orléans, São Paulo and New York (Metropolitan Museum, Hispanic Society, and Frick Coll.). L.E.

 Velázquez
Venus at her Mirror (the **'Rokeby Venus'**)
Canvas. 122 cm × 177 cm
London, National Gallery

Velde
Bram van

Dutch painter
b.Zaeterwoude, 1895 – d.Grimaud, 1981

Velde started work at an early age. From 1907 he was employed by a decorator in The Hague and began painting watercolours and making drawings devoted to city life, which he dashed off with great facility. He spent the years 1922-4 in Germany and went through a brief Impressionist period (*The Sower*, Amsterdam, Stedelijk Museum; *Snow*, 1923, Paris, private coll.). Although in their treatment and the rich texture of their paint his pictures recall those of German artists, the rustic themes and village scenes are comparable with those of the Flemish group, which had been active for some years.

After settling in Paris in 1925 Velde lightened his palette (flower studies, still lifes) and progressively purified his style (*Still Life*, 1925, New York, private coll.). After 1926 he exhibited regularly at the Salon des Indépendants, then at the Surindépendants. In 1930 he went to live in Corsica, then in Majorca (1932-6), but had to leave because of the Civil War. It is in the works painted in Majorca that signs of non-figuration first appear, but he was still using identifiable themes (*Masks*, 1934, Paris, private coll.). In 1938, before the war forced him to stop painting altogether, he made a series of drawings of heads (Paris, private coll.) reduced to their barest outlines: circles and curved triangles in which the socket of the eye forms a focal point. These shapes and many derivations frequently reappear in his later works.

His first one-man exhibition was held in 1946 in Paris, organized by Édouard Loeb at the Galerie Mai. From this time on he enriched his style, rather than developed it. Technically his craft is light, gouache taking the place of oils, even in large formats. The matt effect and absence of relief draw attention to the arrangement and colourful rhythm of the strictly defined surfaces (*Painting*, 1950, Paris, private coll.). In 1948 Samuel Beckett defined Velde's painting as '*l'art d'incarcération*'. The monumental lyricism that emerges from these canvases and gouaches is, however, not without a certain feeling of anguish. Velde's plastic power no sooner takes concrete form on the canvas than it appears to evaporate. After 1970 an increased dynamism became apparent, a jostling of chromatic and formal rhythms in a space full of dramatic activity.

Early on in his career, in 1923, Velde produced lithographs (*Self-Portrait*) and he returned to this technique very much later, especially after 1967; he was regarded as one of the leading lithographers of his time. He made an important donation of his lithographic work to the Museum of Art and History in Geneva, where he made his home from 1965. He is represented in the large museums of modern art in Europe and in the United States. M.A.S.

Velde
Willem van de, the Younger

Dutch painter
b.Leiden, 1633 – d.London, 1707

Like his father, Willem van de Velde, the Elder (*c.*1611-93), the younger Van de Velde specialized in marine painting, and the two men frequently worked closely together. It is often difficult to tell their drawings apart, although in the paintings the son's style differs fundamentally from that of the father.

Van de Velde's early marine paintings, now in Kassel Museum and dating from 1653, show the influence of Simon de Vlieger with whom he was apprenticed. The wide extended seascape rises over a calm, monochrome rhythm of keels, sails and masts. Towards 1660 Van de Velde began to paint other motifs – the water, waves and small boats – with more subtlety. At the same time his composition became more complex. The vessels ceased to be incidentals and became the focal point of the painting, often placed in the foreground in the centre of the picture. This new concept may have been inspired by Jan van de Cappelle, his elder by ten years, whose influence is felt above all in those paintings that evoke the serenity of the sea in calm water (*Two Small Dutch Vessels Inshore in Calm*, *c.*1661, London, N.G.; *Calm Sea*, Chantilly, Musée Condé).

Van de Velde's talent had many aspects, and he was expert, too, at depicting the excitement of fast sailing-vessels swept before a storm. His best works are spontaneous and full of vigour, capturing nature in a most lifelike manner; but when the paintings are examined closely it is apparent that the effects have been achieved with a most delicate technique. Until 1672 father and son worked in Amsterdam, but the war and subsequent economic crisis brought about their departure for England where they received many commissions.

In 1674 Charles II granted them a pension. The two painters specialized in scenes of naval battles, which they drew from a small boat, often in the very thick of action and in great danger. The composition of these paintings was often very overburdened, the accent being placed on the decorative effect, and, at the end of this English period, the execution had become rather more careless.

To judge Van de Velde's painting objectively, account must be taken of the popularity of his work, especially in England. He also had many imitators who used his signature or his monogram (W.V.V.). Of his enormous output there are important collections today in London, at the National Gallery and the Wallace Collection, and in the Rijksmuseum, the Kassel Museum, and the Mauritshuis. Van de Velde is acknowledged as the father of English marine painting. A.Bl.

Venetsianov
Alexei Gavrilovich

Russian painter
b.Moscow, 1780 – d.Tver district, 1847

Coming from a family of Muscovite merchants, Venetsianov is considered to have been the most original painter in Russia during the first half of the 19th century. He had no formal academic education, and it was only at the age of 22, when he arrived in St Petersburg, that he began working in a studio, that of Borovikovsky, who also became his friend. He spent a lot of time in the Hermitage making copies from old masters. He became known as a caricaturist and portraitist, using pastel, and already showing that delicate and tender colouring which was to typify his open-air paintings. His *Self-Portrait* (1811, Leningrad, Russian Museum) opened the doors of the Academy to him. Granet's *Capuchin Mass* (Hermitage), which he saw at an exhibition in 1820, made him aware of chiaroscuro and perspective and he withdrew to his country house at Safonkovo, near Tver, to devote himself to studying these techniques. From this time on he combined painting with teaching in a school he himself founded in 1822 with the aim of investigating nature and peasant life.

The Barn (1823, Leningrad, Russian Museum), the first product of his studies, recalls the early experiments of the Italian 15th-century painters in its meticulous construction. His cycle of the seasons (*At Work*, *Spring*, and *Harvest Time*,

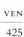

▲ Willem van de Velde the Younger
Calm Sea
Canvas. 83 cm × 105 cm
Chantilly, Musée Condé

▲ Bram van Velde
Painting (1966)
Canvas. 127 cm × 192 cm
Paris, Musée National d'Art Moderne

Summer, c.1830, Moscow, Tretyakov Gal.) again shows him seeking to capture the natural grace and strength of the Russian peasant. Although the geometric precision and the careful disposition of volumes in a luminous space evoke Piero della Francesca, Venetsianov in fact had no knowledge of Piero's work.

The tenderness with which Venetsianov treats his simple, primitive figures is deeply moving (*Sleeping Shepherd*, Leningrad, Russian Museum; various studies of male and female peasants, Leningrad, Russian Museum, and Moscow, Tretyakov Gal.); the warm and golden light on the young trees and on the corn is that of a Russian summer. An engaging poetry, of which Europe has few other examples to offer, is born of this fusion between a pure, sincere naturalism and the masterly style of the artist. Considered as the forerunner of the Peredvizhniki, Venetsianov is perhaps on the edge of this movement. His painting, free from all didacticism, retains a notable freshness and spontaneity. L.E.

Vereshchagin
Vasili Vasilievich
Russian painter
b.Cherepovets district, 1842 – d.off Port Arthur, 1904

Son of an aristocratic landowner and of Tartar origins on his mother's side, Vereshchagin, after training as a naval cadet in St Petersburg, began a four-year course of study at the Academy of Fine Arts in 1864. Following this, he went to study under Gérôme in Paris, a decisive step in his artistic career. Both as an orientalist and as a highly finished painter, pushing realism to extreme limits in his quest for a photographic equivalent of reality, Vereshchagin owed everything to Gérôme. They shared the same compact and close style, in a subtle and harsh polychrome, the vehicle for a powerful escapism. Each is among those painters who, in the second half of the 19th century, aimed to rival the photographer, and only a photographic explanation of their work allows a full appreciation of their realist art, which was carried to the point of obsession: poetic, and in the end, abstract, with the force of purism and stability in its ultra-precision.

An important element in the formation of Vereshchagin's distinctive art proved to be the journeys he made to Turkestan in the years 1867-8 and 1869-71, during which he took part in

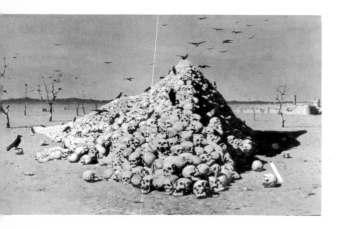

▲ Vasili Vereshchagin
Apotheosis of War (1871)
Canvas
Moscow, Tretyakov Gallery

the military expeditions that formed part of the Russian expansion into central Asia. He took part in the Russian victory at Samarkand and was awarded the Cross of St George. From 1871 to 1874 he lived in Munich where he made use of his experiences and his memories as a war correspondent. From 1874, following his first exhibition at St Petersburg, he met with enormous success with both press and public, as well as with those Tsarist officers who were part of the anti-war movement and who found their views echoed in such grim and provocative paintings as the famous *Apotheosis of War* (1871, Moscow, Tretyakov Gal.), in which human skulls are heaped up in the desert in the form of a symbolic pyramid. But controversy only added to Vereshchagin's reputation.

Tretyakov, the rich merchant who founded the gallery of Russian painting that bears his name, bought up almost the entire exhibition (hence the presence of nearly 240 of Vereshchagin's paintings and drawings in the gallery today). The London public also had an opportunity to see the artist's work, first in 1873 at the Crystal Palace, and then in 1879 at South Kensington.

Turkestan had provided Vereshchagin with an exotic setting, which he exploited to the full, rather as his master Gérôme had exploited the poetry of Egypt and Turkey in the years 1840-50. He went on to India in 1875-6, and then became part of General Skobelev's retinue in Bulgaria during the Russo-Turkish war (1877-8). The paintings from this latter period were shown in Paris in 1880 and were enthusiastically received by the critic Jules Claretie, who stressed their combination of violent, almost crude, colours, and a genuine and original poetry. One of the masterpieces of this new cycle of exotico-military paintings was the *Battle of Shipka* (1878, Moscow, Tretyakov Museum), in which the march-past of the victorious Russian troops before Skobelev is pushed to the back of the composition, and the foreground, as in Gros's *Battle of Eylau*, is filled with a terrifying and accusatory pile of corpses lying in the snow. The frame bore, as an ironic inscription, General Radetski's words to Skobelev: 'In Shipka all is peaceful'.

In 1884 Vereshchagin travelled to Syria and then to Palestine where he painted a *Life of Christ* which brought reprimands from the Archbishop

▲ Alexei Venetsianov
Harvest-Time, Summer (c.1830)
Canvas. 60 cm × 48 cm
Moscow, Tretyakov Gallery

of Vienna, because of the crudely realistic details. Finally established in 1892 in Moscow, he began work on his cycle of *Napoleon in Russia*, which was exhibited towards the end of the decade in all the great capitals of Europe. It was ironic that the military-orientated career of this astringent and fascinating poet of the Russian 'conquests' during the heyday of the Tsarist regime should end in the Port Arthur naval disaster, where Vereshchagin was aboard the imperial warship *Petropavlovsk*.

Apart from the fine collection in the Tretyakov Gallery in Moscow, there is a large number of Vereshchagin's works in the Russian Museum in Leningrad (70 paintings) and some rare pictures are housed in various American museums. J.F.

Vermeer
Jan
Dutch painter
b.Delft, 1632 – d.Delft, 1675

Astounding though it now seems, it was only in the 19th century that Vermeer was recognized as a great master of Dutch art. While Ter Borch, Jan Steen, Jacob van Ruisdael and others were held in high regard during the preceding centuries, Vermeer's star has shone forth in the firmament of European pictorial culture only since the middle of the last century. Although a few voices continued loud in his praise during the 18th century, notably those of the connoisseur J.-B. Le Brun and, more especially, Reynolds, he was completely neglected by writers on Dutch and Flemish art during this time. He did not achieve recognition until he caught the attention of writers and art critics such as Théophile Gautier and the Goncourt brothers, and finally Thoré-Bürger, a man of particularly refined taste for his epoch, who published his studies on Vermeer in 1866. Several painters, too, including Francois Bonvin and Pissarro, were deeply impressed by Vermeer. On the other hand, it was not until the start of the 20th century that his subtle composition, his peaceful perception of life and the cool splendour of his palette received the praise they deserved in Holland and Germany.

Little is known of Vermeer's life, except that his father was first a silk-weaver and part-time picture dealer and later an innkeeper. Vermeer married and had ten children, but does not seem to have reproduced their likenesses in any of his paintings. His financial situation was terrible, and got worse towards the end of his life; he even failed as a picture dealer. His widow owed an enormous sum of money to the baker, who, in settlement, took two of her husband's paintings. Another, *The Artist's Studio*, went to Vermeer's mother-in-law.

It is surprising to learn that a distinguished French traveller, Balthazar de Monconys, visited Vermeer in 1663, but, not seeing a single painting in his studio, had to go to the baker's. Paradoxically, 20 years after his death (1696) the greater part of his known output – 21 paintings – was put up for sale at public auction. Perhaps this was mostly the collection of canvases that a certain printer in Delft, Dissius, had assembled during the artist's lifetime.

While still very young, in 1653, Vermeer was admitted into the Painter's Guild in Delft as a master, and twice elected Dean, for the years

1662-3 and 1669-70. Rare information on his artistic beginnings is available from a quatrain composed by the printer Arnold Bon in 1654 on the death of Carel Fabritius, who was a victim of the great Delft explosion of 12th October. In the quatrain Vermeer is named as the artistic heir of Fabritius, Rembrandt's most inspired pupil. The art of Fabritius, as far as we are able to judge, shows an affinity with that of Vermeer, a circumstance confirmed by Vermeer's possession of several pictures by Fabritius. Delft also harboured towards the middle of the 17th century several painters of church interiors, occupied with the same problems of light and space. The general climate of Delft painting during this time was, therefore, propitious for the genesis and development of Vermeer's vision.

The works which have survived to the present day number only about 40, and many seem to have vanished, including a still life listed in the auction in 1696. Only two of the artist's pictures are dated: *The Procuress* (Dresden, Gg) is from 1656 and *The Astronomer* (Paris, Rothschild Coll.) from 1668. To follow Vermeer's evolution, how-

ever, it is only necessary to examine the different stylistic elements in each painting and appraise their quality.

The early works such as *Diana and her Companions* (Mauritshuis) and *Christ in the House of Martha and Mary* (Edinburgh, N.G.) belong to the general repertoire of European painting, and in particular to the Caravaggesque style of Italian painting, to whose influence Vermeer was exposed by way of some Utrecht painters who had gone to Italy. The painting in The Hague recalls Venice; that in Edinburgh seems to have been influenced by Neapolitan painting. Although interesting and well-balanced, these paintings nevertheless remain insignificant in Vermeer's *oeuvre*. Even *The Procuress*, in which the artist shows on the one hand his dependence on the chiaroscuro of Rembrandt, and on the other hand three-dimensional solutions borrowed from the Utrecht Caravaggists, serves only as a prelude to Vermeer's really mature work.

Henceforward Vermeer was to remain faithful to the same themes: with the exception of the two *Views of Delft*, he devoted himself to genre

▲ Jan Vermeer
Young Woman in Blue reading a Letter
Canvas. 46 cm × 39 cm
Amsterdam, Rijksmuseum

paintings in which there is no real narrative (although attempts are continually made to interpret their hidden meanings). In these paintings women are usually depicted in pensive or dreamy mood, reading a letter, writing, engrossed in music, handling pearls. These women are nearly always the chief performers; men play a secondary role. Chronologically, this collection may be said to begin with *A Young Girl Asleep* (Metropolitan Museum), in which the spatial relationships appear somewhat confused. Then follows a youthful masterpiece, the *Girl Reading a Letter* (Dresden, Gg): the side view of the reader, the reflection of her face in the window-panes, the screen and the chromatic stippling all herald the classic Vermeer to come.

Since the time of Reynolds *The Kitchen Maid* (Rijksmuseum) has aroused particular admiration, with its monumental figure brushed in with strokes of thick pigment and, in the foreground, a

masterly still-life arrangement of bread. *A Street in Delft* (Rijksmuseum) is still thought to belong to the artist's early period. It is unique in Dutch art for its quietude, its calm and the dreamlike atmosphere pervading it. The German artist Max Liebermann called it 'the most beautiful easel painting that ever was'.

A certain number of paintings have music as a common theme: women playing the lute, the spinet or the guitar. A masterwork from this series is in Buckingham Palace: *A Lady and a Gentleman at the Virginals*. The painter has taken infinite pains to work out his spatial problems.

It is believed that paintings such as the *Woman with a Water Jug* (Metropolitan Museum), the *Woman Weighing her Pearls* (Washington, N.G.), the *Young Woman in Blue Reading a Letter* (Rijksmuseum) and the *Young Girl in a Turban* (Mauritshuis) were all executed between 1660 and 1665. These works can be seen as the summit of

Vermeer's art; the *Young Girl* in The Hague, in particular, appears to be not of this world, so infinitely fragile is she, as though made of porcelain. One of Vermeer's best-known works, the *View of Delft* (Mauritshuis), provides a panoramic view unique in 17th-century European painting.

It has become customary to place within the years 1660-70 paintings such as *The Lacemaker* (Louvre) and *The Painter in his Studio* (also called the *Allegory of Painting*) (Vienna, K.M.). The enigmatic content of the latter painting has caused much speculation without any definitive interpretation having been arrived at. It would seem that in his final years Vermeer's creative powers declined. But whatever the artist's experiences, his *Allegory of The New Testament* (Metropolitan Museum), meticulously conceived and executed, is the finest expression of his genius.

Unaffected by the Dutch fondness for narration, Vermeer resolutely turned his back on genre

▲ Jan Vermeer
View of Delft
Canvas. 98 cm × 118 cm
The Hague, Mauritshuis

painting as it is generally accepted. In this respect he is diametrically opposed to Jan Steen. Woman, as depicted by Vermeer, is generally a figure deep in reverie, whose melancholy anticipates a mood encountered later in Watteau and Gainsborough.

V.Bl.

Vernet
Claude Joseph
French painter
b.Avignon, 1714 – d.Paris, 1789

A pupil of Jacques Viali at Aix, Vernet soon left for Italy, thanks to the patronage of the Marquis de Caumont. He spent some time in Rome where he became acquainted with Manglard and enrolled as a pupil of Panini and Locatelli. He painted several studies from nature in the Vale of Tivoli, near the banks of the Tiber, and around Naples. From this first period date his *Villa Ludovisi* and *La Vigne Pamphili* (1749), now in the Hermitage, and the *Ponte Rotto* and *Vue du pont et du château Saint-Ange* (*View of the Ponte and Castel S. Angelo*) (Louvre). The precision and poetry of these compositions show how closely the young artist had studied Claude.

Vernet already enjoyed a great reputation in France (his paintings had been much admired at the Salon of 1750) when he was admitted to the Académie in 1753 (*Soleil couchant sur la mer* [*Sunset over the Sea*], once in the Château de St Cloud, now lost). Marigny commissioned him to paint the *Ports of France* (15 paintings belong to the Louvre, and are on loan to the Musée de la Marine in Paris). This collection is the best guide to Vernet's evolution as a painter. The forthright observation of some of the early painting recalls the studies he had made in Rome, but already Vernet was adding numerous figures painted in great detail, which, as much as the harmony of colour and aerial perspective (port scenes of *Marseilles*, 1754, and *Toulon*, 1756, Louvre), governed his handling. There follow attractive depictions of port life, with dark and gilded contrasting elements (*La Rochelle*, 1763, Paris, Musée de la Marine). Finally, Vernet strengthened the emphasis on accessories, which tended to detract from the strength of his compositions (*Dieppe*, 1765, Musée de la Marine). The collection, which immediately became famous, was engraved by Cochin and Le Bas, from 1760.

Spending his last years in Paris, with occasional visits to St Cloud or Sceaux to see the gardens of Hubert Robert, Vernet now worked from memory, too often painting his landscapes from popular set-pieces and having recourse to the picturesque to cover up his own lack of inspiration (*Baigneurs et baigneuses à l'entrée d'une grotte marine* [*Bathers by a Grotto*], 1787, Strasbourg Museum). He still received many commissions, however (*Les Heures du jour* [*The Times of Day*], Louvre).

After the exquisite sensitivity of his Italian paintings, the skill of his *Ports* and the brilliant execution of several landscapes (*La Bergère des Alpes* [*The Alpine Shepherdess*], 1763, Château de Compiègne), his work became cold, retaining almost nothing of its original warmth and colour. On the eve of the advent of Romanticism Vernet's *oeuvre* still remained, however, one of the finest examples of French landscape painting and was imitated by many less important masters

(Lacroix of Marseilles, François Hue, the Chevalier Volaire, Henry d'Arles), who, in their turn, continued his pre-Romantic interplay of light and water. In fact, Vernet developed a genre of storm scenes, thereby anticipating the Romantic taste for paintings which echoed the emotional turbulence of the period.

Vernet's son Carle (1758-1836) was also a well-known painter, particularly of horses, and worked for Napoleon, as did his grandson, Horace (1789-1863).

C.C.

Veronese
(Paolo Caliari)
Italian painter
b.Verona, c.1528 – d.Venice, 1588

The son of a stonecutter, from whom he apparently learned how to model clay, Veronese became, while still very young, a pupil of Badile and also, according to Vasari, of Caroto. Verona, although a stimulating meeting-place of many different traditions, lacked outstanding personalities and was not the place for Veronese. Despite this, the city was probably a determining factor in his development, because there he could confront with a kind of serene impartiality problems of definition of form that, at the time, were often causes of much heart-searching.

The linear solutions of the Mannerists, introduced into northern Italy by Giulio Romano and followed up by Parmigianino in his experiments with rhythmic values, and by Titian in his study of the constructive role of colour, were presented to Veronese in the heterogeneous cultural climate of his birthplace, as so many complementary choices. In this way, from his first works, which were possibly part of a systematic exploration of the various aspects of Mannerism, he purged it of all intellectual complication and enriched it with chromatic suggestions that already showed his instinct as a colourist (*The Virgin and Child with Saints and Donors*, painted for the Bevilacqua-Lazise family, 1548, Verona, Castelvecchio; allegorical frescoes in 1551, in collaboration with Zelotti, in the Villa Soranzo near Castelfranco Veneto; fragments, notably the *Seasons* and *Truth, Justice and Temperance*, preserved in Castelfranco Veneto Cathedral; *The Temptation of St Anthony*, 1552-3, Caen Museum).

In 1553 Veronese was summoned to Venice to work with Ponchino and Zelotti on the ceiling decorations in the Doge's Palace, and it was there that he discovered colour as his principal means of expression. Now in direct contact with the great masters of the city, where he established a studio in 1555 and which he made his home in 1557, Veronese worked out what was rightly considered to be his 'reply' to Venetian tonal painting, displaying an innovatory force that was understood and admired by Titian himself. The paintings for the Doge's Palace (*Juno Pouring Gifts on Venice*, *Youth and Age*, *Punishment of the Forger* and *Virtue Triumphant* [*in situ*]; *Jupiter Striking down the Vices* and *St Mark Crowning the Virtues*, Louvre) confirmed his great decorative talent, already manifest in the Villa Soranzo. The Mannerist nude figures fill the picture space with daring *sotto in su* perspective and bold foreshortening, invigorated by clear and luminous tones.

After coming into contact with Titian (*The Holy Family with St Catherine and St Anthony*, Venice, Church of S. Francesco della Vigna), Veronese undertook, in 1555, to decorate the ceiling of the sacristy of the Church of S. Sebastiano (*Coronation of the Virgin, Evangelists*). These works reveal a maturing of the figurative style that he had first used in the Doge's Palace. At the same time the artist, probably stimulated by his contacts with Sansovino, Sanmicheli and Palladio, showed a new interest in architecture. This interest was on a par with a striving for monumentality, the outcome of a desire to reconcile, by glorifying them both, three-dimensional form and chromatic values.

Whereas colour became light itself (*The Transfiguration*, 1555-6, Montagnana Cathedral), in the prodigious *Scenes from the Life of Esther* for the ceiling of S. Sebastiano, executed at the same time, the pure, contrasted tones accentuated the majestic solidity of the arrangement and the figures. The frescoes for the central nave of the church (*Scenes from the Life of St Sebastian*, 1558), *The Feast at Emmaus* (Louvre), *The Presentation in the Temple* (Dresden, Gg), and the organ panels and the altarpiece for the high altar of S. Sebastiano (*The Virgin in Glory with St Sebastian and Other Saints*) are so many stages in a logical development that culminated in the *Christ in the House of the Pharisee* (Turin, Gal. Sabauda). The manifold influences underlying the free articulation of masses in space (which, according to some critics, supports the traditional account of a journey to Rome and a close study of Michelangelo's *Last Judgement*) are resolved by a fresh and powerful imagination in a luminous and transparent world of colour.

With the large decorative cycle (1562) for the Villa Barbaro at Maser, near Treviso (now the Villa Maser), Veronese produced one of the major achievements of Venetian painting. This enormous work both sums up earlier experiments and outstrips them. It marks a high point in Veronese's output, which was now on the grandest scale but had lost nothing of its creative power. Works such as *The Preaching of St John the Baptist* (Rome, Gal. Borghese) and *The Rest on the Flight into Egypt* (Ottawa, N.G.), contemporary with the Villa Barbaro cycle, are among the most intensely poetic of Veronese's works. He became increasingly responsive to the taste for pictures painted in austere, sombre tones which had developed in Venice with Jacopo Bassano.

▲ Claude Vernet
The Villa Ludovisi
Canvas. 76 cm × 101 cm
Leningrad, Hermitage Museum

and the *Miracle of St Pantaleon* in the church dedicated to that saint in Venice.

Mention must also be made of Veronese's activity as a portraitist, many of the portraits actually appearing as part of his large compositions. Museums in Budapest and Florence (Pitti) have *Portraits of Men*; other works in this genre include the *Young Man with a Dog* and the *Sculptor* (Metropolitan Museum); *La Bella* (Louvre); the *Portrait of a Woman* (Douai Museum); and *Count Giuseppe da Porto with his Son* (Florence, Pitti, Contini-Bonacossi Donation), in all of which the psychological penetration is tempered by a warm and sincere humanity.

Veronese did not leave a school to carry on his work after his death. His studio, which was a true family enterprise, was composed of moderately competent painters who were entirely subordinate to his genius. But his influence, including his effect on the Venetian Baroque painters, surpassed the limits of generations and the frontiers of his city. For two centuries at least, many artists, including the very greatest, from Rubens and Velázquez to Tiepolo, found a source of inspiration in the richness and inexhaustible variety of Veronese's work. G.R.C.

Villon
Jacques (Gaston Duchamp)
French painter
b.Damville, Eure, 1875 – d.Puteaux, 1963

Villon was the oldest of a family of six children, amongst whom were the sculptor Raymond Duchamp-Villon and the painters Marcel and Suzanne Duchamp. His grandfather Émile Nicolle, who practised drypoint etching, taught him engraving (1891). In 1894 he went to Paris and adopted the poet Villon's name as a pseudonym, abandoning his law studies for an artistic career. In 1895 he worked in Cormon's studio in Montmartre, where he was deeply impressed by his surroundings and met Toulouse-Lautrec.

Villon's outstanding gift for drawing, already apparent at Rouen, assured him of regular commissions, from 1897, from such journals as the *Chat-Noir*, the *Assiette au beurre*, *Gil Blas* and especially the *Courrier français* (1897-1910). His drawings (soldiers, couples, lesbians, café scenes) showed the influence of Forain, Steinlen, Toulouse-Lautrec and the Nabis. After 1899 he engraved for the publisher Edmond Sagot; this period produced the series of *Bain de Minne* (*Minne's Bath*) (1907) and the *Nudes* of 1909-10. Villon exhibited at the foundation of the Autumn Salon in 1903, and in 1906 left Montmartre to settle at Puteaux.

From this time he devoted himself more to painting (*Les Haleurs* [*The Boat Towers*], 1908, United States, private coll.; *Self-Portrait*, 1909, private coll.) and went through a Cubist phase which was still strongly influenced by Cézanne (*Portrait of Raymond Duchamp-Villon*, 1911, Paris, M.N.A.M.). It was in his studio in 1911 that the Section d'Or (Golden Mean) had its beginnings. Rediscovering the governing proportions of the Renaissance and the pyramidal structures of Leonardo, whose *Treatise on Painting* he read in 1912, Villon organized his painting following a 'line of intention' which synthesizes the motif (*Table ser-*

By way of such enormous works as *The Marriage at Cana* (Louvre), the *Martyrdom of St George* (Verona, Church of S. Giorgio in Braida), *The Family of Darius before Alexander* (London, N.G.) and *Christ and the Centurion* (Prado) it is possible to follow the progressive and painful renewal of Veronese's style. It is fully realized in the four canvases painted around 1571 for the Cuccina family (*Presentation of the Cuccina Family to the Virgin, The Ascent to Calvary, The Adoration of the Magi, The Marriage at Cana*; all Dresden, Gg), and in the *Last Supper* (1573, Venice, Accademia), whose title the Inquisition, who hardly approved of the iconographic licence with which the sacred subject had been treated, made Veronese change to *The Feast in the House of Levi*. In fact these *Feasts* (*Marriage at Cana*, Louvre; *Feast of St Gregory the Great*, Vicenza, Monte Berico; *Christ in the House of Levi*, Versailles) often served as an excuse for the artist to re-create, in vast panoramas filled with people striking dramatic poses, the ordinary events of the everyday life of Venice. In the work of 1573 the fantastic effects are increased by the contrast between the lively colouring in the foreground and the cold shadows of the architectural background.

With the decoration of the ceilings in the Sala del Collegio (*Allegories of Venice and the Virtues*, 1575-7, Venice, Doge's Palace), Veronese began a process of simplification that seemed to stem from a need to deepen his artistic consciousness, and which he translated into a language ever more lyrical and intimate. Huge, complicated compositions such as the *Triumph of Venice* (1583) on the ceiling of the Council Chamber in the Doge's Palace, which is the last and most sumptuous example of the style, gave way to pictures that display a new regard for landscape and for the feelings of characters, who are treated with tenderness or pathos (*Rape of Europa*, Doge's Palace). The *Allegorical Scenes for the Emperor Rudolph II* (New York, Frick Coll.), *Mars and Venus* (Metropolitan Museum), *Mercury, Herse and Aglauros* (Cambridge, Fitzwilliam Museum), the *Crucifixion* (Venice, Church of S. Lazzaro dei Mendicanti), inspired by Titian, *Moses Saved from the Water* (Prado) and *Venus and Adonis* (Prado) exemplify this final stage in Veronese's evolution, the implicit intellectualism of which at last declares itself in the painter's final works: the *Lucretia* in Vienna (K.M.), an intense and refined psychological study; the *Pietà* in the Hermitage;

 Veronese
Venus and Adonis
Canvas. 212 cm × 191 cm
Madrid, Museo del Prado

vie [*Prepared Table*], 1912-13, New Haven, Yale University Art Gal.; *Puteaux, fumées et arbres en fleurs* [*Puteaux, Smoke and Flowering Trees*] 1912, New York, private coll.), culminating in the *Portrait de J.B., peintre* (1912, Columbus, Ohio, Museum) and the *Femme assise* (*Seated Woman*) (1914, private coll.).

Following the Futurists and his brother Marcel Duchamp, he became interested in movement, translating it in a fashion more fluid and continuous than that of the former, and less abstract than his brother's (*Homme lisant un journal* [*Man reading a Newspaper*], 1912, private coll.; *Soldats en marche* [*Marching Soldiers*], 1913, Paris, Galerie Louis Carré). With *L'Équilibriste* (*The Acrobat*) (1913, Paris, Galerie Louis Carré) he produced one of the finest engravings ever inspired by the Cubist aesthetic. In 1912 Villon collaborated in the decor of the *Maison cubiste*, and the next year exhibited at the Armory Show, where all his pictures were sold, the first sign of the favourable reception his work was attracting in the United States.

Villon was called up and spent the war in the camouflage section of the army. In 1919 his *Table d'échecs* (*Chess Table*) (private coll.; etching of the subject made in 1920) renewed links with synthetic Cubism, but until about 1924 the artist adopted a much more abstract translation in which flat planes in lively colours were superimposed (racehorse themes: *Galop* 1921, Paris, private coll., *Figure-composition*, 1921, Buffalo, Albright-Knox Art Gal.; *Le Jockey*, 1924, New Haven, Connecticut, Yale University Art Gal.). In 1921 he illustrated Valéry's *Architectures* with 34 plates.

He exhibited only once in Paris, in 1922 at the Galerie Povolotzky, and from 1923 to 1930, in order to earn a living, he had to engrave reproductions of works by Cézanne, Van Gogh, Renoir, Matisse and, notably, Picasso. Abstraction and figuration born of Cubism alternated with each other during this period (*Le Chemineau* [*The Tramp*], 1926, private coll.; *Perspective colorée* [*Tinted Perspective*], 1929, New York, Guggenheim Museum). Taking part in *Abstraction-Création* between 1931 and 1933, Villon referred to the chromatic circle to distribute his colours, tempering the strictness of

his arrangements by the subtlety of his harmonies, and he gave French abstraction some of its masterpieces (*Amro*, 1931, Paris, M.N.A.M.).

Around 1935 the figurative side, enriched by this experience, triumphed (*Homme dessinant, auto-portrait* [*Man Drawing, Self-Portrait*], 1935, private coll.) and once more involved him in movement (*Les Lutteurs* [*The Wrestlers*], 1937, Paris, M.N.A.M.; *L'Arrivée des nageurs* [*The Arrival of the Swimmers*], 1939, private coll.). Shortly before 1940 and during the war the diversity of his intellectual and technical experiments resulted in an unusually fruitful period. The engraved views of Beaugency and the *Trois Ordres* (*The Three Orders*) (etching, 1939) were the beginning of a long series of landscapes executed in the Tarn and in southern France (*Entre Toulouse et Albi* [*Between Toulouse and Albi*], 1941, Paris, M.N.A.M.; *Notre-Dame de vie, Mougins*, 1944, private coll.; a collection of *Potagers* [*Vegetable Patches*], 1940-1). In addition Villon engraved several very beautiful pictures (*Quartier de boeuf* [*Haunch of Beef*], 1941; *Le Globe céleste* [*The Celestial Globe*], 1944).

Better known in the United States than in France, thanks in particular to the critic Walter Pach, he won the first Carnegie prize in 1950 for his *Grande Faucheuse* (*Big Reaper*) (Milwaukee Art Center). His international reputation was at last secured by exhibitions organized in Paris and New York by the Galerie Louis Carré. Entrusted with the designs for five stained-glass windows, for Metz Cathedral in 1956 (Chapel of the Sacred Heart), Villon also continued to paint, up until the time of his death, pictures that display an absolute mastery: landscapes (*Le long du parc* [*Through the Park*], 1955, private coll.); and scenes from contemporary life (*Grues près de Rouen* [*Cranes near Rouen*], 1960, private coll.). 'Cubist Impressionist', as he called himself, he had in fact achieved a singular synthesis of composition and colour, scientifically studied, and a multiform realism seen with a unique perception. He is well represented in Paris (M.N.A.M.); in American galleries, in Los Angeles (*Portrait de Mlle J.D.*, 1913), Minneapolis, New York (Guggenheim Museum and M.O.M.A. and New Haven); and especially in private collections. M.A.S.

Vivarini
Antonio
Italian painter
b.Murano, c.1420 – recorded in Venice until 1470

It has been said of Vivarini that, during the last wave of Venetian Gothic art, he occupied 'the same ambiguous position *vis-à-vis* the Renaissance as Masolino in Florence', or, in other words, that he stood at the crossroads between Gothic art and that of the Renaissance, to neither of which he was fully committed. Such ambiguity makes him all the more interesting because he appears at one and the same time to be catching sight of a new world and revitalizing the tradition of Venetian Gothic: rich, sumptuous, and sometimes full of an aristocratic severity.

Vivarini appears to have begun his career with

Veronese ▲
The Feast in the House of Levi
Canvas. 555 cm × 1280 cm
Venice, Galleria dell'Accademia

Jacques Villon ▶
Portrait d'Yvonne Duchamp (1913)
Canvas. 129 cm × 84 cm
Los Angeles County Museum of Art

the polyptych in the Basilica of Eufrasiana at Parenzo (now Porec), dated 1440. The work reveals a new type of sensitivity in the way in which the volumes are rendered in subtle degrees of shadow, and by the clear tonality of the colours, which seem to soak in the light, as in the works of Gentile da Fabriano and, even more so, of Masolino.

In 1443-4 Vivarini, with his brother-in-law Giovanni d'Alemagna (who was probably responsible for all the wood-carving), signed the three altarpieces of *St Sabina*, the *Madonna of the Rosary* and the *Redeemer* in the Church of S. Zaccaria in Venice. These are subtle works, notable for the richness and delicacy of the framing (which seems to derive from the elaborate architecture of Bartolomeo Buon), as well as for the sensitive rhythms of the drapery, ornamented with golden lozenges according to the tradition of the late 14th century. This fragile world reappears in the huge triptych in the Scuola della Carità in Venice (again executed in collaboration with Giovanni d'Alemagna, in 1446), which shows the Virgin seated on an immensely rich throne before a verdant background recalling the gardens of Germany or Bohemia; and in the *Virgin Enthroned* in the Poldi-Pezzoli Museum in Milan, with its clear tones of rose-pink and green.

In 1448 Vivarini and Giovanni were commissioned to decorate half of the Ovetari Chapel of the Augustinians (Gli Eremitani) in Padua, the other half being painted by two young artists, Pizzolo and Mantegna. This was a decisive year, that of the meeting of two generations: the two Venetian artists decorated the sections of the vault with the usual scroll patterns and traditional *Evangelists* in the circular cornices, while at their side Mantegna and his collaborator pursued the new science of perspective that was the precursor of the future.

When Giovanni d'Alemagna died in 1450, Vivarini retired for good to Venice. The new trends he had witnessed make their appearance in the *Praglia Polyptych* (Brera). The figures, set

against the traditional background, reveal a greater awareness of the three-dimensional – the Virgin, for example (shown without her royal coronet), holds her hand before her in a gesture that attempts to define the spatial surroundings.

Several detached panels of polyptychs depicting the lives of the saints appear to date from after Vivarini's stay in Padua. It is only comparatively recently that these panels have been ascribed to him: the *Scenes from the Life of St Monica*, orchestrated in bright colours, which have the feeling of a fable (Venice, Accademia; London, Courtauld Inst Galleries; Bergamo, Accad. Carrara; Detroit, Inst. of Arts); the *Scenes from the Life of St Peter Martyr* (Berlin-Dahlem; Milan, Crespi Coll.; Metropolitan Museum; private coll.), which show a more knowledgeable use of perspective; and finally, the *Stories of Martyred Saints* (Washington, N.G.; Bergamo, Accad. Carrara; Bassano Museum), still disputed, which reveal, in the perfect construction of the architectural backgrounds, a completely humanist and archaeological approach.

After the 1450s Vivarini went through a period of crisis and tried in vain to copy the new Paduan trends. He worked with his brother Bartolomeo (polyptych in Bologna, P.N.), then, once more, on his own. In these last paintings the figures have become hard and lifeless, drawn with an incisive line that has lost the secret of Vivarini's Gothic poetry. F. d'A.

Vlaminck
Maurice de

French painter
b.Paris, 1876 – d.Rueil-la-Galadière, 1958

Born into a musical family, Vlaminck did poorly at school and subsequently held a variety of jobs: racing cyclist (1893-6), violin teacher (1896-7) and anarchist journalist (1898-9). He did not really

begin painting until 1899, in company with Derain, with whom he shared a studio until 1901. Self-taught, he often boasted that he had never had a lesson in painting, either in an academy or in a studio, and had never even seen the inside of a museum.

In 1904 one of his canvases was shown to the public for the first time. In the following year he took part in the Salon d'Automne and the Salon des Indépendants, and became associated with Matisse, Puy, Braque and others in the Fauvist movement. He managed to make a living from painting only in 1906 when Vollard bought up the contents of his studio. His first private exhibition was held in 1907 in Vollard's gallery. He enlisted in 1914 but soon found a job in a factory. The commercial success of his private exhibition in 1919 enabled him to purchase a country house at Valmondois near Paris. He was also a noted writer of novels, poems and essays.

His art was in his own image: popular, boisterous, rebellious and instinctive, marked by a direct and impassioned love of nature. The first pictures (1899-1903) reveal at once the painter's strong personality, owing nothing to any outside source. *Sur le zinc (At the counter)* (Avignon Museum) shows a brutal realism in the face and in the pose of the model which is already Expressionist. *Le Père Bouju* (c.1900, Paris, M.N.A.M.), a portrait of authority which is to some extent a caricature, is treated with broad sweeps of colour without thought for the design or relief. Clashing brushstrokes produce a violently contrasted effect of light on each side of the model's head.

From 1901 onwards Vlaminck was proficient in the use of pure colour which he discovered at the Van Gogh exhibition given by Bernheim-Jeune. The influence of the Dutch painter over his work was to be henceforth a constant factor: *Intérieur* (1903-4, Paris, M.N.A.M.) and *Moisson sous l'orage (Harvesting in the Storm)* (1946, Paris, M.N.A.M.), which recalls the landscape which Van Gogh painted at Auvers-sur-Oise.

Vlaminck was soon to become a wholehearted

◀ Antonio Vivarini
Martyrdom of St Lucy
Wood. 54 cm × 22 cm
Bergamo, Galleria dell'Accademia Carrara

▲ Maurice de Vlaminck
Houses at Chatou (1904)
Canvas. 81 cm × 101 cm
The Art Institute of Chicago

Fauvist and his canvases of the period 1904–7 show a complete break with the earlier ones. The colours are less mixed: reds, greens, blues and yellows are often used as pure tones (*Bords de Seine à Carrières-sur-Seine*, 1906, Paris, private coll.; *Paysage aux arbres rouges* [*Landscape with red trees*], *Rue à Marley*, 1905, Paris, M.N.A.M., *Marly-le-Roi*, 1906, Louvre, Jeu de Paume; *Bougival*, 1905, Emery Reves Coll.)

In these works, using a very personal manner, Vlaminck often mixed more or less regular and geometrical Divisionist touches or swirling brushstrokes in the manner of Van Gogh with flat tints or with streaks of colour: the *Danseuse du Rat Mort* (*Dancer from the 'Dead Rat'*) (1906, Paris, A. Fries Coll.), the *Femme au chapeau de paille assise* (*Seated Woman in a Straw Hat*) (1906, Paris, private coll.). The *Portrait de Derain* (1905, Paris, private coll.) recalls numerous portraits and nudes done by Matisse, Manguin and Marquet, notably in 1905–6, by its emphatic plasticity, resulting from the use of a thick paste freely applied. *Chatou* (1907, Paris, M.N.A.M.) is one of the first canvases which betrays the influence of Cézanne, an influence which was to remain perceptible in Vlaminck's work until 1910 and was to reappear later at various times (the *Maison à l'auvent* [*The Penthouse*], 1920, Paris, M.A.M. de la Ville, a counterpoint to Cézanne's *Ferme de Belleville*). His admiration for Cézanne led Vlaminck, in spite of himself, for a brief period (1910) in the direction of Cubism, for which he always showed the greatest hostility because he found it too intellectual: *Nature morte-formes cubistes* (New York, private coll.), *Self-Portrait* (1910, private coll.).

Vlaminck soon returned to a style which was more in tune with his temperament and to which he remained faithful until his death: very mixed dark, leaden colours. The intensive use of vermilion, black and whites added a dramatic and violent aspect to his romantic landscapes crushed by thundery skies and shaken by storms: *La Route* (*The Road*) (1926, New York, private coll.), *Barques à marée basse* (*Boats at low tide*) (1938, private coll.), *Coucher de soleil dans la forêt de Senonches* (*Sunset in the Forest at Senonches*) (1938), and *Moisson sous l'orage* (1946, Paris, private coll.). Roads and cornfields were his favourite subjects; portraits were rare: *Chapeau à plumes* (*Hat with Feathers*) (1911), *Portrait de Madeleine* (1912), *M. Itasse* (1924).

He also executed numerous watercolours, woodcuts and lithographs in a style as vigorous as his paintings, but their chronology is difficult to establish as they are very rarely dated. An important retrospective exhibition of Vlaminck's work, who is well represented at the Musée National d'Art Moderne in Paris, was organized in 1946 by the Galerie Charpentier. His paintings are also to be found at the Chicago Art Institute (*Jardin à Chatou*) (1904) and in New York (M.O.M.A.).

B.C.

Vouet
Simon

French painter
b.Paris, 1590 – d.Paris, 1649

Vouet's career falls into two parts: his years in Italy, which ended in 1627 with his return to France, and the Parisian period, from 1627 until

his death 22 years later. One among many other artists in Rome, Vouet became, at a crucial moment in French history, the leading painter in France and of his king, Louis XIII, a great lover of contemporary art.

Vouet's beginnings, like those of so many of his French contemporaries, Vignon, Poussin, Claude, and Valentin, were quite adventurous. Son of a painter, Laurent Vouet, of whom almost nothing is known, he seems to have been sent to England when he was very young, then to Constantinople in 1611-12 and to Venice in 1612-13.

Whether or not all these surmises are correct, Vouet was certainly in Rome in 1614, and, except for the short time he spent in Genoa in 1621-2, lived there until his return to France. In 1617 he received a brevet from the King of France and the following year a royal pension. It is known that he frequented the group of foreign artists in Rome that included Poussin and Mellan, as well as the best-known Italian painters. In 1624 the artist was called upon to be President of the Roman Academy of St Luke. The same year his reputation was made by a commission for St Peter's, of which only some fragmentary sketches survive (Great Britain, private coll.), and he undertook the decoration of the Church of S. Lorenzo in Lucina. In 1626 he married Virginia da Vezzo, herself an accomplished miniaturist, and was ordered to return to France.

Vouet's Roman production is well known. It consists in part of some church paintings, very many *in situ* (*La Naissance de la Vierge* [*The Birth of the Virgin*], 1618-20, Rome, Church of S. Francesco a Ripa; a *Crucifixion*, 1621-2, Genoa, Church of S. Ambrogio; an *Annunciation*, 1622-3, Berlin Museum, destroyed in 1945; a *Circumcision*, 1622, Naples, Church of S. Angelo a Segno; the decoration for the Alaleoni Chapel, 1623-4, Rome, Church of S. Lorenzo in Lucina; *L'Apparition de la Vierge à Saint Bruno* [*The Apparition of the Virgin to St Bruno*], 1626, Naples, Church of S. Martino; *L'Apothéose de Saint Théodore* [*Apotheosis of St Theodore*], painted in Venice in 1627, Dresden, Gg); and in part of some easel paintings such as *Les Amants* (*The Lovers*) (1617-18, Rome, Gal. Pallavicini); *La Diseuse de bonne aventure* (*The Fortune-Teller*) (Ottawa, N.G.); *Saint Jérôme et l'ange* (*St Jerome and the Angel*) (Washington, N.G.); and *Le Temps vaincu* (*Time Vanquished*) (1627, Prado). There is also a series of very fine portraits (Rome, Gal. Pallavicini; Brunswick, Herzog Anton Ulrich Museum; Arles Museum; Lyons Museum) that display a beautiful free handling and a touching spontaneity.

'In Rome he had followed the manner of Caravaggio and of Valentin', wrote d'Argenville, but his large canvases also showed a good knowledge of the Bolognese masters, in particular Lanfranco, and of the current artistic trends in Italy. Before his return to France, as the 1627 painting in the Prado shows, he changed his style, his painting becoming lighter and freer, and he rarely returned to the 'sombre style' which had been imposed on him in Rome.

It is more difficult to follow Vouet's career in France year by year, so numerous were the commissions he received – for church paintings, enormous decorative ensembles and votive paintings. Many of the ensembles, such as the set of *Hommes illustres* (*Famous Men*) commissioned by Richelieu for the Palais Cardinal (now the Palais Royal) around 1636-8, have been split up, and all the church paintings have been removed, if not lost, making it difficult to analyse the development of

his style. Furthermore, more than one important studio – for example, that of Francois Tortebat and of Michel Dorigny, who married two of the artist's daughters, as well as those of Vouet's brother Aubin, Louis and Henri Testelin, Nicolas Chaperon, Charles Poerson and many others – seems to have collaborated increasingly in the execution of his paintings.

Some dates, however, help in the study of his career. Vouet lost his wife in 1638 and remarried in 1640. This was the year of Poussin's return to Paris and of Louis XIII's famous remark, 'Voilà Vouet bien attrapé', which can be roughly translated as 'Now Vouet's nose will be put out of joint'. In 1648 he took an active part in founding the Académie, and he died the following year, at the time when two of his pupils, the most gifted, were fighting for supremacy: Le Sueur and Le Brun.

During his later years Vouet employed a more decorative and highly coloured style for his commissioned ensembles (Châteaux de Chilly, St Germain-en-Laye, Fontainebleau and Wideville; in Paris the Hôtels Bullion and Séguier, and those of Perrault, Bretonvilliers and Tuboeuf). He applied the same formula to his easel paintings, notably his many paintings of the *Virgin and Child*, most of them engraved and widely distributed, something of which he made a speciality.

It is, however, the large allegorical compositions (*Le Temps vaincu par l'Amour* [*Time Vanquished by Cupid*], *Vénus et l'Espérance* [*Venus and Hope*], Bourges Museum) and the religious works painted for churches in Paris (*L'Assomption de la Vierge* [*The Assumption of the Virgin*] in St Nicolas-des-Champs; *Le Martyre de Saint Eustache* [*The Martyrdom of St Eustache*] in St Eustache), as well as those preserved in the Louvre (*Présentation au Temple*), that constitute the very best of Vouet's production. They were often preceded by excellent

Simon Vouet ▲
Le Temps vaincu par l'Amour, Vénus et l'Espérance
Canvas. 184 cm × 133 cm
Bourges, Musée du Berry

sketches in graphite (the two Cholmondeley albums in the Louvre are examples). Gracefully ordered by the play of draperies and their circular rhythm, they are a reply *à la française* to the huge 'classical' canvases of the Roman and Bolognese masters. More than any other artist, Vouet helped to make Paris an important artistic centre. P.R.

Vrubel
Mikhail Alexandrovich
Russian painter
b.Omsk, 1856 – d.St.Petersburg, 1910

Vrubel's mother was half Danish; his father was Polish. He had inherited an instability of character and was by temperament moody. A great traveller, he made many journeys to Europe, particularly to Venice. His knowledge of Greek ceramics, Byzantine mosaics and icon painting led him to restore the frescoes of St Cyril in Kiev but, disqualified by Vasnetsov from the team of restorers of St Vladimir, he left Kiev for Moscow. He had strong affiliations with the Savva Mamontov group, and worked for them at Abramtsevo, discovering there a certain peace of mind. His inner anguish transformed his chosen themes into obsessions, as can be seen in many versions of *The Demon*, inspired by Lermontov's poem.

A rich palette full of oriental harmonies (*The Lady of Tamara*, 1890, Leningrad, Russian Museum), a technique close to that of the Expressionists (*Pan*, *c*.1900, Moscow, Tretyakov Gal.) and the division of his canvas into elements that create an arbitrary and dramatic form all place him on the edge of Russian art at the end of the 19th century, and at the very beginnings of the avant-garde currents of the early 20th century. But his painting, restricted by his academic background, did not bring him the kind of freedom that his Western contemporaries were finding. Vrubel's *oeuvre*, exquisitely dreamlike and little known in the West, is comparable to that of Odilon Redon and Edvard Munch. B. de M.

Vuillard
Édouard
French painter
b.Cuiseaux, Saône-et-Loire, 1868 – d.La Baule, 1940

Vuillard's life was an uneventful one, much of it spent living with his mother until her death in 1928. He attended the Lycée Condorcet in Paris where his fellow-students and friends included Maurice Denis, Lugné-Poe and Ker-Xavier Roussel, who later became his brother-in-law. A promising student, Vuillard made plans for a military career, but, under Roussel's influence, gave them up in order to devote himself to painting. He trained first at the École des Beaux Arts, from 1886 to 1888, then he entered the Académie Julian where the Nabi group was formed (Maurice Denis, Bonnard, Ker-Xavier, Roussel, Sérusier, Ibels). Vuillard became part of the circle centred on the Natanson brothers' *Revue blanche*, and in 1891 joined Denis and Bonnard in Lugné-Poe's studio in the Rue Pigalle.

Like the other painters in the Nabi group, Vuillard took an interest in every type of painting technique, but the one that attracted him most was painting with distemper, which gave to his works their matt, dull surface, and the freshness of a fresco.

Vuillard's style was essentially realist, with a marked penchant for the theme of conventional interiors. Its evolution was marked by three stages. During the first of these, the period of his apprenticeship (1888-90), Vuillard concentrated on the depiction of small subjects painted in harmonious colours and tone values, in which greys were dominant. *Le Verre d'eau et citron* (*Glass of Water and Lemon*) (formerly Arthur Sachs Coll.) and *Le Lapin de garenne* (*The Wild Rabbit*) (Paris, C. Roger-Marx Coll.) are unpretentious still lifes in the style of Chardin and Fantin-Latour which also recall Corot and certain Dutch painters.

The second stage (1890-1900), during which Vuillard formed part of the Nabi group, was the most fruitful and inventive period of his entire career, and was marked by a very pronounced decorative character. He retained his characteristic tone values, at the same time adopting Gauguin's technique of painting flat planes without shading and his use of strident colours partitioned by circles of the brush in the manner of stained glass, as well as adhering to the theories of Maurice Denis. He interpreted Japanese prints (*La Femme en robe à carreaux ravaudant un bas, dans une pièce tendue de papier rouge à fleurs jaunes* [*Woman in a Check Dress Darning a Stocking, in a Room with Red Wallpaper and Yellow Flowers*], 1891, Paris, M.N.A.M.) in a style reminiscent of certain Japanese-orientated canvases of Bonnard's (*Corsage à carreaux* [*Check Bodice*], 1892, Paris, M.N.A.M.); or, less often, he went to extremes of abstraction (*Au lit*, [*In Bed*], 1891, Paris, M.N.A.M.).

The lively colours of his *Autoportrait octogonal* (Paris, private coll.) and *Liseur* (*Man Reading*) (Paris, private coll.) already, in 1891-2, prefigured Fauvism, but had no successors in his work. In 1892 he carried out the first decorative ensemble in the Nabi style for the town house of the Desmarais, cousins of the Natansons (Paris, private coll.). From 1893 he painted many pictures of conventional interiors peopled with figures who appear to be at one with or emerge from the walls: *L'Atelier* (*The Studio*) (1893, Northampton, Massachusetts, Smith College Museum of Art). After the collection of *Jardin publics* (*Public Gardens*), executed for Alexandre Natanson in 1894 (Paris, M.N.A.M.; Houston, Texas, Museum; Cleveland Museum; Brussels, M.A.M.), he painted another decoration, the *Personnages dans des*

intérieurs (*Characters in Interiors*) (1896, decorative panels for Dr Vaquez; Paris, Petit Palais) and portraits of the Natansons (1897-8).

Vuillard was also involved with the world of the avant-garde theatre, including Antoine's Théâtre Libre, Lugné-Poe's L'Oeuvre and Paul Fort's Théâtre d'Art. From this came evocations of the world of entertainment (*L'Acteur Coquelin-Cadet*, 1892; *Actrice dans sa loge* [*Actress in her Dressing-Room*], Paris, private coll.), sometimes executed in watercolour, a medium he did not often use. The theatre, too, provided the occasion for his first lithographs, which caught the attention of Ambroise Vollard. In monochrome and in colour, they paralleled those of Bonnard (aspects of Parisian life) and of Roussel (*Album du paysage*). *Paysages et Intérieurs*, published by Vollard in 1899, is the sum of Vuillard's works in this medium.

After 1900 Vuillard's career turned away from the paths that contemporary art was taking. His compositions became larger and monumental in feeling, taking on a new depth and volume. Some of them were painted for large country houses, such as that of Bernheim-Jeune at Bois-Lurette (1913) or for the Hessel family; others were for public buildings like the Comédie des Champs-Élysées theatre (1913, with Denis, Bonnard and Roussel), the League of Nations building in Geneva (1936, with Roussel, Denis and Chastel), and the Palais de Chaillot (1937, with Roussel and Bonnard). The analysis of the middle class in their apartments is delicate and sometimes touched with humour (*La Famille du peintre ou le Dîner vert* [*The Painter's Family or the Green Dinner*], London, private coll.); *La Conversation ou la Veuve en visite* [*The Widow's Visit*], Toronto, Art Gal. of Ontario; *La Famille*, Paris, private coll.).

Vuillard also painted many portraits that are remarkable for their depth and sensitivity. The Natansons, the Bernheim-Jeunes, the Hessels, Mme Bénard, the Comtesse de Noailles, the Nabi painters (Paris, Petit Palais), Mme Vaquez, Dr Widmer, his mother and sister, the Comtesse de Blignac, and countless others posed for him (*La Mère et la soeur de l'artiste* [*The Artist's Mother and Sister*], *c*.1893, New York, M.O.M.A.; *Anna de Noailles*, *c*.1932, Paris, M.N.A.M.; *Vallotton et Misia*, 1899, Paris, private coll.).

Nudes appear infrequently in these wealthy apartments overcrowded with fin-de-siècle furniture and bric-à-brac. Vuillard had, however, painted a few at the beginning of the century (*Femme se coiffant* [*Woman Combing her Hair*], Paris, private coll.; *Intérieur*, Winterthur, private coll.). If they had neither the splendour nor the inspired freedom of Bonnard, they nevertheless

Mikhail Vrubel ▶
Demon Sitting Down (1890)
Canvas. 115 cm × 212 cm
Moscow, Tretyakov Gallery

recalled his work by their intimism and their relationship with the objects around them.

In spite of several successes (*Paysage à l'Étang-la-Ville* [*Landscape at l'Étang-la-Ville*], 1899; *La Maison de Mallarmé à Valvins* [*Mallarmé's House at Valvins*], 1895, Paris, M.N.A.M.), Vuillard was not at ease working in the open air. Pure landscape embarrassed him, and he was more inspired by the streets and gardens of Paris: *Paysages de Paris* (*Paris Scenes*) (*c*.1905); *Jardins publics* (*Public Gardens*) (1894, Paris, M.N.A.M.); *La Place Vintimille* (1907). In these works recollections of Bazille and Monet mingle with those of Puvis de Chavannes and Bonnard's Parisian streets (1891-2). After 1930, during holidays spent with his friends the Hessels at the Château des Clayes, Vuillard painted still lifes, simple vases of flowers, often placed before a window, relaxed works full of harmony, where his talent as a colourist was seen at its best (*Géranium sur une table bleue, devant une fenêtre* [*Geranium on a Blue Table, in front of a Window*], Paris, private coll.).

Vuillard is represented chiefly at the Musée National d'Art Moderne and in most of the large museums and art galleries in Europe and the United States. B.C.

Warhol
Andy
b.Pittsburgh, 1931 – d.New York, 1987

One of the most famous exponents of Pop Art, Warhol began his career as a painter in 1960. From his arrival in New York, several years previously, he had worked, and had acquired a considerable reputation, as a commercial artist (his drawings of this period were exhibited at the Gotham Book Mart in New York in 1971). Aware of the first signs of a resurgence of figuration in American painting about the end of the 1950s, he began to produce hand-painted canvases, the subjects of which were gleaned from everyday imagery: group drawings (similar to those of his contemporary, Roy Lichtenstein) or extensions of popular motifs (*Dick Tracy*, 1960, Minneapolis, private coll.; *Nancy*, 1961, Aspen, Powers Coll.; *Popeye*, 1961, Rauschenberg Coll.; *Del Monte Peach Halves*, 1961, Stuttgart, Staatsgal.). Still expressionist in treatment, these canvases soon gave way to a series of more controlled paintings where the imagery, in its turn, adopted a mass-produced look (*Campbell's Soup Cans*, 1961-2, Los Angeles, Blum Coll.; *Close Cover before Striking*, 1962, New York, McCrory Corporation; *Plane Crash*, 1963, Cologne, W.R.M.).

In 1964, although he had undoubtedly developed this technique as early as 1961-2, Warhol adopted a mechanized system of silk-screen reproduction on canvas which allowed him to produce multiple works in series such as *Marilyn* (1962, New York, M.O.M.A.); *Jackie Kennedy* (1964, Minneapolis, Walker Art Centre); *Elvis* (1965, Toronto Museum); *Mona Lisa* (1965, Metropolitan Museum) and *Flowers* (1965, Metropolitan Museum). These representations in close-up of the male and female faces forming an integral part of the American sub-culture were later extended with the portraits of *Mao Tse-Tung* (1972).

Inevitably certain aspects of Warhol's art (instant realism and distancing) brought him into contact with the cinema, to which he became increasingly dedicated after 1963. The originality of Warhol's methods of filming (people improvising before a fixed camera) has had a marked effect on avant-garde film making. J.P.M.

Watteau
Jean Antoine
French painter
b.Valenciennes, 1684 – d.Nogent-sur-Marne, 1721

Adulated by art-lovers (Julienne, Crozat, Frederick II) during his lifetime, and for a while after his death, Watteau fell out of fashion in the middle of the 18th century under the influence of Neoclassicism and the new sensibility. It was only during the latter half of the 19th century that he once more gained the attention he deserved. The Goncourt brothers in 1854, Baudelaire (*Les Phares*, 1855) and Verlaine (1867) were quick to recognize him, while Lord Hertford brought several of his paintings, now the pride of the Wallace Collection in London. Through the La Caze bequest (1869) the Louvre finally acquired eight paintings (including *Gilles*), having up till then owned only Watteau's reception piece, *Pèlerinage à l'île de Cythère*, known as *l'Embarquement pour l'île de Cythère* (*The Embarkation for Cythera*).

Watteau first worked in the studio of Gérin at Valenciennes (1699-1702 [?]), then in Paris where he made copies of religious paintings and works of the Dutch school (*La Vieille aux lunettes* [*Old Woman with Spectacles*], after Dou). He also became acquainted with Flemish painting through the works of Vleughels and Spoëde. Apart from the *Vraie Gaieté* (*Peasant Dance*) (1702-3, Valenciennes Museum), the works of this period which are mainly rustic scenes recalling Teniers, are known only from engravings. Between 1703 and 1708 Watteau often visited the print shop in the Rue St Jacques of Pierre Mariette (who had commissioned engravings of the Commedia dell'Arte from Rousselet) and his son Jean (a great collector of Dutch paintings), where he could have also seen the works of Titian, Rubens, Callot, Picart or Simpol. These religious or gallant scenes, engraved by up-to-date processes, may well have provided his earliest source of inspiration.

It was probably at the Mariettes' that he met Gillot, with whom he worked from 1703 to 1707–8 – a decisive period in his career, when he

Édouard Vuillard ▲
L'Atelier (1893)
Cartoon. 44 cm × 51 cm
Northampton, Massachusetts, Smith College
Museum of Art

Andy Warhol ▶
Green Coca Cola Bottles
Silk-screen on canvas
Harry N. Abrams family collection, New York

copied or completed subjects from the Commedia dell'Arte, then greatly in fashion (*Arlequin empereur de la lune* [*Harlequin, Emperor of the Moon*], *c*.1708 Nantes Museum, possibly painted by Watteau from a drawing by Gillot; *Pour garder l'amour d'une belle*, *c*.1706, engraved by Cochin in 1792). During this very important time Watteau enlarged his repertoire of subjects, less sensitive to the rather dry aspect of Gillot's compositions, than to the understanding with which he seized on popular or theatrical themes. Two paintings survive from these years: an undisputed work (*Qu' ay-je fait, assassins maudits?*, 1704-7, Moscow, Pushkin Museum), a satire similar to *Monsieur de Purceaugnac*; and another which has recently been attributed to Watteau, *Les Petits Comédiens* (*Children's Masked Ball*) (1706-8, Paris, Musée Carnavalet), which shows more of the influence of Gillot. It seems that it was from Watteau more than from Gillot that paintings were henceforth commissioned.

The Keeper of the Palais du Luxembourg, Claude Audran, turned to Watteau for help in executing his commissions (*Les Mois grotesques* [*The Months*] for Meudon, begun in 1699; sketch in the Albertina), allotting to him part of the decoration in the Château de la Muette (the King's antechamber, *c*.1708, known from engravings in the *Oeuvre gravée*, published 1731). While following the tradition of Bérain, Watteau broke new ground and showed himself to be the forerunner of Boucher by creating one of the very first ensembles to bear witness to the taste for chinoiserie and the exotic. His decorative work in the Hôtel de Nointe, Poulpry, shows his gift for fantasy. He mingles elegant ladies and their suitors with grotesque figures and arabesques (*Le Faune* [*Bacchus*], *L'Enjôleur* [*A Young Couple*], Paris, private coll., the only two panels to survive).

But during these two years the great revelation

for Watteau was the Medici Gallery at the Luxembourg, with Rubens's great cycle on the life of Marie de' Medici. This was the most famous ensemble in Paris, of which Nattier had personally directed the publication of the engravings (1703–10). The discovery of Rubens had a great effect on Watteau's style; he acquired a smoother, more viscous paint, which from this time he used more fluidly. When he returned to Valenciennes in 1710, he tried out military subjects and showed himself to be very different from his French predecessors in the genre, such as Van der Meulen, in his greater realism (*Camp volant* [*Soldiers in Camp*], 1709-10, Pushkin Museum). But he soon gave up the genre, leaving it to the young Pater, his pupil, although it is possible that he later returned to it: *La Recrue* (*The Recruit*), Paris, Rothschild Coll.

On his return to Paris Watteau went to live with Gersaint's father-in-law, Sirois, whose portrait he painted (*Sous un habit de Mezzetin*, *c*.1717, Wallace Coll.). He devoted himself to painting masquerades in the style of Gillot, thus linking himself to La Roque and Lesage. The protection of La Fosse soon led to his being made an *agréé* of the Académie (*Les Jaloux*, known from an engraving; *La Partie carrée*, Paris, private coll.). There is little information on his activity during the years 1712-15. It is known that he met the Treasurer, Pierre Crozat, who put his estate at Nogent-sur-Marne at Watteau's disposal, and allowed him to study his huge collection of Flemish drawings, particularly those by Van Dyck (*L'Amour désarmé* [*Venus disarming Cupid*], *c*.1715, Chantilly, Musée Condé; *L'Automne* [*Autumn*], Louvre).

Watteau worked for a long time on the technique of landscape painting and evolved a completely personal style (*La Bièvre à Gentilly* [*Beaver at Gentilly*], *c*.1715, Paris, private coll.). During this time he does not appear to have

sought out large commissions, preferring rather to perfect his technique. He did, however, paint a series of *Les Saisons* for Crozat (*c*.1715), of which *L'Été* (*Summer*) (Washington, N.G.) is the only canvas to have survived. He achieved a completely personal synthesis between an aesthetic of Fontainebleau origin which he had already admired at Audran's, a taste for Rubens which followed the colourists of Louis XIV's time, and a very clear preference to the Venetians. All these influences were merged with his extremely delicate colours and experiments with the effects of light to arrive at an atmosphere of a rare poetry (*Nymphe surprise par un satyre* [*Nymph surprised by a Satyr*], also called *Antiope*, in the Louvre. The theme is taken from Van Dyck, but also recalls Titian).

Ill, but also very restless, Watteau changed his domicile many times. Crozat, Sirois and Vleughels welcomed him in turn, and for a time he lived with Edme Jeaurat. In 1717 he presented his reception piece, *Le Pèlerinage à l'île de Cythère* to the Académie, who received him as a painter of *fêtes galantes* (although the picture, with its autumnal tones and figures seen in back view, appears more as a melancholy allusion to youth and love).

In the winter of 1719 Watteau went to London where he met French artists and received commissions, which were later completed by Mercier. He returned to Paris in the summer of 1720 and moved in with Gersaint, for whom he painted a shop sign, with great rapidity. It is known as the *Enseigne de Gersaint* (Berlin, Charlottenburg), and is a kind of evocation of the quarrel between the Ancients and the Moderns, insofar as his own art came from Venice and Flanders. Finally, in the spring of 1721, he settled at Nogent-sur-Marne where he lived in the company of Gersaint, La Roque and Pater: he shared his drawings between them before his death.

His production during these last five years was immense (many paintings have been lost and are

 Antoine Watteau
L'Enseigne de Gersaint (1720)
Canvas. 163 cm × 308 cm
Berlin, Schloss Charlottenburg

known only from engravings or copies). The subjects include those influenced by Flemish realism (*La Marmotte* [*Strolling Player with Marmot*], 1716[?], Hermitage) and several nudes of a sensuous and delicate charm: *Toilette intime* (Paris, private coll.); *La Toilette* (London, Wallace Coll.). He rarely painted portraits: that of *Antoine Pater* (Valenciennes Museum) shows a surprising authority, and the *Gentilhomme* (wrongly called 'Jullienne', Louvre) is one of the most significant portraits of the 18th century. Watteau also painted some religious pictures (*Sainte Famille* [*Holy Family*], Hermitage) and mythological works (*Jugement de Paris,* Louvre).

His most famous works however evoke meetings, pleasures, music, picnics, which may be collectively termed *fêtes galantes*. The world of the theatre (*L'Amour au Théâtre-Francais, L'Amour au Théâtre-Italien*, Berlin-Dahlem; the *Comédiens Francais*, Metropolitan Museum) furnished him with costumes and a poetic theme: the monumental and lonely figure of *Gilles* (Louvre) serves as a pretext for a deep reflection on the sadness and vanity of the world. Apart from solitary figures (*Le Mezzetin*, Metropolitan Museum; *L'Indifférent* and *La Finette*, Louvre; *L'Amante inquiète* [*The Anxious Lover*], Chantilly, Musée Condé), he painted mainly compositions in which several people are grouped together, united by music, or the dance, or for flirtatious conversation beneath the leafy trees in a park, or on the steps of a palace.

The most famous of these *fêtes galantes* include: the second version, painted for Jullienne, of *Pèlerinage à l'île de Cythère* (1718, Berlin, Charlottenburg); the *Perspective* in the Museum of Fine Arts, Boston; the *Champs-Élysées*, the *Divertissements champêtres*, the *Charmes de la vie* and the *Rendez-vous de chasse* (Wallace Coll., London); *Le Plaisir pastoral* (Chantilly, Musée Condé); *Le Plaisir du bal* (Dulwich College Art Gal.); *L'Amour paisible, L'Assemblée dans un parc, Le Concert* and *Iris c'est de bonne heure avoir l'air à la danse* (Charlottenburg); the *Plaisirs d'amour* and the *Réunion champêtre* (Dresden, Gg).

These open-air pleasure gatherings appeared at the end of the 17th century. Watteau approached this genre in an original spirit, composed of virtuosity and delicacy. The mysterious figures, the misty atmosphere, the vague evocation of water, lakes, streams, are the reflection of a completely personal sensibility, strongly influenced by the Crozat circle, not just a simple extension of Rubens and Venice. By 1718 it is possible to witness a transformation of Watteau's visionary lyricism into a more clearly defined depiction of the human comedy. It was almost a return to northern realism (more modern in style, the second version of the *Pèlerinage* is less touching), while the *Enseigne de Gersaint* (1720), probably Watteau's masterpiece, shows how much he remained attached to Venetian serenity, with perhaps a more solid distribution of masses. This might have heralded a new departure, but, like Poussin's half a century before, it was to be brusquely interrupted.

Apart from Pater, Watteau apparently had no pupils. Despite this, the importance of his work very soon became apparent, and Jullienne engraved his drawings (1726) and paintings (1727-34). Moreover, Watteau, who remained an isolated phenomenon, was plagiarized, copied and even perhaps assisted in some paintings (Vleughels may have collaborated in the nymph in the Louvre). Meusnier was inspired especially

by his architecture, and Leclerc and de Bar by his rustic scenes. His nephew Louis Joseph copied his military subjects and his son François Joseph his *fêtes-galantes*, while Boucher utilized his chinoiserie, de Troy published plates of *fêtes-galantes* and the young Oudry imitated his theatrical themes (decorations for Fagon, 1725; *Comédiens italiens dans un parc*, private coll.). Abroad, the same diffusion of Watteau's art took place through Mercier in England (until about 1740), Quillard in Spain and Pesne in Prussia – who was summoned by Frederick II because he copied Watteau so well.

Of Watteau's drawings the three greatest collections are today in Stockholm, the British Museum and the Louvre. They reveal a finely wrought technique using sanguine, black crayon and chalk, and are often executed on tinted paper. Watteau proved himself to be a tireless observer: the elaboration of a feminine type is very characteristic and his repertoire includes a variety of gestures and elegant poses. His mastery of line and superb use of rubbed-out colours make his drawings, so full of fantasy and imagination, the most fascinating part of his work. C.C.

Gal.; *Love and Death*, 1875); Oxford (Ashmolean Museum; *Little Red Riding Hood*, 1864); and in the Louvre (*Love and Life*, 1893). W.V.

Watts
George Frederick
English painter
b.London, 1817 – d.Compton, Surrey, 1904

The son of an unsuccessful piano-tuner, Watts was led by his father's ambition and his own prodigious talent to his exalted aspirations as a history painter. After training under the sculptor William Behnes he attended the Royal Academy Schools for a short time in 1835. His first exhibited work at the Royal Academy, *The Wounded Heron* (1837, Compton, Watts Gal.), reveals the influence of Landseer and Etty, but he soon began to model himself on Italian Renaissance art and, after winning a prize in the 1843 Westminster Hall competition, he went to Italy (*The Four Horsemen of the Apocalypse*, 1843-7, Liverpool, Walker Art Gal.; *Roland Pursuing Morgan le Fay*, 1846-8, Leicester, Museum and Art Gal.). There his aristocratic friends supported him, as they were later to do in England while he devoted himself to 'high' art. Returning to England in 1847, he found little encouragement for his desire to create a monumental 'House of Life' in fresco, and he gradually abandoned the scheme.

Meanwhile he was painting portraits of great power, such as that of *Carlyle* (1868, London, V. & A.), while his style, modelled largely on Titian and Tintoretto, was becoming richer. Instead of large compositions he now painted allegorical subjects consisting of a few closely related figures, a reflection of his growing interest in sculpture. His *Hope* (1885, London, Tate Gal.) is the best known and most concise of these, in which is clearly visible the despair underlying his grandiose vision, so typical of the late 19th century. While his eclecticism and limitations are very obvious today, one cannot overlook his seriousness of intention as compared to the English academic painters of his day.

Watts is represented chiefly at Compton, Surrey, in the gallery (the Watts Gallery) that he had built to house his own work, as well as in London (N.P.G., V. & A., Tate Gal.); Bristol (City Art

West
Benjamin
American painter
b.Springfield, Massachusetts, 1738 – d.London, 1820

Rightly considered as the father of the American school, West was born in a region where no 'master' had ever seen the light of day. The American Indians, he said, had taught him to colour his drawings with earth, using a brush made out of the hairs from a cat. But his real apprenticeship began when he arrived in Europe in 1760. Trained, to begin with, in Rome, in the international atmosphere of Neoclassicism, a friend of Winckelmann, and encouraged by Mengs, West went on to a brilliant career in London where he settled in 1763. His fluency and his talent led him to be nominated in 1792 as Reynold's successor as President of the Royal Academy where, between 1769 and 1819, he exhibited no fewer than 258 paintings.

Although he never returned to his native country, West kept up his connections with his fellow citizens all his life. For nearly a quarter of a century his studio was the meeting place for

George Frederick Watts ▶
Hope (1885)
Canvas. 141 cm × 110 cm
London, Tate Gallery

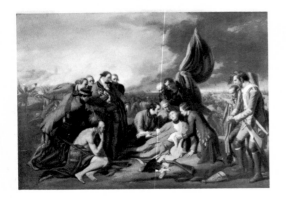

young Americans wishing to become painters. *The Death of General Wolfe* (1770, Ottawa, N.G.) and *Penn's Treaty with the Indians* (1772, Philadelphia, Pennsylvania Academy of Fine Arts) were examples to artists who illustrated the history of the young American nation.

With his historical paintings West played an important part in the spreading of the epic and moralizing style in fashion at the end of the 18th century (*Agar and Ishmaël*, Metropolitan Museum; *The Golden Age*, 1776, London, Tate Gal.; *Death on a Pale Horse*, 1817, Philadelphia, Museum of Art).

He was commissioned to paint large decorations for Windsor Castle: notably eight compositions on the life of Edward III for St George's Hall. He also left likenesses of his contemporaries: *Colonel Guy Johnson* (Washington, N.G.) and *Mr and Mrs Beckford* (1797, Metropolitan Museum).

S.C. and M.D.B.

Weyden
Rogier van der
Flemish painter
b. Tournai, 1399 or 1400 – d. Brussels, 1464

That Rogier van der Weyden came from Tournai is confirmed by a document mentioning the wax tapers burnt after his death by the Guild of Painters in Tournai, in memory of the painter '*natif de cheste ville*'. Only the earliest mentions of him pose problems of interpretation. In 1426 he must have been a master in the guild, as there is a record of a gift of four lots of wine from the Town Council to 'Master Rogier', but he is known to have become apprenticed to The Master of Flémalle (Robert Campin) in 1427, which is surprising. The title of 'master' could have been acquired other than in painting, or even in another city. It is probable that Rogier was in Brussels for his marriage to Ysabel Goffaerts, a native of the city, which appears to have taken place a little before 1426.

Rogier van der Weyden's artistic development was a complex one, as seems to be borne out by the diversity of his works. If the little panel of the *Virgin and Child in a Niche* (Lugano, Thyssen Coll.) are taken to be works of the artist's youth, along with the diptych (Vienna, K.M.) showing the *Virgin and Child with St Catherine*, it is possible to see in them the only lesson that he ever learned from the school of Tournai, a refined and elegant style, and a careful treatment, recalling the art of Jan van Eyck.

WEY

438

 Benjamin West
The Death of General Wolfe (1770)
Canvas. 151 cm × 213 cm
Ottawa, National Gallery of Canada

Only a few of Rogier's works can be approximately dated and form some guiding-marks in the chronology. The *Deposition* (Prado), painted for the Brotherhood of Crossbowmen of Louvain, was painted some time before 1443, probably around 1435. The large figures depicted on the panels, in a composition which imitates those of bas-reliefs in Tournai, have the three-dimensional liveliness found in the Master of Flémalle, although the harmoniously balanced arrangement of masses and the supple arabesques are quite different in spirit. The solemn grief of the scene culminates in the famous figure of the Magdalene, often copied by 15th-century artists.

This duality of inspiration is found in many works. The *Annunciation* (Louvre, centre of a triptych of which the wings, perhaps painted by his studio, and showing a *Donor* and the *Visitation*, are in Turin, Gal. Sabauda), repeats the schema of a triptych by the Master of Flémalle (New York, Cloisters), adding to it a balanced rhythm and a refinement absent from the earlier work. A light in which every reflection is observed precisely lends a note of refined realism. Rogier was inspired in the composition of his *St Luke Painting the Virgin* (Boston, M.F.A.; copies in Munich, Alte Pin., and the Hermitage) by Van Eyck's *Virgin of Chancellor Rolin* (Louvre), but adds a monumental quality to the theme.

The feeling of repressed anguish that marks the Prado *Deposition* reappears in the *Triptych of the Virgin* (Granada, Royal Chapel, and Metropolitan Museum; variant in Berlin-Dahlem) but is definitely more elegant in treatment, following a refined Gothic tradition. In 1439 Rogier seems to have completed two of four panels on the theme of the execution of justice, commissioned for the Town Hall in Brussels. Destroyed in the 17th century, these works are known today only by a tapestry (Bern), which gives a liberal interpretation. Between 1445 and 1450, Rolin commissioned Rogier to paint a large triptych of the *Last Judgement* for the Hospice de Beaune, which developed, in a vast frieze, the traditional theme of the resurrection of souls and their judgement in the presence of a heavenly court.

In 1450, declared a jubilee year, and therefore an important year for pilgrimage, Rogier went to Italy. His contact with the art of the south did not appear to influence him very much, although it confirmed him in his tendency to arrange his composition strictly around a symmetrical axis. This can be seen in the *Entombment* (Uffizi), inspired by a work from Fra Angelico's studio, as well as in the *Madonna with Four Saints* (Frankfurt, Städel. Inst.), painted for the Medicis, or even in the *Braque Triptych* (*Christ between the Virgin and St John the Evangelist, St John the Baptist, The Magdalene*, Louvre), one of his purest creations. This compositional rigour is equally marked in the *Triptych of St John* (Berlin-Dahlem) in which the outer panels balance each other exactly. The *Seven Sacraments* (Antwerp Museum), executed for Jean Chevrot, Bishop of Tournai, in about 1453, consists of a series of scenes set in a majestic church. In the central episode, the *Crucifixion*, the assertion of the line emphasizes the arabesque of the figures.

This emphasis is accentuated in the *Nativity* triptych (Berlin-Dahlem), commissioned by Pierre Bladelin, Duke Philip's treasurer, between 1450 and 1460. It is characteristic, too, of the large *Annunciation* (Metropolitan Museum) painted for a member of the Ferry de Clugny family, and of *The Adoration of the Magi* (centre of a triptych, with side-panels showing the *Annunciation* and the *Presentation in the Temple*, Munich, Alte Pin.), originally in the Church of St Colomba in Cologne. The form now becomes attenuated in a 'Gothic-Mannerist' style. Increasingly dramatic, this graphic style leads on to the great *Crucifixion* in the Escorial, unhappily badly damaged, and the diptych of the *Crucifixion* (Philadelphia, Museum of Art, Johnson Coll.), which dates, perhaps, from a little earlier, and which reveals an intense synthesis of technique and expression.

The same development can be seen in Rogier's portraits. He would appear to have been the originator of a type of diptych with a donor on one wing, and a *Virgin and Child* on the facing wing, both showing head and shoulders. The earliest, that of *Laurent Froimont* (the *Virgin* is in

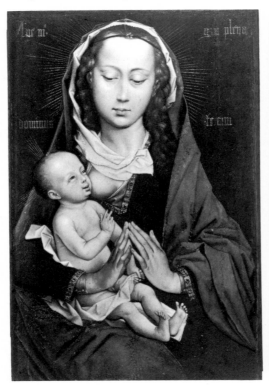

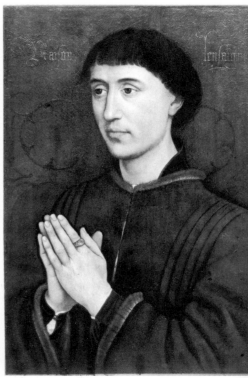

Caen Museum and the portrait in Brussels, M.R.B.A.) shows beautifully three-dimensional figures. The portrait of *Jean de Gros* (formerly Renders Coll. and Chicago, Art Inst.) may have been painted with the aid of collaborators, and a tendency to emphasize the outlines is already apparent. The evolution is complete with the diptych of *Philippe de Croy* (San Marino, California, Huntington Library and Art Gal.; Antwerp Museum) in which the figures have not only become completely linear, but are made more dramatic by the energy of the contours. This graphic quality is also apparent in the portrait of *Isabella of Portugal* (New York, Rockefeller Coll.), the *Portraits of Women* (Berlin-Dahlem and Washington, N.G.), the portrait of *Francesco d'Este* (Metropolitan Museum) and the *Man with an Arrow* (Brussels, Musées Royaux des Beaux Arts). It is equally pronounced in the portraits of *Philip the Good*, known only through copies.

Rogier was the most influential artist in Europe in the 15th century. His art is distinguished by a vision still impregnated with Gothic feeling, but contained within a severe and completely intellectual structure. A.Ch.

Whistler
James Abbott McNeill

American painter
b.Lowell, Massachusetts, 1834 – d.London, 1903

Destined by his parents for a military career, Whistler attended West Point Military Academy, then entered the Cartographic Service in Washington (where he learned the technique of etching). But he resigned in order to devote himself to painting. At the age of 24 he set off for France. Speaking fluent French, he soon took part in the life of Parisian artists, and this period was rich in experience. He worked in Gleyre's studio, at the École des Beaux Arts, and went often to the Louvre. A friend of Courbet who called him his 'pupil', and very close to Fantin-Latour, he became part of Courbet's Realist group which met at the Brasserie Hautefeuille.

Whistler's early works reflect this climate. These were first, engravings (*Twelve Etchings from Nature* or *The French Set*, 1858), followed by a large canvas, *At the Piano* (1858-9, Cincinnati, Art Museum), a very studied composition with fluid brushwork. Refused by the Salon in 1859, this painting was shown the following year by the Royal Academy and marked the beginning of the artist's English career.

Whistler now divided his time between London, where he settled in 1863, and France, which he returned to frequently, especially in the summer, to visit Brittany and the Channel coast. There he again met Courbet, Fantin-Latour and Manet. *The White Girl* (1862, Washington, N.G.) was much commented on at the Salon des Refusés, beside Manet's *Déjeuner sur l'Herbe*. For the first time it was possible to discern a delicate sense of tonal harmony, white on white, which justified the title of *Symphony in White, No. 1*, that Whistler later gave this work. In London the painter's notoriety increased, and at the same time so did the number of enemies of his art. After a lawsuit against Ruskin, Whistler (who was awarded damages of one farthing, and financially ruined by the legal costs) was admitted with reluctance into official circles.

However, in 1859 he had begun a series of

◄ Rogier van der Weyden
Virgin and Child
Wood. 49 cm × 31 cm
Caen, Musée des Beaux-Arts

◄ Rogier van der Weyden
Laurent Froiment
Wood. 49 cm × 31 cm
Brussels, Musées Royaux des Beaux-Arts

▲ Rogier van der Weyden
The Deposition
Wood. 220 cm × 242 cm
Madrid, Museo del Prado

etchings of the *Thames* (published in 1871), then became the poet of London fogs with views of the old docks at Battersea, which he painted in various gamuts of colour: *Nocturne in Blue and Gold* (c. 1870-5, London, Tate Gal.). These ephemeral visions, of great delicacy and full of transparent shadows, were inspired by Japanese art of which he was a fervent admirer. Many of the canvases of the 1860s contained references to the Far East: *Caprice in Purple and Gold, No. 2: The Gold Screen* (1864, Washington, Freer Gal.) and *Rose and Silver: 'La Princesse du pays de la porcelaine'* (1864, Washington, Freer Gal.).

After 1870 Whistler concentrated on portraits with *Arrangement in Grey and Black, No. 1; The Artist's Mother* (1872, Louvre, Jeu de Paume) and *Arrangement in Grey and Black, No. 2;* and *Thomas Carlyle* (1872-3, Glasgow Art Gal.). From now on all his works were given musical sub-titles. A new series of engravings, the *Venetian Suite* (1880), showed him dissolving outlines and experimenting with atmospheric effects, particularly in those scenes depicting the silhouette of a Venetian palace reflected in a canal.

After 1880, through lectures and essays, Whistler defended his artistic position. In France he received the support of Huysmans, the Goncourt brothers, Gustave Geffroy and Mallarmé, who translated his paper, *The Ten o'Clock Lecture*. The commissions he now received set the official seal of approval on his art.

A delicate portraitist, Whistler borrowed from Japanese art the subtle play of simplified outline and the harmony of cool, restricted colours. In the realm of etching he is the master of filtered light and the effects of mist and fog. S.C.

In substituting the musical notion of arrangement of harmony for that of the 'subject', Whistler helped to overthrow the academic realism of the end of the 19th century. The collections in Washington (Freer Gal.; approx. 70 paintings, watercolours, pastels, drawings, and the major part of his etchings and lithographs) and the University of Glasgow (Birnie Philip Bequest) allow his work to be studied in all its forms, but many masterpieces are to be found in other major galleries, notably in New York, Frick Collection, Cambridge, Massachusetts, Fogg Art Museum; London, Tate Gallery and Paris, Louvre. L.E.

Wilkie
David

Scottish painter
b.Cults, Fifeshire, 1785 – d.at sea, 1841

Wilkie studied at the Trustees Academy in Edinburgh for four years and was very much influenced by engravings by Rembrandt and Van Ostade. His first important painting was *Pitlessie Fair* (1804, Edinburgh, N.G.), and the money he earned from the sale of the picture enabled him to travel to London in 1805. Wilkie's first exhibit in the capital, *The Village Politicians* (1806, Great Britain, Mansfield Coll.), was well received. It was conceived in the manner of Hogarth and Teniers and it was works such as this that led to his being called 'the Scottish Teniers'.

Wilkie's work was purchased by several notable patrons: *The Blind Fiddler* (1806, London, Tate Gal.) was bought by Sir George Beaumont;

James McNeill Whistler ▲
Miss Cecily Alexander
Canvas. 189 cm × 97 cm
London, Tate Gallery

and *Blind Man's Buff* (1812, London, Buckingham Palace, Royal Coll.) and *The Penny Wedding* (1819, London, Buckingham Palace, Royal Coll.) were bought by the Prince Regent. *Chelsea Pensioners Reading the Gazette of the Battle of Waterloo* (1822, London, Apsley House), which was so popular when it was exhibited at the Academy that crash barriers were erected to protect it, was purchased by the Duke of Wellington. The latter picture is the finest achievement of Wilkie's early period: it took him four years to complete, and he produced at least 80 drawings and four oil sketches in preparation. Much of this early work is marked by a subtlety of touch and expression that probably derived from Watteau and Rubens whose paintings he had admired on a visit to Paris in 1814.

Meanwhile, Wilkie had been elected to the

Academy as an Associate Member in 1809 and as a full Academician in 1811. He quickly found himself in a position of some importance in London. He returned to Scotland in 1817 with the intention of 'seeing the life and manners of the common people' and stayed with Sir Walter Scott at Abbotsford. George IV's visit to Scotland in 1822 was an excuse for brilliant pageantry and great revelry in Scotland, and Wilkie was there to record the occasion. He painted a full-size portrait of the King, who wore a kilt, and made his first attempt at history painting, *The Entry of George IV into Holyroodhouse* (Edinburgh, Holyroodhouse). This was a 'baroque' picture, influenced by Rubens, and with a depth of tone that owed much to the example of Rembrandt and Correggio. The following year, in 1823, he was appointed 'King's Limner for Scotland'. It seemed that Wilkie's career could suffer no reversals, but in 1824, under the strain of overwork and disturbed by deaths in the family, he had a nervous breakdown and was unable to paint.

In the summer of 1825 Wilkie decided to travel abroad, and he visited Italy and Germany. At first he did no work, and spent his time looking at paintings: in Italy he was very impressed by Correggio, and in Madrid, where he arrived in October 1827, he was struck by the work of Velázquez. Gradually his enthusiasm for painting returned, and he arrived home with seven pictures, of which *The Defence of Saragossa* (London, Buckingham Palace, Royal Coll.) proved to be the most popular amongst his fellow-artists.

These paintings showed important changes in style: their design was more organized, the figures were larger in proportion to the whole, and the paintwork was freer and looser. In the peasant and genre scenes of this period there were similar changes, but the attitudes and gestures of the figures were less perceptively observed, as can be seen in *Peep o' Day Boy* (1835-6, London, Tate Gal.), and in *Irish Whiskey Still* (1840, Edinburgh, N.G.).

In the 1830s Wilkie turned increasingly to the painting of portraits, often conceived on a very large scale, and to subject pieces, such as *The Empress Josephine and the Fortune-Teller* (1834, Edinburgh, N.G.). Amongst his most successful portraits were *Augustus, Duke of Sussex* (1833, London, Buckingham Palace, Royal Coll.), which shows some similarities to Raeburn, and the work that absorbed much of his energy during those years, the immense *Sir David Baird Finding the Body of Tippoo Sahib* (1838, Edinburgh Castle).

All these new developments in Wilkie's career

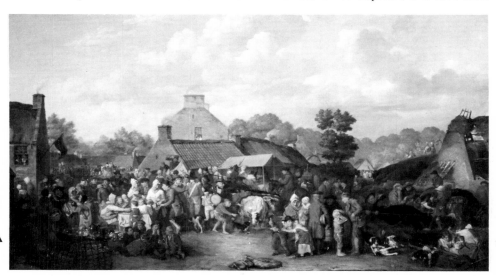

were criticized by those who thought that he had unwisely abandoned the anecdotal style in which he excelled. Nevertheless, his popularity continued, even if it was not quite so remarkable as hitherto, and after becoming Principal Painter to the King in 1830, he was knighted in 1836. In 1840, full of enthusiasm, Wilkie decided to embark on another new venture, and travelled to the Holy Land. He left Palestine after a short visit of five weeks, and on his return voyage, on 1st June 1841, he died at sea. His death was regarded as a national calamity, and the occasion was commemorated by Turner in his celebrated *Peace – Burial at Sea* (London, Tate Gal.). J.H.

Wilson
Richard
English painter
b.Penegoes, 1713/14 – d.Colomendy, Llanferres, 1782

The son of a clergyman, Wilson was given a scholarly education and was brought up with a sound knowledge of the classics. In the 1740s he practised as a portrait painter in London: *Captain Everitt* (Melbourne, N.G.); *Admiral Smith* (Greenwich, National Maritime Museum); *The Princes George and Edward* (1748-9, London, N.P.G.). More significantly for his later career his views of the *Foundling Hospital* and *St George's Hospital* were presented, in 1746, to the Foundling Hospital, where they remain today. He also painted a view of Dover in 1747.

In 1750 he travelled to Italy where he enjoyed the patronage of Cardinal Albani through a letter of introduction from Sir Thomas Mann. In Italy Wilson began to apply himself seriously to landscape painting and his early Italian pictures are in the style of Zuccarelli and Marco Ricci. He was also influenced by Salvator Rosa, Poussin, Gaspard Dughet, and Claude. He was in Rome from 1752 to 1756 and there met Vernet, who encouraged him to continue landscape painting: *Landscape with Banditti: The Murder* (1752, Cardiff Museum); *View of Rome from the Ponte Molle* (1754, Cardiff Museum); *The Isle of Ischia* and *Ariccia* (1752-7, London, Tate Gal.). He was greatly affected by the beauty of such places as the Roman Campagna, Tivoli, Albano, Castel Gandolfo, Lake Nemi and the Bay of Baiae, and they remained a continual source of inspiration for him, even after his return from Italy: *Hadrian's Villa, Maecenas's Villa at Tivoli* (c. 1765, London, Tate Gal.); *View of the Po near Ferrara* (1776, Oxford, Ashmolean Museum).

On his return to London in 1758, Wilson concentrated on three kinds of painting: Italian views with classical figures or banditti; interpretations of British landscapes, especially Welsh, seen as if through a classical eye; and views of country houses. He remained loyal to these themes throughout his life. On his return, the Earl of Pembroke commissioned from him six *Views of Wilton* (Wilton House, Pembroke Coll.) and these pictures are characterized by the use of dramatic light and shade and are far removed from mere topography. As well as Italian memories, the light of Cuyp's landscapes can be found in these views. In 1760 he painted a dramatic historical landscape, *The Death of Niobe's Children* (now destroyed), in the style of Salvator Rosa.

Wilson was a member of the Society of Artists and exhibited 36 works there from 1760 to 1768. In that year he was made a founder-member of the Royal Academy and between 1769 and 1780 he exhibited 30 of his pictures there. He failed to obtain the patronage of George III, however, because the King preferred the more rococo landscapes of Zucarelli, and from the late 1760s Wilson suffered from poverty and lack of commissions.

In 1776 he was offered, and accepted, the post of Librarian to the Royal Academy at a salary of £50 a year, and after this date he painted few pictures. Ruskin wrote that 'with Richard Wilson the history of sincere landscape art founded on a meditative love of nature begins in England'. One of his finest works is his painting of *Snowdon from Llyn Nantlle* (Liverpool, Walker Art Gal.), its rocky eminence observed with a classical tranquillity. His landscapes have a quiet and peaceful air, notable especially for their clear and pellucid atmosphere: *The River Dee near Eaton Hall*, Birmingham, Barber Inst. of Arts; and *View of the Dee* (Glasgow, Art Gal.). Particularly in his depiction of country houses, Wilson managed to break away from the soullessness of topographical art, giving his compositions a quiet grandeur. Reynolds complained that his landscapes were 'too near common nature', but he was the best of the English 18th-century landscape artists and his art paved the way for the two greatest of English landscape painters, Turner and Constable.

Wilson is represented in London (N.G., Tate Gal., and especially in the Brinsley Ford Coll., which has a remarkable collection of works by the painter); Bristol (City Art Gal.); Oxford (Ashmolean Museum); Cambridge (Fitzwilliam Museum); Leicester (Art Gal.); Leeds (City Art Gal.); Glasgow (Art Gal.): Cardiff Museum; Dublin (N.G.); New York (Metropolitan Museum); and Chicago (Art Inst.). J.N.S.

Witte
Emanuel de
Dutch painter
b.Alkmaar, 1615/17 – d.Amsterdam, 1691/2

Although Houbraken states that Emanuel de Witte was a pupil of the still-life painter, Evert van Aelst, in Delft, he began as a figure and portrait painter. In 1636 he joined the Guild of St Luke in Alkmaar. He was in Rotterdam from 1639 to 1640, then Delft from 1641 to 1650, where he executed a painting on a mythological theme, *Vertumnus and Pomona* (1644, Rotterdam, B.V.B.), with a landscape that recalls those of

Poelenburgh. From 1652 to 1653 he was in Amsterdam, from 1654 to 1655 in Delft, and finally, in 1656, he settled in Amsterdam.

Apart from a few genre paintings such as the admirable *Interior with Harpsichord* (1667, Rotterdam, B.V.B.), which clearly evokes the art of Pieter de Hoogh and in which the light, both calm and strong, shines with the poetry of a Vermeer, and his many versions of *Fish Markets in Amsterdam* (London, N.G.; 1672, Rotterdam, B.V.B., Rijksmuseum; Moscow, Pushkin Museum), Emanuel de Witte was a painter who specialized in interiors of religious buildings.

His themes are Gothic churches – both Catholic and Protestant – painted with such imagination that elements are borrowed from several buildings or styles, as in the *Church Interior* in the La Fère museum (also the two *Church Interiors* in the Rijksmuseum; the *Nieuwe Kerk of Amsterdam*, 1656, Rotterdam, B.V.B., and Rijksmuseum; the *Church Interior*, 1668, Mauritshuis). He also painted synagogues (*Interior of the Portuguese Synagogue in Amsterdam*, Rijksmuseum) and funeral monuments such as *The Tomb of William the Silent in the Church in Delft* (1656, Lille Museum), a masterpiece of luminosity in which the red patch of the visitor's coat in the foreground stands out against the white of the columns, bathed in subtle light.

De Witte excels in conveying the effect of light coming from outside and evoking an atmosphere of calm and silence undisturbed by discreet allusions to everyday routine, like the presence of dogs, or people talking in churches, conceived, like his interiors, with the subtle play of light on black-and-white tiled floors. The mellow quality of his light is almost unequalled in Dutch church painting, but does not always avoid coldness of detail, or the dryness of perspectives of Saenredam or even more of Houckgeest or Van Vliet. In the Delft school De Witte must be linked with Fabritius on account of these characteristics. He deserves to be mentioned beside Vermeer because of his poetic style, especially in those of his paintings in Moscow or Rotterdam (*Interior with Harpsichord*). J.V.

Wittel
Gaspar van (Gaspare Vanvitelli)
Dutch painter
b.Amersfoort, 1652/3 – d.Rome, 1736

Before settling permanently in Italy in 1674, Van Wittel studied with Mathias Withoos at Amersfoort. But what he learned of genre painting did

not influence him so much as the new form of 'realism' that many Dutch painters, mainly in Utrecht, were beginning to use in the representation of their native towns and landscapes, going beyond the classicizing, idealizing vision of the Italian landscape artists, following the distant traces of Caravaggio's naturalism. The love of analytical observations and exact transcription of detail, which Wittel had acquired in Holland, developed in Rome where he began his career in the service of the hydraulic engineer, Cornelys Meyer of Amsterdam.

His first task in Rome was 50 drawings illustrating the course of the Tiber between Perugia and Rome, which the engineer used for his work on that section of the river (*Codex Meyer*, Rome, Bibl. Gorsiniana). Wittel's frequent visits to printing works specializing in illustrated guides of Rome, which were much in vogue at the time, helped to turn his interest towards the representation of urban views, a genre in which he specialized from 1680.

His knowledge of perspective, the infinite patience on which he prided himself, a particular sensitivity to the existing aspects of the city, which he interpreted, not as a symbol of classical antiquity, but as a modern, living entity, rapidly made him the undisputed master of the Roman *veduta* of his day.

His best work was concentrated into a relatively short period of time. Between 1680 and 1685 he had produced all the drawings from nature which he was to use later in his paintings and which are characterized by a complete freedom of arrangement, freshness of observation, and meticulous attention to detail. This fundamental vitality never allowed him to fall into 'series' work, even when, after a single study, he produced many copies. About 1690 Van Wittel painted his *vedute* of Roman life along the banks of the Tiber, which are among his most striking works. From this time, his style was established, and views of Rome comprised his principal repertoire.

Numerous visits to Florence, Venice (1695), Verona and especially Naples (1700-1; drawings in Naples, Museo di S. Martino) served to refresh his ideas and allowed him to work *in situ* (*Views of Venice*, Prado). These paintings influenced local artists, such as Carlevarijs and Canaletto in Venice, and the Neapolitan *vedutisti* of the second half of the 18th century. The particular way his art developed, as well as the considerable number of his paintings, makes it difficult to establish a precise chronology of his work, which is now mainly to be seen in Rome (Gal. Colonna, Gal. Doria-Pamphili, G.N. and Gal. Capitolina) and Florence (Pitti). G.R.C.

▲ Gaspar van Wittel
The Ponte Rotto
Tempera on parchment. 23 cm × 43 cm
Rome, Galleria Nazionale d'Arte Antica

Witz came from a family of goldsmiths, originally from the Upper Rhine, and probably spent his early years in France and then at Constance. Arriving in Basel in 1431, he was admitted in 1434 to the guild of painters, stonecutters, glassworkers and goldsmiths. The convening of the Council of Basel by Pope Eugenius IV completely changed the appearance of the town as princes of the Church arrived from everywhere, bringing in their wake the luxury with which they had already adorned their estates and residences. Basel gave hospitality to the artists who had been given important commissions such as altarpieces, frescoes, tapestries, and stained glass. It was in this cosmopolitan atmosphere that Witz was to work. Accepted as a citizen of Basel in 1439, he was commissioned to paint the frescoes in the Kornhaus (now disappeared). In 1444 he went to Geneva at the request of one of the most important members of the Council of Basel, Cardinal Francois de Mies, Bishop of Geneva, to execute the altarpiece for the high altar of the Cathedral of St Peter.

Very few of Witz's works have survived: 12 of the 16 pieces of the polyptych of the *Mirror of Human Salvation*, inspired by the *Speculum humanae salvationis*, painted about 1435 for a church in Basel; a *St Christopher* (Basel Museum); four sections of the altarpiece for St Peter's Cathedral (Geneva); and three later works executed between 1444 and 1446, and originating from one and the same altarpiece: *The Meeting of Anna and Joachim at the Beautiful Gate* (Basel Museum), an *Annunciation* (Nuremberg Museum) and *St Catherine and St Mary Magdalene* (Strasbourg Museum).

The polyptych of the *Mirror of Human Salvation* consisted of a wide centre panel which has disappeared, and two side-pieces painted on both sides, each having four panels. Basel Museum contains five of the eight inside panels (*Caesar and Antipater, Esther and Ahasuerus, Abraham and Melchizedek, David and Abishai, Shabbethai and Benaiah*, with, on the reverse, the *Church*, the *Synagogue*, the *Angel of the Annunciation* and *St Bartholomew*. One of the other panels is in Dijon Museum (*Augustus and the Sibyl*, and, on the reverse, *St Augustine*), and the other is at Berlin-Dahlem (*Solomon and the Queen of Sheba*). In this, Witz's first work, and in the *St Christopher* in Basel Museum, a certain clumsiness is apparent in the drawing, which makes a surprising contrast with the subtle play of light and the power of the relief.

The artist aimed at producing a three-dimensional effect, and, because he remembered the sculpture of Claus Sluter, the contours of his figures recall those of the *Prophets* in the Charterhouse of Champmol. All the accessories are treated with a confident knowledge of the laws of perspective and chiaroscuro. The glittering armour, the rich draperies and precious stones and the effects of transparency, are rendered with extreme realism.

The altarpiece for the Cathedral of St Peter in Geneva, of which there survive only two wings formed by four panels (*The Miraculous Draught of*

Fishes, *The Deliverance of St Peter*, *The Presentation of Cardinal de Mies to the Virgin* and *The Adoration of the Magi*) is a masterpiece of Witz's maturity. The hard and sometimes jarring aspects in the Basel altarpiece have given way to a deep feeling for nature, a new breadth in the composition, and a restraint in the three-dimensional effects. The Geneva altarpiece is the only work to carry the artist's signature, placed on the side-piece showing the *Miraculous Draught of Fishes*, on the frame in tiny Gothic letters: *Hoc opus pinxit Conradus Sapientis de Basilea MCCCCXLIIII* (Conrad Sapientis of Basel painted this work 1444). The dating has allowed part of Witz's production to be reconstructed.

The Miraculous Draught of Fishes demonstrates the evolution of his style following the altarpiece of the *Mirror of Human Salvation*. A realistic landscape is shown, that of the lakeside of Geneva. In this biblical transcription the fishermen lift their nets and manoeuvre a flat-bottomed boat. The piles rising from the water are those of the ancient lake-dwellings of prehistoric Geneva. On the opposite bank the hillside of Cologny is dominated by the Voirons, the tip of the Môle and the Petit Salève; in the distance an escort of horsemen is preceded by the standard bearing the arms of Savoy. The landscape fills the picture, absorbing the action. The general meaning of the composition merges with the feeling for nature and the art of aerial perspective. There is an astounding realism in this work, a historical verisimilitude which represents, in the mid-15th century, an innovatory boldness never before seen at that time. By its 'modernism' *The Miraculous Draught of Fishes* contrasts with the other panels of the altarpiece, which are still full of a medieval naivety especially in *The Deliverance of St Peter*, in which Witz has not escaped the influence of the religious drama, which largely contributed to a renewal of the painter's repertoire.

In his last works, *The Meeting of Joachim and Anna* (Basel) and the *Annunciation* (Nuremberg), which together formed a side-piece painted on two sides; and *St Catherine and St Mary Magdelene* (Strasbourg, Musée de l'Oeuvre-Notre-Dame), which formed the reverse of another side-piece of the same altarpiece, the naturalism of the architectonic background, the perspective achieved through bold foreshortening and the clearly defined planes of light and shadow, reveal the evolution of Witz's style. Beginning from a purely plastic concept, he arrived at a style so vigorous that he was recognized as one of the greatest painters of his age.

Throwing off the last traces of medievalism, Witz lifted his art to a new plane through his pursuit of realism. He had absorbed the discoveries of Van Eyck, and especially those of the Master of Flémalle, and was fully aware of the possibilities of chiaroscuro. A meticulous technique enabled him to achieve a lucid precision of detail that was the basis of the pictorial naturalism. Coming from a German-speaking country in which the most diverse influences clashed and merged, Witz combined in his art those of Burgundy and Flanders. R.L.

Among the works not yet fully established as being by Witz's hand are three superlative paintings, which possibly belong to his early days: a *Crucifixion* (Berlin-Dahlem); a *Pietà* (Pittsburgh, Frick Coll.) and the *Holy Family in a Church* (Naples, Capodimonte). L.E.

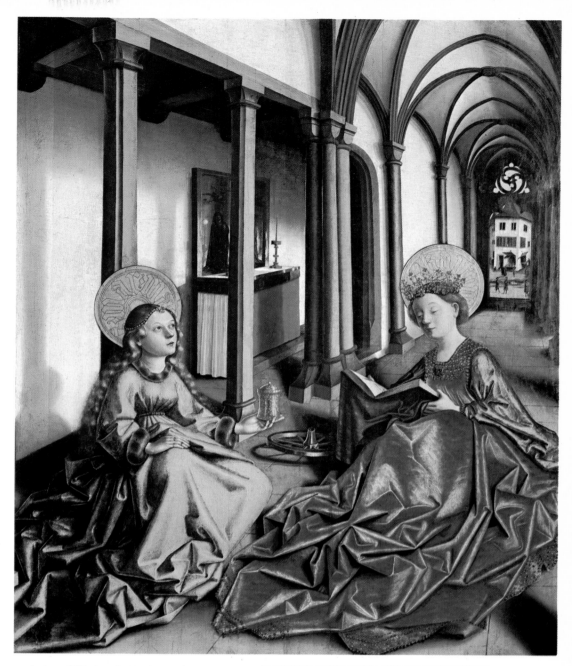

◄ Wolfgang Wols
Vowels (1947)
Canvas. 61 cm × 46 cm
Cologne, Wallraf-Richartz Museum

Wols
(Alfred Otto Wolfgang Schulz)
German painter
b.Berlin, 1913 – d.Paris, 1951

Brought up in Dresden where he trained as a violinist and photographer, Wols was also the pupil of the ethnologist Frobenius. In Paris he was in contact with the Surrealists and in 1932 began to produce drawings in Indian ink and watercolour (*Erotic Mountain*, Paris, private coll.). Between 1933 and 1935 he spent much of his time travelling, staying in the Canary Islands, from which he was eventually expelled by the Falangists. At the outbreak of war he was interned as a German citizen and freed in 1940. He then took refuge in the south of France, returning to Paris only in 1945. From 1946, without deserting watercolour, he produced more paintings, and in 1947 exhibited at René Drouin's.

▲ Konrad Witz
St Catherine and St Mary Magdalene
Wood. 161 cm × 130 cm
Strasbourg, Musée de l'Oeuvre-Notre-Dame

The inventor of tachism, Wols was the European centre of the movement embodied by Jackson Pollock across the Atlantic. His work, executed in a state of deep moral and physical distress, is that of a solitary figure, isolated from artistic circles. Until about 1940 he borrowed from the world about him: vegetable, animal, human and urban themes, from which he gradually built up a most elaborate hieroglyphical language. He recalls some aspects of the art of Klee by the firmness of his stroke and his taste for precise elaborate notations (*Witches on the Move*, c.1945, Meudon, former H.P. Roché Coll.; *Self-Portrait*, Krefeld, private coll.). Often bitter and caricatural, Wol's work embodies the painful experience of man in relationship to the universe (*The Explosion in the Cathedral*, c.1947, Meudon, former H.P. Roche Coll.).

Situated at the crossroads of Expressionism and Surrealism, Wols's art appears as a concise, precious calligraphy: dense, luxuriant networks of lines and harsh forms against backgrounds of pale, impalpable colours, usually dominated by pinks, yellows and blues (*The Magic Town*, c.1951, Freiburg-im-Breisgau, Eva Schulze-Battman Coll.). Because of his singularity and deeply existential approach, in spite of his small output, Wols has an important place in postwar art, as can be seen by his influence on the subsequent development of lyrical abstraction.

Wols also illustrated works by Kafka, Sartre, Paulham and Artaud, as well as writing poems inspired by Far Eastern mysticism. He is represented in German galleries (Hamburg, Cologne, Munich, Stuttgart), in Paris, (M.N.A.M., M.A.M. de la Ville), in Lyons Museum, and in New York (M.O.M.A.). B.Z.

Wouters
Rik

Belgian sculptor and painter
b.Malines, 1882 – d.Amsterdam, 1916

The son of a wood-carver, Wouters worked in his father's workshop and followed courses at the Academy, first in Malines, then in Brussels, where he went in 1902. He was, however, a self-taught painter. Throughout his life he practised both painting and sculpture, the former being more important until 1911. Between 1908 and 1911 he produced etchings (56 plates), mostly landscapes. Wouters married in 1905 and his wife Nel became almost his only model. His early work shows the influence of the Impressionist period of Ensor and uses a sober chromatic range, vigorously executed with a palette knife (*Self-Portrait with a Black Hat*, 1908, Antwerp, private coll.). In 1910 he settled in Boitsfort, near Brussels, where he lived until the war.

A visit to Paris in the spring of 1912 confirmed a trend, first noticeable the previous year, towards a more erotic style. Wouters visited the collections of Durand-Ruel, Vollard and Pellerin, and was particularly struck by the works of Cézanne whom he subsequently approached with a view to learning how to construct a painting using brushstrokes in high colour. Cézanne's influence is evident in the two versions of *The Ravine* (1913, Antwerp, private coll.), but Wouter's more lively temperament inclined him towards the Impressionist use of light. These influences merge in

a very warm intimism, reminiscent of Renoir (*Birthday Flowers*, 1912, Antwerp, private coll.; *Woman Ironing*, 1912, Antwerp Museum).

In 1913 Wouters exploited the contrasts of reds and greens more boldly, following the Fauves (*Red Curtains*, Brussels, private coll.; *Woman in Red*, 1913, Rotterdam, B.V.B.). Similar effects showing an equal mastery are found in the pastels of the period (*Woman Wearing a Mantilla*, Brussels, private coll.). Shortly before the war his palette had lowered in tone, admitting blues, while the themes, increasingly elliptical, left whole parts of the canvas bare (*Woman in Blue*, 1914, Brussels, private coll.).

After being called up, Wouters was interned in Holland. Since 1911 he had been suffering from headaches and, following an operation in Utrecht, he was freed in June 1915. He settled in Amsterdam where he began work again, especially on watercolours and drawings in Indian ink. After a second operation, he lost the use of one eye; a further operation failed (April 1916), and he died two months later. His late paintings are developments of earlier ones, but in some of them the form is more compact, the result of new experiments influenced by the atmosphere of Amsterdam (*Small Reclining Nude*, 1915, Brussels, private coll.).

Wouters was exceptionally gifted as a colourist and draughtsman and his *oeuvre*, produced between 1908 and 1915, is evolved from a spontaneous *joie de vivre* that few 20th-century artists have matched. His sculpted work is also important for its quality and historical range (*The Mad Virgin*, bronze, 1912). His work is in most Belgian galleries, in the Musée National d'Art Moderne in Paris (*Portrait of Nel Wouters*, 1912), in Amsterdam (Stedelijk Museum), in Rotterdam (B.V.B.) and in private collections, of which the most important is that of Ludo von Bogaert in Antwerp. M.A.S.

Wouwermans
Philips

Dutch painter
b.Haarlem, 1619 – d.Haarlem, 1668

The son and pupil of a painter, Paulus Joosten Wouwermans, Philips received lessons from Frans Hals, as well as from the equestrian painter Pieter Verbeeck, who was to have an abiding influence on him. A Protestant, Wouwermans was forced to leave Haarlem for Hamburg in about 1638 in order to marry the girl with whom he had fallen in love, a 19-year-old Catholic. He was summoned back to Haarlem in 1640, however, in

order to discharge his duties to the Guild of St Luke, of which he became Commissioner in 1645. He seems to have enjoyed a comfortable life, and a prosperous one, for he is recorded as having granted his daughter Ludovica a dowry of 20,000 florins on her marriage to the painter Fromantiou in 1672.

Wouwermans's earliest dated works go back to 1646. Among them are *The Halt* at Leipzig (Museum der bildenden Künste), with its plants *à la* Ruisdael in the foreground, and *Cavalry Making a Sortie* (London, N.G.), painted with a beautiful, free 'pre-rococo' handling, in the style of Berchem. Such paintings reveal an art already matured and perfectly formed. Besides the influence of Pieter Verbeeck, Wouwermans had also come under that of Pieter van Laer, the originator of the popular Italian genre of the *bambocciante* – although in fact, it is now known that Van Laer worked as much on landscapes and animal paintings, and was surprisingly advanced for his time. During the 1630s he introduced a whole concept of Italianate rustic landscapes, with large skilfully animated figures and with supple modulations of light that were taken up between 1640 and 1650 by a number of Dutch painters including Weenix, Berchem and Wouwermans. These views contrasted with the 'Roman ruins' with their numerous small figures, sometimes running into hundreds, and their strong contrasts of light and shade, which were cultivated by first-generation Italianists (in the 1620s) such as Poelenburgh, Carel de Hooch, Pynas and Breenbergh.

Wouwermans's was a composite, virtuoso talent, notable for its extreme facility. Although he died at the age of 48, he left over 1,000 paintings, which were admired, copied, and engraved, especially in France in the 18th century. Surrounded by pupils and with a host of imitators, he was considered to be one of the greatest names in Dutch painting of his day. Today he is underrated, a reversal of view that is probably equally exaggerated. The diversity of his inspiration alone is evidence of his stature and of the genuineness of his powers of invention and innovation.

As a landscape painter, Wouwermans, from 1645, showed himself to be one of the most gifted personalities in the Haarlem circle. Like Jacob van Ruisdael, he was fond of views of sand dunes catching the light and standing out picturesquely against cloudy skies. The popular device of the dune placed diagonally across the canvas, much used in the landscapes of Wynants, Adriaen van de Velde and Ruisdael, seems to have originated with Wouwermans, and not Wynants, as is so often claimed. Wouwermans practised pure landscape painting, as well as painting scenes filled with figures and animals. A feeling of light and distance and the sense of an infinite horizon are apparent in the views of dunes in the museums of Leipzig and Rotterdam. The latter is dated 1660, while a small landscape in the Louvre, more precise and diffident in style, seems to be one of his earliest works. The same spaciousness distinguishes the *Dunes and Horseman* of Frankfurt. Its spatial emphasis and the calm intensity of the vast panoramic background make this one of the artist's masterpieces. Wouwermans painted many more landscapes than was at one time thought, about 200 in all, among which are several winter scenes with ice and skaters, the best example being a brilliant signed grisaille in Lyons Museum which was for a long time attributed to Adriaen Pietersz van de Venne.

As well as landscapes and a few religious paint-

WOU

444

▲ Rik Wouters
Woman Ironing (1912)
Canvas. 107 cm × 123 cm
Antwerp, Musée Royal des Beaux-Arts

ings whose most common theme, because of the opportunity it afforded for chiaroscuro effects, is the *Annunciation to the Shepherds* (Aix-en-Provence Museum, Bergues Museum, Dresden, Gg), Wouwermans painted military scenes: skirmishes and cavalry, halts, military camps, inns or stables (another chance to achieve exquisite effects of chiaroscuro), river banks or shores with riders or walkers, departures and hunting scenes. One of his favourite themes is a white horse forming a patch of brightness against a sky and vegetation depicted in a gamut of delicate, velvety greys – a classic device previously exploited by the Van Ostades (Isaac's influence is very evident in Wouwermans' early works).

The development of Wouwermans's style is difficult to follow as so few works are dated, but it seems to move towards an increasingly brilliant painting, clear, detailed and complex, the warm brown palette of his early work giving way to lighter harmonies of silver-grey. The animation increases, while the evening skies, full of swirling clouds, capricious, slightly Italianized construction and subtle blue distances (some fine examples in Apsley House, London) reveal an increasingly 'rococo' art, rich and delicate, which connects him with Weenix and Berchem.

Like so many northern painters, Wouwermans often painted figures in the landscapes of his fellow-artists: Van Ruisdael, Cornelis Decker, Wynants and perhaps Hobbema. His influence was considerable, for he numbered among his pupils not only Pieter and Jan, his brothers, but also Hendrick Berckmans, Emmanuel Murant, Jan van der Bent, Koort Witholt, Jacob Warnars, Antony de Haen, Nicholaes Ficke the engraver, Hendrik de Fromantiou, Barend Gaal, Willem Schellinks and perhaps Adriaen van de Velde, as well as the Germans Jacob Weyer and Matthias Scheits.

Wouwermans had a great reputation in Germany, as proved by the number of his paintings today in German galleries such as Kassel, Dresden and Munich. He was imitated by Huchtenburg, Dirk Maas, Lingelback, Jan Falens, Dirk Stoop, Herman van Lin, Hendrik Verschung, Abraham Hondius, Ondendijk and Bock. Mention must also be made of the extraordinary spread of his engravings, especially in France during the 18th century where many of his works were in private collections. J.F.

Wright
Joseph (Wright of Derby)
English painter
b.Derby, 1734 – d.Derby, 1797

Wright was trained as a portrait painter under Thomas Hudson from 1751 to 1753 and re-entered the studio in 1756-7. Wright's first portraits are in the style of Hudson and continue in this vein until after 1760 (*Miss Catton*, St Louis, Missouri, City Art Gal.; *Thomas Bennett*, Derby Museum). His 'Candlelight' period lasted from 1760 to 1773, when he was living in Derby. During these years he was concerned especially with the play of light on surfaces and with strange effects of light. His work looks back to the painting of Honthorst and Schalken and probably has its origins in Dutch scientific paintings of the 17th century.

In Derby Wright was surrounded by a society

that was helping to create the Industrial Revolution and new experiments were in progress all around him. His *Experiment with the Air Pump* (*c.*1767-8, London, Tate Gal.) and *The Orrery* (1766, Derby Museum) reflect the interest of the Midlands in scientific enquiry. Wright also executed history paintings, a good example being *Miravan Opening the Tombs of his Ancestors* (1772, Derby Museum) where Gothic and Neoclassical elements are introduced and the whole has the eerie quality of a novel by Anne Radcliffe.

In 1773 Wright travelled to Italy and was especially inspired by the eruption of Mount Vesuvius (1774, Derby Museum, 1778, Moscow, Pushkin Museum) and the fireworks at the Castel S. Angelo (1774-5, Birmingham, City Museum; 1775-8, Liverpool, Walker Art Gal.; 1775-9, Hermitage). He used these themes on his return, in 1775, and also painted moonlight landscapes that owe something to Vernet, but are far more scientific enquiries into the natural effects of moonlight than 'Romantic' paintings.

In 1775 he moved to Bath where he hoped to take over the clientèle of Gainsborough, but he failed and in 1777 returned to Derby. Some of his best portraits were painted during this period. That of *Sir Brooke Boothby* (1781, London, Tate Gal.) shows the sitter lying in a wooded landscape, clasping a volume of Rousseau's works in his hand. Wright exhibited at the Royal Academy from 1778 onwards and was made an A.R.A. in 1781, but his loyalties were to Derby and its environs and not to London. In 1784 he painted, for Josiah Wedgwood, the pottery maker, *The Corinthian Maid*. This subject had been popularized by Hayley in a poem and it demonstrates how Wright, for his history paintings, looked to contemporary as well as classical literature.

Wright remained in Derby until his death, painting portraits, landscapes of the Peak District and history paintings. He was 'the first professional painter to express the spirit of the Industrial Revolution' and his work reveals to us the industrial society of the Midlands in the second half of the 18th century. He remained a 'provincial' painter, but in the best sense of the term. His 'history' paintings, with their combination of Gothic and Neoclassical elements, as well as his interest in contemporary literature, mark him out as one of the forerunners of the Romantic movement. Wright of Derby is principally represented in the Derby Museum whose collection includes a *Self-Portrait* (1767-70), *Sarah Carver with her Daughter* (1769-70) and *Hermit Studying a Skeleton* (*c.*1771-3). The Tate Gallery (*Lighthouse on the Coast of Tuscany*, 1789), the Wadsworth Atheneum, Hartford, Connecticut (*Old Man and Death*, *c.*1773), and especially the Mellon collection, are also well endowed. J.N.S.

Joseph Wright of Derby ▲
Experiment with the Air Pump (*c.*1767–8)
Canvas. 184 cm × 243 cm
London, Tate Gallery

Philips Wouwermans ▲
Among the Dunes (1660)
Wood. 35 cm × 31 cm
Rotterdam, Museum Boymans-van Beuningen

Zoffany
Johannes

Anglo-German painter
b.Frankfurt, 1733 – d.London, 1810

The son of Anton Franz Zauffaly, the court cabinet-maker and architect to the Prince von Thurn und Taxis, Johannes Josephus, whose surname was later corrupted in England to Zoffany, was brought up at Regensburg, Bavaria, where he was apprenticed to a local painter, Martin Speer. He completed his training under the portraitist Masucci in Rome, 1750-7 (with one short interruption). While there he learnt from Mengs the new smooth manner of painting that was one of the early features of Neoclassicism. This was to differentiate Zoffany's style not only from most artists in Germany, who were still under the spell of the Baroque, but also from his contemporaries in England. Returning to Germany in 1757, he painted decorative scenes (now lost) in the episcopal palaces at Coblenz and Trier.

In 1760 Zoffany moved to England, presumably in search of wider circles of patronage. His chance came in 1762 when he was taken up by the actor David Garrick, then at the height of his fame. In that year Zoffany painted Garrick, performing his own theatrical 'interlude', *The Farmer's Return*, and also two scenes showing the Garrick household relaxing in the grounds of their villa at Hampton, Middlesex (all three pictures, Great Britain, Lambton Coll.). These paintings reveal how quickly Zoffany adapted his style to English taste. Both pictorial types had been established by Hogarth but by the 1760s they had been refined into gentility. For both, Zoffany used the conventions of the 'conversation piece' (*The Farmer's Return* being treated more like the illustration to a novel than a play), that is to say, the figures are 9-12 in. high, the setting is depicted with as much care as the figures, and the mood is cheerful and relaxed.

Virtually all Zoffany's theatrical scenes, a genre of which he made a speciality, belong to the 1760s but he continued to paint group portraits as conversation pieces, both indoors and outdoors, with the figures growing larger, almost to the end of his career. Thanks perhaps to the artist's German upbringing, their costumes and settings are treated with an unusual amount of detail, suggesting that these pictures can be taken as useful evidence of contemporary garden design, styles of furnishing and so on, but it seems that he may have touched up reality somewhat for the sake of pictorial effect.

By 1764, Zoffany was introduced to Queen Charlotte, who was herself German by birth, and for the next ten years he worked actively for the royal family, portraying them in a domestic light as no painter had been invited to do before by a British monarch (*Queen Charlotte and her Two Eldest Sons*, c.1765, Great Britain, Royal Coll.). In 1769 he was nominated a member of the Royal Academy by its patron George III, and in 1771 he painted for the King *The Academicians of the Royal Academy* (Great Britain Royal Coll.), showing the members standing or seated chatting in carefully posed groups in the Life Room, with the symbols of their trade – classical casts – on the wall behind them.

The following year he was sent by the Queen to Florence to execute a rather similar painting,

with English visitors in the foreground, of *The Tribuna of the Uffizi* (London, Buckingham Palace, Royal Collection). He stayed abroad from 1772 to 1779, working for the courts of Florence and Vienna and being much fêted. However, his luck deserted him after his return to England in the latter year and, to recover his fortunes, he went to India where he remained from 1783 to 1789, painting, inter alia, a *Last Supper* for St John's Church, Calcutta. Among his last pictures, executed when he was once more in England, were the strange *Plundering of the King's Cellar at Paris* (1794, Great Britain, private coll.), stylistically a mixture of Rubens and Hogarth, and the even stranger *Death of Captain Cook* (c.1795, Greenwich, National Maritime Museum), which Zoffany treated as a history painting, employing poses from the antique and Raphael indiscriminately both for the South Sea islanders (those 'noble savages') who murdered Cook and for the English sailors.

Zoffany succeeded initially in England because of his professionalism, the charm of his paintings and his mastery of sharp, clear detail. However, while his later work reflected the expansion of English painting into new fields during this period, his compositions became increasingly stiff and overcrowded and his style lacked that in-

fusion of poetry which distinguished English art on the threshold of Romanticism. M.K.

Zuccaro
Taddeo

Italian painter
b.San Angelo in Vado, 1529 – d.Rome, 1566

Taddeo Zuccaro is one of the most important personalities in the second half of the 16th century in Rome. He played a determining role in the evolution of decorative and monumental painting from about 1550, comparable to that played in the previous generation by Perino del Vaga, Polidoro da Caravaggio or Parmigianino. His influence was prolonged beyond his short working life thanks largely to his brother Federico, who joined him in Rome in 1550 and collaborated with him on several occasions: in Bracciano Castle, the Sala Regia in the Vatican and in the Church of S. Maria dell'Orto. Minor artists such as Raffaellino da Reggio, Cesare Nebbia and Nicolò Tromettà followed his style so closely that the term 'Zuccaresque' became the usual way of defining an

▲ Johannes Zoffany
Charles Towneley and his Friends
Canvas. 127 cm × 99 cm
Burnley, Towneley Hall Art Gallery

important part of the graphic production of the end of the 16th century (resulting in a certain confusion in the appreciation of Zuccaro's drawing and that of his imitators). His painting, mostly in fresco, and well described by Vasari, was mainly carried out in and around Rome.

Born in The Marches, like Barocci, his junior by a few years, he came to Rome in 1543-4, and spent the rest of his life in the city, except for a journey to Urbino and to Verona in 1551-2, to attend the wedding of Vittoria della Rovere, daughter of Duke Guidobaldo; he may also have visited Florence in 1564-5.

Zuccaro's drawings (examples of which are to be found in the major galleries) are numerous and varied, and at times very free in handling. They provide the basis for reconstructing the chronology of his paintings, known from old descriptions, but often lost, in particular those of his early activity during the years 1548-53.

In Rome Zuccaro attracted the patronage of Pope Julius III (elected in 1550), and began as a painter of facades in the genre already practised by Polidoro da Caravaggio and Perino del Vaga. He painted the *trompe-l'oeil* work in the Mattei Palace, of which only the preparatory sketches survive (1548, *Story of Camilla*), then was commissioned by the Pope to carry out part of the decoration in the Villa Giulia (*Triumph of Apollo, Triumph of Flora*), a complex work directed by Vasari and Prospero Fontana (1553-5).

At the same time Zuccaro began two of his most important works: the decoration for the Mattei chapel at the Church of S. Maria della Consolazione (1553-6, *Scenes from the Life of Christ, Prophets* and *Sybils*); and for the Frangipani chapel at the Church of S. Marcello al Corso (1558-9, *Scenes from the Life of St Paul*, unfinished). Still for Julius III, Zuccaro worked in the Belvedere in the Vatican (*Moses and Aaron before Pharaoh*) and, in March 1559, took part in the mournful pomp of the Emperor Charles V's funeral at the Church of S. Giacomo degli Spagnoli. He replaced Francesco Salviati in carrying out the decoration in the Sala di Fasti Farnesiani in the Farnese Palace in Rome, which was interrupted by the death of Duke Ranuccio in 1565.

At the same time he worked on one of the major cycles of decorations of those years: that of the Farnese Palace at Caprarola, the iconographic scheme of which, derived from the humanist Annibale Caro (frescoes in the Anticamera del Concilio, in the Stanza di Aurora, in the Stanza dei Lancefici and in the Stanza della Solitudine), already shows the reaction to Mannerism initiated by the Council of Trent.

Zuccaro's last five years were mainly devoted to work done for the Vatican: in the Cortile della Libreria, in the Sala Regia (*The Donation of Charlemagne, The Siege of Tunis*), and religious decorations, the chief ones being those in the

Pucci chapel at the Church of S. Trinità dei Monti, undertaken in 1563 for the Bishop of Corfu (*Scenes from the Life of the Virgin*) and those in the Cappella Maggiore at the Church of S. Maria dell'Orto.

F.V.

Zurbarán
Francisco de

Spanish painter
b.Fuente de Cantos, 1598 – d.Madrid, 1664

The son of an established Basque merchant who married in Estremadura, Zurbarán left for Seville in 1613. He became apprenticed to a painter of devotional images, Pedro Diaz de Villanueva, who has left no known works. In 1617 Zurbarán settled in Llerena, a town in southern Estremadura, where he married, and remained for more than ten years. He worked for various convents in Estremadura and Seville. His first dated work to have survived (an *Immaculate Conception*, 1616, Bilbao, Valdés Coll.) shows his knowledge of Italian etchings, and his taste for curved and sculptural masses.

The paintings whose dates cause so much controversy probably belong to these early years. Coming from the Charterhouse of Triana they were passed to the museum in Seville (*The Virgin of the Carthusians, St Hugh in the Refectory of the Charterhouse, St Bruno and the Pope*). These are pictures in which the clear tone values and the drama of the arrangement are evidence of the artist's youth. In 1626 Zurbarán began a cycle of paintings with Dominican themes for the monastery at Seville (Seville Museum and the Church of the Magdalene). Traces of tenebrism are already evident: the violent contrasts of light, the compact structure, the skilful handling of the paint (*St Gregory, St Ambrose*, Seville Museum) were henceforth to characterize Zurbarán's style.

In 1628 Zurbarán entered into a contract to paint a series of pictures for the Convent of Mercy in Seville in collaboration with Francisco Reyna whose individual style is now unknown. In these paintings, signed by Zurbarán (*Vision of St Peter Nolasco*, 1629, Prado; *Recovery of the Image of the Virgin of El Puig*, 1630, Cincinnati Museum) the

tenebrism is stronger, painted in a very distinctive gamut of golden tones. From 1629 he was painting another series, this time for the Franciscan College of S. Buenaventura, begun by the elder Herrera (Dresden, Gg; Berlin Museum [destroyed in 1945]; Louvre). These are probably the most solidly constructed paintings in his whole *oeuvre*, and those in which his religious fervour is most intensely expressed.

In this fruitful year (1629) the municipality of Seville invited Zurbarán to establish his home in the city; the artist accepted, and settled there with his second wife, Beatriz de Morales, and his children. His admirers protected him against the hostility of local artists, jealous of his success. He was commissioned to paint an *Immaculate Conception* for the town hall (almost certainly the painting discovered in 1963 at the college of Jadraque with the *Port of Seville* and the *Giralda*).

The decade which began in 1630 was the most prolific and happy in the whole of Zurbarán's career. The large Dominican painting, *The Triumph of St Thomas Aquinas* (1631, Seville Museum) is, despite its old-fashioned arrangement, still Mannerist in style. Constructed in two superimposed parts, it is a masterly work, quite exceptional in its realism, the richness of its colour, and the intensity of feeling on the faces.

In 1634 Zurbarán was called to Madrid, probably at Velázquez's recommendation (they had already known each other in Seville). For the new royal palace of Buen Retiro Zurbarán executed a mythological series (*Labours of Hercules*, Prado) and battle paintings (*Siege of Cadiz*, Prado). In 1637 he began the cycle for the Charterhouse of Jerez (today, divided between the Metropolitan Museum and the museums of Cadiz, Grenoble and Poznán), which counts among his major works. The large paintings for the altarpiece (*The Annunciation, The Adoration of the Shepherds, The Epiphany, The Circumcision*, Grenoble Museum; *The Battle of Jerez*, Metropolitan Museum; *The Vision of St Bruno*, Cadiz Museum) have a solemn and slightly theatrical feeling, and are overshadowed by the series of small figures of Carthusians which form a frieze along the corridor leading to the chapel of the Holy Sacrament (*Sagrario*). The intensity of mysticism is expressed here with great power: *St Anthelm, The Blessed John Houghton, Cardinal Albergati* (Cadiz Museum) emerge from the dark background, powerfully tenebrist, their faces lit with spiritual fervour.

◀ Taddeo Zuccaro
The Donation of Charlemagne
Fresco in the Sala Regia
The Vatican

Francisco de Zurbarán ▲
Still Life (1633)
Canvas. 60 cm × 107 cm
Pasadena, California, Norton Simon Foundation

During this time, from 1638, Zurbarán decorated the sacristy of the monastery at Guadalupe (Cáceres), a famous sanctuary of the Hieronymite Order. This cycle, the only one to have survived in its original position, was not completed until 1645. In the huge pictures dedicated to the life of St Jerome, the tenebrism is even stronger, recalling Ribera whose work Zurbarán may have seen in Madrid in 1634 (*Temptation of St Jerome*). In the paintings showing the principal figures in the Hieronymite Order (*Temptation of Fray Diego de Orgaz, Vision of Fray Pedro de Salamanca*) violent contrasts of light alternate with a solemn peace in scenes of monastic life, filled with a meditative intensity and a mystical concentration (*Apparition of Christ to Fray Andrés Salmerón, Fray Gonzalo, P. de Illescas Writing*). But after this enormous enterprise there is no further trace of monastic commissions.

Murillo became fashionable in Seville, and it seems that Zurbarán, seeing his secular clientèle diminishing, began exporting paintings to Spanish colonies in the New World, with the help of a studio of doubtful reputation. Many documentary sources bear witness to the importance of these cycles; *Apostles, Founders of Religious Orders, Virgin Saints* and *Roman Emperors* were sent to America. Some have been located (*Apostles* in the Church of S. Domingo, Guatemala City, and the Church of S. Francisco in Lima; *Holy Founders* in the monastery of Buena Muerte, Lima) and show great unevenness throughout.

In 1643 Zurbarán painted an altarpiece for the town of Zafra in Estremadura, a fine work, with clear tonalities and a draughtsmanship that is already Baroque.

From Zurbarán's final period only isolated works have been preserved. They are, nevertheless, dated, and allow one to follow his development, and to place the many paintings which have neither documentation or dates. In 1658 Zurbarán returned to Madrid and renewed his acquaintance with Velázquez at the time of the inquiries and procedings (at which he acted as witness) that dragged on before Philip IV made Velázquez a Knight of the Order of Santiago. This was the beginning of his final period of residence in Madrid. Zurbarán, married for the third time, with small children, was a prey to financial difficulties, and may have hoped for the support of Velázquez in finding commissions at court. From this time on, his production consisted of altarpieces or paintings for private chapels, often executed in a small format with a more lyrical treatment of light, and sometimes a smoother, more mellow handling, unknown in his early works or in his maturity (*Christ after the Flagellation*, 1661, church of Jadraque; *Virgin with the Child Jesus and St John*, Bilbao Museum; *The Immaculate Conception*, 1661, Langon Church, Bordeaux, and Budapest Museum). The inventory made after his death shows that he died in virtual poverty.

Zurbarán stands at the core of Spanish painting, and may be seen as the embodiment of certain characteristic traits of the 'Golden Age': a realism full of human simplicity, a deep understanding of monastic spirituality in its most noble aspects, a concern for the humble face of everyday life to which he brought great imaginative strength yet tenderness in depicting the smallest details. His early work is marked by a taste for broad forms and solid masses which found magnificent expression in his *Christ on the Cross* (1627, Chicago, Art Inst.) which, in the half-light of the railed-in

chapel where the Dominicans of Seville placed it, was sometimes mistaken for a sculpture. There is the same effect in the treatment of materials in the processional figures of saints (*St Casilda*, Prado; *St Margaret*, London, N.G.).

Zurbarán's love of objects is revealed in the details of his large paintings, in which he always places a small piece of still life – a book, flowers, a jug. This love of realism appears, too, in some of his intimate religious works (*The Infant Virgin in Ecstasy*, Jerez, Collegiate Church; *The Infant Jesus Pricked by a Crown of Thorns*, Cleveland Museum; Seville, Sánchez Ramos Coll.), as well as in several

bodegones – cups, apples, lemons – which are considered to be masterpieces of the genre (1635, Pasadena, Norton Simon Coll.; Prado). His gift for understanding individuals made him an excellent portraitist (Series of *Doctors of Mercy*, Madrid, Acad. S. Fernando; *Doctor of Salamanca*, Boston, Gardner Museum). Zurbarán was clumsy at composing scenes and often had recourse to Flemish etchings; but his austerity, his silent calm, his great gifts as a colourist and the wonderful humility of his naturalism place him among the masters of the 17th century who most closely approach the modern sensibility.　A.E.P.S.

▲ Francisco de Zurbarán
The Adoration of the Shepherds (1638)
Canvas. 267 cm × 185 cm (Painting from the altarpiece of the Charterhouse of Jerez de la Frontera)
Grenoble, Musée de Peinture et de Sculpture

Bibliography

NOTE. The bibliography has been set out according to the following principles. The only general works included are books serving as basic reference material and the collective body of works dealing with the different schools of painting. As far as the artists are concerned, descriptive catalogues are given first and, if these are not available, the most important works, or articles which include lists of works, and finally exhibition catalogues and, in certain cases, the correspondence or the writings of the artists themselves. Because of this selection a small number of artists do not have a bibliography.

The oldest publications are mentioned first. If more than one was published in the same year the order is alphabetical. The abbreviation *op. cit.* refers the reader to the general works, in the absence of a specific mention. The initials K. d. K. are used to designate the Klassiker der Kunst collection. The initials Cl. d. A. refer to the collections Classici dell'Arte or Classiques de l'Art. The date of publication given is, as far as possible, the most recent.

General Works

DICTIONARIES

U. Thieme et F. Becker, *Allgemeines Lexikon der Bildenden Künstler von der Antike bis zur Gegenwart*, 37 volumes (Leipzig, 1907–50, 2nd ed. 1947–55).
H. Vollmer, *Künstler Lexikon des Zwanzigsten jahrhunderts*, 6 volumes (Leipzig, 1953–62).

BY COUNTRY

Austria
14th–15th centuries
O. Pächt, *Österreichische Tafelmalerei der Gotik* (Vienna, 1929).

Czechoslovakia
14th–15th centuries
A. Matějček, *Ceská malba gotická, deskove maliřstivi (1350–1450)* (Prague, 1950).

15th–16th centuries
J. Pešina, *Ceská malba pozdni gotiky a renesance* (Prague, 1955).
A. Matějček and J. Pešina, *la Peinture gothique tchèque, 1350–1450* (Prague, 1955).

Flanders
15th–16th centuries
M. J. Friedländer, *Die Altniederländische Malerei*, 14 volumes (Berlin-Leiden, 1924–37). English edition, *Early Netherlandish Painting*, 12 volumes published, (Leiden-Brussels, 1967–75).
E. Panofsky, *Early Netherlandish Painting. Its Origins and Character*, 2 volumes (Cambridge, 1953).

17th century
Y. Thiéry, *le Paysage flamand au XVIIᵉ siècle* (Paris-Brussels, 1953).
E. Greindl, *les Peintres flamands de nature morte au XVIIᵉ siècle* (Paris-Brussels, 1956).
M. L. Hairs, *les Peintres flamands de fleurs au XVIIᵉ siècle* (Paris-Brussels, 1965).

France
14th–15th centuries
C. Jacques (Sterling), *la Peinture française. Les Peintres du Moyen Age* (Paris, 1941).
G. Ring, *la Peinture française du XVᵉ siècle* (Paris-London, 1949).
M. Meiss, *French Painting in the time of Jean de Berry*, 5 volumes (London, 1967–74).

18th century
L. Dimier, *les Peintres français du XVIIIᵉ siècle. Histoire des vies et catalogue des œuvres*, 2 volumes (Paris-Brussels, 1928–30).

Germany
14th–15th centuries
A. Stange, *Deutsche Malerei der Gotik*, 11 volumes (Berlin-Munich, 1934–61).

Italy
13th–16th centuries
R. Van Marle, *The Development of the Italian School of Painting*, 19 volumes (The Hague, 1923–38).
R. Offiner, *A Critical and Historical Corpus of Florentine Painting*, 8 volumes (New York, 1930–58), 5 volumes (New York, 1962–69, with K. Steinweg, volumes III, IV, V).
R. Longhi, *Edizione delle opere complete di Roberto Longhi*, 7 volumes (Florence, 1956–74).
B. Berenson, *Italian Pictures of the Renaissance*, 7 volumes (London, 1957–68).
R. Palluchini, *La Pittura veneziana del Trecento* (Venice-Rome, 1964).
C. Volpe, *La Pittura riminese del Trecento* (Milan, 1965).
P. Zampetti, *La Pittura marchigiana del'400* (Milan).
M. Boskovits, *Pittura fiorentina alla vigilia del Rinascimento 1370–1400* (Florence, 1975).

17th century
H. Voss, *Die Malerei des Barok in Rom* (Berlin, 1924).

18th century
R. Pallucchini, *La Pittura veneziana del Settecento* (Venice-Rome, 1960).

Netherlands
16th century
G. J. Hoogewerff, *De Noord-Nederlandische · Schilderkunst*, 5 volumes (The Hague, 1936–47).

17th century
C. Hofstede De Groot, *Beschreibendes und kritisches Verzeichnis der Werke der hervorragendsten holländischen Maler des XVII. Jahrhunderts*, 10 volumes (Paris-Esslingen, 1907–20).

Spain
14th–16th centuries
C. R. Post, *A History of Spanish Painting*, 12 volumes (Cambridge, 1930–58; volumes 13, 14 published by H. E. Wethey, Cambridge, 1966).

17th century
D. Angulo-Iniguez and A.E. Perez-Sanchez, *Historia de la pintura española. Escuela madrileña del primer tercio del siglo XVII* (Madrid, 1969).
D. Angulo-Iniguez and A. E. Perez-Sánchez, *Historia de la pintura española. Escuela toledana de la primera mitad del siglo XVII* (Madrid, 1972).

Engraving

A. Bartsch, *Le Peintre-Graveur*, 21 volumes (Vienna, 1803–21).
A. P. F. Robert Dumesnil, *le Peintre-Graveur français*, 10 volumes (Paris, 1835–71).
C. Le Blanc, *Manuel de l'amateur d'estampes*, 4 volumes (Paris, 1854–89).

L. Delteil, *le Peintre-Graveur illustré*, 32 volumes (Paris, 1906–30).
M. Lehrs, *Geschichte und kritischer Katalog des deutschen niederländischen und französischen Kupferstichs im XV. Jahrhundert*, 9 volumes (Vienna, 1908–34).
L. Delteil, *Manuel de l'amateur d'estampes du XVIIIᵉ siècle* (Paris, 1911).
L. Delteil, *Manuel de l'amateur d'estampes des XIXᵉ et XXᵉ siècles*, 4 volumes (Paris, 1925–6).
W. L. Schreiber, *Handbuch der Holz- und Metallschnitte des XV, Jahrhunderts* (Leipzig, 1926–30).
A. H. Hind, *Early Italian Engraving*, 7 volumes (London, 1938–48).
F. W. Hollstein, *Dutch and Flemish Etchings, Engravings and Woodcuts ca. 1450–1700*, 19 volumes (Amsterdam, 1949–74).
F. W. Hollstein, *German Engravings, Etchings and Woodcuts ca. 1400–1700*, 9 volumes published (Amsterdam, 1954–75).

Individual Painters

Abbate
S. Béguin, *catalogue de l'exposition Nicolo dell'Abate.* (Bologna, 1969).

Aertsen
J. Sievers, *Pieter Aertsen. Ein Beitrag zur Geschichte der niederländischen Kunst im XVI, Jahrhundert* (Leipzig, 1908).

Albers
E. Gomringer, *Josef Albers. Son œuvre et sa contribution à la figuration visuelle au cours du XXᵉ siècle* (Paris, 1972).

Alma-Tadema
V. G. Swanson, *Sir Lawrence Alma-Tadema* (London, 1977).

Altdorfer
F. Winzinger, *Albrecht Altdorfer-Zeichnungen* (Munich, 1952).
F. Winzinger, *Albrecht Altdorfer-Graphik* (Munich, 1963).
E. Ruhmer, *Albrecht Altdorfer* (Munich, 1965).
F. Winzinger, *Albrecht Altdorfer* (Munich-Zurich, 1975).

Altichiero
G. L. Mellini, *Altichiero e Jacopo Avanzi* (Milan, 1965).

Andrea del Castagno
M. Salmi, *Paolo Uccello, Andrea del Castagno, Domenico Veneziano* (Paris, 1939).
M. Salmi, *Andrea del Castagno* (Novara, 1961).

Andrea del Sarto
S. I. Freedberg, *Andrea del Sarto*, 2 volumes (Cambridge, Mass., 1963).
R. Monti, *Andrea del Sarto* (Milan, 1965).
J. Shearman, *Andrea del Sarto*, 2 volumes (Oxford, 1965).

Angelico
F. Schottmüller, *Fra Angelico da Fiesole*, K.d.K. (Stuttgart-Leipzig, 1911).
A. Berne-Joffroy and U. Baldini, *Tout l'œuvre peint de Fra Angelico*, Cl. d. A. (Paris, 1973).
J. Pope-Hennessy, *Fra Angelico* (London, 1974).

Antonello da Messina
S. Bottari, *Antonello* (Milan-Messina, 1953).
L. Sciascia and G. Mandel, *L'Opera completa dell'Antonello da Messina*, Cl. d. A. (Milan, 1967).

Audubon
W. Vogt, *The Birds of America by J. J. Audubon* (New York, 1937).

Baciccio
R. Engass, *The Painting of Baciccio* (Philadelphia, 1964).

Bacon
R. Alley and J. Rothenstein, *Francis Bacon* (London, 1964).
Exhibition Catalogue, *Bacon* (Paris-Düsseldorf, 1972).

Baldung
C. Koch, *Die Zeichnungen Hans Baldung Griens* (Berlin, 1941).
J. Lauts and C. Koch, Exhibition Catalogue, *Hans Baldung Griens* (Karlsruhe, 1959).

Balla
M. Fagiolo dell'Arco, *Futur Balla* (Rome, 1970).

Balthus
Exhibition Catalogue, *Balthus* (London, 1968).

Barbari
A. de Hevesy, *Jacopo de Barbari. Le Maître au caducée* (Paris-Brussels, 1925).
L. Servolini, *Jacopo di Barbari* (Padua 1944).

Barocci
H. Olsen, *Federico Barocci* Copenhagen, 1962.
A. Emiliani and G. Gaeta Bertela, Exhibition Catalogue, *Federico Barocci* (Bologna, 1975).

Bartolommeo
H. von der Gabelentz, *Fra Bartolomeo und die florentinische Renaissance*, 2 volumes (Florence, 1922).

Bassano
E. Arslian, *I Bassano*, 2 volumes (Milan, 1960).

Batoni
E. Emmerling, *Pompeo Batoni, sein Leben und sein Werk* (Darmstadt, 1932).
I. Belli Barsali, Exhibition Catalogue, *Pompeo Batoni* (Lucca, 1967).

Bazaine
J. Tardieu, J.-C. Schneider, V. Bosson, *Bazaine* (Paris, 1975).

Beardsley
S. Weintraub, *Beardsley* (London, 1972).

Beccafumi
D. Sanminiatelli, *Domenico Beccafumi* (Milan, 1967).

Beckmann
B. Reifenberg and W. Hausenstein, *Max Beckmann* (Munich, 1949).
L.-G. Buccheim, *Max Beckmann.* (Feldafing, 1959).
K. Gallwitz, Exhibition Catalogue, *Max Beckmann : graphische Werk* (Karlsruhe, 1962).

Bellange
N. Walch, *Die Radierungen des Jacques Bellange* (Munich, 1971).

Bellini, Jacopo
V. Goloubew, *les Dessins de Jacopo Bellini au Louvre et au British Museum*, 2 volumes (Brussels, 1908–12).

Bellini, Giovanni
G. Gronau, *Giovanni Bellini*, K. d. K. (Stuttgart-Berlin, 1930).
R. Pallucchini, *Giovanni Bellini* (Milan, 1959).
Y. Bonnefoy and T. Pignatti, *Tout l'œuvre peint de Giovanni Bellini*, Cl. d. A. (Paris, 1975).

Bellotto
S. Kozakiewicz, *Bernardo Bellotto*, 2 volumes (London, 1972).
E. Camesasca, *L'Opera completa di Bernardo Bellotto*, Cl. d. A. (Milan, 1974).

Bellows
M. Sharp Young, *The Paintings of George Bellows* (New York, 1973).

Berchem
Hofstede De Groot, *op. cit.*
E. Schaar, *Studien zu Nicolaes Berchem* (Cologne, 1958).

Berghe
E. Langui, *Frits Van den Berghe* (Brussels, 1966).

Bermejo
E. Young, *Bartolomé Bermejo* (London, 1975).

Berruguete
R. Lainez-Alcalà, *Pedro Berruguete Pintor de Castilla* (Madrid, 1935).

Bertram
F. A. Martens, *Meister Bertram Herunft, Werk und Wirken* (Berlin, 1936).
A. Dorner, *Meister Bertram von Minden* (Berlin, 1937).
H. Platte, *Meister Bertram, Schöpfungsgeschichte* (Stuttgart, 1956).

Blake, Peter
Exhibition Catalogue, *Peter Blake* (Amsterdam, 1973).

Blake, William
D. Bindman, Exhibition Catalogue, *William Blake.* (Hamburg, 1975).

Blechen
P. O. Rave, *Karl Blechen, Leben. Würdigung. Werk* (Berlin, 1940).

Bles
Friedländer, *op. cit.*

Bloemaert
B. Delbanco, *Der Maler Abraham Bloemaert* (Strasbourg, 1928).

Boccioni
A. Palazzeschi et G. Bruno, *Tuta l'opera di Boccioni*, Cl. d. A. (Milan, 1969).
P. Bellini, *Catalogo completo dell'opera grafica di Boccioni* (Milan, 1972).

Böcklin
H.-A. Schmid, *Arnold Böcklin* (Munich, 1923).
Exhibition Catalogue, *Arnold Böcklin.* (Düsseldorf, 1974).

Boilly
P. Marmottan, *le Peintre Louis-Léopold Boilly* (Paris, 1913).

Bonington
A. Dubuisson and C. E. Hughes, *Richard Parkes Bonington, his life and work* (London, 1924).
A. Curthis, *Catalogue de l'œuvre lithographié et gravé de Richard Parkes Bonington* (Paris, 1939).
A. Shirley, *Bonington* (London, 1940).

Bonnard
C. Roger-Marx, *Bonnard lithographe* (Monte-Carlo, 1952).
J. and H. Dauberville, *Bonnard. Catalogue raisonné de l'œuvre peint*, 4 volumes (Paris 1965–74).

Borch
S. J. Gudliaugsson, *Gerard Ter Borch*, 2 volumes, (The Hague, 1959).
Exhibition Catalogue, *Ter Borch* (The Hague, 1974).

Borrassa
J. Gudiol Ricart, *Borrassa* (Barcelona, 1953).

Bosch
C. de Tolnay, *Hieronymus Bosch* (Paris, 1967).
M. J. Friedländer and M. Cinotti, *Tout l'œuvre peint de Jérôme Bosch*, Cl. d. A. (Paris, 1967).
R. H. Marijnissen, *Jérôme Bosch.* (Brussels, 1972).

Botticelli
W. von Bode, *Botticelli*, K. d. K. (Stuttgart-Berlin-Leipzig, 1926).
C. Gamba, *Botticelli* (Milan, 1936).
A. Chastel and G. Mandel, *Tout l'œuvre peint de Botticelli*, Cl. d. A. (Paris, 1968).

Boucher
A. Ananoff, *l'Œuvre dessiné de François Boucher*, Volume 1 (Paris, 1966).

Boudin
R. Schmit, *Eugène Boudin, catalogue raisonné de l'œuvre peint*, 3 volumes (Paris, 1973).

Bouts
W. Schöne, *Dieric Bouts und seine Schule* (Berlin, 1938).
Exhibition Catalogue, *Dirk Bouts en zijn tijd* (Louvain, 1975).

Braque
E. Engelberts and W. Hofman, *L'œuvre graphique de Georges Braque* (Lausanne, 1961).
N. S. Mangin, *Catalogue de l'œuvre peint de Braque*, 6 volumes published (Paris, 1959–73).

P. Descargues and M. Carrà, *Tout l'œuvre peint de Braque, 1908–1929*, Cl. d. A. (Paris, 1973).

Breitner
A. Van Schendel, *Breitner* (Amsterdam, 1939).

Bril
Thiéry, *op. cit.*

Bronzino
A. Emiliani, *Il Bronzino* (Busto Arsizio, 1960).
E. Baccheschi, *Tutta l'opera di Bronzino*, Cl. d. A. (Milan, 1973).

Brouwer
W. von Bode, *Adriaen Brouwer, sein Leben und seine Werke* (Berlin, 1924).
G. Knuttel, *Adrien Brouwer. The Master and his Work* (The Hague, 1962).

Brown
F. M. Hueffer, *Ford Madox Brown* (London, 1896).
M. Bennett, Exhibition Catalogue, *Ford Madox Brown* (Liverpool, 1964).

Bruegel, Pieter
G. Glück, *Bruegels Gemälde* (Vienna, 1932).
J. Lavalleye, *Lucas de Leyde, Peter Bruegel l'Ancien, Gravures* (Paris, 1966).
L. Münz, *Bruegel : the Drawings* (London, 1968).
C. de Tolnay and P. Bianconi, *Tout l'œuvre peint de Bruegel*, Cl. d. A. (Paris, 1968).
J. Rousseau and B. Claessens, *Notre Bruegel* (Antwerp, 1969).
F. Grossmann, *Bruegel. The Paintings* (London, 1973).

Bruegel, Jan
M. Eemans, *Brueghel de Velours.* (Paris-Brussels, 1964).

Brugghen
B. Nicholson, *Hendrik Ter Brugghen* (London, 1958).

Burgkmair
K. Feuchtmayr, *Das Malerwerk H. Burgkmairs von Augsburg, kritisches Verzeichnis der Gemälde des Meisters* (Augsburg, 1931).
T. Falk, *Hans Burgkmair. Studien zu Leben und Werk des Augsburger Malers* (Munich, 1968).

Burne-Jones
M. Harrison and B. Waters, *Burne-Jones* (London, 1973).
J. Christian, Exhibition Catalogue, *Burne-Jones* (London, 1975).

Callot
J. Lieure, *Jacques Callot. Catalogue de l'œuvre gravé*, 8 volumes (Paris, 1924–29).
D. Ternois, *Jacques Callot. Catalogue complet de son l'œuvre dessiné* (Paris, 1962). *L'Art de Jacques Callot* (Paris, 1962).

Campin
M. Davies, *Rogier Van der Weyden* (London, 1972).

Canaletto
W. G. Constable and J. G. Links, *Canaletto* (Oxford, 1965).
P. Rosenberg and L. Puppi, *Tout l'œuvre peint de Canaletto*, Cl. d. A. (Paris, 1975).

Cano
H. E. Wethey, *Alonso Cano, Painter, Sculptor and Architect* (Princeton, 1955).
Exhibition Catalogue, *Alonso Cano* (Granada, 1967).

Cappelle
Hofstede De Groot, *op. cit.*

Caravaggio
L. Venturi, *Il Caravaggio* (Rome, 1925).
R. Longhi, *Il Caravaggio* (Milan, 1952).
A. Chastel and A. Ottino della Chiesa, *Tout l'œuvre peint du Caravage* (Paris, 1967).
R. Longhi, *Il Caravaggio* (Rome, 1968).

Carpaccio
G. Fiocco, *Carpaccio* (Paris, 1931).
J. Lauts, *Carpaccio* (London, 1962).
P. Zampetti, Exhibition Catalogue, *Carpaccio* (Venice, 1963).
M. Muraro, *Carpaccio* (Florence, 1966).
M. Cangogni and G. Perocco, *L'Opera completa di Carpaccio*, Cl. d. A. (Milan, 1967).

Carracci
C. Gnudi, F. Arcangeli, M. Calvesi, G. C. Calvesi, Exhibition Catalogue, *I Carracci*, 2 volumes (Bologna, 1958).

Carracci, Annibale
D. Posner, *Annibale Carracci*, 2 volumes (London, 1971).

Carracci, Lodovico
H. Bodmer, *Ludovico Carracci* (Burg, 1939).

Carreño
D. Berjano y Escobar, *El pintor Juan Carreño de Miranda*, (Madrid).
J. Barettini Fernandez, *Juan Carreño, Pintor de camara de Carlos II* (Madrid, 1972).

Cassatt
A. D. Breeskin, *Mary Cassatt. A Catalogue Raisonné of the Oils, Pastels, Watercolours and Drawings* (Washington, 1970).

Castiglione
G. Delogu, *Giovanni Benedetto Castiglione, detto il Grechetto* (Bologna, 1928).
A. Percy, Exhibition Catalogue, *Giovanni Benedetto Castiglione* (Philadelphia, 1971).

Cavallini
G. Matthiae, *Pietro Cavallini* (Rome, 1972).

Cavallino
A. de Rinaldis, *Bernardo Cavallino* (Rome, 1921).

Cézanne
L. Venturi, *Cézanne, son art, son œuvre*, 2 volumes (Paris, 1936).
G. Picon and S. Orienti, *Tout l'œuvre peint de Cézanne*, Cl. d. A. (Paris, 1975).

Chagall
F. Meyer, *Chagall* (Paris, 1964).
F. Mourlot and C. Sorlier, *Chagall lithographe*, 3 volumes (Paris 1960–69).
E. W. Kornfeld, *Marc Chagall, l'œuvre gravé*, (Bern, 1970).

Champaigne
B. Dorival, Exhibition Catalogue, *Philippe de Champaigne.* (Paris, 1952).
B. Dorival, *Philippe de Champaigne*, 2 volumes (Paris, 1976).

Chardin
G. Wildenstein, *Chardin* (Zürich, 1963).

Chase
A. Story, *William Merritt Chase* (Santa Barbara, 1964).

Chassériau
L. Bénédite, *Théodore Chassériau, sa vie, son œuvre* (Paris, 1931).
M. Sandoz, *Théodore Chassériau, catalogue raisonné des peintures et estampes* (Paris, 1974).

Church
D. C. Huntington, *The Landscapes of Frederick Edwin Church* (New York, 1966).

Cima da Conegliano
L. Coletti, *Cima da Conegliano* (Venice, 1959).
L. Menegazzi, Exhibition Catalogue, *Cima da Conegliano* (Venice, 1962).

Cimabue
A. Nicholson, *Cimabue, a Critical Study* (Princeton, 1932).
E. Battisti, *Cimabue* (Milan, 1963).
E. Sindonia, *Cimabue e il momento figurativo pregiottesco*, Cl. d. A. (Milan, 1975).

Claesz
Hofstede De Groot, *op. cit.*

Claude
M. Röthisberger, *Claude Lorrain. The Paintings : Critical Catalogue*, 2 volumes (New Haven, 1961).
M. Röthlisberger, *Claude Lorrain. The Drawings*, 2 volumes (Berkeley-Los Angeles, 1968).

Clouet
E. Moreau-Nélaton, *les Clouet et leurs émules*, 3 volumes (Paris, 1924).
P. Mellen, *Jean Clouet. Catalogue raisonné des dessins, miniatures et peintures* (London-Paris, 1971).

Coello
J. A. Gaya Nuño, *Claudio Coello* (Madrid, 1957).

Cole
L. L. Noble, *The Life and Works of Thomas Cole*, edited by E. S. Vessel (Cambridge, Mass., 1964).

Colville
Exhibition Catalogue, *Alex Colville* (Hanover, 1969).

Constable
R. B. Beckett, *John Constable's Correspondence* (London, 1962–8).
B. Taylor, *Constable. Paintings, Drawings and Watercolours* (London, 1975).
L. Parris, I. Fleming-Williams, C. Shield, Exhibition Catalogue, *Constable Paintings, Watercolours and Drawings* (London, 1976).

Copley
J. Th. Flexner, *John Singleton Copley* (Cambridge, 1948).
J. D. Prown, *John Singleton Copley*, 2 volumes (Cambridge, Mass., 1966).

Coppo di Marcovaldo
E. Sindonia, *Cimabue e il momento figurativo pregiottesco*, Cl. d. A. (Milan, 1975).

Corinth
K. Schwarz, *Das graphische Werk von Lovis Corinth* (Berlin, 1922).
C. Berend-Corinth, *Die Gemälde von Lovis Corinth Werkkatalog* (Munich, 1958).
H. Müller, *Die Spät graphik von Lovis Corinth* (Hamburg, 1960).

Corneille de Lyon
L. Dimier, *Histoire de la peinture de portrait en France au XVIᵉ siècle*, (3 volumes) (Paris-Brussels, 1926).

Cornelius
H. Riegel, *Cornelius der Meister der deutschen Malerei* (Hanover, 1866).
A. Kuhn, *Peter Cornelius und die geistigen Störmungen seiner Zeit* (Berlin, 1921).

Corot
A. Robaut and E. Moreau-Nélaton, *l'Œuvre de Corot* (Paris, 1905).
A. Schoeller and J. Dieterie, *Corot, suppléments à l'œuvre de Corot* (Paris, 1956).
P. Dieterie, *Camille Corot, catalogue raisonné* (Paris, 1974).

Correggio
G. Gronau, *Correggio*, K. d. K. (Stuttgart-Leipzig, 1907).
C. Ricci, *Corrège* (Paris, 1930).
A. E. Popham, *Correggio's Drawings.* (London, 1957).
S. Bottari, *Correggio* (Milan, 1961).
A. Bevillacqua and A. C. Quintavalle, *L'Opera completa di Correggio*, Cl. d. A. (Milan, 1970).

Cossa
S. Ortolani, *Cosme Tura. Francesco del Cossa, Ercole de Roberti* (Milan, 1951).
E. Ruhmer, *Francesco del Cossa* (Munich, 1959).

Cotman
A. P. Oppé, *The Watercolour Drawings of John Sell Cotman* (London, 1923).
S. D. Kitson, *John Sell Cotman* (London, 1937).

Courbet
G. Riat, *Courbet* (Paris, 1906).
C. Léger. *Courbet* (Paris, 1929).
G. Mack, *Courbet* (London, 1951).

Coypel
Dimier, *op. cit.*

Cozens
A. P. Oppé, *Alexander and John Robert Cozens* (London, 1952).

Cranach
M. J. Friedländer and J. Rosenberg, *Die Gemälde von Lucas Cranach.* (Berlin, 1932).
H. Posse, *Lucas Cranach der Ältere.* (Vienna, 1942).
D. Koeplin and T. Falk, *Lukas Cranach. Gemälde. Zeichnungen. Druckgraphik*, Volume 1 (Stuttgart-Basel, 1974).

Crespi
F. Arcangeli, C. Gnudi, R. Longhi, Exhibition Catalogue, *Giuseppe Maria Crespi* (Bologna-Milan, 1948).

Crivelli
P. Zampetti, *Carlo Crivelli* (Milan, 1961).

A. Bovero, *L'Opera completa di Crivelli*, Cl. d. A. (Milan, 1975).

Crome
C. H. Collins Baker, *John Crome* (London, 1921).
D. and T. Clifford, *John Crome* (London, 1968).

Cuyp
Hofstede De Groot, *op. cit.*

Dahl
L. Ostby, *Johan Christian Dahl. Tekninger og akvareller* (Oslo, 1957).

Dali
S. Dali, *Dali par Dali* (Paris, 1970).

Daumier
E. Bouvy, *Honoré Daumier. L'œuvre gravé du maître*, 2 volumes (Paris, 1933).
K. E. Maison, *Honoré Daumier, catalogue de l'œuvre peint* (London, 1968).
P. Georgel and G. Mandel, *Tout l'œuvre peint de Daumier*, Cl. d. A. (Paris, 1972).

David, Gerard
E. F. von Bodenhausen, *Gerard David und seine Schule* (Munich, 1905).

David, Jacques Louis
J. L. J. David, *le Peintre Louis David. Souvenirs et documents inédits*, 2 volumes (Paris, 1880–2).
L. Hautecœur, *Louis David.* (Paris, 1954).
D. and G. Wildenstein, *Documents complémentaires au catalogue de l'œuvre de Louis David* (Paris, 1973).

Davis
E. C. Goossen, *Stuart Davis.* (New York, 1959).
Exhibition Catalogue, *Stuart Davis, Memorial Exhibition* (Washington, 1965).

De Chirico
A. Ciranna, *Giorgio De Chirico. Catalogo delle opere grafiche, 1921–1969* (Milan, 1969).
C. Bruni, I. Far, G. Briganti, *Giorgio De Chirico, catalogue de l'œuvre*, 2 volumes published (Venice, 1971–2).

De Ferrari
Exhibition Catalogue, *Dipinti di Gregorio de Ferrari – Mostra didattica* (Geneva, 1965).

Degas
P. A. Lemoisne, *Degas et son œuvre*, 4 volumes (Paris, 1947–9).
J. Adhémar and F. Cachin, *Degas, gravures et monotypes* (Paris, 1973).
J. Lassaigne and F. Minervino, *Tout l'œuvre peint et sculpté de Degas*, Cl. d. A. (Paris, 1974).

De Kooning
T. B. Hess, *Willem De Kooning* (New York, 1968).
T. B. Hess, *De Kooning. Dessins* (Paris, 1972).
H. Rosenberg, *De Kooning* (New York, 1974).

Delacroix
A. Robaut, *l'Œuvre complet d'Eugène Delacroix, peintures, dessins, gravures, lithographies* (Paris, 1885).
E. Delacroix, *Journal* (introduction and notes by A. Joubon), 3 volumes (Paris, 1960).
M. Sérullaz, *Mémorial de l'exposition Eugène Delacroix organisée au musée du Louvre à l'occasion du centenaire de la mort de l'artiste* (Paris, 1963).
P. Georgel and L. Rossi Bortolatto, *Tout l'œuvre peint de Delacroix*, Cl. d. A. (Paris, 1975).

Delaunay
P. Francastel and G. Habasque, *Du cubisme à l'art abstrait. Les cahiers inédits de Robert Delaunay* (Paris, 1957).

Delvaux
M. Butor, J. Clair, S. Houbart-Wilkin, *Delvaux. Catalogue de l'œuvre peint* (Lausanne-Paris, 1975).

Demuth
E. Farnham, *C. Demuth* (Norman, Oklahoma, 1971).

Denis
P. Cailler, *Maurice Denis. Catalogue raisonné de l'œuvre lithographié et gravé*, (Geneva, 1968).
Exhibition Catalogue, *Maurice Denis* (Paris, 1970).

Derain
G. Hilaire, *Derain* (Geneva, 1969).

Dix
F. Löffler, *Otto Dix, Leben und Werk* (Munich, 1967).
F. Karsch, *Otto Dix, das graphische Werk* (Hanover, 1971).

Domenichino
J. Pope Hennessy, *The Drawings of Domenichino at Windsor Castle* (London, 1948).
E. Borea, *Domenichino* (Milan, 1965).

Domenico Veneziano
M. Salmi, *Paolo Uccello, Andrea del Castagno. Domenico Veneziano* (Paris, 1939).

Dosso Dossi
A. Mezzetti, *Il Dosso e Battista Ferraresi* (Ferrara, 1965).
F. Gibbons, *Dosso and Battista Dossi* (Princeton, 1968).

Dou
W. Martin, *Gerard Dou*, K. d. K. (Stuttgart-Berlin, 1913).

Dubuffet
M. Loreau, *Jean Dubuffet, catalogue de l'œuvre*, 26 parts published, (Paris, 1964–75).

Duccio di Buoninsegna
C. Brandi, *Duccio* (Florence, 1951).
G. Cattaneo and E. Baccheschi, *L'Opera completa di Duccio*, Cl. d. A. (Milan, 1972).

Duchamp
A. Schwartz, *The Complete Works of Marcel Duchamp* (London, 1970).
A. d'Harnoncourt and K. McShine, Exhibition Catalogue *Marcel Duchamp* (New York-Philadelphia-Chicago, 1973).

Dufy
M. Lafaille and B. Dorival, *Raoul Dufy. Catalogue raisonné de l'œuvre peint*, 2 volumes (Geneva, 1972–3).

Dürer
F. Winkler, *Dürer*, K. d. K. (Stuttgart-Leipzig, 1928).
H. Tietze and E. Tietze-Conrat, *Kritisches Verzeichnis der Werke Albrecht Dürers*, 1 volume, (Augsburg, 1928); 2 volumes (Basel-Leipzig, 1937–8).
F. Winkler, *Die Zeichnungen Albrecht Dürers*, 4 volumes (Berlin, 1936–9).
E. Panofsky, *The Life and Art of Albrecht Dürer*, 2 volumes (Princeton, 1955).
K. Knappe, *Dürer. Gravures. L'œuvre complet* (Paris, 1964).
P. Vaisse and A. Ottino della Chiesa, *Tout l'œuvre peint de Dürer*, Cl. d. A. (Paris, 1969).
Exhibition Catalogue, *Albrecht Dürer* (Nuremberg, 1971).

Dyce
M. Pointon, *William Dyce, 1806–1864* (Oxford, 1979).

Dyck
E. Schaeffer, *Van Dyck*, K. d. K. (Stuttgart-Leipzig, 1909).
G. Glück, *Van Dyck. Des Meisters Gemälde*, K. d. K. (Stuttgart, New York, 1931).
H. Vey, *Die Zeichnungen Anton Van Dycks*, 2 volumes (Brussels, 1962).
M. Mauquoy-Hendrickx, *l'Iconographie d'Antoine Van Dyck, catalogue raisonné*, 2 volumes (Brussels, 1965).

Eakins
L. Goodrich, *Thomas Eakins : his Life and Work* (New York, 1933).
F. Porter, *Thomas Eakins* (New York, 1959).
L. Goodrich, Exhibition Catalogue, *Thomas Eakins* (New York, 1970).

Eckersberg
E. Hannover, *Maleren C. W. Eckersberg* (Copenhagen, 1898).

Elsheimer
H. Weizsäcker, *Adam Elsheimer, der Maler von Frankfurt*, 2 volumes (Berlin, 1936–52).
Exhibition Catalogue, *Adam Elsheimer.* (Frankfurt, 1967).

Engelbrechtsz
Friedländer, *op. cit.*

Ensor
P. Haeserts, *James Ensor* (Brussels, 1973).
A. Taevernier, *l'Œuvre gravé de James Ensor* (Brussels, 1974).

Ernst
W. Spies, *Max Ernst. Collagen* (Cologne, 1974).
H. R. Leppien, *Max Ernst Œuvre-Katalog. Das graphische Werk*, Volume 1 (Houston-Cologne, 1975).
W. Spies and G. Metken, *Max Ernst Œuvre-Katalog 1906–25*. Volume II, (Cologne, 1975).

Etty
D. Farr, *William Etty* (London, 1958).

Evenepoel
M. J. Chartrain-Hebbelinck, Exhibition Catalogue, *Hommage à Henri Evenepoel* (Brussels, 1972).

Eworth
Exhibition Catalogue, *Hans Eworth* (London, 1965).

Eyck
C. de Tolnay, *le Maître de Flémalle et les frères Van Eyck* (Brussels, 1939).
L. Baldass, *Jan Van Eyck.* (London – New York, 1952).
A. Châtelet and G. T. Faggin, *Tout l'œuvre peint des Van Eyck*, Cl. d. A. (Paris, 1969).

Fabritius
H. F. Wijnmann, *De Schilder Carel Fabritius. Een reconstructie van zijn leven en werken*, Oud Holland, p. 100–141 (1931).
K. E. Schuuremann, *Carel Fabritius* (Amsterdam, 1947).

Fantin-Latour
Mme Fantin-Latour, *Catalogue de l'œuvre complet de Fantin-Latour* (Paris, 1911).

Fattori
D. Durbé, *Giovanni Fattori* (Leghorn, 1953).
L. Banchiardi and B. Della Chiesa, *L'Opera completa di Fattori*, Cl. d. A. (Milan, 1970).

Feininger
H. Hess, *Lyonel Feininger* (Stuttgart, 1959).
L. E. Prasse, *Lyonel Feininger. Das graphische Werk* (Berlin, 1972).

Fernandez
D. Angulo Iniguez, *Alejo Fernández* (Sèville, 1946).

Feuerbach
H. Uhde-Bernays, *Anselm Feuerbach. Beschreibender Katalog seiner sämtlichen Gemälde* (Munich, 1929).

Flegel
W. Müller, *Der Maler Georg Flegel und die Anfänge des Stillebens* (Frankfurt, 1956).

Floris
D. Zuntz, *Frans Floris, ein Beitrag zur Geschichte der niederländischen Kunst im 16. Jahrhundert* (Strasbourg, 1929).

Foppa
F. Wittgens, *Vincenzo Foppa* (Milan, 1948).
A. Ottino della Chiesa, *Foppa* (Milan, 1963).

Fouquet
K. Perls, *Jean Fouquet* (Paris, 1940).
P. Wescher, *Jean Fouquet et son temps* (Basel, 1947).
Ch. Sterling and Cl. Schaefer, *les Heures d'Étienne chevalier de Jean Fouquet* (Paris, 1971).

Fragonard
G. Wildenstein, *Fragonard* (London, 1960).
A. Ananoff, *l'Œuvre dessiné de Jean-Honoré Fragonard. Catalogue raisonné.* 4 volumes (Paris, 1961–71).
D. Wildenstein and G. Mandel, *Tutta l'opera di Fragonard*, Cl. d. A. (Milan, 1972).

Francis
J. J. Sweeney, Exhibition Catalogue, *Sam Francis* (Houston, 1967).
E. de Wilde and W. Schmied, Exhibition Catalogue, *Sam Francis* (Amsterdam, 1968).

Exhibition Catalogue, *Sam Francis. Paintings, 1947–1972* (Buffalo, 1972).

Francke
Exhibition Catalogue, *Meister Francke und die Kunst um 1400* (Hamburg, 1969).

Friedrich
H. Börsch-Supan and K. W. Jähnig, *Caspar David Friedrich. Gemälde. Druckgraphik und bildmässige Zeichnungen* (Munich, 1973).
H. W. Grohn, E. Reichert, E. Schaar, Exhibition Catalogue, *Caspar David Friedrich* (Hamburg, 1974).
Caspar David Friedrich. Das gesamte graphische Werk, published by Rogner and Bernhardt (Munich, 1974).

Frith
Exhibition Catalogue, *Great Victorian Pictures* (London, 1978).

Furini
E. Berti Toesca, *Francesco Furini* (Rome, 1950).

Fuseli
G. Schiff, *Johan Heinrich Füssli*, 2 volumes (Zürich-Munich, 1973).

Fyt
Greindl, *op. cit.*

Gainsborough
E. K. Waterhouse, *Gainsborough* (London, 1958).
J. Hayes, *The Drawings of Thomas Gainsborough*, 2 volumes (London, 1970).

Gallego
J. A. Gaya Nuño, *Fernando Gallego* (Madrid, 1958).

Gauguin
M. Guérin, *l'Œuvre gravé de Gauguin*, 2 volumes (Paris, 1927).
G. Wildenstein, *Gauguin* (Paris, 1964).
G. M. Sugana, *L'Opera completa di Gauguih*, Cl. d. A. (Milan, 1972).

Geertgen tot Sint Jans
Friedländer, *op. cit.*
Panofsky, *op. cit.*

Gentile da Fabriano
L. Grassi, *Tutta la pittura di Gentile da Fabriano* (Milan, 1954).

Gentileschi
Voss, *op. cit.*

Géricault
C. Clément, *(Géricault, catalogue raisonné Préface et supplément par L. Eitner)* (Paris, 1973).

Ghirlandaio
J. Lauts, *Domenico Ghirlandaio* (Vienna, 1943).

Giacometti
H. C. Lust, *Giacometti. The Complete Graphics* (New York, 1970).
R. Hohl, *Alberto Giacometti* (Lausanne, 1971).

Giordano
O. Ferrari and G. Scarizzi, *Luca Giordano*, 3 volumes (Naples, 1966).

Giorgione
A. Morassi, *Giorgione.* (Milan, 1942).
R. Pallucchini, *Giorgione* (Milan, 1955).
S. Béguin and P. Zampetti, *Tout l'œuvre peint de Giorgione*, Cl. d. A. (Paris, 1967).
T. Pignatti, *Giorgione* (Venice, 1970).

Giotto di Bondone
C. H. Weigelt, *Giotto*, K. d. K. (Stuttgart-Berlin-Leipzig, 1925).
C. Gnudi, *Giotto* (Milan, 1958).
G. C. Vigorelli and E. Baccheschi, *L'Opera completa di Giotto* Cl. d. a. (Milan, 1966).
G. Previtali, *Giotto e la sua bottega* (Milan, 1967).

Giovannetti
E. Castelnuovo, *Un pittore italiano alla corte di Avignone. Matteo Giovannetti e la pittura in Provenza nel secolo XIV* (Turin, 1962).

Giovanni di Paolo
J. Pope-Hennessy, *Giovanni di Paolo* (London, 1937).
C. Brandi, *Giovanni di Paolo* (Florence, 1947).

Girtin
J. Mayne, *Thomas Girtin.* (Leigh-on-Sea, 1949).
T. Girtin and D. Loshak, *The Art of Thomas Girtin* (London, 1954).

Giulio Romano
F. Hartt, *Giulio Romano* 2 volumes (New Haven, 1958).

Giusto de' Menabuoi
S. Bettini, *Giusto de'Menabuoi e l'arte del Trecento* (Padua, 1944)

Goes
F. Winkler, *Das Werk des Hugo Van der Goes* (Berlin, 1964).

(Van) Gogh
Vincent Van Gogh. Correspondance complète enrichie de tous les dessins originaux, Introduction and notes by G. Charensol, 3 volumes (Paris, 1960).
J. -B. de La Faille, *The Works of Vincent Van Gogh. His Paintings and Drawings* (Amsterdam, 1970).
P. Lecaldano, *Tout l'œuvre peint de Van Gogh,* 2 volumes, Cl. d. A. (Paris, 1971).

Goltzius
O. Hirschmann, *Hendrik Golzius als Maler* (The Hague, 1916).
O. Hirschmann, *Verzeichnis des graphischen Werkes von Hendrik Golzius* (Leipzig, 1921).
E. K. J. Reznicek, *Die Zeichnungen von Hendrik Goltzius,* 2 volumes (Utrecht, 1961).

Gonçalves
A. de Gusmao, *Nuño Gonçalves* (Lisbon, 1957).
A. Vieira Santos, *Os Paneis de S. Vicente de Fora* (Lisbon, 1959).

Gorky
H. Rosenberg, *Arshile Gorky. The Man, the Time, the Idea* (New York, 1962).
J. Levy, *Arshile Gorky.* (New York).

Gossaert
A. Ségard, *Jean Gossart dit Mabuse* (Brussels-Paris, 1924).
H. Pauwels, H. P. Hoetink, S. Herzog. Exhibition Catalogue, *Jan Gossaert genaamd Mabuse/Jean Gossaert dit Mabuse* (Rotterdam-Bruges, 1965).

Goya
T. Harris, *Goya. Engravings and Lithographs* (Oxford, 1964).
P. Gassier and J. Wilson, *Goya* (Freiburg, 1970).
J. Gudiol Ricart, *Goya,* 4 volumes (Barcelona, 1970).
P. Gassier, *les Dessins de Goya,* 2 volumes (Freiburg, 1973–5).
P. Guinard and R. D. Angelis, *Tout l'œuvre peint de Goya,* Cl. d. A. (Paris, 1976).

Goyen
H. Van de Waal, *Jan Van Goyen* (Amsterdam, 1941).
H. -U. Beck, *Van Goyen. Ein Œuvreverzeichnis in zwei Bänden,* Volume 1, *Katalog der Handzeichnungen:* Volume II, *Katalog der Gemälde* (Amsterdam, 1972–3).

Graf
E. Major and E. Gradmann, *Urs Graf* (Basel, 1941).

(El) Greco
A. L. Mayer, *El Greco* (Madrid, 1926).
M. Legendre and A. Hartman, *El Greco* (Paris, 1937).
J. Camon Aznar, *Domenico Greco,* 2 volumes (Madrid, 1950).
H. E. Wethey, *El Greco and his School,* 2 volumes (Princeton, 1962).
P. Guinard and T. Frati, *Tout l'œuvre peint de Greco,* Cl. d. A. (Paris, 1971).
J. Gudiol, *Domenikos Theotokopoulos le Greco 1541–1614* (Paris,1973).

Greuze
A. Brookner, *Greuze* (London, 1972).

Gris
D. H. Kahnweiler, *Juan Gris. Sa vie, son œuvre, ses écrits* (Paris, 1946).
D. H. Kahnweiler, *Juan Gris. His Life and Work* (London, 1969).
J. A. Gaya Nuño, *Juan Gris* (Paris, 1974).

Gros
J. -B. Delestre, *Gros, sa vie et ses œuvres* (Paris, 1867).

Grünewald
H. A. Schmid, *Die Gemälde und Zeichnungen von Mathias Grünewald* (Strasbourg, 1911).
W. K. Zülch, *Der historische Grünewald, Mathis Gothardt Neithardt* (Munich, 1938).
E. Ruhmer, *Grünewald. The Paintings* (London, 1958).
L. Behling, *Die Haudzeichnungen der Mathis Gothart Nithart genannt Grünewald* (Weimar, 1955).
A. Weixigärtner, *Grünewald* (Vienna-Munich, 1961).
E. Ruhmer, *Grünewald's Drawings* (London, 1970).
P. Vaisse and P. Bianconi, *Tout l'œuvre peint de Grünewald,* Cl. d. A. (Paris, 1974).

Guardi
A. Morassi, *Antonio e Francesco Guardi,* 2 volumes (Venice, 1973).
L. Rossi Bortolatto, *L'Opera completa di Francesco Guardi* Cl. d. A. (Milan, 1974).

Guercino
D. Mahon, Exhibition Catalogue *Il Guercino,* 2 volumes (Bologna, 1968).

Hals
W. R. Valentiner, *Frans Hals,* K. d. K. (Stuttgart-Berlin-Leipzig, 1923).
S. Slive, Exhibition Catalogue, *Frans Hals* (Haarlem, 1962).
S. Slive, *Frans Hals,* 3 volumes (London, 1970–4).
C. Grimm and E. C. Montagni, *L'Opera completa di Frans Hals,* Cl. d. A. (Milan, 1974).

Hamilton, Gavin
D. Irwin, *Gavin Hamilton, Archaeologist, Painter and Dealer,* in *The Art Bulletin,* 44 (1962).

Hamilton, Richard
R. Morphet, Exhibition Catalogue, *Richard Hamilton* (London, 1970).

Hartung
R. Van Gindertael, *Hans Hartung* (Paris, 1960).
R. Schmucking, *Hans Hartung. Das Graphische Werk, 1921–1965* (Brunswick, 1965).
U. Apollonio, *Hartung* (Milan, 1967).

Hassam
Exhibition Catalogue, *Childe Hassam* (Washington, 1965).

Heemskerck
M. Preibisz, *Marten Van Heemskerk* (Leipzig, 1911).

Hemessen
F. Graeffe, *Jan Sanders Van Hemessen und seine identifikation mit dem Brauschweiger Monogrammisten* (Leipzig, 1909).

Herrera
J. S. Thacher, *Herrera el Viejo: The Art Bulletin XIX* (1937).

Heyden
Hofstede De Groot, *op. cit.*

Hilliard
E. Auerbach, *Nicholas Hilliard* (London, 1961).

Hobbema
W. Stechow, *The Early Years of Hobbema: The Art Quarterly,* pp. 3–18 (Spring, 1959).

Hockney
Nikos Stangos (ed.), *Hockney by Hockney* (London, 1976).

Hodler
C. A. Loosli, *Ferdinand Hodler, Leben, Werk und Nachlass,* 4 volumes (Bern, 1921–4).
H. Mühlestein and G. Schmidt, *Ferdinand Hodler, sein Leben und sein Werk* (Erlembach-Zurich, 1952).

Hogarth
R. B. Beckett, *Hogarth* (London, 1949).
G. Baldini and G. Mandel, *L'Opera completa di Hogarth,* Cl. d. A. (Milan, 1967).
J. Burke and C. Caldwell, *Hogarth gravures* (Paris, 1968).
R. Paulson, *Hogarth, his Life, Art and Times,* 2 volumes (New Haven-London, 1971).

Holbein
P. Ganz, *Hans Holbein der Jüngere,* K. d. K. (Stuttgart, 1911).
P. Ganz, *les Dessins de Hans Holbein le Jeune,* 9 volumes (Geneva, 1939).
P. Ganz, *Hans Holbein Die Gemälde* (Basel, 1950).
P. Vaisse and H. W. Grohn, *Tout l'œuvre peint de Holbein,* Cl. d. A. (Paris, 1972).

Homer
L. Goodrich, *Winslow Homer* (New York, 1945).
L. Goodrich, *The Graphic Art of Winslow Homer* (New York, 1968).
L. Goodrich, Exhibition Catalogue *Winslow Homer* (New York-Washington-Los Angeles-Chicago, 1973).

Honthorst
J. R. Judson, *Gerrit Van Honthorst. Discussion of his position in Dutch Art* (The Hague, 1959).

Hooch
Hofstede De Groot, *op. cit.*
W. R. Valentiner, *Pieter de Hooch,* K. d. K (Berlin-Leipzig, 1928).

Hopper
L. Goodrich, *Edward Hopper* (New York, 1971).

Huber
M. Weinberger, *Wolf Huber* (Leipzig, 1930).
E. Heinzle, *Wolf Huber* (Innsbruck, 1953).

Huguet
J. Gudiol Ricart and J. Ainaud de Lasarte, *Jaime Huguet* (Barcelona, 1948).
J. Ainaud de Lasarte, *Jaime Huguet* (Madrid, 1955).

Hunt
M. Bennett, Exhibition Catalogue, *Holman Hunt* (Liverpool-London, 1969).

Ingres
G. Wildenstein, *Ingres, catalogue complet des peintures* (London, 1954).
D. Ternois and H. Naef, *Exhibition Catalogue, Ingres* (Paris, 1967-8).
D. Ternois and H. Naef, *Tout l'œuvre peint d'Ingres,* Cl. d. A (Paris, 1971).

Inness
L. Ireland, *The Works of George Inness. Catalogue Raisonne* (Austin, Texas, 1965).

Jawlensky
C. Weiler, *Jawlensky* (Cologne, 1959).
C. Weiler, *Jawlensky, Köpfe, Gesichte, Meditationen* (Hanau, 1970).

John
M. Holroyd, *Augustus John,* 2 volumes (London, 1974-5).

Johns
M. Kozloff, *Jasper Johns* (New York, 1967).

Jongkind
V. Hefting, *Jongkind, sa vie, son œuvre, son époque* (Paris, 1975).

Jordaens
M. Rooses, *Jacob Jordaens: his Life and Work* (London, 1908).
M. Jaffé, Exhibition Catalogue, *Jacob Jordaens* (Ottawa, 1968-9).
R. A. d'Hulst, *Jordaens' Drawings,* 4 volumes (Brussels, 1974).

Jorn
G. Atkins, *Jorn in Scandinavia, 1930-1953* (London, 1968).

Jouvenet
A. Schnapper, *Jean Jouvenet et la peinture d'histoire à Paris* (Paris, 1974).

Juan de Borgoña
D. Angulo-Iniguez, *Juan de Borgoña* (Madrid, 1954).

Juan de Flandes
E. Bermejo, *Juan de Flandes* (Madrid, 1962).

Justus of Ghent
J. Lavalleye, *Juste de Gand, peintre de Frédéric de Montefeltre* (Louvain, 1936).

Kalf
L. Grisebach, *Willem Kalf, 1619–1693* (Berlin, 1974).

Kandinsky
W. Grohmann, *Wassily Kandinsky. Sa vie, son œuvre* (Paris, 1958).
H. K. Roethel, *Kandinsky, das graphische Werk* (Cologne, 1970).

Kauffmann
D. M. Mayer, *Angelika Kauffmann* (London, 1972).

Kelly
E. C. Goosen, *Ellsworth Kelly* (New York, 1973).

Kirchner
W. Grohmann, *Ernst-Ludwig Kirchner* (Stuttgart, 1958).
D. E. Gordon, *Kirchner* (Cambridge, Mass., 1968).
A. and W.-D. Dube, *Kirchner, das graphische Werk,* 2 volumes (Munich, 1967).

Klee
W. Grohmann, *Paul Klee* (Stuttgart-Paris-New York-Florence, 1954).
E. W. Kornfeld, *Paul Klee. Verzeichnis des graphischen Werkes* (Bern, 1963).
J. Glaesemer, *Paul Klee. Handzeichnungen I* (Bern, 1973).

Klimt
F. Novotny and J. Dobai, *Gustav Klimt* (Salzburg, 1975).

Kline
J. Gordon, *Franz Kline: 1910–1962* (New York-Washington-London, 1969).

Kneller
M. M. Kilanin, *Sir Godfrey Kneller* (London, 1971).

Købke
M. Krohn, *Maleren Christen Købkes Arbejder* (Copenhagen, 1915).

Koch
O. R. von Lutterotti, *Joseph-Anton Koch* (Berlin, 1940).

Kokoschka
H. M. Wingler, *Oscar Kokoschka, das Werk des Malers* (Salzburg, 1961).
H. M. Wingler and F. Welz, *Kokoschka, Das druckgraphische Werk* (Salzburg, 1975).

Koninck
H. Gerson, *Philips Koninck. Ein Beitrag zur Erforschung der Holländischen Malerei des XVII. Jahrhunderts* (Berlin, 1936).

Konrad von Soest
K. Steinbart, *Conrad von Soest* (Vienna, 1946).
A. Stange, *Conrad von Soest* (Königstein im Taunus, 1966).

Kupka
L. Vachtová, *Frank Kupka* (London, 1968).
J. M. Poinsot, *Frank Kupka. Chronologie, expositions, bibliographie* (Nanterre, 1970).

Laer
A. Janek, *Untersuchung über den holländischen Maler Pieter Van Laer, genannt Bamboccio* (Würzburg, 1968).

Laib
L. Baldass, *Konrad Laib und die beiden Rueland Frueauf* (Vienna, 1946).

Lairesse
J. J. M. Timmers, *Gérard Lairesse I (gravures)* (Amsterdam, 1942).

Lam
M. Leiris, *Wilfredo Lam* (Milan, 1970).

Landseer
Exhibition Catalogue, *Paintings and Drawings by Sir Edwin Landseer* (London, 1961).

Lanfranco
Voss, *op. cit.*

Largillière
G. Pascal, *Largillière* (Paris, 1928).

La Tour, Georges de F.-G. Pariset, *Georges de La Tour* (Paris, 1948).
P. Rosenberg and F. Macé de l'Épinay, *Georges de La Tour, vie et œuvre* (Freiburg, 1973).
J. Thuillier, *Tout l'œuvre peint de Georges de La Tour*, Cl. d. A. (Paris, 1973).
B. Nicolson and C. Wright, *Georges de La Tour* (London, 1974).

La Tour, M. Quentin de
A. Besnard and G. Wildenstein, *La Tour, la vie et l'œuvre de l'artiste* (Paris, 1928).

Lawrence
K. Garlick, *Sir Thomas Lawrence* (London, 1954).
A Catalogue of the Paintings, Drawings and Pastels of Sir Thomas Lawrence (London, Walpole Society, XXXIX, 1962–4).

Le Brun
H. Jouin, *Charles Lebrun et les arts sous Louis XIV* (Paris, 1889).
J. Thuillier and J. Montagu, Exhibition Catalogue, *Charles Le Brun, peintre et dessinateur* (Versailles, 1963).

Léger
Exhibition Catalogue, *Fernand Léger* (Paris, 1972).
J. Cassou and J. Leymarie, *Fernand Léger. Dessins et gouaches* (Paris, 1972).

Leibl
E. Waldmann, *Wilhelm Leibl. Eine Darstellung seiner Kunst* (Berlin, 1930).

Leighton
D. and R. Ormond, *Lord Leighton* (New Haven, 1975).

Lely
R. B. Becket, *Peter Lely* (London, 1951).

Lemoyne
Dimier, op. cit.

Le Nain
P. Fierens, *les Le Nain* (Paris, 1933).
J. Thuillier, *Documents pour servir à l'étude des frères Le Nain*, (B.S.H.A.F., 1963, pp. 155–284).

Leonardo da Vinci
H. Bodmer, *Leonardo*, K. d. K. (Stuttgart, 1931).
A. E. Popham, *The Drawings of Leonardo da Vinci* (London, 1946).
K. Clark, *Leonardo da Vinci* (Cambridge, 1952).
A Chastel and A. Ottino della Chiesa, *Tout l'œuvre peint de Léonard de Vinci*, Cl. d. A. (Paris, 1968).
K. Clark, *The Drawings of Leonardo da Vinci in the Royal Collection at Windsor Castle*, 3 volumes (London, 1969).

Leu
W. Hugelshofer, *Das Werk des Zürcher Malers Hans Leu*, In *Anzeigen für schweizerische Altertumskunde* (Zürich, 1923–4).

Lewis
W. Michael, *Wyndham Lewis* (London, 1971).

Liberale da Verona
C. Del Bravo, *Liberale da Verona* (Florence, 1967).

Lichtenstein
J. Waldman, *Roy Lichtenstein, Drawings and Prints* (New York, 1969).
D. Waldman, *Roy Lichtenstein* (Paris, 1971).

Limbourg brothers
M. Meiss, *French Painting in the Time of Jean de Berry. The Limbourg and their Contemporaries* (London, 1974).

Liotard
F. Fosca, *la Vie, les voyages et les œuvres de Jean-Etienne Liotard* (Lausanne-Paris, 1956).

Lippi, Filippino
A. Scharf, *Filippino Lippi* (Vienna, 1950).
L. Berti and U. Baldini, *Filippino Lippi* (Florence, 1957).

Lippi, Filippo
M. Pittaluga, *Filippo Lippi* (Florence, 1949).

Liss
K. Steinbart, *Johann Liss. Der Maler aus Holstein* (Berlin, 1940).

R. Klessmarr, A. Tzeutschler Lurie, L. S. Richards, Exhibition Catalogue, *Johann Liss* (Augsburg-Cleveland, 1975).

Lochner
O. H. Förster, *Stephan Lochner, ein Maler zu Köhn* (Bonn, 1952).

Longhi
T. Pignatti, *Pietro Longhi* (Venice, 1968).
T. Pignatti, *l'Opera completa di Pietro Longhi*, Cl. d. A. (Milan, 1974).

(Van) Loo
L. Réau, *Carle Van Loo, 1705–1765, Archives de l'Art français, tome XIX, pp. 9–96* (1938).

Lorenzetti, Ambrogio
G. Sinibaldi, *I Lorenzetti* (Siena, 1933).
G. Rowley, *Ambrogio Lorenzetti*, 2 volumes (Princeton, 1958).

Lorenzetti, Pietro
G. Sinibaldi, *I Lorenzetti* (Siena, 1933).
E. Cecci, *Pietro Lorenzetti* (Milan, 1930).

Lorenzo Monaco
O. Siren, *Don Lorenzo Monaco* (Strasbourg, 1905).

Lorenzo Veneziano
Pallucchini, op. cit.

Lotto
A. Banti and A. Boschetto, *Lorenzo Lotto* (Florence, 1953).
B. Berenson, *Lotto* (Milan, 1955).
R. Pallucchini and G. Mariani-Canova, *L'Opera completa di Lotto*, Cl. d. A. (Milan, 1975).

Louis
M. Fried, *Morris Louis* (New York).
M. Fried, Exhibition Catalogue, *Morris Louis* (Los Angeles-Boston-St. Louis, 1967).

Lowry
M. Levy, *The Paintings of L. S. Lowry. Oils and Watercolours* (London, 1975).

Lucas van Leyden
L. Baldass, *Die Gemälde des Lucas Van Leyden* (Augsburg-Vienna, 1923).
J. Lavalleye, *Lucas de Leyde, Peter Bruegel l'Ancien. Gravures* (Paris, 1966).

Luini
A. Ottino della Chiesa, *Bernardino Luini* (Novara, 1956). Exhibition Catalogue, *Sacro e profano nella pittura di Bernardino Luini* (Varese, 1975).

Macke
G. Vriesen, *August Macke, Katalog der Werke* (Stuttgart, 1957).

Maes
W. R. Valentiner, *Nicolas Maes*, K. d. K. (Berlin-Leipzig, 1924).

Maffei
N. Ivanoff, *Francesco Maffei* (Padua, 1947).
N. Ivanoff, Exhibition Catalogue, *Francesco Maffei* (Vicenza, 1956).

Magnasco
B. Geiger, *Saggio d'un catalogo della pittura d'Alessandro Magnasco* (Bergamo, 1949).

Magritte
P. Waldberg and A. Blavier, *René Magritte* (Brussels, 1965).

Malevich
Exhibition Catalogue, *Malevich* (Amsterdam, 1970).
A. B. Nakov, *Malevich, Écrits* (Paris, 1975).

Manet
A. Tabarant, *Manet. Histoire catalographique* (Paris, 1931).
D. Rouart and S. Orienti, *Tout l'œuvre peint de Manet*, Cl. d. A. (Paris, 1967).
D. Rouart and D. Wildenstein, *Édouard Manet, catalogue raisonné*, 2 volumes (Paris, 1975).

Mantegna
F. Knapp, *Andrea Mantegna*, K. d. K. (Stuttgart-Leipzig, 1910).
R. Cipriani, *Tutta la pittura del Mantegna* (Milan, 1956).

C. E. Tietze, *Mantegna. Paintings. Drawings. Engravings* (London, 1955).
E. Camesasca, *Mantegna* (Milan, 1964).
M. Bellonei and N. Garavaglia, *L'Opera completa di Mantegna*, Cl. d. A. (Milan, 1967).

Manuel Deutsch
C. von Mandach and H. Koegler, *Niklaus Manuel Deutsch* (Basel).

Maratta
A. S. Harris and E. Schaar, *Die Handzeichnungen von Andrea Sacchi und Carlo Maratta* (Düsseldorf, 1967).
J. Kuhnmunch, *Carlo Maratta graveur, Revue de l'art, n° 31 p. 5772* (1976).

Marc
K. Lankheit, *Franz Marc. Katalog der Werke* (Cologne, 1970).

Martin
W. Feaver, *The Art of John Martin* (Oxford, 1975).

Martini
G. Paccagnini, *Simone Martini* (Milan, 1954).
G. Contini and M.-C. Gozzoli, *L'Opera completa di Simone Martini*, Cl. d. A. (Milan, 1970).

Martorell
J. Gudiol-Ricart, *Bernardo Martorell* (Madrid, 1959).

Masaccio
R. Longhi, *Fatti di Masolino e di Masaccio, Critica d'Arte, fasc. XXV-XXVI* (1940–1).
M. Salmi, *Masaccio* (Milan, 1948).
K. Steinbart, *Masaccio* (Vienna, 1948).
L. Berti, *Masaccio* (Florence, 1964).
P. Volponi and L. Berti, *L'Opera completa di Masaccio*, Cl. d. A. (Milan, 1968).

Masolino
R. Longhi, *Fatti di Masolino e di Masaccio, Critica d'Arte, fasc. XXV-XXVI* (1940–1).
E. Micheletti, *Masolino da Panicale* (Milan, 1959).

Master of the Aix Annunciation
Sterling, op. cit.
Ring, op. cit.

Master of Flémalle
M. Davies, *Rogier Van der Weyden* (London, 1972).

Master of the Housebook
A. Stange, *Das Hausbuchmeister* (Baden-Baden-Strasburg, 1958).

Master M. S.
Stang, op. cit.

Master of Moulins
C. Sterling, *Jean Hey, dit le Maître de Moulins, Revue de l'Art*, nos 1–2 (May 1968, pp. 27–33).
N. Reynaud, *Jean Hey, peintre de Moulins et son client Jean Cueillette, Revue de l'Art*, nos 1–2 (May 1968, pp. 34–8).

Master of René d'Anjou
E. Trenkler, *Das Livre du cuer d'amour epris des Herzogs René von Anjou* (Vienna, 1946).

Master of Rohan
J. Porcher, *The Rohan Book of Hours* (London, 1959).

Master of the St Bartholomew Altarpiece
K. von Rath, *Der Meister des Bartholomäus-Altars* (Bonn, 1941).
Exhibition Catalogue, *Kölner Maler der Spät-Gotik* (Cologne, 1961).

Master of the St Veronica
Stange, op. cit.

Master Theodoric
Matějček and Pešina, *op. cit.*

Master of the Trebon Altarpiece
Matějček and Pešina, *op. cit.*

Master of Vyšší Brod
Matějček and Pešina, *op. cit.*

Matisse
P. Schneider, Exhibition Catalogue, *Matisse* (Paris, 1970).
F. Woimant and J. Guichard-Meili, Exhibition Catalogue *Matisse, l'œuvre gravé* (Paris, 1970).

M. Luzi and M. Carra, *L'Opera di Matisse, 1904–1928*, Cl. d. A. (Milan, 1971).
A. H. Barr, *Matisse, his Art and his Public* (New York, 1974).

Maulbertsch
K. Garas, *Franz Anton Maulbertsch, Leben und Werk* (Salzburg, 1974).
Exhibition Catalogue, *Maulbertsch* (Vienna, 1974).

Mayno
Angulo-Iniguez and Perez-Sanchez, *op. cit.* 1969.

Meissonier
M. O. Gréard, *Jean-Louis-Ernest Meissonier. Ses souvenirs, ses entretiens, précédés d'une étude sur sa vie et son œuvre* (Paris, 1897).

Melozzo da Forlì
C. Gnudi and L. Bacherucci, Exhibition Catalogue, *Melozzo da Forlì* (Forlì, 1938).

Memling
K. Voll, *Memling*, K. d. K. (Stuttgart-Leipzig, 1909).
L. Baldass, *Hans Memling* (Vienna, 1942).
J. Foucart and G. T. Faggin, *Tout l'œuvre peint de Memling*, Cl. d. A. (Paris, 1973).

Mengs
D. Honisch, *Anton Raphael Mengs und die Bildform des Frühklassizismus* (Recklinghausen, 1965).

Menzel
E. Bock, *Adolph von Menzel. Verzeichnis seines graphischen Werkes* (Berlin, 1923).
K. Scheffler, *Adolph Menzel. Der Mensch, das Werk* (Munich, 1955).

Metsu
Exhibition Catalogue, *Metsu* (Leiden, 1966).
F. W. Robinson, *Gabriel Metsu (1629–1667). A Study of his Place in Dutch Genre Painting of the Golden Age* (New York, 1974).

Metsys
A. de Bosque, *Metsys* (Brussels, 1975).

Michalowski
J. Sienkewicz, *Piotr Michalowski* (Warsaw, 1964).
J. Zanozinski, *Piotr Michalowski. Zyeie i tworzose* (Wroclaw-Warsaw-Kraków, 1965).

Michelangelo
F. Knapp, *Michelangelo* (Stuttgart-Leipzig, 1910).
C. de Tolnay, *Michelangelo*, 5 volumes (Princeton, 1943–1960).
L. Dussler, *Die Zeichnungen des Michelangelo* (Berlin, 1959).
C. de Tolnay and E. Camesasca, *Tout l'œuvre peint de Michel-Ange*, Cl. d. A. (Paris, 1967).

Millais
M. Bennett, Exhibition Catalogue, *Millais* (Liverpool-London, 1967).

Millet
E. Moreau-Nélaton, *Millet raconté par lui-même*, 3 volumes (Paris, 1921).
L. Lepoittevin, *Jean-François Millet, sa vie, son œuvre, ses écrits*, 4 volumes (Paris, 1971–3).
R. L. Herbert, Exhibition Catalogue, *Millet* (Paris, 1975).

Miró
P. Wember, *Miró. Das graphische Werk* (Krefeld, 1957).
J. Dupin, *Joan Miró* (Paris, 1961).
M. Leiris and F. Mouriot *Joan Miró. Lithographe*, volume 1 (Paris, 1972).
Joan Miró. Lithographe, volume II (Paris, 1975).

Modigliani
J. Lauthemann, *Modigliani, catalogue raisonné. Sa vie, son œuvre complet, son art* (Barcelona, 1970).
F. Cachin and A. Ceroni, *Tout l'œuvre peint de Modigliani*, Cl. d. A. (Paris, 1972).

Mondrian
M. Seuphor, *Mondrian* (Paris, 1970).
M. G. Ottolenghi, *L'Opera completa di Mondrian*, Cl. d. A. (Milan, 1974).

Monet
G. Geffroy, *Claude Monet, sa vie, son temps, son œuvre* (Paris, 1922).
L. Rossi Bortolatto, *L'Opera completa di Claude Monet, 1870–1889*, Cl. d. A. (Milan, 1972).

Monet *continued*
D. Wildenstein, *Claude Monet. Biographié et catalogue raisonné, tome I, 1840–1881* (Lausânne-Paris, 1974).

Mor
L. C. J. Fierichs, *Antonio Moro* (Amsterdam, 1947).
H. Hymans, *Antonio Moro, son œuvre et son temps* (Brussels, 1910).
G. Marlier, *Anthonis Mor Van Dashorst* (Brussels, 1934).

Morales
J. A. Gaya Nuño, *Luis de Morales* (Madrid, 1961).

Morandi
F. Arcangeli, *Giorgio Morandi* (Milan, 1964).
L. Vitali, *Giorgio Morandi* (Milan, 1964).
L. Vitali, *L'Opera grafica di Giorgio Morandi* (Turin, 1964).

Moreau
R. Van Holten, Exhibition Catalogue, *Gustave Moreau* (Paris, 1961).

Moretto
G. Gombosi, *Il Moretto da Brescia* (Basel, 1943).
C. Boselli, *Il Moretto* (Brescia, 1954).

Moroni
D. Cugini, *Moroni Pittore* (Bergamo, 1939).

Morrice
K. D. Pepper, *James Wilson Morrice* (Toronto-Vancouver, 1966).

Morse
H. B. Wehle, *S. F. B. Morse, American Painter* (New York, 1932).

Moser
J. Waldburg-Wolfegg, *Lukas Moser* (Berlin, 1939).

Mostaert
Friedländer, *op. cit.*

Munch
A. Moen, *Edvard Munch's Age and Milieu* (Oslo, 1956).
A. Moen, *Edvard Munch. Woman and Eros* (Oslo, 1957).
A. Moen, *Edvard Munch, Nature and Animals* (Oslo, 1958).
W. Timm, *Edvard Munch Graphik* (Berlin, 1969).
G. Schieffler, *Edvard Munch, das graphische Werk, 1906–1926* (Oslo, 1974).
G. Schiefler, *Verzeichnis des graphischen Werks Edvard Munchs bis 1906* (Oslo, 1974).

Munkácsy
Z. Farkas, *Munkácsy* (Budapest, 1943).
L. Vegvari, *Katalog der Gemälde und Zeichnungen Mihaly Munkácsys* (Budapest, 1959).

Murillo
A. L. Mayer, *Murillo*, K. d. K. (Stuttgart-Berlin, 1913).
S. Montoto, *Bartolomé Esteban Murillo. Estudio biográfico critica* (Séville, 1923).

Nash
A. Causey, *Paul Nash* (Oxford, 1979).

Nattier
P. de Nolhac, *Nattier, peintre de la cour de Louis XV* (Paris, 1925).

Newman
T. B. Hess, *Barnett Newman* (New York, 1971).

Nicholson
H. Read, *Ben Nicholson. Paintings, Reliefs, Drawings*, 2 volumes (London 1955–6).
J. Russell, *Ben Nicholson. Drawings, Paintings and Reliefs, 1911–1968* (London, 1969).

Nicolau
Post, *op. cit.*

Nolan
E. Lynn, *Sidney Nolan. Myth and Imagery* (London, 1967).

Nolde
W. Haftmann, *Emil Nolde* (Cologne, 1958).
G. Schiefler, *Emil Nolde. Das graphische Werk*, 2 volumes (Cologne, 1965–7).

O'Keeffe
Exhibition Catalogue, *Georgia O'Keeffe* (New York, 1970).

Orcagna
K. Steinweg, *Andrea Orcagna. Quellengeschichte und Stillkritische Untersuchung* (Strasbourg, 1929).

Orley
J. de Borchgrave d'Altena, M. Crick-Kuntziger, J. Helbig, L. Lavalleye, O. Le Maire, J. Maquet-Tombu, C. Terlinden, H. Velge, *Bernard Van Orley* (Brussels, 1943).

Ostade
Holstede De Groot, *op. cit.*
L. Godefroy, *l'Œuvre gravé d'Adriaen Van Ostade* (Paris, 1930).

Oudry
Dimier, *op. cit.*

Overbeck
M. Howitt, *Friedrich Overbeck. Sein Leben und Schaffen*, 2 volumes (Frieburg, 1886).

Pacher
E. Hempel, *Das Werk Michael Pachers* (Vienna, 1952).
N. Rasmo, *Michael Pacher* (London, 1971).

Palma
G. Gombosi, *Palma Vecchio*, K. d. K. (Stuttgart-Berlin, 1937).
G. Mariacher, *Palma il Vecchio* (Milan, 1968).

Palmer
G. Grigson, *Samuel Palmer, the Visionary Years* (London, 1947).
R. Lister, *Samuel Palmer and his Etchings* (London, 1969).
R. Lister, *Samuel Palmer, a biography* (London, 1974).
J. Sellars, *Samuel Palmer* (New York, 1974).

Panini
F. Arisi, *Gian Paolo Pannini* (Piacenza, 1961).

Paolo Veneziano
Pallucchini, *op. cit.*, 1964.

Paret y Alcazar
O. Delgado, *Paret Y Alcázar* (Madrid, 1957).

Parmigianino
A. O. Quintavalle, *Il Parmigianino* (Milan, 1948).
S. J. Freedberg, *Parmigianino. His Works in Paintings* (Cambridge, Mass., 1971).
A. E. Popham, *Catalogue of Drawings by Parmigianino*, 3 volumes (New York-London, 1971).

Pasmore
J. Reichardt, *Victor Pasmore* (London, 1963).

Patenier
R. A. Koch, *Joachim Patinir* (Princeton, 1968).

Pellegrini
A. Bettagno, Exhibition Catalogue, *Disegni e dipinti di Giovanni Antonio Pellegrini, 1675–1741* (Venice, 1959).

Pereda
E. Tormo, *Antonio de Pereda* (Valladolid, 1916).

Permeke
R. Avermaete, *Permeke* (Brussels, 1970).

Perronneau
P. Ratouis de Limay and L. Vaillant, *J. B. Perronneau, sa vie, son œuvre* (Paris, 1923).

Perugino
W. Bombe, *Perugino*, K. d. K. (Stuttgart-Berlin, 1914).
U. Gnoli, *Pietro Perugino* (Spoleto, 1923).
C. Castellaneta and E. Camesasca, *L'Opera completa di Perugino*, Cl. d. A. (Milan, 1969).

Piazzetta
R. Pallucchini, *Piazzetta* (Milan, 1961).

Picabia
M.-L. Borràs, *Picabia* (Paris, 1976).
W. A. Camfield, *Picabia* (Princeton, 1976).
J. H. Martin and H. Seckel, Exhibition Catalogue, *Francis Picabia* (Paris, 1976).

Picasso
C. Zervos, *Pablo Picasso. Catalogue de l'œuvre*, 28 volumes published (Paris, 1932–75).

F. Mourlot, *Picasso lithographe*, 4 volumes (Monte-Carlo, 1950–64).
P. Daix, G. Boudaille, J. Rosselet, *Picasso, 1900–1906* (Neuchâtel, 1966).
G. Bloch, *Catalogue de l'œuvre gravé et lithographié de Pablo Picasso*, 2 volumes (Bern, 1968–71).
A. Moravia and P. Lecaldano, *Picasso blu e rosa*, Cl. d. A. (Milan, 1968).
F. Russoli and F. Minervino, *Picasso cubista*, Cl. d. A. (Milan, 1972).

Piero della Francesca
R. Longhi, *Piero della Francesca* (Florence, 1963).
H. Focillon and P. De Vecchi, *Tout l'œuvre peint de Piero della Francesca* Cl. d. A. (Paris, 1968).
K. Clark, *Piero della Francesca* (London, 1969).
E. Battisti, *Piero della Francesca*, 2 volumes (Milan, 1971).

Piero di Cosimo
M. Bacci, *Piero di Cosimo* (Milan, 1966).

Pietro da Cortona
G. Briganti, *Pietro da Cortona o della pittura barocca* (Florence, 1962).

Piranesi
M. A. Hind, *Giovanni Battista Piranesi* (London, 1922).
H. Thomas, *The Drawings of Giovanni Battista Piranesi* (London, 1954).
H. Focillon, *Giovanni Battista Piranesi* (Paris, 1963).

Pisanello
M. Fossi-Todorow, *I Disegni del Pisanello e della sua cerchia* (Florence, 1966).
G. A. Dell'Acqua, *L'Opera completa di Pisanello*, Cl. d. A. (Milan, 1972).
G. Paccagnini, *Pisanello e il ciclo cavalleresco di Mantova* (Milan, 1972).

Pissarro
L. R. Pissaro and L. Venturi, *Camille Pissarro, son art, son œuvre*, 2 volumes (Paris, 1939).

Poelenburgh
A. Blanckert, Exhibition Catalogue, *Nederlandse XVII*[e] *eeuwse italianiserende Landschapschilders* (Utrecht, 1965).

Poliakoff
A. Poliakoff, *Serge Poliakoff. Les estampes* (Paris, 1974).
G. Marchiori, *Serge Poliakoff* (Paris, 1976).

Pollaiuolo
A. Sabatini, *Antonio e Piero del Pollaiolo* (Florence, 1944).
S. Ortolani, *Il Pollaiuolo* (Milan, 1948).
A. Busignani, *Pollaiuolo* (Florence, 1970).

Pollock
F. O'Hara, *Jackson Pollock* (New York, 1959).
B. Robertson, *Jackson Pollock* (London, 1960).
F. O'Connor, *Jackson Pollock* (New York, 1967).

Pontormo
L. Berti, *Pontormo* (Florence, 1964).
J. C. Rearick, *The Drawings of Pontormo*, 2 volumes (Cambridge, Mass., 1964).
K. W. Forster, *Pontormo* (Munich, 1966).
L. Berti, *L'Opera completa di Pontormo*, Cl. d. A. (Milan, 1973).

Pordenone
G. Fiocco, *G. A. Pordenone* (Udine, 1939).

Potter
Hofstede De Groot, *op. cit.*

Poussin
W. Friedländer and A. Blunt, *The Drawings of Nicolas Poussin*, 5 volumes (London, 1939–74).
A. Blunt, *The Paintings of Nicolas Poussin*, 3 volumes (London, 1966–68).
J. Thuillier, *Tout l'œuvre peint de Poussin*, Cl. d. A. (Paris, 1974).

Preti
C. Refice Taschetta, *Mattia Pretti* (Brindisi, 1959).

Primaticcio
L. Dimier, *Le Primatice* (Paris, 1928).

Prud'hon
E. de Goncourt, *Catalogue raisonné de l'œuvre peint, dessiné et gravé de P. P. Prud'hon* (Amsterdam, 1971).
J. Guiffrey. *L'Œuvre de P. P. Prud'hon* (Paris, 1924).

Pucelle
K. Morand, *Jean Pucelle* (Oxford, 1962).

Puvis de Chavannes
M. Lagaisse and J. Vergnet-Ruiz, Exhibition Catalogue, *Puvis de Chavannes et la peinture lyonnaise du XIX*[e] *siècle* (Lyon, 1937).
R. J. Wappenmacker, Exhibition Catalogue, *Puvis de Chavannes and the Modern Tradition* (Toronto, 1975).
L. d'Argencourt and J. Foucart, Exhibition Catalogue, *Puvis de Chavannes* (Paris-Ottawa, 1976).

Quarton
C. Sterling, *le Couronnement de la Vierge par Enguerrand Quarton* (Paris, 1939).

Raeburn
J. Greig, *Sir Henry Raeburn, R. A. His Life and Works* (London, 1911).
D. Baxandall, Exhibition Catalogue, *Raeburn* (Edinburgh, 1956).

Ramsay
A. Smart, *Allan Ramsay* (London, 1952).

Raphael
A. Rosenberg, *Raffael*, K. d. K. (Stuttgart-Leipzig, 1904).
O. Fischel, *Raphaels Zeichnungen*, 8 volumes (Berlin, 1913–1941, volume VIII, London); Volume IX by K. Oberhuber (Berlin, 1972).
E. Camesasca, *Tutta la pittura di Raffaelo. I quadri* (Milan, 1962).
E. Camesasca, *Tutta la pittura di Raffaelo. Gli affreschi* (Milan, 1962).
O. Fischel, *Raphael*, 2 volumes, (Berlin, 1962).
H. Zerner and P. De Vecchi, *Tout l'œuvre peint de Raphaël*, Cl. d. A. (Paris, 1969).
L. Dussler, *Raffael. A Critical Catalogue of his Pictures, Wall-Paintings and Tapestries* (London, 1971).

Rauschenberg
A. Forge, *Rauschenberg* (New York, 1969).

Redon
A. Mellerio, *Odilon Redon, catalogue de l'œuvre gravé et lithographique* (Paris, 1913).
O. Redon, *À soi-même* (Paris, 1922).
R. Bacou, *Odilon Redon*, 2 volumes (Geneva, 1956).
R. Bacou, Exhibition Catalogue, *Odilon Redon* (Paris, 1956).
K. Berger, *Odilon Redon. Phantasie und Farbe* (Cologne, 1964).

Rembrandt
W. R. Valentiner, *Rembrandt*, K. d. K. (Stuttgart-Leipzig, 1909).
W. R. Valentiner, *Rembrandt. Wiedergefundene Gemälde (1910 bis 1920)*, K. d. K. (Stuttgart-Leipzig, 1923).
W. R. Valentiner, *Rembrandts Handzeichnungen*, 2 volumes (Stuttgart-Leipzig, 1925–34).
L. Münz, *The Etchings of Rembrandt*, 2 volumes (London, 1952).
O. Benesch, *The Drawings of Rembrandt*, 6 volumes (London, 1954–7).
K. Bauch, *Rembrandts Gemälde* (Berlin, 1966).
A. Bredius and H. Gerson, *Rembrandt. The Complete Edition of the Paintings* (London, 1969).
H. Gerson, *Rembrandt* (Paris, 1969).
J. Foucart and P. Lecaldano, *Tout l'œuvre peint de Rembrandt*, Cl. d. A. (Paris, 1971).

Reni
C. Gnudi and B. C. Cavalli, *Guido Reni* (Florence, 1955).
C. Garboli and E. Baccheschi, *L'Opera completa di Guido Reni*, Cl. d. A. (Milan, 1971).

Renoir
F. Daulte, *Auguste Renoir. Catalogue raisonné de l'œuvre peint*, Volume I (Lausanne, 1971).
E. Fezzi, *L'Opera completa di Renoir nel periodo impressionnista, 1869–1883*, Cl. d. A. (Milan, 1972).

Repin
I. Grabar, *Rjepin*, 2 volumes (Moscow, 1937).
O. Liaskovskaia, *I. E. Rjepin* (Moscow, 1953).

Valckenborch, Frederick van
 Flemish, 1566–1623. See Bruegel;
 Schönfeld.
Valckenborch, Lucas van
 Flemish, c.1530–1597. See Flegel.
Valdés Leal, Juan
Valenciennes, Pierre Henri de
Valentin
Vallotton, Felix Édouard
Van Dongen, Kees
Vanni, Andrea
 Italian, 1332?–c.1414. See Martini.
Vanni, Lippo
 Italian, mentioned in records from 1341 to
 1375. See Martini.
Varin, Quentin
 French, 1570?–1634. See La Hyre; Poussin.
Vasarely, Viktor
Vasari, Giorgio
 Italian, 1511–74. See Aertsen; Bronzino;
 Gentile da Fabriano;
 Margarito d'Arezzo; Masaccio;
 Masolino; Pontormo; Salviati;
 Schongauer; Sebastiano del Piombo.
Vasnetsov, Victor Mikhailovich
 Russian, 1848–1926. See Repin; Vrubel.
Vecchietta (Lorenzo di Preto)
 Italian, c.1412–1480. See Giovanni di
 Paolo.
Veen, Otto van or Vaenius
 Flemish, 1556–1629. See Rubens.
Velázquez, Antonio Gonzalez
 Spanish, 1729–93. See Paret y Alcázar.
Velázquez, Diego
Velde, Adriaen van de
 Dutch, 1636–72. See Heyden; Laer;
 Potter; Wouwermans.
Velde, Bram van
Velde, Esaias van de
 Dutch, 1590/91–1630. See Cappelle;
 Cornelis van Haarlem; Goyen; Laer;
 Ruysdael.
Velde, Henry van de
 Belgian, 1863–1957. See Seurat.
Velde, Willem van de, the Elder
 Dutch, c.1611–1693.
Velde, Willem van de, the Younger
Venetsianov, Alexei Gavrilovich
Verbeeck, Pieter Cornelisz
 Dutch, 1610/15–1652/54. See
 Wouwermans.
Verdoël, Adriaen
 Dutch, c.1620–after 1695. See Rembrandt.
Vereshchagin, Vasili
Verhaecht, Tobias
 Flemish, 1561–1631. See Rubens.
Vermeer, Jan
Vermeyen, Jan Cornelisz
 Flemish, c.1500–1559. See Scorel.
Vernet, Carle
 French, 1758–1836. See Géricault.
Vernet, Claude Joseph

Veronese
Verrocchio, Andrea di Cione
 Italian, 1435–88. See Andrea del
 Castagno; Botticelli; Leonardo da
 Vinci; Perugino; Signorelli.
Verschuring, Hendrik
 Dutch, 1627–90. See Wouwermans.
Verster, Floris
 Dutch, 1861–1927. See Breitner.
Viali, Jacques
 French, c.1650–1745. See Vernet.
Victors, Jan
 Dutch, 1620–76. See Maes; Rembrandt.
Vien, Joseph Marie
 French, 1716–1809. See David;
 Fragonard; Ingres; (Van) Loo; Poussin.
Vigée-Lebrun, Élisabeth
 French, 1755–1842. See Nattier.
Vignali, Jacopo
 Italian, 1592–1664. See Dolci.
Villate, Pierre
 French, ?–after 1495. See Quarton.
Villon, Jacques
Vivarini, Alvise
 Italian, 1445–1505. See Barbari; Cima da
 Conegliano.
Vivarini, Antonio
Vlaminck, Maurice de
Vleughels, Nicolas
 French, 1668–1737. See Subleyras;
 Watteau.
Vlieger, Simon de
 Dutch, 1601–53. See Cappelle; Velde
 Willem van de.
Vliet, Hendrick Cornelisz van
 Dutch, 1611–75. See Witte.
Vliet, Joris van
 Dutch, c.1610–?. See Dou.
Volaire, Pierre Jacques
 French, 1729–1802. See Vernet.
Vos, Cornelis de
 Flemish, 1584–1651. See Champaigne;
 Snyders.
Vos, Martin de
 Flemish, 1532–1603. See Bruegel;
 Heemskerck.
Vos, Paul de
 Flemish, 1595–1678. See Snyders.
Vosterman, Lucas
 Flemish, 1595–1675. See (Van) Dyck.
Vouet, Aubin
 French, 1599–1641. See Vouet, Simon.
Vouet, Laurent
 French, second half of 16th cent. See Vouet,
 Simon.
Vouet, Simon
Vrel, Jacobus
 Dutch, active c.1654–1662. See Metsu.
Vroom, Hendrick Cornelisz
 Dutch, 1556–1640. See Ruisdael.
Vrubel, Mikhail Alexandrovich
Vuillard, Édouard

W

Wael, Cornelis de
 Flemish, 1592–1667. See Magnasco;
 Strozzi.
Wagner, Alexander
 German, 1838–1919. See Munkácsy;
 Szinyei-Merse.
Wals, Gottfried
 German, active in Italy in 17th cent. See
 Claude.
Wampe, Bernard Joseph
 French, 1689–1750. See Restout.
Wappers, Egidius Karel Gustav
 Belgian, 1803–74. See Alma Tadema;
 Brown.
Warhol, Andy
Warnars, Jacob
 Dutch, active in 17th cent. See
 Wouwermans.
Watteau, François Joseph
 French, 1758–1823. See Watteau, Jean
 Antoine.
Watteau, Jean Antoine
Watteau, Louis Joseph
 French, 1737–98. See Watteau, Jean
 Antoine.
Watts, George Frederick
Wechtlin, Hans
 German, 1480/85–1526. See Graf.
Weenix, Jan Baptist
 Dutch, 1621–1660?. See Bloemaert; Laer;
 Maes; Metsu; Ruysdael.
West, Benjamin
Wet, Jan de
 Dutch c.1610–after 1675. See
 Rembrandt.
Weyden, Rogier van der
Weyer, Jacob Matthias
 German c.1620–1670. See Wouwermans.
Whistler, James MacNeill
Wicar, Jean-Baptiste Joseph
 French, 1762–1834. See David, Jacques
 Louis.
Wiegers, Jan
 Dutch, 1893–1959. See Kirchner.
Wilhelm, Master
 German, mentioned in records at Cologne
 from 1358 to 1378. See Master of the St
 Veronica.
Wilkie, David
Wille, Jean Georges
 French, of German origin, 1715–1808. See
 Prud'hon.
Willeboirts, Thomas
 Flemish, 1614–54. See Fyt.
Willemsz, Cornelis
 Dutch, first half of 16th cent. See
 Heemskerck.
Willumsen, Jens Ferdinand
 Danish, 1863–1958. See Gauguin.

Wils, Jan
 Dutch, c.1600–1666. See Berchem.
Wilson, Richard
Winstanley, Hamlet
 English, 1699–1756. See Stubbs.
Withoos, Mathias
 Dutch, 1627?–1703. See Wittel.
Witte, Emmanuel de
Wittel, Gaspar van
Witz, Konrad
Wolgemut, Michael
 German, 1434–1519. See Barbari; Dürer.
Wols
Wood, Christopher
 English, 1901–30. See Nicholson.
Wouters, Rik
Woutersz, Jan
 Dutch, 1593–1663. See (Ter) Brugghen.
Wouwermans, Jan
 Dutch, 1629–69. See Wouwermans,
 Philips.
Wouwermans, Paulus Joosten
 Dutch, ?–1642. See Wouwermans, Philips.
Wouwermans, Pieter
 Dutch, 1623–82. See Wouwermans,
 Philips.
Wouwermans, Philips
Wright of Derby, Joseph
Wtewael or Witte-Wael, Joachim
 Dutch, 1560–1638. See Cornelis van
 Haarlem; Spranger.
Wynants, Jan
 Dutch, 1620/25–1685. See Gainsborough;
 Ruisdael; Wouwermans.
Wynrich von Wesel, Hermann
 German, active at Cologne 1378–1413. See
 Master of the St Veronica.

Z

Zandomeneghi, Federico
 Italian, 1841–1917. See Toulouse-Lautrec.
Zaragoza, Lorenzo
 Spanish, known from 1364 to 1402. See
 Nicolau.
Zeitblom, Bartolomäus
 German, c.1455–c.1518. See Strigel.
Zelotti, Battista
 Italian, 1526–78. See Veronese.
Zenale, Bernardino
 Italian, ?–1526. See Leonardo da Vinci.
Zoffany, Johannes
Zucarelli, Francesco
 Italian, 1702–88. See Wilson.
Zuccaro, Federico
 Italian, c.1540?–1609. See Caravaggio.
Zuccaro, Taddeo
Zurbarán, Francisco de

Acknowledgements

Photographs

A.C.L., Brussels 135 top; Aberdeen Art Gallery and Museums 191 bottom; Agraci 54 top, 72 bottom, 327 bottom; Albright–Knox Art Gallery, Buffalo, New York 422; Alinari, Florence 51, 143, 144, 197 top, 222 bottom, 237 top right, 238, 291 bottom left, 303 right, 323 bottom, 420 top right; Allen Memorial Art Museum, Oberlin College, Ohio 397 bottom; Anders 34, 52, 186; Anderson, Florence 10 top, 134, 147, 159 bottom, 225, 229 left, 233 top left, 241 bottom, 248, 278, 328, 348, 369 bottom left, 420 top left, 431 top, 447 bottom left; Archives Photographiques, Paris 68 bottom; Art Gallery of South Australia, Adelaide 300 top left; Art Institute of Chicago, Illinois 55 top, 301, 432 top right; Arts Council, London 270 bottom left; Bayerische Staatsgemaldesämmlugen, Munich 116, 156, 206 right, 210 top, 274 right, 398 top; Bibliothèque Nationale, Paris 264, 336; Blaüel, Gauting 4, 13, 201 bottom; Braun 42 bottom, 102 bottom; Bridgeman Art Library–Phaidon, London 64; British Council 389 left; British Museum, London 18 bottom, 324; British Museum (Natural History), London 9; Brogi, Florence 29 bottom; Bruckmann, Munich 437 top; Carnegie Institute, Pittsburgh, Pennsylvania 175; Cercle d'Art, Paris 184 bottom left, 268, 286, 419, 429; A. Chevallier 98; Chomon-Perino, Turin, 83; Cleveland Museum of Art, Ohio 22, 416; Commeau 313 top; *Connaissance des Arts*, Paris 12 right; Courtauld Institute Galleries, London 247; Gregoire de Brouhus 411; Detroit Institute of Arts, Michigan 385 left; Dingjan 66, 288 left; Hein Engelskirchen 18 top; J. Evers 80; Fratelli Fabbri Editori, Milan 6, 7 left, 8 top, 15, 17 right, 23, 25, 30 top, 31 top, 35 top, 36–37, 38, 43 top left, 43 bottom, 45 top, 49 left, 53, 56 left, 61, 65 bottom, 69 bottom, 71, 72 bottom, 78 left, 78 right, 84 left, 85 top, 90 right, 101, 102 top, 105, 108, 109, 110, 113, 114, 123 bottom, 127, 131, 135 bottom, 138, 140, 141 top, 145 top, 148, 152, 153 top, 155, 163, 167, 187 bottom left, 192, 194 left, 203, 204, 205, 208, 209 right, 211, 212 top right, 217 right, 229 right, 235, 243 left, 245 bottom, 246, 251 top right, 253, 256 top right, 257, 260 top, 261, 269, 270 top right, 272 top left, 274 left, 277, 279, 280 right, 283, 284, 285, 289, 291 top right, 293 right, 304 right, 309 left, 313 bottom, 316 right, 322, 323 top, 349, 352 left, 353, 355 left, 358 left, 358 right, 371

bottom left, 371 top left, 371 top right, 390, 393, 394, 396, 402, 407, 413, 415, 418, 430, 432 top left, 435 bottom, 441 top, 442, 448; Flammarion 150; Fogg Art Museum, Cambridge, Massachusetts 27; Fotostudio Otto 374 bottom; Frans Halsmuseum, Haarlem 171; Frequin, The Hague 266 right, 294, 428; Frick Collection, New York 20; Fundação Calouste Gulbenkian, Lisbon 214 left; Gabinetto Fotografico Nazionale, Rome 446; Galleria degli Uffizi, Florence 47; Gemäldegalerie, Berlin-Dahlem 153 bottom, 182, 214 right, 375 bottom; Gemäldegalerie, Dresden 29 top; Photographie Giraudon, Paris 1 right, 2, 7 right, 8 bottom, 10 bottom, 16 left, 19 top, 19 bottom, 21, 31 bottom, 33, 39 right, 40, 43 top right, 45 bottom, 46 top, 49 right, 50, 54 bottom, 60, 65 top, 72 top left, 75 top, 79, 86 bottom, 87, 88, 89 left, 90 left, 93, 94, 95, 99 left, 100 bottom, 106 left, 117 top, 119, 122 top, 123 top, 126 left, 128, 129, 132, 141 left, 142, 146, 151 top, 151 bottom, 159 top, 164, 165, 166, 168, 169, 176 right, 177 bottom left, 184 top right, 188, 189, 193 top, 202, 207 bottom left, 210 bottom, 215, 217 left, 218, 219, 223, 226, 230, 232, 234 left, 234 right, 244 bottom right, 250, 256, bottom left, 258, 259, 260 bottom, 262, 265 top right, 265 bottom right, 266 left, 267, 271 top, 272 top right, 272 bottom left, 273 left, 273 right, 275, 276 top, 276 bottom, 280 left, 287, 290, 296, 297 top, 304 left, 307, 308, 311, 314 right, 316 left, 318, 319, 326, 327, 331 top right, 333, 339 top, 342, 354, 355 right, 356 right, 357, 359 bottom left, 363, 365, 366, 375 top right, 377 left, 378 left, 378 centre, 378 right, 386, 387 bottom, 391 left, 391 right, 395, 397 top, 401 top, 403 bottom, 405, 406, 410, 420 bottom left, 421 bottom left, 421 top right, 423, 425 left, 425 right, 433, 438 bottom left, 439, 443 top right, 444, 445 top; Glasgow Art Gallery and Museum 91, 240; G. Goodyear & the Buffalo Fine Arts Academy, Buffalo, New York 12 left; Carlfried Halbach 124; Hamlyn Group Picture Library 17 left; Hamlyn Group–John Webb 3 bottom, 28 left, 310, 385 right; Hermitage Museum, Leningrad 334 bottom; Herzog Anton Ulrich Museum, Brunswick 56 right, 115 bottom; Hessisches Landesmuseum, Darmstadt 125 top left; Hans Hinz, Allschwil 162, 173, 361; Imperial War Museum, London 297 top; Minneapolis Institute of Arts, Minnesota 201 top; Kempfer 305; Ralph Kleinhempel 26, 369 top right; Kunsthaus, Zurich 145 bottom;

Kunsthistorisches Museum, Vienna 30 bottom, 409; Kunstmuseum, Dusseldorf 74; Lam 212 bottom; Landesbildstelle Rheinland, Cologne 220; L. Laniepce, Paris 404; Larousse, Paris 130, 191 top, 193 bottom, 228 bottom left, 295 right, 299 top right, 306 top right, 339 bottom, 362, 403 top left, 447 top right; J. Löwy, 374 top; Denis Mahon Collection, London 233 bottom right; Manor, Kay & Foley 81; Mansell–Alinari 199 bottom; Mas, Barcelona 24 right, 35 bottom, 69 top, 125 top right, 136 bottom, 187 top right, 195, 196, 254, 288 right, 299 bottom left; F. G. Mayer 92, 368, 382; Metropolitan Museum of Art, New York 239 right, 329, 344, 364; Meyer 44, 125 bottom; Museé des Beaux-Arts, Lille 327 top; Museé des Beaux-Arts, Ostend 24 left, 392 bottom; Museé du Louvre, Paris 338, 369 bottom right, 388; Museés Nationaux, Paris 14 bottom, 16 right, 55 bottom, 57, 100 top, 126 right, 154, 170, 194 right, 197 bottom, 198, 227, 281, 431 bottom; Museés royaux des Beaux-Arts, Brussels 245 top, 303 left, 351, 438 right; Museo Civico d'Arte e Storia, Vicenza 244 top left; Museo del Prado, Madrid 271 bottom, 352 right; Museum Boymans-van Beuningen, Rotterdam 381, 414 bottom left, 441 bottom; Museum of Fine Arts, Boston, Massachusetts 360 bottom; Museum of Modern Art, New York 59, 157 left, 375 top left; Museu Nacional de Arte Antiga, Lisbon 157 right; Národni Galeri, Prague 111; Nationalgalerie, Berlin–Dahlem 133; National Galleries of Scotland, Edinburgh 118, 137, 172, 222 top, 340, 440 bottom; National Gallery, London 67, 121, 136 top, 178 right, 181, 207 top right, 252 top, 400, 424; National Gallery of Art, Washington D.C. 48, 68 top, 265 top left, 399; National Gallery of Canada, Ottawa 11, 70, 120, 174, 199 top, 209 left, 242, 292, 438 top left; Sydney W. Newberry 46 bottom; New-York Historical Society 312; Nolde Museum, Seebüll 300 bottom right; Novosti Press Agency 350, 434; Öffentliche Kunstammlung, Basel 41, 117 bottom; Österreichische Nationalbibliothek, Vienna 263; Hans Petersen 115 top, 206 left; Phillips Collection, Washington D.C. 3 top; Pinacoteca di Biera, Milan 14 top; Eric Pollitzer, New York 200; Pushkin Museum, Moscow 398 bottom; G. Rampazzi 380; A. Realie 373; G. Rheinhold, Leipzig–Mölkau 82; Rijksmuseum, Amsterdam 72 top right, 139, 161, 212 top left, 231, 331 bottom left, 346, 370, 427; Rijksmuseum Kröller–Müller, Otterlo 412; Roland 314 left; Scaioni's Studio 28 right; Scala,

Antella 5, 76, 106 right, 158, 236, 237 bottom left, 255, 302, 309 right, 315, 321, 325, 330 left, 330 right, 334 top, 341, 379, 387 top, 408; Schwitter 180; Smith College Museum of Art, Northampton, Massachusetts 435 top; Soichi Sunami 185; Staatliche Museen zu Berlin 389 right; Staatliche Kunsthalle, Karlsruhe 176 left, 177 top right, 251 bottom, 376; Staatliches Museum, Shwerin 122 bottom: Staatsgalerie, Stuttgart 1 left, 99 right; Städelsches Kunstinstitut, Frankfort 345; Statens Museum for Kunst, Copenhagen 249, 359 top right; Stedelijk Museum, Amsterdam 42 top, 298, 343; Stedelijk Museum "de Lakenhal", Leiden 241 top; Sterling & Francine Clark Art Institute, Williamstown, Massachusetts 62 top; Stijns 243 right; Studio Littré 403 top left; Studio Lourmel, Paris 75 bottom; Szepmüvézeti Museum, Budapest 239; Tasmanian Museum & Art Gallery, Hobart 104; Tate Gallery, London 72 top, 84 right, 96, 112, 213, 228 top right, 252 bottom, 360 top, 372, 392 top, 401 bottom, 437 bottom, 440 top, 445 bottom; Thyssen–Bornemisza Collection, Lugano 306 bottom left; Tretiakov Gallery, Moscow 426 bottom left, 426 top right; O. Vaering 295 left; Victoria and Albert Museum, London 178 bottom left; Wadsworth Atheneum, Hartford, Connecticut 103, 190; Walker Art Gallery, Liverpool 179, 221; Wallace Collection, London 32, 39 left, 335; Wallraf–Richartz Museum, Cologne 443 bottom left; Whitney Museum of American Art, New York 89 right, 97, 383; Whitworth Art Gallery, Manchester 356 right; Liselotte Witzel 85 bottom, 377 right; A. J. Wyatt 58, 86 top, 107; Yale University Art Gallery, New Haven, Connecticut 183, 293 right, 414 top right; Ziolo–Percheron 436.

© A.D.A.G.P., Paris 1981 16 right, 33, 41, 59, 86 top, 95, 99 left, 105, 107, 124, 145 bottom, 165, 198, 209 right, 245 top, 270 bottom left, 283, 284, 316 right, 327 top, 356 right, 391 left, 394, 401 bottom, 403 top left, 411, 431 bottom.
© S.P.A.D.E.M., Paris 1981 12 right, 18 top, 24 left, 33, 90 left, 91, 98, 108, 117 top, 117 bottom, 180, 201 bottom, 203, 207 bottom left, 212 bottom, 219, 257, 269, 286, 287, 314 left, 316 right, 318, 319, 344, 349, 362, 375 top right, 377 right, 386, 391 left, 403 bottom, 419, 421 bottom left, 421 top right, 422, 435 top, 443 bottom left.